A CHECKLIST
OF PAINTERS
*c*1200-1976

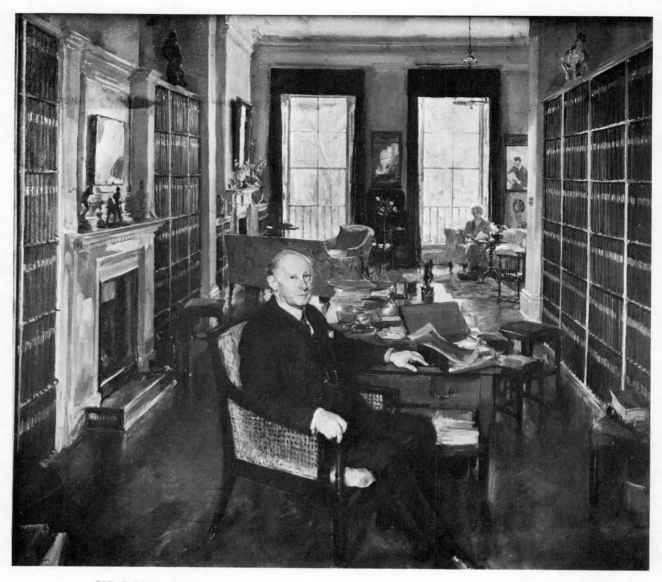

SIR ROBERT WITT IN HIS LIBRARY AT 32 PORTMAN SQUARE, LONDON
by Thomas Cantrell Dugdale. *Oil on canvas, 90 x 97.5 cm. Signed and dated 1931.*
This picture was exhibited at the Royal Academy in 1931 and presented to Sir Robert and Lady Witt
by the National Art-Collections Fund in 1932. Today it hangs in the Witt Library in the Courtauld
Institute of Art.

A CHECKLIST
OF PAINTERS
*c*1200-1976

REPRESENTED IN
THE WITT LIBRARY,
COURTAULD INSTITUTE OF ART,
LONDON

MANSELL · LONDON
1978

ISBN 0 7201 0718 0

Mansell Information/Publishing Limited,
3 Bloomsbury Place, London WC1A 2QA

First published 1978

© The Courtauld Institute of Art, London, 1978

British Library Cataloguing in Publication Data
Witt Library
 A checklist of painters *c*1200-1976 represented in
 the Witt Library, Courtauld Institute of Art,
 London.
 1. Painters – Biography
 I. Title
 759 ND35

ISBN 0 7201 0718 0

Printed in Great Britain by
The Scolar Press Limited, Ilkley, Yorkshire

CONTENTS

FOREWORD

BY SIR JOHN WITT

It is now more than 57 years since my father Sir Robert Witt published privately in 1920 the *Catalogue of Painters and Draughtsmen represented in the Library of Reproductions of Pictures & Drawings formed by Robert and Mary Witt*. This catalogue comprised the names of about 8,000 European artists from about 1200 to the 1850s, and the Library contained about 150,000 reproductions of their works. A *Supplement* incorporating all subsequent additions to the Library was published privately by my father in 1925; by that date the number of artists' names had risen to 13,000 and the reproductions exceeded 250,000. The Library was subsequently given to the Courtauld Institute of Art by my father and moved from his house at 32 Portman Square, London to Number 19 in the same square shortly after his death in 1952.

Since the 1925 supplement no further supplements to the catalogue have been published. Today there are about 50,000 artists represented in the Witt Library and the number of reproductions is now in excess of 1,200,000. The publication of an up-to-date checklist of artists' names is therefore long overdue. Such a checklist with their names, nationality, and dates will not only be an invaluable guide to the Witt Library itself, but will also act as a quick reference dictionary or a 'mini Thieme-Becker' as John Sunderland, the Witt Librarian, describes it. It will have the added value of including many artists, especially of the nineteenth and twentieth centuries, who are not recorded in Thieme-Becker or any of the standard reference dictionaries.

It may be of interest to users of this checklist to know the origins of the Witt Library. My father and mother were up at Oxford in the early 1890s and both were interested in pictures. They did not know each other well at that time, but each when travelling abroad in the vacation acquired photographs and postcards of pictures they had seen and liked. They kept these in a drawer in their homes. When in 1899 they married, they combined their little collections of photographs and postcards, the whole of which were easily contained in one chest of drawers in their flat in Westminster. After their move to 32 Portman Square, the main library was housed on the first floor but eventually much of the house including the dining-room and pantries, as well as a bedroom, was gradually invaded by library boxes.

I suppose the most radical and bold decision about the Library, which was taken by my father at an early stage, was to cut up books and catalogues and to remove the reproductions so that they could be arranged under the name of the artist concerned. If the reproductions were back to back and neither was already included in the Library, it became necessary to buy a second copy of the book or catalogue, a heavy expense if only a few back to back reproductions were involved. Nowadays, as the value of the Library has become better-known, authors and publishers often generously present a set of plates or even two sets if a back to back situation arises.

The compilation of this checklist has naturally involved John Sunderland, the Witt Librarian, and the staff of the Witt Library in a very considerable expenditure of time and effort for which I would like to express to each of them my warmest thanks.

The frontispiece of this checklist is a reproduction of the picture painted in 1931 by Thomas Dugdale of my father and mother in the Library on the first floor of 32 Portman Square. It gives an excellent idea of the L-shaped room looking out over Portman Square, not unlike the present first floor of Number 19, while the figure reflected in the mirror is the writer of this Foreword.

JOHN WITT

February 1978

INTRODUCTION

The Witt Library now contains illustrations of the work of some 50,000 European artists from about 1200 to the present and it is hoped that the following checklist of all these names will be useful. It includes the names of the artists, the national school under which they are filed in the Library, and their dates. There are now well over three times more artists' names in the Library than there were in 1925, when the only supplement to the original catalogue was published by Sir Robert Witt.

Since the Library was given to the Courtauld Institute of Art by Sir Robert Witt and moved to 19 Portman Square on his death in 1952, the collection has continued to grow. The size of the Library now stands at over 1,200,000 separate photographs and reproductions. Any collection of this size which aims to be as comprehensive as possible within its own limits is bound to contain inconsistencies and factual errors, as well as disputed and out-of-date attributions. The policy of the Library has always been, as a priority, to add as much illustrative material as possible, in the belief that it is the size of the collection which is of primary importance and that scholars and users of the Library will be able to select from the mass of material what they judge to be of relevance and interest. It is the purpose of this introduction to explain briefly the principles and scope of the Library and thus to put the present checklist into context.

In the introductory note to the *Catalogue of Painters and Draughtsmen represented in the Library of Reproductions of Pictures & Drawings formed by Robert and Mary Witt*, London, 1920, Sir Robert wrote, 'What has been attempted . . . is to form, after the analogy of the great Oxford Dictionary of the English Language, a kind of Murray's Dictionary of Pictures and Drawings, by concentrating and bringing together reproductions of, as nearly as may be, the whole body of European painting and drawing, and arranging it as a Dictionary in the manner most convenient for easy reference. As a Dictionary it has, accordingly, to include not only what is most interesting and important, and not only the work of the great but also that of the little Masters, many of them of quite secondary consideration, yet playing some part in their time, and as such contributing to the general history of the painter's craft' (page v). In building up the collection on these lines with great diligence and attention to scholarly standards, Sir Robert created a Library unique of its kind, which has proved of inestimable value to all art historians and art lovers.

Sir Robert's aims have been pursued in fundamentally the same way since the Library has been part of the Courtauld Institute, but the scope of the collection has become some-what broader. The starting date for artists included is still about 1200, but the Library now aims to cover art up to the present day, whereas Sir Robert's Library did not contain painters working after about 1850. Also, while Sir Robert aimed to include any painters who were

mentioned in the standard reference dictionaries or in monographs, the Witt Library now includes many painters who do not appear in such works, although it should be made plain that there are still many painters mentioned in the dictionaries who are not in the Library. The majority of artists who appear in the Witt, but who are not to be found in any reference work, are from the nineteenth and twentieth centuries. Many have entered the Library through its policy, which has been fundamental from the earliest days, of taking illustrations from sale catalogues and exhibition catalogues. Because of this and because of the many minor painters who are included from the whole period covered by the Library, it is hoped that this list of names will be useful not only as a guide to the Witt Library itself but also as a quick reference dictionary, however inadequate in ideal terms, to much of European art.

Although the Library aims to be as comprehensive as possible within its terms of reference, limitations of time, space, money and staff will always prevent this aim from being fully realized. Some further caveats may be mentioned. The term 'Library' is used for reasons of tradition and continuity, even though the Witt is a collection of photographs and reproductions, not of books. The scope of the collection is European or European-inspired art. This includes any painter working in the European or Western tradition of art, even if the artist lived, or lives, in Japan or South America or elsewhere in the world. The Library covers painting and drawing, but excludes architecture and sculpture. However, in certain cases the drawings of architects and sculptors are included, especially if they do not relate specifically to buildings or statues. Because it is impossible to draw the line between painters and draughtsmen on the one hand and decorative artists for example on the other, the latter are often included. Some reproductive engravers are also included, although engravings are usually filed in the Library under the name of the original artist. The major emphasis, however, is on painters and draughtsmen.

In the Library, all the photographs and reproductions are arranged first by national school and then by artist in alphabetical order within each school. This checklist, however, is arranged by artist in alphabetical order regardless of school. Because it is a transcription of the information on the artists' index cards in the Library, it must remain a provisional work to a considerable extent. Over the past twenty-five and especially over the past ten years the number of new artists added has been enormous and we are aware that, largely due to the rate of acquisition, mistakes have occurred. In the last two or three years we have been attempting to eradicate as many as possible by checking and rechecking the cards against some of the standard reference dictionaries. Amongst the works consulted are the following: Dr. Ulrich Thieme and Dr. Felix Becker, *Allgemeines Lexikon der Bildenden Künstler von der Antike bis zur Gegenwart*, Leipzig, 1907-50; Hans Vollmer, *Allgemeines Lexikon der Bildenden Künstler des XX. Jahrhunderts*, Leipzig, 1953-62; E. Bénézit, *Dictionnaire critique et documentaire des Peintres, Sculpteurs, Dessinateurs et Graveurs . . .*, France, 1966 ed. The following national dictionaries have also been consulted: Dr. Alfred von Wurzbach, *Niederländisches Künstler-Lexikon*, Vienna and Leipzig, 1906-11; Pieter A. Scheen, *Lexicon Nederlandse Beeldene Kunstenaars, 1750-1950*, The Hague, 1969; Grant M. Waters, *Dictionary of British Artists Working 1900-1950*, Eastbourne, 1975; *The Dictionary of British Artists 1880-1940*, compiled by J. Johnson and A. Gruetzner, Woodbridge, 1976.

It should be mentioned that we have not had enough time to consult all the dictionaries which have been published in recent years, although we hope to repair such omissions in future. There are many cases in which information has been found in monographs, books, museum catalogues, exhibition catalogues, sale catalogues and other works which are too numerous to mention here. Information has also been provided by the scholars, dealers and other users of the Library. Nonetheless, it would be imprudent to maintain that all the information in this checklist is absolutely accurate or entirely up-to-date in every particular. As the work of checking and correcting has progressed we have become increasingly aware of the number of errors in the index cards and the difficulty of eradicating all of them in the time at our disposal. We are, however, particularly grateful to the following for the arduous task involved: Stella Beddoe, Sheila Bruce-Lockhart, Lady Campbell, Joan Hervey, Rupert Hodge and Susan Paton. In addition, some other members of the Witt Library staff have been of great assistance and some members of the teaching staff in the Courtauld Institute have generously given advice and valuable time, in particular Professor John Shearman, who has read part of the typescript. We are also grateful to Sir John Witt, who originally suggested the idea of an updated publication and who provided encouragement throughout. The publishers, Mansell Information/Publishing Limited, have been extremely forbearing of the numerous corrections, often necessitated by our own mistakes, which have been incorporated into the checklist.

JOHN SUNDERLAND

Witt Librarian
Courtauld Institute of Art
20 Portman Square
London W1H 0BE

GUIDE FOR USERS

The checklist is basically self-explanatory, but some indications of format and usage may prove helpful. It should be pointed out that there are nearly always exceptions to the guidelines mentioned below.

NAMES

1. Double-barrelled names are treated as one name if hyphenated and as two if not with the artist being filed under the second half of his name, e.g.

> CLUSEAU-LANAUVE, Jean
> HUNT, William Holman

2. Compound names are variably treated. In the Spanish school the artist will be found under the first part of his surname and Christian name, e.g.

> GARCIA y Reynoso, Antonio
> GARCIA, Fernandez

3. Prefixes such as 'da', 'de', 'du', 'ten', 'ter', 'van', 'van de', 'van der', 'von' and so on are not normally counted as part of the surname, e.g.

> DYCK, Sir Anthony van
> BORCH, Gerard ter

But occasionally when the prefix has become incorporated into the main part of the surname, the above ruling is waived, e.g.

> VANDERBANCK, John
> DELLA BELLA, Stefano

French names with the prefix 'Le' or 'La' are usually found under 'L', e.g.

> LE BRUN, Charles
> LA TOUCHE, Gaston de

When there are variations on the ruling about prefixes, the examples set by Thieme-Becker are usually followed.

4. If the name of a town or district is incorporated into the name, the artist is usually found under his Christian name, e.g.

> LUCAS van Leyden
> LEONARDO da Vinci
> BARTOLOMMEO Veneto

Similarly when nicknames are incorporated, e.g.

> ANDREA del Sarto

But there are exceptions, e.g.

> CORREGGIO, Antonio Allegri da
> WEYDEN, Rogier van der

5. No initial comes before any initial. A title or rank comes before an initial. An initial comes before any Christian name, e.g.

> SMITH
> SMITH, Captain
> SMITH, A.
> SMITH, Albert

6. Modified vowels ä, ö, ü, are treated as a, o, u, even though in some lexicons these are treated as the same letters with e added. Whether the vowel is modified or followed by an e depends in the Witt Library index on Thieme-Becker. The French acute, grave and circumflex accents are omitted on capitals.

7. 'Mac' and 'Mc' are both treated as 'Mac' as far as alphabetical order is concerned.

8. Variations in the spelling of an artist's name are usually given, e.g.

> DANCKERTS, Dankers or Dankerts

Cross references are given from the variations to the one under which the artist is filed. But not all variations are given, usually only those in Thieme-Becker. Similarly, the Witt Library index usually follows Thieme-Becker in the spelling chosen for the prime version. Especially in old names there are, of course, no 'correct' spellings, but one version has to be selected. Variations in the spelling of Christian names are not usually given.

9. Alternative names, as opposed to variations in spelling, are usually given in brackets. This also applies to some nicknames, e.g.

> LIANO, Felipe de ('El pequeno Titiano')

But nicknames are sometimes so well known that they have become accepted as the main name, e.g.

> GUERCINO, Giovanni Francesco Barbieri

10. Artists known by their initials are filed in alphabetical order under a sub-heading 'Monogrammists' in the M's.

11. In Dutch and Flemish names IJ is treated as Y, e.g.

> RYMSDYCK, Andreas van
> RYMSDYCK, Jan van
> RIJN, Jan van (de)
> RYNE, Jan van

NATIONAL SCHOOLS

The national school or nationality under which an artist is filed in the Witt Library is primarily a guide to where the artist can be found on the shelves. It should not be seen as an authoritative ruling on nationality. There are many borderline cases which could be disputed endlessly and the guide-lines adopted in the Library to determine nationality are not entirely consistent. It should therefore be made plain that for the purposes of the Library the question of nationality is primarily one of practicality and accepted local and sometimes eccentric usage. In most cases the country of birth is taken to determine an artist's given nationality, but in some cases it is the country in which the artist spent the most significant part of his career.

The schools represented in the Library are: American (U.S.A.), Australian, British (including English, Irish, Scottish and Welsh), Bulgarian, Canadian, Czech, Dutch, Flemish, French, German (including Austrian, a distinction only sometimes made in the card index), Greek, Hungarian, Italian, Polish, Portuguese, Rumanian, Russian, Scandinavian (Danish, Finnish, Norwegian, Swedish), South African, South and Central American (including Mexican), Spanish, Swiss, Turkish and Yugoslavian. The Dutch and Flemish schools are classified under the general heading of Netherlands in the Library, but in the card index and checklist are distinguished as follows: artists from the Low Countries are all called Netherlands up to about 1610; between this date and about 1835 they are classified as Dutch or Flemish except in some cases of dispute or ambiguity, where Netherlands is still used; after about 1835 Flemish becomes Belgian. The checklist includes a few additional nationalities, such as Japanese and Vietnamese, which are filed under the general classification of Oriental.

DATES

The following table explains the style and abbreviations used for artists' dates:

1500-1550	born 1500, died 1550
1500-	born 1500; no other known dates of any relevance
-1550	died 1550; no other known dates of any relevance
c.1500-1550	born about 1500, died 1550
1500-c.1550	born 1500, died about 1550
c.1500-c.1550	born about 1500, died about 1550

1500-p.1550	born 1500, died after 1550
1500-a.1550	born 1500, died before 1550
a.1500-1550	born before 1500, died 1550
a.1500-p.1550	born before 1500, died after 1550
op.1500-1550	working from a known date of 1500 to a known date of 1550
op.c.1500-1550	working from around 1500 to 1550
op.1500-m.1550	working from a known date of 1500, died 1550
op.1500-m.a.1550	working from a known date of 1500, died before 1550
op.1500-m.c.1550	working from a known date of 1500, died about 1550
1500/1-1550	born 1500 or 1501, died 1550
c.1500/15-1550	born between 1500 and 1515, died 1550
1500/15-1550	born either 1500 or 1515, died 1550
op.1545	dated work of 1545; no other known dates of any relevance
op.c.1545	working around 1545, though no dated works
16th cent.	working in the sixteenth century; no more precise dates known

All the above dates may be followed by a question mark in brackets, i.e. (?), denoting some degree of uncertainty, often due to ambiguous or conflicting evidence.

ARRANGEMENT OF ILLUSTRATIONS IN THE WITT LIBRARY

Users of this checklist may be interested to know how the photographs and reproductions are arranged within the files of each artist. Apart from minor changes, the arrangements conform with the 'Subject Index' which Sir Robert Witt gives on page xiii of his *Catalogue of Painters and Draughtsmen represented in the Library* . . . and can be tabulated as follows:

PAINTINGS

Old Testament
Apocrypha
New Testament
 Annunciation
 Visitation
 Nativity
 Adoration of the Shepherds
 Adoration of the Magi
 Presentation
 Circumcision
 Flight into Egypt
 Massacre of the Innocents
 Christ among the Doctors
 Baptism of Christ
 Acts of Christ
 Miracles
 Parables
 Scenes from the Passion
 Deposition
 Pietà
 Burial
 Resurrection
 Appearances after Resurrection
 Ascension
Representations of Christ
 (Good Shepherd, etc.)
Last Judgement
Trinity
Life of the Virgin

Madonnas
Saints
Religious Allegories
Historical
Mythological
Allegorical
Literary
Genre
Still Life
Fruit and Flowers
Animals
Landscape
Seascape
Architecture
Portraits
Decorative Designs (Tapestry, Stage Scenery, Stained Glass, Metalwork, etc.)

DRAWINGS

Follows the same order as Paintings.

ENGRAVINGS

Usually these are filed with the paintings or drawings from which they derive. Occasionally, where the Library possesses a large amount of illustrations of engravings after an artist's work, they are arranged in a third section after drawings in the same subject order.

A CHECKLIST
OF PAINTERS
*c*1200-1976

A

AA, Dirk van der
Dutch, 1731-1809
AACK or Aeck, Johannes
Claesz. van der
Dutch, 1635/6-p.1680
AADNÄS, Peder Pedersen
Norwegian, 1739-1792
AAGAARD, Carl Frederic
Danish, 1833-1895
AARTMAN, A.
Dutch, op.1758
AARTMAN, Nicolaas
Dutch, 1713-1793
ABADIA, Juan de la
(Master of Almudévar)
Spanish, op.1473-1496
ABA-NOVAK, Vilmos
Hungarian, 1894-1941
ABÄSCH, Anna Barbara
see Abesch
ABATE de' Ferrari, 1'
see Ferrari, Lorenzo de'
ABBATE, Niccolo dell'
(Niccolino)
Italian, c.1512-1571
ABBATE, Pietro Paolo, I
Italian, 1512-c.1571
ABBATI, Giuseppe
Italian, 1836-1868
ABBATI, Vincenzo
Italian, 1803-p.1859
ABBATINI, Guido Ubaldo
Italian, c.1600-1656
ABBE, Hendrik
Flemish, 1639-p.1676
ABBEMA, Louise
French, 1858-1927
ABBEY, Edwin Austin
American, 1852-1911
ABBIATI, Alessandro Paolo
Italian, op.1686
ABBIATI, Filippo
Italian, 1640-1715
ABBOT, John
British, 18th cent.
ABBOT, John
British, 1943-
ABBOTT,
British, 16th cent.(?)
ABBOTT, Bradley
British, 19th cent.
ABBOTT, John White
British, 1763-1851
ABBOTT, Lemuel Francis
British, 1760-1803
ABEELE, Albijn van den
Belgian, 1835-1918
ABEELE, Jodocus Sebastiaen
van den
Belgian, 1797-1855
ABEILLE
French(?), 18th cent.
ABEL, d'Abelè or d'Abelle,
Ernst August
German, c.1720-c.1780
ABEL, d'Abele or d'Abelle,
E.H.
German, 1737-p.1773
ABEL, Hans
see Master of the Mass
of S. Gregory
ABEL, Josef
German, 1764-1818
ABELLON, André
French, c.1375-1450

ABELS, Jacobus Theodorus
Dutch, 1803-1866
ABERCROMBIE, Lady Julia
Janet Georgiana
British, 1840-1915
ABERDAM, Alfred
Polish, 1894-
ÅBERG, Martin
Swedish, 1888-1946
ÅBERG, Pelle
Swedish, 1909-
ABERLI, Johann Ludwig
Swiss, 1723-1786
ABESCH, Abäsch, ab Esch
or Vonesch von Sursee,
Anna Barbara
Swiss, 1706-c.1760(?)
ABESCH, Johann Peter
(Joan Petrus von Esch)
Swiss, 1666-c.1740
ABIDINE
French, 20th cent.
ABILDGAARD, Nicolai Abraham
Danish, 1743-1809
ABLETT, William Albert
French, 1877-1936
ABOM, Johan Fredrik
Swedish, 1817-1900
ABONDIO, Alessandro
German, c.1580-c.1675
ABORN, John
British, op.1885-1922
ABOT, Eugène Michel Joseph
French, 1836-1894
ABRAHAM, Tancrède
French, 1836-1895
ABRAHAMS, Ivor
British, 20th cent.
ABRAM
French, 20th cent.
ABRAM, Marthe
French, 19th cent.
ABRAMOVITZ, Albert
Russian, op.1911
ABRAMS, Joan
British, 20th cent.
ABROSIMOFF, F.
Russian, op.1680
ABRY, Léon Eugène Auguste
Belgian, 1857-1905
ABSOLON, John
British, 1815-1895
ABSOLON, Kurt
German, 1925-1958
ABT, Otto
Swiss, 1903-
ABT, Ulrich
see Apt
ACCAMA, Bernardus
Dutch, 1697-1756
ACCARDI, Carla
Italian, 1924-
ACCIACCAFERRI, Antongiacomo
Italian, op.1519-1545
ACCIUS, Cesare Antonio
Italian, op.1609
ACEVEDO or Acebedo, Manuel
Spanish, 1744-1800
ACHARD, Jean Alexis
French, 1807-1884
ACHEN, Georg Nicolai
Danish, 1860-1912
ACHEN or Aken, Johann von
(Hans von Aachen)
German, 1552-1615
ACHENBACH, Andreas
German, 1815-1910
ACHENBACH, Oswald
German, 1827-1905

ACHENER, Maurice
French, 1881-
ACHILLE
French, 19th cent.
ACHT, René Charles
Swiss, 1920-
ACHTSCHELLINCK or
Achtschellincx, Lucas
Flemish, 1626-1699
ACKE, Johan Axel Gustav
Swedish, 1859-1924
ACKER, Florimond Marie (Flori)
van, Belgian, 1858-1940
ACKER, Johannes Baptista
or Jean Baptiste van
or Johannes Baptista
Vanacker
Belgian, 1794-1863
ACKERMANN, Arthur Gerald
British, 1876-1960
ACKERMANN, George Friedrich
German, 1787-1843
ACKERMANN, Max
German, 1887-
ACKERMANN, Peter
German, 1934-
ACKLOM, A.C.
British, 18th cent.
ACKROYD, Norman
British, 20th cent.
ACLOCQUE, Paul Léon
French, 1834-p.1881
ACONTZ, Nutzi
Rumanian, 1901-
ACOSTA, A.Aguila
Spanish, 20th cent.
ACQUA, Bernardino del
see Agua
ACQUA, Cesare Félix Georges
dell'
Italian, 1821-1904
ACS, Ferencz
Hungarian, 1876-
ACZEL, George
British, 20th cent.
ADALBERT, Prince of Prussia
German, 1811-1873
ADAM, Albrecht
German, 1786-1862
ADAM, Benno
German, 1812-1892
ADAM, Bernard
British, 20th cent.
ADAM, Ed.
American, op.1870-1895
ADAM, Edward
British, 20th cent.
ADAM, Emil
German, 1843-1924
ADAM, Eugen
German, 1817-1880
ADAM, Franz
German, 1815-1886
ADAM, H.
French, op.1798
ADAM, Heinrich
German, 1787-1862
ADAM, Henri Georges
French, 1904-
ADAM, Jakob
German, 1748-1811
ADAM, James
British, 1730-1794
ADAM, Jean Victor
French, 1801-1867
ADAM, Joseph Denovan
British, 1842-1896

ADAM, Julius
German, 1852-1913
ADAM, Lambert Sigisbert
French, 1700-1759
ADAM, Patrick William
British, 1854-1929
ADAM, Robert
British, 1728-1792
ADAM, Victor Vincent
French, 1801-1866
ADAMA, N.
Dutch(?) 17th cent.(?)
ADAMEK, Johann
German, op.c.1814-m.1840
ADAMI, Valerio
Italian, 20th cent.
ADAMO, Max
German, 1837-1901
ADAMOFF, Helena
French, 20th cent.
ADAMS, Bernard
British, -1965
ADAMS, Christine
British, 20th cent.
ADAMS, Douglas
British, op.1880
ADAMS, George Gammon
British, 1821-1898
ADAMS, H.J.
British, 20th cent.
ADAMS, Harry William
British, 1868-1947
ADAMS, Henry Clayton
British, 19th cent.
ADAMS, John Clayton
British, 1840-1906
ADAMS, John Quincy
German, 1874-1933
ADAMS, L.B.
British, op.1824-1844
ADAMS, Lee
American, 1922-
ADAMS, Lucy
British, op.1815-1843
ADAMS, Norman
British, 1927-
ADAMS, R.
British, op.1820-1824
ADAMS, Robert
British, 1917-
ADAMS, W.Bridges
British, 20th cent.
ADAMS, Wayman Eldridge
American, 1883-1959
ADAMS, William Dacres
British, 1864-1951
ADAMSE, Marinus
Dutch, 1891-
ADAMSON, Dorothy
British, 19th cent.
ADAMSON, H.Violet
British, 20th cent.
ADAMSON, Sidney
British, 20th cent.
ADAN, Louis Emile
French, 1839-1937
ADANSON, Jean Baptiste
French, op.1732-1796
ADCOCK, Frederick
British, 19th cent.
ADDERTON, Charles William
British, 1866-
ADDINGTON, D.
British, 20th cent.
ADDINGTON, Sarah
British, op.1778

ADDISON, William Grylls
British, op.1876-m.1904
ADDYMAN, John
American, 20th cent.
ADE, Albrecht
German, 20th cent.
ADELE, R.
French, 19th cent.
ADELINE, Jules Louis
French, 1845-1909
ADELO, R. van
Dutch(?), op.1628
ADEMOLLO, Carlo
Italian, 1825-
ADEMOLLO, Luigi
Italian, 1764-1849
ADICKES, David
American, 1927-
ADLARD, Henry
British, 19th cent.
ADLER, C.
Dutch(?), 19th cent.
ADLER, Edmund
German, 1871-1957
ADLER, Evelyn
American, 20th cent.
ADLER, Ivan Walter
British, 20th cent.
ADLER, Jankel
Polish, 1895-1949
ADLER, Jules
French, 1865-
ADLER de Danzig, Salomon
German, op.1679-1691
ADLERSPARRE, Sophia
Adolfina
Swedish, 1808-1862
ADLOFF, Karl
German, 1819-1863
ADMIRAAL, B.
Dutch, 17th cent.
ADMIRAL, Jan l'
see Ladmiral
ADNAMS, Marion
British, 20th cent.
ADOLPH, Josef Franz
German, 1671-1749
ADOLPH, M.F.
German, op.c.1788
ADOLPHUS
British, 18th cent.
ADORNI, Francesco
Italian, op.1627
ADRENO, E.
Italian, 19th cent.
ADRIAENSEN, Jasper
Flemish, op.1620-m.1632
ADRIAENSSEN, Alexander, I
Flemish, 1587-1661
ADRIAN, Fritz
German, 1889-
ADRIAN-NILSSON, Gösta
Swedish, 1884-1965
ADRION, Lucien
French, 1889-1953
ADSHEAD, Mary
British, 1904-
ADVINENT, Etienne Louis
French, 1767-1831
ADZAK, Roy
British, 1927-
AECK, Johannes van der
see Aack
AEGERI or Egeri, Carle
or Carolus von
Swiss, c.1510/15-1562

AEGERY, Johannes von
Swiss, op.1582
AELST, Evert van
Dutch, 1602-1657
AELST, Nicolaus van
Netherlands,
c.1526(?)-c.1612/13
AELST, Coecke, Cock,
Kock or Koecke van
see Coecke van Aelst
AELST, Willem van
Dutch,
c.1625/6(?)-c.1683
AENVANCK, Theodor van
Flemish, 1633-p.1686
AERDENBERG, Wilhelm van
see Ehrenberg
AERNI, Franz Theodor
Swiss, 1853-1918
AERSSEN, Jeanne van
Flemish(?), 17th cent.
AERT or Aertgen van
Leyden
see Claesz.
AERTS or Arts, Hendrick
Netherlands, op.c.1600
AERTSEN, Dierk
Netherlands, op.1607
AERTSEN, Pieter
(Lange Pier)
Netherlands,
1507/8-1575
AERTSZ., Lambert Rycx
see Ryckx
AERTTINGER, Karl-August
German, 1803-1876
AETHER
German, 19th cent.
AFFANNI, Ignazio
Italian, 1828-1889
AFFELTRANGER, Jean
Swiss, 1874-
AFFLECK, Andrew F.
British, op.1910-1935
AFFLECK, William
British, 1869-
AFFNER
see Haffner
AFFONSO, Jorge
Portuguese, op.1508-1540
AFONSO, Nadir
Portuguese, 1920-
AFRO (Basaldella)
Italian, 1912-
AGABITI, Pietro Paolo
Italian, c.1470-c.1540
AGACHE, Alfred Pierre
French, 1843-1915
AGAM, Jacob Gipstein
Israeli, 1928-
AGAOGLU, Tektas
British, 1934-
AGAR or d'Agar, Charles
French, 1669-1723
AGAR, Eileen
British, 1904-
AGAR, Jacques d'
French, 1640-1715
AGARD, Charles-Jean
French, 1866-1950
AGASSE, Jacques Laurent
Swiss, 1767-1849
AGATA, Giovanni del
Italian, op.1778
AGAZZI, Rinaldo
Italian, op.1884-1893

AGESCY, Bernard d'
French, 1757-1828
AGGAS or Angus, Robert
British, c.1616-1679
AGGER, Knud
Danish, 1895-
AGLIO, Agostino
British, 1777-1857
AGLIO, Augustine
British, 1816-1885
AGNEAU, l'
British, 18th cent.
AGNEESSENS, Edouard
Joseph Alexander
Belgian, 1842-1885
AGNELLI, Marino
Italian, op.1501
AGNENI, Eugenio
Italian, 1819-1888
AGNESI, Flora
Italian, 20th cent.
AGNOLO di Domenico
di Donnino
Italian, 1466-c.1513
AGOSTINI
Swiss, 19th cent.
AGOSTINI, G.P.de'
Italian, op.1510-1520
AGOSTINI, Tony
Italian, 1916-
AGOSTINO da Fabriano
Italian, op.1474
AGOSTINO da Monyebello
Italian, op.1491
AGOSTINO da Rimini
Italian, op.1522
AGOSTINO Veneziano
(Agostino dei Musi)
Italian, 1490-1540
AGRASOT y Juan, Joaquin
Spanish, 1836-
AGRATE, Gian Francesco
Ferrari d'
Italian, op.1515-1547
AGRESTI, Livio (da Forli)
Italian,
op.c.1550-m.c.1580
AGRICOLA, Christoph Ludwig
German, 1667-1719
AGRICOLA, Filippo
Italian, 1776-1857
AGRICOLA, Joachim
Italian, op.1758-1785
AGRICOLA, Karl Josef
Aloysius
German, 1779-1852
AGRICOLA, Lidia
Rumanian, 1914-
AGTHE, Curt
German, 1862-
AGUA or Acqua, Bernardino del
Italian, op.1587
AGUADO, Antonio López
Spanish, op.1816
AGUADO y' la Alameda de
Osuna, Martin Lopez
Spanish, op.1815
AGUAYO, Fermin
Spanish, 1926-
AGUELI, Ivan Gustaf
Swedish, 1869-1917
AGUERO, Benito Manuel de
Spanish, 1626-1670
AGUIAR, José
Spanish, 1895-

AGUIAR, Tomas de
Spanish, op.c.1660
AGUIRRE, Domingo de
Spanish, op.c.1773-1775
AGUIRRE, Gines Andres de
Spanish, 1731-c.1785
AGUIRRE, Ignacio
Mexican, 1902-
AGUSTIN y Grande,
Francisco
Spanish, 1753-1800
AGUTTE, Georgette
French, 1867-1922
AHANI, G.
Italian, 19th cent.
AHERDAN, M.
French, 1924-
AHIL
French, 20th cent.
AHLBORN, August Wilhelm
Julius
German, 1796-1857
AHLERS-HESTERMANN, Friedrich
German, 1883-
AIFFRE, Raymond René
French, 1806-1867
AIGEN, Karl
German, 1684-1762
AIGNER, Joseph Matthäus
German, 1818-1886
AIGNER, Karl
Polish, op.1786
AIGUIER, Louis Auguste
Laurent
French, 1819-1865
AIKEN, John Macdonald
British, 1880-1961
AIKMAN, John
British, 1713-1731
AIKMAN, William
British, 1682-1731
AILLOUD, Camille
French, 1924-
AINMILLER, Max Emanuel
German, 1807-1870
AINSLEY or Ainslie, G.
British, 1799-1819
AINSLEY, Samuel James
British, a.1820-1874
AINSLIE, John
British, 1827-1834
AINSWORTH, Edgar
British, 20th cent.
AIRE, Cila d'
Swiss, 20th cent.
AIRY, Anna
British, 1882-1964
AITCHISON, Craigie
British, 1926-
AITCHISON, H.
British, 19th cent.
AITKEN, John M.
British, 20th cent.
AIWASOFFSKI (Aivazowsky),
Ivan Konstantinowitsch
Russian, 1817-1900

AIXUBERT
French, 18th cent.
AIZENBERG, Roberto
Argentinian, 20th cent.
AIZPIRI
French, 1919-
AJAY, Abe
American, 20th cent.

AJDUKIEWICZ, Sigismond
von
Polish, 1861-p.1896
AJDUKIEWICZ, Thassäus
von
Polish, 1852-1916
AJMONE, Giuseppe
Italian, 1923-
AKEN, Arnold or Arnout
van
Flemish, 18th cent.
AKEN, François (Frans)
van
Flemish, op.c.1720
AKEN, Jan van
Dutch, op.1652
AKEN, Jozef or Joseph
van
Flemish, c.1709-1749
AKERSLOOT, Jacob
Dutch, op.1704
AKERSLOOT, Willem
Outgertsz.
Dutch, op.1624-1634
AKERSTRÖM, Jonas
Swedish, 1759-1795
AKKERINGA, Johannes Evert
Hendrik
Dutch, 1864-1942
AKKERSDIJK, Jacob
Dutch, 1815-1862
AKOLO, Jimo
British, 20th cent.
AKREL, Carl Fredrik
Swedish, 1779-1868
ALAMAGNA, Giovanni de
(Johanes Alamanus)
see Giovanni de Alamagna
ALAMANNO, Pietro de
Ghoetbei
Italian, op.1471-1489
ALANKO, Uuno
Finnish, 1878-
ALASTAIR
British, 20th cent.
ALAUX, Jean
French, 1786-1864
ALAUX, Jean-Pierre
French, 1925-
ALAVOINE, Jean Antoine
French, 1776-1834
ALBA, Macrino d'
see Macrino
ALBACINI
Italian, op.1807
ALBAN, Francisco
South American, 18th cent.
ALBANESI, Ubaldo
Italian, 19th cent.
ALBANI, Francesco
Italian, 1578-1660
ALBANI, Giovanni
Battista
Italian, 1616-1661
ALBANIS de Beaumont,
Jean François
British, op.1787-c.1810
ALBEREGNO or Albaregno,
Jacopo
Italian, op.1397
ALBERI, Clemente
Italian, 1812-1850
ALBERICI, Enrico
see Albrizzi
ALBERINI or Alberino,
Giorgio
Italian, 1606-

ALBERS, Josef
American, 1888-
ALBERT, Prince of
Saxe-Coburg
British, 1819-1861
ALBERT, H.
German(?), 19th cent.
ALBERT, Henry
Swiss, 20th cent.
ALBERTI, Alberto
Italian, 1525/6-1599
ALBERTI, Antonio
(Antonio da Ferrara)
Italian, c.1390/1400-p.1449
ALBERTI, Cherubino
(Borgheggiano or
Borcheggiano)
Italian, 1553-1615
ALBERTI, Durante
(del Nero)
Italian, 1538-1613
ALBERTI, Giovanni
Italian, 1558-1601
ALBERTI di Arona,
Giuseppe
ALBERTI, Joannes Echarcus
Carolus (Jean Eugène
Charles)
Dutch, 1781-p.1843
ALBERTI, Michele
Italian, 16th cent.
ALBERTI, Pierfrancesco
Italian, 1584-1638
ALBERTI, Pietro
Italian, 1553-1615
ALBERTI, Rafael
Spanish, 1902-
ALBERTINELLI,
Bigio di Bindo
Italian, 1474-1515
ALBERTINI, Edouard
French(?), op. 1864
ALBERTIS, Sebastiano de
Italian, c.1760-p.1828
ALBERTIS, Sebastiano de
Italian, 1828-1897
ALBERTOLLI, Giocondo
Italian, 1742-1839
ALBERTONI, Paolo
Italian, 1670-p.1695
ALBERTRANDI, Anton
Polish, c.1730-1808
ALBERTS, Jakob
German, 1860-1941
ALBERTUS, Pictor
Swedish, op.1473-1509
ALBIN or Albinus,
Eleazar (Weiss)
British, op.1720-1740
ALBINET, Gabriel
French, 19th cent.
ALBONI, Paolo or Paolo
Antonio
Italian, 1670-1730/4
ALBORESI, Giacomo or Jacobo
Italian, 1632-1677
ALBRECHT, Balthasar
Augustin
German, 1687-1765
ALBRECHT, Carl
German, 1862-p.1905
ALBRECHT, Joachim
German, 1913-
ALBRIER, Joseph
French, 1791-1863
ALBRIGHT, Adam Emory
American, 1862-

ALBRIGHT, Ivan le
Lorraine
American, 1897-
ALBRIGHT, Malvin Marr
(Zsissly)
American, 1897-
ALBRIZZI or Alberici,
Enrico
Italian, 1714-1775
ALCANIZ, Miguel
Spanish, 15th cent.
ALCOCK, Edward
British, op.1750-c.1778
ALCOCK, William, British, op.1760
ALDANA, Maldonato Amadis de
Italian, 18th cent.
ALDE, Yvette, French 1911-
ALDEGREVER, Heinrich
(Trippenmeker)
German, 1502-p.1555
ALDENRATH, Heinrich Jakob
German, 1775-1844
ALDER, Emile
Swiss, 1870-1933
ALDERANI, Emanuele
Italian, op.c.1830
ALDEWERELD, Herman van
Dutch, 1628/9-1669
ALDI, Pietro
Italian, 1852-1888
ALDIN, Cecil Charles
Windsor
British, 1870-1935
ALDOBRANDI, Mauro
see Aldrovandini
ALDOBRANDO
Italian, 15th cent.
ALDRIDGE, Alan
British, 20th cent.
ALDRIDGE, Frederick James
British, 1849/50-1933
ALDRIDGE, John
British, 1905-
ALDROVANDI, Ulisse
Italian, 1772-
ALDROVANDINI or
Aldobrandi, Mauro
Italian, op.1669-1680
ALDROVANDINI, Pompeo
Italian, 1677-1735/9
ALDROVANDINI, Tommaso
Italian, 1653-1736
ALECHINSKY, Pierre
Belgian, 1927-
ALEFOUNDER, John
British, 1730-1795
ALEKSIUN, Jan Jaromir
Polish, 20th cent.
ALEMANNO, Giovanni
see Giovanni de Alamagna
ALEMANY, Pedro
Spanish, op.1492-1497
ALENIS, Tommaso de
(Il Fadino)
Italian, op.1500-1515
ALENZA y Nieto. Leonardo
Spanish, 1807-1845
ALEOTTI dall' Argenta,
Antonio
Italian, op.1498
ALEOTTI, Giovanni Battista
(Argenta)
Italian, 1546-1636
ALES or Alesch, Nikolaus
Czech, 1852-1913
ALESIO da Napoli
Italian, 18th cent.(?)

ALESSANDRI, Angelo
Italian, 19th cent.
ALESSANDRI, Innocente
Italian, c.1740-
ALESSANDRO Bresciano
see Romanino
ALESSANDRO da Farnese
see Mattia
ALESSANDRO da Padova
Italian, op.1507-1529
ALESSANDRO della Torre
see Casolani
ALESSANDRO Veronese
see Turchi
ALESSIO or Alesio de'
Marchis or da Napoli,
Benedetto
Italian, c.1671-c.1751
ALESSIO, d'Elia
Italian, 1717-1755
ALESSO d'Andrea
Italian, op.1341
ALEWIJN, A(braham)
Dutch, 1673-1735
ALEXANDER, Cosmo
British, 1724-1772
ALEXANDER, Donald
British, op.1826
ALEXANDER, Edwin J.
British, 1870-1926
ALEXANDER, Francis
American, 1800-1881
ALEXANDER, Guy
British, 1882-
ALEXANDER, Henry
American, 1860-1895
ALEXANDER, Herbert
British, 1874-1946
ALEXANDER, James E.
American, op.1831
ALEXANDER, John
British, op.1715-1752
ALEXANDER, John-White
American, 1857-1915
ALEXANDER, N.
British, 20th cent.
ALEXANDER Paduano,
Alexander Maler or
Barboni (?)
Italian, op.1564
ALEXANDER, R.D.G.
British, 19th cent.
ALEXANDER, Robert
British, 1840-1923
ALEXANDER, William
British, 1767-1816
ALEXANDER, William Cleverly
British, 1840-1916
ALEXANDRE
French, op.1693
ALEXANDRE, Louis
German 1759-1827
ALEXEÏEFF, Alexandre
Russian, 1901-
ALEXEJEFF, Alexander
Alexejewitch
Russian, 1811-1878
ALEXEJEFF, Nikolai
Mikhailovitch
Russian, 1813-1880
ALEXY, Janko
Czech, 1894-
ALF, Eusebius Johann
see Alphen
ALFANI the Elder,
Domenico
Italian, 1479/80-p.1553

ALFANI, Orazio
Italian, c.1510-1583
ALFARO y Gomez, Juan de
Spanish, 1640-1680
ALFEN, Eusebius Johann
see Alphen
ALFIAN or Arfian,
Antonio de
Spanish, op.1542-1575
ALFIERI, Benedetto
Innocente
Italian, 1700-1767
ALFIERI, C.
Italian, 20th cent.

ALFONSO de Cordoba, Jaime
(Master Alfonso; Alfonso
de Baena)
see Bru, Anye
ALFORD, Viscountess
Marian Margaret
British, 1817-1888
ALFSEN, John Martin
Canadian, 1902-
ALGARDI, Alessandro
Italian, 1602-1654
ALGAROTTI, Francesco
Italian, 1712-1764
ALGHISI
see Galasso di Matteo
Piva
ALHEIM, Jean d'
French, op.1866-m.1894
ALIANI, Lorenzo
Italian, 1825-1862
ALIBRANDO, Girolamo
(Il Raffaello de
Messina)
Italian, 1470-1524
ALIENSE, Antonio
(Vassilacchi)
Italian, 1556-1629
ALIGNY, Claude François
Théodore Caruelle d'
French, 1798-1871
ALIJ, H.v.d.
Dutch, 18th cent
ALIMBROT, Louis
see Master of the
Encarnación
ALINE
French, 18th cent.
ALIPRANDI, Giacomo
Italian, op.1566
ALIPRANDI, Giacomo
Italian, 18th/19th cent.
ALIPRANDI, Michelangelo
Italian, op.1560-1582
ALISON, David
British, 1882-1955
ALIX, Pierre Michel
French, 1762-1817
ALIX, Yves
French, 1890-
ALIZARD or Alizart, J.B.
French, op.1762-1776
ALKEMA, Wobbe Hendrik
Dutch, 1900-
ALKEN, George
British, 19th cent.
ALKEN, Henry
British, 1774-1815

ALKEN, Samuel, I
British, 1756-1815
ALKEN, Samuel, II
British, 1784-c.1823

ALKEN, Samuel Henry
(Henry Gordon)
(Miscalled Henry Alken
Junior)
British, 1810-1894

ALKEN, Seffrien John
British, 19th cent.

ALKENS, Johan Martin
Dutch, 1748-1828
ALLADIO, Gian Giacomo de
see MACRINO d'Alba
ALLAIS, Alphonse
French, 1855-1905
ALLAIS, Angelique, (née
Briceau)
French, op.1789
ALLAIS, Louis Jean
French, 1762-1833
ALLAIS, Pierre
French, op.1745-m.1781/2
ALLAN, Alexander
British, 1764-1820
ALLAN, David
British, 1744-1796
ALLAN, John
British, 18th cent.
ALLAN, R.
British, 19th cent.
ALLAN, Robert Weir
British, 1851-p.1900
ALLAN, Rosemary
British, 1911-
ALLAN, Sir William
British, 1782-1850
ALLARD, Hugo or Huych
Dutch, op.1647-m.1684
ALLARD, Reginald Geoffrey
British, 20th cent.
ALLCOTT, Walter Herbert
British, 1880-1951
ALLEBÉ, Augustus (August)
Dutch, 1838-1927
ALLEGRAIN, Etienne
French, 1644-1736
ALLEGRAIN, Gabriel
French, 1679-1784
ALLEGRETTO
see Nuzzi, Allegretto
ALLEGRI, Antonio
see Correggio
ALLEGRI, Pomponio
Italian, 1521-p.1593
ALLEGRINI, Francesco
Italian, 1587-1663
ALLEMAND, Gustave
French, 1846-1888
ALLEMAND, Hector
French, 1809-1886
ALLEN, (Miss)
American, op.c.1860
ALLEN, Andrew
British, op.c.1730
ALLEN, Boyd
American, 1931-
ALLEN, D.
British, 19th cent.
ALLEN, Daphne
British, 1899-
ALLEN, George
British, op.1712
ALLEN, George
British, 1798-1847
ALLEN, Harry Epworth
British, 1894-1958
ALLEN, J.
British, 17th cent.

ALLEN, Joseph
British, 1770-1839
ALLEN, Joseph William
British, 1803-1852
ALLEN, M.
British, 19th cent.
ALLEN, Olive
British, 20th cent.
ALLEN, Richard
British, 20th cent.
ALLEN, Robert
British, 20th cent.
ALLEN, Thomas
British, op.1767-1772
ALLEN, or Allan, Ugolin
British, 20th cent.
ALLEN, Walter-James
British, 19th cent.
ALLEROUX
French, 20th cent.
ALLEYN, Edmund
Canadian, 1932-
ALLEYNE, Francis
British, op.1774-1776
ALLFREE, G.S.
British, -1918
ALLINGHAM, Charles
British, op.1802-1812
ALLINGHAM, Helen (née
Paterson)
British, 1848-1926
ALLINSON, Adrian Paul
British, 1890-1959
ALLIS, Harry C.
American, c.1880-1938
ALLISON, Robert
British, 1901-
ALLISON, W.
British, op.1817
ALLIX, Susan
British, 1943-
ALLMAN-SMITH
see Smith
ALLOM, Thomas
British, 1804-1872
ALLONGE, Auguste
French, 1833-1898
ALLORI del Bronzino,
Alessandro
Italian, 1535-1607
ALLORI, Cristofano
Italian, 1577-1621
ALLOT, R.
German, 19th cent.
ALLOU, Gilles
French, 1670-1751
ALLPORT, Henry C.
British, op.1808-1823
ALLSTON, Washington
American, 1779-1843
ALMA-TADEMA, Anna
British, -1943
ALMA-TADEMA, Lady
Laura Theresa,(née Epps)
British, 1852-1909
ALMA-TADEMA, Sir Lawrence
British, 1836-1912
ALMAINE, Georges d'
French, 19th cent.
ALMAND(E), Charles
British, op.1777
ALMASY, Luise
German, op.1850
ALMEIDA, Feliciano d'
Portuguese, op.1684

ALMEIDO, Jose Ferraz II
de
Brazilian, 1851-1899
ALMERICO di Ventura
Italian, op.1480-m.1506
ALMOND
British, op.1739-1783
ALMOND, William Douglas
British, 1866-1916
ALOISE
Swiss, 20th cent.
ALOISI-GALANINI or
Galanino, Baldassarre
Italian, 1577-1638
ALONSO, Angel
Spanish, 19th cent.
ALONSO de Sedano
(Master of Burgos)
Spanish, 16th cent.
ALONSO de Villanueva
Spanish, op.1510-1546
ALOPHE, Marie Alexandre
French, 1812-1883
ALPENNY, Joseph Samuel
see Halfpenny
ALPERIZ, Nicolas
Spanish, 1869-p.1914
ALPHEN, Alf, Alfen or
Alwen, Eusebius Johann
German, 1741-1772
ALPHEN, Michael van
Belgian, 1840-
ALPHONS, Theodor
Polish, 1860-1897
ALQUATI, Franco
Italian, 1928-
ALS, Peter
Danish, 1726-1776
ALSINA, Ramon Marti
Spanish, 1826-1895
ALSLOOT, Denis van
Flemish, op.1599-m.c.1628(?)
ALSOP, George
British, op.1730
ALSOP, J.J.
British, -1954
ALSTON, Roland Wright
British, 1895-1958
ALT, Franz
German, 1821-1914
ALT, Jakob
German, 1789-1872
ALT, Otmar
German, 20th cent.
ALT, Rudolf von
German, 1812-1905

ALT, Theodor
German, 1846-1937
ALTAMURA, Saverio
Italian, 1826-1897
ALTBALIN
British, 19th cent.
ALTDORFER or Altdorffer,
Albrecht
German, c.1480-1538
ALTDORFFER, Erhard
German, op.1512-1561
ALTENA, Maria Engelina van
Regteren, Dutch, 1868-1958
ALTENKOPF, Joseph
Austrian, 1818-
ALTENRATH, J.H.
Dutch(?), op.1814
ALTHAUS, Franz Friedrich
Wilhelm
German, 1870-

ALTHERR, Heinrich
 Swiss, 1878-1947
ALTICJIERO da Zevio
 Italian, c.1320-c.1385
ALTINK, Jan
 Dutch, 1885-
ALTISSIMO, Cristofano
 (di Papi) dell'
 Italian, op.1552-m.1605
ALTMANN, Alexandre
 Russian, 1885-
ALTMANN, Anton, II
 Austrian, 1808-1871
ALTMANN, F.
 German, 15th cent.
ALTMANN, Joseph
 Austrian, 1795-1867
ALTMANN, Karl
 German, 1800-1861
ALTMANN, Nathan
 Russian, 20th cent.
ALTMUTTER, Franz
 German, 1746-1817
ALTO, Monsù
 Italian, 17th cent.
ALTOBELLO, Francesco
 Antonio
 Italian, 1675-1692
ALTOMONTE, Bartolomeo
 Austrian, 1702-1779
ALTOMONTE, Martino
 Italian, 1657-1745
ALTOON, John
 American, 1925-
ALTSON, Aby
 British, op.c.1896
ALTSON, Daniel Myer
 British, 1881-
ALUNNO
 see Niccolò di
 Liberatore
ALUNNO di Andrea
 Italian, 15th cent.
ALUNNO di Benozzo
 (Master Esiguo or
 Amadeo da Pistoia)
 Italian, op.c.1470-1490
ALUNNO di Domenico
 see Bartolommeo di
 Giovanni
ALVA
 German, 1901-
ALVAR
 French, 20th cent.
ALVARADO, Jose Lorenzo
 Venezuelan, op.c.1795-1816
ALVAREZ y Catalan,
 Luis
 Spanish, 1836-1901
ALVAREZ, Cesar Mazola
 Cuban, 20th cent.
ALVAREZ, Lorenzo
 Spanish, op.c.1638
ALVARO di Piero, de
 Pedro or Pires
 Portuguese, op.1411-1434
ALVARO, Vicente
 Spanish, op.1784-1789
ALVENSLEBEN, Oscar von
 German, a.1840-1903
ALVES, James
 British, c.1738-1808
ALVIANI, Getulio
 Italian, 1939-
ALWASOFFSKI, Ivan
 Konstantinovich
 Russian, 1817-1900

ALWEN, Eusebius Johann
 see Alphen
ALIJ, H. v.d.
 Dutch, 18th cent.
AMADEO da Pistoja
 see Alunno di Benozzo
AMADEO, Giuseppe
 Italian, 18th cent.
AMADIO, Andrea
 Italian, op.1415
AMALIE von Sachsen-
 Koburg-Gotha, Princess
 German, 1848-1894
AMALTEO, Girolamo
 Italian, op.1542
AMALTEO, Pomponio
 Italian, 1505-1588
AMAN, Theodor
 Rumanian, 1831-1891
AMAN-JEAN, Edmond-
 François
 French, 1860-1935
AMAND, Jacques François
 French, 1730-1769
AMANS, Jacques
 American, 1801-1888
AMANT
 French, 18th cent.(?)
AMARAL, Tarsila do
 Brazilian, 20th cent.
AMATO, Francesco
 Italian, 17th cent.
AMATO, Giovanni
 Antonio, I d'
 Italian, c.1475-c.1555
AMATO, Giuseppe d'
 Italian, 17th cent.
AMATRICE, Cola dall'
 (Niccolò di Filotesio)
 Italian, 1489-1559
AMAURY-DUVAL, Eugène
 Emmanuel
 French, 1808-1885
AMBERG, Wilhelm
 German, 1822-1899
AMBERGER, Christoph
 German, c.1500-1561/2
AMBERGER, Gustave
 German, 1831-1896
AMBIANUS
 see Dubois, François
AMBIVERI, Cristoforo
 Italian, 1718-1744
AMBLING, Karl Gustav
 (von)
 see Amling
AMBROGI, Domenico
 (Menichino del Brizio)
 Italian, c.1600-p.1678
AMBROGIANI, Pierre
 French(?), 1907-
AMBROGIO d'Asti
 Italian, 16th cent.
AMBROGIO di Baldese
 Italian, 1352-1429
AMBROGIO di Baldese,
 Pseudo
 Italian, 15th cent.
AMBROGIO di Cremona
 Italian, 15th cent.
AMBROGIO da Fossano
 see Borgognone
AMBROGIO, Monaco
 Italian, 17th cent.
AMBROGIO or Ambrosi,
 Pietro di Giovanni
 see Pietro

AMBROGIO da Predis
 see Predis
AMBROISE, Ambroos or
 Ambrose, Master
 French, op.1530-1538
AMBROSE, C.
 British, op.1824-1848
AMBROSI, Marco degli
 see Melozzo da Forlì
AMDEN, Otto Meyer
 Swiss, 1885-1933
AMEDEO da Pistoia
 Italian, 15th cent.
AMEGLIO, Merio
 Italian, op.1930
AMELIN, Albin
 Swedish, 1902-
AMELING, Karl Gustav
 (von)
 see Amling
AMENDE or Amendo
 see Ende, Johann
 Heinrich
AMENDOLA, Giulio di
 Italian, 15th cent.
AMERICO, Don Pedro di
 Figuiredo
 Portuguese, 1843-1905
AMERIGHI
 see Caravaggio
AMERINGIUS, Petrus
 see Heyden, Pieter van
 der
AMERLING, Friedrich von
 Austrian, 1803-1887
AMES, Ezra
 American, 1768-1836
AMES, Joseph Alexander
 American, 1816-1872
AMESEDER, Eduard
 German, 1856-
AMICI, Domenico
 Italian, 1808-p.1858
AMICIS, Christoforo de
 Italian, 1902-
AMICO Friuliano del
 Dosso
 Italian, op.c.1500
AMICONI, Jacopo
 see Amigoni
AMIDANO, Giulio Cesari
 Italian, 1566-1630
AMIDANO, Luigi
 Italian, op.c.1640-1650
AMIET, Kuno
 Swiss, 1868-1961
AMIGONI or Amiconi, Jacopo
 Italian, 1675-1752
AMIGONI, Ottavio
 Italian, 1605-1661
AMLING, Ambling or Ameling,
 Karl Gustav (von)
 German, 1651-1702
AMMAN, Jost
 Swiss, 1539-1591
AMMANATI, Bartolommeo
 Italian, 1511-1592
AMMANN, Eugen
 Swiss, 1882-
AMMANN, Johann Conrad
 German, 1669-1724
AMMANN, Marguerite
 Swiss, 1911-
AMMON, Konrad
 German, op.1611-1622
AMNCHASTEGUI, Axel
 Argentine, 20th cent.

AMOEDO, Rodolpho
 Portuguese, 19th cent.
AMOGOLI, Stefano
 Italian, op.c.1600
AMON, Rosalia
 Italian, 1825-
AMOROSI, Antonio
 Italian, c.1660-p.1736
AMORT, Kaspar, I
 German, 1612-1675
AMOS, Imre
 Hungarian, -1946
AMPENBERGER, Iris
 South African, 20th cent.
AMPICHL, J.
 German, op.c.1840
AMSDEN, Candy
 British, 20th cent.
AMSHEWITZ, John Henry
 British, 1882-1942
AMSLER, Samuel
 Swiss, 1791-1849
AMSTEL, Jan van
 (Jan de Hollander;
 possibly identified
 with Master of the
 Brunswick Monogram)
 Netherlands,
 op.1527-m.a.1544(?)
AMUCHASTEGUI, Axel
 Mexican, 20th cent.
ANASTASI, Auguste Paul
 Charles
 French, 1820-1889
ANCELET
 French, op. 1900
ANCELOT, Marguerite
 Virginie, (née Chardon)
 French, 1792-1875
ANCHER, Anna Kirstine,
 (née Brøndum)
 Danish, 1859-1935
ANCHER, Michael Peter
 Danish, 1849-1927
ANCKARSVARD, Johann August
 Swedish, 1783-1874
ANCONA, Vito d'
 Italian, 1825-1884
ANCONITANO, Girolamo
 see Bonini
ANDERBOUHR, Paul-Jean
 French, 1909-
ANDERLE, Jiri
 Czech, 1936-
ANDERLECHT, Englebert van
 Belgian, 1918-1961
ANDERS, Ernst
 German, 1845-1911
ANDERSEN, Mogens
 Danish, 1916-
ANDERSEN, Peder
 (Peder Nordmand)
 Norwegian, op.c.1680-m.1694
ANDERSEN, Robin Christian
 German, 1890-1969
ANDERSEN-LUNDBY, Anders
 Danish, 1841-1923
ANDERSON, Abraham A.
 American, 1847-1940
ANDERSON, Andrew Arthur
 South African, 20th cent.
ANDERSON, Karl
 American, 1874-
ANDERSON, J.
 British, 19th cent.
ANDERSON, J.C.
 British, 19th cent.

ANDERSON, Karl (Göte)
Swedish, 1904-
ANDERSON, Nils
Swedish, 1817-1865
ANDERSON, Percy
British, op.1886
ANDERSON, Ralph
American, 20th cent.
ANDERSON, Ronald Lee
American, 1886-1926
ANDERSON, Stanley
British, 1884-1966
ANDERSON, T. Percival
British, 20th cent.
ANDERSON, Mrs Walter
(Sofie)
British, 1823-c.1898
ANDERSON, William
British, 1757-1837
ANDERSON, William
British, 19th cent.
ANDERSSON, Anders Gustaf
Swedish, 1780-1833
ANDERSSON, Lennart
Swedish, 1915-
ANDERSSON, Oskar
Swedish, 1877-1906
ANDERTON, Henry
British, 1630-p.1665
ANDOR, Sugár
Hungarian, 1903-1944
ANDRE, Albert
French, 1869-1954
ANDRE, Carl
American, 1935-
ANDRE, Dietrich Ernst
(Theodoricus Ernst
Andrae)
German, c.1680-p.1735
ANDRE, Edmond Marthe
Alphonse
French, 1837-1877
ANDRE, Eugène
French, 19th cent.
ANDRE, Gaston
French, 20th cent.
ANDRE, James Paul
British, op.1823-1859
ANDRE, Jean
(Frère André)
French, 1662-1753
ANDRE, John
British, 1751-1780
ANDRE, Jules
French, 1807-1869
ANDRE, Master
German, op.c.1410-1425
ANDRE, Rudolf
Hungarian, 1873-
ANDREA, Abate
see Belvedere
ANDREA d'Agnolo
see Andrea del Sarto
ANDREA d'Ancona nella
Marca
see Lilio
ANDREA da Ancona or
Antonio da Andrea or
Nicola di Maestro
Antonio
(Possibly identified
with Andrea Toscano)
Italian, op.1472
ANDREA, Angelo d'
Italian, 1880-

ANDREA d'Assisi
see Ingegno
ANDREA di Bartolo
Italian, op.1389-m.1428
ANDREA da Bologna
Italian, op.1369-1372
ANDREA del Castagno
Italian, 1423-1457
ANDREA di Cioni
see Orcagna
ANDREA di Cosimo
(Feltrini)
Italian, c.1490-c.1554
ANDREA da Fiesole
see Ferrucci
ANDREA (Bonaiuto) da
Firenze
Italian, op.c.1343-1377
ANDREA di Giovanni da
Orvieto
Italian, op.1387-1417
ANDREA di Giovanni da
Perugia
Italian, op.c.1490-1498
ANDREA di Giusto Manzini
Italian, op.1424-1455
ANDREA da Lecce
Italian, op.1450-1473
ANDREA de'Licio
see Andrea da Lecce
ANDREA di Luigi
see Ingegno
ANDREA di Mantova
see Zoan
ANDREA di Michelangiolo
Italian, op.c.1500
ANDREA da Milano
see Solario
ANDREA da Murano
Italian, op.1462-1507
ANDREA di Niccolò di
Giacomo
Italian, op.1424-1455
ANDREA, Nicolaus
German, op.1573-1606
ANDREA da Salerno
see Sabatini
ANDREA da Salerno
see Salaj
ANDREA del Sarto
(Andrea d'Agnolo)
(Andreas Angeli
Francisci)
Italian, 1486-1530
ANDREA Toscano
see Andrea da Ancona
ANDREA di Niccolo da
Viterbo
Italian, op.1465
ANDREANI, Andrea
Italian, op.1584-1610
ANDREANI, Carlo
Italian, 1905-
ANDREAS, Rico or
Rizzo (Rico or Richo
de Candia)
Greek, 16th cent.
ANDREASI, Andreasino,
Andreazio or Andreazzi,
Ippolito
Italian, 1548-1610
ANDREESCU, Ion
Rumanian, 1850-1882
ANDREIS, Alex de
British, op.c.1922

ANDREJENKO, Mikhail
Russian, 1895-
ANDREOLI, Attilio
Italian, 1877-
ANDREOTTI, Federigo
Italian, 1847-1930
ANDREOZZI, Antonio
Francesco
Italian, 18th cent.
ANDREU, Mariano
Spanish, 1888-
ANDREW, H.
British, 1868-
ANDREW, J.W.
British, op.c.1812
ANDREWS, A.
American, op.c.1849
ANDREWS, Douglas
Sharpus
British, 1885-1944
ANDREWS, George Henry
British, 1816-1898
ANDREWS, Henry
British, op.1797-1828
ANDREWS, Henry
British, op.1830-1868
ANDREWS, James
British, 1801-1876
ANDREWS, John
British, op.1852
ANDREWS, Joseph
American, 1806-1873
ANDREWS, Lilian
British, 1878-
ANDREWS, Michael
British, 1928-
ANDREWS, P.
American(?), op.1765
ANDREWS, R.C.
British, op.1792-1798
ANDREWS, Samuel
British, c.1750-p.1807
ANDREWS, Sperry
American, 1917-
ANDREY-PREVOST, Fernand
French, 20th cent.
ANDRI, Ferdinand
Austrian, 1871-1956
ANDRIES, Michael
Dutch, op.1748
ANDRIESSEN, Anthonie
Dutch, 1746-1813
ANDRIESSEN, Christiaan
Dutch, 1775-1846
ANDRIESSEN or Andriesz,
Juriaan
Dutch, 1742-1819
ANDRIESZ, Hendrick
(Manke Heyn)
Flemish, 1607-1655
ANDRIEU, Bertrand
French, 1761-1822
ANDRIEU, Pierre
French, 1821-1892
ANDRIEUX, Clement-
Auguste
French, 1829-p.1880
ANDRIOLI, Girolamo
Italian, op.c.1600
ANDRIOLLI, Elviro
Michael
Polish, 1836-1893
ANELAY, Henry
British, op.1858-1873

ANELLI, Francisco
(Francis Annellio)
American, c.1805-
ANESI, Paolo
Italian, op.1725-1766
ANESI, Pseudo
Italian, op.c.1750
ANETHAN, Alix d'
Belgian, 1848-1921
ANETTI
French, 18th cent.
ANFOSSO
French, 20th cent.
ANGAS, George French
Australian, 1822-1886
ANGEL, Philips
Dutch, 1616-c.1683
ANGELETTI, Pietro
Italian, op.c.1758-1786
ANGELI, Filippo de
Liano d'
(Il Napoletano)
Italian, c.1600-c.1640
ANGELI, Giuseppe
Italian, c.1709-1798
ANGELI, Heinrich von
Austrian, 1840-1925
ANGELI, Lorenzo degli
see Lorenzo Monaco
ANGELI, Fra Marino
Italian, op.1448
ANGELI del Moro,
Battista
see Angolo
ANGELI, Pietro di
Simone degli
Italian, 18th cent.
ANGELICO, Fra Giovanni
da Fiesole
Italian, 1387-1455
ANGELIS, D. de
Italian, op.1875
ANGELIS, Domenico
de
Italian, op.1803
ANGELIS, Giuseppe de
Italian, 17th cent.
ANGELIS, Pieter
see Angillis
ANGELL, Helen Cordelia,
(née Coleman)
British, 1847-1884
ANGELO di Lorentino
d'Arezzo
Italian, op.1513-m.1527
ANGELO di Michele d'
Angelo da Poggibonsi
see Montorsoli
ANGELO da Siena
see Macagnini, Angelo
di Pietro di Angelo
ANGELUCCI, Camillo
Italian, 16th cent.
ANGELUCCI, Gaspare
Italian, 16th cent.
ANGELUCCIO
Italian, 17th cent.
ANGERMEYER or Angermayer,
Johann Adalbert or
Albert
German, 1674-c.1740
ANGHELUTA, Octavian
Rumanian, 1902-
ANGILLIS or Angelis,
Pieter
Flemish, 1685-1734

ANGIOLI
Italian, 17th cent.
ANGIOLINO, Angiolo
Italian, op.1792
ANGIOLINI, Napoleone
Italian, 1797-1864
ANGIOLINI, Pietro
Italian, op.1801-1803
ÄNGKVIST, Olle
Swedish, 1922-
ANGLADA-CAMAROSA,
Ermengildo (Hermen)
Spanish, 1873-
ANGLER, Gabriel
(Master of the
Pollinger Tafeln)
German, op.c.1450
ANGLES, Matthäus des
French, 1667-1741
ANGLOIS, Guillermo
Spanish, 18th cent.
ANGO or Angot, Robert(?)
French, 18th cent.
ANGOLO, Agnolo or
Angeli del Moro,
Battista (Gian
Battista)
Italian, op.1562
ANGOLO del Moro, Giulio
Italian, op.1618
ANGOLO del Moro, Marco
(Marco Angelo or
Angeli del Moro)
Italian, op.1565-1586
ANGOT, Robert
see Ango
ANGRAND, Charles
French, op.1887-1901
ANGST, Carl
Swiss, 1875-
ANGUIANI, P.
Italian, op.c.1600
ANGUIANO, Raúl
Mexican, 1909-
ANGUIER, François
French, 1604-1669
ANGUIER, Michel
French, 1612-1686
ANGUILLA, Francesco
Andrea di
see Francesco Lola
ANGUISCIOLA, Angosciola
or Angussola, Lucia
Italian, -1565
ANGUISCIOLA, Angosciola
or Angussola, Sofonisba
(Moncada and Lomellino)
Italian, 1527(?)-p.1623
ANGUISSOLA, B.
Italian, 18th cent.
ANGUS, Rita
New Zealand, 1908-
ANGUS, William
British, 1752-1821
ANHALT-DESSAU, Princess
Marie Eleanore von
see Radziwill
ANIEMOLO, Vincenzo
(Vincenzo da Pavia)
Italian, op.1542
ANIL, Gamini Jayasuriya
French, 1944-
ANISFELD, Boris
Israelewitsch
American, 1879-

ANKARCRONA, Sten
Gustaf Herman
Swedish, 1869-1933
ANKELEN, Eugen
German, 1858-1942
ANKER, Albert
Swiss, 1831-1910
ANKER, Johann Baptist
Austrian, op.1790-1793
ANNA, Baldassare d'
Italian, op.c.1560
ANNA, Vito d'
Italian, 1720-1769
ANNAN, J.Craig
British, 19th cent.
ANNAND, Carol
British, 20th cent.
ANNE, L.
French, 20th cent.
ANNE, Marie
British(?), op.1840-1851
ANNENKOFF, Yuri
Russian, 1890-
ANNESLEY, C.
British, op.1850
ANNETTI
German, 18th cent.
ANNIGONI, Pietro
Italian, 1910-
ANNOIS, Leonard Lloyd
British, 1906-1966
ANNONI, Felice
Italian, 18th cent.
ANNONI, Michele
Italian, op.1774-1786
ANQUETIN, Louis
French, 1861-1932
ANRAADT or Anraedt,
Pieter van
Dutch, op.1660-m.1678
ANREITER, Alois von
Austrian, 1803-1882
ANREP, Boris
Russian, 20th cent.
ANRIQUES, Francisco
see Henriques
ANROOY, Anton Abraham
van
Dutch, 1870-1949
ANSALDO, Andrea
Italian, 1584-1638
ANSALONI or Anselini,
Vincenzo
Italian, op.c. 1600
ANSDELL, Richard
British, 1815-1885
ANSE, Felix
French, 19th cent.
ANSELIN, Jean-Louis
French, 1754-1823
ANSELL, Charles
British, op.1780-1787
ANSELMI, Giorgio
Italian, 1723-1797
ANSELMI, Michelangelo
(Michelangelo da Siena or
da Lucca or Lo Scalabrino)
Italian, 1491-1554
ANSELMO
Italian, 1921-
ANSELMO di Giovanni
di Giacobbe
Italian, op.1470-m.1491
ANSHUTZ, Thomas Pollock
American, 1851-1912

ANSIAUX, Jean Joseph
Eléonore Antoine
(Antoine)
French, 1764-1840
ANSINGH, Maria Elisabeth
Georgina (Lizzy)
Dutch, 1875-1959
ANSON, Anne Margaret
Coke, Viscountess
British, 18th cent.
ANSON, F.V.
British, 19th cent.
ANSON, Mark
British, 19th cent.
ANSOVINO da Camerino
Italian, op.1487
ANSPACH, Jean Louis
German, 1795-1873
ANSTED, William Alexander
British, op.1888-1893
ANSTEY-DOLLAND, W.
British, op.1879-1889
ANSUINO da Forlì
Italian, 15th cent.
ANTAL, Ilona
Hungarian, 1932-
ANTES, Horst
German, 1936-
ANTHONISSEN, Arnoldus
van
Dutch, op.1662-1669
ANTHONISSEN, Hendrick
van
Dutch, 1605/6-p.1656
ANTHONISZ., Cornelis
(Cornelis Teunissen,
Teunisz. or Theunissen)
Netherlands,
c.1499-p.1556
ANTHONY of Crete
Greek, op.1544
ANTHONY, George Wilfred
(Gabriel Tinto)
British, 1810-1859
ANTHONY, Henry Mark
British, 1817-1886
ANTHONY, William
American, 20th cent.
ANTIER, V.
French, op.1699
ANTIGNA, Alexandre
French, 1817-1878
ANTINORI or Antinoro,
Giovanni
Italian, op.1566
ANTINOZZI
Italian, 18th cent.
ANTIQUUS, Johannes
Dutch, 1702-1750
ANTOHI, Richard
Italian, 1929-
ANTOINE, Montas
Haitian, 1926-
ANTOINE, Otto
German, 1865-c.1940
ANTOIOSI ALEONIS (?)
Italian, op.1521
ANTOKOLSKI, Markus
Russian, 1843-1902
ANTOLCIC, Ivan
Yugoslav, 20th cent.
ANTOLINEZ y Sarabia,
Francisco (Ochoa de
Meruelo y Antolinez)
Spanish, 1644-1700

ANTOLINEZ, José
Spanish, 1639-1676
ANTOLINI di Faenza,
Filippo
Italian, 1786-1859
ANTON
German, 19th cent.
ANTON, Frater, a Sto.
Joanne
Polish, 1593-p.1630
ANTONAZZO or Antoniazzo
Romano (di Benedetto
Aquilio)
Italian, op.1461-m.1508/9
ANTONELLO da Messina
Italian, c.1414-1493
ANTONELLO da Palermo
(Antonello Panormita)
Italian, op.1497-1528
ANTONELLO, R(oartis)?
Italian, 15th cent.
ANTONELLO de lu Re
see Giuffrè
ANTONELLO de Saliba
see Antonio de Saliba
ANTONELLO da Serravalle
Italian, op.c.1485
ANTONI, Antonio degli
Italian, op.1812
ANTONI, Ib.
Danish, 20th cent.
ANTONI, Louis Ferdinand
French, op.1908-1937
ANTONI of Wroclaw
ANTONIANI, Francesco
Italian, -1805
ANTONIANI, Pietro
Italian, -1805
ANTONIN (Pater or
Kapuzinerpater)
French, 17th cent.
ANTONINI, Pietro
Italian, op.1771
ANTONIO di Agostino di
Ser Giovanni da Fabriano
see Antonio da Fabriano
ANTONIO da Alatri
Italian, 15th cent.
ANTONIO da Ancona,
Francesco d'
Italian, 14th cent.
ANTONIO da Andrea
see Andrea da Ancona
ANTONIO da Bologna, Fra
Italian, op.1434-m.1467
ANTONIO da Bologna(Rimpacta)
Italian, op.1509
ANTONIO da Brescia,
Giovanni
Italian, 16th cent.
ANTONIO de Bruxelas
see Wyngaerde, Antonius
van den
ANTONIO di Calvis
see Calvis
ANTONIO del Cerajola
Italian, 16th cent.
ANTONIO della Corna
Italian, op.c.1469-1491
ANTONIO da Crevalcore
see Leonelli
ANTONIO di Donnino di
Domenico Mazzieri
Italian, op.1525-m.1547
ANTONIO dal Dos
Italian, op.1794

ANTONIO da Fabriano
(Antonio di Agostino
di Ser Giovanni da
Fabriano)
Italian, op.1450-1485
ANTONIO da Faenza
(Antonio di Mazzone de'
Domenichi)
Italian, op.1515-1525
ANTONIO Federighi or
di Federigo dei Tolomei
Italian, c.1420-1490
ANTONIO da Ferrara
see Alberti, Antonio
ANTONIO da Firenze
(Antonius de Florentia)
Italian, 15th cent.
ANTONIO di Giusa
Italian, op.1428-1467
ANTONIO de Hollanda
Portuguese, 16th cent.
ANTONIO da Imola
Italian, op.1470
ANTONIO del Maestro
(Antonio di Eglio?)
Italian, 14th cent.
ANTONIO Massari
see Antonio da Viterbo
ANTONIO da Messina
Italian, op.c.1500
ANTONIO da Monte Oliveto,
Fra
Italian, 15th cent.
ANTONIO da Monza, Fra
Italian, op.c.1500
ANTONIO da Negroponte
Italian, 15th cent.
ANTONIO da Padova
Italian, 14th cent.
ANTONIO da Pavia
Italian, op.1514-1528
ANTONIO or Antonello
de Saliba
Italian, 1466/7-p.1535
ANTONIO da Tisoio
Italian, op.1512
ANTONIO da Trento
Italian, c.1508-p.1550
ANTONIO da Udine
Italian, -1411(?)
ANTONIO Veneziano
(Antonio di Francesco
da Venezia)
Italian, op.1370-1388
ANTONIO Vicentino
(Tognone)
Italian, op.c.1580
ANTONIO da Viterbo
Italian, op.c.1450
ANTONIO (Massari) da
Viterbo (Pastura)
Italian, c.1460-m.1516
ANTONIO, Zoan
Italian, 16th cent.
ANTONISSEN, Henricus
Josephus
Flemish, 1737-1794
ANTONOZZI
Italian, op.1730
ANTRAL, Louis Robert
French, 1895-1939
ANTROPOFF, Alexei
Petrovitsch
Russian, 1716-1795
ANTUM, Aert van
Dutch, op.1604-1618

ANTUNES, Bartolomeu
Portuguese, 18th cent.
ANTY, Henri d'
French, 1910-
ANUSZKIEWICZ, Richard
American, 1930-
ANWANDER, Johann
German, c.1715-c.1770
APARICIO, José
Spanish, 1773-1838
APELDOORN, Jan
Dutch, 1765-1838
APOIL, Charles Alexis
French, 1809-1864
APOL, Lodewijk Franciscus
Hendrik (Louis)
Dutch, 1850-1936
APOLINAIRE, Guillaume
French, 19th cent.
APOLLONIO di Giovanni
di Tomaso
Italian, 1415-1465
APOLLONIO, Giacomo
Italian, c.1583-1654
APONTE, Pedro de
Spanish, 15th/16th cent.
APOSTOL, Nicolae
Dutch, 20th cent.
APOSTOOL, Cornelis
Dutch, 1762-1844
APPEL, Christiaan
Karel (Karel)
Dutch, 1921-
APPEL, Jacob
Dutch, 1680-1751
APPEL, Johann Joseph
Dutch, op.1767
APPEL, Wilhelmine
Caroline Amalie (Amalie),
(née Tischbein)
see Tischbein
APPELIUS, Johannes
Dutch, op.1774-1790
APPELMAN, Bartholomeus or
Barend (Hector)
Dutch, 1640-1686
APPERLEY, C.J.
British, op.c.1835
APPERLEY, George Owen
Wynne
British, 1884-1960
APPERT, Eugène
French, 1814-1867
APPIA, Adolphe
Swiss, 1862-1928
APPIAN, Jacques Barthélémy
(Adolphe)
French, 1818-1898
APPIANI, Andrea, I
Italian, 1754-1817
APPIANI, Andrea, II
Italian, 1817-1865
APPIANI, Giuseppe
Italian, 1701-1786
APPIANI, Niccolò
Italian, op.c.1510
APPIER, Jean (Hanzelet)
French, 1596-1630
APPLEBEE, Leonard
British, 1914-
APPLEBY, Ernest W.
British, op.1885-1907
APPLEYARD, Frederick
British, 1874-1963
APSHOVEN, Ferdinand, II,
van
Flemish, 1630-1694

APSHOVEN, Thomas (also
erroneously, Theodor)
van
Flemish, c.1622-1664/5
APT or Abt, Ulrich, I
German, op.1486-m.1532
APT or Apt, Ulrich, II
(Master of the Rehlingen
Altarpiece and of the
Regensburger
Demherrnporträts)
see also Master of the
Angrer Portrait
German, op.1512-1520
AQUILA
see Halen, Arnoud van
AQUILA, Francesco Faraone
Italian, op.1690-1740
AQUILA, Johannes
Hungarian, op.1392-1405
AQUILA, Pietro
Italian, -1692
AQUILA, Pompeo dell'
see Cesura
AQUILANO
see Cesura
AQUILES, Julio de
(Julio Romano)
Spanish, op.1533-1546
AQUILI, Evangelista
Italian, op.1524
AQUILIO, Marcantonio
Italian, op.1511-1514
ARAGON, Juan de
Spanish, op.c.1580
ARAGONESE, Sebastiano, di
Ghedi
Italian, 1523-p.1567
ARAKAWA, Shusaku
Japanese, 1936-
ARALDI, Alessandro
Italian, c.1460-p.1528
ARALDI, Josaphat
Italian, op.1519
ARANDA, José Jimines
Spanish, 1837-1903
ARANDA, Luis Jimines
Spanish, 19th cent.
ARANGO, José Maria
Spanish, c.1787-p.1829
ARANOVA, Ulia
Russian, 20th cent.
ARAPOFF, Alexis
Pawlowitsch
Russian, 1904-
ARAPOV, Anatolii
Russian, 1876-1949
ARATA, F.
French(?), 18th cent.
ARATYM, Hubert
German, 20th cent.
ARBAS, Avni
French, 1919-
ARBIEN, Hans or Johan
Norwegian, 1713-1766
ARBO, Peter Nicolai
Norwegian, 1831-1892
ARBOIS, Jean d'
French, op.1373-1375
ARBORELIUS, Olof Per
Ulrik
Swedish, 1842-1915
ARCAGNUOLO
see Orcagna
ARCANGELO di Cola da
Camerino
Italian, op.1416-1421

ARCANGELO, Alan d'
American, op.1963
ARCHAMBAULT, Louis
Canadian, 1915-
ARCHENAULT, Adrien
Francois
Théodore
French, 1825-p.1879
ARCHER, Anna
British, 19th cent.
ARCHER, Archibald
British, op.c.1810-1845
ARCHER, James
British, 1823-1904
ARCHER, John Wykeham
British, 1806-1864
ARCHIPENKO, Alexander
American, 1887-1964
ARCHIPOV, Abram
Jefimowitsch
Russian, 1862-1930
ARCIERO, Matteo
Italian, 17th cent.
ARCIMBOLDO, Giuseppe
Italian, c.1530-1593
ARCO, Alonso del
(El Sordillo de
Pereda)
Spanish, op.1878-1881
ARCO, Carlo d'
Italian, op.c.1827
ARCOS y Megalde,
Santiago
Spanish, op.1878-1881
ARCUCCIO or Artuzzo,
Angelillo
Italian, op.1464-1492
ARDEMANS, Baroness
British, op.1788-1812
ARDEN, the Rev.
British, 19th cent.
ARDENTI, Alessandro
Italian, op.1565-m.1595
ARDIN, Johann Friedrich
German, 18th cent.
ARDIZZONE, Charlotte
British, 1945-
ARDIZZONE, Edward
British, 1900-
ARDON, Mordechai
Polish, 1896-
AREGIO, Pablo de
see Paolo da San
Leocadio
ARELLANO, Juan de
Spanish, 1614-1676
ARENAL, Luis
Mexican, 1908-
ARENDS, Jan
Dutch, 1738-1805
ARENDTSON, Cornelius
Swedish, op.1611-1633
ARENIUS, Olof
Swedish, 1701-1766
ARENTSZ., (Cabel)
Arent
Dutch, 1585/6-c.1635
ARENZ, Max
German, 19th cent.
ARETUSI, Cesare
Italian, 1540(?)-1612
ARETUSI, Pellegrino
(Munari)
Italian, c.1460/5-1523
ARFIAN, Antonio de
see Alfian

ARGALL, Edward
British, op.1682
ARGENCE, Eugène d'
French, 1853-c.1920
ARGENT, J.F.
British, op.1885
ARGENTA
see Aleotti, Giovanni
Battista
ARGENTA, Michele d'
Italian, op.1522
ARGENTO
Italian, 18th cent.
ARGENTO, Giovanni
Antonio Dianti dall'
(Sansone)
Italian, op.1495-1527
ARGENTORATENSIS, Jacobus
see Jacob of Strasbourg
ARGUELLO, Miguel Angel
Spanish, 1941-
ARGUNOFF, Ivan
Petrovitch
Russian, 1727-p.1797
ARGUNOFF, Nikolai
Iwänowitsch
Russian, 1771-p.1829
ARGYLL, Duchess of
see Louise, Princess
ARHARDT, Johann Jakob
German, op.1636-1663
ARIAS Fernandez,
Antonio
Spanish, c.1620-1684
ARIAS, Francisco
Spanish, 1911-
ARIAS, Ignacio
Spanish, 17th cent.
ARIAS, Migues
Brazilian, op.1880
ARICO, Rodolfo
Italian, 1930-
ARIENTI, Carlo
Italian, 1801-1873
ARIGONI, Francesco
Italian, op.1628
ARINO, Pedro
Spanish, 20th cent.
D'ARISTA, Robert
American, 1929-
ARISTOTE, Anne-Eliane
French, 20th cent.
ARLAUD, Benoît or
Benjamin
Swiss, op.1707-1719
ARLAUD, Jacques Antoine
Swiss, 1668-1743
ARLAUD, Jérémie
Swiss, 1758-1827
ARLAUD, Léonard Isaac
Swiss, 1767-c.1800
ARLAUD, Louis Ami
Swiss, 1751-1829
ARLES, Jean Henry d'
French, 1734-1784
ARLIN, J.C.V.
French, 1868-
ARLIOTI, Lili
Greek, 20th cent.
ARMAN, Fernandez
French, 1928-
ARMANCOURT, Jean Auguste
Massary d'
French, op.1761-1776
ARMAND, Antoine
French, 19th cent.

ARMAND-DUMARESQ,
Edouard
French, 1826-1895
ARMANI, Antonio
Italian, op.1807
ARMBRUST, Karl
German, 1867-1928
ARMBRUSTER, Jean Francois
(Francois)
French, 1835-p.1895
ARMENISE, Raffaello
Italian, 1852-p.1887
ARMET y Portanel, José
Spanish, op.1864-1886
ARMFIELD, Diana M.
British, 1920-
ARMFIELD, Edward
British, 19th cent.
ARMFIELD (Smith), George
British, op.1840-1862
ARMFIELD, Maxwell
British, 1882-1972
ARMINGTON, Frank Milton
Canadian, 1876-
ARMITAGE, Edward
British, 1817-1896
ARMITAGE, Kenneth
British, 1916-
ARMOUR, George Denholm
British, 1864-1949
ARMOUR, Mary, (née
Steel)
British, 1902-
ARMS, John Taylor
American, 1887-
ARMSTEAD, Henry Hugh
British, 1828-1905
ARMSTRONG, Elizabeth Adela
see Forbes
ARMSTRONG, Francis Abel
William Taylor
British, 1849-1920
ARMSTRONG, John
British, 1893-1973
ARMSTRONG, Thomas
British, 1835-1911
ARMYTAGE, James Charles
British, 1820-1897
ARMYTAGE, P.
British, 19th cent.
ARNAIZ,
French, 20th cent.
ARNAL, Francois
French, 1924-
ARNALD or Arnold, George
British, 1763-1841
ARNALDIN, Benito
Spanish, 15th cent.
ARNAUD de Caseneuve
French, op.1480
ARNAUD, A.d'
French, op. 1776
ARNAUD, Marcel
French, 1877-1956
ARNAUDIES, Francisco
Spanish, op.c.1774
ARNAULT
Flemish, op.c.1730
ARNAULT
French, 19th cent.
ARNDT, Axel
German, 1941-
ARNEGGER, Alwin
Austrian, 1883-1916
ARNOLD
British, op.1719

ARNOLD, Carl Heinrich
German, 1793-1874
ARNOLD, Carl Johann
German, 1829-p.1858
ARNOLD, Edward
British, op.c.1824-1866
ARNOLD, George
see Arnald
ARNOLD, Georg Adam
German, op.1680
ARNOLD, Harriet, (née
Gouldsmith)
British, c.1787-1863
ARNOLD, Jonas
German, op.1640-m.1669
ARNOLD, Josef, I
Austrian, 1788-1879
ARNOLD, Josef, II
Austrian, 1823-1862
ARNOLD, Peter
German, 20th cent.
ARNOLD, R.
British, op.1682
ARNOLD, Samuel James
British, op.1800-1808
ARNOLF
Dutch, op.1684
ARNOULD, Georg
German, 1843-p.1887
ARNOULT, Nicolas
French, 17th cent.
ARNOUT, Louis Jules
French, 1814-p.1867
ARNOUX, Charles Albert
Vicomte d' (Bertall)
French, 1820-1883
ARNSWALD, Bernhard
German, 1807-p.1840
ARNTZENIUS, Pieter
Florentius Nicolaas
Jacobus (Floris)
Dutch, 1864-1925
ARNULL, J. (George?)
British, 19th cent.
ARNULPHY or Arnulphi,
Claude
French, 1697-1786
ARONSON, David
American, 1923-
ARONSON, Naoum Lwowitch
Polish, 1872-
AROSENIUS, Ivar Axel
Henrik
Swedish, 1878-1909
AROUX, Nicolas
French, 18th cent.
ARP, Carl
German, 1867-1913
ARP, Hans (Jean)
German, 1887-1966
ARPINO, Il Cavaliere d'
see Cesari, Giuseppe
ARREDONDO, Isidoro
Spanish, 1653-1702
ARRIARAN
Spanish, 19th cent.
ARRIGO Fiammingo or
Arrigo Paludano
see Broeck, Hendrick van
den
ARRIGO di Luca da
Arezzo
Italian, 14th cent.
ARRIGONI, Anton
Austrian, 1788-1851

ARRIGONI, Giovanni
see Laurenti
ARRIS, Margot Phillips
Canadian, 20th cent.
ARRIVET, J.
French, op.1766-1779
ARROWSMITH, Thomas
British, op.1792-1829
ARSENAULT, Real
Canadian, 1931-
ARSENIO, Fra
see Mascagni, Donato
ARSENIUS, Johan Georg
Swedish, 1818-1903
ARSENIUS, Karl Georg
Swedish, 1855-1908
ARSTENIUS, Carel Augusti
German, op.c.1745-1750
ARTAN de Saint Martin,
Louis
Belgian, 1837-1890
ARTARIA, Mathias
German, 1814-1885
ARTAUD, Francois
French. 1767-1838
ARTAUD, William
British, op.1780-1822
ARTAULT, Robert
French, 20th cent.
ARTEAGA y Alfaro,
Matias
Spanish, c.1630-1703
ARTEAGA, Sebastian de
Spanish, 17th cent.
ARTER, Paul Julius
Swiss, 1797-1839
ARTHOIS or Artois,
Jacques d'
Flemish, 1613-p.1684
ARTHUR, Reginald
British, op.1880-1896
ARTIGAS, Gardy
South American, 20th cent.
ARTIGUE, Albert Emile
French, op.1875-1901
ARTIGUE, Jean
French, op.1811
ARTOIS, Jacques d'
see Arthois
ARTOS TIZON
Spanish, op.1581
ARTS, Hendrick
see Aerts
ARTSCHWAGER, Richard
American, 20th cent.
ARTUZZO, Angelillo
see Arcuccio
ARTVELT, Andries van
see Eertvelt
ARTZ, David Adolph
Constant
Dutch, 1837-1890
ARUNDALE, Francis
British, 1807-1853
ARUS, Raoul Joseph
French, 1848-1921
ARVARI, Ranuccio
Italian, 15th cent.
ARVI, Bernardo
Italian, 17th cent.(?)
ARX, Hans von
Swiss, op.1513
ARY, Henry
American, 1802-1859
ARZERE, Stefano dall'
Italian, 16th cent.

AS, Pieter van
see Asch
ASAM, Cosmas Damian
German, 1686-1739
ASAM, Egid Quirin
German, 1692-1750
ASAM, Hans Georg
German, c.1649-1711
ASARO, Pietro (Il
Monocolo)
Italian, 1597-1647
ASCH, Hans van
Dutch,
op.1603-m.c.1655(?)
ASCH or As, Pieter
Jansz. van
Dutch, 1603-1678
ARGGER, Georges
Polish, 20th cent.
ASCHMANN, Johan Jacob
Swiss, 1747-1809
ASCIONE, Aniello or
Angelo
Italian, op.1680-1708
ASENSIO, Julio
Spanish, 19th cent.
ASHBERY, John
American, 20th cent.
ASHBY, Henry
British, 1744-1818
ASHER, Elise
American, 20th cent.
ASHER, Florence May
British, 1888-
ASHER, Julius Ludwig
(Louis)
German, 1804-1878
ASHFIELD, Edmund
British, op.1670-m.c.1700
ASHFORD, William
British, c.1746-1824
ASHLEY, Alfred
British, op.1850
ASHPITAL, Arthur
British, 1807-1869
ASHTON, G.R.
British, op.1874-1877
ASHTON, Julian R.
Australian, 1851-1942
ASHTON, Will
Australian, 1881-1963
ASHTON, Sir William
British, op.1899-1904
ASHWORTH, Edward
British, op.1845
ASINIO, Asinius or
Asinus, Michel
see Lasne
ASIS, Antonio
Italian, 20th cent.
ASKEVOLD, Anders Monsen
Norwegian, 1834-1900
ASKEW, John
British, 18th cent.
ASKEW, Victor
British, 1909-
ASLUND, Acke
Swedish, 1881-1958
ASMUS, Dieter
American, 1936-
ASMUSSEN, Claus Anton
Christian (Anton)
German, 1857-1904
ASNE, Michel
see Lasne
ASPARI, Domenico
Italian, 1745-1831

ASPER, Hans
Swiss, 1499-1571
ASPERTINI, Amico
Italian, c.1475-1552
ASPERTINI, Guido
Italian, op.1486-1491
ASPETTI, Tiziano
Italian, c.1565-1607
ASPLUND, Nils
Swedish, 1874-
ASPRUCK, Franz
Netherlands, op.1598-1603
ASSCHE, Henri van
Belgian, 1774-1841
ASSE, Geneviève
French, op.1967
ASSELBERGS, Alphonse
Belgian, 1839-1916
ASSELIN, Maurice
French, 1882-1947
ASSELINEAU, Léon Auguste
French, 1808-1889
ASSELIJN, Jan (Crabbetje)
Dutch, c.1610-1652
ASSEN, A. van
Dutch(?), -c.1817
ASSEN, Jan van
Dutch, 1635-1695
ASSERETO, Asserto or
Axareto, Giovacchino
Italian, 1600-1649
ASSMAN, Johan
German, op.1630
ASSMANN, J.E.
German, 19th cent.
ASSMUS, Robert
German, 1837-p.1870
ASSONVILLE, Gerrit d'
Dutch, 1627-p.1681
ASSONVILLE, Jacques d'
see Dassonville
ASSTEYN, Bartholomeus
Dutch, 1607-a.1668
ASSUERUSZ. van Montfoort,
Hendrick
Netherlands, op.1545-1570
ASSUS, Armand Jacques
French, 1892-
AST, Balthasar van der
Dutch, 1593/4-1657
ASTA or Aste, Andrea
dell'
Italian. 1673-1721
ASTI, Angelo
Italian, c.1847-1903
ASTLEY, Henry
British, op.1807
ASTLEY, John
British, 1730-1787
ASTON, L.
South African, op.1820
ASTORINO, Gerardo
Italian, op.1624-1637
ASTROM, Michael
Swedish, op.1764
ASTRUC, Edmond
French, 20th cent.
ASTRUP, Nicolai Johannes
Norwegian, 1880-1928
ATALYA, Enrique
Spanish, -c.1914
ATCHE, Jane
French, op.1904
ATHALIN, Laurent
French, 19th cent.
ATHERTON, John
American, 1900-1952
ATKEN, J.
see Edward Penny

ATKIN, G.
British, 20th cent.
ATKIN, Thomas
British, op.1771
ATKINS, James
British, -1834
ATKINS, Raymond
British, 1937-
ATKINS, Samuel
British, op.1787-1808
ATKINS, W.E.
British, 19th cent.
ATKINSON, Eric
British, 1928-
ATKINSON, George
British, 18th cent.
ATKINSON, George
British, 19th cent.
ATKINSON, George M.
British, 1880-1941
ATKINSON, James
British, 1780-1852
ATKINSON, John Augustus
British, 1775-p.1831
ATKINSON, John Gunson
British, op.1849-1879
ATKINSON, Joseph
British, 1776-1816
ATKINSON, Lawrence
British, 1873-1931
ATKINSON, Maud Tindall
British, op.1906-1937
ATKINSON, P.
British, 20th cent.
ATKINSON, Richard
American, 19th cent.
ATKINSON, W.A.
British, op.1849-1867
ATKINSON, William
Canadian, 1862-1926
ATLAN, Jean Michel
French, 1913-1960
ATOCHE, Louis Jean Marie
French, 1785-1832
ATTANASIO, Natale
Italian, 1846-p.1892
ATTERSEE, Christian
Ludwig
German, 1942-
ATTEVELT, Diederik van
Dutch, op.1673-1726
ATTEVELT, Joost van
Dutch, 1621-1692
ATWOOD, Clare
British, 1866-1962
ATTWOOD, J.R.
British, op.1776
ATWATER, Grace(?)
American, op.1877-m.1909
ATWOOD, John
(Possibly identified with
Thomas)
British, op.1761-1766
ATZELT, Johann
see Azelt
AUBEE, Martin
Flemish, 1729-c.1805
AUBERJONOIS, René Victor
Swiss, 1872-1957
AUBERT, Augustin Raymond
French, 1781-1857
AUBERT, Jean Ernest
French, 1824-1906
AUBERT, Louis
French, op.c.1740-1780
AUBERTIN, J.P.
see Bosschère, Jean de
AUBIGNY, Amélie d'
see Daubigny

AUBIN, Etienne Gustave
French, 1821-1865
AUBLET, Albert
French, 1851-1937(?)
AUBRAY-PLISSON
French, 20th cent.
AUBREY, John
British, 1626-1697
AUBRIET, Claude
French, 1651/65-1742
AUBRY, Charles
French, op.1822-1830
AUBRY, Emile
French, 1880-
AUBRY, Etienne
French, 1745-1781
AUBRY, Louis Francois
French, 1767-1851
AUBRY, Pierre
French, 1610-1686
AUBRY-LECOMTE, Hyacinthe
Louis Victor Jean
Baptiste
French, 1787-1858
AUBUISSON, Julien
Honoré Germain,
Marquis d'
French, 1786-p.1822
AUBURTIN, Jean Francis
French, 1866-1930
AUDEBERT, Jean Baptiste
French, 1759-1800
AUDENAERD, Auden-Aerd
or Auden-Aert, Robert
van
(Monogrammist R.V.A.)
Flemish, 1663-1743
AUDENAERDE, J. d'
French, op.c.1772
AUDINET, Philipp
British, 1766-1837
AUDRAN, Benoît, I
French, 1661-1721
AUDRAN, Charles
French, 1594-1674
AUDRAN, Claude, II
French, 1639-1684
AUDRAN, Claude, III
French, 1658-1734
AUDRAN, Gérard
French, 1640-1703
AUDRAN, Jean
French, 1667-1756
AUDUBON, John James
American, 1780-1851
AUDUBON, John Woodhouse
American, 1812-1862
AUDUBON, Victor Gifford
American, 1809-1860
AUER, Johann Paul
German, 1638-1687
AUER, Peter
German, op.1508-1535
AUERBACH, Frank
British, 1931-
AUERBACH, Johann Gottfried
German, 1697-1753
AUERBACH, Johann Karl
German, 1723-1788
AUERBACH-LEVY, William
American, 20th cent.
AUFNER
see Haffner
AUFRAY, Joseph
Athanase
French, 1836-p.1885

AUGER the Younger
French, op.1830
AUGSBOURG, Géo
Swiss, 1902-
AUGUST, J.
German, op.c.1860
AUGUST, Johann Friedrich
Herebach
German, op.1685
AUGUSTA, Princess von
Hesse-Kassel
German, 1780-1841
AUGUSTE, Jules Robert
French, 1789-1850
AUGUSTIN, Jean Baptiste
Jacques
French, 1759-1832
AUGUSTIN, Pauline,
(née du Cruet)
French, 1781-1865
AUGUSTINI, Jacobus
Luberti
Dutch, 1748-1822
AUGUSTINI, Jan
(Degelenkamp)
Dutch, 1725-1773
AUJAME, Jean
French, 1905-1965
AUMOND, Jean
French, 20th cent.
AUMONIER, James
British, 1832-1911
AUMONT, Louis Auguste
Francois
Danish, 1805-1879
AURAEUS, F.A.
German, op.1777
AUREL, Emod
Hungarian, 1897-1958
AURELE, Robert
French, 19th cent.
AURELI, Giuseppe
Italian, 1858-p.1900
AURELLER, Johan, I
Swedish, 1626-1696
AURHAYM, Henri
German, op.1410
AUSTEN, Anton J.
Polish, 1865-
AUSTEN, Cassandra
Elizabeth
British, 18th cent.
AUSTEN, J.S.
British, op.1855
AUSTEN, Winifred Marie
Louise (Winifred Frick)
British, op.1899-1940
AUSTIN, Darrel
American, 1907-
AUSTIN, F.W.
British, 20th cent.
AUSTIN, H.
British, op.1833
AUSTIN, Richard T.
British, op.1800-1818
AUSTIN, Robert Sargent
British, 1895-1973
AUSTIN, Samuel
British, 1796-1834
AUSTIN, William
British, 1721-1820
AUSTIN, William F.
British, op.1840-1860
AUSTIN, W.T.
British, 20th cent.
AUSTRIAN, Ben
American, -1921

AUSTRINIA, Ilma
Russian, 20th cent.
AUTENRIETH, C.F.
German, 18th cent.
AUTEROCHE, Alfred Eloi
French, 1831-1906
AUTHIER, Guy
French, 20th cent.
AUTISSIER, Louis Marie
French, 1772-1830
AUTREAU, Jacques
French, 1657-1745
AUTREAU, Louis
French, c.1692-1760
AUVERA, Jakob van der
German, c.1700-c.1760
AUVERA, Johann Wolfgang
van der
German, -1756
AUVERA, Lukas Anton
van der
German, -1766
AUVIGNY, Charles d'
French, 1740-1830
AUVRAY, Felix Henri
French, 1800-1833
AUXENTIOS, Symeon
Greek, 16th cent.
AUZOU, Pauline, (née
Desmarquets)
French, 1775-1835
AVANZARANI, Francesco
(Il Fantastico)
Italian, op.1494
AVANZINI, Pier Antonio
Italian, 1656-c.1733
AVANZO or Avanzi,
Jacopo
Italian, 14th cent.
AVANZO, Pseudo- Jacopo
(Jacopo dei Bavosi or
Jacopo da Bologna)
Italian, 14th cent.
AVARNE, Charlotte,
(née Hemington)
British, 1749-p.1795
AVATI, Mario
French, 1921-
AVED, Jacques André
Joseph Camelot
French, 1702-1766
AVEDISIAN, Edward
American, 1936-
AVEELE, Johannes
van den
Dutch, op.1678-m.1727
AVELINE, Francois-
Antoine
French, 1718-1780
AVELINE, Pierre
Alexandre
French, 1702-1760
AVENET, Simon François
French, c.1710-1774
AVERANI, Antonio
Italian, op.1755
AVERARA, Averaria,
Avernaria or d'Averara,
Giambattista
Italian, op.1533-m.1548
AVERARA, Scipione da
Italian, 16th cent.
AVERCAMP, Berent
Petersz.
Dutch, 1612/13-1679
AVERCAMP, Hendrick
Berentsz. (de Stom or
Stomme van Kampen)
Dutch, 1585-1634

AVERNARIA, Giambattista
see Averara
AVERY, Milton
American, 1893-1965
AVIA, Amalia
Spanish, 1930-
AVIANI, Francesco
Italian, op.1713
AVIAT, Jules Charles
French, 1844-
AVIGDOR, René
French, op.1891-1905
AVILA, Abelardo
Mexican, 1907-
AVITABLE, Gennaro
Italian, op.1905-1910
AVONDO, Vittorio
Italian, 1836-1910
AVONT, Peeter van
Flemish, 1600-1632
AVRAMIDIS, Joannis
Austrian, 1922-
AVRIL
French, 20th cent.
AVY, Marius Joseph
French, 1871-
AW or Ow, Meinrad
von
German, 1712-p.1780
AWERCHS
Netherlands, 15th cent.
AXENFELD, Heinrich
Russian, op.c.1873
AXELSON, Victor
Swedish, 1883-1954
AXENTOWICZ, Theodor
Polish, 1859-1938
AYALA, Bernabé
Spanish, op.1660-m.c.1672
AYALA, Josefa de
(Josefa de Obidas)
Spanish, c.1630-1684
AYLESFORD, Heneage
Finch, 4th Earl of
(Lord Guernsey)
British, 1751-1812
AYLESFORD, Louisa,
Countess of
British, 1760-1832
AYLMER, T.B.
British, op.1838-1855
AYLWARD, James D.
British, 20th cent.
AYOUB, Moussa
British, op.1903-1938
AYRES, Gillian
British, 1930-
AYRES, T.A.
British, op.1855
AYRTON, Annie
British, op.1879-1888
AYRTON, Michael
British, 1921-1976
AYTON, Joseph
British(?), op.1863
AZANI da Pavia,
Vincenzo degli
Italian, c.1500-1557
AZCUY-CARDENAS, René
Cuban, 20th cent.
AZEGLIO, Massimo
Taparelli d'
Italian, 1798-1866
AZELT, Atzelt or
Azold etc.,
Johann
German, c.1654-p.1692

AZNAR y Garcia,
Francisco
Spanish, op.1854-1881
AZOCAR, J.
Spanish, 20th cent.
AZOLD, Johann
see Azelt
AZZOLINI, Giovanni
Bernardo or Bernardino
(Massolini or
Mazzolini)
Italian, 1560-p.1610

B

BAADE, Knud Andreassen
Norwegian, 1808-1879
BAADER, Johann
German, 1709-1779
BAADER, Johann Michael
German, 1736-1792
BAADER, Louis Marie
French, 1828-c.1919
BAAGØE, Carl Emil
Danish, 1829-1902
BAAR, Hugo
German, 1873-1912
BABA, Corneliu
Rumanian, 1906-
BABB, Johannes Staines
British, op.1870-1892
BABBERGER, August
Swiss, 1885-1936
BABBIDGE, J.G.
American, 19th cent.
BABCOCK, William P.
American, 1826-1899
BABEL, Pierre Edmé
French, c.1720-1775
BABER, J.
British, op.1806-1812
BABIJ, Iwan
Russian, 1896-
BABON, A.
Italian, 18th cent.
BABOULENE, Eugène
French, 20th cent.
BABRON, A.
French, 18th cent.
BABUREN, Dirck or
Theodor van
Dutch, op.1611-m.1624
BABUT, Louise
see Rang-Babut
BACA-FLOR, Carlos
Peruvian, 1869-1941
BACAREEL, Baccarelles
or Baccarelli, Gillis
see Backereel
BACARISAS, Gustavo
Spanish, op.1897-1905
BACCHELLI, Mario
Italian, 1893-1951
BACCHI, N.
Italian, op.1830
BACCHI, Petrus or
Pietro
see Bacchius
BACCHI or Bachy,
Raffaele
Italian, 1716-1767
BACCHIACCA, Francesco
Ubertini dei Verdi, Il
Italian, 1494-1557
BACCHIUS, Bacchi or
Bacchus, Petrus
Netherlands,
op.1647-m.c.1650(?)

BACCI, Baccio Maria
 Italian, 1888-
BACCI, Edmondo
 Italian, 1913-
BACCIARELLI, Marcello
 Italian, 1731-1818
BACCIO
 see Bianco
BACCIO della Porta
 see Fra Bartolommeo
BACCONI, A.
 Italian, op.1896
BACCUET, Prosper
 French, 1798-1854
BACH, Alois
 German, 1809-1893
BACH, Armand Eugène
 French, op.1879-m.1921
BACH, Ferdinand Sigismond
 (Bac)
 German, 1859-1952
BACH, Gottlieb Friedrich
 German, 1714-1785
BACH, Guido
 German, 1828-1905
BACH, Johann Philipp
 German, 1752-1846
BACH, Johann Samuel
 German, 1749-1778
BACHE, Otto
 Danish, 1839-1927
BACHER, Otto H.
 American, 1856-1909
BACHELDER, John Badger
 American, 1825-1894
BACHELIER, Jean Jacques
 French, 1724-1806
BACHELIN, Auguste
 Swiss, 1830-1890
BACHEM, Bele
 German, 1916-
BACHER, David
 Dutch(?), 18th cent.
BACHER, David
 Dutch, 18th cent.
BACHER, Otto Henry
 American, 1856-1909
BACHEREAU-REVERCHON,
 Victor
 French, 1842-
BACHMANN, Pachmann or
 Bachman, Georg
 German, c.1600-1652
BACHMANN, Hans
 German, 1852-1917
BACHMANN, Hermann
 German, 1922-
BACHMANN, John
 American, op.1850-1877
BACHMANN, Karoly
 Hungarian, 1874-
BACHMEISTER, A.
 Danish(?), op.1807
BACHORIK, Otokar
 Czech, 20th cent.
BACHRACH-BAREE, Helmuth
 German, 1898-
BACHTA, Johann
 German, 1782-1856
BACHY, Raffaele
 see Bacchi
BACICCIA, Giovanni Battista
 (Il Gaulli)
 Italian, 1639-1709
BACK, Jakob Conrad
 German, op.1760-1761
BACK, Veli Yngve Paivio
 Finnish, 1904-

BACKER, Adriaen
 Dutch, 1635/6-1684
BACKER, Catharina
 (Catharina de la
 Court)
 Dutch, 1689-1766
BACKER, Harriet
 Norwegian, 1845-1932
BACKER, Hilmar
 Johannes
 Dutch, 1804-1845
BACKER, Jacob de
 Netherlands, c.1560-1590/1
BACKER, Jacob
 Adriaensz.
 Dutch, 1608-1651
BACKER, Johann Franz
 de
 Flemish, op.1693-1749
BACKER, John James
 Netherlands,
 op.1697-1701
BACKEREEL, Bacareel,
 Baccarelles or
 Baccerelli, Gillis
 Flemish, c.1572-a.1662
BACKHUYSEN, Backhuyzen
 or Bakhuisen, Ludolf, I
 Dutch, 1631-1708
BACKHUIJZEN, Gerrit
 Dutch, c.1700-1760
BACKHUIJZEN or Backhuyzen,
 Ludolf, II
 Dutch, 1717-1782
BACLE, Bernardo
 Spanish, 20th cent.
BACLER d'Albe, Baron
 Louis Albert Guillain
 French, 1761-1824
BACO, Ferrarius de
 see Ferrer Bassa
BAÇÓ, Jaime (Jacomart)
 Spanish, op.1440-m.1461
BACON, Alan
 British, 20th cent.
BACON, Francis
 British, 1909-
BACON, Henry
 American, 1839-1913
BACON, James
 British, op.c.1850
BACON, John H.F.
 British, 1868-1914
BACON, Sir Nathaniel
 British, 1585-1627
BACON, Nathaniel
 British, 1698-1763
BACON, Peggy
 American, 1895-
BACON, T.
 British, op.1844-1855
BACON, W.
 British, op.1809-1823
BADALOCCHIO, Sisto
 Italian, 1581/5-1647
BADAROCCO, Giovanni
 Raffaello
 Italian, 1648-1726
BADCOCK, B.
 British, op.1800
BADEL, Jules Louis
 Swiss, 1840-1869
BADEN, Hans Jurriaensz.
 van
 Dutch, c.1604-1663

BADEN-POWELL, Robert
 Lord
 British, 1857-1941
BADENS, Francesco
 (Frans)
 Flemish, 1571-a.1619
BADGER, Joseph
 American, 1708-1765
BADGER, S.F.M.
 American, 19th cent.
BADGER, Thomas
 American, 1792-1868
BADHAM, Edward Leslie
 British, 1873-1944
BADIALI di Bologna,
 Giuseppe
 Italian, 1798-1859
BADILE, Antonio IV, or
 Giovanni Antonio
 Italian, c.1516-1560
BADILE, Bartolomeo I
 Italian, op.1445-1451
BADILE, Giovanni
 Italian, a.1409-a.1478
BADIN, Jean Jules
 French, 1843-p.1880
BADITZ, Otto
 Hungarian, 1849-
BADMIN, Stanley Roy
 British, 1906-
BADODI, Arnaldo
 Italian, 1913-1943
BAECK or Böck, Elias
 ("Heldenmuth")
 German, 1679-1747
BAECK, Johannes
 Dutch, op.1610-1655
BAEDER
 American, 20th cent.
BAEGERT or Boegert,
 Derick
 German, op.1476-1515
BAEHM, Barthel
 see Beham
BAEHR, Johann Karl
 German, 1801-1869
BAELLIEUR, Cornelis, I
 de
 Flemish, 1607-1671
BAEN, Gerbrandt
 Dutch, op.1651
BAEN, H.G. de
 Flemish(?), 17th cent.
BAEN, Jan de
 Dutch, 1633-1702
BAENA, Alfonso de
 see Alfonso de Cordoba,
 Jaime
BAENDELER, D.
 Flemish, 17th cent.
BAER, Christian
 Maximillian
 German, 1853-1911
BAER, George
 American, 1895-
BAER, William Jacob
 American, 1860-1941
BAERA, Nils H.
 see Sata
BAERENTZEN, Emilius
 Ditlev
 Danish, 1799-1868
BAERS, Johannes or
 Jan
 Dutch, op.1630-1640

BAERTLING, Olle
 Swedish, 1911-
BAERTSOEN, Albert
 Belgian, 1866-1922
BAES, Firmin
 Belgian, 1874-1943
BAES, Bas, Basse or
 Bassius, Martin
 Flemish, 1614-1631
BAES, Rachel
 French, 20th cent.
BAESU, Aurel
 Rumanian, 1897-1928
BAETS, Angelus de
 Belgian, 1793-1855
BAETS, Marc
 Flemish, op.c.1700
BAGAZOTTI or Bagazoto,
 Camillo
 Italian, 1535-p.1573
BAGER, Johann Daniel
 German, 1734-1815
BAGETTI, Giuseppe Pietro
 (Joseph Pierre)
 Italian, 1764-1831
BAGG, William
 British, op.1827-1829
BAGGE, Eva
 Swedish, 1871-
BAGGE, Magnus Thulstrup
 Norwegian, 1825-c.1890
BAGLIONE, Giovanni
 (Sordo del Barezzo)
 Italian, 1571-1644
BAGLIONI, Cesare
 Italian, op.1610
BAGNACAVALLO, Bartolomeo
 (Ramenghi)
 Italian, 1484-1542
BAGNARA, Francesco
 Italian, 1784-1866
BAGNARA, Bagnaja or
 Baynara, Padre Pietro da
 Italian, op.1537-p.1579
BAGNATORI, Pietro Maria
 (Il Bagnadore)
 Italian, c.1550-c.1619
BAGOLI, A.
 Italian, 18th cent.
BAGSHAWE, C.F.
 British, op.1829
BAGHOT DE LA BERE,
 Stephen
 British, 1887-1927
BAGUR, Rivera
 Spanish, 1919-
BAGUTTI, Abbondio
 Italian, 1788-1850
BAHIEU, J.G.
 French, op.1885-1895
BAHUNEK, Anten
 Yugoslav, 1912-
BAIG, Theodor
 German, 17th cent.
BAIKOFF, Feodor
 Russian, 1825-1879
BAIL, Antoine Jean
 French, 1830-1919
BAIL, Joseph
 French, 1862-1921
BAILEY, Albert E.
 British, op.1890-1904
BAILEY, A.L.
 British, 20th cent.
BAILEY, James G.
 American, 1870-

BAILEY, Robert
American, 20th cent.
BAILEY, Vernon Howe
American, 874-
BAILLE, Edouard
French, 1814-1888
BAILLE, Hervé
French, 1896-
BAILLIE, William
British, 1723-1792
BAILLIU or Bailleul,
Pieter de
Flemish, 1613-1660
BAILLY or Bally,
Alexandre
French, 1764-1835
BAILLY, Alice
Swiss, 1872-1938
BAILLY, David
Dutch, 1584-1657(?)
BAILLY, Jacques I.
French, c.1634-1679
BAILLY, Nicolas
French, 1659-1736
BAILY, E.P.
British, 19th cent.
BAIN, Donald
British, 1904-
BAIN, George
British, 20th cent.
BAINES, Henry
British, 1823-1894
BAINES, J.T.
British, 1820-1875
BAIRD, Nathaniel
Hughes J.
British, 1865-
BAIRD, William Baptiste
American, op.1872-1899
BAIRNSFATHER, Bruce
British, 1888-
BAISCH, Hermann
German, 1846-1894
BAISTROCCHI, Pietro
Italian, 17th cent.
BAIXERAS VERDAGUER,
Dionisio
Spanish, 1862-
BAJ, Enrico
Italian, 1924-
BAJENARU, Dan I
Rumanian, op.c.1880
BAK, Jerzy
Polish, 20th cent.
BAKALOWICS, Stephan
Vladislavovich
Russian, 1857-
BAKALOWICZ, Ladislaus
Polish, 1833-1904
BAKEREL or Bakkarell
Gillis
see Backereel
BAKEL, Nellie van
Dutch, 20th cent.
BAKELS, Reinier
Sybrand
Dutch, 1873-1956
BAKER, Captain
American, 19th cent.
BAKER, Charles H.
Collins
British, 1880-1959
BAKER, Frederick W.
British, op.1850-1868
BAKER, Geoffrey Alan
British, 1881-

BAKER, George Augustus
American, 1821-1880
BAKER, Harry
British, 1849-1875
BAKER, J.
American, op.c.1850
BAKER, Jack
British, 20th cent.
BAKER, John
British, c.1736-1771
BAKER, John
American, op.1832-1835
BAKER, Joseph
British, -1770
BAKER, Oliver
British, 1856-1939
BAKER, Samuel H.
British, op.1875-1896
BAKER, Thomas
(Baker of Leamington)
British, 1809-1864
BAKER, William
British, op.1479-1488
BAKER, William Carmichael
British, 19th cent.
BAKER, W.G.
Australian, 20th cent.
BAKEWELL, Robert
American, c.1790-p.1850
BAKHUISEN, Ludolf, I
see Backhuysen
BAKHUYZEN, Geraldine
Jacoba van de Sande
Dutch, 1826-1895
BAKHUZEN, Hendrikus
van de Sande
Dutch, 1795-1860
BAKHUZEN, Julius Jacobus
van de Sande
Dutch, 1835-1925
BAKHUYZEN, Ludolf, II
see Backhuijzen
BAKKEN, Ole M.
Norwegian, 1920-
BAKKEN, van
Dutch, 17th cent.
BAKKER, F. de
Dutch, op.1736-1765
BAKOF, Julius
German, 1819-1857
BAKST, Leon
Nikolaievich
Russian, 1866-1924
BAL
French, 20th cent.
BALAIRE, Charles
French, op.1875-1882
BALANDE, Gaston
French, 1881-
BALASA, Sabin
Rumanian, 1932-
BALASSA, Ferenc (Franz)
Hungarian, 1794-
BALASSI, Mario
Italian, 1604-1667
BALBI, Angelo
Italian, 1872-1934
BALBI, Filippo
Italian, op.1855
BALCAR, Jiri
Czech, 1929-1968
BALDASSARE d'Este or
Estense
Italian, op.1461-m.1504
BALDELLI, Francesco
Italian, op.c.1588

BALDEN, J.V. de
Flemish, op.1662
BALDESE, G.
Italian, 15th cent.
BALDESSARI, Luciano
Italian, 1896-
BALDESSIN, George
Australian, 1939-
BALDI, Bernardino
Italian, c.1599-m.1615
BALDI or Baldo, Lazzaro
Italian, c.1624-1703
BALDINACCI, Pietro Paolo
(Pierpaolo di Filippo
Baldinacci)
Italian, op.1525-1527
BALDINI, Baccio or
Bartolommeo
Italian, op.1460-1485
BALDINI, Fra Tiburzio
Italian, op.1611
BALDINI, Taddeo
Italian, op.c.1680
BALDINUCCI, Filippo
Italian, 1624-1696
BALDOCK, James Walsham
British, op.1867-1887
BALDORNERO, Galofre
Spanish(?), 19th cent.
BALDOVINETTI, Alesso
Italian, 1425(?)-1499
BALDOVINI, Bernardo
Italian, op.c.1681
BALDREY, John (or Joshua)
Kirby
British, c.1750-p.1821
BALDRIGHI, Giuseppe
Italian, 1723-1802
BALDRY, Alfred Lys
British, 1858-1939
BALDRY, Harry
British, op.1883-1890
BALDUCCI, Giovanni
(Cosci)
Italian, op.1590-m.1603
BALDUCCI, Matteo di
Giuliano di Lorenzo
Italian, op.1509-p.1554
BALDUNG, Hans
(Grien or Grün)
German, c.1480-1545
BALDWIN, H.T.
British, op.1861
BALDWIN, Samuel
British, op.1843-1858
BALDWIN, T.R.
British, op.1827
BALE, Charles Thomas
British, op.1866-1875
BALE, Edwin
British, 1838-1923
BALE, T.
British, op.1692
BALECHOU, Jean Joseph
French, 1719-1764
BALEN, Gaspard van
Flemish, 1615-1641
BALEN, Hendrik, I
van
Flemish, 1575-1632
BALEN, J. van
Flemish, op.1739
BALEN, Jan van
Flemish, 1611-1654
BALEN, Matthys
Dutch, 1684-1766

BALESTRA, Antonio
Italian, 1666-1740
BALESTRIERI, Lionello
Italian, 1872-
BALET, Jan
American, 1913-
BALFOUR, Maxwell
British, 1874-1914
BALICKI, Boguslaw
Polish, 20th cent.
BALINT, Endre
Hungarian, 1914-
BALKANSKI, Aleksander
Bulgarian, 20th cent.
BALKE, Peder
Norwegian, 1804-1887
BALL, Alexander C.
British, 19th cent.
BALL, F.H.
British, 19th cent.
BALL, James
British, op.1760
BALL, Wilfrid Williams
British, 1853-1917
BALLA, Giacomo
Italian, 1874-1958
BALLANTYNE, John
British, 1815-1897
BALLARINI, Ernesto
Italian, 1845-p.1883
BALLAVOINE, Jules Frédéric
French, op.1880-1901
BALLENBERGER, Karl
German, 1801-1860
BALLESIO, F.
Italian, 19th cent.
BALLETTA, Il
see Francesco d'
Antonio da Viterbo
BALLIN, Hugo
American, 1879-1956
BALLINGALL, Alexander
British, op.c.1883
BALLINI, Camillo
Italian, op.1574-1578
BALLIQUANT, N.
French, c.1880
BALLOT, Clémentine
French, 1879-1964
BALLUE, Pierre-Ernest
French, 1855-1928
BALLURIAU, Paul
French, op.20th cent.
BALLUSION, Paul
French, 19th cent.
BALLY, Alexandre
see Bailly
BALMASEDA, Juan de
Spanish, op.1516
BALMER, Derek
British, 1934-
BALMER, George
British, 1806-1846
BALMER-VIEILLARD,
Paul Friedrich
Wilhelm
Swiss, 1865-1922
BALOG, Michael
American, 20th cent.
BALOGH, Janos Nagy
Hungarian, 1874-1919
BALSGAARD, Carl Vilhelm
Danish, 1812-1893
BALSON, Ralph
Australian, 1890-1964

BALTARD, Louis-Pierre
French, 1764-1846
BALTARD, Victor
French, 1805-1874
BALTATU, Adam
Rumanian, 1899-
BALTAZAR, Apcar
Rumanian, 1880-1909
BALTEN, Baltens or
Balthazar, Pieter
(Custodis or de
Costere)
Netherlands,
op.1540-m.c.1598(?)
BALTHUS, (Balthasar
Klossowsky)
French, 1903-
BALTZ, J.Georges
French, 1760-1831
BALUGANI, Luigi
Italian, 1737-1770
BALUSCHEK, Hans
German, 1870-1935
BALWE, Arnold
Dutch, 1898-
BALZANI, Giov. Girolamo
Italian, 1657-1734
BALZE, Jean Paul
Etienne
French, 1815-1884
BALZER, Anton
German, 1771-1807
BAMBAJA
see Busti, A.
BAMBER, B.
British, op.1904-1909
BAMBERGER, Friedrich
German, 1814-1873
BAMBERINI, Antonio
Domenico
Italian, 1666-1741
BAMBINI, Giovanni
Italian, op.1724
BAMBINI, Niccolò
Italian, 1651-1736
BAMBOCCIO, Il
see Laer, Pieter de
BAMFYLDE, Copplestone
Warre
British, 1719-1791
BAN, Gerbrandt
Dutch, c.1613-p.1652
BANC, Jef
French, 1930-
BANCE, Silv(estre?)
French, op.1810
BANCHI, Francesco
d'Antonio
see Francesco
d'Antonio di Bartolomeo
BANCILA, Octav
Rumanian, 1872-1944
BANCK or Banc, Pieter
van der
French, 1649-1697
BANCO, Nanni d'Antonio
di
Italian, c.1373-1421
BANCROFT, Elias
British, op.1874-m.1924
BANCROFT, Milton
American, 1866/7-1947
BAND, Franz
(Bandinelli)
Swiss, op.1798-m.1813
BAND, Max
Russian, 1900-

BANDAU, Joachim
German, 20th cent.
BANDINELLI, Baccio or
Bartolommeo
Italian, 1493-1560
BANDINELLI, Franz
see Band
BANDINI, Giovanni di
Benedetto da Castello
(Giovanni dell' Opera)
Italian, 1540-1599
BANDO, Toshio
Oriental, 1890-
BANFORD, James
British, op.1790-1795
BANGS, Jeremy Dupertuis
American, 20th cent.
BANKEN or Banquy,
Quirinus van
Flemish, op.1618-1640
BANKES, H.
British, op.1813
BANKS, Geoffrey Watson
British, 1930
BANKS, J.O.
British, op.1856-1873
BANKS, Robert
British, 20th Cent.
BANKS, Thomas
British, 1735-1805
BANKS, Thomas J.
British, op.1860-1880
BANNARD, W.Darby
American, 1931-
BANNATYNE, J.J.
British, op.1869-1898
BANNER, Delmar Harmond
British, 1896-
BANNERMAN, Alexander
British, c.1730-p.1780
BANNETTER
Norwegian, 1822-1904
BANNIER, Gerhard
Nilant
Dutch, c.1780-1877
BANNING, William J.
American, 1810-1856
BANNISTER, John
British, op.1795
BANNON, John
American, 1933-
BANO, Endre
Hungarian, 20th cent.
BANQUY, Quirinus van
see Banken
BANTELMANN, Johann
Wilhelm David
German, 1806-1877
BANTI, Cristiano
Italian, 1824-1904
BANTING, John
British, 1902-1972
BANTZER, Carl Ludwig
Noah
German, 1857-1941
BANUELOS-THORNDIKE,
Antonia de
(Marquis d' Alcedo)
Spanish, -1914/21
BAPTISTA, M.A.
Italian(?), op.1845-1848
BAPTISTE, Martin
Sylvestre
French, 1791-1859
BAQUOY, Jean Charles
French, 1721-1777
BAR, Bonaventure de
French, 1700-1729

BAR.... Jaco....
see Barbari, Jacopo d'
BARABAS, Miklos
Hungarian, 1810-1898
BARABAS, Stefan
Rumanian, 1914-
BARABINO, Nicolò
Italian, 1832-1891
BARALET, John James
see Barralet
BARAM, P.
French, 20th cent.
BARANOFF-ROSSINE,
Vladimir
Russian, 1882-1942
BARANYO, Sandor
Hungarian, 1920-
BARAT, Barrat or Berat,
Pierre Martin
French, op.1774-1785
BARATHIER
French, 19th cent.
BARAT-LEVRAUX, Georges
French, 1878-
BARATTA, Alessandro B.
Italian, 1637-1714
BARATTA, Carlo Alberto
Italian, 1754-1815
BARATTI, Felipe
Italian, op.1886
BARAU, N.
French, op.1790
BARAU, Emile
French, 1851-1931
BARAUD, D.
French(?) op.1815
BARB de la Broue
see Labroue, Louise
BARBA, Genesio del
Italian, 1691-p.1736
BARBAGELATA, Giovanni
di Niccolò
Italian, op.1484-1508
BARBAGLIA, Giuseppe
Italian, 1841-1910
BARBALONGA, Antonio
Italian, 1600-1649
BARBALUNGA, Antonio
see Barbalonga
BARBARELLI, Giorgio
see Giorgione
BARBARI, Jacopo de' or
Bar...Jac... or
Barbarj, Jacopo de
(Master of the Caduceus)
Italian, c.1440/50-p.1511/
15
BARBIERI, Niccolò de'
Italian, op.1516
BARBARIGO, Ida
Italian, 1923-
BARBARINI, Ernst
German, 19th cent.
BARBARINI, Franz
German, 1804-1873
BARBARINI, Gustav
German, 19th cent.
BARBARIO, Saverio
Italian, 1924-
BARBASAN y Lagueruela,
Mariano
Spanish, 1864-1924
BARBAT, J.
French, 18th cent.
BARBATELLI, Bernardino
see Poccetti

BARBAULT, Jean
French, c.1705-1766
BARBAZZA, Antonio
Giuseppe
Italian, 1722-p.1771
BARBELLA or Barbello,
Giovanni Giacomo
Italian, 1590-1656
BARBER, Alfred R.
British, 19th cent.
BARBER, Charles Burton
British, 1845-1894
BARBER, Charles Vincent
British, op.1810-1854
BARBER, John
American, 1898-1965
BARBER, John Thomas
see Beaumont
BARBER, John Vincent
British, a.1800(?)-p.1830
BARBER, John Warner
American, 1798-1885
BARBER, Joseph
British, 1757/8-1811
BARBER, Joseph Moseley
British, op.1859-1889
BARBER, Otto H.
British, 19th cent.
BARBER, R.(?)
British, op.c.1775
BARBER, Reginald
British, op.1885-1895
BARBER, Rupert
British, op.1736-1772
BARBER, Thomas
British, c.1768-1843
BARBER, William
British, 18th cent.
BARBERI,
French, op.1834
BARBERI, Giuseppe
Italian, 1746-1809
BARBERINO, Francesco da
Italian, 14th cent.
BARBEROV, Milcek
Yugoslav, 1950-
BARBETTE, Josias or
Josie
German, c.1660-p.1728
BARBEY, Valdo
Spanish, 1883-
BARBIANI, Andrea
Italian, c.1709-1779
BARBIANI, Giovanni
Battista
Italian, 1619-p.1650
BARBIANI, Domenico
Italian, op.1744
BARBIANO di Belgioioso,
Rinaldo
Italian, 1801-1849
BARBIE or Barbier,
Jacques
French, 1755-1790
BARBIER
French(?), 18th cent.
BARBIER, G.P.
French(?), op.1792-1795
BARBIER, Georges
French, 20th cent.
BARBIER, Jean Jacques
Francois le
see Lebarbier
BARBIER, Nicolas
Alexandre
French, 1789-1864

BARBIER, Nicolas Louis
French, -1779
BARBIER, Paul
French, 1760-1819
BARBIERE, Alessandro
del
see Fei di Vincenzio
BARBIERE, Domenico del
(Domenico Fiorentino)
Italian, c.1506-1565/75
BARBIERI, Francesco
(Francesco Sfrisa or
Sfrisato or Il Legnago)
Italian, 1623-1698
BARBIERI, Giovanni
Italian, 1596-1640
BARBIERI, Giovanni
Francesco
see Guercino
BARBIERI, Lodovico
Italian, op.1660-1704
BARBIERI, Luca
Italian, 17th cent.
BARBIERI, Paolo
Italian, 20th cent.
BARBIERI, Paolo Antonio
Italian, 1603-1649
BARBIERS, Marie Geertruyd
(née Snabilié)
see Snabilié
BARBIERS, Pieter, I
Dutch, 1717-1780
BARBIERS, Bartholomeusz.,
Pieter
Dutch, 1772-1837
BARBIERS, Pietersz.,
Pieter
Dutch, 1749-1842
BARBIER-WALBONNE,
Jacques Luc
French, 1769-1860
BARBISAN, Giovanni
Italian, 1914-
BARBONI, Alexander
see Alexander, Paduano
BARBOR, Lucius
British, -1767
BARBOSA, Domingos
see Vieira, Domingos
BARBOT, Prosper
French, 1798-1878
BARBOUR, F.
American, op.1835-1836
BARBUDO-SANCHEZ, Salvador
Spanish, 1857-1917
BARCALO, Joan
British, op.1777-1786
BARBUT-DAVRAY, Luc
French, 1863-1926
BARCA, Celia Calderon
de la
Mexican, 1921-
BARCALO, Joan
see Barcelo
BARCELO, Barcalo or
Barcels, Juan or
Joan
Spanish, op.1510
BARCELS, Joan
see Barcelo
BARCET, Emmanuel
French, op.1909
BARCHENKOV, Nikolai
Russian, 20th cent.
BARCHUS, J.H.
American, 19th cent.

BARCKHAN, Johann
Hieronymous
German, 1785-1865
BARCLAY, Edgar
British, 1842-1913
BARCLAY, John Maclaren
British, 1811-1887
BARCLAY, John Rankine
British, 1884-
BARCLAY, W.
British, op.1832-1856
BARCO, Garcia del
Spanish, op.1476
BARCSAY, Jenö
Hungarian, 1900-
BARD, James
American, 1815-1897
BARD, Jean-Auguste
French, 1812-p.1861
BARD, John
American, 1815-1856
BARDEL, Louis Thomas
French, 1804-p.1841
BARDELLI, Alessandro
Italian, 1583-1633
BARDELLINI, Pietro
Italian, 18th cent.
BARDI, Boniforte, Conte
de'
Italian, op.1434-1453
BARDI, Donato, Conte de'
Italian, op.1426-m.1451
BARDI, Donato di Niccolò
di Betto
see Donatello
BARDIAN, Aleksandr
Russian, 20th cent.
BARDIN, Jean
French, 1732-1809
BARDON, Michel François
Dandré- (Dandré-Bardon)
French, 1700-1783
BARDON, Paul Joseph
German, 1745-1814
BARDONE, Guy
French, 1927-
BARDOU or Bardow, Johann P.
German, op.1775-1788
BARDOU, Karl Wilhelm
German, op.1797-1842
BARDOU, Paul Joseph
German, 1745-1814
BARDOW, Johann P.
see Bardou
BARDUA, Caroline
German, op.1805-1840
BARDWELL, Thomas
British, op.1735-m.c.1780
BAREN, Johannes Antonius
van der
Flemish(?), c.1615-1686
BARENDSZ., Dirck
Netherlands, 1534-1592
BARENGER, James
British, 1780-p.1831
BARETTE, François
French, 20th cent.
BARGAS, A.F.
Flemish, op.1692
BARGHEER, Eduard
German, 1901-
BARGIGLI, Paolo
Italian, op.1791-1814
BARGUE, Charles
French, 1826-1883
BARILLOT, Léon
French, 1844-1900

BARINI, A.
Italian, 18th cent.
BARISIEN, Friedrich
Hartmann
German, 1724-1796
BARISINO
see Tommaso da
Modena
BARISON, Giuseppe
Italian, 1853-p.1907
BARKER
British, 19th cent.
BARKER, Allen
Australian, 1937-
BARKER, Anthony Raine
British, 1880-1963
BARKER the Younger,
Benjamin
British, 1776-1838
BARKER, C.F.
British, op.1845
BARKER, D.
British, 19th cent.
BARKER, Henry Aston
British, 1774-1856
BARKER, John Joseph
British, op.1835-1863
BARKER, Joseph
British, op.1808-1809
BARKER, Kit
British, 1916-
BARKER, Marianne A.
British, op.1820-1848
BARKER of Bath, Thomas
British, 1769-1847
BARKER, Thomas Jones
British, 1815-1882
BARKER, Walter
American, 1921-
BARKER, Wright
British, op.1893
BARKO, Nina
French, 20th cent.
BARLACH, Ernst
German, 1870-1938
BARLACH, Ludwig
German, op.1921
BARLAND, Adams
British, op.1843-1863
BARLANGUE, Gabriel Antoine
French, op.1900-1934
BARLIN, F.B.
British, op.1802-1807
BARLOW, Edward
British, op.1659-1703
BARLOW, Francis
British, 1626-1704
BARLOW, Inigo
British, op.1790
BARLOW, John Noble
British, 1861-1917
BARLOW, Myron
American, 1873-1938
BARNABA da Modena
Italian, op.1367-1383
BARNABE, Duilio
Italian, 1914-
BARNABEI, Tommaso
see Papacello
BARNA da Siena
Italian, op.c.1350-1360
BARNARD
French, op.1766
BARNARD, Edward
British, 1785-1861
BARNARD, Elinor
British, 1872-

BARNARD, Frederick
British, 1846-1896
BARNARD, George
British, op.1837-m.1890
BARNARD, M.
British, 20th cent.
BARNARD, Philip Augustus
British, op.1840-1884
BARNARD, Roger
British, 1944-
BARNARD, William Henry,
The Rev.
British, op.1795-1810
BARNARD, Leon
American, 20th cent.
BARNES, Archibald George
British, 1887-
BARNES, E.C.
British, op.1856-1882
BARNES, J.
British, op.1796
BARNES, Robert
American, 20th cent.
BARNES, Robert
British, op.1873-1891
BARNES, Samuel John
British, op.1884-1886
BARNES, W.M.
American, 19th cent.
BARNET, Will
American, 1911-
BARNETT, M.G.
British, op.1814-1819
BARNEY, Alice (Mrs.
Clifford Barney)
American, 20th cent.
BARNEY the Elder, Joseph
British, 1751-p.1827
BARNHAM, Nicholas
British, 1939-
BARNOU
French, op.1774
BARNUTZ, F.
German, op.1842
BAROCCI or Baroccio,
Federigo (Fiori da
Urbino)
Italian, 1526-1612
BAROD, Anthoine
French, op.c.1600
BAROJA y Nessi,
Ricardo
Spanish, 1872-1953
BAROLET, John James
see Barralet
BARON, Mlle.
French, op.1764
BARON, Bernard
French, 1696-1762
BARON, Dominique
French, op.1842-1881
BARON, Emile
French, op.1870-1878
BARON, Henri Charles
Antoine
French, 1816-1885
BARON, Stéphane
French, 1830-p.1882
BARON, Théodore
Belgian, 1840-1899
BARONI, Antonio
(Baroni il Giovane)
Italian, 1678-1744
BARONI, Domenico
Italian, -1671
BARON-RENOUARD
see Renouard

BARONZIO da Rimini,
Giovanni
Italian, op.1362
BAROSSO, Girolamo
d'Andrea (Jeronimo
Baroxo)
Italian, op.1378-1409
BARR, Harry
British, 20th cent.
BARR, William
American, 1867-
BARRA, Didier
Italian, op.1608-1647
BARRA or Bara, Johan
Dutch, 1581-1634
BARRABAN or Barraband,
Jacques
French, 1767/8-1809
BARRABINO, Simone
Italian, c.1585
BARRADAS, Rafael
South American,
1890-1919
BARRALET, Barelet or
Barolet, John James
British, 1747-1815
BARRALET, John Melchior
British, op.1775-1787
BARRAS, Sebastien
French, 1653-1703
BARRAT, Pierre Martin
see Barat
BARRATT, G.
British, 19th cent.
BARRATT, Reginald
British, 1861-1917
BARRATT, Thomas
British, op.1852-1893
BARRAU, Laureano
Spanish, 1864-
BARRAUD, Aimé
Swiss, 1902-1954
BARRAUD, Allan
British, op.1873-1900
BARRAUD, Aurèle
Swiss, 1903-1969
BARRAUD, Charles
Swiss, 1897-
BARRAUD, Charles Decimus
British, 1822-1897
BARRAUD, Cyril Henry
British, 1877-1965
BARRAUD, Francis
British, op.1878-m.1924
BARRAUD, François Emil
Swiss, 1899-1934
BARRAUD, F.P.
British, 19th cent.
BARRAUD, Gustave François
see François, Gustave
BARRAUD, Henry
British, 1811-1874
BARRAUD, Maurice
Swiss, 1889-1954
BARRAUD, William
British, 1810-1850
BARRE, Jean Auguste
French, 1811-1896
BARRE, Martin
French, 1924-
BARRE, Raoul
Canadian, 1872-1932
BARREDA, Ignacio Maria
Spanish, op.1792-1794
BARREDA, Joanno F.B.
Italian, op.1734

BARRENA, Carmelo Garcia
Spanish, 20th cent.
BARRERA, Antonio
Italian, 1889-
BARRERA, Francisco
Spanish, op.1640
BARRET the Elder, George
British, 1728/32-1784
BARRET the Younger, George
British, c.1767-1842
BARRET, James
British, op.1785-1819
BARRET, Mary
British, 1732-1784
BARRET, Ranelagh
British, -1768
BARRETO, Benedito Bastos
(Belmonte)
Brazilian, 20th cent.
BARRETO, José Teixeira
Portuguese, 1761-1810
BARRETT, Eliza
British(?), 19th cent.
BARRETT, G.
British, 18th cent.(?)
BARRETT, G.
British, 19th cent.
BARRETT, Jeremiah
British, op.c.1761
BARRETT, Jerry
British, 1814-1906
BARRETT, Martin
German(?), 15th cent.
BARRETT, Roderick
Westwood
British, 1920-
BARRETT, Tom
British, 1936-
BARRETT, W.
British, 18th cent.
BARRETT, William S.
British, 1854-1927
BARRIAS, Félix Joseph
French, 1822-1907
BARRIE, Jean-Pierre
French, c.1830-
BARRIERE, Dominique
French, c.1610/20-c.1678
BARRIGUES or Barrigue de
Fontainieu, Prosper
François Irénée
French, 1760-1850
BARROIS, Jean Pierre
Frédéric
French, 1786-p.1841
BARRON, Hugh
British, c.1745-1791
BARRON y Carrillo, Manuel
Spanish, op.1828-1844
BARROSO, Miguel
Spanish, 1538-1590
BARROW
British, op.1773
BARROW, Joseph Charles
British, op.1789-1802
BARROW, Julian
British, 20th cent.
BARROW, Mrs.
see Ross, Janet
BARRY, Sir Charles
British, 1795-1860
BARRY, Claude Francis
British, 1883-1970
BARRY, James
British, 1741-1806
BARRY, John
British, op.1784-1827

BARRY, T.T.
British, 19th cent.
BARTELS, C.A.
German, 1900-
BARTELS, Hans von
German, 1856-1913
BARTEZAGO or Bartezatti,
Luigi
Italian, 1820-1905
BARTH, Bradi
French, 20th cent.
BARTH, Carl
German, 1896-
BARTH, F.
German, 19th cent.
BARTH, J.S.
British, op.1797-1809
BARTH, Karl
German, 1787-1853
BARTH, Paul Basilius
Swiss, 1881-1955
BARTH, Sigmund
Swiss, op.1754-1772
BARTHE, Gérard de la
French, op.1787-1810
BARTHEL, Friedrich
German, 1775-1846
BARTHELEMY, Emilien
Victor
French, 1885-
BARTHELEMY, J.S.
see Berthelemy
BARTHOLD, Manuel
American, 1874-1947
BARTHOLDI, Frédéric
Auguste
French, 1834-1904
BARTHOLOME, Leon
French, op.1899-1907
BARTHOLOMEW or Turnbull,
Anne Charlotte, née
Fayerman
British, 1800-1862
BARTHOLOMEW, Valentine
British, 1799-1879
BARTHOW, Mihail
Vasilievitch
Russian, 19th cent.
BARTIGNANI, C.
Italian, 19th cent.
BARTLETT, Charles W.
British, 1860-
BARTLETT, Frederic
Clay
American, 1873-1953
BARTLETT, Harold Charles
British, 1921-
BARTLETT, William H.
British, 1809-1854
BARTLETT, William Henry
British, 1858-
BARTLEY, Sally
British, 20th cent.
BARTOLENA, Giovanni
Italian, 1869-
BARTOLI, Pietro Santo,
Sante or Santi
Italian, c.1635-1700
BARTOLINI, Francesco
Italian, op.1844-1881
BARTOLINI, Giuseppe Maria
Italian, 1657-1725
BARTOLINI, Louisa Grace
Italian, 1818-1865
BARTOLINI, Luigi
Italian, 1892-

BARTOLINI, Paolo
Italian, 19th cent.
BARTOLINI, S.
Italian, 20th cent.
BARTOLINO or Bertolino
da Piacenza
Italian, 15th cent.
BARTOLO, Andrea di
see Andrea
BARTOLO, Domenico di
see Domenico
BARTOLO di Fredi
Battilore
Italian, c.1330-p.1410
BARTOLOMEO d'Andrea
Bocchi da Pistoia
Italian, op.1450-1465
BARTOLOMEO da Fano
see Morganti
BARTOLOMEO di Matteo
Marescalchi
see Morganti
BARTOLOMEO da Brescia
(Olmo, Lolmo or Lulumus)
Italian, 1506-p.1576
BARTOLOMMEO, Fra
(Baccio della Porta,
Bartolommeo da San
Marco)
Italian, 1472-1517
BARTOLOMMEO da Arezzo
Italian, op.1560-1578
BARTOLOMMEO da Carmogli
(de Camulio)
Italian, op.1346-p.1358
BARTOLOMMEO da Forlì
Italian, op.1510-1538
BARTOLOMEO di Fruosini
Italian, 15th cent.
BARTOLOMMEO della Gatta
(Don Piero d'Antonio
Dei)
Italian, 1448-1502/3
BARTOLOMMEO di Giovanni
(Alunno di Domenico)
Italian, op.1488
BARTOLOMMEO di Maestro
Gentile
Italian, c.1470-c.1534
BARTOLOMMEO da Miragna
Italian, op.c.1450(?)
BARTOLOMMEO di Nuto
(Nutino)
Italian, 14th cent.
BARTOLOMMEO da San Marco
see Fra Bartolommeo
BARTOLOMMEO da
Seraphino
Italian, 16th cent.
BARTOLOMMEO di Tommaso
da Foligno
Italian, op.1425-1455
BARTOLOMMEO Veneto
Italian, op.1502-c.1531
BARTOLOZZI, Francesco
Italian, 1727-1815
BARTON, General Sir E.
British, op.c.1793-1814
BARTON, Rose
British, op.1884-1904
BARTONEK, Vojtech
Adalbert
Czech, 1859-1908
BARTSCH, Adam von
German, 1757-1821
BARTSIUS, Willem
Dutch, c.1612-p.1639

BARUCCI, Pietro
 Italian, 1845-1917
BARUCHELLO, Gianfranco
 Italian, op.1965
BARUFFI, Alfredo
 Barfredo
 Italian, 1874-
BARUFFI, Giuseppe
 Italian, 17th cent.
BARVITIJS, Victor
 Czech, 1834-1902
BARWELL, Frederick
 Bacon
 British, op.1855-m.1897(?)
BARWELL, John
 British, 1798(?)-1876
BARWICK, J.
 British, op.1844-1849
BARY, Hendrik
 Dutch, c.1640-1707
BARYE, Antoine Louis
 French, 1796-1875
BAS, le
 see Lebas
BAS, Edward le
 British, 1904-1966
BAS, Jean de
 French(?) 17th cent.
BAS, Martin
 see Baes
BASAITI, Marco
 Italian, op.1490-p.1521
BASAITI, Pseudo-
 Italian, 15th cent.
BASALDELLA, Afro
 see Afro
BASCH, Arpåd
 Hungarian, 1873-
BASCH, Julius Gyula
 Hungarian, 1851-
BASCHENIS, Cristoforo I
 Italian, op.1572
BASCHENIS, Evaristo
 Italian, 1617-1677
BASCHENIS, Simone
 Italian, op.1519-1544
BASCHET, Marcel André
 French, 1862-1941
BASCHILOFF, Jakowl
 Stepanowitsch
 Russian, 1839-1896
BASCHIS, C.
 French(?) op.1867
BASCHNY, Emmanuel
 German, 1876-1932
BASCOM, Ruth Henshaw
 Miles
 American, 1772-1848
BASEBE, C.
 British, op.1843-1879
BASELEER, Richard
 Belgian, 1867-
BASHKIRTSEFF, Marie
 Konstantinowna
 French, 1860-1884
BASILE, Gennaro
 Italian, 1722-1782
BASILETTI, Luigi
 Italian, 1780-1860
BASILI, Pier Angelo
 Italian, p.1550-1604
BASIRE, C.J. (James
 Basire III (?)
 British, 1796-1869
 British, 1730-1802

BASKETT, Charles E.
 British, op.1872-1893
BASKETT, Charles Henry
 British, 1872-1953
BASKIN, Leonard
 American, 1922-
BASOLI di Castelguelfo,
 Antonio
 Italian, 1774-1848
BASS, Maria
 Italian, 1897-1948
BASS, Otis
 American, 19th cent.
BASS, Saul
 American, 1920-
BASSA
 see Ferrer
BASSAGET, Numa
 French, op.1824
BASSANINO, Valerio
 Italian, 18th cent.
BASSANO, Antonio
 see Scaiaro
BASSANO the Elder,
 Francesco da Ponte
 Italian, 1470/75-1539/41
BASSANO the Younger,
 Francesco da Ponte
 Italian, c.1549-1592
BASSANO, Gerolamo da
 Ponte
 Italian, 1566-1621
BASSANO, Giambattista,
 (Giovanni Battista)
 da Ponte
 Italian, 1553-1613
BASSANO, Jacopo or
 Giacomo da Ponte, Il
 Italian, 1510/15-1592
BASSANO, Leandro da
 Ponte
 Italian, 1557-1622
BASSANTE
 see Passante
BASSE, J.
 Dutch, 17th/18th cent.
BASSE, Martin
 see Baes
BASSE, Willem
 Dutch, 1613/14-1672
BASSEN, Bartholomeus
 van
 Dutch, op.1613-m.1652
BASSETTI, Marcantonio
 Italian, 1588-1630
BASSINGTHWAIGHTE, Lewis
 British, 20th cent.
BASSILIOU, Spyros
 Greek, 1902-
BASSIUS, Martin
 see Baes
BASSOTTI, Giovan
 Francesco
 Italian, c.1600-1665(?)
BAST, Dominique de
 Belgian, 1781-1842
BAST, Pieter
 Netherlands,
 op.1595-m.1605
BASTARD, Marc-Auguste
 Swiss, 1863-1926
BASTAROLO, Il
 see Mazzuoli, Giuseppe
BASTERT, Syvert
 Nicolaas (Nicolaas)
 Dutch, 1854-1939

BASTIAN, Anton
 German, 1690-1759
BASTIANI, Lazzaro di
 Jacopo (Sebastiani)
 Italian, op.1449-m.1512
BASTIANI, Prete
 Sebastiano
 Italian, op.1489-m.1538
BASTIANINI, Augusto
 Italian, 1875-1936/40
BASTIANINO, Sebastiano
 (Filippi)
 Italian, 1532-1602
BASTIANO di Francesco
 di Sano
 Italian, op.1471-1483
BASTIANO, Veronese
 (Sebastiano dal Vini)
 Italian, op.1548-1596
BASTIANSZ., Abraham
 Dutch, op.1654-1658
BASTIEN, Alfred
 Théodore Joseph
 Belgian, 1873-1947
BASTIEN-LEPAGE, Jules
 French, 1848-1884
BASTIER DE BEZ or Betz,
 Jean Joseph
 French, 1780-c.1845
BASTIN, A.D.
 British, op.1871-1892
BASTIN, Henry
 Australian 1896-
BASTINE, Johann Baptiste
 Joseph
 Belgian, 1783-1844
BASTINE, Johann Baptist
 Joseph
 Flemish, 1783-1844
BASTON, Thomas
 British, op.1721
BATE, Francis J.P.
 British, 1858-1950
BATE, Louis Robert
 French, 1898-
BATE, M.N.
 British, op.1821
BATE, Thomas
 British, op.1692
BATE, William
 British, op.1779-m.c.1845
BATEMAN, Harry
 British, 19th cent.
BATEMAN, Henry Mayo
 British, 1887-
BATEMAN, James
 British, 1814-1849
BATEMAN, James
 British, 1893-1959
BATEMAN, John
 British, 18th cent.
BATEMAN, Robert
 British, 1841/2-p.1889
BATERMAN, J.
 British, 19th cent.
BATES, David
 British, op.1868-1893
BATES, H.
 British, 17th cent.
BATES, Maxwell
 Canadian, 1806-
BATES, Robert
 British, 20th cent.
BATES, W.E.
 British, 1812-p.1867
BATHURST, George
 British, -1647
BATHURST, R.H.
 British, 20th cent.

BATIST, Karel
 Dutch, op.1659-1663
BATISTE, M.
 French, op.c.1879
BATLEY, M.E.
 British, 19th cent.
BATONI or Battoni,
 Pompeo Girolamo
 Italian, 1708-1787
BATTA, Petter Pettersen
 Norwegian, c.1700-1735
BATTAGLIA, Dionisio
 Italian, op.c.1547
BATTAGLINI, Francesco
 (Francesco Debais de
 Imola)
 Italian, op.1511-1515
BATTAGLIOLI, Francesco
 Italian, 18th cent.
BATTAGLIOLI, Francesco
 Italian, op.1750
BATAILLE, George
 French, 19th cent.
BATTEM, Gerard or
 Gerrit (van)
 Dutch, c.1636-1684
BATTEN, John Dixon
 British, 1860-1932
BATTIGNANT, J.
 French, 19th cent.
BATTISS, Walter
 British, 1906-
BATTISTA, Giovanni
 Italian, 1858-1925
BATTISTA de' Luteri or
 de' Constantino
 see Dossi
BATTISTA di Maestro
 Gerio (Battista da
 Pisa)
 Italian, op.1418
BATTISTA del Moro
 see Angolo del
 Moro, Battista
BATTISTA da Pisa
 see Battista di
 Maestro Gerio
BATTISTA de Verona
 see Zelotti,
 Giambattista
BATTISTA da Vicenza
 Italian, op.c.1400-1408
BATTISTELLI, Pier
 Francesco
 Italian, op.1610-1625
BATTISTELLO, Il
 see Caracciolo,
 Giovanni Battista
BATTISTINI, Alessandro
 Italian, c.1850-
BATTISTONI, Vasco
 Italian, 1895-
BATTONI, Pompeo
 Girolamo
 see Batoni
BATTY, Elizabeth
 Frances
 British, op.1817
BATTY, John
 British, op.1772-1788
BATTY, Robert
 British, 1789-1848
BATURIN, Victor
 Pavlovitch
 Russian, 1863-1938

19

BAUBY, Ae.
French, op.1804
BAUCE
French, 18th cent.(?)
BAUCHANT, André
French, 1873-1958
BAUD, Maurice
Swiss, 1866-1915
BAUD-BOVY, Auguste
Swiss, 1848-1899
BAUDE, François Charles
French, 1880-
BAUDELAIRE, Charles
French, 1821-1867
BAUDENBACH, John
British, op.1772-1777
BAUDESSON, Nicolas
French, 1611-1680
BAUDET, Marie
French, 20th cent.
BAUDEWYNS, Adriaen
Frans
see Boudewyns
BAUDIN, Alessandro W.
see Bodin
BAUDIN, Eugène
French, 1843-1907
BAUDIN or Bodin,
Joseph
British, op.1711-1744
BAUDIN, N.(?)
Flemish(?), 17th cent.
BAUDIOT, François
French, 1772-p.1814
BAUDIT, Amédée
French, 1825-1890
BAUDIT, Louis
Swiss, 1890-1965
BAUDO, Luca
Italian, -c.1509
BAUDOIN, Bhotet
French, op.1770
BAUDOUIN, Paul Albert
French, 1844-1931
BAUDOUIN, Pierre
Antoine
French, 1723-1769
BAUDOUS, Robert Willemsz.
de
Flemish,
1574/5-p.1656(?)
BAUDRI, P.L.F.
German, 1808-1874
BAUDRIER, P.
French, 20th cent.
BAUDRINGIEN, Baudrigeen,
Baudrighem or
Baudrigen, David
Dutch, c.1581-c.1650
BAUDRY de Balzac,
Caroline
see Cerres
BAUDRY, Paul Jacques
Aimé
French, 1828-1886
BAUDUIN, François or
Frans
Flemish, op.1725-1736
BAUDUINS, Adriaen
Frans
see Boudewyns
BAUER, Conrad
(Monagrammist C.B.)
German, op.1517-1532
BAUER, Ferdinand
German, 1760-1826
BAUER, Franz Andreas
German, 1758-1840

BAUER, Johann Wilhelm
see Baur
BAUER, John
Swedish, 1882-1918
BAUER, Joseph Anton
German, 1820-1904
BAUER, Konstantin
Czech, 1852-
BAUER, Marius Alexander
Jacques
Dutch, 1867-1932
BAUER or Baur,
Nicolaas
Dutch, 1767-1820
BAUER, Rudolf
German, 1889-1953
BAUER, Wilhelm Gottfried
German, 1779-1853
BAUERMEISTER, Mary
American, 1934-
BAUERNFEIND or
Baurenfeind, Georg
Wilhelm
German, op.1759-m.1763
BAUGEAN, Jean Jérôme
French, 1764-1819
BAUGIN, A.
French, op.1630
BAUGIN, Lubin
French, c.1610-1663
BAUGNIES, Eugène
French, c.1842-1891
BAUGNIET, Charles
Belgian, 1814-1886
BAUHOT
French, op.1808
BAUKNECHT, Paul
German, 20th cent.
BAUKNECHT, Philipp
Swiss, 1884-1933
BAULAY
British, 19th cent.
BAUM, Paul
German, 1859-1932
BAUMAN, Leila T.
American, op.1860
BAUMANN, Adolf
German, 1829-1865
BAUMANN-HIOOLEN,
Cornelia, (née
Hioolen)
see Hioolen
BAUMBERGER, Otto
Swiss, 1889-
BAUME, Bertha de la
French, 1860-1911
BAUMEISTER, Willi
German, 1889-1955
BAUMER, Eduard
German, 20th cent.
BAUMER, Lewis
British, 1870-
BAUMGART, Isolde
German, 20th cent.
BAUMGARTNER, Anton
Czech, 1729-
BAUMGARTNER, Johann
(Pater Norbert)
German, c.1717-1773
BAUMGARTNER, Johann Jakob
German, op.1720-1727
BAUMGARTNER, Johann
Wolfgang
German, 1712-1761
BAUMGARTNER, Peter
German, 1834-1911

BAUMGARTNER, Thomas
German, 1892-1962
BAUMGARTNER-STOILOFF, A.
German, 19th cent.
BAUMHAUER, Sebald
German, op.1499-m.1533
BAUR, Albert
German, 1835-1906
BAUR, Carl Albert
German, 1851-1907
BAUR, Johannes
Antonius
German, op.1767-m.1820
BAUR or Bauer, Johann
Wilhelm
German, c.1600-1640
BAUR, Nicolaas
see Bauer
BAURENFEIND, Georg
Wilhelm
see Bauernfeind
BAUSA, Gregorio
Spanish, 1590-1656
BAUSE, Johann Friedrich
German, 1738-1814
BAUZIL or Bauziel, Juan
Spanish, op.1800-1812
BAVARESE
see Oefele, Franz
Ignaz
BAVIER, Hans Georg
Swiss, 1700-p.1735
BAWDEN, Edward
British, 1903-
BAXTER, Charles
British, 1809-1879
BAXTER, George
British, 1804-1867
BAXTER, Nellie
British, op.1896
BAXTER, Thomas
British, 1782-1821
BAXTER, Thomas Tennant
British, 1894-1947
BAXTON, J.
British, 18th cent.
BAY, August Hyacinth
de
see Debay
BAYARD, Emile Antoine
French, 1837-1891
BAYER, Anton
Czech, op.1836
BAYER, August von
Swiss, 1803-1875
BAYER, Gabriel
German, 18th cent.
BAYER, Herbert
American, 1900
BAYER, Jakob
German, 1874-1929
BAYERLEIN, Fritz
German, 1872-
BAYES, Alfred Walter
British, op.1858-1903
BAYES, Jessie
British, 19th cent.
BAYES, Walter
British, 1869-1956
BAYEU y Subias, D.
Francisco
Spanish, 1734-1795
BAYEU y Subias, Ramon
Spanish, 1746-1793
BAYLAC, Lucien
French, 19th cent.

BAYLESS, Raymond
American, 20th cent.
BAYLIS, J.C.
British, op.1866-1867
BAYLISS, Sir Wyke
British, 1835-1906
BAYNARA, Padre Pietro da
see Bagnara
BAYNES, Frederick T.
British, op.1833-1864
BAYNES, James
British, 1766-1837
BAYNES, Keith
British, 1887-
BAYNES, Thomas Mann
British, 1794-1854
BAYOT, Adolphe Jean-
Baptiste
French, 1810-1866
BAYRE, Antoine-Louis
French, 19th cent.
BAYRLE, Thomas
British, 20th cent.
BAYROS, Franz von
German, 1866-1924
BAZAINE, Jean René
French, 1904-
BAZETT, Sarah
see Malden, Lady
BAZICALUVA or
Bazzicaluve, Ercole
Italian, op.c.1638
BAZILE, Caserta
Haitian, 1923-
BAZILLE, Jean Frédéric
French, 1841-1870
BAZIN, Charles Louis
French, 1802-1859
BAZIN, Pierre Joseph
French, 1797-1866
BAZIOTES, William
American, 1912-1963
BAZOVSKY, Milos Alexander
Czech, 1899-
BAZZACCO
see Ponchino
BAZZANI, Giuseppe
Italian, 1690/1701-1769
BAZZANI, Luigi
Italian, 1836-1927
BAZZARO, Leonardo
Italian, 1853-1937
BAZZI, Giovanni Antonio de'
see Sodoma
BAZZICALUVE, Ercole
see Bazicaluva
BEA, Manolo
(Manuel)
Spanish, 1934-
BEACH, Ernest George
British, 1865-c.1934
BEACH, Thomas
British, 1738-1806
BEADLE, James Prinsep
British, 1863-1947
BEAL, Franz de
French, 19th cent.
BEAL, Clifford
American, 1879-1956
BEAL, Jack
American(?), 20th cent.
BEAL, Reynolds
American, 1867-1951
BEALE, Charles
British, 1660-

BEALE, Mary, (née Cradock)
British, 1633-1697
BEAMENT, Thomas Harold
Canadian, 1898-
BEANLAND, Frank
British, 1936-
BEARBLOCK, J.
British, 18th cent.
BEARD, James Henry
American, 1814-1893
BEARD, William Holbrook
American, 1823-1900
BEARDEN, Romare
American, 20th cent.
BEARDMORE, William
British, op.1822-1826
BEARDSLEY,
American, 18th cent.
BEARDSLEY, Aubrey Vincent
British, 1872-1898
BEARE, George
British, op.1741-1747
BEATON, Cecil
British, 1904-
BEATRICIUS
see Master of the Die
BEATRIZ, Dulce H. de
American, 20th cent.
BEATRIZET, Beatricetto, Beatricius or Beautrizet, Nicolaus
French, c.1515-p.1565
BEATTIE, Basil
British, 1936-
BEATTIE, Lucas
British, op.1832
BEATTY, John William
Canadian, 1869-1941
BEAU, Giuseppe de
French, op.1730
BEAU, Henri
Canadian, 1863-1949
BEAUBOIS de Montoriol, Isabel
French, 1876-
BEAUBRUN, Charles
French, 1604-1692
BEAUBRUN, Henri, II
French, 1603-1677
BEAUBRUN, Louis
French, op.1609-m.c.1627
BEAUCHAMP, Charles
British, 20th cent.
BEAUCHAMP, Robert
American, 1924-
BEAUCLAIR, René
French, op.1910
BEAUCLERK, Lady Diana
British, 1734-1808
BEAUCOURT, Francois
Canadian, 1740-1794
BEAUDELOT, Francois
French, 20th cent.
BEAUDIN, André Gustave
French, 1895-
BEAUDIN, Jean
French, op.c.1903
BEAUDUIN, Jean
Belgian, 1851-1916
BEAUFOND, Ines de
French, op.1892
BEAUFORT, J.P.
British, op.1843
BEAUFORT, Jacques Antoine
French, 1721-1784

BEAUHARNAIS, Hortense de
French, 1783-1837
BEAUGEAN, Jean Jérome
French, 1764-1819
BEAULIEU, Anatole Henri de
French, 1819-1884
BEAUME, Joseph
French, 1796-1885
BEAUMETZ, Beaumes or Biaumez, Jean de
French, op.1361-m.1396
BEAUMONT, Anne (Anne Pierce)
British, op.1820-1833
BEAUMONT, Charles Edouard de
French, 1821-1888
BEAUMONT, Claudio Francesco
Italian, 1694-1766
BEAUMONT, Frederick Samuel
British, 1861-
BEAUMONT, Sir George Howland
British, 1753-1827
BEAUMONT, Harold
British, 20th cent.
BEAUMONT, Hugues de
French, 1874-
BEAUMONT, Jean François
see Albanis
BEAUMONT, Jean-Georges
French, 1895-
BEAUMONT, John Thomas Barber
British, 1774-1841
BEAUNEVEU, Andre
French, op.1360-m.a.1413
BEAUNIER, Firmin Hippolyte
French, 1782-p.1824
BEAUPIN, G.
French, 20th cent.
BEAUQUESNE, Wilfrid
French, 1847-1914
BEAURY-SAUREL, Julien
French, 19th cent.
BEAUTRIZET, Nicolaus
see Beatrizet
BEAUX, Cecilia
American, 1863-1942
BEAVIS, Richard
British, 1824-1896
BEBBINGTON, Evelyn
British, 20th cent.
BEBIE, W.
American, op.1845
BECCAFUMI, Domenico (Mecuccio or Mecarino)
Italian, 1486-1551
BECCALINI, Giovanni
Italian, 1655-
BECCARUZZI, Francesco
Italian, op.1520-1550
BECCI
see Bezzi
BECERI or Benci, Domenico
Italian, op.1565
BECERRA, Anton
Spanish, op.1511-1525
BECERRA, Gaspar
Spanish, c.1520-1570

BECERRIL, Juan
see Gonzalez
BECH, Johan Anton
Danish, 1797-1825
BECHARD
French, op.1785
BECHER, Lieut. A.
British, 19th cent.
BECHI, Luigi
Italian, 1830-1919
BECHON, Carl
Polish, 1732-1812
BECHTEJEFF, Vladimir Georgievitch
Russian, 1878-
BECHTEL, Michael
German(?), op.1665
BECHTLE, Robert
American, 1932-
BECHTOLD, Jacob Konrad
German, 1726-p.1775
BECHTOLSHEIM, Gustav Freiherr von
German, 1842-1924
BECI
see Bezzi
BECK, David
Dutch, 1621-1656
BECK, Georg
German, 15th cent.
BECK, George
British, op.1790-1803
BECK, Gerlinde
German, 20th cent.
BECK, Hans Jacob
Swiss, 1786-1868
BECK or Beek, Jacob Samuel
German, 1715-1778
BECK, Leonhard
German, c.1480-1542
BECK, Peregrin
German, 1749-1823
BECKENKAMP, Caspar Benedikt
German, 1747-1828
BECKER, A.
German, op.1827
BECKER, Adolf von
Finnish, 1831-1909
BECKER, Albert
German, 1830-1896
BECKER, August
German, 1822-1887
BECKER, Carl Ludwig Friedrich
German, 1820-1900
BECKER, E.
British, op.1793-1810

BECKER, F.W.
British(?) 18th cent(?)
BECKER, J.J.
German, op.1808-1840
BECKER, Jacob (Becker von Worms)
German, 1810-1872
BECKER, Joseph
American, 1841-1910
BECKER, Ludwig Hugo
German, 1833-1868
BECKER, Nicolas
Russian, 20th cent.
BECKER, Peter
German, 1828-1904
BECKER, Philipp Jakob
German, 1759-1829
BECKER, W.G.
American, 19th cent.

BECKERATH, Moritz von
German, 1838-1896
BECKER-GUNDAHL, Karl Johann
German, 1856-1925
BECKERS, F.
German(?), op.1789
BECKERT, Paul
German, 1856-1922
BECKET, Issac
British, 1653-1719
BECKLEY, John
American, 20th cent.
BECKMAN, Sir Martin
British, op.1660-m.1702
BECKMANN, Conrad
German, 1846-1902
BECKMANN, Ernst
German, 20th cent.
BECKMANN, Johann (Hans)
German, 1809-1882
BECKMANN, Max
German, 1884-1950
BECKNER, J.A.
Dutch(?), 17th cent.(?)
BECKX
see Becx
BECQUER, Joaquin Dominguez
Spanish, 1805-1841
BECQUER, Valeriano Dominguez
Spanish, 1834-1870
BECX or Beckx, J. (Johannes?)
Dutch, 17th cent.
BECX or Beckx, Jaspar
Dutch, op.1630-m.1647
BEDA, Francesco
German, 1840-1900
BEDA, Giulio
German, 1879-
BEDESCHINI, Giulio Cesare
Italian, 17th cent.
BEDFORD the Younger, E.
British, op.1833-c.1852
BEDFORD, Ella M.
British, op.1882-1906
BEDFORD, Francis Donkin
British, c.1867-1934
BEDFORD, George
British, 1849-1920
BEDFORD, John Bates
British, 1823-1886
BEDI, Jacopo
Italian, op.1458
BEDIKIAN, Krikor
Lebanese, 20th cent.
BEDINI, Paolo
Italian, 1844-1924
BEDNAR, Stefan
Czech, 1909-
BEDOLO, Girolamo
see Mazzola-Bedolo
BEDUZZI, Beducci or Beducius, Antonio Maria Nicolao
Italian, op.c.1705-1710
BEEBY-THOMPSON
British, op.1822
BEECHAM, William Row
British, op.1824-33
BEECHEY, Lady Anne Phyllis, (née Jessop)
British, 1764-p.1805

BEECHEY, George
Duncan
British, 1798-1852
BEECHEY, Admiral
Richard Brydges
British, 1808-1895
BEECHEY, Sir William
British, 1753-1839
BEECHY, John
British, op.1786
BEECK, Johannes or
Jan Symoonisz. van
see Torrentius
BEECKMAN, Andries
Dutch, op.1651-1657
BEECQ, Jan Karel
Donatus van
Dutch, c.1638-1722
BEEK, Jacob Samuel
see Beck
BEEK, Theodor von der
German, 1838-1921
BEEKKERK or Beekerk,
Herman Wouter
Dutch, 1756-1796
BEEKMAN, Christiaan
Hendrik (Chris)
Dutch, 1887-1964
BEELDEMAECKER, A.B.
Netherlands, 16th cent.
BEELDEMAKER, Adriaen
Cornelisz.
Dutch, 1618-1709
BEELDEMAKER, Cornelis
Dutch, op.1689-1736
BEELDEMAKER, Johannes
Cornelis
Dutch, 1630(?)-p.1710
BEELT, Cornelis
Dutch, op.c.1660-m.a.1702
BEENFELDT, Ulrich
Ferdinand
Danish, 1714-1782
BEER, G.J.
British, 20th cent.
BEER, George
(of Bristol)
British, 18th cent.
BEER, J. or I. de
Dutch, op.1766-1777
BEER, Jan de
(Identified with
Master of the Milan
Adoration)
Netherlands,
op.1490-1520
BEER, Johann
Friedrich
German, 1741-1804
BEER, Joost de
(Monogrammist B)
Netherlands,
op.1550-m.a.1595
BEER, Richard
British, 20th cent.
BEER, Wilhelm Amandus
German, 1837-1907
BEERBLOCK, Johannes
or Jean
Flemish, 1739-1806
BEERBOHM, Max
British, 1872-1956
BEERESTEYN, Claes van
see Beresteyn
BEERI
Swiss, 20th cent.
BEERNAERT, Euphrosine
Flemish, 1831-1901

BEERS, de
French, 19th cent.
BEERS, Jan van
Belgian, 1852-1927
BEERS, Julie Hart
American, 1835-1913
BEERSTRAATEN or
Beerstraten, Abraham
Dutch, op.1656-1665
BEERSTRAATEN or
Beerstraten, Anthonie
Dutch, op.1664-1667
BEERSTRAATEN or
Beerstraten, Johannes
(Possibly identified
with Johannes Abrahamsz.
Beerstraaten)
Dutch, op.1663
BEERSTRAATEN or
Beerstraten, Johannes
or Jan Abrahamsz.
Dutch, 1622-1666
BEERT, Osias, I
Flemish, c.1580-1624
BEERT, Osias, II
Flemish, 1622-c.1678
BEEST, Albertus van
Dutch, 1820-1860
BEEST, Sybrandt van
Dutch, 1610-1674
BEESTEN, Abraham
Hendrik van
Dutch, c.1696-1773
BEET (also, erroneously,
Beel), C.D.
Dutch, op.1652
BEETHAM, Miss J.
British, op.1794
BEETHOLME, George
Law
British, op.1847-1878
BEETON, Alan
British, 1880-1942
BEFANIO, Gennaro
Italian, 1866-
BEFORT, Mlle
French, op.1812-1819
BEGA, Abraham
see Begeijn
BEGA, Cornelis
Pietersz.
Dutch, 1631/2(?)-1664
BEGAS, Carl Joseph
German, 1794-1854
BEGAS, Reinhold
German, 1831-1911
BEGAS-PARMENTIER,
Luise
German, op.1877
BEGEIJN, Begein,
Begeyn or Begheyn,
Abraham Cornelisz.(?)
or Jansz.(?)
Dutch, op.1655-m.1697
BEGG, S.
British, op.1897-1911
BEGGARSTAFF, Brothers
(William Nicholson
and James Pryde)
British, 20th cent.
BEGGS, Guy
South African, 1947-
BEGHEYN, Abraham
see Begeyn
BEGHI, Enrico
Italian, 20th cent.

BEGUIER, S.
French, 20th cent.
BEHAGLE, Antoni
Netherlands, op.1560
BEHAM, Baehm, Beheim,
Böhm or Peham,
Barthel
German, 1502-1540
BEHAM, Georg
see Pecham
BEHAM, Beheim, Böhm
or Peham, Hans
Sebald
German, 1502-1550
BEHAM, Pseudo
see Schön, Erhard
BEHAN, Peter
British, 20th cent.
BEHM, Karl
German, 1858-1905
BEHMER, Marcus
German, 1879-1958
BEHN, Andreas von
Swedish, 1650-1713
BEHNES, William
British, c.1794-1864(?)
BEHR, Carel Jacobus
Dutch, 1812-1895
BEHR, Johann Philipp
German, op.1740-m.1756
BEHRENS, Frank Louis
Swiss, 1883-
BEHRENS, Peter
German, 1868-1940
BEHRENS, Timothy
British, 1937-
BEHRINGER, Ludwig
German, 1824-1903
BEICH, Joachim Franz
German, 1665-1748
BEILBY, William
British, op.1780-1791
BEINASCHI, Giovanni
Battista
see Benaschi
BEINKE, Fritz
German, 1842-1907
BEISCHLAG or Beyschlag,
Johann Christoph
German, 1645-1712
BEITLER, Beutler or
Beytler, Mathias
German, c.1582-1614
BEJARANO, Antonio
Cabral
Spanish, op.1825-1847
BEKE, Daniel van
Dutch, op.1707
BEKE, Joos van der
see Cleve
BEKEL or Beckel,
Josef
German, 1806-1865
BELANGER or Bellanger,
Francois Joseph
French, 1744-1818
BELANGER or Bellanger,
Louis
French, 1736-1816
BELANGER, Paul
French, op.1785
BELAU, Nikolaus
Bruno
German, 1684-1747
BELAU, Tobias
German, 18th cent.

BELAY, Pierre de
French, 1890-
BELBELLO, Giovanni
Italian, 15th cent.
BELCAMP, Jan or John
van
see Belkamp
BELCHER, George
Frederick Arthur
British, 1875-1947
BELGIAN SCHOOL,
Anonymous painters
of the
BELGIOIOSO, Rinaldo
see Barbiano
BELIN, Auguste
French, 19th cent.
BELIN, Claude
Alexandre
French, op.1794
BELIN, Francois
French, op.c.1660
BELIN, Blain or Blin
de Fontenay, Jean
Baptiste, I
French, 1653-1715
BELIN de Fontenay,
Jean Baptiste, II
French, 1688-1730
BELIN de Fontenay,
Louis
French, c.1603-p.1666
BELIN, Nicolas
(Niccolò da Modena)
Italian, op.1533-1534
BELKAMP, Belcamp,
Belchamp or Belcom,
John or Jan van
British, 1653-
BELKIN, Cornelius
see Bellekin
BELKNAP, Zedekiah
American, 1781-1858
BELL, A.
British, 19th cent.
BELL, Alexander
Carlyle
British, op.1866-1891
BELL, Charles
American, 1935-
BELL, Edward
British, op.1794-1847
BELL, George
Frederick
British, op.1908-1913
BELL, Graham
British, 1911-1943
BELL, J.A.
British, 19th cent.
BELL, J.C.
British, 19th cent.
BELL, John
British, 1811-1895
BELL, John
Zepheniah
British, 1794-1883
BELL, Larry
American, 20th cent.
BELL, Laura Anning
British, 1867-1950
BELL, Lady Maria,
(née Hamilton)
British, op.1816-m.1825
BELL, Peggy
British, 20th cent.

BELL, Robert
Anning
British, 1863-1933
BELL, Rodolphe
Swiss, op.1822-1827
BELL, Trevor
British, 1930-
BELL, Vanessa
British, 1879-1961
BELL, William
British, 1740-1804
BELLA, Gabriele
Italian, 18th cent.
BELLA, Stefano della
see Della Bella
BELLAMY
Swiss, op.1730
BELLAMY
Australian, 20th cent.
BELLAN, Louis Gilbert
French, 1868-c.1935
BELLANGE
French, 16th cent.
BELLANGE or Bellangé, A.
French, op.1591
BELLANGÉ, Eugene
French, 1837-1895
BELLANGE, Joseph Louis
Hippolyte
French, 1800-1866
BELLANGE, Jacques or
Thierry
French, 1594-1638
BELLANGER
see also Belanger
BELLANGER, Camille
Félix
French, 1853-1923
BELLANGER-ADHÉMAR,
Paul
French, 1868-
BELLANY, John
British, 1942-
BELLARDEL, Napoleon
Joseph
French, 19th cent.
BELLATI, Filippo
Italian, op.1801-1817
BELLAVIA, Marcantonio
Italian, 17th cent.
BELLAVITE, Innocente
Italian, 1692-1762
BELLAY, François
French, c.1790-1840/54/58
BELLE, Alexis Simon
French, 1674-1734
BELLE, Clément Louis
Marie Anne
French, 1722-1806
BELLE, Marcel
French, 20th cent.
BELLE, Narcisse
French, 1900-
BELLECHOSE de Brabant,
Henri
French, op.1415-1440
BELLECOURT, Veron
French, 1773-
BELLEE, Léon de
French, 1846-1891
BELLEFLEUR, Léon
Canadian, 1910
BELLEGAMBE, Jean
Netherlands,
c.1470-c.1534
BELLEGARDE, Claude
French, 1927-

BELLEI, Gaetano
Italian, 1857-1922
BELLEKIN, Belkin or
Bellequin, Cornelius
Dutch, op.1664
BELLEL, Jean Joseph
Francois
French, 1816-1898
BELLENGER, Clément
French, 1851-1898
BELLENGER, Georges
French, 1847-1915
BELLEQUIN, Cornelius
see Bellekin
BELLERMANN, Ferdinand
German, 1814-1889
BELLEROCHE, Albert de
British, 1864-1944
BELLEROCHE, William de
British, 1913-
BELLERS, William
British, op.1761-1773
BELLERY-DEFONAINES, Henri
Jules Ferdinand
French, 1867-1910
BELLET du Poisat,
Alfred
French, 1823-1883
BELLETTE, Jean
Australian, 1919-
BELLEUSE, Louis
Robert Carrier
French, 19th cent.
BELLEVOIS, Jacob
Adriaensz.
Dutch, 1621-1675
BELLI, Valerio
(Valerio Vicentino)
Italian, c.1468-1546
BELLIAS, Richard
French, 1921-
BELLICARD, Jérôme Charles
French, 1726-1786
BELLIER, Jean François
Marie
French, 1745-1836
BELLIN, Edward
British, op.1636
BELLINGHAM-SMITH, Elinor
British, 1906-
BELLINI, Bellino
Italian, 15th cent.
BELLINI, E.
Spanish, 20th cent.
BELLINI, Filippo
Italian, 1550/5-p.1604
BELLINI, Gentile
Italian, 1429-1507
BELLINI, Giovanni
Italian, c.1430-1516
BELLINI, Jacopo
Italian, c.1400-1470/1
BELLINI, Vincenzo
Italian, 19th cent.
BELLINIANO, Vittore
Italian, op.1507-m.1529
BELLIS, Antonio de
Italian, -1656
BELLIS, Hubert
Belgian, 1831-1902
BELLISARIO
Italian, 16th cent.
BELLIVERT, Giovanni
see Biliverti
BELLMANN, Carl Michael
Swedish, 1784-1839

BELLMER, Hans
Polish, 1902-
BELLO, Giacomo
Italian, op.c.1500
BELLO or Belli, Marco
Italian, op.c.1511
BELLO, Pedro
Spanish, op.1503
BELLOC, Jean-Hilaire
French, 1786-1866
BELLONI, Vicenzio
Italian, 18th cent.
BELLOSIO, Carlo
Italian, 1801-1849
BELLOSTRENGA da Modena
Italian, 16th cent.
BELLOT, Maurice
Geneviève
see Favart
BELLOTTI, Ambrogio
Italian, op.c.1689-1720
BELLOTTI, Arcangelo
Italian, 18th cent.
BELLOTTI, Canonico
Biagio
Italian, 1714-1789
BELLOTTI, Francesco
Italian, op.c.1689-1720
BELLOTTI, Pietro
Italian, 1627-1700
BELLOTTI, Pietro
Italian, 18th cent.
BELLOWS, Albert Fitch
American, 1829-1883
BELLOWS, George Wesley
American, 1882-1925
BELL-SMITH, Frederic
Marlett
British, 1846-1923
BELLUCCI, Antonio
Italian, 1654-1726
BELLUCCI, Giovanni
Battista di Bartolomeo
(San Marino)
Italian, 1506-1554
BELLUCCI, Giuseppe
Italian, 1827-1882
BELLUNELLO, Andrea
Italian, op.1462-1490
BELLY, Léon Adolphe
Auguste
French, 1827-1877
BELMONDO, Paul
French, 1898-
BELMONT, Louise Josephine
de Sarazin
French, 1790-1870
BELOBORODOFF, Andrej
Russian, op.1921
BELOTTO, Bernardo
(Canaletto)
Italian, 1720-1780
BELSKY or Bjelsky,
Alexii Ivanovitch
Russian, 1730-1796
BELTRAFFIO, Giovanni
Antonio
see Boltraffio
BELTRAMI, Nascimbene
Italian, 15th cent.
BELTRAN, Alberto
Mexican, 1923-
BELTRAN-MASSET, Federigo
Spanish, 1885-
BELTRANO, Agostino
(Agostiniello)
Italian, 1616-1665

BELTZ
German, 19th cent.
BELUCCI, G.B.
Italian, op.1800
BELUGA, Vidal
Spanish, 15th cent.
BELVEDERE, Andrea
(Abate Andrea)
Italian, 1642-1732
BELVEDERE, Augusto
Italian, 18th cent.
BELZILE, Louis
Canadian, 1929-
BEMBERG
French, 20th cent.
BEMBO or Bembi, Benedetto
Italian, op.1465
BEMBO or Bembi,
Bonifazio
Italian, op.1447-1478
BEMBO or Bembino,
Gian Francesco
Italian, op.1514-1524
BEMBO di Giovanni
Italian, 16th cent.
BEMBRIDGE, Henry
see Benbridge
BEMELMANS, Ludwig
American, 1898-
BEMME, Adriaansz.,
Joannes
Dutch, 1775-1841
BEMMEL, Carl
Sebastian van
German, 1743-1796
BEMMEL, Georg
Christoph Gottlieb
von
German, 1788-
BEMMEL, J. (Jacob?)
van
Dutch, op.1650-1669
BEMMEL, Johann
Christoph von
German, p.1707-1778
BEMMEL, Johann Georg von
German, 1669-1723
BEMMEL, Peter van
German, 1685-1754
BEMMEL, Willem van
Dutch, 1630-1708
BEN
French, 20th cent.
BENAGLIA, Giuseppe
Italian, 1796-1830
BENAGLIA, Pietro
Italian, 18th cent.
BENAGLIO, Francesco
Italian, c.1432-p.1487
BENAGLIO, Girolamo
Italian, 1469-p.1502
BENAIDICTUS
see Rainaldo di
Ranuccio da Spoleto
BENARD or Besnard, Jean
Baptiste
French, op.1751-m.a.1789
BENASCHI or Beinaschi,
Giovanni Battista
Italian, 1636-1688
BENATOV, Leonardo
Russian, 1899-
BENAVIDES, Vicente
de
Spanish, 1637-1703

BENAZECH, Charles
British, 1767-1794
BENBRIDGE or Bembridge,
Henry
American, 1744-1812
BENCI, Domenico
see Beceri
BENCI, Giambattista
Italian, op.1625-1650
BENCI, Giovanni
Italian, op.c.1556
BENCINI, Antonio
Italian, 18th cent.
BENCIVENNI, Sebastiano
di Maestro Antonio
Italian, op.1530-1583
BENCOVICH, Federico
(Ferighetto or Il
Dalmatino)
Italian, c.1670-p.1740
BENCZUR, Gyula
(Julius)
Hungarian, 1844-1920
BENDA, G.K.
French, op.1907-1910
BENDA, Wladislaw
Theodore
American, 1873-1948
BENDALL, Claude
British, 20th cent.
BENDELER or Bendler,
Christian Johann
German, 1688-1728
BENDELL
American, 20th cent.
BENDEMANN, Eduard Julius
Friedrich
German, 1811-1889
BENDEMANN, Rudolf
German, 1851-1884
BENDER, Johann
Ferdinand
German, 1814-p.1848
BENDIEN, Jacob
Dutch, 1890-1933
BENDINI, Vasco
Italian, 1922-
BENDIXEN, Bernhard
(Benny) Axel
Danish, 1810-1877
BENDIXEN, Siegfried
Detlev
see Bendixon
BENDIXON or Bendixen,
Siegfried Detlev
German, 1786-1864
BENDORP, Carel
Frederick, I
Dutch, 1736-1814
BENDZ, Wilhelm
Ferdinand
Danish, 1804-1832
BENE, Del
Polish, 18th cent.
BENEDETTE
Italian, 17th cent.(?)
BENEDETTI, Andries
Flemish, op.1636-1649
BENEDETTI, Michele
Italian, 1745-1810
BENEDETTI, Tommaso
Italian, 1796-1863
BENEDETTO, Angelo di
Italian, 20th cent.

BENEDETTO di Bindo
Zoppo (Benedetto da
Siena; possibly
identified with
Benedetto di Bindo
da Valdorcia)
Italian, op.1411-m.1417
BENEDETTO da Maiano
(Benedetto di
Leonardo)
Italian, 1442-1497
BENEDETTO da Milano
Italian, op.1503
BENEDETTO Padovano
see Bordone,
Benedetto
BENEDETTO di Pietro
dal Mugello
Italian, 1389-1448
BENEDETTO da Rovezzano
(Benedetto di
Bartolommeo de' Grazini)
Italian, 1474-p.1552
BENEDETTO da Siena
see Benedetto di Bindo
Zoppo
BENEDICT, R.
British, op.1856-1862
BENEDICTER, Alois Josef
German, 1843-
BENEDIT, Luis Fernando
Argentinian, 20th cent.
BENEDITO y Vives,
Manuel
Spanish, 1875-
BENEFIAL, Marco
Italian, 1684-1764
BENEKE, R.
German, 18th cent.
BENEŠ, Vincenc
Czech, 1883-
BENES, Vlastimil
Czech, 1919-
BENETT, Newton
British, 1854-1914
BENETTI, R.
Italian(?), 20th cent.
BENEZIT, Emmanuel-
Charles
French, 1887-
BENFATTO, Luigi
(Alvise 'Dal Friso')
Italian, 1559-1611
BENGE, Walter von
German(?), 19th cent.
BENGER, Berenger
British, 1868-1935
BENGSTON, Billy Al
American, 20th cent.
BENING, Alexander or
Sanders
see Master of Mary
of Burgundy
BENING, Lievine
(Lievine Teerlink)
Netherlands,
op.1545-1570
BENING, Simon
Netherlands,
1483/4-1561
BENITO, Master
Spanish, op.1519
BENIVIENI, Lippus
(Lippo di Benivieni)
Italian, op.1296-1327

BENIZY or Benisy
French, op.1760
BENJAMIN (Benjamin
Roubaud)
French, 1811-1847
BENJAMIN, Anthony
British, 1931-
BENJAMIN, Hilda
British, 20th cent.
BENJAMIN, Karl
American, 20th cent.
BENKA, Martin
Czech, 1888-
BENKERT or Kertbeny,
Imre or Emerich
German, 1825-1855
BENLLIURE y Gil,
José
Spanish, 1855-1919
BENNEKENSTEIN, Hermann
German, op.1856-1877
BENNER, Emmanuel
French, 1836-1896
BENNER, Gerrit
Dutch, 1897-
BENNER, Henri
French, 1776-1818
BENNER, Jean
French, 1836-1906
BENNERT, Karl
German, 1815-1885
BENNET, Karl Stefan
Swedish, 1800-1878
BENNET, Theresa
British, 18th cent.
BENNETT, A.J.
British, op.1861-1917
BENNETT, Charles
British, 1828-1867
BENNETT, Frank Moss
British, 1874-1953
BENNETT, Mick
British, 1948-
BENNETT, Sterndale
British, 20th cent.
BENNETT, Thomas
British, op.1796-1799
BENNETT, William
British, 1811-1871
BENNETT, William B.
British, op.1895
BENNETT, William James
American, 1787-1844
BENNETT, William Mineard
British, 1778-1858
BENNETTER, Johan Jacob
Norwegian, 1822-1904
BENNETTER, T.
Australian(?),
op.1876
BENNEWITZ von Löfen
the Elder, Carl
German, 1826-1895
BENNING, R.
British, op.1714-1746
BENNO, Adam
German, 1812-1892
BENOIS, Alexander
Nikolaivitch
Russian, 1870-1960
BENOIS, Nadia
British, 1896-1928
BENOIS, Nicolai A.
Russian, 1852-1936

BENOIS, Nicolus
French, 19th cent.
BENOIST or Benoît du
Cercle, Antoine
French, 1632-1717
BENOIST, Félix
French, 1818-
BENOIST, J.L.
French, op.c.1800-1840
BENOIST, Marie
Guilhelmine, (née
de Laville-Leroux)
French, 1768-1826
BENOIST, Philippe
French, 1813-p.1879
BENOIST, Pierre
French, op.1676
BENOIT, Rigaud
Haitian, 1911-
BENOIT-LEVY, Jules
French, 1866-1935
BENOUVILLE, Jean Achille
French, 1815-1891
BENOUVILLE, Léon or
François Léon
French, 1821-1859
BENOZZO, Leonardo da
Italian, 15th cent.
BENOZZO GOZZOLI
(Benozzi di Lese di
Sandro)
Italian, 1420-1497
BENRATH, Frédéric
French, 1930-
BENS, Gerhard
German, op.1628
BENSA, Alexander,
Ritter von
German, 1820-1902
BENSA, Ernesto
Italian, op.c.1897
BENSELL, George
Frederick
American, 1837-1879
BENSO, Giulio
Italian, 1601-1668
BENSON, Abraham Harris
British, 1878-1929
BENSON, Ambrosius
(Identified with
Master of the
Deipara Virgo of
Antwerp or Master
of Segovia)
Netherlands,
op.1519-m.1550
BENSON, E.
British, 1800-1886
BENSON, Frank Weston
American, 1862-1951
BENSON, John P.
American, 1865-1947
BENT, Johannes or
Jan van der
Dutch, c.1650-1690
BENTLEY, Charles
British, 1806-1854
BENTLEY, Joseph
Clayton
British, 1809-1851
BENTLEY, Richard
British, -1782
BENTON, Fletcher
American, 20th cent.

BENTON, George Bernard
British, 1872-
BENTON, Thomas Hart
American, 1889-
BENTUM, Philipp
Christian
Netherlands,
op.1713-1757
BENTZ, Achilles
see Benz
BENTZEN, Axel
Scandinavian, 1893-1952
BENUCCI, Filippo
Italian, 1779-1848
BENVENUTI, Gaetano
Italian, op.1718
BENVENUTI, Giovanni
Battista
see Ortolano
BENVENUTI, Pietro
Italian, 1769-1844
BENVENUTI, Tito
Italian, op.1824-1845
BENVENUTO di Giovanni
di Meo del Guasta
(Benvenuto da Siena)
Italian, 1436-c.1518
BENVENUTO, Robert
American, op.c.1900
BENVENUTO Tisi
see Garofalo
BENWELL, John Hodges
British, 1764-1785
BENWELL, Mary
(Mary Code)
British, 1739-p.1800
BENYON, Eric
Swiss, 1935-
BENZ or Bentz,
Achilles
Swiss, 1766-
BEÖTHY-STEINER, A.
Hungarian, 1902-
BER, Jacob
(Jacobber, Moise)
French, 1786-1863
BERAIN, Claude
French, op.1726
BERAIN the Elder,
Jean (Louis)
French, 1637-1711
BERALDINI, Ettore
Italian, 1887-
BERANGER, Charles
French, 1816-1853
BERANGER, Gabriel
British, c.1750-1817
BERANGER, Jean-Baptiste-
Antoine-Emile
French, 1814-1883
BERARD, Christian
French, 1902-1949
BERARD, Honoré-Marius
French, 1896-
BERARDINO di Lorenzo
see Bernardino
BERAT, Eustache
French, 1792-1884
BERAT, Pierre Martin
see Barat
BERAUD, Jean
French, 1849-1936
BERAULT or Beraud,
André
French, op.1678-1683

BERBURGH, C.G.
British, op.1852
BERCHE, Willem Jan
van den
see Berghe
BERCHEM, Berghem,
Berighem or Berrigham,
Nicolaes (Claes)
Pietersz.
Dutch, 1620-1683
BERCHERE, Narcisse
French, 1819-1891
BERCHET or Berchett,
Pierre
French, 1659-1720
BERCHMANS, Emile
Belgian, 1867-
BERCI
see Bezzi
BERCK, H. van
Dutch, op.1620
BERCKENRODE
see Berkenrode
BERCKHEYDE, Berck
Heyde, Berckheijde,
Berkheyde etc.,
Gerrit Adriaensz.
Dutch, 1638-1698
BERCKHEYDE, Berck
Heyde, Berckheijde,
Berkheyde etc.,
Job Adrianesz.
Dutch, 1630-1693
BERCKHOUT, G.W.
Dutch, op.1653
BERCKMAN or
Berckmans, Hendrick
Dutch, 1629-1679
BERCOT, Paul
French, 1898-
BERCOVITCH, Alexandre
Canadian, 1893-1951
BERCZY, Wilhelm
German(?), 18th cent.
BERDA, Erno
Hungarian, 1914-1961
BERDUSAN, Vicente
Spanish, op.1650
BEREA, Dimitri
Rumanian, 1908-
BEREND-CORINTH,
Charlotte
German, 1880-
BERENGER
see Benger
BERENS, Joseph
Henry
British, op.1808
BERENTZ, Christian
German, 1658-1722
BERENY, Emmanuel
Didier
French, 1900-p.1953
BERENY, Robert
Hungarian, 1887-1953
BERENY, Rudolf
German, 1869-
BERESFORD, Miss C.M.
or E.M.
British, op.1865-1885
BERESTEYN or
Beeresteyn, Claes
van
Dutch, c.1627-1684
BERETTA, Petrus
Augustus
Dutch, 1805-1866

BERG, A. van
Dutch, op.1713
BERG, Adrian
British, 1929-
BERG, Albert
German, 1825-1884
BERG, Albert
Scandinavian,
1832-1916
BERG, Else (Else
Schwarz)
Dutch, 1877-1942
BERG, F.T.
Scandinavian, 19th cent.
BERG, Gunnar
Norwegian, 1864-1894
BERG, Gijsbertus
Johannes van den
Dutch, 1769-1817
BERG, J. van der
Dutch, op.1846
BERG, Magnus
Norwegian, 1666-1739
BERG, Simon van den
Dutch, 1812-1891
BERG, T.Th.
Swedish, op.1812
BERG, Werner
German, 1904-
BERG, Willem Hendrik
van den
Dutch, 1886-1970
BERG, Yngve
Swedish, 1887-
BERGAIGNE, H.
French, 17th cent.
BERGAIGNE, P.
French, op.1699-1716
BERGAMESCO, Il
see Castello,
Giovanni Battista
BERGAMINI, Francesco
Italian, 19th cent.
BERGANDER, Rudolf
German, 1909-
BERGE, Auguste
Charles de la
French, 1807-1842
BERGE, Bernardus
Gerardus ten
Dutch, 1835-1875
BERGE, Pieter
van den
Dutch, op.1689-m.1737(?)
BERGEL, Johann Baptist
see Bergl
BERGEN, Claus
German, 1885-
BERGEN or Berghen,
Dirck van (den)
Dutch, 1645(?)-c.1690
BERGEN, Fritz
German, 1857-
BERGEN, Karl von
German, 1794-1835
BERGER
French, 20th cent.
BERGER, Daniel
German, 1744-1824
BERGER, Ernst
German, 1857-1919
BERGER, F.W.
German, op.1838
BERGER, Giacomo
(Jacques)
Italian, 1754-1822

BERGER, Hans
Swiss, 1882-
BERGER, Johan
Christian
Swedish, 1803-1871
BERGER, Joseph
French, 1798-1870
BERGERET, Pierre
Nolasque
French, 1782-1863
BERGGOLD, Carl Moritz
German, 1759-1814
BERGH, Edward
Scandinavian,
1828-1880
BERGH, Gillis de
Dutch, c.1600-1669
BERGH, Johan Edvard
Swedish, 1828-1880
BERGH, Matthys van
den
Flemish, c.1615/17-1687
BERGH, Nicolas van den
Flemish, 1725-1774
BERGH, Sven Richard
Swedish, 1858-1919
BERGHE, Augustin
van den
Flemish, 1756-1836
BERGHE, Christoffel
van den
Dutch, op.1617-1642
BERGHE, Frits van den
Belgian, 1883-1939
BERGHE, Ignatius
Joseph van den
Flemish, 1752-1824
BERGHE or Bergh,
Svante
Swedish, 1885-1946
BERGHE, Willem Jan
van den
Dutch, 1828-1901
BERGHEM, Nicolaes
(Claes)
see Berchem
BERGHEN, Dirck van
(den)
see Bergen
BERGHINZ, E.
German, op.c.1860
BERGIUS, Andreas or
Anders
Swedish, 1718-1793
BERGL or Bergel,
Johann Baptist
German, c.1718-1789
BERGMAN, Anna Eva
(Annie)
Swedish, 1909-
BERGMAN, Stephenie
British, 20th cent.
BERGMANN, Julius Hugo
German, 1862-1940
BERGMANN, Max
German, 1884-1955
BERGMANN, Stefan
German, 20th cent.
BERGMANN-MICHEL, Ella
German, 1896-
BERGMÜLLER, Johann
Baptist
German, 1724-1785
BERGMULLER, Johann Georg
German, 1688-1762
BERGOGNONE, Ambrogio
Stefani da Fossano
see Borgognone

BERGOLLI, Aldo
Italian, 1916-
BERGOMI, Giovanni
Antonio
Italian, 18th cent.
BERGON or Bergons,
C.
Dutch, op.1661
BERGSTRÖM, Alfred
Maurits
Swedish, 1869-1930
BERGUE, Tony François
de
French, 1820-
BERICOURT
French, 18th cent.
BERIGHEM, Nicolaes
(Claes)
see Berchem
BERJON, Antoine
French, 1754-1843
BERKA, Johann
Czech, 1758-1815
BERKBORCH or Berkborgh,
G. van
Dutch, op.1650-1655
BERKE, Hubert
German, 1908-
BERKELEY, Stanley
British, op.1862-1894
BERKENBOOM, Martinus
Dutch, op.1702-m.c.1712
BERKENRODE or Berkenrode,
Cornelis Florisz.
van
Dutch, 1607/8-1635
BERKENRODE or Berckenrode,
Floris Balthasarsz.
van
Dutch, c.1563-1616
BERKES, Antal
Hungarian, 1874-1938
BERKHEYDE
see Berckheyde
BERKHOUT, K. or N.
Dutch, 19th cent.
BERKLEY, Stanley
British, 19th cent.
BERKMANS, Matheus
Flemish, op.1650-1667
BERLEPSCH-VALENDAS, Hans
Eduard von
Swiss, 1849-1921
BERLEWI, Helene
see Hel Enri
BERLEWI, Henri
French, 1894-
BERLINGHIERI, Barone
Italian, op.1240-1284
BERLINGHIERI,
Berlinghiero
Italian, op.1228-m.a.1243
BERLINGHIERI, Bonaventura
Italian, op.1235-1244
BERLINGHIERI, Camillo
(Il Ferraresino)
Italian, 1596-1635
BERLINGHIERI, Marco
Italian, op.1229-1250
BERLIT, Ruediger
German, 1883-1939
BERMAN, Eugene
American, 1899-
BERMEJO, (Batolomé de
Cardenas)
Spanish, op.1470-1495/8

BERMINGHAM, Nathaniel
British, op.1740-1780
BERNA da Siena
see Barna
BERNABEI, Pier Antonio
(della Casa, Maccabeo)
Italian, 1567-1630
BERNABEI, Tommaso
see Papacello
BERNAER, Z.
French(?), 18th cent.
BERNAERT, Nicasius
see Bernaerts
BERNAERTS, Henri
Belgian, 1768-1849
BERNAERTS, Laurens
Dutch, op.1644-m.1676
BERNAERTS or Bernaert,
Nicasius
Flemish, 1620-1678
BERNARD
French, 18th cent.
BERNARD le Petit
see Salomom
BERNARD, Armand
French, 1829-1894
BERNARD, Emile
French, 1868-1941
BERNARD, Jacques
French, op.1637-1657
BERNARD, Jean
Dutch, 1765-1833
BERNARD, Jean
French, 1908-
BERNARD, Jeanne
see Dabos
BERNARD, Joseph
French, 1866-1931
BERNARD, O.P.
French, op.1937
BERNARD, Paul
French, 1849-
BERNARD, Pierre
French, 1704-1777
BERNARD, Pierre
French, 20th cent.
BERNARD, Reginald
French, 1930-
BERNARD, Valère
French, -1936
BERNARDI, Francesco
Italian, 17th cent.
BERNARDI, Lambert
Italian, op.1519
BERNARDINO
Italian, op.1553-1569
BERNARDINO d'Antonio
del Signoraccio (da
Pistoja or dei Detti)
Italian, 1460-1532
BERNARDINO da Asola
(da Brescia)
Italian, op.1526
BERNARDINO di Betto
see Pintoricchio
BERNARDINO di Colo del
Merlo da Penne
Italian, 15th cent.
BERNARDINO da Cotignola
see Zaganelli
BERNARDINO da Firenze
see Daddi, Bernardo
BERNARDINO or Berardino
di Lorenzo
Italian, op.1484-1511
BERNARDINO di Mariotto
(di Stagno)
Italian, c.1478-1566

BERNARDINO da Milano
Italian, op.c.1500
BERNARDINO da Murano
Italian, op.1460-1490
BERNARDINO di Nanni dell'
Eugenia
Italian, op.1473-1505
BERNARDINO da Verona
Italian, op.1463-1528
BERNARDO
Italian, op.1515
BERNARDO da Firenze
see Daddi, Bernardo
BERNARDO delle
Girandole
BERNARDO di Dominici
Italian, 17th cent.
BERNARDO, Francesco
Italian, 19th cent.
BERNARDO Girolamo da
Gualdo
Italian, 1441-1523
BERNARDO, Monsù
see Keil
BERNARDO de Montflorit
Spanish, op.c.1390-
m.c.1392
BERNARDO di Nello di
Giovanni Falconi
Italian, 14th cent.
BERNARDO di Passignano
Italian, op.1515
BERNARDO da Siena
see Barna da Siena
BERNARDT, Adam
Dutch(?), op.1664
BERNARDUS, Theodorus
see Barendsz., Dirck
BERNASCONI, Ugo
Italian, 1874-1960
BERNAT, Martin
Spanish, op.c.1469-1496
BERNATH, Aurél
Hungarian, 1895-
BERNATZIK, Wilhelm
German, 1853-1906
BERNAZZANO, Cesare
Italian, op.1536(?)
BERNDES, Anton Ulrik
Swedish, 1757-1844
BERNDTSON, Gunnar
Fredrik
Finnish, 1854-1895
BERNE-BELLECOUR, Etienne
Prosper
French, 1838-1910
BERNE-BELLECOUR, Jean
Jacques
French, 1874-
BERNEDE, Pierre-Emile
French, 1820-
BERNERS, Miss
(Mrs. Jarratt)
British, 18th cent.
BERNERS, Lord Gerald
British, 1883-1950
BERNHARD, Gustav
see Osterman
BERNHARD, Peter
German, op.1734-1750
BERNHARDT, Joseph
German, 1805-1885
BERNHEIM, Gerard
Swiss, 1925-
BERNI, Antonio
Argentine, 1905-

BERNIER, C.P.
French(?), 18th cent.
BERNIER, Camille
French, 1823-1902
BERNIER, Géo
Belgian, 1862-1918
BERNIGEROTH, Martin
German, 1670-1733
BERNIK, Janez
Yugoslavian, 1933-
BERNINGER, Edmund
German, 1843-
BERNINGHAUS, Oscar Edmund
Edward
American, 1874-
BERNINI, Gian Lorenzo
Italian, 1598-1680
BERNITZ, Bruno
German, 1915-
BERN-KLENE,
French, 20th cent.
BERNSTEIN, Richard
American, 1939-
BERNSTEIN, Saul
Russian, 1872-1905
BERNUTH, Max
German, 1872-
BERNWALLER, Joseph
German, op.1837
BERON, Erik Gustav
Swedish, 1748-1780
BERONNEAU, André
French, 1886-
BEROUD, Louis
French, 1852-1930
BERQ, H.
Flemish, 17th cent.
BERRE, Jean Baptiste
Flemish, 1777-1838
BERRES, Joseph von
German, 1821-
BERRETTINI
see Pietro da Cortona
BERRETTINI, Lorenzo
Italian, 17th-18th cent.
BERRI, Alessandro
Italian, op.1550
BERRIDGE, John
British, op.1766-1797
BERRIE, John Archibald
Alexander
British, 1887-1962
BERRIGHAM, Nicolaes
(Claes)
see Berchem
BERRUGUETTE y Gonzales,
Alonso
Spanish, 1480/6-1561
BERRUGUETE, Pedro
Spanish, -1503
BERRY, Agnes
British, 18th cent.
BERRY, Duchesse de
French, 1798-1870
BERRY, N.
French, op.1780
BERRY, T.
British, 18th cent.(?)
BERSIER, Jean Eugene
French, 1895-
BERTACCINI, Antonio
Italian, op.1851
BERTALL
see Arnoux, Charles
Albert, Vicomte d'
BERTANI, Giovanni Battista
di Egidio
Italian, 1516-1576

BERTAUD, Pierre
French, op.1580
BERTAUX, Emile
French, 1869-1916
BERTAUX, Jacques
French, op.1776-1802
BERTEAUX, Hippolyte
Dominique
French, 1843-1926
BERTELLI, Donato
Italian, op.1568-1574
BERTELLI, Ferdinando
Italian, op.1563
BERTELLI, Francesco
Italian, op.1574-1616
BERTELLI, Luigi
Italian, 1833-1916
BERTELLO, Cristoforo
Italian, 16th cent.
BERTHAULT, Pierre
Gabriel
French, 1748-1819
BERTHE, Louis-Maurice
French, op.1907-1937
BERTHELEMY or Barthelemy,
Jean Simon
French, 1743-1811
BERTHELIN, Max
French, 1811-1877
BERTHELON, Eugène
French, 1829-1914
BERTHOLD, Master
see Landauer
BERTHOLLE, Jean
French, 1909-
BERTHON, George Theodore
Canadian, 1806-1892
BERTHON, Paul
French, op.c.1909
BERTHON, René Théodore
French, 1776-1859
BERTHON, Roland
French, 1909-
BERTHOT, Jake
American, 1939-
BERTHOUD, Auguste Henri
French, 1829-1887
BERTHOUD, H.
German(?), 19th cent.
BERTHOUD, Rodolphe
Léon
Swiss, 1822-1892
BERTI
see also Bezzi
BERTI, Giorgio
Italian, 1794-1863
BERTI, Mauro
Italian, 1772-1842
BERTIERI, Pilade
Italian, 1874-
BERTIN, François
Edouard
French, 1797-1871
BERTIN, Jean Victor
French, 1775-1842
BERTIN, Nicolas
French, c.1667-1736
BERTINI, Francesco
di Fausto
Italian, op.c.1634
BERTINI, Gianni
Italian, 1922-
BERTINI, Giuseppe
Italian, 1825-1898
BERTO di Giovanni
(di Marco)
Italian, op.1497-m.a.1529

BERTOJA or Bertogia,
Jacopo Zanguidi
Italian, 1544-1574
BERTOLI, Conte Antonio
Daniele
Italian, 1678-1743
BERTOLINO da Piacenza
see Bartolino
BERTON, Armand
French, 1854-1917
BERTOZZI, Eduardo
South American,
20th cent.
BERTRAM, Abel
French, 1871-1954
BERTRAM of Minden,
Master
German, c.1345-a.1415
BERTRAND, François
French, 1756-1805
BERTRAND, Gabrielle
(Beyer)
French, 1730-1790
BERTRAND, Gaston
Belgian, 1910-
BERTRAND, Georges
Jules
French, 1849-1929
BERTRAND, Jean Baptiste
(James)
French, 1823-1887
BERTRAND, Jean Claude
French, 20th cent.
BERTRAND, Noël François
French, 1784-1852
BERTRAND, Raymond
French, 1945-
BERTUCCI the Elder,
Giovanni Battista
da Faenza
Italian, op.1503-p.1516
BERTUCCI, Jacopo
(Jacopone da Faenza)
Italian, c.1500-c.1579
BERTUCCI, Michele
Italian, op.1519-m.a.1521
BERTUCCI or Bertuzzi,
Niccolò
Italian, op.1737-m.1777
BERTUSI or Bertusio,
Giovanni Battista
Italian, c.1650
BERTZIK, A.
Austrian, 19th cent.
BERUETE y Moret,
Aureliano de
Spanish, 1845-1912
BERVEILLER, Edouard
French, op.1874/5
BERVIC, Charles Clément
French, 1756-1822
BESCHEY, Balthasar
Flemish, 1708-1776
BESCHEY, Charles or
Karel
Flemish, 1706-
BESCHEY, Jacob Andries
Flemish, 1710-1786
BESCHEY, Jan Frans
Flemish, 1717-1799
BESHAW, J.
British, 19th cent.
BESLER, Basil
German, 1561-1629
BESNARD, Jean Baptiste
see Benard

BESNARD, Paul Albert
French, 1849-1934
BESOIN
French, 19th cent.
BESOLI, Carlo di
Francesco
Italian, 1709-1754
BESOZZI, Giovanni
Ambrogio
Italian, 1648-1706
BESOZZO, Bissucio or
Bisuccio, Leonardo
Molinari da
Italian, op.1442-1488
BESOZZO, Bissucio or
Bisuccio, Michelino
Molinari da
Italian, op.1394-1442
BESSA, Pancrace
French, 1772-1835
BESSA, Pietro
Italian, a.1800
BESSARABESCU, At.
Roumanian, 19th cent.
BESSE, Raymond
French, 1899-
BESSELIÈVRE, Claude-
Jean
French, op.1802-1824
BESSEMER, Johann
German, 1679-p.1697
BESSER, Arne
American, 1938-
BESSERER, Johann Jacob
German, 1600-1657
BESSI, Bartolommeo
Italian, 19th cent.
BESSI, M.
Italian, 20th cent.
BESSO, Amalia
Italian, 1856-1932
BESSON, Charles Jean
Baptiste
French, 1816-1861
BESSON, Faustin
French, 1821-1882
BESSON, Jules Gustave
French, 1868-
BEST, Hans
German, 1874-1942
BEST, Harry Cassie
American, 1863-1936
BEST, John
British, op.1750-1792
BESTALL, Alfred
Edmeades
British, 1892-
BESTERS, Albertus
Jacobus
Dutch, 1747-1819
BESTLAND, Charles
British, op.1783-1837
BETHAM, H.
British, 19th cent.
BETHAM, Mary Matilda
British, 1776-1852
BETHELL, James
British, op.1827-1835
BETHKE, Hermann
German, 1825-1895
BETHUNE, Gaston
French, 1857-1897
BETOLDI, Gaspare
French, 18th cent.
BETREMIEUX
French, 18th cent.

BETS, Johan
Dutch, op.1661-m.c.1665
BETTE, Michael
British, 20th cent.
BETTELINI or Bettalini,
Pietro Antonio Leone
Italian, 1763-1829
BETTENCOURT, Pierre
French, 20th cent.
BETTERA, Bartolommeo
Italian, op.c.1600
BETTERIDGE
see Jennens
BETTES, John, I
British, c.1530-c.1573
BETTES, John, II
British, op.1578/9-1599
BETTI, Giusto
see Juste, Juste de
BETTI, Niccolò
Italian, op.1576-1578
BETTINI, Antonio
Bastiano
Italian, 1707-
BETTINI, Domenico
Italian, 1644-1705
BETTINO da Faenza
Italian, 15th cent.
BETTOLI, Romualdo
Italian, 19th cent.
BETTS, Edward Howard
American, 1920-
BETTS, Harold Harrington
American, 1881-
BETTS, Louis
American, 1873-
BETZ, Jean Joseph
Bastier de
see Bastier
BEUCHOLT
see Beugholt
BEUCHOT, Jean Baptiste
French, 1821-
BEUCKELAER, E.
Flemish, 18th cent.
BEUCKELAER or Bueckelaer,
Joachim C.
Netherlands,
c.1530/3-c.1573/4
BEUCKELS, Pieter or
Pierre
Flemish, 1728-1815
BEUCKER, Pascal de
Belgian, 19th cent.
BEUGHOLT or Beucholt, L.
Dutch, op.1709-1732
BEUGO or Beugho, John
British, 1759-1841
BEUL, Armand de
Belgian, 1874-
BEUL, Charles de
Belgian, 19th cent.
BEUL, Franz de
Belgian, 1849-1919
BEUL, Henri de
Belgian, 1845-1900
BEUL, Laurent de
Belgian, 19th cent.
BEULLENS, André
Belgian, 1930-
BEUSEKOM, Francoys van
Dutch, op.1649
BEUTLER, Clemens
Swiss, 17th cent.
BEUTLER, Mathias
see Beitler

BEUYS, Joseph
German, 1921-
BEVAN, Oliver
British, 1941-
BEVAN, Mrs Robert
see Karlowska,
Stanislava de
BEVAN, Robert Polhill
British, 1865-1926
BEVAN, S.
British, 18th cent.
BEVEREN, Charles van
Belgian, 1809-1850
BEVERENSE or Beverenzi,
Antonio Domenico
Italian, op.c.1660
BEVERLEY, William
Roxby
British, 1824-1889
BEVERVOORDT, Magdalena
van (née Passe)
see Passe
BEVILACQUA, Giovanni
Ambrogio (Il
Liberale)
Italian, op.1485-1502
BEVINGTON, W.G.
British, 20th cent.
BEWICK, John
British, 1760-1795
BEWICK, Thomas
British, 1753-1828
BEWICK, William
British, 1795-1866
BEWLAY, M.P.
British, 20th cent.
BEYEL, Daniel
Swiss, 1760-1823
BEYER, Alfred
German, 1880-
BEYER, Gabrielle
see Bertrand
BEIJER, Jan de
Dutch, 1703-c.1785
BEYEREN, Abraham van
Dutch, 1620/1-1690
BEYEREN, Leendert
Cornelisz. van
Dutch, c.1620-1649
BEYLE, Pierre M.
French, 1838-1902
BEYSCHLAG, Johan
Cristoph
see Beischlag
BEYSCHLAG, Robert
German, 1838-1903
BEYTLER, Mathias
see Beitler
BEZ, Jean Joseph
Bastier de
see Bastier
BEZARD, Jean Louis
French, 1799-p.1861
BEZOMBES, Roger
French, 1913-
BEZZI, Bartolomeo
Italian, 1851-
BEZZI or Becci,
Giovanni Filippo
(Giambologna)
Italian, op.c.1690
BEZZI, Giovanni
Francesco (Nosadella)
Italian, 1500?-1571
BEZZI, Becci, Beci,
Berci or Berti,
Lorenzo
Italian, op.1517-1521

BEZZI, Becci, Beci,
Berci or Berti,
Zanino de'
Italian, op.1471-1487
BEZZUOLI, Giuseppe
Italian, 1784-1855
BIAGIO di Antonio
(Utili da Faenza,
Giovanni Battista)
Italian, op.1476-1504/15
BIAGIO da Bologna
see Lame
BIAGIO, Il
see Pintoricchio
BIALA, J.
Russian, 20th cent.
BIANCHI, Baldassare
Italian, 1614-1678
BIANCHI, Ben
American, 1934-
BIANCHI, Carlo
Italian, op.1737-1778
BIANCHI, Gaetano
Italian, 1819-1892
BIANCHI, Isidoro
(Campione)
Italian, 1602-1690
BIANCHI, Mosè di
Giosuè
Italian, 1845-1904
BIANCHI, Pietro
Italian, 1694-1740
BIANCHI, Pompeo
Italian, 17th cent.
BIANCHI FERRARI or
Bianco Ferraro,
Francesco de
Italian, c.1460-1510
BIANCHINI, Bartolomeo
Italian, 17th cent.
BIANCHINI, Charles
French, 1860-1905
BIANCO, Baccio del
Italian, 1604-1656
BIANCO, T.
French, 19th cent.
BIANCO FERRARO,
Francesco de
see Bianchi Ferrari
BIANCONI, Carlo
Italian, 1732-1802
BIANEY, J.
Dutch, 18th cent.
BIARD, Francois
Auguste
French, 1798/9-1882
BIARD, Pierre the
Younger
French, 1592-1661
BIARD, Pierre-Noël
French, 1559-1609
BIASI
Italian, 20th cent.
BIASION, Renzo
Italian, 1914-
BIAUMEZ, Jean de
see Beaumetz
BIAYS
French, op.1827
BIAZACI, Busacio or
Buzaci, Tommaso
Italian, op.1463-1483
BIBBY, H.
British, 19th cent.
BIBIENA, Alessandro
Calli
Italian, 1687-a.1769

BIBIENA, Antonio
Galli
Italian, 1700-1774
BIBIENA, Carlo Galli
Italian, 1728-p.1778
BIBIENA the Younger,
Ferdinando Galli
Italian, 1657-1743
BIBIENA, Francesco
Galli
Italian, 1659-1739
BIBIENA, Giovanni Maria
Galli
Italian, 1625-1665
BIBIENA, Giuseppe Galli
Italian, 1696-1756
BICAT, André
French, 1909-
BICCI, Compagno di
Italian, 15th cent.
BICCI di Lorenzo
Italian, 1373-1450
BICCI, Lorenzo di
Italian, c.1350-1427(?)
BICCI, Neri di
see Neri di Bicci
BICE, Clare
Canadian, 20th cent.
BICH, Nguyen
Vietnamese, 20th cent.
BICHARD, (or Gery-
Bichard) Alphonse
Adolphe
French, 1841-
BICHERAY
British, op.1752
BICHLER, Heinrich
(Possibly Master
with the Pink, Berne,
St. John High Altar)
Swiss, op.c.1466/7-1501
BICKE, Jan
see Miel
BICKHAM, George, I
British, 1684-1769
BICKHAM, George, II
British, op.1742-m.1758
BICKS, Thomas
British, op.1903
BIDA, Alexandre
French, 1813-1895
BIDAU, Eugène
French, op.1900
BIDAULD, Jean Pierre
Xavier
French, 1745-1813
BIDAULD, Joseph
(Jean Joseph Xavier)
French, 1758-1846
BIDAULT, L. de
French, 18th cent.
BIDDLE, George
American, 1885-
BIDDLE, Lawrence
British, op.c.1931-1938
BIDDLE, Tyrrell E.
British, 19th cent.
BIE, Adriaen de
Flemish, 1593-1668
BIE, Cornelis de
Dutch, 1621/2-1664
BIE, Erasme de
Flemish, 1629-1675
BIE, J. de
French, op.1643

BIE, Jacques de
Flemish, 1581-c.1640
BIE, Jean-Baptiste de
Flemish, op.1673-1691
BIE, Marcus de
see Bye
BIE, P. van
Dutch, op.1642
BIEBERSTEIN, Marschall
v.
German, op.1810
BIEDERMAN, Emmanuel
Rudolph
Swiss, 1790-1850
BIEDERMANN or Bidermann,
Johann Jakob
Swiss, 1763-1830
BIEDERMANN-ARENDTS,
Hermine
German, 1855-
BIEFVE, Edouard de
Belgian, 1808-1882
BIELER, André
Canadian, 1896-
BIELER, Ernst
Swiss, 1863-
BIELING, H.F.
German, 1921-
BIELJAJEW, Marat
Russian, 20th cent.
BIEN, Bin or Binn,
Hans
German, 1590-1632
BIENEMANN, Eduard
William
Russian, 1795-1842
BIENNOURRY, Victor
Francois Eloi
French, 1823-1893
BIERGE, Roland
French, 20th cent.
BIERLING, Adam
Alexius
German, op.1646
BIERMANN, Ill
Johann Jakob
Swiss, 1718-1769
BIERMANN, Peter
see Birmann
BIERSTADT, Albert
American, 1830-1902
BIESCZAD, Sewerin
Polish, 1852-
BIESELINGEN, Christiaen
Jansz. van
Netherlands,
1557/8-1600
BIETRY, Paul
French, 1894-1960
BIGAND, Auguste
French, 1803-1875
BIGARI, Vittorio
Maria
Italian, 1692-1776
BIGAUD, Wilson
Haitian, 1931-
BIGEE, Charles
Flemish, op.1758-1759
BIGELOW, Charles Bowen
British, op.c.1900
BIGELOW, Daniel Folger
American, 1823-1910
BIGELOW, Larry
American, 1925-
BIGELOW, Olive
British, op.c.1922

BIGG, William Redmore
British, 1755-1828
BIGGI, Felice
Fortunate
(Felice de' Fiore)
Italian, op.c.1680
BIGIARINI, Gino
Italian, op.1927
BIGLAND, Percy
British, op.1882
BIGLEOSCHI, L.
Italian, 18th cent.
BIGOLA, Lodovico
Italian, 1822-1905
BIGORDI
see Ghirlandajo
BIGOT
French, op.1635-1639
BIGOT, C.
British, op.1820
BIGOT, Raymond
French, 1872
BIGOT, T.F.
American, op.1816-1841
BIGOT, Théophile
see Master of the
Candlelight
BIHARI, Sandor
(Alexander
Hungarian, 1856-1906
BIJONE, Bjone, Byione
or Byone, C.
Italian, 17th cent.
BIKE, Jan
see Miel
BILBAO y Martinez,
Gonzalo
Spanish, 1860-
BILBO, Jack
British, 20th cent.
BILCIUS, Cornelis
see Biltius
BILCOQ or Billecoq,
Marie Marc Antoine
French, 1755-1838
BILDERS, Albert Gerard
Dutch, 1838-1865
BILDERS, Johannes
Wernardus
Dutch, 1811-1890
BILDSTEIN
German, op.1809
BILEK, Frantisek
Czech, 1872-1941
BILGER, Margret or
Margarete
German, 1904-
BILIBIN, Alexander
Russian, 20th cent.
BILIBIN, Ivan
Jakowlevitch
Russian, 1875-1942
BILINSKA, Anna
(Bogdanowicz)
Polish, 1857/8-1893
BILINSKI, Boris
Russian, 20th cent.
BILIVERTI, Bellivert,
Bilivetti or Birivetti,
Giovanni (Antonio)
Italian, 1576-1644
BILL, Max
Swiss, 1908-
BILL, Rosa
Swiss, 19th cent.
BILLARDET, Léon Marie
Joseph
French, 1818-1862

BILLE, Edmond
Swiss, 1878-
BILLE, Ejler
Danish, 1910-
BILLE, Thorben Viking
Norwegian, 1852-1876
BILLE, Wilhelm Victor
Danish, 1864-1908
BILLET, Pierre
Célestin
French, 1837-1922
BILLINGS, Robert
William
British, 1813-1874
BILLINGSLEY, William
British, 1758-1828
BILLINGTON, Horace W.
British, op.1802-m.1812
BILLMARK, Karl Johan
Swedish, 1804-1870
BILLOTTE, René
French, 1846-1914
BILOUL, Louis François
French, 1874-1947
BILS
French, 1884-1968
BILSTON, S.
British, 19th cent.
BILTIUS, Jacobus or
Jacob van der Bilt
Dutch, op.1651-1676
BILTIUS, Bilcius or
Bilzius, Cornelius
German, op.1654-1673
BIMBACCI, Atanasio
Italian, c.1649-
BIMBI, Bartolommeo
Italian, 1648-c.1725
BIMMERMANN, Caesar
German, 1835-1885
BINASCO, Francesco
Italian, 15th cent.
BINCK, Jacob
German, c.1500-1569
BINDER, Douglas
British, 1941-
BINDER, Joseph
German, 1805-1863
BINDESBOLL, Thorvald
Danish, 1846-1908
BINDON, Francis
British, c.1700-1765
BINET, Adolphe Gustave
French, 1854-1897
BINET, Georges-Jules-
Ernest
French, 1865-
BINET, Louis
French, 1744-c.1800
BINET, René
French, 1866-1911
BINET, Victor Jean
Baptiste Barthélemy
French, 1849-1924
BING
see also Byng
BING, Henry
French, 20th cent.
BINGE, Geoffrey
British, 19th cent.
BINGHAM, George
Caleb
American, 1811-1879
BINGHAM, Lavinia
see Spencer

BINI, P.
Italian, 18th cent.
BINNEY, Don
New Zealand, 1940-
BINNIE, Frederick
British, op.1771
BINNING, Bertram
Charles
Canadian, 1909-
BINOIT, Peter
German, op.1611-1624
BINSTEAD, J.
British, op.1809-1814
BINZER, Karl von
German, 1824-1902
BIOCHAYE, Colin de la
see La Biochaye
BIONDA, Mario
Italian, 1913-
BIONDI, Francesco
Antonio
Italian, 1735-1805
BIONDO, Antonino
Italian, op.c.1600
BIONDO, Giovanni del
see Giovanni
BIOT, Charles Jérome
Flemish, 1754-1838
BIRAT, Amélie
(née d'Archies)
French, 1812-p.1847
BIRCH, Charles Bell
British, 1832-1893
BIRCH, James
British, 1807-1857
BIRCH, S.J. Lamorna
British, 1869-1955
BIRCH, Thomas
American, 1779-1851
BIRCH, William
British, 1755-1834
BIRCKENHOLTZ or
Birckenhultz, Paul
German, 17th cent.
BIRD, Cyril Kenneth
(Fougasse)
British, 1887-
BIRD, Elisha Brown
American, 1867-
BIRD, Edward
British, 1772-1819
BIRD, Francis
British, 1667-1731
BIRD, George Frederick
British, 1883-
BIRD, Isaac F.
British, op.1826-1861
BIRD, John
(Bird of Liverpool)
British, 1768-1829
BIRD, June
Canadian, 20th cent.
BIRD, W.
British, 20th cent.
BIRELINE, George
Canadian, 20th cent.
BIRGER, Hugo
Swedish, 1854-1887
BIRINGUCCI, Oreste
(Vannocci)
Italian, 1558-1585
BIRIVETTI, Giovanni
see Biliverti
BIRKBECK, Geoffrey
British, 1875-
BIRKBECK, Jane
British, 18th cent.

BIRKETT, P.
British, op.1847-1848
BIRLEY, Oswald
British, 1880-1952
BIRMANN or Biermann,
Peter
Swiss, 1758-1844
BIRMANN, Samuel
Swiss, 1793-1847
BERMELIN, Robert
American, 20th cent.
BIRNBAUM, Uriel
German, 1894-1956
BIROLLI, Renato
Italian, 1906-1959
BIRON
British, 18th cent.
BIRRELL, A.
British, 18th cent(?)
BIRRELL, Ebenezer
Canadian, op.1823
BIRTIN, N.
German, 18th cent.
BISCAINO, Bartolommeo
Italian, 1632-1657
BISCH, François Xavier
André
German, 1793-1841
BISCHOFF, Elmer
American, 1916-
BISCHOFF, Jakob Christoph
Swiss, 1793-1825
BISCO, Adaline
American, 19th cent.
BISEO, Cesare
Italian, 1843-1909
BISET, Charles or Karel
Emmanuel
Flemish, 1633-c.1710(?)
BISET, Jean Andreas
(also erroneously,
Jean Baptist)
Flemish, 1672-p.1729
BISHIP, A.
British, op.1874
BISHOP, Henry
British, 1868-1939
BISHOP, Isabel
American, 1902-
BISHOP, S.M.
British, op.1811
BISHOP, W. Fallen
British, 19th cent.
BISI, Fra Bonaventura
(Padre Pittorino)
Italain, 1612-1659
BISI, Ernesta (née
Legnani)
Italian, op.1816-1824
BISI, Giuseppe
Italian, 1787-1869
BISI, Luigi
Italian, 1814-1886
BISI, Michele
Italian, c.1788
BISON da Palmanova,
Giuseppe Bernardino
Italian, 1762-1844
BISPHAM, Henry Collins
American, 1841-1882
BISQUERT, Antonio
Spanish, 1596(?)-1646
BISSCHOP, Abraham
Dutch, 1670-1731
BISSCHOP, Christoffel
Sutch, 1828-1904
BISSCHOP, Cornelis
Dutch, 1630-1674

BISSCHOP, Jan de
(Johannes Episcopius)
Dutch, c.1628-1671
BISSCHOP, Susanne,
(née Robertson)
see Robertson
BISSEN, Herman Vilhelm
Danish, 1798-1868
BISSIER, Jules
French, 1893-1965
BISSIERE, Roger
French, 1888-1964
BISSOLO or Bissuolo,
Francesco
Italian, op.1492-m.1554
BISSON, Edouard
French, 1856-
BISSON, Giuseppe
Bernardino
see Bison
BISSON, Jacques
French, -1737
BISSONI, Giambattista
Italian, -1636
BISSUCIO
see Besozzo
BISTAAGNE,
French, c.1850-1886
BITLOR, Grin B.
(Possibly Master with
the Pink, Freiburg High
Altar)
Swiss, op.c.1480-1500
BITRAN, Albert
French, 19th cent.
BITTER
French, op.1817-m.1832
BITTERLICH, Eduard
German, 1834-1872
BITTI
see Caporali, Giovanni
Battista
BITTINGER, Charles
American, 1879-
BITTINO or Bitino da
Faenza
Italian, op.1398-m.1427
BITTNER, Norbert
German, 1786-1851
BITZAN, Ion
Rumanian, 20th cent.
BIVA or Piva, Giovanni
Battista
Italian, -c.1750
BIVA, Henri
French, 1848-1928
BIVOLET
French, op.1792
BIZAMANUS, Angelus
Greek, op.c.1500
BIZET
Flemish, 17th cent.
BIZUTI, Filippo
see Rusuti
BIZZELLI, Giovanni
Italian, 1556-1612
BIZZOZZERO, Ottavio
Italian, op.1669-1690
BJELSKY, Alexii
Ivanovitch
see BELSKY
BJERRE, Niels
Danish, 1864-1942
BJONE, C.
see Bijone

BJÖRCK, N.
Swedish, op.1756
BJÖRK, Gustaf Oskar
Swedish, 1860-1929
BJÖRK, Jacob
Swedish, 1726-1793
BJURSTRÖM, Tor
Swedish, 1887/8
BLAAS, Eugen von
German, 1843-1931
BLAAS, Julius von
German, 1845-1923
BLAAS, Karl von
German, 1815-1894
BLAAUW, Pieter Aartsze
Dutch, 1744-1808
BLACK, Arthur John
British, 1855-1936
BLACK, Clara
British, 18th cent.
BLACK, Mary
British, c.1737-1814
BLACK, N.R.
British, op.1798-1803
BLACK, Norman Irving
British, op.1783-1803
BLACK, Thomas
British, op.c.1760-m.1777
BLACKADDER, Elizabeth
British, 1931-
BLACKBURN, David
British, 20th cent.
BLACKBURN, Mrs. Hugh,
(née J. Wedderburn)
British, op.1863-1875
BLACKBURN, Joseph
(not Jonathan B.)
American, c.1730-p.1778
BLACKBURNE, E.R.
Irelande
British, op.1891-1895
BLACKLOCK, Thomas Bromley
British, 1863-1903
BLACKLOCK, William
James
British, c.1815-1858
BLACKMAN, Charles
Australian, 1928-
BLACKMAN, Walter
British, 19th cent.
BLACKWELL, Elizabeth
British, op.1737-m.1774
BLACKWELL, Tom
American, 1938-
BLACKWOOD, Lord Basil
British, 19th cent.
BLAGDEN, Allen
American, 20th cent.
BLAIKLEY, Alexander
British, 1816-1903
BLAIKLEY, Ernest
British, 1885-
BLAILE, Alfred Henri
French, 1878-1967
BLAIN de Fontenay
see Belin
BLAIR, John
Canadian, op.1885-1888
BLAIR, Streeter
American, 1888-
BLAISOT, Noël Joseph
French, 1792-1820
BLAIZE, Candide
French, 1795-c.1855

BLAKE, Benjamin
British, op.1807-
m.1828/30
BLAKE, C.S.
British, op.1757-1775
BLAKE, Catherine,
(née Boucher)
British, op.1782
BLAKE, Donald
American, 1889-
BLAKE, F.
British, op.1847
BLAKE, Gary
British, 20th cent.
BLAKE, Henry E.
British, 19th cent.
BLAKE, Peter
British, 1932-
BLAKE, Quentin
British, 20th cent.
BLAKE, Robert
British, 1762-1787
BLAKE, Robert
British, op.c.1830
BLAKE, T.
British, op.1825-1831
BLAKE, William
British, 1757-1827
BLAKELOCK, Ralph
Albert
American, 1847-1919
BLAKESLEY, Anna
British, op.1769-1770
BLAKEY or Blakay,
Nicholas
British, op.1752-1758
BLAMPIED, Edmund
British, 1886-
BLANC, Alexandre le
see Leblanc
BLANC, Célestin
Joseph
French, 1818-1888
BLANC, Charles
French, 1896-
BLANC or Le Blanc,
Horace
French, -1637
BLANC, Louis Ammy
or Onimus
German, 1810-1885
BLANC, Numa
French, op.c.1843
BLANC-GARIN, Ernest
French, 1843-1916
BLANCHARD
German, 1779-
BLANCHARD, Antoine
French, 20th cent.
BLANCHARD, Carl Anton(?)
German, 1770(?)-p.1799
BLANCHARD, Edouard
Théophile
French, 1844-1879
BLANCHARD, (louis)
Gabriel
French, 1630-1704
BLANCHARD, Henri Pierre
Léon Pharamond
French, 1805-1873
BLANCHARD, Jacques
French, 1600-1638
BLANCHARD, Jean Baptiste
French, c.1595-1665
BLANCHARD, Laurent
French, c.1762-1819

BLANCHARD, Maria
French, 1881-1932
BLANCHARD, Maurice
French, 1903-
BLANCHARD, Pharamond
French, 1805-1873
BLANCHARD, Sisson
Haitian, 1929-
BLANCHARD, Washington
American, op.1831-1843
BLANCHE, Jacques Emile
French, 1861-1942
BLANCHET, Alexandre
Swiss, 1882-
BLANCHET, Gabriel
(Louis Gabriel)
French, 1705-1772
BLANCHET, Thomas
French, 1614/17-1689
BLANCKAERT, Antoon
Flemish, 1621-p.1679
BLANCKERHOFF, Jan
Theunisz.
(Janmaat)
Dutch, 1628-1669
BLANCO, Rafael
Spanish, 19th cent.
BLANCOUR, Marie
French, 17th cent.
BLAND, Emily Beatrice
British, 1864-1951
BLANES, Juan Manuel
Uruguayan, 19th cent.
BLANK, Joseph Bonavita
German, 1740-1827
BLANSERI or Blancheri,
Vittorio
Italian, 1735-1775
BLANT, Julien le
see Le Blant
BLARE, Magnus du
Swedish(?), 18th cent.(?)
BLARENBERGHE, Henri
Désirée van
French, 1734-1812
BLARENBERGHE, Henri
Joseph van
French, 1741-1826
BLARENBERGHE, Jacques
Guillaume van
French, 1679(?)-1742
BLARENBERGHE, Louis van
French, 1734-1812
BLARENBERGHE, Louis
Nicolas van
French, 1716-1794
BLASCHECK, Franz
German, 1776-c.1860
BLASCHNIK, Arthur
German, 1823-p.1883
BLASHFIELD, Edwin
Howland
American, 1848-1936
BLATAS, Arbit Nicolai
French, 1909-
BLATCH, G.
British, 19th cent.
BLÄTTER, Bruno
German, 19th cent.
BLÄTTNER, Johann
Samuel, II
German, 1731-1800
BLAU-LANG, Tina
German, 1845-1916
BLAYE, Henri de
Flemish(?), 18th cent.

BLECHEN, Carl Eduard
Ferdinand
German, 1798-1840
BLEECK, Pieter van
Dutch, 1700-1764
BLEECK, Richard van
Dutch, 1670-c.1733
BLEIDEL, Melchior
German, 16th cent.
BLEIDORN, J.G.
Dutch, op.1772
BLEKER, Dirck
Dutch, c.1622-p.1672
BLEKER, Gerrit Claesz.
Dutch, op.1625-m.1656
BLELL
German, op.c.1820
BLENDIGER, Georg
(Johann Georg)
German, 1667-1741
BLENNER, Carle John
American, 1864-
BLERST, J.
Dutch, 17th cent.
BLES, David Joseph
Dutch, 1821-1899
BLES, Herri met de,
or Henricus Blesius
(Herry de Patenir?;
Civetta)
Netherlands,
c.1510-p.1550
BLES, Joseph
Dutch, 1825-1875
BLESENDORF, Constantin
Friedrich
German, 1674-1754
BLESENDORF, Samuel
German, 1633-1706
BLESIUS, Henricus
see Bles, Herri met de
BLESIUS, Pseudo
(Master of the Munich
Adoration)
Netherlands, op.c.1520
BLEULER, Johann
Heinrich
Swiss, 1758-1823
BLEULER, Johann Ludwig
Swiss, 1792-1850
BLEYSWYCK, Francois
van
Dutch, op.1706-1745
BLIECK, Daniel de
Dutch, op.c.1648-m.1673
BLIECK, Maurice
Belgian, 1876-1922
BLIGNY, Honoré
Thomas
French, c.1742-1785
BLIN de Fontenay
see Belin
BLIND, Rudolph
British, 1846-1889
BLINE, J.
British, 20th cent.
BLINKS, Thomas
British, 1860-1912
BLISS, Douglas Percy
British, 1900-
BLISS, H.
American, 19th cent.
BLITTON, J.
British, 18th cent.
BLOCH, Albert
American, 1882-1961

BLOCH, Alexandre
French, 20th cent.
BLOCH, Carl Heinrich
Danish, 1834-1890
BLOCH, Martin
German, 1883-1954
BLOCK, Blockh or
Blok, Benjamin
von
German, 1631-1690
BLOCK, Eugène Francois
de
Belgian, 1812-1893
BLOCK, Laurence
American, op.1650
BLOCK, Wilhelm von
dem
German, op.1576-m.1628
BLOCKHAUWER, Herman
Bertholomiez
Dutch(?), op.1621
BLOCKLANDT van Montfoort,
Anthonie (van)
Netherlands, 1532-1583
BLOEM, A.
Dutch, 17th cent.
BLOEM, Matheus
Dutch, op.1643-1664
BLOEMAERT, Abraham
Dutch, 1564-1651
BLOEMAERT, Adriaen
Dutch, 1609-1666
BLOEMAERT, Cornelis, II
Dutch, 1603-c.1684
BLOEMAERT, Frederick
Dutch, c.1610-p.1668
BLOEMAERT, Hendrick
Dutch, c.1601-1672
BLOEMAERT, J.
Dutch, op.1623
BLOEME, Herman Antonie
de
Dutch, 1802-1867
BLOEMEN, Jan Frans
van (Orizonte)
Flemish, 1662-1749
BLOEMEN, Norbertus
van (Cefalus)
Flemish, 1670-c.1746
BLOEMEN, Pieter van
(Standaard)
Flemish, 1657-1720
BLOEMERS, Arnoldus
Dutch, 1792-1844
BLOIS, Abraham de
Dutch, op.1679-1720
BLOK, Benjamin von
see Block
BLOM, Jan
Dutch, c.1622-1689(?)
BLOME, Richard
British, 18th cent.
BLOMFIELD, Charles
New Zealand, 19th cent.
BLOMMAERDT, Maximilian
Flemish, op.1696-1697
BLOMMENDAEL, Reyer
Jacobsz. van
Dutch, op.1662-m.1675
BLOMMER, Nils Johan
Olsson
Swedish, 1816-1853
BLOMMERS, Bernardus
Johannes
Dutch, 1845-1914

BLOMMERS, Hendrick
Dutch, 19th cent.
BLOMSTEDT, Väinö
Alfred
Finnish, 1871-1947
BLON, le
see Le Blon
BLOND, Jean Baptiste
Alexandre le
French, 1679-1719
BLOND, Maurice
French, 1899-
BLONDEEL, Lancelot
Netherlands,
1496-1561
BLONDEL, Edouard
French, 19th cent.
BLONDEL the Elder,
Francois
French, 1617-1686
BLONDEL, Georges
Francois
French, 1730-p.1791
BLONDEL, Jacques
Francois
French, 1705-1774
BLONDEL, Merry Joseph
French, 1781-1853
BLONDIN, Charles
French, 20th cent.
BLOOD, H.S.
American, 19th cent.
BLOOM, Hyman
American, 1913-
BLOOMER, Hiram
Reynolds
American, 1845-
BLOORE, Ronald
Canadian, 1925-
BLOOS, Richard
German, 1878-1956
BLOOT, Pieter de
Dutch, c.1601/2-1658
BLOOTELING or
Bloteling, Abraham
Dutch, 1640-1690
BLORE, Edward
British, 1789-1879
BLOSUM, Vern
American, 20th cent.
BLOT, Jacques
French, 20th cent.
BLOT, Maurice
French, 1753-1818
BLOTELING, Abraham
see Blooteling
BLOTT, Geo
French, 19th cent.
BLOUET, Abel
(Guillaume Abel)
French, 1795-1853
BLOUNT, T.
British, 18th cent.(?)
BLOW, Sandra
British, 1925-
BLUCK, J.
British, op.1791-1831
BLUEMNER, Oscar
American, 1867-1938
BLUHM, Norman
American, 1920-
BLUHM, Oscar
German, 19th cent.
BLUM, Louis
German, 1822-1854

BLUM, Maurice
French, 1832-
BLUM, Robert
Frederick
American, 1857-1903
BLUME, Peter
American, 1906-
BLUMENSCHEIN, Ernest
Leonard
American, 1874-
BLUMENTHAL, Hermann
German, 1905-1942
BLUMENTHAL, Mathias
German, c.1719-1763
BLUMER, Lucien
French, 1871-
BLUME-SIEBERT,
Ludwig
German, 1853-
BLUMMER, E.
American, 20th cent.
BLUNAUS, Harij
Janovich
Russian, 1924-
BLUNK, Detlev Konrad
Danish, 1799-1853
BLUNT, Lady Anne
British, op.1854-1877
BLUNT, Henry
British, op.c.1840
BLUNT, John S.
American, 1798-1835
BLUNT, John Silvester
British, 1874-1943
BLUNTSCHLI, Niklaus
Swiss, a.1525-1605
BLYENBERCH, Abraham
Flemish, op.1617-1622
BLYHOOFT, Zacharias
Dutch,
op.1658/59-m.1680/2
BLIJK, Frans Jacobus
van den
Dutch, 1806-1876
BLYTH, Benjamin
American, 1740-p.1781
BLYTH, Robert
British, 1750-1784
BLYTH, Robert Henderson
British, 1919-
BLYTHE, David Gilmour
American, 1815-1865
BO, Lars
Scandinavian, 20th cent.
BOADEN, John
British, op.1812-m.c.1839
BOADLE, N.E.
British, 19th cent.
BOAL, James M.
American, 1800(?)-1862
BOARD, Ernest
British, 1877-1934
BOARDMAN, William G.
American, c.1815-c.1895
BOATERI, Jacopo
Italian, op.c.1500
BOBA, Georges
French, op.1572-1599
BOBADILLA, Geronimo de
Spanish, op.1666-m.1680
BOBAK, Bruno
Canadian, 1923-
BOBAK, Molly Lamb
Canadian, 1922-
BOBBIN, Tim
see Collier, John

BOBELDIJK, Felicien
Dutch, 1876-
BOBERG, Anna
Swedish, 1864-1935
BÖBLINGER, Hans
German, -a.1511
BOBLY, De
Italian, 19th cent.
BOBROV, A.
Russian, 19th cent.
BOCANEGRA, Pedro
Atanasio
Spanish, 1635(?)-1689
BOCCACCINO the Elder,
Boccaccio
Italian, c.1467-1524/5
BOCCACCINO, Camillo
Italian, 1501-1546
BOCCACCINO, Pseudo
(Giovanni Agostino
da Lodi)
Italian, op.c.1500
BOCCACCIO, Giovanni
Italian, 1313-1375
BOCCANERA, Giacinto
Italian, 1666-1746
BOCCANI, A.
Italian(?), 19th cent.
BOCCARDI, Giovanni di
Giuliano
Italian, 1460-1529
BOCCATI, Giovanni
Italian, op.1445-1481
BOCCATI da Camerino,
Giovanni
Italian, c.1420-p.1480
BOCCHI, Amedeo
Italian, 1883-
BOCCHI da Pistoia,
Bartolommeo d'Andrea
Italian, op.1430-1450
BOCCHI, Faustino
Italian, 1659-1742
BOCCHI, Pseudo
Italian, op.c.1700-1740
BOCCHINO
French, 19th cent.
BOCCIARDO, Clemente
Italian, 1620-1658
BOCCIONI, Umberto
Italian, 1882-1916
BOCHDANI, Jacob
see Bogdany
BOCHMANN, Gregor von
German, 1878-1930
BOCHNER, Mel
American, 20th cent.
BOCHOLT, Franz von
see Monogrammist F.V.B.
BOCHOVEN, Andries van
Dutch, op.1628
BOCION, François Louis
David
Swiss, 1828-1890
BOCK, Friedrich
(Wilhelm)
German, 1759-1805
BOCK, Hans the Elder
German, c.1550-c.1623
BOCK, Théophile
Emile Achille de
Dutch, 1851-1904
BOCK, Thomas
Australian, 1790-1855

BOCK, Tobias
see Pock
BOCKELMANN, Manfred
German, 20th cent.
BOCKHORNI, Felix
German, 1794-
BÖCKLIN, Arnold
Swiss, 1827-1901
BÖCKMAN, Bengt
German, 20th cent.
BOCKMAN, Gerhard
(not C. or George)
British, 1686-1773
BOCKMANN, A.
German, 18th cent.
BOCKSBERGER, Johann
(Hans), I
German, op.1536-a.1569
BOCKSBERGER, Johann
or Hans, II
German, op.c.1560
BOCKSBERGER, Melchior
German, c.1520-1587
BOCKSTIEGEL, Peter
August
German, 1889-1951
BOCKSTORFFER or
Boksdorfer, Christoffel
or Christian
Swiss, op.1522-m.1552
BOCOURT, Etienne
Gabriel
French, 1821-p.1840
BOCQUET, Anne Rosalie
see Filleul
BOCQUET, Jean Baptiste
French, 18th cent.
BOCQUET, Nicolas
French, op.1752-1773
BOCQUET, Pierre Jean
French, 1751-1817
BODAN the Younger,
Andreas
French, 1656-1696
BODDINGTON, Edwin H.
British, op.1853-1869
BODDINGTON, Henry John
(Williams)
British, 1811-1865
BODDINGTON, J.
British, op.1699
BODDY, William James
British, 1832-1911
BODE, B.
German, 17th cent.(?)
BODE, Leopold
German, 1831-1906
BODECKER, Johann
Friedrich
German, c.1658-1727
BODEMAN, Willem
Dutch, 1806-1880
BODEMER, Jacob
German, 1777-1824
BODEM, André-Joseph
French, 1791-
BODEN, Hans
Swiss, op.1520-1526
BODEN, Jakob
Swiss, op.1505-1534
BODEN, Leonard
British, 20th cent.
BODENHEIM, Johanna
Cornelia Hermana (Nelly)
Dutch, 1874-1951

BODENMÜLLER, Alfons
German, 1847-1886
BODENMÜLLER, Friedrich
German, 1845-1913
BODIN or Baudin,
Alessandro W.
Italian(?),
op.1711-1740
BODIN, Joseph
see Baudin
BODINIER, Guillaume
French, 1795-1872
BODLEY, Josselin
Reginald Courtenay
British, 20th cent.
BODMER, Karl
Swiss, 1809-1893
BODMER, Paul
Swiss, 1886-
BODMER, Walter
Swiss, 1903-
BODOY, Ernest-
Alexandre
French, op.1874
BODT, Jean de
French, 1670-1745
BOECK, Felix de
Belgian, 1898-
BOECKHORST, Johann
(Lange Jan)
Flemish, 1605-1668
BOECKL, Herbert
German, 1894-1966
BOECOP, Mechteld toe,
(née Lichtenberg)
Netherlands,
op.1547-1578
BOEGERT, Derick
see Baegert
BOEHLE, Fritz
German, 1873-1916
BOEHM, Adolf
German, 1861-1927
BOEHM, Eduard
German, 19th cent.
BOEHM, Elizabeth
Merkurevna,
(née Endaurov)
Russian, 1843-
BOEHM, Sir Joseph
Edgar
German, 1834-1890
BOEHME, Karl Theodor
German, 1866-1939
BOEKHORST, Johann
German, 1661-1724
BOEKSENT, Jan
Flemish, 1660-1727
BOEL or Bol, Cornelis
Flemish, c.1576-c.1621
BOEL, J.A. (A.J.)
British(?), op.1899-1903
BOEL, Jean Baptist
Flemish, op.1674-m.1689
BOEL or Boels, Louis
Netherlands,
op.1477-1518
BOEL, Peter
Flemish, 1622-1674
BOEL or Bol, Quirin
or Coryn
Flemish, 1620-1668
BOELEMA de Stomme,
Maerten
Dutch, op.1642-1664

BOELS, Frans
Netherlands,
op.1583-1594
BOELS, Louis
see Boel
BOEMM, Ritta
Hungarian, 1868-
BOENER, Johann Alexander
German, 1647-1720
BOENISCH, Gustav Adolf
German, 1802-1887
BOER, Saskia de
British, 20th cent.
BOERNER, Johann Andréas
German, 1785-1862
BOESE, Henry
American, op.1844-1860
BOESEN, August Vilhelm
Danish, 1812-1857
BOESEN, Johannes
Danish, 1847-
BOET, J.
Flemish, op.1658
BOETTCHER, Christian
Eduard
German, 1818-1889
BOETTINGER, Hugo
Czech, 1880-1934
BOETTJER, Oskar
German, 1865-
BOEYERMANS, Theodor
Flemish, 1620-1678
BOFA, Gus (Gustave
Blanchot)
French, 20th cent.
BOGAERT, Gaston
Belgian, 20th cent.
BOGAERT, Hendrik
Hendricksz.
Dutch, 1626/7-p.1672
BOGAJEWSKY, Konstantin
Fedorowitsch
Russian, 1872-1942
BOGALEVITCH, Feodor
Russian, op.1796
BOGART, Bram
see Boogaart,
Abraham
BOGDANOFF, Ivan
Petrovich
Russian, 1855-1932
BOGDANOFF-BJELSKI,
Nikolai Petrowitsch
Russian, 1868-1945
BOGDANOWICZ, Anna
see Bilinska
BOGDANY, Bochdani,
Bogdane or Bogdani,
Jakob
Hungarian, c.1660-1724
BOGERT, George Hirst
American, 1864-1944
BØGGILD, Mogens
Danish, 1901-
BOGGIO, Emile
French, 1857-1920
BOGGS, Frank Myers
American, 1855-1926
BOGH, Carl Henrik
Danish, 1827-1893
BOGLE, John
British, op.1769-1792
BOGLE, W. Lockhart
British, op.1886-1893

BOGLIARDI, Oreste
Italian, 1900-
BOGNER, Betty
see Fröhlich
BOGOLIUBOFF, Alexis
Russian, 1824-1896
BOGOMAZOV, Alexander
Russian, 1880-
BOGUET, Nicolas
Didier
French, 1755-1839
BOGUSZEWSKI, Christoph
Alexander
Polish, op.1628
BOHEIM, Carl
German, 1830-1870
BOHEMEN, Cornelis
Bernardus (Kees)
van
Dutch, 1928-
BOHEMIAN SCHOOL
Anonymous Painters
of
see Czech
BOHER, Francois
French, 1769-1825
BÜHLER, Hans
German, 1884-1961
BÖHM
see also Beham
BÖHM, Adolf
German, 1861-1927
BÖHM, Adolph
German, 1844-
BÖHM, Alfred
German, 1850-1885
BÖHM, Amadeus
Wenzel
Czech, 1769-1823
BÖHM the Younger,
Johann George
German, c.1696-1738
BÖHM, Joseph Daniel
German, 1794-1865
BOHM, Max M.
American, 1868-1923
BÖHM, Paul
Hungarian, 1839-1908
BÖHME, Auguste
see Dörffling
BÖHME, Rachel Rosina,
(née Dietrich)
German, 1725-1770
BÖHMEN
German, 18th cent.
BOHMER, Heinrich
German, 1852-p.1907
BOHN, Charles Jr.
American, op.1805-6
BOHN, German von
German, 1812-1899
BÖHNDEL, Conrad Christian
August
German, op.1796-m.1847
BOHRDT, Hans
German, 1857-
BOHROD, Aaron
American, 1907-
BOHUN, Peter Michael
Czech, 19th cent.
BOICHARD, Henri Joseph
French, 1783-p.1859
BOICHOT, Guillaume
(Jean Guillaume)
French, 1735-1814
BOIESSIERE, La
French, op.1818

BOIGNARD, Camille
French, 19th cent.
BOILAUGES, Fernand
French, 1891-
BOILEAU, Francois
Jacques
French, 1720-1785
BOILLOT, Joseph
French, c.1546-p.1603
BOILLY, Eugène
French, op.1859-1866
BOILLY, Julien (Jules)
Léopold
French, 1796-1874
BOILLY, Louis
Léopold
French, 1761-1845
BOINARD, Jean
French, c.1627-1711
BOIS
see also Dubois
BOIS or Boys,
Cornelius
Dutch, op.1647
BOIS, Mathieu de
see Dubus
BOISFREMONT, Charles
Boulanger de
French, 1773-1838
BOISSARD, Jean
French, op.1685
BOISSARD, Jean Jacques
French, 1533-1598
BOISSARD de Boisdenier,
Joseph Ferdinand
French, 1813-1866
BOISSARD, Robert
French, c.1570-p.1597
BOISSELIER the Elder,
Félix
French, 1776/81(?)-1811
BOISSIER, André
Claude
French, 1760-1833
BOISSIERE, Jean Le Roy
de la
French, op.1608
BOISSIEU, Jean Jacques de
French, 1736-1810
BOISSON or Buisson,
André
French, 1647-1733
BOISSONAS, Henri
Swiss, 1894-
BOIT, Carl (Charles)
Swedish, 1663-1727
BOIT, Edward Darley
American, 1843-1915
BOITARD, Francois
French, 1670-1715
BOITARD the Elder, Louis
Philippe
(not Louis Pierre)
French, op.1738-1763
BOIZOT or Boyzot,
Antoine
French, c.1702-1782
BOIZOT, Louis Simon
French, 1743-1809
BOJANUS, D.
German, 18th cent.
BOJATO, Giuseppe
Italian, 1771-1849
BOKELMANN, Christian
Ludwig
German, 1844-1894

BOKENES, H.
Dutch(?), op.1647
BOKLUND, Johan
Kristofer
Swedish, 1817-1880
BOKROS, Laszlo
Hungarian, 1928-
BOKS, Evert Jan
Belgian, 1838-1914
BOKSDORFER, Christoffel
see Bockstorffer
BOKSHOORN, Joseph
Dutch, op.c.1675
BOL, Cornelis
Dutch, 1589-p.1652
BOL, Cornelis
Dutch, op.c.1666
BOL, Ferdinand
Dutch, 1616-1680
BOL, Hans or
Johannes
Netherlands, 1534-1593
BOL, Philips
Flemish, op.1639-m.1664
BOL
see also Boel
BOLANDER, Lars
Swedish, op.1774-m.1795
BOLCKMAN, P.
Flemish, op.1664
BOLDING, Cornelis
(Cees)
Dutch, 1897-
BOLDINI, Giovanni
Italian, 1845-1931
BOLDIREV, Victor
Russian, 20th cent.
BOLDRINI, Leonardo
Italian, op.1452-m.1497/8
BOLDRINI, Niccolò
Italian, 1410-p.1466
BOLENS, Ernst
Swiss, 1881-
BOLIN, Gustave
French, 1919-
BOLIN, Lars
Scandinavian, 18th cent.
BOLINDER, Johan Erik
Swedish, 1768-1808
BOLINGBROKE, Viscountess
British, 18th cent.
BOLL, Ludwig Eduard
German, 1805-1875
BOLLE, Martin
Belgian, 20th cent.
BOLLENRATH, Johann
Chrysanth
German, 1696-1776
BOLLERY or Bolleri,
Jérome
French, op.c.1560-1597
BOLLERY or Bolleri,
Nicolas
French, 1540-1630
BOLLES, Reginald F.
American, 20th cent.
BOLLINGER, Friedrich
Wilhelm
German, 1777-1825
BOLLONGIER or
Boulenger, Hans
Dutch, c.1600-p.1644
BOLOGNA, Giovanni da
Italian, c.1524-1608
BOLOGNESE, Il
see Grimaldi, Giovanni
Francesco

BOLOGNESE SCHOOL,
Anonymous Painters
of the
BOLOGNINI, Carlo
Italian, 1662-
BOLOMEY, Benjamin Samuel
Swiss, 1739-1819
BOLOMEY, Pierre Francois
Louis
Swiss, op.1769
BOLOTOFF, Dimitri
Michaelovitch
Russian, 1837-
BOLOTOWSKY, Ilya
Russian, 1907-
BOLSI or Bols,
Hieronymous or Girolamo
Italian, op.1560
BOLSTERER, Bölsterer,
Bolz, Polster or
Polsterer, Hans
German, op.1547-m.1573
BOLSWERT, Boetius Adams
Dutch, 1580-1633
BOLSWERT, Schelte
Dutch, c.1581-1659
BOLT, Johann Friedrich
German, 1769-1836
BOLTEN, Arent van
Dutch, op.c.1637
BOLTOVSKY, Ilya
Russian, 1907-
BOLTRAFFIO or Beltraffio,
Giovanni Antonio
Italian, 1467-1516
BOLTRAFFIO, Pseudo
Italian, op.c.1510-c.1530
BOLTRI, Genaro
Italian, 1730-1786
BOLZ, Hans
German, 1887-1918
BOLZE, Carl
German, 1832-
BOLZONI
see Gigli, Andrea
BOMAN, Lars Henning
Swedish, 1720-p.1789
BOMBELLI, Sebastiano
Italian, 1635-1716
BOMBERG, David
British, 1890-1957
BOMBLED, Karel Frederik
Dutch, 1822-1902
BOMBLED, Louis Charles
French, 1862-1927
BOMBOIS, Camille
French, 1883-
BOMHARD, A. von
German, 19th cent.
BOMMEL, Elias Pieter
van
Dutch, 1819-1890
BOMMER, Christoph
Wilhelm
German, 1801-
BOMPARD, Maurice
French, 1857-1936
BOMPIANI, Augusto
Italian, 1852-1930
BOMPIANI, Roberto
Italian, 1821-1908
BOMY, Laurens
French, op.1629-m.1661
BON, Ambrogio
Italian, op.1695-1712

BONACINA, Antonio
Italian, 18th cent.
BONACINA, Giovanni
Battista
Italian, c.1620-p.1670
BONAGUIDA, Pacino di
see Pacino
BONALUMI, Agostino
Italian, 20th cent.
BONAMI, Philippe
French, 20th cent.
BONAMICUS
Italian, op.1225
BONANNI, Filippo
Italian, 1638-1725
BONAPARTE (Napoleon II)
François Charles
Joseph Duc de
Reichstadt
French, 1811-1832
BONAPARTE, Princesse
Mathilde
French, 1820-1904
BONARELLI, Godeardo
(Conte)
Italian, 1806-p.1883
BONARIA, Carlo
see Bonavia
BONASCIA or Bonasci,
Bartolommeo
Italian, c.1450-1527
BONASONE, Bonasoni or
Buonasona, Giulio di
Antonio
Italian, op.1531-1574
BONASTRI, Lattanzio
Italian, op.c.1550
BONATTI, Giovanni
(Il Ferraresino or
Giovanni del Pio)
Italian, c.1635-1681
BONAVENTURA
see Segna
BONAVENTURA di Michele
Italian, 13th cent.
BONAVERA, Domenico
Italian, c.1640-
BONAVIA or Bonaria,
Carlo
Italian, op.c.1740-1756
BONAVIA, George
British, 19th cent.
BONAVITA, Franco di
see Franco Bolognese
BOND, Douglas
American, 1937-
BOND, Frances Flora
(Fanny)
see Palmer
BOND, John Daniel
British, c.1725-1803
BOND, John Lloyd
British, 19th cent.
BOND, William Joseph J.C.
British, 1833-1926
BONDE, Carl
Swedish, op.1616
BONDET, E.
French, 1879-
BONDI, Francesco
Antonio
Italian, 17th cent.
BONDOUX, Jules Georges
French, -1919
BONDT or Bont, Jan
de
Dutch, op.1639-1653

BONDT, Daniel de
Dutch, op.1661-1671
BONDUCCI, Andrea
Italian, 18th cent.(?)
BONE, Charles Richard
British, op.1815-1848
BONE, Henry
British, 1755-1834
BONE, Henry Pierce
British, 1779-1855
BONE, Muirhead
British, 1876-1953
BONE, Robert Trewick
British, 1790-1840
BONE, Stephen
British, 1904-1958
BONE, William
British, op.1815-1843
BONECCHI or Bonechi,
Matteo
Italian, c.1672-c.1752
BONELLI, Carlo
Italian, a.1800-
BONELLI, Guiseppina
Italian, 1898-
BONESCU, Marius
Rumanian, 1881-
BONESTELL, Chesley
British, 20th cent.
BONETTI da Cortona,
Baccio
Italian, 17th cent.(?)
BONEVARDI, Marcelo
Argentinian, 1929-
BONFANTI, A.
Italian, 20th cent.
BONFIELD, George R.
American, 1802-1898
BONFIELD, William van
de Velde
American, op.1860-1869
BONFIGLI, Antonio
Italian, 1806-1865
BONFIGLIO or Buonfigli,
Benedetto
Italian, c.1420-1496
BONFIGLIOLI, Luigi
Italian, 1874-
BONFIGLIONI
Italian, 17th cent.
BONFORT, Robert Vernet
French, 20th cent.
BONFRATELLI, Apollonio de'
Italian, op.1523-1572
BONHAM-CARTER, Joanna
Hilary
British, 1821-1865
BONHEUR, Auguste François
French, 1824-1884
BONHEUR, Rosa or Rosalie
French, 1822-1899
BONHOMME, Ignace François
French, 1809-1881
BONHOMME, Léon
French, 1870-1924
BONHOT, Etienne
French, op.c.1820
BONI, Bianca
Italian, 18th cent.
BONI, E.
Italian, 19th/20th cent.
BONI or de Bonis,
Giovanni Martino dei
Italian, 1753-p.1810
BONI, Paolo
Italian, 20th cent.

BONICHI, Gino
Italian, 1904-1933
BONIES
see Nieuwenhuis,
Bob
BONIFAZIO, Natale di
Girolamo
Italian, op.c.1580-1594
BONIFAZIO, Veronese
(di Pitati)
Italian, 1487-1553
BONILLI, Vincenzo di
Francesco (Morgante)
Italian, op.1540-1556
BONILLY, E.
French, 19th cent.
BÖNINGER, Robert
German, 1869-
BONINGTON, Richard
British, op.1797-1834
BONINGTON, Richard
Parkes
British, 1801-1828
BONINI, Girolamo
(L'Anconitano)
Italian, op.c.1660-m.c.1680
BONINSEGNA di Zenone
(da Clocego)
Italian, op.1407-m.a.1443
BONISOLI or Bonizoli,
Agostino
Italian, c.1638-1707
BONITO, Giuseppe
Italian, 1707-1789
BONJOUR, Jean Baptiste
Swiss, 1801-1882
BONN, J.F.A. von
Flemish, op.1741-1766
BONNAR, William
British, 1800-1853
BONNARD, Camille Marie
French, c.1793-p.1827
BONNARD, Pierre
French, 1867-1947
BONNART, Nicolas
French, c.1636-1718
BONNART, Robert
French, 1652-p.1729
BONNAT, Léon
French, 1834-1922
BONNECROY, Jean Baptiste
Flemish, 1618-1676
BONNECROY, Philipp
Flemish, 1720-p.1771
BONNEFOND, Claude
French, 1796-1860
BONNEFOY, Henry
French, op.1880-1889
BONNEMAISON, Féréol
French, op.1796-m.1827
BONNEMAISON, Georges
French, op.1874-m.1885
BONNEMAISON, Jules de
French, 1809-p.1863
BONNEMAISON, T.
French, op.1835
BONNEMER, François
French, 1637-1689
BONNENCONTRE, Ernest
French, 1862-p.1900
BONNER, Thomas
British, op.1773-m.a.1812
BONNET, Anne
Belgian, 1908-1960
BONNET, Félix Alfred
French, 1847-
BONNET, Philippe
French, 1927-

BONNET, Louis Marin
French, 1743-1793
BONNET, Rudolf
French, 19th cent.
BONNETON, Germain Eugène
French, 1874-1915
BONNEVILLE, François
French, op.1787
BONNIN, Luis
Spanish, 19th cent.
BONNOR, J.H.M.
British, 19th cent.
BONO, Eduardo dal
Italian, 1831-1915
BONO da Ferrara
Italian, op.1450-1461
BONO, Michele di Taddeo
(Giambono or Zambone)
Italian, op.1420-1460
BONOMI, Carlo
Italian, 1880-
BONOMI the Younger,
Joseph
British, 1796-1878
BONOMINI, Vincenzo
Italian, 1757-1834
BONONI, Bartolommeo
Italian, op.1501
BONONI, Carlo
Italian, 1569-1632
BONSI, Giovanni
Italian, op.1366-1371
BONSI, Pietro Paolo
see Bonzi
BONSIGNORI, Francesco
Italian, c.1455-1519
BONSIGNORI, Fra Girolamo
(Matteo?)
Italian, 1472(?)-
BONSTETTEN, Abraham Sigmund
August von
Swiss, 1796-1879
BONT, Jan de
see Bondt
BONTECOU, Lee
American, 1931-
BONTEMPS, Pierre
French, op.1536-1561
BONTEPAERT
see Santvoort
BONTULLI Paolo da
Percanestro
(Camerino)
Italian, op.1520-1531
BONVICINO
see Moretto, Alessandro
BONVIN, François
French, 1817-1887
BONVIN, Léon
French, 1834-1866
BONVOISIN, Jean
French, 1752-1837
BONVOISIN, Maurice
(Mars)
Belgian, 1849-1912
BONY, Jean François
French, c.1760-m.a.1828
BONZI or Bonsi, Pietro
Paolo (Il Gobbo dei
Carracci, Gobbo da
Cortona or da' frutti)
Italian, c.1573/84-1633/44
BOODLE, Walter
British, 20th cent.
BOOGAART, Abraham
(Bram Bogart)
Dutch, 1921-

BOOGAERT, J.
 Dutch, 17th cent.
BOOM, Karel or
 Charles
 Belgian, 1858-1939
BOON, Constantin
 Belgian, 19th cent.
BOON, J.
 Dutch, op.c.1724
BOONE, Daniel
 Flemish,
 1630/1-c.1698/1700
BOONEN, Arnold
 Dutch, 1669-1729
BOONEN, C.L.
 Dutch(?), op.1694
BOONEN, Jasper
 Dutch, 1677-1729
BOONS, P. van
 Dutch, op.1627
BOONZAIER, D.C.
 French, 19th cent.
BOOSEY, W.
 British, op.1848-1872
BOOT, William Henry
 James
 British, 19th cent.
BOOTH, Denis
 British, 1916-
BOOTH, Edward C.
 British, op.1856-1864
BOOTH, Elizabeth M.
 British, 19th cent.
BOOTH, Franklin
 American, 1874-
BOOTH, J.L.C.
 British, op.1901-1908
BOOTH, Raymond C.
 British, 20th cent.
BOOTH, Rev. Richard
 Sabvey
 British, op.1796-1807
BOOTH, S.Lawson
 British, -1928
BOOTH, William
 British, 1807-1845
BOOTT, Elizabeth O.L.
 American, 1846-p.1884
BOOTY, Edward
 British, 1812-1879
BOOYS, Eduard du
 see Dubois
BOPFINGER GESELLE, The
 German, op.c.1469-c.1472
BOQUET, Jules Charles
 French, 1840-1932
BOQUET, L.
 French, 18th cent.
BOQUET, Marie Virginie
 French, op.1835-1878
BOQUET, Pierre Jean
 French, 1751-1817
BOR, Paulus (Orlando)
 Dutch, c.1600-1669
BOR, Vane
 Yugoslavian, 1908-
BORBONI, Jacopo
 Italian, op.1611
BORCH, A. van der
 Dutch, op.1663
BORCH, Gerard, I ter,
 or Gerard Terborch
 Dutch, 1584-1662
BORCH, Gerard, II ter,
 or Gerard Terborch
 Dutch, 1617-1681

BORCH, Gesina ter,
 or Gesina Terborch
 Dutch, 1633-1690
BORCH, Herman ter,
 or Herman Terborch
 Dutch, 1638-a.1677
BORCH, Jan ter, or
 Jan Terborch
 Dutch, op.c.1634-1643
BORCH, Moses ter, or
 Moses Terborch
 Dutch, 1645-1667
BORCH, Fraulein W.
 von dem
 German, op.1798
BORCHARD, Edmond
 French, 1848-1922
BORCHARDT, Félix
 German, 1857-
BORCHARDT, Hans
 German, 1865-
BORCHT, Hendrik, I
 van der
 Flemish, 1583-1660
BORCHT, Hendrik, II
 van der
 Flemish, 1614-c.1690
BORCHT, Lazarus van der
 Flemish, op.1601-1611
BORCHT, Peter van der
 Netherlands, 1545-1608
BORCHT, Peter van der
 Flemish, op.1604-1618
BORCHT or Borght,
 Pierre van der
 Flemish, -1763
BORČIČ, Bogdan
 Yugoslav, 1926-
BORCKERT, Adam
 see Burghardt
BORCKHARDT, Charles
 British, op.1784-1825
BORCKMANN, August
 German, 1827-1890
BORD, Léon de
 French, op.1866-1874
BORDALLO-PINHEIRO
 see Pinheiro
BORDES, Ernest
 French, 1852-1914
BORDES, Joseph
 French, 1773-p.1835
BORDIER, Jacques
 French, 1616-1684
BORDIER du Bignon,
 Jacques Charles
 French, 1774-1846
BORDIER, Pierre
 French, 17th cent.
BORDIEU, Pieter du
 see Dubordieu
BORDIN, M.
 French, 20th cent.
BORDLEY, John Beale
 American, 1800-1882
BORDONE, Andrea
 Italian, 16th cent.
BORDONE, Benedetto
 (Benedetto Padovano)
 Italian, op.1480-m.1539
BORDONE or Bordon, Paris
 Paschalinus
 Italian, 1500-1571
BORDUAS, Paul-Emile
 Canadian, 1905-1960
BOREHAM, J.
 British, 18th cent.(?)

BOREIN, Edward
 American, 1872-1945
BOREL, Antoine
 French, 1743-p.1810
BOREL, J.
 Swiss, 1932-
BOREL, Paul
 French, 1828-
BOREL, Pierre
 French, op.1787-1788
BORELLI or Borrello,
 Gennaro
 Italian, op.1755-1760
BORELY, Jean Baptiste
 French, 1776-1823
BORES, Emile
 French, 20th cent.
BORES, Francisco
 Spanish, 1898-
BORG, Axel Leonard
 Swedish, 1847-1916
BORG, Carl Oscar
 American, 1879-1946
BORGANI, Francesco
 Italian, 1557-1624
BORGEAUD, Marius
 French, 19th cent.
BORGET, Auguste
 French, 1809-1877
BORGHEGGIANO or
 Borcheggiano
 see Alberti, Cherubino
BORGHESE, Ippolito
 Italian, op.1603-p.1627
BORGHESI, Giovanni
 Battista
 Italian, 1790-1846
BORGHINI, Vincenzo
 Italian, 16th cent.
BORGHT, Jacques van der
 Flemish, op.1685/6-1699
BORGHT, Pierre van der
 see Borcht
BORGIANI or Borgianni,
 Orazio
 Italian, 1578(?)-1616
BORGIANNI, Giovanni
 Italian, 20th cent.
BORGIOTTI, Mario
 Italian, 1906-
BORGLUM, John Gutzon Mothe
 American, 1867-1941
BORGNINI, C.J.
 see Borgnis
BORGNIS or Borgnini,
 Giovanni Maria
 Italian, op.1783
BORGNIS or Borgnini,
 Giuseppe
 Italian, op.1783
BORGNIS, I.J.
 British, 19th cent.
BORGOGNONE dalle Teste
 see Giachinetti Gonzales,
 Giovanni
BORGOGNONE or Bergognone,
 Ambrogio Stefani da
 Fossano
 Italian, op.1480-m.1523
BORGOGNONE, Bernardino
 Italian, c.1460/70-1524
BORGOGNONE, Il
 see Courtois
BORGONA, Juan de
 Spanish, op.1495-1533
BORGONZONI, Aldo
 Italian, 1913-

BORGORD, Martin
 American, 1869-1935
BORIE, Adolphe
 American, 1877-1934
BORINI, Ludovico
 Italian, 17th cent.
BORIONE, Bernard Louis
 French, 20th cent.
BORISSOFF, Alexandre
 Sergejewitsch
 Russian, 1866-1934
BORISSOFF-MUSSATOFF
 see Mussatoff
BORJE, Gideon
 Swedish, 1891-
BORJESSON, Augusta
 (Agnes) Fredrika
 Swedish, 1827-1900
BORLA, Hector
 Argentinian, 1937-
BORLAND, Oswald
 British, op.c.1838
BORLOZ, Claude
 Swiss, 20th cent.
BORMAN, Johannes
 Dutch, op.1653-1659
BORNEMANN, Hans or
 Johann
 German, op.1448-m.s.1474
BORNEMANN, Hinrich
 German, c.1450-p.1499
BORNER, Carl Gustav
 German, 1790-1855
BORNER, Elise
 see Winkler
BORNET, Claude
 French, op.1774-1801
BORNET, T.
 American, op.c.1830
BORNFRIED, Jacob
 British, 1904-
BOROS, Eugene
 Hungarian, 20th cent.
BOROVIKOVSKI, Vladimir
 Lukitch
 Russian, 1757-1825
BORRA, Giovanni Battista
 Italian, 19th cent.
BORRÀ, Pompeo
 Italian, 1898-
BORRADAILLE, Rosamund
 British, 20th cent.
BORRAMANS, F.
 Dutch(?), 17th cent.(?)
BORRANI, Odoardo
 Italian, 1834-1905
BORRÁS, Nicolás
 Spanish, 1530-1610
BORRAS y Mompó, Vicente
 Spanish, 1837-p.1871
BORRASSÀ, Honorato
 Spanish, op.1453
BORRASSÀ, Lucas or Lluch
 Spanish, op.1419-m.1434
BORRASSÀ, Luis
 Spanish, op.1390-1424
BORREL, Maurice
 French, 1804-1882
BORREMANS, Guglielmo
 (Guglielmo Fiammingo)
 Flemish, op.1688-1737
BORRILLY, Jean Baptiste
 French, op.1790-1796
BORRO, Luigi
 Italian, 1826-1886
BORROMINI, Paolo Vincenzo
 Italian, -1839

BORRONI, Giovanni Angelo
Italian, 1684-1772
BORRONI, Paolo
Italian, 1749-1819
BORROW, George
British, 1803-1881
BORROW, John Thomas
British, op.1800-1833
BORSATO, Giuseppe
Italian, 1771-1849
BORSCHE, Georg W.
German, 20th cent.
BORSELAER or Borselaar,
Pieter
see Borssler
BORSELEN, Jan Willem
van
Dutch, 1825-1892
BORSOS, Joseph
Hungarian, 1821-1883
BORSSELER, Borselaar
or Borselaer, Pieter
Dutch, op.1664-1687
BORSSOM or Borssum,
Anthonie van
Dutch, 1629/30-1677
BORSTEEGH, Cornelis
Dutch, 1773-1834
BORSTEL, R.A.
British, 20th cent.
BORTHWICK, Alfred Edward
British, 1871-
BORTIGNONI, Giuseppe
Italian, 1778-1860
BORTNYIK, Sandor
Hungarian, 1893-
BORTOLONI, Mattia
Italian, 1696-1750
BORTOLUZZI, Pietro
Bianco
Italian, 1875-1940(?)
BORZIONE, B.
Italian, 19th cent.
BORZONE, Carlo
Italian, -1657
BORZONE, Francesco
Maria (Bourzon)
Italian, 1625-1679
BORZONE, Luciano
Italian, 1590-1645
BORZSONYI-KOLLARITS,
Ferenc.
Hungarian, 1901-1963
BOS
see also Bosch
BOS, Bernardus (Ben)
Dutch, 1930-
BOS, Casper, Gaspar or
Jasper van den
Dutch, 1634-p.1656
BOS, F.
Netherlands, 16th cent.
BOS, Jacob (Jacobus
Bosius or Bossius)
Netherlands,
op.c.1549-1580
BOS, L. van
Netherlands,
17th/18th cent.
BOS, R. ten
Dutch, 17th cent.
BOSA, Louis
American, 1906-
BOSBOOM, Dirk
Dutch, c.1648-p.1678
BOSBOOM, Johannes
Dutch, 1817-1891

BOSCARATI, Felice
Italian, 1721-1807
BOSCH or Bos, Balthasar
van den (Balthasar
Sylvius)
Netherlands, op.1518-1580
BOSCH, Balthasar van den
see Bossche
BOSCH or Bos, Cornelis
(Cornelis Sylvius)
Netherlands,
c.1506/10-p.1564
BOSCH, Edouard van den
Belgian, 1828-1878
BOSCH, Ernst
German, 1834-1917
BOSCH, Etienne Marie
Theodore
Dutch, 1863-1933
BOSCH, Hendrick
Dutch, op.1644-1649
BOSCH, Hendrik van den
Dutch, op.1710
BOSCH, Hieronymus
(Hieronymus or Jerome
van Aken)
Netherlands,
op.1474-m.1516
BOSCH, Johannes or
Joannes de
Dutch, 1713-1785
BOSCH or Bos, Lodewyck
Jansz. van den
Netherlands,
c.1525/30-p.1568
BOSCH, M. van den
Dutch, op.1794
BOSCH, P. van den
Dutch, op.1713
BOSCH or Bos, Paulus
van den
Dutch, 1614/15-1664
BOSCH, Philipp van den
see Bossche
BOSCH or Bos, Pieter
van den
Dutch, c.1613/15-p.1663
BOSCHI, Achille
Italian, 1852-1932
BOSCHI, Benedetto
Italian, op.1620
BOSCHI, Dino
Italian, 1923-
BOSCHI, Fabrizio
Italian, c.1570-1642
BOSCHI, Francesco
Italian, 1619-1675
BOSCO
French, 20th cent.
BOSCOLI, Andrea
Italian, 1550-1606
BOSE, Arun
French, 1934-
BOSELLI, Antonio
Italian, op.1495-1527
BOSELLI or Botelli
the Elder, Felice
Italian, 1650-1732
BOSER, Carl Friedrich
Adolf
German, 1809-1881
BOSHAMER, Johan Hendrik
Dutch, 1775-p.1798
BOSHER, Donald
British, 20th cent.
BOSHIER, Derek
British, 20th cent.

BOSIA, Agostino
Italian, 1886-
BOSIERS, Rene
Belgian, 1875-1927
BOSIO, Giuseppe
Italian, 20th cent.
BOSIO, Jean François
French, 1764-1827
BOSKERCK, Robert Ward
van
American, 1855-1932
BOSMAN, Marija
Yugoslav, 1940-
BOSQUIER, Charles Joseph
French, 1824-p.1875
BOSS, Eduard
Swiss, 1873-1958
BOSSAM, John
British, op.c.1550
BOSSCHAERT, Abraham
Dutch, 1613-p.1638
BOSSCHAERT, Ambrosius,
I
Flemish, 1573-1621
BOSSCHAERT, Ambrosius, II
Dutch, 1609-1645
BOSSCHAERT, Jan Baptist
Flemish, 1667-c.1746
BOSSCHAERT, Johannes
Dutch, 1610/11-p.1628
BOSSCHAERT, Nicolas
Flemish, op.1702
BOSSCHAERT, Thomas
Willeboirts
see Willeboirts
BOSSCHE, Agnes van den
Netherlands, op.1482
BOSSCHE or Bosch,
Philipp van den
Flemish(?), 1604-1615
BOSSCHERE, Jean de
(J.P.Aubertin)
Belgian, 1881-1953
BOSSE, Abraham
French, 1602-1676
BOSSE, Hélène, (née
Girardot)
French, 1831-p.1868
BOSSE, M. Bileers van
Dutch, 19th cent.
BOSSHARD, Anna
Swiss, 1875-1908
BOSSHARD, Rodolphe Théophile
Swiss, 1889-
BOSSHARDT, Caspar
Swiss, 1823-1887
BOSSI, Benigno
Italian, 1727-1793(?)
BOSSI, Domenico
Italian, 1765-1853
BOSSI, Giuseppe
Italian, 1777-1815
BOSSI, S.
Italian, 19th cent.
BOSSOLI, Carlo
Italian, 1815-1884
BOSSUET, François
Antoine
Belgian, 1798-1889
BOSSUT, Etienne
French, 20th cent.
BOSTELMANN, Karl
(Louis Georg)
German, 1825-p.1866
BOSTOCK, John
British, op.1826-1869
BOSVELT, G. van
Dutch, op.1779-1782

BOSWELL, James
British, 1906-
BOSWELL, Jane
British, 20th cent.
BOTELHO, Carlos
Portuguese, 1899-
BOTELLI, Felice
see Boselli
BOTEN, Anton
German, op.1626-1627
BOTERIE, Raymond
French, op.1509
BOTERO, Fernando
Colombian, 1932-
BOTH, Andries
Dutch, c.1611/12-a.1650
BOTH, Heinrich
Dutch(?), 18th cent.
BOTH, Jan
Dutch, op.1618(?)-1652
BOTH, S.W. Il
Hungarian, op.c.1880
BOTHINAN, G.
French, 19th cent.
BOTHWELL, Dorr
American, 1902-
BOTHWICK, J.
British, 19th cent.
BOTKINE, Marie-Sergine
Russian, op.1910
BOTNEN, Trond
Scandinavian, 20th cent.
BOTT, Francis
German, 1904-
BOTT, R.T.
British, op.1847-1862
BOTTALLA, Giovanni Maria
(Raffaelino Bottalla)
Italian, 1613-1644
BOTTANI, Giuseppe
Italian, 1717-1784
BOTTARELLI, Maurizio
Italian, 1943-
BOTTEZ, Seymour
Haitian, 1926-
BÖTTGER, Herbert
German, 1898-1954
BÖTTGER, Rudolf
German, 1887-
BOTTI, Domenico
Italian, 19th cent.
BOTTI, Francesco
Italian, c.1640-1710
BOTTI, Vincenzo
Italian, op.1827-1832
BOTTICELLI, Alessandro
(Sandro) Filipepi
Italian, 1444-1510
BOTTICINI, Compagno di
Italian, 15th cent.
BOTTICINI, Francesco
Italian, 1446-1497
BOTTICINI, Raffaello
Italian, 1477-p.1520
BOTTINI, Georges
French, 1874-1907
BÖTTNER, Wilhelm
German, 1752-1805
BOTTOMLEY, Albert Ernest
British, 1873-1950
BOTTOMLEY, Alfred
British, op.1859-1863
BOTTOMLEY, John William
German, 1816-1900
BOTTOMLEY, R.O.
British, 19th cent.
BOTTON, Jean Isy de
French, 1898/1900-

BOTTRIGARI, E.
 Italian, 16th cent.
BOTTS, John
 American, 20th cent.
BOTTSCHILD, Samuel
 German, 1641-1706
BOUCART, Gaston Hippolyte
 Ambroise
 French, 1878-
BOUCH
 British, op.1797
BOUCHARD
 Edith
 Canadian, 20th cent.
BOUCHARD, Pierre François
 French, 1831-1889
BOUCHARD, S. Mary
 Canadian, 20th cent.
BOUCHARDON, Edmé
 French, 1698-1762
BOUCHARDY, Etienne
 French, 1797-1849
BOUCHAUD, Etienne
 French, 20th cent.
BOUCHE, Georges
 French, 1874-1941
BOUCHE, Louis Alexandre
 French, 1838-1911
BOUCHÉ, Louis
 American, 1896-
BOUCHER, Madame
 French, op.c.1750
BOUCHER, Alfred Jean
 French, -1934
BOUCHER, Catherine
 see Blake
BOUCHER the Elder,
 François
 French, 1703-1770
BOUCHER, Guillaume
 French, op.1241-1242
BOUCHER, Jean
 French, 1568-1633(?)
BOUCHER, Juste-Nathan
 (Juste-François)
 French, 1736-1782
BOUCHER, Marie-Jeanne
 French, 1716-c.1785
BOUCHER, William Henry
 British, op.1883-m.1906
BOUCHERETTE, Emilia
 British, 19th cent.
BOUCHERON, Jean Baptiste
 French, op.c.1778-1793
BOUCHERVILLE, Adrien de
 French, op.1864-m.1912
BOUCHERY, Michel
 French, 1929-
BOUCHET, Elizabeth
 see Le Moine
BOUCHET, Jules Frédéric
 French, 1799-1860
BOUCHET, Louis André
 Gabriel
 French, 1759-1842
BOUCHEZ, Charles
 French, 1811-p.1846
BOUCHON
 French, 18th cent.
BOUCHOR, Joseph Félix
 French, 1853-1937
BOUCHOT, François
 French, 1800-1842
BOUCKHORST, Jan
 Philipsz. van
 Dutch, 1588-1631
BOUCOIRAN, Numa
 French, 1805-1869

BOUCQ d'Artois,
 Jacques le
 French, 16th cent.
BOUCQUET, Auguste
 see Bouquet
BOUCQUET, Victor
 Flemish, 1619-1677
BOUDER, Annette
 French, 1929-
BOUDET, Pierre
 French, 20th cent.
BOUDEWYNS, Baudewyns
 or Bauduins, Adriaen
 Frans
 Flemish, 1644-1711
BOUDEWYNS, Frans
 Flemish, op.1720-m.1766
BOUDIER, Edouard-
 Louis
 French, op.1869-m.1903
BOUDIN, Eugène
 French, 1824-1898
BOUDRY, Alois
 Belgian, 1851-
BOUET, Georges Adelmard
 French, 1817-p.1868
BOUFFLERS, Stanislas
 Jean, Marquis de
 French, 1738-1815
BOUG, Hippolyte
 d'Orschwiller
 German, 1810-1868
BOUGER, Didier
 French, op.1792
BOUGH, Samuel
 British, 1822-1878
BOUGHTON, George Henry
 British, 1833-1905
BOUGHTON, H.
 British, op.1828-1858
BOUGUEREAU, Adolphe
 William
 French, 1825-1905
BOUHOT, Etienne
 French, 1780-1862
BOUILLET, André
 French, op.1913
BOUILLIER
 French, 18th cent.
BOUILLON, Mlle.
 French, 1867-
BOUILLON, Léon
 French, op.1877-1890
BOUILLON, Michel
 French, op.1638-
BOUILLON, Pierre
 French, 1776-1831
BOUILLOT, Maurice
 French, op.1931-1939
BOUIS, André
 see Bouys
BOUIS, Jacques Victor
 French, 1893-
BOULAND, J.
 Dutch(?) op.c.1728
BOULANGE, Louis Jean-
 Baptiste
 French, 1812-1878
BOULANGER, Clément
 French, 1805-1842
BOULANGER, François
 Joseph Louis
 Belgian, 1819-1873
BOULANGER, Gustave
 Clarence Rodolphe
 French, 1824-1888
BOULANGER, Jean
 French, 1566(?)-1660

BOULANGER, Jules Joseph
 Belgian, 1822-p.1855
BOULANGER, Louis
 French, 1807-1867
BOULANGER, Mathieu
 French, op.1685
BOULARD, Auguste
 French, 1825-1897
BOULARD, Emile
 French, op.1885-1894
BOULAYE, C.A. Paul
 de la
 French, 19th cent.
BOULENGER, Hans
 see Bollongier
BOULENGER, Pierre
 Emmanuel Hippolyte
 (Hippolyte)
 Belgian, 1837-1874
BOULET, Eugène Cyprien
 French, 1877-1927
BOULIARD or Bouliar,
 Marie-Geneviève
 French, 1772-1819
BOULIER, Lucien
 French, 20th cent.
BOULLE, André Charles
 French, 1642-1732
BOULLOGNE or Boullonge
 Bon
 French, 1649-1717
BOULLOGNE, Jean de
 see Valentin de Boullogne
BOULLOGNE or Boullongne
 the Elder, Louis
 French, 1609-1674
BOULLOGNE or Boullonge
 the Younger, Louis
 French, 1654-1733
BOULLOGNE or Boullonge,
 Madeleine
 French, 1646-1710
BOULNOIS, Maurice
 French, 20th cent.
BOULOGNE, Jean de
 see Bologna, Giovanni da
BOULONOIS, E. de
 Flemish, op.c.1682
BOULT, A.S.
 British, op.1815-1853
BOULT, Francis Cecil
 British, op.1885
BOULTBEE, John
 British, 1752-1802
BOULVENE, Jacques
 French, op.1595-
BOULY, F.
 German, op.1710
BOUMAN, Johann
 German, 1602-p.1626
BOUMAN, Johanna Laura
 see Kruyder
BOUMEESTER, Christine
 Annie
 Dutch, 1904-
BOUMEESTER, Cornelis
 Dutch, c.1670-1733
BOUNETHEAU, Henry
 Brintnell
 American, 1797-1877
BOUNIEU, Michel-Honoré
 French, 1740-1814
BOUQUET, Augustin
 French, 17th cent.
BOUQUET or Boucquet,
 Auguste
 French, 1810-1846
BOUQUIER, Gabriel
 French, 1739-1810

BOUR, Charles
 French, op.1844-1880
BOURASSA, Napoleon
 Canadian, 1827-1916
BOURBON, Alexandrine de
 French, 18th cent.
BOURBON, Isabelle Marie
 Louise (Louise
 Elisabeth of France,
 Duchess of Parma)
 French, 1727-1759
BOURCART, Emile
 Swiss, 1827-1900
BOURCE, Henry
 Belgian, 1826-1899
BOURDE, Danielle
 French, 20th cent.
BOURDELLE, Antoine Emile
 French, 1861-1929
BOURDET, Joseph Guillaume
 French, 1799-1869
BOURDICHON, Jean
 French, c.1457-1521
BOURDIER, fils
 French, op.1789
BOURDILLON, Frank W.
 British, op.1881-1892
BOURDON, Louise
 (Weyler)
 French, 18th cent.
BOURDON, Pierre
 French, op.c.1703-1707
BOURDON, Pierre Michel
 French, 1778-1841
BOURDON, Sebastien
 French, 1616-1671
BOURDONNAYE, La
 French, 20th cent.
BOUREL, Everhard
 German, 1803-1871
BOURG, Louis
 Fabritius du
 see Dubourg
BOURGAIN, Gustave
 French, op.c.1880-m.1921
BOURGE, Hélène Charlotte
 Juliette (née
 Destailleur)
 French, 1812-
BOURGEOIS, Amédée
 French, 1798-1837
BOURGEOIS, Charles
 Guillaume Alexandre
 French, 1759-1832
BOURGEOIS, Eugène
 French, 1855-1909
BOURGEOIS, Florent
 Fidèle Constant
 French, 1767-1841
BOURGEOIS, Max
 Swiss, 20th cent.
BOURGEOIS, Sir Peter
 Francis
 British, 1756-1811
BOURGEOIS, Victor
 French, 1874-1957
BOURGES, Pauline-Elise-
 Léonide
 French, 1838-1910
BOURGET, Camille
 French, 19th cent.
BOURGOIN, Aimé Gabriel
 Adolphe
 French, 1824-
BOURGOIN, François Jules
 French, op.1796-1812
BOURGONJON, Pierre
 see Bourguignon

BOURGUIGNON, Hubert
François
see Gravelot
BOURGUIGNON or Bourgonjon,
Pierre
French, op.1671-m.1698
BOURGUIGNON, Le
see Courtois
BOURGUIGNON
see also Perrier,
Francois
BOURJE, Johan Pieter
Dutch, 1774-1834
BOURJOT, Ferdinand
French, 1768-p.1838
BOURLARD, Antoine Jos.
French, 1826-1899
BOURNE, Edmunda
British, 18th cent.
BOURNE, Elizabeth
British, op.1870(?)
BOURNE, Herbert
British, c.1820-p.1885
BOURNE, James
British, 1773-1854
BOURNE, John C.
British, op.1836-1846
BOURNE, Joseph
French, 1740-1808
BOURNE, Olive Grace
British, 1897-
BOURNICHON, François
Edouard
French, 1816-1896
BOURRIT, Marc Théodore
Swiss, 1735-1815
BOURON, T.
French, op.1898
BOUROTTE, Auguste
French, 1853-
BOURSSE, Esaias or
Esias
Dutch, 1631-1672
BOUSSARD, Jacques
French, 1915-
BOUSSINGAULT, Jean Louis
French, 1883-1944
BOUT, Peeter
Flemish, 1658-1719
BOUTATS, Jacob
see Bouttats
BOUTEILLIER, Sophie de
see Browne, Henrietta
BOUTELLE, Dewitt Clinton
American, 1817-1884
BOUTELON, Madame
French, op.c.1790
BOUTELOT, F.
French, 18th cent.
BOUTELOU, Guillaume
French, c.1530-c.1573
BOUTER, Cornelis
Wouter (Cor)
Dutch, 1888-1966
BOUTET, Henri
French, 1851-1900
BOUTET de Monvel,
Bernard
French, 1884-
BOUTET de Monvel,
Maurice
French, 1851-1913
BOUTEVILLE
French, op.1805
BOUTEUX, le
see Lebouteux
BOUTIBONNE, Charles
Edouard
French, 1816-1897

BOUTIGNY, Paul Emile
French, 1854-1929
BOUTON, Charles Marie
French, 1781-1853
BOUTON, Joseph
French, op.1790-1803
BOUTON, Guillaume
Gabriel
French, op.1756-m.1782
BOUTS, Aelbrecht
(Identified with Master
of the Assumption of
the Virgin)
Netherlands,
op.1473-m.1549
BOUTS, Dieric, Dierick,
Dirk, Thierry or
Theodoricus, I (Also
identified with Master
of the Rotterdam St.
John on Patmos, Master
of the Munich Betrayal
and Master of the Pearl
of Brabant)
Netherlands, op.1448-m.1475
BOUTS, Dieric, II
see Master of the Pearl
of Brabant
BOUTTATS, Frederik, I
Flemish, op.1612-m.1661
BOUTTATS, Frederik, II
Flemish, op.1643-m.1676
BOUTTATS, Gaspar
Flemish, 1625-1695
BOUTTATS or Boutats,
Jacob
Flemish, op.1700
BOUTTATS, Johann Baptiste
Flemish, op.1706-1735
BOUTTATS, Filibert or
Philibertus, II
Dutch, c.1675-p.1700
BOUTTATS, Pieter
Balthazar
Flemish, 1666-1755
BOUTWOOD, Charles E.
British, op.1881-1887
BOUVARD, Hugo Ritter von
German, 1879-1959
BOUVARD, Joseph Antoine
French, 1840-1920
BOUVERET, P.A.J.D.
French, 19th cent.
BOUVET, Henri Marius
Camille
French, 1859-
BOUVIER, Amand
French, 20th cent.
BOUVIER, Augustus Jules
British, c.1825-1881
BOUVIER, Joseph
French, op.1839-1888
BOUVIER the Elder, Jules
British, 1800-1867
BOUVIER, Laurent
French, 1840-1901
BOUVIER, Pierre Louis
Swiss, 1766-1836
BOUVIER de Cachard
French, 20th cent.
BOUVIGNES, Henri de
Netherlands, 16th cent.
BOUVOISIN, Catherine
Helie
French, 1788-
BOUVY, Firmin
French, 1822-1891
BOUYS, Bouis or Boys,
André
French, 1656-1749

BOUYS, Claude
French, op.c.1695
BOUYSSOU
French, 20th cent.
BOUZIER, van
Dutch(?), 18th cent.(?)
BOUZONNET, Antoine
(Bouzonnet-Stella or
Stella)
French, 1637-1682
BOUZONNET, Claudine
(Stella)
French, 1636-1697
BOVI or Bova, Marino
Italian, 1758-p.1805
BOWDEN, Jonathan
British, 20th cent.
BOWDEN, Leonard
British, 20th cent.
BOWEN, Denis
British, 1921-
BOWEN, John
British, 20th cent.
BOWER, Edward
British, op.1647
BOWER, Gary
American, 1940-
BOWER, John
American, op.1810-1819
BOWERIE(?)
German, op.1625
BOWERS, Edward
American, op.1855-1861
BOWERS, George Newell
American, op.c.1889
BOWERS, Georgina
British, 1836-1912
BOWES, J.
British, 20th cent.
BOWEY, Olwyn
British, 20th cent.
BOWKER, Daniel
American, op.1830
BOWKETT, Jane Maria
(Jane Maria Stuart)
British, op.1860-1885
BOWLER, Henry Alexander
British, 1824-1903
BOWLER, Thomas William
British, -1869
BOWLES, Carington
British, op.1744-1793
BOWLES, James
British, op.1852-1857
BOWLES, John
British, op.1723-1724
BOWLES, Oldfield
British, 1739-1810
BOWLES, Thomas
British, c.1712-p.1753
BOWLING, Frank
British, 20th cent.
BOWNESS, William
British, 1809-1867
BOWRING, E.J.
British, op.1787-1817
BOWYER, Robert
British, 1758-1834
BOWYER, Samuel
British, op.1890
BOX, E.
British, 20th cent.
BOXALL, Sir William
British, 1800-1879
BOXER, P. Noel
British, op.1912
BOY, Adolf
German, 1612-1680

BOY, Gottfried
German, 1701-p.1747
BOY, Boyen or Boyens,
Guillaume (Willem Boy)
Swedish, 1520-1592
BOY the Younger,
Peter
German, 1681-1742
BOYCE, George Price
British, 1826-1897
BOYCE, Joanna Mary
see Wells
BOYD, Alice
British, 19th cent.
BOYD, Arthur
Australian, 1920-
BOYD, A.S.
British, op.1896-1907
BOYD, David
Australian, 1924-
BOYD, Fionnuala
British, 1944-
BOYD-HARTE, Glynn
British, 20th cent.
BOYDELL, John
British, 1719-1804
BOYDELL, John
British, 1839-1913
BOYDELL, Josiah
British, 1752-1817
BOYEN or Boyens,
Guillaume
see Boy
BOYER, Andrea Joséphine
see Marlef
BOYER, Auguste
French, 1823-
BOYER, Jacques de
French, op.1696
BOYER, Michel
French, 1667-1724
BOYER-BRETON, Marthe
Marie Louise
French, -1926
BOYER-d'AGUILLES, Jean-
Baptiste
French, c.1650-1709
BOYLE, Caleb
American, op.1801
BOYLE, Charlotte
(Baroness de Ros)
British, 1769-1831
BOYLE, Eleanor Vere
British, 19th cent.
BOYLE, Ferdinand Thomas
Lee
American, 1820-1906
BOYLE, James
American, 19th cent.
BOYNE, John
British, c.1750-1810
BOYS, André
see Bouys
BOYS, Cornelius
see Bois
BOYS, Mathieu de or du
see Dubus
BOYS, Paul du, or Paul
Dubois
Flemish, op.c.1610
BOYS, Thomas Shotter
British, 1803-1874
BOYVIN, René
French, 1525-1580/98
BOYZOT, Antoine
see Boizot
BOZE, Joseph
French, c.1744-1826

BOZE, Marie-Claudine-
Ursule (Victoire Boze)
French, 18th cent.
BOZNANSKA, Olga
Polish, 1865-1942
BOZZATO
see Ponchino
BOZZETTI, Francesco
Italian, 1876-1949
BOZZINI, Paolo
Italian, 1815-1892
BOZZOLINI, Silvano
Italian, 1911-
BRABAZON, Hercules
British, 1821-1906
BRABY, Newton
British, 19th cent.
BRACCESCO, Carlo
(Carlo di Giovanni)
(called Carlo da
Milano or Carlo del
Mantegna)
Italian, op.1481-1514
BRACCI, Pietro
Italian, 17th cent.
BRACCIOLI or Bracciuoli,
Mauro
Italian, 1761-1810
BRACELLI, Giovanni
Battista
Italian, 1584-1609
BRACHFELD, J.C.
German, 18th cent.
BRACHO, Angel
Mexican, 1911-
BRACHT, Eugen Felix
Prosper
German, 1842-1921
BRACK, Cecil John
Australian, 1920-
BRACK, Max Eugen
Swiss, 1878-
BRACKENBURY, Georgina A.
British, 20th cent.
BRACKETT, Walter M.
American, 1823-1919
BRACKMAN, Robert
American, 1896-
BRACQUEMOND, Félix
(Joseph Auguste)
French, 1833-1914
BRACQUEMONT, Marie
French, op.1874-m.1916
BRADDON, Paul
British, 19th cent.
BRADE, Helmut
German, 20th cent.
BRADFORD, Alexander
American, 1791-1850
BRADFORD, Miss
British, op.1828
BRADFORD, William
American, 1830-1892
BRADLEY, Basil
British, 1842-1904
BRADLEY, I.J.H.
American, op.c.1830-1855
BRADLEY, John
British, 1786-1843
BRADLEY, John Henry
British, 1832-p.1884
BRADLEY, Martin
British, 20th cent.
BRADLEY, Mary
British, op.1809-1811
BRADLEY, W.
Australian, 19th cent.

BRADLEY, W.
British, 19th cent.
BRADLEY, William
British, 1801-1857
BRADLEY, Will H.
American, op.1894-1895
BRADSHAW, Brian
British(?) 20th cent.
BRADSHAW, J.C.
British, 19th cent.
BRADSHAW, T.
British, 1767-
BRADSHAW, Violet
British, 20th cent.
BRADSHAW, William
American, 1928-
BRADY, Mathew B.
American, 19th cent.
BRAEKELEER, Adrien de
Belgian, 1818-1904
BRAEKELEER, Ferdinand, I
de
Belgian, 1792-1883
BRAEKELEER, Henri de
Belgian, 1840-1888
BRAGADIN, Donato di
Giovanni (Donato
Veneziano)
Italian, op.1438-m.1473
BRAGAGLIA, Guidi
Italian, 20th cent.
BRAGER, Durand
British(?) 19th cent.
BRAGG, E.
British, 1785-1875
BRAIG, Paul
French, 1906-
BRAINARD, Joe
American, 20th cent.
BRAINE, T.
British, op.1791-1802
BRAITH, Anton
German, 1836-1905
BRAKENBURG or Brakenburgh,
Richard
Dutch, 1650-1702/3
BRÄM, Heinrich
Swiss, 1792-p.1827
BRAMANTE da Urbino,
Donato (Lazzari)
Italian, c.1444-1514
BRAMANTINO, Bartolommeo
Suardi
Italian, op.c.1490-m.1536
BRAMANTINO, Pseudo
Italian, op.c.1500
BRAMATI, Antonio
Italian, op.1829-1831
BRAMATI, G.
Italian, op.1818
BRAMBILLA, Ambrosius
Italian, op.c.1582-1599
BRAMBILLA, Eduino
Italian, 19th cent.
BRAMBILLA, Ferdinando
Italian, 1838-1921
BRAMELLUS, Paulus
Netherlands, op.1603
BRAMER, Leonard
Dutch, 1596-1674
BRAMIZZO
Italian, 17th cent.
BRAMLEY, Frank
British, 1857-1915
BRAMPTON, Richard
see Brompton
BRAMTOT, Alfred Henri
French, 1852-1894

BRANCACCIO, Carlo
Italian, 1861-p.1907
BRANCACCIO, Giovanni
Italian, 1903-
BRANCH, Winston
American, 19th cent.
BRANCHARD, Emile
American, 1881-1938
BRANCILA, Octav
Rumanian, 20th cent.
BRANCUSI, Constantin
Rumanian, 1876-1957
BRAND, Friedrich August
German, 1735-1806
BRAND or Brandt, Christian
Hülfgott or Hilfgott
German, 1695-1756
BRAND, H.
Dutch(?), op.1756
BRAND, Johann Christian
German, 1722-1795
BRAND, L.
German, op.1775
BRAND, William
British, op.1789-1802
BRAND
see also Brandt
BRANDARD, John
British, 1812-1863
BRANDARD, Robert
British, 1805-1862
BRANDE or Brandt,
Johannes van den
Dutch, op.1683-1693
BRANDEGEE, Robert B.
American, 1851-1922
BRANDEIS, Antonietta
Czech, 1849-
BRANDEIS, Johann
German, 1818-1872
BRANDEL, Peter
see Brandl
BRANDENBURG, Johann
Swiss, 1661-1729
BRANDENBURG, Martin
German, 1870-
BRANDER, Fredrik
Swedish, c.1705-1779
BRANDES, Hans Heinrich
Jürgen
German, 1803-1868
BRANDES, Willy
German, 1876-
BRANDI, Aniello
Italian, 17/18th cent.
BRANDI, Domenico
Italian, 1683-1736
BRANDI, Francesco Paolo
Italian, 17th cent.
BRANDI, Giacinto
Italian, 1623-1691
BRANDIS, August von
German, 1862-1947
BRANDIS, F.
Dutch(?) 17th cent.
BRANDL or Brandel,
Petr, or Peter
Czech, 1660/8-1739
BRANDMÜLLER, Gregor
Swiss, 1661-1691
BRANDOIN, Michel Vincent
(also erroneously
Charles) (L'Anglais)
Swiss, 1733-1807
BRANDON, Jacques Emile
Edouard
French, 1831-1897

BRANDON, Jean Henri
French, op.1688-m.1714
BRANDT, Fritz
German, 1853-1905
BRANDT or Brand, Heinrich
Carl
German, 1724-1787
BRANDT, Johann Heinrich
German, 1740-1783
BRANDT, Johannes van den
see Brande
BRANDT, Josef von
Polish, 1841-1914
BRANDT, Otto
German, 1828-1892
BRANDT, Peter
see Brandl
BRANDT, Robert
Wiljamowitsch
Russian, 1823-1887
BRANDT, Warren
American, 20th cent.
BRANDTNER, Fritz
German, 1896-
BRANGWYN, Frank
British, 1867-1956
BRANNON, George
British, 18th cent.
BRANNON, P.
British, op.1842
BRANSOM, Paul
American, 1885-
BRANSON, Paul
British, 20th cent.
BRANTZKY, Franz
German, 1871-
BRANWHITE, Charles
British, 1817-1880
BRANWHITE, Nathan Cooper
British, 1775-1857
BRAQUAVAL, Louis
French, 1853(?)-1919
BRAQUE, Georges
French, 1881-1963
BRAQUEHAYE, Charles
French, 17th cent.(?)
BRAQUEMOND, Pierre
French, 19th cent.
BRARD
French, op.1781
BRASCASSAT, Jacques
Raymond
French, 1804-1867
BRASCH, Herman
German, 1861-
BRASCH or Prasch,
Magnus
German, 1731-1787
BRASCH, Wenzel Ignaz
see Prasch
BRASCHLER, Otto
Swiss, 1909-
BRASS, Italico
Italian, 1870-
BRASSAUW or Brisjouw,
Melchior
Flemish, 1709-c.1757
BRASSEMARY, William
see Strijker
BRASSER, Leendert
Dutch, 1727-1793
BRATBY, Jean
British, 20th cent.
BRATBY, John
British, 1928-
BRATTINGA, Pieter Dirk
Dutch, 1931-
BRAUDEY, Paul
French, 1930-

BRAUE, Nicolaus
(Claes)
see Breen
BRAUER, Albrecht
German, 1830-1897
BRAUER, Erich
Austrian, 1929-
BRAUN, Adam
German, 1748-1827
BRAUN or Brun,
Augustin
German, op.1591-1639
BRAUN, Johann Wilhelm
German, 1796-1863
BRAUN, Louis (Ludwig)
German, 1836-1916
BRAUN, Nikolaus
German, 20th cent.
BRAUN, Reinhart
German, 20th cent.
BRAUND, Allin
British, 1915-
BRAUNER, Victor
Rumanian, 1903-1966
BRAUNS, P.
German, 19th cent.
BRAUSEWETTER, Otto
German, 1835-1904
BRAUT, Albert
French, 1874-1912
BRAUWER, Adriaen
see Brouwer
BRAVO, Cecco Il
see Montelatici,
Francesco
BRAVO, Claudio
Chilean, 1936-
BRAY, Caroline
British, 1814-1905
BRAY, Dirck Salomonsz.
de
Dutch, op.1651-1678
BRAY, Jacob Salomonsz.
de
Dutch, -1664
BRAY or Braij, Jan
Salomonsz. de
Dutch, c.1626/7(?)-1697
BRAY, Joseph Salomonsz.
de
Dutch, -1664
BRAY, Salomon de
Dutch, 1597-1664
BRAYER, Yves
French, 1907-
BRAZANO
see Ponchino
BRAZICOW, Aleksander
Bulgarian, 20th cent.
BRAZZI, Lorenzo di
Cristoforo
see Rustici, Lorenzo
BREA or Bré, de
Italian(?) 18th cent.
BREA, Antonio
Italian, op.1516-1518
BREA, Francesco
(Giovanni Francesco)
Italian, op.1538-1547
BREA, Lodovico
Italian, c.1443-c.1520
BREAKSPEARE, William A.
British, 1855/6-1914
BREALIER
French, op.1793
BREANSKI, Alfred de
British, op.1869-1893

BREANSKI, Gustave de
British, op.1877-1893
BREARD, Henri-Georges
French, 1873-
BREBIETTE, Pierre
French, 1598-c.1650
BRECCIOLI or Braccioli,
Bartolommeo
Italian, op.1627-m.1637
BRECHEISEN, Joseph
German, op.1748-1766
BRECHTEL or Prechtel,
Bartholomaeus
German, op.1558-1600
BRECK, Josephine
American, 19th cent.
BRECKERVELD, Herman
Dutch, op.1623-1634
BREDA, Carl Fredrik von
Swedish, 1759-1818
BREDA, Lucas von
Swedish, 1676-1752
BREDAEL, Alexander van
Flemish, 1663-1720
BREDAEL, Jan Frans or
Jean Francois, I van
Flemish, 1686-1750
BREDAEL, Jan Pieter
or Jean Pierre, I van
Flemish, 1654-1745
BREDAEL, Jan Pieter or
Jean Pierre, II van
Flemish, 1683-1735
BREDAEL, Joseph van
Flemish, 1688-1739
BREDAEL, Peeter or
Pierre van
Flemish, 1629-1719
BREDSDORFF, Niels
Danish, 1938-
BREE, A. de
Dutch, op.1876
BREE, J. van
Dutch, op.1675
BREE, Jos van
Flemish(?), 18th/19th cent.
BREE, Mattheus Ignatius
van
Belgian, 1773-1839
BREE, Philippe Jacques
van
Belgian, 1786-1871
BREE, William
British, 1753-1822
BREECKER, Jan
Flemish, op.1632-1646
BREEKVELT, Adriana,
(née Spilberg)
see Spilberg
BREEN, Adam van
Dutch, op.1611-1636
BREEN, Nicolaes (Claes)
or Gillis van
(Nicolaes or Claes
Braeu)
Netherlands, op.1597-1602
BREENBERGH, Breenberch,
Breenberg or Breenborch,
Bartholomeus
Dutch, 1599/1600(?)-1657
BREEZE, Claude
Canadian, 20th cent.
BREGNO, Andrea
see Briosco
BREHAN, Marquise de
French, op.1793
BREIDWISER or Breitwieser,
Theodor
German, 1847-

BREININ, Raymond
American, 1908-
BREISACH, Hans von
German, 15th cent.
BREITBACH, Karl
German, 1833-1904
BREITENSTEIN, Carl
August
Dutch, 1864-1921
BREITNER, George
Hendrik
Dutch, 1857-1923
BREKELENKAM, Gerritsz.
Quiringh van
Dutch, op.1648-m.1667/8
BREKENKAMP
German, op.1782
BREKER, Walter
German, 20th cent.
BRELING, Heinrich
German, 1849-
BRELY, Auguste de La
French, 1838-1906
BREMER, Uwe
German, 20th cent.
BREMMER, Hendricus
Petrus
Dutch, 1872-1956
BREMOND, Jean François
French, 1807-1868
BRENBEECK, F.
Dutch, 17th cent.
BRENCKMANN
German, 19th cent.
BRENDEKILDE, Hans
Andersen
Danish, 1857-1942
BRENDEL, Albert Heinrich
German, 1827-1895
BRENDSTRUP, Thorald
Danish, 1812-1883
BRENET, Nicolas Guy
French, 1728-1792
BRENNA, Vincenzo
Italian, 1745-1820
BRENNAN, M.A.
British, 19th cent.
BRENNAN, Michael George
British, 1840-1871
BRENNER, Anton Joseph von
see Prenner
BRENNER, Carl C.
American, op.c.1880
BRENNER, Elias
Finnish, 1647-1717
BRENNINKMEYER, B.
German, 15th cent.
BRENOT
French, 20th cent.
BRENTANA, Simone
Italian, 1656-1742
BRENTEL, Friedrich
(Brentel le Père)
German, c.1580-1651
BRENTEL, Hans Friedrich
(Brentel le Jeune)
German, 1602-
BRENTON, Sir Jahleel
British, 1770-1844
BRERETON, Helen A.
American, op.1902
BREREWOOD, F.
American, op.c.1730
BRESCIA, Bernardino da
see Bernardino da Asola
BRESCIANINO, Andrea
(Piccinelli)
Italian, c.1485(?)-p.1525

BRESCIANINO delle
Battaglie
see Monti, Francisco
BRESCIANO, Alessandro
see Romanino
BRESCIANO, Miguel
Italian, 20th cent.
BRESCIANO, Prospero
(Scavezzi?)
Italian, 1500(?)-1590
BRESCIANO, Il
see Pirovani
BRESDIN, Rodolphe
(Chien Caillou)
French, 1825-1885
BRESLAU, Marie Louise
Catherine
French, 1856-1928
BRESSANO
see Muziano, Girolamo
BRESSE, C.
French, 18th cent.
BRESSLERN-ROTH, Norbertine
von
German, 1891-
BRESSTER, Henriette
French, 19th cent.
BREST, Germain Fabius
French, 1823-1900
BRETEGNIER, Georges
French, 1863-1892
BRETHERTON, Charles
British, c.1760-1783
BRETHERTON, James
British, op.1770-1781
BRETLAND, Thomas W.
British, 1802-1874
BRETON, André
French, 1896-1966
BRETON, C. le
French, 20th cent.
BRETON, Emile Adelard
French, 1831-1902
BRETON, Jules (Adolph Aimé
Louis)
French, 1827-1906
BRETON, L. de
French, 18th cent.
BRETSCHNEIDER, Andreas III
German, c.1578-1640
BRETSCHNEIDER the Younger,
Daniel
German, op.1623-m.1658
BRETSCHNEIDER, Johann
Michael
German, op.1678-1723
BRETT, Hon. Dorothy
British, 1883-1977
BRETT, J.
British, op.1762
BRETT, John
British, 1830-1902
BRETT, Rosa
British, op.1858-1881
BRETZ, Pierre le
French, 20th cent.
BREU, Preu or Prew,
Jörg, I
German, c.1480-1537
BREU, Jörg, II
German, c.1510-1547
BREU, M.
German, 19th cent.
BREUGEL or Breughel
see Brueghel
BREUILLAUD, André
François
French, 20th cent.

BREUKLERWAERT, Joan
Raye van
Dutch, op.1764-1769
BREUR, Florian
French, 1916-
BREVAL, H. de
French, 19th cent.
BREVEGLIERI, Cesare
Italian, 1902-1948
BREVOORT, James Renwick
American, 1832-
BREWER, Henry William
British, op.1858-1893
BREWER, J.
British, op.1763-1779
BREWER the Younger,
John
British, op.c.1790-1792
BREWER, Julian C.
British, op.1855-1885
BREWER, Mary, (née
Jenkins)
British, op.1832-1874
BREWER, Robert
British, op.1796
BREWERTON, George Douglas
American, 1820-1901
BREWSTER, Anna
Richards
American, 1870-
BREWSTER, John
American, 1766-1854
BREWTNALL, Edward
Frederick
British, 1846-1902
BREYDEL, Karel
(Le Chevalier)
Flemish, 1678-1733
BREYDEL, Frans
Flemish, 1679-1750
BREYSIG, Johann Adam
German, 1766-1831
BRIA, Paul
French, c.1625-1673
BRIANCHON, Maurice
French, 1899-
BRIANT or Brian, Jean
French, 1760-1799
BRIANTE, Ezelino
Italian, 1901-1970
BRIARD or Briart,
Gabriel
French, 1729-1777
BRIAS, Charles
Belgian, 1798-1884
BRIAUDEAU, Paul Charles
Jean
French, 1869-
BRICARD, François Xavier
French, 20th cent.
BRICCIO, Francesco
see Brizzi
BRICEAU
French, op.c.1709
BRICEAU, Angelique
see Allais
BRICH, Henry
British, 1814-1873
BRICHE
French, op.c.1790
BRICHER, Alfred Thompson
American, 1837-1908
BRICK, Michael
British, 1946-
BRICKDALE, Eleanor
Fortescue
British, 1871-1945

BRICOUX, Jules Charles
French, op.1878-
BRIDELL, Frederick Lee
British, 1831-1863
BRIDELL-FOX, Eliza
Florence
British, 1848-1883
BRIDGE, Joseph
British, 1845-1894
BRIDGEFORD, Thomas
British, 1812-1878
BRIDGEMAN, Charles
British, op.1713-m.1738
BRIDGES, Charles
British, op.1736-1750
BRIDGES, Fidelia
American, 1835-1923
BRIDGES, James
British, op.1819-1853
BRIDGES, John
British, op.1818-1854
BRIDGFORD, Thomas
British, 1812-1878
BRIDGMAN, Frederick
Arthur
American, 1847-1927
BRIDGMAN, George B.
British, 19th cent.
BRIDPORT, Hugh
British, 1794-p.1837
BRIDT, Bernaert de
Flemish, op.1688-1722
BRIE, Gabriël François
Louis de
see Debrie
BRIEL, Jean Rougeot de
French, op.1833-1852
BRIER, C.D.
German, op.1668
BRIERLY, Oswald Walter
British, 1817-1894
BRIESEN, August von
German, 20th cent.
BRIET, Arthur Henri
Christiaan
Dutch, 1867-1939
BRIGANTI, N.
American, op.1898
BRIGGS, E. Irlam
British, 19th cent.
BRIGGS, Ernest Edward
British, 1866-1914
BRIGGS, Henry Perronet
British, 1791/3-1844
BRIGHT
British, op.1904
BRIGHT, Beatrice
British, 1861-1940
BRIGHT, Harry
British, op.1883
BRIGHT, Henry
British, 1814-1873
BRIGHT-MORRIS
British, 19th cent.
BRIGHTON, Andrew
British, 20th cent.
BRIGHTWELL, Cecilia Lucy
British, -1876
BRIGHTY, G.M.
British, op.1809-1827
BRIGLIA, Giovanni Francesco
Italian, 1737-1794
BRIGNONI, Sergio
Italian, 1903-
BRIIGSTOCKE, Thomas
British, 1809-1881

BRIL, Brill, Brilli
etc., Mattheus or
Matthys, II
Netherlands, c.1550-1583
BRIL, Brill, Brilli
etc., Paul
Flemish, 1554-1626
BRILL, E.
French, op.1930
BRILL, Frederick
British, 20th cent.
BRILLOUIN, Louis Georges
French, 1817-1893
BRIN, Emile Quentin
French, 1863-
BRINAU
see Dumeray, Madame
BRINCKMANN, Philipp
Hieronymus
German, 1709-1761
BRINDIT, Reginald
British, 20th cent.
BRINDLEY, Charles A.
British, op.1888-1898
BRINI or Brina,
Francesco
Italian, c.1540-p.1577
BRINI, Giovanni
Italian, op.1571-m.1599
BRINISHOLTZ, Sophie
see Lemire
BRION
French, 18th cent.
BRION, Gustave
French, 1824-1877
BRION, Jean Louis
French, 1805-1864
BRIOSCHI, Carlo
Italian, 1826-1895
BRIOSCHI, Othmar
German, 1854-1905
BRIOSCHI, Vincenzo di
Giovanni or Ivanovitch
Italian, 1786-1843
BRIOSCO or Bregno, Andrea
(Riccio)
Italian, 1470-1532
BRIOT, Isaac II
French, 1585-1670
BRISCOE, Arthur
British, 1873-1943
BRISE, Cornelis
see Brizé
BRISJOUW, Melchior
see Brassauw
BRISIGHELLA, Carlo
see Eismann
BRISPOT, Henri
French, 1848-1928
BRISSART, P. (Pierre?)
French, 17th cent.
BRISSAUD, Pierre
French, 1885-
BRISSET, Pierre Nicolas
French, 1810-1890
BRISSOT, Frank
British, op.1879
BRISSOT de WARVILLE, Félix
Saturnin
French, 1818-1892
BRISTOL, John Bunyan
American, 1826-1909
BRISTOW, Edmund
British, 1787-1876
BRISTOWE, Mrs. S.
British, 19th cent.
BRISVILLE, Hugues
French, op.c.1663

BRITISH SCHOOL,
Anonymous Painters
of the
BRITTAND, F.
British, 19th cent.
BRITTAIN, Miller Gore
Canadian, 1912-
BRITTEN, William Edward
Frank
British, op.1873-1888
BRITTON, John
British, 1771-1857
BRITTON, William
American, op.1825-1830
BRIULLOV, Karl Pavlovich
Russian, 1799-1852
BRIZE or Brisé, Cornelis
Dutch, 1622/35-c.1665/70
BRIZIANO or Brižio
see Bertani
BRIZZI, Brizio or Briccio,
Francesco
Italian, 1575-1623
BRIZZI, Serafino
Italian, 1684-1737
BROADBENT, Samuel
American, 1759-1828
BROC, Jean
French, c.1780-c.1850
BROCA, Alex de
French, 1868-
BROCARD (Broccardo?)
French, op.1674
BROCAS, Charles
French, 1774-1835
BROCAS, Henry
British, 1766-1838
BROCAS, James Henry
British, c.1790-1846
BROCAS, Samuel
Frederick
British, op.1804-m.1847
BROCAS, William
British, c.1794-1868
BROCHART, Constant
Joseph
French, 1816-1899
BROCHE, Ignace and
Joseph
French, op.1763-1809
BROCK, Alan Clutton
British, 20th cent.
BROCK, Charles Edmond
British, 1870-1938
BROCK, Helen
British, op.1926
BROCK, Henry Matthew
British, 1875-1960
BROCKEDON, William
British, 1787-1854
BRÖCKER, Ernst
German, 1893-1963
BROCKHURST, Gerald Leslie
British, 1890-
BROCKTORFF, C.F. de
German (?) op.1823
BROCKWAY, Michael
British, 20th cent.
BROCKY, Charles
British, 19th cent.
BROCKY, Karoly (Carl)
Hungarian, 1807-1855
BROCQUY, Louis le
see Le Brocquy
BRODERSON, Maurice
American, 1928
BRODIE, James
British, op.1736

BRODOWSKI, Alexander
Polish, 19th cent.
BRODOWSKI, Anton
Polish, 1784-1832
BRODSZKY, Thaddeus
Polish, 1821-1848
BRODSKI, J.G.
Polish, 20th cent.
BRODSZKY, Horace
Australian, 1885-1969
BRODSZKY, Sandor
(Alexander)
Hungarian, 1819-1901
BROECK, Crispin or
Crispyn van den
(Paludanus)
Netherlands, 1524-c.1591
BROECK or Broek, Elias
van den
Dutch, 1657-1708
BROECK, Hendrick van
den (Arrigo Fiammingo,
Arrigo dei Paesi Bassi?,
Nicolas Hendrick,
Henricus Malinus,
Henricus van Mecheln,
Hennequin de Meecle,
or Arrigo Paludano)
Netherlands, op.1561-1590
BROEDERLAM, Melchior
Netherlands,
op.c.1381-1409
BROEK, Elias van den
see Broeck
BROEK, Jan van
see Jorisz.
BROEK, Jan Karel van den
Dutch, 1937-
BROERS, Jasper or Casper
Flemish, 1682-1716
BROERS, Sara, (née
Saftleven)
see Saftleven
BROILUS, F.
see Daniele da Volterra
BRÖKER, Wilhelm
German, 1848-
BROME, Richard
British, 18th cent.
BROMELS, August
German, 1813-1881
BROMLEY, Valentine Walter
British, 1848-1877
BROMLEY, William A.E.
British, 1769-1842
BROMLEY, William,
British, op.1843-1870
BROMPTON, Richard
British, 1734-1783
BRONCKHORST, Arnold (van)
see Bronckorst
BRONCKHORST or Bronchorst,
Gerard or Gerrit van
Dutch, c.1637-1673
BRONCKHORST or Bronchorst,
Jan Gerritsz. van
Dutch, c.1603-c.1661
BRONCKHORST, Pieter
Anthonisz. van
Dutch, 1588-1661
BRONCKORST, Bronckhorst,
Brounckhorst,
Brounckhurst etc.,
Arnold (van)
Netherlands,
op.1565/6-1583

BRONDGEEST, Albertus
Dutch, 1786-1849
BRÖNDUM, Anna Kirstine
see Ancher
BRONIN, Zakharns
Russian, 18th cent.
BRONKHORST, Johannes
Dutch, 1648-1727
BRONNIKOFF, Feodor
Andrejewitsch
Russian, 1827-1902
BRONTË, Charlotte
British, 1816-1855
BRONTË, Emily Jane
British, 1818-1848
BRONTË, Patrick Branwell
British, 1817-1848
BRONZINO, Angelo di
Cosimo di Mariano
Italian, 1503-1572
BROODTHAERS, Marcel
Belgian, 1924-1976
BROOK, Alexander
American, 1898-
BROOK, Henry Jermyn
British, op.1884-1900
BROOK, J.W.
British, 20th cent.
BROOK, Joseph
British, 18th cent.
BROOKE, A. Newton
British, 19th cent.
BROOKE, Henry
British, 1738-1806
BROOKE, Richard Norris
American, 1847-1920
BROOKE, William Henry
British, 1772-1860
BROOKER, Harry
British, op.1876-1901
BROOKER, Peter Alfred
British, 1900-1965
BROOKER, William
British, 1918-
BROOKES, Richard
British, 1721-1763
BROOKES, Samuel Marsdon
American, 1816-1892
BROOKES, Warwick
(Brookes of Manchester)
British, 1808-1882
BROOKING, Charles
British, 1723-1759
BROOKS, Frank
British, 1854-1937
BROOKS, G.W.
British, op.1784
BROOKS, H.
British, op.1816-1836
BROOKS, Henry Jamyn
(Jermyn)
British, 1865-1925
BROOKS, James
American, 1906-
BROOKS, Nicolas Alden
American, 19th cent.
BROOKS, Romaine
American, 20th cent.
BROOKS, Thomas
British, 1818-1891
BROOKS, Vincent
British, op.1851
BROOKS, William
British, op.1780-1801
BROOKSHAW, Richard
British, 1736-1800
BROOME
British, 18th cent.

BROOME, G.J.
British, op.1880
BROQUET, Espérance Léon
French, 1869-1936
BROSAMER, Hans
German, c.1500-c.1554
BROSSARD de Beaulieu,
Marie Renée Geneviève
French, 1760-p.1781
BROSSE, Salomon de
French, c.1562-1626
BROSTERHUISEN, Jan van
Dutch, c.1596-1650
BROSTOLONI, Giovanni
Battista
see Brustolon
BROSUSO, J.
Italian, op.1712
BROUARD
French, 18th cent.
BROUET, Auguste
French, 1872-1941
BROUGH, Robert
British, 1872-1905
BROUILLET, André
French, 1857-1914
BROUNCKHORST or Brounckhurst,
Arnold (van)
see Bronckorst
BROUNOVER
see Brownover
BROUTIN, Raymond
French, 20th cent.
BROUWER or Brauwer,
Adriaen
Flemish, 1605/6-1638
BROUWER, Cornelis
Dutch, op.c.1654-m.1681
BROUWER, Cornelis
Dutch, op.1781-m.1802
BROUWER, D.
Dutch, op.1640
BROUWER, Justus
Dutch, c.1646-p.1677
BROUWER, Petrus Marius
Dutch, 1819-1886
BROUWER, Xaver
Belgian, 1840-1911
BROWERE, Albertus
(Albertis del Orient)
American, 1814-1887
BROWN, Alexander Kellock
British, 1849-1922
BROWN, Arnesby
see Brown, Sir John Arnesby
BROWN, Carlyle
American, 1919-
BROWN, Charles Armitage
British, op.1819
BROWN, D.B.
American, 19th cent.
BROWN, David
British, op.1792-1797
BROWN, Dorothy Foster
American, 1901-
BROWN, E.
British, op.1760
BROWN, E.B.
British, op.1834
BROWN, E.C. Austen
British, 20th cent.
BROWN, F. Gregory
British, 20th cent.
BROWN, Ford Madox
British, 1821-1893
BROWN, Frederick
British, 1851-1941

BROWN, George Loring
American, 1814-1889
BROWN, H.
British, op.1828
BROWN, H. Harris
British, 19th cent.
BROWN, Helen Paxton
British, 20th cent.
BROWN, J.
British, 19th cent.
BROWN, James
American, op.1844-1859
BROWN, J.G.
British, op.1880-1885
BROWN, John
British, 1752-1787
BROWN, Sir John Arnesby
British, 1866-1955
BROWN, John George
British, 1831-1913
BROWN, John Henry
American, 1818-1891
BROWN, John Lewis
French, 1829-1890
BROWN, J.W.
British, 1842-1928
BROWN, Lucy Madox
British, 1843-1894
BROWN, Maria
British, op.c.1820
BROWN, Mather
American, 1761-1831
BROWN, Maynard
British, op.1883-1902
BROWN, M.E.D.
American, op.1832-1896
BROWN, M.Harris
British, 19th cent.
BROWN, Mia Arnesby
British, 20th cent.
BROWN, Nathaniel
British, op.1760-1779
BROWN, Neil Dallas
British, 20th cent.
BROWN, Oliver Madox
British, 1855-1874
BROWN, Peter
British, op.1766-1791
BROWN, Philip (of
Southampton)
British, op.c.1868
BROWN, Robert
British, op.1792-1834
BROWN, Roger
American, 20th cent.
BROWN, R.W.
British, 19th cent.
BROWN, S.
British, op.1808
BROWN, Thomas Austen
British, 1859-1924
BROWN, Thomas
British, 19th cent.
BROWN, W.
British, op.1820
BROWN, W.
British, op.c.1795-1809
BROWN the Younger,
William
American, 19th cent.
BROWN, William Beattie
British, c.1831-1909
BROWN, William G.
American, op.1808
BROWN, William Henry
American, 1808-1883

BROWN, William Linn
American, op.c.1820
BROWN, William Marshall
British, 1863-1936
BROWN, William Mason
American, 1828-1898
BROWN, William Theo
American, 1919-
BROWNE, A.
British, op.1826
BROWNE, Charles Francis
American, 1859-1920
BROWNE, C. Stephen
British, op.1685-1691
BROWNE, George Elmer
American, 1871-1946
BROWNE, George H.
British, op.1836-1885
BROWNE, Gordon Frederick
British, 1858-1932
BROWNE, H.K.
British, 17th cent.
BROWNE, Hablot Knight
(Phiz)
British, 1815-1882
BROWNE, Harry E.J.
British, op.c.1889-1893
BROWNE, Henrietta (Mme.
Jules de Saux, née
Bouteillier)
British, 1829-1901
BROWNE, J.
British, op.1767
BROWNE, Tom
British, 1872-1910
BROWNE, William C.
American, 19th cent.
BROWNELL, Franklin
American, 1857-1946
BROWNING, Amy Katherine
British, 1882-
BROWNING, Robert Barrett
British, 1846-1912
BROWNING, G.F.
British, op.1854-1873
BROWNLOW, Emma (King)
British, op.1852-1869
BROWNLOW, George Washington
British, op.1858-1875
BROWNOVER or Brounover,
T. (Sylvanus)
British, 18th cent.
BROWNRIGG, George
British, 20th cent.
BROZIK, Wenzel von
Czech, 1851-1901
BRU, Anye
Spanish, op.1502-1506
BRUANDET, Lazare
French, 1755-1804
BRUCE, Dr.
British, 18th cent.
BRUCE, Edward Caledon
American, op.1840-1877
BRUCE, James (Abyssinian
Bruce)
British, 1730-1794
BRUCE, John
British, op.1836
BRUCE, M.
British, op.1846
BRUCE, Patrick Henry
American, 1880-1933
BRUCE, William Blair
Canadian, 1857-1906
BRUCH, Hans
German, 1887-1913
BRUCHNALSKI, Janusz.
Polish, 20th cent.

BRUCK, Lajos (Ludwig)
Hungarian, 1846-1910
BRUCK, Miksa (Max)
German, 1863-1920
BRÜCKE, Wilhelm
German, 1829-p.1870
BRUCKER, Nikolaus
see Prucker
BRUCKMAN, Willem Leonardus
Dutch, 1866-1928
BRÜCKNER, G.
German, 19th cent.
BRUCKNER the Younger,
Isaak
Swiss, op.1712-m.1762
BRUCKNER, R.
German(?) 19th cent.
BRUDER, Harold
American, 1930-
BRUDER, Johann Friedrich
Franz
German, 1782-1838
BRUDERMANN, Franz
German, 1803-1858
BRUEGHEL, Breugel, Breughel
or Bruegel, Abraham
(Rijngraaf)
Flemish, 1631-c.1690
BRUEGHEL, Breugel, Breughel
or Bruegel, Ambrosius
Flemish, 1617-1675
BRUEGHEL, Breugel, Breughel
or Bruegel, Jan, I (Velvet
Brueghel)
Flemish, 1568-1625
BRUEGHEL, Breugel, Breughel
or Bruegel, Jan, II
Flemish, 1601-1678
BRUEGHEL, Breugel, Breughel
or Bruegel, Jan Peeter
Flemish, 1628-p.1662
BRUEGHEL, Breugel, Breughel
or Bruegel, Philips
Flemish, 1635-p.1662
BRUEGHEL, Breugel, Breughel
or Bruegel, Pieter, I
(Peasant Brueghel)
Netherlands,
op.1551-m.1569
BRUEGHEL, Breugel, Breughel
or Bruegel, Pieter, II
(Hell Brueghel)
Flemish, c.1564-1637/8
BRUEGHEL, Breugel,
Breughel or Bruegel,
Pieter, III
Flemish, 1589-p.1608
BRUEGHEL, U.
Flemish, op.1635
BRUEHLMANN, Hans
Swiss, 1878-1911
BRUGAIROLLES, Victor
French, 1867-
BRUGGE, Frans van
see Frans
BRUGGEMANN, Herman
German, 1647-1694
BRÜGGER, Arnold
Swiss, 1888-
BRUGGHEN, Guillaume
Anne van der
Dutch, 1811-1891
BRUGGHEN, Hendrick Jansz.
ter, or Hendrick
Terbrugghen
Dutch, 1688(?)-1629

BRUGGHEN, Pieter van
der
see Verbrugghen
BRUGH, Cornelis van
Dutch, 17th cent.
BRÜGNER, Colestin
German, op.1854-1866
BRUGNOT, Henri
French, 1874-1940
BRUGO, Giuseppe
Italian, 19/20th cent.
BRUIN or Bruijn, D. de
Dutch, op.1772-1797
BRULL Y Vinolas, Juan
Spanish, 1863-
BRULOV, Alexandr Pavlovitch
Russian, 1798-1877
BRÜLOV, Carl Pavlovitch
Russian, 1799-1853
BRULS, Ludwig Josef
German, 1803-1882
BRUMBACH, Louise Upton
American, 19th cent.
BRUMIDI, Constantino
Italian, 1805-1880
BRUN, Alexandre
French, op.1877-1895
BRUN, Bartholomeus
see Bruyn
BRUN, Charles
French, 1825-1908
BRUN, Donald
Swiss, 1909-
BRUN, Elsa de
American, 20th cent.
BRUN, Emmanuel
French, 19th cent.
BRUN, Franz
German, op.1550-1563
BRUN, Hans
Norwegian, op.1728
BRUN or Brunn, Isaac
German, c.1590-p.1669
BRUN, J.
German(?) 18th cent.
BRUN, le
see Lebrun
BRUN, Louis Auguste
(Brun de Versoix)
Swiss, 1758-1815
BRUN, Nicolas Antoine
French, op.1798-1819
BRUNAIS, Augustin
(also erroneously,
Brunias, Abraham)
British, op.1763-1780
BRUNAZZI, Giovanni
Italian, 20th cent.
BRUNDRIT, Reginald Grange
British, 1883-1960
BRUNE, Aimée, née
Pagès
French, 1803-1866
BRUNE, Christian
French, 1789-1849
BRUNE, Emmanuel
French, 1836-1886
BRUNE, Maréchal
French, 18th cent.
BRUNEAU, Kittie
Canadian, 1929-
BRUNEL de Neuville, Alfred
Arthur
French, 19th cent.
BRUNELLESCHI, Umberto
Italian, 1879-
BRUNER, Hans
German, 19th cent.

BRUNERY, Francesco
(Francois)
Italian, op.1898-1909
BRUNERY, Marcel
Italian, 20th cent.
BRUNET, Jean Jacques
French, -1897
BRUNET-DEBAINES, Alfred
French, 1845-
BRUNET-HOUARD, Pierre Auguste
French, 1829-1922
BRUNETTI, Gaetano
Italian, op.1731-m.1758
BRUNETTI, Paolo Antonio
Italian, op.1745-m.1783
BRUNI, Feodor (Fidelio)
Antonovitch
Russian, c.1800-1875
BRUNI, Ferdinand Carl
German, 18th cent.
BRUNIAS, Abraham
see BRUNAIS, Augustin
BRUNIN, Léon
Belgian, 1861-1949
BRÜNING
German, 18th cent.
BRÜNING, B.
German, 1720/30-
BRÜNING, Peter
German, 1929-
BRUNKLAUS, Bernard Heinrich
(Ben)
Dutch, 1907-
BRUNNER, Ferdinand
German, 1870-
BRUNNER, Hans
German, 1813-1888
BRUNNER, Josef
German, 1826-1893
BRUNNER, Karl
Swiss, 1796-1867
BRUNNER the Elder,
Leopold
German, 1788-1866
BRUNNER the Younger,
Leopold
German, 1822-1849
BRÜNNICH, Andreas Petersen
Danish, 1704-1769
BRUNO, Emil
German, 19th cent.
BRUNO di Giovanni
Italian, op.1350
BRUNORI, Enzo
Italian, 1924-
BRUNOVSKY, Albin
Czech, 1935-
BRUNSCHWEILER, Hans
Jakob
Swiss, 1758-1845
BRUNSCHIG, Marcelle
French, 20th cent.
BRUNSDON, John
British, 20th cent.
BRUNTON, Winifred Mabel
British, 1880-
BRUSAFERRO, Girolamo
Italian, c.1700-1760
BRUSASORCI, Domenico del
Riccio
Italian, c.1516-1567
BRUSASORCI, Felice
Italian, c.1542-1605
BRUSCA, Jack
American, 20th cent.
BRUSCAGLIA, Renato
Italian, 1921-
BRUSCO, Paolo Girolamo
Italian, 1742-1820
BRUSH, George de Forest
American, 1855-1941

BRUSSEL, Hermanus van
Dutch, 1763-1815
BRUSSEL, Paulus
Theodorus van
Dutch, 1754-1795
BRUSSELMANS, Jan or
Jean
Belgian, 1884-1953
BRUST, Karl Friedrich
German, 1897-
BRUSTOLON, Brustolon or
Brostoloni, Giovanni
Battista
Italian, 1726-
BRÜTT, Ferdinand
German, 1849-1936
BRUUN, Erik
Finnish, 20th cent.
BRUUN, Johann Jacob
Danish, 1715-1789
BRUUN, Thomas
Danish, 1742-1800
BRUYCKER, François
Antoine de
Belgian, 1816-1882
BRUYCKER, Jules de
Belgian, 1870-1945
BRUYERE, Elise (née
Lebarbier)
French, 1776-1842
BRUYN, Abraham de
Netherlands, c.1540-1587
BRUYN or Brun,
Bartholomaeus, I
German, 1493-1555
BRUYN, Bartholomaeus, II
German, op.1550-m.a.1610
BRUYN, Cornelis de
(Adonis)
Dutch, 1652-1726
BRUYN, Cornelis de
Dutch, c.1768-1801/(?)5
BRUIJN, D. de
see Bruin
BRUYN, Johannes
Cornelis or Cornelis
Johannes
Dutch, c.1800-1844
BRUYN, Nicolaes de
Flemish, 1571-1656
BRUYN, Theodor de
Flemish, op.1753-m.1804
BRUYNE, Nicolò de
Italian(?), op.c.1550
BRUIJNINX, Daniel
Dutch, 1724-1787
BRUYNS, Anna Francisca
de (Anna Francisca
Builart)
Flemish, 1605-p.1629
BRY, A. de
Dutch(?) 17th cent.
BRY, Johann Israel de
German, a.1570-1611
BRY, Jan or Johann
Theodor de
Flemish, 1561-1623
BRY, Theodor or Dirk de
Netherlands, 1528-1598
BRYAN
British, 20th cent.
BRYAN, Alfred
British, 1852-1899
BRYANT, H.C.
British, op.1860-1880
BRYANT, J.
British, 19th cent.

BRYANT, John
British, op.1764-1791
BRYANT, Joshua
British, op.1795-1810
BRYCE, Alexander Joshua
Caleb
British, 1868-1940
BRYEN, Camille
French, 1907-
BRYER, C. de
Dutch, op.1650-1658
BRYMNER, William
Canadian, 1855-1925
BRYOCHE, Felix
Haitian, 1936-
BRYSON, W.
British, 20th cent.
BRZEZINSKI, Leon
Polish, 1809-1865
BRZOZOWSKI, Tadeusz
Polish, 1918-
BUAL, Artur
Portuguese, 1826-
BUBENIK, G.
Czech, 20th cent.
BUBNA, F.
German, 18th cent.
BUCAN, Boris
Yugoslav, 20th cent.
BUCCARELLI, M.
Italian, 18th cent.
BUCCI, Anselmo
Italian, 1887-
BUCCI or Buzzi, Giulio
(Nicola)
Italian, 1711-1776
BUCH, Franz
German, op.c.1542-1568
BUCH, Jörg
German, 16th cent.
BUCHAN, Henry David Erskine,
Earl of
British, 1710-1767
BUCHAN-HEPBURN, Ninian
British, 20th cent.
BUCHANAN, Anne
British, 20th cent.
BUCHANAN, George F.
British, op.c.1848-1864
BUCHANAN, J.
British, op.c.1848
BUCHANAN, Lieut.
British, 18th cent.
BUCHANAN, John
New Zealand, 1819-1898
BUCHANAN, Peter S.
British, 19th cent.
BUCHBINDER, Simeon
Polish, 1853-
BÜCHE, Josef
German, 1848-
BUCHEGGER, Erich
German, 20th cent.
BUCHEL, Charles A.
British, op.1898-1910
BÜCHEL, Emmanuel
Swiss, 1705-1775
BUCHER, Karl
Swiss, 1819-1891
BUCHER, Leopold
German, 1797-m.p.1858
BUCHERON, François
French, 19th cent.
BUCHET, Gustave
Swiss, 1888-1963
BUCHET, Verlaine
French, 20th cent.
BUCHHEISTER, Carl
German, 1890-1964

BUCHHOLZ, Heinrich
German, -c.1800
BUCHHOLZ, Karl
German, 1849-1889
BUCHHORN, Ludwig
German, 1770-1856
BÜCHLER, Heinrich
Swiss, op.1467-p.1484
BUCHNER, Georg Paul
German, 1780-
BUCHNER, Johann Georg
German, 1815-1857
BUCHSBAUM or Puxbaum,
Hans
German, op.c.1440-1457
BUCHSER, Frank
Swiss, 1828-1890
BUCHWALDER, Ernst
Swiss, 20th cent.
BUCK, Adam
British, 1759-1834
BUCK, Francis
British, 18th cent.
BUCK, Frederick
British, 1771-c.1840
BUCK, Nathanial
British, op.1773/4
BUCK, Samuel
British, c.1696-1779
BUCK, Sidney
British, op.1842-1850
BUCKEN, J. van
Dutch, op.1635
BÜCKEN, Peter
German, 1831-1915
BUCKETT, Rowland
British, 19th cent.
BUCKINGHAMSHIRE, Albinia,
Countess of
British, 1738-1816
BUCKLAND, Arthur Herbert
British, 1870-
BUCKLAND-WRIGHT, John
New Zealand, 1897-
BUCKLER, John
British, 1770-1851
BUCKLER, John Chessel
British, 1793-1894
BUCKLER, William
British, 1836-1858
BUCKLEY, C.F.
British, op.1845-1846
BUCKLEY, G.
British, op.1849
BUCKLEY, J.E.
British, op.1843-1861
BUCKLEY, Stephen
British, 1944-
BUCKMAN, Edwin
British, 1841-1930
BUCKMAN, Percy W.I.
British, op.1886-1894
BUCKMAN, W.L.
British, 20th cent.
BUCKNALL, Ernest
British, op.1887
BUCKNER, Richard
British, op.1820-1879
BUCQUOY
French, 18th cent.
BUDD, Charles Jay
American, 1859-1926
BUDD, George
British, op.c.1750
BUDDINGTON, Jonathon
American, op.c.1798-1812
BUDELOT, Philippe
French, op.1793-1841

BUECKELAER, Joachim
see Beuckelaer
BUEHR, Karl Albert
German, 19th cent.
BUELER, Hans Ulrich
see Bühler
BUENO, Xavier
Spanish, 1915-
BUESEM, Jan Jansz.
Dutch, c.1600-p.1649
BUESING, Ludolph
see Büsing
BUET, Clémentine
French, 19th cent.
BUFFAGNOTTI, Carlo
Antonio
Italian, c.1660-p.1710
BUFFALMACCO, Buonamico
di Cristfano (Master
of St. Cecilia)
Italian, 1262/72-1340
(see also Master of
St. Cecilia)
BUFFET, Amédée
French, 1869-1933
BUFFET, Bernard
French, 1928-
BUFFET, François
French, 1789-1843
BUFFET, Paul
French, 1864-
BUFFETTI, Lodovico
Italian, c.1722-1782
BUFFORD, John H.
American, op.1835-1871
BUGATTO da Milano,
Zanetto
Italian, op.1458-1474
BUGIARDINI, Giuliano di
Piero di Simone
Italian, 1475-1554
BUGLIONI, Benedetto
Italian, 1461-1521
BUGUET, Henri
French, 1761-1833
BÜHLER, Hans Adolph
German, 1877-1951
BÜHLER, Bueler or Büller,
Hans Ulrich
German, op.1616-m.1618
BÜHLER, Gerhard
Swiss, 1868-1940
BUHLER, Robert
British, 1916-
BÜHLER, Wolfgang
Swiss, op.1586
BÜHLMAYER, Conrad
German, 1835-1883
BÜHLMEYER, F.
German, op.1803
BUHOT, Félix Hilaire
French, 1847-1898
BUHRE, Gustav Johan
German(?) op.1756
BUISMAN, Hendrik van
Borssum
Dutch, 1873-1951
BUISSERET, Louis
Belgian 1888-1957
BUISSON, Gayot du
see Dubuisson, Jean
Baptiste
BUKEN, Jan van
Flemish, 1635-1694
BUKOVAC, Vlacho
Yugoslav, 1855-1923
BUKOWSKI, M.
Polish, 17th cent.

BUKTENICA, Eugen
Yugoslav, 1914-
BULAND, Eugène
French, 1852-1926
BULFINCH, Charles
American, 1763-1844
BULGARIAN SCHOOL,
Anonymous Painters of the
BULGARINI da Siena,
Bartolommeo
Italian, op.1345-1373
BULL, Charles Livingstone
American, 1874-
BULL, René
British, c.1875
BULLART, Anna Francesca
(née de Bruyns)
see Bruyns
BULLEID, George Lawrence
British, 1858-1933
BÜLLER, Hans Ulrich
see Bühler
BULLFINCH, John
British, op.1666
BULLINGER, Johann Balthasar
Swiss, 1713-1793
BULLOCK, G.G.
British, op.1827-1858
BULMAN, J.
British, op.1767
BULMER, Lionel
British, 20th cent.
BULPE or Vulpis, Fra
Gabriele
Italian, op.1535
BULTEAU, Charles
French, op.c.1870-1882
BULTHUIS, Jan
Dutch, 1750-1801
BULTMAN, Fritz
American, 1919-
BULWER, James
British, 1794-1879
BUMA, Johannes
Dutch, 1694-1756
BUNBURY, Henry William
British, 1750-1811
BUNCE, William Gedney
American, 1840-1916
BUNDEL, Willem van den
Flemish, c.1575-1655
BUNDSEN, Jes (Jens)
Danish, 1766-1829
BUNDY, Edgar
British, 1862-1922
BUNDY, Horace
American, 1814-1883
BUNEL, Charles Eugène
French, 1863-
BUNEL, François, II
French, c.1552-a.1599
BUNEL, Jacob
French, 1558-1614
BUNEL, Marie Barbe
(Manon Buteux)
French, op.1778-1816
BUNESCU, Marius
Rumanian, 1881-
BUNGE, Kurt
German, 1911-
BUNIC, Branko
Yugoslav, 20th cent.
BUNING, Johannes
Norbertus (Johan)
Dutch, 1893-1963
BUNK or Bunck, James H.
British, op.1766-1775

BUNKER, Dennis
American, 1861-1890
BUNKER, Joseph
British, op.1871-1890
BUNKER, Phoebe Ann
American, 1863-
BUNNER, Andrew Fisher
American, 1841-1897
BUNNEY, John Wharlton
British, 1828-1882
BUNNEY, W.
British, op.1853-1859
BUNNIK, Jan van
(Keteltrom)
Dutch, 1654-1727
BUNNING, James Bunstone
British, 1802-1863
BUNNY, Rupert Charles
Wolsten
Australian, 1864-1947
BUNS, Johannes
Dutch, op.1660-1667
BUNSEN, Baroness Frances
née Waddington
British, 1791-1876
BUONACCORSI, Francesco
Italian, op.1496
BUONACCORSO, Niccolò di
Italian, op.1356(?)-m.1388
BUONACORSI, Pietro
see Perino del Vaga
BUONAIUTI, Andrea
see Andrea da Firenze
BUONASONA, Giulio di
Antonio
see Bonasone
BUONCONSIGLIO, Giovanni
(Il Marescalco)
Italian, op.1495/7-m.1535/7
BUONCONSIGLIO, Vitruvio or
Vitrulio
Italian, op.1523-1573
BUONCUORE or Boncori,
Giovanni Battista
Italian, 1643-1699
BUONFIGLI, Benedetto
see Bonfiglio
BUONGIORNO, C.
Italian, 19th cent.
BUONO, Eugenio
Italian, 19th cent.
BUONO, Silvestro
Italian, op.1575-1582
BUONTALENTI
(Bernardo delle Girandole)
Italian, 1536-1608
BUQUOY, Count Ludwig E.G.
German, op.c.1800
BURATTO, Giovanni Battista
Italian, 1731-1787
BURBAGE, Richard
British, 1567(?)-1619
BURBANK, Elbridge Ayer
American, 1858-1949
BURCH, Albertus van der
Dutch, 1672-p.1745(?)
BURCH, Drilem
Dutch, 17th cent.
BURCH, Edward
British, c.1730-1814
BURCH the Younger, H.
British, op.1787-1831
BURCHARD, Adam
see Burghardt
BURCHARD, Franz
German, 1799-1835

BURCHARDT
German, op.1789-1798
BURCHARTZ, Max
German, 1887-1961
BURCHELL, William John
British, 1781-1863
BURCHETT, Richard
British, 1815-1875
BURCHFIELD, Charles
American, 1893-
BURCI, Emilio
Italian, -1879
BURCKERTT, Adam
see Burghardt
BURCKHARDT, C.
American(?) op.c.1840
BURCKHARDT, Carl
Swiss, 1878-1923
BURCKHARDT, Heinrich
German, 1853-1906
BURCKHARDT, Daniel
Swiss, 1752-1819
BURCKHARDT the Elder,
Johann Friedrich
Swiss, 1756-1827
BURCKHARDT, Paul
Swiss, 1880-
BÜRDE, Frederick Leopold
German, 1792-1849
BÜRDE, Paul
German, 1819-1874
BURDEN, J.
British, op.1796-1814
BURDER, G.
British, op.1777
BURDER, W.C.
British, 19th cent.
BURDETT, Peter Perez
British, op.c.1770-1773
BURDETTE, Hattie E.
American, op.1928
BURDIN, Amelie
French, 1834-
BURE, D. van
Netherlands, 17th cent.
BURE, P.I.
Swedish, op.c.1750
BUREAU, Pierre-Isidore
French, 1827-p.1876
BURFORD, John
British, op.1812-1829
BURFORD, Robert
British, 1792-1861
BURFORD, Thomas
British, c.1710-p.1774
BURG, Adriaan van der
Dutch, 1693-1733
BURG, Dirk van der
Dutch, 1723-1773
BURGAT, P.
French, 19th cent.
BURGAU, Franz Michael
Siegmund von, I
see Purgau
BURGAU, P.
German, op.1750
BURGDORFER, Daniel David
Swiss, 1800-1861
BÜRGEL, Hugo
German, 1853-1903
BURGER, Anton
German, 1824-1905
BURGER, Fritz
German, 1867-1927
BÜRGERS, Felix
German, 1870-1934
BURGERS, Hendricus
Jacobus (Hein)
Dutch, 1834-1899

BURGES, R.S. de
Dutch(?), 17th cent.(?)
BURGES, William
British, 1827-1881
BURGESS, Adelaide
British, op.1857-1872
BURGESS, Arthur James
Wetherall
Australian, 1879-1957
BURGESS, Ethel K.
British, 20th cent.
BURGESS, Henry William
British, op.1809-1860
BURGESS, John
British, c.1814-1874
BURGESS, John Bagnold
British, 1830-1897
BURGESS, Thomas
British, op.1778-1791
BURGESS, William
British, 1749-1812
BURGH, Hendrick van der
(Monogrammist H.V.B.)
Dutch, op.1645-1664
BURGH, Hendrik van den
Dutch, 1769-1858
BURGH, Hendrik Adam van der
Dutch, 1798-1877
BURGH, Jacques van der
Flemish(?) op.c.1760
BURGH, J. van der
Dutch, 17th cent.
BURGH, Pieter Daniel van der
Dutch, 1805-1879
BURGHARDT, Burchard,
Burckertt or Borckert,
Adam
German, op.c.1603-m.1623
BURGHERS, Michael
Dutch, c.1640-c.1723
BÜRGI, Jakob
Swiss, 1745-
BURGIN, Victor
British, op.1970
BURGINDIS, Bartholomeus
van
Dutch, op.1663
BURGIS, William
American, op.c.1726
BURGKMAIR the Elder,
Hans
German, 1473-1531
BURGKMAIR the Younger,
Hans
German, c.1500-1559
BURGKMAIR, Thoman
German, 1444-1523
BURGOS, Juan de
see Juan
BURGOS y Mantilla,
Francisco
Spanish, op.c.1650
BÜRI, Friedrich
see Bury
BURI, Max Alfred
Swiss, 1868-1915
BURI, Samuel
Swiss, 1935-
BURINI, Gian Antonio
Italian, 1656-1727
BURKE, Harold Arthur
British, 1852-1942
BURKE, Thomas
British, 1749-1815
BÜRKEL, Heinrich
German, 1802-1869
BURKERT, Eugen
German, 1866-1922

BURKETT, Norman
British, 20th cent.
BURLAND, William
British, op.1834
BURLEIGH, Averil
British, op.1912-m.1949
BURLEIGH, Charles C.
American, 1848-1882
BURLEIGH, C.H.H.
British, -1956
BURLE-MARX, Roberto
Brazilian, 20th cent.
BURLIN, Paul
American, 1886-
BURLINGTON, Dorothy
Countess of
British
BURLIUK, David
Russian, 1882-
BURLIUK, N.
Russian, 19th cent.
BURLIUK, Vladimir
Russian, 19th cent.
BURMANN, Fritz
German, 1892-1945
BURMEISTER, Ludwig Peter
August
see Lyser, Johann
Peter
BURMEISTER, Paul
German, 1847-c.1893
BURN, Gerald Maurice
British, op.1885-1899
BURN, Henry
British, op.1845
BURN, Rodney Joseph
British, 1899-
BURNACINI, Giovanni
Italian, op.1642-m.1655
BURNACINI, Jacob
Italian, op.1667
BURNACINI, Lodovico
Ottavio
Italian, 1636-1707
BURNAND, Eugène
Swiss, 1850-1921
BURNAND, Victor Wyatt
British, 1868-1940
BURNE-JONES, Sir Edward
British, 1833-1898
BURNE-JONES, Sir Philip
British, 1861-1926
BURNELL, Benjamin
British, op.1790-1828
BURNET, James
British, 1788-1816
BURNET, John
British, 1784-1868
BURNETT, Cecil Ross
British, 1872-1933
BURNEY, Charles
British, 18th cent.
BURNEY, Edward Francis
British, 1760-1848
BURNEY, Thomas Frederick
American, 19th cent.
BURNHAM, Thomas Mickell
American, 1818-1866
BURNHAM, T.O.H.P.
see Burnham, Thomas
Mickell
BURNICI
Italian, 18th cent.(?)
BURNIER, Richard
Dutch, 1825-1884
BURNITZ, Carl Peter
German, 1824-1886

BURN-MURDOCH, William G.
British, 1862-1939
BURNS, Cecil Leonard
British, op.1888
BURNS, Margaret Delisle
British, 1888-
BURNS, Robert
British, 1869-1941
BUROW, Raczo
Bulgarian, 20th cent.
BURR, Alexander Hohenlohe
British, 1835-1899
BURR, George Elbert
American, 1859-1939
BURR, John
British, 1831/4-1893
BURRA, Edward
British, 1905-
BURRAGE, Ben
British, 20th cent.
BURRARD, Sir Charles
British, 19th cent.
BURRAS, Thomas
British, 19th cent.
BURRELL, James
British, op.1859-1865
BURRELL, Joseph Francis
British, op.1801-1854
BURRI, Alberto
Italian, 1915-
BÜRRI or Burry, Friedrich
see Bury
BURRIDGE, Frederick
Vango
British, 1869-1945
BURRINGTON, Arthur
British, 1856-1924
BURRINI, Gian Antonio
Italian, 1656-1727
BURROUGHS, Bryson
American, 1869-1934
BURROWS, Robert
British, op.1851-1855
BURSLER, Peter
see Borsseler
BURT, Albin R.
British, 1784-1842
BURT, Charles Thomas
British, 1823-1892
BURTHE, Leopold
French, 19th cent.
BURTON, Charles
American, op.1824
BURTON, Decimus
British, 1800-1881
BURTON, Dennis
Canadian, 1933-
BURTON, Sir Frederick
William
British, 1816-1900
BURTON, James
British, op.1800-1830
BURTON, John
British, op.1769-1836
BURTON, William Paton
British, 1828-1883
BURTON, William
Shakespeare
British, 1830-1914
BURTY, Philippe
French, 1830-1890
BURTY-HAVILAND, Frank
French, 1878-1972
BURY, Adrian
British, 1891-
BURI, Büri, Bürri or
Burri, Friedrich
German, 1763-1823

BURY, G.
British, 19th cent.
BURY, Pol
Belgian, 1922-
BURY, Thomas Talbot
British, 1811-1877
BURY, Viscount
British, 19th cent.
BUS, Mathieu de or du
see Dubus
BUSACIO, Tommaso
see Biazaci
BUSATI or Bussati,
Andrea
Italian, op.c.1503-1529
BUSATTI, Giuseppe Carlo
Antonio
Italian, 1694-p.1769
BUSBY, Thomas Lord
British, op.1804-1821
BUSCA, Antonio
Italian, c.1625-1686
BUSCATTI, Luca Antonio
Italian, op.1516
BUSCH, Georg Paul
German, op.1737-m.1756
BUSCH, Ludwig Wilhelm
(not Joh. Christ.)
German, 1703-1772
BUSCH, Wilhelm
German, 1832-1908
BUSCHMANN, Gustav
Belgian, 1818-1852
BUSH, Harry
British, 1883-
BUSH, Jack Hamilton
Canadian, 1909-
BUSH, Joseph Henry
American, 1794-1865
BUSH, Norton
American, 1834-1894
BUSHBY, Thomas
British, 1861-1918
BUSHE, Letitia
British, -1757
BUSHE, Peter Kendal
British, -1960
BUSI, Giovanni de'
see Cariani
BUSI, Luigi
Italian, 1838-1884
BUSIERI, Giovanni
Battista
see Busiri
BÜSING, Buesing, Büsingk
or Büsinck, Ludolph
(not Ludwig)
German, 1599/1602-1669
BUSIRI or Busieri,
Giovanni Battista
Italian, 18th cent.
BUSK, Miss E.M.
British, op.1873-1889
BUSK, Mary
British, 20th cent.
BUSQUETS, Jean
French, 20th cent.
BUSS, Robert William
British, 1804-1875
BUSS, Rev. Septimus
British, 19th cent.
BUSSATI, Andrea
see Busati
BUSSE, George Heinrich
German, 1810-1868
BUSSE, Jacques
French, 1922-
BUSSET
French, 19th cent.

BUSSET-DUBRUSTE,
Madame G.
French, op.1806-1817
BUSSEY, Robert
British, op.1865
BUSSIÈRE, Gaston
French, 1862-1929
BUSSILLIAT
French, 19th cent.
BUSSON, Charles
French, 1822-1908
BUSSON, George Louis Charles
French, 1859-1933
BUSSY, Simon Albert
French, 1869-1954
BUSSY, Jane Simone
French, 20th cent.
BUSTAMANTE, Juan de
Spanish, 1625-
BUSTI, Agostino
(Il Bambaja)
Italian, 1483-1548
BUSTINO
see Crespi, Benedetto
BUSTOS, Arturo Garcia
Mexican, 1926-
BUTAFOGO, Buttafogo
or Butafoco, Antonio
Italian, op.1772-p.1817
BUTEUX, Manon
see Bunel, Marie Barbe
BUTHAUD, René
French, 1886-
BUTHE
German, 20th cent.
BUTI, Domenico
Italian, 17th cent.
BUTI, Gianantonio
Italian, op.c.1748-1754
BUTI, Lodovico
Italian, c.1560-p.1603
BUTIN, Ulysse
French, 1838-1883
BUTINONE, Bernardino
Jacobi
Italian, a.1436-p.1507
BUTLAND, G.W.
British, op.1831-1843
BUTLER, Charles Ernest
British, 1864-
BUTLER, Edward Riché
American, 1855-
BUTLER, Lady (Elizabeth
Southerden Thompson)
British, 1850-1933
BUTLER, George Edmund
British, 1872-
BUTLER, Howard Russell
American, 1856-1934
BUTLER, Mary E.
British, op.1867-1893
BUTLER, Mildred Anne
British, 1858-1941
BUTLER, Reginald
British, 1913-
BUTLER, Samuel
British, 1835-1902
BUTLER, Theodore E.
American, 1876-
BUTLER, Thomas
British, op.1750
BUTLER, William
British, op.1850
BUTLIN, Malcolm J.
American, op.1910
BUTNIK, Sam
American, 20th cent.

BUTTERI, Giovanni Maria
Italian, c.1540-1606
BUTTERSACK, Bernhard
German, 1858-1925
BUTTERSWORTH, James E.
American, 1817-1894
BUTTERSWORTH, Thomas
British, 1775-1832
BUTTERWOOD, J.F.
American, 19th cent.
BUTTERWORTH, F.
British, op.1797
BUTTI, Lorenzo
Italian, 19th cent.
BUTTIGNY, E.
French, c.19th cent.
BUTTIN, L.
French, 19th cent.
BUTTLER, Joseph
Swiss(?) 1822-1885
BÜTTLI, Jörg
German, op.1617
BÜTTNER, Emilie de
German, 1804-1867
BÜTTNER, Georg Heinrich
German, 1799-1879
BUTTNER, Jurriaan
German, op.1737
BUTTON, John
American(?) 20th cent.
BUTTS, John
British, c.1727-1764
BUTTURA, Antoine Eugène
Ernest
French, 1841-1920
BUVELOT, Abraham Louis
Australian, 1814-1888
BUXTON, Hannah P.
American, 19th cent.
BUYS, Corneille (Cornelis)
Dutch, 1746-1826
BUYS, Cornelis, I
Netherlands,
op.1516-m.a.1524
BUYS, Cornelis, II
Netherlands, a.1524-1546
BUYS, Jacobus
Dutch, 1724-1801
BUYSON, C. Du
French, op.c.1780
BUYSSE, Georges Léon
Ernest
Belgian, 1864-1916
BUYTEWECH, Willem
Pietersz.
Dutch, 1591/2-1624
BUYTEWECH or Buytewegh,
Willem Willemsz.
Dutch, 1625-1670
BUZACI, Tommaso
see Biazaci
BUZINO, Antonio
Italian, 17th cent.
BUZZI, Giulio
see Bucci
BYDGOSZCZ, D.
Russian, 19th cent.
BYE, Harmen de
Dutch, c.1601/2-p.1670
BYE or Bie, Marcus de
Dutch, 1639-p.1688
BYETT, H.D.
Dutch, 17th cent.
BYFIELD, N.
American, op.1713
BYLANT, A. de
British, op.1853-1879

BIJLERT or Bylert, Jan
Harmensz., van
Dutch, 1603(?)-1671
BYLINA, Michal
Polish, 1904-
BYNG or Bing
British, op.1806
BYNG, Edward
British, op.1723-m.1753
BYNG, G.
British, 20th cent.
BYNG or Bing, Robert
British, 18th cent.
BYONE or Byione, C.
see Bijone
BYRES, James
British, 1733-1817
BYRNE, Anne Frances
British, 1775-1837
BYRNE, Charles
British, 1757-1810(?)
BYRNE, H.
British, 17th cent.
BYRNE, John
British, 1786-1847
BYRNE, Mary
see Green
BYRNE, W.
British, 1743-1805
BYRON, Frederick George
British, 1764-1792
BYRON, William, 4th Baron
British, 1669-1736
BYSS, Johann Rudolf
Swiss, 1660-1738
BYWATER, Katherine D.M.
British, op.1879-1896
BYZANTINE SCHOOL,
Anonymous Painters of the
BZDOK, Henryk
Polish, 20th cent.

C

CABAILLOT-LASSALLE, Camille
Léopold
French, 1839-
CABALLERO, Maximo
Spanish, 19th cent.
CABANE, Edouard
French, 1857-
CABANE, Florian Némorin
French, 1831-
CABANEL, Alexandre
French, 1823-1889
CABANYES, Antonio
see Master of Cabanyes
CABAT, Louis
French, 1812-1893
CABAY or Cabaay, Michiel
see Cabbaey
CABBAEY, Cabaay, Cabay,
or Cabouy, Michiel
Flemish, op.1672-m.1722
CABEL, Adrian, Adrien or
Ary van der
see Kabel
CABEL, Arent
see Arentsz.
CABEZALERO, Juan Martin
Spanish, 1633-1673
CABIANCA, Vincenzo
Italian, 1827-1902
CABIE, Louis Alexandre
French, 1853-
CABIN, E. Charles
see Saint-Aubin, Edmé

CABOT, Edward Clarke
American, 1818-1901
CABOUY, Michiel
see Cabbaey
CABRAL y Aguado, Manuel
Spanish, 1818-1891
CABRERA, Jaime
Spanish, op.1399-1406
CABRERA, Juan
Spanish, op.1450
CABRERA, Miguel
Mexican, 1695-1768
CABRESELLE, Il
see Parise, Francesco
CACAULT, Pierre René
French, 1744-1810
CACCIA, Guglielmo
(Il Moncalvo)
Italian, c.1568-1625
CACCIA, Ursula Magdalena
Italian, 1666/78
CACCIANEMICI, Vincenzo
Italian, -1542
CACCIANIGA, Francesco
Italian, 1700-1781
CACCIDRELLI, V.
Italian, 19th cent.
CACCINI, Giovanni
Battista
Italian, 1556-1612/13
CACCIOLI, Giuseppe Antonio
Italian, 1672-1740
CACERES, Lorenzo
Spanish, op.1679
CACHEUX, Armand
Swiss, 1868-
CACHOUD, François Charles
French, 1866-
CADBURY, Alan
British, 19th cent.
CADBY, Walter Frederick
British, op.1896-1904
CADDICK, Richard
British, c.1750-c.1823
CADDICK, William
British, 1719-1794
CADELL, Francis Campbell
Bolleau
British, 1883-1937
CADENHEAD, James
British, 1858-1927
CADES, Giuseppe
Italian, 1750-1799
CADET, Viktorine de
see Joly
CADINI, P.
Italian, 19th cent.
CADIOLI, Giovanni
Italian, 1710-1767
CADIOU, Pierre
French, 20th cent.
CADMUS, Paul
American, 1904-
CADOLLE, Auguste Jean
Baptiste Antoine
French, 1782-1849
CADORIN, Guido
Italian, 1892-
CADORIZI
Italian, op.1700-1707
CADY, Emma
American, op.c.1820
CADY, Harrison
American, 1877-
CAESEMBROOD or
Caesbruut
Netherlands, op.1453-1459

CAETANI, Giovanni
Colacicchi
see Colacicchi
CAFE, Thomas Smith
British, 1793-p.1841
CAFE, Thomas Watt
British, 1856-1925
CAFFA, Cafa or Cofa,
Melchiorre
Italian, 1630/5-1667
CAFFE, Daniel
German, 1756-1815
CAFFE, Daniel Ferdinand
German, 1793-p.1837
CAFFE, Nino
Italian, 1909-
CAFFERTY, James H.
American, 1819-1869
CAFFI, Ippolito
Italian, 1809-1866
CAFFI, Margherita
Italian, 17th cent.
CAFFIERI, Charles Marie
French, 1736-p.1774
CAFFIERI, Hector
British, 1847-1932
CAFFIERI, Jean-Jacques
French, 1725-1792
CAFFYN, Walter Wallor
British, op.1874-1897
CAGLI, Corrado
Italian, 1910-
CAGNACCI, Il
(Guido Canlassi)
Italian, 1601-1681
CAGNIART, Emile
French, c.1856-1911
CAGNOLA or di Cagnolia,
Tommaso
Italian, op.1481
CAHARD, André
French, 20th cent.
CAHN, Marcelle
French, 1895-
CAILLARD, Christian
French, 1899-
CAILLAT, Jean Antoine
Claude
French, 1765-p.1787
CAILLAUD, Aristide
French, 20th cent.
CAILLAUX, Rodolphe
French, 20th cent.
CAILLE, Léon Emile
French, 1836-1907
CAILLEAU, Mlle.
French, op.1765
CAILLEBOTTE, Gustave
French, 1848-1894
CAILLETEAUX, Pierre
see Assurance, Pierre L'
CAILLOT, Jacques
French, op.1693
CAIN, Charles William
British, 1893-
CAIN, Nevil
American, 20th cent.
CAIN, George Jules
Auguste
French, 1856-1919
CAIN, Henri
French, 1859-1937
CAINS, George
French, 18th cent.
CAIRATI, Gerolamo
Italian, 1860-1943

CAIRNS, John
British, op.1854-1865
CAIRO, Francesco del
(Il Cavaliere del
Cairo)
Italian, 1598-1674
CAIRONI, Agostino
Italian, op.1870-1900
CAISERMAN-ROTH, Ghitta
Canadian, 1923-
CAISNE, Henri de
see Decaisne
CAJES
Spanish, 17th cent.
CAJETAN
see Elfinger, Ant.
CAJETAN, J.
German, op.1846-1854
CALABANA, G.
Spanish, 19th cent.
CALABRESE
see Cardisco, Marco
CALABRESE
see Preti, Mattia
CALAIS
French, 19th cent.
CALAMAI, Baldassarre
Italian, 1787-1851
CALAMAR, Gloria
American, 20th cent.
CALAMATTA, Luigi
Italian, 1801/2-1869
CALAME, Alexander
Swiss, 1810-1864
CALAME, Marie Anne
Swiss, 1775-1834
CALAND, Léon
French, 19th cent.
CALANDRI, Mario
Italian, 1914-
CALANDRUCCI, Giacinto
Italian, 1646-1707
CALAU, Benjamin
German, 1724-1785
CALAU, F.A.
German, op.c.1790-1830
CALBET, Antoine
French, 1860-1944
CALCAGNO, Lawrence
American, 1916-
CALCAR, Jan or Johannes
Stephan van
(Giovanni da Calcar)
German, op.c.1536/7-m.c.1546
CALDARA, Domenico
Italian, 1814-1897
CALDARA, Polidoro
see Caravaggio
CALDECOTT, Florence
Zerffi
South African, 20th cent.
CALDECOTT, Harry Stratford
(Strat Caldecott)
South African, 1886-1929
CALDECOTT, Randolph
British, 1846-1886
CALDENBACH, Martin
see Kaldenbach
CALDER, Alexander
American, 1898-
CALDERARA, Antonio
Italian, 1903-
CALDERARI, Giovanni Maria
(Zaffoni)
Italian, c.1500-1564/70
CALDERON, Philip
Hermogenes
British, 1833-1898

CALDERON, William Frank
British, 1865-1943
CALDONI, Vittoria
Italian, op.1821
CALDWELL, Edmund
British, 1852-1930
CALEIS, H.
French, 18th cent.
CALET, Louis
French, op.1898
CALETTI, Giuseppe
(Il Cremonese)
Italian, c.1600-c.1660
CALIARI, Benedetto
Italian, 1538(?)-1598
CALIARI, Carlo
(Carletto)
Italian, 1570-1596
CALIARI, Gabriele
Italian, 1568-1631
CALIARI, Paolo
Italian, op.1875
CALIARI, Paolo
see Veronese
CALIFANO, Giovanni
(John)
Italian, 1864-
CALIGA, Isaac Henry
American, 1857-
CALISTO da Lodi
see Piazza
CALKETT, S.D.
British, c.1800-1863
CALKIN, Lance
British, 1859-
CALL, Jan, I van
Dutch, 1656-1706(?)
CALLAHAN, Kenneth
American, 1907-
CALLANDER, Adam
British, op.1780-1811
CALLANDER, Henrietta
Rose
British, 19th cent.
CALLANI, Gaetano
Italian, 1736-1809
CALLAWAY, William Frederick
British, op.1855-1861
CALLCOTT, Sir Augustus
Wall
British, 1779-1844
CALLCOTT, Frederick T.
British, op.c.1877-1898
CALLCOTT, Maria, Lady
British, 1785-1842
CALLCOTT, William J.
British, op.1843-1890
CALLEGARI, Giovanni
Battista
Italian, 1785-1855
CALLEJA, Andres de la
Spanish, 1705-1785
CALLENS, Philippe
Belgian, op.c.1800-1850
CALLENS, Philippe
Belgian, op.1825
CALLET or Calet, Antoine
François
French, 1741-1823
CALLIANO, Antonio
Raffaele
Italian, 1785-c.1825
CALLIYANNIS, Manolis
Greek, 1923/6-
CALLOT, Henri Eugene
French, 1875-
CALLOT, Jacques
French, 1592-1635

CALLOW, John
British, 1822-1878
CALLOW, William
British, 1812-1908
CALMETTE, Edouard Georges
Guillaume
French, 20th cent.
CALMETTES, Jean-Marie
French, 1918-
CALMETTES, Pierre-P.
French, 1874-
CALMEYER, Jacob Mathias
Norwegian, 1802-1884
CALOI, Alessandro
Italian, 20th cent.
CALOS, Nino
Italian, 1926-
CALOSCI, Arturo
Italian, 1855-1926
CALRAET, Calraat or
Kalraet, Barent
Pietersz.
Dutch, 1649-1737
CALRAET, Calraat or
Kalraet, Abraham
Pietersz.
Dutch, 1642-1722
CALS, Adolphe Félix
French, 1810-1880
CALSTOCK, R.
British, op.c.1700
CALTHROP, Claude Andrew
British, 1845-1893
CALTHROP, Dion Clayton
British, 1875-1937
CALUGARU, Titina
Rumanian, 1911-
CALVAERT, Denys or Dionys
(Dionisio Fiammingo)
Flemish, 1540-1619
CALVANO or Galvano
Italian, op.1487-1529
CALVERT, Edward
British, 1799-1883
CALVERT, Frederick
British, c.1785-c.1845
CALVERT, Giles
British, 17th cent.
CALVERT, Henry
British, op.1826-1854
CALVERT, S.W.
British, 19th cent.
CALVES, Léon Georges
French, 1848-
CALVES, Léon Georges
French, 1848-
CALVET, Carlos
Portuguese, 20th cent.
CALVI, Lazzaro
Italian, 1502-1607
CALVI, Panciatico
d'Antonello da
Italian, op.1477
CALVI, Rinaldo da
(Jacovetti)
Italian, op.1521-m.1528
CALVIS, Antonio di
Italian, 15th cent.
CALYO, Nicolino
Italian, 1799-1884
CALZA, Antonio
Italian, 1653-1725
CALZA or Calze,
Francesco
see Cunningham, Edward
Francis
CALZETTA, Pietro di
("P. Petri"?).
Italian, op.1455-m.1486

CAMACHO, Jorge
Cuban, 1934-
CAMALDOLESE, Don
Silvestro
Italian, 1350-p.1410
CAMARENA, Jorge
Gonzales
Mexican, 20th cent.
CAMARLENCH, Ignacio
Pinazo
Spanish, 20th cent.
CAMARO, Alexander
German, 1901-
CAMARON y Boronat, José
Spanish, 1730-1803
CAMARON y Meliá, Manuel
Spanish, 1763-p.1801
CAMASSEI, Andrea
Italian, 1602-1649
CAMBI, Jacopo
Italian, op.1521
CAMBIAGGIO, E.
French, 19th cent.
CAMBIASO or Cangiaso,
Luca (Luchetto or
Luqueto)
Italian, 1527-1585
CAMBIASO, Orazio
Italian, 16th cent.
CAMBIER, Guy
French, 19th cent.
CAMBOIN, Eugène
French, op.1878
CAMBON, Armand
French, 1819-1885
CAMBRUZZI, Giacomo
Italian, 1744-p.1803
CAMDEN, John
(possibly assumed name
for Joseph Farington)
CAMDEN, P.
British, op.1805-1809
CAMENISCH, Paul
Swiss, 1893-1970
CAMERARIUS, Adam
Dutch, op.1644-1665
CAMERATA, Giuseppe the
Elder
Italian, c.1668-1761/2
CAMERINI, Joseph
Italian, op.c.1724
CAMERINO, Girolamo di
Giovanni
see Girolamo
CAMERON
British, 18th cent.
CAMERON, Charles
British, c.1740-1812
CAMERON, Sir David Young
British, 1865-1945
CAMERON, Duncan
British, 19th cent.
CAMERON, Hugh
British, 1835-1918
CAMERON, J.
American, op.1866
CAMERON, John
British, 19th cent.
CAMERON, Katharine
British, 1874-1965
CAMERON, Mary
(Mrs. Alexis Millar)
British, -1921
CAMESI, Gianfredo
Swiss, 20th cent.
CAMETTI, Bernardino
Italian, 1682-1736

CAMFFERMAN, Peter
Dutch, 1890-
CAMILLIANI or della
Camilla, Camillo
Italian, op.1574-1599
CAMILO, Francisco
Spanish, 1635-1671
CAMINADE, Alexandre
François
French, 1783-1862
CAMINO, Giuseppe
Italian, 1818-1890
CAMMARANO, Michele
Italian, 1835/49-1920
CAMMAS, Anne Guibal
French, 1781-
CAMMAS, Lambert François
Thérèse
French, 1743-1804
CAMMILLIERI, Nicolas
American, 19th cent.
CAMOCCIO, Giovanni
Francesco
Italian, op.1560-1572
CAMOIN, Charles
French, 1879-
CAMOIN, P.
French, 19th cent.
CAMOREYT, Jacques Marie
Omer
French, op.1891
CAMP, J.
Dutch, op.1662
CAMP, Jacob de
Netherlands, op.1518
CAMP, Jeffery
British, 1923-
CAMP, Nicolaes (Claes)
de
see Kemp
CAMPAGNA, Gerolamo
Italian, 1549/50-p.1626
CAMPAGNOLA, Domenico
Italian, op.1517-1562
CAMPAGNOLA, Giulio
Italian, 1482-
also Master I.I.C.A.
CAMPAGNOLA
Italian, 20th cent.
CAMPANA or Campani,
Andrea
Italian, op.c.1450-1460
CAMPANA, François
see Campana, Ignace
Jean Victor
CAMPANA, Giacinto
Italian, c.1600-c.1650
CAMPANA, Ignace Jean Victor
(identical with F.Campana
or François Campana)
Italian, 1744-1786
CAMPANA, Pedro, Petrus
Campania or Campaniensis
see Kempener
CAMPARET
American, 19th cent.
CAMPBELL, Alexander
American, op.1775
CAMPBELL, Sir Archibald
British, 1739-1791
CAMPBELL, Cecilia
British, op.1820
CAMPBELL, F. A.
British, 19th cent.
CAMPBELL, George
British, 20th cent.

CAMPBELL, Iain
British, 19th cent.
CAMPBELL, James
British, c.1828-1903
CAMPBELL, John
Australian, op.1889
CAMPBELL, John Henry
British, 1757-1829
CAMPBELL, John Patrick
('Seaghan MacCathmhaoil')
British, op.1904-7
CAMPBELL, Michael
American, 20th cent.
CAMPBELL, N.J.
British, 20th cent.
CAMPBELL, Nesta
British, 19th cent.
CAMPBELL, Nora Molly
British, op.c.1915-1950
CAMPBELL, Orland
American, 1890-
CAMPBELL, Reginald Henry
British, 1877-
CAMPBELL, Robert Richmond
British, 20th cent.
CAMPBELL, Tom
British, 20th cent.
CAMPBELL-MACKIE, T.C.
British, 20th cent.
CAMPDEN, J.
British, 18th cent.
CAMPECHE, José
American (Puerto Rico)
1752-1809
CAMPEN or Kampen, Jacob
van
Dutch, 1595-1657
CAMPEN, R. van
Dutch, 17th cent.
CAMPENDONCK, Heinrich
German, 1889-1957
CAMPESINO y Mingo, Vicente
Spanish, op.1876-1890
CAMPESTRINI, Alcide
Davide
Italian, 1863-op.1894
CAMPHAUSEN, Wilhelm
German, 1818-1885
CAMPHUYSEN or Camphuijsen,
Govert Dircksz.
Dutch, 1623/4-1672
CAMPHUYSEN or Camphuijsen,
Jochem Govertsz.
Dutch, 1601/2-1659
CAMPHUYSEN or Camphuijsen,
Rafel Dircksz.
Dutch, 1619-1691
CAMPHUYSEN or Camphuijsen,
Rafel Govertsz.
Dutch, 1598-1657
CAMPI, Antonio
(Antonio da Cremona)
Italian, op.1556-m.c.1591
CAMPI, Bernardino
Italian, 1522-c.1590/5
CAMPI, Galeazzo
Italian, 1477-1536
CAMPI, Giulio
Italian, c.1502-1572
CAMPI, Vincenzo
Italian, 1536-1591
CAMPICH
French, 18th cent.
CAMPIDOGLIO, Michelangiolo
di Pace di
Italian, 1610-1670
CAMPIGLI, Massimo
Italian, 1895-1971

CAMPIGLIA, Giovanni
Domenico
Italian, 1692-p.1762
CAMPILLI, Bernardino
Italian, op.1502
CAMPIN, Robert
see Master of Flémalle
CAMPINO, Giovanni
see Campo
CAMPION, F.
French, 17th cent.
CAMPION, George B.
British, c.1796-1870
CAMPIONE
see Bianchi, Isidoro
CAMPIS
see Campus
CAMPO, Federico del
Peruvian, op.1880-1912
CAMPO, Galcar de
Italian(?), op.1623
CAMPO, Giovanni di
Filippo del or Giovanni
Campino (Jean Duchamp)
Flemish, c.1600-p.1638
CAMPO, Victoria Martin
del
Spanish, op.1840
CAMPOLO, Placido
Italian, 1693-1743
CAMPOLONGO, Imp.
Italian, 16th cent.
CAMPORA, Francesco
Italian, c.1693-1763
CAMPOS, Joaquin
Spanish, op.1773-1812
CAMPOTOSTO, Henry
Belgian, -1910
CAMPOVECCHIO, Luigi
Italian, op.1788-m.1804
CAMPRIANI, Alceste
Italian, 1848-1933
CAMPROBIN, Pedro de
Spanish, op.1660
CAMPUS, Benignus
German, op.1555-1573
CAMUCCINI, Vincenzo
Italian, 1771-1844
CAMULLO, Francesco
Italian, c.1570-1650
CAMUS, Gustave
Belgian, 1914-
CANADIAN SCHOOL
CANAL, Fabio
Italian, 1703-1767
CANAL, Giambattista
Italian, 1745-1825
CANAL, Gilbert von
German, 1849-1927
CANALE, Antonio
see Canaletto
CANALE, Giuseppe
Italian, 1725-1802
CANALETTO
(Antonio Canale)
Italian, 1697-1768
CANALETTO, Cristoforo
Italian, 18th cent.
CANALETTO
see Belotto, Bernardo
CANALI, Gaetano
Italian, 18th cent.
CANALS y Llambi,
Ricardo
Spanish, 1876-
CANASTA, Chan
see Mifelew

CANAVESIO, Giovanni
Italian, op.1450-1491
CANCELLIERI, Bartolommeo
di Guido
Italian, 16th cent.
CANCLINO or Canclini,
Antonio
Italian, op.1585-1591
CANDID, Peter, or Pietro
Candido
see Witte
CANDIDO, Salvatore
Italian, op.1839
CANE, Ottaviano
Italian, c.1495-p.1570
CANELLA, A.
Italian, 19th cent.
CANELLA, Carlo
Italian, 1800-1880
CANELLA, Giuseppe
Italian, 1788-1847
CANELLA, Giuseppe V.
Italian, 1837-1913
CANERA, Caneri, Canerio
or Carlerio, Anselmo
Italian, op.1566-c.1575
CANERI
see Canera
CANERIO
see Canera
CANEVARI, Giovanni
Battista
Italian, 1789-1876
CANGIASO, Luca, Luchetto
or Luqueto
see Cambiaso
CANH, Duong Ngoc
Vietnamese, 20th cent.
CANIARIS, Vlassis
Greek, 1928-
CANIF, Milton
American, 20th cent.
CANINI, Pietro
Italian, 18th cent.
CANINI, Giovanni Angelo
Italian, 1617-1666
CANIZZARO, Vincenzo
Italian, op.1757-1814
CANJURA, N.
Spanish, 20th cent.
CANLASSI, Guido
see Cagnacci, Il
CANNA, Pasquale
Italian, 18th cent.
CANNELLA, Giovanni
Italian, op.c.1600
CANNICCI, Niccolò
Italian, 1846-1906
CANNOY, Frans or
François van
see Duquesnoy
CANO, Alonso
Spanish, 1601-1667
CANO de Arévalo, Juan
Spanish, 1656-1696
CANO de la Peña, Eduardo
Spanish, 1823-1897
CANOGAR, Raphael
Spanish, 1934-
CANOI, Frans or François
van
see Duquesnoy
CANON, Hans (Johann
von Strasiripka)
German, 1829-1885
CANON, Jean-Louis
French, 1809-1892

CANOT, Philippe
French, 18th cent.
CANOT, Pierre Charles
French, 1710-1777
CANOVA, Antonio
Italian, 1757-1822
CANOZZI, Cristoforo da
Lendinara
Italian, c.1426-1491
CANOZZI, Lorenzo da
Lendinara
Italian, 1425-1477
CANPENER, Peter
see Kempener
CANSY, de
French, op.1748
CANT, James
Australian, 1911-
CANTA, Johannes
Antonius
Dutch, 1816-1888
CANTAGALLINA, Remigio
Italian, c.1582-p.1635
CANTALAMESSA, Giulio
Italian, 1846-1924
CANTARINI, Simone
(Il Pesarese)
Italian, 1612-1648
CANTATARE, Domenico
Italian, 1906-
CANTELBEECK, H.
see Castelbeeck
CANTELBEECK, Hendrick
Flemish, op.1709-1718
CANTER, James
British, c.1735-c.1790
CANTI, Giovanni
Italian, 1635-1716
CANTO
Italian, 1788-p.1834
CANTON, Franz Thomas
German, 1671-1734
CANTON, Johann Gabriel
German, 1710-1753
CANTONI, Giovacchino
Italian, 1770-1844
CANTRELL, Arthur
South African, 20th cent.
CANTRILL, William
British, op.1825-1830
CANTZLER, Axel Leopold
Swedish, 1832-1875
CANU
French, 20th cent.
CANU, Jean Dominique
Etienne
French, 1768-p.1816
CANUTI, Domenico Maria
Italian, 1620-1684
CANY or Cani, Jean
Baptiste de
French, -1693
CANZI, August Alexis
German, 1808-1866
CANZIANI, Louisa
see Starr
CAP, Constant Aimé
Marie
Belgian, 1842-1915
CAPACINI, Dominique
Italian, op.1565-1577
CAPALTI, Alessandro
Italian, c.1810-1868
CAPANNA, Puccio
Italian, op.1350
CAPARRA, Niccolò Grosso
see Grosso

CAPASSINI, Giovanni
Italian, op.1577
CAPDEVIELLE, Louis
French, op.1874
CAPDEVILLA, Manuel
Spanish, 20th cent.
CAPE, Thomas S.
British, 19th cent.
CAPEK, Josef
Czech, 1887-1945
CAPEL, Jan or Joannes
van de
see Cappelle
CAPELAIN, Jean de
French, c.1814-1848
CAPELLE, Cornelis van de
see Corneille de Lyon
CAPELLE, Jan or Joannes
van de
see Cappelle
CAPELLI, Camillo di
(Camillo Mantovano)
Italian, op.1514-m.1568
CAPET, Lucien
French, 1873-1928
CAPET, Marie Gabrielle
French, 1761-1818
CAPEY, Reco
British, 20th cent.
CAPIEUX, Johann Stephan
German, 1748-1813
CAPITELLI, Bernardino
Italian, 1589-1639
CAPO, Francesco
Italian, op.1775
CAPOBIANCHI, V.
Italian, 19th cent.
CAPODIBUE, Giambattista
see Codebue
CAPOGROSSI, Guarna
Giuseppe
Italian, 1900-
CAPON, Georges
French, 1890-
CAPON, William
British, 1757-1827
CAPONE, Gaetano
Italian, 1845-1920
CAPORALI, Giacomo
(di Segnola)
Italian, op.1471-1478
CAPORALI, Bartolommeo
Italian, op.1442-1492
CAPORALI, Giovanni
Battista (not Benedetto)
called Bitti
Italian, c.1475-1560
CAPPADOCIAN SCHOOL
Anonymous Painters of
the
see under Greek
CAPPELEN, Herman August
Norwegian, 1827-1852
CAPPELLA, Francesco
(Daggiù)
Italian, 1714-1784
CAPPELLE, Capel or
Capelle, Jan or Joannes
van de
Dutch, c.1623/5-1679
CAPPELLI, Pietro
Italian, -1724
CAPPELLINI, Giovanni
Domenico
Italian, 1580-1651
CAPPELLI, Giovanni
Italian, 1923-

CAPPELLO, Carlo
Italian, 18th cent.(?)
CAPPERS, Gerhard Martin
see Coppers
CAPPIELLO, Leonetto
Italian, 1875-1942
CAPPONI
see Raffaellino del
Garbo
CAPPUCCINO, Il
see Strozzi, Bernardo
CAPRA, Pietro Paolo
Italian, op.1710
CAPRIANI, Francesco
(Francesco da Volterra)
Italian, op.1562-m.1588(?)
CAPRILE, Vincenzo
Italian, 1856-1936
CAPRIOLI, Caurioli or
Cavrioli, Francesco
Italian, op.1450-m.1505
CAPRIOLO, Domenico di
Bernardino
Italian, 1494-1528
CAPRON, Jean-Pierre
French, 20th cent.
CAPROTTI, Gian Giacomo de'
see Salaj
CAPSIUS, Margareta
see Gavelin
CAPULETTI, Jose
Spanish, 1926-
CAPUTO, Ulisse
Italian, 1872-
CARABAIN, Jacques François
Belgian, 1834-
CARABELLI, Bartolommeo
Italian, 18th cent.
CARACCA, Isidoro
see Kraek, Jan
CARACCIOLO di Vercano,
Antonio
Italian, 17th cent.
CARACCIOLO or Carracciulo,
Giovanni Battista
(Il Battistello)
Italian, c.1570-1637
CARAFFE, Armand Charles
French, 1762-1822
CARAGLIO or Carrallio, A.
Italian, 17th cent. (?)
CARAGLIO, Caralio,
Caralius or Karalis,
Giovanni Jacopo
Italian, 1498/1500-1565
CARAGNA, Giovanni
see Kraek, Jan
CARAGUA, Giovanni
see Kraek, Jan
CARALIO, Giovanni Jacopo
see Caraglio
CARALIUS, Giovanni Jacopo
see Caraglio
CARAN D'ACHE,
(Emmanuel Poiré)
Russian, 1859-1909
CARANDINI, Paolo
Italian, op.1650-1677
CARATO, Mateo
Spanish, op.c.1628
CARATTI, Borgo
Italian, op.c.1860
CARAUD, Joseph
French, 1821-1905
CARAVAGGINO
see Luini, Tommaso

CARAVAGGIO, Michelangelo
Merisi (wrongly Merigi,
Amerigi or Amerighi) da
Italian, 1571-1609/10
CARAVAGGIO, Polidoro
Caldara da
see Polidoro
CARAVAQUE or Karavak,
Louis
French(?) a.1715-1754
CARAVOGLIO, Bartolomeo
Italian, c.1628-1678/91
CARBAJAL or Carvajal,
Luis de
Spanish, 1534-1607
CARBASIUS, Dirck or
Theodorus
Dutch, 1619-1681(?)
CARBIN, Wilhelmine,
(née Gips)
see Gips
CARBON, Hecquet de
French, 20th cent.
CARBONCINI or Carboncino,
Cav. Giovanni
Italian, op.1672-1692
CARBONERO, José Moreno
Spanish, 1860-
CARBONI, Angiolo
Italian, op.1738-1762
CARBONI, Giovanni Bernardo
Italian, 1614-1683
CARBONNET
French, op.1784
CARBONNIER, Casimir
French, 1787-1873
CARCANO, Filippo
Italian, 1840-1914
CARDELLI, Salvatore
Italian, op.1797-1814
CARDELLO, Tommaso
Italian, op.1468
CÁRDENAS, Bartolomé de
see Bermejo
CÁRDENAS, Juan Ignacio de
Spanish, 1928-
CARDERARA y Solano,
Valentin
Spanish, 1796-1880
CARDI, Lodovico
see Cigoli
CARDI, Lorenzo
Italian, op.c.1608
CARDINALL, Robert
British, op.1730
CARDINAUX, Emil
Swiss, 1877-1936
CARDISCO, Marco
(Calabrese)
Italian, c.1486-1542
CARDON, Antoine or
Anthony
Flemish, 1772-1813
CARDONA, Alfredo Opisso
Spanish, op.1898
CARDUCCI da Norcia,
Michelangelo
Italian, op.1555-m.a.1577
CARDUCHO or Carducci,
Bartolome
Spanish, 1560-1608
CARDUCHO, Vincenzo
Spanish, 1578-1638
CARE, Georg
German, op.c.1910
CAREAGA
French, 20th cent.

CARECCIA, Enzo
Italian, 20th cent.
CAREEL, Johann or Jan,
Dutch, op.1760-1780
CARELLI, Conrad H?R.
British, 1869-
CARELLI, Consalvo
Italian, 1818-1900
CARELLI, Gabriel
Italian, op.1853-1880
CARELLI, Giuseppe
Italian, 1859-
CARELLI, Raffaello
Italian, op.1825
CARENA, Felice
Italian, 1879/80-
CARENA, Leonardo
Italian, 16th cent.
CARESME or Carême,
Philippe
French, 1734-1796
CARETTAI, Pietro
see Giovanni da
Firenze, Fra
CARETTE, Georges Emile
French, op.1893-1907
CAREY, J.
British, op.1816
CAREY, Robert
British, op.c.1830
CARFRAE, G.
British, op.1787
CARGALEIRO, Manuel
Portuguese, 1927-
CARI, Fabrito
Italian, 16th cent.(?)
CARIANI, Giovanni de'
Busi
Italian, 1485/90-p.1547
CARIGIET, Alois
Swiss, 1902-
CARILLO
Spanish, 15th cent.
CARILLO, Juan
Spanish, 20th cent.
CARILLO, Mariano
South American, 18th cent.
CARINGS, Alexander
see Keirincx
CARINGS or Cierings,
Jacob or Johann
see Keirincx, Alexander
CARINO, Angelo
Italian, 19th cent.
CARINO, Francesco
see Duquesnoy
CARIS, Johann Wilhelm
German, 1747-1830
CARISTIE, Augustin
Nicolas
French, 1783-1862
CARL, Adolf
German, 1814-1845
CARL (Karl XV.) Ludvig
Eugène
Swedish, 1826-1872
CARLANDI, Onorato
Italian, 1848-1939
CARLBERG, Hugo
Scandinavian,
1880-1943
CARLEBUR, François, II
Dutch, 1821-1893
CARLEGLE, Emile
Charles
French, 1877-1936

CARLERIO
see Canera
CARLES, Arthur B.
American, 1882-1952
CARLETON, Clifford
American, 1867-
CARLETON, John
British, op.1636
CARLEVARIS, Luca
(Luca da Ca'Zenobio)
Italian, 1665-1731
CARLI, Raffaello de'
see Raffaellino
CARLIER, Jean Guillaume
Flemish, 1638-1675
CARLIER, Marie
French(?), 20th cent.
CARLIER, Modeste
Belgian, 1820-1878
CARLIER, René
French, -1722
CARLIERI, Alberto
Italian, 1672-1720
CARLILE, Joan
British, 1600-79
CARLILL, Stephen Briggs
British, op.1888-m.1903
CARLIN, A.B.
American, op.1871
CARLIN, John
American, 1813-1891
CARLINE, Anne
British, 20th cent.
CARLINE, George F.
British, 1855-1920
CARLINE, Hilda Anne
British, 1889-1950
CARLINE, Nancy
British, 20th cent.
CARLINE, Richard
British, 1895-
CARLINE, Sydney William
British, 1888-1929
CARLINI, Agostino
Italian, op.1760-m.1790
CARLINI, Francesco
Italian, 20th cent.
CARLINI, Giulio
Italian, 1830-1887
CARLISLE, George James
Howard, 9th Earl of
British, 1843-1911
CARLISLE, R.
British, 18th cent.
CARLO,
Italian, op.1520-1523
CARLO da Camerino
Italian, op.1396
CARLO dei Fiori
see Vogelaer, Karel
CARLO di Giovanni
see Braccesco
CARLO da Lodi
Italian, 1701-1765
CARLO da Milano or del
Mantegna
see Braccesco
CARLO Napolitano
Italian, op.c.1635
CARLO Veneziano
see Saraceni
CARLONE, Andrea
(Giovanni Andrea)
Italian, 1639-1697
CARLONE, Carlo
(Innocenz?)
Italian, 1686-1775

CARLONE, Giovanni
(Il Genovese)
Italian, 1590-1630
CARLONE, Giovanni Battista
Italian, 1592-1677
CARLONE, Luigi
Italian, 17th cent.
CARLONE, Marco
Italian, 1742-1796
CARLONI, Pietro
Italian, 18th cent.
CARLOS, Frey
Netherlands, op.1517-1540
CARLOS, Nicolas
Spanish, op.1504-1509
CARLOTTO
see Loth, Johann Carl
CARLOW, Viscount
British, 18th cent.
CARL-ROSA, Mario
French, 1855-1913
CARLSEN, Dines
American, 1901-
CARLSEN, Frederik Wilhelm
Christian
Danish, 1909-
CARLSEN, Soren Emil
Danish, 1848/53-1932
CARLSON, John
Swedish, 1874/5-1945
CARLSUND, Otto
Swedish, 1897-1948
CARLTON, William Tolman
American, 1816-1888
CARLU, Jean
French, 1900-
CARLUS, Jacques
French, op.1922
CARLYLE, T.
British, op.1816-1837
CARLYON, Cecily K.
British, 20th cent.
CARMASSI, Arturo
Italian, 1925-
CARMI, Eugenio
Italian, 1920-
CARMICHAEL, Franklin
Canadian, 1890-1945
CARMICHAEL, Herbert
British, 1856-1935
CARMICHAEL, James Wilson
British, 1800-1868
CARMICHAEL, Stewart
British, 20th cent.
CARMIENCKE, Johann Herman
German, 1810-1867
CARMIGNANI, Guido
Italian, 1838-1909
CARMINE, Michele
Italian, 1854-1894
CARMONTELLE, Louis
Carrogis de
French, 1717-1806
CARNE, Michele Felice
American, 19th cent.
CARNE, Ohac
French, 20th cent.
CARNEGIE, Agnes Lady
British, 19th cent.
CARNEGIE, Eliza
Countess of Hopetoun
British, 18th cent.
CARNEIRO, Antonio
Texeira
Portuguese, 1872-1930
CARNEO or Carnio, Antonio
Italian, op.1640-1680

CARNEO the Younger,
Giacomo
Italian, op.c.1680-p.1711
CARNEVALE, Fra (Bartolommeo
di Giovanni Corradini)
Italian, op.1451-m.1484
CARNEVALI, Giovanni
see Carnovali
CARNEVALI, Giulio Cesare
Italian, op.1820-1830
CARNICERO, Antonio
Spanish, 1748-1814
CARNIER, H.
French, op.c.1880
CARNIO, Antonio
see Carneo
CARNOVALI or Carnevali,
Giovanni (Il Piccio)
Italian, 1806-1873
CARNULO, Simone da
Italian, op.c.1519
CARO, Baldassare de
Italian, 18th cent.
CARO, Juan
Spanish, 17th cent.
CARO, Lorenzo de
Italian, 18th cent.
CARO, Marco di
Italian, 18th cent.
CARO, Martin
American, 20th cent.
CARO DE TORRES, Manuel
Spanish, 1651-1710
CAROBIO, Giovanni
Italian, 1691-1752
CARO-DELVAILLE, Henry
French, 1876-1928
CAROLI da Forlì
see Carrari the
Younger, Baldassare
CAROLINO da Viterbo
Italian, op.1478
CAROLIS, Adolfo de
Italian, 1874-1928
CAROLIS, Jacobus de
Italian, 15th cent.
CAROLSFELD, Julius
see Schnorr
CAROLUS, Jean
Belgian, op.1867
CAROLUS, Louis Antoine
Belgian, 1814-1865
CAROLUS-DURAN, Emile
Auguste
French, 1838-1917
CARON or Charon,
Antoine
French, c.1515-1593
CARON, Auguste
French, 1806-
CARON, E.
French, op.c.1600
CARON, Henri
French, 1860-
CAROSELLI, Angelo
Italian, 1585-1652
CAROSELLI, Cesare
Italian, 1847-
CAROTO, Carotto or
Carotis, Giovanni
Italian, 1488/95-1563/6
CAROTO, Giovanni
Francesco
Italian, c.1478/82-1555
CAROZZI, Giuseppe
Italian, 1864-1938

CARPACCIO, Benedetto
 Italian, op.1530-1545
CARPACCIO, Pietro
 Italian, op.1513-1526
CARPACCIO or Scarpaza,
 Vittore
 Italian, op.1472-m.a.1526
CARPEAUX, Jean Baptiste
 (Jules)
 French, 1827-1875
CARPELAN, Wilhelm
 Maximilian
 Swedish, 1787-1830
CARPENA, Antonio da
 (Il Carpenino)
 Italian, op.1530-m.a.1564
CARPENEL, Jacques
 French, 1726-1769
CARPENTER, Francis Bicknell
 American, 1830-1900
CARPENTER, J.
 British, op.1770
CARPENTER, John
 British, op.c.1827
CARPENTER, Margaret Sarah
 British, 1793-1872
CARPENTER, Percy
 British, op.1841-1858
CARPENTER, William
 British, 1818-1899
CARPENTERO, Hendrik
 Joseph Gommarus
 Belgian, 1820-1874
CARPENTERO, Jean Charles
 Belgian, 1784-1823
CARPENTIER
 French, op.1750-1776
CARPENTIER, Evariste
 Belgian, 1845-1922
CARPENTIER, G.
 French, 20th cent.
CARPENTIER, H.
 German(?), 19th cent.
CARPENTIER, Jean Baptiste
 French, 1726-1808
CARPENTIER, Paul Claude
 Michel le
 see Lecarpentier
CARPENTIERS, Carpentière
 or Charpentière, Adrien
 British, op.1745-m.1778
CARPI, Antonio Maria da
 Italian, op.1495
CARPI, Baccio
 see Ciarpi
CARPI, Girolamo da
 see Girolamo
CARPI, Ugo da
 Italian, c.1450-p.1525
CARPINONI, Domenico
 Italian, 1566-1658
CARPIONE the Elder,
 Giulio
 Italian, 1611-1674
CARPORALI, Bartolomeo
 Italian, 17th cent.
CARQUEVILLE, Will
 British, 19th cent.
CARR, David
 British, 1847-1920
CARR, Dorothy
 British, 20th cent.
CARR, Emily
 Canadian, 1871-1945
CARR, Henry Marvell
 British, 1894-1970

CARR, John
 British, op.1802-1807
CARR, Johnson
 British, c.1743-1765
CARR, Lyell
 American, 1857-1912
CARR, Samuel S.
 American, op.1878-98
CARR, Sebastian
 British, c.1928-
CARR, T.
 British, 20th cent.
CARR, Rev. William
 Holwell
 British, 1758-1830
CARRA, Baldassare di
 Matteo
 see Carrari
CARRA, Carlo
 Italian, 1881-
CARRACCA, Isidoro
 see Kraeck
CARRACCI, Agostino
 Italian, 1557-1602
CARRACCI, Annibale
 Italian, 1560-1609
CARRACCI, Antonio
 Italian, 1583-1618
CARRACCI, Franceschino
 Italian, 1595-1622
CARRACCI, Lodovico
 Italian, 1555-1619
CARRACCI, Paolo
 Italian, -1625
CARRACCIULO, Giovanni
 Battista
 see Caracciolo
CARRACH, Jan or Giovanni
 Carracha, Carracka or
 Carragua
 see Kraek
CARRALLIO, A.
 see Caraglio
CARRAND, Louis Hilaire
 French, 1821-1899
CARRARD, Louis Samuel
 Swiss, 1755/6-1839
CARRARI the Elder,
 Baldassare
 Italian, op.c.1354
CARRARI, Carra or Caroli
 the Younger, Baldassare
 di Matteo (Caroli da
 Forlì)
 Italian, c.1460-p.1520
CARRE, Jacques
 French, 1649-1694
CARRE de Malberg, Jean
 Baptiste Louis
 French, 1749-1835
CARRE, Léon Georges
 French, 1878-
CARREE or Carré,
 Franciscus
 Dutch, c.1630-1669
CARREE or Carré, Hendrik,
 II
 Dutch, 1696-1775
CARREE or Carré, Johannes
 Dutch, 1698-1772
CARREE or Carré, Michiel
 Dutch, 1657-1727/47
CARREÑO di Miranda, Juan
 Spanish, 1614-1685
CARRENO, Mario
 Cuban, 1913
CARRERA
 Spanish, 18th cent.

CARRERA, Augustin
 Spanish, 1878-
CARRERAS, Theobald
 British, 1829-1895
CARRERE, René
 French, op.1917
CARRESANA, Cristoforo
 see Carsana
CARRETTE, Georges-Emile
 French, 20th cent.
CARREY, Du
 French, op.c.1810
CARREY, Jacques
 French, 1649-1726
CARRICK, J.Mulcaster
 British, op.1854-1878
CARRICK, Robert
 British, op.1847-m.1904
CARRICK, Thomas
 British, 1802-1875
CARRIER-BELLEUSE, Pierre
 French, 1851-1933
CARRIERA, Giovanna
 Italian, 1683-1738
CARRIERA, Rosalba
 Giovanna
 Italian, 1675-1757
CARRIERE, Alphonse
 French, 1808-
CARRIERE, Eugène
 French, 1849-1906
CARRIERE, Lisbeth
 (Mme. Delvolvé-
 Carrière)
 French, op.1899-m.1934
CARRILLO, Achille
 Italian, 1818-1880
CARRINGTON, Dora
 British, 1893-1932
CARRINGTON, Jennifer
 British, 20th cent.
CARRINGTON, Leonora
 British, 20th cent.
CARRION, Juan Francisco
 Spanish, op.1672
CARROLL, John
 American, 1892-
CARROLL, J. Wesley
 British, 20th cent.
CARROLL, Lewis
 see Dodgson, Charles
 Lutwidge
CARRON, Pierre
 French, 20th cent.
CARROT, D.
 American, 20th cent.
CARRUCCI, Jacopo
 see Pontormo
CARRUTHERS, George
 British, op.1901
CARRUTHERS, Richard
 British, op.1816-1819
CARSANA or Carresana,
 Cristoforo
 Italian, op.1618
CARSE, Alexander
 ("Old Carse")
 British, op.1808-1836
CARSE, William
 British, op.1818-1845
CARSTAIRS, James Stewart
 American, 1892-1932
CARSTENS, Jacob Asmus
 German, 1754-1798
CARSTENS, Julius Viktor
 German, 1849-1908

CARTA, Natale
 Italian, 1872-1944
CARTE, Antoine (Anto)
 Belgian, 1886-1954
CARTER, Bernard
 British, op.1961
CARTER, C.
 British, op.1797-1802
CARTER, Christopher
 British, 17th cent.
CARTER, Clarence
 Holbrook
 American, 1904-
CARTER, D. Broadfoot
 British, 19th cent.
CARTER, Denis Malone
 American, 1827-1881
CARTER, Frederic
 British, 1885-1967
CARTER, George
 British, op.1769-m.1795
CARTER, H.B.
 British, op.c.1827-1841
CARTER, Howard
 British, 1873-1939
CARTER, Hugh
 British, 1837-1903
CARTER, John
 British, 1748-1817
CARTER, John
 British, 20th cent.
CARTER, Joseph Newington
 British, 1835-1871
CARTER, Richard Harry
 British, 1839-1911
CARTER, Rubens Charles
 British, 1877-1905
CARTER, Samuel John
 British, 1835-1892
CARTER, William
 British, op.c.1836-1876
CARTERET, Grace
 British, 18th cent.
CARTIER, Carl
 French, 1855-
CARTIERI, Alberto
 Italian, op.1703
CARTON, Jean Maurice
 French, 1912-
CARTWRIGHT, Joseph
 British, c.1789-1829
CARTWRIGHT, Peter
 British, 1939-
CARTWRIGHT, W.P.
 British, op.1887
CARUANA, Gabriel
 Italian, 20th cent.
CARUANA, R.
 Italian, op.c.1860
CARUELLE d'Aligny
 see Aligny
CARUS, Carl Gustav
 German, 1789-1869
CARUSO, Bruno
 Italian, 1927-
CARUSON, S.
 British, op.1830-1840
CARVAJAL, Luis de
 see Carbajal
CARVALHO
 Portuguese, 16th cent.
CARVALHO, Alexandrino
 Pedro de
 Portuguese, 1730-1810
CARVELLE, Jean Baptiste
 French, op.c.1782

CARVER, Robert
British, 1730(?)-1791
CARWARDEN, J. (not T.)
British, op.1659
CARWITHAM, John
British, op.1723-1741
CARWITHAM, Thomas
British, op.1723
CARWOOD, Amyas
British, op.1587
CARY, Francis Stephen
British, 1808-1880
CARY, William de la
Montagne
American, 1840-1922
CARZIL
Russian, 20th cent.
CARZOU, Jean Marie
French, 1907-
CASA, Giacomo
Italian, c.1835-1887
CASA, Giovanni Martino
Italian, 17th cent.
CASA, Nicolò della
(Nicole de Maison)
French, op.1543-1547
CASADO del Alisal,
José
Spanish, 1832-1886
CASALE, Francesco
see Musso, Niccolò
CASALI, Andrea
Italian, 1720/24-p.1783
CASALINI, Lucia
(wife of Felice Torelli)
Italian, 1677-1762
CASANOVA, Agostino di
Italian, op.1550
CASANOVA y Estorach,
Antonio
Spanish, 1847-1896
CASANOVA, Carlos
Spanish, op.1736-m.1762
CASANOVA, Francesco
(François-Joseph)
Italian, 1727-1802
CASANOVA, Giovanni
Battista
Italian, 1728/30-1795
CASANOVAS, Enrique
Spanish, op.c.1876
CASARIN, Alonso
(Alexander)
American, -1907
CASARINI, Athos
Italian, 1883-1917
CASAS, Juan Vila
Spanish, 1920-
CASAS, Ramon
Spanish, 1866-1932
CASAS ABARCA, Agapito
Spanish, 1874-
CASAUBON, Friedrich
see Kerseboom
CASAUS, Jesus
Spanish, 20th cent.
CASCALLA, Michele
Italian, 20th cent.
CASCAR, Henri
French, c.1605-1701
CASCELLA, Basilio
Italian, 19th cent.
CASCELLA, Tommaso
Italian, 1890-
CASCIARO, Giuseppe
Italian, 1863-1945

CASE, E.E.
American, op.1885
CASELLA, Polidoro
Italian, op.1345
CASELLI, Cristoforo
(de'Temperelli)
(Cristoforo da Parma)
Italian, c.1460-1521
CASEMBROT, Abraham
Dutch, op.c.1650-1675
CASENTINO, Giovanni dal
see Giovanni del Biondo
CASENTINO, Jacopo dal
(Landini)
see Jacopo
CASERO, Antonio
Spanish, 19th cent.
CASEY, William Linnaeus
British, 1835-1870
CASHIN, E. or F.
British, op.1825
CASILE, Alfred
French, 1847-
CASILEAR, John W.
American, 1811-1893
CASINI, Valore
Italian, op.1617
CASINI or Cassini,
Vittore
Italian, op.c.1570-1571
CASINIERE, Joelle de la
French, 20th cent.
CASISSA, Nicola
Italian, -1730
CASKIEL
British, 18th cent.
CASNELLI, Victor
American, 19th cent.
CASOLANI, Alessandro di
Agostino (Alessandro
della Torre)
Italian, 1552-1606
CASORATI, Felice
Italian, 1886-
CASPAR
German, 15th cent.
CASPAR, Carl
German, 1879-1956
CASPAR-FILSER, Maria
German, 1878-
CASPARI, Walther
German, 1869-1913
CASPARI
see Gaspari
CASPERS, Jan Baptist
see Jaspers
CASSAB, Judy
Australian, 1920-
CASSAGNE, Armand
Théophile
French, 1823-1907
CASSANA, Giovanni Agostino
("Abate Cassana")
Italian, c.1658-1720
CASSANA, Giovanni Battista
Italian, 1668-1738
CASSANA, Giovanni
Francesco
Italian, c.1611-1690
CASSANA, Niccolò
(Nicoletto)
Italian, 1659-1713
CASSANDRE, Adolphe Mouron
French, 1901-
CASSARINI, Jean
French, 1910-

CASSARINO
Italian, 17th cent.
CASSAS, Charles Hippolyte
French, 1800-
CASSAS, Louis François
French, 1756-1827
CASSATT, Mary
American, 1845-1926
CASSENS, D.
Dutch(?) op.1635/65
CASSI, Antonio
Italian, op.1905
CASSIE, James
British, 1819-1879
CASSIERS, Henry or
Hendrick
Belgian, 1858-
CASSINARI, Bruno
Italian, 1912-
CASSINELLI, B.
French, op.1850-1860
CASSINI, Giovanni Maria
Italian, c.1780
CASSIOLI, Amos
Italian, 1832-1891
CASSIOPYN, Thomas
Dutch, 1629/30-1704
CASSON, Alfred Joseph
Canadian, 1898-
CASSTEELEN, Jan Gerardus
see Casteelen
CAST, Jesse Dale
British, 20th cent.
CASTAGNO, Andrea dal
see Andrea dal Castagno
CASTAGNOLA, Gabriele
Italian, 1828-1883
CASTAGNOLI
Italian, 18th cent
CASTAIGNE, J.André
French, op.1885-1896
CASTAING, René Marie
French, 1896-
CASTAN, Gustave
Swiss, 1823-1892
CASTAN, Pierre Jean
Edmond
French, 1817-1892
CASTAÑEDA, Abdón
Spanish, -1629
CASTAÑEDA, Gregorio
Spanish, -1629
CASTEELEN or Cassteelen,
Jan Gerardus
Dutch, 1795-1847
CASTEELS, Alexander
Flemish,
op.1658/9-m.c.1681/2
CASTEELS, Frans
Flemish, 1686-1727
CASTEELS, Jacob
Flemish, op.1689-1702
CASTEELS, Pauwel
Flemish, op.1656/7
CASTEELS, Peter, I
Flemish, op.1629-m.c.1682/3
CASTEELS, Peter, III
Flemish, 1684-1749
CASTEELS, Peter Franz
Flemish, op.1690-1698
CASTEL, Moshe
American, 20th cent.
CASTELBEECK or Cantelbeeck,
H.
Dutch(?) 17th cent.
CASTELBELL, Joseph Mayr
German, op.1882

CASTELEYN, Casper or
Jasper
Dutch, op.1653
CASTELEYN, Pieter
Dutch, op.1635
CASTELL, Johan Anton
German, 1810-1867
CASTELLAMONTE, Conte
Amedeo di
Italian, op.1646-1674
CASTELLAN, Antoine
Laurent
French, 1772-1838
CASTELLANI
Italian, 20th cent.
CASTELLANI, Enrico
Italian, 1930-
CASTELLANI, Charles Jules
French, 1838-1913
CASTELLANOS, Julio
Mexican
1905-1947
CASTELLI, Bernardino
Italian, 1750-1810
CASTELLI, Bernardo
see Castello
CASTELLI, Carlo
Italian, op.1670-1680
CASTELLI, Giovanni Antonio
Italian, op.c.1700
CASTELLI, Louis
(Anton Louis Gottlob)
German, 1805-1849
CASTELLI, Paolo
Italian, op.1707-1754
CASTELLO, Annibale
Italian, op.c.1618
CASTELLO, Battista
Italian, 1547-1637
CASTELLO or Castelli,
Bernardo
Italian, 1557-1629
CASTELLO, Fabrizio
Spanish, op.1576-m.1617
CASTELLO, Felix
Spanish, 1602-1656
CASTELLO, Francesco da
see Tifernate
CASTELLO, Giacomo da
Italian, c.1550-p.1600
CASTELLO, Giovanni
Battista (Il
Bergamasco)
Italian, c.1509-1569
CASTELLO, Valerio
Italian, 1625-1659
CASTELLO y Gonzales
del Campo, Vicente
Spanish,1815-1872
CASTELLON, Federico
American, 1914-1971
CASTELLUCCI, Salvo
Italian, 1608-1672
CASTELNAU, Alexandre
Eugène
French, 1827-1894
CASTELNAU, P. de
French, 19th cent.
CASTIGLIONE, Francesco
Italian, -1716
CASTIGLIONE, Giovanni
Benedetto
(Il Grechetto)
Italian, 1616-1670
CASTIGLIONE or Castilhone,
Giuseppe
Italian, 1698-1768

CASTIGLIONE, Giuseppe
Italian, op.1869-1900
CASTIGLIONE, Salvatore
Italian, op.1645
CASTILHONE, Giuseppe
see Castiglione
CASTILLA, Juan
Spanish, 20th cent.
CASTILLO y Saavedra,
Antonio del
Spanish, 1603-1667
CASTILLO, Augustin del
Spanish, 1565-1626
CASTILLO, Jorge
Spanish, 1933-
CASTILLO, José del
Spanish, 1737-1793
CASTILLO, José Manuel
Villa
Cuban, 20th cent.
CASTILLO, Juan del
Spanish, 1584-1640
CASTRES, Edouard
Swiss, 1838-1902
CASTRES, Edouard
(the Younger)
Swiss, 20th cent.
CASTRO, Bartolomé de
Spanish, -1507
CASTRO, Felipe de
Spanish, 1711-1775
CASTRO, Francisco de
Spanish, op.c.1520
CASTRO, Gabriël Henriques
de
Dutch, 1808-1853
CASTRO, Giacomo di
Italian, op.1664-m.1687
CASTRO, Louis
French, 20th cent.
CASTRO, L.
(Laureys a Castro?)
British,
op.1664/5(?)-c.1700
CASTRO, L.A. de
Spanish, op.1637-1640
CASTRO, Lorenzo da
Spanish, op.1678-1680
CASTRO, Pedro de
Portuguese, op.1559
CASTRO, Paul de
French, 1882-1939
CASTRO, Sergio de
Argentina, 1923-
CASTRO-CID, Enrique
South American, 20th cent.
CASTROCARO
see Giovanni Jacopo da
Castrocaro
CASTY, Gian,
Swiss, 1914-
CATALA, Luis Alvarez
Spanish, 1836-1901
CATALANO, Antonio
(Il Romano)
Italian, 1560-1630
CATALANO, Gian Domenico
Italian, op.1604
CATALDI, Renato
Brazilian, 20th cent.
CATARGI, Henri
Rumanian, 1894-
CATE, Hendrik Gerrit ten
Dutch, 1803-1856
CATE, Siebe Johannes
ten
Dutch, 1858-1908

CATEL, Franz Ludwig
German, 1778-1856
CATEL, Pieter
see Cattel
CATELANI, Pietro
Italian, 17th cent.
CATELLANO, Franco
Greek, op.1560
CATELLI, Alessandro
Italian, 1809-1902
CATENA, Vincenzo di
Biagio
Italian, c.1470-1531
CATENE, Giovanni Gerardo
dalle
Italian, op.1522-1528
CATERINO Veneziano I
Italian, op.1362-1382
CATESBY, Mark
British, 1679-1749
CATHELIN, Bernard
French, 1920-
CATHELIN, Louis Jacques
French, 1738-1804
CATHELINEAU, Gaëtan
French, 1787-1859
CATHERWOOD, Frederick
British, 1799-1854
CATI, Pasquale
Italian, c.1550-c.1620
CATLETT, Elizabeth
Mexican, 1919-
CATLIN, George
American, 1796-1872
CATORIZA, Wolfgang
Joseph
see Kadorizi
CATS, Dirck van
Dutch, op.1622-1632
CATS, Jacob
Dutch, 1741-1799
CATTANEO, C.
Italian, 20th cent.
CATTANEO, Felice
Italian, c.1790-1827
CATTANEO, Gaetano
Italian, op.1800-m.1841
CATTANEO, Pietro
Italian, -1554
CATTANEO, Santo
(Santino)
Italian, 1739-1819
CATTANIO or Catanio,
Costanzo Orlandi
("Francesco Costanzo")
Italian, 1602-1665
CATTAPANE, Luca di
Gabriele di Giovanni
Francesco
Italian, op.1585-1597
CATTEI or Catel, Pieter
Dutch, 1712-p.1753
CATTEL, Pieter
see Catel
CATTELL, R.
Canadian, 20th cent.
CATTERMOLE, Charles
British, 1832-1900
CATTERMOLE, George
British, 1800-1868
CATTERSON-SMITH, S.
British, 19th cent.
CATTI, Michele
Italian, 1855-1914
CATTINI, Giovanni
Italian, c.1725-c.1800
CATTON the Elder, Charles
British, 1728-1798

CATTON the Younger,
Charles
British, 1756-1819
CATULLE, Madame J.
French, op.1898-1908
CAUCHOIS, Eugène Henri
French, 1850-1911
CAUCIG, Franz
German, 1762-1828
CAUDRON, Louis
French, op.1679-1702
CAUKERCKEN, Cornelis van
Flemish, c.1625-c.1680
CAULA or Cavola,
Sigismondo
Italian, 1637-p.1713
CAULDWELL, Leslie Giffen
American, 1861-
CAULFIELD, J.
British, 1764-1826
CAULFIELD, Patrick
British, 1936-
CAULITZ, Peter
German, 1650-1719
CAULLERY, Caulery or
Coulery, Louis de
Flemish(?), op.1594-1620
CAULLET, Charles
Alexandre Joseph
French, 1741-1825
CAURIOLI, Francesco
see Caprioli
CAUSABON, Friedrich
see Kerseboom
CAUSER, William Sidney
British, 1880-1958
CAUSSIERS, Jan
see Cossiers
CAUSTHWAITE, D.
British, 19th cent.
CAUVET, Gille Paul
French, 1731-1788
CAUVIN, Louis Edouard
Isidore
French, 1817-1900
CAUVY, Léon
French, 1874-1933
CAUWER, Emile Pierre
Joseph de
German, 1827-1873
CAUX, Martin de
French, 17th cent.
CAVACEPPI, Bartolommeo
Italian, c.1716-1799
CAVAEL, Rolf
German, 1898-
CAVAGNA, Giovanni Paolo
Italian, 1556-1627
CAVAILLES, Jean
French, 1901-
CAVALCANTI, Carlos
South American, 20th cent.
CAVALCASELLE, G.B.
Italian, 1820-1897
CAVALIER, Nicolas
see Chevalier
CAVALIERE
see Porta, Teodoro della
CAVALIERI, Giovanni
Battista
Italian, 1525(?)-1601
CAVALLERI, Ferdinando
Italian, 1794-1865
CAVALLI, Alberto
Italian, 16th cent.

CAVALLI, Gian Marco
Italian, a.1454-p.1506
CAVALLI
see Vitale da Bologna
CAVALLINI, Pietro
Italian, c.1250-1330
CAVALLINO, Bernardo
Italian, 1622-1654
CAVALLON, Giorgio
American, 1904-
CAVALLUCCI, Antonio
Italian, 1752-1795
CAVALORI, Mirabello di
Antonio(da Salincorno)
Italian, 1510/20-p.1572
CAVANYES, Antonio
see Master of Cabanyes
CAVARO, Charles Adolphe
Richard
see Richard-Cavaro
CAVARO, Michele
Italian, op.c.1544
CAVARO, Pietro
Italian, -c.1541
CAVAROZZI (Crescenzio
or dei Crescenzi)
Bartolommeo
Italian, c.1600-1625
CAVAZZA, Giovanni Battista
Italian, c.1620
CAVAZZOLA, Paolo Morando,
Il
Italian, 1486-1522
CAVAZZONI, Francesco
Italian, 1559-p.1612
CAVE, François Morellon
La
French, op.1731
CAVE, Henry
British, 1780-1836
CAVE, Jules Cyrille
French, 1859-
CAVE, Peter 1e or 1a
British, op.1769-1806
CAVE, William (James?)
British, op.1794
CAVEDONE or Cavedoni,
Giacomo
Italian, 1577-1660
CAVELERI, Lodovico
Italian, 19th cent.
CAVELIES, F. de
French, 18th cent.
CAVERSEGNO, Agostino da
see Facheris
CAVOLA, Sigismondo
see Caula
CAVRIOLI, Francesco
see Caprioli
CAWDREY, J.
see Cordrey
CAWÉN, Alvar
Finnish, 1886-1935
CAWSE, John
British, c.1779-1862
CAXES, Caxesi or
Caxete, Eugenio
Spanish, 1577-1642
CAYER, Jean de
French, 17th cent.
CAYLEY, Neville
British, op.1893
CAYLUS, Anne Claude
Philippe (de Tubières de
Grimoard de Pestels de
Levi) Comte de
French, 1692-1765

CAYRON, Jules
French, 1868/71-1940
CAZARES, Lorenzo
Spanish, -1678
CAZENAVE, J.F.
French, c.1770-
CAZES, Myrra de
(Cazes le Fils)
French, 18th cent.
CAZES, Pierre Jacques
French, 1676-1754
CAZES, Romain
French, 1810-1881
CAZIN, Jean Baptiste
Louis
French, op.1782-1839
CAZIN, Jean Charles
French, 1841-1901
CAZIN, J.M. Michel
French, 1869-1917
CAZIN, Marie
French, 1845-1924
CAZNEAU, Edward
Lancelot
British, 1809-
CAZOT
French, 18th cent.
CAZOT, Paul
French, 20th cent.
CAZZANIGA, Giancarlo
Italian, 1930-
CECCARELLI, Aurelio
Italian, 1924-
CECCARELLI, Naddo
(Nardo?)
see Ceccharelli
CECCARINI, Sebastiano
Italian, 1703-1783
CECCHARELLI or Ceccarelli,
Naddo (Nardo?)
Italian, op.1347
CECCHI, Adriano
Italian, op.1879
CECCHI, Augusto
Italian, 19th cent.
CECCHI, Dario
Italian, 1918-
CECCHI, Gaetano
Italian, op.1790
CECCHI, Sergio
Swiss, 1921-
CECCHINI, Giovanni
Battista
Italian, 1804-1879
CECCHINO da Verona
Italian, op.1477-m.a.1480
CECCO Bravo, Il
see Montelatici,
Francesco
CECCO del Caravaggio
Italian, op.1613-1620
CECCO di Pietro
Italian, op.1371-m.c.1402
CECCOLO di Giovanni
Italian, 15th cent.
CECCONI, Eugenio
Italian, 1842-1903
CECILL, Thomas
British, op.1625-1640
CEDASPE, Paolo
see Cespedes
CEDERSTRÖM, Gustaf Olof
Swedish, 1845-1933
CEDERSTRÖM, Theodore V.
Swedish, 19th cent.
CEDERSTRÖM, Ture Nikolaus
Swedish, 1843-1924

CEDINI, Constantino
di Domenico
Italian, 1741-1811
CEINITZ, Ignatius
German, 18th cent.
CELANTANO, Francis
American, 1928-
CELEBONOVIC, Marko
Yugoslavian, 1902-
CELEBRANO, Francesco
Italian, 1729-1814
CELENTANO, Bernardo
Italian, 1835-1863
CELESTI, Andrea
Italian, 1637-1706
CELESTI, Stefano
Italian, op.1638-1640
CELIĆ, Stojan
Yugoslavian, 1925-
CELIO, Gaspare
Italian, 1571-1640
CELLINI, Benvenuto
Italian, 1500-1571
CELLINI, F.
Italian, op.1891
CELLONY the Elder,
Joseph
French, 1663-1731
CELLONY the Younger,
Joseph
French, 1730-1786
CELLONY, Joseph André
French, 1696-1746
CELOMMI, Pasquale
Italian, 1860-
CELOS, Julien
Belgian, 1884-
CELS, Cornelis
Belgian, 1778-1859
CEMICKY, Ladislav
Czech, 1909-
CEMMO, G. Pietro da
Italian, 15th cent.
CENATIEMPO, Geronimo
Italian, op.1705-1730
CENEDA, Guido
Italian, 20th cent.
CENNI di Francesco di
Ser Cenni
Italian, op.1410
CENNINI, Cennino di Drea
Italian, op.c.1370-p.1398
CENTINO, Il
see Nagli, Francesco
CERACCHI, Giuseppe
Italian, 1751-1802
CERAMANO, Charles-
Ferdinand
Belgian, 1829-1909
CERANO, Il
see Crespi, Giovanni
Battista
CERCEAU, Jacques, I.
Androuet du
see Ducerceau
CERCONE, Ettore
Italian, 1850-1896
CERESA, Carlo
Italian, 1609-1679
CERET
French, 20th cent.
CEREZO the Younger,
Mateo
Spanish, 1635-1685

CERIA, Edmond
French, 1884-
CERIEZ, Théodore
Belgian, 1832-1904
CERIGHELLI, Pietro
Italian, op.c.1740
CERIPPA, Gaetano
Italian, 20th cent.
CERMAK, Jaroslaw
see Czermak
CERNOTTO or Cernotis,
Stefano
Italian, op.1530-m.1548
CEROLI, Mario
Italian, 1938-
CERQUOZZI, Michelangelo
(Michelangelo delle
Battaglie or delle
Bambocciate)
Italian, 1602-1660
CERRES, Caroline (née
Baudry de Balzac)
French, 1799-p.1836
CERRI, Giulio
see Cervi
CERRINI or Cerini,
Giovanni Domenico
(Cavaliere Perugino)
Italian, 1609-1681
CERROTI, Violante
Beatrice
see Siries
CERRUTI, Michelangelo
Italian, 1666-1748
CERUTI, Giacomo
Italian, op.1750
CERUTTI, Juan Santiago
Spanish, (?) 18th cent.
CERVA, Antonio
Italian, op.1649
CERVA, Antonio
Italian, op.1649
CERVA, Giovanni
Battista della
Italian, op.1540-1548
CERVELLI, Enrico
Italian, 20th cent.
CERVELLI, Federigo
Italian, 1625-a.1700
CERVI, Bernardino
Italian, c.1596-1630
CERVI or Cerri, Giulio
Italian, 17th cent.
CERVI, G.
Italian, 19th cent.
CESA or Chiesa, Matteo
Italian, op.c.1500
CESAR, Baldaccini C.
French, 1921-
CESARE da Conegliano
Italian, op.1583
CESARE di Piemonte or
da Saluzzo
Italian, 16th cent.
CESARE da Sesto
Italian, 1476/77-1523
CESAREI, Piero
(Pierino di Cesarei
da Perugia)
Italian, c.1530-1602
CESARETTI, Serafino
Italian, 19th cent.
CESARI, Bernardino
Italian, -1614
CESARI, Giuseppe
(Il Cavaliere d'Arpino
or Josepin)
Italian, 1568-1640

CESARIANO, Cesare di
Lorenzo
Italian, 1483-1543
CESARINE, F.
French, 18th cent.
CESCHINI, Giovanni
Italian, 1583-1649
CESETTI, Giuseppe
Italian, 1902-
CESI, Bartolommeo
Italian, 1556-1629
CESIO, Carlo
Italian, 1626-1686
CESPEDES, Pablo de
(Paolo Cedaspe)
Spanish, 1538-1608
CESTARO, Jacopo
Italian, 18th cent.
CESTNIK, Franz
German, 1921-
CESURA, Pompeo
(Pompeo dell'Aquila
or Aquilano)
Italian, op.1569-m.1571
CETL, G.
Czech, 19th cent.
CETNAROWSKI, Antoni
Polish, 20th cent.
CEUSTER, Adam de
see Coster
CEZANNE, Paul
French, 1839-1906
CHABAN, Herban
French, 20th cent.
CHABANNE, Flavien
Emmanuel
French, 1799-p.1858/59
CHABAS, Maurice
French, 1863-1947
CHABAS, Paul
French, 1869-1937
CHABAUD, Auguste
French, 1882-
CHABAUD, Jean
French, 20th cent.
CHABORD, Joseph
French, 1786-1848
CHABOT, Duchesse de
French, op.1778
CHABOT, Georges
French, 1883-1968
CHABOT, Hendrikus
(Hendrik)
Dutch, 1894-1949
CHABRIE, le Père
French, op.1756
CHABRILLAC, Charles
Raymond
French, 1804-p.1842
CHABRILLAN, Roselyne,
Marquise de
French, 20th cent.
CHABRY, Leonce
French, 1832-1883
CHACATON, Jean Nicolas
Henri de
French, 1813-p.1857
CHACÓN, Francisco
Spanish, op.1480
CHADWICK, Lynn
British, 1914-
CHADWICK, Tom
British, op.1930-1950
CHAFRION, Lorenzo
(Fray Matias de
Valencia)
Spanish, 1696-1749
CHAGALL, Marc
Russian, 1889-

CHAGOT, Emond
French, 1832-p.1885
CHAHINE, Edgar
French, 1874-1937
CHAIGNEAU, Jean
Ferdinand
French, 1830-1906
CHAIGNEAU, Theophilus
Henry
British, c.1760-p.1792
CHAILLON, Louis de
see Chatillon
CHAILLOT, Louis de
see Chatillon
CHAILLOU, Narcisse
French, 1837-
CHAIR, R.B. de
French, op.c.1785
CHAISSAC, Gaston
French, 1910-1964
CHAIX, Louis
French, c.1740-c.1811
CHAJET
French, 20th cent.
CHALEM
French, 20th cent.
CHALETTE, Jean
French, 1581-1643
CHALEYE, Jean
(Joannès)
French, 1878-1960
CHALFANT, Jefferson
David
American, 1856-1931
CHALGRIN, Jean François
Thérèse
French, 1739-1811
CHALIAPIN, Boris
Russian, 20th cent.
CHALIAPIN, Feodor
Russian, 1873-1938
CHALIZOW, Sergei
Russian, 20th cent.
CHALLAMEL, Jules Robert
(Pierre Joseph)
French, 1813-p.1848
CHALLE, Charles Michel-
Ange
French, 1718-1778
CHALLE or Challes,
Simon
French, 1719-1765
CHALLENGER, Michael
British, 20th cent.
CHALLENER, Frederick
Sprosten
Canadian, 1869-1959
CHALLEE, Jean
French, 1880-1943
CHALLENOR
British, 18th cent.
CHALLIN, A.J. Miss
British, 20th cent.
CHALMERS, Sir George
British, op.1755-m.1791
CHALMERS, George Paul
British, 1833-1878
CHALMERS, J.
British, op.1721
CHALMERS, Roderick
British, op.1721-1730
CHALMERS, W.A.
British, op.1790-1798
CHALON, Alfred Edward
British, 1780-1860
CHALON, Christina
(Christina Rüppe)
Dutch, 1748-1808

CHALON, Henry Bernard
British, 1770-1849
CHALON, John James
British, 1778-1854
CHALON, Louis
Dutch, 1687-1741
CHALON, Louis
French, 1866-
CHAM
see Noé, Amedée
Charles Henri de
CHAMAILLARD, Ernest de
French, 1865-1930
CHAMBARS, Thomas
British, c.1724-1789
CHAMBERLAIN, Brenda
British, 1912-
CHAMBERLAIN, Sir Henry
British, 1796-1843
CHAMBERLAIN, Mason
see Chamberlin
CHAMBERLAIN, William
British, op.1794-m.1817
CHAMBERLIN, Mason
British, op.1760-m.1787
CHAMBERLIN or Chamberlain,
Mason the Younger
British, op.1786-1826
CHAMBERS, Charles Edward
American, 1883-1941
CHAMBERS, George
British, 1803-1840
CHAMBERS, George
British, op.1848-1862
CHAMBERS, John
Canadian, 1931-
CHAMBERS, Thomas
American, 1808(?)-p.1866
CHAMBON, Emil
Swiss, 1905-
CHAMBRE, Jean de la
Dutch, c.1600-1668
CHAMISSO, Adelbert von
(Louis Charles Adelaide,
Comte de)
French, 1781-1838
CHAMPAGNE or Champaigne,
Jean Baptiste de
French, 1631-1681
CHAMPAGNE or Champaigne,
Philippe de
French, 1602-1674
CHAMPEAUX DE LA BOULAYE,
Octave de
French, 1827-1903
CHAMPIN, Jean Jacques
French, 1796-1860
CHAMPION, Theo
German, 1887-1952
CHAMPMARTIN, Charles
Emile (Callande de
Champmartin)
French, 1797-1883
CHAMPNEY, Benjamin
American, 1817-1907
CHAMPNEY, James Wills
American, 1843-1903
CHANA, Alexandre de la
Swiss, 1703-1765
CHANCE, Julia Charlotte
(Mrs. W. Chance)
née Strachey
British, 19th Cent.
CHANTCOURTOIS, René
Louis Maurice Béguyer
de
French, 1757-1817

CHANDELLE, Andreas
Joseph
German, 1743-1820
CHANDLER, Joseph Goodhue
American, 1813-1880(?)
CHANDLER, John W.
British, c.1769-c.1804
CHANDLER, Winthrop
American, 1747-1790
CHANDOR, Douglas
American, 1897-
CHANDRA, Avinash
British, 20th cent.
CHANEY, Lawrence
American, 20th cent.
CHANLER, Robert Winthrop
American, 1872-1930
CHANSON, Emile Charles
French, 1820-p.1872
CHANTAL, Jean Adelin
Louis (Louis)
Dutch, 1822-1899
CHANTALAT, Edouard
French, op.1890-1898
CHANTEREAU, Chantreau
or Chantreau, Jérôme
François
French, c.1710-1757
CHANTREY, Sir Francis
Legatt
British, 1781-1841
CHANTRON, Alexandre
Jacques
French, 1842-1918
CHANTRON, Antoine
French, 1771-1842
CHANTRY, John
British, 17th cent.
CHAPELAIN-MIDY, Roger
French, 1904-
CHAPELAT
French, op.1824
CHAPELLIER, P.
French, 19th cent.
CHAPERON
French, 18th cent.
CHAPERON, Eugène
French, 1857-
CHAPIN, David
British, 20th cent.
CHAPIN, Francis
American, 1899-
CHAPIN, Henry C.
American, 19th cent.
CHAPIN, James Ormsbee
American, 1887-
CHAPIN, John R.
American, 1823-
CHAPIRO, Jacques
Russian, 1887-
CHAPLIN, A. Lawson
British, 19th cent.
CHAPLIN, Arthur
French, 1869-
CHAPLIN, Charles
(Charles Joshua)
French, 1825-1891
CHAPLIN, Edward
American, 1932-
CHAPLIN, Elizabeth
French, 20th cent.
CHAPLIN, Florence E.
British, 19th cent.
CHAPLIN, Stephen
British, 20th cent.
CHAPMAN, Miss C.
British, 20th cent.

CHAPMAN, Carlton
Theodore
American, 1860-1925
CHAPMAN, Charles
British, op.1776
CHAPMAN, Charles S.
American, 1879
CHAPMAN, Conrad Wise
American, 1842-1910
CHAPMAN, George
British, 19th cent.
CHAPMAN, George
British, 1908-
CHAPMAN, John
British, op.1792-1823
CHAPMAN, John Gadsby
American, 1808-1889
CHAPMAN, John Linton
American, 19th cent.
CHAPMAN, John Watkins
British, op.1853-1903
CHAPMAN, Mary Elizabeth
British, 19th cent.
CHAPMAN, Thomas
British, op.1747
CHAPONNIER or Chaponnière,
Alexandre
Swiss, 1753-1805
CHAPPEL, Alonzo
American, 1828-1887
CHAPPEL, Edouard
Belgian, 1859-
CHAPPELL, William
British, op.1858-1882
CHAPRON, Nicolas
French, 1612-c.1656
CHAPU, Henri
(Michel Antoine)
French, 1833-1891
CHAPUIS the Elder
French, op.1761-1787
CHAPUY, Nicolas Marie
Joseph
French, 1790-1858
CHARAVEL, Paul Frédéric
Antoine
French, 1877-
CHARBONNEAU, Monique
Canadian, 1928-
CHARBONNET or Charbonnel
French, op.1551/1561
CHARBONNIER, Pierre
French, 1897-
CHARCHOUNE, Serge
Russian, 1888-
CHARDERON, Francine
French, op.1885
CHARDIN, Gabriel-
Gervais
French, 1814-1907
CHARDIN, Jean Baptiste
Siméon
French, 1699-1779
CHARDIN, Paul Louis Léger
French, 1833-
CHARDON, F.
British? 19th cent.
CHARDON, Marguerite
Virginie
see Ancelot
CHAREN, Eugenie Marguerite
Honorée Lethière
see Servières
CHARETTE-DUVAL, Francois
French, op.1836-1878
CHARLAMOFF, (Harlamoff),
Alexej Alexejewitsch
Russian, 1842-

CHARLEMAGNE, Paul
French, 1892-
CHARLEMONT, Eduard
German, 1848-1906
CHARLEMONT, Hugo
German, 1850-1939
CHARLEMONT, Matthias
Adolf
German, 1820-1872
CHARLES, J.
French(?) op.1795
CHARLES, James
British, 1851-1906
CHARLES, Samuel M.
American, op.1836-1840
CHARLES, William
American, 1776-1820
CHARLET, Frantz
Belgian, 1862-1928
CHARLET, Nicolas
Toussaint
French, 1792-1845
CHARLIER, Jacques
French, c.1720-1790
CHARLOT, Jean
French, 1898-
CHARLOT, Louis
French, 1878-
CHARLOT, Paul
French, 1906-
CHARLTON, Mrs. Edith M.
English op.1894-1904
CHARLTON, Edward Wm.
British, 1859-1935
CHARLTON, Evan
British, 1904-
CHARLTON, George
British, 1899-
CHARLTON, J.
British, 20th cent.
CHARLTON, John
British, 1849-1917
CHARLTON, W.H.
British, op.1889-1908
CHARLY, C.
French, 18th cent.
CHARMAISON, Raymond
French, op.1898-1911
CHARMET, Pierre
French, 20th cent.
CHARMET, Raymond
French, 20th cent.
CHARMETON, Georges
French, 1623-1674
CHARMY, Emilie
French, 1880-
CHARNAY, Armand
French, 1844-1915
CHARODEAU, François
Auguste
French, 1840-1882
CHARON, Antoine
see Caron
CHARONTON, Charton,
Quarton or Charretier,
Enguerrand
French, c.1410-p.1461
CHAROS, A.R. de
see Kerseboom, Friedrich
CHAROUX, Siegfried
German, 1896-
CHARPENTIER, Alexandre
Louis Marie
French, 1856-1909
CHARPENTIER, Auguste
French, 1813-1880
CHARPENTIER, Caroline de
French, op.c.1790

CHARPENTIER, Constance
Marie
French, 1767-1849
CHARPENTIER, George
French, 19th cent.
CHARPENTIER the Elder,
Jean Baptiste
French, 1728-1806
CHARPENTIER, René
French, 1680-1723
CHARPIN, Albert
French, 1842-1924
CHARPY, C.
French, op.c.1815
CHARRAT
French, 20th cent.
CHARRETIER, Enguerrand
see Charonton
CHARRETON, Victor
French, 1864-1937
CHARTERIS, A.
British, 19th cent.
CHARTIER, Henri Georges
Jacques
French, 1859-1924
CHARTIER, Jean
French, c.1500-p.1584
CHARTON, Camille
French, op.1810
CHARTON, Enguerrand
see Charonton
CHARTON, Ernest
American, 19th cent.
CHARTRAN, Théobald
French, 1849-1907
CHARTRES, F.L.D.
see Langlois, François
CHARVET, J.C.
French, op.1804
CHASE, G.
British, op.1797-1811
CHASE, Henry (Harry)
American, 1853-1889
CHASE, John
British, 1810-1879
CHASE, Marian Emma
British, 1844-1905
CHASE, William Arthur
British, 1878-1944
CHASE, William Merrit
American, 1849-1916
CHASNIK, Ilya
Russian, 20th cent.
CHASSAIGNAC, Madame
French, op.c.1815
CHASSE, Barthélemy
French, 18th cent.
CHASSELAT, Charles
Abraham
French, 1782-1843
CHASSELAT, Henri Jean
Saint Ange
French, 1813-1880
CHASSELAT, Pierre
French, 1753-1814
CHASSERIAU, Théodore
French, 1819-1856
CHASSEVENT, Marie Joseph
Charles
French, 19th cent.
CHASSEVENT-BACQUES,
Gustave Adolphe
French, 1818-1901
CHASTEL, François du
see Duchatel
CHASTEL, Roger
French, 1897-
CHASTELET, Claude Louis
see Chatelet

CHASTILLON, Louis de
see Chatillon
CHATAIGNER, Alexis
French, 1772-1817
CHATEAUBOURG, Le
Chevalier de
(or Dechateaubourg)
French, op.1790-1837
CHATELAIN
French, 18th cent.
CHATELAIN, Antoine
French, 1794-1859
CHATELAIN or Chatelin,
Jean Baptiste Claude
French, c.1710-c.1771
CHATELET or Chastelet,
Claude Louis
French, 1753-1794
CHATFIELD
American, 20th cent.
CHATFIELD, Rev. H.
British, op.1781-1801
CHATILLON, Auguste de
French, 1808-1881
CHATILLON, Charles de
French, 1777-1844
CHATILLON or Chastillon,
Claude
French, 1560-1616
CHATILLON, Chastillon,
Chaillon or Chaillot,
Louis de
French, 1639-1734
CHATILLON, Zoé Laure de,
née Delaune
French, c.1826-1908
CHATTEL, Frederick
Jacobus van Rossum du
Dutch, 1856-1917
CHAUDET, Antoine-
Denis
French, 1763-1810
CHAUDET, Henriette
Amélie
French, op.1879-1882
CHAUDET and Husson,
Jeanne-Elisabeth
née Gabiou
French, 1767-1832
CHAUFOURIER, Jean
French, 1679-1757
CHAURAND-NAURAC, Jean
Raoul
French, 1878-1932
CHAUVEAU, François
French, 1613-1676
CHAUVEL, Théophile
Narcisse
French, 1831-1909
CHAUVIN, Pierre
Athanase
French, 1774-1832
CHAVAL
French, 20th cent.
CHAVANE, E.
British, op.c.1850
CHAVANNE
see Domenchin de,
Pierre Salomon
CHAVANNES, Alfred
Swiss, 1836-1894
CHAVARD, A.
French, 1810-1885
CHAVES, Balthasar
see Echave
CHAVET, Victor Joseph
French, 1822-1906

CHAVEZ y Artiz,
José de
Spanish, op.1860-1880
CHAYLLERY, Eugène
Louis
French, op.1879
CHAYS, Louis
French, op.1776-1804
CHAZAL, Toussaint
Antoine de
French, 18th cent.
CHAZEL, Malcolm de
French, 1902-
CHAZERAND, Alexandre
Claude-Louis-Alex
French School, 1757-1795
CHEARNLEY, Anthony
British, op.1740-1785
CHECA y Sanz, Ulpiano
Spanish, 1860-1916
CHEDEL, Pierre Quentin
French, 1705-1763
CHEDRIN, Silvestre
Russian, op.1821
CHEEPEN, David
British, 1946-
CHEERE, Sir Henry
British, 1703-1781
CHEESMAN, Harold
British, 1915-
CHEESMAN, Thomas
British, 1760-c.1834/5
CHELIUS, Adolf
German, 1856-1923
CHELMINSKI, Jan
Polish, 1851-1925
CHELMONSKI, Josef
Polish, 1850-1914
CHEN, Hilo
American, 1942-
CHENARD, Christian
French, 1918-
CHENARD-HUCHE, Georges
French, 1864-1937
CHENAVARD, Paul Marc
Joseph
French, 1807-1895
CHENEVIX TRENCH, P.
South African,
op.1854-1855
CHENEY, John
American, 1801-1885
CHENEY, Leo
British, 20th cent.
CHENEY, Seth Wells
American, 1810-1856
CHENIER, Madame
French, 18th cent.
CHENU, Augustin Pierre
Bienvenu (Fleury
Chenu)
French, 1833-1875
CHERE, Giovanni
see Leclerc, Jean
CHEREAU, Claude
French, 1883
CHEREAU, François
French, 1680-1729
CHERET, Jean Louis
(Lachaume de Gavaux)
American, 1820-1882
CHERET, Jules
French, 1836-1932
CHERIANE, Cherie-Anne
French, 1900-

CHERIKA
Russian, 20th cent.
CHERNETZOFF, Gregor
Russian, 18th -19th cent.
CHERNY, Danila
Russian, 15th cent.
CHERON, Elisabeth-Sophie
(Mme. Le Hay)
French, 1648-1711
CHERON, Louis
French, 1660-1713(?)
CHERPIN, Alexina
(Lecomte)
French, 1834-p.1894
CHERPITEL, Mathurin
French, 1736-1809
CHERTON
French, 19th cent.
CHERUBINI, A.
Italian, 19th cent.
CHERUBINI, G.D.
Italian, op.1811
CHERUBINI, Marie Louis
Charles Zanobi
Salvador
French, 1760-1842
CHERUBINO, Antonio
see Gherardi
CHERUBINUS, Frater
German, op.1639
CHERVIN
French, 20th cent.
CHERY, J.B.
Haitian, 20th cent.
CHERY, Philippe
French, 1759-1838
CHESELDEN, William
British, 1665-1745
CHESHAM, Francis
British, 1749-1806
CHESHER, A.W.
British, 20th cent.
CHESSA, Luigi (Gigi)
Italian, 1898-1935
CHESTER, George
British, 1813-1897
CHESTER, S.
British, op.1849-1885
CHESTERTON, G.K.
British, 1874-
CHESTERTON, M.
British, op.1920-1940
CHESTON, Charles Sidney
British, 1882-
CHESTON, Evelyn
née Davy
British, 1875-1929
CHETTLE, James Patchell
British, 1871-
CHEVAL, Bertrand
French, 20th cent.
CHEVALIER, Adolf
German, 1831-
CHEVALIER, Ferdinand
Belgian, 19th cent.
CHEVALIER, Jean-Pierre
French, 20th cent.
CHEVALIER, Jean
French, c.1725-c.1790
CHEVALIER, L.
French, 19th cent.
CHEVALIER, Nicholas
British, 1828-1902
CHEVALIER, Cavalier or
Chevallier, Nicolas
French, op.1677-m.1720
CHEVALIER, William
British, 19th cent.

CHEVARDI
French, 18th cent.(?)
CHEVAUX
French, op.1780
CHEVE, Giovanni
see Leclerc, Jean
CHEVENEAU, (Chaveneau)
Claude
French, op.1589-1633
CHEVENIR, C.
French, op.1809
CHEVILLET, Justus
German, 1729-1802
CHEVILLIARD or
Chevillard, Vincent
French, 1841-1904
CHEVIN, R.
French, 18th cent.
CHEVIOT, Lilian
British, op.1895-1911
CHEVOTET, Jean Michel
French, 1698-1772
CHEVTCHENKO, T.
Russian, op.1840-58
CHIALIVA, Luigi
Italian, 1842-1914
CHIALLI, Vincenzo
Italian, 1787-1840
CHIANTZ
German(?)op.1810
CHIAPORY, Bernard
Charles
French, op.1851-1859
CHIAPPE, Giovanni
Battista
Italian, 1723-1765
CHIARELLA, G.
Italian, 19th cent.
CHIARELLI, Giacomo
Italian, 17th cent.
CHIARI, Fabrizio
Italian, 1615-1695
CHIARI, Giuseppe
Bartolomeo
Italian, 1654-1727
CHIARI, Tommaso
Italian, 1665-1733
CHIARINI, Marcantonio
Italian, 1652-1730
CHIAROTTINI or
Chiaruttini, Francesco
Italian, 1748-1796
CHIAVEGHINO, Il
see Mainardi, Andrea
CHIAVELLI, Antonio
Italian, 18th cent.
CHIAVISTELLI, Jacopo
Italian, 1621-1698
CHIAZZELLA, Andrea
see Squazella
CHIBANOFF, M.
Russian, op.1764-1788
CHICHARRO y Aguera,
Eduardo
Spanish, 1873-
CHICHKIN, Ivan
Ivanovitch
Russian, 1834-1898
CHIEM, To
Oriental, 20th cent.
CHIERICI, Gaetano
Italian, 1838-1921
CHIERICO, Francesco
d'Antonio del
Italian, 15th cent.(?)
CHIESA, Giovanni della
Italian, op.1490-1519
CHIESA, Joseph
British(?) op.1760

CHIESA, Matteo
see Cesa
CHIESA, Pietro
Swiss, 1876/78-1959
CHIESA, Silvestro
Italian, 1623-1657
CHIFFLARD
French, op.1812-1815
CHIFFLART, François
Nicolas
French, 1825-1901
CHIGHINE, Alfredo
Italian, 1914-
CHIGHIUE, Alfredo
Italian, 20th cent.
CHIGNOLI, Girolamo
Italian, c.1630
CHIGOT, Eugène
(Henri Alexandre)
French, 1860-1923
CHILD, Edwin Burrage
American, 1868-
CHILD, Thomas
British, -1706
CHILDE, Elias
British, op.1798-m.1848
CHILDE or Child, James
Warren
British, 1778-1862
CHILDS, F.
American, op.1860
CHILDS, George
British, op.1833-1873
CHILLIDA, Eduardo
Spanish, 1924-
CHIMENTI, Jacopo
(Jacopo da Empoli)
Italian, c.1554-1640
CHIMONAS
Greek, 20th cent.
CHIMOT, Edouard
French, 19th cent.
CHIN.RD, Joseph
French, 1756-1813
CHINI, Galileo
Italian, 1873-
CHINN, Samuel Thomas
British, op.1833-1848
CHINNERY, George
British, 1748-1847
CHINTREUIL, Antoine
French, 1814-1873
CHIODAROLO or Chiodaruolo,
Giovanni Maria
Italian, op.1506
CHIOZZOTTO
see Marinetti, Antonio
CHIPMAN
American, op.c.1840-c.1850
CHIPPENDALE, Thomas
British, c.1709-1779
CHIRICO, Giacomo di
Italian, 1844/5-1884
CHIRICO, Giorgio de
Italian, 1888-
CHIRIN, Procopius
Russian, op.1620-1640
CHIRNOAGA-MILARENCO,
Marcel
Rumanian, 1930-
CHISHOLM, Alexander C.
British, 1792/3-1847
CHITI, Remo
Italian, 20th cent.
CHITTUSSI, Anton
Czech, 1847-1891
CHIULINOVICH, Giorgio di
Tommaso
see Schiavone, Giorgio
CHLEBOWSKI, Stanislaus
Russian, 1835-1884

CHMEIKOFF, P.
Russian, 19th cent.
CHOCARNE-MOREAU, Paul
Charles
French, 1855-1930
CHODACIEVICH
Russian, 20th cent.
CHODOWIECKA, Susanne
(Mme. Henry)
German, 1763-1812
CHODOWIECKI, Daniel
Nikolaus
German, 1726-1801
CHODOWIECKI, Gottfried
German, 1728-1781
CHODOWIECKI, L. (Ludwig?)
Wilhelm
German, 1765-1805
CHODOWIECKI-GRETSCHEL,
Marianne
German, 19th cent.
CHOFFARD, Pierre Philippe
French, 1730-1809
CHOISEUL-GOUFFIER
French, 18th cent.(?)
CHOISY, A.
French, op.1873
CHOPARD, Jean-Francois
French, 18th cent.
CHOPIN, Henri Frédéric
see Schopin
CHOQUET, Pierre Adrien
French, 1743-1813
CHORIS, Ludwig
Russian, 1795-1828
CHOTENOVSKY, Zdenek
Czech, 20th cent.
CHOUBRAC
French, 19th cent.
CHOULANT, Ludwig
Theodor
German, 1827-1900
CHOULTSE, Ivan F.
Russian, 1877-
CHOW KWA SCHOOL
Oriental, 19th cent.
CHOWNE, Gerard
British, 1875-1917
CHRETIEN, Félix
French, c.1510-1579
CHRETIEN, Gilles Louis
French, 1754-1811
CHRETIEN, René Louis
French, 1867-
CHRIST, Joseph
German, 1732-1788
CHRIST, Martin
Swiss, 1900-
CHRIST, Pieter Caspar
Dutch, 1822-1888
CHRISTENSEN, Carl C.A.
Danish, 1831-1912
CHRISTENSEN, Dan
American, 1942-
CHRISTENSEN, Finn
Scandinavian, 20th cent.
CHRISTENSEN, Godfred
Danish, 1845-1828
CHRISTENSEN, John
Danish, 1896-1940
CHRISTENSEN, Kay
Scandinavian, 1899-
CHRISTENSEN, N.
Danish, op.c.1817
CHRISTIAN, Ewan
British, 1813-1895
CHRISTIAN, Jan
Dutch, op.1677

CHRISTIAN-ADAM,
Raoul Raymond
French, 20th cent.
CHRISTIANSEN, Hans
German, 1866-1945
CHRISTIANSEN, N.H.
Scandinavian, 19th cent.
CHRISTIANSEN, Paul Simon
Danish, 1855-1933
CHRISTIE, James Elder
British, 1847-1914
CHRISTINA, Queen of
Sweden
Swedish, 1626-1689
CHRISTINEC, Ludwig
(Carl Ludwig)
Russian, 1762-1813
CHRISTO
Bulgarian, 1935-
CHRISTOFFELS, Melchior
Flemish, 1615-p.1635
CHRISTOFFERSEN, Frede
Danish, 1919-
CHRISTOFOROU, John
British, 20th cent.
CHRISTOPH van Utrecht
Netherlands, c.1498-1557
CHRISTOPHE or
Christophle, Joseph
French, 1662-1748
CHRISTOPHERSON, John
British, 1921-
CHRISTUS or Cristus,
Petrus
Netherlands,
op.1444-m.1472/3
CHRISTY, Howard Chandler
American, 1873-
CHRYSOLORAS, Spiridon
Greek, op.c.1550
CHRYSSA
American, 20th cent.
CHUBB, John
British, 18th cent.
CHUBBARD, Thomas
British, c.1738-1809
CHUDANT, Jean Adolphe
French, 1860-
CHUDJAKOFF, Vassily
Grigorjevich
Russian, 1826-1871
CHUIKOV (Tschuikoff)
Semjon Afanasjewitch
Russian, 1902-
CHUMAKOV, A.
Russian, op.c.1900-
CHUNG, Nguyen Tien
Vietnamese, 20th cent.
CHURBERG, Fanny Maria
Finnish, 1845-1892
CHURCH, Sir Arthur
Herbert
British, 1834-1915
CHURCH, C.
British, op.1821
CHURCH, Frederick Edwin
American, 1826-1900
CHURCH, Frederic S.
American, 1842-1924
CHURCHILL, William W.
American, 1858-1926
CHURCHILL, Winston
Spencer
British, 1874-1965
CHURCHYARD, Thomas
British, 1798-1865
CHURRIGUERA, Alberto de
Spanish, a.1700-p.1747

CHURRIGUERA, José or
Joseph
Spanish, 1650-1723
CHWALA, Adolf
Czech, 1836-1888
CHWALA, Fritz
Czech, op.1880-1900
CHWATAL
see Quadal
CHWISTEK, Leon
Polish, 19th cent.
CIABILLI, Giovanni
Cammillo
Italian, 1675-1746
CIAFFERI, Pietro
(Smargiasso)
Italian, c.1610-p.1651
CIALDIERI, Girolamo
Italian, 1593-1680
CIALOWICZ, Tadeusz
Polish, 20th cent.
CIAMBERLANO, Luca
Italian, c.1580-1641
CIAMPELLI, Agostino
Italian, 1565-1630
CIAMPELLUS, Domenicus
see Domenchino
CIAMPI, F.
Italian, 19th cent.
CIANFANELLI, Nicola
Italian, 1793-1848
CIANFANNI, Giovanni di
Benedetto
Italian, 1462-1542
CIANGOTTINI, Giovanni
Italian, 1912-
CIANI, Cesare
Italian, 1854-1925
CIARDI, Beppe
(Giuseppe)
Italian, 1875-1932
CIARDI, Emma
Italian, 1879-1933
CIARDI, Giuseppe
Italian, op.1808-1845
CIARDI, Guglielmo
Italian, 1843-1917
CIARDO, Vicenzo
Italian, 1894-
CIARPI or Carpi,
Baccio
Italian, 1578-p.1644
CIARROCHI, Arnoldo
Italian, 1916-
CIARTRES, F.L.D.
see Langlois, François
CIBOT, Edouard
(François Berthelemy
Michel)
French, 1799-1877
CIBURRI, Polidoro di
Stefano
Italian, op.1540-m.1567
CICCIO, l'Abbate
see Solimena, Francesco
CICCIO, Il
see Fracanzano,
Francesco
CICERI, Eugène
French, 1813-1890
CICERI, Pierre Luc
Charles
French, 1782-1868
CICILIANO, Giacomo
see Duca, Giacomo del
CICOGNARA or Cicognari,
Antonio
Italian, op.1483-1500

CIERINGS or Cierinx,
Alexander
see Keirincx
CIERINGS, Jacob or
Johann
see Keirincx, Alexander
CIESLEWICZ, Roman
Polish, 20th cent.
CIESLEWSKI, Tadeusz
Polish, 1870-1956
CIESZKOWSKI, Henryk
Polish, 1835-1895
CIETARIO, Jacopo
Italian, op.1460
CIETTY, (Cietti)
French, 1750-
CIEZA, Josef de
Spanish, 1656-1692
CIEZA, Manuel Jeronimo
Spanish, 1611-1685
CIFRONDI or Zifrondi,
Antonio
Italian, 1657-1730
CIGNANELLI, Michele
Italian, 16th cent.
CIGNANI, Carlo
Italian, 1628-1719
CIGNANI, Felice
Italian, 1660-1724
CIGNAROLI, Fra Felice
(Giuseppe)
Italian, 1726-1796
CIGNAROLI, Giovanni
Bettino
Italian, 1706-1770
CIGNAROLI, Giovanni
Domenico
Italian, 1722-1793
CIGNAROLI, Martino
(Il Veronese)
Italian, 1649-1726
CIGNAROLI, Scipione
Italian, 1715-1766
CIGNAROLI, Vittorio
Amadeo
Italian, 1747-1793
CIGNONI or Cingnoni,
Bernardino di Michele
Italian, op.1464-m.1496
CIGOLA, Giovanna
Battista
Italian, 1769-1841
CIGOLI, Lodovico Cardi
da
Italian, 1559-1613
CIKOVSKY, Nicolai
American, 1894-
CIMA da Conegliano,
Giovanni Battista
Italian, c.1459-1517/8
CIMABUE, Cenni di Pepo
Italian, c.1240-c.1301
CIMAROLI, Giovanni
Battista
Italian, op.c.1700-p.1753
CIMATORI, Antonio
(Il Visaccio or Visaccio)
Italian, c.1550-1623
CIMIERE, Reine
French, 20th cent.
CINA, Colin
British, 1943-
CINCINNATO, Romulo
Italian, 1502(?)-1593/1600
CINGANELLI, Michelangelo
Italian, c.1580-1635
CINGELAER, Cingelaar or
Singelaer, Melchior
Dutch, op.1710-m.1755

CINI, Giovanni di
Lorenzo
Italian, op.1526-1545
CINI, Mario
Italian, 19th cent.
CINIER or Ponthus-
Cinier, Claude Antoine
French, 1812-1885
CINOTTI, D.Ubaldus
Italian, 1591-1664
CINQUI, Giovanni del
Italian, 1667-1743
CIOBOTARU, Gillian Wise
British, 1936-
CIOCA, Dan
Rumania, 20th cent.
CIOCCHI (Cioci) Antonio
Italian, op.1722-c.1780
CIOLI, Valerio di
Simone
Italian, 1529-1599
CIONE
see Orcagna
CIOR, Pierre Charles
French, 1769-p.1838
CIPOLLA, Fabio
Italian, 1854-
CIPPER or Zippa, Giacomo
Francesco (Todeschini)
Italian, op.1707-1736
CIPRIANI, Giovanni
Battista
Italian, 1727-1785
CIPRIANI, Nazzareno
Italian, 1843-1925
CIPRIANI, Sebastiano
Italian, op.1696-1733
CIRCIGNANI
see Pomarancio
CIREFICE, Vittorio
British, 20th cent.
CIRERA, Jaime
Spanish, op.1425-1452
CIRILLO, Santolo
Italian, op.1733-1737
CIRO da Conegliano
Italian, 16th cent.
CIRUELOS, Modesto
Spanish, 1908-
CIRY, Michel
French, 1919-
CISERI, Antonio
Italian, 1821-1891
CISNEROS, Pedro de
Spanish, op.1535-1545
CITROEN, Roelof Paul
(Paul)
Dutch, 1896-
CITTADINI, Pier Francesco
(Il Milanese)
Italian, 1616-1681
CITTATO, Giulio
American, 20th cent.
CIUCURENCU, Alexandru
Rumanian, 1903/4-
CIUPE, Aurel
Rumanian, 1900-
CIVERCHIO, Vincenzo
(Il Fanone)
Italian, 1468/70-1544
CIVET, André
French, 1911
CIVETON, Christophe
French, 1796-1831
CIVETTA
see Bles, Herri
met de

CIVITA, Sergio
 Italian, 20th cent.
CLACHER, Daniel
 Dutch, op.1628
CLACK, Richard Augustus
 British, c.1804-1881
CLACK, Thomas
 British, 1830-1907
CLACY, Ellen
 British, op.1870-1900
CLAEISSINS or Claeissens,
 Anthuenis
 Netherlands, c.1536-1613
CLAEISSINS, Claeis or
 Claeissens, Gillis
 Netherlands, op.1566-m.1605
CLAEISSINS, Claeiss,
 Claeissens, Claeissz or
 Claissz, Jan
 Flemish, op.1609-m.1653
CLAEISSINS or Claeissens,
 Petrus Anthuenis(?)
 Netherlands, 16th cent.
CLAEISSINS, Claeis, Claeiss
 or Claeissens, Pieter, I
 Netherlands,
 1499/1500-1576
CLAEISSINS, Claeis,
 Claeissens or Claeissz,
 Pieter, II
 Flemish, op.1571-m.1623
CLAES, Jans
 Netherlands, 16th cent.
CLAESSEN, George
 Dutch, 1909-
CLAESSENS, A.B. or A.R.
 Dutch(?), op.1644
CLAESSENS, J.C.
 Belgian, 19th cent.
CLAESZ., Aert or Aertgen
 (Aert or Aertgen van
 Leyden)
 Netherlands, 1498-1564
CLAESZ., Allaert
 Netherlands, 1508-p.1555
CLAESZ., Anthony, I
 Dutch, 1592-1635/6
CLAESZ., Anthony, II
 Dutch, 1616-c.1652
CLAESZ., Trajectensis,
 Jacob
 see Jacob van Utrecht
CLAESZ., Jan
 Netherlands, op.1600
CLAESZ., Pieter
 Dutch, 1597/8-1661
CLAESZ., Reyer
 Dutch, op.1620-m.c.1655
CLAEUW or Claeu, Jacques de
 (Jacques de Grief)
 Dutch, op.1642-1676
CLAGUE, Richard
 American, 1812-1873
CLAIR, Charles
 French, 1860-
CLAIRIN, Georges Jules
 Victor
 French, 1843-1919
CLAIRIN, Pierre Eugène
 French, 1897-
CLAISSE, Geneviève
 French, 1935-
CLAMA, (Glama-Stroberle)
 João
 Portuguese, 1708-1792
CLAMP, R.(?)
 British, op.1789-1798

CLANDY, J.
 British, 18th cent.
CLAPIER, Marguerite
 French, op.1802
CLAPP, W.H.
 Canadian, 1879-1954
CLARE, Benedict
 British, op.1747
CLARE, George
 British, 1844-1899
CLARE, Oliver
 British, 19th cent.
CLARE, Vincent
 British, 19th cent.
CLARENBACH, Max
 German, 1880-1952
CLARET, William
 British, op.1670-m.c.1706
CLARK, Albert
 British, op.1883
CLARK, Alson Skinner
 American, 1876-1949
CLARK, Alvan
 American, 1804-1887
CLARK, Anne
 British, 20th cent.
CLARK, Christopher
 British, 1875-1942
CLARK, Cosmo
 British, 1897-1967
CLARK, Eliot
 American, 1883-
CLARK of Eton
 British, 18th cent.
CLARK, George
 British, op.1850
CLARK, I.
 British, op.1824
CLARK, J.
 British, op.1767
CLARK, James
 British, 1858-
CLARK(E), James
 British, 19th cent.
CLARK (not Clarke),
 John Heaviside
 ('Waterloo-Clark')
 British, c.1771/2-1863
CLARK, Joseph
 British, 1834-1926
CLARK, Joseph Benwell
 British, 1857-
CLARK, Minerva R.
 American, op.c.1830
CLARK, O.T.
 British, 1850-1921
CLARK, Paraskeva
 Canadian, 1898-
CLARK, Thomas
 British, op.1827-1858
CLARK, Walter Appleton
 American, 1876-1906
CLARK, William I and II
 British, op.c.1830-1870
CLARKE, Geoffrey
 British, 1924-
CLARKE, George
 British, op.c.1825
CLARKE, Harry
 British, 1890-
CLARKE, John Clem
 American, 20th cent.
CLARKE, Joseph Clayton
 ('Kyd')
 British, op.1883
CLARKE, Margaret
 British, 20th cent.

CLARKE, P.
 British, 19th cent.
CLARKE, R.E.
 British, op.1825-1848
CLARKE, Theophilus
 British, c.1776-c.1832
CLARKE, W.B.
 British, op.1832-1835
CLARKE, William
 American, op.1785-1806
CLARKE, William Hanna
 British, 1882-1924
CLARKSON, Ralph Elmer
 American, 1861-1943
CLAROT, Alexander
 German, 1796-1842
CLAROT, Johann Baptist
 German, 1797(?)-p.1854
CLARY, Jean Eugène
 French, 1856-c.1930
CLARY, Justinian
 Nicolas
 French, 1816-1869
CLARY-BAROUX, Adolphe
 French, 1865-1933
CLATER, Thomas
 British, 1789-1867
CLATERBOS, Augustijn
 Dutch, 1750-1828
CLAUCE, Franz Ludwig
 see Close
CLAUCE, Jacques
 German, 1728-1789
CLAUDE Gellée or Gillée,
 Le Lorrain
 French, 1600-1682
CLAUDE, Georges
 French, 1854-1922
CLAUDE, Jean Maxime
 French, 1824-1904
CLAUDIUS, Comte François
 French, op.c.1800
CLAUDOT, Jean Baptiste
 Charles
 French, 1733-1805
CLAUREAU, P.
 see Clavareau
CLAUS, Camille
 French, 1920-
CLAUS, Emile
 Belgian, 1849-1924
CLAUSADE, Pierre de
 French, 19th cent.
CLAUSEN, Franziska
 Danish, 1899-
CLAUSEN, Sir George
 British, 1852-1944
CLAUSEN, Katherine Frances
 (O'Brien)
 British, -1937(?)
CLAUSEN, S.
 British, 19th cent.
CLAUSER or Klauser,
 Jacob
 Swiss, 1520/30-1578
CLAUS-MEYER, Eduard
 see Meyer
CLAVAREAU, Claureau,
 Clavar or Clavarrau,
 P.
 French, op.c.1750
CLAVE, Anthoni
 French, 1913-
CLAVE y Roque,
 Pelegrin
 Spanish, 1811-1880

CLAVEL, Marie Joseph
 Léon
 see Iwill
CLAVO, Javier Clavo Gil.
 Spanish, 1919-
CLAXTON, Florence
 British, op.1859-1879
CLAXTON, Marshall
 British, 1813-1881
CLAY, Alfred Barron
 British, 1831-1868
CLAY, Sir Arthur
 Temple Felix, Bt.
 British, 1842-1928
CLAY, Edward W.
 American, 1792-1857
CLAY, Lady Rachel
 British, 20th cent.
CLAYPOOLE, James
 American, op.1762-m.c.1796
CLAYS, Paul Jean
 Belgian, 1819-1900
CLAYTON, Alfred B.
 British, 1795-1855
CLAYTON, Benjamin, III
 British, 1809-1883
CLAYTON, Harold
 British, 19th cent.
CLAYTON, J.R.
 British, 19th cent.
CLEAR, Thomas Le
 American, 1818-1882
CLEAVER, Reginald
 British, 19th cent.
CLEEF
 see Cleve
CLEENEKNECHT, Barent
 see Kleeneknecht
CLEIN, Franz
 see Cleyn
CLEMENS, Curt
 Swedish, 1911-1947
CLEMENS, Johan Frederik
 Danish, 1749-1831
CLEMENS, Paul Lewis
 American, 1911-
CLEMENS, Samuel
 Langhorne
 (Mark Twain)
 American, 1835-1910
CLEMENT, Armand
 French, op.1897
CLEMENT, Charles
 Swiss, 1889-1972
CLEMENT, D.A.
 Dutch(?) 18th cent.
CLEMENT, Félix Auguste
 French, 1826-1888
CLEMENT, G.R.
 British, op.1827
CLEMENTE, Jack
 Italian, 20th cent.
CLEMENTI
 (La Clementina),
 Maria Giovanni Battista
 Italian, 1690-1761
CLEMENTI, Prospero
 Italian, -1584
CLEMENTS, Gerald
 British, 1936-
CLEMENTS, John
 British, op.1818-1831
CLEMENTSCHITSCH, Arnold
 German, 1887-
CLEMINSON, Robert
 British, op.1865-68

CLENIN, Walter
Swiss, 1897-
CLENNELL, Luke
British, 1781-1840
CLERCK or Klerck,
Hendrik de
Flemish, 1570-1629
CLERCQ, Alfons De
Belgian, 1868-
CLERCQ, Hugo De
Belgian, 1930-
CLERE, Georges Prosper
French, 1829-
CLERGET, Charles
Ernest
French, 1812-
CLERICI, Fabrizio
Italian, 1913-
CLERIGINO di Capodistria
Italian, op.1471
CLERHIHEW, William
British, c.1814-c.1880
CLERISSEAU, Charles
Louis (Jacques Louis)
French, 1722-1820
CLERK, Sir John, Bt.
British, 1676-1755
CLERK of Eldin, John
British, 1728-1812
CLERK, Pierre
Canadian, 1928-
CLERMONT, Andien de
French, op.1716/7-m.1783
CLERMONT, Jean
French, 1630-p.1660
CLERMONT, Jean Francois
French, 1717-1807
CLERMONT, Louis
French, op.1925
CLERQ, C.L.
French, op.1778
CLESS, Jean Henri
French, op.c.1795-1811
CLESSE, Louis Liévin
Theophile
Belgian, 1889-
CLETCHER, Daniel
Dutch, op.1633
CLEVE or Cleef, Cornelis
van (Sotte-Cleef)
Netherlands, 1520-1567
CLEVE or Cleef,
Hendrick van
(Hendricus Clivensis)
Netherlands, c.1525-1589
CLEVE or Cleef, Jan van
Flemish, 1646-1716
CLEVE or Cleef, Joos
van, or Joos van der
Beke (Identified with
Master of the Death
of the Virgin)
Netherlands,
op.1511-m.1540/1
CLEVE or Cleef, Marten,
I van
Netherlands, 1527-1581
CLEVE or Cleef, Marten,
II van
Netherlands, c.1560-p.1604
CLEVELEY the Elder,
John
British, op.1747-p.1792(?)
CLEVELEY the Younger,
John
British, 1747-1786

CLEVELEY, Robert
British, 1747-1809
CLEVENBERGH, Antoine
Flemish, 1755-1810
CLEVERLEY, Charles F.
British, 19th cent.
CLEYN, Clein or
Kleine, Franz
German, 1582-1658
CLEYN, John
German, 17th cent.
CLEYN, Penelope
German, 17th cent.
CLEYNEKNECHT, Barent
see Kleeneknecht
CLIFFE, Henry
British, 1919-
CLIFFORD, Edward
British, 1844-1907
CLIFFORD, Edward C.
British, 1858-1910
CLIFFORD, Henry Charles
British, 1861-1947
CLIME, Winfield Scott
American, 1881-
CLINEDINST, Benjamin
West
American, 1859-
CLINT, Alfred
British, 1807-1883
CLINT, George
British, 1770-1854
CLIPPELE, Elise
(née Mercier)
see Mercier
CLITE, Lievin van den
Netherlands,
op.1386-m.1422
CLIVE, Thomas
British, 18th cent.
CLIVENSIS, Henricus
see Cleve, Hendrick
van
CLOAR, Carroll
American, 1913-
CLOCHE, N. de
Flemish(?) 17th cent.(?)
CLODION, Claude Michel
French, 1738-1814
CLOEWE, Peeter or Petrus
see Clouwet
CLOMP, Albert
see Klomp
CLOQUET, Lise
French, c.1800
CLOS, Antoine Jean du
see Duclos
CLOSE, Charles
American, 20th cent.
CLOSE, Klose or Clauce,
Franz Ludwig
German, 1753-p.1822
CLOSON, Henri-Jean
Belgian, 1888-
CLOSS, Gustav Paul
German, 1840-1870
CLOSTERMAN or
Kloosterman, Johann
Baptist
British, 1660-1711
CLOT, Hans (Johannes)
German, 16th cent.
CLOTZ or Clots,
Valentin
see Klotz

CLOUE, Peeter or
Petrus
see Clouwet
CLOUET, E.
French, 19th cent.
CLOUET, Félix
French, -1882
CLOUET, Francois
(Jehannet or Janet)
French, 1510(?)-1572
CLOUET, Jean
(Jehannet or Janet)
French, op.1516-m.1540
CLOUET, Peeter or
Petrus
see Clouwet
CLOUET de Navarre
French, op.1529
CLOUGH, Prunella
British, 1919-
CLOUGH, William
American, 19th cent.
CLOUWET, Cloewe, Cloué,
Clouet or Clowe,
Peeter or Petrus
Flemish, 1629-1670
CLOVER, Joseph
British, 1779-1853
CLOVIN, T.B.
British, 19th cent.
CLOVIO, Giulio
(Giorgio)
Italian, 1498-1578
CLOVIS, Francois Auguste
Didier
French, 1858-
CLOWE, Peeter or Petrus
see Clouwet
CLOWES, Daniel
British, 1790-1849
CLOWES, J.
British, 1790-1849
CLUSEAU-LANAUVE, Jean
French, 1914-
CLUTTERBUCK, Robert
British, 1772-1831
CLUTTON-BROCK, Alan
Francis
British, 1904-
CLUYSENAAR, Alfred Jean
André
Belgian, 1837-1902
CLUYSENAAR, André Edmond
Alfred
Belgian, 1872-
CLUYSENAAR, John Gordon
Belgian, 1899-
CIJYT, Pieter Dircksz.
Dutch, c.1580-p.1656
CNOOP or Cnopp, Cornelia
(Cornelia David)
Netherlands, op.c.1496
COASE, E. Irving
American, 20th cent.
COAT, Pierre Tal
French, op.1942
COATES, E.C.
American, op.1835-1857
COATES, George James
British, 1869-1930
COBB, Charles David
British, 1921-
COBBETT, Edward John
British, 1815-1899
COBER, Martin
see Kober

COBERGHER, Wenzel or
Wenceslaus
see Coebergher
COBLITZ, Louis
French, op.1842
COBOURN, Major
South African, op.1818
COBURN, Frederick
Simpson
Canadian, 1871-
COBURN, John
Australian, 1925-
COCA, Alberto Rippoi
Spanish, 20th cent.
COCCAPANI, Sigismondo
Italian, 1583-1642
COCCETTI, Napoleon
Italian, c.1880-
COCCHI, Dn.
Italian, op.1764
COCCHI, Francesco
(Ermengildo Baldassare)
Italian, 1788-1865
COCCHI, Pompeo di
Pergentile
Italian, op.1523-m.1552
COCCORANTE or
Cuccorante, Leonardo
Italian, op.1743
COCHERAU, Léon Matthieu
French, 1793-1817
COCHET, Gérard-Paul
French, 1888-
COCHETTI, Luigi
Italian, 1802-1884
COCHIN, Charles Nicolas,
I
French, 1688-1754
COCHIN, Charles Nicolas, II
French, 1715-1790
COCHIN, Nicolas
French, 1610-1686
COCHRAN, William
British, 1738-1785
COCK van Aelst
see Coecke van Aelst
COCK, César de
Belgian, 1823-1904
COCK or Kock or Wellens
de Cock, Hieronymus
Netherlands, c.1510-1570
COCK, Jan de, or Jan
Wellens de Cock
Netherlands, op.1506-m.a.1529
COCK, Cocq, Cocx or
Kock, Jan Claudius de
Flemish, c.1668/70-1736
COCK, Marten de
Dutch, op.1620-1646
COCK or Kock or Wellens
de Cock, Mathys
Netherlands, c.1509-c.1548
COCK, Paul-Joseph de
Flemish, 1724-1801
COCK, Xavier de
Belgian, 1818-1896
COCKBURN, Edwin
British, op.1835-1870
COCKBURN, James Pattison
British, 1778-1847
COCKBURN, R.D.
British, 19th cent.
COCKERELL, Charles Robert
British, 1788-1863
COCKERELL, Christabel A.
(Lady Frampton)
British, op.1884-1910

COCKERELL, S. Pepys
British, 1844-
COCKETT, S.D.
British, 1800-1863
COCKRAM, George
British, 1861-
COCKS, E.W.
British, 18th cent.
COCKS, Gonzales or
Gonsalo
see Coques
COCKSON or Coxon,
Thomas
British, op.1591-1636
COCKX, Philibert
Belgian, 1879-
COCLERS, Jean Baptiste
Bernard (Louis Bernard)
Flemish, 1741-1817
COCLERS, Jean Baptiste
Pierre
Dutch, 1696-1772
COCQ, Jan Claudius de
see Cock
COCTEAU, Jean
French, 1889-1963
COCX, Jan Claudius de
see Cock
COCYLAS, Henry
French, 19th cent.
CODA, Bartolommeo
Italian, op.1543-1563
CODA, Benedetto
Italian, op.1495-m.c.1520
CODA, Francesco di
Maestro Sebastiano
Italian, op.1560-1576
CODAZZI, (not Codagora)
Viviano (A. Viviani)
Italian, c.1603-1672
CODDE, Carel
Dutch, op.1653-m.1698
CODDE, Pieter
Jacobsz.
Dutch, 1599-1678
CODE, Mary
see Benwell
CODEBUE or Capodibue,
Giambattista
Italian, op.1598
CODINA y Langlin,
Victoriano
Spanish, 1844-1911
CODINO, Francesco
Italian, op.1621
CODMAN, Charles
American, 1800-1842
CODNER, Maurice
Frederick
British, 1888-1958
CODRINGTON, Isabel
British, op.c.1923
COE, Elias V.
American, op.1837
COE, Sue
British, 20th cent.
COEBERGHER, Cobergher
or Koeberger, Wenzel
or Wenceslaus
Flemish, 1561-1634
COECKE, Cock, Kock or
Koecke, Aelst or Alost
Pauwels
Netherlands, c.1530-
COECKE, Cock, Kock or
Koecke van Aelst or
Alost, Pieter, I
Netherlands, 1502-1550

COECKE, Cock, Kock or
Koecke van Aelst or Alost,
Pieter, II
(Monogrammist P.v.A.)
Netherlands, a.1527-c.1559
COELEMANS, Jacobus
Flemish, 1654-1731/2/5
COELENBIER, Jan
Dutch, op.1630-1677
COELLO, Alonso Sanchez
see Sanchez-Coello
COELLO, Claudio
Spanish, 1630/5-1693
COEMAN, Jacob Jansz.
Dutch, op.1651-1676
COENE, Constantinus
Fidelio
Belgian, 1780-1841
COENE, Cona or Cone,
Jacques, Jacobus or
Jacopo
Netherlands,
op.1398-1411
COENE, Jean Baptiste
Belgian, 1805-
COENE, Jean Henri de
(Henri)
Belgian, 1798-1866
COENRAAD, Jacob Jan
Dutch, 1837-1923
COENS, C.
Dutch, op.1829
COESERMANS, Johannes
Dutch, op.1661
COETS, Herman
Dutch, 1663-p.1707
COETS, Roelof Claessen
see Koets
COETSIERS, Jan
see Cossiers
COETZEE, Christo
S.African, 1930-
COEURE, Sébastien
French, 1778-p.1831
COFFERMANS, Koffermans
or Koffermaker,
Marcellus or Marcellis
Netherlands, op.1549
COFFIN, William
Anderson
American, 1855-1925
COFFRE or Coiffre,
Benoît
French, op.1692-m.1722
COGELL, Pierre
(Per Eberhard)
Swedish, 1734-1812
COGELS, Joseph Carl
Flemish, 1785-1831
COGEN, Félix
Belgian, 1838-1907
COGHETTI, Francesco
Italian, 1804-1875
COGHILL, Egerton Bush
British, 1851-1921
COGHUF, Ernst (Stocker)
Swiss, 1905-
COGNACQ, Jean
French, 1909-
COGNIET, Catherine,
Caroline, née Thévenin
French, 1813-1892
COGNIET, Léon
French, 1794-1880
COGNIET, Marcel
French, 1857-1914

COGNIET, Marie
Amélie
French, 1798-1869
COGOLLO
Italian, 20th cent.
COHEN, Alfred
American, 1920-
COHEN, Bernard
British, 1933-
COHEN, Eduard
German, 1838-1910
COHEN, George
Marshall
American, 1919-
COHEN, Harold
British, 1928-
COHEN, Isaac
Australian, 1884-1951
COHEN, Minnie Agnes
British, 1864-
COIFFRE, Benoît
see Coffre
COIFFRE (?) P.
Dutch(?) op.1660
COIGNARD
French, 1930-
COIGNARD, Louis
French, 1810/12-1883
COIGNET, Jules
(Louis Philippe)
French, 1798-1860
COIGNET
see also Congnet
COIMBRA, G.L. of
Portuguese, op.c.1530
COINER, Charles
American, 19th cent.
COISEVAUX, Antoine
see Coysevox
COKE, Arthur
Sacheverell
British, op.1869-1892
COKE, Thomas William,
Earl of Leicester
British, 1752-1842
COKER, Peter
British, 1926-
COL, Jan David
Belgian, 1822-1900
COLA dall'Amatrice
see Amatrice
COLA, Arcangelo di
see Arcangelo
COLA, Benedetto
Italian, 15th cent.
COLA del Merlo di
Civita di Penne
Italian, 15th cent.
COLA, Petruccioli
Italian, op.1380-1385
COLACICCHI, Giovanni
Italian, 1900-
COLAERT or Collaert,
Johannes
Dutch, 1621/2-p.1667
COLAHAN, Colin
Australian, 1897-
COLANTONI
Italian, op.c.1810
COLANTONIO, Niccolò
Antonio (del Fiore)
Italian, c.1420-c.1460
COLBERT, R.
French, c.1880-
COLBOURN, Lilian
Victoria
British, 1898-

COLBAY, Joseph
British, op.1852-64
COLDSTREAM, William
British, 1908-
COLE, Alphaeus Philemon
American, 1876-
COLE, B.
British, op.1755
COLE, Ernest Alfred
British, 1890-
COLE, George
British, 1810-1883
COLE, George Vicat
British, 1833-1893
COLE, Sir Henry
British, 1808-1882
COLE, Herbert
British, op.1898-1904
COLE, James
British, op.1720-1743
COLE, James William
British, op.1849-1882
COLE, John
British, 1903-
COLE, Joseph Greenleaf
American, 1806-1858
COLE, Sir Ralph
British, c.1625-1704
COLE, Rex Vicat
British, 1870-1940
COLE, Tennyson Philip
British, 19th cent.
COLE, Thomas
American, 1801-1848
COLEBERTI, Pietro da
Piperno
Italian, 15th cent.
COLEMAN, A.
British, 19th cent.
COLEMAN, Charles Caryl
American, 1840-1928
COLEMAN, Edward
British, op.1829-m.c.1867
COLEMAN, Enrico
(Henry)
Italian, 1846-1911
COLEMAN, Francesco
Italian, 1851-
COLEMAN, Glenn O.
American, 1884-1932
COLEMAN, Helen Cordelia
see Angell
COLEMAN, J.
British, 19th cent.
COLEMAN, Roger M.
British, 20th cent.
COLEMAN, S.
British, op.1767
COLEMAN, William
Stephen
British, 1829-1904
COLENBERGH, Christiaen
van
Dutch, op.c.1667/8
COLERIDGE, Lady, née
Jane Fortescue
Seymour (Mrs John Duke
Coleridge)
British, op.1846-m.1878
COLERIDGE, F.G.
British, 20th cent.
COLERT, M.L.
Dutch(?) 17th cent.
COLES, John
American, c.1749-1809

COLES, John, II
American, 1776/80-1854
COLI, Giovanni
Italian, 1636-1681
COLIA, Jean
French, 20th cent.
COLIBERT, Nicolas
French, c.1750-1806
COLIE, Mary Spain
American, 20th cent.
COLIGNON, François
see Collignon
COLIN, Alexandre Marie
French, 1798-1875
COLIN, Arnold
see Colyns
COLIN, Gerard
Philippe
Flemish, op.1756-1771
COLIN, Gustave
French, 1828-1910
COLIN, N.
French, 18th cent.
COLIN, Paul
French, 1892-
COLIN, Paul Alfred
French, 1838-1916
COLIN, Paul-Emile
French, 1877-
COLIN de la Biochaye
French, op.1794
COLINET, A.
French, 18th cent.
COLIS, R.
British, op.c.1829
COLKETT, Samuel David
British, 1806-1863
COLLA, Ettore
Italian, 1899-
COLLAERT, Adriaen
Flemish, c.1560-1618
COLLAERT, Hans or
Jan, I
Netherlands,
c.1530-a.1581
COLLAERT, Hans or Jan,
II (Jan Baptist)
Flemish, 1566-1628
COLLAERT, Johannes
see Colaert
COLLANTES, Francisco
Spanish, 1599-1656
COLLART, A.
French, op.1784
COLLART, Marie
(Marie Henrotin)
Belgian, 1842-
COLLAS, Louis Antoine
French, 1775-p.1833
COLLE, Madeleine Jeanne
see Lemaire
COLLE, Michel Auguste
French, 1872-1949
COLLE, Raffaello dal
see Raffaellino
COLLEN, Henry
British, op.1820-1872
COLLEN, Johan van
(Master of the Lübeck
Mass of St. Gregory)
German, op.1535-1562
COLLENIUS, Herman
Dutch, c.1649/50-c.1720
COLLEONI, Girolamo
Italian, op.1536

COLLES, Dorothy
British, 20th cent.
COLLET, John
British, c.1725-1780
COLLETT, Fredrik Jonas
Lucian Botfield
Norwegian, 1839-1914
COLLETTE, W.C.
French, op.1898
COLLEY, Andrew
British, 19th cent.
COLLEY, P.M.
British, op.1852
COLLEY, T.
British, op.1781
COLLI, Antonio
Italian, op.c.1725-c.1800
COLLIER, Alan Caswell
Canadian, 1911-
COLLIER, Edwaert
see Colyer
COLLIER, John
(Tim Bobbin)
British, 1708-1786
COLLIER, Hon. John
British, 1850-1934
COLLIER, Thomas
British, 1840-1891
COLLIER, Thomas F.
British, op.1855-1874
COLLIGNON, François
French, 1609-1657
COLLIGNON, Jules
French, op.c.1900
COLLIMAN, Leonard W.
British, 1816-1881
COLLIN de Vermont,
Hyacinthe
see Vermont
COLLIN, Dominique
French, 1725-1781
COLLIN, Markus
Finnish, 1882-
COLLIN, Raphaël (Louis
Joseph Raphael)
French, 1850-1916
COLLIN, Richard
Flemish, 1626/7-c.1697
COLLINA, Mariano
Italian, c.1720-1780
COLLINGBOURNE, Stephen
British, 20th cent.
COLLINGS, Albert Henry
British, op.1893-m.1947
COLLINGS, Charles John
British, 1848/9-1931
COLLINGS, Samuel
British, op.1784-1789
COLLINGWOOD, William
British, 1819-1903
COLLINGWOOD, William
Gersham
British, 1854-1932
COLLINO, Filippo
Italian, op.1754-
COLLINS, Alfred Quinton
American, 1862-1903
COLLINS, Cecil
British, 1908-
COLLINS, Charles
British, op.1730-m.1744
COLLINS, Charles Allston
British, 1828-1873
COLLINS, Hugh
British, op.1868-1891

COLLINS, J.
British, op.1670-1690
COLLINS, James Edgell
British, 1820-p.1875
COLLINS, Jess
American, 20th cent.
COLLINS, John
British, 1725-1758/9
COLLINS, Richard
British, -1732
COLLINS, Samuel
British, op.1762-1775
COLLINS, W.
British, op.1736
COLLINS, William
British, 1788-1847
COLLINS, William Wiehe
British, op.1886
COLLINSON, Captain
British, op.c.1851
COLLINSON, James
British, c.1825-1881
COLLINSON, Robert
British, 1832-1890
COLLISHONN, Nanette
German, 19th cent.
COLLMANN, Johann Friedrich
Wilhelm Ferdinand
German, 1763-1837
COLLOGNON, Giuseppe
Italian, 1776-1863
COLLOMBE, de la
French, op.c.1702-1736
COLLIS, Ebenezer
British, op.1852-1854
COLLYER, Joseph
British, 1748-1827
COLMAN
British, 19th cent.
COLMAN
German, op.1797
COLMAN, Samuel
British, op.1816-1840
COLMAN, Samuel
American, 1832/3-1920
COLMAN, W. Gooding
British, 19th cent.
COLMEIRO, Manuel
Spanish, 20th cent.
COLOMANUS, Pater
see Fellner, Coloman
COLOMB, Christophe
American, op.c.1790
COLOMBANI
Italian, 16th cent.
COLOMBE, Jean
French, op.c.1467-m.1529
COLOMBEL, Nicolas
French, 1644-1717
COLOMBET, Cécile
French, op.1843
COLOMBI, Plinio
Swiss, 1873-1951
COLOMBINO, Carlos
Paraguay, 1937-
COLOMBO, Colomba or
Columba, Luca Antonio
Italian, 1661-1737
COLOMBO, Giovanni Battista
Innocenzo
Italian, 1717-1793
COLONIA, Adam de
British, c.1593
COLONIA, Adam (de)
Dutch, 1634-1685
COLONIA, Adam Louisz. (de)
Flemish, c.1574-1651

COLONIA, Hendrik Adriaan
Dutch, 1668-1701
COLONNA, Fabio
Italian, 1566-1640
COLONNA, Michel Angelo
Italian, 1600-1687
COLONNA
see Mingozzi, Girolamo
COLOSWAR, Thomas de
see Kolozsvár
COLQUHOUN, Ithell (Miss)
British, 1906-
COLQUHOUN, Robert
British, 1914-1962
COLSON, Charles Jean
Baptiste
French, 1733-1803
COLSON, Guillaume François
French, 1785-1850
COLSON, Jean François
(Gilles)
French, 1733-1803
COLSON, T.
British, 18th cent.
COLTELLINI or Cortellini,
Michele di Luca dei
Italian, op.1535-m.1559
COLUCCI, Gio
Italian, 20th cent.
COLUMBA, Luca Antonio
see Colombo
COLUMBANO
see Pinheiro
COIVERSON, Ian
British, 1940-
COLVILLE, Alexander
Canadian, 1920-
COLVIN, Anne
British, 20th cent.
COLYER or Collier,
Edwaert
Dutch, op.1662-m.a.1703(?)
COLYER, M.H.
British, 19th cent.
COLYER, Vincent
American, 1825/29-1888
COLYN, Crispiaen
Flemish,
op.1575-1613
COLYN or Colyns, David
Dutch, c.1582-p.1668
COLYN or Colyns, Jacob
Dutch, 1614/15-1686
COLYN, Michiel
Dutch, op.1609
COLYNS or Colin, Arnold
German, op.1579-1582
COLZI de' Cavalcanti,
Giuseppe
Italian, op.1803-1838
COMBAZ, Ghisbert
Belgian, 1869-1941
COMBERFORD, Nicholas
British, op.1650-1657
COMBES, Léon, I
French, 1786-1875
COMBES, Léon, II
French, op.1856
COMBES, Louis
French, 1754-1818
COMBETTE, Joseph
Marcellin
French, 1770-1840
COMEGYS, George H.
American, op.1836-1845

COMER, Alexander(?)
British, op.1677-1685
COMERFORD, John
British, c.1762-1832/5
COMERIO, Agostino
Italian, 1784-1829
COMERRE, Léon Francois
French, 1850-1916
COMERRE-PATON, Jacqueline
French, 1859-p.1896
COMES, Francisco
Spanish, op.1415
COMFORT, Charles Fraser
Canadian, 1900-
COMI, Girolamo
Italian, 1507-1581
COMMERE, Jean
French, 1920-
COMMERE, X.
French, 20th cent.
COMMODI or Comodi,
Andrea
Italian, 1560-1638
COMOLERA, Mlle. Melanie
de
French, op.1816-1854
COMOLLI, Giacomo
see Jacopo d'Antonello
COMONTES, Antonio de
Spanish, op.1500-1519
COMONTES, Francisco de
Spanish, op.1526-m.1565
COMPAGNO di Agnolo,
Gaddi
see Starnina
COMPAGNO di Bicci
see Bicci
COMPAGNO di Botticini
see Botticini
COMPAGNO dell' Orcagno
see Orcagna
COMPAGNO di Pesellino
see Piero di Lorenzo
di Pratese di Bartolo
Zuccheri
COMPAGNO, Scipione
Italian, op.1637-1646
COMPARD, Emile
French, 1900-
COMPE or Kompe, Jan ten
Dutch, 1713-1761
COMPTE-CALIX, Francois
Claudius
French, 1813-1880
COMPTON, Edward Harrison
British, 1881-
COMPTON, Edward Theodore
British, 1849-1921
COMPTON, T.
British, op.1818
COMTE, Jacques Louis
Swiss, 1781-p.1812
COMTE, Meiffren
see Conte
COMTE, Pierre Charles
French, 1823-1895
COMTOIS, Ulysse
Canadian, 1931-
CONA, Jacques, Jacobus
or Jacopo
see Coene
CONANT, A.
American, op.1845
CONANT, Cornelia W.
American, 19th cent
CONCA, Giovanni
Italian, op.1706-1739

CONCA, Sebastiano
Italian, 1676/80-1764
CONCA, Tommaso
Italian, op.1770-m.1815
CONCANEN, Alfred
British, 19th cent.
CONCEPCION, Felix Beltran
Cuban, 20th cent.
CONCHILLOS y Falco,
Juan
Spanish, 1641-1711
CONCONI, Luigi
Italian, 1852-1917
CONCONI, Mauro
Italian, 1815-1860
CONDAMIN, Cond'Amin or
Cond'Amain, Henri
(Joseph Henri)
French, 1847-1917
CONDAMY, Charles Fernand
de
French, 1878-1882
CONDE, Jean
French, 1725-m.1794
CONDER, Charles
British, 1868-1909
CONDIT, W.J.
American, op.1847
CONDIVI, Ascanio
Italian, c.1525-1574
CONDY or Cundy, Nicholas
British, c.1793-1857
CONDY, Nicholas Matthews
British, 1816-1851
CONE, Jacques, Jacobus
or Jacopo
see Coene
CONEGIAN, A.
Italian(?) 17th cent.
CONEY, John
British, 1786-1833
CONFORTINI, Jacopo C.
Italian, op.1617
CONGDON, William
American, 1912-
CONGIO, Camillo
see Cungi
CONGNET or Coignet,
Gillis or Aegidius
(Aegidius Quinetus)
Netherlands, c.1535-1599
CONGNET, Coignet or
Kouniet, Michiel
Flemish, op.1640/1
CONICKSVELT, Abraham
see Conincxvelt
CONINCK
see also Koninck
CONINCK or Koninck,
David de
(Rammelaer)
Flemish, 1643/5(?)-c.1699
CONINCK, Gregorius de
Dutch, c.1633/4-p.1677
CONINCK, Kauninck, Keuninck
Keuning or Koninck,
Kerstiaen de
Flemish, op.1580-m.c.1632/5
CONINCK, Pierre Louis
Joseph de
French, 1828-1910
CONINCK, Roger de
French, 1925-
CONINCXVELT or Conicksvelt,
Abraham
Dutch, op.1636-m.a.1653
CONING or Coningh
see also Koninck

CONING, N.
Dutch, 17th cent.
CONINXLOO or Coninxloo
Scernier, Cornelis van
Netherlands, op.1529-1559
CONINXLOO or Koningsloo,
Gillis van
Netherlands, 1544-1607
CONINXLOO, Hans, I van
Netherlands, c.1540-c.1595
CONINXLOO, Hans, II van
Flemish, c.1565-c.1620
CONINXLOO, Hans, III van
Flemish, c.1589-p.1645
CONINXLOO, Isaac Gillisz.
Flemish, op.c.1620
CONINXLOO, Jan, II van
Netherlands,
c.1489(?)-p.1555
CONINXLOO or Kueninexloo,
Pieter van
Netherlands, op.1544
CONIO, Tommaso di
see Corvo
CONLIN, Bill
American, 1925-
CONNARD, Philip
British, 1875-1959
CONNAWAY, Jay Hall
American, 1893-
CONNER, Bruce
American, 20th cent.
CONNINGH, Jacob
see Koninck
CONOLLY, Ellen
British, op.1873-1885
CONOR, William
British, 1881-1968
CONRAD
see also Konrad
CONRAD von Creuznach
see Faber
CONRAD, Albert
German, 1837-1887
CONRAD, J.W.B.
British, op.1809
CONRAD, R.
British(?) 19th cent.
CONRAD von Soest
German, op.1402-1404
CONRADE, Alfred Charles
British, 1863-1955
CONRADER, Georg
German, 1838-1911
CONSAGRA, Piero
Italian, 1920-
CONSCIENCE, Francis
Antoine
French, 1794/5-1840
CONSETTI, Antonio
Italian, 1686-1766
CONSINERY, Esprit-Marie
French, 1747-1833
CONSONI, Nicola
Italian, 1814-1884
CONSONNI, Giovanni
Italian, op.1891
CONSTABLE, Charles Golding
British, 1821-1879
CONSTABLE, John
British, 1776-1837
CONSTANS, Louis Aristide
Léon
French, op.1836-1867
CONSTANT, Benjamin
(Jean Joseph
Benjamin)
French, 1845-1902

CONSTANT, Raymond (Rémy)
French, op.1606-m.1657
CONSTANTIN, Abraham
Swiss, 1785-1855
CONSTANTIN, Auguste
Aristide Fernand
French, 1824-1895
CONSTANTIN, Jean Antoine
French, 1756-1844
CONSTANTIN, Joseph
Sébastien
French, 1793-1864
CONSTANTINESCU, Stef-n
Rumanian, 1898-
CONSTANTINI, Giuseppe
see Constanti
CONSTANTINI, Virgilio
Italian, 20th cent.
CONSTANTIJN, Paulus
Dutch, 19th cent.
CONSTANTYN, René
Auguste
Dutch, op.1712-1726
CONTARINI, Giovanni
Italian, 1549-a.1604
CONTE, Jacopo or
Jacopino del
Italian, 1510-1598
CONTE, M.
Italian, 20th cent.
CONTE, (Lecomte, Leconte)
Meiffren (Ephrem,
Ephraim)
French, c.1630-1705
CONTE, Nicolas Jacques
French, 1755-1805
CONTENTI, Giuseppe
Italian, op.c.1755-1787
CONTESTABILE, Nicolò
Italian, 1759-1824
CONTI, Bernardino dei
Italian, op.1496-1522
CONTI, Carl
German, 1740-1795
CONTI, Domenico
Italian, op.1767-m.1817
CONTI, Francesco
Italian, 1681-1760
CONTI, Giacomo
Italian, 1818-1889
CONTI, Primo
Italian, 1900-
CONTI or Conty,
Sebastiano
Italian, 18th cent.
CONTI, Tito
Italian, 1842-1924
CONTI, Vincenzo
Italian, op.1612-m.1625
CONTINI, Emilio
Italian, 1930-
CONTINOWSKI, Alexis
Polish, 19th cent.
CONTRAFEIER
see Johan
CONTRERAS, Antonio
(Master of the Retable
of SS, Mark and
Catherine)
Spanish, op.1496-1500
CONTRERAS, Antonio de
Spanish, 1587-1654
CONTUCCI
see Sansovino, Andrea
CONWAY, Charles
British, 1820-1884
CONXOLUS
Italian, 13th cent.

CONYERS, Julia
British, op.1790-1800
CONZ, Gustav
German, 1832-1914
COOGE or Kooge, Abraham
de
Dutch, op.1620-1680
COOGHEN, Leendert van
der
Dutch, 1610-1681
COOK, Clarence
Chatham
American, 1828-1900
COOK, Ebenezer Wake
British, 1843-1926
COOK, Henry (Enrico)
British, 1819-c.1890
COOK, Howard Norton
American, 1901-
COOK, J.
British, 18th cent(?)
COOK, Nelson
American, 1817-1892
COOK, Richard
British, 1784-1857
COOK, Samuel
British, 1806-1859
COOK, T.C.
British, 19th cent.
COOK, Theodore
British, op.1881-1895
COOK, Thomas
British, 1744-1818
COOK, William Delafield
British, 1936-
COOKE, Allan
British, 20th cent.
COOKE, Anthony R.
British, 20th cent.
COOKE, Arthur Claude
British, 1867-
COOKE, Barrie
British, 1931-
COOKE, E. Wake
British, op.1870
COOKE, Edward William
British, 1811-1880
COOKE, George
American, 1793-1849
COOKE, George
British, 1781-1834
COOKE, Henry
British, 1642-1700
COOKE, Isaac
British, 1846-1922
COOKE, Jean (Mrs.
John Bratby)
British, 1927-
COOKE, John
British, op.1883
COOKE, L.M.
American, 19th cent.
COOKE, William Bernard
British, 1778-1855
COOKE, William John
British, 1797-1865
COOKSEY, May Louise
Greville
British, 1878-
COOL, Jan Damen or
Daeman
Dutch, 1589-1660
COOL, Thomas Simon
Dutch, 1831-1870
COOL, Willem Gillisz.
see Kool
COOLEN, Adriaen van
Dutch, 17th cent.

COOLEN, Willem Gillisz.
see Kool
COOLEY, J.H.
British, op.1856
COOLIDGE, E.B.
American, op.c.1790
COOLING, John Albert
British, op.1880-m.1931
COOMANS, Auguste
Belgian, op.1850
COOMANS, C.
German, 19th cent.
COOMANS, Pierre Olivier
Joseph
Belgian, 1816-1889
COOPE, I.
German(?) op.1715
COOPER, Abraham
British, 1787-1868
COOPER, Alexander
British, 1605(?)-1660
COOPER, Alexander Davis
British, op.1837-1888
COOPER, Alfred Egerton
British, 1883-1974
COOPER, Alfred Heaton
British, c.1864-1929
COOPER, Austin
Canadian, 1890-
COOPER the Younger, B.
British, 18th cent.
COOPER, Colin Campbell
American, 1856-1937
COOPER, Edward
British, op.1803-1831
COOPER, Edwin
British, 1785-1833
COOPER, Frederick
Charles
British, op.1844-1868
COOPER, George
British, op.1792-1830
COOPER, Gerald
British, 20th cent.
COOPER, Isaac
British, 17th cent.
COOPER, J.
American, c.1695-p.1754(?)
COOPER, J.C.
British, op.1842
COOPER, John L.G.
British, 1894-
COOPER, Peter
American, op.c.1720
COOPER, Richard, I
British, a.1730-1764
COOPER, Richard, II
British, c.1740-p.1814
COOPER, Ron
American, 20th cent.
COOPER, Samuel
British, 1609-1672
COOPER, T.C.
British, op.1813
COOPER, Thomas George
British, op.1844-1896
COOPER, Thomas Sidney
British, 1803-1902
COOPER, W.H.
American, op.c.1886
COOPER, W. Savage
British, op.1885-1903
COOPER, William
British, 1923-
COOPER, William Brown
American, 1811-1900
COOPER, William Sidney
British, op.1871-1908

COOPER, Winifred
British, op.1904
COOPSE, Pieter
Dutch, op.1668-1677
COORNHERT or Cuerenhert,
Dirck Volckertsz.
Netherlands,
1519/22-1590
COORNHUUSE, Jacques or
Jacob van den
Netherlands,
c.1529/30-p.1584
COORTE, S. Adriaan
Dutch, op.1685-1723
COOSEMANS, Alexander
Flemish, 1627-1689
COOSEMANS, Joseph
Théodore
Belgian, 1828-1904
COOTES, F. Graham
American, 1879-
COOTWYCK, Jurriaan
Dutch, 1714-1798
COPE, Sir Arthur
Stockdale
British, 1857-1940
COPE, Charles West
British, 1811-1890
COPE, George
American, 1855-1929
COPLEY, Alfred
American(?) 1910-
COPLEY, G.
British, 19th cent.
COPLEY, John
British, 1875-1950
COPLEY, John Singleton
American, 1737-1815
COPLEY, William
American, 1919-
COPNALL, Frank T.
British, 1870-c.1948
COPNALL, John
British, 1928-
COPPA, Il Cavaliere
see Giarolo, Antonio
COPPEE, Annette
French, 19th cent.
COPPENOL, Lieven
Willemsz. van
Dutch, 1598-1662/8
COPPENOLLE, Jacques van
French, 20th cent.
COPPENS, Augustin
Flemish, 1668-p.1695
COPPENS, Francois
Flemish, op.1650
COPPERS, Cappers or
Kappers, Gerhard Martin
German, op.1709-1763
COPPI, Giacomo (del
Meglio)
Italian, 1523-1591
COPPING, Harold
British, 1863-1932
COPPO di Marcovaldo
(Salerno di Coppo)
Pistoia
Italian, 1225/30-p.1274
COPPOLA or Copula,
Carlo
Italian, -1655/72
COPPOLA, Gennaro
Italian, 18th cent.(?)
COPPOLA, Giovanni Andrea
Italian, c.1597-c.1659
COPPOLA, Silvio
Italian, 20th cent.

COPSEY, Helen Dorothy
British, 1888-
COQUERET, Achille
French, op.1835-1849
COQUES, Cocks or Cox,
Gonzales or Gonsalo
Flemish, 1614/18-1684
CORABOEUF, Jean Alexandre
French, 1870-
CORAM, Thomas
American, 1757-1811
CORARD
French, op.1839
CORBAUX, Louisa
British, 1808-p.1852
CORBELLINI, A.
Italian, 20th cent.
CORBELLINI, Louisa
Italian, op.c.1689
CORBELLINI, Luigi
Italian, 1901-
CORBET
French, op.1816
CORBET, Edith
British, op.1892-1896
CORBET, J.
British, op.1830
CORBET, Matthew Ridley
British, 1850-1902
CORBET (not Corbett),
Philip
British, op.1828-1856
CORBETT, Edward
American, 1919-
CORBETT, John
British, 1779/80-1815
CORBETTA, Simone da
Italian, 14th cent.
CORBI, Domenico
see Corvi
CORBIN, Aline
French, op.1835-1847
CORBINEAU, Charles
Auguste
French, 1835-1901
CORBINO, Jon
American, 1905-
CORBOISIER, J.
French, 20th cent.
CORBOULD, Alfred
British, op.1831-1875
CORBOULD, Alfred Chantry
British, op.1850-m.1920
CORBOULD, Edward Henry
British, 1815-1905
CORBOULD, Henry
British, 1787-1844
CORBOULD, Richard
British, 1757-1831
CORBOULD, R.C.
British, 19th cent.
CORBUSIER, le
see Jeanneret, Charles
Edouard
CORBUTT, C.
see Purcell, Richard
CORCOS, Vittorio Matteo
Italian, 1859-1933
CORDELLIAGHI, Andrea
see Previtali
CORDER, F.D.
British, 20th cent.
CORDER, Rosa
British, op.1879-1882
CORDERO, F.
Spanish, 20th cent.
CORDERO, José
Spanish, 19th cent.

CORDERO, Juan
Spanish, 1824-1884
CORDES, Johann Wilhelm
German, 1824-1869
CORDESCU, Florica
Rumanian, 1914-
CORDEY, Frédéric
French, 1854-1911
CORDIANI, Antonio
see Sangallo
CORDIANI
see Sangallo, Battista
da
CORDINER, Rev. Charles
British, 1746(?)-1794
CORDOBA, Alonzo di
Italian, op.1509-10
CORDOBA, Pedro de
Spanish, op.1475
CORDOBA, Pedro
Fernández de
Spanish, 15th cent.
CORDREY or Cawdrey, J.
British, op.1804
CORDUA, Corduba, Courda,
Courdo, Curta or
Kurte, Joannes
Flemish, op.1663-m.1702
CORDUA, Corduba, Courda,
Courdo, Curta, Kurte,
Johann Baptist
Flemish, 1649-1698
CORDWELL, J.
British, op.1821
CORELLI, Auguste
Italian, 1853-
CORELLI, Consalvo
Italian, op.1859
CORENZIO or Corentio,
Belisario or Baldassare
Italian, 1558/60-1640/3
CORFIELD, Colin
British, 20th cent.
CORFIELD, R.
British, 18th cent.
CORGNA, Antonio della
see Cornia
CORINTH, Lovis (Louis)
German, 1858-1925
CORIOLANI, Bartolommeo
Italian, op.1627-1653
CORIOLANO, Giovanni
Battista
Italian, op.1616-m.1649
CORIS, José Blanco
Spanish, 19th cent.
CORIYN, Reinard
Dutch, 17th cent.
CORKOLE, Auguste
Belgian, 1822-1875
CORMACK, N.
British, op.1814-1830
CORMON, Fernand Piestre
French, 1845-1924
CORNA, Antonio della
Italian, op.1469-1491
CORNAC, Lucas
Spanish, 16th cent.
CORNACCHINI, Agostino
Italian, 1685-p.1740
CORNE, Michele Felice
Italian, 1752-1832
CORNEILLAN, Pierre de
French, 18th cent.
CORNEILLE, Jean
Baptiste, II
French, 1649-1695

CORNEILLE de Lyon or
de la Haye (Possibly
identified with Cornelis
van de Capelle or
Corneille de la
Chapelle)
French, op.1534-1574
CORNEILLE, Michel
French, 1601/3-1664
CORNEILLE, Michel or
Michel Ange (Corneille
des Gobelins or Corneille,
I)
French, 1642-1708
CORNEJO, Pedro Duque
Spanish, 1677-1757
CORNELIS or Cornelys,
Albert
Netherlands,
op.1513-m.1532
CORNELIS van de Capelle
see Corneille de Lyon
CORNELIS van Haarlem
(Cornelis Cornelisz.)
Dutch, 1562-1638
CORNELISZ., Cornelis
(Kunst)
Netherlands, 1493-1544
CORNELISZ. van Amsterdam
or van Oostsanen, Jacob
(Jacob van Amsterdam)
Netherlands, c.1470-1533
CORNELISZ. de Kok or
Cornelisz. Kunst,
Lucas
(Formerly identified
with Luca d'Olanda)
Netherlands,
1493/5-1552
CORNELISZ.Kunst, Pieter
or Pieter Cornelisz.
Netherlands, op.1514-1542
CORNELIUS
Dutch, 20th cent.
CORNELIUS, Peter (Joseph)
German, 1783-1867
CORNELYS, Albert
see Cornelis
CORNELL, Joseph
American, 1903-
CORNELY, Andrea
Italian, op.1678-1687
CORNEO, Julie
Italian, 19th cent.
CORNER, Frank W.
British, -1928
CORNER, Thomas Cromwell
American, 1865-1938
CORNET, Alphonse
French, op.1864-1887
CORNET, Jacobus
Ludovicus
Dutch, 1815-1882
CORNIA or Corgna,
Antonio della
Italian, op.1634
CORNICELIUS, Georg
German, 1825-1898
CORNILL, Otto
(Philipp Otto)
German, 1824-1907
CORNILLAUD, Eulalie
see Morin
CORNILLIER, Pierre Emile
French, 1863-
CORNILLIET, Alfred
(Jean Baptiste Alfred)
French, 1807-c.1895

CORNILLIET, Jules
French, 1830-1886
CORNING, Merv
American, 20th cent.
CORNISH, H.
British, 18th cent.
CORNISH, John
British, 18th cent.
CORNISH, Norman
British, 1919-
CORNOYER, Paul
American, 1864-1923
CORNU, Jean Alexis
French, 1755-1807
CORNU, Jean-Jean
French, 1819-1876
CORNU, Pierre
French, 1895-
CORNU, Sebastien
Melchior
French, 1804-1870
CORNUZ, Christiane
Swiss, 1944-
COROËNNE, Henri
French, 1822-p.1883
COROMALDI, Umberto
Italian, 1870-
CORONA, G.A.
Italian, 16th cent.
CORONA, Lionardo
(Lionardo da Murano)
Italian, 1561-1605
CORONADO, Jose Gonzalez
Spanish, 19th cent.
CORONAT, Prosper Pierre
French, 1822-1897
CORONELLI, A.
Italian, 20th cent.
CORONELLI, P. Vicenzo
Maria
Italian, -1718
COROT
French, op.1774
COROT, Jean Baptiste
Camille
French, 1796-1875
CORPORA, Antonio
Italian, 1909-
CORR, Isabelle Marie
Françoise (Fanny)
see Geefs
CORRADI
see Curradi, Francesco
CORRADI, Konrad
Swiss, 1813-1878
CORRADINI, Bartolommeo
see Carnevale
CORRADO
see Giaquinto
CORRADO d'Alemagna
Italian, op.1477-1483
CORRADO, Francesco
Italian, 17th cent.
CORREA de Vivar, Juan
Spanish, op.c.1550
CORREA, Marcos
Spanish, op.1667-1673
CORREDOIRA, Jesus
Rodriguez
Spanish, 1889-
CORREGE, Courrège or
Courrèges, Jean
French, op.1751-m.1787(?)
CORREGGIO, Antonio
Allegri da
Italian, c.1489-1534
CORREGGIO, Joseph
German, 1810-1891

CORREGIO, Max
German, 1854-1908
CORRENS, Jozef Cornelius
Belgian, 1814-1907
CORRODI, Arnold
Italian, 1846-1874
CORRODI, Hermann
Italian, 1844-1905
CORRODI, Salomon
Swiss, 1810-1892
CORRODI, Salvator
Italian, op.1866
CORSI, Carlo
Italian, 1878-1966
CORSI, Nicolò de'
Italian, 1882-
CORSIA, G.
French, 20th cent.
CORSINI, Domenico
Italian, 1774-1814
CORSO di Buono
Italian, op.1284-1295
CORSO di Giovanni
Italian, op.c.1344
CORSO, Monaldo
see Monaldo
CORT or Kort, Cornelis
(Cornelius Curtius)
Netherlands, 1533/6-1578
CORT, Hendrik Frans de
Flemish, 1742-1810
CORTAZZO, Oreste
Italian, 1836-
CORTBEMDE or Curtbemde,
Balthasar van
Flemish, 1612-1663
CORTE, Cesare
Italian, 1550-1613/14
CORTE, Juan de la
Spanish, 1597-1660
CORTELLINI, Michele di
Luca dei
see Coltellini
CORTENS, Anna M.
Flemish, 17/18th cent.
CORTES, Andre
Spanish, 20th cent.
CORTES, H. Edouard
French, op.1899-1910
CORTESE, Federigo
Italian, 1829-1913
CORTESE, J. and G.
see Courtois
CORTESI, Marmoccifini
see Fratellini, Giovanna
CORTI, C.
Italian ? op.1795-1797
CORTONA, Pietro da
see Pietro
CORTOT, Jean
French, 1925-
CORTOT, Jean Pierre
French, 1787-1843
CORVI or Corbi,
Domenico
Italian, 1721-1803
CORVINA, Corvino or
Corvini, Maddalena
Italian, op.1630
CORVO, Baron
see Rolfe, P.W.
CORVO or di Conio,
Tommaso
Italian, op.1506-1532
CORVUS, Augustinus
German, 16th cent.

CORVUS, Hans or
Johannes (Jan Raf
or de Rave?)
Netherlands,
op.1512(?)-1545
CORWINE, Aaron Houghton
American, 1802-1830
COSATTINI, Giovanni
Giuseppe
Italian, op.1659-1698/9
COSCI, Giovanni Balducci
see Balducci
COSENZA, Giacomo de
Italian, 16th cent.
COSENZA, Giuseppe
Italian, 1847-
COSGROVE, Stanley
Canadian, 1911-
COSIDA y Ballejo,
Jeronimo
Spanish, op.1530-1572
COSIMO, Piero di
see Piero
COSME da Ferrara
see Tura, Cosimo
COSOMATI, Ettore
Italian, 1873-
COSSA, Francesco del
Italian, c.1435-1477
COSSAAR, Jacobus Cornelis
Wyand (Jan)
Dutch, 1874-1966
COSSALI or Gozzali,
Grazio
Italian, 1563-p.1627
COSSARD, Jean
French, 1764-1838
COSSE, Laurence J.
British, op.1784-1837
COSSIAU, Jan Joost van
Dutch, c.1660-1732(?)/4
COSSIERS, Caussiers,
Coetsiers or Cotsiers,
Jan
Flemish, 1600-1671
COSSINGTON SMITH, Grace
Australian, 1892-
COSSIO, Francesco
Gutiérrez
Spanish, 1898-
COSSIO, Pancho
Spanish, 20th cent.
COSSMANN, Hermann Moritz
German, 1821-1890
COSSON, J.L.Marcel
French, 20th cent.
COST, James Peter
American, 20th cent.
COSTA, Alessandro
Italian, 16th cent.
COSTA da Milano, Angelo
Maria
Italian, op.1709-1714
COSTA, Annibale
Italian, op.1503
COSTA, Antonio
Italian, 1804-1875
COSTA, Catherina da
British, op.1718
COSTA, Francesco
Italian, 1672-1740
COSTA, Giovanni
Italian, 1833-1893
COSTA, Giovanni
(Nino)
Italian, 1827-1903

COSTA, Giovanni Battista
Italian, op.1652-1670
COSTA, Giovanni Francesco
Italian, op.1750-m.1773
COSTA, Ippolito
Italian, c.1506-1561
COSTA, John da
British, 1867-1931
COSTA the Elder,
Lorenzo
Italian, c.1460-1535
COSTA, Milton da
Brazilian, 20th cent.
COSTA, M.V.
French, 18th cent.
COSTA, Oreste
Italian, 1851-
COSTA, Pilides
American, op.1933
COSTA, Rinaldo Veronese
Italian, 18th cent.
COSTA, Tony
Italian, 1935-
COSTA, Vasco
Italian, 20th cent.
COSTA, Vincenzo
Italian, op.1718
COSTANTINI, Ermenegildo
Italian, op.1776-1791
COSTANTINI, Eugenio di
Giulio
Italian, op.1579-1583
COSTANTINI, Giuseppe
Italian, 1850-
COSTANTINI, Virgilio
Italian, 1882-
COSTANTINO da Monopoli
Italian, op.1513
COSTANZI, Placido
Italian, c.1690-1759
COSTANZO da Ferrara
Italian, op.1481
COSTANZO, Francesco
see Cattanio
COSTANZO, Marco
Italian, 15th cent.
COSTE, Jean Baptiste
French, op.c.1777-1809
COSTEN, Isaak van
Flemish, 1613-1661
COSTER or Ceuster or
Ceustere, Adam de
Flemish, c.1586-1643
COSTER, Anne Vallayer
see Vallayer Coster
COSTER, Dominicus (de)
see Custos
COSTER, Hendrick
Dutch, op.1638-1659
COSTERE, Pieter de
see Balten
COSTETTI, Romeo
Italian, 1871-
COSTIGAN, John E.
American, 1888-
COSTOIRIS, Johann
Netherlands(?) op.1666
COSTOLI, Aristodemo
Italian, 1803-1871
COSWAY, Maria Louisa
Catherine Cecilia,
née Hadfield
British, 1759-1838
COSWAY, Richard
British, 1742-1821
COSYN or Cousyn, Aert
Dutch, op.1662-1673

COSYN or Cousyn, Pieter
Dutch, 1630-p.1667
COSYN or Cousyn,
Stephanus
Dutch, op.1670-m.1697(?)
COT, Pierre Auguste
French, 1837-1883
COTAN, Fray Juan Sanchez
see Sanchez Cotan
COTANDA, V. Nicolau
Spanish, 19th cent.
COTE, Aurèle de Foye Suzor
Canadian, 1869-1937
COTEAU, D.
French, op.1785
COTEAU, Jean
Swiss, 1739?-1812
COTELLE, Cotel or
Costel, Jean, I
French, 1607-1676
COTELLE, Jean, II
French, 1642-1708
COTER, Colijn de
Netherlands,
op.1493(?)-1506
COTES, E.C.
American, 19th cent.
COTES, Francis
British, c.1725-1770
COTES, Penelope
British, 18th cent.
COTES, Samuel
British, 1734-1818
COTESSE(?)
French, op.c.1820
COTIGNOLA
see Zaganelli
COTMAN, A.
British, 19th cent.
COTMAN, Frederick
George
British, 1850-1920
COTMAN, Henry William
British, 19th cent.
COTMAN, John Joseph
British, 1814-1878
COTMAN, John Sell
British, 1782-1842
COTMAN, Kenneth G.
British, 20th cent.
COTMAN, Miles Edmund
British, 1810-1858
COTOS, George
Rumanian, 1915-
COTSIERS, Jan
see Cossiers
COTTA, Giacomo
Italian, op.1659-m.1689
COTTAVOZ, André
French, 20th cent.
COTTENET, Jean
French, 20th cent.
COTTERELL, A.N.
British, 20th cent.
COTTET, Charles
French, 1863-1925
COTTIN, Eugène
French, 1840-1902
COTTIN, Pierre
French, 1823-1886/87
COTTINGHAM, Lewis
Nockalls
British, 1787-1847
COTTINGHAM, Robert
American, 1935-
COTTO, Pedro
Spanish, op.1694

COTTON, Mariette
American, op.1889-1912
COTTON, Michel (or Pierre?)
French, op.1675-1688
COTTON, William
American, 1880-
COTTRAU or Cottreau,
Félix (Pierre Félix)
French, 1799-1852
COTTREAU, Félix
see Cottrau
COTTRAU, Luis
French, op.1832
COUASKY, Alexander
see Kucharski
COUBAUD
French, 19th cent.
COUBERTIN, Charles Louis
Frédy de
French, 1822-1908
COUBINE, Othon (Otakar)
Czech, 1883-
COUDER, Jean Alexandre
French, 1808-1879
COUDER, Louis Charles
Auguste
French, 1790-1873
COUDON, Roland
French, 20th cent.
COUDRES, Louis des
German, 1820-1878
COUGHTRY, Graham
Canadian, 1931-
COULDERY, Horatio Henri
British, 1832-p.1910
COULERY, Louis de
see Caullery
COULIN-MOINOT, Maria
Eugénie née Moinot
French, 19th cent.
COULOM, Jean Baptiste
French, op.1695-1735
COUNHAYE, Charles
Belgian, 1884-1971
COUNIHAN, Noel
Australian, 1913-
COUNIS, Elisa
Italian, 1812-1848
COUNTZE or Countz,
Frederick
German, op.1795-1801
COUPE, Fred
British, 1875-
COUPIN de la Couperie,
Marie Philippe
French, 1773-1851
COUR, Janus Andreas
Bartholin la
Danish, 1837-1909
COUR, Jean Gilles de
la or del
see Delacour
COURAND, J. de
French, 19th cent.
COURANT, Maurice
French, 1847-1925
COURBES, J. de
French, 1592-p.1630
COURBET, Gustave
French, 1819-1877
COURBOIN, Francois
(Jules-Marie)
French, 1865-1926
COURCELLES, Pauline
de
see Knip

COURDA or Courdo,
see Cordua
CORDOUAN, Vincent
(Joseph Francois)
French, 1810-1893
COURIER, Mme Paul-
Louis
French, op.1817
COURMES, Alfred
French, 1898-
COURNAULT, Étienne
French, 1891-1948
COURNERIE or Cournery,
Louis
French, 18th cent.
COURREGE or Courrèges,
Jan
see Corrège
COURSELLES-DUMONT, André
Paul
French, 1889-
COURT, Catharina de la
(née Backer)
see Backer
COURT or Curtius, Jean de
see Decourt
COURT, Jean Gilles del
see Delacourt
COURT, Johannes
Franciscus de la
Dutch, 1684-p.1753
COURT, Joseph-Désiré
French, 1797-1865
COURT, Martinus de la
Flemish, 1640-1710
COURT, Pierre la
see Lacour
COURTEILLE, N. de
French, op.1779
COURTEN, Angelo, Comte
de
Italian, 1848-1925
COURTEN, M.L.
Flemish(?) op.1782
COURTENS, Frans
Belgian, 1854-1943
COURTENS, Herman
Belgian, 1884-
COURTIN
French, 20th cent.
COURTIN, Caroline
French, 19th cent.
COURTIN, Jacques François
French, 1672-1752
COURTNEY, Jeffery
British, 20th cent.
COURTOIS, Guillaume
(Guglielmo Cortese, il
Borgognone)
French, 1628-1679
COURTOIS, Jacques
(P. Giacomo Cortese or
Cortesi) (il
Borgognone or Le
Bourguignon)
French, 1621-1675
COURTOIS, Nicolas André
French, 1734-p.1797
COURTONNE, Jean Baptiste
French, c.1711-1781
COURTRY, Charles (Jean
Louis)
French, 1846-1897
COURVOISIER, Jules
Swiss, 1884-
Couse, Eanger-Irving
American, 1866-1936

COUSET
French, 18th cent.
COUSIN, Charles Louis
Auguste
French, 1807-1887
COUSIN, Jean, I
French, 1490-1560
COUSIN, Jean, II
French, c.1522-1594
COUSIN, Louis
see Gentile, Luigi
Cousins, Samuel
British, 1801-1887
COUSSEDIERE, Charles
Jean
French, op.1895
COUSSENS, Armand
French, 1881-1935
COUSTOU, Guillaume, I
French, 1677-1746
COUSTOU, Jean
French, 1719-1791
COUSTOU, Nicolas
French, 1658-1733
COUSTURIER, Lucie
French, 1878-1925
COUSYN
see Cosyn
COUTAUD, Lucien
French, 1904-
COUTELLIER, J.
French, op.1776-1789
COUTOURIER, Léon Antoine
French, 1842-1900
COUTURE, Guillaume
Martin
French, 1732-1799
COUTURE, Thomas
French, 1815-1879
COUTURIER, Hendrick
Dutch, op.1648-m.c.1684
COUTURIER, Léon Philibert
French, 1823-1901
COUTURIER, Robert
French, 1905-
COUTY, Jean
French, 20th cent.
COUVAY, Jean
French, 1622-
COUVELET, Adolphe
Hippolyte
French, 1802-1867
COUVELET, Jean Baptiste
French, 1772-1830
COUVER, Jan van
see H. Koekkoek
COUWENBERCH, Couwenberg
or Couwenbergh, Christiaen
van
Dutch, 1604-1667
COUWENBERG, Abraham
Johannes
Dutch, 1606-1844
COUWENBERG, Henricus
Wilhelmus
Dutch, 1814-1845
COUWENBERGH, Christiaen
van
see Couwenberch
COUWENHORN or Kouwenhorn,
Pieter
Dutch, op.c.1624-1635
COVALIU, Bradut
Rumanian, 1924-
COVARRUBIAS, Miguel
Mexican, 1904-1957

COVENTRY, C.C.
British, op.1802-1819
COVENTRY, F.H.
British, 20th cent.
COVENTRY, Robert
McGown
British, 1855-1914
COVEY, Arthur Sinclair
American, 1877-
COVIELLO, Peter
British, 1930-
COVYN or Covijn,
Reynier
Flemish, 1636-p.1667
COWDEN, Virginia
American, 20th cent.
COWDEN, William
British, op.1798-1820
COWEN, William
British,
1797(?)-c.1860/1
COWERN, Raymond Teague
British, 1913-
COWIE, James
British, 1886-1956
COWLES, Fleur
American, 20th cent.
COWLES, Russell
American, 1887-
COWPER, Douglas
British, 1817-1839
COWPER, Frank Cadogan
British, 1877-1958
COWPER, Max
British, op.1901-1911
COX, David, I
British, 1783-1859
COX, David, II
British, 1809-1885
COX, David
British, 1914-
COX, E. Albert
British, 1876-1955
COX, Gonzales
see Coques
COX, Jacob
American, 1810-1892
COX, Jan
Dutch, 1919-
COX, Kenyon
American, 1856-1919
COX, Louise Howland
King (Mrs Kenyon
Cox)
American, 1865-1945
COXIE, Jan Michiel
Flemish, p.1650-p.1689
COXIE, Coxcie, de Coxcie,
Coxcien or Coxius,
Michiel, I
Netherlands, 1499-1592
COXIE, Michiel, III
Flemish, 1603-p.1669
COXIE, Raphael
Flemish, c.1540-1616
COXON, Raymond
James
British, 1896-
COXON, Thomas
see Cockson
COY, James B.
British, op.1769-m.c.1780
COYPEL, Antoine
French, 1661-1722
COYPEL, Charles Antoine
French, 1694-1752

COYPEL, Noël
French, 1628-1707
COYPEL, Noël Nicolas
French, 1690-1734
COYSEVOX, Coisevaux
or Quoyzeveau,
Antoine
French, 1640-1720
COZENS, Alexander
British, c.1717-1786
COZENS, Charles
British, 19th cent.
COZENS, John Robert
British, 1752-1797
COZENS, K.
British, 20th cent.
COZENS, William
British, op.1778-1823
COZETTE, Charles
French, op.1757
COZETTE, Pierre François
French, 1714-1801
COZZA, Francesco
Italian, 1605-1682
COZZARELLI, Guidoccio
di Giovanni
Italian, op.1450-1516
COZZENS, Frederick
Schiller
German, -1928
CRABB, William
British, 1811-1876
CRABBE van Espleghem,
Frans (Master of the
Crab)
Netherlands, c.1480-1552
CRABEELS, Florent
Nicolas
Belgian, 1829-1896
CRABETH, Adriaen
Pietersz.
Netherlands, -1553
CRABETH, Dirck Pietersz.
Netherlands,
op.1545-m.c.1577
CRABETH, Wouter
Pietersz., I
Netherlands,
op.1561-m.1590
CRABETH, Wouter
Pietersz., II
(Almanack)
Dutch, c.1595-1644
CRACHT or Craft,
Tyman Arentsz.
Dutch, op.1622-m.a.1647
CRACKLOW, Charles
Thomas
British, op.1806-1823
CRACKNELL, Alan
British, 20th cent.
CRADOCK, Marmaduke
(not Luke)
British, c.1660-1717
CRADOCK, Mary
see Beale
CRAEN, Laurens
Dutch, op.c.1635(?)-1664
CRAENBURCH
Dutch, 17th cent.
CRAESBEECK or
Craesbeke, Joos
van
Flemish, c.1605-c.1654/61
CRAEY, Dirck
Dutch, op.1634-m.c.1666
CRAEYVANGER, Reinier
Dutch, 1812-1880

68

CRAFFONARA (not
 Graffonara) Giuseppe
 Italian, 1792-1837
CRAFT, Percy Robert
 British, 1856-1934
CRAFT, Tyman
 see Cracht
CRAFT, William H.
 British, op.1774-m.1805
CRAHAY, Albert
 Belgian, 1881-1914
CRAIG, Alexander
 British, op.1840-m.1878
CRAIG, Charles
 American, 1846-1931
CRAIG, Frank
 British, 1874-1918
CRAIG, Edward Gordon
 British, 1872-1966
CRAIG, James
 British, op.1811-1812
CRAIG, William Marshall
 British, op.1788-1828
CRAIG-MARTIN, Michael
 British, 20th cent.
CRAJKOWSKI, Stanislas
 Polish, 20th cent.
CRAKE, F.
 British, op.1687
CRAMER, June Campbell
 British, 20th cent.
CRAMER, Molly
 German, 1862
CRAMER, Peter
 Danish, 1726-1782
CRAMER, Petrus
 Dutch, 1670-c.1703
CRAMER, Rie
 British, 20th cent.
CRAMPTON
 British, 19th cent.
CRANACH, Hans
 German, op.1516-1537
CRANACH, Lucas, I
 (Müller or Sunder)
 German, 1472-1553
CRANACH, Lucas, II
 German, 1515-1586
CRANCH, John
 British, 1751-1821
CRANE, Bruce
 American, 1857-1937
CRANE, R.
 British, 19th cent.
CRANE, Thomas
 British, 1808-1859
CRANE, Walter
 British, 1845-1915
CRANKE, James, I
 British, 1707/8-1781
CRANMER, Charles, II
 British, 1780-1841
CRANSTONE, Lefevre
 J.
 British, op.1845-1867
CRANSTOUN, James H.
 British, 19th cent.
CRANZ or Kranz,
 Thomas
 German, 1786-1853
CHAPELET, Louis Amable
 French, 1823-1867
CRASKELL, Thomas
 British, op.c.1750
CRATS, de
 see Decritz
CRANK, Charles Alexandre
 French, 1819-1905

CRAVEN, Alfred
 British, 1917-
CRAVEN, Hawes
 British, 1837-1910
CRAW, James
 American, 18th cent.
CRAWFORD, Edmund
 Thornton
 British, 1806-1885
CRAWFORD, Ralston
 American, 1906-
CRAWFORD, Richard Goldie
 British, op.1898-1910
CRAWFORD, Robert Cree
 British, 1842-1924
CRAWFORD, Susan
 British, 20th cent.
CRAWFORD, Susan
 Fletcher
 British, op.1892
CRAWFORD, William
 British, 1825-1869
CRAWHALL, Joseph
 British, 1860-1913
CRAWHALL, W.
 British, 19th cent.
CRAXTON, John
 British, 1922-
CRAYER, Caspar, Gaspar
 or Jasper de
 Flemish, 1584-1669
CRAYER, J.
 Dutch, 19th cent.
CREALOCK, John Mansfield
 British, 1871-1959
CREARA, Sante
 Italian, c.1572-
CREC or (?) Cree, Carel
 Jacob
 Flemish, op.1707-1717
CRECOLINI, Cricolini or
 Gregolini, Giovanni
 Antonio
 Italian, 1675-c.1736
CREDI, Lorenzo di
 see Lorenzo
CREE, Carel Jacob
 see Crec
CREE, E.H.
 British, op.1847
CREE, Janet (Mrs Platt-
 Mills)
 British, 1910-
CREECHER, Thomas
 British, op.1678-1679
CREFFIELD, Dennis
 British, 1931-
CREGAN, Martin
 British, 1788-1870
CREIXAMS, Pedro
 Spanish, 20th cent.
CREME, Benjamin
 British, 1922-
CREMER, Fritz
 German, 1906-
CREMIEUX, Edouard
 French, op.1895
CREMONA, Antonio da
 see Carpi, Antonio
CREMONA, E.V.
 Italian, 20th cent.
CREMONA, Tranquillo
 Italian, 1837-1878
CREMONESE, Il
 see Caletti, Giuseppe
CREMONINI, Giovanni
 Battista (Zamboni)
 Italian, op.1599-m.1610

CREMONINI, Leonardo
 Italian, 1925-
CREPIN, Joseph
 French, 20th cent.
CREPIN, Louis Philippe
 French, 1772-1851
CREPON, L.
 French, 19th cent.
CREPU, Jan Baptist de
 Flemish, op.1652-m.c.1689
CRESCENT or Cressant,
 Jacobus Andreas
 Dutch, c.1768/9-1819
CRESCENZI, Giovanni
 Battista
 Italian, 1577-1660
CRESCENZIO, Antonello da
 (not Antonello da
 Palermo)
 Italian, c.1467-1542
CRESCENZIO or dei
 Crescenzi
 see Cavarozzi, Bartolommeo
CRESCI, Giovanni
 Francesco
 Italian, op.1560-1570
CRESCI, Mario
 Italian, 20th cent.
CRESCIMBENI, Angelo
 Italian, 1734-1781
CRESCUOLO, Giovan Filippo
 see Criscuolo
CRESPI, Antonio
 Italian, 1704(1700?)-1781
CRESPI, Benedetto
 (Bustino)
 Italian, 17th cent.
CRESPI, Daniele
 Italian, 1590-1630
CRESPI, Francesco
 Italian, 18th cent.
CRESPI, Giovanni Battista
 (Il Cerano)
 Italian, c.1557-1633
CRESPI, Giuseppe Maria
 (Lo Spagnuolo)
 Italian, 1665-1747
CRESPI, Luigi
 Italian, c.1709-1779
CRESPI, Ortensio
 Italian, 17th cent.
CRESPIN de Valenciennes
 French, 18th cent.
CRESPY, Baronne de
 see Leprince, Juliette
CRESPY Le Prince, Charles
 Edouard, Baron de
 see Le Prince
CRESSANT, Jacobus Andreas
 see Crescent
CRESSWELL, P.F.
 British, 20th cent.
CRESSWELL, Lieut. S.G.
 British, op.1853
CRESTI, Domenico
 see Passignano
CRESWICK, Thomas
 British, 1811-1869
CRETI, Donato (Donatino)
 Italian, 1671-1749
CRETIUS, Konstantin
 Johann Franz
 Swiss, 1814-1901
CREUSE, Auguste de
 French, 1806-1839
CREUTZBERGHER, Paul
 see Kreutzberger
CREUTZFELDER the Elder,
 Johann
 German, 1570-1636

CREVALCORE, Antonio
 Leonelli da
 see Leonelli
CREVATIN, G.B.
 (or Crevattin)
 Italian, 1835-1910
CREW, Emma
 British, op.1783
CREW, John Thistlewood
 British, 1830-1860
CREYKE-CLARK, Thyra
 British, 20th cent.
CRICOLINI, Giovanni
 see Crecolini
CRIPPA, Luigi
 Italian, 1921-
CRIPPA, Roberto
 Italian, 1921-
CRISCITO, D.
 Italian, 19th cent.
CRISCOLO, Giovan
 Filippo
 see Criscuolo
CRISCUOLO, Crescuolo,
 Crisqolo or Criscolo,
 Giovan Filippo
 Italian, c.1500-1584
CRISP, Arthur
 Canadian, 1881-
CRISQOLO, Giovan Filippo
 see Criscuolo
CRISSAY, Marguerite
 French, op.1921-m.1945
CRISTALL, Joshua
 British, 1767/9-1847
CRISTIANI, Giovanni di
 Bartolommeo da Pistoia
 Italian, op.1366-1398
CRISTOFANO di Bindoccio
 see Cristoforo
CRISTOFANO dal Borgo
 see Gherardi
CRISTOFORO or Cristofano
 di Bindoccio (Malabarba)
 Italian, op.1361-1406
CRISTOFORO, Cristofano
 or Cristofalo da
 Bologna the Elder
 Italian, op.1359(?)-1387
CRISTOFORO da Bologna the
 Younger
 Italian, op.1456-1497
CRISTOFORO de'Cortese
 Italian, op.1360-1371
CRISTOFORO da Faventia
 Italian, op.1430-1440
CRISTOFORO da Ferrara
 see Cristoforo da
 Bologna
CRISTOFORO di Giovanni
 (Cristoforo da San
 Severino)
 Italian, op.1448-1457
CRISTOFORO da Marsciano
 Italian, op.1527
CRISTOFORO da Parma
 see Caselli
CRISTOFORO da San
 Severino
 see Cristoforo di
 Giovanni
CRISTOFORO da Seregno
 Italian, op.1476-1480
CRISTUS, Petrus
 see Christus
CRITZ, de
 see Decritz

69

CRIVELLI, Angelo Maria
(Crivellone)
Italian, -c.1730
CRIVELLI, Carlo
Italian, 1430/5-c.1495
CRIVELLI, Francesco
Italian, op.1450
CRIVELLI, Protasio
Italian, op.1497-1506
CRIVELLI, Vittorio
Italian, op.1481-1501
CRIVELLONE
see Crivelli, Angelo
Maria
CROASDALE, E.
American, 19th cent.
CROCCHIA, Girolamo
(Il Crocicchia)
see Palmerini, P.A.
CROCE, Croci or della
Croce, Baldassare
Italian, c.1558-1628
CROCE, C.F. della
see Lacroix
CROCE, Johann Nepomuk
della
German, 1736-1819
CROCE, Theodor della
see Verkruys
CROCI, Domenico Frilli
Italian, op.1614
CROCIFISSI, Simone dei
(Simone di Filippo di
Benvenuto and Simone da
Bologna and il Crocifissajo)
Italian, c.1330-c.1399
CROCKATT, W.
British, op.1793
CROCKER, Phillip
British, 18th cent.
CRODEL, Matthias, II
see Krodel
CRODEL, Paul Eduard von
German, 1862-1928
CROEGAERT, Georges
Belgian, 1848-1923
CROES, Jacques van
Flemish, 17th cent.
CROESE, Floris
Dutch, 1763-1808
CROFT, Arthur
British, op.1865-1893
CROFT, John Ernest
British, 19th cent.
CROFTS, Ernest
British, 1847-1911
CROIZER, A.
French, op.1819
CROLA or Croll, Georg
Heinrich
German, 1804-1879
CROLL, Carl Robert
German, 1800-p.1844
CROMBIE, Benjamin
William
British, 1803-1847
CROMBIE, Charles
British, op.1912
CROME the Elder, John
(Old Crome)
British, 1768-1821
CROME the Younger, John
Berney
British, 1794-1842
CROME, William Henry
British, 1806-1873
CROMEK, Thomas Hartley
British, 1809-1873

CROMER, Giovanni Battista
Italian, c.1667-1750
CRONACA, Il
see Pollaiuolo, Simone
del
CRONE, Robert
British, op.1748-m.1779
CRONENBURG or Cronenburgh,
Adriaen van
Netherlands,
c.1525-c.1604
CRONHIORT, Carl Gustaf
Swedish, 1694-1777
CROOKE, Ray
Australian, 1922-
CROOM, C.
British, op.1820-1860
CROON, T.J.
Dutch(?) op.1661
CROONENBERGH, Isaack
Dutch, op.1670-1678
CROOS or Kroos, A.
Dutch, op.1740
CROOS or Croost, Anthony
Jansz. van der
Dutch, 1606/7-c.1662/3(?)
CROOS or Croost, Jacob
van der
Dutch, op.1654-m.a.1700
CROOS, Jan Jacobsz. van der
Dutch, 1654/5-c.1711/16
CROOS, Croost or Kroos,
Pieter van der
Dutch,
c.1609/11-1677/1701(?)
CROPLEY, Miss
British, op.1789-1811
CROPSEY, Jasper Francis
American, 1823-1900
CROS, Henri (César
Isidore Henri)
French, 1840-1907
CROSATO, Giovanni
Battista
Italian, 1695/7-1756
CROSBIE, William
British, 1915-
CROSBY
British, 20th cent.
CROSBY, Raymond Moreau
American, c.1875/7-1945
CROSBY, William
British, op.1859-1873
CROSIO, Giovanni
(or Guglielmo)
Italian, 1560(?)-1626
CROSIO, Luigi
Italian, 19th cent.
CROSIO
see Le Crosio
CROSNIER, Jules
Swiss, 1843-1917
CROSS, Gerald
American, 20th cent.
CROSS, Henri Edmond
French, 1856-1910
CROSS, Henry H.
American, op.1862-1887
CROSS, John
British, 1819-1861
CROSS, Julian
British, 20th cent.
CROSS, Max
British, op.1896-1898
CROSS, P.
British, op.1667
CROSS the Elder, Thomas
British, op.1644-1682

CROSSE, Laurence
(not Lewis)
British, 1650-1724
CROSSE, Richard
British, 1742-1810
CROSSLEY, Bob
British, 1912-
CROTCH, William
British, 1775-1847
CROTTI, Jean
Swiss, 1878-
CROUCH, Brian
British, 20th cent.
CROUCH, John
British, op.1830-1850
CROUSE
British, 18th cent.
CROUTER, A.
American, op.1850-1865
CROUWEL, Wilm
Hendrik
Dutch, 1928-
CROWE, Eyre
British, 1824-1910
CROWE, Stephen
British, 1812-p.1848
CROWHALL, Joseph
British, 1861-1913
CROWLEY, Grace
Australian, 1891-
CROWLEY, Nicholas
Joseph
British, 1813-1857
CROWQUILL, Alfred
(Alfred Henry
Forrester)
British, 1804-1872
CROZIER
French, 18th cent.
CROZIER, Jean Pierre
French, op.1654
CROZIER, Robert
British, op.1853(?)-1882(?)
CROZIER, William
British, 1933-
CRUET, Pauline du
see Augustin
CRUICKSHANK, Frederick
British, 1800-1868
CRUICKSHANK, William
British, op.1866-1887(?)
CRUICKSHANK, George
British, 1792-1878
CRUIKSHANK, Isaac
British, 1756-1810
CRUIKSHANK, Robert Isaac
British, 1789-1856
CRUIKSHANK, William
Canadian, 1849-1922
CRUSELLS, Crussells or
Cruzells, Pere or
Pierre
Spanish, 1672(?)-p.1734
CRUSET, Sebastien
American, 19th cent.
CRUSIUS, Gottlieb
Leberecht
German, 1730-1804
CRUSSENS, Anton
Flemish, op.1655
CRUST, John
British, 16th cent.
CRUYL, Lievin or
Levin (Livinus
Cruylius)
Flemish, c.1640-c.1720
CRUYS or Kruys, Cornelia
Dutch, op.1644-m.a.1660

CRUZ, Diego de la
Spanish, op.1487-1496
CRUZ, Manuel de la
Spanish, 1750-1792
CRUZADO, J.Fernandez
Spanish, 1791-1856
CRUZ-DIEZ, Carlos
Venezualan, 1923-
CRYER, John Vernon
British, 20th cent.
CSAKY, Jozsef
Hungarian, 1888-
CSEMICZKY, Tihamer
Hungarian, 1904-1960
CSIKY, Toba
Hungarian, 20th cent.
CSONTVARY
Hungarian, 1853-1919
CUBELLS y Ruiz, Enrique
Martinez
Spanish, 1874-1917
CUBELLS, Salvador
Martinez
Spanish, 1845-1914
CUBITT, Thomas
British, 1788-1855
CUCCORANTE, Leonardo
see Coccorante
CUCUEL, Edward
American, 1879-
CUDWORTH, Nick
British, 20th cent.
CUEMAN, Egas
see Egas
CUEPINCK, G.
Netherlands, op.1627
CUERA, Pedro
see Zuera
CUERENHERT, Dirck
see Coornhert
CUETT, John
British, op.1710-
CUEVAS
Spanish, op.1550
CUEVAS, José Luis
Mexican, 1933-
CUGNET
French, 19th cent.
CUGNI, Francesco di
Leonardo
Italian, op.1587
CUIP, H.
Dutch, 19th cent.
CUISIN, Charles
Emile
French, 1832-1900
CUITT the Elder,
George
British, 1743-1818
CUITT the Younger,
George
British, 1779-1854
CUIXART, Modest
Spanish, 1925-
CULL, S.B.
British, 19th cent.
CULLEN, Maurice
Galbraith
Canadian, 1866-1934
CULLEN, T.
British, op.1778
CULLIN, Isaac
British, op.1881-1889
CULLUM, John
British, op.1833-1849
CULMER, Henry L.A.
American, 1854-1914

CULVERHOUSE, Johan
Mengels
Dutch, 1820-
CUMBERLAND, George
British,
1758/64-1848
CUMBO, Ettore
Italian, 1833-p.1874
CUMELIN, Johan Peter
Swedish, 1764-p.1789
CUMING, William
British, 1769-1852
CUMMING, James
British, op.1833
CUMMING, James
British, 1922-
CUMMING, Richard
British, op.1797-1803
CUMMING, W. Skeoch
British, op.1885-1906
CUMMINGS, Edward
Eatlin
American, 1894-1962
CUNAEUS, Conradijn
Dutch, 1828-1895
CUNDALL, Charles
Ernest
British, 1890-1971
CUNDELL, Nora Lucy
Mowbray
British, 1889-1948
CUNDIER, Jean Claude
French, 1650-1718
CUNEGO, Domenico
Italian, 1726-1803
CUNEO, Terence
Tenison
American, 1907-
CUNGI, Congio or
Cungius, Camillo
Italian, op.1617-1646
CUNGI, Francesco di
Leonardo
Italian, op.1587
CUNGI, Leonardo
Italian, op.1558-m.1569
CUNIBERTI, Per
Achille
Italian, 1923-
CUNINGHAM, Vera
British, 1897-1955
CUNLIFFE, D.
British, op.1826-1855
CUNLIFFE, Margaret
British, op.1778
CUNNINGHAM, Ben
American, 20th cent.
CUNNINGHAM, Edward
Francis (Francesco
Calza or Calze)
British, 1741/2-1793/5
CUNTZ, Henri
French, 1907-
CUNZ, Thaddäus
see Kuntz
CUOSTA, Francesco
della or Francesco de
la Questa
Italian, 1652-1723
CURDIE, John
British, 19th cent.
CURIA or Kuria,
Francesco
Italian, 1538-1610
CURIE, A.
British, op.1806

CURIE or Currie,
Adine
French, op.1838-1840
CURNOCK, James
British, 1812-1870
CURNOE, Greg
Canadian, 1936-
CURRADI, Francesco
Italian, 1570-1661
CURRAN, Amelia
British, op.1819-m.1847
CURRAN, Charles
Courtney
American, 1861-1942
CURRENS, Josef
Belgian, 19th cent.
CURRIE, Miss
British, 19th cent.
CURRIE, James
British, op.1846
CURRIE, John S.
British, c.1890-1914
CURRIER, Nathaniel
American, 1813-1888
CURRIER, J. Frank
American, 1843-1909
CURRIER, Robert
American, op.1855
CURRY, Harry S.
British, 20th cent.
CURRY, John-Stuart
American, 1897-1946
CURSITER, Stanley
British, 1887-
CURTA
see Cordua
CURTBEMDE, Balthasar
van
see Cortbemde
CURTI, Francesco
Italian, 1603-1670
CURTI, Girolamo
(Il Dentone)
Italian, 1570/5-1632
CURTI, Louis
Italian, 20th cent.
CURTIS, Cecile
British, 20th cent.
CURTIS the Elder, John
British, op.1790-1822
CURTIS, J. Digby
British, op.1790-1827
CURTIS, Sarah
see Hoadly
CURTIS, William
British, 1746-1799
CURTIUS, Cornelius
see Cort
CURTIUS, Jean de
see Decourt
CURTY, Joseph
Emmanuel
Swiss, 1750-1813
CURVEN, P.F.
American, 19th cent.
CURZON, Paul Alfred de
French, 1820-1895
CURZON, Robert
British, 1810-73
CUSATI, Gaetano
Italian, -c.1720
CUSHING, Otho
American, 20th cent.
CUSIGHE, Simone da
see Simone
CUSIN, Federico
Italian, 1875-

CUSSELLE, P.
Dutch, 18th cent.
CUSSETTI, Carlo
Italian, 1866-
CUSSEUS, Cornelis
see Kussens
CUSSIO, Giorgio di
Italian, op.1919
CUSTODIS, Dominicus
see Custos
CUSTODIS, Hieronymus
Netherlands,
op.1589-1598
CUSTODIS, Jakob
see Custos
CUSTODIS, Pieter
see Balten
CUSTODIS, Raphael
German, c.1590-1651
CUSTOS, David
German, op.c.1600
CUSTOS, de Coster or
Custodis, Dominicus
Netherlands, p.1550-1612
CUSTOS or Custodis,
Jakob
German, 17th cent.
CUTALLI, Salvator
Italian, 17th cent.
CUTANDA y Toraya,
Vicente
Spanish, 1850-p.1892
CUTHBERT, Virginia
American, 1908-
CUTLER, Cecil
British, 19th cent.
CUTTOLD
French, op.1925
CUVENES I, Johannes
German, op.1645-1666
CUVILLIES the Elder,
François de
(Jean François)
French, 1695-1768
CUVILLIES the Younger,
François de
German, 1731-1777
CUYCK, Catharina,
(née Dubois)
see Dubois
CUYCK de Mierhop,
Mierop, Mirop or
Myerhop, Frans van
Flemish, c.1640-1689
CUYCK or Kuyk, Maria
Kristina van
Dutch, 1711-1781
CUYCK or Kuyck, Petrus,
II (Pieter Johannes)
van
Dutch, 1720-1787
CUYLENBURG or Cuylenborch,
Abraham van
Dutch, op.1624(?)-m.1658
CUYLENBURG or Cuylenburgh,
Cornelis van
Dutch, 1758-1827
CUYLENBURG or Cuylenburgh,
Johannes Elize van
Dutch, 1793-1841
CUYP, A.B.
Netherlands,
op.1594/7(?)
CUYP or Cuijp, Aelbert
Dutch, 1620-1691
CUYP or Cuijp, Benjamin
Gerritsz.
Dutch, 1612-1652

CUYP or Cuijp, Jacob
Gerritsz.
Dutch, 1594-1651/2
CUYPER, Cypers, Kueper
or Kuyper, Abraham
German, op.1605-1652
CUYPERS, C.
see Kuipers
CUYPERS, Cuyper or
Kuyper, Diderick Herman
Dutch, 1707-1779
CWICZECK, Mathias
see Czwiczek
CWIK, Jefim
Russian, 20th cent.
CYPERS, Abraham
see Cuyper
CYBIS, Boleslaw
Polish, 1896/99-1957
CYBIS, Jan
Polish, 1897-
CYOPIC, W.
Canadian, 20th cent.
CYPSKY, Frank
American, 1948-
CZACHORSKI, Ladislaw von
Polish, 1850-1911
CZAPSKI, Josef
Polish, 1896-
CZAUCZIK, Josef
Hungarian(?) 1781-1857
CZECH, Emil
German, 1862-
CZECH & BOHEMIAN SCHOOL,
Anonymous Painters
of the
CZECHOWICZ, Simon
Polish, 1689-1775
CZECHTAROW, Ludmil
Bulgarian, 20th cent.
CZEPCOW, E.M.
Polish, 20th cent.
CZERMAK or Cermak,
Jaroslav
Czech, 1831-1878
CZESCHKA, Carl Otto
German, 1878-1960
CZETTEL
French, 20th cent.
CZOBEL, Béla
Hungarian, 1883-
CZOK, Istvan (Stefan)
Hungarian, 1865-
CZOCK, Thamar J.
Hungarian, 19th cent.
CZWICZEK, Cwiczek or
Schwezge, Mathias
Czech, op.1628-1652
CZYMERMANN, Hans
see Zimmermann
CZYZEWSKI, Tytus
Polish, 1885-1945

D

DAALEN, Jan or Johan
van
see Dalen
DAALHOFF or Daalhof,
Hermanus Antonius
(Henri) van
Dutch, 1867-1953
DABADIE, Henri
French, 1867-
DABAT, Alfred
French, 1869-
D'ABELE or D'Abelle,
Ernst August
see Abel

DABO, Leon
American, 1868-
DABOS, Jeanne (née
Bernard)
French, 1763-1842
DABOS, Laurent
French, 1761-1835
DABROWSKI, Andrej
Onegin
Polish, 20th cent.
DACHTLER, N.
German, op.1800
DACKETT, T.
British, op.1684
DACRE, Susan Isabel
British, 1844-p.1929
DACRE, Winifred
see Nicholson, Winifred
DACZYNSKI, Stanislaus
Polish, 1856-
DADD, Frank
British, 1851-1929
DADD, Richard
British, 1819-1887
DADDI, Bernardo
(Bernardo da Firenze)
Italian, c.1280-1348
DADE, Ernest
British, op.1887-1901
DADELBEEK, G.
Dutch, op.1772
DADLEY, R.W.
British, op.1816
DADO, Miodrag Djurie
(Dado)
Yugoslav, op.1947-58
DAEGE, Eduard
German, 1805-1883
DAEGEN or Daegn
German, 18th cent.
DAEGN
see Daegen
DAEL, C. van den
Belgian, 19th cent.
DAEL, Jan or Johannes
van
see Dalen
DAEL, Jan Frans or Jean
Francois van
Belgian, 1764-1840
DAELEN, Eduard
German, 1843-1923
DAELLEN, F.V.
Netherlands, 17th cent.
DAELLIKER, Johann
Rudolf
German, 1694-1769
DAEMS or Dams, Joannes
Flemish, op.1634/5
DAEMS, Damen or Dams,
Lenaerd
Flemish, op.1630-1645
DAENELSEN, Hendrick
see Danielsz.
DAENZEL or Dentzel,
Michael
German, 1748-p.1804
DAEUBLER, Johann Martin
German, 1756-p.1800
DAEYE, Hippolyte
Belgian, 1873-1952
DAFFINGER, E.P.
German, 19th cent.
DAFFINGER, Moritz Michael
German, 1790-1849
DAFFORNE, James
British, op.1837-m.1880
DAGEN, Dismar
see Degen

DAGGIU
see Cappella, Francesco
DAGLEY, Richard
British, c.1765-1841
DAGLISH, Eric Pitch
British, 1894-
DAGNAN, Ididore
French, 1794-1873
DAGNAN-BOUVERET, Pascal
Adolphe Jean
French, 1852-1931
DAGOMER, Charles
French, op.1762-4
DAGOTY, Gautier
see Gautier
DAGUERRE, Louis Jacques
Mandé
French, 1787-1851
DAHL, Carl
German, 1813/14-p.1862
DAHL, Hans
Norwegian, 1849-p.1910
DAHL, Johan Christian
Clausen
Norwegian, 1788-1857
DAHL the Elder, Michael
British, 1656-1743
DAHL, Nils T.
Norwegian, 1876-
DAHL, Peter
American, 20th cent.
DAHL, Siegwald Johannes
Norwegian, 1827-1902
DAHLBERG, Erik
Swedish, 1625-1703
DAHLEN, Reiner
German, 1836-1874
DÄHLING, Heinrich Anton
German, 1773-1850
DAHLÖ, Ture
Swedish, 1895-
DAHMEN, Karl Fred
German, 1917-
DAHMEN, M.
German, 19th cent.
DÄHN, Fritz
German, 1908-
DAIG, Sebastien
see Deig
DAINGERFIELD, Elliot
American, 1859-
DAINTREY, Adrian
British, 1902-
DAIWAILLE, Alexander
Josef
German, 1818-1888
DAIWAILLE, Jean Augustin
German, 1786-1850
DAKE, Carel Lodewijk,
II
Dutch, 1886-1946
DAKIN, J.H.
American, op.1831
DAKIN, Malcolm
British, 1943-
DAL, Harald
Norwegian, 1902-
DALAGER, Mathias Ferslew
Norwegian, 1769-1843
DALBE, Bailer
French, 18th cent.
DALBEY, Albert L.
American, 19th cent.
DALBONO, Edoardo
Italian, 1843-1905
DALBY, David (of York)
British, op.1780-1849

DALBY, John
British, op.c.1826-1853
DALE, Cornelis van
see Dalem
DALE, Jan or Johannes
van
see Dalen
DALEM or Dale,
Cornelis van
Netherlands,
c.1530/5-1575
DALEM, Jan or
Johannes van
see Dalen
DALEN
Dutch, 17th cent.
DALEN, Cornelis, I
van
Dutch, c.1602(?)-1665
DALEN, Cornelis, II
van
Dutch, 1638-c.1664
DALEN or Daalen,
Jan or Johan van
Dutch, c.1611-p.1677
DALEN, Dael, Dale
or Dalem, Jan or
Johannes van
Flemish, op.1632-1653
DALENS, Dirck, I
Dutch, c.1600-1676
DALENS, Dirck, II
Dutch, 1658/9-1688
DALENS, Dirck, III
Dutch, 1688-1753
DALGAS, Carlo Eduardo
Danish, 1821-1851
DALI, Salvador
Spanish, 1904-
DALIWES or Dalive,
Jaques
Netherlands, 15th cent.
DALL, Don van
American, 20th cent.
DALL, Nicholas
Thomas
British, op.c.1760-m.1777
DALLA ZORZA, Carlo
Italian, 1903-
DALLEAS, Jacques
French, op.1939-
DALLINGER von Dalling,
Alexander Johann
German, 1783-1844
DALLINGER von Dalling,
Johann, I
German, 1741-1806
DALLINGER von Dalling,
Johann, II
German, 1782-1868
DAIMASIO, Lippo di
see Lippo
DAIMATICO, Giorgio
see Giorgio da
Sebenico
DAIMATINO, Il
see Bencovich, Federico
DALMAU, Antonis
Spanish, op.1480
DAIMAU, Luis
Spanish, op.1428-1461
DALP bei Arlesheim
German, op.1814
DALRYMPLE, Lady
Harriet
British, op.1802-m.1823
DALSGAARD, Christen
Danish, 1824-1907

DALVIMART, Octavian
French(?) op.1800-1803
DALVIT, Oskar
Swiss, 1911-
DALY, Jehan
Canadian, 20th cent.
DALY, Kathleen
Canadian, 20th cent.
DALZIEL, Edward
Gurden
British, 1849-1888
DALZIEL, Owen
British, 1860-p.1904
DALZIEL, Robert
British, 1810-1842
DALZIEL, Thomas Bolton
Gilchrist Septimus
British, 1823-1906
DAM, Gautier van
Dutch, 18th cent.
DAM, W. van
Dutch, op.1854
DAM, Wouter
Dutch, c.1726-1786
DAMAME-DEMARTRAIS,
Michel Francois
French, 1763-1827
DAMASCENO or
Damaschino, Michele
Greek, op.1577-1586
DAMBACHER, Jacob
Joseph
German, 1794-1868
DAMBACHER, V.D.
German, op.c.1780-1783
DAMBERGER, Joseph
German, 1867-1951
DAME, Cornelis
(Cornelis Dame
Rietwijk)
Dutch, op.1630-1661(?)
DAME, Jan
see Veth, Jan
Damesz de
DAMELS, André
Flemish, c.1580-
DAMEN, Lenaerd
see Daems
DAMERON, Emile Charles
French, 1848-1908
DAMERY, Walther or
Gauthier
Flemish, 1610-1672
DAMFORD, F.A.
British, 19th cent.
DAMIAN, Horia
French, 1922-
DAMINI, Angela
Italian, op.1741
DAMINI, Pietro
Italian, 1592-1631
DAMINI, Vincenzo
Italian, op.1720-1730
DAMM, Bertil
Swedish, 1887-1942
DAMM, Walter
German, 1889-
DAMOURETTE, Abel
French, 1842-1878
DAMOYE, Pierre Emmanuel
French, 1847-1916
DAMPIERRE, Marquis de
French, op.c.1770
DAMROW, Charles
American, 19th cent.
DAMS
see Daems

DAMS, Lenaerd
see Daems
DAMSCHRÖDER or Damschreuder,
Jan Jacobus Matthijs
Dutch, 1825-1905
DAMSTE, Christiaan
Paul (Paul)
Dutch, 1944-
DAMY, Ken
(Giuseppe Damiani)
Italian, 20th cent.
DAN, Nguyen
N.Vietnamese, 20th cent.
DANA, Charles A.
American, op.1838
DANA, William Parsons
Winchester
British, 1833-1927
DANBY, Francis
British, 1793-1861
DANBY, James Francis
British, 1816-1875
DANBY, Ken
American, 20th cent.
DANBY, Thomas
British, c.1818-1886
DANCE, George, II
British, 1741-1825
DANCE, Sir Nathaniel
(Dance-Holland)
British, 1735-1811
DANCKERTS, Cornelis
Dutch, c.1603-1656
DANCKERTS, Dancker
Dutch, 1633/4-1666
DANCKERTS, Hendrick
Dutch, c.1625-1680
DANCKERTS, Danckersz.
or Dankerts, Johan
Dutch, 1613-c.1686
DANCKERTS, Dankerse,
Dankerss or Dankerts
de Rij, Peter
Dutch, 1605-1661
DANCKERTS, S.
Netherlands, 17th cent.
DANCX or Danks,
Francoys (Schildpad)
Dutch, op.1654-m.1703(?)
DANDINI, Cesare
Italian, c.1595-1658
DANDINI, Ottaviano
Italian, -p.1750
DANDINI, Pietro
Italian, c.1646-1712
DANDINI the Elder,
Vincenzo
Italian, 1607-1675
DANDOY, Jan Baptist
Flemish, op.1631-1638
DANDRE-BARDON, Michel
Francois
see Bardon
DANDRIDGE, Bartholomew
British, op.1711-1751
DANDRILLON, Pierre
Bertrand
French, 1725-1784
DANEDI, Giovanni
Stefano (Montalto)
Italian, 1608-1689
DANEDI, Giuseppe
(Montalto)
Italian, 17th cent.
DANEELS or Daniells,
Andries
Flemish, op.1599-1602

DANELS, Hendrick
see Danielsz.
D'ANGOULEME, Jaques
see Jacques, Pierre
DANHAUER, Dannengauer,
Donauer or Tannauer,
Gottfried
German, c.1680-1733/7
DANHAUSER, Josef
German, 1805-1845
DANI, Francesco
Italian, 1895-
DANICHE, J.
German(?) op.1770
DANIEELS, Andries
see Daneels
DANIEL, C.G.
British, op.1836
DANIEL, Gérôme
French, 1649-p.1718
DANIEL, W.B.
British, op.1805
DANIELE, Cavaliere
see Seiter
DANIELE, Fiammingo
see Seiter
DANIELE da Volterra
(Ricciarelli)
Italian, 1509-1566
DANIELI, Francesco
Italian, 1853-1922
DANIELL of Bath, Abraham
British, op.1790-m.1803
DANIELL, Rev. Edward
Thomas
British, 1804-1842
DANIELL, Frank
British, op.1889-1910
DANIELL, Samuel
British, c.1775-1811
DANIELL, Thomas
British, 1749-1840
DANIELL the Elder,
William
British, 1769-1837
DANIELS, Alfred
British, 1924-
DANIELS, William
British, 1830-1880
DANIELSZ., Daenelsen or
Danels, Hendrick
Dutch, op.1617
DANILOFF, T.
Russian, op.1802
DANIN, R.
British, 20th cent.
DANISH SCHOOL,
Anonymous Painters
of the
DANKERTS, Dankerse
or Dankerss
see Danckerts
DANKMEIJER, Carel
Bernardus (Charles)
Dutch, 1861-1923
DANKS, Francoys
see Dancx
DANLOUX, Henri
Pierre
French, 1753-1809
DANNAT, William
Turner
American, 1853-1929
DANNECKER, Johann
Heinrich von
German, 1758-1841

DANREITER, Franz
Anton
German, op.1728-m.1760
DANSAERT, Léon Marie
Constant
Belgian, 1830-1909
DANSE, Auguste
Belgian, 1829-1929
DANSELAER, H.
Dutch, 18th cent.
DANSON, George
British, 1799-1881
DANSON, H.
British, 20th cent.
DANTAN, Joseph
Edouard
French, 1848-1897
DANTE, Girolamo
see Dente
DANTI, Egnazio
(Pellegrino Danti de'
Rinaldi)
Italian, 1536-1586
DANTI or Rinaldi,
Vincenzo
Italian, 1530-1576
DANTIN, Jean-Pierre
French, 1800-1869
DANVIN, C.
French, 1837-1880
DANY
French, 1921-
DANZWOHL, Paul
German, op.1750-1794
DAPHNIS, Nassos
American, 1914-
DAPLANTE
British(?) 19th cent.
DARAGNES, Jean Gabriel
French, 1886-1950
DARANIYAGALA, Justin
British, 1903-
DARASCU, Nicolae
Rumanian, 1883-1959
DARBES, Joseph Friedrich
August
German, 1747-1810
DARBY, Henry F.
American, 1829-1897
DARDANONE, Gaetano
Italian, op.c.1720-1746
DARDEL, Fritz Ludwig
von
Swedish, 1817-1901
DARDELS, Nils
Scandinavian,
1888-1943
DAREL, Georges
Swiss, 1892-1943
DARELL, Sir H.
British, op.1840
DARDENNE, Léon
Louis
Belgian, 1865-1912
DARET, Daniel
Netherlands,
op.1433-1449
DARET, Jacques
Netherlands,
op.1418-1468
DARET, Pierre
French, c.1632-1677
DARETTI, Lorenzo
Italian, 18th cent.
DARGAUD, Paul Joseph
Victor
French, op.1873-1904

DARGELAS, André
Henri
French, 1828-1906
DARGENT, Jean Edouard
(Yan)
French, 1824-1899
DARGIE, William
Australian, 1912-
DARIEN, Henri Gaston
French, 1864-1926
DARIF, Giovanni
Italian, 1801-1871
DARIO del Cavaliere
Bardi
Italian, 15th cent.
DARIO di Giovanni
(Dario da Treviso)
Italian, c.1420-a.1498
DARJOU, Henri Alfred
French, 1832-1874
DARJOU, Victor
French, 1804-1877
DARLEY
American, op.1809
DARLING, W.
British, op.c.1762
DARLY, Matthew (not
Matthias Darley)
British, op.1754-1778
DARMANCOURT, Nicolas
French, op.1715-1722
DARMON, Claude-Jean
French, 20th cent.
DARNAUT, Hugo
German, 1850-1937
DARNSTEDT, Johann
Adolph
German, 1769-1844
DARRICAU, Henry
Léonce
French, 1870-
DART, Harry Grant
American, 20th cent.
DARVALL, Henry
British, op.1848-1889
DARWIN, Gwendolen
see Raverat
DARWIN, Sir Robin
British, 1910-
DASBURG, Andrew
American, 1887-
DASH, Robert
American, 20th cent.
DASSIER, Adrien
French, 1630-p.1686
DASSONVILLE, Assonville
or Dassonneville,
Jacques
French(?) 1619-c.1670
DASSY, Jean Joseph
French, 1796-1865
DASTUGUE, Maxime
French, op.1876-1908
DASVELDT, Jan
Dutch, 1770-1855
DATHAN, Johann Georg
German, 1703-p.1748
DAUBIGNY
French, 18th cent.
DAUBIGNY or d'Aubigny,
Amélie (née Dautel)
French, 1793/6-1861
DAUBIGNY, Carl (Charles
Pierre)
French, 1846-1886

DAUBIGNY, Charles
Francois
French, 1817-1878
DAUBIGNY, Edmonde-
François
French, 1789-1843
DAUBIGNY, Pierre
French, 1793-1858
DAUBIN, Jean Pierre
French, 20th cent.
DAUBRAWA or Daubrava,
Henry de
British, op.1840-1861
DAUCHEZ, André
French, 1870-1948
DAUCHEZ, Jeanne
see Simon
DAUCHOT, Gabriel
French, 1925-
DAUDET, Etienne Joseph
French, 1672-1730
DAUDET, Samuel
British, 18th cent.
DAUGE, F.
Belgian, 19th cent.
DAUGER or Daucher,
Hans
German, op.1561
DAULLE, Jean
French, 1703-1763
DAUMET, Honoré (Pierre
Gérôme Honoré)
French, 1826-1911
DAUMIER, Honoré
French, 1808-1879
DAUPHIN, Delphin or
Dofin, Charles Claude
French, op.1644-m.1677/93
DAUPHIN, Joseph or Jean
French, 1821-1849
DAURER, Juan
Spanish, op.1358-1404/7
DAUTEL, Amélie
see Daubigny
DAUTIEUX, Joseph
German, op.1800-1832
DAUZATS, Adrien
French, 1804-1868
DAUZATS, J. (?)
French, 19th cent.
DAVAUX, Henri
French, 20th cent.
D'AVERARA, Giambattista
see Averara
DAVERDOING, Charles-
Aimé-Joseph
Belgian, 1813-1895
DAVESNE or Davenne,
P.
French, op.1764-1796
DAVEY, William
British, 18th cent.
DAVID
Italian, 20th cent.
DAVID, Alphonse
(Louis Alphonse)
French, 1798-p.1849
DAVID, Antonio
Italian, a.1684
DAVID, Charles
French,
c.1600-1636/8
DAVID, Charles
French, 1797-1869
DAVID, Claude
French, 1650-p.1722

DAVID, Cornelia,
(née Cnoop)
see Cnoop
DAVID, Gerard
Netherlands,
op.1484-m.1523
DAVID, Giovanni
Italian, 1743-1790
DAVID, Gustave
French, 1824-1891
DAVID, H.V.
Dutch, 18th cent.
DAVID, Jean Louis
French, 1792-1868
DAVID, Jérôme
(Hieronymous)
French, c.1605-p.1670
DAVID, Johann Marcus
German, 1764-p.1810
DAVID, Joseph Antoine
(David de Marseille)
French, 1725-1789
DAVID, Jules (Jean
Baptiste Jules)
French, 1808-1892
DAVID, Lodovico
(not Lodovico Antonio)
Swiss, 1648-1728/30
DAVID, Louis
(Jacques Louis)
French, 1748-1825
DAVID, Maxime
French, 1798-1870
DAVID, Mme.
French, 19th cent.
DAVID, S.
British, 19th cent.
DAVID, Villiers
British, 20th cent.
DAVID-NILLET, Germain
French, 1861-1932
DAVID-RIQUIER, Alfred
Hector
French, op.c.1880
DAVIDSON, Allan D.
British, 1873-1932
DAVIDSON, Charles
British, 1824-1902
DAVIDSON, Daniel Pender
British, 1885-1933
DAVIDSON, Ezechiel
Dutch, 1792-1870
DAVIDSON, Jeremiah
see Davison
DAVIDSON, L.
British, 18th cent.
DAVIDSON, Thomas
British, op.1863-1903
DAVIE, Alan L.G.
British, 1920-
DAVIES, Arthur B.
American, 1862-1925
DAVIES, Arthur Edward
British, 1893-
DAVIES, Charles William
American, 1854-
DAVIES, David
Australian, 1864-1939
DAVIES, David
British, op.1970
DAVIES, Edgar W.
British, op.1893-1910
DAVIES, Edward
British, 1841-1920
DAVIES, Geoff
American, 20th cent.

DAVIES, Henry Eason
Australian, 1831-1868
DAVIES, J.
British, op.1778
DAVIES, J.B.
British, 20th cent.
DAVIES, James Hey
British, 1844-1930
DAVIES, Janet
British, 19th cent.
DAVIES, Kenneth
American, 1925-
DAVIES, Norman Prescott
British, 1862-1915
DAVIES, Thomas
British, op.1797-1803
DAVIN, Cesarine Henriette
Flore, (née Mirvault)
French, 1773-1844
DAVIS, Alexander Jackson
American, 1803-1892
DAVIS, Arthur
British, 1711-1787
DAVIS, C.W.
British, op.1824
DAVIS, Charles Harold
American, 1856-1933
DAVIS, Edward (Le Davis)
British, 1640-1684
DAVIS, Edward Thompson
British, 1833-1867
DAVIS, Gene
American, 1920-
DAVIS, Gladys Rockmore
American, 1901-
DAVIS, Henry William
Banks
British, 1833-1914
DAVIS, Joseph Barnard
British, 1861-
DAVIS, J. Pain
(Pope Davis)
British, 1784-1862
DAVIS, John Scarlett
British, 1804-1845/6
DAVIS, Joseph Hilliard
American, 1820-p.1859
DAVIS, Laurence
British, 1879-
DAVIS, Louis
British, op.1895-1909
DAVIS, Lucien
British, 1860-1951
DAVIS, Lady Mary
British, 1866-1941
DAVIS, Milo
American, op.1840
DAVIS, Richard Barrett
British, 1782-1854
DAVIS, Robert
American, 20th cent.
DAVIS, Ron
American, 1937-
DAVIS, Samuel
British, 1757-p.1809
DAVIS, Stuart
American, 1894-1964
DAVIS, Stuart G.
British, op.1893
DAVIS, Theodore Russell
American, 1840-1894
DAVIS, Tyddesley R.T.
British, op.1831-1857
DAVIS, W.H.
British, op.1803-1849
DAVIS, Warren B.
American, 1865-1928

DAVIS, William (Davis
of Liverpool)
British, 1812-1873
DAVISON, (not Davidson),
Jeremiah
British, c.1695-p.1750
DAVISON, Thomas Raffles
British, 1853-1937
DAVISON, William
British, op.1813-1843
DAVRINGHAUSEN, Heinrick
German, 1894-
DAVY, Evelyn
see Cheston
DAVY, Henry
British, 20th cent.
DAWANT, Albert Pierre
French, 1852-1923
DAWBARN, Joseph Yelverton
British, 1856-p.1912
DAWBER, Edward Guy (Sir)
British, c.1860-1938
DAWE, George
British, 1781-1829
DAWE, Henry Edward
British, 1790-1848
DAWE, Philip
British, c.1750-c.1785
DAWES, T.
British, op.1576
DAWES, William
British, op.1760-1774
DAWLEY, Joseph
American, 20th cent.
DAWS, Lawrence
Australian, 1927-
DAWSON, Alfred
British, op.1860-1894
DAWSON, Arthur
British, 1858-1922
DAWSON, Byron Eric
British, 1896-1968
DAWSON, Gladys
British, 1909-
DAWSON, Henry
British, 1811-1878
DAWSON the Younger,
Henry Thomas
British, op.1866-1878
DAWSON, Manierre
American, op.1909-1913
DAWSON, Montague J.
British, c.1894-1973
DAWSON, Nelson
British, op.1885-1912
DAWSON, S.M.
British, op.1798
DAX the Elder, Paul
German, c.1503-1561
DAY, Alexander
British, 1773-1841
DAY, Ellen
British, c.1841-
DAY, George
British, 19th cent.
DAY, Horace Talmage
American, op.1860-m.1909
DAY, Thomas
British, op.1768-1788
DAY, William
British, 1797-1845
DAYES, Edward
British, 1763-1804
DAYEZ, Georges
French, 1907-
DAYG, Sebastian
see Deig

DAYRELL, B.
British, op.1853
DEACON, Allan
British, 1858-p.1914
DEAIN, C.
see Derin
DEAK-EBNER, Lajos
(Ludwig)
Hungarian, 1850-1934
DEAKIN, Christopher
British, 20th cent.
DEAKIN, Peter
British, op.1855-1879
DEALY, Jane M.
(Lady Lewis)
British, op.1880-m.1939
DEAN, Christopher
British, op.1895-1899
DEAN, Frank
British, 1865-
DEAN, Hugh Primrose
British, op.1775-m.1784
DEAN, T.A.
British, op.1818-1840
DEANE, Charles
British, op.1815-1855
DEANE, Dennis Wood
British, op.1841-1868
DEANE, Emmeline
British, op.1879-
DEANE, William Wood
British, 1825-1873
DEAR, Mary E.
British, op.1848-67
DEARMAN, John
British, op.1824-m.c.1856/7
DEARTH, Henry Golden
American, 1864-1918
DEAS, Charles
American, 1818-1867
DEBACQ, Charles Alexandre
French, 1804-1850
DEBAIS, Francesco
see Battaglini,
Francesco
DEBAT-PONSAN, Edouard
Bernard
French, 1847-1913
DEBAY, Auguste-
Hyacinthe
French, 1804-1865
DEBENHAM, Alison
British, 20th cent.
DEBERITZ, Per
Norwegian, 1880-
DEBIA, Bernard-Prosper
French, 1791-1876
DEBILJ, F.C.
Swiss, op.1796
DEBON, François
Hippolyte
French, 1807-1872
DEBRE, Olivier
French, 1920-
DE BREE, A.
British, 19th cent.
DEBRET, Jean Baptiste
French, 1768-1848
DEBRIE or de Brie,
Gabriël Francois Louis
Dutch, op.1729-1754
DEBRIVE
French, 19th cent.
DEBUCOURT, Louis Philibert
French, 1755-1832
DECAEN, Alfred Charles
Ferdinand
French, 1820-p.1893

DECAISNE or de Caisne,
Henri
Belgian, 1799-1852
DE CAMP, Joseph Rodefar
American, 1858-1923
DECAMPS, Alexandre
Gabriel
French, 1803-1860
DECAMPS, Maurice Alfred
French, 1892-
DECAN, C.J.
German, op.1709
DECAN, Eugène
French, 1829-p.1894
DECANIS, Théophile Henri
French, 1848-1917
DE CAT, A.P.
French, 20th cent.
DECAUX, Vicomtesse
Iphigénie née
Milet-Mureau
French, 1780-p.1819
DECHAR, Peter
American, 1944-
DECHATEAUBOURG
see Chateaubourg
DECHELETTE, Louis
Augustin
French, 1894-1964
DECHENAUD, Adolphe
French, 1868-1929
DECINI, J.
Italian, op.1644
DECKELMANN, Andreas
German, 1820-1882
DECKER, Albert
German, 1817-1871
DECKER, Conraet or
Conraad
Dutch, 1651-1685
DECKER or Dekker,
Cornelis Gerritsz.
Dutch, op.1640-m.1678
DECKER, David
Dutch, op.1645-1651
DECKER or Dekker, Frans
Dutch, 1684-1751
DECKER, Gabriel
German, 1821-1855
DECKER, Georg
Hungarian, 1818/9-1894
DECKER, Jan
Dutch, op.1644-1670
DECKER, Jan Willemsz.
Dutch, c.1553-p.1616
DECKER, Johann Stephan
German, 1784-1844
DECKER, Paul
German, 1677-1713
DECKER the Younger, Paul
German, 1685-1742
DECKER, Willem Jansz. II
Dutch, op.1609-m.1623/4
DECKERT
Dutch, 17th cent.
DECKIN, Maillet (?)
German, 18th cent.
DECLER, F.
German, 18th cent.
DECOCK, Gilbert
Belgian, 1928-
DECOTE, Georges
French, 1870-
DECOURT, de Court or
Curtius, Jean
French, op.1572-1585
DECRITZ, Emmanuel
British, c.1605-1665

DECRITZ, De Crats,
De Critz or Decretts
the Elder, John
British, c.1555-c.1641
DECRITZ, Oliver
British, c.1625-p.1645
DECRITZ, Thomas
British, a.1605-c.1676
DEDINAC, Milan
Yugoslav, 20th cent.
DEDREUX-DORCY, Pierre
Joseph
French, 1789-1874
DEEBLE, William
British, op.1814-1849
DEELEN, Dirck van
see Delen
DEEM, George
American, 1932
DEFAUX, Alexandre
French, 1826-1900
DEFAVANNE
see Favanne
DEFENDENTE Ferrari
see Ferrari
DEFER, Jean Joseph
Jules
French, 1803-op.1869
DEFERT, Félicie
French, 19th cent.
DEFERT, Maxime
French, 20th cent.
DEFRAINE, Defraisne,
Defrêne or Defresne,
Jean Florentin
French, 1754-p.1804
DEFRANCE, Léonard
Flemish, 1735-1805
DEFREGGER, A.
German, 19th cent.
DEFREGGER, Franz von
German, 1835-1921
DEGAS, Edgar
(Hilaire Germain)
French, 1834-1917
DEGAULT
see Gault
DEGELENKAMP
see Augustini, Jan
DEGEN or Dägen, Dismar
Dutch, op.c.1730-m.c.1751
DEGEN, H.
German, op.c.1490
DEGER, Ernst
German, 1809-1885
DEGHETTA, Michael
German (?) op.1706
DEGLE, Franz Josef
German, 1724-1812
DEGORGE, Christophe
Thomas
French, 1786-1854
DEGOTTEX, Jean
French, 1918-
DEGOURMONT, Jean
see Gourmont
DEGOUVE de Nuncques,
William
French, 1867-1915
DEGRAIN, Antonio Muñoz
Spanish, 19th cent.
DEGREEF, Jean
see Greef
DEGROUX, Charles
Corneille Auguste
see Groux
D'EGVILLE, Alan Harvey
British, 1891-1951

D'EGVILLE, James
Herve
British, -1880
DE HAMILTON, Jacob
or James
see Hamilton
DEHAUSSEY, Jean-Baptiste
Jules
French, 1812-1891
DEHN, Georg
German, 1843-1904
DEHÒ, Alessandro
Bernardino
Italian, 18th cent.
DEHODENCQ, Alfred
(Edmé Alfred Alexis)
French, 1822-1882
DEI, Matteo di
Giovanni
Italian, op.1455
DEI, Don Piero d'Antonio
see Gatta, Bartolommeo
della
DEIG, Dayg, Taig or
Tayg, Sebastian
(Bastian Daig)
German, op.1508-1554(?)
DEIGHTON, Richard
British, 19th cent.
DEIKER, Carl Friedrich
German, 1836-1892
DEIKER, Friedrich
German, 1792-1843
DEIKER, Johannes
(Christian)
German, 1822-1895
DEISCH, Matthaeus
German, 1718-c.1789
DEITERS, Heinrich
German, 1840-1916
DEJNEKA, Alexander
Alexandrovitch
Russian, 1899-
DEJUINNE or De Juinne,
François Louis
French, 1786-1844
DEKKER
see Decker
DEKKERT, Eugène
German, 1865-
DELABORDE, J.
French, op.1683-1690
DELACHAUX, Léon
French, 1850-1919
DELACOUR or de la Cour, F.
French, op.1787
DE LA COUR, F.J.
British, op.1830
DELACOUR or De Lacour,
Pierre
see Lacour
DELACOUR or de la Cour,
William
French, op.1747-m.1767
DELACROIX, Auguste
French, 1809-1868
DELACROIX, Charles F.
see Lacroix
DELACROIX, Eugène
(Ferdinand Victor
Eugène)
French, 1798-1863
DELACROIX, Henri Eugène
French, 1845-p.1929
DELACROIX, M.
French, 20th cent.
DE LA CROIX, Pieter
Frederik
see La Croix

DELAERE, Boudewijn
Belgian, 20th cent.
DELAFONTAINE, Pierre
Maximilien
French, 1774-1860
DELAFOSSE
see Lafosse
DELAGATINE
French, op.1715
DE LA HOUGUE, Jean
French, 1874-1959
DELAISTRE, Jacques-
Antoine
French, 1690-1765
DELAMAIN, Paul
French, 1821-1882
DELAMARRE, Henri Louis
French, 1829-
DELAMONCE, Ferdinand
(Sigismond Pierre
Joseph Ignace)
French, 1678-1753
DELAMONCE, Jean Baptiste
French, 1635-1708
DE LAMOTE-BARACE, Pierre
François, Marquis de
Senonnes
French, 1758-1793
DELAMOTTE, George Orleans
British, op.1809-1821
DELAMOTTE, Philip Henry
British, op.1851-m.1889
DELAMOTTE, William
Alfred
British, 1775-1863
DE LA MOULYNEUX
French, op.1794
DELANCE, Paul Louis
French, 1848-1924
DELANCE-FEURGARD, Julie
French, 1859-1892
DELANE, Solomon,
British, 1727-1812(?)
DELANNOY, Aristide
French, 1874-1911
DELANO, Gerard Curtis
American, 1890-1972
DELANOY the Younger,
Abraham
American, 1740-1786
DELANOY, Jacques
French, 1820-1890
DELAPEINE, Charles
Samuel
French, 1826-1894
DELAPIERRE, Nicolas
Benjamin
French, op.1767-1788
DELAPLACE, Jacques
French, 1767-p.1831
DELAPORTE, Henri Horace
Roland
see Roland
DELARAM, Francis
British, c.1590-1627
DELARIVE, Nicolas Louis
Albert
see Delerive
DELARIVE, Pierre-Louis
Swiss, 1753-1817
DE LA ROCHE, Charles
Ferdinand
French, op.c.1868
DELAROCHE, Hippolyte
Paul
French, 1797-1856

DELAROCHE, Paul Charles
French, 1886-1914
DELARQUE, Lucretia
Catherine
French, 18th cent.
DELARUE
French, 19th cent.
DELARUE, F.R.
French, c.1751-
DE LARUE
see Larue
DELASALLE, Angèle
French, 1867-p.1938
DELASCOURT
French, op.1807
DELASSUS, Alexandre
Victor
see Lassus
DELATRE, Eugène
French, 1864-op.1892
DELATTRE, Henri
French, 1801-1867
DELATTRE, Joseph-Marie-
Louis
French, 1858-1912
DELATTRE, Louis
Belgian, 1815-1897
DELAUNAY, Elie (Jules
Elie)
French, 1828-1891
DELAUNAY, Nicolas
French, 1739-1792
DELAUNAY, Pierre
French, 1870-1915
DELAUNAY, Robert
French, 1749-1814
DELAUNAY, Robert
French, 1885-1941
DELAUNAY, Simone
French, 20th cent.
DELAUNAY-TERK, Sonia
Russian, 1885-
DELAUNE, Delaulne or
de Laune, Etienne
French, 1518/9-1895
DELAUNE, Jean
French, op.1578
DELAUNE, Zoé Laura
see Chatillon
DELAUNEY, Alfred
Alexandre
French, 1830-1894
DELAUNEY, J.
French, 19th cent.
DELAUNEY, Pierre
François
French, 1759-1789
DELAUNOIS, Alfred
Napoléon
Belgian, 1876-1941
DELAVILLE, Henri
French, op.1851-1865
DELAW, Georges
French, 1874-1929
DELAWARR, Val
New Zealand,
op.1880-1890
DELAYE, lice
French, 1884-
DELAYE, Charles Claude
French, 1793-p.1848
DELBEKE, Léopold Jean
Ange
Belgian, 1866-
DELBEKE, Louis Auguste
Corneille
Belgian, 1821-1891

DELBENE, L.
Italian, op.1836
DEL BON, Angelo
Italian, 1898-1952
DELCLOCHE, Paul Joseph
Flemish, 1716-1755
DELCOUR, De La Cour,
Del Cour or Del Court,
Jean Gilles
Flemish, 1632-1695
DELDERENNE, Lucien
Belgian, 18th/19th cent.
DELECHAUX, Marcelin
French, c.1835-1902
DELECIJZE, Etienne
Jean
French, 1781-1863
DELECOURT, Delcourt
or Delecour
French, op.1789-1805
DELEFRARD, A.
French, op.1880
DELEITO, Andrés
Spanish, op.1680
DELEN or Deelen,
Dirck van
Dutch, 1604/5-1671
DELERA, Giovanni
Battista
see Era
DELERIVE, Delarive,
Delrive or della Riva,
Nicolas-Louis Albert
French, 1775-m.1818
DELESSERT
Swiss, -1885
DELETANG, Robert Adrien
French, 1874-
DELEU, Thomas
see Leu
DELEWARE, V.
French, 20th cent.
DELFER, Johann Georg
(Probably identified
with Johann Delser)
Swiss, op.1787-1794
DELFF, Adriaen
Cornelisz.
Dutch, op.1643-1650
DELFF or Delft, Cornelis
Jacobsz.
Dutch, 1571-1643
DELFF, Jacob Willemsz., I
(Jacobus Wilhelm Delphius)
Netherlands, c.1550-1601
DELFF, Jacob Willemsz., II
(Jacobus Delffius or
Delfius)
Dutch, 1619-1661
DELFF or Delfft, Willem
Jacobsz. (Guglielmus
Jacobus Delphius)
Dutch, 1580-1638
DELFOS, Abraham
Dutch, 1731-1820
DELFOSSE, Eugène
Belgian, 1825-1865
DELFT, Cornelis Jacobsz.
see Delff
DELGADO, Alvaro
Spanish, 20th cent.
DELGADO y Meneses, José
Spanish, 1775-
DELGADO, Juan
Spanish, op.1719
DELGADO, Pedro
Spanish, op.1524-1529

DELGRAELLES, Adriaen
Dutch(?) 18th cent.
DELHOMMEAU, Charles
French, 1883-
DELIEN or De Lien,
Jacques François
see Lyen
DELIERRE, Auguste
French, 1829-op.1882
DELIN or de Lein,
N.J. or C.
Dutch, op.1782-1797
DELITIO the Younger,
Andrea
Italian, op.1473
DELKESKAMP, Friedrich
Wilhelm
German, 1794-1872
DELL, Ethelene Eva
British, op.1885-1923
DELL, John H.
British, 1830-1888
DELLA BELLA, Stefano
(Etienne de la Belle)
Italian, 1610-1664
DELLAURANA, Lucianus
see Laurana
DELLEANI, Lorenzo
Italian, 1840-1908
DELLERA, Giovanni
Battista
see Era
DELLESSIANE(?), Giovanni
Maria
Italian, 1660-1759
DELLI, Sansone
Spanish, op.1432-1490
DELLO or Delle (Daniello)
(Nicolao Fiorentino)
Italian, c.1404(?)-1471
DELLOW, R.
British, op.1700-1740
DELIJNIGIANA
see Gualtieri di
Giovanni
DELMAR, William
British, op.1802-1856
DELMONT or van der Mont,
Deodat or Dieudonné
(Deodati del Monte)
Flemish, 1582-1644
DELMONT, Félix
French, 1794-1867
DELMOTTE, Marcel
Belgian, 20th cent.
DELOBBE, François
Alfred
French, 1835-1915
DELOBEL, Nicolas
French, 1693-1763
DELONNE
French, 19th cent.
DELORGE, Jacques
French, op.1770-1786
DELORGE, Joseph
French, op.1759-1761
DELORME, De Lorme,
Del'Orme or De L'Orme,
Anthonie
Dutch, op.1627-m.1673
DELORME, Julien Paul
French, 1788-p.1833
DELORME, Pierre
French, 1716-p.1775
DELORME, Pierre Claude
Francois
French, 1783-1859

DELORT, Charles
 Edouard
 French, 1841-1895
DELORT, Joseph
 British, 18th cent.
DELOS or Delose
 German, op.1780-1802
DELOTZ, George
 Gregor
 British, 1819-1879
DELPECH, Francois
 Séraphin
 French, 1778-1825
DELPEREE, Emile
 Belgian, 1850-1896
DEL PEZZO, Lucio
 Spanish, 20th cent.
DELPHIN, Charles
 Claude
 see Dauphin
DELPHIUS
 see Delff
DELPORTE, Charles
 French, 20th cent.
DELPY, Hippolyte
 Camille
 French, 1842-1910
DELPY, Jacques
 Henri
 French, 1877-
DELRAILLE, H.C.
 French(?) op.1912
DELRIVE, Nicholas Louis
 Albert
 see Delerive
DELSENBACH, Johann Adam
 German, 1687-1765
DELSER, Johann
 see Delfer
DELTIL
 American, op.1834
DELTOMBE, Paul
 French, 1878-
DELUERMOZ, Henri
 Canadian, 1876-1943
DELUUW, H. or A.
 Dutch, op.1747(?)
DELVAUX, Edouard
 Belgian, 1806-1862
DELVAUX, Paul
 Belgian, 1897-
DELVILLE, Jean
 Belgian 1867-1953
DELVIN, Jean Joseph
 Belgian, 1853-1922
DELVOLVE-CARRIERE, Lisbeth
 see Carrière
DELYEN or De Lyn,
 Jacques François
 see Lyen
DEMACHY, Pierre Antoine
 see Machy
DEMAGEON, Louis Albert
 French, 1909-
DEMAIS
 French, 18th cent.
DEMARCENAY or
 Marcenay de Ghuy,
 Antoine de
 French, 1724-1811
DEMARCHIS, Alessio
 see Marchis
DEMARCO
 Italian, 20th cent.
DEMAREST
 French, op.1759

DEMAREST, Guillaume
 Albert
 French, 1848-1906
DEMARIA, Pierre-Jean
 French, 1896-
DEMARNE, Caroline
 French, op.1822-1825
DEMARNE, Jean Louis
 see Marne
DEMARNE, Pierre
 French, 1924-
DEMARTEAU, Gilles
 Flemish, 1722-1776
DEMARTEAU, Gilles
 Antoine
 Flemish, 1750-1802
DEMAY, Jean Francois
 French, 1798-1850
DEMELE, Mathäus
 see Mele
DEMETRIUS, Jean
 Dutch, op.1659/60
DEMEURISSE, René
 French, 1894-
DEMIANI, Carl
 Friedrich
 German, 1768-1823
DEMIN, Giovanni
 Italian, 1786-1859
DEMING, Edwin Willard
 American, 1860-1942
DEMIO, G.
 see Fratino
DEMONCHY
 French, 20th cent.
DEMONT, Adrien Louis
 French, 1851-1928
DEMONT-BRETON, Virginie
 Elodie
 French, 1859-1935
DE MORGAN, William
 British, 1832-1917
DEMSKI, J.
 Polish, 19th cent.
DEMUTH, Charles
 Henry
 American, 1883-1935
DENDUYTS, Gustave
 see Duyts
DENEC, Erol
 German, 1941-
DENENS, Jan
 Dutch, op.c.1650-1683
DENEVE, Franciscus
 or Frans
 see Neve
DENHAM, John Charles
 British, op.c.1796-1858
DENIES, Deniese,
 Denise, Denys or de
 Niese, Isaac
 Dutch, 1647-1690
DENING, A. van
 Dutch, op.1622
DENIS, Claude
 (Claudius)
 French, 1878-
DENIS, Maurice
 French, 1870-1945
DENIS, Simon Joseph
 Alexander Clemens
 Flemish, 1755-1813
DENISART, J.
 Flemish, 17th cent.
DENISE, Isaac
 see Denies

DENISE, Joan
 see Denysz.
DENISOT or Denizot,
 Nicolas
 French, 1515-1559(?)
DENIZARD, Charles
 Jacques
 French, 1816-p.1869
DENIZARD, J.
 French, op.1666
DENK, Josef Lambert
 German, 1783-1860
DENMAN, Herbert A.
 American, 1855-1903
DENNEL, Antoine
 François
 French, op.1760-m.1815
DENNEL, Louis
 French, 1741-1806
DENNER, B.
 German, op.1571(?)
DENNER, Balthasar
 German, 1685-1749
DENNER, Jacob
 German, c.1720-c.1750
DENNEULIN, Jules
 French, 1835-1904
DENNING, Stephen Poyntz
 British, c.1795-1864
DENNIS, John
 British, op.1800-1835
DENNY, Robyn
 British, 1930-
DENON, Dominique Vivant
 French, 1747-1825
DENOVAN ADAMS, J.
 American, op.1904
DENT, Douglas
 British, 20th cent.
DENT, Robert Stanley
 Gorrell
 British, 1909-
DENT, W.
 British, op.1847
DENTE, Girolamo
 (not Dante)
 (Girolamo di Tiziano)
 Italian, c.1510-p.1568
DENTE, Marco
 (Marco da Ravenna)
 Italian, -1527
DENTONE, Il
 see Curti, Girolamo
DENTZEL, Michael
 see Daenzel
DENUNE, William
 British, c.1710-1750
DENY, Jeanne
 French, 1749-p.1815
DENY, Martial
 French, 1745-p.1815
DENYS or de Nys,
 Frans
 Flemish, c.1610-1670
DENYS, Glaudi Georgie
 Dutch, op.c.1642-1670
DENYS, Isaac
 see Denies
DENYS or de Nys, Jacob
 Flemish, 1644-1708
DENYS, Master
 Russian, op.c.1500
DENYSZ., Jan
 (Joan Denise)
 Dutch, op.c.1643

DENZEL, Hans
 German, op.1604
DEODATUS Orlandi
 Italian, op.1288-1301
DEPAY, Johann de
 see Pay
DE PELCHIN, J.F.
 Flemish, c.1770-c.1835
DEPERO, F.
 Italian, 20th cent.
DEPERTHES, Jacques
 French, 20th cent.
DEPEY, Johann de
 see Pay
DEPORRIS, Charles or
 Deparis Chevalier
 French(?) op.1779
DEPORTES, Francisque
 see Desportes
DEPRÉ, Marcel
 French, 20th cent.
DEPREZ, Henri
 Flemish, 1727-1797
DERAIN, André
 French, 1880-1954
DERANTON, Joseph
 French, op.1792
DERBY, Alfred Thomas
 British, 1821-1873
DERBY, William
 British, 1786-1847
DERHAM, Bridget
 British, 1943-
DERICKX, Louis or
 Lodewijk
 Belgian, 1835-1895
DERIKSEN, Felipe
 (Philips Dircksz.)
 Flemish, op.1627/8
DERIN, C.
 Dutch(?) 18th cent.
DERKERT, Siri
 Swedish, 1888-
DER KEVORKIAN
 French, 20th cent.
DERKINDEREN or der
 Kinderen, Antonius
 Johannes (Anthonie)
 Dutch, 1859-1935
DERKOVITS, Gyula
 Hungarian, 1894-1934
D'ERLANGER, Baroness
 Marie Rose Antoinette
 Catherine
 British, op.1918
DERMILLJ
 French, c.1880-
DERMILLT
 German, 19th cent.
DEROSIER
 French, 18th cent.
DEROY, Emile
 French, 1825/6-1848
DEROY, Laurent
 (Isidore Laurent)
 French, 1797-1886
DERREY, Jacques
 French, 20th cent.
DERUET or de Ruet,
 Claude
 French, 1588-1660
DERY, Béla
 Hungarian, 1870-1932
DERY, Kalman
 Hungarian, 1859-

DESAIRE, F.
French, 20th cent.
DESANGES, Chevalier
Louis William
British, 1822-p.1887
DESANGLES, Thomas
French, c.1749-
DESANI, Pietro
Italian, 1595-1657
DESARNOD the Elder,
Auguste Joseph
French, 1788-1840
DESAULX or de Saulx,
Jean
French, op.c.1786-c.1846
DESAVARY, Charles Paul
Etienne
French, 1837-1885
DES BARRES, Joseph F.W.
British, op.1763-1773
DESBORDES, Constant
Joseph
French, 1761-1827
DESBOUTIN, Marcellin
Gilbert
French, 1823-1902
DESBROSSES, Jean
Alfred
French, 1835-1906
DESCAINE, H.
French, op.c.1830
DESCAMPS, Guillaume
(Désiré Joseph)
French, 1779-1858
DESCAMPS, Jean
Baptiste, I
French, 1706-1791
DESCAMPS, Jean
Baptiste, II
French, 1742-1836
DESCAMPS-SABOURET,
Louis Cécile
French, 1855-
DESCH, Auguste
Théodore
French, 1877-
DESCHAMPS
Dutch(?) 17th cent.
DESCHAMPS, Louis Henri
French, 1846-1902
DESCHAZELLE or de
Chazelle, Pierre
Toussaint
French, 1752-1833
DESCOSSY, Camille
French, 1904-
DESCOURS or Hubert
Descours, Michel
French, 1707-1775
DESCOURTILZ, Jean
French, op.c.1843
DESCOURTIS, Charles
Melchior
French, 1753-1820
DESCUDE, Cyprien
French, 1881-1920
DESDEBAN, Jean-Baptiste
French, 1781-1833
DESENNE, Alexandre
Joseph
French, 1785-1827
DESENZANO, Antonio
da
Italian, op.1493
DESENZANO, Bernardo
da
Italian, op.1493

DESENZANO, Giovanni da
Italian, op.1493
DESFONTAINES, Jacques
Francois Joseph
see Swebach
DESFOSSES or Defossez,
Charles Henri
French, 1764-1809
DESFRICHES, Aignan-
Thomas
French, 1715-1800
DESGOFFE, Blaise Alexandre
French, 1830-1901
DESGRANGE (Selmersheim-
Desgrange) Jeanne
French, 20th cent.
DESHAYES, Charles
Félix Edouard
French, 1831-1895
DESHAYES, Eugène
French, 1828-1890
DESHAYES, François
Bruno
French, op.1765-1767
DESHAYES, Deshaies or
Deshays de Colleville,
Jean Baptiste Henri
(Le Romain)
French, 1729-1765
DESHAYES, Philippe
French, -1665
DESHAYS, Raymond
French, 19th cent.
DESIDERII, Giovanni Domenico
Italian, 1623-1667
DESIDERIO, Francesco
Italian, op.1630
DESIDERIO, Monsù (François de
Nome), Italian, 1593-p.1618
DESIDERIO da Settignano
(Desiderio di Bartolommeo
di Francesco dello Ferro)
Italian, 1428-1464
DESINGUE, J.
French, 19th cent.
DESJARDINS, Louis-Léon
French, op.1857
DESJOBERT, Eugène
French, 1817-1863
DESLAVIERS or Delaviez,
Nicolas
French, op.1732-1735
DESLYENS, Jacques François
see Lyen
DESMARAIS, Jean Baptiste
Frédéric
French, 1756-1813
DESMAREES or des or
de Marées, George
Swedish, 1697-1776
DESMAREST or Desmares, Martin
French, 17th cent.
DESMARQUAIS, Charles
Hippolyte
French, 1823-p.1900
DESMARQUETS, Pauline
see Auzou
DESMOND, Cresswell
Hartley
British, 1877-
DESMOULINS, Auguste
Francois Barthélemy
French, 1788-1856
DESNOS, Ferdinand
French, op.1934
DESNOS, Robert
French, 20th cent.

DESNOYER, Francois
French, 1894-
DESORAN, Jean Baptiste
French, op.1810
DESORIA, Jean Baptiste
François
French, 1758-1832
DESPAGNE, Artus
French, op.1823-1835
DESPALLARGUES or
Pallargues, Pedro
(not Espalargues)
Spanish, op.1490
DESPARANE
see Sparapane
DESPAX, Jean Baptiste
French, 1709-1773
DESPECHES, Florent
French, op.1588-1603
DESPIAU, Charles
French, 1874-1946
DESPIERRE, Jaques
French, 1912-
DESPINOSSA, Juan
Baptista
see Espinosa
DESPORTES, Alexandre
Francois
French, 1661-1743
DESPORTES, Claude
François
French, 1695-1774
DESPORTES or Déportes,
Francisque
French, 1849-p.1891
DESPORTES, Henriette
French, op.1899-
DESPREZ, Monsù (François
Auguste
French, op.1834-1836
DESPREZ, Desprée or
Després, Louis Jean
or Jean Louis
French, 1734-1804
DESRAIS, Claude Louis
French, 1746-1816
DESRIVIERES, Elisa,
(née Leroy)
French, op.1847-1882
DESROCHERS, Etienne
French, 1668-1741
DESROUSSEAUX, H.A.L.
see Laurent-Desrousseaux
DESSAR, Louis Paul
American, 1867-1952
DESSAU
French, 20th cent.
DESSURNE, Mark
British, 1825-1885
DESTORRENS, Ramon
Spanish, op.1343-1363
DESTOUCHES, Louis
Nicolas Marie
French, 1789-1850
DESTOUCHES, Paul Emile
see Detouches
DESTOURS, Mlle.
see Duchateau
DESTRE, Vincenzo dalle
(Vincenzo da Treviso)
Italian, op.1488-m.a.1543
DESTREE, Johannes
Joseph
Belgian, 1827-1888
DESTREZ (possibly
Destrée, Pierre,
op.1714)
French, 18th cent.

DESTURMES, Fernando or
Hernando
see Sturm
DESUBLEO, Desublei
de Sobleau, Sobleo
or Subleo, Michele di
Giovanni (Michele
Fiammingo)
Italian, 1601(?)-1676
DESUIGNE, H.
French, op.1835
DESURMONT, Ernest
French, 1870-
DESVALLIERES, Georges
Olivier
French, 1861-1950
DESVARREUX, Raymond
French, 1876-
DESVERNOIS or Devernois,
J.
German, op.1799
DESVERNOIS, Joseph
Eugène
Swiss, 1790-1872
DETAILLE, Jean Baptiste
Edouard
French, 1848-1912
DETAILLE, P.E.
French, 19th cent.
DETALEVO
see Tiberio d'Assisi
DETHIER, de Thier or
de Tieer, Hendrik
Dutch, op.1631-1634
DETHOMAS, Maxime
French, 1867-1929
DETILLEUX, Servais
Belgian, 1874-
DETLESEN, Paul
American, 19th cent.
DETMOLD, Charles Maurice
British, 1883-1908
DETMOLD, Edward Julian
British, 1883-1957
DE TOTT, Madame
French, op.1801
DETOUCHES or Destouches,
Paul Emile
French, 1794-1874
DETROY, Léon
Belgian, 19th/20th cent.
DETTHOW, Eric
Swedish, 1888-1952
DETTI, Cesare Agostino
Italian, 1847-1914
DETTI, Gonzale
Italian, op.1877
DETTMAN, Ludwig Julius
Christian
German, 1865-1944
DEUCHERT, Heinrich
German, 1840-1923
DEUREN or Durren,
Olivier Pietersz. van
Dutch, 1666-1714
DEURS, Gerrit Arentsz.
van
Dutch, op.1663-m.a.1702
DEUSSER, August
German, 1870-1942
DEUTSCH, Hans Rudolf
Manuel
Swiss, 1525-1571
DEUTSCH, Ludwig
German, 1855-
DEUTSCH (Alleman, Alemand
Alamann), Niklaus
Manuel
Swiss, c.1484-1550

DEUTSCH, Peter
 Canadian, 20th cent.
DEVAL, Pierre Jean
 Charles
 French, 1897-
DEVALENCIENNES
 see Valenciennes
DEVAMBEZ, André Victor
 Edouard
 French, 1867-1943
DEVARENNE, Jean
 French, c.1743-1809
DEVAS, Anthony
 British, 1911-1958
DEVAULX, Jacques
 French, op.1633
DEVEDEUX, Louis
 French, 1820-1874
DEVELLY or Devély,
 Jean Charles
 French, 1783-1849
DEVENTER, Jan Frederik
 van
 Dutch, 1822-1886
DEVENTER, Willem
 Anthonie van
 Dutch, 1824-1893
DEVER, R.
 Dutch, 17th cent.
DEVERELL, Walter
 Howell
 British, 1827-1854
DEVEREUX, Elizabeth D.
 American, 19th cent.
DEVERIA, Achille
 (Jacques Jean Marie
 Achille)
 French, 1800-1857
DEVERIA, Eugène
 Francois Marie
 Joseph
 French, 1805-1865
DEVERIA, Laure
 French, 1813-1838
DEVERIA, V.
 French, 1829-1897
DEVERNOIS, J.
 see Desvernois
DEVIENNE, Adolphe
 French, op.1840-1848
DEVIEUX, (Robelin)
 Charles
 French, 1787-1865
DE VILLA y Prades
 Julie
 Spanish, 19th cent.
DEVILLE, Vickers
 British, op.1887-1902
DEVILLEBICHOT, Jean
 Auguste
 French, 1804-1862
DEVIS, A.
 British, op.1736
DEVIS, Anthony
 British, 1729-1816
DEVIS, Arthur
 British, 1708-1787
DEVIS, Arthur William
 British, 1763-1822
DEVIS, E.T.
 British, 18th cent.
DEVIS, Thomas Anthony
 British, 1757-1810
DE VITA, Luciano
 Italian, 1929-
DEVITA, Sebastiano
 (Sebastianus Devita
 Dalmata)
 Italian, op.c.1770

DEVITO, Ferdinand
 American, 1926-
DE VIVIER, Dervivier,
 Durvivier or Duvivier,
 Jean
 French, 1687-1761
DEVONSHIRE, William,
 4th Duke of
 British, 1720-1764
DEVOS, Léon
 Belgian, 1897-
DEVOSGE, Anatole
 French, 1770-1850
DEVOSGE or De Vosge
 III, Francois (Claude
 Francois)
 French, 1732-1811
DEVOTO, John
 British, op.1719-1776
DEVOUGES or Devouge,
 Louis Benjamin
 Marie
 French, 1770-1842
DEVRIENT, Wilhelm
 German, 1799-
DEWASNE, Jean
 French, 1921-
DEWHURST, Wynford
 British, 1864-
DEWING, Thomas Wilmer
 American, 1851-
DEWIT (or de Wit?),
 P.J.
 Dutch(?) 18th cent.(?)
DEXEL, Walter
 German, 1890-
DEXTER, Walter
 British, 1876-
DEXTER, William
 British, 20th cent.
DEYM, Maerten Pietersz.
 Dutch, c.1576-1624
DEYNUM or Deynen, Antoon
 van
 Flemish, op.1595-1643
DEYNUM, Gerardt van
 see Duynen
DEYNUM or Deynen,
 Guilliam van
 Flemish, op.1596-1618
DEYNUM, Duinen or Dynen,
 Jan Baptist
 Flemish, 1620-1668
DEYROLLE, Jean Jacques
 French, 1911-
DEYROLLE, Théophile-
 Louis
 French, -1923
DEYS, Jan (van)
 Netherlands, op.1560-1574
DEYSTER, Lodewyk de
 Flemish, c.1656-1711
DEZAUNAY, Emile Alfred
 French, 1854-1940
DE ZAYAS, Marius
 Mexican, 19th cent.
DEZIRE, Henri
 French, 1878-
D'HARCOURT, Mary
 British, op.1760-1786
DHOEY
 see Hoey
DIAGHILEV, Serge P.
 Russian, 19th cent.
DIAMANTE, Fra
 Italian, c.1430-p.1498
DIAMANTINI, Fiorella
 Italian, 1931-

DIAMANTINI, Giuseppe
 di Vincenzo (not
 Giovanni)
 Italian, 1621-1705
DIAMANTOPOULOS, D.
 Greek, 20th cent.
DIANA, Benedetto
 (Rusconi)
 Italian, c.1460-1525
DIANA, Giacinto (Il
 Pozzuolani)
 Italian, 1730-1803
DIANA, Mantovano
 see Scultore
DIAO, David
 American, 20th cent.
DIAQUE, Ricardo
 French, op.1870-1900
DIART, Jules Edouard
 French, op.1868-1879
DIAS, Cicero
 Brazilian, 1908-
DIATELEVI
 see Tiberio d'Assisi
DIAZ, Antonio
 Spanish, 20th cent.
DIAZ, Daniel Vazquez
 Spanish, 20th cent.
DIAZ, Gonzalo
 Spanish, op.1497-1534
DIAZ d'Oviedo, Pedro
 Spanish, op.1489-1494
DIAZ de la Peña,
 Virgilio Narcisse
 French, 1807-1876
DIBBETS, Gerardus
 Johannes Maria
 Dutch, 1941-
DIBDIN, C.(?)
 British, 1745-1814
DIBDIN, Thomas Colman
 British, 1810-1893
DICHTL, Erich
 German, 1890-1955
DICHTL, Dichtel or
 Dychtl, Martin
 German, op.1661-1670
DICK, Alexander L.
 British, c.1805-1865
DICK, David
 Swiss, 1655-1701/2
DICK, John
 British, op.1813
DICK, Karl
 Swiss, 1884-
DICKENSON, Edwin Walter
 American, 20th cent.
DICKERSON, Bob
 Australian, 1924-
DICKES, W.
 British, op.1881
DICKEY, Edward Montague
 O'Rourke, British, 1894-
DICKINSON, Anson
 American, 1779-1852
DICKINSON, Daniel
 American, 1795-
DICKINSON, J.R.
 British, op.1867-1881
DICKINSON, Lowes Cato
 British, 1819-1908
DICKINSON, Preston
 American, 1891-1930
DICKINSON, William
 British, 1746-1823
DICKSEE, Sir Frank
 (Francis Bernard)
 British, 1853-1928

DICKSEE, Herbert Thomas
 British, 1862-1942
DICKSEE, Margaret Isabel
 British, 1858-1903
DICKSEE, Thomas Francis
 British, 1819-1895
DICKSON, Frank
 British, 1862-1936
DICKSON, Jennifer
 British, 1936-
DICKSON, Malcolm
 British, 1941-
DIDAY, Francois
 Swiss, 1802-1877
DIDIER, Jules
 French, 1831-p.1880
DIDIER-POUGET, William
 French, 1864-1959
DIDIONI, Francesco
 Italian, 1859-1895
DIEBENKORN, Richard
 American, 1922-
DIEBOLDT or Diebolt,
 Melchior
 German, op.1674-m.c.1693
DIEFFENBACH, Anton Heinrich
 German, 1831-1914
DIEFFENBACHER, August
 Wilhelm
 German, 1858-
DIEGHEM, J. van
 Dutch, 19th cent.
DIEGO
 see also Cruz
DIEGO de Urbino
 Spanish, op.1570-1594
DIEGO da Villanueva
 Spanish, op.1773
DIEHL, Ferdinand
 German, 1854-1928
DIEHL, Hugo von
 German, 1821-1883
DIELAERT, Ch. van
 Dutch, op.1666
DIELAI
 see Surchi, Giovanni
 Francesco
DIELITZ, Conrad
 German, 1845-1933
DIELMAN, Frederick
 German, 1847-p.1913
DIELMANN, Jacob
 Fürchtegott
 German, 1809-1885
DIEMER, Zeno (Michael-
 Zeno)
 German, 1867-1939
DIEN, Achille (Louis
 Félix Achille)
 French, 1832-
DIENST, A. van
 Flemish(?) 17th cent.
DIEPENBEECK, Abraham
 Jansz. van
 Flemish, 1596-1675
DIEPRAAM or Diepraem,
 Arent(?) or Abraham(?)
 Dutch, 1622(?)-1670(?)
DIER, E.A.
 German, 1893-
DIERCKX, Pierre Jacques
 Belgian, 1855-
DIERICKX, Adriaen
 see Rodriguez
DIERKSEN, Dirk
 see Diricks
DIES, Albert Christoph
 German, 1755-1822
DIESEL, Disel or Dissl
 German, op.1706-m.1752

DIEST, Adriaen van
Dutch, 1655/6-1704
DIEST, Jeronymus or
Hieronymus van
Dutch, 1631(?)-p.1675
DIEST, Johan van
Dutch, op.c.1718-1736
DIEST, Willem van
Dutch, a.1610-p.1663
DIETEKEN, C.
Dutch, op.1630
DIETRICH, Johann
Friedrich
German, 1787-1846
DIETERLE, Maria (née
van Marcke de Lumner)
French, 1856-1935
DIETHELM, Walter J.
Swiss, 1913-
DIETISALVI di Speme
see Diotisalvi
DIETLER, Johann Friedrich
Swiss, 1804-1874
DIETRICH, A.
German, 20th cent.
DIETRICH, Adelheid
German, 1827-
DIETRICH or Dietricy,
Christian Wilhelm
Ernst
German, 1712-1774
DIETRICH, Frederich
Christoph
German, 1779-1847
DIETRICH, Fritz
German, 19th cent.
DIETRICH, Klaus
German, 20th cent.
DIETRICH, Master
German, op.1364
DIETRICH, Rachel Rosina
see Böhme
DIETRICH, S.
German, op.c.1760
DIETRICHSEN, Dirk
see Diricks
DIETSCH, Margareta
Barbara
German, 1726-1795
DIETTERLIN, Bartholomäus
German, c.1590-p.1630
DIETTERLIN, Dieterlin,
Dietherlin, Dietterle or
Dietrich the Elder,
Wendel, Wendelin or
Wendling (Wendling
Grapp)
German, 1550/1-1599
DIETTERLIN the Younger,
Wendel
German, op.1610-1614
DIETZ, Diana
see Hill
DIETZ, Feodor
German, 1813-1870
DIETZ or Diez,
Ferdinand
German, op.1743-m.c.1780
DIETZER, August
Dutch, op.1791-1804
DIETZSCH, Barbara
Regina
German, 1706-1783
DIETZSCH, Johann
Christoph
German, 1710-1769

DIETZSCH, Johann Israel
German, 1681-1754
DIEU, Antoine
French, 1662-1727
DIEU, Jean de
(Saint Jean)
French, c.1625-p.1709
DIEZ, Cruz
Spanish, 20th cent.
DIEZ, Ferdinand
see Dietz
DIEZ, Wilhelm von
German, 1839-1907
DIEZ, Julius
German, 1870-1957
DIEZ, Samuel Friedrich
German, 1803-1873
DIGBY, Simon
British, op.1691-m.1720
DIGHTON, Denis
British, 1792-1827
DIGHTON, J.
British, op.c.1785
DIGHTON, Joshua
British, 19th cent.
DIGHTON, Richard
British, 1795-1880
DIGHTON, Robert
British, c.1752-1814
DIGHTON, William Edward
British, 1822-1853
DIGNAM, Michael
British, op.c.1893
DIGNIMONT, André
French, 1891-
DILGER, Alexander
German, 1824-1906/7
DILGER, Michael
German, -1833
DILICH, Dilich-Schäffer
or Scheffer, Wilhelm
German, 1571/72-1650
DILL, Ludwig
German, 1848-1940
DILL, Otto
German, 1884-1957
DILLENS, Adolf Alexander
Belgian, 1821-1877
DILLENS, Albert
Belgian, 1844-
DILLENS, Hendrik Joseph
Belgian, 1812-1872
DILLER, Burgoyne
American, 1906
DILLIS, Cantius
(Johann Cantius)
German, 1779-1856
DILLIS, Maximilian
Johann-Georg von
German, 1759-1841
DILLON, Frank
British, 1823-1909
DILLON, Henri Patrice
French, 1851-p.1901
DILLON, R.
British, op.1749
DILWORTH, Norman
British, 1933-
DIMELE, Mathäus
see Mele
DIMITRESCU, Stefan
Rumanian, 1886-1933
DINARELLI, Giuliano
Italian, 1629-1671
DINE, Jim
American, 1935-

DINET, Etienne
(Alphonse Etienne)
French, 1861-
DINGLE, Adrian
Canadian, 20th cent.
DINGLE, Thomas
British, op.1846-1888
DINGLI, B.
British, 20th cent.
DINGLI, Edward
Caruana
British, 1876-
DINGLINGER, Johann
Melchior
German, 1664-1731
DINGLINGER, Sophie
Friedrike
German, 1739-1791
DINKEL, Ernest Michael
British, 1894-
DINKEL, Markus
Swiss, 1762-1832
DINSDALE, George
British, op.1808-1829
DIOFEBI, Francesco
Italian, 19th cent.
DIOG or Diogg, Felix
Maria
Swiss, 1762-1834
DIONGE, H.
Flemish, 17th cent.
DIONYSIUS, Master
Greek(?), 16th cent.
DIOTALLEVI
see Tiberio d'Assisi
DIOTISALVI or Dietisalvi
di Speme
Italian, op.1259-1291
DIOTTI, Giuseppe
Italian, 1779-1846
DIPRE, Nicolas
French, op.1495-m.1532
DIPSE, Constantin
Rumanian, 20th cent.
DIRANIAN, Serkis
Armenian, c.1850-p.1910
DIRCKS, Jonas
see Dyrks
DIRCKSZ., Barend
(Doove Barend)
Netherlands,
op.1534-1557
DIRCKSZ., Philips
see Deriksen
DIRICKS, Diricksen,
Dierksen or Dietrichsen,
Dirk
German, 1613-1653
DIRIKS, Karl Edward
Norwegian, 1855-1930
DIRIT, Harry
American, 20th cent.
DIRKS, Andreas
German, 1866-
DIRVEN, Jan
Flemish, op.1632-m.1653
DISCART, Jean
French, op.1884
DISCHER, Carl Marcus
see Tuscher
DISEL or Disal
see Diesel
DISERTORI, Benvenuto
Italian, 1887-
DISMORR, Jessica
British, 1885-1939

DISTELI, Martin
Swiss, 1802-1844
DITCHFIELD, Arthur
British, 1842-1883
DITSCHEINER, Adolf
Gustav
German, 1846-1904
DITTENBERG, Gustav
(or Dittenberger,
Von)
German, 1794-1879
DITTMANN, Edmund
German, 19th cent.
DITTMERS, Ditmarsen,
Dittmars, etc.
Heinrich
Danish, op.1665-m.1677
DIX, Otto
German, 1891-
DIXON, Annie
British, 1817-1901
DIXON, Arthur A.
British, op.1892-1912
DIXON, C.
American, op.1757
DIXON, Charles
or Dickson
British, op.c.1772-1774
DIXON, Charles
British, 1872-1934
DIXON, Dudley
British, 20th cent.
DIXON, E.
British, op.1835-1839
DIXON, Frank
British, 19th cent.
DIXON, George
British, 1760-1842
DIXON, Harry
British, 1861-1942
DIXON, John
British, 1720/30-1804
DIXON, Matthew
British, op.1671-m.1710
DIXON, Maynard
American, 1875-1945
DIXON, Nicolas
(not Nathaniel)
British, op.1665-1708
DIXON, Robert (William
Robert)
British, 1780-1815
DIXON, Samuel
British, op.c.1755
DIJKSTRA, Johan
Dutch, 1896-
DIZIANI, Antonio
Italian, 1737-1797
DIZIANI, Gasparo
Italian, 1689-1767
DIZIANI, Giuseppe
Italian, 18th cent.
DJURIE, Miodrag
see Dado
DMITRIEFF-ORENBOURGSKY,
Nicolas
Russian, 1838-1898
DMITRIENKO, Pierre
French, 1925-
DO, Giovanni
Italian, -1656
DOAN, Do Xuan
N. Vietnamese,
20th cent.
DOBASHI, Junichi
French, 20th cent.

DOBBIN, John
 British, 1815-1888
DOBIASCHOFSKY
 see Dobyaschofsky
DOBOUJINSKY, Mitislav
 Russian, 20th cent.
DOBROWSKY, Josef
 German, 1889-
DOBRIAN, Vasile
 Roumanian, 20th cent.
DOBRINSKY
 Polish, 20th cent.
DOBSON, Frank
 British, 1888-1963
DOBSON, Henry John
 British, 1858-
DOBSON, J.
 British, 1787-1865
DOBSON, Sarah P.
 Ball
 British, 1847-1906
DOBSON, William
 British, 1610-1646
DOBSON, William Charles
 Thomas
 British, 1817-1898
DOBYASCHOFSKY, Franz
 Joseph
 German, 1818-1867
DOCENO
 see Gherardi,
 Cristofano
DOBELL, William
 Australian, 1899-1973
DOCHARTY, Alexander
 Brownie
 British, 1862-1940
DOCHARTY, James
 British, 1829-1878
DOCHEN, H.
 British(?) 17th cent.
DOCKING, Shay
 Australian, 1928-
DOCKREE, Mark Edwin
 British, 1858-1890
DODD, Charles
 Tattershall
 British, 1815-1878
DODD, Daniel
 British, op.1760-1790
DODD, Francis
 British, 1874-1949
DODD, J.J.
 British, op.1832-1839
DODD, J.S.
 British, 19th cent.
DODD, Lamar
 American, 20th cent.
DODD, Lois
 American, 20th cent.
DODD, Louis
 British, 19th cent.
DODD, Mrs.P.
 British, op.1959
DODD, Ralph
 British, op.1779-1809
DODD, Robert
 British, 1748-1810
DODEIGNE, Eugene
 French, 1923-
DODEL, Wilhelm
 German, 20th cent.
DODGE, John Wood
 American, 1807-1893
DODGE, Joseph Jeffers
 American, 1917-

DODGSON, Catherine
 British, 20th cent.
DODGSON, Charles
 Lutwidge (Lewis
 Carroll)
 British, 1832-1898
DODGSON, George
 Haydock
 British, 1811-1880
DODGSON, John Arthur
 British, 1890-1969
DODIN
 French, 1734-p.1802
DOE, Jean
 see Hoey
DOEBLER, Gottlieb
 see Doeppler
DOEDYNS, Willem
 see Doudijns
DOEL, Adriaen van
 see Verdoel
DOELL, Ludwig
 (Friedrich Ludwig
 Theodor)
 German, 1789-1863
DOEPLER, Gottlieb
 see Doeppler
DOEPPLER, Doepler or
 Doebler, Gottlieb
 German, op.1786
DOERFLINGER, Hans
 German, 20th cent.
DOERGER, Marc
 German, 1444-p.1475
DOERR, Otto Erich
 Friedrich August
 German, 1831-1868
DOES, Antony van der
 Flemish, 1609-1680
DOES, Jacob, I van der
 (Tamboer)
 Dutch, 1623-1673
DOES, Jacob, II
 Jacobsz. van der
 Dutch, 1654-1699
DOES, Simon van der
 Dutch, 1653/4-p.1718
DOESBURG, Theo van
 (Christiaan Emil
 Maria Küpper)
 Dutch, 1883-1935
DOESBURGH, Thomas
 Dutch, op.1692-1714
DOETECHUM or Doetecom,
 Joannes, I van
 Netherlands,
 op.1559-1608
DOETECHUM or Doetecom,
 Lucas
 Netherlands, op.1559-1593
DOEVEN, Frans Bartholomeus
 see Douven
DOFIN, Charles Claude
 see Dauphin
DOGAN, Boris
 Yugoslav, 1923-
DOGARTH, Erick Josef
 German, 20th cent.
DOGGER, Gerard A.
 British, 20th cent.
DOHR
 German, 20th cent.
DOI, Ismai
 American, 1903-1965
DOIGER, Marc
 see Doerger

DOIGNEAU, Edouard Edmond
 French, 19th cent.
DOISSE, F. de
 Dutch, 17th cent.
DOLABELLA or Dollabella,
 Tommaso
 Italian, c.1570-1650
DOLANDA, Francisco
 see Francisco de
 Hollanda
DOLASKI, M.
 Yugoslav, 20th cent.
DOLBY, Edwin Thomas
 British, op.1849-1865
DOLCI, Agnese (not Maria)
 Italian, -1686
DOLCI, Carlo (Carlino)
 Italian, 1616-1686
DOLE, William
 American, 20th cent.
DOLENDO, Bartholomeus
 Willemsz.
 Dutch, c.1571-c.1629
DOLENDO, Zacharias
 Netherlands, 1561-c.1604
DOLIVAR, Juan
 Spanish, 1641-1692
DOLL, Anton
 German, 1826-1887
DOLLAND, W. Anstey
 British, op.1879-89
DOLLE, William
 British, op.1660-1680
DOLIMAN, Herbert P.
 British, op.1874-1892
DOLLMAN, John Charles
 British, 1851-1934
DOLPH, John Henry
 American, 1835-1903
DOLST, Christian (Gottlieb)
 German, 1740-1814
DOM, Paul (Pol)
 Belgian, 1885-
DOMANOVSZKY, Endre
 Hungarian, 1907-
DOMASHNIKOV, Boris
 Russian, 1924-
DOMAT, Jean
 French, 1625-1696
DOMBROWSKI, Carl von
 German, 1872-
DOMELA, Cesar
 Dutch, 1900-
DOMENCHIN de Chavanne,
 Pierre Salomon
 French, 1672/3-1744
DOMENICHINO (Domenico
 Zampieri or Dominicus
 Ciampellus)
 Italian, 1581-1641
DOMENICO di Bartolo
 (Ghezzi)
 Italian, c.1400-1444/6
DOMENICO Bolognese
 Italian, 17th cent.
DOMENICO di Cecco di
 Balso
 Italian, -1488
DOMENICO Fiorentino
 see Barbiere,
 Domenico del
DOMENICO di Francesco
 see Domenico di
 Michelino
DOMENICO, Giovanni
 see Desiderii

DOMENICO da Lepnessa
 Italian, op.1461-1466
DOMENICO di Michelino
 (Domenico di
 Francesco)
 Italian, 1417-1491
DOMENICO Napoletano
 Italian, 17th cent.
DOMENICO da Sansovino
 Italian, -1530
DOMENICO da Tolmezzo
 Italian, op.1479
DOMENICO Veneziano
 Italian, op.1438-m.1461
DOMENICO da Venezia
 see Master of the
 Self-Portraits
DOMERGUE, Jean
 Gabriel
 French, 1889-1962
DOMINGO y Fallola,
 Roberto
 Spanish, 1867-1956
DOMINGO y Marqués,
 Francisco (José)
 Spanish, 1842-
DOMINGUES, Joseph
 French, 1845-
DOMINGUEZ, O.
 Spanish, 1906-1958
DOMINICI, Antonio de'
 Italian, c.1730-a.1800
DOMINICIS, Achille
 de
 Italian, op.c.1881
DOMJAN, Josef
 Hungarian, 1907-
DOMMERSEN, Louis
 Dutch, 19th cent.
DOMMERSEN, William R.
 Dutch, 19th cent.
DOMMERSHUIZEN or
 Dommelshuizen, Cornelis
 Christiaan
 Dutch, 1842-1928
DOMMERSHUIJZEN,
 Dommelshuizen or
 Dommershuizen, Pieter
 Cornelis
 Dutch, 1834-
DOMOND, Wilmino
 Haitain, 1925-
DOMOTO, Hisso
 American, 20th cent.
DOMSAITIS, Pranas
 South African, 20th cent.
DOMSCHEIT, Frans
 German, 1880-
DONAGH, Rita
 Hungarian, 20th cent.
DONAGHY, John
 American, 1838-1931
DONALD, John Milne
 British, 1819-1866
DONALD-SMITH, Helen
 British, op.1883-1893
DONALDSON, Andrew
 British, 1790-1846
DONALDSON, Andrew Brown
 British, 1840-1919
DONALDSON, Antony
 British, 1939-
DONALDSON, David A.
 British, 20th cent.
DONALDSON, J.H.
 British, op.1883-1892

DONALDSON, John
British, 1737-1801
DONALDSON, Willaim
British, op.1820
DONATELLO, Donato
di Niccolò di Betto
Bardi
Italian, 1386(?)-1466
DONATH, Gabriel
Ambrosius
German, 1684(?)-1760
DONATI, Antonio
Italian, op.1784
DONATI, Luigi or Alvise
Italian, op.1494-1510
DONATI, Enrico
American, 1909-
DONATI, Lazzaro
Italian, 20th cent.
DONATI, Vittorio
Italian, op.1884
DONATO, Donao or
Donà Alvise
Italian, op.1528-1568
DONATO d'Arezzo
Italian, op.1315
DONATO de' Bardi,
Pavese
Italian, op.1507
DONATO, Elio
Italian, 15th cent(?)
DONATO da Formello
(also known as
Donatello)
Italian, 16th cent.
DONATO Martini
Italian, op.1339-m.1347
DONATO da Montorfano,
Giovanni
Italian, op.1495
DONATO Veneziano
Italian, a.1344-a.1388
DONATO Veneziano
see Bragadin
DONAUER, Georg
German, 1571/72-p.1611
DONAUER, Donnauer,
Thonauer, Tonauer
or Thunauer, Hans
or Johannes
German, 1521-1596
DONCHER
see Doncker
DONCHERY, H.
French, 18th cent.
DONCK, G. (van)
Dutch, op.1627-1640
DONCKER or Doncher,
Herman Mijnerts
Dutch, a.1620-p.1656
DONCKER or Doncher,
J.H.
Dutch(?) op.1645
DONCKT, Joseph
Octave van der
Flemish, 1757-1814
DONCRE, Dominique
(Guillaume Dominique
Jacques)
French, 1743-1820
DONDUCCI, Giovanni
Andrea
(Il Mastelletta)
Italian, 1575-1655
DONELLA or Donelli da
Carpi, Giovanni
Francesco
Italian, op.1509-1514

DONGEN, Cornelis
Theodorus Maria
(Kees) van
Dutch, 1877-1968
DONGEN, Dionys van
Dutch, 1748-1819
DONGHI, Antonio
Italian, 1897-
DONI, Adone (Dono dei
Doni)
Italian, p.1500-1575
DONINI or Donnini,
Girolamo (Domini)
Italian, 1681-1743
DONIS, Nicolaus
German, op.1464-1471
DONIZETTI, C.
Italian, 19th cent.
DONIZAU, P.
French, 20th cent.
DONK, R. van
Dutch, op.1653
DONKER or Donkers,
Pieter P.
Dutch, c.1635-1668
DONLEY, J.O.
British, 20th cent.
DONN, William
British, op.1770-1775
DONNAY, Auguste
Belgian, 1862-1921
DONNE, Walter J.
British, 1867-
DONNER, Raphael
(Georg Raphael)
German, 1693-1741
DONNER von Richter,
Otto
German, 1828-1911
DONNINI, Emilio
Italian, op.1855-1861
DONO, Paolo di
see Uccello
DONOSO, José Ximenez
Spanish, 1628-1690
DONOWELL, John
British, op.1755-1786
DONTHORNE, W.J.
British, op.1817-1853
DONVE, Louis Joseph
French, 1760-1802
DONZE, Numa
Swiss, 1885-
DONZEL, Charles
French, 1824-1889
DONZELLI, Pietro
Italian, 1452-1509
DONZELLO, Ippolito
Italian, 1455-p.1494
DOOGE, J. van
Dutch, 17th/18th cent.
DOOLITTLE, Amos
American, 1754-1832
DOOMER, Gertrud
Netherlands,
17th cent(?)
DOOMER, Lambert
Dutch, c.1622/3-1700
DOORDT or Dort,
Jacob van der
German, op.1610-1629
DOORN, Martinus
Jacob (Tinus)
van
Dutch, 1905-1940
DOORNBOS, Abraham
Dutch, op.1679

DOORNIK or Doornick,
F.V.
Dutch, op.1731
DOORNIK or Dornick,
Jan van
Netherlands,
op.1474-1511
DOORNIK, Jan van
Dutch, op.1731
DOORT, Jacob van
see Doordt
DOOIJEWAARD, Jacob
(Jaap)
Dutch, 1876-
DÖPLER the Elder,
Carl Emil
German, 1824-1905
DOPPELMAYER, M.
German, op.1874/5
DOPPELMAYR, Friedrich
Wilhelm
German, 1776-p.1833
DORATT, Charles
American, op.1838-1839
DORAZIO, Piero
Italian, 1927-
DÖRBECK, Franz Burchard
German, 1799-1835
DORCE, Jacques
Haitian, 1942-
DORE, Louis Christophe
Paul Gustave
French, 1832-1883
DORE, Madame
French, op.1765-1769
DOREN, Emile van
Belgian, 1865-
DORESIC, Vilma
Yugoslav, 1935-
DOREY, D.M.
French, 19th cent.
DORFFLING, Auguste,
née Böhme
German, 1813-1868
DORFFMEISTER, Joseph
German, 1764-1814
DORFFMEISTER, Stephan
German, c.1729-1797
DORFMEISTER, Johann-
Evangelist
German, 1741-1765
DORFMEISTER, Johann Georg
German, 1736-1786
DORIAN
French, 20th cent.
DORIANI, William
American, 1893-
DORIGNY, Charles
French, op.1533-m.a.1551
DORIGNY, Louis
French, 1654-1742
DORIGNY, Michel
French, 1617-1685
DORIGNY, Sir Nicolas
French, 1657-1746
DORING, Hans
(Monogrammist H.D.)
German, 1490-1560
DORIS, J.S.
British, 19th cent.
DORISY, Peter
German, op.1566-1582
DORIVAL, Paul
French, 1604-1684
DORN or Dornauch(?),
Hans
German, op.1590-1601

DORN, Ignaz
German, 1822-1869
DORN, Joseph
German, 1759-1841
DORNBUSCH, Th.
German, op.c.1825
DORNE, Francois
van
Belgian, 1776-1848
DORNE, H.
Dutch, op.1630
DORNE, Johann van
Flemish,
18th/19th cent.
DORNE, Martin van
Flemish, 1736-1808
DORNER, Johann Jacob,
I
German, 1741-1813
DORNER, Johann Jakob,
II
German, 1775-1852
DORNICK, Jan van
see Doornik
DORNY
French, 20th cent.
DOROGOFF, Alexander
Matvjejevich
Russian, 1819-1850
DORPH, Anton Laurids
Johannes
Danish, 1831-1914
DORPH, Bertha, (née
Green)
Danish, 1875-
DORPH, Niels
Vinding
Danish, 1862-1931
DORR, Harry
British, 19th cent.
DORR, O.E.F.A.
German, 1831-1868
DORRELL, Edmund
British, 1778-1857
DORRIES, Bernhard
German, 1898-
DORSTEN, Dorste or
Drost, Jacob van
Dutch, 1627-1674
DORT, Jacob van der
see Doordt
DORTMUND, Pitt Moog
German, 20th cent.
DÖRTSCHACHER
see Görtschacher
DOSAMANTES, Francisco
Mexican, 1911-
DOSE, Ferdinand Theodor
German, 1818-1851
DOSIO or Dosi,
Giovanantonio
Italian, 1533-p.1609
DOSSI, Battista
(de Luteri or Lutero
or de Constantino)
Italian, op.1512-m.1548
DOSSI, Dosso (Giovanni
de Lutero or Luteri or
de Constantino)
Italian, -a.1542
DOTTORI, Gherardo
Italian, 1888-
DOU, Gerrit or
Gerard
Dutch, 1613-1675
DOU, Simon Johannes
van
see Douw

DOUANIER, Le
see Rousseau,
Henri
DOUARD, Cécile
Belgian, 1866
DOUAY, Nicolas
see Hoey
DOUBLET, Louis
French, op.1731
DOUCET, Dominique
French, 18th cent.
DOUCET, Henri
French, 1883-1915
DOUCET, Jacques
French, 1924-
DOUCET, Lucien
French, 1856-1895
DOUDELET, Charles
Belgian, 1861-1938
DOUDIJNS or Doedyns,
Willem (Diomedes)
Dutch, 1630-1697
DOUE, Nicolas
see Hoey
DOUFFET, Doufeet,
Douffeit or
d'Ouffet, Gérard
Flemish, 1594-1660
DOUGAL, William H.
American, 1822-1895
DOUGHERTY, F.
American, op.1810
DOUGHERTY, Paul
American, 1877-
DOUGHTY, Thomas
American, 1793-1856
DOUGHTY, William
British, op.1776-m.1782
DOUGLAS, Andrew
British, 1871-1935
DOUGLAS, Brian
British, 20th cent.
DOUGLAS, Caroline Lucy
British, 1784-1857
DOUGLAS, Edward Algernon
Stuart
British, op.1880-1892
DOUGLAS, Edwin
British, 1848-1914
DOUGLAS, S.
British, 20th cent.
DOUGLAS, William
British, 1780-1832
DOUGLAS, Sir William
Fettes
British, 1822-1891
DOUMENJOU
French, op.1835
DOURER, Juan
see Daurer
DOUST, W.H.
British, op.1859-1880
DOURO, S. van
Dutch(?) 17th cent.
DOUROUZE, Daniel
Urbain
French, 1874-1923
DOUSSAULT, Charles
French, 19th cent.
DOUTHWAITE, Patricia
British, 20th cent.
DOUTNEY, Charles
Australian, 1908-1957
DOUTRELEAU
French, 20th cent.
DOUVEN or Doeven, Frans
Bartholomeus ('Douven
de Jonge')
German, 1688-p.1726

DOUVEN, Jan Frans
Dutch, 1656-1727
DOUW or Dou, Simon
Johannes van
Flemish, c.1630-p.1677
DOUWE, D.J. de'
see Dowe
DOUWE, Franciscus
Carolus van
Dutch, 18th cent.(?)
DOUWEN, Hendrik or Heinrich
(van)
see Düvens
DOUZETTE, Louis (Carl
Ludwig Christoph)
German, 1834-1924
DOVA, Gianni
Italian, 1925-
DOVASTON, M.
American, 19th cent.
DOVE, Arthur G.
American, 1880-1946
DOVE, Thomas
British, -1887
DOVIANE
see Viande, Auguste
DOW, A. Warren
British, 1873-1948
DOW, Thomas
Millie
British, 1848-1919
DOWBIGGIN, E.
British, op.1820-1824
DOWD, H.P.
British, 20th cent.
DOWD, J.H.
British, 1884-1956
DOWE or Douwe, D.J.
de
Dutch, op.c.1647-1660
DOWER, J.
British, op.1831
DOWLING, Jane
British, 20th cent.
DOWLING, Robert H.
Australian, 1827-1886
DOWLING, R. Blewitt
British, 19th cent.
DOWLING, Terrence
British, 20th cent.
DOWNARD, Ebenezer
Newman
British, 1849-1889
DOWNE, J.
British, op.1777
DOWNES, Bernard
British, -p.1775
DOWNIE, John P.
British, 1871-1945
DOWNIE, Patrick
British, op.1887-1912
DOWNING, Barry
British, 20th cent.
DOWNING, Delapoer
British, op.1886-1902
DOWNING, H.E.
British, op.1827-m.1835
DOWNING, H.P.
Burke
British, 1865-
DOWNING, Thomas
American, 20th cent.
DOWMAN, Isabella
British, 18th cent.
DOWMAN, John
British, 1750-1824
DOWMAN, Lieut. J.N.
British, 19th cent.

DOWNMAN, J.T.
British, op.1810
DOXAT, Robert
German, 1930-
DOY, A.
French, op.1633-1634
DOYEN, Gabriel François
French, 1726-1806
DOYEN, Gustave
French, 1837-
DOYEN, L.
French, 17th cent.
DOYENBURGH, C. van
Dutch, 17th cent.
DOYLE, C.
British, 20th cent.
DOYLE, Charles Altamont
British, op.1859-1885
DOYLE, Henry Edward
British, 1827-1892
DOYLE, James William
Edmund
British, 1822-1892
DOYLE, John ('H.B.')
British, 1797-1868
DOYLE, M.
British, 19th cent.
DOYLE, Margaret Byron
American, op.1820-1830
DOYLE, Richard
British, 1824-1883
DOYLE, William M.S.
American, 1769-1828
D'OYLY, Sir Charles
British, 1781-1845
DOZE, Jean-Marie M.
French, 1827-1913
DRAEHE, Ludwig
see Droeche
DRAGO, G. del
Italian, 17th cent.
DRAINS, Georges
French, op.c.1912
DRAKE, Nathan
British, op.1750-1783
DRAPENTIER, Johannes
see Drappentier
DRAPER, Herbert
James
British, 1864-1920
DRAPPENTIER or
Drapentier, Johannes
Dutch, op.c.1669-1700
DRAIJER, Reindert
Juurt (Rein)
Dutch, 1899-
DREBBEL or Drebber,
Cornelis Jacobsz.
Dutch, 1572-1634
DREBER, Heinrich
(Franz-Dreber)
German, 1822-1875
DRECHSLER, Johann
Baptist
German, 1756-1811
DREGT, Johannes van
Dutch, c.1737-1807
DREHER, Richard
(Eduard Richard)
German, 1875-1932
DREIBHOLTZ, Cristiaan
Lodewijk Willem
Dutch, 1799-1874
DREMPE, J.E.
British(?) op.1811
DRENOVSKA, Katia
Yugoslavian, 20th cent.
DRENTWETT the Elder,
Abraham
German, 1647-1727

DRENTWETT, Jonas
German, 1650-1720
DREPPE, Joseph
Flemish, 1737-1810
DRESA, Jacques
French, 1869-1929
DRESSLER, Adolf
German, 1833-1881
DRESSLER, August
Wilhelm
German, 1886-
DREUX, Alfred de
French, 1810-1860
DREVER, Adrian van
Dutch, op.c.1670-1680
DREVET, Claude
French, 1697-1781
DREVET, Jean
Baptiste
French, 1854-
DREVET, Pierre
French, 1663-1738
DREVET, Pierre
Imbert
French, 1697-1739
DREW, Clement
American,
1807/(?)10-p.1889
DREW, George W.
American, 19th cent.
DREW, Mary
British, op.1881-1901
DREWE, Reginald Frank
Knowles
British, 1878-
DREXEL, Francis
Martin
American, 1792-1863
DREYER, Dankwart
Christian Magnus
Danish, 1816-1852
DREYER, Paul Uwe
German, 1939-
DRIADE, Isidore
Netherlands(?)
18th cent.(?)
DRIAN
British(?) 20th cent.
DRIBEGEN, Sebastian
van
see Dryweghen
DRIELENBURCH or
Drillenburg, Willem
van
Dutch, 1635-p.1677
DRIELST, Egbert van
Dutch, 1746-1818
DRIELST, Jan Vuuring
van
Dutch, 1789-1813
DRIELST, Petrus van
Dutch(?) 17th cent(?)
DRIFT, Johannes
Adrianus van der
Dutch, 1808-1883
DRILLENBURG, Willem
van
see Drielenburch
DRING, William
British, 1904-
DRINKWATER, A.
British, 19th cent.
DRINKWATER, George
Carl
British, 1880-1941
DRIVIER, Léon
French, 1878-1951
DROC, Marla
Spanish, 20th cent.

DROECHE or Draehe,
Ludwig
German, op.1822
DROESHOUT, Johannes
(John)
British, 1596-1652
DROESHOUT, Martin,
II
British, 1601-p.1650
DROESHOUT, Michael
British, c.1570-p.1632
DROLLING, Louise
Adéone (Mme. V.
Pagnierre)
French, 1797-p.1831
DROLLING, Martin
German, 1752-1817
DRÖLLING, Michel-
Martin
French, 1786-1851
DROMAT
French, 19th cent.
DRONSFIELD, John
South African,
1900-1951
DROOCHSLOOT,
Drooghsloot or
Droogsloot, Cornelis
Dutch, 1630-1673
DROOCHSLOOT, Joost
Cornelisz.
Dutch, 1586-1666
DROOCHSLOOT, Nicolaes
Dutch, 1650-1702
DROST, Anthonie
Dutch, 18th cent.
DROST, Jacob van
see Dorsten
DROST, P.
Dutch, 17th cent.
DROST, Willem (or
Wilhelm?)
Dutch, op.1652-1654
DROUAIS, François
Hubert (Drouais le
fils)
French, 1727-1775
DROUAIS, Germain
Jean
French, 1763-1788
DROUAIS, Hubert
French, 1699-1767
DROUET
French, 19th cent(?)
DROUNGAS, Achilles
French, 20th cent.
DROUYEN, J.
French, 16th cent.
DROZ, Jean Pierre
Swiss, 1746-1823
DRUCKER, Amy J.
British, op.1899-1908
DRULIN, Antoine
French, 1802-1869
DRUMMOND, Eliza A.
British, op.1822-1843
DRUMMOND, James
British, 1816-1877
DRUMMOND, Malcolm
L.G.
British, 1880-1945
DRUMMOND, Samuel
British, 1765-1844
DRUMMOND, William
British, op.1800-1850
DRURY, Alfred
British, 1859-1944

DRURY, Paul-Dalou
British, 1903-
DRURY, Susannah
British, op.1733-1750
DRUIJF or Druyf,
Dirk
Dutch, c.1620-p.1659
DRYANDER, Johann
Friedrich
German, 1756-1812
DRYSDALE, Russell
Australian, 1912-
DRYWEGHEN, Dreywegen
or Dribegen, Sebastian
van
Dutch, op.c.1650-1676
DUARTE, Salomon
German, op.1650-p.1666
DUBAE, A.
French(?), 18th cent.
DUBAN, Jacques
Félix
French, 1797-1870
DUBAUT, Pierre
French, 1886-
DUBBELS, Hendrick
Jacobsz.
Dutch, 1620/1(?)-1676(?)
DUBBELS, Jan
Dutch, op.1717
DUBISSON, William C.
British, op.1821-1847
DUBOIS
French, op.c.1800
DUBOIS (de Sainte
Marie)
French(?), 18th cent.
DUBOIS or du Bois,
Ambroise
French, 1543-1614
DUBOIS or du Bois,
Carl Sylva
Flemish, 1668-1753
DUBOIS or du Bois,
Catharina (Catharina
Cuyck)
Dutch, -1776
DU BOIS, Charles
Edward
American, 1847-1885
DUBOIS or du Bois,
Christien (Chrétien)
Dutch, 1765-1837
DUBOIS or du Booys,
Eduard
Flemish, 1619-1697
DUBOIS, François
(Ambianus)
French, 1529-1584
DUBOIS, Francois
French, 1790-1871
DUBOIS, Frédéric
French, op.1780-1819
DUBOIS or du Bois,
Guillam or Willem
Dutch, c.1610-1680
DU BOIS, Guylène
French, 19th cent.
DUBOIS, Guy Pène
American, 1884-1958
DUBOIS, Hippolyte
Henri Pierre
French, 1837-1890
DUBOIS, J.
French, 1804-1879
DU BOIS, Jean
Swiss, 1789-1849

DUBOIS, Jean Etienne
Franklin
French, -1854
DUBOIS, Louis
Belgian, 1830-1880
DUBOIS, Maurice
French, 19th cent.
DUBOIS, N.
Netherlands(?), 18th cent.
DUBOIS, Paul
French, 1829-1905
DUBOIS, Paul
see Boys
DUBOIS, Pietro
see Lignis
DUBOIS, S.F.
American, 1805-1889
DUBOIS or du Bois, Simon
Flemish, 1632-1708
DUBOIS, Victor
French, 1779-1850
DUBOIS-DRAHONET, Alexandre
Jean
French, 1791-1834
DUBOIS-PILLET, Albert
French, 1845-1890
DUBORDIEU or du Bordieu,
Pieter
Dutch, 1609/10-c.1678
DUBOST, Antoine
French, 1769-1825
DUBOURCQ, Pierre Louis
Dutch, 1815-1873
DUBOURG, Augustin
French, op.c.1800
DUBOURG or du Bourg,
Louis Fabritius or
Fabricius
Dutch, 1693-1775
DUBOURG, Matthew
British, 18th cent.
DUBOURG, Victoria
French, 1840-1926
DUBOURJAL, Savinien Edmé
French, 1795-1853
DUBOVSKOY, Nikolay
Nikanorovich
Russian, 1859-1918
DUBREUIL, J.
French, op.1649
DUBREUIL, Pierre
French, 1891-1970
DUBREUIL or Du Breuil,
Toussaint
French, 1561-1602
DUBREUIL, Victor
French, 20th cent.
DUBSKY, Mario
British, 1939-
DUBUFFE, Claude Marie
French, 1790-1864
DUBUFFE, Edouard Marie
Guillaume
French, 1853-1909
DUBUFE, Louis Edouard
French, 1820-1883
DUBUFFET, Jean
French, 1901-
DUBUIS
French, op.1871
DUBUIS, Fernand
French, 20th cent.
DUBUISSON, G.
French, 18th cent.
DUBUISSON, Jean Baptiste
(Gayot-Du Buisson)
French, op.c.1700-1717

DUBUISSON, P.
French, op.1711
DUBUISSON, Monsù
French(?), 17th cent.
DUBUS, de Bois, de or
du Boys or de or du
Bus, Mathieu
Flemish, c.1590-1665/6
DU BUYSON, C.
see Buyson
DUC, Dao
N.Vietnamese, 20th cent.
DUCA, Giacomo del
(Jacopo Siciliano or
Ciciliano)
Italian, c.1520-p.1601
DUCAILLE, D.
French, op.1801
DUCAMPS, Jean
French, 17th cent.
DU CANE, Ella
British, 20th cent.
DU CARREY
see Carrey
DUCARUGE, Pierre Léon
French, 1843-1911
DUCATEL, Louis
French, 1902-
DUCAYER or du Cayer,
Jean
French, op.1635
DUCCIO di Buoninsegna
Italian, c.1255-1319
DUCE, Aimone
Italian, op.1417-1418
DU CERCEAU, Baptiste
Androuet
French, 1544/7-1590
DUCERCEAU or Du Cerceau,
Jacques, I Androuet
French, 1510-p.1584
DUCERCEAU, Jean Androuet
French, c.1585-p.1649
DUCHAINE, A.
French, 19th cent.
DUCHAMP, Jean
see Campo, Giovanni di
Filippo del
DUCHAMP, Marcel
French, 1887-1968
DUCHAMP, Suzanne
French, 20th cent.
DU CHATEAU, Mme. (née
Destours)
French, op.1779-1797
DUCHATEL, Duchastel or
du Chastel, François
Flemish, 1616/25-1679/94
DUCHE de Vancy (not
Nancy), Gaspard
French, -1788
DUCHE du Vancy, René
French, 18th cent.
DUCHE, Thomas Spence
American, 1764-1790
DUCHEMIN or Du Chemin,
Catherine (Girardon)
French, 1630-1698
DUCHEMIN, Daniel
French, op.1893
DUCHENE
Dutch(?), 18th cent(?)
DUCHESNE, Emery
French, 1847-
DUCHESNE, Jean Baptiste
Joseph (des Argilliers
or de Gisors)
French, 1770-1856

DUCHINO
see Landriani, Paolo
Camillo
DUCIS, Louis
(Jean Louis)
French, 1775-1847
DUCK, G.
Dutch, 17th cent.
DUCK or Duyck, Jacob
Dutch, c.1600-1667
DUCK, L.
Dutch, 17th cent.
DÜCKER, Eugène Gustav
German, 1841-1916
DUCKORT, J.
Dutch, op.1851
DUCLAUX, Antoine Jean
French, 1783-1868
DUCLAUX or Duclo,
Gabriel Jean Boniface
French, 17th cent.
DUCLERE, Teodoro
Italian, 1816-1869
DUCLOS, Antoine Jean
French, 1742-1795
DUCLUZEAU, Marie Adélaide
French, 1787-1849
DUCOMMUN, Jean-Félix
Swiss, 1920-1955
DUCORRON, Julien Joseph
Belgian, 1770-1848
DUCQ, Joseph Francois
Flemish, 1762-1829
DUCREUX, Greux or Creux,
Joseph
French, 1735-1802
DUCROIS
French, 18th cent.
DUCROS, A.
Swiss, 19th cent.
DUCROS, Abraham Louis
Rudolfe (not Pierre)
Swiss, 1748-1810
DUCROS, Pierre
see A.L.R. Ducros
DUCROT, Antoine
French, 1814-
DUCULTIT, Gabriel
French, 1878-1955
DUCUYER
French, 17th cent.
DUDANT, Roger
Belgian, 1929-
DUDGEON, Thomas
British, 19th cent.
DUDLEY, Arthur
British, op.1890-1893
DUDLEY, Robert
British, 19th cent.
DUDLEY, T.
British, 19th cent.
DUDLEY, Thomas
British, c.1634-p.1687
DUDOT, René
French, op.1653-1659
DUERIN, Paulin
French, 19th cent.
DUEZ, Ernest Ange
French, 1843-1896
DUFAU, Clémentine
Hélène
French, 1869-
DUFAU, Fortuné
French, c.1770-1821
DUFAUX the Younger,
Frédéric
Swiss, 1852-

DUFAUX, Henri
French, 19th cent.
DUFAUZ, Fr.
Swiss, 1830-1871
DUFEU, Edouard
(Jacques Edouard)
French, 1840-1900
DUFF, Euan
British, 20th cent.
DUFF, J.R.K.
British, 1862-1938
DUFFAUD, Jean Baptiste
French, 19th cent.
DUFFAUT, Prefete
Haitian, 1923-
DUFFEIT, Gérard
see Douffet
DUFFEY, E.B.
American, 20th cent.
DUFFIELD, Harding
British, 19th cent.
DUFFIELD, Mary Elizabeth,
(née Rosenberg)
British, 1819-1914
DUFFIELD, William
British, 1816-1863
DUFFIN, Paul
British, op.c.1750-1775
DUFLOCQ or Duflos
French, -1749
DUFLOS, Claude
French, 1662-1727
DUFO, Alain
French, 20th cent.
DUFOUR, Bernard
French, 1922-
DUFOUR, Camille
French, 1841-1898
DUFOUR, Joseph
French, op.1807-1840
DUFOUR, Lorenzo
Italian, -1686
DUFRENE, Maurice
French, 1876-
DUFRESNE, Charles Georges
French, 19th cent.
DUFRESNOY or du Fresnoy,
Charles Alphonse
French, 1611-1668
DUFRENOY, Georges
(Georges Léon)
French, 20th cent.
DUFY, Jean
French, 1888-
DUFY, Raoul
French, 1878-1953
DUGASSEAU, Charles
French, op.1835-1878
DUGUAY, Rodolphe
Canadian, 1891-
DUGDALE, Rebecca
British, op.1832
DUGDALE, Thomas Cantrell
British, 1880-
DUGHET, Gaspar
see Poussin
DUGMORE, Edward
American, 20th cent.
DUGOURC or du Gour,
Jean Demosthène
French, 1749-c.1810
DU GUERNIER the
Younger, Louis
French, 1677-1716
DUGUID, H.
British, op.1831-1860
DUGY, J.
British, op.1629

DUHAMEL, A. B.
French, 1736-
DUHAMEL, Marcel
French, 20th cent.
DUHAMEL du Monceau, H.L.
French, op.1835
DUHANOT, Euphémie
see Muraton
DUHEM, Henry Aimé
French, 1860-
DUHEM, Marie Geneviève
French, 19th cent.
DUHEN, Jacques Joseph
French, 1748-1840
DUIA, Dugia or
Duya, Pietro di
Niccolò
Italian, op.1520-1529
DUIFHUYZEN, Pieter
Jacobsz.
see Duyfhuijsen
DUINEN, Jan Baptist
van
see Deynum
DUISART, Christiaen
Jansz.
see Dusart
DUJARDIN, du Gardin,
du Gardijn or du Jardin,
Guilliam
Dutch, c.1597-p.1647
DUJARDIN, du Gardin,
du Gardijn or du
Jardin, Karel (Bockbaert)
Dutch, 1621/2(?)-1678
DUJARDIN-BEAUMETZ, Mme.
Marie, (née Marie Petiet)
French, -1893
DUKES, Charles
British, op.1829-1865
DULAC, Edmond
British, 1882-1953
DULAC, Marie-Charles
French, c.1898-
DULAC, Sébastien
French, 1802-p.1849
DULIEU, René
French, 20th cent.
DULIN or d'Ulin, Pierre
French, 1669-1748
DULLAERT, Heyman
Dutch, 1636-1684
DULONGPRÉ, Louis
Canadian, 1754-1843
DULORRON, J.
French, 18th cent.
DULUDE, Claude
Canadian, 1931-
DUMAIS, Alexandre
French, op.1831
DUMARESQ, Charles Edouard
Armand
see Armand-Dumaresq
DUMAS, Alice Dick
French, 1878-
DUMAS, Antoine
French, 1820-1859
DUMAS, Gaetan
French, op.1927
DUMAS, M.
French, 1812-1885
DUMAX, Ernest-Joachim
French, 1811-p.1882
DUMEE, Ange-René
French, 19th cent.
DUMEE, Guillaume
French, op.1601-1626

DUMENIL, Paul Chrétien
Romain
French, 1779-
DUMENIL, Pierre
French, 1862-
DUMERAY, Madame
(née Brinau)
French, op.1806-1831
DUMESNIL, Dumenil or
Dumeny, Louis
Michel
French, 1680-p.1746
DUMESNIL the Younger,
Pierre Louis
French, 1698-1781
DUMET, Jean Philibert
French, op.1808-m.c.1814
DUMINI, Adolfo
Italian, 1863-
DUMITRESCO, Natalia
Rumanian, 1915-
DUMKET, Le Chevalier
French, op.1680-1704
DUMMER, Jeremiah
American, 1645-1718
DUMOND, Alfred-Etienne
French, 19th cent.
DUMONSTIER, Dumoustier
or Du Monstier Family, The
French, 16-18th cent.
DUMONSTIER the Younger,
Cosmé
French, op.1574-m.1605
DUMONSTIER, Daniel
French, 1574-1646
DUMONSTIER, Etienne, II
French, 1540-1603
DUMONSTIER, Etienne, III
French, 1604-a.1630
DUMONSTIER, Geoffroy or
Godefroy
French, op.1510-1560
DUMONSTIER, Pierre, I
(L'Oncle)
French, 1545-p.1599
DUMONSTIER, Pierre, II
French, 1585-1656
DUMONT, François
French, 1751-1831
DUMONT, Gabriel Pierre
Martin
French, c.1720-p.1790
DUMONT, Henri
French, 1859-
DUMONT the Elder, Jacques
(Le Romain)
French, 1701-1781
DUMONT, Marie Nicole,
(née Vestier)
French, op.1785
DUMONT, Pierre
French, 1884-1936
DUMOULIN, Aimé
(Francois Aimé
Louis)
Swiss, 1753-p.1793
DUMOULIN, Lambert
Flemish, c.1665-1743
DUMOULIN, Louis (Louis
Jules)
French, 1860-
DUMOURIEZ, C.
French, op.c.1800
DUN, Elizabeth
British, 20th cent.
DUN, Nicolas François
French(?), 1764-1832

DUNBAR, Evelyn
Mary
British, 1906-1960
DUNCAN, Ann
British, 1920-
DUNCAN, Edward
British, 1803-1882
DUNCAN, Frank
American, 1915-
DUNCAN, James Allan
British, 20th cent.
DUNCAN, John
British, 1866-1945
DUNCAN, Thomas
British, 1807-1845
DUNCANNON, Frederick,
Viscount
British, 1758-1844
DUNCANSON, Robert S.
American, 1821-1872
DUNCOMBE, Susanna,
(née Highmore)
British, c.1730-1812
DUNDAS, Douglas
Australian, 1900-
DUNDAS, J.
British, 19th cent.
DUNEUF-GERMAIN, Mlle.
French, 18th cent.
DUNKARTON or Tunckerton,
Jones
British, 1746-1795
DUNKARTON, Robert
British, 1744-1811/7
DUNKER, Balthasar
Anton
German, 1746-1807
D'UNKER, C.
Swedish, 19th cent.
DUNKERLEY
American, 18th cent(?)
DUNKI, Louis
Swiss, 1856-1915
DUNLAP, Joseph
American(?), 18th cent.
DUNLAP, William
American, 1766-1839
DUNLOP, Ronald Ossory
British, 1894-1973
DUNLUCE, Sarah
British, 20th cent.
DUNN, Alfred
British, 1937-
DUNN, Andrew
British, op.1771-1825
DUNN, Anne
British, 1929-
DUNN, Charles Frederic
American, 1810-1882
DUNN, Edith
see Edith Hume, Mrs.
DUNN or Dun, John
British, op.1768-1805
DUNN, Treffry H.
British, 19th cent.
DUNNAGE, W.
British, op.1852
DUNNING, Goddard
British, 1614-p.1677
DUNOUY, Alexandre
Hyacinthe
French, 1757-1841
DUNSMORE, John Ward
American, 1856-
DUNSTALL, John
British, c.1660-1693

DUNSTAN, Bernard
British, 1920-
DUNTHORNE, John
British, 1770-1844
DUNTHORNE, John
British, 1798-1832
DUNTHORNE the Younger,
John
British, op.1783-1792
DUNTON, W.Herbert
American, 1878-1936
DUNTZE, J.B.
German, 1823-1895
DÜNZ, Hans Jakob, I
Swiss, c.1580-p.1649
DÜNZ, Johannes
Swiss, 1645-1736
DUNZINGER
German, op.c.1820
DUPAN or Du Pan,
Barthélemy
Swiss, 1712-1763
DUPARC, Françoise
French, 1705-1778
DUPAS, Jean Théodore
French, 1882-
DUPASQUIER or Du
Pasquier, Antoine
Léonard
French, op.1791-1822
DU PATY, Léon
French, op.1869-1880
DUPERAC, Etienne
see Pérac
DUPERRE, Gabriel
French, op.1836-45
DUPEYRAC, Etienne
see Pérac
DUPLAY, Eléonore
French, 18th cent.
DU PLESSIS, H.E.
French, 20th cent.
DUPLESSIS, J.V.
French, 18th cent.
DUPLESSIS, Jacques
French, op.1770-1726
DUPLESSIS or Plessis,
Joseph Siffred
French, 1725-1802
DUPLESSIS or Plessis,
Michel (C. Michel H.)
French, op.1791-1799
DUPLESSIS-BERTAUX, Jean
French, 1749-1819
DUPONT
French, op.1797-1811
DUPONT, François Léonard
French, 1756-1821
DUPONT, Gainsborough
British, c.1754-1797
DUPONT, Henriquel
see Henriquel, Louis
Pierre
DUPONT, Louis-G.
French, -1775
DUPONT de Montfiquet,
Louis François Richard
French, 1734-1761
DUPONT, N.
French, -1765
DUPONT, Pieter
Dutch, 1870-1911
DUPOUCH, Claude
French, op.1739
DUPPA, Bryan Edward
British, op.1832-1853

DUPRA, Duprat or
Dupraz, Domenico
(Giorgio Domenico)
Italian, 1689-1770
DUPRA, Duprat or
Dupraz, Giuseppe
Italian, op.1731-1778
DUPRAT, Albert Ferdinand
French, 1882-
DUPRAT, Giuseppe
see Duprà
DUPRAT, Sophie
French, op.1833-1851
DUPRAY, Henri (Henri-
Louis)
French, 1841-1909
DUPRAZ, Giuseppe
see Duprà
DUPRE or du Pré, Daniël
Dutch, 1751-1817
DUPRE, Giovanni
Italian, 1817-1882
DUPRE, Jules
French, 1811-1889
DUPRE, Julien
French, 1851-1910
DUPRE, Léon-Victor
(Victor)
French, 1816-1879
DUPRE, Louis
French, 1789-1837
DUPRESSOIR, François
Joseph
French, 1800-1859
DUPUIS, Charles
French, op.1766-1790
DUPUIS, Georges
French, 1875-
DUPUIS, Gilbert
French, 20th cent.
DUPUIS, Maurice
Belgian, 1882-
DUPUIS, Philippe Félix
French, 1824-1888
DUPUIS or Dupuy, Pierre
French, 1610-1682
DUPUIS, Pierre
French, 1833-
DUPUY, du Grez, Bernard
French, 17th cent.
DUPUY or Du Puy, Guy
François
see Francois, Guy
DUPUY, Jean
French, 1925-
DUPUY, Nicolas
French, 17th cent.
DUPUY, Paul Michel
French, 1869-
DUQUE CORNEJO y Roldan,
Pedro
see Cornejo
DUQUESNOY or du, de or
di Quesnoi or Quesnoy,
or van Cannoy, Canoi or
Kenoy, Frans or François
(Francesco Carino or
Franciscus Quercetus;
Il Fiammingo, Il Fiamengo,
Le Flameng or Le Flamend)
Flemish, 1594-1643
DURADE, Francois d'Albert
French, 1804-1886
DURAMEAU or Rameau,
Louis Jean Jacques
French, 1733-1796

DURAN, Luis Maria
Spanish, op.1843
DURAN CAROLUS, Emile
Auguste
see Carolus-Duran
DURAND, André
Canadian, 1942-
DURAND, Antoine
French, op.1645-1663
DURAND, Asher Brown
American, 1796-1886
DURAND, C.E.A.
British, 20th cent.
DURAND, Cyrile
French, 1790-1840
DURAND, Denis
French, op.1656
DURAND, G.
French, 1832-
DURAND, Gabriel
French, 1812-p.1856
DURAND, I.
French, 20th cent.
DURAND, Jean François
French, 1731-p.1778
DURAND, Jean Nicolas
Louis
French, 1760-1834
DURAND, Jérôme
French, 1555-1606/7
DURAND, John
American, op.c.1770
DURAND, Louis
French, 1817-1890
DURAND, Louis (Pierre
Louis)
French, op.1745-1797(?)
DURAND, Marie Adélaide
see Ducluzeau
DURAND, Simon
Swiss, 1838-1896
DURAND-BRAGER, J.B.H.
French, 1814-1879
DURAND-DURANGEL, Antoine-
Victor-Léopold
French, 1828-1891/8
DURANDI or Duranti,
Jacques or Jacopo
French, 1410-a.1469
DURANT, Godefroy
French, 19th cent.
DURANTE, Carlo
Italian, -1712
DURANTE or Duranti,
Conte Giorgio
Italian, 1685-1755
DURANTI, Fortunato
Italian, 1787-1863
DÜRCK, Friedrich
German, 1809-1884
DURDEN, James
British, 1878-1964
DURENNE, Eugène Antoine
French, 1860-
DÜRER, Albrecht
German, 1471-1528
DÜRER, Hans
German, 1490-c.1538
DUREST, G.
French, 20th cent.
DUREUIL, M.
French, 20th cent.
DUREY, René
French, 1890-1959
DÜRFELDT, Friedrich
German, 1765-1827

DURHAM, Cornelius B.
British, op.1827-1865
DURHAM, Mary Edith
British, op.1892-1900
DURHEIM, Johann Ludwig
Rudolf
Swiss, 1811-1895
DÜRIG, Rolf
German, 1926-
DÜRINGER, Daniel
Swiss, 1720-1786
DURINK, Stanilas
Polish, op.1426-1481
DURLOO
French, op.1952
DURNFORD, Elias
British, 18th cent.
DURNO, James
British, c.1745-1795
DUROLLER, A.
French, op.1795
DUROURE, Susanna
British, op.1764
DÜRR or Dürre, Johann
German, a.1650-p.1667
DÜRR the Elder, Wilhelm
German, 1815-1890
DURRANS, Louis François
French, 1754-1847
DURRANT, Jennifer
British, 1942-
DURRANT, Roy Turner
British, 1925-
DURREN, Olivier van
see Deuren
DURRIE, George Henry
American, 1820-1863
DURSTE, Auguste
French, 1842-
DURUPT, Charles
Barthelemy Jean
French, 1804-1838
DURY, Antoine (Tony)
French, 1819-p.1878
DURY, G.
American, 1817-1894
DUSART or Duisart,
Christiaen Jansz.
Dutch, 1618-1682/3
DUSART, Dusaert or
du Sart, Cornelis
Dutch, 1660-1704
DUSAUTOY or Du Sautoy,
Jacques Léon
French, 1817-1894
DUSI, Cosroe
Italian, 1808-1859
DUSILLION, Jean Baptiste
see Dussillion
DU SIMITIERE, Pierre
Eugène
Swiss, c.1736-1784
DUSSART
French, 20th cent.
DUSSILLON or Dusillion,
Jean Baptiste
French, c.1748-1788
DUTAILLY
French, op.1790-1803
DUTCH SCHOOL,
Anonymous Painters
of the
DUTERTRE or Du Tertre,
André
French, 1753-1842
DUTHE, J.
French, op.1800-1840

DU TIELT, Louis
French, op.1641-1644
DUTILLEUX, Henri Joseph
Constant
French, 1807-1865
DUTILLOIS, Auguste
French, op.1830-1850
DUTKIEWICZ, Jan
Polish, 1911-
DUTOIT, Ulysse
Swiss, 1870-
DUTTENHOFER, Anton
German, 1812-1843
DUTTON, Mary Martha
see Pearson
DUTTON, Thomas G.
British, op.1838-1879
DUTZSCHOLD, Henri
French, 1841-1891
DUVAL
see Amaury-Duval,
Eugène Emmanuel
DUVAL, A.
American, op.c.1820
DUVAL, Charles Allen
British, 1808-1872
DUVAL, Constant Léon
French, 1877-
DUVAL, Etienne
Swiss, 1824-1914
DUVAL, Eustace François
French, op.1784-1836
DUVAL or Duvall, John
British, op.1834-1881
DUVAL, Marc
French, c.1530-1581
DUVAL or du Val, Robbert
(Fortuyn)
Dutch, 1649-1732
DUVAL-LE-CAMUS, Pierre
French, 1790-1854
DUVAL, Philippe
French, op.1672-c.1709
DUVAL, Victor
French, 1795-p.1868
DUVALL, John
see Duval
DUVEAU, Louis-Jean-Noel
French, 1818-1867
DUVENECK, Frank
American, 1848-1919
DÜVENS or Douwen, Hendrik
or Heinrich (van)
Dutch, op. 1700-1705
DUVENT, Charles Jules
French, 1867-
DUVERGER, P.
French, 18th cent.
DUVERGER, Théophile
Emmanuel
French, 1821-
DUVET, Jean
French, 1481-p.1561
DUVIDAL de Montferrier,
Louise Rose Julie, (née
Comtesse Hugo)
French, 1797-1869
DUVIERT, Joachim
Netherlands,
op.c.1609-1614
DUVIEUX, Henri
French, op.1880-1882
DUVILLIER, René
French, 20th cent.
DUVUVIER, Aimée
French, op.1786-1824
DUVIVIER or du Vivier,
Ignace
French, 1758-1832

DUVIVIER, Jean
French, 1687-1761
DUVIVIER, Pierre Simon
Benjamin (or Benjamin)
French, 1730-1819
DUWART, Salomon
Dutch, op.1633-1650
DUWATER, Isaac
Dutch(?), op.1788
DUWEE, Henri Joseph
Belgian, op.c.1830-1870
DÜWETT, Johan or Jan
see Wet
DUXA, Karl
German, 1871-
DUYA, Pietro di Niccolò
see Duia
DUYCK, Edouard
Belgian, 1856-1897
DUYCK, Jacob
see Duck
DUYCKINCK, Evert, III
American, 1677-1727
DUYCKINCK, Gerardus
American, 1695-1742
DUYCKINCK, Gerrit or
Gerret
American, 1660(?)-1710
DUYFHULJSEN or
Duifhuyzen, Pieter
Jacobsz. (Colinchovius)
Dutch, 1608-1677
DUYL, Thérèse van,
(née Schwartze)
see Schwartze
DUYNEN or (?) Deynum,
Gerardt van
Dutch, op.1665-1673
DUYNEN, Isaac van
Dutch, c.1625/30-c.1677/81
DUYREN, Johann van
see Master of the Life
of the Virgin
DUYSEN, S. van
Dutch, op.1629
DUYSTER, Willem Cornelisz.
Dutch, c.1598/99-1635
DUYTS, Gustave den or
Gustave Denduyts
Belgian, 1850-1897
DUYTS, Jan de
Flemish, 1629-1676
DUYVEN, Steven van
Dutch, op.1669-1683
DUZER, Clarence E. van
American, 20th cent.
DVORNIKOV, Tit Yakovlevich
Russian, op.1900
DWORKOWITZ, Alan
American, 1946-
DYCE, Rev. Alexander
British, 1798-1869
DYCE, Charles
British, op.1848
DYCE, William
British, 1806-1864
DYCHTL, Martin
see Dichtl
DYCK, A. van (or von) den
Netherlands, 17th cent.
DYCK, Abraham van
Dutch, 1635/6-1672
DYCK, Andries van
Flemish, op.1633/4
DYCK, Albert van
Belgian, 1902-1951
DYCK, Sir Anthony van
Flemish, 1599-1641
DYCK, Daniel van den
Flemish, op.1631-m.1670

DYCK, Floris Claesz.
van
Dutch, 1575-1651
DYCK, Hermann
German, 1812-1874
DYCK, J.A.
Flemish, 17th cent.
DYCK, James van
American, 19th cent.
DYCKMANS, Josephus
Laurentius
Belgian, 1811-1888
DYER, Charles
British, op.c.1800
DYF, Marcel
French, 19th cent.
DIJKSTRA, Johannes
(Johan)
Dutch, 1896-
DYK or Dijk, Philip
van
Dutch, 1680-1753
DYKE or Dyck, Pieter
van, or Pieter
Vandyke
British, 1729-1799
DYKE, Samuel P.
American, op. 1856-1869
DYKHOFF or Dijkhoff
Joannes
Dutch, 1795-1862
DYNEN, Jan Baptist
van
see Deynum
DYONNET, Edmond
Canadian, 20th cent.
DYRKS or Dircks, Jonas
Swedish, op.1780
DYS, Habert
French, op.c.1900
DYSART, Lionel, Lord
British, op.1718
DYSART, Wilbraham,
6th Earl of
British, 1739-1821
DYSON, Will
Australian, -1938
DYSSELHOF or Dijsselhof,
Gerrit Willem
Dutch, 1866-1924
DZIERZYNSKI, André
British, 1936-
DZUBAS, Friedel
American, 1915-
DZWIG, Kazimierz
Polish, 1923-

E

EAGAR, W.
British,op.1831
EAGLES, Rev. John
British, 1783/4-1855
EAKINS, Susan Macdowell
American, 1851-1938
EAKINS, Thomas
American, 1844-1916
EAMES, J.
British, 18th cent.
EARDLEY, Joan
British, 1921-1963
EARL, George
British, op.1856-1883
EARL, Maud
British, op.1884-1908
EARL, Ralph E.W.
American, 1788-1837
EARL, Thomas
British, op.1836-1885

EARL, William
Robert
British, op.1823-1867
EARLE, Augustus
British, op.1806-1839
EARLE, Eyvind
American, 20th cent.
EARLE or Earl,
James
American, 1761-1796
EARLE, Lawrence C.
American, 1845-1921
EARLE, Paul Barnard
Canadian, 1872-1930
EARLE or Earl, Ralph
American, 1751-1801
EARLOM, Richard
British, 1743-1822
EARLOM, William
British, 1772-1789
EARNSHAW, M.
British, 19th cent.
EARP, G.
British, op.c.1834
EARP, Henry
British, op.1871-1884
EAST, Sir Alfred
British, 1849-1913
EAST, H.S.
British, 19th cent.
EASTLAKE, Caroline H.
British, op.1868-1873
EASTLAKE, Charles
Herbert
British, 19th cent.
EASTLAKE, Sir Charles
Lock
British, 1793-1865
EASTLAKE, Mrs. Mary A.,
(née Bell)
Canadian, 19th cent.
EASTLEY, J.
British, op.c.1846
EASTLEY, S.R.
British(?), 19th cent.
EASTMAN, Emily
American, 19th cent.
EASTMAN, Frank S.
British, 1878-
EASTMAN, Seth
American, 1808-1875
EASTON, Reginald
British, 1807-1893
EATON, B.M. Knight
British, op.1914
EATON, Joseph Oriel
American, 1829-1875
EATON, Wyatt
Canadian, 1849-1896
EAUBONNE, Louis Lucien
d'
French, 1834-1894
EAVES, John
British, 1929-
EBEL, Fritz
German, 1835-1895
EBEL, Heinz
German, 20th cent.
EBELMANN, Hans Jakob
German, op.c.1600
EBEN, Frédéric Baron d'
Swedish, op.1808
EBERHARD, George Adam
German, op.1656-1688
EBERHARD, Konrad
German, 1768-1859
EBERHARD, Robert George
Swiss, 1884-

EBERHARDT, Jacob
German, 1820-1889
EBERL, Frantisek Zdenek
Czech, 1888-
EBERLE, Adam
German, 1804-1832
EBERLE, Adolf
German, 1843-1914
EBERLE, Johann
German, op.c.1783-1788
EBERLE, Robert
German, 1815-1862
EBERT, Anton
German, 1845-1896
EBERT, Carl
German, 1821-1885
EBERZ, Josef
German, 1880-1942
EBLE, Theo
Swiss, 1899-
EBURNE, Emma S.
see Oliver
EBYL, Franz
German, 1806-1880
ECCARDT or Eckhardt,
John Giles
British, op.1740-m.1779
ECHARD or Eschard,
Charles
French, 1748-1810
ECHARD, G.
French, op.1756
ECHARLINGER
German, 19th cent.
ECHAVE or Chaves the
Elder, Balthasar
Spanish, op.1603-1630
ECHENA, José
Spanish, 1845-p.1883
ECHEVARRIA, Federico de
Spanish, 1916-
ECHEVARRIA, Juan de
Spanish, 1875-1931
ECHTER, Michael
German, 1812-1879
ECHTLER, Adolf
German, 1843-1914
ECKARDT, Aloys
German, 1845-1906
ECKE, John
see Eycke
ECKENBRECHER, Karl Paul
Themistocles von
German, 1842-1921
ECKENER, Alexander
German, 1870-1944
ECKENFELDER, Friedrich
Swiss, 1861-1938
ECKERSBERG, Christoffer
Vilhelm
Danish, 1783-1853
ECKERSBERG, Johan
Fredrik
Norwegian, 1822-1870
ECKERT, Georg Maria
German, 1828-1903
ECKERT, Heinrich Ambros
German, 1807-1840
ECKERT, Walter
German, 1913
ECKHARDT, Carl Peter
German, 1800-1850
ECKHARDT, Georg
Ludwig
German, 1770-1794
ECKHARDT, Johannes
Aegidius
German, 18th cent

ECKMAN, Jean
French, 1641-1677
ECKMANN, Otto
German, 1865-1902
ECKSTEIN, Franz Gregor
Ignaz
German, op.1700-1736
ECKSTEIN, Johannes
(John), I
British, op.1762-1802
ECONOMOS, Michael
American, 1937-
EDDINGTON, William Clarke
British, op.1860-1885
EDDIS, Eden Upton
British, 1812-1901
EDDY, Don
American, 1944-
EDDY, Oliver Tarbell
American, 19th cent.
EDE, Basil
British, 20th cent.
EDE, Frederick Charles
Vipont
Canadian, 1865-p.1909
EDELFELT, Albert Gustaf
Aristides
Finnish, 1854-1905
EDELINCK, Gerard
Flemish, 1640-1707
EDELINCK, Nicolas
Etienne
French, 1681-1767
EDELMANN, Hanno
German, 1923-
EDELMANN, Otto Robert
Canadian, 20th cent.
EDEMA, Gerard van
Dutch, c.1652-c.1700
EDEN, Denis William
British, 1878-1949
EDEN, Sir William
British, 1849-1915
EDENS or Eden, J.
Dutch, op.1651
EDGAR, James H.
British, op.1860-1864
EDIE, Stuart Carson
American, 1908-
EDION, Henri
French, 1905-
EDKINS, John
British, 1931-1966
EDLINGER or Etlinger,
Joseph Georg von
German, 1741-1819
EDMOND, Martin
Swedish, 20th cent.
EDMONDS, John Francis W.
American, 1806-1863
EDMONDSON the Younger, E.
American, 19th cent.
EDMONDSON, James
British, op.c.1810
EDMONDSON, Leonard
American, 1916-
EDMONSTON, Samuel
British, 1825-
EDMONSTONE, Robert
British, 1794-1834
EDOUART, Augistin
Amant Constant
Fidèle
French, 1789-1861
EDRIDGE, Henry
British, 1769-1821
EDSON, Allan
British, op.1883-m.1888

EDUGENE, Pierre
Haitian, 1941-
EDWARD VI.
British, 1537-1553
EDWARD VII
British, 1841-1910
EDWARD, Charles
British, op.1884
EDWARDS OF HALIFAX
British, 18th cent.
EDWARDS, Cyril W.
British, 1902-
EDWARDS, D.
British, 19th cent.
EDWARDS, The Rev.E.
British, 19th cent.
EDWARDS, Edward
British, 1738-1806
EDWARDS, Edwin
British, 1823-1879
EDWARDS, F.
British, 19th cent.
EDWARDS, George
British, 1694-1773
EDWARDS, George Henry
British, op.1883-1910
EDWARDS, H. Sutherland
British, op.1867
EDWARDS, Harry C.
American, 1868-1922
EDWARDS, James
British, op.1868
EDWARDS, John
British, op.c.1763-1812
EDWARDS, John
British, 1938-
EDWARDS, Lionel
British, 1878-1966
EDWARDS, Mary Ellen
British, 1839-p.1908
EDWARDS, Pryce Carter
British, op.1832-1833
EDWARDS, S.C.
British, 19th cent.
EDWARDS, Sydenham Teast
British, c.1768-1819
EDWARDS, Thomas
American, op.1825
EDWIN, David
British, 1775-1841
EDWIN, Douglas
British, 19th cent.
EDY, John William
British, op.1780-1820
EDY-LEGRAND, Edouard
Léon Louis
French, 1892-
EDZARD, Dietz
German, 1893-
EECKELE or Heckele,
Jan van (Jan van
der Heke)
Netherlands,
op.1534-m.1561
EECKHOUDT, Jean van den
Belgian, 1875-1946
EECKHOLT or Eyckhout,
Albert van der
Dutch, op.1637-1664
EECKHOUT, Anthonie
van den
Flemish, 1656-1695
EECKHOUT, Gerbrand
Jansz. van den
Dutch, 1621-1674
EECKHOUT, Jacobus
Josephus
Belgian, 1793-1861

EECKHOUT, Victor
Belgian, 1821-1879

EEKMAN, Nikolaas
Belgian, 1889-

EELKEMA, Eelke
Jelles
Dutch, 1788-1839

EEMANS, Marcel (Marc)
Belgian, 1907-

EEMONT or Emont, Adriaen
van
Dutch, c.1627-1662

EERELMAN, Otto
Dutch, 1839-1926

EERENBERCH, Wilhelm
(Schubert) van
see Ehrenberg

EERTVELT or Artvelt,
Andries van
Flemish, 1590-1652

EEWOUTS or Ewoutsz,
Hans, Jan or Haunce
see Eworth

EFFEL, Jean
French, 20th cent.

EGAN, Wilfred
British, 20th cent.

EGAN, William
British, op.1850

EGEDIUS, Halfdan
Johnsen
Norwegian, 1877-1899

EGELER, Stefan
German, 1894-1969

EGELL, Paul
German, 1691-1752

EGENBERGER, Johannes
Hinderikus
Dutch, 1822-1897

EGER or Egger, Georg
Adam
German, 1727-1808

EGERI, Carle or Carolus
von
see Aegeri

EGERSDORFER, Heinrich
British, op.1909

EGERTON, 'Ariana' M.
British, op.1777

EGERTON, Daniel
Thomas
British, op.1824-m.1842

EGERTON, M.
British, op.c.1825

EGG, Augustus
Leopold
British, 1816-1863

EGGENHOFER, Nick
American, 20th cent.

EGGENSCHWILER, Franz
Swiss, 20th cent.

EGGER, Jean
Swiss, 1893-1934

EGGER-LIENZ, Albin
German, 1868-1925

EGGERT, Sigmund
German, 1839-1896

EGGINTON, Wycliffe
British, 1875-1951

EGINTON, John
British, op.1763-1800

EGLEY, William
British, 1798-1870

EGLEY, William Maw
British, op.1843-1898

EGLINTON, Samuel
British, op.1830-1855

EGMONT, Justus van
(Justus Verus ab
Egmont)
Dutch, 1601-1674

EGMONT, Théodore Juste d'
Flemish, 1627-1672

EGNER, Marie
German, 1850-1940

EGO, Ernest
French, 19th cent.

EGON, Nicholas
British, 20th cent.

EGORNOFF, Alexander
Simionovitch
Russian, 1858-1902

EGORSHINA, N.A.
Russian, 1926-

EGRY, József
Hungarian, 1883-1951

EGUSQUIZA, Rogelio
Spanish, 1845-c.1920

EGVILLE, James Hervé d'
British, c.1810-1880

EHINGER, Emanuel
German, 17th cent.

EHLERS, Carl
German, 1854-

EHMSEN, Heinrich
German, 1886-1964

EHNLE, Adrianus Johannes
Dutch, 1819-1863

EHRENBERG, Aerdenberg,
Eerenberch, Hardenberg
or Herdenberg, Wilhelm
van (Wilhelm Schubert
van Ehrenberg)
Flemish, 1630-c.1676

EHRENBERGER, Ludwig
Lutz
German, op.c.1920

EHRENSTRAHL
see Klöcker

EHRENSVÄRD, Augustin
Swedish, 1710-1772

EHRENTRAUT, Julius
German, 1841-1923

EHRET, Georg Dionys
German, 1710-1770

EHRHARDT, Adolf
(Carl Ludwig
Adolf)
German, 1813-1899

EHRICH, Bruno
German, 1861-

EHRINGER, J.W.
American, 19th cent.

EHRKE, Eduard
German, 1837-p.1876

EHRLICH, Georg
British, 1897-1966

EHRLICH, R.A.
German, op.1828

EHRMANN, Francois Emile
French, 1833-1910

EHRMANNS, C.B.
Austrian, op.1830

EHRMANNS, Theodor von
German, 1846-

EIBISCH, Eugeniusz
Polish, 1896-

EIBL, Franz
see Eybl

EIBL, Ludwig
German, 1842-1918

EIBNER, Friedrich
German, 1825-1877

EICH, Johann Friedrich
German, 1748-1807

EICHBAUM, M.D.
British, op.1822

EICHEL the Younger,
Emanuel
German, 1717-1782

EICHHORN, Albert
German, 1811-1851

EICHHORN or Eichorn,
Franz Joseph
German, c.1712-1785

EICHINGER, E.
German, 19th cent.

EICHINGER, Ernest
German, 1929-

EICHLER the Elder,
Gottfried
German, 1677-1759

EICHLER, Johann Conrad
(Wollust)
German, 1688-1748

EICHLER the Younger,
Johann Gottfried
German, 1715-1770

EICHLER, Matthias
Gottfried
German, 1748-p.1818

EICHLER, Reinhold Max
German, 1872-

EICHLER, Wilhem
German, op.c.1830

EICHOLTZ, Jacob
American, 1776-1842

EICHSTAEDT, Rudolf
German, 1857-1924

EICKELBERG, Willem
Hendrik
Dutch, 1845-1920

EICKHOFF, Gottfried
Danish, 1902-

EIEBAKKE, August
Norwegian, 1867-

EIFFE, Christian
Wilhelm
German, 1826-1893

EIGE, Howard A.
American, 20th cent.

EIGTVED, Nikolaj
Danish, 1701-1754

EIKELENBERG or
Eykelenberg, Symon
Dutch, 1663-1738

EILSHEMIUS, Louis
Michel
American, 1864-1941

EIMART or Eimmart the
Younger, Georg Christoph
German, 1638-1705

EINSLE, Anton
German, 1801-1871

EINSLIE, S.
British, op.1785-1808

EINSTEIN, William
American, 20th cent.

EISEN, Charles Joseph
Dominique
French, 1720-1778

EISEN, Francois
French, 1695-1778

EISENBERG, Baron d'
German, 18th cent.

EISENBERGER, Nikolaus
Friedrich
German, 1707-1771

EISENDIECK, Suzanne
Polish, 1908-

EISENHOWER, Dwight D.
American, 1890-1969

EISENHUT, Ferenc
Hungarian, 1857-1903

EISENMANN, Germaine
French, 1894-

EISENMANN, Georg
German, 18th cent.

EISENMENGER, August
German, 1830-1907

EISENSCHITZ, Willy
German, 1889-

EISENSTAT, Ben
American, 20th cent.

EISERMANN, Richard
German, op.1878-1884

EISL, Therese
German, 20th cent.

EISLER, Georg
German, 1928-

EISMAN-SEMENOWSKY,
Emile
Polish, op.c.1878

EISMANN, Carlo
(Brisighella)
Italian, 1629(?)-p.1718

EISMANN or Leismann,
Johann Anton
German, 1604-1698

EISNER or Eissner,
Joseph, II
German, 1788-1861

EJSMOND, Franz
Polish, 1859-

EK, Sándor
Hungarian, 1902-

EKELAND, Arne
Norwegian, 20th cent.

EKELS, Jan, I
Dutch, 1724-1781

EKELS, Jan, II
Dutch, 1759-1793

EKHARD, Godwin
German, 19th cent.

EKMAN, Robert Wilhelm
Scandinavian, 1808-1873

EKSTRÖM, Per
Swedish, 1844-1935

EKVALL, Hans
Swedish, 1918-

EKVALL, Knut
Scandinavian, 1843-1912

ELAND, John Shenton
British, 1872-1933

ELANDT, Elands or
Elandts, Cornelis
Dutch, op.1663-1670

ELBFAS, Jacob
Hendrik
Swedish, op.1627-m.1664

ELBO, José
Spanish, 1804-1844

ELBURCHT, Elborch,
Elburg, Elsborch
etc., Hans or Jan
van der (Cleen Hansken)
Netherlands,
op.1536-1553

ELDER, Andrew
Taylor
British, 1908-1966

ELDER, John
American, 1833-1895

ELDERFIELD, John
British, 1943-

ELDRED, Charles
American, 1938-

ELDRIDGE, Martin
British, 20th cent.

ELDRIDGE, Mildred E.
British, 1909-
ELEMBRECH, Dirk or
Theodoor
see Helmbreker
ELEN, Philip West
British, op.1838-1872
ELESZKIEVICZ, Stanislaw
Polish, 1900-1963
ELEUTER, Jersy
see Semiginowski
ELFELDAR (Elfeldes,
Alfeldes) Hanuš
Czech, op.c.1511-1517
ELFINGER, Ant
(Cajetan)
German, 19th cent.
ELFORD, Sir William
British, 1747-1837
ELGOOD, George S.
British, 1851-1943
ELI, C.
British, 19th cent.
ELI, Christel (Johann
Heinrich Christian)
German, 1800-1881
ELIAERTS, Jan Frans
Belgian, 1761-1848
ELIAS, Annette
British, op.1881-m.1921
ELIAS or Elyas, Isaac
Dutch, op.1620
ELIAS, Elie, Elyas or
Elye, Matthieu
Flemish, 1658-1741
ELIAS, Nicolaes
see Eliasz.
ELIAS, T.H.
Dutch(?), 18th cent.(?)
ELIASBERG, Paul
German, 1907-
ELIASZ. or Elias,
Nicolaes (Nicolaes
Eliasz. Pickenoy)
Dutch, c.1591-c.1653/6
ELIE, Matthieu
see Elias
ELINGA, Pieter Janssens
see Janssens
ELIZABETH of France,
Mme.
French, 1764-1794
ELIZABETH, Princess
British, 1770-1840
ELIZALDE, (Ilizolde,
Legolde, Lizolde)
see Licalde
ELKIM, Maria
American, 20th cent.
ELLE, Edouard
French, 1859-1911
ELLE, Elie or Helle,
Ferdinand
French, c.1585-m.1637/40
ELLE, Elie or Helle,
Louis ('Ferdinand
fils')
French, 1648-1717
ELLE, Elie, Helle or
van Helle the Elder,
Louis Ferdinand
(Ferdinand le Vieux)
French, c.1612-1689
ELLENDER, Raphael
American, 1906-
ELLENRIEDER, Maria
(Anna Maria)
German, 1791-1863

ELLENSHAW, Peter
American, 20th cent.
ELLERMANN, Karl
German, 1887-1910
ELLIGER, Antoni
Dutch, 1701-1781
ELLIGER, Ottmar, I
German, 1633-1679
ELLIGER, Ottmar, II
German, 1666-1735
ELLIOT, George
British, op.1856
ELLIOT, Robert
James
British, 1790-1849
ELLIOT, Daniel Girard
American, op.1860-1877
ELLIOTT, Charles
Loring
American, 1812-1868
ELLIOTT, Philip Clarkson
American, 1903
ELLIOTT, Robinson
British, 1814-1894
ELLIOTT, T.
British, 18th cent.
ELLIOTT, William
(not Robert)
British, op.1774-m.1792
ELLIS, A.
American, op.1820-1830
ELLIS, Edwin
British, 1841-1895
ELLIS, Fremond F.
American, 1897-
ELLIS, Gordon
British, 20th cent.
ELLIS, Harvey
American, 1852-1904
ELLIS, Joseph Francis
British, c.1783-1848
ELLIS, Lionel
British, 1903-
ELLIS, Paul H.
British, 19th cent.
ELLIS, Tristram J.
British, 1844-p.1893
ELLIS, William
British, 1747-1810
ELLISCOMBE, Maj. Gen.
British, 18th cent.
ELLSWORTH, Clarence
American, 1885-1961
ELLSWORTH, James Sanford
American, 1802-1874
ELLYS, John
British, 1700/1-1757
EIMER, Edwin R.
American, 1850-1920
EIMER, Stephen
British, op.1764-m.1796
EIMER, William
British, op.1772-1799
EIMES, William
British, op.1797-1814
EIMINGER, Ignaz
German, 1843-1894
ELMORE, Alfred
British, 1815-1881
EIMSLIE, J.F.
British, 19th cent.
ELOUIS, Henri (Jean
Pierre Henri)
French, 1755-1840
ELSASSER, Friedrich
August
German, 1810-1845

ELSBORCH, Hans or Jan
van der
see Elburcht
EISEN, Alfred
Belgian, 1850-1914
ELSEVIER, Louys
Dutch, 1617/18-1675
ELSHEIMER, Adam
German, 1578-1610
EISHEMIUS, Louis
American, 1864-1941
EISHOLTZ, Ludwig
German, 1805-1850
ELSLAND, Jacob van
Dutch, 18th cent.
EISIEY, Arthur John
British, 1861-
EISNER or ÖLSZNER,
Jakob
German, op.1486-m.1517
EIST, Hieronymous
van der
Dutch, op.1595-1612
EIST, van der or ver
see also Helst and
Verelst
EISTRACK or Elstrake,
Renold
British, 1571-p.1625
EIJTEN, D. van
Dutch, op.1783
ELTON, Samuel Averill
British, 1827-1886
ELTON, Edmund Harry
British, 1846-
EITZE, F.
British, 19th cent.
ELUARD, Paul
French, 20th cent.
ELVEN, Ivan
French, op.1871
ELVERY, Beatrice
British, 19th cent.
ELVERY, James
British, op.1762
ELWELL, Francis Kenneth
British, 20th cent.
ELWELL, Frederick W.
British, 1870-p.1909
ELWELL, R. Farrington
American, 1874-1962
ELWES, Francis E. Cary
British, 19th cent.
ELWES, Simon
British, 1902-1975
ELYAS, Isaac
see Elias
ELYAS or Elye, Matthieu
see Elias
ELZINGRE, Edouard
Swiss, 20th cent.
EMANUEL, Frank Lewis
British, 1865-1948
EMANUEL, K.
Netherlands(?)
17th/18th cent.
EMANUEL, Peter
German, 1799-1873
EMBDE, August von der
German, 1780-1862
EMBRING, Margaretha
Christina
Swedish, 1756-1843
EMEIE, Wilhelm
German, 1830-1905
EMERIC, Honorine
French, 1814-p.1880
EMERSON, P.H.
American, 19th cent.

EMERY, Charles E.
British, 19th cent.
EMERY, W.F.
British, op.1870
EMES, John
British, op.1786-m.1810
EMK(?), J.M. van
Dutch, 18th cent.
EMLER, Bonaventura
German, 1831-1862
EMMANUEL (Emmanuel
Tzane)
Greek, 17th cent.
EMMANUELE da Lampardo
Italian, 16th cent.
EMMENEGGER, Hans
Swiss, 1866-1940
EMMENRAET or Emmelraet,
Michael Angelo
see Immenraet
EMMERSON, Henry H.
British, op.1851-m.1895
EMMET, Lydia Field
American, 1866-
EMMINGER, Eberhard
German, 1808-1885
EMMONS, Alexander H.
American, 1816-1879
EMMONS, Nathaniel
American, 1702-1740
EMMONS, Sylvia
British, 1938-
EMMS, John
British, 1843-1912
EMONT, Adriaen van
see Eemont
EMPERAIRE, Achille
French, 19th cent.
EMSLIE, Alfred Edward
British, 1848-p.1897
ENCKE, Fedor
German, 1851-1926
ENCKELL, Knut Magnus
Finnish, 1870-1925
ENDE, Edgar
German, 1901-1965
ENDE, Hans am
German, 1864-1918
ENDE, Johann or Hans
Heinrich am (not
Amende, Amendo or A.M.
Ende)
German, 1645-1695
ENDEN, Ende or Eynde,
Martinus, I van den
Flemish, op.1630-1654
ENDER, Boris
Russian, 20th cent.
ENDER, Eduard
German, 1822-1883
ENDER, Johann Nepomuk
German, 1793-1854
ENDER, Rosa
German, 1903-
ENDER, Thomas
German, 1793-1875
ENDERLE, Anton
German, 18th cent.
ENDERLE, Johann Baptist
German, 1725-1798
ENDERS, Jean Joseph
French, 1862-c.1930
ENDICOTT
American, op.1846
ENDLINGER, Johann
German, 1733-1789
ENDNER, Gustav Georg
German, 1754-1824

ENDOGOUROFF, Jean
(Jendoguroff)
Russian, 1861-1898
ENDRE
French, 20th cent.
ENDT, Walter Vom
German, 1925-
ENGALIERE, Marius
French, 1824-1857
ENGEBRECHTSZ., Engelbertsz.,
Engelbrechtsen or
Engelbrechtsz.,
Cornelis
Netherlands,
1468(?)-1533
ENGEL, Carl
(Engel von der Rabenau)
German, 1817-1870
ENGEL, Johann Friedrich
German, 1844-1921
ENGEL, Otto Heinrich
German, 1866-1949
ENGELBERT, S.
Dutch, op.1751
ENGELBRECHT, Martin
German, 1684-1756
ENGELBRECHTSZ.,
Engelbertsz., or
Engelbrechtsen,
Cornelis
see Engebrechtsz.
ENGELEN, Peter van
Flemish, 1664-1711
ENGELEN, Piet van
Belgian, 1863-1924
ENGELHART, Catherine
(Catherine Amyot)
Danish, 1845-
ENGELHART, Josef
German, 1864-1941
ENGWIMAN, C.F.
American, op.1814-1831
ENGELMAN, Martin
French, 20th cent.
ENGELMANN, Gottfried
or Godefroy
German, 1788-1839
ENGELS, 1.
Netherlands, 17th cent.
ENGELS, Pieter
Dutch, 1938
ENGELSCHMAN de
see Reysschoot, Petrus
Johannes
ENGELSZ., Cornelis
(Cornelis Engelsz.
Verspronck)
Dutch, 1575-c.1642/53
ENGER, Erling
Norwegian, 20th cent.
ENGERS, Lauzero
French, 20th cent.
ENGERT, Erasmus Ritter
von
German, 1796-1871
ENGERTH, Eduard von
German, 1818-1897
ENGL, Joseph B.
German, 1867-1907
ENGELHEART, Francis
British, 1775-1849
ENGLEHEART, George
British, 1752-1829
ENGLEHEART, Henry
British, 1801-1885
ENGLEHEART, John Cox
Dillman
British, 1783-1862

ENGLEHEART, Timothy
Stansfeld
British, 1803-1879
ENGLERTH, Emil
German, 1882-
ENGLISH, Josias
British, c.1630-1718
ENGONOPOULOS, Nicos
Greek, 1910-
ENGRAMELLE, R.P.
French, 18th cent.
ENGSTRÖM, Albert
Laurentius Johannes
Swedish, 1869-1940
ENGSTROM the Elder,
Leander
Swedish, 1886-1927
ENHUBER, Carl
German, 1811-1867
ENJOLRAS, Delphin
French, 1857-
ENNEKING, John Joseph
American, 1841-1916
ENNESS, Augustus
William
British, 1876-
ENNIS, George Pearse
American, 1884-1936
ENNIS, Jacob
British, 1728-1771
ENRI, Hélène Berlewi
French, 1873-
ENRICO da Monreale
(Erroneously called
Monteregali)
Italian, 15th cent.
ENRICO di Tedice
see Tedice
ENRIQUES, Nicolas
Mexican, op.1738-m.1780
ENS, Johann
see Heintz
ENSEL
French, 20th cent.
ENSINCK, Karel Victor
(Charles Victor)
Dutch, 1846-1914
ENSLEN, Carl Georg
German, 1792-1866
ENSLEN, Johann Carl
German, 1759-1848
ENSOR, James
Belgian, 1860-1949
ENSOR, R.
British, 20th cent.
ENTWISLE, William
British, 1943-
ENTZENSPERGER, Johann
Baptist
see Enzensberger
ENZ or Enzo, Joseph
see Heintz
ENZENSBERGER,
Entzensperger,
Enzenberger or
Enzensperger, Johann
Baptist
German, 1733-1773
ENZINGER, Anton
German, c.1683-1768
ENZINGER, Hans
Austrian, 1889-
ENZO, Johann
see Heintz
EOSANDER, Johann
Friedrich (Freiherr
von Goethe)
Danish, c.1670-1729

EOTTES, Hans, Jan or
Haunce
see Eworth
EPISCOPIUS, Johannes
see Bisschop, Jan de
EPKO
American, 20th cent.
EPP, Rudolf
German, 1834-1910
EPPELE
French, op.1970
EPPLE
German, op.1823-1839
EPPS, E.
British, 1842-
EPPS, Laura Theresa
see Alma-Tadema
EPSTEIN
Polish, 1892-1944
EPSTEIN, Sir Jacob
British, 1880-1959
EPSTEIN, Jehudo
German, 1870-1946
ERA, Giovanni Battista
dell' ('Delara' or
'Dellara')
Italian, 1765-1798
ERASMUS, Desiderius
(Erasmus von Rotterdam)
Netherlands, 1467-1536
ERASMUS, Johann Georg
German, 1659-1710
ERASMUS, Nel
South African, 1928-
ERBE, Julius
German, op.1866-1870
ERBEN, Ulrich
German, 1940-
ERBEN, Tino
Austrian, 20th cent.
ERBSLÖH, Adolf
American, 1881-1947
ERCK, J.M. van
Flemish(?), 17th cent.
ERCOLE di Giulio Cesare
Grandi or Ercole da
Ferrara
see Grandi
ERCOLE de' Roberti
(da Bologna)
see Roberti
ERCOLI, Alcide Carlo
Italian, op.1857-1866
ERDELY, Francis de
American, 1904-1959
ERDMANN, Moritz
(Heinrich Edward Moritz)
German, 1845-1919
ERDMANN, Otto
German, 1834-1905
ERDOS, Paul
Rumanian, 1916-
ERDTUELT, Alois
German, 1851-1911
EREMITA or L'Ermite,
Daniel
Flemish, 1584-1613
ERGO, Engelbert
Flemish, op.c.1629/30-1652
ERHARD von Augsburg
German, 16th cent.
ERHARD, Johann Christoph
German, 1795-1822
ERHARDT, Hans Martin
German, 1935-
ERICH, August
German, op.1620-1644

ERICHSEN, Nelly
British, op.1882-1893
ERICHSEN, Thorvald
Norwegian, 1868-1939
ERICHSEN, Vigilius
Danish, 1722-1782
ERICKSON, Carl O.A.
American, 1893-1958
ERICSON, Johan Erik
Swedish, 1849-1925
ERICSSON, Erling
Swedish, 20th cent.
ERIXSON, Sven
Swedish, 1899-
ERKELENS, Anthonie,
(Possibly identified
with Abraham Erkeles)
Dutch, op.1665(?)
ERLACH
see Fischer von
ERLANGER, Rodolphe
Francois d'
French, 1872-1930/34
ERLER (Erler-Samaden),
Erich
German, 1870-
ERLER, Fritz
German, 1868-1940
ERMELEIN, Georg Paul
see Ermels
ERMELS, Ermel or
Ermelein, Georg Paul
German, c.1666-p.1700
ERMELS, Johann Franz
German, 1621-1693
ERMENEV, Ivan
Russian, 1746-p.1789
ERMILOV, Vassily
Russian, 1894-1968
ERMINI, Pietro
Italian, op.1799-1820
ERMOLAEV, Boris
Nicolaevich
Russian, 20th cent.
ERNEST, E.
British, 19th cent.
ERNEST, John
American, 1922-
ERNESTINE, Princess
von Nassau-Hadamar
German, -1668
ERNI, Hans
Swiss, 1909-
ERNOU, Pierre (Le
Chevalier Ernou)
French, 1665-p.1739
ERNST, Alfred von
Swiss, 1799-1850
ERNST, Alphonsine
Thuot
American, 1873-1952
ERNST, Jimmy
American, 1920-
ERNST, Karl Mathias
German, 1758-1830
ERNST, Max
German, 1891-
ERNST, Rodolphe
German, 1854-
ERNYEI, Sandor
Hungarian, 20th cent.
EROLI, Erulo
Italian, 1854-1916
ERPIKUM, Léon
(Vuilleminot)
French, 19th cent.
ERRANTE, (Pellegrino
Errante) Giuseppe
Italian, 1760-1821

ERRARD, Charles, II
French, c.1606-1689
ERRI, Agnolo degli
Italian, op.1448-1482
ERRI, Bartolommeo degli
Italian, op.1460-1476
ERRO
French, 20th cent.
ERSKINE, Colin
British, 18th cent.
ERSKINE, W.C.C.
British, op.c.1879
ERTE, Romain de Tirtoff
French, 1892-
ERTINGER, Franz
German, 1640-c.1710
ERTINGER
German, 18th cent.
ERTZ, Edward Frederick
American, 1862-
ERWULL, I.
German, 19th cent.
ERZAGEN, E. van
Netherlands, op.1736
ES, Esch or Essen, Jacob
Fopsen or Foppens van
Flemish, op.1617-m.1666
ESBRARD
French, op.1800-1830
ESBRAT, Raymond Noël
French, 1809-1856
ESCALANTE, Juan Antonio
de Frias y
Spanish, 1630-1670
ESCALLIER, Eléonore-
Caroline (Marie Caroline
Eléonore)
French, 1827-1888
ESCH, Anna Barbara
see Abesch
ESCH, Jacob Fopsen or
Foppens van
see Es
ESCH, Joan Petrus von
see Abesch, Johann
Peter
ESCH, Mathilde
German, 1820-p.1880
ESCHARD, Charles
see Echard
ESCHER, Gielijn
Dutch, 20th cent.
ESCHER, Hans
German, 1918-
ESCHER, Maurits Cornelis
Dutch, 1898-
ESCHKE, Hermann (Wilhelm
Benjamin H.)
German, 1823-1900
ESCOBEDO, Jesus
Mexican, 1917-
ESCOUDIER
Italian, 19th cent.
ESCHWEGE, F.A. Elmar or
Eilmar von
German, 1856-
ESCUT, Cornelis
see Schut
ESCUYER, Pierre
Swiss, 1749-1834
ESKILSSON, Peter
Swedish, 1820-1872
ESKRICH, Escricheus,
Cruche, Couche, Cruzy,
Vase or Du Vase,
Pierre
French, 1515/20-p.1590

ESMAU
French, 20th cent.
ESMENARD, Inès d'
French, op.1814-1851
ESPAGNAT, Georges d'
French, 1870-1950
ESPAGNAT, Joseph d'
French, 19th cent.
ESPALARGUCS, José
Spanish, 15th cent.
ESPALARGUCS, Pedro
see Despallargues
ESPALTER y Rull,
Joaquin
Spanish, 1809-1880
ESPARBES, Jean d'
French, 19th cent.
ESPERLIN, Joseph
German, 1707-1775
ESPERSTEDT, August
Wilhelm
German, 1814-p.1839
ESPIN, John
British, 18th cent.
ESPIN, Thomas
British, 18th cent.
ESPINAL, Juan de
Spanish, -1783
ESPINASSE, Raymond
French, 1897-
ESPINOS, Benito
Spanish, 1748-1818
ESPINOSA, Eduardo
Argentine, 20th cent.
ESPINOSA, Jerónimo
Jacinto
Spanish, 1600-1680
ESPINOSA or Espinossa,
Joannes Baptista or
Juan Bautista de
Spanish, op.1616-1626
ESPINOSA, Manuel
Spanish, 20th cent.
ESPINOUZE, Henri
French, 1915-
ESPOSITO, Gaetano
Italian, 1858-1911
ESQUIVEL, Antonio Maria
Spanish, 1806-1857
ESQUIVEL, Vicente
Spanish, 19th cent.
ESSELENS, Jacob
Dutch, 1626-1687
ESSEN or Esse, Cornelis
van
Dutch, op.c.1700-1757
ESSEN, Hans van
Flemish, c.1587/9-p.1648
ESSEN, Jacob Fopsen or
Foppens van
see Es
ESSEN, Johannes Cornelis
(Jan) van
Dutch, 1854-1936
ESSER, Jerome E.
British, 20th cent.
ESSESTEYN, Adrianus
(van)
see Ysselstein
ESSEX, Countess of
see Malden, Sarah
ESSEX, Richard Hamilton
British, 1802-1855
ESSEX, Robert
British, 18th cent.
ESSEX, William
British, 1784-1869

ESTALL, William Charles
British, 1857-1897
ESTERLE, Max
German, 1870-1947
ESTES, Richard
American, 1936-
ESTEVE, Agustin
Spanish, 1753-p.1809
ESTEVE, Maurice
French, 1904-
ESTEVE, Miguel
Spanish, op.1513-1520
ESTEVES or Estevens,
David
Danish, op.1691-1703
ESTIENNE, Henry d'
French, 1872-
ESTORMES, Fernando or
Hernando
see Sturm
ESTRADA, Adolfo
Mexican, 1942-
ESTROUVRE, Jean d'
see Stoevere
ESTURMES, Fernando or
Hernando
see Sturm
ETANG, Henri de l'
French, 1809-p.1844
ETCHELLS, Frederick
British, 1886-1973
ETCHEVERRY, Hubert Denis
French, 1867-p.1903
ETEX, Antoine (Tony)
French, 1808-1888
ETGENS, Jan Jiri or
Johann Georg
Czech, 1693-1757
ETHOFER, Theodor Josef
German, 1849-p.1912
ETIENNE, Francois-Paul
French, 1874-
ETIOLES, Jean Antoinette
d'
see Pompadour
ETITO
Italian, 19th cent.
ETLINGER, Joseph Georg
von
see Edlinger
ETTY, William
British, 1787-1849
ETZDORF, Christian
(Johann Christian
Michael)
see Ezdorf
EUDES de Guimard, Louise
French, 1827-1904
EUERTS, Hans, Jan or
Haunce
see Eworth
EUGEN, Napoleon Nikolaus
Prinz von
Swedish, 1865-1947
EUGERTHE, Eduard von
German, 19th cent.
EURARD, Perpète or
Jacques
see Evrard
EURICH, Richard Ernest
British, 1903-
EUSEBI, Luis
Spanish, op.1813-1830
EUSEBIO da San Giorgio
(Eusepius Jacobi
Cristofori; Eusepio
Perugino)
Italian, 1465/70-p.1539(?)

EUSEBIUS, Johannes Alphen
German, 1741-1772
EUSTACE, A.W.
Australian, 19th cent.
EUSTACE, Samuel B.
British, op.1819
EVALINA
American, 20th cent.
EVANCE, Hans, Jan or
Haunce
see Eworth
EVANGELISTA di Pian di
Meleto
Italian, c.1458-1549
EVANGELISTI, Filippo
Italian, c.1684-1761
EVANS, Bernard Walter
British, 1848-1922
EVANS, Frederick H.
British, 19th cent.
EVANS, Frederick James
McNamara
British, op.1888-1911
EVANS, Garth
British, 20th cent.
EVANS, George
British, 1763-1819
EVANS, J.
American, 19th cent.
EVANS, L.
British, 19th cent.
EVANS, Lesley
British, 1945-
EVANS, Merlyn Oliver
British, 1910-1973
EVANS, Powys Arthur
British, 1899-
EVANS, Richard
British, 1784-1871
EVANS, Samuel
British, op.1798-m.1835
EVANS, Sidney
British, 20th cent.
EVANS, William
British, op.1797-1856
EVANS, William
(Evans of Bristol)
British, 1809-1858
EVANS, William
(Evans of Eton)
British, 1798-1877
EVE, Jean
French, 1900-
EVELEIGH, Laurence
British, 1921-
EVELYN, John
British, 1620-1706
EVELYN, Susanna
British, c.1634-1708/9
EVENEPOEL, Henri Jacques
Edouard
Belgian, 1872-1899
EVERAERDT, Everard,
Everards or Everardt,
Perpète or Jacques
see Evrard
EVERBAG, Franciscus (Frans)
Dutch, 1877-1947
EVERBROECK, Frans van
Flemish, op.1654-1672
EVERDINGEN, Adrianus van
Dutch, 1832-1912
EVERDINGEN, Allart or
Aldert Pietersz. van
Dutch, 1621-1675
EVERDINGEN, Cesar Pietersz.
Cesar or Boetius van
Dutch, c.1616/17(?)-1678

EVERDINGEN, Tetar van
Dutch, 19th cent.
EVERETT, Bruce
American, 1942-
EVERETT, John
British, 20th cent.
EVERGOOD, Philip
Howard
American, 1901-
EVERITT, Allen Edward
British, 1824-1882
EVERS, Anton Clemens
German, 1802-1848
EVERSDYCK, Cornelis
Willemsz.
Dutch, op.1613-1635
EVERSDYCK or Eversdijck,
Willem
Dutch, op.1633-m.1671
EVERSEN, Adrianus
Dutch, 1818-1897
EVERSEN, Jan H.
Dutch, 20th cent.
EVES, Reginald Grenville
British, 1876-1941
EVETT, Kenneth
American, 20th cent.
EVRARD, Adèle
Belgian, 1792-1889
EVRARD, Jacques
see Evrard, Perpète
EVRARD, Jean Marie
French, 1776-1860
EVRARD, Eurard, Everaerdt,
Everard, Everards or
Everardt, Perpète or
Jacques
Flemish, 1662-1727
EWALD, Ernst Deodat
Paul Ferdinand
German, 1836-1904
EWALD, Reinhold
German, 1890-
EWART, David
British, op.1919-1955
EWBANK, John Wilson
British, c.1779-1847
EWING, George Edwin
British, 1828-1884
EWORTH, Eewouts, Eottes,
Euerts, Ewottes, Ewoutsz,
Evance or Huett, Hans
Jan or Haunce
British, op.1540-1574
EXILIOUS, John F.
American, op.1810-1814
EXNER, Johan Julius
Danish, 1825-1910
EXSHAW, Charles
British, op.1747-m.1771
EXTER, Alexandra
Russian, 20th cent.
EXTER, Julius
German, 1863-1930
EYBE, Carl Gottfried
German, 1813-1893
EYBL or Eibl, Franz
German, 1806-1880
EYCK, Hubrecht or
Hubert van
Netherlands,
c.1366/70-1426
EYCK, Jan, Jean or
Johannes van
Netherlands,
op.1422-m.1441

EYCK, Jan Carel van
Flemish, 1649-p.1685
EYCK, Johannes Lodevicus
Nicolaas (Jan) van
Dutch, 1927-
EYCK, Kasper van
Flemish, 1613-1673
EYCK, Nicolaas, I van
Flemish, 1617-1679
EYCKE or Ecke, John
Netherlands(?), op.1618
EYCKEN, Charles van den
Belgian, 1859-
EYCKEN, Felix van den
Dutch, 19th cent.
EYCKEN, Jan Baptist van
Belgian, 1809-1853
EYCKENS
see Ykens
EYCKHOUT or Eyckholt,
Albert van der
see Eechhout
EYDEN or Eyde, Jeremias
van der
Flemish, op.1658-m.1697
EYES, Charles
British, c.1754-1803
EYK or Yk, Abraham van
der or Abraham Vereyk
Dutch, op.1709-1725
EYKELENBERG, Symon
see Eikelenberg
EYKES, John
British, 16th cent.
EYLES, John
British, 20th cent.
EYMAR, Louis-Charles
French, 1882-1944
EYMER, Arnoldus
Johannes
Dutch, 1803-1863
EYNDE, Martinus van den
see Enden
EYNDEN, Frans van
Dutch, 1694-1742
EYNDEN, Jacobus, II van
Dutch, 1733-1824
EYRE, Edward
British, op.1771-1786
EYRE, Ivan
Canadian, 20th cent.
EYRE, John
Australian, op.1806
EYRIES, J.B.B.
Swiss, op.c.1800
EYSDEN, Robert van
Dutch, 1810-1890
EYSEN, Eisen or Eyssen,
Johann Jacob
German, op.1665-1677
EYSEN, Louis
British, 1843-1899
EYSSENHARDT, Friedrich
Albert
German, 1801-1832
EYTON, Anthony
Canadian, 20th cent.
EZDORF (not Etzdorf),
CHRISTIAN (Johann
Christian Michael)
German, 1801-1851
EZEKIEL, Gottfried
German, 1744-1767
EZPELETA, P.
Spanish, op.1596

F

FAABORG, Finn
Norwegian, 20th cent.
FABBRI, Agenore
Italian, 1911-
FABBRICA, Francesco
Italian, op.c.1680
FABBRINI, Angiolo
Italian, op.1853
FABBRINI or Fabrini,
Giuseppe Antonio
Italian, 1740-p.1792
FABBRIS, G.
Italian, op.1733
FABBRONI, Cristoforo
Italian, 18th cent.
FABER, Conrad (Conrad
von Creuznach, Master
of the Holzhausen Family)
German, c.1500-1552/3
FABER, F.
German(?), op.1797
FABER, Frédéric Théodore
Belgian, 1782-1844
FABER, J.
German, op.1763
FABER, Jacob
Swiss, op.1516-1558
FABER, John or Johan, I
Dutch, c.1650/60-1721
FABER, John, II
British, 1684-1756
FABER, Johann Friedrich
German, 17th/18th cent.
FABER, Johann Joachim
German, 1778-1846
FABER, Martinus Hermanus
German, 1587-1648
FABER, R.
British, 18th cent.
FABER, Traugott (Carl
Gottfried Traugott)
German, 1786-1863
FABER, William
German, 1901-
FABER du Faur, Christian
Wilhelm
German, 1780-1857
FABER du Faur, Otto von
German, 1828-1901
FABERT, Jacques
American, 20th cent.
FABIAN, Adrian G.
see Sandels
FABIAN, Gottfried
German(?), op.1959
FABIANO da Urbino, Frate
Italian, op.1533
FABIGAN, Hans
Austrian, 1901-
FABRE, François Xavier
French, 1766-1837
FABRE, Henri
French, 19th/20th cent.
FABRE, J.H.
British(?), op.1797
FABRE, Louis André
French, 1750-1814
FABRE, Louis Eugène
French, 20th cent.
FABRES y Costa, Antonio
Maria
Spanish, 1854-
FABRI, A.
Italian, op.1593

FABRICATORE, Nicola
Italian(?), op.1928
FABRICIUS
see Fabritius
FABRIS, Giacomo
Italian, 1689-1761
FABRIS, Gino
Italian, op.1768
FABRIS, Pietro
Italian, op.1768-1778
FABRIS, Placido
Italian, 1802-1859
FABRITIUS or Fabricius
Barent or Bernard
Pietersz.
Dutch, 1624-1673
FABRITIUS or Fabricius,
Carel or Carolus
Pietersz.
Dutch, 1622-1654
FABRITIUS, Carl
Ferdinand
German, 1637-1673
FABRITIUS, Chilian
German, op.1612-m.1633
FABRITIUS or Fabricius,
Johannes Pietersz.
Dutch, 1636-p.1693
FABRIZI, F. or S.
Italian, op.1881
FABRY, Emile
Barthélémy
Belgian, 1865-1966
FACHERIS, Agostino
(da Caversegno)
Italian, 1500-p.1552
FACCHETTI or Fachetto,
Pietro
Italian, 1535-1619
FACCINI or Facini,
Pietro
Italian, 1562-1602
FACIN, Nicolas Henri
Joseph, Chevalier de
see Fassin
FACCIOLI, Raffaello
Italian, 1846-
FACKERE, Jef van de
Belgian, 1879-1946
FACZYNSKI, Jerzy
Polish, 20th cent.
FADEN, W.
American, op.1776
FADINO, Il
see Alenis, Tommaso de
FAED, James
British, 1857-1920
FAED, John
British, 1820-1902
FAED, Thomas
British, 1826-1900
FAEN, Guillaem de
see Fal
FAENZONI, Ferrau
see Fenzoni
FAES, Peter
van der
see Lely
FAES, Peter
Flemish, 1750-1814
FAESCH, Johann Ludwig
Wernhard
Swiss, 1738-1778
FAESI-GESSNER, Johann
Konrad
Swiss, 1796-1870

FAGAN, Betty Maud
Christian
British, -1932
FAGAN, Robert
British, c.1745-1816
FAGE, Raymond de la
see Lafage
FAGERLIN, Ferdinand
Julius
Swedish, 1825-1907
FAGERKVIST, Thor
Swedish, 1884-1960
FAGES, Arthur R.
French, 1902-
FAGET, Athalie Joséphine
Mélanie du
French, 1811-p.1844
FAGNANI, Giuseppe
Italian, 1819-1873
FAGUELIN, Jean
French, 16th cent.
FAGUNDES, Ary
Brazilian, 20th cent.
FAHEY, Edward Henry
British, 1844-1907
FAHEY, James
English, 1804-1885
FAHLCRANTZ, Carl Johan
Swedish, 1774-1861
FAHLSTRÖM, Öyvind
Scandinavian, 1928-
FAHRBACH, Carl Ludwig
German, 1835-1902
FAHRENKROG, Ludwig
German, 1867-1952
FAHRINGER, Carl
German, 1874-
FAHRLÄNDER, Franz
German, 1793-p.1850
FAICHTMAIR, Franz Xaver
see Feichtmayr
FAILLE, Monique della
French, op.1914
FAINE, Duran
Spanish, 20th cent.
FAIRBAIRN
British, 18th cent.
FAIRBURN
British, 19th cent.
FAIRCHILD, Louis
American, 1800-p.1840
FAIRCHILD, Mary
see Low
FAIRCLOUGH, Wilfred
British, 1907-
FAIRFAX-LUCY, Edmund
British, 20th cent.
FAIRFAX-MUCKLEY, Louis
British, 19th cent.
FAIRFIELD, A.N.
British, 19th cent.
FAIRFIELD, Charles
British, 1759/61-1804
FAIRHOLT, Frederick
William
British, 1814-1866
FAIRLAND, Thomas
British, c.1804-1852
FAIRLESS, Thomas Kerr
British, c.1825-1853
FAIRWEATHER, Ian
Australian, 20th cent.
FAISTAUER, Anton
German, 1887-1930
FAISTENBERGER (not
Feistenberger), Andreas,
II
German, 1647-1736

FAISTENBERGER, Anton, I
German, 1663-1708
FAISTENBERGER, Anton, II
German, 1678-1722
FAISTENBERGER, Ignaz
German, 1662-1728
FAISTENBERGER, Joseph
German, 1675-1724
FAISTENBERGER,
Faistenperger or
Feistenberger, Simon
Benedikt
German, 1695-1759
FAITHFULL, Leila
British, 20th cent.
FAITHORNE the Elder,
William
British, 1616-1691
FAIVRE, A.
French, 19th cent.
FAIVRE, Abel (Jules
Abel)
French, 1867-
FAIVRE, Antoine Jean
Etienne (Tony)
French, 1830-1905
FAIVRE-DUFFER, Louis
Stanislas
French, 1818-1897
FAIZAN-COUNIS, Alexandre
Swiss, 1791-1871
FAL or Faen,
Guillaem de
Dutch, op.1660-1663
FALAT, Julian
Polish, 1853-
FALBE, Joachim Martin
German, 1709-1782
FALCH or Falck, Johann
German, 1687-1727
FALCHETTI, Alberto
Italian, 1878-
FALCIATORE, Filippo
Italian, 18th cent.
FALCINI, Carlo
Italian, op.1860
FALCK or Falk, Jeremias
German, c.1609/10-1677
FALCKENBURG
see Valckenborch
FALCO, Nicolas, II
Spanish, op.1560-1576
FALCONE, Aniello
(Oracolo delle Battaglie)
Italian, 1600-1656
FALCONET, Pierre Etienne
French, 1741-1791
FALCONETTI, Angelo
Italian, 16th cent.
FALCONETTO, Giovanni Maria
Italian, c.1486-a.1540
FALCONI, Bernardo Nello
di Giovanni
see Bernardo
FALCONI, Silvio
Italian, op.c.1514
FALDA, Giovanni Battista
Italian, op.1655-m.1678
FALDI, Arturo
Italian, 1856-1911
FALDONI, Giovanni Antonio
Italian, 1690-1770
FALEN, Johannes
Netherlands, op.1672
FALENS or Valens, Carel
van
Flemish, 1683-1733
FALENS, J. van
Netherlands, 17th/18th cent.

FALERO, Luis Riccardo
Spanish, 1851-1896
FALGUIERE, Jean Alexandre
Joseph
French, 1831-1900
FALK, Hans
Swiss, 1918-
FALK, Robert
Rafailowitsh
Russian, 1886-p.1931
FALKEISEN, Sebastian
Swiss, 1719-1788
FALKENBERG, Richard
German, 1875-
FALKENSTEIN, Claire
American, 1908-
FALLARO, Foller or
Follador(?), Jacopo
Italian, 16th cent.
FALLENDER of Fallenter,
Franz
Swiss, op.1577-m.1612
FALLER, Felix
German, 1835-1887
FALOT or Fallot, J.
French, op.1764-1825
FALZAGALLONI da Ferrara,
Stefano (Stefano da
Ferrara)
Italian, -1500
FALZONI, Giordino
Italian, 20th cent.
FAMMIERI, Giambattista
see Fiammeri
FANCELLI, G.
Italian, 16th cent.
FANCELLI, Pietro
Italian, 1764-1850
FANCHER, Louis
American, 1884-
FANE, E.
British, 18th cent.
FANFANI, Enrico
Italian, op.1847-1861
FANGEL, H.G.
British(?), 19th cent.
FANGOR, Wojciech
Polish, 1922-
FANHAUZER, Franciszek
see Pfanhauser
FANNEN, J.
British, 20th cent.
FANNER, Alice Maud
(Alice Maud Taite)
British, 1844-1907
FANONE, Il
see Civerchio, Vincenzo
FANTASTICO, Il
see Avanzarini,
Francesco
FANTIN-LATOUR, Ignace
Henri Jean Théodore
French, 1836-1904
FANTIN-LATOUR, Victoria,
(née Dubourg)
French, 1840-1926
FANTO, Leonhard
German, 1874-
FANTONI da Norcia,
Francesco
Italian, op.1530
FANTUZZI, Antonio
Italian, c.1510-p.1550
FANTUZZI di Bologna,
Rodolfo
Italian, 1779-1832
FANTUZZI, Eliano
Italian, 1909-

FANZONI, Ferrau
see Fenzoni
FARASYN, Edgard
Belgian, 1858-1938
FARDELLA, Giacomo
see Farelli
FARELLI, Fardella
or Farella, Giacomo
Italian, 1624-1706
FARELLI, Farella or
Fardella, Giacomo
Italian, 1624-1706
FAREY, Cyril
British, op.1922
FARGE, Henri
French, 1884-
FARGE, John la
see La Farge
FARGE, P.
French, 20th cent.
FARINA, Achille
Italian, 1804-1879
FARINA, Ernesto
Italian, 20th cent.
FARINA, Pietro
Francesco
Italian, op.1695
FARINATI, Battista
see Zelotti,
Giambattista
FARINATO, Orazio
Italian, 1559-p.1616
FARINATO, Paolo
Italian, 1524-p.1606
FARINGDON, R.
see Ffaringdon
FARINGTON, George
British, 1752-1788
FARINGTON, Joseph
British, 1747-1821
FARKAS, István
Hungarian, 1887-1947
FARLEIGH, John
British, 1900-
FARMER, Alexander, Mrs.
British, op.1855-1867
FARMER, Emily
British, c.1826-1905
FARNBOROUGH, Lady
see Long, Amelia
FARNELLI, G.
Italian, 19th cent.
FARNERIUS, Abraham
see Furnerius
FARNY, Henry F.
American, 1847-1916
FAROCHON, Jean Baptiste
Eugène
French, 1812-1871
FARRAN, Thomas
British, 19th cent.
FARQUHARSON, David
British, 1839-1907
FARQUHARSON, Joseph
British, 1846-1935
FARRELL, Micheal
British, 1940-
FARRER, Henry
British, op.1826
FARRER, Nicholas
British, 1750-1805
FARRER, Thomas C.
British, 1839-1891
FARRERAS, Francisco
Spanish, 1927-
FARRET, Coenraad or
Coenraet
Dutch, op.1712-1727
FARRIER, Robert
British, 1796-1879

FARUFFINI, Federico
Italian, 1831-1869
FASANO, Michelangelo
Italian, 1750-1775
FASCE, Gianfranco
Italian, 1927-
FASOLO or Fazolo,
Bernardino
Italian, 1489-p.1526
FASOLO or Fasuolo,
Giovanni Antonio
Italian, c.1530-1572
FASOLO or Fazolo,
Lorenzo (Lorenzo da
Pavia)
Italian, op.1494-m.1516/8
FASSBENDER, Joseph
German, 1903-
FASSETT, Cornelia A.
American, 1831-1898
FASSIANOS, Alecos
Spanish, 20th cent.
FASSIN, Nicolas Henri
Joseph de
(Chevalier de Fassin)
Flemish, 1728-1811
FATH, René Maurice
French, 1850-1922
FATOUROS, Dimitri
Greek, 1928-
FATTORI, Giovanni
Italian, 1825-1908
FAU, Fernand
French, 19th cent.
FAUCHIER, Laurent
French, 1643-1672
FAUGIGNY
French, op.1797
FAUCK, François
French, 19th cent.
FAUDRAN, Jean Baptiste
de
French, 1620-1694
FAUERHOLDT, Viggo
Danish, 1832-1883
FAUGERON, Adolphe
German, 1866-
FAULKNER, Benjamin
Rawlinson
British, 1787-1849
FAULKNER, C.
British, op.1874
FAULKNER, John
British, op.1852-1887
FAULKNER, Joshua Wilson
British, 1780-p.1820
FAULKNER, Patricia
British, 1946-
FAULTE, Michel
French, op.1619-1638
FAUQUIER, W.
British, 18th cent.
FAURE, Amédée
(Victor Amédée)
French, 1801-1878
FAURE, Elisa
French, 19th cent.
FAURE, Eugène
French, 1822-1879
FAURE, Jean
French, op.c.1820-1840
FAURE, L.
French, op.1770
FAURE, Léon
French, 1819-1887
FAURE-BEAULIEU, Emile
French, op.1864

FAUST, Carl
German, 1874-1935
FAUST, Heinrich
German, 1843-1891
FAUSTINI, Modesto
Italian, 1839-1891
FAUSTNER, Luitpold
German, 1845-1925
FAUSTO, Pirandello
Italian, 20th cent.
FAUTEUX-MASSE,
Henriette
Canadian, 20th cent.
FAUTRIER, Jean
French, 1898-
FAUVEL
French, op.1789
FAUVELET, Jean Baptiste
French, 1819-1883
FAUX-FROIDURE, Eugénie
Juliette
French, 1886-
FAVA
see Macrino d'Alba
FAVANNE, Henri Antoine
de
French, 1668-1752
FAVANNE, Jacques de
French, 1716-1770
FAVART, Maurice
Geneviève (née
Bellot)
French, op.1780-1808
FAVEN, Yrjo Antti
Scandinavian, 1882-1948
FAVERKVIST, Thor
Swedish, 1884-1960
FAVEROT, Joseph
French, 1862-
FAVORSKY, Vladimir
Andreyevich
Russian, 1886-
FAVORY, André
French, 1889-1937
FAVRAY (not Fauray),
Antoine de
French, 1706-1791/2
FAVRE, Pierrette
(Bédié)
French, 1827-p.1864
FAVRETTO, Giacomo
Italian, 1849-1887
FAVRIN, Louis
French, op.1789-1813
FAWKES, L.G.
British, op.1895
FAWORSKI
Polish, 18th cent.
FAXON, Richard
French, op.c.1865-1870
FAY, Augustus
American, op.1854-
FAY, Joseph
German, 1813-1875
FAYERMAN, Anne Charlotte
see Bartholomew
FAYET, Gustave
French, 1865-1925
FAYRAM, John
British, op.1727-1743
FAYRER, Fanny Jane
see Maltese
FAZEKAS, Magdolna
Hungarian, 1933-
FAZOLO
see Fasolo

FAZZINI, Pericle
Italian, 1913-
FEARNLEY, Thomas
Norwegian, 1802-1842
FEARNSIDE, W.
British, op.1791-1801
FEARON, Hilda
British, 20th cent.
FEARY, John
British, 1745/50-1788
FEBURE or Febvre,
Claude
see Lefebvre
FEBVRE, Edouard
French, 20th cent.
FECHHELM, Carl Traugott
German, 1748(?)-1819
FECHNER, Eduard Clemens
German, 1799-1861
FECHNER, Hans
German, 1860-1931
FECHTER IV, Johann
Ulrich
Swiss, 1742-1796
FECKERT, Gustav Heinrich
Gottlob
German, 1820-1899
FEDDEN, A. Romilly
British, 1875-
FEDDEN, Mary
British, 1915-
FEDDER, Otto
German, 1873-1919
FEDDERSEN the Younger,
Hans Peter
German, 1848-1941
FEDDES, Petrus or Pieter
(Pieter van Harlingen)
Dutch, 1586-1634(?)
FEDELE di San Biagio,
Padre
Italian, 18th cent.
FEDER, Adolphe
French, 1886-
FEDERICHO di Lamberto
Sustris; Federigo di
Lamberto Fiammingo, di
Lamberto d'Amsterdam
Fiammingo or del Padovano
see Sustris, Friedrich
FEDERLIN, Hans Balthasar
Swiss, op.1571
FEDI, Pio
Italian, 1816-1892
FEDIER, Franz
Swiss, 1920-
FEDINI, Giovanni
Italian, op.1565-1582
FEDOROVSKY, Feodor
Russian, 1883-1955
FEDOROWITSCH, Sophia
Russian, -1953
FEDOTOFF, Pauwel
Andreievitch
Russian, 1815-1852
FEELEY, Paul
American, 1910-
FEER, Anna van der
(Anneke)
Dutch, 1902-
FEETAG, R.
German, 19th cent.
FEGUIDE
French, 20th cent.
FEHLING, Heinrich
Christoph (not Christian)
German, 1654-1725

FEHR
British, op.1793
FEHR, Carl Friedrich
Bartholomaeus
Swiss, op.1834-1841
FEHR, Konrad
German, 1854-1933
FEHR, Peter
German, 1681-1740
FEHRMANN, Jakob
German, 1760-1837
FEI, Alessandro
(di Vincenzio) del
Barbiere
Italian, 1543-1592
FEI, Paolo di Giovanni
(Frederici)
Italian, op.1372-1410
FEIBUSCH, Hans
British, 1898-
FEICHTMAYR, Faichtmair,
Feichtmayer, Feichtmeier,
Feuchtmair or Feuchtmayer,
Franz Xaver, I
German, 1705-1764
FEICHTMAYR, Johan Michael, I
German, c.1666-1713
FEICHTMAYR, Joseph Anton
German, 1696-1770
FEID, Joseph
German, 1806-1870
FEIGEL, Carl
German, 19th cent.
FEILER, Paul
British, 1918-
FEILLER, R.
German, 18th cent.
FEILLET, Hélène
French, op.c.1836-1848
FEININGER, Lyonel
American, 1871-1956
FEINT, Adrian
British, 1894-
FEISTENBERGER
see Faistenberger
FEITAMA, Sybrand
Dutch, 1694-1758
FEITO, Luis
Spanish, 1929-
FEKE, Robert
American, 1724-1769
FELAERT, Dirk
see Vellert
FELDBAUER, Max
German, 1869-1948
FELDHÜTTER, Ferdinand
German, 1842-1898
FELDMANN, Louis
German, 1856-1938
FELDMANN, Wilhelm
German, 1859-1932
FELGENTREFF, Paul
German, 1854-1933
FELICE de'Fiore
see Biggi, Felice
Fortunato
FELICIANO d'Almeida
see Almeida
Portuguese, op.1684
FELICIANO da Foligno
(Mutis)
Italian, a.1490-p.1518
FELICIANUS
see Almeida, F.d'
FELICIATI, Lorenzo
Italian, 1732-1799
FELIX, Eugen
German, 1837-1906

FELIX, Léon Pierre
French, 1869-1940
FELIX, Nicholas
British, 1804-1876
FELIXMULLER, Conrad
German, 1897-
FELL, J.C.
British, op.1844
FELL, Herbert Granville
British, 1872-1951
FELL, Sheila
British, 1931-
FELLER, Frank
Swiss, 1848-1908
FELLNER or Felner,
Coloman (Pater
Colomanus or Kolomanus)
German, 1750-1818
FELLNER, Ferdinand
August Michael
German, 1799-1859
FELLOWES, James
British, op.1710-1745
FELLOWES, W.M.
British, op.1827
FELLOWS, William Dorset
British, op.1807-1878
FELNER, Coloman
see Fellner
FELON, Joseph
French, 1818-1896
FELPACHER or Felpacker,
J.
Dutch, op.1639
FELS, Jan Jacob
Dutch, 1816-1883
FELSEN, Dirk van
Netherlands, op.1650
FELTRINI, Andrea
see Andrea di Cosimo
FELU, Charles Francois
Belgian, 1830-1900
FELVIDEKI, Andras
Hungarian, 20th cent.
FEMMINCK, H.C.
German, op.1842
FENBAUM(?), Ivan
Russian, 20th cent.
FENDI, Peter
German, 1796-1842
FENDRICK, Charles
American, c.1841-
FENDT, Tobias
German, op.1566-m.1576
FENESI, Paolo
Italian, 18th cent.
FENITZER, Georg
see Fennitzer
FENN, Harry
British, 1845-1911
FENNELL, John Greville
British, 1807-1885
FENNEMA, G.D.
Dutch, op.1650
FENNITZER, Fenitzer or
Venitzer, Georg
German, op.1697-1700
FENOUIL (H), Jean César
French, op.1738-1746
FENOUIL (H), P. (Paul?)
French, op.1738-1746
FENOULET, W.
British, op.1836-1839
FENTON, John
British, 18th cent.
FENTON, Michael
American, 20th cent.
FENWICK, C.G.
British, 19th cent.

FENWICK, Thomas
British, -1850
FENYES, Adolf
Hungarian, 1867-1945
FENZONI, Faenzoni or
Fanzoni, Ferraù
(Ferraù da Faenza)
Italian, 1562-1645
FERAT, Serge
Russian, 1881-1958
FERDENANDES, J.
Dutch, 17th cent.
FERDINAND, Louis
see Elle
FERDINAND PHILIPPE,
Duke of Orleans
French, 1810-1842
FERENCZY, Beni
Hungarian, 1890-
FERENCZY, Br. Hatvany
Hungarian, 20th cent.
FERENCZY, Károly
Hungarian, 1862-1917
FERET, Jean-Baptiste
French, 1664/5-1739
FERG, Franz de Paula
(Franz Josef or Paul)
German, 1689-1740
FERGOLA, Salvatore
Italian, 1799-p.1877
FERGUSON, James
British, 1710-1776
FERGUSON, James
British, op.1817-1858
FERGUSON, John Knox
British, op.1886
FERGUSON, Roy Young
British, 1907-
FERGUSON, William Gowe
British, 1632/3-p.1695
FERGUSON, William J.
British, op.1849-1886
FERGUSSON, John Duncan
British, 1874-1961
FERIGHETTO
see Bencovich, Federico
FERMO di Stefano or
da Carravaggio
see Ghisoni
FERNAND-TROCHAIN, Jean
French, 1879-
FERNANDES, Garcia
Portuguese, op.1514-1551
FERNANDES, Vasco
Portuguese, -1541/3
FERNANDEZ, Alexo or
Alejo
Spanish, c.1470-p.1543
FERNANDEZ, Amalio
Spanish, 19th/20th cent.
FERNANDEZ, Domingo
Spanish, 1862-
FERNANDEZ, Luis
Spanish, op.1543-1579
FERNANDEZ, Luis
Spanish, 1596-1654
FERNANDEZ, Luis
Spanish, 1900-
FERNANDEZ da Guadalupe,
Pedro
Spanish, op.1506-1539
FERNANDEZ de Navarrete,
Juan (El Mudo)
Spanish, 1526-1579
FERNANDI or Ferrando,
Francesco
see Imperiali

FERNELEY, Claude
British, op.1851-1868
FERNELEY, John E.
British, 1782-1860
FERNELEY the Younger,
John
British, 1815-1862
FERNELEY, Margaret
British, op.1851
FERNELEY, Sarah
British, op.1836
FERNHOUT, Edgar Richard
Johannes
Dutch, 1912-
FERNOW, Carl Ludwig
German, 1763-1808
FEROGIO, Fortuné
(Francois Fortuné
Antoine)
French, 1805-1888
FERON, Eloi Firmin
French, 1802-1876
FERON, Paul
French, 20th cent.
FERONI, Paolo
Italian, 1807-1864
FERRABOSCO
see Forabosco
FERRAJUOLI, Nunzio
Italian, 1660/1-1735
FERRAMOLA, Floriano or
Fioravante
Italian, 1480-1528
FERRAND, Jacques Philippe
French, 1653-1732
FERRANDO de la Almedina
see Yañez
FERRANDO, Spagnuola
see Llanos
FERRANDO, Francesco
see Fernandi
FERRANT y Llamas
(y Llausas)
Spanish, 1806-1868
FERRANTE, Francesco
Italian, op.1672
FERRARESE SCHOOL,
Anonymous Painters
of the
FERRARESINO, Il
see Berlinghieri,
Camillo
FERRARESINO, Il
see Bonatti, Giovanni
FERRARI, Bernardo
Italian, op.1626-1649
FERRARI, Cesare
(Cesare Augusto
Ferrarese)
Italian, 17th cent.
FERRARI or de Ferrari,
Defendente
Italian, c.1490-p.1535
FERRARI, Domenico
Italian, 16th cent.
FERRARI, Eusebio
Italian, a.1470-a.1533
FERRARI, Federigo
Italian, op.1768-1781
FERRARI, Francesco de'
Bianchi
see Bianchi Ferrari
FERRARI, Francesco
Italian, 1634-1708
FERRARI, Gaudenzio
(Gaudenzio de Vincio)
Italian, 1470/80-1546
FERRARI, Giacomo (Giuseppe
Giacomo)
Italian, 1747-1807

FERRARI, Giovanni
Italian, op.1585
FERRARI or Deferrari,
Giovanni Andrea
Italian, 1598-1669
FERRARI, Girolamo
Italian, 16th cent.
FERRARI, Giuseppe
Italian, 1921-
FERRARI, Gregorio de'
Italian, 1644-1726
FERRARI, Lorenzo de'
(L'Abate de' Ferrari)
Italian, 1680-1744
FERRARI, Luca
(Luca da Reggio)
Italian, 1605-1654
FERRARI, Orazio de'
Italian, 1605-1657
FERRARI, Pietro
Melchiorre
Italian, 1735-1787
FERRARI, Vincenzo
Italian, op.1790-1793
FERRARINI, Pier Giuseppe
Italian, 1846-p.1882
FERRARIO, Carlo
Italian, 1833-1907
FERRARIS, Arthur von
Hungarian, 1856-
FERRATTINI, Gaetano
Italian, 1697-1765
FERRAÙ da Faenza
see Fenzoni
FERRAZANA, Pietro
Italian, 19th cent.
FERRAZZI, Ferruccio
Italian, 1891-
FERRAZZI, Luigi
Italian, op.1887
FERRE, Georges
French, op.1886
FERREN, John
American, 1905-
FERRER Bassa
(Ferrarius Bassa or de
Baço)
Spanish, c.1290-1348
FERRER, Jaime, I and II
Spanish, op.1457
FERRER y Miro, Juan
Spanish, 1850-
FERRER, Vincentius
Spanish, op.1372
FERRERI, Vincenzo
Italian, op.1780-1793
FERRERIS or Freres,
Dirck or Theodorus
Dutch, 1639-1693
FERRERIS, Heindrick
Dutch, op.1617-1625
FERRERS, Benjamin
British, op.1697-m.1732
FERRERS, Rebecca
Dulcibella
British, 19th cent.
FERRETTI da Imola,
Giovanni Domenico
Italian, 1692-a.1769
FERRETTI, Paolo
Italian, 1866-
FERREY, Benjamin
British, 1810-1880
FERRI, Antonio Maria
Italian, 1651-1716
FERRI, Augusto
Italian, 1829-

FERRI, Ciro
Italian, 1634-1689
FERRI, Domenico
Italian, 1808-1865
FERRI di Bologna,
Domenico
Italian, 1829-1896
FERRI, Gesualdo
Francesco
Italian, 1728-c.1788
FERRIER, Gabriel Joseph
Marie Augustin
French, 1847-1914
FERRIERE, François
Swiss, 1752-1839
FERRIERES, Martin
French, op.1700
FERRIERES, Martin
French, 20th cent.
FERRIS, Stephen James
American, 1835-p.1881
FERRO, Gregorio
Spanish, 1742-1812
FERRON, Marcelle
Canadian, 1924-
FERRONI, Egisto
Italian, 1835-1912
FERRONI, Gianfranco
Italian, 1927-
FERRONI, Violante
Italian, 1720-
FERRUCCI or Ferruzzi,
Andrea di Piero
(Andrea da Fiesole)
Italian, 1465-1526
FERRUCCI da Fiesole,
Francesco di Simone
Italian, 1437-1493
FERRUCCI, Nicodemo
(Niccolo) di
Michelangelo
Italian, 1574-1650
FERRY, Jules-Jean
French, 1844-
FERSTEL, E.
German, 19th cent.
FERSTEL, Heinrich
Freiherr von
German, 1828-1883
FERSTLER, Heinrich
German, 1800-
FERTBAUER, Leopold
German, 1802-1875
FERVILLE, L.
French, op.1825
FESEL, Christoph
German, 1737-1805
FESELEN or Feselein,
Melchior
German, op.1521-m.1538
FESSARD, Etienne
French, 1714-1777
FESTA, Matilde
Piacentini (or Bianca)
Italian, op.1830
FETI, Camillo
Italian, 17th cent.
FETI or Fetti, Domenico
Italian, c.1589-1624
FETTI, Mariano
Italian, 17th cent.
FEUCHERE, Jean-Jacques
French, 1807-1852
FEUCHTMAYER
see Feichtmayr
FEUCHTMAYR, Joseph A.
see Feichtmayer

FEUERBACH, Anselm
German, 1829-1880
FEUERLEIN, Johann Peter
German, 1668-1728
FEUERSTEIN, Martin
German, 1856-1931
FEUILLEE, Rév. Père L.
French, 18th cent.
FEURE, Georges de
French, 1868-
FEVRE
French, op.1765
FEVRET de Saint-Ménin
see Saint-Ménin
FEYEN, Jacques Eugène
French, 1815-1908
FEYEN-PERRIN, François
Nicolas Auguste
French, 1826-1888
FEYERABEND, Franz
Swiss, 1755-1800
FEYERABEND, Johann
Rudolf
Swiss, 1779-1814
FFARINGDON, R.
British, 18th cent.
FIACCO or Flacco, Orlando
Italian, c.1530-p.1591
FIALA, R.
Italian, 20th cent.
FIALETTI, Odoardo
Italian, 1573-1638
FIALI, Carl
German(?), 18th cent.
FIAMMINGO
see Borremans, Guglielmo
FIAMMENGHINO, Il
see Rovere, Giovanni
Mauro
FIAMMERI or Fammieri,
Giambattista
Italian, p.1530-1606
FIAMMINGO, Arrigo
see Broeck, Hendrick
van den
FIAMMINGO, Bernardo
see Rantvic
FIAMMINGO, Dionisio
see Calvaert, Denys
FIAMMINGO, Enrico
Italian, op.c.1650
FIAMMINGO, Errico
see Hendricksz., Dirck
FIAMMINGO, Francesco
see Duquesnoy, Frans
FIAMMINGO, Gherardo
see Honthorst, Gerrit van
FIAMMINGO, Guglielmo
see Borremans
FIAMMINGO, Guglielmo
see Tertrode, Willem van
FIAMMINGO, Il
see Duquesnoy, Frans
FIAMMINGO, Il
see Longe, Robert
FIAMMINGO, Il
see Mera, Pietro
FIAMMINGO, Lamberto
see Sustris, Lambert
FIAMMINGO, Lionardo
see Thiry, Leonard
FIAMMINGO, Ludovico
see Toeput, Lodewyk
FIAMMINGO, Michele
see Desubleo
FIAMMINGO, Paolo
see Franck, Pauwels

FIAMMINGO, Rinaldo
see Mytens, Aert
FIAMMINGO, Teodoro
(d'Errico)
see Hendricksz., Dirck
FIASELLA, Domenico
(Il Sarzana)
Italian, 1589-1669
FICARA, Franz
Italian, 1926-
FICHARD, C.
Dutch, 17th cent.
FICHEL, Eugène (Benjamin
Eugène)
French, 1826-1895
FICHERELLI or Ficarelli,
Felice (Il Riposo)
Italian, 1605-1660
FICHTENBERGER, Bartholomaeus
German, op.1561-m.1592
FICHTNER, J.
German, 19th cent.
FICKE, Fuk or Fyk, Nicolaes
Dutch, op.1642-m.c.1702
FICQUET or Fiquet, Etienne
French, 1719-1794
FIDANI, Orazio
Italian, c.1610-p.1656
FIDANZA, Gregorio
Italian, 1759-1823
FIDANZA, Raffaele
Italian, 1797-1846
FIDLER, Anton
German, op.1828-1850
FIDLER, Frank
British, 1910-
FIDLER, Harry
British, -1935
FIDLER, Nora
British, 20th cent.
FIDUS (Hugo Hoppener)
German, 1868-1948
FIEBIGER, Julius (Gottlieb
Moritz Julius)
German, 1813-1883
FIECHTER, Arnold
Swiss, 1879-1943
FIEDLER, Bernhard
Austrian, 1816-1904
FIEDLER, Carl Christian
German, 1789-1851
FIEDLER, Joachim
German, 20th cent.
FIEDLER, Johann Christian
German, 1697-1765
FIEDOROW, Michail
Russian, 20th cent.
FIEDOTOW, Aleksandr
Russian, 20th cent.
FIEKIERZ, Szykier
Polish, 19th cent.
FIELD, Dorothie
British, 20th cent.
FIELD, Erastus Salisbury
American, 1805-1900
FIELD, G.C.
British(?), op.1911
FIELD, Hamilton Easter
American, 1873-1922
FIELD, I.
British, op.1815
FIELD, John
British, 1771-1841
FIELD, Maurice
British, 20th cent.
FIELD, Robert
British, op.1810-m.1819
FIELD, Walter
British, 1837-1901

FIELDING, Anthony Vandyke
Copley
British, 1787-1855
FIELDING, Basil
British, 1907-
FIELDING, Brian
British, 1933-
FIELDING, Nathan Theodore
British, op.1775-1818
FIELDING, Newton Smith
British, 1799-1856
FIELDING, Thales
British, 1793-1837
FIELDING, Theodore Henry
Adolphus
British, 1781-1851
FIENE, Ernest
American, 1894-
FIERAVANTI
see Fioravanti
FIERAVINO, Francesco
(Il Maltese or Le
Maltais)
Italian, op.1650-1680
FIERENS, Pierre
see Firens
FIERLANTS, Nicolaas
Marten
Dutch, c.1622-1694
FIERROS, Dionisio
Spanish, c.1830-a.1899
FIESCHI, Giannetto
Italian, 1921-
FIEVRE, Yolande
French, 20th cent.
FIGANIERES, Henry de
French, 20th cent.
FIGARI, Andrea
Italian, 20th cent.
FIGARI, Filippo
Italian, 1885-
FIGARI, Pedro
Uruguayan, 1861-1938
FIGINO, Ambrogio
Giovanni
Italian, 1548-1608
FIGUEIREDO, Christovaeo
de
Portuguese, op.1518-1540
FIGUERA, Juan
Spanish, op.c.1455-1456
FIIGENSCHOUG, Elias
see Fugelschaug
FILARSKI, Dirk Herman
Willem
Dutch, 1885-1964
FILDES, Denis
British, 1889-
FILDES, Sir Samuel Luke
British, 1844-1927
FILIASI
Italian, op.1749
FILIGER, Charles
French, 1863-1928
FILIPART, Jean Jacques
French, 18th cent.
FILIPEPI, Alessandro
see Botticelli
FILIPKIEWICZ, Stephan
Polish, 1879-
FILIPOV, I.F.
Russian, 20th cent.
FILIPOVIC, Franio
Jugoslav, 1930-
FILIPPI, Camillo
Italian, 1500-1574
FILIPPI, Sebastiano
see Bastianini

FILIPPINI, Felice
Italian, 20th cent.
FILIPPINI, Francesco
Italian, 1853-1895
FILIPPO d'Angelo
see Angeli
FILIPPO Napoletano
see Angeli
FILIPPO de Veris
Italian, op.1400-1420
FILIPPO da Verona
Italian, op.1509-1515
FILLA, Emil
Czech, 1882-1953
FILLEUL, Anne Rosalie
de (née Bocquet)
French, 1752-1794
FILLIA, Luigi Colombo
Italian, 1904-
FILLIAN, John
British, op.1658-1680
FILLON, Arthur
French, 1900-
FILLIOU
French, 20th cent.
FILONOV, Pavel
Russian, op.1912
FILOSA, Giovanni
Battista
Italian, 1850-1935
FILOTESIO, Niccolò di
see Amatrice, Cola dall'
FINART, (David) Noël
Dieudonné
French, 1797-1852
FINCH, Alfred William
(Willy)
Belgian, 1854-1930
FINCH, The Hon. Daniel
British, 1789-1868
FINCH, Elizabeth
British, 19th cent.
FINCH, Francis Oliver
British, 1802-1862
FINCH, Heneage
see Aylesford, 4th Earl of
FINCH, Keith
American, 1920-
FIND, Ludwig Frederik
Danish, 1869-1945
FINDEN, William
British, 1787-1852
FINDLATER, William
British, op.1800-1821
FINDLAY
British, op.1720-1780
FINDLAY, J.
British, op.c.1825-1857
FINDLAY, William
British, 20th cent.
FINE, Oronce
French, op.1536
FINELLI, Edoardo
Italian, 19th cent.
FINETTI, Gino Ritter von
German(?), 1877-
FINEZ, Gregoire Nicolas
French, 1884-
FINIGUERRA, Maso
(Tommaso di Antonio)
Italian, 1426-1464
FINK, August
German, 1846-1916

FINK, Denman
American, 1880-
FINK, Frederick
American, 1817-1849
FINKERNAGEL, Ernest
German, op.1843-1844
FINLAY, Eric
British, 1930-
FINLAY, H.
Australian, 19th cent.
FINLAYSON, John
British, 1730-1776
FINN, Herbert J.
British, 1860
FINNBERG, Gustav
Wilhelm
Finnish, 1784-1833
FINNIE, John
British, 1829-1907
FINNISH SCHOOL,
Anonymous Painters
of the
FINOGLIA, Paolo
Domenico
Italian, op.1620-m.1656
FINSON or Finsonius,
David
Dutch, c.1597-p.1625
FINSON, Finsonius or
Vinson, Ludovicus or
Louis
Flemish, a.1580-1617
FIOCCHI, Alexandre
French, 1803-p.1858
FIOR, Robin
British, 20th cent.
FIORAVANTI (Fieravanti)
Italian, op.1620-1660
FIORE
see Jacobello del
FIORE, Nicola
Italian, op.1775
FIORENZO di Lorenzo
Italian, c.1445-a.1525
FIORETTI, Carles Vergen
Spanish, 19th cent.
FIORI, Carlo dei
see Vogelaer, Karel van
FIORI, Cesare
Italian, 1636-1702
FIORI da Urbino
see Barocci, Federigo
FIORILLO, Francesco or
Domenico
Italian, op.1521
FIORINO or Fiorini,
Giovanni Battista, II
Italian, c.1540-c.1600
FIORINO, Jeremias David
Alexander
German, 1797-1847
FIORONI
see Voigt, Teresa
FIORONI, Luigi
Italian, 1795-1864
FIOZZI, Aldo
Italian, op.1921
FIQUET, Etienne
see Ficquet
FIRABET (of Rapperswil)
Swiss, op.1465-80
FIRENS, Pierre
French, 1637-c.1673
FIRENS or Fierens, Pierre
Flemish, op.1597-m.c.1636/9
FIRFIRES, Nicholas S.
American, 20th cent.

FIRLE, Walther
German, 1859-1929
FIRMIN, Claude
French, 1864-
FIRMIN-GERARD, Marie
François
French, 1828-1921
FIRSSOFF, Iwan
Russian, op.1747-1756
FISCH vom Stein, Hans
Ulrich, I or H. von
Fisch the Elder
Swiss, 1583-1647
FISCHBACH, Johann
German, 1797-1871
FISCHER, Adolf
(Fischer-Gurig)
Carl Franz Adolf
German, 1860-1918
FISCHER, Benno Joachim
Theodor
German, 1828-1865
FISCHER, Ernst (Georg
Ernst)
German, 1815-1874
FISCHER, Eva
Yugoslavian, 20th cent.
FISCHER, Hans
Swiss, 1909-1958
FISCHER, Jacob Adolph
German, 1755-p.1799
FISCHER, Johann Christian
Richard (Richard)
German, 1826-p.1872
FISCHER von Erlach,
Johann Bernard
German, 1656-1723
FISCHER, Johann Georg
see Vischer
FISCHER, Johannes or Hans
German, c.1570/80-1643
FISCHER, Johannes
German, 1888-1955
FISCHER, Johannes August
Danish, 1854-1921
FISCHER, Joseph
German, 1769-1822
FISCHER, Joseph Anton
German, c.1700-1750
FISCHER von Erlach,
Joseph Emanuel
German, 1693-1742
FISCHER, Karl von
German, 1782-1820
FISCHER, Leopold
German, 1814-1864
FISCHER, Louis
German, 1784-1845
FISCHER, Ludwig Hans
German, 1848-1915
FISCHER, Paul (Johann
Georg Paul)
German, 1786-1875
FISCHER, Paul Gustaf
Scandinavian, 1860-1934
FISCHER, Richard
see Fischer, Johann
Christian Richard
FISCHER, Vinzenz
German, 1729-1810
FISCHES the Elder, Isaac
(Jesaias Isaics)
German, 1638-1706
FISCHES the Younger,
Isaac F.
German, 1677-1705
FISCHETTI, Fedele
Italian, 1734-1789

FISCHHOF, George
German, 1859-
FISCHLI, Hans
Swiss, 1909-
FISEN, Englebert
Flemish, 1655-1733
FISH, Anne Harriet
(Anne Sefton)
British, 20th cent.
FISHER, Alfred Hugh
British, 1867-1945
FISHER, Alvan
American, 1792-1863
FISHER, Amy E.
British, op.1866-1890
FISHER, Brian
Canadian, 20th cent.
FISHER, Edward
British, 1722-1785
FISHER, F.
British, 18th cent.
FISHER, Sir George
Bulteel
British, 1764-1834
FISHER, Harrison
American, 1875-1934
FISHER, Horace
British, op.1882-m.1893
FISHER, J.
British, 19th cent.
FISHER, Jonathan
British, op.1763-m.1809/12
FISHER, Mark
(William Mark)
British, 1841-1923
FISHER, J.
American, op.1858
FISHER, James
British, 1818-1896
FISHER, Robert
British, op.1655
FISHER, Stefani Melton
British, 1861-1939
FISHER, Thomas
British, 1782-1836
FISHER, Vignoles
British, 19th cent.
FISHER, William
British, 1817-1895
FISK, William Henry
British, 1827-1884
FISKE, J. Warren
American, 19th cent.
FISSETTE, Léopold
German, 1814-
FISZMAN, Gilles
Belgian, 20th cent.
FITCH, Captain
American, op.1800
FITTLER, James
British, 1758-1835
FITTON, Hedley
British, 1859-1929
FITTON, James
British, 1899-
FITZGERALD, Edward
British, 1809-1883
FITZGERALD, Florence
British, op.1887/1893-m.1927
FITZGERALD, Lord Gerald
British, 1821-1886
FITZGERALD, John Anster
British, 1832-p.1906
FITZGERALD, Lionel
Lemoine
Canadian, 1890-1956

FITZGERALD, M.
British, op.1875-1885
FITZI, Johann Ulrich
Swiss, 1798-p.1850
FITZMAURICE, Capt. E.
British, op.1833
FIUMI, Napoleone G.
Italian, 1898-
FIUMICELLI or Fumicelli,
Lodovico
Italian, op.1527-1570
FIXON, Claude Pierre
French, 18th cent.
FIXON, Louis Pierre
French, 1748-1792
FIZELLE, Rah
Australian, 1891-1964
FJAESTAD, Gustav Edolf
Swedish, 1868-
FJELL, Kai
Norwegian, 20th cent.
FLACCO or Fiacco,
Orlando
Italian, c.1530-c.1590
FLACK, Audrey
American, 1931-
FLAGG, James Montgomery
American, 1877-
FLAGG, Jared Bradley
American, 1820-1899
FLAMEN, Flaman or Flamand,
Albert
Flemish, op.1648-1669
FLAMEN or Flamand the
Elder, Anselme
French, 1647-1717
FLAMENCO, Juan
see Juan Flamenco
FLAMENCO, Michiel
see Sittow
FLAMENG, Francois
French, 1856-1923
FLAMENG, Léopold
Belgian, 1831-1911
FLAMENG, Marie Auguste
French, 1843-1893
FLAMM, Albert
German, 1823-1906
FLANDERS, Dennis
British, 20th cent.
FLANDIN, Eugène
Italian, 1809-1876
FLANDRIN, Auguste René
French, 1804-1843
FLANDRIN, Jean Hippolyte
French, 1809-1864
FLANDRIN, Jules Léon
French, 1871-1947
FLANDRIN, Paul
(Jean Paul)
French, 1811-1902
FLANNAGAN, John B.
American, 1898-1942
FLASHAR, Max
German, 1855-1915
FLASSCHOEN, Gustave
Belgian, 1868-
FLATMAN, Thomas
British, 1637-1688
FLATTERS, Richard
German, 1822-1876
FLATZ, Gebhard
German, 1800-1881
FLAVELLE, William
British, c.1786-p.1813
FLAVET, Claude
French, 1940-
FLAVIN, Dan
American, 1933-

FLAWIIZKY, Konstantin
Dmitrejewitsch
Russian, 1830-1866
FLAXMAN, John
British, 1755-1826
FLAXMAN, Mary Ann
British, 1768-1833
FLECK, Joseph A.
American, 1892-
FLEETWOOD-WALKER,
Bernard
British, 1893-1965
FLEGEL, Georg
German, 1563-1638
FLEISCHER, Max
American, 20th cent.
FLEISCHMANN, Adolf
Richard
German, 1892-
FLEISCHMANN, Carl
German, 1853-
FLEISCHMANN, Friedrich
German, 1791-1834
FLEJSAR, Josef
Czech, 1922-
FLEMAL, Flemael or
Flémalle, Bertholet
Flemish, 1614-1675
FIEMING, Fr. v.
German(?), op.1726
FLEMING, John
British, 1792-1845
FLEMISH SCHOOL,
Anonymous Painters of the
FLEMWELL, George
British, 19th cent.
FLENSBURG, Nicolaus
Andree von
German, 16th cent.
FLERS, Camille
French, 1802-1868
FIESCH-BRUNNINGEN,
Ludmilla von (Luma)
German, 1856-p.1915
FLESSIERS, Balthasar
Flemish, op.c.1575-
m.c.1619/27
FLESSIERS, Benjamin
Flemish, op.1629-1666
FLESSIERS, Willem
Dutch, op.c.1627
FLETCHER, Blandford
British, 1866-1936
FLETCHER, Edwin
British, 19th cent.
FLETCHER, Hanslip
British, 1874-
FLETCHER, Thomas
British, op.1789
FLETCHER, William
British, op.1644
FLETTNER, Peter
see Flötner
FLEURET
French, op.1820-1850
FLEURY, Antoine Claude
French, op.1795-1822
FLEURY, Fanny, Mme.
French, 1848-p.1888
FLEURY, François Antoine
Léon
French, 1804-1858
FLEURY, H.
British, 19th cent.
FLEURY, J.V. de
French, op.1847-1868
FLEURY, Lucien
French, 20th cent.

FLEURY, Robert
see Robert
FLEUSS, Henry
British, 1847-1874
FLICK, Auguste
Emile
French, 19th cent.
FLICKE or Fliccius,
Gerlach or Garlicke
British, op.1547-1558
FLIEGER, Rainer
German, 20th cent.
FLIGHT, Claude
British, 1881-
FLINCK, Govert Teunisz.
or Anthonisz.
Dutch, 1615-1660
FLINCK, Nicolaes
Anthoni
Dutch, 1646-1723
FLINDT, Flint, Flynt,
Flynth or Vlindt the
Younger, Paul
German, op.1592-1618
FLINSCH, Alexander
German, 1834-1912
FLINT, Andreas
Danish, c.1768-1824
FLINT, Francis M.R.
British, 1915-
FLINT, R. Purves
British, 1883-
FLINT, Sir William
Russell
British, 1880-1969
FLINTOE, Johan
Norwegian, 1786-1870
FLIPART, Charles
Joseph
French, 1721-1797
FLIPART, Jean Jacques
French, 1719-1782
FLISAK, Jerzy
Polish, 20th cent.
FLOCH, Josef
German, 1894-
FLOCKET or Flocquet
see Floquet
FLOCON, Albert
French, 1909-
FLODING, Per
Gustav
Swedish, 1731-1791
FLOIENCE, P.
British, 19th cent.
FLOIRAT, Marie
French, 1900-
FLOQUET, Flocket
or Flocquet, Lucas,
I
Flemish, 1578-1635
FLOQUET, Flocket or
Flocquet, Simon
Flemish, op.c.1634/5
FLOR, Ferdinand
German, 1793-1881
FLOREANI, Francesco
Italian, op.1534-m.1593
FLORÉN, Lars
(Lasse)
Swedish, 1899-
FLORENCE, Henry
Louis
British, 1844-1916
FLORENCE, Mary
(née Sargant)
British, 1857-
FLOR or Florer, Ignaz
see Flurer

FLORENTINE SCHOOL,
Anonymous Painters
of the
FLORENTINO, Nicolao
see Dello
FLORES, Javier
Venezuelan, op.c.1774
FLORES, Pedro
Spanish, 20th cent.
FLORES, Ricardo
French, 1878-1918
FLORETT
German(?), 19th cent.
FLORIAN, Maximilian
German, 1901-
FLORIAN, Olga Winsinger
German, 1844-1926
FLORIANO da Brescia
Italian, 16th cent.
FLORIGERIO, Sebastiano
Italian, c.1500-p.1543
FLORINDO, Alonso Ruiz
Spanish, 17th cent(?)
FLORIS de Vriendt,
Cornelis, II
Netherlands, 1514-1575
FLORIS de Vriendt,
Frans, I
Netherlands, c.1518-1570
FLORIS de Vriendt,
Jacob, I
Netherlands, 1524-1581
FLORQUIN, Louis
French, 20th cent.
FLORSHEIM, Lillian H.
American, 20th cent.
FLÖTNER or Flettner,
Peter
German, c.1485-1546
FLOUEST, Joseph Marie
French, 1747-1833
FLOUQUET, Pierre
Belgian, 1900-
FLOWER, Cedric
Australian, 1920-
FLOWER, Clement
British, 19th cent.
FLOWER, John
British, 1795-1861
FLOWERS, J.
British, 19th cent.
FLUERER, Ignaz
see Flurer
FLÜGGEN, Gisbert
German, 1811-1859
FLÜGGEN, Josef
German, 1842-1906
FLULK, A.
German, 20th cent.
FLURER, Flor, Florer or
Fluerer, Ignaz
(Franz Ignaz Joseph)
German, op.1729-m.1742
FOCHI, Ferdinando
Italian, 18th cent.
FOCK, Hermanus
Dutch, 1766-1822
FOCKE, Carl
German, op.1803-1810
FOCKENS, Elisabeth
Geertruida (née
Wassenbergh)
see Wassenbergh
FOCLISE, H.
German, 1757-1821
FOCOSI, Alessandro
Italian, 1836-1869

FOCOSI, Roberto
Italian, 18th cent.
FOCQUIER, Jacques
see Fouquier
FOCUS, Georges (Faucas)
French, 1641-1708
FODON, A.J.
Netherlands, op.1665/85
FOELIX, Heinrich
German, 1757-1821
FOERSTER, Emil
American, 1822-1906
FOERSTER, Heinrich von
German, 1832-1889
FOERSTER, Peter
German, 1887-1948
FOGAS, Peter
Hungarian, 20th cent.
FOGEL, Seymour
American, 1911-
FOGGIA, Michele
Italian, op.1832
FOGGIE, David
British, 1878-
FOGGINI, Giovanni
Battista
Italian, 1652-1725
FOGOLINO, Marcello
Italian, c.1470-a.1550
FOHN, Sofie
German, 1899-
FOHR, Carl Philipp
German, 1795-1818
FOHR, Daniel
German, 1801-1862
FOKKE, Jan
Dutch, c.1745-1812
FOKKE, Simon
Dutch, 1712-1784
FOLCHETTI da
Sanginesio, Stefano
Italian, op.1492-1513
FOLDES, Peter
British, 1924-
FOLDSONE, Anne
see Mee
FOLDSONE, John
British, op.1769-m.c.1784
FOLER or Foller,
Antonio
Italian, 1528-1616
FOLKARD, Julia B.
British, op.1872-1902
FOLKEMA, Jacob
Dutch, 1692-1767
FOLKESTAD, Bernhard
Dorotheus
Norwegian, 1879-1933
FOLLENWEIDER, Rudolf
Swiss, 1774-1847
FOLLER, Antonio
see Foler
FOLLER or Follador,
Jacopo
see Fallaro
FOLLI, Sebastiano
Italian, 1568-1621
FOLLINI, Carlo
Italian, 1848-
FOLON, Jean Michel
French, 1934-
FOLSOM, Mrs. Elizabeth A.
(Clara)
American, 1812-1899
FOLTYN
French, 19th cent.

FOLTZ, Philipp von
German, 1805-1877
FOLWELL, Samuel
American, 1765-1813
FONDULLI, Fondulio,
Fondulo or Fundulli,
Giovanni Paolo
Italian, op.1574-1592
FONG, Lia
Oriental, op.1899
FONGARIO, Bernardino
see Fungai
FONHAVE, Heinrich
see Funhof
FONNART
French, op.1807
FONNER, F.
German, 18th cent.
FONSECA, Antonio Manuel
da
Portuguese, 1796-1890
FONTAINE, Gabriel
Swiss, 1696-1767
FONTAINE, Jacques Francois
Joseph
see Swebach
FONTAINE, Louis de
French, op.1723-1757
FONTAINE, Pierre François
Léonard
French, 1762-1853
FONTAINES, André des
French, 1869-
FONTALLARD, Jean François
Gerard
French, 1777-1858
FONTANA, Alberto
Italian, op.1518-m.1558
FONTANA, Andrea (di)
Italian, op.c.1516
FONTANA, Carlo Stefano
(l'Abbate)
Italian, op.c.1700-1711
FONTANA, Corsin
Swiss, 1944-
FONTANA, Gerardo
Italian, 16th cent.
FONTANA, Giovanni
Italian, op.1731
FONTANA, Giovanni
Battista
Italian, c.1524-1587
FONTANA, Girolamo
Italian, op.1690-1714
FONTANA, Lavinia (Zappi)
Italian, 1552-1614
FONTANA, Lucio
Italian, 1899-1968
FONTANA, Luigi
Italian, 1827-1908
FONTANA, Prospero
Italian, 1512-1597
FONTANA di Cento,
Riccardo
Italian, 1840-1915
FONTANA, Roberto
Italian, 1844-1907
FONTANAROSA, Lucien
French, 1912-
FONTANESI, Antonio
Italian, 1818-1882
FONTANESI, Francesco
Italian, 1751-1795
FONTAYNE, René
French, 20th cent.
FONTEBASSO, Francesco
Salvator
Italian, 1709-1768/9

FONTEBUONI, Anastasio
Italian, c.1580-1626
FONTENAY, Eugène
French, 1824-
FONTENAY, Henry François
French, 1657-p.1704
FONTENAY, J.B. de
see Belin
FONTENAY, Louis Henri de
Dutch, 1800-
FONTENAY de Saint-
Afrique
French, 20th cent.
FONTENE, Robert
French, 1892-
FONTENY, C.D.
Dutch, 18th cent.
FONTEYN, Adriaen
Lucasz.
Flemish, op.1626-m.1661
FONTYN, Pieter
Dutch, 1773-1839
FOOT, D.D.
American, op.c.1820-1830
FOOT, F.
British, op.1857-1874
FOOTE, Mary Hallock
American, 20th cent.
FOOTTET, Frederick
Francis
British, op.1873-1901
FOPPA, Vincenzo
Italian, 1427/30-1515/16
FORABOSCO (Ferrabosco)
Girolamo
Italian, c.1605-1679
FORAIN, Jean Louis
French, 1852-1931
FORBES
British, 19th cent.
FORBES, A.
British, -1839
FORBES, Anne
British, 1745-1834
FORBES, Edward
British, 19th cent.
FORBES, Elizabeth Adela,
(née Armstrong)
(Mrs. Eliz. Stanhope
Forbes)
British, 1859-1912
FORBES, Ernest
British, 20th cent.
FORBES, J.
British, 17th cent.
FORBES, Kenneth K.
Canadian, 1892-
FORBES, Stanhope
Alexander
British, 1857-1947
FORBES, Vivian
British, 1891-1937
FORBES-ROBERTSON, Eric
British, 1865-1935
FORBES-ROBERTSON, Sir
Johnstone
British, 1853-
FORBIN, Louis Nicolas
Philippe Auguste,
Comte de
French, 1777-1841
FORBIN-JANSON, N. de
French, 19th cent.
FORCELLINI, Simone
Italian, op.1686-1691
FORD, Charles
British, op.1830-1856

FORD, F.J.
British, op.1845-1853
FORD, Harriet
British, op.1822-1825
FORD, Henry Justice
British, 1860-1941
FORD, J.A.
British, op.1911
FORD, Richard
British, 1796-1858
FORD, Rudolph Onslow
British, op.1880-1914
FORD, William
British, op.1848-m.1880
FORD, William Bishop
British, op.1847-1892
FORD, Wolfram Onslow
British, 1880-
FORDE, Samuel
British, 1805-1828
FORDET, Comtesse de
French, 19th cent.
FORE, Philippe
French, 1917-
FOREAU, Louis Henri
French, 1866-1940
FOREST, Jean Baptiste
French, 1635-1712
FOREST, Roy de
American, 1930-
FORESTIER, Amedee
British, -1930
FORESTIER, Henri-Claude
Swiss, 1875-1922
FORESTIER, Henri Joseph
de
French, 1787-1872
FORESTIER, Marie Anne
Julie
French, 1789-
FORESTIER, Marius
French, 19th cent.
FORGE, F. de
French, 18th cent.
FORGEOT
French, op.1711
FORISSIER, Roger
French, 19th cent.
FORMENT or Formente,
Damián
Spanish, c.1480-c.1542
FORMENTI, Tommaso
(Formentino)
Italian, op.1720-1729
FORMENTIN, Mlle.
French, 18th cent.
FORMIS-BEFANI, Achille
Italian, 1832-1906
FORMOSA, Romualdo
Italian, op.1755
FORNARA, Carlo
Italian, 1871-
FORNARI, E.
Italian, 19th cent.
FORNENBURGH, Jan Baptist
van
Dutch, op.1621-1649
FORNER, Master Robin
French, 15th cent.
FORNER, Raquel
Argentinian, 1902-
FORNEROD, Rodolphe
Swiss, 1877-p.1913
FORNI, Girolamo
Italian, 16th cent.
FORREST, A.S.
British, op.1897-1905

FORREST, Charles
British, op.1765-1776
FORREST, Erik
British, 20th cent.
FORREST, H.
British, op.1879
FORREST, Thomas
Theodosius
British, 1728-1784
FORREST, W.S.
British, op.1851
FORRESTER, Alfred
see Crowquill
FORRESTER, J.J.
British, op.1834
FORRESTER, James
British, 1729-1775
FORRESTER, John
British, 1922-
FORSBERG the Elder, Nils
Swedish, 1842-1934
FORSBERG, Nils
Swedish, 1870-
FORSETH, Einar
Swedish, 1892-
FORSSELL, Victor
Swedish, 1846-1931
FORSSLUND, Jonas
Swedish, 1754-1809
FORST, Johann Hubert
Anton
German, 1756-p.1815
FORSTER the Younger,
Charles
British, op.1828-1876
FÖRSTER, Ernst
German, 1800-1885
FORSTER, F.L.M.
British, 19th cent.
FORSTER, G.
American, op.1866
FORSTER, George
British, op.1816-1842
FORSTER, J.G.A.
British, op.1774
FORSTER, Noel
British, 20th cent.
FORSTER, Thomas
British, op.1695-1712
FORSTERLING, Otto
German, 1843-1904
FORSTNER, Leopold
German, 1878-1936
FORSYTH, Gordon Mitchell
British, 1879-
FORT, Jean Antoine
Siméon
French, 1793-1861
FORT, Théodore
French, 19th cent.
FORTE, Gaetano
Italian, 1790-1871
FORTE, Giacomo
see Forti
FORTE, Luca
Italian, op.1640-1670
FORTENAGEL, Lucas or
Laux
see Furtenagel
FORTES, Vitor
Portuguese, 1943-
FORTESCUE, Hon. Henrietta
Anne
British, c.1765-1841
FORTESCUE, William B.
British, op.1880-m.1924

FORTI, Edwardo
Italian, 19th cent.
FORTI, Ettore
Italian, op.c.1892-1935
FORTI or Forte, Giacomo
Italian, op.1483-1485(?)
FORTIN, Augustin-Félix
French, 1763-1832
FORTIN, Jeanne Besnard
French, 19th cent.
FORTIN, Marc-Aurèle
Canadian, 1888-
FORTNER, Georg
German, 1814-1879
FÖRTSCH, Hans
German, 1859-
FÖRTSCH, Hans
German, 1924-
FORTUNY, Lucia
French, 20th cent.
FORTUNY y Carbo, Mariano
José Maria Bernardo
Spanish, 1838-1874
FOSBURGH, James Whitney
American, 1910-
FOSCHI, Francesco
(not Ferdinando)
Italian, op.c.1750
FOSCHI, Pier Francesco
Italian, 1502-1567
FOSCHI, Sigismondo
Italian, op.1520-1532
FOSSANO, Ambrogio Stefani
da
see Borgognone
FOSSATI, Davide-Antonio
Italian, 1708-1780
FOSSATI, Domenico
Italian, 1743-1784
FOSSATI, The Brothers
Gaspare and Giuseppe
Swiss, 1809-1883
1822-1891
FOSSE, Coëssin de la
French, 19th cent.
FOSSE, Jean Charles de la
see Delafosse
FOSSI, Fra Domenico de'
Italian, 1479-p.1547
FOSTER, Alan
American, 1892-
FOSTER, Ben
American, 1852-1926
FOSTER, Charles A.
American, 1850-1931
FOSTER, Deryck
British, 20th cent.
FOSTER, Edward Ward
British, 1761-1864
FOSTER, Gilbert
(William G.)
British, 1855-1906
FOSTER, Herbert Wilson
British, op.1870-1899
FOSTER, John
American, 1648-1681
FOSTER, John
British, c.1787-1846
FOSTER, Myles Birket
British, 1825-1899
FOSTER, Philip
Australian, 20th cent.
FOSTER, Thomas
British, 1798-1826
FOSTER, William Gilbert
British, 1855-1906

FOTHERGILL, Charles
British, op.1850-1883
FOUACE, Guillaume
Romain
French, 1827-1895
FOUBERT, Emile Louis
French, -1910/11
FOUCEEL, Jan
Flemish, op.c.1670
FOUCHE or Foucher,
Nicolas
French, 1653-1733
FOUCHIER, Bartram de
Dutch, 1609-1673
FOUDRAS
French, 19th cent.
FOUGASSE
see Bird, Cyril Kenneth
FOUGEREL, F.
French, op.1791
FOUGERON, André
French, 1912-
FOUGSTEDT, Arvid
Swedish, 1888-1949
FOUJITA, Tsugouharu
Léonard
French, 1886-
FOULKES, Llyn
American, 20th cent.
FOULON or Foullon,
Benjamin
French, c.1550-c.1612
FOULLON or Foulon,
Lucile, (née Vachot)
French, c.1775-1865
FOULQUIER, Jean-Antoine-
Valentin
French, 1822-1896
FOULSTON, John
British, 1772-1842
FOUNTAIN, Georg Wilhelm
see Lafontaine
FOUNTAINE, F.
British, op.1908
FOUQUE, Jean Marius
(not Jean Marie Baptiste)
French, 1822-
FOUQUET, François
(Maître François?) et
Louis
French, 15th cent.
FOUQUET, Jacques
French, op.1685-1704
FOUQUET or Foucquet,
Jean
French, c.1420-1477/81
FOUQUET, Jean
French, op.1781-1798
FOUQUET, Louis Vincent
French, 1803-1869
FOUQUIER, Focquier,
Fouquière or Fouquières,
Jacques
Flemish, c.1580/90-1659
FOURAU or Foureau, Hugues
French, 1803-1873
FOUREAU, Hugues
see Fourau
FOURIE, Albert Auguste
French, 1854-
FOURMOIS, Théodore
Belgian, 1814-1871
FOURNIER, Alexandre de
French, 1831-
FOURNIER, Charles
French, 1803-1854

FOURNIER, Félicie
see Schneider
FOURNIER, Fortuné
(Jean Baptiste Fortuné)
French, 1798-1864
FOURNIER, Gabriel
Francisque
French, 1893-
FOURNIER, Jean
French, c.1700-1765
FOURNIER, Jean Simon
French, op.1791-1799
FOURNIER, Louis Edouard
Paul
French, 1857-
FOURNIER, Marcel
French, 1869-1917
FOURTINA, Annie
French, 20th cent.
FOUS, Jean
French, 1901-
FOWLER, O.K.
American, op.1838
FOWLER, Robert
British, 1853/4-1926
FOWLER, Trevor Thomas
British, c.1800
FOWLER, Walter
British, op.1887-1902
FOWLER, William, II
British, op.1825-1867
FOWLER, William, III
British, 1796-c.1880
FOWLES, Arthur Wellington
British, c.1815-1883
FOX, Charles, I
British, 1749-1809
FOX, Charles, II
British, 1794-1849
FOX, Charles James
British, c.1860-
FOX, Edward
British, op.1813-1854
FOX, Emmanuel Philips
Australian, 1865-1915
FOX, G.M.
British, op.1852
FOX, George
British, op.1870-1900
FOX, John
British, op.1830-1846
FOX, Kathleen
British, 19th cent.
FOX, R.
British, 19th cent.
FOX, Sir William
New Zealand, 1812-1893
FOX, William Edward
British, 1872-
FOX-PITT, Douglas
British, 1867-1922
FOY, Katherine
British, op.1879
FOY, William
British, 1791-p.1861
FRACANZANI or Fracanzano,
Cesare
Italian, c.1600-a.1653
FRACANZANI, Michelangelo
Italian, p.1644-c.1685
FRACANZANO, Francesco
(Il Ciccio)
Italian, c.1612-1656(?)
FRACASSINI or Fracassi,
Cesari
Italian, 1838-1868

FRADELLE, Henri Joseph
French, 1778-1865
FRAENCKEL, Liepmann
German, 1772-1857
FRAEULY, Charles
French, op.1936
FRAGIACOMO, Pietro
Italian, 1856-1922
FRAGONARD, Alexandre
Evariste
French, 1780-1850
FRAGONARD, Etienne
Théophile Evariste
French, 1806-1876
FRAGONARD, Jean Honoré
French, 1732-1806
FRAI, Felicita
Italian, 20th cent.
FRAICHOT, Pierre Antoine
French, 1690-c.1763
FRAIGEVISE, Frédéric
see Fregevize
FRAILE
French, 20th cent.
FRAIN, R.
British, 19th cent.
FRAISINGER, Caspar
German, op.1581-1599
FRAISSE, Jean Antoine
French, op.1733-1740
FRAMPTON, Edward Reginald
British, 1873-1923
FRAMPTON, Christabel A.,
Lady, (née Cockerell)
see Cockerell
FRAMPTON, Sir George
James
British, 1860-1928
FRAMPTON, Meredith
British, 1894-
FRANCA, Manuel Joachim
de
American, 1808-1865
FRANÇAIS, Francois Louis
French, 1814-1897
FRANCART, Franckaert,
Francquaert or Francquart,
Jacques, I
Netherlands,
op.1571-m.1601
FRANCART or Francquart,
Jacques, II
Flemish, 1582/3-1651
FRANCART, Francois, I
French, c.1622-1672
FRANCES, Esteban
Spanish, 20th cent.
FRANCES, Juana
Spanish, 20th cent.
FRANCES, Nicolas
Spanish, op.1480
FRANCESCA, Piero della
see Piero
FRANCESCHI, Francesco de'
Italian, op.1445-1456
FRANCESCHI, Mariano de
Italian, 1849-1896
FRANCESCHI, Marie Cathérine
see François
FRANCESCHI, Paolo dei
see Franck, Pauwels
FRANCESCHI, Piero dei
see Piero della Francesca
FRANCESCHIELLO
see Mura, Francesco de
FRANCESCHINI, Baldassarre
(Il Volterrano)
Italian, 1611-1689

FRANCESCHINI, Carlo
Italian, 17th cent.
FRANCESCHINI, Marc Antonio
Italian, 1648-1729
FRANCESCHINI, Mattia
Italian, op.c.1745
FRANCESCO, de
Italian, 19th cent.
FRANCESCO di Andrea
see Anguilla
FRANCESCO d'Antonio di
Bartolomeo (Banchi,
Francesco Fiorentino)
Italian, op.1409(?)-1429
FRANCESCO d'Arezzo
Italian, op.1432
FRANCESCO d'Antonio del
Cherico
Italian, op.1463-1484
FRANCESCO d'Antonio da
Viterbo (Il Balletta)
Italian, op.1441-1464
FRANCESCO de Bais Imolese
Italian, 16th cent.
FRANCESCO da Bologna
Italian, op.1612
FRANCESCO da Castello
Italian, 16th cent.
FRANCESCO da Cotignola
see Zaganelli
FRANCESCO di Cristofano
see Franciabigio
FRANCESCO Fiorentino
see Francesco d'Antonio
di Bartolommeo
FRANCESCO dei Gabrielli
da Viterbo
see Gabrielli
FRANCESCO da Gattinara
Italian, op.1542
FRANCESCO di Gentile da
Fabriano
Italian, op.c.1460-1500
FRANCESCO di Giorgio
Martini
Italian, 1439-1502
FRANCESCO di Giovannetto
Italian, 15th cent.
FRANCESCO di Giovanni
Italian, op.1491
FRANCESCO di Lorenzo
Italian, 15th cent.
FRANCESCO di Luca
Italian, 16th cent.
FRANCESCO di Maria
Italian, 1623-1690
FRANCESCO di Michele
see Francesco Fiorentino
FRANCESCO da Milano
see Pagani, Francesco
di Antonio
FRANCESCO da Montereale
Italian, op.1509-1541
FRANCESCO da Nanto
Italian, 15th cent.
FRANCESCO Napoletano
Italian, op.c.1500
FRANCESCO d'Oberto
Italian, op.1357-1410
FRANCESCO dell' Orioli
Italian, 15th cent.
FRANCESCO Ortensi di
Girolamo dal Prato
see Prato
FRANCESCO Padovanino
Italian, 1561-1617
FRANCESCO da Pavia
see Grasso, Francesco di
Giannino

FRANCESCO di Pietro del
Fusari da Faenza
Italian, op.1448-m.1453
FRANCESCO da Rimini
Italian, 14th cent.
FRANCESCO dei Rossi
see Salviati, Il
Cecchino del
FRANCESCO di Segna di
Bonaventura
Italian, op.1399
FRANCESCO di Simone
see Ferrucci
FRANCESCO da Tolentino
(Tholentinus)
Italian, op.1525-1530
FRANCESCO da Urbino
Italian, op.1561-1575
FRANCESCO di Vannuccio
Italian, op.1361-1388
FRANCESCO Veneto
Italian, op.1561
FRANCESCO de Veris
Italian, op.1400-1420
FRANCESCO da Vicenza
Italian, 15th cent.
FRANCESCO da Vico
Italian, op.1472
FRANCESCO da Volterra
see Capriani, Francesco
FRANCESCO da Volterra
(Francesco Neri)
Italian, op.1343-1371
FRANCESCUCCIO da Fabriano
see Ghissi
FRANCESE, Il
see Mattei, Michele
FRANCESE, Franco
Italian, 1920-
FRANCESQUITO
see Francisquito
FRANCHI, Alessandro
Italian, 1828-1914
FRANCHI, Antonio
(Lucchese)
Italian, 1634-1709
FRANCHI, Battista di
see Franco
FRANCHI, Rossello di
Jacopo
Italian, c.1377-1456
FRANCHINI, Niccolò
Italian, 1704-1783
FRANCHOYS, Franchois,
Franchoijs or François
Lucas, II
Flemish, 1616-1681
FRANCHOYS, Paul
see Franck, Pauwels
FRANCHOYS, Franchois or
Franchoijs, Peeter
Flemish, 1606-1654
FRANCIA, Alexandre
French, 1815/20-1884
FRANCIA, Domenico
Italian, 1702-1758
FRANCIA, Francesco di
Marco di Giacomo
Raibolini, Il
Italian, c.1450-1517
FRANCIA, François Louis
Thomas
French, 1772-1839
FRANCIA, Giacomo
Italian, a.1486-1557
FRANCIA, Giulio
Italian, 1487-1540
FRANCIA, Peter de
Italian(?), 20th cent.

FRANCIABIGIO
(Francesco di Cristofano)
Italian, 1482/3-1525
FRANCINI, Franchine or
Francyne, Alexander
Italian, op.1598-m.1648
FRANCIS, Jabez
British, op.1870
FRANCIS, John Deffet
British, 1815-1901
FRANCIS, John F.
American, 1808-1886
FRANCIS, Sam
American, 1923-
FRANCIS, Thomas William
British, 19th cent.
FRANCISCO de Hollanda
d'Ollanda or Dolanda
Portuguese, c.1517/18-1584
FRANCISQUITO or
Francesquitto
Spanish, 18th cent.
FRANCK
see also Francken
FRANCK, Albert
Canadian, 20th cent.
FRANCK, Christoffel
Frederik
Dutch, 1758-1818
FRANCK, Franz
German, 1627-1687
FRANCK, Hans
German, op.1485-m.a.1522
FRANCK von Bubendorf,
Hans
Swiss, op.1505-m.a.1522
FRANCK, Hans Ulrich
(Monogrammist H.V.F. 1647?)
German, 1603-1680
FRANCK, Jan
Flemish, 16th/17th cent.
FRANCK, Maximilian
German, c.1780-p.1830
FRANCK, Pauwels (Paul
Franchoys or Paolo
Fiammingo or dei Franceschi)
Netherlands, 1540-1596
FRANCK, Philipp
German, c.1780-p.1837
FRANCK, Philipp
German, 1860-1944
FRANCK, Sebastian
see Vrancx
FRANCK
see Simon von
Aschaffenburg
FRANCKAERT, Jacques
see Francart
FRANCKE, Christoph Bernard
German, op.1693-m.1729
FRANCKE, Johann
see Frank
FRANCKE, Master
German, op.1424-1435
FRANCKEN or Franck,
Ambrosius, I
Flemish, 1544-1618
FRANCKEN or Franck,
Ambrosius, II
Flemish, op.1616-m.1632
FRANCKEN or Franck,
Frans, I
Flemish, 1542-1616
FRANCKEN or Franck,
Frans, II
Flemish, 1581-1642
FRANCKEN or Franck,
Frans, III
Flemish, 1607-1667

FRANCKEN, Franck, Franckx,
Franken or Vranken,
Gabriel
Flemish, op.1605-m.1639
FRANCKEN or Franck,
Hieronymus, I
Netherlands, 1540-1610
FRANCKEN or Franck,
Hieronymus, II
Flemish, 1578-1623
FRANCKEN, Jan Baptist
see Francken, Frans, II
FRANCKEN or Franck,
Maximilaen
Flemish, -1651
FRANCKEN, P.H.
Flemish, op.1655
FRANCKEN, Ruth
Czech, 20th cent.
FRANCKEN or Franck,
Thomas
Flemish, op.1601-1626
FRANCKENBERGER the Elder,
Hans
German, op.c.1530
FRANCKENBERGER the
Younger, Tobias
German, c.1600-m.p.1660
FRANCKS, C.
Netherlands,op.1610
FRANCKX, Gabriel
see Francken
FRANCO, Alfonso
(Argentero)
Italian, 1466-1523
FRANCO Bolognese
(possibly Franco di
Bonavita)
Italian, op.1312-1313
FRANCO di Bonavita
see Franco Bolognese
FRANCO, Giacomo
Italian, 1550-1620
FRANCO, Giovanni Battista
(Il Semolei)
(Battista di Franchi)
Italian, 1498-1561
FRANCO, Giuseppe
Italian, c.1550-1628
FRANCOI, Hans Antoni
Netherlands, op.1591
FRANCOIS, André
French, 1915-
FRANÇOIS, Charles Emile
French, 1821-
FRANÇOIS, Claude
(Frère Luc)
French, 1615-1685
FRANÇOIS, F.L.
French, 19th cent.
FRANÇOIS, Gustave
(Gustave François
Barraud)
Swiss, 1883-1968
FRANCOIS, Guy or Guide
('Le Grand Francois')
French, c.1578-1650
FRANÇOIS, Henri-J.
French, op.1785-1806
FRANÇOIS, Jean
French, -1684
FRANÇOIS, Jean Charles
French, 1717-1769
FRANÇOIS, Lucas, II
see Franchoys
FRANÇOIS, Maître
see Fouquet, François

FRANCOIS or Franceschi,
Marie Catherine, (née
Frédou)
French, c.1712-1773
FRANCOIS, Pierre Joseph
Célestin
Belgian, 1759-1851
FRANCOIS or Francoys,
Simon
French, 1606-1671
FRANCOLIN, Robert
French, 20th cent.
FRANCOLINI, F.
Italian, 19th cent.
FRANCQ, le J.
see Berkhey
FRANCQUART or Franquaert,
Jacques
see Francart
FRANCUCCI
see Innocenzo da Imola
FRANCYNE, Alexander
see Francini
FRANGIPANE, Niccolò
Italian, op.1563-1597
FRANGIPANNI, F.
Italian, 18th cent.
FRANK, Friedrich
German, 1900-
FRANK?, Heinrich
German, 1805-1890
FRANK, Francke or Franke,
Johann (Johann Andreas
Joseph)
German, 1756-1804
FRANK, Lucien
Belgian, 1857-1920
FRANK, Raoul
German, 1867-1939
FRANK, William Arnee
British, op.1889
FRANK-KRAUSS, Robert
German, 1893-1950
FRANKE, Albert Joseph
German, 1860-1924
FRANKE, Heinrich
(Johann Heinrich Christian)
German, 1738-1792
FRANKE, Johann
see Frank
FRANKEN, Gabriel
see Francken
FRANKEN, Marianne
Dutch, 1884-1945
FRANKEN, Paul von
German, 1818-1884
FRANKENBURG
Hungarian(?), 16th cent.
FRANKENBURGER, Johann
German, 1807-1874
FRANKENSTEIN, Wolfgang
German, 1918-
FRANKENTHALER, Helen
American, 1928-
FRANKIE, A.F.
French(?), 19th cent.
FRANKL, Gerhardt
German, 1901-
FRANKLAND, Sir Robert
British, 1784-1849
FRANKLIN, George
British, op.1825-1847
FRANKLIN, John
British, c.1800-p.1868
FRANKLIN, Mary
British, op.1823
FRANKLIN, Stanley Arthur
British, 20th cent.

FRANKS, Sebastian
see Vrancx
FRANQUE, François
French, 1710-1786
FRANQUE, Jean Pierre
French, 1774-1860
FRANQUE, Joseph
French, 1774-1833
FRANQUELIN, Jean Augustin
French, 1798-1839
FRANQUET, L.
Belgian, 19th cent.
FRANS van Brugge
see Monogrammist F.V.B.
FRANS, Nicolaus
Netherlands, 1539-
FRANSE, Cornelis (Kees)
Dutch, 1924-
FRANSE, P.
Netherlands, 17th cent.
FRANZ, A.
German, 19th cent.
FRANZ, Carl Joseph
German, 1829-1875
FRANZ, Ettore Roesler
Italian, 1845-1907
FRANZ, Johann Michael
German, op.1760-1768
FRANZONI, A.G.
Italian, 20th cent.
FRAPPA, José
German, 1854-1904
FRARY, Michael
American, 1918-
FRASA, Carlo
Italian, op.1711
FRASCHERI, Giuseppe
Italian, 1809-1886
FRASCONI, Antonio
South American, 1919-
FRASER, Alexander
British, 20th cent.
FRASER, Alexander, I
British, 1786-1865
FRASER, Alexander, II
British, 1827/8-1899
FRASER, Charles
American, 1782-1860
FRASER, Claud Lovat
British, 1890-1921
FRASER, Donald Hamilton
British, 1929-
FRASER, Francis Arthur
British, op.1867-1883
FRASER, Ian
British, 1933-
FRASER, J.A.
Canadian, 20th cent.
FRASER, James Baillie
British, 1783-1856
FRASER, John
British, 1858-p.1914
FRASER, Justina
British, op.1822
FRASER, Oliver
American, 1808-1864
FRASER, Thomas
British, -1851
FRASER, William
British, 19th cent.
FRASNEDI, Alfonso
Italian, 1934-
FRATE, Domenico (di
Sante) del
Italian, c.1765-1821
FRATE FELICE DELLA
SAMBUCA
Italian, 18th cent.

FRATE, Il
see Scacciera
FRATELLINI, Giovanna,
(née Marmocchini Cortesi)
Italian, 1666-1731
FRATELLINI, Lorenzo
Italian, 1691/3-1729
FRATER, William
Australian, 1890-
FRATINO, Giovanni (de
Mio or Visentin)
Italian, op.1538-1560
FRATREL the Elder, Joseph
French, 1730-1783
FRATTA, Domenico Maria
Italian, 1696-1763
FRAUSTADT, Friedrich
August
German, 1821-p.1880
FRAYE, Andre
French, 1887-1963
FRAZER, Donald Hamilton
see Fraser
FRAZER, William Miller
British, 1864-1961
FRAZIER, John Robinson
American, 1889-1966
FRECHER, Daniel
Polish, op.1664
FRECHOU, Charles
French, op.1841-1887
FREDDIE
see Carlsen
FREDEAU, Ambroise
French, 1589-1673
FREDEAU, Mathieu
Flemish, op.1629-1634
FREDENTHAL, David
American, 1914-
FREDERIC, Léon Henri Marie
Belgian, 1856-1940
FREDERICI
see Fei
FREDERICK, Empress of
Germany
German, 1840-1901
FREDERICKE
Spanish, op.1833
FREDI Battilore,
Bartolo di
see Bartolo
FREDOU, Jean Martial
French, 1711-1795
FREDOU, Marie Catherine
see François
FREDSBERG, Olof
Swedish, 1728-1795
FREEBAIRN, Robert
British, 1765-1808
FREEBORN, Victor
British, 20th cent.
FREEDMAN, Barnett
British, 1901-1958
FREEDMAN, Maurice
American, 1904-
FREEMAN
British, op.1853
FREEMAN of Cambridge
British, 18th cent.
FREEMAN, George
British, op.1828-1833
FREEMAN, James
American, 20th cent.
FREEMAN, James Edward
American, 1808-1884/5
FREEMAN, John
British, op.1670-1720
FREEMAN, William Philip Barnes
British, 1813-1897

FREER, H.B.
British, op.1870-1900
FREESE, N.
American, op.1798
FREETH, Herbert Andrew
British, 1912-
FREETH, W.
British, 18th cent.
FREGEVIZE, Fraigevise
or Frégevise, Frédéric
Swiss, 1770-1849
FREGOLI, Matteo
Italian, 16th cent.
FREHER, Paul
German, op.1688
FREIBERG, Maria von
German, 18th cent.
FREIFELD, Eric
Canadian, 20th cent.
FREILICHER, Jane
American, 1924-
FREIMAN, Lillian
Canadian, 1908-
FREISLHIEN
see Frieselhem
FREITAS, Lima de
Portuguese, 20th cent.
FREIXAS, Vivo
Spanish, 20th cent.
FREL, Jacobus
see Vrel
FRELAUT, Jean
French, 1879-1954
FRELICH, Laux
see Frölich
FRELINGHUYSEN, Suzy
American, 1912-
FREMEZ, Jose Gomez
Fresquet
S.American, 20th cent.
FREMIET, Emmanuel
French, 1824-1910
FREMIET, Sophie
see Rude
FREMIN, René
French, 1672-1744
FREMINET, Louis de
French, -c.1651
FREMINET, Martin
French, 1567-1619
FREMUND, Richard
Czech, 1928-
FREMY, Jacques Nöel
Marie
French, 1782-1867
FRENCH, Annie
British, op.c.1900-1915
FRENCH, Frank
American, 1850-1933
FRENCH, Leonard
Australian, 1928-
FRENCH, Nathanael
British, op.1747
FRENCH SCHOOL,
Anonymous Painters
of the
FRENCH, William
British, c.1815-1898
FRENES, Rudolf Hirth du
see Hirth du Frênes
FRENKIEL, Stanislaw
Polish, 1918-
FRENTIU, Sever
Rumanian, 20th cent.
FRENZEL, Oskar
German, 1855-1915
FRENZENY, Paul
American, op.c.1898

FRERE, Charles Theodore
French, 1814-1888
FRERE, Pierre Edouard
French, 1819-1886
FRERE, P. Joseph
Swedish(?), op.1789
FRERES, Dirck
see Ferreris
FRERICHS, William Charles
Antony
American, 1829-1905
FRESCHEL, Daniel
see Fröschl
FRESET, Georges Eugène
French, 1894-
FRESNAYE, de la Roger
French, 1885-1925
FREUD, Lucien
British, 1922-
FREUDEBERG or
Freudenberger, Sigmund
Swiss, 1745-1801
FREUDEMANN, Victor
German, 1857-c.1919
FREUDENREICH, Marek
Polish, 20th cent.
FREUDWEILER, Heinrich
Swiss, 1755-1795
FREUND, Christoph
(Johann Christoph)
German, op.c.1720-1750
FREUNDLICH, Otto
German, 1878-1943
FREW, Mrs. Alexander
see MacNicol, Bessie
FREY or Freij, Anna de
Dutch, c.1775-1808
FREY, Hans
German, -1523
FREY the Elder, Johan
Jacob (Giacomo)
Swiss, 1681-1752
FREY, Johann Jakob
Swiss, 1813-1865
FREY, Johann Wilhelm
German, 1830-
FREY, Wilhelm
German, c.1816-1841
FREY, Wilhelm
German, 1826-1911
FREYBERG, Conrad
German, 1842-
FREYBERG, Electrina von
German, 1797-1847
FREYBERGER, Johann
German, 1571-1631
FREYBURG, Frank P.
British, op.c.1896
FREYHOFF, Eduard
German, c.1810-1842/4
FREYHOLD, Carl von
German, 1878-1944
FREY-MOOCK, Adolf
German, 20th cent.
FREYSE, Albert
German, op.1643-m.1652
FREY-SURBEK, Marguerite
Swiss, 1886-
FREYTAG, Johann Konrad, I
Swiss, 1770-1837
FREYTAG, Otto
German, 20th cent.
FREZZA, Giovanni
Girolamo
Italian, 1659-p.1741
FRIANT, Emile
French, 1863-1932

FRIBERG, Arnold
American, 19th cent.
FRIBOULET, Jef
French, 20th cent.
FRICH, Joachim Christian
Geelmuyden Gyldenkrantz
Norwegian, 1810-1858
FRICKE, August
German, 1875-
FRICX, Bernard
Flemish, 1754-1814
FRIDELL, Axel
Swedish, 1894-1935
FRIDRICH or Friedrich,
Jacob Andreas
German, 1684-1751
FRIDSBERG, O.
Swedish, 19th cent.
FRIED, Heinrich Jakob
German, 1802-1870
FRIED, Pal
Hungarian, 1893-
FRIEDEL, Christof
German, op.1600
FRIEDENSOHN, Elias
American, 1924-
FRIEDENSON, Arthur A.
British, 1872-
FRIEDLAENDER
French 1912-
FRIEDLAENDER, Alfred
Austrian, 1860-
FRIEDLAND, Jeffrey
American, 20th cent.
FRIEDLANDER, Camilla
German, 1856-
FRIEDLÄNDER, Friedrich,
Ritter von Malheim
German, 1825-1901
FRIEDLANDER, Hedwig
Austrian, 1863-
FRIEDLANDER, Johnny
German, 1912-
FRIEDLANDER, Max
German, 1867-1958
FRIEDMAN, Arthur
British, op.c.1912-1940
FRIEDMANN
French, 20th cent.
FRIEDRICH von
Aschaffenburg
German, op.1448-1462
FRIEDRICH, Adolf
German, 1824-1889
FRIEDRICH, Caroline
Friederike
German, 1749-1815
FRIEDRICH, Caspar David
German, 1774-1840
FRIEDRICH, Harald
German, 1858-
FRIEDRICH, Jacob
(Johann Christian
Jacob)
German, 1746-1813
FRIEDRICH, Jacob Andreas
see Fridrich
FRIEDRICH de Lamberto
Sustris, Friedrich
FRIEDRICH, Otto
German, 1862-1937
FRIEDRICH, Peter
German, -1616
FRIEDRICH Wilhelm IV
German, 1795-1861
FRIEND, Donald
Australian, 1914-

FRIEND, Washington F.
American, op.c.1870
FRIENZ, Eduard de
French(?), 19th cent.
FRIER, Walter
British, c.1721
FRIES, Adriaen de
see Vries
FRIES, Anna Susanna
Swiss, 1827-1901
FRIES, Anton
German, 1764/8-1834
FRIES, Bernhard
German, 1820-1879
FRIES, Ernst
German, 1801-1833
FRIES, Hans
Swiss, c.1465-c.1520
FRIES, Willy
Swiss, 1881-
FRIESACH, Konrad von
see Konrad von
Freisach
FRIESE, Richard
German, 1854-1918
FRIESEKE, Frederick
Carl
American, 1874-1939
FRIESELHEM (Freislhien),
P.
German, 18th cent.
FRIESZ, Emile Othon
French, 1879-
FRIIS, Hans Gabriel
Danish, 1839-1892
FRILLIE, Félix Nicolas
French, 1821-1863
FRIMLARGST, P.A.
Danish, op.1667
FRINK, Elizabeth
British, 1930-
FRIPP, Alfred Downing
British, 1822-1895
FRIPP, Charles Edwin
British, 1854-1906
FRIPP, George Arthur
British, 1813-1896
FRIPP, J.H.
British, 19th cent.
FRIQUET, Jacques
('de Vauroze')
French, 1638-1716
FRIS, Jan or Johannes
Dutch, 1627/8-1672
FRIS or Frits, Pieter
Dutch, 1627/8-a.1708
FRISCH, Johan Didrik
Norwegian, 1835-1867
FRISCH, Johann Christoph
German, 1738-1815
FRISCHE, Heinrich Ludwig
German, 1831-1901
FRISIUS or Vriesius,
Simon Wynhoutsz. or
Weynouts (Simon Wynhoutsz.
de Vries)
Dutch, c.1580-1629
FRISIUS, Theodorus
see Vries, Dirck de
FRISO dal, Alvise
see Benfatto, Luigi
FRISSELL, Toni
American, 20th cent.
FRISTER, Carl (Johann Carl)
German, 1742-1783
FRISTOM, Claus Edward
New Zealander, -1942
FRISTON, Adrian de
British, 1900-

FRITH, Clifford
British, 20th cent.
FRITH, F.
American, op.1781
FRITH, William Powell
British, 1819-1909
FRITS, Pieter
see Fris
FRITSCH, Christian
Friedrich
see Fritzsch
FRITSCH, Ernst
German, 1892-
FRITSCH, F.J.
American, op.1843/4
FRITSCH, Melchior
German, 1826-1889
FRITSCHE or Fritzsche,
George Christian
German, op.1681-1709
FRITZ, August
German, 1843-p.1878
FRITZEL, Wilhelm
German, 1870-1943
FRITZSCH or Fritsch,
Christian Friedrich
German, 1719-a.1774
FRITZSCH, Claudius
Ditlev
Danish, 1763-1841
FROBENIUS, Hermann
German, 1871-c.1954
FROELIX, H.
German, op.1721
FROER, Veit
German, 1828-c.1900
FRÖHLICH, Betty
(Bogner)
German, 1798-1878
FROHNER, Adolf
German, 1934-
FROISART
Flemish(?), 18th cent.
FRÖLICH, Lorens
Danish, 1820-1908
FRÖLICH, Lucas
(Laux Frelich)
(Monogrammist L.F.)
Danish, op.1490-1511
FRÖLICHER, Otto
Swiss, 1840-1890
FROLOV, V.A.
Russian, 20th cent.
FROMANTIOU, Hendrik de
Dutch, 1633/4-1694/1700
FROMENT, Nicolas
French, op.1450-1490
FROMENTIN-DUPEUX, Eugène
Samuel Auguste
French, 1820-1876
FROMILLER, Josef
Ferdinand
German, 1693-1760
FROMMEL, Carl Ludwig
German, 1789-1863
FROMMER, Wilhelm
German, op.1638-1653
FROMUTH, Charles Henry
American, 1861-
FRONTIER, Jean Charles
French, 1701-1763
FROOD, Hester
(Gwynne-Evans)
British, 1882-
FROSCHEL, Hanns
German, op.1620
FROSCHL, Carl
German, 1848-

FRÖSCHL, Freschel,
Froschlein or Frossley,
Daniel
German, a.1570-1613
FROSINO, Luca
Italian, 15th cent.
FROSNE, Jean
French, c.1623-p.1676
FROSSARD, Claude
French, 20th cent.
FROSSARD, L.
French, 19th cent.
FROST
British, 18th cent.
FROST, Arthur Burdett
American, 1851-1928
FROST, George
British, c.1754-1821
FROST, George Albert
American, 1843-
FROST, J.O.J.
American, 1852-1928
FROST, James
British, op.1766-1783
FROST, Terry
British, 1917-
FROST, William Edward
British, 1810-1877
FROTHINGHAM, James
American, 1786-1864
FROUDE, Rev. Robert
Hurrell
British, 18th cent.
FROY, Martin
British, 1926-
FRUEAUF, Rueland, I
German, 1440/50-1507
FRUEAUF, Rueland, II
German, op.1498-1545
FRÜHBECK, Franz
German(?), op.1795-1830
FRÜHTRUNK, Gunter
German, 1923-
FRÜHWIRTH or Fruwirth,
Carl
German, 1810-1878
FRUITIERS, Philip
see Fruytiers
FRUMI, Lotte
Italian, 20th cent.
FRUTET, Frans or
Francesco
Netherlands, op.1548
FRUWIRTH, Carl
see Frühwirth
FRUYTIERS or Fruitiers,
Philip
Flemish, 1610-1666
FRY, Anthony
British, 1927-
FRY, C.Arthur
British, 20th cent.
FRY, Helen
British, -1937
FRY, Malcolm
British, 1909-
FRY, Margery
British, 20th cent.
FRY, Roger
British, 1866-1934
FRY, S.
British, op.1783
FRYBERG
German, 18th cent.
FRYE, Thomas
(not Theodore)
British, 1710-1762

FRYER, Edward H.
British, op.1819-1843
FRYER, G.G.
British, 19th cent.
FRYER, William
British, 19th cent.
FRYS, Adriaen de
see Vries
FRYTOM, Frederick
van
Dutch, op.1658-1690
FRYTOM, Joanna van
Dutch, 17th cent.
FUCHS, Emil
German, 1866-1929
FUCHS, Ernst
German, 1930-
FUCHS, Felix Cajetan
Christoph
Swiss, 1749-1814
FUCHS, Feodor
American, 19th cent.
FUCHS, Georg Mathias
German, 1719-1797
FUCHS, Jack
American, 20th cent.
FUCHS, Joseph
German, 1810-1880
FUECHSEL, Hermann
American, 1833-1915
FUERTES, Louis Agassize
American, 1874-1927
FUETER, E.
German, 18th cent.
FUGE, James
British, op.1830-m.1838
FUGELSCHAUG, Fiigenschoug
or Fügenschaug, Elias
Norwegian, op.1635-1652
FÜGER, Friedrich
Heinrich
German, 1751-1818
FUHER, W.
German, op.1843
FUHR, Xavier
German, 1898-
FÜHRICH, Joseph Ritter
von
German, 1800-1876
FÜHRMANN, C.G.
German, op.1842-1850
FUK, Nicolaes
see Ficke
FULCHRAM, Jean Harriet
French, op.1796
FULDA, Albert
German, op.1820-1854
FULDE, Edward B.
American, op.1896-1912
FULLA, Ludovit
Czech, 1909-
FULLER, George F.
American, 1822-1884
FULLER, Henry Brown
American, 1867-
FULLER, Isaac
British, 1606-1672
FULLER, Martin
British, 1943-
FULLER, Samuel
American, 19th cent.
FULLEYLOVE, John
British, 1845-1908
FÜLLMAURER, Heinrich
Swiss, op.1536-1543
FULLWOOD, Albert
Henry
British, 1863-

FULLWOOD, John
British, op.1881-1915
FULTON, Hamish
British, 20th cent.
FULTON, Robert
American, 1765-1815
FULUTTI or Fulutto,
Pietro
Italian, op.1512-1519
FUMAGALLI, Gerolamo
Italian, 16th cent.
FUMERON, Rene
French, 20th cent.
FUMIANI, Giovanni Antonio
Italian, 1643-1710
FUMICELLI, Lodovico
see Fiumicelli
FUMMACCHINI, Orazio
see Samacchini
FUNCK or Vonck,
Cornelis
Dutch, op.1693-1712
FUNCK, Valerian
German, op.1754-1770
FUNGAI, Fongario or
Fungari, Bernardino
Italian, c.1460-1516
FUNHOF, Fonhave,
Funghoff or Vonhoff
(not Van Hof)
Heinrich
German, op.1475-m.1484/5
FUNI, Achille
Italian, 1890-
FUNK, Hans, I
Swiss, a.1470-1539
FUNK, Hans, II
Swiss, op.1523-m.1562
FUNK, Heinrich
German, 1807-1877
FUONTEBUONI, Anastasia
Italian, 17th cent.
FURCK, Sebastian
German, c.1600-1655
FURINI, Francesco
Italian, 1600/4-1646
FURNASS, John Mason
American, 1763-1804
FURNERIUS or Farnerius,
Abraham
Dutch, c.1628-p.1648
FURNISS, Harry
British, 1855-1941
FURNIVAL, John
British, 20th cent.
FURSE, Charles Welligton
British, 1868-1904
FURSE, Roger
British, 20th cent.
FURSE, W.H.
British, op.1830-1850
FURST, Josef
German, op.1798
FÜRST, Paul
German, c.1605-1666
FÜRSTENBERG, Theodor
Caspar, Baron von
German, op.1624-m.1675
FURTENAGEL or
Fortenagel, Lucas
or Laux
German, 1505-p.1546
FURTTENBACH or
Furttembach the Elder,
Josef
German, 1591-1667
FUSELI, Henry
see Füssli, Johann Heinrich

A Checklist of Painters c1200-1976

G

FUSSEL, Alexander
British, op.1838-1881
FUSSELL, Charles Lewis
American, 1840-1909
FUSSELL, Joseph
British, op.1821-1845
FUSSELL, Michael
British, 1927-
FÜSSLI, Friedrich
Salomon
Swiss, 1802-1847
FÜSSLI, Heinrich, I
Swiss, 1720-1802
FÜSSLI, Heinrich, II
Swiss, 1755-1829
FÜSSLI the Elder,
Johann (Hans)
Caspar
Swiss, 1706-1782
FÜSSLI, Fuseli,
Fusslin or Füssly
the Younger, Henry
or Johann Heinrich
Swiss, 1741-1825
FÜSSLI, Mathias, I
Swiss, 1598-1665
FÜSSLI, Mathias, III
Swiss, 1671-1739
FÜSSLI, Melchior
(Johann Melchior)
Swiss, 1677-1736
FÜSSLI, Rudolf, I
(Johann Rudolf)
Swiss, 1680-1761
FÜSSLI, Rudolf, II
(Johann or Hans
Rudolf)
Swiss, 1709-1793
FÜSSLI, Rudolf, III
Johann Rudolf)
Swiss, 1737-1806
FÜSSLI, Wilhelm
Heinrich
Swiss, 1830-1916
FUSTO, F.
Italian, 17th cent.
FÜTERER, Fuetrer,
Furtrer, Fütrer
etc., Ulrich
German,
op.1460-m.1496/1500
FUTTERER, Josef
German, 1871-1930
FUX, Franz
German, 1745-p.1787
FUX, Johann Adam
German, op.1750-1753
FUIJCK, Maerten
van der
Dutch, op.1660-1683
FYFE, William Baxter
British, 1836-1882
FYK, Nicolaes
see Ficke
FYOL, Conrad
German,
op.1448-m.1499/1500
FYT or Fijt,
Joannes or Jan
Flemish, 1611-1661

GAAL, Pieter
German, 1770-1819
GAALEN, Alexander van
see Gaelen
GABAIN, Ethel
British, 1883-1950
GABBI
Italian, 18th cent.
GABBIANI, Antonio
Domenico
Italian, 1652-1726
GABE, Nicolas Edward
French, 1814-1865
GABINO, Amadeo
Spanish, 20th cent.
GABIOU, Jeanne
Elisabeth
see Chaudet
GABL, Alois
German, 1845-1893
GABLER, Ambrosius
German, 1762-1834
GABO, Naum
Russian, 1890-1977
GABORIAUD, Josue
French, 20th cent.
GABRIEL
French, 18th cent.
GABRIEL, Jacques Ange
French, 1698-1782
GABRIEL, Justin
(Joseph Marie Justin)
French, 1838-
GABRIEL, Paul Joseph
Constantin
Dutch, 1828-1903
GABRIEL, Richard
British, 1924-
GABRIELLI da Viterbo,
Francesco dei
(Francischo Ghabriellis)
Italian, op.1426-1427
GABRIELLI, Gaspare
Italian, op.1805-m.1828
GABRIELLI or Gabriello,
Onofrio
Italian, 1616-1705/6
GABRINI, Pietro
Italian, 1856-1926
GABRITSCHEVSKY, Eugene
Russian, 20th cent.
GABRON, Guilliam or
Willem
Flemish, 1619-1678
GACHET
see Gatschet
GACHET, Doctor
see Ryssel
GACSI, Mihaly
Hungarian, 1926-
GADANYI, Jeno
Hungarian, 1896-1960
GADBOIS
French, op.1791-m.c.1826
GADDI, Angelo or Agnolo
di Taddeo
Italian, c.1350-1396
GADDI, Compagno di
Agnolo
see Starnina

GADDI, Gaddo di
Zanobi
Italian, op.c.1308-1330
GADDI, Giovanni di
Taddeo
Italian, op.1369-m.1383
GADDI, Taddeo di
Gaddo
Italian, op.1334-m.1366
GADSBY, Eric
British, 1943-
GAEL, Adriaen, II
Dutch, c.1618/24-1665
GAEL, Barend
Dutch, op.1658-1681
GAEL, Cornelis
Adriaensz., I
Dutch, 1589/90-p.1672
GAEL, Cornelis
Adriaensz., II
Dutch, c.1618/24-c.1654/60
GAELEN or Gaalen,
Alexander van
Dutch, 1670-1728
GAEREMYN, Jan Anton
see Garemyn
GAERNTER, Christoff
see Gerttner
GAERTNER, Carl Frederick
American, 1898-1952
GAERTNER de la Peña,
José
Spanish, c.1860-
GAERTNER, Peter
see Gertner
GAESBEECK, Adriaen van
Dutch, 1621/2-1650
GAETA, Francesco
Italian, 17th cent.
GAETANO, Scipione
see Pulzone
GAEY
see Grey
GAGARIN, Gregori
Grigorievitch, Prince
Russian, 1810-1893
GAGEN, Robert Ford
British, 1847-1926
GAGGIOTTI-RICHARDS,
Emma
Italian, 1825-1912
GAGINI or Gaggini,
Antonello
Italian, 1478-1536
GAGLIARDI, Bernardino
Italian, 1609-1660
GAGLIARDI, Filippo
Italian, op.1640-m.1659
GAGLIARDI, Pietro
Italian, 1809-1890
GAGLIARDINI, Julien
Gustave
French, 1846-1927
GAGNAIRE, Aline
French, 20th cent.
GAGNERAUX, Bénigne
(not Benjamin or
Benedetto)
French, 1756-1795
GAGNERY, Jean Auguste
French, 1778-p.1845
GAGNEUX
French, op.1733
GAGNON, Charles
Canadian, 1934-

GAGNON, Clarence A.
Canadian, 1881-1942
GAHRLIEB von der Mühlen,
Gustaf Casimir
German, 1630-1717
GAIANI, Carlo
Italian, 1929-
GAIBANO, Giovanni
(de Gaibana)
Italian, op.1253
GAIDANO, Paolo
Italian, 1861-1917
GAIG, G.M.M.
British(?), 1638-p.1659
GAIL, Joseph
German, op.1796-p.1818
GAIL, Wilhelm
German, 1804-1890
GAILLARD, Claude
Ferdinand
French, 1834-1887
GAILLARD, Francois
Flemish, op.1634-m.1664
GAILLARDOT, Pierre
French, 20th cent.
GAIN, Jacob de
see Gheyn
GAINSBOROUGH, Thomas
British, 1727-1788
GAINSFORD, F.G.
British, op.1805-1822
GAISSER, Jakob Emanuel
German, 1825-1899
GAISSER, Max
German, 1857-1922
GAITIS, Yannis
Greek, 1923-
GAL, Menchu
Spanish, 20th cent.
GALANDA, Mikulas
Czech, 1895-1938
GALANINI
see Aloisi, Baldassare
GALANIS, Demetrios
French, 1882-1966
GALANTE, Francesco
Italian, 1884-
GALANTINI, Ippolito
Italian, 1627-1706
GALARD, Gustave
French, c.1777-1840
GALASSO di Matteo Piva
(Galasso Galassi or
Alghisi)
Italian, op.c.1450
GALBRUND, Alphonse
Louis
French, 1810-1885
GALE, Benjamin
British, op.c.1775-1830
GALE, William
British, 1823-1909
GALEA, L.
British, op.1894
GALEN, G.D.
Dutch, op.1779
GALEN, Nicolaes van
Dutch, c.1620-p.1683
GALEN, Thyman van
Dutch, 1590-p.1632
GALEOTTI, Giuseppe
Italian, 1708-1778
GALEOTTI, Sebastiano
(Bastiano)
Italian, c.1676-1746

GALESTRUZZI, Giovanni
Battista
Italian, 1615/8-p.1669
GALEY, Gaston Pierre
French, 1880-
GALGARIO, Fra
see Ghislandi
GALIANI, Rossano
Italian, 19th cent.
GALIANO, Alvaro Alcala
Spanish, 19th cent.
GALIBERT, Pierre
French, op.1870-1876
GALICE, Louis
French, 19th cent.
GALIEGUE, Marcel
French, 20th cent.
GALIEN-LALOUE or
Gallien-Laloue,
Eugène
French, 1854-1941
GALIMARD, Auguste
(Nicolas Auguste)
French, 1813-1880
GALIMBERTI, Francesco
Italian, 1755-1803
GALINDO, Victoriano P.
Spanish, 20th cent.
GALIZIA or Gallizi,
Fede
Italian, 1578(?)-1630(?)
GALIZZI, Giovanni
Italian, op.1543
GALKUS, Juozas
Russian, 20th cent.
GALL, Francois
French, 1912-1945
GALL, Joseph
French, 1807-1886
GALLAIT, Louis
Belgian, 1810-1887
GALLAND, Pierre Victor
Swiss, 1822-1892
GALLARD, Michel de
French, 1921-
GALLARD-LEPINAY,
Emmanuel
French, 1842-1885
GALLARDO, Luis
Spanish, 19th cent.
GALLATIN, A.E.
American, 20th cent.
GALLE, Cornelis, I
Flemish, 1576-1650
GALLE, Cornelis, II
Flemish, 1615-1678
GALLE, Hieronymus, I
Flemish, 1625-p.1679
GALLE, Joan or Joannes
Flemish, 1600-1676
GALLE, Philipp
Netherlands, 1537-1612
GALLE, Theodor
Flemish, c.1571-1633
GALLE, Tibor
Hungarian, 1896-1944
GALLEE, Elias
German, 17th cent.
GALLEGOS, Fernando
(Fernandus Galecus)
Spanish, c.1440-p.1507
GALLEGOS, Francisco
Spanish, op.1500
GALLEGOS y Arnosa,
José
Spanish, 1859-1917

GALLEN-KALLELA, Akseli
Valdemar
Swedish, 1865-1931
GALLENSTEIN, Kuntz
German, 19th cent.
GALLERI, Charles
French, op.1601-1602
GALLES, Juan
Spanish, op.c.1850
GALLETTI, Filippo Maria
Italian, 1636-1714
GALLHOF, Wilhelm
German, 1878-1918
GALLI, Alfredo
Italian, 20th cent.
GALLI, Gino
Italian, 1893-
GALLI, Giovanni
Italian, op.1547-1568
GALLI, Giovanni Antonio
Italian, op.c.1615-
GALLI, Luigi
Italian, 1820-1906
GALLI, Q.
German, 18th cent.
GALLI, Riccardo
Italian, 1839-m.p.1890
GALLIARI, Bernardino
Italian, 1707-1794
GALLIARI, Fabrizio
Italian, 1709-1790
GALLIARI, Gasparo
Italian, c.1760-1818
GALLIARI, Giovanni
Antonio
Italian, 1718-1783
GALLIBERT, Geneviève
French, 1888-
GALLIE, P.
French, 18th cent.
GALLIEN, Pierre-Antoine
French, op.c.1919
GALLIMARD, Claude
Olivier
French, 1718/19-1774
GALLINA, Lodovico
Italian, 1752-1787
GALLIS, Pieter
Dutch, 1633-1697
GALLIZI, Fede
see Galizia
GALLIZIO, Pinot
Italian, 1902-
GALLO, Giovanni
Antonio (Spadarino
or Spadaro)
Italian, op.1615-1650
GALLO, Girolamo
Italian, 17th cent(?)
GALLOCHE, Jean
see Louis Galloche
GALLOCHE, Louis
French, 1670-1761
GALLON, Robert
British, op.1868-1905
GALLOWAY, A.
British, 19th cent.
GALOFRE y Giménez,
Baldemiro
Spanish, 1849-1902
GALSWORTHY, Gordon C.
British, 20th cent.
GALSWORTHY, Olive
British, 19th cent.

GALTIER-BOISSIERE,
Louise
French, 19th cent.
GALTON, Ada Mary
British, 19th cent.
GALTON, H.
British, 19th cent.
GALVÁN, Jésus
Guerrero
Mexican, 1912-
GALVAN y Candela,
José Maria
Spanish, 1864-
GALVANO
see Calvano
GALVEZ, Juan
Spanish, 1774-1847
GAMAR, A.
Italian, 19th cent.
GAMASSIONI
see Ganassoni
GAMBACCIANI, Francesco
Italian, 1701-p.1771
GAMBARA, Lattanzio
Italian, c.1530-1573/4
GAMBARATO, Gambarotto
or Gamberati, Girolamo
Italian, op.1591-m.1628
GAMBARDELLA, Spiridione
British, op.1842-1868
GAMBARDI
Italian, 19th cent.
GAMBARINI, Giuseppe
Italian, 1680-1725
GAMBARUCCIO or Gamberucci,
Cosimo
Italian, op.1598-1619
GAMBEL
British, op.1773
GAMBERINI, Giovacchino
Italian, 1859-
GAMBINO, Giuseppe
Italian, 1928-
GAMBS or Gams, Benedickt
Swiss, op.1745-1751
GAMELIN, Jacques
French, 1738-1803
GAMMON, James
British, op.1660-1670
GAMPENRIEDER, Karl
German, 1860-
GAMPER, Gustav Adolf
Swiss, 1873-
GAMPERT, Otto
Swiss, 1842-1924
GAMUSSONI
see Ganassoni
GANASSONI, Giacomo
Italian, 18th cent.
GANDAGLIA, Luca
Italian, 18th cent.
GANDAR, A.A.
French, op.1799
GANDARA, Antonio de la
French, 1862-1917
GANDAT
French, op.1779-m.1797
GANDIA, Juan de
(Juan Fernandez de
Gandia)
Spanish, op.1659
GANDINI or Gandino,
Antonio
Italian, op.1602-m.1630
GANDINI, Francesco
Italian, 1723-p.1778

GANDINI del Grano, Giorgio
Italian, 1489-1538
GANDOLFI, Francesco
Italian, 1824-1873
GANDOLFI, Gaetano
Italian, 1734-1802
GANDOLFI, Mauro
Italian, 1764-1834
GANDOLFI, Ubaldo
Italian, 1728-1781
GANDOLFINO di Boreto or
de Roretis d'Asti
Italian, op.1493-1510
GANDON, James
British, 1742-1823
GANDON, Pierre
French, 1899-
GANDY, Herbert
British, 19th cent.
GANDY, James
British, 1619-1689
GANDY, Joseph Michael
British, 1771-1843
GANDY, Thomas
British, op.1848-1859
GANDY, William
British, c.1660-1729
GANJU, Ioan
Rumanian, 1942-
GANNE, Yves
French, 1931-
GANNUOLO, Il
see Pallavicini,
Giacomo
GANSO, Emil
American, 1895-1941
GANTER, Bernard
French, 1928-
GANTER, Dionys
German, 1800-1864
GANTER, Nikolaus
German, 19th cent.
GANTER, W.
German, op.c.1800
GANTZ, Justinian
British, op.1850
GANZ, Edwin
Swiss, 1871-
GANZINOTTO, G.P.
Italian, 17th cent.(?)
GAPUTYTE, Elena
British, 1927-
GARANJOUD, Claude
French, 1926-
GARAT, Francis
French, op.c.1898
GARAUD, G.B.
French, op.c.1750-1778
GARBAS, Marco
Italian, 18th cent.
GARBELL, Alexandre
French, 1903-
GARBER, Daniel
American, 1880-
GARBETT, Gordon
British, 19th cent.
GARBI, Domenico
Italian, op.1797-1812
GARBIANI, G.B.
Italian, 17th cent.
GARBIERI, Lorenzo
Italian, 1580-1654
GARBIZZA, Angelo
French, op.c.1810
GARBO, Raffaellino del
see Raffaellino

GARBRAND, Caleb J.
 British, op.1775-1789
GARCEMENT, Alfred
 British, op.1868-1903
GARCIA y Reynoso,
 Antonio
 Spanish, c.1623-1677
GARCIA y Salmeron,
 Cristobal
 Spanish, c.1603-1666
GARCIA, Fernandez
 Spanish, op.1519-1540
GARCIA, Joaquin Torres
 Uruguayan, 1874-1949
GARCIA el Hidalgo,
 José
 Spanish, c.1650-1717
GARCIA y Ramos, José
 Spanish, 1852-1912
GARCIA de Miranda,
 Juan
 Spanish, 1677-1749
GARCIA, Luis Ignacio
 de Homa
 Spanish, 20th cent.
GARCIA y Barcia,
 Manuel
 Spanish, op.1858-1877
GARCIA y Rodriguez,
 Manuel
 Spanish, 1863-
GARCIA de Benabarre,
 Pedro
 Spanish, op.1455-1456
GARCIA y Garcia, Rafael
 (Garcia Hispaleto)
 Spanish, 1833-1854
GARCIA MELGAREJO, Diego
 Spanish, -1724
GARCIN, Gilles
 French, op.1690-1700
GARCIN, Laure
 French, 1896-
GARD, de
 British, 17th cent.
GARDELLE, Elie(?)
 Swiss, 1688-1748
GARDELLE the Younger,
 Robert
 Swiss, 1682-1766
GARDELLE, Théodore
 Swiss, 1722-1761
GARDENER, Rev. William
 British, 18th cent.
GARDIE, Mrs.
 British, op.1824-1837
GARDIER, Raoul du
 French, 1871-1952
GARDIN
 see Dujardin
GARDINER, Miss
 British, op.1759
GARDINER, Clive
 British, 20th cent.
GARDINER, Eliza
 British, op.1802
GARDINER, William Nelson
 British, 1766-1814
GARDIJN
 see Dujardin
GARDNER, Daniel
 British, 1750-1805
GARDNER, Derek George
 Montague
 British, 1914-
GARDNER, Elizabeth Jane
 (Elizabeth Jane Bouguereau)
 American, 1851-1922

GARDNER, G.B.
 American, 19th cent.
GARDNER, W. Biscombe
 British, 1847-1919
GARDNOR, Rev. John
 British, 1729-1808
GAREIS, Franz
 German, 1775-1803
GARELLI or Garello,
 Tommaso d'Alberto
 (Masacodo)
 Italian, op.1452-1495
GAREMYN or Gaeremyn,
 Jan Anton
 Flemish, 1712-1799
GARETS, Odette des
 French, 1891-
GARF, Salomon
 Dutch, 1879-1943
GARGIULI, Domenico
 (Micco Spadaro)
 Italian, 1612-a.1679
GARI, A.
 German, 18th cent.
GARIBALDI, Joseph
 French, 1863
GARIBALDI or Garibaldo,
 Marc Antonio
 Flemish, 1620-1678
GARIBBO, Luigi
 Italian, 1784-1869
GARINEI, Giuseppe
 Italian, op.1887
GARIPUY, Jules
 French, 1817-1893
GARLAND, Henry
 British, op.1854-1890
GARLAND, Valentine
 Thomas
 British, op.1867-1893
GARLE(?)
 German(?), 18th cent.
GARNELO y Alda, José
 Ramón
 Spanish, 1867-
GARNER, Edith Mary
 (Edith Mary Lee-Hankey)
 British, 1881-
GARNERAY, Louis
 (Ambroise Louis)
 French, 1783-1857
GARNEREY, Auguste Simon
 French, 1785-1824
GARNEREY (not Garneray),
 Francois Jean
 French, 1755-1837
GARNEREY, Hippolyte Jean
 Baptiste
 French, 1787-1858
GARNEY, William
 British, op.1772
GARNIER, Antoine
 French, 1611-1694
GARNIER, Claude
 French, 20th cent.
GARNIER, Etienne
 Barthélemy
 French, 1759-1849
GARNIER, Francois
 French, 1590-1658
GARNIER, Geoffroy
 French, 20th cent.
GARNIER, Jean
 French, 1632-1705
GARNIER, Jean Baptiste
 French, -1759
GARNIER, Jules Arsène
 French, 1847-1889

GARNIER, Michel
 French, op.1793-1814
GAROFALINI or
 Garofolini, Giacinto
 Italian, 1661-1723
GAROFALO, Benvenuto
 Tisio da
 Italian, 1481-1559
GAROLI or Garola,
 Pier Francesco
 Italian, 1638-1716
GARRARD, George
 British, 1760-1826
GARRARD, Marcus
 see Gheeraerts
GARRATT, Arthur P.
 British, op.1899-1908
GARRAUD, Léon
 French, 1877-
GARRET, Marcus
 see Gheeraerts
GARRETT, H.
 British, op.1650
GARREZ, Pierre Joseph
 French, 1802-1852
GARRI, Giorgio
 Italian, -c.1731
GARRIDO, Eduardo Leon
 Spanish, 1856-
GARRIDO, Leandro Ramón
 French, 1868-1909
GARRIGA, Umberto Pena
 S.America, 20th cent.
GARRIOT
 French, 18th cent.
GARRISON, Benjamin
 British, op.1757
GARRISON, Eve
 American, 20th cent.
GARRISON, T.
 British, op.1713
GARSIDE, Helen
 British, 1893-
GARSTIN, Alethea
 British, op.1910-1970
GARSTIN, Norman
 British, 1855-1926
GARTHWAITE, W.
 British, 19th cent.
GÄRTNER, Eduard
 (Johann Philipp
 Eduard)
 German, 1801-1877
GÄRTNER, Friedrich
 German, 1824-1905
GÄRTNER, Fritz
 Czech, 1882-1958
GÄRTNER, Heinrich
 German, 1828-1909
GARVEY, Edmund
 British, op.1767-m.1813
GARVIE, Thomas Bowman
 British, 1859-1934
GARZI, Luigi
 Italian, 1638-1721
GARZIA, Giuseppe
 Italian, op.1922
GARZONI, Giovanna
 Italian, 1600-1670
GASC, Anna Rosina
 see Lisiewska
GASCAR, Henri
 French, 1634/5-1701
GASCO, Joan
 Spanish, op.1502-1529
GASCO, Pere or Pedro
 Spanish, op.1522-1546
GASILEWSKIJ, Nikolay, I
 Russian, 20th cent.

GASKELL, Percival
 British, 1868-1934
GASKIN, Arthur Joseph
 British, 1862-1928
GASNER, Johann Nikolaus
 German, 18th cent.
GASPARD, Leon
 Russian, 1882-
GASPARE or Guaspare
 d'Agostino
 Italian, op.1451-1455
GASPARE da Imola
 see Sacchi, Gaspare
GASPARE da Pesaro
 Italian, op.1421-m.a.1462
GASPARI, Antonio
 Italian, 1793-p.1823
GASPARI or Caspari,
 Giovanni Paolo
 Italian, 1714-1775
GASPARI or Caspari,
 Pietro
 Italian, c.1720-c.1785
GASPARINI, Gasparo
 Italian, -p.1570
GASPARO dei Fiori
 see Lopez
GASPARO degli Occhiali
 see Wittel
GASPARO Veronensis
 Italian, op.1550
GASPAROLI
 Italian, op.c.1830
GASPERS, Jan Baptist
 see Jaspers
GASSEBNER, Hans
 German, 1902-1966
GASSEL, Lucas
 Netherlands,
 op.1538-1568
GASSELIN, François(?)
 French, c.1683-1703
GASSELIN, Noel (?)
 French, op.1703
GASSER, Anton
 German, op.1610-1615
GASSER, Hans
 German, 1817-1868
GASSER, Leonardo
 Italian, 1831-
GASSIES, Arnaldo
 (Master of Elne)
 Spanish, op.1434-m.c.1456
GASSIES, Jean Bruno
 French, 1786-1832
GASTALDI, Andrea
 Italian, 1826-1889
GASTAUD, Pierre
 French, 20th cent.
GASTE, Georges Constant
 French, 1869-1910
GASTI, (?)
 Italian(?), op.1861
GASTINEAU, Henry
 British, 1791-1876
GATCH, Lee
 American, 1902-
GATES, Henry L.
 British, 20th cent.
GATEWOOD, Maud
 American, 20th cent.
GATIER, Pierre-Louis
 French, 1878-
GATINE, Georges Jacques
 French, 1773-1831
GATON, Juan
 Spanish, op.1518
GATSCHET or Gachet,
 Niklaus
 Swiss, 1736-1817

GATTA, Bartolommeo
della
see Bartolommeo
GATTA, Saverio or
Xavier della
Italian, op.1777-1811
GATTERI, Giuseppe
Lorenzo
Italian, 1829-1884
GATTI, Annibale
Italian, 1828-1909
GATTI, Bernardino or
Bernardo (Il Sojaro)
Italian, c.1495-1575
GATTI, Gervasio
(Il Sojaro)
Italian, 1549-1631
GATTI, Girolamo
Italian, 1662-1726
GATTI, L.
Italian, 19th cent.
GATTI, Saturnino de'
Italian, 1463-c.1521
GATTIKER, Herman
Swiss, 1865-1951
GAU, Franz Christian
German, 1790-1853
GAUCHER, Charles Etienne
or Stephan
French, 1741-1802
GAUCHER, Yves
Canadian, 1934-
GAUCHEREL, Léon
French, 1816-1886
GAUCI, M.
British, op.c.1810-1846
GAUCI, Paul
British, op.1834-1866
GAUCI, William
British, op.1825-1840
GAUD, Léon
Swiss, 1844-1908
GAUDENZIO Ferrari
see Ferrari
GAUDIER-BRZESKA, Henry
British, 1891-1915
GAUDION, Andre
French, op.1612-1634
GAUDIOSO, Pietro
Italian, op.1674-1682
GAUDREAU, Pierre
see Goudreaux
GAUDY, Thomas
British, op.1849
GAUERMANN, Friedrich
German, 1807-1862
GAUERMANN, Jacob
German, 1773-1843
GAUFFIER, Cath.
French, 19th cent.
GAUFFIER, Louis
French, 1761-1801
GAUFFIER, Pauline
French, -1801
GAUGAIN, Philip A.
British, op.1808-1842
GAUGAIN, Thomas
French, 1748-1812
GAUGENGIGL, Ignaz
Marcel
German, 1855-1932
GAUGUIN, Paul
French, 1848-1903
GAUGUIN, Paul Rene
Danish, 1911-
GAUGUIN, Pola (Paul)
Rollon
Danish, 1883-

GAUL
German, 20th cent.
GAUL, August
German, 1869-1921
GAUL, Franz
German, 1837-1906
GAUL, Gilbert William
American, 1855-1919
GAUL, Gustav
German, 1836-1888
GAUL, Winifred
German, 1928-
GAULD, David
British, 1866-
GAULD, John Richardson
British, op.1913-1960
GAULLI, Giovanni
Battista
see Baciccia, Il
GAULT de Saint Germain,
Mme. E. de
French, op.1791-1797
GAULT de Saint-Germain,
Pierre Marie
French, 1754-1842
GAULTIER, Leonard
French, 1561-c.1641
GAULTIER, P.
French, 19th cent.
GAULTIER, Pierre Jacques
French, op.1740
GAUNERAY, J.F.
French, 18th cent.
GAUNT, William
British, 1874-
GAUPMANN, Rudolf
German, 1815-1877
GAUSE, Wilhelm
German, 1853-1916
GAUSSON, Léo
French, 1860-
GAUTHEROT, Pierre
French, 1769-1825
GAUTHIER, Oscar
French, 1921-
GAUTIER, Amand Désiré
French, 1825-1894
GAUTIER, Rodolphe
(Jean Rodolphe)
Swiss, 1764-1820(?)
GAUTIER, Théophile
French, 1811-1873
GAUTIER DAGOTY, or
D'Agoty, Arnaud Eloi
French, 1741-a.1780
GAUTIER DAGOTY or
d'Agoty, Edouard
French, 1744-1783/4
GAUTIER-DAGOTY, Fabien
French, 1747-p.1781
GAUTIER DAGOTY or
d'Agoty, Jacques
French, 1710-1781
GAUTIER DAGOTY or
d'Agoty, Jean Baptiste
André (Gautier Fils)
French, 1740-1786
GAUTIER-DAGOTY, Louis
(Honoré Louis)
French, 1746-p.1787
GAUTIER-DAGOTY, Pierre
Edouard
French, 1775-1871
GAUTIEZ, Pierre
French, 20th cent.
GAVARD, C.
French, op.1833/4

GAVARNI, Chevalier
Hippolyte Guillaume
Sulpice
French, 1804-1866
GAVASETTI or Gavassette,
Camillo
Italian, op.1625-m.1628
GAVASIO or Gavazzi,
Giovanni Giacomo
Italian, op.1512
GAVASSETTE, Camillo
see Gavasetti
GAVELIN, Margareta,
(née Capsius)
Finnish, op.1725-1751
GAVENCKY, Frank J.
American, 1888-1968
GAVIN, Robert
British, 1827-1883
GAW, William A.
American, 1895-
GAWDY or Gawdie, Sir
John
British, 1639-1699/1709
GAWELL, Oscar
German, 1888-1955
GAWINSKI, Antoni
Polish, 1876-
GAY, Bernard
British, 20th cent.
GAY, Edward B.
American, 1837-1928
GAY, N.
French, op.1780
GAY or Ge, Nikolai
Nikolajevitch
(Nicolas Gué)
Russian, 1831-1894
GAY, P. or B.
German(?), op.1792
GAY, Walter
American, 1856-1937
GAYFORD, T.
British, 18th cent.
GAYS, Howard
British, 19th cent.
GAYWOOD, Richard
British, op.1650-1680
GAZARD, François
Valentin
French, -1817
GAZE, Harold
British, 20th cent.
GAZI, Dragan
Yugoslav, 1930-
GAZOVIC, Vladimir
Czech, 1939-
GAZZETTA
Italian, op.1795
GEALST, S.
Netherlands(?), op.1697
GEAR, John W.
British, op.1821-m.1866
GEAR, William
British, 1915-
GEBAUER, Christian David
German, 1777-1831
GEBAUD, Y.
French, op.1828
GEBAUER, Paul Ernst
German, 1782-1865
GEBHARD, Albert
Finnish, 1869-
GEBHARD, Andreas
German, 1704-1774
GEBHARD, Johann
German, 1676-1756
GEBHARD, Otto
German, 1700-1773

GEBHARDT, Carl
German, 1860-1917
GEBHARDT, Eduard
(Carl Franz Eduard
von)
German, 1838-1925
GEBHARDT, Ludwig
German, 1830-1908
GEBHARDT, Wolfgang
Magnus
German, op.1730-1750
GEBLER, Otto
(Friedrich Otto)
German, 1838-1917
GECCELLI, Johannes
German, op.1959
GECHTOFF, Sonia
American, 1926-
GEDDES, Andrew
British, 1783-1844
GEDDES, Patrick
British, op.1895/6
GEDDES, William
British, op.c.1850
GEDELER or Goedeler,
Elias
German, 1620-1693
GEDLEK, Ludwig
Polish, 1847-
GEE, Joseph
British, 19th cent.
GEEFS, Isabelle Marie
Francoise (Fanny),
(née Corr)
Belgian, 1807-1883
GEEL, Daniel van
Dutch, op.1635-1660
GEEL, Jacob Jacobsz.
van
Dutch, c.1585-p.1638
GEEL, Joost van
Dutch, 1631-1698
GEELEN, Christiaan, I
van
Dutch, 1755-1824
GEELEN, Christiaan, II
van
Dutch, 1794-1826
GEER, Maximilian von
German, 1680-1768
GEERAERTS, Jasper
see Gerardi
GEERAERTS, Marcus
see Gheeraerts
GEERAERTS, Marten
Jozef
Flemish, 1707-1791
GEERARDI, Jasper
see Gerardi
GEERTGEN, Pseudo
see Master of the
Figdor Deposition
GEERTGEN tot Sint Jans
(Gerard or Gerrit van
Haarlem)
Netherlands,
c.1455/65-c.1485/95
GEERTZ, Julius
German, 1837-1902
GEESINK, Johan Louis
(Joop)
Dutch, 1913-
GHEEST, François de
Netherlands, 17th cent.
GEEST, Julius or
Juliaen Franciscus de
Dutch, op.1657-m.1699

GEEST, Wybrand
Simonsz. de
Dutch, 1592-p.1667
GEETS, Willem
Belgian, 1838-1919
GEFFCKEN, Walter
German, 1872-1950
GEFFROY, Edmond Aimé
Florentin
French, 1804-1895
GEGENBAUER, A. von
German, 1800-1876
GEGERFELT, Vilhelm
Swedish, 1844-1920
GEHBE, Eduard
German, 1845-
GEHR, Ferdinand
Swiss, 1896-
GEHRMANN, Johann Michael
German, -1770
GEHRTS, Carl
German, 1853-1898
GEHRTS, Johannes
German, 1855-p.1884
GEIBEL, Casimir
German, 1839-1896
GEIGENBERGER, Otto
German, 1881-1946
GEIGER, Carl Joseph
German, 1822-1905
GEIGER, Conrad
German, 1751-1808
GEIGER, Margarete
German, 1783-1809
GEIGER, Peter Johann
Nepomuk
German, 1805-1880
GEIGER, R.
British, 20th cent.
GEIGER, Rupprecht
German, 1908-
GEIGER, Willi
German, 1878-
GEIKIE, Walter
British, 1795-1837
GEIL(?), F. van
see Geit
GEIRNAERT, Jozef Lodewyk
Belgian, 1791-1859
GEISMAR, Hans von
German, op.1499
GEISSLER, Christian
Gottfried Heinrich
German, 1770-1844
GEISSLER, Christian
Gottlieb
German, 1729-1814
GEISSLER, J.G.
German, op.c.1780-1800
GEISSLER, Rudolf Carl
Gottfried
German, 1834-1906
GEISSLER, Wilhelm
German, 1848-1928
GEIST, August Christian
German, 1835-1868
GEIT, Geil or
Gell(?), F. van
Netherlands(?),
19th cent.(?)
GELASIO di Niccolò
('della Masnada di S.
Giorgio')
Italian, op.1242
GELBE, Eduard
German, 19th cent.

GELDART, Joseph
British, 1808-1882
GELDER, Arent or
Aert de
Dutch, 1645-1727
GELDER, J. van
Belgian(?), 19th cent.
GELDER, Nicolaes
(Claes) van
Dutch,
c.1625 or c.1635-1675/7
GELDERMAN, G.J.
Dutch, op.1828
GELDORP, Georg or Jorge
Flemish, op.1610-1653
GELDORP or Gualdorp,
Gortzius
Flemish, 1553-c.1616
GELDORP, Melchior
German, op.1615-1637
GELDTON, Toussaint or
Tousseijn
see Gelton
GELENG, Otto
German, 19th cent.
GELGER, J.
German, 19th cent.
GELHAY, Edouard
French, 1856-
GELIBERT, Jules Bertrand
French, 1834-1916
GELINET, Marcel
French, op.1927-1931
GELITON, T.
French, 17th cent.
GELIUS, Aegidius
Netherlands, op.1616
GELL(?), F. van
see Geit
GELLE, Johann
German, c.1580-1625
GELLEE or Gillée
see Claude
GELLER, Johann Nepomuk
German, 1860-1954
GELLI, Odoardo
Italian, 1852-1933
GELLIG, Jacob
see Gillig
GELTON, Geldton or
Geltton, Toussaint
or Tousseijn
Dutch, c.1630-1680
GEMELL or Gemelli, H.
British, 18th cent.
GEMIGNANI or Geminiani,
Giacinto
see Gimignana
GEMINUS, Thomas
Netherlands, c.1500-c.1570
GEMITO, Vincenzo
Italian, 1852-1929
GEMPERLE (Gemperlinus),
Tobias
German, c.1550-1601/2
GEMPT, Bernard te
Dutch, 1826-1879
GENBERG, Anton
Swedish, 1862-1939
GENCE, Robert
French, op.1713
GENDALL, John
British, 1790-1865
GENDRON, Ernest
Augustin
French, 1817-1881

GENDRON, Pierre
Canadian, 1934-
GENELLI, Bonaventura
(Giovanni Bonaventura)
German, 1798-1868
GENELLI, Camillo
German, 1840-1867
GENELLI or Genelly,
Janus
Danish, 1761-1813
GENER or Jener, Gerado,
Gerardo, Gerau or
Guerau
Spanish, 1369-p.1407
GENERALIC, Ivan
Yugoslavian, 1914-
GENERALIC, Josip
Yugoslav, 20th cent.
GENERALIC, Milan
Yugoslav, 20th cent.
GENET, Alexandre
French, op.1838
GENEVOIS, Genovese
or Lomellini,
Manuel
Italian, op.1509-1557
GENGA, Girolamo
Italian, c.1476-1551
GENGE, Charles
British, 20th cent.
GENIA
French, 20th cent.
GENICOT, Robert
French, 1890-
GENILLION, Jean Baptiste
François
French, 1750-1829
GENIN, Lucien
French, 1894-1958
GENIN, Robert
Russian, 1884-
GENIOLE, Alfred André
French, 1813-1861
GENIS, Renée
French, 1922-
GENISSON, Jules Victor
Belgian, 1805-1860
GENKINGER, Friez
German, 1934-
GENNARI the Elder,
Benedetto
Italian, op.1585-m.1610
GENNARI the Younger,
Benedetto
Italian, 1633-1715
GENNARI, Carlo
Italian, 1712-1790
GENNARI, Cesare
Italian, 1637-1688
GENNARI, Domenico
Italian, 18th cent.
GENOD, Michel
Philibert
French, 1796-1862
GENOELS, Abraham
(Archimedes)
Flemish, 1640-1723
GENOUD, Nanette
Swiss, 1907-
GENOVES, Juan
Spanish, 1930-
GENOVESE, Il
see Carlone,
Giovanni
GENOVESINO, II
see Miradori, Luigi

GENOVESINO, I1
see Roverio,
Bartolomeo
GEN-PAUL, (Eugene Paul)
French, 1895-
GENSLER, Günther
German, 1803-1884
GENSLER, Jacob
German, 1808-1845
GENSLER, Martin
German, 1811-1881
GENT, G.W.
British, op.1804-1822
GENTER, Heinrich
German, 1854-
GENTILE, Luigi
(Louis Cousin or
Luigi Primo; Gentiel)
Flemish, 1606-1667
GENTILE di Niccolò di
Giovanni Massi (Gentile
da Fabriano or
Gentilino)
Italian, 1360/70-1427
GENTILE da Sulmona
Italian, 13th cent.
GENTILESCHI, Artemisia
Lami (Schiattesi?)
Italian, 1597-p.1651
GENTILESCHI, Francesco
Italian, 1599-p.1665
GENTILESCHI, Orazio
Lomi
Italian, 1562-1647
GENTILI or Gentile,
Antonio (Antonio da
Faenza)
Italian, c.1519-1609
GENTILINI, Franco
Italian, 1909-
GENTLEMAN, David
British, 1930-
GENTRY, Herbert
Swedish, op.1959-1961
GENTZ, Heinrich
German, 1766-1811
GENTZ, Ismaël
(Wolfgang Christian)
German, 1862-1914
GENTZ, Wilhelm Carl
German, 1822-1890
GENZMER, Berthold
German, 1858-1927
GEOFFREY, Eqbal M.J.I.
British, 1939-
GEOFFROY, Jean Jules
Henri
French, 1853-1924
GEORG or George, Johann
Wilhelm or Jean
Guillaume
British, 1728-1791
GEORGALIDES, Stéphane P.
(Le Grec)
Greek, 20th cent.
GEORGE III, King
British, 1738-1820
GEORGE, Adrian
British, 20th cent.
GEORGE, Eric
British, 1881-
GEORGE, Sir Ernest
British, 1839-1922
GEORGE, J.
British, op.1821-1838

GEORGE, Jean Philippe
French, 1818-1888
GEORGE, John
British, op.1763-1771
GEORGE, Patrick
British, 1923-
GEORGE, T.
British, op.1819-1838
GEORGE, Thomas
American, 1918-
GEORGES
French, op.1798
GEORGES, Claude
French, 1929-
GEORGES, Emile
(Geo-Weiss)
French, 1861-
GEORGES, Paul
American, 20th cent.
GEORGESCU, Sergiu
Rumanian, 20th cent.
GEORGI, Friedrich Traugott
German, 1783-1838
GEORGI, Giovanni
Italian, op.1617-1656
GEORGI, Otto
(Friedrich Otto)
German, 1819-1874
GEORGI, Walter
German, 1871-1924
GEORGIADIS, Nicholas
British, 1925-
GEORGIOS or Georgius
Greek, op.1454
GEORGIUS
Polish, op.1517
GERA, Jacopo di
Michele, Il
Italian, op.1389-1390
GERAEDTS, Wijnandus
Aloisius (Wijnand)
Dutch, 1883-1958
GERARD, Claude Charles
French, 1757-1826
GERARD, E.
British, op.1815
GERARD, François Pascal
Simon, Baron
French, 1770-1837
GERARD, Gaston
(Louis Gaston)
French, 1859-
GERARD van Haarlem
see Geertgen tot
Sint Jans
GERARD, Jean Ignace
Isidore ('Grandville')
French, 1803-1847
GERARD, Johann
Friedrich
see Gerhard
GERARD, John
British, 1545-1612
GERARD, Joseph
Belgian, 1821-1895
GERARD, Lucien
French, 19th cent.
GERARD, Marcus
see Gheeraerts
GERARD, Marguérite
French, 1761-1837
GERARD d'Orléans
French, op.c.1359
GERARD, Théodore
Belgian, 1829-1895

GERARDI, Geerardi or
Geeraerts, Jasper
Flemish,
op.1634-m.a.1655
GERARDIN, Désiré
Delplace
French, 20th cent.
GERARDS, Marcus
see Gheeraerts
GERASCH, August
German, 1892-
GERASIMOV, A.
Russian, 1885-
GERASIMOV, Sergei
Vasilyevich
Russian, 1885-
GERBAUD, Abel
French, 1888-
GERBAULT, Henry
French, 1863-
GERBEL, Anton
German, op.1480-1510
GERBER, Theo
Swiss, 1928-
GERBES, H.
German, op.1866
GERBIER d'Ouvilly,
Balthazar
Dutch, c.1591/3-1667
GERE, Charles March
British, 1869-1934
GERE, Margaret
British, 1878-
GERHARD or Gerard, Johann
Friedrich
German, c.1695-1748
GERHARDI, Ida
German, 1867-1927
GERHARDINGER, Constantin
German, 1888-
GERHARDT, Eduard
German, 1813-1888
GERHART, Frankl
German, 19th cent.
GERICAULT, Jean Louis
André Théodore
French, 1791-1824
GERICKE, Samuel Theodor
German, 1665-1730
GERINI, Lorenzo di
Niccolò
Italian, op.1392-1440
GERINI, Niccolò di
Pietro
Italian, op.1368-m.1415
GERINO da Pistoja
(Gerino d'Antonio Gerini)
Italian, 1480-p.1529
GERLI, Agostino
Italian, op.1759-1787
GERLING, Johann Kasper
German, 18th cent.
GERMAIN, Alphonse
(Thil)
French, 19th cent.
GERMAIN, Pierre, II
(Le Romain)
French, 1716-1783
GERMAIN, Thomas
French, 1673-1748
GERMAN .y Llorente,
Bernardo
Spanish, 1680/1-1759
GERMAN SCHOOL,
Anonymous Painters
of the

GERMANN, Charles (Franz
Carl Andreas)
Swiss, 1755-1830
GERMELA, Raimund
German, 1868-
GERMISONI, Filippo
Italian, op.1682-m.1743
GERNEZ, Paul Elie
French, 1888-1948
GEROFF
British(?), 18th cent.
GEROLA, Antonio
see Giarola
GEROLAMO di Giovanni
da Camerino
Italian, op.1450-1473
GEROLAMO di Matteo da
Gualdo
Italian, 15th cent.
GEROME, Jean Léon
French, 1824-1904
GERRICO, Teodoro
see Hendricksz., Dirck
GERRIT van Haarlem
see Geertgen tot Sint
Jans
GERRITSZ., Gerrits or
Gerryts, Hessel
Dutch, 1581-1632
GERRITZ., Claes or Claus
Netherlands, op.c.1560
GERRY, Samuel Lancaster
American, 1813-1891
GERSON, Wojciech (Adalbert)
Polish, 1831-1901
GERSTL, Hermina
British, 20th cent.
GERSTL, Richard
German, 1883-1908
GERSTMAIER or Gerstmayer,
Joseph
German, 1801-1870
GERTLER, Mark
British, 1892-1939
GERTNER, Johan Vilhelm
Danish, 1818-1871
GERTNER or Gaertner,
Peter (Monogrammist P.G.)
German, op.1524-1537
GERTSCH, Franz
Swiss, 1930-
GERTTNER or Gaernter,
Christoff
German, op.1604-1621
GERUNG or Geron, Mathias
or Mathis
German, c.1500-1568/70
GERUZZI, S.
Italian, 19th cent.
GERVAIS or Gervase,
Charles
see Jervas
GERVAIS, Elie
British, op.1758
GERVAIS, Paul Jean Louis
French, 1859-1934(?)
GERVEX, Henri
French, 1852-1929
GERWEN, Reynier van
see Gherwen
GERY-BICHARD, Alphonse
Adolphe
see Bichard
GESELL, Georg
see Gsell
GESELSCHAP, Eduard
Dutch, 1814-1878

GESELSCHAP, Friedrich
German, 1835-1898
GESEMANN, Heinrich
German, 1886-
GESINUS, Bob (Johannes
Gesinus Visser)
Dutch, 1898-
GESLER, Alejandrina
Anselma de
Spanish, 1831-
GESLIN, P.
French, 19th cent.
GESMAR, C.
French, op.c.1925
GESNER, Abelard
South American, 1922-
GESNER, Conrad
Swiss, op.c.1730
GESSEY or Gessé, Henry
see Gissey
GESSI, Francesco
Italian, 1588-1649
GESSNER, Conrad
(Johann Conrad)
Swiss, 1764-1826
GESSNER, Richard
German, 1894-
GESSNER, Salomon
Swiss, 1730-1788
GESTEL, A. van
Dutch, 17th cent.
GESTEL, Leendert (Leo)
Dutch, 1881-1941
GETHIN, Percy Francis
British, 1874-1916
GETTO di Jacopo
Italian, op.1391
GETZ, Ilse Bechold
American, 20th cent.
GEUENS, J.
French, 20th cent.
GEUSENDAM, Gerrit Jacobus
Dutch, 1771-p.1815
GEUSLAIN, Geslin, Geuslin
or Gueslin, Charles
French, 1685-1865
GEYER, Elias
German, op.1572-m.1634
GEYER, Georg
German, 1823-1912
GEYER, Johann
German, 1807-1875
GEYER, Ludwig Heinrich
Christian
German, 1779-1821
GEYER, Otto M.
German, 1955-
GEYLING, Carl
German, 1814-1880
GEYLING, Remigius
German, 1878-
GEYN
see Gheyn
GEYST, P.J.
Netherlands, op.1764
GFALL, Johann
German, 1725-p.1800
GHABRIELLIS, Francischo
see Gabrielli da
Viterbo
GHEDINI, Giuseppe Antonio
Italian, 1707-1791
GHEDUZZI di Crespellano,
Ugo
Italian, 1853-1925
GHEERAERTS, Garrard,
Garret, Geeraerts or
Gerard the Younger, Marcus,
British, 1561-1635

GHEERAERTS, Garret,
Geeraerts or Gerard
the Elder, Marcus
British, 1516/21-a.1604
GHELLI, Francesco
Italian, 1637-1703
GHENDT, Emmanuel Jean
Nepomucène de
Flemish, 1738-1815
GHEORGHE, Mihai
Rumanian, 20th cent.
GHEQUIER, Alexis de
French, 1817-1869
GHERARDI, Antonio
(Reatino)
Italian, 1644-1702
GHERARDI, Cristofano
(Cristofano dal Borgo
or Doceno)
Italian, 1508-1556
GHERARDI, Filippo
(Sancasciani)
Italian, 1643-1704
GHERARDI, Giuseppe
Italian, op.1850
GHERARDINI, Alessandro
Italian, 1655-1723
GHERARDINI, Melchiorre
Italian, -1675
GHERARDINI, Tommaso
Italian, 1715-1797
GHERARDO del Fora
(Gherardo di Giovanni
Master of the Triumph
of Chastity)
Italian, 1444/5-1497
GHERARDO di Jacopo
see Starnina
GHERARDO della Notte
or delle Notti
see Honthorst,
Gerrit van
CHERINGH, Anton Günther
(also, erroneously,
Jan)
Flemish, op.1662-m.1668
GHERWEN or Gerwen,
Reynier van
Dutch, op.1652-m.c.1661
GHEYN or Geyn,
Guilliam or Willem de
Dutch, 1610-p.1650
GHEYN, Gain, Geyn
etc., Jacob, I Jansz. de
Netherlands,
c.1532-1582
GHEYN or Geyn,
Jacques or Jacob,
II de
Flemish, 1565-1629
GHEYN or Geyn, Jacob,
III de
Dutch, c.1596-1641
GHEYSELS, Pieter
see Gysels
GHEZZI
see Domenico di Bartolo
GHEZZI, Giuseppe
Italian, 1634-1721
GHEZZI, Pier Leone
Italian, 1674-1755
GHIATA, Dumitru
Rumanian, 1888-
GHIBERTI, Lorenzo
Italian, 1378-1455

GHIGLIA, Oscar
Italian, 1876-
GHIGLION-GREEN, Maurice
French, 1913-
GHIKA, Nikolaos Alexander
Hadjikyriacos
Greek, 1906-
GHILCHIK, David
British, 1892-
GHIN, J.
French, 20th cent.
GHIRLANDAIO, Benedetto
Italian, 1458-1497
GHIRLANDAIO, Davide
Italian, 1452-1525
GHIRLANDAIO, Domenico
(Bigordi), Il
Italian, 1449-1494
GHIRLANDAIO, Michele di
Ridolfo
see Tosini
GHIRLANDAIO, Ridolfo
(Bigordi), Il
Italian, 1483-1561
GHISENI, Giambattista
see Gisleni
GHISI, Diana
see Scultori
GHISI, Giorgio
(Mantuano)
Italian, 1520-1582
GHISI, Teodoro
(Mantovano)
Italian, 1536-1601
GHISLANDI, Fra Vittore
(Fra Paolotto or Fra
Galgario)
Italian, 1655-1743
GHISOLFI (not Grisolfi),
Giovanni
Italian, c.1623-1683
GHISONI or Guisoni, Fermo
di Stefano (Fermo da
Carravaggio)
Italian, c.1505-1575
GHISSI, Francescuccio or
Francesco
(Francescuccio da
Fabriano)
Italian, op.1359-1374
GHITTI, Pompeo
Italian, 1631-1703
GHIZZARDI, Bernardino
Italian, c.1730-1770
GHOBERT, Bernard
Belgian, 20th cent.
GHYSIS, Nicolas
Greek, 1842-1906
GIACHI, E.
Italian, 19th cent.
GIACHINETTI GONZALEZ,
Giovanni
(Borgognone dalle Teste)
Spanish, op.1630-1696
GIACHOSA, Fernando
German, op.1836-1849
GIACOBONI, Giorgio
Italian, op.1739-m.c.1777
GIACOMELLI, Hector
French, 1822-1904
GIACOMETTI, Alberto
Swiss, 1901-1966
GIACOMETTI, Augusto
Swiss, 1877-1947
GIACOMETTI, Giovanni
Swiss, 1868-1933

GIACOMO
see also Jacopo
GIACOMO (or Jacopo)
da Campli
Italian, op.1461-1479
GIACOMO di Giovanni
see Jacomo
GIACOMO del Meglio
see Coppi
GIACOMO da Recanati
Italian, 1414/15-1456
GIACOMOTTI, Félix Henri
French, 1828-1909
GIAMBERTI
see Sangallo, Francesco
da
GIAMBERTI, Marco del
Buono
Italian, 1402-1489
GIAMBOLOGNA
see Bezzi, Giovanni
Filippo
GIAMBOLOGNA
see Bologna, Giovanni da
GIAMBONO or Zambone,
see Bono, Michele di
Taddeo
GIAN Giacomo de' Caprotti
see Salaj
GIANBOLOGNA
see Bologna, Giovanni da
GIANCARLI or Zancarli,
Polifilo
Italian, op.1628-1636
GIANGIACOMO, Tertulliano
Italian, 19th cent.
GIANI or Gianni, Felice
Italian, 1757/60-1823
GIANI, Giuseppe
see Gianni
GIANI di Portogallo,
Luigi
Italian, op.1452
GIANLISI, Antonia
Italian, 18th cent.
GIANNATTASIO, Ugo
Italian, 1888-
GIANNETTI, Raffaele
Italian, 1832-1916
GIANNI, Giancinto
Italian, 19th cent.
GIANNI, Giuseppe
Swiss, 1829-1885
GIANNICOLA di Paolo di
Giovanni
see Manni
GIANNOLO, Il
see Pallavicini, Giacomo
GIANOL, A.
Danish(?), 19th cent.(?)
GIANOLI, Louis
Swiss, 1868-
GIANOLI, Pietro Francesco
Italian, op.1679-1690
GIANPAOLO di Agostino
see Giovanni Paolo di
Agostino
GIAN PAOLO di Pace
Italian, op.1528-1560
GIANPIETRINO
(Giovanni Pietro Rizzo
Pedrini)
Italian, op.c.1520-1540
GIAQUINTO, Corrado
Italian, 1699-c.1765
GIARDINI, Giovanni
Italian, 1646-1722

GIAROLA or Gerola,
Antonio (Il Cavaliere
Coppa)
Italian, c.1595-1665
GIARRIZZO, Carmelo
Italian, 1850-1917
GIBB, Henry Phelan
British, 1870-1948
GIBB, J.
British, 19th cent.
GIBB, Lewis Taylor
British, 20th cent.
GIBB, Robert
British, 1801-1837
GIBB, Robert
British, 1845-1932
GIBB, T. or J.
British, op.1820
GIBBENS, Abiah
Dutch, op.1629-1635
GIBBERD, Eric
British, 20th cent.
GIBBINGS, Robert
British, 1889-1958
GIBBONS, F.
British, 19th cent.
GIBBS, Evelyn
(Evelyn Willatt)
British, 1905-
GIBBS, Henry
American, op.1670
GIBBS, Henry
British, op.1865-1907
GIBBS, Horatio
British, 18th cent.
GIBBS, J.B.
British, 19th cent.
GIBBS, Percy William
British, op.c.1895-1925
GIBBS, Snow
British, 1882-
GIBELIN, Esprit Antoine
French, 1739-1813
GIBELLO, Cleto
Italian, 1896-
GIBERNE, George de
British, 1797-1875
GIBS, J.
British, op.1832
GIBSON, Charles Dana
American, 1867-1944
GIBSON, D.
British, op.c.1655-1660
GIBSON, David
British, op.1790-1796
GIBSON, Edward
British, 1668-1701
GIBSON, F.
British, op.1786-1834
GIBSON, John
British, 1790-1866
GIBSON, Joseph Vincent
British, op.1857-1888
GIBSON, Patrick or
Peter
British, 1782-1829
GIBSON, Richard
British, 1615-1690
GIBSON, W. Hamilton
American, 20th cent.
GIBSON, Susan Penelope
see Rosse
GIBSON, Thomas
British, c.1680-1751
GIBSON, William
British, c.1644-1702
GIBSON, William Alfred
British, 1866-1931

GID, Raymond
French, 1905-
GIDE, Théophile
(François Théophile
Etienne)
French, 1822-1890
GIELDER, Gerrit op
Dutch, op.1620
GIERGL, Alajos or Alois
see Györgyi
GIERS, Walter
German, 1937-
GIERSING, Harald
Danish, 1881-1927
GIERYMSKI, Alexander
Polish, 1849-1901
GIERYMSKI, Maximilian
(Maks)
Polish, 1846-1874
GIESE, Gottlieb Christian
Johannes
German, 1787-1838
GIESSEN, G. van
Dutch, 18th cent.
GIESSMANN, Friedrich
German, 1810-1847
GIETL, Josua von
German, 1847-1922
GIFFART, Gifart or
Giffard, Pierre
French, 1637-1723
GIFFORD, E.A.
British, op.1843-58
GIFFORD, George
British, op.c.1635-1640
GIFFORD, John
British, 19th cent.
GIFFORD, Robert Swain
American, 1840-1905
GIFFORD, Sanford Robinson
American, 1823-1880
GIGANTE, Achille
Italian, 1828-1846
GIGANTE, Ercole
Italian, 1815-1860
GIGANTE, Gaetano
Italian, op.1811-1822
GIGANTI, Giacinto
Italian, 1806-1876
GIGER, Hansruedi
Swiss, 1940-
GIGLI, Andrea
(Bolzoni)
Italian, 16th cent.
GIGNOUS, Eugenio
Italian, 1850-1906
GIGNOUX, Pierre
Swiss, c.1646-1716
GIGNOUX, Régis François
American, 1816-1882
GIGOLA, Giovanni Battista
Italian, 1769-1841
GIGOUX, Jean François
French, 1806-1894
GIHON, Clarence
Montfort
American, 1871-1929
GIKOW, Ruth
American, 1914-
GIL, Geronimo
Antonio
Spanish, 1732-1798
GIL, José
Spanish, 1759-1828
GILARDI, Pier Celestino
Italian, op.1888

GILARDI, Pietro
Italian, 1679-1730
GILARTE, Mateo
Spanish, c.1620-p.1680
GILBERT, Achille Isidore
French, 1828-1899
GILBERT, Albert
British, 18th cent(?)
GILBERT, Sir Alfred
British, 1854-1934
GILBERT, Arthur
see Williams
GILBERT, Auguste
French, 1822-
GILBERT, Camille
French, 17th cent.
GILBERT, Charles Allan
American, 1873-
GILBERT, Graham
see Graham, John
GILBERT, Horace W.
British, op.1873-1885
GILBERT, J.M.
British, op.1825-1855
GILBERT, Sir John
British, 1817-1897
GILBERT, Joseph Francis
British, 1792-1855
GILBERT, Josiah
British, 1814-1892
GILBERT, Norman
British, 20th cent.
GILBERT, Pierre Julien
French, 1783-1860
GILBERT, Pierre-Vincent
French, 1801-1883
GILBERT, René Joseph
French, 1858-1914
GILBERT, Victor Gabriel
French, 1847-1935
GILBERT, William S.
British, 1836-1911
GILCHRIST, Mrs
British, op.1774-5
GILDER, Henry
British, op.1773-1778
GILDEWART, Vordemberge
German, 20th cent.
GILEMANS, A.
Netherlands, op.1615
GILES, Geoffrey Douglas
British, 1857-1941
GILES or Gyles, Henry
British, c.1640-1709
GILES, Howard
American, 1876-
GILES, James William
British, 1801-1870
GILES, John West
British, op.1834
GILFILLAN, John Alexander
British, op.1830-1840
GILFOY, J.
British, op.1830-1835
GILIBERT
French, 19th cent.
GILIO di Pietro
(Pseudo Maestro
Gilio)
Italian, op.1258
GILIOLI, Emile
French, 1911-
GILL, André
see Gosset de Guines,
Louis Alexandre

GILL, Bob
British, 20th cent.
GILL, C.R.
British, 19th cent.
GILL, Charles
British, op.1749-1819
GILL, Colin Unwin
British, 1892-1940
GILL, Edmund Marriner
British, 1820-1894
GILL, Edmund Ward
British, op.1843-1868
GILL, Edward
British, 19th cent.
GILL, Edwin
British, op.1809-1810
GILL, Eric
(Arthur Eric Rowton
Peter Joseph)
British, 1882-1940
GILL, James
American, 20th cent.
GILL, Samuel Thomas
Australian, 1818-1880
GILL, William
British, 1826-1869
GILLABOZ, de
German, op.1796-1800
GILLARD, William
British, c.1812-p.1876
GILLBERG, Jakob Axel
Swedish, 1769-1845
GILLE, Christian Friedrich
German, 1805-1899
GILLEMANS, Jan Paulwel, I
or Joan Paulo
Flemish, 1618-1675
GILLEMANS, Jan Paulwel, II
Flemish, 1651-1704
GILLES, Werner
German, 1894-1961
GILLESPIE, Gregory
American, 1936-
GILLET, Numa Francois
French, 1868-
GILLET, Roger Edgard
French, 1924-
GILLI
Italian, 20th cent.
GILLI, Alberto Maso
Italian, 1840-1894
GILLIAM, Sam
American, 20th cent.
GILLIES, Margaret
British, 1803-1887
GILLIES, William George
British, 1898-1973
GILLIG or Gellig,
Jakob
Dutch, c.1636-1701
GILLILAND, Hector
Australian, 1912-
GILLIS, J.
Flemish(?), 18th/19th cent.
GILLIS, Nicolaes
Dutch, op.1601-1632
GILLOT, Claude
French, 1673-1722
GILLOT, Eugène
Louis
French, 1867-1925
GILLRAY, James
British, 1757-1815
GILMAN, Harold J.W.
British, 1876-1919

GILMOR the Younger,
Robert
American, op.1800
GILOT, Françoise
(Françoise Picasso)
French, 1922-
GILPIN, John Bernard
British, 1701-1776
GILPIN, Sawrey
British, 1733-1807
GILPIN, Rev. William
British, 1724-1804
GILPIN, William Sawrey
British, 1762-1843
GILROY
British, 20th cent.
GILSOUL, Victor Olivier
Belgian, 1867-1939
GILTLINGER, Gueltinger,
Gultlinger or
Gutlinger, Gumpolt
German, op.1481-m.1522
GIMBREDE, Thomas
American, 1781-1832
GIMENEZ, Edgardo Miguel
Argentina, 20th cent.
GIMIGNANI, Gemignani
or Geminiani, Giacinto
Italian, 1611-1681
GIMIGNANI, Lodovico
Italian, 1643-1697
GIMINEZ y Aranda, Luis
see Jimenez
GIMMI, Wilhelm
Swiss, 1886-
GIMOND, Marcel
French, 1894-
GINAIN, Louis Eugène
French, 1818-1886
GINDRIEZ, Charles
French, 19th cent.
GINER, Francisco
Spanish, 15th cent.
GINER, Tomas
Spanish, 15th cent.
GINER, Vicente
Spanish, op.1676-1677
GINESI, Edna
British, 1902-
GINGELEN, Jacques van
Belgian, 1801-
GINGER, Phyllis
British, 20th cent.
GINNASI, Caterina
Italian, c.1590-1660
GINNER, Charles Isaac
British, 1878-1952
GINNETT, Louis
British, 1875-1946
GINOVSZKY or Ginowski,
Josef
Hungarian, 1800-1857
GINTER or Ginther
see Günther
GINTNER, Anton
American, 1941-
GINTRAC, Jean Louis
French, 1808-
GIOBBI, Edward
American, 20th cent.
GIOJA, Belisario
Italian, 1829-1906
GIOJA, Edoardo
Italian, 1862-1936

GIOLFINO, Niccolò
Italian, 1476/7-1555
GIOLI, Antonio
see Joli
GIOLI, Francesco
Italian, 1846-1922
GIOMO del Sodoma
see Magagni, Girolamo di
Francesco
GIONIMA, Antonio
Italian, 1697-1732
GIORDANI, Pietro
Italian, 14th cent.
GIORDANICO, Pietro
Italian, op.1493
GIORDANO, Luca Fapresto
Italian, 1632-1705
GIORDANO, Stefano
Italian, op.1540
GIORGETTI, Ercole
Italian, 1814-1860
GIORGI
Italian, 20th cent.
GIORGI, Antonio de'
Italian, 1720-1793
GIORGI, Giovanni de'
(Torellino)
Italian, c.1684-1717
GIORGI da Piacenza,
Giuseppe
Italian, op.1823-1842
GIORGO, Ettore di
Italian, 1890-
GIORGIO, Francesco di
see Francesco
GIORGIO Mantuano
see Ghisi
GIORGIO da Sebenico
(Giorgio Dalmatico)
Italian(?), op.1441-m.1475
GIORGIONE, Giorgio
Barbarelli
Italian, 1477/8-1510
GIOTTINO, Giotto di
Maestro Stefano
Italian, op.1368
GIOTTINO, Maso di Banco
Italian, op.1341-1350
GIOTTO di Bondone
Italian, 1276-1337
GIOVANNELLO d'Italia
(Itala)
Italian, op.1504-1531
GIOVANETTI
see Pericle, Luigi
GIOVANNETTI, Matteo
Italian, op.1346
GIOVANNI, Agostino da
Lodi
see Boccaccino, Pseudo
GIOVANNI de Alamagna
(Johanes Alamanus,
Zuane or Giovanni da
Murano)
German, op.1440-m.1450
GIOVANNI di Andrea di
Domenico
Italian, 1455-p.1488
GIOVANNI Angelo, Fra
see Lottini, Lionetto
GIOVANNI Angelo di Antonio
da Camerino
Italian, op.1451-1460(?)
GIOVANNI di Angelo
di Balduccio
Italian, c.1370-1452

GIOVANNI Antonio da
Brescia
Italian, op.c.1500-1520
GIOVANNI Antonio da
Mesco
Italian, op.1450
GIOVANNI Antonio da
Parma
Italian, 15th cent.
GIOVANNI Antonio di
Gaspare da Pesaro
Italian, op.1462-1511
GIOVANNI d'Asciano
Italian, op.1372
GIOVANNI da Asola
see Giovanni da Brescia
GIOVANNI
(di Barcellona?)
Italian, 15th cent.
GIOVANNI di Bartolommeo
Cristiani
Italian, op.1366-1396/8
GIOVANNI Battista da
Città di Castello
Italian, op.1492
GIOVANNI Battista da
Faenza
see Bertucci
GIOVANNI Battista da
Milano
Italian, op.1495
GIOVANNI Battista del
Porto
Italian, op.c.1503
GIOVANNI Battista da
Vicenza
Italian, 14th cent.
GIOVANNI di Benedetto
Italian, op.1352-1361/78
GIOVANNI di Bindino da
Travale
Italian, op.1392-m.1417
GIOVANNI del Biondo
(dei Landini ?) dal
Casentino
Italian, op.1356-1392
GIOVANNI da Bologna
Italian, op.1377-1389
GIOVANNI da Bologna
see Bologna, G. da
GIOVANNI (or Zuanne) da
Brescia (Zuane da Asola)
Italian, op.1512-m.1531
GIOVANNI di Brunico
Italian, 15th cent.
GIOVANNI da Calcar
see Calcar, Jan Stephan
von
GIOVANNI da Ciclonio da
Eggi
Italian, 14th cent.(?)
GIOVANNI di Consalvo
(or Jean de Portugal)
Portuguese, op.1436-1439
GIOVANNI di Corraduccio
Italian, op.1413-1422
GIOVANNI da Faenza
see Giovanni da Oriolo
GIOVANNI da Firenze, Fra
(Pietro Carettai)
Italian, 1572-1619/20
GIOVANNI di Francesco del
Cervelliera (Master
of the Carrand Triptych
or Giovanni Rovezzano)
Italian, op.1446-m.1459

GIOVANNI Francesco da
Rimini
Italian, op.1459-1470
GIOVANNI Francesco da
Tolmezzo
Italian, c.1450-p.1510
GIOVANNI di Francesco
Toscani
see Toscani
GIOVANNI di Francis
Italian, op.1429-1432
GIOVANNI da Gaeta
Italian, op.1456
GIOVANNI Jacopo
(Gianiacopo) da
Castrocaro (Mattoncini,
Master of the Göttingen
Crucifixion)
Italian, op.1525-m.1581
GIOVANNI, Luigi di
Italian, 1856-
GIOVANNI de Luteri or
de Constantino
see Dossi, Dosso
GIOVANNI di Marco
see Giovanni dal Ponte
GIOVANNI Maria da Brescia
Italian, op.1500-1512
GIOVANNI Maria da Treviso
(Trevisano)
Italian, op.1506-1513
GIOVANNI da Mel
Italian, 16th cent.
GIOVANNI da Milano
(Giovanni di Jacopo di
Guido da Kaverzaio or
Giovanni da Como)
see also A. Orcagna
and Master of the
Rinuccini Chapel
Italian, op.c.1350-1370
GIOVANNI di Modena
(Giovanni di Pietro
Faloppi)
Italian, op.1420-1451
GIOVANNI da Monte
Cremasco
Italian, op.1580
GIOVANNI da Monte
Rubiano
Italian, op.1506
GIOVANNI da Murano
see Giovanni de
Alamagna
GIOVANNI di Niccola da
Pisa
Italian, op.1358-1423
GIOVANNI da Nola
see Marigliano
GIOVANNI da Oriolo
(Giovanni di Giuliano
Savoretti ? Giovanni
Marcio or Giovanni da
Faenza ?)
Italian, op.1443-m.1473/4
GIOVANNI (di Giorgio)
da Padova
Italian, op.1367-1397
GIOVANNI Paolo di
Agostino
Italian, op.c.1510-1525
GIOVANNI Paolo dal Borgo
Italian, op.1542-1561
GIOVANNI di Paolo di
Grazia
Italian, 1403-1483

GIOVANNI Paolo Tedesco
see Schor, Johann Paul
GIOVANNI di Paolo da
Venezia
Italian, op.1345-1358
GIOVANNI di Piamonte
(not Piemontese)
Italian, op.1456
GIOVANNI Piero da
Gemona
Italian, op.1401
GIOVANNI di Pietro da
Napoli
Italian, op.1402-1405
GIOVANNI Pietro da
San Vito
Italian, op.1485-1529
GIOVANNI del Pio
see Bonatti
GIOVANNI da Pisa
see Giovanni di Niccola
da Pisa
GIOVANNI dal Ponte or
da San Stefano
(Giovanni di Marco)
Italian, 1385-1437(?)
GIOVANNI da Rimini
Italian, op.1439-c.1463
GIOVANNI da Riolo
Italian, op.1433
GIOVANNI da San Giovanni
see Mannozzi
GIOVANNI da Santo Pietro
Italian, 17th cent.
GIOVANNI del Sega
Italian, op.1506-m.1527
GIOVANNI da Siena (Neri)
Italian, op.1426-1462
GIOVANNI di Stefano da
Siena
Italian, c.1446-a.1506
GIOVANNI Tedeschi
Italian, -1752
GIOVANNI da Tortona
see Quirico, Giovanni
GIOVANNI da Udine
see Martini
GIOVANNI da Udine or
Recamatori (Nanni)
Italian, 1487/94-1564
GIOVANNI di Ugolino da
Milano
Italian, op.1436
GIOVANNI da Varese
Italian, 17th cent.
GIOVANNI Veneziano
see Giovanni di Paolo
da Venezia
GIOVANNI da Verona, Fra
Italian, c.1457-1525
GIOVANNI di Zanello
Italian, 14th cent.
GIOVANNINO (Zannino)
di Pietro da Venezia
Italian, op.1407
GIOVANNOLI, Alo(isio)
Italian, c.1550-1618
GIOVENONE the Elder,
Girolamo
Italian, c.1490-1555
GIOVENONE, Giovanni
Battista
Italian, op.1548-79
GIOVENONE the Younger,
Giuseppe
Italian, 1524-a.1609

GIOVENONE, Raffaelo
Italian, op.1572-1604
GIPKYN, John
British, op.1616
GIPS, Wilhelmine
(Wilhelmine Carbin)
Dutch, 1897-
GIRALDI or Ziraldi di
Guglielmo (del Magro)
Italian, op.1445-m.c.1480
GIRAN, Max Léon
French, 1867-1927
GIRAND
French, 19th cent.
GIRARD, Claude
Canadian, 1938-
GIRARD, Ernest J.A.
French, 1813-1898
GIRARD, Pedro
see Master of the
Muntadas Collection
GIRARD, Romain
French, c.1751-
GIRARDEL, E.
French, 19th cent.
GIRADET, Abraham
Swiss, 1764-1823
GIRADET, Carl
Swiss, 1813-1871
GIRADET, Edouard Henri
Swiss, 1819-1880
GIRARDET, Eugène
French, 1853-1907
GIRARDET, Jean
French, 1709-1778
GIRARDET, Jules
French, 1856-
GIRARDET, Léon
French, 1857-1895
GIRARDET, Léopold Henri
Swiss, 1848-
GIRARDI, Guglielmo
Italian, 15th cent.
GIRARDIN, Alexandre
François Louis,
Comte de
French, 1777-p.1836
GIRARDIN, E.
French, 19th cent.
GIRARDON, Catherine
see Duchemin
GIRARDON, François
French, 1628-1715
GIRARDON, Gustave
French, 1821-1888
GIRARDOT
see Bosse, Madame
GIRARDOT, Ernest
Gustave
British, op.1860-1893
GIRARDOT, Louis Auguste
French, 1858-1933
GIRAUD, Charles
(Sebastian Charles)
French, 1819-1892
GIRAUD, Eugène
(Pierre François
Eugène)
French, 1806-1881
GIRAUD, Georges
French, 1882-
GIRAUD, Jean Baptiste
French, 1752-1830
GIRIEUD, Pierre Paul
French, 1875-1940
GIRIN, David-Eugène
French, 1848-1917
GIRLING, Edmund
British, 1796-1871

GIRLING, Richard
British, 1799-1863
GIROD
French, 19th cent.
GIRODET-TRIOSON, Anne
Louis de Roussy
French, 1767-1824
GIROLAMO di Benvenuto
del Guasta
Italian, 1470-1524
GIROLAMO di Bernardino
da Udine
Italian, op.1506-m.1512
GIROLAMO da Brescia
Italian, op.1501-1519
GIROLAMO da Carpi,
Grassi, de'Livizzani
or Sellari
Italian, 1501-1556
GIROLAMO da Cotignola
see Marchesi
GIROLAMO da Cremona
Italian, 1467-1475
GIROLAMO di Domenico
see Ponsi
GIROLAMO di Giovanni da
Camerino
Italian, op.1450-1473
GIROLAMO dai Libri
(Veccio)
Italian, 1474-1555
GIROLAMO dei Maggi
Italian, op.c.1500
GIROLAMO Sordo, del Santo,
di Padova or Padovano
Italian, 1480-1550
GIROLAMO da Trento
Italian, op.1492-1502
GIROLAMO da Treviso the
Elder
Italian, c.1450-1496(?)
GIROLAMO da Treviso the
Younger
see Pennacchi
GIROLAMO da Udine
see Girolamo di
Bernardino da Udine
GIROLAMO da Vicenzo
Italian, op.c.1500
GIROLAMO da Vignola
see Vignola
GIRON, Charles
Swiss, 1850-1914
GIRONDE, Victor de
French, 1788-1866
GIRONELLA
Italian, op.1962
GIROT, Antoine Marie
French, 1809-1885
GIROUST, Jean Antoine
Théodore
French, 1753-1817
GIROUST, Marie Suzanne
see Roslin
GIROUST, R.
French, op.1897
GIROUX, André
French, 1801-1879
GIRSCHER, Bernhard
Moritz
German, 1822-1870
GIRTIN, Thomas
British, 1775-1802
GISBERT, Antonio
Spanish, 1835-p.1899
GISCHIA, Léon
French, 1903
GISEKEN, Georgi
Russian, 20th cent.

GISELA, Josef
(Reznicek)
German, 1851-1899
GISELAER
see Gyselaer
GISLANDER, William
Scandinavian, 1890-1937
GISLENI or Ghiseni,
Giambattista
Italian, 1600-1672
GISLER, Edouard
Belgian, op.1836-1851
GISMONDI, Paolo
(Paolo Perugino)
Italian, 1612-c.1685
GISSEY, Gessé, Gessey
or Jessé, Henry
French, 1621-1673
GISZINGER, J.
Hungarian, op.c.1880
GITSCHMANN the Elder,
Hans
(Hans von Ropstein or
Raperstein)
German, op.1515-m.1564
GITTARD, Alexandre Charles
Joseph
French, 1832-1904
GIUDICI, Luigi del
Italian, op.1777-1811
GIUDICI, Rinaldo
Italian, op.1886-
GIUFFRE, Juffre or
Jufre, Antonino or Antonio
(Antonello de lu Re)
Italian, 15th cent.
GIUGNI or Giugno,
Francesco
see Zugni
GIULIANI, Giovanni
Italian, 1663-1744
GIULIANNO, Il
see Traballesi, Giuliano
GIULIANO, Fra
Italian, op.1487
GIULIANO d'Arrighi
(Il Pesello)
see Pesello
GIULIANO, Bartolommeo
Italian, 1825-1909
GIULIANO da Fano
see Presciutti
GIULIANO da Maiano,
Giuliano di Leonardo
(Nardo) d'Antonio
Italian, 1432-1490
GIULIANO da Rimini
Italian, op.1307-m.1346
GIULIANO di Simone
Italian, op.c.1389
GIULIO del Moro
see Angolo del Moro,
Giulio
GIULIO PIERINO da Amelia
Italian, op.1543-1581
GIULIO Romano (Giulio
Pippi or di Pietro de'
Gianuzzi)
Italian, 1499-1546
GIUNNI, Piero
Italian, 1912-
GIUNTA, Pisano
Italian, op.c.1202-m.1255/67
GIUNTOTARDI, Filippo
Italian, 1768-1831
GIUSEPPINI, Filippo
Italian, 1815-1862

GIUSTI, Guglielmo
Italian, 1824-p.1916
GIUSTI da Pistoja,
Gregorio
Italian, 1732-p.1756
GIUSTI, T.
Italian, 19th cent.
GIUSTO, Andrea di
see Andrea da Firenze
GIUSTO, d'Andrea di
Giusto
Italian, 1440-1496
GIUSTO, Betti
see Juste, Juste de
GIUSTO, Felice
(Giuseppe Giusti)
Italian, 1872-
GIUSTO di Giovanni or
Giusto Padovano
see Menabuoi
GIUSTO da Guanto
see Justus of Ghent
GIUTTI, G.
Italian, 19th cent.
GLABBEECK, Gladbeek
or Gladbek,
Jan van
Dutch,
op.1653-m.c.1686
GLACKENS, William
James
American, 1870-1938
GLADBEK or Gladbeek,
Jan van
see Glabbeeck
GLADSTONE, Thomas
British, 1803-1832
GLADWELL, Rodney
British, 20th cent.
GLADYSZ, Christopher
German, 19th cent.
GLAESER, Gotthelf
Lebrecht
German, 1784-1851
GLAESNER, J.Doucet
see Suriny
GLAIN, Léon or Pascal(?)
French, op.1749-1778
GLAIZE, Auguste Barthélemy
French, 1807-1893
GLAIZE, Léon
(Pierre Paul Léon)
French, 1842-1932
GLANTSCHNIGG, Ulrich
German, 1661-1722
GLARDON, Charles Louis
François (Glardon-
Leubel)
Swiss, 1825-1887
GLARNER, Fritz
American, 1899-
GLASCO, Joseph
American, 1925-
GLASER, Anthony
Swiss, 1490-1551
GLASER, Hans Wolff
German, op.c.1560
GLASGOW, Alexander
British, op.1859-1884
GLASGOW, Edwin
British, 1874-1955
GLASGOW, Robert
British, op.c.1828
GLASS, James
Willaim
American, 1825-1857
GLASS, John Hamilton
British, op.c.1920

GLASS, Rhoda
British, 20th cent.
GLASS, William Mervyn
British, 1885-1965
GLASSON, Lancelot Myles
British, 1894-
GLATZ, Oszkar
Hungarian, 1872-
GLAUBER, Gheorghe
Rumanian, 1921-
GLAUBER, Johannes or
Jan (Polidoro or
Polidoor)
Dutch, 1646-c.1726
GLAUBER, Johannes
Gottlieb
German, c.1656-1703
GLAZEBROOK, Hugh de
Twenebrokes
British, 1870-1935
GLAZIER, Louise M.
British, 20th cent.
GLAZIER or Glisier, P.
French, op.c.1754
GLAZUNOV, Ilya
Russian, 1921-
GLEB-KRAKOTCHWIL, Maria
Polish, 20th cent.
GLEESON, James
Australian, 1915-
GLEGHORN, Thomas
Australian, 1925-
GLEHN, Oswald von
British, 1858-
GLEHN, Wilfred Gabriel
von
English, 1870-
GLEICHEN-RUSSWORM,
Heinrich Ludwig,
Freiherr von
German, 1836-1901
GLEICHMANN, Otto
German, 1887-
GLEIZES, Albert
French, 1881-1953
GLEIZES, Philippe
French, -a.1801
GLEN, Graham
British, 20th cent.
GLENDENNING or
Glendinning the
Younger, Alfred
British, op.1861-1903
GLENK, G.
German, 18th cent.
GLENNIE, Arthur
British, 1803-1890
GLENNIE, John David
British, 1796-1874
GLEYRE, Charles
(Marc Charles Gabriel)
Swiss, 1806-1874
GLICENSTEIN, Enoch
(Henryk)
Russian, 1870-1942
GLIDDON, Anne
British, op.c.1840
GLIHA, Oton
Yugoslav, 1914-
GLIMES, P. de
British, op.c.1780-1793
GLINDONI, Henry Gillard
British, 1852-1913
GLINK, Franz Xaver
German, 1795-1873
GLINTENKAMP, Hendrik
American, -1946

GLINZ, Theo
Swiss, 1890-
GLINZER, Karl
German, 1802-1878
GLIRI, Nicola
Italian, op.1658-1680
GLISENTI, Achille
Italian, 1906-
GLOAG, Isobel Lilian
British, 1865-1917
GLOCKENDON, Glockenthon,
Glockenton etc.,
the Younger, Albrecht
German, op.1547-1568
GLOCKENDON the Elder,
Georg or Jorg
German, op.1484-m.1514
GLOCKENDON the Elder,
Nicolaus
German, op.c.1514-m.1534
GLOCKER or Glöckler,
Johann
German, op.1637-1646
GLOERSEN, Jacob
Norwegian, 1852-1912
GLOGOWSKY, Georg
Czech, 1777-1838
GLOGSTEIN, J.W.
Danish, op.c.1835
GLORIEFLOREN, Lambert
German(?), op.c.1762
GLOSS, Ludwig
German, 1851-1903
GLOUTCHENKO, N.P.
Russian, 20th cent.
GLOVER, George
British, op.1625-1653
GLOVER, John
British, 1767-1849
GLOVER, William
British, op.1808-1839
GLOWACKI, Jan Nepomucen
Polish, 1802-1847
GLUBER, Hans Hug
see Klauber
GLUCK, Louis T.E.
German, 1820-1898
GLUCK, M.
British, 1895-
GLÜCKHER, Johann
Georg
German, op.1691-1697
GLUCKLICH, Simon
German, 1863-1943
GLUCKMANN, Grigory
Russian, 1898-
GLUME, Johann Gottlieb
German, 1711-1778
GMELIN, Georg
(Johann Georg)
German, 1810-1854
GMELIN, Wilhelm Friedrich
German, 1760-1820
GNEHM, Peter
German, 1712-1799
GNOCCHI, Giovanni Pietro
(Gnocheus)
Italian, op.1579-1603
GNOLI, Domenico
Italian, 1933-
GOBAUT, Gaspard
French, 1814-1882
GOBBIS, Giuseppe
Italian, op.1772-1783
GOBBO, Il
see Sangallo, Battista
da

GOBBO, Il
see Solari, Cristoforo
GOBBO dei Carracci, da
Cortona or da' Frutti
see Bonzi, Pietro
Paolo
GÖBEL, Angilbert
Wunibald
German, 1821-1882
GÖBEL, Johann Emanuel
German, 1720-1759
GOBERT, Henri Toussaint
French, op.1831-1881
GOBERT, Pierre
French, 1662-1744
GOBIN, Michel
French, op.1681
GOBIUS, Hendrik Anthony
Frederik Agathus
Dutch, 1815-1899
GOBLAIN, Antoine Louis
French, 1779-p.1838
GOBLE, Steven
Dutch, 1749-1799
GOBO, Georges
American, 1876-
GODAARD, Johannes
see Goedaert
GODBOLD, Samuel Barry
British, op.c.1842-1875
GODBY, James
British, op.1790-1820
GODCHAIN
French, 19th cent.
GODDARD, J.
British, op.1811-1842
GODDING, Emil Hendrik
Karel Passchaal
German, 1841-1898
GODDYN
see Godyn
GODEFROY
French, op.1482
GODEFROY, Adrien
Pierre Francois
(Godefroy jeûne)
French, 1777-1805
GODEFROY, E.
French, op.1856
GODEFROY, Francois
French, 1743-1819
GODEFROY, François
Ferdinand Joseph
French, 1729-1788
GODEFROY or Godefroij,
Jan
Dutch, 1882-1958
GODEFROY, Jean or John
French, 1771-1839
GODEFROY or Godefroid,
Maria Eléanore
French, 1778-1849
GODEFROY, P.L. de
Larive
French, 1753-1814
GODERIS, Hans
Dutch, op.1622-1638
GODET, Julius
British, op.1844-1884
GODEWYK, Margaretha
van
Dutch, 1627-1677
GODFREY, Richard Bernard
(not René)
British, 1728-p.1794
GODHAUX
French, 19th cent.

GÖDING, Göddeck,
Goddigen, Götting etc.,
the Elder, Heinrich
German, 1531-1606
GODLEVSKY, Ivan Ivanovich
Russian, 20th cent.
GODOR
French, 20th cent.
GODWARD, John William
British, op.1887-1905
GODWIN, James
British, op.1846-m.1876
GODWIN, Mary
British, 1887-1960
GODYN or Goddyn,
Abraham
Dutch, op.c.1680-1723
GODYN or Goddyn, Pieter
Matthias
Flemish, 1752-1811
GOEBEL, Angilbert
Wunibald
German, 1821-1882
GOEBEL, Carl
German, 1824-1899
GOEBEL, Carl Peter
German, 1791-1823
GOEDAERT or Godaard
Johannes
Dutch, c.1620-1668
GOEDE, Jules de
Dutch, 1937-
GOEDELER, Elias
see Gedeler
GOEDING, Andreas
German, 1570-1625
GOEDSCHALKSZ., Jacobus
Kops
Dutch, 1736-1773
GOEJE, Pieter de
Dutch, 1779-1859
GOEMARE, Goeimare or
Goeymare, Joos
Flemish, c.1575-1618
GOENBERGER, S.
Dutch, 19th cent.
GOENEUTTE, Norbert
French, 1854-1894
GOEPP, Maximilienne
see Guyon
GOEREE, Jan
Dutch, 1670-1731
GOERG, Christian
German, 19th cent.
GOERG, Edward
French, 1893-
GOERITZ, Mathias
French, 1915-
GOES, Hugo van der
Netherlands,
op.1467-m.1482
GOETHALS, Eugène
Raymond
French, 1804-1864
GOETHE, Freiherr von
see Eosander, Johann
Friedrich
GOETHE, Johann Wolfgang
von
German, 1749-1832
GOETKINT, Goetkind or
Goetkindt, Peter, I
Netherlands,
op.1555-m.1583
GOETS, A.
Dutch(?), op.1767

GOETZ, Gottfried
Bernhard
German, 1708-1774
GOETZ, Henri
French, 1909-
GOETZ, Peter
Canadian, 20th cent.
GOETZE, Sigismund
Christian Hubert
British, 1866-1939
GOEVAERTS, Abraham
see Govaerts
GOEYMARE, Joos
see Goemare
GOEZ, Josef Franz
Freiherr von
German, 1754-1815
GOFF, Fred E.J.
British, 1855-1931
GOFF, Robert
Charles
British, 1837-1922
GOFREDI, Goffredi or
Goffredy
see Godefroy
GOGH, Vincent van
Dutch, 1853-1890
GOGIN, Charles
British, 1844-1931
GOGUEN, Jean
Canadian, 1928-
GOHL, Johann Christian
Samuel
German, 1743-1825
GOHLER, Hermann
German, op.1890
GOINGS, Ralph
American, 1928-
GOIS Etienne Pierre
Adrien
French, 1731-1823
GOITIA, Francisco
Mexican, 1884-
GOLA, Emilio
Italian, 1851/2-1923
GOLD, Charles
Emilius
British, op.1806-m.1842
GOLDAR, John
British, 1729-1795
GOLDBÄCKER, J.
German, 19th cent.
GOLDBERG, Elias
American(?), 20th cent.
GOLDBERG, Eric
Canadian, 1890-
GOLDBERG, Michael
American, 1924-
GOLDEN, Daniel (Daan)
van
Dutch, 1936-
GOLDER, C.H.
American, 19th cent.
GOLDICUTT, John
British, 1793-1842
GOLDIE, Charles
Frederick
New Zealand, op.1903
GOLDING, John
British, 1929-
GOLDSCHMID, Hans
German, op.1521-1535
GOLDSCHMIDT, David
Swiss, 20th cent.
GOLDSMITH, J.
British, op.1815

GOLDSTEIN, Johann
Theodor
Polish, 1798-p.1871
GOLDTHWAITE, Anne
American, 1875-1944
GOLE, Jacob
Dutch, c.1660-c.1737
GOLIKE, William
Alexandrowitsch
Russian, op.1819-m.1848
GOLL van Frankenstein
or Franckerstein,
Johann, I.
Dutch, op.1722-m.1785
GOLLER, Bruno
German, 1901-
GOLLINGS, Edward
American, op.1916
GOLLINGS, William
American, 20th cent.
GOLOVIN, Alexander
Yakovlevitch
Russian, 1863-1930
GOLOVINE, Countess
Russian, 18th cent.
GOLTZ, Alexander
Demetrius
German, 1857-1944
GOLTZIUS, Hendrick
Dutch, 1558-1617
GOLTZIUS, Hubert,
Hubertus or Hubrecht
Goltz
Netherlands, 1526-1583
GOLUB, Leon Albert
American, 1922-
GOLZL, André
American, op.1763
GOMA, Francesco
Italian, op.1797
GOMAR y Gomar, Antonio
Spanish, 1853-1911
GOMERY
French, 20th cent.
GOMES, Dordio
Portuguese, op.1924-1964
GOMES, Fernando
Portuguese, 16th cent.
GOMEZ y Gil, Guillermo
Spanish, 19th cent.
GOMEZ, Juan
Spanish, op.1555-m.1597
GOMEZ de Mora, Juan
Spanish, c.1580-1648
GOMEZ the Elder,
Sebastian
Spanish, 1646-c.1682
GOMEZ, T.
Spanish, 17th cent.
GOMEZ de Valencia,
Felipe
Spanish, c.1634-1694
GOMEZ, Vicente Salvador
see Salvador Gomez
GOMIEN, Paul
French, 1799-1846
GOMPERTZ, M.
British, op.1833-1835
GONÇALVES, Luis
Portuguese, 1936-
GONÇALVES, Nuno
Portuguese, op.1450-1471
GONCOURT, Jules Huot de
French, 1830-1870
GONDOIN or Gondouin,
Jacques
French, 1737-1818

GONDOLACH, Matthäus
see Gundelach
GONDOR, Bertalan
Hungarian, 1908-1945
GONDOUIN, Emmanuel
French, 1883-1934
GONIN, Francesco
Italian, 1808-1889
GONNE, Friedrich
(Christian Friedrich)
German, 1813-1906
GONORD, Francois
French, 1756-1819/25
GONTCHAROVA, Nathalie
Russian, 1881-
GONTIER, Clément
French, 19th cent.
GONTIER, Pierre Camille
French, 19th cent.
GONYN de Lirieux or
Lurieux, Adèle
(Adèle Yvanhoé Rambosson)
French, 1865-
GONZAGA, Pietro di
Gottardo
Italian, 1751-1831
GONZALEZ de Cedillo,
Antonio
Spanish, op.c.1680
GONZALEZ, Ruiz Antonio
Spanish, op.1738-m.1785
GONZALEZ y Serrano,
Bartolomé
Spanish, 1564-1627
GONZALEZ, Eva
French, 1849-1883
GONZALEZ Tavé, Federico
Spanish, 1823-1867
GONZALEZ de la Serna,
Ismael
Spanish, 1889-
GONZALEZ, Joan
Spanish(?), 20th cent.
GONZALEZ, Juan
(Francisco?)
Spanish, 1854-1933?
GONZALEZ Becerril, Juan
Spanish, op.c.1500
GONZALEZ, Julio
Spanish, 1876/81-1942
GONZALEZ, Raul Martinez
Cuban, 20th cent.
GONZALEZ, Roberta
French, 1909-
GONZALEZ, Vicente
Palmaroli Y.
Spanish, 1834-1896
GONZALEZ, Xavier
American, 1898-
GONZALEZ, Zacarias
Spanish, 20th cent.
GONZALEZ VELAZQUEZ
the Elder, Antonio
Spanish, 1723-1793
GONZALEZ-VELAZQUEZ,
Isidoro
Spanish, 1764-1840
GONZALEZ VELAZQUEZ,
Luis
Spanish, 1715-1763
GONZALEZ VELAZQUEZ,
Zacarias
Spanish, 1763-1834
GOOCH, James
British, op.1819-1837
GOOCH, T.
British, op.1777-1802

GOOD, Thomas Sword
British, 1789-1872
GOODALL, Edward Alfred
British, 1819-1908
GOODALL, Frederick
British, 1822-1904
GOODALL, Frederick
Trevelyan
British, 1848-1871
GOODALL, Herbert
British, op.1890-m.1907
GOODALL, J. Edward
British, 19th cent.
GOODALL, John Strickland
British, 1908-
GOODALL, Thomas F.
British, 1856/7-1944
GOODALL, Walter
British, 1830-1889
GOODALL, William
American, 20th cent.
GOODE, J.
British, op.1815-1860
GOODE, Joe
British, 20th cent.
GOODE, Louise
see Jopling
GOODEN, James Chisholm
British, op.1835-1865
GOODEN, Stephen
Frederick
British, 1892-1955
GOODERSON, Thomas
Youngman
British, op.1846-1860
GOODHALL, H.
British, op.c.1780
GOODMAN, Maude
British, op.1874-m.1938
GOODMAN, Robert Gwelo
South African, 1871-1939
GOODMAN, Sidney
American, 1936-
GOODMAN, Walter
British, 1838-
GOODNOUGH, Robert
American, 1917-
GOODNOUGH, Robert
American, 19th cent.
GOODRICH, Jerome
British, op.1829-1859
GOODRIDGE, Eliza
American, 1798-1882
GOODRIDGE, Henry Edmund
British, op.1835
GOODRIDGE, Sarah
American, 1788-1853
GOODWIN, Albert
British, 1845-1932
GOODWIN, Arthur Clifton
American, 1866-1929
GOODWIN, Edward
British, op.1802-1816
GOODWIN, Edwin Weyburn
American, 1800-m.1845
GOODWIN, Harry
British, -1925
GOODWIN, Richard Labarre
American, 1840-1910
GOOL, Jan van
Dutch, 1685(?)-1763/5
GOOR, Cornelia van
(née Rijck)
see Rijck
GOOR, G. van
Dutch, -c.1694(?)
GOOR, Steven Jansz. van
Dutch, c.1608-c.1657/63

GOOS, Berend
German, 1815-1885
GOOSEN, Jan van
Dutch, op.1667/8
GOOSSENS, Josse
German, 1876-1929
GOOVAERTS, Hendrick
see Govaerts
GOPAL-CHOWDHURY, Paul
British, 1949-
GÖRBITZ, Johan
Norwegian, 1782-1853
GORCZYN, Jan Alexander
Polish, op.1645-1704
GORDIGIANI, Eduardo
Italian, 1866-
GORDIGIANI, Michele
Italian, 1830-1909
GORDON, Arthur
British, 19th cent.
GORDON, Rev. James
British, op.c.1646
GORDON, John Sloan
Canadian, 1868-1940
GORDON, Sir John Watson
British, 1788-1864
GORDON, Peter
American, op.c.1735
GORDON, Robert James
British, 19th cent.
GORDON, T.J.L.
British, op.1807
GORDOT, Claude Marie
French, op.1774
GORE, Charles
British, 1729-1807
GORE, Frederick
British, 1913-
GORE, Spencer
Frederick
British, 1878-1914
GORE, William Henry
British, 19th cent.
GORECKI or Goretzky,
Tadeusz von
Polish, 1825-1868
GORGE, Paul
Belgian, 19th cent.
GORGUET, Auguste
Francois
French, 1862-1927
GORI, Alessandro
Italian, 17th cent.
GORI, Angiolo
Italian, op.1658
GORI, Lamberto Cristiano
Italian, 1730-1801
GORI, Ottavio
Italian, 18th cent.
GORI, Rosalba
Italian, 18th cent(?)
GORIN, Jean-Albert
French, 20th cent.
GORKA, Wiktor
Polish, 20th cent.
GORKY, Arshile
American, 1904-1948
GORMAN, Richard
American, 20th cent.
GORNI, Giuseppe di
Nuvolato
Italian, 1894-
GOROWSKI, Mieczyslaw
Polish, 20th cent.
GORP, Henri Nicolas van
French, op.1793-1819

GORRA, Giulio
Italian, 1832-1884
GORSON, Aaron Henry
American, 1872-1933
GORT
Dutch(?), op.1661
GORTER, Arnold Marc
Dutch, 1866-1933
GÖRTSCHACHER (not
Dörtschacher) Urban
German, op.1508
GOS, Albert
Swiss, 1852-
GOSCIMSKI, Wladislaw
Polish, 1904-
GOSE, Francisco Xavier
Spanish, 1876-1915
GÖSER, Simon
Swiss, op.1772-1814
GOSLING, William W.
British, 1824-1883
GOSSAERT, Jan
see Mabuse
GOSSART or Gosser,
Jean or Jen
Netherlands,
op.1428-1430
GOSSE, H.
French, op.1831
GOSSE, Laura Sylvia
British, 1881-1968
GOSSE, Nicolas Louis
François
French, 1787-1878
GOSSE, Thomas
British, 1765-1844
GOSSE, W.
British, op.1814-1839
GOSSEE, B.
French, op.1779
GOSSELIN, Albert
(Ferdinand Jules Albert)
French, 1862-
GOSSENS
Flemish(?), 18th cent.
GOSSER, Jean or Jen
see Gossart
GOSSET, Isaac
British, 1713-1799
GOSSET de Guines, Louis
Alexandre (André Gill)
French, 1840-1885
GOSSIN, Gerard
see Goswin
GOSTL, Johana Baptist
German, 1813-1895
GOSWIN, Gossin or
Gosuin, Gerard
Flemish, 1616-1691
GOTCH, Bernard Cecil
British, 1876-
GOTCH, Thomas Cooper
British, 1854-1931
GOTH, Moricz
Hungarian, 1873-
GOTHARDT, Matthias
see Grünewald
GÖTHE, H.
German, 19th cent.
GOTHEIN, Werner
German, 1890-
GOTHEREAU
French(?), 19th cent.(?)
GOTLIB, Henryk
Polish, 1892-1966

GOTMAN, Miles Edmund
British, 20th cent.
GOTO, Joseph
American, 1926-
GOTTFRIED, A.
British, op.1870
GOTTGETREU, Rudolf
Wilhelm
German, 1821-p.1877
GÖTTING, Heinrich
see Göding
GOTTLIEB, Adolph
American, 1903-
GOTTLIEB, or Gotlieb,
Leopold
Polish, 1883-1933
GOTTLIEB, Moritz
Polish, 1856-1879
GOTTLOB, Fernand Louis
French, 1873-
GOTTMAN, Lorens
Swedish, 1708-1779
GOTTSCHALK, Albert
Danish, 1866-1906
GOTTSCHALK, Joachim
Danish, op.1667
GOTTSMANN, Werner
German, 20th cent.
GÖTZ, Franz Augustin
German, 1752-1827
GÖTZ, Gottfried
Bernhard
see Goetz
GÖTZ, Karl Otto
German, 1914-
GÖTZ, Theodor von
German, 1826-1892
GÖTZENBERGER, Jacob
German, 1800-1866
GÖTZINGER, Hans
German, 1867-
GOTZLOFF, Carl Wilhelm
German, 1799-1866
GOUBAU, Antoni or
Antoon
Flemish, 1616-1698
GOUBAU, Frans
Flemish, 1622-1678
GOUBAU, Laureys
Flemish, op.1651-1670
GOUBAUD, Innocent Louis
French, c.1780-1847
GOUBIE, Jean Richard
French, 1842-1899
GOUDET, Pierre
see Gourdelle
GOUDREAUX or Gaudréau,
Pierre Louis
French, 1694-1731
GOUDT, Hendrick
Dutch, 1585-1630
GOUEZOU, Joseph René
French, 1821-1880
GOUGE, E.
British, op.1719-1742
GOUILLET, Jules
French, 1826-p.1882
GOUIOT, J.
French, 19th cent.
GOUJON, Jean
French, op.1526-1564/8
GOULD, Alec Carruthers
British, 1870-
GOULD, Elizabeth
British, 19th cent.

GOULD, Francis
Carruthers
British, 1844-1925
GOULD, John
British, 1804-1881
GOULD, William Buelow
Australian, 1801-1852
GOULDSMITH, Harriet
see Arnold
GOULIN, Francis
see Goullin
GOULINAT, Jean Gabriel
French, 1883-
GOULLIN or Goulin,
Francis
French, 18th cent.
GOUNARO
French, 20th cent.
GOUNOD, Francois Louis
French, 1758-1823
GOUPIL, Jules Adolphe
French, 1839-1883
GOUPIL, Léon Lucien
French, 1834-1890
GOUPIL-FESQUET, Frederic
French, op.c.1839-1842
GOUPY, Joseph
British, 1680(?)-1768(?)
GOUPY, Louis or Lewis
French, a.1700-1747
GOURANOPOULOS, George
Greek, 20th cent.
GOURDAULT, Pierre
French, 1880-1915
GOURDELLE or Gourdel,
Pierre (Goudet)
French, op.1555-1588
GOURDON, R.
French, 19th cent.
GOUREAU, Charles
French, 1797-p.1834
GOURGAUD, General
French, op.1818
GOURMONT, Jean de
French, c.1483-p.1557
GOURMONT the Younger,
Jean de
French, op.1565-1585
GOURMONT, Remy de
French, op.1895
GOURSAT, Georges
(Sem)
French, 1863-1934
GOUSSIER
French, 18th cent.
GOUT, Jean Francois
German, c.1748-1812
GOUTHIERE, Pierre
French, 1732-1813/14
GOUVAERT, Abraham
see Govaerts
GOUWI, Jacob Peter
see Gowy
GOUY, de
French, 18th cent.
GOUY, M.A.
American, 20th cent.
GOVAERTS, Goevaerts,
Gouvaert or Goyvaert,
Abraham
Flemish, 1589-1626
GOVAERTS or Goovaerts,
Hendrick
Flemish, 1669-1720
GOVAERTS, Jan Baptiste
Flemish, op.1713-m.1746

GOVAERTS, Jean
Belgian, 1898-
GOVERTSZ., Goversz. or
Goverts, Dirck
Dutch, c.1580-c.1645/54
GOVETT, William Romaine
British, op.1828-1837
GOW, Andrew Carrick
British, 1848-1920
GOW, Charles
British, 19th cent.
GOW, James
British, -1886
GOW, Mary L.
(Mrs. Sydney Prior
Hall)
British, 19th cent.
GOWER, George
British, op.1579-c.1596
GOWER, T.
British, op.1790
GOWERS, David
British, op.1801-1808
GOWING, Lawrence
Burnett
British, 1918-
GOWY, Gouwi or
Gowi, Jacob Peter
Flemish, op.1632-1661(?)
GOYA y Lucientes,
Francisco José de
Spanish, 1746-1828
GOYEN, Jan Josephsz. van
Dutch, 1596-1656
GOYRAND, Antoine-Gabriel
French, 1754-1826
GOYVAERT, Abraham
see Govaerts
GÖZ, Gottfried
Bernhard
see Goetz
GOZIAN, Leon Duval
French, 1853-
GOZZALI, Grazio
see Cossali
GOZZARD
British, 19th cent.
GOZZI, Marco
Italian, 1759-1839
GOZZINI, Giuseppe
Italian, op.1824-1870
GOZZINI, Vincenzo
Italian, 19th cent.
GOZZO, Bruno
Italian, 20th cent.
GOZZOLI
see Benozzo
GRAAF, Johann
see Graf
GRAAF, Josua de
see Grave
GRAAF, Kees
Dutch, 20th cent.
GRAAF or Graaff,
Timotheus de
see Graef
GRAAT or Graet, Barend
Dutch, 1628-1709
GRAAUW or Grauw,
Hendrick (de)
Dutch, c.1627-1693
GRAB, Bertha von
Czech, 1846-
GRABAR, Jigor
Emmanuilowitsch
Russian, 1872-

GRABENBERGER, Johann
Bernard
German, 1637-1710
GRABENBERGER, Michael
Cristoph
German, op.1674-m.1684
GRABMULLEROVA, Eva
Czech, 20th cent.
GRABONE, Arnold
French, 20th cent.
GRABOWSKI, Andrzej
Polish, 1938-1969
GRABOWSKI, Tadeusz
Polish, 20th cent.
GRACE, Alfred
Fitzwalter
British, 1844-1903
GRACE, W.
British, 19th cent.
GRACHT, Jacob van der
Dutch, 1593-1652
GRADA, Raffaele de
Italian, 1885-
GRADO, Arcangelo de
Italian, 18th cent.
GRAEB, Carl Georg
Anton
German, 1816-1884
GRAEB, Paul
German, 1842-1892
GRAEF, Gustav
German, 1821-1895
GRAEF, Johann
see Graf
GRAEF, Oscar
German, 1861-1912
GRAEF, Graaf or Graaff,
Timotheus de
Dutch, op.1682-1718
GRAEFF, Werner
German, 1901-
GRAEME, Colin
British, 19th cent.
GRAEME, James
British, op.1820
GRAENICHER, Samuel
German, 1758-1813
GRAESER, Camille
Swiss, 1892-
GRAET, Barend
see Graat
GRAEVENITZ, Gerhard van
Dutch, 20th cent.
GRAF, F.
Dutch(?), op.1733
GRAF or Fraaf, Hans
German, 1680-1734
GRAF, Graaf, Graef or
Graff, Johann or Hans
German, 1653-1710
GRAF, Oscar
German, 1870-1957
GRAF or Graff the Elder,
Urs
Swiss, c.1485-1527
GRAFAIT, P.
French, op.1695-1700
GRAFF, Anton
Swiss, 1736-1813
GRAFF, Carl Anton
German, 1774-1832
GRAFF, Dorothea Maria
Henrietta
see Gsell
GRAFF, Johann
see Graf

GRAFF, Graf or Grav,
Johann Andreas
German, 1637-1701
GRAFF, Johanna Helena
see Herold
GRAFF, Graf or Grav,
Michael
German, op.c.1520-m.1550
GRAFFIONE, Giovanni di
Michele Scheggini da
Larciano
Italian, 1455-1527
GRAFFMAN, Carl Samuel
Swedish, 1802-1842
GRAFFONARO, Giuseppe
see Graffonara
GRÄFLE, Albert
German, 1807-1889
GRAGLIA, Andrea
Italian, op.1777-1792
GRAHAM, Alexander
British, 1858-p.1893
GRAHAM, C.
British, op.1839-1850
GRAHAM, Dan
British, 20th cent.
GRAHAM, David
New Zealand, 1928-
GRAHAM, George
British, op.1786-1813
GRAHAM, George
British, 1881-1949
GRAHAM, H.B.
British, 20th cent.
GRAHAM, James Lillie
Canadian, 1890-1965
GRAHAM, John
American, 1890-
GRAHAM the Younger,
John
British, 1754-1817
GRAHAM, John D.
American, 1881-1961
GRAHAM, Peter
British, 1836-1921
GRAHAM, Thomas Alex
Fergusson
British, 1840-1906
GRAHAM, Wilhelmina
Barns
British, 1912-
GRAHAM, William
American, 1841-1910
GRAHAM-GILBERT, John
British, 1794-1866
GRAHL, August
German, 1791-1868
GRAHN, Hjalmar
Swedish, 1882-1949
GRAILLON, Pierre Adrien
French, 1807/9-1872
GRAILLY, Victor de
French, 1804-1889
GRAIMBERG, Carl, Graf von
(Charles de)
German, 1774-1865
GRAINE, Colin
British, op.1906
GRALLENI, H.
British(?), op.c.1845
GRAM, Lennart
Swedish, 1910-
GRAMATTE, Walter
German, 1897-1929
GRAMATZKI, Eve
French, 20th cent.

GRAMICCIA, Lorenzo
Italian, 1702-1795
GRAMMATICA, Antiveduto
Italian, 1571-1626
GRAMMONT
French, 19th cent.
GRAMMORSEO, Pietro
Italian, op.1523-1533
GRAMONT(?)
French(?), 18th cent.
GRAN, Daniel
German, 1694-1757
GRANACCI, Francesco
Italian, 1477-1543
GRANACCI, Pseudo
Italian, op.c.1500
GRANBY, Violet,
Marchioness of
see Rutland, Violet,
Duchess of
GRANCINI, Amos
Italian, op.1809
GRANDE, Francisco
Agustin y
see Agustin
GRANDEE, Joe
American, 20th cent.
GRANDGERARD, Lucien
Henri
French, 1880
GRAND'HOMME, Paul V
French, 19th cent.
GRANDI
Italian, op.1782
GRANDI, Ercole de
Giulio Cesare
(Ercole da Ferrara)
Italian, c.1463-a.1525
GRANDI, Francesco
Italian, 1831-1891
GRANDI, Girolamo
Italian, op.c.1530-48
GRANDIN, Jacques Louis
Michel
French, 1780-p.1814
GRANDIO, Constantino
Spanish, 1924-
GRANDJEAN, Edmond Georges
French, 1844-1908
GRANDJEAN, Jean
Dutch, 1755-1781
GRANDON, Charles
French, c.1691-1762
GRANDSIRE, Pierre
Eugène
French, 1825-1905
GRANDVILLE
see Gerard, Jean Ignace
Isidore
GRANELL, E.F.
French, 20th cent.
GRANELLO or Granelo,
Niccola
Italian, op.1567-m.1593
GRANER y Vinuelas,
Antonio
Spanish, 19th cent.
GRANER, Ernst
German, 1865-
GRANER y Arrufi, Luis
Spanish, 1867-1927
GRANERI, Giovanni
Michele(?)
Italian, op.c.1730-m.a.1778
GRANET, François Marius
French, 1775-1849

GRANGE, Robert
French(?), 18th cent.
GRANGER, Mme
French, 19th cent.
GRANGER, Jean Pierre
French, 1779-1840
GRANGES, David Des
British, 1611-1675
GRÄNICHER, Samuel
(Johann Samuel)
Swiss, 1758-1813
GRANIE, Joseph
French, 1866-1915
GRANINGER, Leopold
German, 19th cent.
GRANO, Antonino Nino
Italian, op.1680-m.1718
GRANT, A.
British, op.1786-1789
GRANT, A.
British, op.1852
GRANT, Alistair
British, 1925-
GRANT, Baron
British, 19th cent.
GRANT, C.J.
British, op.1832
GRANT, Clement Rollins
American, 1849-1893
GRANT, Duncan
British, 1885-
GRANT, Sir Francis
British, 1803-1878
GRANT, Gordon
American, 1875-
GRANT, Ian Macdonald
British, 1904-
GRANT, John
British, -1873
GRANT, Keith
British, 20th cent.
GRANT, Thomas
British, op.1819-1849
GRANT, William James
British, 1829-1866
GRANTHOMME, Jacques
French, op.1574-1613
GRANUCCI, Bartolommeo
Italian, 18th cent.
GRANZOW, Wladislaw
Polish, 1872-
GRAPINELLI, Flaminio
Italian, -c.1750
GRAPP, Balthasar
see Gropp
GRAPP, Wendling
see Dietterlin
GRAPPE-ROY, C.
French, op.1922
GRAS, Willem
Dutch, 17th cent.
GRASDORP, Jan Gerrit
Dutch, 1651-1693
GRASDORP, Willem
Dutch, 1678-1723
GRASEL
German, 20th cent.
GRASMAIR, Grasmayer,
Grasmayr or Graszmayer,
Johann Georg Dominikus
German, 1691-1751
GRASS, Adolf
(Joseph Adolf)
German, 19th cent.
GRASS, Carl Gotthard
German, 1767-1814

GRÄSSEL, Franz
German, 1861-c.1921
GRASSET, Auguste
French, 1829-p.1884
GRASSET, Eugène Samuel
Swiss, 1841-1917
GRASSI, Bartolomeo
Italian, 16th cent.
GRASSI, Giovanni
Battista di Raffaello
Italian, op.1545-m.1578
GRASSI, Giovannino de'
Italian, op.1389-m.1398
GRASSI de Livizzani,
Girolamo
see Girolamo da Carpi
GRASSI or Grassy,
Joseph
German, c.1758-1838
GRASSI, Nicola
(Giannicola)
Italian, a.1682-c.1750
GRASSMAN, Marcelo
Brazilian, 1925-
GRASS-MICK, Augustin
French, 19th cent.
GRASSO, Filippo D.
Italian, op.1644
GRASSO, Francesco di
Giannino (Francesco
da Pavia)
Italian, op.1490-1502
GRATAMA, Gerrit David
Dutch, 1874-1965
GRATI, Alessandro
Italian, 18th/19th cent.
GRATI, Giovanni Battista
Italian, 1681-1758
GRATISE, Sebastian
German, op.1785-1795
GRATTAN, George
British, 1787-1819
GRÄTZ, Carl Mayr
German, 20th cent.
GRAU y Andreu,
Francisco
Spanish, 1772-1834
GRAU, Gustave Adolphe
French, 1873-1919
GRAUBNER, Gotthard
German, 1930-
GRAUMANN, Julius
German, 1878-
GRAU-SALA, Emilio
French, 1911-
GRAUSMAN, Philip
American, 20th cent.
GRAUSS, Gerardus Hendrik
(Geert)
Dutch, 1882-1929
GRAUW, Hendrick de
see Graauw
GRAUWELS, J.
Flemish, op.1798
GRAV, Johann Andreas
see Graff
GRAVATT, W.
British, 18th cent.
GRAVE, Charles
British, 1886-
GRAVE, Jan Evert
Dutch, 1759-1805
GRAVE or Graaf,
Josua de
Dutch, op.1660-m.c.1712

GRAVELOT, Hubert
François
(Bourguignon)
French, 1699-1773
GRAVES, Frederick Percy
British, 1837-1903
GRAVES, the Hon.Henry
Richard
British, op.1846-1881
GRAVES, Morris
American, 1910-
GRAVES, Nancy
American, 20th cent.
GRAVES, P. de
British, 17th cent.
GRAVES, Robert
British, 1798-1873
GRAY, Cedric
British, 19th cent.
GRAY, Don
American, 20th cent.
GRAY, Douglas Stannus
British, 1890-1959
GRAY, Felix de
French, 1889-
GRAY, H.G.
British, 19th cent.
GRAY, Henry
British, op.1849-1897
GRAY, John
British, op.c.1906
GRAY, Kate
British, 19th cent.
GRAY, Nicolas Henry de
French, 19th cent.
GRAY, Paul Mary
British, 1842-1866
GRAY, Ronald
British, 1868-1951
GRAYSON, Clifford
Prevost
American, 1857/9-
GRAZI, Giulio Cesare
Italian, op.1583-1589
GRAZI, L.
Italian, 19th cent.
GRAZIA or Gratia,
Leonardo
(Leonardo da Pistoia)
Italian, c.1502-p.1548
GRAZIADEI
see Mariano da Pescia
GRAZIANI, Ciccio and/or
Pietro
Italian, 17th cent.
GRAZIANI the Younger,
Ercole
Italian, 1688-1765
GRAZIANI, Pietro
see Graziani, (Ciccio)
GRAZIANI, Sante
American, 1920-
GRAZIOLI, Walmar
Italian, 20th cent.
GREACEN, Edmund William
American, 1877-1949
GREASE, Jack
see Gresse, John
Alexander
GREAVES, Derrick
British, 1927-
GREAVES, Henry
British, 1850-1900
GREAVES, Walter
British, 1846-1930
GREAVES, William
British, op.1885-1910

GREB
Russian, op.1832
GREBBER, Adriaen Claesz.
de
Dutch, 1576-1661(?)
GREBBER, Frans Pietersz.
de
Dutch, 1573-1649
GREBBER, Maria
Dutch, op.1628-1631
GREBBER, Pieter Fransz.
de
Dutch, c.1600-c.1652/3
GREBE, Fritz
German, 1850-
GRECHE, Domenicho
dalle
Italian, op.1543-1549
GRECHETTO, Il
see Castiglione,
Giovanni Benedetto
GRECO, Domenico Theotokopuli
El
Spanish, 1541-1614
GRECO, Emilio
Italian, 1913-
GRECO, Gennaro
('Mascacotta')
Italian, 1663-1714
GRECO, George Manuel
Theotokopuli
Spanish, 1578-1631
GRECO or Griego, Nicolás
(El Greco Segoviano)
Spanish, 16th cent.
GRECO, Vettor
(Vittore)
Greek, op.1522-1539
GREEF, Jean or Jan de,
or Jean Degreef
Belgian, 1851-1894
GREEK SCHOOL,
Anonymous Painters
of the
GREEN, Alan
British, 20th cent.
GREEN, Alfred H.
British, op.1844-1862
GREEN, Amos
British, 1735-1807
GREEN, Anthony
British, 20th cent.
GREEN, Benjamin
British, c.1736-1800
GREEN, Benjamin Richard
British, 1808-1876
GREEN, Bertha
see Dorph
GREEN, Charles
British, 1840-1898
GREEN, Charles
British, 20th cent.
GREEN, David Gould
British, 1854-1918
GREEN, Elizabeth
Shippen
British, 20th cent.
GREEN, F.
British, c.1767-1850
GREEN, George Pycock
Everett
British, op.1841-1873
GREEN, Harriet
British, 1751-p.1807
GREEN, Henry Towneley
British, 1836-1899

GREEN, James
British, 1771-1834
GREEN, John
British, c.1729-c.1757
GREEN, Joshua
British, 19th cent.
GREEN, Kenneth
British, 1916-
GREEN, Madeline
French, -1947
GREEN, Mary, (née Byrne)
British, 1776-1846
GREEN, Peter
British, 20th cent.
GREEN, T.
British, op.1747
GREEN, Valentine
British, 1739-1813
GREEN, W.
British, op.1765
GREEN, William
British, 1760-1823
GREENAWAY, Kate
British, 1846-1901
GREENBANK, Arthur
British, op.1888-1899
GREENBURY, Richard
(not Robert)
British, op.1622-c.1670
GREENE, Balcomb
American, 1904-
GREENE, Stephen
American, 1917-
GREENE, Walter L.
American, 19th/20th cent.
GREENHAM, Peter George
British, 1909-
GREENHILL, John
British, 1649-1676
GREENLEES, Robert M.
British, 1820-1894
GREENLY, Miss B.
British, op.1795-1801
GREENWOOD, C.J.
British, 19th cent.
GREENWOOD, Ernest
British, 1913-
GREENWOOD, Ethan Allen
American, 1779-1856
GREENWOOD, John
American, 1727-1792
GREENWOOD, Orlando
British, op.1920
GREER, Lulu
British, 20th cent.
GREEVEN, Hendrik
Dutch, 1787-1854
GREFE, Konrad
German, 1823-1907
GREFICE, Victoria
British, 20th cent.
GREGOIRE, Aleandre
Haitian, 1922-
GREGOIRE, Gaspard
French, 1751-1846
GREGOIRE, Paul
French, op.1781-1823
GREGOLINI, Giovanni
see Crecolini
GREGOOR, Gillis Smak
see Smak-Gregoor
GREGOOR, Pieter
Martinus
Dutch, 1784-1846
GREGOR, Harold
American, 1929-
GREGORI, Antonio (di
Taddeo?)
Italian, 1583-1646

GREGORI, Carlo
Italian, 1719-1759
GREGORI, Ferdinando
Italian, 1743-1804
GREGORIEV
Russian, 20th cent.
GREGORIO d'Arezzo
Italian, op.1315
GREGORIO di Cecco di
Luca
Italian, op.1389-1423
GREGORIO, Giuseppe de
Italian, 20th cent.
GREGORIO, Marco di
Italian, 1829-1876
GREGORIO, N.H. de
Italian, op.1875
GREGORIUS, Albert Jakob
Frans
Belgian, 1774-1853
GREGOROVIUS, Michael
Carl
German, op.1814-1834
GREGORY, Charles
British, 1850-1920
GREGORY, Charles
British, op.1838-1854
GREGORY, Edward John
British, 1850-1909
GREGORY, George
British, 19th cent.
GREGORY, Josef
German, 1774-1810
GREIFFENHAGEN, Maurice
British, 1862-1931
GREIG, E.
British, 19th cent.
GREIG, John
British, op.1803-1853(?)
GREIL, Alois
German, 1841-1902
GREIL, Philipp Jakob
German, 1729-1787
GREIN, Caspar Arnold
German, 1764-1835
GREINER, H.
German, op.1840-1860
GREINER, Otto
German, 1869-1916
GREIPPEL, Johann Franz
(not Johann Georg)
German, 1720-1798
GREITHER
see Greuter
GREIVE, Johan Conrad
Dutch, 1837-1891
GRELA, Juan
Spanish, 1914-
GRELLET, Alexandre
Athanèse
French, 19th cent.
GRELLIN, W.
British, 19th cent.
GRENDEL, A.
Dutch, op.1781
GRENIER de Saint-
Martin, François
French, 1793-1867
GRENIER de Saint Martin,
Henry
French, op.1857-66
GREPPI, Giovanni Battista
Italian, c.1600-1647
GRES, Gerard du
French(?), 18th cent.
GRESELY, Greseli or Gresly,
Gaspard (not Gabriel)
French, 1712-1756

GRESELY, Nicolas
French, c.1715-p.1777
GRESSE, John Alexander
(Jack Grease or Greese)
British, 1741-1794
GRESTY
British, op.1854
GRESY, Prosper
French, 1804-1874
GRETHE, Carlos
German, 1864-1913
GREUELL, Arthur
Belgian, 1891-1966
GREUTER, Greither,
Kreitter or Kreuter,
Elias, I
German, op.1591-m.1646
GREUTER, Greither,
Greitherer, Kreitter
or Kreuter, Elias, II
German, c.1595-1641/2
GREUTER, Greither,
Greitherer, Kreitter
or Kreuter, Johann or
Hans
German, op.1607-m.1641
GREUTER, Lorenzo
Italian, 1620-1668
GREUTER or Greuther,
Matthäus
German, c.1564/6-1638
GREUX, Amedée Paul
French, 1836/8-1919
GREUZE, Anne Geneviève
French, 1762-1842
GREUZE, Jean-Baptiste
French, 1725-1805
GREVE, Guillaume
Ernest
French, op.1612-m.1639
GREVE, Hedwig
German, 1850-
GREVEDON, Henri or Pierre
Louis
French, 1776-1860
GREVENBROECK, Alessandro
Italian, op.1717-1724
GREVENBROECK, Charles-
Leopold van
Dutch, op.1731-1799
GREVENBROECK, Jan, II
Italian, 1731-1807
GREVENBROECK, Martinus van
Dutch, 1646-p.1670
GREVENBROECK, Orazio
Dutch, 1678(?)-
GREVILLE, Lady Louisa
Augusta
British, op.1757-1770
GREVIN, Alfred
French, 1827-1892
GREY or Caey, J. de
British, op.1720(?)
GREY, Roger de
British, 1918-
GREZNA, C.
British, op.1785
GRIAR, L.H.
German(?), op.1767
GRIBELIN the Younger,
Simon
French, 1661-1733
GRIBBLE, Bernard Finegan
British, 1872-
GRIBBLE, Herbert
Augustine Keate
British, op.1874-1882
GRIEB, Ludwig
German, 1884-

GRIEBEL, Fritz
German, 1877-
GRIEBEL, Otto
German, 1895
GRIECO, Gennaro
see Greco
GRIEDER, Walter
Swiss, 1914-
GRIEF or Grieff, Adriaen de
see Gryef
GRIEF, Jacques de
see Claeuw
GRIEFEN, John
American, 20th cent.
GRIEGO, El
see Serafin, Pedro
GRIEMER
see Grimmer
GRIEN, Hans Baldung
see Baldung
GRIENT, Cornelis de
Dutch, 1691-1783
GRIEPENKERL, Christian
German, 1839-1916
GRIESHABER, H.A.P.
German, 1909-
GRIEVE, Thomas
British, 1799-1882
GRIEVE, Walter Graham
British, -1937
GRIEVE, William
British, 1800-1844
GRIF, Adriaen de
see Gryef
GRIFFIER, A.R.
Netherlands(?), 18th cent(?)
GRIFFIER, Jan, I
Dutch, c.1652/6-1718
GRIFFIER, Jan, II
Dutch, -c.1750(?)
GRIFFIER, Robert
Dutch, 1688-c.1760
GRIFFIN, Walter
American, 1861-1953
GRIFFINS, S.S.Boulton
American, op.1885
GRIFFITH, Moses
British, 1749-1819
GRIFFITH, Roberta
Jean
American, 1937-
GRIFFITHS, C.J.
British, op.1820
GRIFFITHS, John
British, 18th cent.
GRIFFITHS, John
British, 1837-1918
GRIFFONI, C.M.
Italian, op.1776
GRIFFONI, Fulvio
Italian, op.1604-1650
GRIFFONI, Giovanni
Maria
Italian, op.c.1800
GRIFFONI or Grifoni,
Girolamo
Italian, op.1620
GRIFFOUL, E.
German, 19th cent.
GRIFONI, Girolamo
see Griffoni
GRIFONI, Giuseppe
see Grisoni
GRIGGS, Frederick
Landseer Maur
British, 1876-1938
GRIGIOTTI, Francesco
Italian, op.1604-1635
GRIGNION (not Grignon)
the Elder, Charles
British, 1717-1810

121

GRIGNION the Younger,
Charles
British, 1754-1804
GRIGOLETTI, Michelangelo
Italian, 1801-1870
GRIGORE, Ion
Rumanian, 20th cent.
GRIGORE, Vasile
Roumanian, 1935-
GRIGORE, Zincovschi
Roumanian, 20th cent.
GRIGORESCU, Lucien
Rumanian, 1894-
GRIGORESCU, Nicolae Jon
Roumanian, 1838-1907
GRIGORJEFF, Boris
Russian, 1886-1939
GRILLO, John
American, 1917-
GRIMALDI, Giovanni
Francesco
(Il Bolognese)
Italian, 1606-1680
GRIMALDI, Jacopo
Italian, c.1560-1623
GRIMALDI, Lazzaro
Italian, op.1496-1504
GRIMALDI, William
British, 1751-1830
GRIMANI
see Jacobsz., Huybrecht
GRIMBALDSON, Walter
British, op.1738
GRIMELUND, Johannes
Martin
Norwegian, 1842-1917
GRIMER
see Grimmer
GRIMES, John
American, 1804-1837
GRIMM, Arthur
German, 1883-1948
GRIMM, Hugo
German, 1866-1944
GRIMM, Ludwig Emil
German, 1790-1863
GRIMM, Max von
German, op.1783-1797
GRIMM, P.H.
German, 19th cent.
GRIMM, Samuel
Hieronymus
Swiss, 1733-1794
GRIMM, Stanley
British, 1891-
GRIMM, Wilhelm (Willem)
German, 1904-
GRIMMER, Grimer or
Grimmaert, Abel
Netherlands, op.1592-1614
GRIMMER (not Griemer)
Adam
German, op.1562-m.1596/8
GRIMMER or Grimer, Hans
or Johannes
German, op.1560
GRIMMER, Griemer,
Grimer or Grimmaer,
Jacob
Netherlands, c.1525-1590
GRIMMOND, William
British, 1884-
GRIMOU or Grimoult,
Alexis (not Jean or
Nicolas Grimoud or
Grimoux)
French, 1678-1733

GRIMSHAW, Arthur E.
British, 1868-1913
GRIMSHAW, Atkinson
British, 1836-1893
GRIMSHAW, Louis
British, 1870-1944
GRIMSHAW, Thomas
British, op.1844
GRIMSHAW, W.H. Murphy
British, op.1886-1907
GRIMSON, Malvina
see Hoffman
GRINBERG, Jacques
Belgian, 20th cent.
GRINDLAY, Robert
Melville
British, op.1828
GRINTZNER
German, 19th cent.
GRIPS, Carel Jozeph
Belgian, 1825-1920
GRIS, Juan
Spanish, 1887-1927
GRISET, Ernest Henry
British, 1844-1907
GRISON, Adolphe
French, 1845-1914
GRISON, Francois-
Adolphe
French, 1845-
GRISON, Pierre Joseph
see Grisoni
GRISONI or Grifoni,
Giuseppe
(Pierre Joseph Grison)
Italian, 1699-1769
GRISSON, Giovanni Maria
Italian, 18th cent.
GRITCHENKO, Alexis
Russian, 20th cent.
GRITSAY or Grizai,
Aleksey Mikhaylovich
Russian, 1914-
GRITTEN, Henry
British, op.1835-1848
GRITZNER, Gunter
German, 20th cent.
GRIVAZ, Eugène
Swiss, 1852-1915
GRIVEAU, Lucien
French, 1858-1923
GRIVOLAS, Pierre
French, 1823-1906
GROB, Konrad
Swiss, 1828-1904
GROBON, Michel (Jean
Michel)
French, 1770-1853
GRODECKI, Wlodzimierz
Polish, 20th cent.
GROEBER, Hermann
German, 1865-1935
GROELL, Carl
Polish, 1770-1857
GROEN, A. van der
Dutch, op.1774-m.c.1788
GROENEDAEL, Cornelis
Belgian, 1785-1834
GROENEWEGEN, Adrianus
Johannes
Dutch, 1874-1963
GROENEWEGEN, Gerrit
Dutch, 1754-1826
GROENEWEGEN, Pieter
Anthonisz. van
Dutch, op.1623-1657

GROENIA, Petrus
Dutch, 1767-1844
GROENNING, Groennig
or Groningus, Gerard
P. van
(Gerard Paludanus van
Gröningen?)
Netherlands. op.1573
GROENSVELD, Johannes
see Gronsveld
GROER, Ferdinand
German, op.c.1830
GROGAN, Nathaniel
British, c.1740-1807
GRÖGER, Ferdinand
German, 18th cent.
GROGER, Friedrich Carl
German, 1766-1838
GROGLER, Wilhelm
German, 1839-1897
GROGNARD, Alexis
French, 1752-1840
GROHAIN, Pierre Joseph
French, 1780-1872
GROHAR, Ivan
Yugoslav, 1867-1911
GROIN, Jost van
Dutch, 17th cent.
GROIS, Josef
German, op.1830-c.1850
GROLL, Albert Lorey
American, 1866-1952
GROLL, Henriette
French, 20th cent.
GROLL, Theodor
American, 1857-1913
GROLLERON, Paul Louis
Narcisse
French, 1848-1901
GROLLIER, Marquise de,
(née de Fuligny Damas)
French, 1742-1828
GROMAIRE, Marcel
French, 1892-
GRONE, Johann Baptist
German, 1682-1748
GRONEN, Bruno
German, 20th cent.
GRONER, Anton
German, 1823-1889
GRÖNINGEN, Jan Swart van
see Swart
GRONLAND, Theude
Swedish, 1817-1876
GRÖNNINGER, J.H.
German, op.1771
GRONON
French, 19th cent.
GRONSVELD, Groensveld
or Gronsvelt, Johannes
Dutch, c.1660-1728
GRONVOLD, Bert
Borchgrewink
Norwegian, 1859-p.1894
GRONVOLD, Hendrik
British, 1858-1940
GROOMBRIDGE, William
British, op.1770-1796
GROOMS, Red
American, 1937-
GROOT, Johannes or
Jan de
Dutch, 1650(?)-1726
GROOT, Johannes Willem
Simon de
Dutch, 1877-1956

GROOT, Pieter de
Dutch, 1742-
GROOTE, A. de
Dutch, 19th cent.
GROOTE, Otto von
German, 1883-
GROOTH, George Christof
German, 1716-1749
GROOTH, Johann Friedrich
German, 1717-1801
GROOTH, Johann Nikolaus
German, 1721/3-1797
GROOTVELT, Jan Hendrik
van
Dutch, 1808-1855
GROOTZ., F.
Netherlands, 17th cent.
GROPEANU, Nicolae
Roumanian, 1864-1936
GROPIUS, Carl Wilhelm
German, 1793-1870
GROPP or Grapp, Balthasar
Swiss, op.1549
GROPPER, William
American, 1897-
GROPPI, A.
Italian, 18th cent.
GROPPOLI, Francesco
Italian, 17th cent.
GROS, Antoine Jean
French, 1771-1835
GROS, Henri
French, 19th cent.
GROS, Jacques Marie Le
see Legros
GROS, Jean-Antoine
French, 1725-p.1786
GROSCLAUDE, Louis Aimé
Swiss, 1784-1869
GROSE or Grosse, Francis
British, c.1731-1791
GROSIO
see Vallorsa, Cipriano
GROSJEAN, Henry
(Marie Gustave Henry)
French, 1866-
GROSMAN, Johann
Czech, op.1707-1730
GROSPERRIN, Claude
French, 1936-
GROSPIETSCH or Grosspietsch,
Florian
German, 1789-p.1830
GROSS, Anthony
British, 1905-
GROSS, Arnold
Hungarian, 1929-
GROSS, Chaim
American, 1904-
GROSS, Fritz M.
German, 1895-1969
GROSS, Leopold
German, op.1830-1845
GROSS, P.A.
French, 19th cent.
GROSS, Valentine
see Hugo
GROSSBERG, Carl
German, 1894-1940
GROSSE, Theodor
German, 1829-1891
GROSSI, Bartolino
or Bartolommeo de'
Italian, op.1425-m.1464
GROSSMANN, Rudolf
German, 1882-1941

GROSSMITH, Weedon
British, 1854-1919
GROSSO, Luigi
Italian, 20th cent.
GROSSO, Giacomo
Italian, 1860-1938
GROSSO, Niccolò
(Caparra)
Italian, op.c.1500
GROSSPIETSCH, Florian
see Grospietsch
GROSSRUBATSCHER, Johanna
see Isser
GROSZ, August J.
German, 1847-1917
GROSZ, George
German, 1893-1959
GROTTGER, Artur
Polish, 1837-1867
GROUX, Charles de
French, 18th cent.
GROUX, Charles Corneille
Auguste de
Belgian, 1825-1870
GROUX, Henry Jules
Charles Corneille de
Belgian, 1867-1930
GROVE, J.
British, op.1789-1805
GROVE, Nordahl
Danish, 1822-1885
GROVER, Oliver Dennett
American, 1861-
GROZER, Joseph
English, op.1784-1797
GRÙ or Grue, Giuseppe
le
Italian, c.1715-1775(?)
GRUBACS, Carlo
Italian, op.c.1840-1870
GRUBACS, Giovanni
Italian, -1919
GRUBE, Georg Ernst
German, op.1694-1701
GRUBER, Francis
French, 1912-1948
GRUBER, Franz Xaver
German, 1801-1862
GRUBER or Grueber,
Johann Friedrich
German, op.1662-m.1681
GRUBHOFER, Tony
German, 1854-1935
GRUBICY de Dragon,
Vittore
Italian, 1851-1920
GRUBIN, D.B.
German, 20th cent.
GRUDMANN,
German, 19th cent.
GRUE, Francesco Antonio
I di Giovanni
Italian, 1594-c.1680
GRUE, Le
see Grù
GRUEBER, Johann Friedrich
see Gruber
GRUELLE, Richard
Buckner
American, 1851-1914
GRUEMBROECH, Gruenbroeck
or Gruenbroek, Johann
German(?), op.1757
GRUMEAUX
French(?), 19th cent.

GRÜMMER, Hansjürgen
German, 20th cent.
GRÜN or Grien
see Baldung, Hans
GRÜN, Jules Alexandre
French, 1869-
GRUNBAUM
Netherlands(?),
18th cent.
GRÜNBAUM, Laurent
German, c.1760-p.1830
GRUND, Johann
German, 1808-1887
GRUND, Norbert Joseph
Carl
German, 1717-1767
GRUNDIG, Hans
German, 1901-1958
GRUNDIG-LANGER, Lea
German, 1906-
GRUNDMANN, Basilius
German, 1726-1798
GRUNDY, Robert
Hindmarsh
British, 1816-1865
GRUNE, Johann Samuel
Benedictus
German, c.1782-1848
GRÜNENWALD, Jakob
German, 1822-1896
GRUNER, Elioth
Australian, 1882-1939
GRÜNER, Vincenz Raimund
Czech, 1771-1832
GRÜNER, Wilhelm Heinrich
Ludwig
German, 1801-1882
GRÜNEWALD, Isaac
Swedish, 1889-1946
GRÜNEWALD, Matthias,
Mathis, Matthaeus or
Mathes (Neithardt,
Nithardt or Gothardt)
(Monogrammist M.G.N.
or M.N.)
German, 1470/80-c.1530
GRÜNEWALD, Pseudo
see Simon von
Aschaffenburg
GRÜNLER, Ehregott
(Heinrich Ehregott)
German, 1797-1881
GRÜNWALD, Béla Iványi
Hungarian, 1867-1940
GRÜNWALD, Carl
German, 1907-
GRUPELLO, Gabriel
Flemish, 1644-1730
GRUPPE, Charles Paul
American, 1860-1940
GRUPPO
Italian, 20th cent.
GRUSDIN, Artemij
Michailowitsch
Russian, 1825-1891
GRÜSON, Johann David
German, 1780-1848
GRUSS, Julius Theodor
Czech, 1825-1865
GRUTTNER, Erhard
German, 20th cent.
GRUTTNER, Rudolf
German, 20th cent.
GRÜTZNER, Eduard
German, 1846-1925

GRUYTER, E. de
Dutch, 17th cent.
GRUYTER, Jacob de
Dutch, op.1655-m.1681
GRUIJTER or Gruyter,
Willem
Dutch, 1817-1880
GRYEF, Grief(f),
Grif, Gryeff or
Gryf(f), Adriaen
de
Flemish, op.1687-m.1715
GRYGAR, Milan
Czech, 20th cent.
GRYGLEWSKI, Alexander
Polish, 1833-1879
GRYMBAULT, Paoul
French, 15th cent.
GRZYBOWSKI, Ryszard
Kuba
Polish, 20th cent.
GSELL, Gesell, Ksell,
Xell, etc. Dorothea
Maria Henrietta,
(née Graff)
German, 1678-1743
GSELL, Gesell, Ksell,
Xell, etc. Georg
Swiss, 1673-1740
GSUR, Karl Friedrich
German, 1871-
GUACCIMANNI, Vittorio
Italian, 1859-1938
GUADAGNINO
see Zoan Andrea di
Mantova
GUAL, Adrian
Spanish, 19th cent.
GUALA or Gualla, Pier
Francesco
Italian, 1698-1760
GUALDI, Antonio
American, op.1847
GUALDI, Pietro
Italian, 1716-
GUALDO, Bernardo
Girolamo da
Italian, c.1500
GUALDORP, Gortzius
see Geldorp
GUALTEROTTI or Gualdarotti,
Raffaello
Italian, op.1580-c.1600
GUALTIERI or Gualtiero
di Giovanni da Pisa
or Dellunigiana
Italian, op.1389-1445
GUALTIERI or Gualtiero,
Girolamo(?)
Italian, op.1539-a.1560
GUARANA, Jacopo
Italian, 1720-1808
GUARDABASSI, Giacomo
Italian, 19th cent.
GUARDABASSI, Guerrino
Italian, 1841-
GUARDASSONI, Alessandro
Italian, 1819-1888
GUARDI, Francesco
Italian, 1712-1793
GUARDI, Giacomo
Italian, 1764-1835
GUARDI, Giovanni Antonio
Italian, 1698-1760
GUARDI, Niccolò
Italian, 1715-1785

GUARDIA, Gabriel
Spanish, op.1501
GUARDIAGRELE, Nicola da
see Nicola
GUARIENTI, Carlo
Italian, 1923-
GUARIENTO
Italian, op.1338-m.1368/70
GUARINI or Guarino,
Francesco
Italian, 1611-1654
GUARINO, Luigi
Italian, 1853-
GUARNIERI, Luciano
Italian, 1930-
GUAS, Juan
Spanish, op.1459-m.a.1497
GUASCO, Charles Fortuné
French, 1826-1869
GUASTALLA, Pierre
French, 1891-
GUAY, Charles Etiènne le
see Le Guay
GUAYAZAMIN
South American, 20th cent.
GUBAI(?)
Italian, 19th cent.
GUBERNATIS, Giovanni
Battista de
Italian, 1774-1837
GUBIG,
German(?), 19th cent.
GUBLER, Max
Swiss, 1898-1958
GUCCIONE, Piero
Italian, 1935-
GUCHT, Benjamin van der
British, op.1767-m.1794
GUCHT, Gerard van der
British, 1696-1776
GUCHT, John van der
British, 1697-1776
GUCHT, Michiel van der
British, 1660-1725
GUCKH, Gordian
German, op.1513-m.a.1545
GUDE, Hans Fredrik
Norwegian, 1825-1903
GUDIN, Herminie
(Herminie Fauchier)
French, 19th cent.
GUDIN, Jacques Gérôme
French, op.1769-1784
GUDIN, Théodore
(Jean Antoine Théodore)
French, 1802-1880
GUDMONAS, Jonas
Russian, 20th cent.
GUDMUND, Johan O.
see Sager-Nelson,
Olof
GUDNASON, Svavar
Scandinavian, 1909-
GUE, Julien Michel
French, 1789-1843
GUE, Nicolas
see Gay, Nikolai
GUELDRY, Joseph
Ferdinand
French, 1858-
GUELTINGER, Gumpolt
see Giltlinger
GUENEUTTE, Norbert
see Goeneutte
GUENIOT, Arthur
French, 1866-1951

GUERARD, Bernhard von
German, op.1793-m.1836
GUERARD, Eugène Charles
François
French, 1821-1866
GUERARD, Henri
(Charles Henri)
French, 1846-1897
GUERARD, Nicolas
French, op.1680-m.1719
GUERAU, Antonio
Spanish, op.1411-1439
GUERCINI
see Guérin, Jean
GUERCINO, Giovanni
Francesco Barbieri
Italian, 1591-1666
GUERHARD
French, op.1786-1829(?)
GUERIN, A.M.
French, 1913
GUERIN, Charles François
Prosper
French, 1875-1939
GUERIN, Christophe
French, 1758-1831
GUERIN, Ernest-Pierre
French, 19th/20th cent.
GUERIN, Francois
French, op.1751-1791
GUERIN, Gustave
French, op.1810
GUERIN, Jean
French, 1734-1787
GUERIN, Jean Urbain
French, 1760-1836
GUERIN, Jules
American, 1866-1946
GUERIN, Jules
French, op.c.1845
GUERIN, Louis
French, op.1751
GUERIN, Paulin
(Jean Baptiste Paulin)
French, 1783-1855
GUERIN, Pierre Narcisse,
Baron
French, 1774-1833
GUERIN, Thomas François
French, 1767-1829
GUERINI, Giovanni
Francesco
see Guerrieri
GUERINONI, Giovanni
Battista
Italian, op.1576-1580
GUERMACHEFF, Michel
Markinovitch
Russian, 1867-
GUERNE
French, 1748-
GUERNEREY,
French, op.1830
GUERNIER, Charles
Joseph du
French, 1820-1881
GUERNIER, Louis I du
French, 1614-1659
GUERNIER, Louis, II du
French, 1658/9-1716(?)
GUERRA, Camillo
Italian, p.1797-1852
GUERRA, Giovanni
Italian, c.1540-1618
GUERRA, Giuseppe, I
Italian, op.1740-m.1761
GUERRERO, José
American, 1914-

GUERRESCHI, Giuseppe
Italian, 1929-
GUERRI or Guerra,
Dionisio
Italian, 1598-1640
GUERRIER, Raymond
French, 1920-
GUERRIERI, Guerini or
Guerreri, Giovanni
Francesco
Italian, 1589-c.1655/9
GUERRINI, Lorenzo
Italian, 1914-
GUERY, Armand
French, 1850-1912
GUESLIN, Charles
see Geuslain
GUESOAN
French, 19th cent.
GUEST, Thomas Douglas
British, 1781-p.1839
GUËT, Charlemagne
Oscar
French, 1801-1871
GUET, Jean Baptiste
French, op.1682/3
GUEVARA, Alvaro
Chilean, 1894-1951
GUEVARA, Juan 'Nino' de
Spanish, 1632-1686
GUEVARA, Melchor de
Spanish, op.c.1660-1690
GUFFENS, Egide Godfried
(Godfried)
Belgian, 1823-1901
GUGEL, Carl Adolf
German, 1820-1885
GUGG, Hugo
German, 1878-
GUGGENBERGER, Thomas
German, 1866-
GUGGENHEIM, Willy
see Varlin
GUGLIELMI, Gregorio
Italian, 1714-1773
GUGLIELMI, O. Louis
American, 1906-
GUGLIELMINO, Luigi
Italian, 19th cent.
GUGLIELMO da Forlì
(degli Organi)
Italian, 14th cent.
GUGLIELMO di Pietro de
Marcillat
see Marcillat,
Guillaume Pierre
GUGLIELMO della Porta
Italian, -1577
GUGLIELMO Veneziano
Italian, op.1382
GUGLIELMO
see Crosio
GUHR, Richard
German, 1873-
GUI, J. Romano
Spanish, 17th cent.
GUIARD, Mme. Adélaïde
Labille (Mme. Vincent)
née Labille des Vertus
French, 1749-1803
GUIAUD, Jacques
French, 1811-1876
GUIBAL, Nicolas
French, 1725-1784
GUIBAL-CAMMAS, Anne
see Cammas
GUIBERT, François
French, 18th cent.

GUICHARD, Benoît
Joseph
French, 1806-1880
GUICHARD, H. Th.
French, 19th cent.
GUIDI, Domenico
Italian, 1625-1701
GUIDI the Elder,
Giovanni
Italian, 1407-1480/98
GUIDI, Giuseppe
Italian, 1884-1931
GUIDI, Guido
Italian, op.1867-c.1911
GUIDI, Pietro
Italian, op.1490-1530
GUIDI, Raffaello
Italian, c.1540-p.1614
GUIDI, Virgilio
Italian, 1892-
GUIDO da Bologna
Italian, 14th cent.
GUIDO di Cino or
Cinatti
Italian, op.1319-1352(?)
GUIDO di Palmerucci
Italian, c.1280-p.1345
GUIDO Reni
see Reni
GUIDO da Siena
Italian, op.1221(?)
GUIDOBONO, Bartolommeo
('Il Prete Savonese')
Italian, 1657-1709
GUIDOBONO, Domenico
Italian, 1670-1746
GUIDON, Jacques
Swiss, 1931-
GUIETTE, René
Belgian, 1893-
GUIGNARD, Alberto da
Veiga
Brazilian, 1893/6-
GUIGNARD, Gaston
(Alexandre Gaston)
French, 1848-1922
GUIGNEBERT, Jean-Claude
(Vincent)
French, 1921-
GUIGNET, Adrien
French, 1816-1854
GUIGOU, Paul Camille
French, 1834-1871
GUIGUET, François Joseph
French, 1860-
GUILBERT, Narcisse
French, 1878-1942
GUILDING, The Rev.
Lansdown
British, 1798-1831
GUILLAIN, Simon
French, c.1581-1658
GUILLAUME, Albert
French, 1873-1942
GUILLAUME le Flamand
see Leroy, Guillaume
GUILLAUME, Louis Mathieu
Didier
French, op.1837-1852
GUILLAUME-ROGER
see Roger, G.G.
GUILLAUMET, Gustave
Achille
French, 1840-1887
GUILLAUMIN, Jean-Baptiste
Armand
French, 1841-1927

GUILLELMUS
Italian, op.1138
GUILLEMARD, Pierre
Michel
French, op.c.1705
GUILLEMER, Ernest
French, 1839-
GUILLEMET, Antoine
(Jean Baptiste
Antoine)
French, 1843-1918
GUILLEMIN, Alexandre
Marie
French, 1817-1880
GUILLEMINET, Claude
French, 1821-
GUILLEMOT, Alexandre
Charles
French, 1786-1831
GUILLEN, Asilia
Nicaraguán, 1887-
GUILLERMO, Juan
Spanish, 1916-
GUILLEROT
French, op.c.1672-1680
GUILLIBAUD, Barthélemy
Swiss, 1687-a.1742
GUILLIBAUD or Guillebaud,
Jean François
Swiss, 1718-1799
GUILLIER, Emile Antoine
French, 19th cent.
GUILLON
see also Lethière
GUILLON, Adolphe
Irénée
French, 1829-1896
GUILLON, Charles Nicolas
French, 18th cent.
GUILLON, Eugène Antoine
French, 1834-p.1914
GUILLON, Maurice
French, 1924-
GUILLONNET, Octave Denis
Victor
French, 1872-
GUILLOU, Alfred
French, 1844-1926
GUILT, Roger
French, 19th cent.
GUIMARAES-GUIMA, Antonio
Ferreira de Oliveira
Portuguese, 20th cent.
GUIMARD, Adeline
American, 1875-
GUIMARD, Barnabé
French, op.1765-m.1792
GUIMERA
Spanish, 15th cent.
GUINDRAND, Antoine
French, 1801-1843
GUINET, Claude
French, op.1496-m.1512/13
GUINIER, Henri Jules
French, 1867-1927
GUINOVART, José
Spanish, 1927-
GUIOT, Hector
French, 1825-1903
GUIPON, Léon
French, 1872-1910
GUIRAMAND
French, 20th cent.
GUIRAND (de Scevola)
Lucien-Victor
French, 1871-1950
GUISE
British(?), 18th cent.

GUISE, Constantin
Swiss, 1811-1858
GUISONI, Fermo di
Stefano
see Ghisoni
GUITET, James
French, 1925-
GUITRY, Sacha
French, 20th cent.
GUITTON, E.
Dutch(?), op.1882
GULACSY, Lajos Kalman
Hungarian, 1882-1932
GULAGI(?), I.(?)
Italian, 18th cent.
GULBRANSSON, O.
Scandinavian, 1873-1958
GULDAGER or Gullager,
Christian
American, 1762-1826
GULDENMUND, Güldenmundt
or Guldenmundt, Hans
German, op.c.1490-m.1560
GULDI, Heinrich
Swiss, 1606-p.1650
GULICH
British(?), op.1760
GÜLICH, John Percival
British, 1864-1898
GULINO
Italian, 20th cent.
GULLAGER or Guldager,
Christian
American, 1762-1826
GULLIBAND, J.F.
British, op.1758
GULLY, John
British, 1819-1888
GULTLINGER, Johannes
Gumpolt
see Giltlinger
GULYAS, Gyula
Hungarian, 20th cent.
GUMB, Johann
Baptist
see Gumpp
GUMERY, Adolphe Ernest
French, 1861-
GUMOWSKI, Jan
Polish, 1883-
GUMPP, Johann Anton
German, 1654-1719
GUMPP, Gumb or Gump
the Elder, Johann
Baptist
German, 1651-1728
GUNDELACH, Gondelach or
Gondolach, Matthäus
German, c.1566-1653
GUNDERSEN, Gunnar S.
Norwegian, 20th cent.
GUNETZRHAINER, Johann
German, 1692-1763
GUNN, Sir Herbert
James
British, 1893-1964
GUNSCHMANN, Carl
German, 1895-
GUNST, Pieter Stevens
van
Dutch, 1659-c.1724
GUNSTON, G.W.
British, op.1823-1833
GÜNTHER van Geringh,
Antonius
German, op.1641-m.1668

GÜNTHER, Christian
August
German, 1759-1824
GÜNTHER, Ginter,
Ginther, Günder or
Gundter, Ignaz
(Franz Ignaz)
German, 1725-1775
GÜNTHER, Manfred
German, 20th cent.
GÜNTHER, Gindter,
Ginter or Gündter,
Matthäus
German, 1705-1788
GUNZ, Thaddäus
see Kuntz
GUOL
French, op.c.1795
GURBRAND
German, op.1778
GURK, Eduard
German, 1801-1841
GURLITT, Louis
(Heinrich Louis
Theodor)
German, 1812-1897
GURNEY, J.
British, 19th cent.
GURNEY, L.
British, 20th cent.
GURNEY, Priscilla
British, 20th cent.
GURNEY, Richenda
British, 20th cent.
GURSCHNER, Herbert
German, 1901-
GURSKAS, Albertas
Russia, 20th cent.
GUSH, William
British, op.1833-1874
GUSMAN, Pierre
French, 1862-
GUSMIN of Cologne
see Master of Heiligen-
kreuz
GUSSMANN, Otto
German, 1869-1926
GUSSOW, Carl
German, 1843-1907
GUSTAV III, King of
Sweden
Swedish, 18th cent.
GUSTON, Philip
American, 1913-
GUTAGAZA, Gyula Nemeth
Hungarian, 1880-
GÜTERBOCK, Leopold
German, c.1820-1881
GUTERSLOH, Albert Paris
German, op.1956
GUTFREUND, Otto
Czech, 1889-1927
GUTH, Hella
German, 1912-
GUTHERZ, Carl
American, 1844-1907
GUTHFELDT(?) or
Guyfeldt(?), O.(?)
Netherlands(?), op.1655
GUTHRIE, Sir James
British, 1859-1930
GUTHRIE, Robin Craig
British, 1902-1971
GUTIERREZ, Ernesto
Spanish, 19th cent.
GUTIERREZ de la Vega,
José
Spanish, 1815-1865

GUTIERREZ, Juan Simon
Spanish, 1644-1718
GUTLINGER, Johannes
Gumpolt
see Giltlinger
GUTMAN, N.
German, 19th cent.
GUTON, Raja
Danish, 19th cent.
GUTRECHT, Matthäus, I
Swiss, c.1450-1505
GUTRECHT, Matthäus, II
Swiss, op.1506-1524
GUTRUF, Gerhard
German, 20th cent.
GUTTENBERG or Guttenberger,
Carl Gottlieb or
Gottfried
German, 1743-1790
GUTTENBRUNN, J.A.
German, 18th cent.
GUTTENBRUNN, Ludwig
(not Lorenz)
German, op.1770-1813
GUTTERE, Alfredo
Italian, 19th cent.
GUTTFREUND, Otto
Czech, 19th cent.
GUTTI, Rosina Mantovani
Italian, 20th cent.
GUTTUSO, Renato
Italian, 1912-
GUTZWILLER, Sebastian
German, 1800-1872
GUY, Francis
British, 1760-1820
GUY; Hippolyte
(Maurice Hippolyte)
French, 1868-
GUY, J.B.Louis
French, 1824-1888
GUY, Seymour Joseph
American, 1824-1910
GUYARD
French, op.1774-1778
GUYFELDT(?), O.(?)
see Guthfeldt
GUYOMARD
French, 20th cent.
GUYON, Maximilienne
(Goepp)
French, 1868-1903
GUYOT, Laurent
French, op.1600-1664
GUYOT, Laurent
French, 1756-p.1806
GUYOT, Louise
French, op.1841-1845
GUYOT, R.
French, op.1827
GUYS, Constantin
(Ernest Adolphe
Hyacinthe Constantin)
French, 1805-1892
GUZMAN, Rodriguez de
Spanish, 1818-1867
GUZZARDI, Leonardo
Italian, op.1799
GUZZI, Beppe
Italian, 1902-
GUZZONE, Sebastiano
Italian, 1856-1890
GWATHMEY, Robert
American, 1903-
GWENNAP, Thomas
British, op.1821-1828
GWERK, Edmund
Czech, 1895-

GWIN, Gwim, Gwinn or
Gwyn, James
British, p.1700-1769
GWYNN, W.
British, op.1807-1817
GWYNN-EVANS, Hester
see Frood
GWYNNE-JONES, Allan
British, 1892-
GWYNNE-JONES, Emilie
British, 20th cent.
GYARFAS, Jeno (Eugen)
Hungarian, 1857-1925
GYARMATHY, M.
Hungarian, 20th cent.
GYFFORD, Edward
British, 1772-1834
GYFFOTHS
Dutch(?), 18th cent.
GYLES, Henry
see Giles
GYONGYI, Yvonne
Hungarian, 20th cent.
GYÖRGYI or Giergl,
Alajos or Alois
Hungarian, 1821-1863
GYOZO, Szilas
Hungarian, 20th cent.
GYP (Sybille-Gabrielle-
Marie Antoinette de
Riquetti-Mirabeau,
Comtesse de Martel de
Janville)
French, 1850-1932
GYRMATHY
French, 20th cent.
GYSAERTS or Gijsaerts,
Gualterus
Flemish, 1649-p.1674
GYSBRECHTS, Cornelis
Norbertus
Flemish, op.1659-1672
GYSBRECHTS, Franciscus
Dutch, op.1674
GYSELAER or Giselaer,
Nicolaes de
Dutch, op.1616-1654
GYSELAER or Giselaer,
Philip
Flemish, op.1634/5
GYSELINCKX, Joseph
Belgian, 19th cent.
GYSELS, Geysels, Gheysels,
Gijsels, Gyssels,
Gysens etc. Peeter
Flemish, 1621-1690/1
GYSIS, Nikolaus
Greek, 1842-1901
GYSSLER, Felix
Swiss, 20th cent.

H

HAACH, Ludwig
German, 1813-1842
HAAG, Carl
German, 1820-1915
HAAG, Hans
German, 1841-
HAAG, Tethart Philip
Christian
German, 1737-1812
HAAGA, Edouard
German, op.1888-1897
HAAGEN
see also Hagen
HAAGEN or Haage,
Franciscus
Dutch, op.1686

HAAKE
British, 16th cent.
HAAN
see also Haen
HAAN or Haen, Dirk de
Dutch, 1832-1886
HAAN, Franciscus
Antonius de
Dutch, 1823-1873
HAAN, Meijer Isaac de
Dutch, 1852-1895
HAANEBRINK, Willem
Albertus
Dutch, 1762-1840
HAANEN, Adriana Johanna
Dutch, 1814-1895
HAANEN, Casparis
Dutch, 1778-1849
HAANEN, Cecil van
Dutch, 1844-
HAANEN, Elisabeth
Alida
Dutch, 1809-1845
HAANEN, George Gillis
Dutch, 1807-1879/81
HAANEN, Remigius
Adrianus (Remy or
Remi van Haanen)
Dutch, 1812-1894
HAANSBERGEN, Johan or
Jan van
see Haensbergen
HAARING, Daniel
see Haringh
HAARS, Peter
Norwegian, 20th cent.
HAAS, Franz Sebastian
German, op.1730-1737
HAAS, Georg
see Has
HAAS, Georg
(Johann Jakob Georg)
Danish, 1756-1817
HAAS, Jean
German(?), 18th cent.
HAAS, Johannes Hubertus
Leonardus de
Dutch, 1832-1908
HAAS, Maurits Frederik
Hendrik de
Dutch, 1832-1895
HAAS, Meno
(Johann Meno)
German, 1752-1833
HAAS, P.
American, op.c.1840
HAAS, Peter
(Christian Peter Jonas)
German, 1754-p.1804
HAAS, William
Frederick de
American, 1830-1880
HAAS, Wynand de
Dutch, op.1698-1700
HAASBROEK, Geraerd
Dutch, op.1775
HAASE, Karl
German, -c.1877
HAASE-JASTROW, Kurt
German, 1885-1958
HAASS, Terry
Dutch, 1923-
HAASTER, Leendert
van
see Haestar

HAASTERT, Isaac van
Dutch, 1753-1834
HAASZ., Jacobus
Netherlands(?), op.1655
HABENSCHADEN, Sebastian
German, 1813-1868
HABERJAHN, Gabriel
Eduard
Swiss, 1890-1956
HABERLE, John
American, 20th cent.
HABERMANN, Franz Edler
von
Czech, 1788-
HABERMANN, Franz Xavier
German, 1721-1796
HABERMANN, Hugo von
German, 1849-1929
HABERSCHRACK, Nicolas
Polish, op.1454-1481
HABERT, François
French, op.c.1645
HABERT, Nicolas
French, c.1650-p.1715
HABILIUS, Johannes
German(?), 17th cent(?)
HABL, Willi Paul Rudolf
German, 1888-
HACCOU, Johannes Cornelis
Dutch, 1798-1839
HACKAERT or Hackert,
Jan or Joan
Dutch, c.1629-c.1685
HACKER, Arthur
British, 1858-1919
HACKER, Horst
German, 1842-1906
HACKER, L.
Swedish(?), 18th cent(?)
HACKERT, Carl Ludwig
German, 1740-1796
HACKERT, Jacob Philipp
German, 1737-1807
HACKERT, Jan or Joan
see Hackaert
HACKERT, Johann Gottlieb
German, 1744-1773
HACKHOFER, Johann Cyriak
Austrian, 1675-1731
HACKL, Gabriel von
German, 1843-
HACKNEY, Alfred
British, 1926-
HACKNEY, Arthur
British, 1925-
HADAMARD, Auguste
French, 1823-1886
HADDELSEY, Vincent
British, 1929-
HADDOCA, A.
American, op.c.1830
HADDON, Trevor
British, 1864-1941
HADFIELD, Maria Louisa
Catherine Cecilia
see Cosway
HAEBERLIN, Carl von
German, 1832-1911
HAECHT, Tobias van, or
Tobias Verhaagt,
Verhaecht or Verhaeght
Flemish, 1561-1631
HAECHT, Willem, II van
Flemish, 1593-1637
HAECKEN, Alexander van
Flemish, 1701(?)-c.1758

HAEFTEN, Nicolas (Walraven)
van
see Haften
HAELBECK, Jan van
see Halbeeck
HAELWEGH, Adriaen
Dutch, c.1637-c.1696
HAELWEGH, Albert
Danish, c.1600-1673
HAEN, Abraham II de
Dutch, 1707-1748
HAEN, Anthony de
Dutch, 1640-c.1675
HAEN or Haan, David de
Dutch, 17th cent.
HAEN or Haan, David de
Flemish, op.1619-m.1622
HAEN, Dirck de
see Haan
HAEN or Haan, German
Dutch, op.1667-1682
HAEN or Haan, Joseph
Charles de
Dutch, 1777-1836
HAENEN, F. de
French, 19th cent.
HAENSBERGEN or
Haansbergen, Johan or
Jan van
Dutch, 1642-1705
HAENTZ, Zacharie
see Heince
HAERING, Hans
see Hering
HAERT, Hendrik Anna
Victoria van der
Belgian, 1790-1846
HAESE, D. de
(possibly identified
with Haan)
Dutch, op.1700
HAESELE, Emmy
German, 1894-
HAESELICH, Johann Marcus
German, 1807-1856
HAESKEL
Dutch, op.1647
HAESLICH, Johann Georg
German, 1806-1894
HAESTAR or Haaster,
Leendert Maertensz. van
Dutch, op.1639-m.1675
HAFFE, E.
German, 19th cent.
HAFFIELD, Cooper
British, -1821
HAFFNER, Affner or
Aufner, Anton Maria
Italian, 1654-1732
HAFFNER, Affner or
Aufner, Enrico
(Il Tenente)
Italian, 1640-1702
HAFSTRÖM, Axel Gillis
Swedish, 1841-1909
HAFSTRÖM, Jan
Scandinavian, 20th cent.
HAFTEN or Haeften,
Nicolas van
(Nicolas Walraven van
Haften)
Dutch, c.1663-1715
HAG de Dillingen, Lenhart
German, 17th cent.
HAGARTY, James
British, op.1767-1782

HAGBORG, August (Vilhelm
Nikolaus August)
Swedish, 1852-1921
HAGEDORN, Christian
Ludwig von
German, 1712-1780
HAGEDORN, Herman Conrad
German, op.1828-1838
HAGELGANS, Michael
Christoph Emanuel
German, 1725-1766
HAGELSTEIN, Jakob Ernst
Thomann
German, 1588-1633
HAGEMANN, Godefroy de
German, op.1861-m.1877
HAGEMEISTER, Karl
German, 1848-1933
HAGEN or Hagens, Christian
(also erroneously,
Christoph)
Dutch, op.1663-1688
HAGEN, Dingeman van der
Flemish, c.1610/20-a.1682
HAGEN, J.
British, op.1710-1746
HAGEN, J.
Dutch, 1703-p.1791
HAGEN or Haagen, Jacob
Jorisz. van der, or Jacob
Verhagen, Dutch, 1657-1715
HAGEN or Haagen, Joris
Abrahamsz. van der or
Joris Verhaegen or Verhagen
Dutch, c.1615-1669
HAGEN or Haagen, Joris
Cornelisz. van der
Dutch, 1676-c.1745
HAGEN, Theodor Joseph
German, 1842-1919
HAGEN, Willem van der
Dutch, 17th./18th. cent.
HAGENAUER, Johann
Baptist
German, 1732-1810
HAGENBUCH the Elder,
Caspar
Swiss, op.1534-1553
HÄGG, Axel Herman
Swedish, 1835-1921
HÄGG, Jakob
Swedish, 1839-1931
HAGHE, C.
British, op.1848
HAGHE, Louis
British, 1806-1885
HAGIUS
Netherlands, op.1657
HAGN, Ludwig von
German, 1819-1898
HAGNAUER, Eugen
German, op.c.1820-1848
HAGREEN, Henry Browne
British, 1831-1912
HAGUE, J.Anderson
British, 1850-1916
HAGUE, J. Edward
Homerville
British, op.1885-1917
HAHN
German, op.c.1820
HAHN, Friedrich
(Jacob Friedrich)
German, c.1805-1870(?)
HAHN, Georg
German, 1841-1889
HAHN, Gustav Adolph
German, 1819-1872

HAHN or Han, Hermann
German, c.1570-1628
HAHN, Joseph
German, 1839-1906
HAHN, Karl
American, 19th cent.
HAHN, Karl Wilhelm
German, 1829-1887
HAHN, William
American, 1840(?)-1890(?)
HAHNEL, Ernst Julius
German, 1811-1891
HÄHNISCH, Anton
German, 1817-1897
HAHNLOSER-BÜHLER, Hedy
Swiss, 19th cent.
HAID, Anna Maria
see Werner
HAID, C.
German, op.1722
HAID, Johann Elias
German, 1739-1809
HAID or Hayd, Johann
Jakob
German, 1704-1767
HAID or Hayd, Johann
Philipp
German, 1730-c.1806
HAID, John Gottfried
German, 1710-1776
HAIDER, Andreas
Swiss, op.1530-1532
HAIDER, Karl
German, 1846-1912
HAIDT, John Valentin
German, 1700-1780
HAIER or Hayer, Joseph
German, 1816-1891
HAIG, Earl
British, 1861-1928
HAILE, Sam
British(?), 20th cent.
HAILER or Hailler,
Daniel
German, op.1604-a.1630
HAILMAN, Johanna K.
Woodwell
American, 1871-
HAINARD, Robert
Swiss, 1906-
HAINAULT or Henault
French, op.1752-1789
HAINCELIN de Haguenot
or Hagueneau (Hänslein
von Hagenau or Jean
Haincelin or Haimelin)
French, op.1403-1448
HAINES, Richard
American, 1906-
HAINES, William
British, 1778-1848
HAINES, William Henry
(William Henry)
British, 1812-1884
HAINS, Raymond
French, 20th cent.
HAINSSE, Zacharie
see Heince
HAINZ, Heintz, Hinz
or Hintzsch, Georg
(Johann Georg)
German, op.1666-1700
HAINZ, Joseph
see Heintz

HAINZEIMANN or
Heinzelmann, Johann
German, 1641-1693/1700
HAIR, Thomas H.
British, op.1838-1849
HAISNE, Abbé de
French, op.c.1785-1786
HAITE, George Charles
British, 1855-c.1919
HAJEMA, Freerk
Dutch, op.1717-1746
HAKEWILL, James
British, 1778-1843
HAKEWILL or Hakewell,
John
British, 1742-1791
HAL, Jacob van
Flemish, 1672-1750
HALAPY, Janos
Hungarian, 1893-1961
HALASIEWICZ
Polish, 19th cent.
HALAUSKA, Ludwig
German, 1827-1882
HALBAX, Michael Wenzel
German, 1661-1711
HALBEECK or Haelbeck,
Jan van
Flemish(?), op.1600-1618
HALBERG-KRAUSS, Fritz
German, 1874-1951
HALBERSTADT, Ernst
American, 20th cent.
HALBOU, Louis Michel
(not Jean Louis)
French, 1730-1809
HALD, Smitz(?)
Danish(?), 19th cent(?)
HALDENWANG, Friedrich
Swiss, -1820
HALDENWANGER, Henri
German, op.1766-1770
HALE, Edward Matthew
British, 1852-
HALE, Kathleen
British, 20th cent.
HALE, Lillian (née
Westcott)
American, 1881-
HALE, Phillip L.
American, 1865-1931
HALE, Walter
American, 1869-1917
HALE, William Matthew
British, 1852-1924
HALEMAN or Halemans,
Thomas
see Halleman
HALEN, Arnoud or Arend
yan (Aquila)
Dutch, op.1679-m.1732
HALEN, Francisco de
Paula van
Spanish, -1887
HALEN, Peter van
Flemish, 1612-1687
HALES, John
see Hayls
HALEY, Henry James
British, op.1901-1919
HALEY, John
American, 20th cent.
HALFNIGHT, Richard
William
British, op.1878-1892

HALFORD, Sir Henry
British, 1766-1844
HALFPENNY, Joseph S.
British, 1748-1811
HALFPENNY or Alpenny,
Joseph Samuel
British, 1787-1858
HALKETT, George Roland
British, 1865-1918
HALICKA, Alice
Czech, 1895-
HALL
British, 17th cent.
HALL, Adelaide
Victorine
Swedish, 1752-1844
HALL, Anne
American, 1792-1863
HALL, Arthur Henderson
British, 1906-
HALL, Bernard
British, 20th cent.
HALL, Charles
British, c.1720-1783
HALL, Christopher
British, 20th cent.
HALL, Clifford
British, 1904-
HALL, Lady Edna
Clarke
British, 1879-
HALL, Frederick
British, 1860-1948
HALL, George Henry
American, 1825-1913
HALL, George Lothian
or Lowthian
British, 1825-1888
HALL, Harry
British, op.1838-m.1882
HALL, Henry Bryan I
American, 1808-1884
HALL, James
British, 1797-1854
HALL, John
Swedish, 1771-1830
HALL, Lindsay Bernard
British, 1859-1935
HALL, Nigel
British, 20th cent.
HALL, Oliver
British, 1869-1957
HALL, Patrick
British, 1906-
HALL, Peder Adolf
Swedish, 1739-1793
HALL, Sydney Prior
British, 1842-p.1920
HALL, Mrs. Sydney Prior
see Gow, Mary L.
HALL, Thomas P.
British, op.1837-1867
HALL, William
British, op.1859-1885
HALLART, Jean
French, 1616-1685
HALLATZ, Emil
German, 1837-1888
HALLBECK, Carl Svante
Swedish, 1826-1897
HALLBROCK, Jo
British, op.c.1620
HALLE, Charles Edward
British, 1846-1914
HALLE, Claude Guy
French, 1652-1736

HALLE, Daniel
French, 1614-1675
HALLE, Ludwig
German, 1824-1889
HALLE, Noël
French, 1711-1781
HALLE, William
British, 20th cent.
HALLEMAN, Haleman or
Halemans, Thomas
Dutch, 1665-p.1690
HALLER, Andre or Andrä
German, op.1509-1522
HALLER, Christoph Jakob
Wilhelm Carl Joachim,
(Freiherr von
Hallerstein)
German, 1771-1839
HALLER, Hermann
Swiss, 1880-
HALLER, Johann Carl
Christoph Joachim
(Freiherr von
Hallerstein)
German, 1774-1817
HALLER, Joseph
German, 1737-1773
HALLER, Philipp
German, 1698-1772
HALLEWELL, Ben
British, op.1865-1869
HALLEZ, Germain-Joseph
Belgian, 1769-1840
HALLIDAY, Charlotte
British, 20th cent.
HALLIDAY, Edward Irvine
British, 1902-
HALLIDAY, Irene
British, 1932-
HALLIDAY, Michael
Frederick or Michael
Henry
British, 1822-1869
HALLIDAY, Trevor
British, 1939-
HALLORAN, O.
British, 19th cent.
HALLS, John James
British, op.1791-1834
HALLSTROM, Eric
Swedish, 1893-1946
HALLSTRÖM, Gunnar August
Swedish, 1875-1943
HALM, Felix
German, 1758-1810
HALM, M.
German, op.1766
HALM, Peter von
German, 1854-1923
HALMI, Artur Lajos
Hungarian, 1866-1939
HALONEN, Pekka
Finnish, 1865-1933
HALPERN, Miriam
American, 20th cent.
HALPERT, Samuel
American, 1883-1930
HALS, Dirck
Dutch, 1591-1656
HALS, Frans, I
Dutch, c.1580(?)-1666
HALS, Frans, II
Dutch, c.1618-1669
HALS, Harmen or Herman
Dutch, 1611-1669

HAHN or Han, Hermann
German, c.1570-1628
HALS, Jacob
Dutch, 1624-
HALS, Johannes or
Jan
Dutch,
c.1617/23(?)-1674(?)
HALS, Nicolaes (Claes)
Dutch, 1628-1686
HALS, Reynier
Dutch, 1627(?)-1671
HALS, Willem
Netherlands, 17th cent.
HALSWELLE, Keeley
British, 1832-1891
HÄLSZEL, Johann Baptist
(von?)
German, 1710/12-1777
HALY, Robert
see Healy
HAM, J. van
Dutch, 17th cent.
HAMACHER, Willy
German, 1865-1909
HAMAGUCHI, Yozo
Japanese, 1909-
HAMBACH, Johann Michael
German, op.1672-1675
HAMBIDGE, Jay
American, 1867-p.1900
HAMBLETT, Theora
American, 1895-
HAMBLING, Maggie
British, 1943-
HAMBOURG, André
French, 1909-
HAMBUCHEN, Wilhelm
German, 1869-
HAMBURGER, Johann Conrad
German, 1809-a.1870
HAMEEL or Hamel,
Alart du
Netherlands,
c.1449-c.1509
HAMEL, Julius
German, 1834-1907
HAMEL, Theophile
Canadian, op.1846
HAMEL, Willem
Dutch, 1860-1924
HAMEN y Leon, Juan
van der
Spanish, 1596-a.1632
HAMER, Rawthmal
American, op.1859-1861
HAMERTON, Robert Jacob
British, op.1831-1858
HAMILTON, Lady Anne
British, 1766-1846
HAMILTON, Anton Ignaz
German, 1696-1770
HAMILTON, C.
British, op.1831-1867
HAMILTON, C.C.
British, op.1810
HAMILTON, Charles William
de
see Hamilton, Karl
Wilhelm de
HAMILTON, Cuthbert
British, 1885-1959
HAMILTON, Franz de
Flemish, op.1661-1695
HAMILTON, Gavin
British, 1723-1798
HAMILTON, Gawen
British, c.1697-1737

HAMILTON, Gustavus
British, c.1739-1775
HAMILTON, Hugh Douglas
British, 1739-1808
HAMILTON, Jacob or
James de
British, c.1640-1720
HAMILTON, James
British, 1819-1878
HAMILTON, James Whitelaw
British, 1860-1932
HAMILTON, Johann
German, -c.1750
HAMILTON, Johann Georg
de
Flemish, 1672-1737
HAMILTON, John McLure
American, 1853-1936
HAMILTON, Karl Wilhelm
or Charles William de
Flemish, 1668-1754
HAMILTON, Kathleen
Canadian, 20th cent.
HAMILTON, Mary F.
British, op.1807-1849
HAMILTON, Philipp
Ferdinand de
Flemish, c.1664(?)-1750
HAMILTON, Richard
British, 1922-
HAMILTON, Lady Sophia
South African, op.1800
HAMILTON, William
British, 1751-1801
HAMM
German, op.1806
HAMM, Eugen
German, 1885-1930
HAMM, Henri
French, 20th cent.
HAMMAN, Edouard Jean
Conrad
Belgian, 1819-1888
HAMMAN, Edouard Michel
Ferdinand
French, op.1880-1889
HAMME, Alexis van
Belgian, 1818-1875
HAMME, Johann Christoph
van
German, 1701-1755
HAMMENHOG, V.
Swedish, 19th cent.
HAMMER, Christian
Gottlob or Gottlieb
German, 1779-1864
HAMMER, Franz
German, op.1700
HAMMER, John J.
German, 1842-1906
HAMMER, Viktor
German, 1882-
HAMMERSHOI, Svend
Danish, 1873-1848
HAMMERSHOI, Wilhelm
Danish, 1864-1916
HAMMERSLEY, James
Astbury
British, 1815-1869
HAMMON, G.H.
Australian, 19th cent.
HAMMOND, Mrs.
British, op.1810-1826
HAMMOND, A.
British, op.1781-1803
HAMMOND, A.H.K.
British, 20th cent.

HAMMOND, Thomas
American, 20th cent.
HAMMONDS, Albert L.
British, 20th cent.
HAMON, Jean Louis
French, 1821-1874
HAMON, Pierre Paul
French, 1817-1860
HAMPE, Guido
German, 1839-1875
HAMFE, Karl Friedrich
German, 1772-1848
HAMPEL, Carl
British, 1891-
HAMPEL, Charlotte
German, 1863-
HAMPEL, Sigmund Walter
German, 1868-1949
HAMPELN, Carl von or
Charles de
Russian, 1808-p.1880
HAMPER, W.
British, op.1793-1795
HAMSON, T.B.
British, 19th cent.
HAMZA, Johann
German, 1850-1927
HAN, Balthasar
German, 1505-1578
HAN, Franz
German, op.1526-1528
HAN, H.
Oriental, 1939-
HAN, Hermann
see Hahn
HANAEMAN, W.
Netherlands, 17th cent.
HANBURY, W.
British, op.1770-1771
HANCOCK, Charles
British, op.1819-1868
HANCOCK, N.
American, op.1792-1809
HANCOCK, Robert
British, 1730-1817
HANCOCK, William Lynett
American, 1942-
HAND, Thomas
British, op.1790-m.1804
HANDEL, Maximilian
Joseph
see Hannl
HANDKE, Johann Christoph
German, 1694-1774
HANDLER, Richard
German, 20th cent.
HANDLEY-READ, Captain
Edward Henry
British, 1870-1935
HANDMANN, Emanuel
(Jacob Emanuel)
Swiss, 1718-1781
HANDSCHICK, Heinz
German, 20th cent.
HANDVILLE, Robert
American, 20th cent.
HANDY, John
British, op.1787-1791
HANE, Roger
American, 20th cent.
HANEBECK, Gerd
German, 20th cent.
HANEDOES, Louwrens
Dutch, 1822-1905
HANEL, Maximilian
Joseph
see Hannl

HANES, F.W.
British, 19th cent.
HANEY, William L.
American, 20th cent.
HANF, Bob
German, 20th cent.
HANFSTAENGL, Ernst
German, 1840-1897
HANFSTAENGL, Hanfstängl
or Hanfstingl, Franz
Seraph
German, 1804-1877
HANGEN, Heijo
German, 1927-
HÄNGER, Max
German, 1874-
HANIAS, Johannes
German, op.1650-1654
HANICOTTE, Augustin
French, op.1900-1914
HANIOTI, Elise
French, 20th cent.
HANISCH, Alois
German, 1866-
HÄNISCH the Elder,
Alois
German, op.1840
HANIX, Robert
Netherlands(?), op.1730
HANKE, Hans
German, 19th cent.
HANKEY, William Lee
British, 1869-1952
HANKINS, P. Abraham
American, 20th cent.
HANL, Maximilian
Joseph
see Hannl
HANNAFORD, Charles E.
British, 1863-1955
HANNAH, B.
British, 20th cent.
HANNAH, George
British, c.1896-
HANNAN, William
British, op.1757-m.c.1775
HANNAUX, Paul
French, 1899-1954
HANNEMAN, Adriaen
Dutch, c.1601-1671
HANNEMANN, William
British, op.1786
HANNEQUART, Jean
see Hennecart
HANNL, Handel, Händel,
Hanel, Hannel or
Hennel, Maximilian
Joseph
German, 1694/6-1759
HANNONG, Hannon or
Hannung, Paul Anton
German, 1700-1760
HANNOT, Johannes
Dutch, op.1650-1683
HANNOTIAU, Alexandre
Auguste
Belgian, 1863-1901
HANNOTIAU, M.
Belgian, 19th/20th cent.
HANOTEAU, Hector
French, 1823-1890
HANRATH, Johann Otto
(Otto)
Dutch, 1882-1944
HANS von Aachen
see Achen

HANS von Cöln
German, op.1520-1522
HANS von Frankfurt
German, op.1537
HANS, Josefus
Gerardus
Dutch, 1826-1891
HANS von Judenborg
see Master of the
Votive picture of
Ernest the Iron
HANS von Metz
German,
op.1448-m.1462/3
HANS von Ropstein
or Raperstein
see Gitschmann the
Elder, Hans
HANS von Tübingen,
Teubing, Teubingen,
Tulbing or Twbing
German, op.1433-m.a.1462
(possibly identified
with Master of the
S. Lambert Altar
and with Master of
the Linz Crucifixion)
HANS von Wilheim
see Krumpper
HANS von Zurich
Swiss, op.1456
HANSCH, Anton
German, 1813-1876
HANSEN, Anton
Danish, 1891-1960
HANSEN, Asor
(Henrik Asor)
Norwegian, 1862-1929
HANSEN, Carel Lodewijk
Dutch, 1765-1840
HANSEN, Constantin
(Carl Christian
Constantin)
Danish, 1804-1880
HANSEN, Ernst
Danish, 1892-1968
HANSEN, Hans
Danish, 1769-1828
HANSEN, Heinrich
Danish, 1821-1890
HANSEN, Henry W.
American, 1853-1924
HANSEN, Josef Theodor
Danish, 1848-1912
HANSEN, Lambertus
Johannes
Dutch, 1803-1859
HANSEN, Peter Marius
Danish, 1868-1928
HANSEN, Robert
American, 1924-
HANSEN, Sine
Scandinavian, 20th cent.
HANSEN, Svend Wiig
Danish, 1922-
HANSEN, Theofilus
Edvard, (Freiherr
von Hansen)
Danish, 1813-1891
HANSON or Hansonn,
Christian Heinrich
Johann
German, 1790-1863
HANSON, Duane
American, 1925-

HANSON, P.
American, op.1886
HANSON, Philip
American, 20th cent.
HANSSON, Holger
Swedish, op.1586-1619
HANSTEIN, Hermann von
German, 1809-1878
HANTAI, Simon
Hungarian, 1922-
HANTZSCH, Johann
Gottlieb
German, 1794-1848
HANULA, József
Hungarian, 1863-1944
HANZELET
see Appier, Jean
HAPPEL, Carl
American, 19th cent.
HAPPELMANN, Jacob
Andreas
Swiss, op.1738
HAQUETTE, Georges Jean
Marie
French, 1854-1906
HARALD-GALLEN, Arthur
Finnish, 1880-
HARASZTY, István
Hungarian, 20th cent.
HARBURGER, Edmund
German, 1846-1906
HARCOURT, Françoise d'
French, op.1965
HARCOURT, George
British, 1868-1947
HARCOURT, George Simon
(not Charles), Earl
of
British, 1736-1809
HARCOURT, Mary
British, op.1760
HARDACRE, Charles
British, 20th cent.
HARDEN, John
British, 1772-1847
HARDENBERG, Lambertus
Dutch, 1822-1900
HARDENBERG, Wilhelm
van
see Ehrenberg
HARDENBERGH or Hardenberg,
Cornelis van
Dutch, 1755-1843
HARDIE, Charles Martin
British, 1858-1916
HARDIE, Martin
British, 1875-1952
HARDIME, Paul
Flemish, 17th cent.
HARDIME, Pieter
Flemish, 1677/8-c.1758
HARDIME, Simon
Flemish, 1664/72-1737
HARDING, Charlotte
American, 20th cent.
HARDING, Chester
(not Charles)
American, 1792-1866
HARDING, D.
British, 19th cent.
HARDING, Edward
see Harding,
Sylvester
HARDING, Francis
British, op.c.1730-m.a.1767
HARDING, Frederick
British, op.1825-1857

HARDING, George
Perfect
British, op.1797-m.1853
HARDING, H.J.
British, op.1818-1825
HARDING, J.L.
American, op.1835-1882
HARDING, James Duffield
British, 1798-1863
HARDING, Sylvester or
Edward
British, 1745-1809
HARDING, T.
British, op.1788-1796
HARDING, Thomas(?)
British, op.c.1800
HARDING, W.
British, op.c.1790
HARDIVILLER, Charles
Achille d'
French, 1795-p.1835
HARDORFF the Elder,
Gerdt
German, 1769-1864
HARDOUIN, Jules
see Mansart
HARDWICK, John Jessop
British, 1831-1917
HARDWICK, Thomas
British, 1752-1829
HARDWICK of Bath,
William N.
British, op.1829-m.1865
HARDY, Anna Eliza
American, 1839-1934
HARDY, Carel
Dutch, op.1649-1651
HARDY, David
British, op.1855-1870
HARDY, Dorofield
British, op.1882-1920
HARDY, Dudley
British, 1866/7-1922
HARDY, E.
British, 18th cent.
HARDY, F. le
British, op.1790-1802
HARDY, Frederick Daniel
British, 1826-1911
HARDY, Heywood
British, op.1861-1893
HARDY the Younger,
James
British, 1832-1889
HARDY, Jeremiah P.
American, 1800-1887
HARDY, Thomas
British, op.1777-1805
HARDY, Thomas Bush
British, 1842-1897
HARE, Alice
see Westlake
HARE, Augustus J.C.
British, op.c.1860
HARE, Augustus William
British, 1792-1834
HARE, St.George
British, 1857-1933
HAREMBOURG
see Horenbault
HARFORD the Younger,
John Scandrett
British, 1786-1866
HARGITT, Edward
British, 1835-1895
HARGREAVES, George
British, 1797-p.1834

HARGREAVES, Thomas
British, 1775-1846
HARI, Johannes, I
Dutch, 1772-1849
HARING, H.
German, 17th cent.
HARINGER, Carl
Joseph
German, op.c.1716-1733
HARINGH or Haaring,
Daniel
Dutch, c.1636-1706
HARITONOFF, Nicholas
Russian, op.1930
HARKER, Joseph
Cunningham
British, 1855-1927
HARLAMOFF
see Charlamoff
HARLEY, George
British, 1791-1871
HARLOFF, G.
German, 20th cent.
HARLOW, George Henry
British, 1787-1819
HARMAR or Harmer,
Fairlié (Viscountess
Harberton)
British, 1876-1945
HARMER, Harry
British, 20th cent.
D'HARMOY, Tristan
French, 20th cent.
HARMS, Anton Friedrich
German, 1695-1745
HARMS, Harmes or Horms,
Johann Oswald
German, 1643-1708
HARNEST, Fritz
German, 20th cent.
HARNETT, William M.
American, 1848-1892
HARNIER, Wilhelm I von
German, 1800/1-1838
HARNY, Henry F.
American, 19th cent.
HARO, Etiénne Francois
French, 1827-1897
HAROLD, F.
British, 19th cent.
HARPER, Adolph
Friedrich
German, 1725-1806
HARPER, Claudius
British, 19th cent.
HARPER, Edward Samuel
British, 1854-1941
HARPER, Edward Steel
British, 1878-1951
HARPER, Henry Andrew
British, 1835-1900
HARPER, Jean
British, 20th cent.
HARPER, John
British, 1809-1842
HARPER, T.
British, op.1817-1843
HARPIGNIES, G.
French, 19th cent.
HARPIGNIES, Henri Joseph
French, 1819-1916
HARPSAU
German, 19th cent.
HARRACH, Ferdinand Graf
von
German, 1832-1915
HARTCAMP, Theodorus
see Smits, Casparus

A Checklist of Painters c1200-1976

HARRADEN, Richard Banks
British, 1778-1862
HARREWIJN or Harrewyn,
François
Flemish, 1700-1764
HARREWIJN or Harrewyn,
Jacobus
Flemish, c.1660-p.1732
HARRICH or Harrisch,
Jost or Jobst
German, c.1580-1617
HARRIET, Fulchran
Jean
French, op.1789-m.1805
HARRINGTON, Addie A.
American, op.1863
HARRINGTON, Charles
British, -1943
HARRINGTON, R.
British, 19th cent.
HARRIOTT, William
Henry
British, op.1811-m.1839
HARRIS, Albert
British, 19th cent.
HARRIS, Charles X
American, 1856-
HARRIS, Daniel
British, op.1789-1799
HARRIS, Edwin
British, 1855-1906
HARRIS, Frances
Elisabeth Louise
née. Rosenberg
(Mrs. J. Dafter Harris)
British, 1822-1873
HARRIS, George Walter
British, op.1864-1893
HARRIS, Henry
British, op.1826-1878
HARRIS, J.
British, op.c.1760-1765
HARRIS, James
British, op.1847-1876
HARRIS, Jefferey
British, 1932-
HARRIS, John
British, op.1686-1740
HARRIS the Elder,
John,
British, a.1793-m.1834
HARRIS, John I
British, 1770-1834
HARRIS, Lawren S.
Canadian, 1885-
HARRIS, Moses
British, 1731-p.1785
HARRIS, Robert
British, 1849-1919
HARRIS, Tomás
British, 1908-
HARRISON, Anthony
British, 20th cent.
HARRISON, Arthur P.
British, op.1816-1821
HARRISON, Alexander
(Thomas Alexander)
American, 1853-1930
HARRISON, Bernard
British, op.1893-c.1912
HARRISON, F.C.
British, 20th cent.
HARRISON, George Henry
British, 1816-1846
HARRISON, James
British, op.1827-1881
HARRISON, J.C.
British, op.1882-1891

HARRISON, L.A.
British, -1937
HARRISON, Lovell Birge
American, 1854-p.1904
HARRISON, Mary Kent
British, 1915-
HARRISON, Thomas Erat
British, op.1875-1910
HARROUART
French, 19th cent.
HARRY, Philip
American, op.1843
HARSDORFF, Caspar
Frederik
Danish, 1735-1799
HARSSENS, S.L.
Flemish, 17th cent.
HART, George Overbury
(Pop)
American, 1868-1933
HART, James MacDougal
American, 1828-1901
HART, James Turpin
British, 1835-1899
HART, Joel Tanner
American, 1810-1877
HART, Pro (Kevin)
Australian, 20th cent.
HART, Solomon Alexander
British, 1806-1881
HART, Thomas
British, op.1776-m.1785
HART, Thomas Gray
British, 1797-1881
HART, William
British, 19th cent.
HART, William M.
American, 1823-1894
HARTA, Anton
Hungarian, 1884-
HARTA, Felix Albrecht
Hungarian, 1884-
HARTCAMP, Theodorus
see Smits, Casparus
HÄRTEL, Hermann
German, op.1841-1843
HARTELL, John Anthony
American, 1902-
HARTENKAMPFE, G.T.
Kempfe von
German, 1876-1956
HARTIGAN, Grace
American, 20th cent.
HARTINGER, Anton
German, 1806-1890
HARTLAND, Henry Albert
British, 1840-1893
HARTLEY, Alfred
British, 1855-1933
HARTLEY, Jonathon
Scott
American, 1845-
HARTLEY, Marsden
American, 1878-1943
HARTLEY, Mary
British, op.1761-1775
HARTMAN, Bertram
American, 1882-
HARTMANN, Carl
German, 1818-p.1857
HARTMANN, Ferdinand
(Christian Ferdinand)
German, 1774-1852
HARTMANN, Franz
German, c.1697-1728
HARTMANN, Johann or
Johannes Jakob
Czech, 1680-p.1728

HARTMANN, Johann Joseph
Swiss, 1753-1830
HARTMANN, Johannes
German, op.c.1480
HARTMANN, Joseph
German, op.1747-p.1788
HARTMANN, Karl
German, 1861-
HARTMANN, Ludwig
German, 1835-1902
HARTMANN, Matthäus
Christoph
German, c.1791-a.1850
HARTMANN, Oluf
Danish, 1879-1910
HARTMANN, Wolfgang or
Wolffgang
Swedish, op.1640-54
HARTRICK, Archibald
Standish
British, 1864-1950
HARTUNG, Hans
German, 1904-
HARTUNG, Heinrich
German, 1851-1919
HARTUNG, Karl
German, 1908-
HARTWICK, George Gunther
American, op.1847-1857
HARTWIG, Max
German, 1873-
HARTZ, Lauritz
Danish, 1903-
HARTZ, Louis Jacob
Dutch, 1869-1935
HARVELL the Younger, J.
British, op.1840
HARVEY, Elizabeth
British, op.1802-1812
HARVEY, George
British, 1799-p.1877
HARVEY, Sir George
British, 1806-1876
HARVEY, Harold C.
British, 1874-1941
HARVEY, H.J.
British, 1883-1928
HARVEY, Henrietta
British, 19th cent.
HARVEY, J.
British, op.1827
HARVEY, J.S.
British, 18th cent.
HARVEY, James
British, op.1789
HARVEY, Robert
American, 1924-
HARVEY, William
British, 1796-1866
HARVEY, William, II
British, op.c.1900
HARVIE, R.
British, op.1751
HARWICK of Bath
British, 19th cent.
HARWOOD, Edward
British, 1814-p.1872
HARWOOD, Henry
British, 1803-1868
HARWOOD, James
British, 1816-1872
HARWOOD, John
British, op.1829
HARWOOD, Robert
British, 1830-p.1876
HAS, Haas, Hase or
Hass, Georg
German, op.1571-1583

HASCH, Carl
German, 1834-1897
HASE, A.
Netherlands, op.1669
HASELDEN, William
Kerridge
British, 1872-1953
HASELER, H.
British, op.1814-1825
HASELTINE, William
Stanley
American, 1835-1900
HASEMANN, Wilhelm Gustav
Friedrich
German, 1850-1913
HASENAUER, Karl Freiherr
von
German, 1833-1894
HASENCLEVER, Johann
Peter
German, 1810-1853
HASENPFLUG, Carl Georg
Adolph
German, 1802-1858
HASHAGEN, A.
American, 19th cent.
HASKELL, Ernest
American, 1876-1925
HASLBÄGCK, Franz
German, op.1497
HASLEHURST, Ernest W.
British, 1866-1949
HASLOCK, J.
British, 19th cent.
HASLUND, Otto Carl
Bentzon
Danish, 1842-1917
HASPEL von Biberach,
Jorg
German, 15th cent.
HASSALL, John
British, 1868-1948
HASSAM, Childe
American, 1859-1935
HASSEBRAUK, Ernst
German, 1905-
HASSEL or Hassells,
Werner (Warner)
German, op.1674-1707
HASSEL, William
British, op.1770
HASSELGREN, Gustaf Erik
Swedish, 1781-1827
HASSELHORST, Heinrich
(Johann Heinrich)
German, 1825-1904
HASSELL, Edward
British, 1777-1852
HASSELL, John
British, op.1789-m.1825
HASSELT, J.C. van
Netherlands, op.1659
HASSELT, Wilhelmus Josephus
(Willem) van, Dutch, 1882-1963
HASSLWANDER, Josef
German, 1812-1878
HASTAIN, Eugene
British, op.1907
HASTED, Edward
British, op.1778-1799
HASTEN, Frank
British, 19th cent.
HASTENBERGH or Hastenburg
Dutch, op.1651-1660
HASTINGS, Edward
British, op.1804-1827
HASTINGS, I.
British, op.1829

HASTINGS, Thomas
(Captain Thomas)
British, op.1813-1831
HASTNER, Hieronymus
(Il Corazza)
Italian, 1665-1729
HATCH, C.
British, op.1855
HATELEY, Edward
see Haytley
HATH
British, 18th cent.
HATHAWAY, Rufus
American, 1770-1822
HATHERELL, William
British, 1855-
HATMANU, Dan
Rumanian, 1926-
HATTEMORE, Archibald
British, 20th cent.
HATTICH or Hattick,
Petrus or Pieter van
Dutch, op.1646-1665
HATTON, Brian
British, 1887-1916
HATTON, Helen Howard
(Helen Margetson)
British, op.1895
HATZ, Felix
Swedish, 1904-
HAUBER, Joseph
German, 1766-1834
HAUBER, Wolfgang
German, 16th cent.
HAUCH, J.M.
German, 18th cent.
HAUCK, Friedrich
Ludwig
German, 1718-1801
HAUCK, Inigo Maurice
British, op.1761-1767
HAUCK, J.P.F.
Swiss, op.1752-1760
HAUCK or Hauckh,
Johann Veit
German, op.1700-1746
HAUDEBOURT-LESCOT,
Antoine Cécile
Hortense (née Lescot)
French, 1784-1845
HAUEISEN, Albert
German, 1872-1954
HAUER, Jean Jacques
French, 1751-1829
HAUG, Robert von
German, 1857-1922
HAUGH, George
British, op.c.1777-1818
HAUGHTON, Benjamin
British, 19th cent.
HAUGHTON, David
British, 20th cent.
HAUGHTON, Moses, I
British, 1734-1804
HAUGHTON, Moses, II
British, c.1772-p.1848
HAUNOLD, Karl
German, 1832-1911
HAUPT, Friedrich
German, 1940-
HAUPT, Zygmunt
Polish, 20th cent.
HAUPTMANN, Eugénie,
(née Sommer)
Austrian, 1865-

HAUPTMANN, Ivo
German, 1886-
HAUPTMANN, K.
German, op.1931
HAUPTMANN, Susette
(née Hummel)
French, 1811-1890
HAUS, Rudolf
German, 20th cent.
HAUSCHILD, Max
German, 1907-1961
HAUSCHILD, Wilhelm
Ernst Ferdinand Franz
German, 1827-1887
HAUSERMAN, Charles
Swiss, 20th cent.
HAUSHOFER, Maximilian
German, 1811-1866
HAUSLAB, Franz Edler
von
German, 1749-1820
HAUSMANN, Friedrich
Karl
German, 1825-1886
HAUSMANN, Gustav
German, 1827-1899
HAUSMANN, Raoul
French, 1886-1971
HAUSNER, Rudolf
German, 1914-
HAUSSARD, Jean Baptiste
French, 1679-1767
HAUSSER von Aachen,
Johann
German, op.1603
HAUSSMANN or Hausmann,
Elisa Gottlob or
Gottlieb
German, 1695-1774
HAUSSOULLIER, W.
French, 1818-1891
HAUSSY, Arsène Désiré d'
French, 1830-p.1870
HAUTH, Emil van
German, 1899-
HAUTZINGER, Josef
see Hauzinger
HAUWEDE, Herbert
German, 1912-
HAUZINGER or Hautzinger,
Josef
German, 1728-c.1786
HAVELAAR, A.
Netherlands, 17th/18th cent.
HAVELKA, Josef Ignac
Russian, 1716-1788
HAVELL, Charles Richards
British, op.1858-1866
HAVELL, Daniel
British, op.1810-m.1826(?)
HAVELL, Edmund, I
British, op.1814-m.1853
HAVELL, Edmund, II
British, 1819-p.1895
HAVELL, George
British, op.1826-1833
HAVELL, Robert, I
British, a.1793-1832
HAVELL, Robert, II
British, 1793-1878
HAVELL, William
British, 1782-1857
HAVELOCK, Helen
British, 18th cent.
HAVEN, Frank de
American, 1856-1934

HAVEN, Lambert von
Norwegian, 1630-1695
HAVEN, Michael von
Norwegian, 1625-1683(?)
HAVENITH, Hugo
German, 1853-
HAVERKAMP, Gerhard
Christiaan (Gerrit)
Dutch, 1872-1926
HAVERMAN, Hendrik
Johannes
Dutch, 1857-1928
HAVERS, Alice
(Alice Morgan)
British, 1850-1890
HAVERTY, Joseph Patrick
British, 1794-1864
HAVILAND, Miss Harriet
M.
British, op.1864
HAVILL, Frederick
British, 1849-1874
HAVINDEN, Ashley Eldrid
British, 1903-
HAVLICEK or Hawlicek,
Vincenz
German, 1864-1900
HAVRANEK, Friedrich
Czech, 1821-1899
HAWA, Eliane
French, 20th cent.
HAWES of Doncaster
British, 18th cent.
HAWES, Meredith
William
British, 1905-
HAWKER, Gareth Wyn
British, 20th cent.
HAWKER, J.
British, op.1804-1809
HAWKER, Thomas (not
Edward)
British, c.1640-a.1722
HAWKES, E.
British, 19th cent.
HAWKES, W.
British, 19th cent.
HAWKESWORTH, J.
British, 18th cent.
HAWKESWORTH, J.H.
British, op.1858
HAWKESWORTH, William
Thomas
British, 20th cent.
HAWKINS, C.
British, 19th cent.
HAWKINS, Dennis
British, 1925-
HAWKINS, F.K.
British, op.c.1841
HAWKINS, George II
British, 1819-1852
HAWKINS, Jane, Miss
British, op.1871-1874
HAWKINS, Louis Weldon
French, -1910
HAWKINS, Louisa
(Mrs. W. Hawkins)
British, op.1839-1868
HAWKSLEY, Arthur
British, 1842-1915
HAWKSLEY, Dorothy
Webster
British, 1884-1970
HAWKSWORTH, W.T.M.
British, op.1881-1893
HAWLEY, Hughson
American, 19th cent.

HAWLEY, Margaret
Foote
American, 1880
HAWORTH, B. Cogill
Canadian, 20th cent.
HAWORTH, Miss E. Fanny
British, op.1844-1855
HAWS
British, op.c.1700
HAWTHORNE, Charles
Webster
American, 1872-
HAWTHORNE, Elwin
British, 20th cent.
HAXTON, Elaine
Australian, 20th cent.
HAY, Alex
British, 1936-
HAY, Andrew
British(?), op.1710
HAY, George
British, 1831-1913
HAY, Helen
British, op.1895
HAY, James
British, op.1887-1892
HAY, James Hamilton
British, 1874-1916
HAY, Jean
see Hey
HAY, John Arthur
Machray
British, 1887-1960
HAY, Paul
German, 1867-
HAY, Peter Alexander
British, 1866-1952
HAY, W.
British, op.1776-1797
HAYD or Haid, Anna
Maria
see Werner
HAYD, Johann Jakob
see Haid
HAYD, Johann Philipp
see Haid
HAYDEN, Charles Henry
American, 1856-1901
HAYDEN, Henri
French, 1883-
HAYDOCK, Richard
British, c.1570-c.1640
HAYDON, Benjamin
Robert
British, 1786-1846
HAYE, La
see La Haye
HAYECK or Hayek,
Hans von
German, 1869-
HAYER, Joseph
see Haier
HAYES, Claude
British, 1852-1922
HAYES, Edward
British, 1797-1864
HAYES, Edwin
British, 1819-1904
HAYES, Frederick
William
British, 1848-1918
HAYES, George
British, 1823-1895
HAYES, George A.
American, op.c.1860
HAYES, John
British, c.1786-1866

HAYES, Matilda
British, op.1821
HAYES, Michael Angelo
British, 1820-1877
HAYES, William
British, op.1773-1799
HAYET, Jacques
French, -1916
HAYEZ, Francesco
Italian, 1791-1881
HAYLEY, Thomas Alphonse
British, 1780-1800
HAYLLAR, Edith
British, op.1881-1897
HAYLLAR, James
British, 1829-c.1898
HAYLLAR, Jessica
British, 1858-1940
HAYLS, Hayles or Hales,
John
British, op.1651-m.1679
HAYM, Niccolò Francesco
Italian, c.1688-c.1729
HAYMAN, Francis
British, 1708-1776
HAYMAN, Patrick
British, 1915-
HAYNE de Bruxelles
Netherlands, op.c.1460
HAYNES, Arthur S.
British, op.1887-1890
HAYNES, John
British, op.1730-1753
HAYNES, John William
British, op.1852-1882
HAYNES-WILLIAMS, John
British, 1836-1908
HAYS, William Jacob, II
American, 1872-1934
HAYTER, Charles
British, 1761-1835
HAYTER, Edwin
British, 19th cent.
HAYTER, Sir George
British, 1792-1871
HAYTER, John
British, 1800-1891
HAYTER, Stanley William
British, 1901-
HAYTLEY or Hateley,
Edward
British, 1746-1761
HAYWARD, Mrs.
British, 19th cent.(?)
HAYWARD, Alfred
Frederick William
British, 1856-
HAYWARD, Alfred Robert
British, 1875-1971
HAYWARD, Arthur
British, 1889-
HAYWARD, George
American, op.c.1834-72
HAYWARD, John Samuel
British, 1778-1822
HAYWOOD, William
British, op.1844-1867
HAZENPLUG, Frank
American, 1873-
HAZLEHURST, Thomas
British, op.1760-1818
HAZLITT, John
British, 1769-1837
HAZLITT, William
British, 1778-1830

HEAD, Charles
British, op.c.1904
HEAD, Guy
British, 1753-1800
HEAD, Jonathan
British, 20th cent.
HEADE, Martin Johnson
American, 1814-1904
HEADLEY or Hidley,
Joseph H.
American, 1830-1872
HEALEY, G.R.
British, op.1840-1852
HEALY, George Peter
Alexander
American, 1808-1894
HEALY or Haly, Robert
British, op.1765-1771
HEAN, J. de
Netherlands, 18th cent.
HEAPHY, Charles
British, 1822-1881
HEAPHY, Elizabeth
see Murray
HEAPHY, Miss M.A.
(Mrs W. Musgrave)
British, op.1821-1847
HEAPHY, Thomas, I
British, 1775-1835
HEAPHY, Thomas, II
British, 1813-1873
HEARD, J.
British, op.c.1850
HEARN, Joseph
British, 18th cent.
HEARNDEN, Anthony
British, 20th cent.
HEARNE, Thomas
British, 1744-1817
HEARSEY, Captain
Hyder
British, op.1808
HEARTFIELD, John
German, 1891-1968
HEATH, Adrian
British, 1920-
HEATH, Edda Maxwell
American, 20th cent.
HEATH, Ellen
British, 19th cent.
HEATH, Ernest Dudley
British, 19th cent.
HEATH, Frank L.
American, 1857-1921
HEATH, H.
British, 19th cent.
HEATH, James
British, 1757-1834
HEATH, Margaret A.
British, op.1886-1893
HEATH, William
British, 1795-1840
HEATHCOTE, H.M.
British, 19th cent.
HEATON, E.
British, 19th cent.
HEATON, John Aldan
British, 1830(?)-1897
HEBBE
German(?), 18th cent(?)
HEBBELYNCK, Anselmus
see Hulle
HEBBORN, E.
British, 20th cent.
HERBERT, Ernest Auguste
Antoine
French, 1817-1908

HERBERT, Ernest Auguste
Antoine
French, 1817-1908
HEBERT, Jules
Swiss, 1812-1897
HEBUTERNE, André
French, 20th cent.
HECHT, Guillaume
van der
Belgian, op.1851-1863
HECHT, Hendrik (Henri)
van der
Belgian, 1841-1901
HECHT, Joseph
Polish, 1891-
HECK or Hecke, Abraham
van den
see Hecken
HECK, Claes Dirksz.
van der
Dutch, op.1604-m.1649
HECK, Nicolaes (Claes)
Jacobsz. van der
Dutch, c.1575/81-1652
HECKE, Jan, I van den
Flemish, 1620-1684
HECKE, Peter van den
Flemish, op.1711-m.1752
HECKEL, Abraham
German(?), 18th cent.
HECKEL, Augustin
German, 1690-1770
HECKEL, Catharina
see Sperling
HECKEL, Erich
German, 1883-
HECKELE, Jan van
see Eeckele
HECKEN, Heck or Hecke,
Abraham, II van den
Flemish, op.1635-1655
HECKEN, Samuel van den
Flemish, op.1616-1637
HECKENDORF, Franz
German, 1888-
HECKER, C.
American, 19th cent.
HECKROTH, Hein
German, 1901-
HECQUET, F.
French, op.1822-1824
HEDA, Gerrit
Willemsz.
Dutch, c.1620-a.1702
HEDA, Willem Claesz.
Dutch, 1594-1680
HEDBERG, Kalle
Swedish, 1894-
HEDEGAARD, Peter
Dutch, 20th cent.
HEDERICH, D.
German, op.1597
HEDLEY, H.
British, op.1738
HEDLEY, Ralph
British, 1851-1913
HEDLINGER, Johann
Karl
Swiss, 1691-1771
HEDLUND, Börje
Swedish, 20th cent.
HEDMAN, R.
British, 19th cent.
HEDOUIN, Pierre Edmund
Alexandre
French, 1820-1889

HEEDE, Vigor van
Flemish, 1661-1708
HEEL, Johann
German, op.1738-1759
HEEL, L. van
Flemish, 17th cent.
HEEM, Cornelis de
Dutch, 1631-1695
HEEM, David, I de
Dutch, c.1570-c.1632
HEEM, David Davidsz. de
Dutch, op.1668
HEEM, Jan Davidsz. de
Dutch, 1606-1683/4
HEEMSKERCK or Heemskerk,
Bastiaan or Sebastiaan
Dutch, op.1691-m.1748
HEEMSKERCK or Heemskerk,
Egbert, I van
Dutch, c.1634-1704
HEEMSKERCK or Heemskerk,
Egbert, II van
Dutch, -1744(?)
HEEMSKERCK or Heemskerk,
Maarten van
Netherlands, 1498-1574
HEEMSKERK van Beest,
Jacob Eduard van
Dutch, 1828-1894
HEEMSKERK van Beest,
Jacoba Berendina van
Dutch, 1876-1923
HEENCK, Jabes
Dutch, 1752-1782
HEER, Gerrit Adriaensz.
de
Dutch, op.1634-1652
HEER, K.
German(?), 18th cent.
HEER, Margarethe de
German, op.1650-1651
HEER, Michael
see Herr
HEER, Willem or
Guilliam de
Dutch, c.1638-1681
HEERBRANT, Henri
Belgian, 1913-
HEERDT, Johann
Christian,
German, 1812-1878
HEERE, Lukas de
Netherlands, 1534-1584
HEERE, Michael
see Herr
HEEREMANS, Thomas
(also erroneously,
F.H. Mans)
Dutch, op.1660-1697
HEERICH
German, 20th cent.
HEERMANN, L.
German, 1811-1881
HEERSCHOP or Herschop,
Hendrick
Dutch, 1620/1-p.1672
HEERUP, Henry
Dutch, 20th cent.
HEES, F. van
Netherlands, op.1656
HEES, Gerrit van
Dutch, op.1650-m.1670
HEESCHE, Franz
German, 1806-1876
HEEUSMAN, P.T.
Netherlands, 17th/18th cent.

HEFELE, J.F.
German, -c.1710
HEFFNER, Karl
German, 1849-p.1889
HEFTEL, Daniel L.
Central and South
American, 20th cent.
HEFTI, Anja
Swiss, 20th cent.
HEGEDUSIC, Krsto
Jugo-Slav, 1901-
HEGENBART, Fritz
German, 1864-
HEGENBARTH, Josef
German, 1884-
HEGG, Theresa
Maria, (née de
Landerset)
Swiss, 1829-p.1875
HEGGLI, Hans
see Jegli
HEGI, Franz
Swiss, 1774-1850
HEGI, Salomon
Swiss, 1783-1837
HEIBERG, Astri
Welhaven
Norwegian, 1883-
HEIBERG, Jean Hjalmar
Norwegian, 1883-
HEICKE, Joseph
German, 1811-1861
HEIDBRINCK, Oswald
French, 1850-1914
HEIDE, Henning von der
see Heyde
HEIDECK, Heidegger
or Heydeck, Karl
Wilhelm Freiherr von
German, 1788-1861
HEIDEGGER or Heid,
Johann (Hans)
Ulrich
Swiss, 1700-1747
HEIDELBACH, Karl
German, 20th cent.
HEIDELOFF or Heydeloff,
Carl Alexander von
German, 1789-1865
HEIDELOFF, Nicolaus
Innocentius Wilhelm
Clemens von
German, c.1761-1837
HEIDELOFF, Victor
Wilhelm Peter
German, 1757-1817
HEIDLAND, R.
German, op.c.1850
HEIER or Hoeur, Johann
German, op.1737
HEIGEL, Franz Napoleon
French, 1813-1888
HEIGEL, Joseph
German, 1780-1837
HEIGHWAY, Richard
British, op.1787-1793
HEIL, Daniel van
Flemish, 1604-1662(?)
HEIL, Jan Baptist
van
Flemish, 1609-p.1661
HEIL, Théodore van
Flemish, op.1668
HEILBROECK, Norbert
see Heylbroeck
HEILBUTH, Ferdinand
French, 1826-1889

HEILEMANN, Ernst
German, 1870-
HEILIGER, Bernhard
German, 1915-
HEILMAIR, Emil
German, 1802-1836
HEILMANN, Anton
German, 1830-1912
HEILMANN, Johann
Kaspar
German, 1718-1760
HEILMAYER, Karl
German, 1829-1908
HEIM, François Joseph
French, 1787-1865
HEIM, Heinz
German, 1859-1895
HEIMBACH, Wolfgang
(not Christian)
German, c.1615-p.1678
HEIMBERG, Theodor
German, 19th cent.
HEIMIG, Walter
German, 1881-
HEIMLICH, Johann Daniel
French, 1740-1796
HEIN, Franz
German, op.1863
HEIN, Hendrik Jan
Dutch, 1822-1866
HEIN, M.
Dutch, 17th cent.
HEINCE, Haentz,
Hainsse, Heins,
Heintze, Hinse or
Hintz, Zacharie
French, 1611-1669
HEINDL or Heintl,
Wolfgang Andreas
Austrian, 1683/4-1757
HEINE, Adalbert
German, 1769-1831
HEINE, Carl
German, 1842-1882
HEINE, Johann Adalbert
German, op.1885-1890
HEINE, Ludwig
(Friedrich Ludwig)
German, op.1816-1834
HEINE, Thomas Theodor
German, 1867-
HEINE, Wilhelm (Peter
Bernhard Wilhelm)
German, 1827-1885
HEINE, Wilhelm Joseph
German, 1813-1839
HEINER, Wilhelm
German, 1902-
HEINISCH, Karl Adam
German, 1847-1927
HEINKEL, G. van der
Dutch, 18th cent.
HEINLEIN, Heinrich
German, 1803-1885
HEINRICH, August
(Johann August)
German, 1794-1822
HEINRICH, C.
German, 17th/18th cent.
HEINRICH, Eduard
Hungarian, 1819-1885
HEINRICH, Franz
German, 1802-1890
HEINRICH, Hans
German, 17th cent.
HEINRICH, Olivier
German, op.1815

HEINRICH, P.S. or T.
German(?), 18th cent.
HEINRICH, Thugut
German, op.1828-1859
HEINRICI, Johann Martin
Swiss, 1711-1786
HEINS, D.
British, op.c.1725-p.1779
HEINS, John Theodore
British, 1732-1771
HEINS, Zacharie
see Heince
HEINSCH, Jan Jiri
Czech, 19th cent.
HEINSIUS, Johann Ernst
German, 1740-1812
HEINTL, Wolfgang Andreas
see Heindl
HEINTZ, Abraham
German, op.1650
HEINTZ, Georg
see Hainz
HEINTZ, Ens or Enzo
Johann (Giovanni)
Italian, op.1611-1656
HEINTZ, Hainz or Heinz,
Joseph, I
Swiss, 1564-1609
HEINTZ, Enz, Enzo,
Heintius, Heinz or
Henz, Joseph, II
German, op.1600-p.1678
HEINTZ, Richard
Belgian, 1871-1929
HEINTZE, Zacharie
see Heince
HEINZ(?)
German(?), 17th cent.
HEINZ, Johannes
German, op.1622
HEINZ, Johann Georg
see Hainz
HEINZELMANN, Johann
see Hainzelmann
HEINZLMANN, Anton
German, 1798-1829
HEINZMANN, Carl
Friedrich
German, 1795-1846
HEISE, Wilhelm
German, 1892-1965
HEISS, Elias Christoph
German, c.1660-1731
HEISS, Gottlieb, I
German, 1684-1740
HEISS, Johann
German, 1640-1704
HEISTER, C.
German, 19th cent.
HEITINGER
German, 19th cent.
HEITLAND, Ivy
British, 1875-1895
HEITZINGER, Jakob
German, op.c.1500-1510
HEIZER, Michael
American, 20th cent.
HEKE, Jan van der
see Eeckele
HEKKING, W.Junior
American, 1885-
HEKKING, Willem, I
Dutch, 1796-1862
HELAND, Martin Rudolf
Swedish, 1765-1814
HELANT or Heland,
Anthonie Joseph
Dutch, c.1752-c.1837

HELBIG, Jules Chrétien
Charles Joseph Henri
Belgian, 1821-1906
HELBIG, Peter
German, 1841-1896
HELBIGK or Helwick,
Jacob Heinrich
German, -1746
HELBLING, Franz
Thaddäus
German, op.1776
HELCKE, Arnold
British, op.1865-1898
HELD, Al
American, 20th cent.
HELD, John, II
American, 1889-
HELD, M. von
German, 19th cent.
HELDENMUTH
see Baeck, Elias
HELDT, A.
German, op.1712
HELDT, Werner
German, 1904-1954
HELE, Ivar
Australian, 1912-
HELENYI, Tibor
Hungarian, 20th cent.
HELFER, Hans
German, 1908-
HELIE, A.
Swedish(?), op.1783
HELIKER, John
American, 1909-
HELTON, Jean or Jesu
French, 1904-
HELL, Johannes Gerardus
Diederik (Johan) van
Dutch, 1889-
HELL, Willy ter
German, 1883-
HELLART or Hélart, Jacques
French, 1664-1719
HELLART, Louis Charles
or Louis
French, 1696/9(?)-1757(?)
HELLE
see Elle
HELLEBRANTH, Bertha de
American(?), op.1929
HELLEMANS, Pierre Jean
Belgian, 1787-1845
HELLEMONT
see Helmont
HELLENBROEK, Anna Elisabeth
(née Ruysch)
see Ruysch
HELLER, Bert
German, 1912-
HELLER, Ruprecht
German, op.1529
HELLESEN, Julius
(Lars Julius August)
Danish, 1823-1877
HELLEU, J.
French, 1894-
HELLEU, Paul
French, 1859-1927
HELLQVIST, Carl
Gustaf
Swedish, 1851-1890
HELLWAG, Rudolf
German, 1867-1942
HELLYER, Thomas
British, op.1800
HELM, Katherine
American, 19th cent.
HELMAN, Robert
French, 20th cent.

HELMBERGER, Adolf
German, 1885-
HELMBREKER, Helmbreecker
or Elembrech, Dirk,
Theodor or Teodoro
Dutch, 1633-1696
HELMICK, Howard
American, 1845-1907
HEIMLE or Helmlin,
Sebastian
German, 1799-p.1841
HELMONT or Hellemont,
Mattheus van
Flemish, 1623-p.1674
HELMONT, Theodor
Dutch(?), op.1656
HELMONT or Hellemont,
Zeger Jacob van
Flemish, 1683-1726
HEIMSDORF, Friedrich
(Johann Friedrich)
German, 1783-1852
HELSBY, Alfredo
S.American, op.c.1889
HEIST or Elst,
Bartholomeus,
Bartelmeus or
Bartel van der, or
Bartholomeus Verelst
or Verhelst
Dutch, 1613(?)-1670
HELST, G. van
Netherlands,
17th/18th cent.
HELST, Jeronimus van der
Dutch, c.1629-p.1671
HELST or Elst,
Lodewyk van der
Dutch, 1642-p.1682
HELSTED, Axel Theofilus
Danish, 1847-1907
HELSTED, Frederik
Ferdinand
Danish, 1809-1875
HELT Stockade,
Nicolaes van
Dutch, 1614-1669
HELTIUS, J.
Netherlands, 17th cent.
HELVIG, Amalia von
Swedish, op.1805
HELWICK, Jacob Heinrich
see Helbigk
HEM, Hermann van der
Dutch, op.1638-m.1649
HEM, Pieter (Piet)
van der
Dutch, 1885-1961
HEMERT, Jan van
Dutch, op.1645
HEMERY, Mlle.
French, op.1797
HEMESSEN, Jan Sanders
van or de (Also
identified with Master
of the Brunswick
Monogram)
Netherlands,
op.1519-m.a.1566
HEMESSEN, Katharina
van or de
Netherlands, 1527/8-1587
HEMING, Matilda, (née
Lowry)
British, 1808-1855
HEMINGTON, Charlotte
see Avarne

HEMKEN, Willem de
Haas
Dutch, 1831-1911
HEMPEL, Joseph Ritter
von
German, 1800-p.1862
HEMPFING, Wilhelm
German, 1886-1951
HEMPTON, Paul
British, 1946-
HEMSLEY, J.
British, 19th cent.
HEMSLEY, William
British, 1819-p.1893
HEMY, Charles Napier
British, 1841-1917
HEMY, Thomas Marie
Madawaska
British, op.c.1873
HEN, Catharina de,
(née Knibbergan)
see Knibbergen
HENARD, C.
French, op.1785-1812
HENAULT
see Hainault
HENCKEL, Anton
Swiss, op.1525-1538
HENDERSON, Andrew
British, 1783-1835
HENDERSON, Arthur
Edward
British, 1870-1956
HENDERSON, Charles
Cooper
British, 1803-1877
HENDERSON, Cornelius
British, 1799-
HENDERSON, Elsie Marian
British, 1880-
HENDERSON, F.
British, 19th cent.
HENDERSON, Jan
American, 20th cent.
HENDERSON the Elder,
John
British, 1764-1834
HENDERSON, John
British, 1860-1924
HENDERSON, Joseph
British, 1832-1908
HENDERSON, Joseph
Morris
British, 1863-1936
HENDERSON, Keith
British, 20th cent.
HENDERSON, Nigel
British, op.1949
HENDERSON, T.
British, op.1864
HENDERSON, William
British, 20th cent.
HENDERSON, W.S.P.
British, op.c.1836-1874
HENDLER, Maxwell
American, 20th cent.
HENDLER, Raymond
American, 20th cent.
HENDRICH, Antal
Hungarian, 1878-
HENDRICK van Montfoort
see Montfoort, Hendrick
van
HENDRICK, Nicolas
see Broeck, Hendrick
van den

HENDRICKSZ. or
Heyndricsx, Dirck
(Enrico or Teodoro
[d'Errico] Fiammingo;
possibly identified with
Teodoro Gerrico)
Flemish, op.1574-m.1618
HENDRIE, John
British, op.1677
HENDRIKS, Arend
Dutch, 1901-1951
HENDRIKS, Frederik
Hendrik
Dutch, 1808-1865
HENDRIKS, Gerardus
Dutch, 19th cent.
HENDRIKS, Sara Fredricka
Dutch, 1846-1925
HENDRIKS, Wybrand
Dutch, 1744-1831
HENDSCHEL, Albert
Louis Ulrich
German, 1834-1883
HENDTZSCHEL, Gottfried
Norwegian,
op.1625-p.1648
HENDY, W.
British, 19th cent.
HENGELER, Adolf
German, 1863-
HENGSTENBURG, Herman
see Henstenburgh
HENKES, Gerke
Dutch, 1844-1927
HENKES, Koelof Lucas
Johannes (Dolf)
Dutch, 1903-
HENLEY, Lionel Charles
British, op.1862-93
HENN, Ulrich
German, op.c.1957
HENNE, Eberhard
Siegfried
German, 1759-1828
HENNE, Joachim
German, op.1702
HENNEBERG, Georg or
Jörg, II
German, op.1556-1590
HENNEBERG, Rudolf
Friedrich August
German, 1826-1876
HENNEBERGER, Hans
German, op.1593-m.1601
HENNEBICQ, André
Belgian, 1836-1904
HENNECART, Hannequart
or Hennequart, Jean
Netherlands,
op.1454-1475
HENNEKYN or Hennekin,
Paulus
Dutch, 1611/14-1672
HENNEL, Maximilian
Joseph
see Hannl
HENNELL, Robert
British, 1826-1892
HENNELL, Thomas
British, 1903-1944
HENNEQUART, Jean
see Hennecart
HENNEQUIN de Meecle
see Broeck, Hendrick
van den

HENNEQUIN, Philippe
Auguste
French, 1762-1833
HENNER, George P.
German, op.1784
HENNER, Jean Jacques
French, 1829-1905
HENNESSY, William
John
British, 1839-c.1920
HENNIG, Gustav Adolph
German, 1797-1869
HENNIG, Johann
Friedrich
German, c.1778-p.1806
HENNIG, Karl
German, 1871-
HENNIGS, Gösta
(Carl Gustaf Albert)
von
Swedish, 1866-1941
HENNIN, Henny or Henyn,
Adriaen de
Dutch, op.1664-m.1710
HENNIN, Jacob de
Dutch, 1629-c.1688
HENNING, Archibald S.
British, op.1825-1834
HENNING, Christian
German, 1741-1822
HENNING, Gerhard
Swedish, 1880-1967
HENNING, John
British, 1771-1851
HENNINGS, Johann
Friedrich
German, 1838-1899
HENNINGSEN, Erik Ludvig
Danish, 1855-1930
HENNY, Adriaen de
see Hennin
HENRI, Adrian
British, 20th cent.
HENRI, Florence
French, 20th cent.
HENRI, Pierre
French, 18th cent.
HENRI, Robert
American, 1865-1929
HENRICH, Albert
German, 1899-
HENRICHSEN, Carsten
Danish, 1824-1897
HENRICHSEN, Johann
Georg
Swedish, 1707-1779
HENRICI or Henrizi,
Johann Josef Karl
German, 1737-1823
HENRICO da Dinant
see Bles, Herry met de
HENRICUS van Mecheln
see Broeck, Hendrick
van den
HENRIQUEL, Louis Pierre
(Henriquel Dupont)
French, 1797-1892
HENRIQUES or Anriques,
Francisco
Portuguese, -c.1519
HENRIQUES, Lady Rose L.
British, 20th cent.
HENRIQUEZ, Benoît Louis
French, 1732-1806
HENRIQUEZ, Emmanuel
Spanish, 1593-1653
HENROTIN, Marie, (née Collárt)
see Collart

HENRY, A.
British(?), 19th cent.
HENRY, Aimé
French, 20th cent.
HENRY, Edward Lamson
American, 1841-1919
HENRY, George
British, 1859-1943
HENRY, Grace
British, op.c.1930
HENRY, James
British, 19th cent.
HENRY, Jean
(Henry d'Arles)
French, 1734-1784
HENRY, John
British, 19th cent.
HENRY, Maurice
French, 1907-
HENRY, Paul
British, 1876-1958
HENRY, Susanne
see Chodowiecka
HENRY, T.M.
British, 19th cent.
HENRY, William
British, op.1847-1883
HENS, Frans
Belgian, 1856-1928
HENSCH, Gotthilf
Friedrich
German, 1732-1785
HENSCHEL, Moritz
German, op.1804-1818
HENSCHEL, Wilhelm
German, 1781-1865
HENSEL, Hermann
German, 1898-
HENSEL, Wilhelm
German, 1794-1861
HENSELER, Ernest
German, 1852-p.1900
HENSETT, J.
British, 19th cent.
HENSHALL, Henry
(John Henry)
British, 1856-1928
HENSHAW, Frederick Henry
British, 1807-1891
HENSHAW, I.N.
British, 19th cent.
HENSON, S. or L. or T.
British, op.1799
HENSTENBURGH or
Henstenburg, Anton
Dutch, 18th cent.
HENSTENBURGH, Hengstenburg
or Henstenburg, Herman
Dutch, 1667-1726
HENWOOD, J.
British, 19th cent.
HENWOOD, Th.
British, 19th cent.
HENYN, Adriaen de
see Hennin
HENZ, Joseph
see Heintz
HENZELL, Isaac
British, op.1854-1875
HENZI, Hentzi or
Hentzy, Rudolf
Swiss, 1731-1803
HEPHER, David
British, 20th cent.
HEPPLE, Robert Norman
British, 1908-

HEPPLEWHITE, A.
British, 18th cent.
HEPWORTH, Barbara
British, 1903-1975
HER, Theodor
German, 1838-1892
HERAIL, Jean Baptiste
French, 19th cent.
HERALD, James
Watterston
British, -1914
HERBACH, H.F.
German(?), 17th cent.
HERBEL, Charles
French, c.1656-1703
HERBERT, Albert C.
British, 20th cent.
HERBERT, Alfred
British, op.1844-m.1861
HERBERT, Arthur John
British, 1834-1856
HERBERT, James Dowling
British, c.1762-1837
HERBERT, John Rogers
British, 1810-1890
HERBERT, Wilfred Vincent, II
British, op.c.1863-1891
HERBERTE, E.B.
British, 19th cent.
HERBIG, Otto
German, 1889-
HERBIG, Wilhelm
(Friedrich Wilhelm
Heinrich)
German, 1787-1861
HERBIN, Auguste
French, 1882-1960
HERBIN, Girard
French, op.c.1600-1658(?)
HERBO, Fernand
French, 19th cent.
HERBO, Léon
Belgian, 1850-1907
HERBST or Herbster,
Hans
German, 1468-1550
HERBST, Thomas Ludwig
German, 1848-1915
HERBSTHOFFER, Karl
(Peter Rudolf Karl)
German, 1821-1876
HERDE, Jan de
see Herdt
HERDEBOUT, H.
Flemish, 17th cent.
HERDENBERG, Wilhelm
van
see Ehrenberg
HERDER van Gröningen
Netherlands,
c.1550(?)-c.1609(?)
HERDINCG, Hermann A.
German, op.1663
HERDMAN, Robert
British, 1829-1888
HERDMAN, Robert
Duddingstone
British, 1863-1922
HERDMAN, William Gawin
British, 1805-1882
HERDT, Friedrich
Wilhelm
German, c.1790-p.1840
HERDT, Herde or Hert
Jan de
Flemish, op.1646-1668

HEREAU, Jules
French, 1839-1879
HERFORD or Hereford,
Laura A.
British, op.c.1861-m.1870
HERGENROEDER,
Herchenröder or
Hergenruder, George
Heinrich
German, 1736-c.1794
HERIGELANDT, Pieter van
Netherlands, op.1691
HERING, George Edwards
British, 1805-1879
HERING or Haering,
Hans (Johann Georg)
German, op.1587-1635
HERING, P.
Dutch, 20th cent.
HERIOT, George
British, op.1789-1820
HERISSON, Jean Louis
French, 19th cent.
HERKENRATH, Peter
German, 1900-
HERKOMER, Herman
Gustave
American, 1863-1935
HERKOMER, Sir Hubert von
British, 1849-1914
HERLAND, Mlle. Emma
French, 1856-p.1901
HERLE, F. van
Dutch, op.1857
HERLEIN, P.
German(?), 18th cent.
HERLIN, Auguste Joseph
French, 1815-1900
HERLIN, Herleinn,
Herlen, Hörlein or
Horlin the Elder,
Friedrich
German, c.1435-c.1500
HERLUISON, Louis
French, 1667-1706
HEPMAN
British, op.1826-1839
HERMAN d'Italie
see Swanevelt
HERMAN, Josef
British, 1911-
HERMAN, Sali
Australian(?), 1898-
HERMAN, Stephan
German, op.1568-1609(?)
HERMANN
German, 16th cent.
HERMANN, Christian
Gottfried
German, 1743-1813
HERMANN the Elder, Franz
Georg
German, op.1665-m.1735
HERMANN, Franz Ludwig
Swiss, 1710-1791
HERMANN or Hörmann,
Joseph Markus
German, 1732-1811
HERMANN, Ludwig
German, 1812-81
HERMANN, W.
South African, 19th cent.
HERMANN-LEON, Charles
French, 1838-1908
HERMANN, Paul
French, 1865-

HERMANN-PAUL
German, 1874-1940
HERMANNS, Heinrich
German, 1862-
HERMANS, Charles
Belgian, 1839-1924
HERMANS, Josephine
Dutch, 1895-
HERMELIN, Olof
Swedish, 1820-1913
HERMES, Gertrude
British, 1901-
HERMES, Johannes
German, 1842-1901
HERMITTE, Léon
Augustin 1'
see l'Hermitte
HERNANDEZ y Amores,
German
Spanish, 1823-1804
HERNANDEZ, Daniel
Peruvian, 1856-1932
HERNANDEZ, Francisco
Spanish, 17th cent.
HERNANDEZ, Santiago
Mexican, 1833-1908
HERNANDO
see also Llanos
HERNANDO de la Almedina
see Yanez
HERNEISEN, Herneissen,
Herneyssen or Horneiser,
Andreas or Endres
German, 1538-1610
HEROLD, Jacques
French, 1910-
HEROLD, Heroldt or
Höroldt, Johann
Gregor
German, 1696-1775
HEROLD or Herolt,
Johanna Helena,
(née Graff)
German, 1668-p.1702
HERON, Patrick
British, 1920-
HERP, Willem or
Guilliam, I van
Flemish, 1614-1677
HERPFER, Carl
German, 1836-1897
HERPIN, Léon Pierre
French, 1841-1880
HERR, Claudius
(Johann Claudius)
German, 1775-p.1838
HERR, Laurenz
German, 1787-p.1850
HERR or Heer, Michael
German, 1591-1661
HERRAN, Saturnino
Mexican, 20th cent.
HERRANT, Crispin
German, op.1529-m.1549
HERREGOUDTS, Pieter
German, 17th cent.
HERREGOUTS, Hendrik
Flemish, 1633-1704
HERREGOUTS, Jan Baptist
Flemish, c.1640-1721
HERREGOUTS, Maximilian
Flemish, op.1674
HERRENBURG, Johann
Andreas
German, 1824-1906

HERRERA, Alonso de
Spanish, op.1579-1611
HERRERA, Carlos
Maria
Uruguayan, 1875-1914
HERRERA, Francisco,
I
Spanish, 1576-1656
HERRERA, Francisco,
II
Spanish, 1622-1685
HERRERA, Juan M
Spanish, 18th cent.
HERRERA, Madame de
see Sanchez-Coello,
Isabella
HERRERA, Fray Miguel
de
Spanish, op.1725-1778
HERRERA BARNUEVO,
Sebastiano de
Spanish, 1619-1671
HERREYNS or Herryns,
Jacob, I
Flemish, 1643-1732
HERREYNS, Willem
Jacob
Flemish, 1743-1827
HERRFURTH, Oskar
German, 1862-
HERRICK, William
Salter
British, op.1852-1888
HERRING, Benjamin
British, op.c.1861-1871
HERRING, James
American, 1796-1867
HERRING, John
Frederick, I
British, 1795-1865
HERRING, John
Frederick, II
British, 1815-1907
HERRLEIN, Johann Andreas(?)
German, 1720-1796
HERRLEIN or Hörlein,
Johann Peter
German, op.1750-1803
HERRLIBERGER, David
Swiss, 1697-1777
HERRMANN, Alexander
German, 1814-1845
HERRMANN, Augustin
American, op.c.1685
HERRMANN, Carl Gustav
German, 1857-
HERRMANN, Curt
German, 1854-1929
HERRMANN, Hans
German, 1813-1890
HERRMANN, Hans
(Johann Emil Rudolf)
German, 1858-1942
HERRMANN, Léo
French, 1853-
HERRMANN, Léon Charles
French, 1838-1907
HERRMANNS, Heinrich
German, 1862-1942
HERRMANSTÖRFER, Josef
or Joseph
German, 1817-1901
HERRYNS, Jacob
see Herreyns
HERSCH, Eugen
German, 1887-

HERSCH, Stefan
American, 20th cent.
HERSCHOP, Hendrick
see Heerschop
HERSENT, Louis
French, 1777-1860
HERSENT, Mme. Louise
Marie-Jeanne,
(née Mauduit)
French, 1784-1862
HERSEY, John
British, 20th cent.
HERSHOM, Eliza
German, 20th cent.
HERST, Auguste
Clément Joseph
French, 1825-p.1861
HERT, Jan de
see Herdt
HERTEL, Albert
German, 1843-1912
HERTEL, Karl Konrad
Julius
German, 1837-1895
HERTEL, Gottlieb
German, 1683-1743
HERTER, Albert
German, 19th cent.
HERTERICH, Heinrich
Joachim
German, 1772-1852
HERTERICH, Johann
Kaspar
German, 1843-1905
HERTERICH, Ludwig
German, 1856-1932
HERTERVIG or Hertewik,
Lars
Norwegian, 1830-1902
HERTOCHS or Hertocks, A.
Dutch, op.1626-1672
HERTZ, Johann
see Herz
HERVE, Gabriel
French, 1868-p.1907
HERVE, Jules
French, 1887-
HERVENS, Jacques
Belgian, 1890-1928
HERVEY-BATHURST,
Caroline
British, 20th cent.
HERVIER, Adolphe
(Louis Henri Victor
Jules Francois
Adolphe)
French, 1818-1879
HERVIEU, August
British, op.1819-1858
HERVIEU, Louise Jeanne
Aimée
French, 1878-1954
HERWEGEN or
Herwegen-Manini,
Veronik Maria
German, 1851-
HERZ, Christoph
German, op.1658
HERZ or Hertz, Johann
German, 1599-1635
HERZ or Hertz the
Younger, Johann Daniel
(von Herzburg)
German, 1720-1793
HERZFELD, Helmut
see Heartfield, John

HERZLEIN, Kiliane de
German, 18th cent.
HERZMANOVSKY-ORLANDO,
Fritz von
Austrian, 1877-1954
HERZOG, Herman
German, 1832-1877
HERZOG, Jakob
Swiss, 1867-1959
HERZOG, Wolfgang Werner
German, 1933-
HESDIN, Esdin or Odin,
Jacquemart de
French, op.1384-m.c.1409
HESELTINE, John Postle
British, 1843-1929
HESLEWOOD, Tom
British, 20th cent.
HESLOP, Arthur
British, 1881-1955
HESS, Berthe
French, 20th cent.
HESS, Carl Adolph
Heinrich
German, 1769-1849
HESS, Carl Ernst
Christoph
German, 1755-1828
HESS, David
Swiss, 1770-1843
HESS, Eugen
German, 1824-1862
HESS, Georg Friedrich
German, 1697-1782
HESS, Heinrich Maria von
German, 1798-1863
HESS, Hieronymous
Swiss, 1799-1850
HESS, Ignatius
German, op.1748-m.1784
HESS, James
American, op.c.1879
HESS, Ludwig
Swiss, 1760-1800
HESS, Martin
see Kaldenbach
HESS, Max
German, 1825-1868
HESS, Peter von
German, 1792-1871
HESSE, Alexandre Jean
Baptiste
French, 1806-1879
HESSE, Hans
German, op.1497-1521
HESSE, Henri Joseph
French, 1781-1849
HESSE, Martin
see Kaldenbach
HESSE, Nicolas Auguste
French, 1795-1869
HESSE, Rudolf
German, 1871-
HESSELBOM, Otto
(Johan Otto)
Swedish, 1848-1913
HESSELIUS, Gustaf, I
American, 1682-1755
HESSELIUS, Gustaf, II
Swedish, 1727-1775
HESSELIUS, Johan
American, 1728-1778
HESSEMER, Friedrich
Maximilian
German, 1800-1860

HESSING, Leonard
Australian, 1931-
HESTERBERG, Hesto
German, 1895-
HESTERMAN, H.A.
Dutch, 17th cent.
HESZ, Janos Mihaly
Hungarian, 1768-1833
HETLIE, M.(?)
Dutch(?), op.1683
HETREAU, Rémy
French, 1913-
HETSCH, Philipp
Friedrich von
German, 1758-1838
HETTNER, Otto
(Hermann Otto)
German, 1875-1931
HETZENDORF or Hezendorf
von Hohenberg, Johann
Ferdinand
see Hohenberg
HEUBEL, Jakob
German, op.c.1676-1680
HEUDE, Nicholas
French, op.1672-p.1682
HEUMANN, Georg Daniel
German, 1691-1759
HEUR, Cornelis Joseph d'
Flemish, 1707-1762
HEUSCH or Heus, Abraham
de
Dutch, c.1650-1712(?)
HEUSCH, Jacob or
Giacomo de (Afdruk)
Dutch, 1657-1701
HEUSCH or Heus,
Willem, Guilliam or
Guglielmo de
Dutch, 1625-1692
HEUSDEN, Adolphe van
Dutch, op.1665-1682
HEUSDEN, Wouter Bernard
(Wout) van
Dutch, 1896-
HEUSEL, Wilhelm
German, 19th cent.
HEUSER, Christian
German, 1897-
HEUSER, Heinrich
German, 1887-
HEUSEUX, Lucette
Belgian, 1913-
HEUSLER, Antonius
(possibly identified
with Anthoni Maler or
Monogrammist A.H.)
German, op.1525-1533
HEUSS, Eduard (Franz
Eduard)
German, 1808-1880
HEUSS, H.D.
Netherlands, op.1660
HEUSS di Magonza, M.
German, 19th cent.
HEUSSEN, Nicolaas
(Claes) van
Dutch, op.1626-1631
HEUSSLER, Valérie
Swiss, 1920-
HEUVEL, Anton van den
Flemish, c.1600-1677
HEUVEL, Gerrit
van den
Dutch, c.1725-1809

HEUVEL, Théodore
Bernard de
Belgian, 1817-
HEUVICK, Huevic or
Heuwick, Kaspar
Netherlands,
c.1550-p.1590
HEUZE, Edmond Amédée
(Le Trouvé)
French, 1884-p.1949
HEVDICOURT, Mlle. F.P. d'
French, 17th cent.
HEVELIUS, Hewel or
Hewelke, Johann or
Jan
German, 1611-1687
HEVEZI, Endre
Hungarian, 1923-
HEWARD, Prudence
Canadian, 1896-1947
HEWEL or Hewelke, Johann
or Jan
see Hevelius
HEWELSKI
see Oefele
HEWETSON, Edward
British, 19th cent.
HEWETT, Lieut.
British, 19th cent.
HEWETT, Sir Prescott
Gardiner
British, 1812-1891
HEWINS, A.
American, 20th cent.
HEWITT, I.
American, 19th cent.
HEWLETT, James
British, op.1799-m.1836
HEY or Hay, Jean
(*see* Master of Moulins)
HEIJBOER or Heyboer,
Anton
Dutch, 1924-
HEYDE or Heide,
Henning von der
German, op.1487-1520
HEYDE, Jan van der
see Heyden
HEYDECK, Adolf von
(Poussin Heydeck)
German, 1787-1856
HEYDECK, Carl Wilhelm
Freiherr von
see Heideck
HEYDEHOPER, G.M.J. van
Netherlands, 17th cent.(?)
HEYDEN, August Jakob
Theodor von
German, 1827-1897
HEYDEN, J.H. von
German, 19th cent.
HEYDEN or Heyde, Jan
van der
Dutch, 1637-1712
HEYDEN, Karl
German, 1845-1933
HEYDEN, Pieter van
der, or Pieter
Verheyden (Petrus
a Merica, Ameringius,
Mericinus, Miricenys,
Miricinus, Miriginus
or Myricenis)
Netherlands,
c.1530-p.1572
HEYDENDAHL, Joseph
German, 1844-1906

HEYDERDAHL, Hans
Olaf
Norwegian, 1857-1913
HEYENBROCK or Heijenbrock,
Johan Coenraad Herman
(Herman)
Dutch, 1871-1948
HEYER, Pieter
German, 18th cent.
HEYGENDORF, Caroline
von, (née Jagemann)
German, 19th cent.(?)
HEYL or Heijl, Marinus
Dutch, 1836-1931
HEYLBROECK, Heilbroeck,
Heylbrouck etc.,
Norbert, II
Flemish, c.1735/40-1785
HEIJLIGERS or Heyligers,
Antoon Francois
Dutch, 1828-1897
HEYMANS, Adriaan Jozef
(Jozef)
Belgian, 1839-1921
HEIJMANS, Eduard Hendrick
Dutch, 1912-
HEYMARK, Gustave
German, 19th cent.
HEYN, Augustus
German, 1837-
HEYNDRICSX, Dirck
see Hendricksz.
HEYRAULT, Louis Robert
French, op.1847-1880
HEYSEN, Hans
Australian, 1871-1968
HIBBART, William
British, op.c.1760-c.1800
HIBBERT, J.
British, 19th cent.
HICHSBEIN
see Hischbein
HICKEL, Anton or Carl
Anton
German, 1745-1798
HICKEL, Hickl or Hikl,
Joseph
German, 1736-1807
HICKEN, John
British, 18th cent.
HICKEY, Thomas
British, 1741-1824
HICKIN, George
British, op.1858-1877
HICKMAN, David
American, 1937-
HICKMANN
German, 19th cent.
HICKS, Edward
American, 1780-1849
HICKS, George Edgar
British, 1824-1914
HICKS, Lilburne
British, op.1830-1861
HICKS, Robert
British, 19th cent.
HICKS, Thomas
American, 1823-1890
HIDALGO, Maria
Spanish, 19th cent.
HIDDEMANN, Friedrich
Peter
German, 1829-1892
HIDER, F.
British, 19th cent.
HIDLEY, Joseph H.
American, 1830-1872
HIE, G. Le
French, 19th cent.

HIEGER, Simon
British, 20th cent.
HIELS, T.(?)
Netherlands(?),
17th/18th cent.
HIEM, Pham
Oriental, 20th cent.
HIEN, Daniel
German, 1725-1773
HIEPES, Tomas
see Yepes
HIER, Joachim van
see Hierschl-Minerbi
HIERL-DERONCO, Otto
German, 1859-1935
HIERONIM
Polish, 1916-
HIERSCHL-MINERBI,
Joachim van
(Joachim van Hier)
Austrian, 1834-
HIETALA, Lasse
Finland, 20th cent.
HIGGINS
British, op.c.1803
HIGGINS, Eugene
American, 1874-1958
HIGGINS, W.Victor
American, 1884-
HIGHAM, J.W.
British, op.1821-1835
HIGHAM, Thomas
British, 1796-1844
HIGHMORE, Anthony
British, 1719-1799
HIGHMORE, Joseph
British, 1692-1780
HIGHMORE, Susanna
see Duncombe
HILAIR, Jean Baptiste
French, 1753-1822
HILAIRE, Camille
French, 1916-
HILDA, E.Baily, Mlle.
Austrian, op.c.1895
HILDEBRAND, Adolf Ernst
Robert
German, 1847-1921
HILDEBRANDT, Eduard
German, 1818-1869
HILDEBRANDT, Fritz
German, 1819-1855
HILDEBRANDT, Johann
Lucas von
German, 1668-1745
HILDEBRANDT, Theodor
(Ferdinand Theodor)
German, 1804-1874
HILDER, J.J.
Australian, 1881-1916
HILDER, P.John
British, 1811-1839
HILDER, Richard H.
British, 1813-1852
HILDER, Rowland
British, 1905-
HILDITCH, George
British, 1803-1857
HILFGATT, Brand
Christian
German, 18th cent.
HILGARDUS, Master
German, 16th cent.
HILGERS, Carl
German, 1818-1890
HILL, Adrian Keith-
Graham
British, 1895-

HILL, Amelia Robertson,
(née Paton)
British, op.1863-p.1891
HILL, Anthony
British, 1930-
HILL, Arthur
British, op.1858-1893
HILL, Carl Frederik
Swedish, 1849-1911
HILL, David Octavius
British, 1802-1870
HILL, Derek
British, 1916-
HILL, Diana, (née
Dietz)
British, op.1785
HILL, Friedrich Jakob
German, 1758-1846
HILL, Howard
American, op.1860
HILL, James John
British, 1811-1882
HILL, James Stevens
British, 1854-1921
HILL, Jockey
British, 1753-p.1795
HILL, John
British, 1770-1850
HILL, John Henry
American, 1839-1922
HILL, John William
British, 1812-1879
HILL, Leonard Raven
see Raven-Hill
HILL, Norman
British, 19th cent.
HILL, Pamela
American, 1803-1860
HILL, Robert
British, op.1750
HILL, Robin
British, 20th cent.
HILL, Rowland H.
British, 1873-
HILL, Samuel
American, op.1789-1803
HILL, T.
British, op.1839
HILL, Thomas
British, 1661-1734
HILL, Thomas
American, 1829-1908
HILL, Vernon
English, 1887-
HILLAIRET, Anatole-
Eugène
French, 19th cent.
HILLEBERGHE or
Hulleberghe(?), Antoine
van
Netherlands
op.1552-1556
HILLEBRANDT, Master
German, op.1528
HILLEGAERT or Hilligaert,
Pauwels, I van
Dutch, 1595/6-1640
HILLEMACHER, Ernest
(Eugène Ernest)
French, 1818-1887
HILLER, H.
German, op.1865-1894
HILLESTROM the Elder,
Per
Swedish, 1732-1816
HILLEVELD, Adrianus David
Dutch, 1836-

HILLIARD, John
British, 20th cent.
HILLIARD, Laurence
British, c.1581-p.1640
HILLIARD, Nicholas
British, 1537-1619
HILLIER, Tristram
British, 1905-
HILLIGAERT, Pauwels
van
see Hillegaert
HILLIGSOE
Swedish, 20th cent.
HILLINGFORD, Robert
Alexander or Richard
British, 1828-p.1864
HILLIOTH, P.
Dutch, 19th cent.
HILLMANN, Hans
German, 1925-
HILLNER or Hilner,
Frans (not Christoph)
German, 1745-1812
HILLS, Laura
Coombs
American, 1859-p.1904
HILLS, Robert
British, 1769-1844
HILLYARD, J.W.
British, op.1833-1861
HILSCHER, Hubert
Polish, 20th cent.
HILTEN, Hendrik van
Dutch, op.1750-1773
HILTENSBERGER or
Hiltensperger, Johann
Jost
Swiss, 1711-1792
HILTENSPERGER, Johann
Georg (Otto)
German, 1806-1890
HILTON, Roger
British, 1911-
HILTON, William, I
British, 1752-1822
HILTON, William, II
British, 1786-1839
HILVERDINK, Eduard
Alexander
Dutch, 1846-1891
HILVERDINK, Johannes
Dutch, 1813-1902
HILVERDINK, Johannes
Jacobus Antonius
Dutch, 1837-1884
HIME, Harry
British, op.1887-1892
HIMELY, Sigismond
French, 1801-1872
HIMLY, Franz Peter
Joseph
see Kymli
HIMPEL, Aarnout ter
Dutch, 1634-1686
HINCHCLIFFE, Richard
George
British, 1868-
HINCHEY, William J.
American, 1829-1893
HINCKLEY, Thomas Hewer
American, 1813-1896
HINCKS, William
British, op.1773-1788
HIND, Arthur M.
British, 1880-1957

HIND, William
Canadian, op.1862
HINDENLANG, Charles
Swiss, 1894-1960
HINDER, Frank
Australian, 1906-
HINDLEY, Godfrey C.
British, op.1876-1903
HINE, Henry George
British, 1811-1895
HINES, Frederick
British, op.1875-97
HINES, Theodore
British, op.1876-1889
HINGELAND, Pieter van
Dutch, 17th cent.
HINMAN, Charles
American, 20th cent.
HINRICHSEN, Lorens
Vilhelm
Danish, 1865-p.1900
HINS(?), D.
Netherlands(?), op.1758
HINSE or Hintz,
Zacharie
see Heince
HINTSCH, Georg
see Hainz
HINTZ, Julius
German, 1805-1862
HINTZE, Heinrich
(Johann Heinrich)
German, 1800-a.1862
HINTZE, Jedrzej
(Andreas)
Polish, op.1814-1826
HINZ, Georg
see Hainz
HINZ, Gerrit
Netherlands, 17th cent(?)
HIPKINS, Edith J.
British, 19th cent.
HIOOLEN, Cornelia
(Cornelia Baumann
Hioolen)
Dutch, 1885-
HIPOLITE or Hyppolite,
Auguste
French, op.1799-1845
HIPPIUS, Gustave Adolf
Russian, 1792-1856
HIPWELL, W.
British, 19th cent.
HIRE or Hyre, Laurent
de la
see La Hire
HIRSCH, Alphonse
French, 1843-1884
HIRSCH, Auguste
Alexandre
French, 1833-1912
HIRSCH, Hanna
see Pauli
HIRSCH, J.M.(?)
American, op.1908
HIRSCH, Joseph
American, 1910
HIRSCH, Ursula
German, 1929-
HIRSCH-PAULI
see Pauli
HIRSCHELI or Hirschely,
Caspar
German, 1698-1743
HIRSCHENBERG, Samuel
Polish, 1865-1908
HIRSCHER, Heinz E.
German, 1927-

HIRSCHFELD, Emil
Benediktoff
Russian, 1867-1922
HIRSCHFELDER, Salomon
German, 1832-1903
HIRSCHFIELD, Morris
American, 1872-1946
HIRSCHMANN, Johann
Baptist
German, 1770-p.1821
HIRSCHMANN, Johann
Leonhard
German, 1672-1750
HIRSCHMANN, Thomas
German, op.1670-1691
HIRSCHNAER, J.
German, op.1764
HIRSCHVOGEL, Hirsfogel
or Hirsvogel, Augustin
German, 1503-1553
HIRSCHVOGEL the Elder,
Veit
German, 1461-1525
HIRST, Claude Raquet
American, 1855-1942
HIRST, Derek
British, 20th cent.
HIRST, William
British, op.1766-1783
HIRT, Joseph Conrad
German, op.1673-1687
HIRT, M.G.
German, op.1748
HIRT, Wilhelm
Friedrich
German, 1721-1772
HIRTH du Frenes,
Rudolf
German, 1846-1916
HIRTZ, Hans
German, op.1558-m.a.1582
HIRZEL, Heinrich
Swiss, 1729-1790
HIRZEL, Susette (Ott)
Swiss, 1769-1858
HIS, René Charles
Edmond
French, 1877-
HISCHBEIN or Hichsbein
German, op.1762
HISLOP, Walter Balmer
British, 19th cent.
HISPALENSE, Juan
see Juan
HISPANUS, Johannes
see L'Ortolano
HITCHCOCK, George
American, 1850-1913
HITCHCOCK, Harold
American, 20th cent.
HITCHCOCK, Lucius
Wolcott
American, 1868-
HITCHENS, Ivon
British, 1893-
HITTORF, Jakob Ignaz
German, 1792-1867
HITZ, Conrad
Swiss, 1798-1866
HITZ, Dora
German, 1856-p.1891
HIXON, R.
British, op.1813
HJERTEN, Sigrid
(Grunewald)
Swedish, 1885-1948
HJORT, Bror
Scandinavian, op.1958

HJORTZBERG, Olle
(Gustav Olaf)
Swedish, 1872-p.1929
HLAVACEK, Anton (Avlov?)
German, op.1842
HNIZDOVSKY, Yakiv
Czech, op.1915
HOADLY, Sarah, (née Curtis)
British, op.1700-m.1743
HOAR, Frank
British, 20th cent.
HOARE, Peter Richard
British, 18th cent.
HOARE, Prince
British, 1755-1834
HOARE, Sir Richard
Colt
British, 1758-1838
HOARE, William
(Hoare of Bath)
British, 1706-1799
HOBBEMA, Meyndert
Lubbertsz.
Dutch, 1638-1709
HOBBS, George T.
American, 1846-
HOBBS, Peter
British, 1930-
HOBDAY, William Armfield
British, 1771-1831
HOBDEN, Frank
British, op.c.1879-c.1930
HOBLEY, Edward G.
British, op.1893-1916
HOBSON, Cecil J.
British, 19th cent.
HOBSON, Henry E.
British, op.1857-1866
HOBSON, Kenneth
British, 1897-
HOCH, Friedrich
(Georg Friedrich)
German, 1751-1812
HOCH, Hannah
German, 1889-
HOCH, Johann Jakob
German, 1750-1829
HOCH, Kate
German, 20th cent.
HOCHARD, Gaston
French, 1863-1913
HOCHFELD or Hocfeld,
Cristoph
German, op.1728-1767
HOCHL, Anton
German, 1820-1897
HOCHLE or Höchle,
Johann Baptist
see Hoechle
HOCHMANN, Franz Gustav
German, 1861-
HÖCKERT, Johan
Fredrik
Swedish, 1826-1866
HOCKNEY, David
British, 1937-
HÖD, Edmund
German, 19th cent.
HODE, Pierre
French, 1899-1942
HODGE, Francis Edwin
British, 1883-1949
HODGES, C.M.
British, 19th cent.
HODGES, Charles Howard
British, 1764-1837
HODGES, Sidney (J.S. Willis)
British, 1829-1900

HODGES, Walter Parry
British, 1760-1845
HODGES, William
British, 1744-1797
HODGETTS, Emily
British, op.1820
HODGINS, Henry
British, op.1760-m.1796
HODGKIN, C. Eliot
British, 1905-
HODGKIN, Howard
British, 1932-
HODGKIN, Jonathan
Edward
British, 1875-1953
HODGKINS, Frances
British, 1871-1947
HODGKINS, Thomas F.
British, -1903
HODGKINS, William
Mathew
New Zealand, 1833-1898
HODGKINSON, Frank
Australian, 1919-
HODGKINSON, John
British, 1883-
HODGSON, Charles
British, op.1802-1825
HODGSON, David
British, 1798-1864
HODGSON, John Evan
British, 1856-1895
HÖDICKE, Karl Horst
German, 20th cent.
HODLER, Ferdinand
Swiss, 1853-1918
HODSON, John
British, 1945-
HODSON, S.J.
British, 1836-1908
HOECHLE, Hochle or
Höchle, Johann
Baptist
Swiss, 1754-1832
HOECHLE, Johann
Nepomuk
German, 1790-1835
HOECK, Hinrich van
Belgian, 19th cent.
HOECK or Houck, Peter
Cornelisz. van den
Flemish, op.1603-1626
HOECKE, Jan van den
Flemish, 1611-1651
HOECKE, Kaspar or Jasper
van den
Flemish, op.1595-1648
HOECKE, Robert van den
Flemish, 1622-1668
HOECKER, Paul
German, 1854-1910
HOECKGEEST
see Houckgeest
HOECKL, Herbert
German, 20th cent.
HOEF, A. van der
Dutch, op.1642-1659
HOEFFIUS
Netherlands, 17th cent.
HOEFNAGEL or Hufnagel,
Georg or Joris
Netherlands, 1542-1600
HOEFNAGEL, Jacob
(also, erroneously,
Jan)
Flemish, 1575-c.1630

HOEHENRIEDER, Johann
German, 1790-1866
HOEHME, Gerhard
German, 1920-
HOELLOFF, Curt
German, 1887-
HOELPERL, Anton
see Holperl,
Antonin
HOELSCHER, Richard
German, 1867-
HOELZEL, Adolf
German, 1853-1934
HOENOW, Max
German, 1851-1909
HOENSBROEK, van
Netherlands, 18th cent.(?)
HOEPPE or Höppe,
Ferdinand Bernhard
German, 1831-1922
HOEPINER, Franz
German, 19th cent.
HOERLE, Heinrich
German, 20th cent.
HOERNES-KASIMIR,
Tanna
German, op.1887
HOESE, Jean de la
Belgian, 1846-1917
HOESS, Eugen Ludwig
German, 1866-
HOESSLIN, George von
Hungarian, 1831-1923
HOET, Gerard, I
Dutch, 1648-1733
HOET, Hendrik Jacob
Dutch, 1693-1733
HOET, Johan
Dutch, op.1673
HOEUR, Johann
see Heier
HOEVEN, Jan van
Dutch, op.1655
HOEY, Jean de, or
Jean Dhoey or Doe
(Jan Dammesz.)
Netherlands,
1545(?)-1615
HOEY, Nicolas de, or
Nicolas Dhoey, Douay,
Doue or Doué
Netherlands,
op.c.1590-1611
HOEY, Nicolas van
see Hoy
HOEYDONCK, Paul van
Belgian, 1925-
HOEYE or Hoye,
Rombout van den
Dutch, 1622-
HOF, F.
German, 18th cent.
HOFBAUER, Ferdinand
German, 1801-1864
HOFBAUER, Ludwig
German, 1843-
HOFELICH, Ludwig
Friedrich
German, 1842-1903
HOFER, Adolf
German, 1869-
HOFER, Hans
Swiss, op.1580
HÖFER, Heinrich
German, 1825-1878

HOFER, Ignaz
German, 1790-1862
HOFER, Karl
German, 1878-1955
HOFER, Konrad
Swiss, 1928-
HOFF the Elder, Karl
German, 1838-1890
HOFF, Margo
American, 1912-
HOFF, Simon Simonson
Norwegian, op.1770
HOFFBAUER, Charles C.J.
French, 1875-p.1906
HOFFBAUER, Theodor
Josef Hubert
German, 1839-p.1892
HOFFMAN, Anton
German, 1863-1938
HOFFMAN, Ernst Theodor
Wilhelm (Amadeus)
German, 1776-1822
HOFFMAN, F.G.
German, op.c.1790
HOFFMAN, Fels Char
Swiss, op.1651
HOFFMAN, Georg Andreas
German, 1752-1808
HOFFMAN, Georges
Johannes
Dutch, 1833-1873
HOFFMAN, Hans
German, 1880-
HOFFMAN, Johan Franz
German, 1701-c.1766
HOFFMAN, Jonas
Swedish, 1731-1780
HOFFMAN, Josef
German, 1870-1956
HOFFMAN, M.
Luxembourg, 1914-
HOFFMAN, Malvina
(Grimson)
America, 1887-
HOFFMAN, Martin
American, 1935-
HOFFMAN, Vlastimil
Polish, 1881-p.1921
HOFFMANN, Felicità
(née Sartori)
Italian, op.1728-m.1760
HOFFMANN, Hans
German, op.1568-m.1591/2
HOFFMANN, Heinrich-Adolf-
Valentin
German, 1814-1896
HOFFMANN, Josef
German, 1831-1904
HOFFMANN, L.
German, 19th cent.
HOFFMANN, Samuel
Swiss, c.1592-1648
HOFFMANN-FALLERSLEBEN,
Franz
German, 1855-1927
HOFFMEISTER, Adolf
Czech, 1902-
HOFFMEISTER, Johann
Peter
German, 1740-1772
HOFFMEISTER, Johann
Philipp
German, -1771
HOFFNAS, Hoffnass,
Hofnaas, Hofnass etc.,
Johann Wilhelm
German, 1727-1795

HOFFNAS, Hoffnaass or
Hofnaas, Lorenz
German, 1772-1837
HOFFNUNG, Gerard
British, 1925-1959
HOFFSTADT, Pieter
van der
see Hofstadt
HOFFSTADTER, Friedrich
Czech, 1910-
HOFFY, Alfred M.
American, c.1790-1860
HOFKUNST, Alfred
Swiss, op.1971
HOFLAND, Thomas
Christopher
British, 1777-1843
HOFLEHNER, Rudolf
German, -1916
HOFLER, Max
German, 19th cent.
HOFLING, Salomon
Swedish, 1778-1827
HOFLINGER, Christian
Jacob
German, 1759-1837
HOFMAN, Charles
American, op.1878
HOFMAN, Samuel
Swiss, op.1619-1645
HOFMANN, A.
German, 19th cent.
HOFMANN, Armin
Swiss, 1920-
HOFMANN, Egon
German, 1884-1972
HOFMANN, Hans
American, 1880-
HOFMANN, Heinrich
(Johann Michael
Ferdinand Heinrich)
German, 1824-1911
HOFMANN, Ludwig von
German, 1861-1945
HOFMANN, Werner
German, 1897-
HOFMEISTER, Eugen
German, 1843-
HOFMEISTER, Johannes
German, 20th cent.
HOFNAAS, Lorenz
see Hoffnas
HOFREITER or Hofreuter,
Karl
German, op.1724-1736
HOFSTADT or Hoffstadt,
Pieter van der
(Pieter de Vocht)
Netherlands,
op.1523-1569
HOFSTED or Hofstede
van Essen, G.
German, op.1693-1703
HOFSTETTEN, Franz Xaver
von
German, 1811-1883
HOFSTOTTER, Franz
German, 1871-
HOFWERBERG, Carl
Swedish, op.1737
HOGARTH, Paul
British, 1917-
HOGARTH, William
British, 1697-1764

HOGENBERG, Hogenbergh,
Hohenberg, Hoochberg,
Hoogenberg, Hougenberghe
or van Hooberg, Franz
Netherlands,
a.1540-c.1590(?)

HOGENBERG, Hogenbergh,
Hohenberg, Hoochberg,
Hoogenberg, Hoogenberghe
or van Hooberg the
Younger, Johann or Hans
German, op.1594-1614

HOGENBERG, Hogenbergh,
Hohenberg, Hoochberg,
Hoogenberg, Hoogenberghe
or van Hooberg the
Elder, Nikolaus (Johann
Nicolaus)
German, op.1523-m.1539

HOGENBERG, Hogenbergh,
Hohenberg, Hoochbergh,
Hoogenberg, Hoogenberghe
or van Hooberg,
Remigius
Netherlands,
c.1536-p.1587

HÖGER, Joseph
German, 1801-1877

HÖGER, R.A.
German, 19th cent.

HOGERS, Jacob
Dutch, 1614-p.1655

HOGG, Herbert W.
British, op.1883-1885

HÖGLER, Wolfgang
German, 1674-1754

HOGUE, Alexandre
French, op.1936

HOGUET, Charles
German, 1821-1870

HOHE, Christian
Nikolaus
German, 1798-1868

HOHENBERG
see also Hogenberg

HOHENBERG, Johann
Ferdinand von
(Hetzendorf, Hezendorf,
Hötzendorf or
Hözendorf von
Hohenberg)
German, 1732-1816

HOHENBERG, Martin
see Altomonte

HOHENBERGER, Franz
Austrian, 1867-

HOHENSTEIN, Adolfo
Russian, 1854-

HOHNBAUM, Carl Franz
German, 1825-1867

HOHR, Franz Xaver
Ludwig
French, 1766-1848

HOIJER, Cornelius
Scandinavian, 1741-1804

HOILE, H.
Australian, op.1835

HOIN, Claude Jean
Baptiste
French, 1750-1817

HOIT, Albert Gallatin
American, 1809-1856

HOKANSON, Lars
Scandinavian, 20th cent.

HOKE, Giselbert
German, 1927-

HOLAREK, Emil
Czech, 1867-1919

HOLBEIN, Ambrosius
Prosy, Ambrose or
Ambrosy
German, c.1494-c.1520

HOLBEIN, Hans, I
German, 1460/5-1524

HOLBEIN (Olpeius
Olpenus, Holby, Holben
etc.,) Hans, II
German, c.1497-1543

HOLBEIN, Sigismund
German, 1465/70-m.1540

HOLBEIN, Thérèse
German, c.1785-1859

HOLBÖ, Kristen
Norwegian, 1869-p.1900

HOLBROOK, Peter
American, 1940-

HOLDANOWICZ, Leszek
Polish, 20th cent.

HOLDCROFT, John
British, 1926-

HOLDEN, Clifford
British, 1919-

HOLDEN, Harold
British, 1885-

HOLDER, Edward Henry
British, op.1864-m.1917

HOLDER, Franz van
Belgian, 1882-1919

HOLDING, Edgar Thomas
British, 19th cent.

HOLDING, John
British, 19th cent.

HOLDREDGE, Ransome G.
American, 1836-1899

HOLDSTOCK, Arthur
Worsley
Canadian, op.1850

HOLE, Henry Fulke
Plantaganet Woolcombe
British, op.1798-m.1820

HOLE, William
British, op.1607-1624

HOLE, William Brassey
British, 1846-1917

HOLFELD, Anke
German, 20th cent.

HOLFELD, Hippolyte
Dominique
French, 1804-1872

HOLGATE, Edwin Headley
Canadian, 1892-

HOLIDAY, Henry
British, 1839-1927

HOLL, Elias
German, 1573-1646

HOLL, Francis Montague
(Frank)
British, 1845-1888

HOLL, William, I
British, 1771-1838

HOLLAGAN, M.J.
British, op.1795-1809

HOLLAMS, F. Mabel
British, op.1897-1912

HOLLAND, George
(John Joseph)
American, c.1776-1820

HOLLAND, H.
British, 17th cent.

HOLLAND, Henry
British, c.1740-1806

HOLLAND, James
British, 1800-1870

HOLLAND, John
British, 18th cent.

HOLLAND, John
British, op.1831-1879

HOLLAND, Sir Nathaniel
Dance
see Dance

HOLLAND, Peter
British, op.1781-1812

HOLLAND, Tom
American, 20th cent.

HOLLAND, William
British, op.1798

HOLLANDER, Cz., Hendrik
Dutch, 1823-1884

HOLLANDER, Jan de
see Amstel

HOLLANDERS, Johannes
Belgian, 1821-

HOLLANDINE, Princess
Louise de
see Louise

HOLLAR, Wenzel
(Wenceslas von Pracha)
German, 1607-1677

HOLLEBEKE, Bruno Jean
Charles van
Belgian, 1817-1892

HOLLEGHA, Wolfgang
German, 1929-

HOLLIER, Jean François
French, 1772-1845

HOLLINGDALE, Richard
British, op.1850-1899

HOLLINGWORTH, T.
British, 19th cent.

HOLLINGSWORTH, George
American, 1813-1882

HOLLINS, John
British, 1798-1855

HOLLINS, T.
British, 18th cent.

HOLLIS, George
British, 1792-1842

HOLLIS, Thomas
British, 1818-1843

HOLLOSY, Simon
Hungarian, 1857-1918

HOLLOWAY, Charles Edward
British, 1838-1897

HOLLOWAY, J.
British, 19th cent.

HOLLOWAY, Thomas
British, 1748-1827

HOLLYER, Eva
British, op.1891-1892

HOLM, Anders
Swedish, c.1770-p.1822

HOLM, Christian Frederik
Carl
Danish, 1804-1846

HOLM, Harald Martin
Hansen
Danish, 1866-1920

HOLM, Heinrich Gustav
Ferdinand
Danish, 1816-1861

HOLM, Niels Emil Severin
Scandinavian, 1860-

HOLM, O.
Scandinavian, 19th cent.

HOLM, P.D.
Scandinavian, 1835-1903

HOIMAN, Francis
British, op.1767-1784

HOIMAN, R.
British, op.1765

HOLMBERG, August
Johann
German, 1851-1911

HOLMBERG, Gustaf
Werner
Finnish, 1830-1860

HOLMBERGSSON, Johan
Swedish, 1804-1835

HOLMBOE, Thorolf
Norwegian, 1866-1935

HOLME, Rathbone
British, 20th cent.

HOLMES
British, 19th cent.

HOLMES, Sir Charles
John
British, 1868-1936

HOLMES, Edward
British, op.1841-1891

HOLMES, George
British, op.1789-1802

HOLMES, George Augustus
British, op.c.1852-m.1911

HOLMES, James
British, 1777-1860

HOLMES, Oliver Wendell
American, 1809-1894

HOLMES, Reg
Canadian, 20th cent.

HOLMLUND, Josefina
Scandinavian, 1827-1905

HOLM-MØLLER, Olivia
Danish, 1875-

HOLODILINA, Elena
Nikolaevna
Russian, 20th cent.

HOLPEIN,
Russian, op.c.1850-1854

HÖLPERL, Antonin
Czech, 1820-1888

HOLROYD, Sir Charles
British, 1861-1917

HOLSØE, Carl Vilhelm
Danish, 1863-1935

HOLST, Johann van
Dutch, op.1689-1725

HOLST, Johan Gustaf
von
Swedish, 1841-1917

HOLST, Laurits Bernhard
Danish, 1848-p.1878

HOLST, Richard Nicolaus
Roland
Dutch, 1868-1938

HOLST, Theodor M. von
British, 1810-1844

HOLSTAYN, Josef
German, 20th cent.

HOLSTEIN, A. van
Netherlands, 17th cent.

HOLSTEIJN or Holsteyn,
Cornelis,
Dutch, 1618-1658

HOLSTEYN, J.
Dutch, 18th cent.

HOLSTEIJN or Holsteyn,
Pieter, I
Dutch, c.1580/90-1662

HOLSTEIJN or Holsteyn,
Pieter, II
Dutch, c.1614-1673/83

HOLSTOCK, J. van
Dutch, op.1806

HOLT, E.F.
British, op.c.1850-1865

HOLT, Eric
British, 1944-
HOLT, Henri Friso ten
(Friso)
Dutch, 1921-
HOLT, Herbert
British, 1894-p.1958
HOLT, J.
British, op.1855
HOLT, Sara Barton
American, op.1881
HOLTE, Frank Augustus
Brandish
British, 1869-
HOLTERMANN, Peter
Höyer
Norwegian, 1820-1865
HOLTHAUSEN, Ludwig
German, 1807-1890
HOLTMAN
German, 18th cent.
HOLTY, Carl Robert
American, 1900-
HOLTZ, Franz Viktor
German, 1859-
HOLTZMANN, Hans
German, 16th cent.
HOLTZWART, F.A.
American, op.1838
HOLUB, Georg
Czech, 1861-1919
HOLWORTHY, James
British, 1781-1841
HOLY, Adrien
French, 1898-
HOLYOAKE, William
British, 1834-1894
HOLZ, Johann Daniel
German, 1867-1945
HÖLZEL, Adolf
German, 1853-
HOLZEL, Jean Baptiste
von
German, op.1770-1780
HOLZER, Johann Evangelist
(Elias)
German, 1709-1740
HOLZER, Joswph
German, 1824-1876
HOLZALB, Johann Rudolf
Swiss, 1723-1806
HOLZL, G.E.
(Giovanni? Evangelista?)
German, op.1755-1759
HÖLZL, Johann Felix
German, 18th cent.
HOLZMANN, Adolf
Swiss, 1890-
HOLZMANN, Carl Friedrich
German, 1740-1811
HOLZMANN, Johann
see Hulsman
HOMAR, Lorenzo
American, 20th cent.
HOME, Robert
British, 1752-1834
HOMER, Winslow
American, 1836-1910
HOMFRAY, Jeston
British, 1797-1851
HOMOLATSCH, Otto
German, 1883-
HOMPEL, Ludwig ten
German, 1887-1932
HONDECOETER, Hondecoutre
or Hondekoeter, Gillis
Claesz. de or d'
Dutch, c.1580-1638

HONDECOETER, Hondecoutre
or Hondekoeter, Gysbert
Gillisz. or Jillisz.
de or d'
Dutch, 1604-1653
HONDECOETER, Hondecoutre
or Hondekoeter, Melchior
de or d'
Dutch, 1636-1695
HONDIUS or de Hondt,
Abraham
Dutch, c.1625/30-1695
HONDIUS, Hendrik, I
Flemish, 1573-p.1649
HONDIUS, Jodocus or
Joos, I
Netherlands, 1563-c.1611
HONDIUS, Willem
Dutch, c.1597-c.1660
HONDT or Hont, Hendrik de
Flemish, 17th cent.
HONDT, Lambert de
Flemish, op.1679
HONDT, Philipp de
Flemish, op.1739
HONE, Evie
British, 1894-1955
HONE, Horace
British, 1756-1825
HONE, Nathaniel, I
British, 1718-1784
HONE, Nathaniel, II
British, 1831-1917
HONEGGER, Gottfried
Swiss, 1917-
HONICH, Adriaen
see Honing
HONICH, Heinrich
German, 1875-1957
HONNET, Gabriel
France, 17th cent.
HONING or Honich,
Adriaen (Lossenbruy)
Dutch, op.1663-1683
HONT, Hendrik de
see Hondt
HONTHORST, Gerrit or
Gerard van (Gherardo
della Notte or delle
Notti, or Gherardo
Fiammingo)
Dutch, 1590-1656
HONTHORST, Willem or
Guglielmo van
Dutch, 1594-1666
HONUPHRUS, Crescenzio
see Onofrio
HOOBERG
see Hogenberg
HOOCH, Hoogh or Hooghe,
Carel or Charles
Cornelisz. de
Dutch, op.1627-m.1638
HOOCH or Hoogh, Gerrit
de
Dutch, op.1660-1679
HOOCH or Hoogh, Horatius
de
Dutch, op.1652-1692(?)
HOOCH, Hoogh or Hooghe,
Pieter Hendricksz. de
Dutch, 1629-p.1683
HOOCH, Romeyn de
see Hooghe
HOOCHBERG
see Hogenberg
HOOD, James
British, 18th cent.

HOOD, John
British, op.1762-1771
HOOD, Thomas
British, 1835-1874
HOODLESS, H.E. (Harry
Taylor?)
British, 1913-
HOOF, P.
German, op.1781
HOOFT, Cornelis Gerardus 't
Dutch, 1866-1936
HOOFT, J.
Dutch, 17th cent.
HOOFT, Nicolas
Dutch, 1664-1748
HOOG, J.
Dutch, op.c.1650
HOOG, Johan Bernard
(Bernard) de
Dutch, 1866-1943
HOOGE, Romeyn de
see Hooghe
HOOGENBERG
see Hogenberg
HOOGER, F.
Netherlands, 17th cent.
HOOGERHEYDEN, Engel
Dutch, 1740-1809
HOOGERS, Hendrik
Dutch, 1747-1814
HOOGH or Hooghe
see also Hooch
HOOGHE, Balthasar
Richard de
Flemish, 1636-1697
HOOGHE, Hooch, Hooge
or Hoogh, Romeyn de
Dutch, 1645-1708
HOOGKAMER, Willem Hendrik
Dutch, 1790-1864
HOOGHSTOEL or Hoogstoel,
Emmanuel Bernard
French, op.c.1766
HOOGSAAT, Hooghsaet or
Hoogzaat, Jan Cornelisz.
Dutch, 1654-p.1730
HOOGSTRATEN or Hoogstraaten,
Abraham van
Dutch, op.1685-m.1736
HOOGSTRATEN, Dirk or
Theodor van
Dutch, c.1595/6-1640
HOOGSTRATEN, J. van
Dutch(?), op.1789
HOOGSTRATEN, Jan van
Dutch, c.1627/32-1654
HOOGESTRATEN, Samuel
Dircksz. van
Dutch, 1627-1678
HOOGZAAT, Jan
see Hoogsaat
HOOK, Bryan
British, 1856-1916
HOOK, James Clarke
British, 1819-1907
HOOKER, Sir Joseph
Dalton
British, 1817-1911
HOOP, Wouter
Dutch, op.1643/4
HOOPER, John Horace
British, op.1877-1899
HOOREN, G. van
Dutch, 18th cent(?)
HOOREN, Isaack Jacobsz.
van
Dutch, op.1646-m.1651/2
HOORENBAULT
see Horenbout

HOORN, Jordanus
Dutch, 1753-1833
HOOVE, or Hoven, Frederick
Hendrick van, or Frederick
Hendrick van den Hooven
see Hove
HOPE, James
American, 1818-1892
HOPE, Mrs. James
British, 19th cent.
HOPE, Sir James Archibald
British, 1785-1871
HOPE, Robert
British, 1869-1936
HOPE, T.H.
American, 19th cent.
HOPFER or Hopffer,
Bartholomäus, II
German, op.c.1650-1698
HOPFER or Hopffer, Daniel, I
German, c.1470-1536
HOPFER or Hopffer,
Hieronymus
German, op.1528-1550
HOPFER, Johann Berhard
Gottfried
German, c.1716-1789
HOPFER, Lambert
German, 16th cent.
HOPFER, Wolfgang Ludwig
German, 1648-1698
HOPFGARTEN, August
Ferdinand
German, 1807-1896
HOPKINS, Arthur
British, 1848-1930
HOPKINS, Budd
American, 1931-
HOPKINS, Frances Ann,
(née Beechey)
British, 1838-1918
HOPKINS, James R.
American, 1878-p.1937
HOPKINS, W.
British, op.c.1790-1820
HOPKINS, William H.
British, op.1853-m.1892
HOPKINSON, Charles
Sydney
American, 1869-p.1952
HOPKINSON, Francis
American, 1737-1791
HOPLEY, Edward William
John
British, 1816-1869
HÖPPE, Ferdinand
Bernhard
see Hoeppe
HOPPE, Erik
Danish, 1896-1968
HOPPE, Ferdinand Theodor
German, 1848-1890
HOPPENBROUWERS, Johannes
Franciscus
Dutch, 1819-1866
HOPPENHAUPT the Elder,
Johann Michel II
German, 1709-c.1750
HOPPER, Edward
American, 1882-
HOPPER, Thomas
British, 1776-1856
HOPPIN, Thomas Frederick
American, 1816-1872
HOPPNER, John
British, 1758-1810
HOPPNER, Lascelles H.
(William H. Lascelles)
British, 1788-p.1833

HOPPNER, Richard
(not Robert) Belgrave
British, 1786-1872
HOPWOOD, Henry Silkstone
British, 1860-1914
HOPWOOD, William
British, op.1801-1807
HÖR, Andreas
Swiss, op.1558-1575
HORAZIO, Bernardus
Italian, 17th cent.
HORBERG, J.
German, 19th cent.
HÖRBERG, Pehr
Swedish, 1746-1816
HORDIJK, Gerardus
(Gerard)
Dutch, 1899-1958
HORE, James
British, op.c.1829-1837
HOREAU, Hector
French, 1801-1872
HOREMANS, Jan Josef, I
Flemish, 1682-1759
HOREMANS, Jan Josef, II
Flemish, 1714-p.1790
HOREMANS, Pieter Jacob
Flemish, 1700-1776
HORENBANT, Joseph
Belgian, 1863-
HORENBOUT, Harembourg,
Hoorenbault, Hornebout
etc., Gerard
Netherlands,
op.1487-m.1540/I
HORENBOUT, Harembourg,
Hoorenbault, Hornebout
etc., Lukas
Netherlands,
op.1534-m.1544
HORGNIES, Norbert Joseph
Belgian, op.1830-1870
HORION, Alexander de
Flemish, 1590-1659
HORLBECK-KAPPLER,
Irmgard
German, 20th cent.
HÖRLEIN or Hörlen the
Elder, Friedrich
see Herlin
HÖRLEIN, Johann Peter
see Herrlein
HÖRLING, Johan Frederik
Swedish, 1718-1786
HORLIN, Tor
Swedish, 1899-
HORLEMAN
Swedish, 18th cent(?)
HORLOR, George W.
British, op.c.1849-1890
HORLOR, Joseph
British, op.1830-1866
HÖRMANN, Joseph Marcus
see Hermann
HÖRMANN, Theodor von
German, 1840-1895
HORMS, Johann Oswald
see Harms
HORN, R.
Dutch, op.1648
HORN, W.
German, 19th cent.
HORNBROOK, T.L.
British, op.1814-1844
HORNBY, Lester George
American, 1882-

HORNE, Cleeve
Canadian, 1912-
HORNEBOUT
see Horenbout
HORNECKER, Léon
German, 1864-1924
HORNEISER, Andreas
see Herneisen
HORNEL, Edward Atkinson
British, 1864-1933
HORNEMAN, Christian
Danish, 1765-1844
HORNER
British, 19th cent.
HORNER, G.(?)
Christopher
British, op.1857-1867
HÖRNER, Johan
Swedish, 1711-1763
HORNER, Friedrich
Swiss, 1800-1864
HORNER, Thomas
see Hornor
HORNER, Rev. W.
British, op.1808-1820
HORNICK, Erasmus
German, op.c.1550
HORNIZ
German, op.1795
HORNOR or Horner,
Thomas
British, op.1823-1844
HORNSEY, J.
British, op.1795-1800
HORNSTAIN, Gabriel
German, op.1640
HORNUNG, David
German, op.1671
HORNUNG, Emile Charles
Swiss, 1883-
HORNUNG, Joseph
Swiss, 1792-1870
HORNY, Franz Theobald
German, 1798-1824
HOROLDT, Johann Gregor
see Herold
HOROVITZ or Horovicz,
Leopold (Lipot) Stefan
Hungarian, 1838-1917
HORRIZ
German(?), op.1795
HORSBURGH, J.
British(?), op.1888
HORSCHELT, Theodor
(Fedor Fedorowitsch)
German, 1829-1871
HORSFALL, Charles M.
British, 19th cent.
HORSFIELD, Dr. Thomas
British, op.1800-1818
HORSLEY, G.H.
British, 19th cent.
HORSLEY, Hopkins Horsley
Hobday
British, 1807-1890
HORSLEY, John Calcott
British, 1817-1903
HORSLEY, Walter Charles
British, 1855-p.1911
HORST, Gerrit Willemsz.
Dutch, c.1612-1652
HORST, J. var
Dutch, 18th cent.(?)
HORST, Nicolaus van der
Flemish, 1587/98-1646
HORST, P. van der
Dutch, op.c.1660

HORST, S.
Dutch, op.1662
HORST-SCHULZE, Paul
German, 1876-1937
HORSTIG, Eugen
German, 1843-1901
HORSTOK, Johannes
Petrus van
Dutch, 1745-1825
HORT, Aart or Arnold
van
see Ort
HORTENSE, Queen of
Holland
French, 1783-1837
HORTER, Earl
American, 1881-1940
HORTI, Pál
Hungarian, 1865-1907
HORTON, E.
British, 19th cent.
HORTON, George Edward
British, 1859-1950
HORTON, William Samuel
American, 1865-1936
HORVAT-ZDALSKI, Josef
Yugoslav, op.1923-1966
HOSCHEDE-MONET, Blanche
French, 1865-1947
HOSEMANN, Theodor
(Friedrich Wilhelm
Heinrich Theodor)
German, 1807-1875
HOSENFELDER, Christian
Friedrich
German, 1706-1780
HOSIASSON, Philippe
French, 1898-
HOSKING, Knighton
British, 1944-
HOSKINS, John, I
British, op.1620-m.1665
HOSKINS, John, II
British, op.1658-1686
HOSLWANGER, Wolfganger
German, op.1600
HOSSON, F.C.
Dutch, 1717-1799
HØST, Oluf
Danish(?), 20th cent.
HOTCHKISS, Thomas H.
American, op.c.1856-m.1869
HOTHAM, Amélia
British, op.1793
HOTSHKIS, Mary
British, 17th cent.(?)
HÖTZENDORF von
Hohenberg
see Hohenberg
HÖTZENDORFF, Conrad von
German, op.1820
HOUASSE or Ouasse,
Michel Ange
French, c.1680-1730
HOUASSE or Ouasse,
René Antoine
French, 1644/5-1710
HOUBEN, Henri
Belgian, op.1885-1898
HOUBIGANT, Armand
Gustave
French, 1789-1862
HOUBOLT, Eduard Johannes
Fredericus
Dutch, 1885-1954
HOUBRAKEN, Arnold
Dutch, 1660-1719

HOUBRAKEN, Giovanni van,
or Giovanni Vanderbrach
or Vanhoubraken
Flemish, op.c.1635-1674
HOUBRAKEN, Jacobus
Dutch, 1698-1780
HOUBRAKEN, Niccolino van,
or Niccolino Vanderbrach
or Vanhoubraken
Flemish, op.1706-1724
HOUBRON, Frédéric Anatole
French, c.1851-1908
HOUCK, Peter van den
see Hoeck
HOUCKGEEST or Hoeckgeest,
Gerard, Geraert or
Gerrit
Dutch, c.1600-1661
HOUCKGEEST or Hoeckgeest,
Joachim Ottensz.
Dutch, c.1580/90-a.1645
HOUDARD, Charles-Louis-
M.
French, 19th cent.
HOUDETOT, Comte Frédéric d'
French, 19th cent.
HOUDON, Jean Antoine
French, 1741-1828
HOUEL, Jean Pierre Louis
Laurent
French, 1735-1813
HOUEL, Nicholas
French, 16th cent.
HOUGH, William
British, op.1857-1894
HOUGHTON, Arthur Boyd
British, 1836-1875
HOUGHTON, Matthew
British, 18th cent.
HOUNSOM, G.
British, op.1796-1806
HOUSE, Gordon
British, 1932-
HOUSEZ, Charles
French, 1822-1888
HOUSMAN, Jacob
see Huysmans
HOUSMAN, Laurence
British, 1867-1959
HOUSSAYE, Joséphine
French, 1840-p.1900
HOUSTON, George
British, 1869-1947
HOUSTON, H.H.
British, op.1791-1798
HOUSTON, John
British, op.1930-34
HOUSTON, John Adam
British, 1812-1884
HOUSTON, Richard
British, c.1721-1775
HOUSTON, Robert
British, 1891-c.1942
HOUSTON, Thomas
British(?), 18th cent.
HOUSTOUN, D. Mackay
Canadian, 20th cent.
HOUT, Jan van
Netherlands, op.1506
HOUT, T. van
see Houten
HOUTE, C. ten
Dutch, op.1644
HOUTE, Pietro van den
see Lignis

HOUTE, Rombout van den
Dutch, op.1613
HOUTEN, Barbara
Elisabeth van
Dutch, 1862-1950
HOUTEN, F. van
Flemish, 17th cent.
HOUTEN, Gerard van
Dutch, op.1675-m.1706
HOUTEN, H.L. van den
Australian, op.1876
HOUTEN, Hans van
Flemish, 1578(?)-p.1625
HOUTEN or Hout, T. van
Flemish(?), 17th cent.
HOUTHUENSEN, Albertus
Antonius
British, 1903-
HOUTHUIJSEN, Houthuijse
or Houthuysen, Jan
Jansz. van
Dutch, op.1648-m.1662
HOUTMAN, Maerten
Dutch, op.1766-1790
HOUVE or Hoeven,
Abraham van der
Dutch, op.1615-m.1621
HOUVE, Paul de la
see La Houve
HOUVE, Salomon de la
French(?), 17th cent.
HOUWEN, Joris
Belgian, 20th cent.
HOVADIK, Jaroslav
Canadian, 20th cent.
HOVE
Netherlands(?),
op.1784-1791
HOVE, Bartholomeus
Johannes van
Dutch, 1790-1880
HOVE, Edmond Theodor van
Belgian, 1853-1913
HOVE, Hoove or Hoven,
Frederick Hendrick
van, or Frederick
Hendrick van den Hooven
Dutch, c.1628-1698
HOVE, Hubertus van
Dutch, 1814-1864
HOVE, Johannes
Huybertus van
Dutch, 1827-1881
HOVE, Victor François
Guillaume van
Belgian, 1826-1891
HOVEL, A. van
Flemish(?), 17th cent.
HÖVEMEYER, August
German, 1824-1878
HOVEN, H. ten
Dutch, 20th cent.
HOVENDEN, Thomas
American, 1840-1895
HOW, Beatrice
British, 1867-1932
HOW, F.
British, op.1648
HOWARD, Anthony Christian
British, 20th cent.
HOWARD, Charles
British, 1899-
HOWARD, E.Stirling
British, op.1834-1870
HOWARD, Francis
British, 1874-1954
HOWARD, Frank
British, 1805-1866

HOWARD, George James
see Carlisle, 9th
Earl of
HOWARD, H.R.
British, 20th cent.
HOWARD, H.W.
British, 19th cent.
HOWARD, Henry
British, 1769-1847
HOWARD, Henry Mowbray
American, 1873-
HOWARD, Hugh
British, 1675-1737
HOWARD, Luke
British, 1772-1864
HOWARD, Vernon
British, 1840-1902
HOWARD, Wil (Wilhelm
Rudolf Hermann; Wil
de Vray)
German, 1879-
HOWARD, William
British, 19th cent.
HOWARTH, Albany E.
British, op.1906-1918
HOWDELL, Thomas
British, op.c.1768
HOWE, G.T.
British, 19th cent.
HOWE, James
British, 1780-1836
HOWE, Robert
British, 20th cent.
HOWE, William Henry
American, 1846-
HOWELL, Félicie Waldo
American, 1897-
HOWELL, Luke
British, 18th cent.
HOWELL, Samuel
British, op.1828-1854
HOWES, John
British, op.1772-1795
HOWGATE, William
British, op.1884-1904
HOWISON or Howieson,
William
British, 1798-1850
HOWITT, Samuel
British, c.1765-1822
HOWLAND, John D.
American, 1842-1914
HOWLETT, Bartholomew
British, 1767-1827
HOWLIN, John
British, 1940-
HOWMAN, Rev. A.E.
British, op.1827
HOWSE, George
British, op.1830-m.c.1860
HOXFORD, Ignazio Enrico
see Hugford
HOY or Hoey, Nikolaus
van
Flemish, 1631-1679
HOYE, Rombout van den
see Hoeye
HOYER, Cornelius
German, 1741-p.1774
HOYER, David
German, 1670-1720
HOYER, Edward
British, 19th cent.
HOYER, Joseph
(Jean Louis Joseph)
Swiss, 1762-1829
HOYLAND, Francis
British, op.1965-66

HOYLAND, Henry G.
British, 1894-1948
HOYLAND, John
British, 1934-
HOYLE, Walter
British, 1922-
HOYNCK van Papendrecht,
Jan
Dutch, 1858-1933
HOYNCK, Otto
Dutch, c.1630-p.1686
HOYOLL, Philipp
German, 1816-p.1875
HOYRUP, Paul
Danish, 20th cent.
HOYTE, John Clarke
B.C.
British, 1835-1913
HOIJTEMA, Theodoor (Theo)
van
Dutch, 1863-1917
HÖZENDORFF von
Hohenberg
see Hohenberg
HRADIL, Rudolf
German, 1925-
HRDLICKA, Alfred
Austrian, 1928-
HUARD, Charles
French, 1875-1965
HUARD, Frances Wilson
American, 19th cent.
HUAS, Pierre Adolphe
French, 1838-1900
HUAUD, Amy
Swiss, 1657-1724
HUAUD, Huault or Huaugt,
Jean Pierre
Swiss, 1655-1723
HUAUD, Pierre, II
Swiss, 1647-c.1698
HUBARD, William James
American, 1807-1862
HUBAY, Anton von
Hungarian, 1898-
HUBBARD, B.
British, op.1839-1864
HUBBARD, Eric Hesketh
British, 1892-
HUBBARD, John
American, 20th cent.
HUBBARD, Richard William
American, 1817-1888
HUBBARD, W.
British, op.1809-1867
HUBBELL, Henry Salem
American, 1870-
HUBBERT
British, 16th cent.
HUBBUCH, Karl
German, 1891-
HUBER, Conrad
German, 1752-1830
HUBER, Ernst
German, 1895-
HUBER, Hans
(Monogrammist h.h.)
German, op.1491-1501
HUBER, Hermann
Swiss, 1888-
HUBER, Jacob Wilhelm
German, 1787-1871
HUBER, Jean Daniel
German, 1754-1845
HUBER, Jean
('Huber Voltaire')
Swiss, 1721-1786

HUBER, Johann Kaspar
Swiss, 1752-1827
HUBER the Elder,
Johann Rudolf
Swiss, 1668-1748
HUBER or Hueber, Joseph
(Johann Joseph Anton)
Swiss, 1737-1815
HUBER, Ludwig
German, op.1837
HUBER, Max
Swiss, 1903-
HUBER, R.
Swiss, 1668-1748
HUBER, Rudolf
Swiss, 1770-1844
HUBER, Rudolf Carl
German, 1839-1896
HUBER or Hubert,
Thomas
German, 1700-1779
HUBER, Wolfgang or Wolf
German, ·c.1490-1553
HUBERT, Edgar
British, 1906-
HUBERT, F.
German, 19th cent.
HUBERT, Jean Baptiste
Louis
French, 1801-
HUBERT, Laurent
French, op.1749-m.1776/86
HUBERTI, Edouard Jules
Joseph
Belgian, 1818-1880
HUBLIN, Auguste
(Emile Auguste)
French, 1830-1891
HÜBNER, Carl
German, 1797-1831
HÜBNER, Carl-Wilhelm
German, 1814-1879
HÜBNER, Heinrich
German, 1869-
HÜBNER, J.M.
German, 19th cent.
HÜBNER, Julius Rudolf
Julius Benno
German, 1806-1882
HÜBNER, L.
German(?), op.1752
HÜBNER, Ulrich
German, 1872-1932
HUBSCH, Heinrich
German, 1795-1863
HUCHTENBURG, Jacob van
Dutch, c.1640/5-1675
HUCHTENBURG, Huchtenburgh,
Hughtenburgh, Hugtenburg
or Hugtenburgh, Johann or
Jan van
Dutch, 1647-1733
HUCK, Johann Gerhard
German, c.1759-1811
HUDDESFORD, George
British, 1749-1809
HUDE, von der
German, op.c.1750
HUDEČEK, Antonin
Czech, 1872-1941
HUDON, Wieslaw
Polish, 20th cent.
HUDSON, Anna Hope
(Nan)
American, 1869-1957
HUDSON, Erlund
British, 20th cent.

HUDSON, Grace
Carpenter
American, 1865-1937
HUDSON, Henry M.
British, op.1782-1800
HUDSON, Julien (Jules)
American, op.1830-1840
HUDSON, N.
British, op.1782
HUDSON, Robert, II
British, -1884
HUDSON, Thomas
British, 1701-1779
HUDSON, William
British, op.1813-m.1847
HUE, Alexandre
French, op.1810-1842
HUE, Charles Désiré
French, op.1883
HUE, Jean Francois
French, 1751-1823
HUE, Lambertus Jansz. de
Dutch, 1623-1681
HUEBLER, Douglas
American, 20th cent.
HUELLER, Otto
German, op.1920
HUENS
Flemish(?), op.c.1620
HUERTA, Gaspar de la
Spanish, 1645-1714
HUET, Christophe
(not Charles)
French, op.1735-m.1759
HUET, Huet-Villiers
or Villiers-Huet,
François, (Jean
François Marie)
French, 1772-1813
HUET, Hippolyte
French, op.c.1831
HUET, Jean Baptiste
French, 1745-1811
HUET the Elder, Nicolas
French, c.1718-p.1788
HUET, Paul
French, 1803-1869
HUETT, Hans, Jan or
Haunce
see Eworth
HUET-VILLIERS, Jean
Francois Marie
see Huet
HUEVIC, Kasper
see Heuvick
HUFFAM, A.W.
British, op.1828-1832
HUFNAGEL, Georg or Joris
see Hoefnagel
HUGARD de la Tour,
Claude-Sebastien
French, 1818-1886
HUGENSZ. or Huygensz.,
Dirck
Netherlands,
op.1521-1538
HUGFORD, Ferdinand
Enrico
Italian, 1659-1771
HUGFORD, Hughford,
Hugsford, Hoxford or
Oxford, Ignazio Enrico
Italian, 1703-1778
HUGGINS, J.M. II
British, op.1827-1842
HUGGINS, William
British, 1820-1884

HUGGINS, William John
British, 1781-1845
HUGHES, Arthur
British, 1805-1838
HUGHES, Arthur
British, 1832-1915
HUGHES, C.E.
British, 19th cent.
HUGHES, Edward
British, 1829-1908
HUGHES, Edward John
Canadian, 1913-
HUGHES, Edward Robert
British, 1851-1914
HUGHES, Edwin
British, 19th cent.
HUGHES, George
British, op.1813-1858
HUGHES, Hugh
British, 1790-1863
HUGHES, John
British, 1790-1857
HUGHES, Malcolm
British, 1920-
HUGHES, Margaret
British, 20th cent.
HUGHES, Myra Kathleen
British, 1877-1918
HUGHES, Patrick
British, 20th cent.
HUGHES, Mrs. Philippa
Swinnerton
British, 19th cent.
HUGHES, R.
British, op.1793-1799
HUGHES, S.
British, 19th cent.
HUGHES, Sydney
British, 20th cent.
HUGHES, T.J.
British, op.1851-1865
HUGHES, Talbot
British, 1869-1942
HUGHES, Trajan
(Tregan)
British, op.1709-1712
HUGHES, Vernon
British, op.1852-1855
HUGHES, William
British, 1842-1901
HUGHES-STANTON, Blair
Rowlands
British, 1902-
HUGHES-STANTON, Sir
Herbert Edwin Pelham
British, 1870-1937
HUGHTENBURGH, Johann or
Jan van
see Huchtenburg
HUGIN, Karl
Swiss, 1887-
HUGNET, Georges
French, 20th cent.
HUGO, Comtesse
see Duvidal de
Montferrier
HUGO, Jean
French, 1894-
HUGO, Valentine,
(née Gross)
French, 1890-
HUGO, Victor
French, 1802-1885
HUGONNET, Aloys
Swiss, 1879-1938
HUGREL, Pierre Honoré
French, 1827-p.1868

HUGTENBURG or Hugtenburgh,
Johann or Jan van
see Huchtenburg
HUGUE, Manuel Martínez
(Manolo)
Spanish, c.1876-m.1945
HUGUENET, Jacques Joseph
French, 1815-p.1864
HUGUENIN-LASSANGUETTE,
Fritz Edouard
Swiss, 19th cent.
HUGUENIN-PANCHAUD, Augustin
Swiss, c.1806-p.1857
HUGUET, Enric
Spanish, 20th cent.
HUGUET, Jaime
Spanish, op.1448-1489
HUGUET, Jean Charles
French, 1815-p.1861
HUGUET, Pere or Pedro
Spanish, op.1439
HUGUET, Victor Pierre
French, 1835-1902
HUHN, Carl Theodor
Fjodorowitsch
Russian, 1830-1877
HUIDEKOPER or Huidekoper,
Christiaan (Chris)
Dutch, 1878-1939
HUILLIER, Jacques
French, 19th cent.
HULLIOT or Huillot,
Claude
French, 1632-1702
HUILLOT, Pierre Nicolas
French, 1674-1751
HUIN
Swiss, op.1790
HUISMAN, Jacob
see Huysmans
HUISMANS, Sipke
Dutch, 1938-
HUKLENBROK, Henri J.H.
German, op.c.1893-1903
HULBERT, Fanny
British, op.1841
HULBERT, Thelma
British, 1913-
HULDE
Swiss, 19th cent.
HULE, P. van
Netherlands, op.1656
HULETT or Hulet, James
British, op.1740-m.1771
HULK, Abraham, I
Dutch, 1813-1897
HULK, Abraham, II
British, op.1876-1898
HUIK, Hendrik
Dutch, 1842-1937
HULK, Johannes Frederik, I
Dutch, 1829-1911
HULK, Johannes (John)
Frederick, II
Dutch, 1855-1913
HULK, William Frederik
British, 1852-
HULL, Edward
British, op.1827-1877
HULL, Thomas
British, op.1775-m.1800
HULL, William
British, 1820-1880
HULLE, Anselmus von
(Anselmus Hebbelynck)
Flemish, 1601-p.1674
HULLEBERGHE, Antoine van
see Hilleberghe

HULLEGARDEN or Hullegaerde,
Carel van
Dutch, op.1647-1669
HULLEY, H.
British, op.1783-1800
HULLEY the Elder,
Thomas
British, op.1798-1817
HULLGREN, Oscar
Swedish, 1869-1948
HÜLLNER, C.
German, 19th cent.
HULMANS, J.
Flemish, 17th cent.
HULME, Frederick William
British, 1816-1884
HULME, J.Henry
British, 18th cent.
HULSBERG, Henry
British, -1729
HULSDONCK, Gillis van
Flemish, c.1625-p.1669
HULSDONCK, Jacob
(also, erroneously, Jan)
van
Flemish, 1582-1647
HULSEBOOM, Gerrit
Dutch, 1784-1863
HULSEBOS, R.
Dutch(?), op.1800-1819
HULSEN, Esaias van
(Esaias Hulsius)
Dutch, 1570(?)-a.1627
HULSEN, Friedrich van
(Federicus Hulsius)
Dutch, c.1580(?)-c.1660
HUISMAN or Hülsmann
(not Holzmann, Johann
German, op.1634-1644
HULST, Frans de or van der
Dutch, c.1610-1661
HULST, Hendrik van
Dutch, 1685-1754
HULST, Jan Baptist van der
Belgian, 1790-1862
HUIST, Hulft or Ulst,
Maerten Fransz. van der
Dutch, op.c.1630-1645
HUIST, Pieter, I van der,
or Pieter Verhulst
Flemish, op.1583-m.c.1628
HULST, Pieter, II van der,
or Pieter Verhulst
Flemish, op.1623-1637
HUIST or Hult, Pieter
van der, or Pieter Verhulst
(Zonnebloom)
Dutch, 1651-1727
HUISTIJN, Cornelis Johannes
van
Dutch, 1813-1879
HULSWIT, Jan
Dutch, 1766-1822
HULT, Pieter van der
see Hulst
HULTBERG, John
American, 1922-
HUMAIR, Daniel
French, 20th cent.
HUMBERT, André Louis
Maxime
French, 1879-
HUMBERT, Charles (Jean
Charles Ferdinand)
Swiss, 1813-1881
HUMBERT de Superville,
David Pierre Giottino
Dutch, 1770-1849

HUMBERT, Frédéric
French, 19th/20th cent.
HYMBERT, Jacques Fernand
French, 1842-1934
HUMBERT, Jean
Dutch, 1734-1794
HUMBLOT, Humbelot or
Humblau, Antoine
French, op.1720-m.1758
HUMBLOT, Roberto
French, 1907-1962
HUMBOLDT, Alexander
Freiherr von
German, 1769-1859
HUMBORG, Adolf
German, 1847-
HUME, Amelia
see Long
HUME, Edith, (née Dunn,
wife of Thomas Hume)
British, op.1862-1896
HUMMEL, Carl
German, c.1769-1840
HUMMEL, Carl Maria
Nicolaus
German, 1821-1907
HUMMEL, Erdmann
(Johann Erdmann)
German, 1769-1852
HUMMEL, Gustav Adolf
Swiss, 1850-p.1893
HUMMEL, Ludwig
(Luigi)
Italian, 1770-1840
HUMMEL, Susette
see Hauptmann
HUMMEL, Theodor
German, 1864-1939
HUMPHREY, Jack Waldon
Canadian, 1901-
HUMPHREY, Ralph
American, 1932-
HUMPHREYS, Charles S.
American, op.1854-1870
HUMPHREYS-JOHNSTONE,
John
see Johnston
HUMPHRY, Ozias
British, 1742-1810
HUN, J.C.
Dutch(?), op.1708
HUNDERTPFUND, Liberat
German, 1806-1878
HUNDERTWASSER, Fritz
German, 1928-
HÜNE or Hühne, Andreas
Caspar
German, c.1758-1813
HUNGERBÜHLER, Emil
Swiss, 1914-
HUNIN, Pierre Paul
Alouis (Alouis)
Belgian, 1808-1855
HUNNEMAN, Christopher
William
British, 1730-1793
HUNSLEY, William
British, op.1841
HUNSRUCK, Hans von
(Duke Johann II of
Bavaria)
German, 15th cent.
HUNT, Alfred William
British, 1830-1896
HUNT, Arthur Ackland
British, op.1865-1902
HUNT, C.H.
Australian, 1857-1938
HUNT, Cecil Arthur
British, 1873-1965

HUNT, Charles
British, 1803-1877
HUNT, E. Aubry
American, 1855-1922
HUNT, Edgar
British, 19th cent.
HUNT, G.
British, op.1823
HUNT, James
British, 19th cent.
HUNT, Richard
British, op.1640
HUNT, S.V.
British, 1803-
HUNT, Thomas
British, 1854-1929
HUNT, Violet
British, 1856-
HUNT, Walter
British, 1861-1941
HUNT, Marion Elizabeth
(Mrs. William)
British, 19th cent.
HUNT, William Henry
British, 1790-1864
HUNT, William Holman
British, 1827-1910
HUNT, William Hoyes
British, 19th cent.
HUNT, William Morris
American, 1824-1879
HUNTEN, Emil
French, 1827-1902
HÜNTEN, Franz Johann
German, 1822-1887
HUNTER, B.F.
British, 19th cent.
HUNTER, Colin
British, 1841-1904
HUNTER, George Leslie
British, 1879-1931
HUNTER, George
Sherwood
British, op.c.1882-m.1920
HUNTER, J.
British, 19th cent.
HUNTER, James
British, 1715-1745
HUNTER, John Young
British, 1874-1955
HUNTER, Leslie
British, 1879-1931
HUNTER, Mary Young
British, op.c.1899-1914
HUNTER, Robert
British, op.1745-1803
HUNTING, Leonard
British, 20th cent.
HUNTINGTON, Daniel
American, 1816-1906
HUNZIKER, Max
German(?), 1901-
HUNZINGER, Werner
American, 1816-p.1861
HUOT, Charles François
French, c.1782
HUOT, Robert
American, 1935-
HÜPPI
German, op.1970
HUQUIER, Jacques Gabriel
French, 1725-1805
HURD, Nathaniel
American, 1730-1770
HURD, Peter
American, 1904-
HUREL, Suzanne
French, 1876-

HURET, Grégoire
French, 1606-1670
HURLSTONE, Frederick
Yeates
British, 1801-1869
HURLSTONE, Richard
British, op.1764-1780
HURN, P.S.
British, 19th cent.
HURRY, Leslie
British, 1909-
HURST, Henry William
Lowe (Hal)
British, 1865-1938
HURTADO de Mendoza,
Estéban
Spanish, op.1630
HURTER, Hans
Swiss, 20th cent.
HURTER, Johann Heinrich
Swiss, 1734-1799
HURTU, Jacques
French, op.1614-1619
HURTUBISE, Jacques
Canadian, 20th cent.
HUSKINSON
British, 19th cent.
HUSKINSON or Huskisson, R.
British, op.1832-m.c.1854
HUSKISSON or Huskinson, L.
British, op.1839-1859
HUSNIK, Jakub
German, 1837-1916
HUSON, Thomas
British, 1844-1920
HUSSEM, William Frans Karel
Dutch, 1900-
HUSSEY, Giles
British, 1710-1788
HUSSEY, Philip
British, 1713-1783
HUSSON, Jeanne Elisabeth
see Chaudet
HUSTWICK, F.
British, op.1800
HUSZAR, Vilmos
Dutch, 1884-1960
HUTCHINSON, Henry
British, 1800-1831
HUTCHISON, Frederick
William
Canadian, 1871-1953
HUTCHISON, James
British, 18th cent.
HUTCHISON, Robert
Gemmell
British, 1855-1936
HUTCHISON, William
Oliphant
British, 1889-1970
HUTCHISSON
British, 19th cent.
HÜTHER, Julius
German, 1881-1954
HUTIN, Charles François
French, 1715-1776
HUTIN, Pierre
French, c.1720-1763
HUTT, Henry
American, 20th cent.
HÜTTER, Emil
German, 1835-1886
HUTTER, Joos
Swiss, 1914-
HUTTER, Wolfgang
German, 1928-
HUTTON, John
British, 1906-

HUTTON, W.
British, op.1821
HUXLEY, Paul
British, 1938-
HUYBERTS or Huybrechts,
Cornelis
Dutch, 1669/70-c.1712
HUYBRECHTS, Peeter
Flemish, 1614-c.1660
HUYGENS, Christian
Dutch, 1629-1695
HUYGENS, Constantin, II
Dutch, 1628-1697
HUYGENS, François Joseph
Belgian, 1820-
HUYGENS, Frederik Lodewijk
Dutch, 1802-1887
HUYGENS, Philips
Dutch, 1633-1657
HUYGENSZ., Dirck
see Hugensz.
HUYS, Frans
Netherlands, 1522-1562
HUYS, Jan van
Dutch(?), 17th/18th cent.
HUYS, Pieter
Netherlands,
op.1545-1577
HUYSEN, Hans
Dutch, 20th cent.
HUYSMANS, Cornelis
Flemish, 1648-1727
HUYSMANS, Houseman,
Huisman or Huysman,
Jacob
Flemish, c.1633-1696
HUYSMANS, Jan Baptist
Flemish, 1654-1716
HUYSMANS, Jan Baptist
Belgian, 1826-
HUYSMANS, P.J.
Flemish, op.c.1800
HUYSSING, Hans
see Hysing
HUYSUM, Ad.
Dutch, op.1704
HUYSUM or Huijsum,
Jacob van
Dutch, c.1687/9-1740(?)
HUYSUM or Huijsum, Jan van
Dutch, 1682-1749
HUYSUM, Justus, I van
Dutch, 1659-1716
HUYSUM, Michiel van
Dutch, op.1729-1760
HUZESHVILI, Jemal
Nikolaevich
Russian, 20th cent.
HYATT, Derek
British, 1931-
HYDE, Annie
American, 19th cent.
HYDE, Helen
American, 1868-
HYDE, William
British, op.1889-1915
HYDE or Hydt, William
Henry
American, 1858-1943
HYDE-POWNALL, George
British, 1876-1932
HYNAIS, Vojtech (Adalbert)
Czech, 1854-1925
HYNCKES, Raoul
Belgian, 1893-
HYNES, Gladys
British, 1888-1958
HYON, Georges Louis
French, 1855-

HYPPOLITE, August
see Hipolite
HYPPOLITE, Hector
Haitian, 1889-1948
HYRE, Laurent de la
see Lahire
HYRE, Philippe de la
see La Hyre
HYSEBRANT, Adriaen
see Isenbrandt
HYSING (noy Huyssing
or Huyssings), Hans
Swedish, 1678-1752/3

I

IACOVIEFF or Iakovieff,
Alexander
Ievgienievitch
Russian, 1887-
IACURTO, Francesco
Canadian, 1908-
IANENKO, Feodossij
Iwanowitsch
see Janjenko
IBARRA, José
Spanish, 1688-1756
IBBETSON, Denzil
British, op.1821
IBBETSON, Julius
Caesar
British, 1759-1817
IBBOTT, Terence
British, 1941-
IBELS, Henri Gabriel
French, 1867-1936
IBI, Sinibaldo
Italian, c.1475-c.1550
IBSEN, Immanuel
Scandinavian, 1887-1944
ICIAR or Yciar, Juan de
Spanish, 1525-p.1550
IDANOFF
Russian, 18th cent.
IDSERTS, Idserdts or
Idsertz, Pieter
Dutch, op.1727-1771
IDSINGA, Wilhelmina
Geertruida van
Dutch, 1788-1819
IEGOROFF, Alexej
Jegorowitsch
see Jegoroff
IFOLD, Frederick
British, op.1846-1867
IGEL, Peter
German,
op.1496-1515/16
IGLER, Gustav
German, 1842-1908
IGOUNET de Villers,
Charles-André
French, 1881-1944
IHLEE, Eduard
German, 1812-1885
IHLEE, R.
German, 19th cent.
IHLY, Daniel
Swiss, 1854-1910
IHNATOWICZ, Maria
Polish, 20th cent.
ILARIO da Viterbo
Italian, op.1393
ILG, Fritz
German, 19th cent.

ILIPRANDI, Giancarlo
Italian, 1925-
ILLIDGE, Thomas Henry
British, 1799-1851
ILLINGWORTH
British, 19th cent.
ILLINGWORTH, Michael
New Zealand, 1932-
ILLIES, Arthur Karl
Wilhelm
German, 1870-1953
ILSTED or Ilstedt,
Peter Vilhelm
Danish, 1861-1933
IMAGE, Selwyn
British, 1849-1930
IMBACHHAUSEN, Siegmund
Haffner von
German, 18th cent.
IMBAULT, Léonce Edouard
French, 1845-
IMBERT, Anthony
French, op.1825
IMBERT, J.F.
French, op.1779-m.1787
IMBONATE
see Isacco
IMER, Edouard Auguste
French, 1820-1881
IMHOFF, Carl C.A.
Baron von
German, op.1771-1777
IMKAMP, Wilhelm
German, 1906-
IMMENRAET, Emmelraet,
Emmenraet etc., Michael
Angelo
Flemish, 1621-1683
IMMENRAET, Emmelraet,
Emmenraet etc.,
Philips Augustyn
Flemish, 1627-1679
IMMERZEEL, Christiaan
Dutch, 1808-1886
IMMERZEEL, J.
Dutch, 1808-1858
IMOF, Gérard
Swiss, 1940-
IMOLA, Innocenzo da
see Innocenzo
IMPARATO, Francesco
Italian, op.1603
IMPARTO, Girolamo
Italian, op.1573-1621
IMPERIALE, Gerolamo
Italian, -c.1660(?)
IMPERIALI, Francesco
(also Fernandi or
Ferrando)
Italian, op.1723-1737
IMRIE, Archibald Brown
British, 1900-
INCE, A.C.
British, 1868-
INCE, Captain
British(?), op.1758
INCE, Evelyn Grace
British, a.1886-1941
INCE, Joseph Murray
British, 1806-1859
INCE, William
British, op.1754-1762
INCERTI, Achille
Italian, 1907-p.1965
INCHBOLD, John William
British, 1830-1888

INCONTRI, Camillo
Italian, 17th cent.
INDACO, L'
see Torni
INDEMIO
see Fratino, Giovanni
INDIA the Elder,
Bernardino
Italian, c.1528-1590
INDIA, the Younger,
Tullio
Italian, p.1550-p.1624
INDIANA, Robert
American, 1928-
INDONI, Filippo
Italian, op.c.1883
INDUNO, Domenico
Italian, 1815-1878
INDUNO, Gerolamo
Italian, 1827-1890
INGALTON, William
British, 1794-1866
INGANNATI, Pietro degli
Italian, op.1529-1548
INGANNI, Angelo
Italian, 1807-c.1880
INGEGNO, Andrea Alovigi
or Aloysii (d'Assisi)
Italian, c.1470-1516
INGEN, E.
British, 19th cent.
INGEN, Jennifer van
Dutch(?), 20th cent.
INGEN, Willem or
Guillelmo van
Dutch, 1651-1708
INGEN, William Brantley
van
American, 1858-
INGHAM, Charles Cromwell
British, 1796-1863
INGLEBY, J.
British, 18th cent.
INGLEFIELD, E.A.
British, op.1845-1870
INGLES, David N.
British, op.c.1810-1820
INGLES, Jorge
Spanish, op.1455
INGLIS, Esther
British, 16th cent.
INGOLI, Matteo
(Il Ravennate)
Italian, 1587-1631
INGOUF, Francois
Robert, I
French, 1747-1812
INGRAM, C.
British, 19th cent.
INGRAM, William Ayerst
British, 1855-1913
INGRES, Jean Auguste
Dominique
French, 1780-1867
INGRES, Joseph
(Jean Marie Joseph)
French, 1755-1814
INLANDER, Henry
British, 1925-
INMAN or Inmann, Henry
American, 1801-1846
INMAN, John O'Brien
American, 1828-1896
INNES, Here
Dutch, 17th cent.
INNES, James Dixon
British, 1887-1914

INNES, Robert
British, op.1833
INNESS, George
American, 1825-1894
INNESS the Younger,
George
American, 1853-
INNOCENTI, Battista
degli
see Naldini
INNOCENTI, Camillo
Italian, 1871-
INNOCENZO da Imola
(Francucci)
Italian, 1490/4-1547/50
INO, Pierre
French, 1909-
INSKIPP, James
British, 1790-1868
INSLEY, Will
American, 20th cent.
INSTITORIS
German, op.c.1830
INTERGUGLIELMI, Elia
Italian, -1773
INTERNARI, Giovanni
Battista
Italian, op.1749-m.1761
INVREA, Irene
French, 20th cent.
INZA or Ynza, Joaquin X.
Spanish, op.1784
IOANES, Hispanus
see Johannes
IONESCU, Alexandru Dan
Rumanian, 20th cent.
IONESCU, Gheorghe
Rumanian, 1912-
IONI, Federico
see Joni
I'ONS, Frederick
Timpson
South African, op.1850
IPPOLITO, Angelo
American, 1922-
IPOUSTEGUY, Jean
French, 1920-
IPSEN, Ernest Ludvig
American, 1869-
IPSEN, Paul
Swedish, 1746-p.1781
IRELAND, Samuel
British, op.1760-m.1800
IRELAND, Thomas
British, 19th cent.
IRIARTE, Ignacio de
Spanish, 1621-1685
IRIARTE, José Mariá
Mexican, op.1852
IRIBE, Paul
French, -1935
IRMER, Carl
German, 1834-1900
IRMINGER, Valdemar
Henrik Nicolai
Danish, 1850-1938
IROLLI, Vincenzo
Italian, 1860-1945
IRONSIDE, Robin
British, 1912-
IRTON, Major
British, op.1820-1830
IRVIN, Albert
British, 1922-
IRVINE, Hugh
British, op.1808-1829
IRVINE, John/James?
British, op.1787-1834

IRVINE, Wilson Henry
American, 1869-1936
IRVING, J.Beaufain
American, 1826-1877
IRVING, Laurence Henry
Forster
British, 1897-
IRWIN, Gwyther
British, 1931-
IRWIN, Robert
American, 20th cent.
ISAAC, Isaacs, Isac
etc., Jaspar de
Flemish, op.1612-m.1654
ISAAC, John R.
British, op.1847-m.1871
ISAACH de Imbonate
see Isacco
ISAACHSEN, Olaf Wilhelm
Norwegian, 1835-1893
ISAACHSEN, Pieter
see Isaacsz.
ISAACS, Esther S.
British, op.1885-1890
ISAACS, Jaspar de
see Isaac
ISAACSZ., Isacs, Isacson
etc., Isaac
Dutch, 1599-p.1665
ISAACSZ., Isaachsen,
Isacs or Isaksen,
Pieter Fransz.
Danish, 1569-1625
ISABELLE, Marie Louise
of France
see Bourbon
ISABEY, Eugène
(Louis Gabriel Eugène)
French, 1803-1886
ISABEY, Jean Baptiste
French, 1767-1855
ISAC, Jaspar de
see Isaac
ISACCO or Isaach de
Imbonate
Italian, op.1402-1423
ISACS, Isaksen or
Isakson
see Isaacsz.
ISAKSONS, Karl Oscar
Swedish, 1878-1922
ISCHELAN, Hans
German, 1873-1964
ISEBRANT, Adriaen
see Isenbrant
ISELI, Rolf ·
Swiss, 20th cent.
ISENBART, Marie Victor
Emile
French, 1846-1921
ISENBRANT, Isebrant,
Ysenbaert or Ysenbrant,
Adriaen
Netherlands,
op.1510-m.1551
ISENMANN, Caspar
German, op.1433-m.1472
ISENRING, Johann Baptist
Swiss, 1796-1860
ISER, Iosif
Rumanian, 1881-
ISMAN, Johann
German, op.1670
ISNARD, Pierre François
French, op.1776-1781
ISOLA, Emma
British, 19th cent.

ISOLA, Giuseppe
Italian, 1808-1893
ISRAEL, Marvin
American, 20th cent.
ISRAELS, Isaac Lazerus
Dutch, 1865-1934
ISRAELS, Jozef
Dutch, 1824-1911
ISSEL, Georg Wilhelm
German, 1785-1870
ISSELSTEYN
see Ysselstein
ISSER, Johanna von,
(née Grossrubatscher)
German, 1802-1880
ISSTOMIN, Konstantin
Russian, 1887-
ISSUPOFF, Alessio
Italian, 19th cent.
ISTA, Ernest
French, op.c.1877
ISTED, Ambrose
British, 19th cent.
ISTRATI, Alexander
Roumanian, 1915-
ITALIAN SCHOOL
(Unidentified)
Anonymous Painters
of the
ITEM, Georges
Swiss, 1927-
ITERSON, Olga van,
(née Knöpfle)
see Knöpfle
ITSCHNER, Carl
Swiss, 1813-1879
ITTAR, Sebastiano
Italian, op.1800
ITTEN, Johannes
Swiss, 1888-
ITTENBACH, Franz
German, 1813-1879
ITURRINO, Francesco de
Spanish, 1864-1924
IVANCENCO, Gheorghe
Rumanian, 1914-
IVANOFF, Alexandre
Russian, 1806-1858
IVANOFF, S.V.
Russian, 1854-1910
IVANYI-GRUNWALD, Bela
(Adelbert)
Hungarian, 1867-1940
IVARA, Filippo
see Juvara
IVARSON, Ivan
Swedish, 1900-1939
IVASIUK, M.
Ukrainian, op.c.1900
IVERNOIS, Jean François
Jules d'
French, 1823-1884
IVERNY, Jacopo
French, 15th cent.
IVES, James Merritt
American, 1824-1895
IWAN, Johannes
Swedish, op.1452
IWANOFF, Alexander
Andrejevitsch
Russian, 1806-1858
IWANOFF, Michail
Matwejewitsch
Russian, 1748-1823
IWANOW, Fedor
Russian, c.1765-1832
IWANOW, Jurij
Russian, 20th cent.

IWILL, Frank
see Will
IWILL, Léon C.
French, 1850-1923
IWILL or Clavel, Marie
Joseph Léon
French, 1850-1923
IXNARD, Pierre Michel d'
French, 1723-1795
IZMIROGLU, Esen
Turkish, 20th cent.
IZQUIERDO, Begoña
Spanish, op.1957-1964

J

JAASTER, Jochem
Dutch, op.1647
JABLONSKAJA, Tatiana
Russian, 1917-
JACHIMOWICZ, Theodor
Polish, 1800-1889
JACK, Richard
British, 1866-1952
JÄCKLI, Hans
see Jeggli
JACKLIN, Bill
British, 1943-
JACKMAN, P.
British, 19th cent.
JACKMAN, William G.
British, op.c.1841-1860
JACKSON, Alexander Young
Canadian, 1883-
JACKSON, Arthur
British, 1911-
JACKSON, F.J.
American, 19th cent.
JACKSON, Francis
Ernest
British, 1872-1945
JACKSON, Frederick
William
British, 1859-1918
JACKSON, G.
British, op.1839-1844
JACKSON, Gilbert
British, c.1622-c.1642
JACKSON, J.G.
British, op.1817-1844
JACKSON, John
British, 1778-1831
JACKSON, John Baptist
(Jackson of Battersea)
British, 1701-c.1780
JACKSON, John Richardson
British, 1819-1877
JACKSON, Richard
American, 1939-
JACKSON, Samuel
British, 1794-1869
JACKSON, Samuel Phillips
British, 1830-1904
JACKSON, Welby
British, 19th cent.
JACKSON, William
British, 1730-1803
JACOB van Amsterdam
see Cornelisz.
JACOB of Strasbourg
(Jacobus Argentoratensis)
German, op.1494-1530
JACOB, Frank van
German(?), 16th cent.
JACOB, H.H.
British, op.1817
JACOB, Julius, I
German, 1811-1882

JACOB, Julius, II
German, 1842-1929
JACOB, Max Cyprien
French, 1876-1944
JACOB, Nicolas-Henri
French, 1782-1871
JACOB van Oostsanen
see Cornelisz.
JACOB von Utrecht
(Jacob Claesz. or
Klaesz. Trajectensis)
Netherlands, op.1506(?)-1524
JACOB, Walter Friedrich
Richard Walter)
German, 1893-
JACOBELLO d'Antonello
see Jacopo d'Antonello
JACOBELLO di Bonomo
Italian, op.c.1378-1385
JACOBELLO del Fiore
Italian, op.1401-m.1439
JACOBI, F.C.
Italian(?), op.1771
JACOBI, Jacques
Swiss, 1877-1922/32
JACOBI, Otto R.
Canadian, 19th cent.
JACOBO (Jacobus) da
Fabriano
Italian, op.1460-1474
JACOBS, Emil
(Paul Emil)
German, 1802-1866
JACOBS, François
German, 19th cent.
JACOBS of Rotterdam,
Gerrit
Dutch, op.1652
JACOBS, Huybrecht or
Hubertus
see Jacobsz.
JACOBS, J.
British, op.1816-1864
JACOBS, Jacobus Albertus
Michael (Jacob)
Belgian, 1812-1879
JACOBSEN, Anthony
American, op.c.1850-1890
JACOBSEN, David
Danish, 1821-1871
JACOBSEN, Egille
Danish, 20th cent.
JACOBSEN, Sophus
Norwegian, 1833-1912
JACOBSZ., Dirk
Netherlands, c.1497-1567
JACOBSZ., Hughe, Huge,
Hugo or Huygh (possibly
identified with Master
of the St. John Altarpiece)
Netherlands,
op.1494-m.c.1534/8
JACOBSZ. or Jacobs,
Huybrecht or Hubertus
(Grimani)
Dutch, c.1562-1631
JACOBSZ or Jacobsen,
Juriaen or Jürgen
German, 1625/6-1685
JACOBSZ., Lambert
Dutch, c.1598-1636
JACOBUS
Spanish, 15th cent.
JACOBY, V.
Russian, 1834-1905
JACOMART
see Baçó

147

JACOMB-HOOD, George
Percy
British, 1857-1929

JACOMETTO Veneziano
Italian, -a.1497

JACOMIN, Alfred
French, 1842-1913

JACOMIN, Marie Ferdinand
French, 1843-1902

JACOMO di Giovanni
(di Onofrio)
Italian, op.c.1515-1522

JACOMO del Pisano
Italian, 15th cent.

JACONE
see Jacopo di Giovanni
di Francesco

JACONO, Jan
British, 1949-

JACOPINO del Conte
see Conte

JACOPINO di Francesco
Italian, op.1350-1385

JACOPO di Alessandro
del Tedesco
Italian, op.1503

JACOPO or Jacobello
d'Antonello
Italian, c.1455-p.1490

JACOPO Avanzi
see Avanzo

JACOPO dei Bavosi
see Avanzo, Pseudo-
Jacopo

JACOPO da Bologna
see Ripanda

JACOPO da Camerino
Italian, 15th cent.

JACOPO da Campli
Italian, op.1461-1479

JACOPO dal Casentino
(Landini)
Italian, 1279-1358

JACOPO Ciciliano
see Duca, Giacomo del

JACOPO di Cione
Italian, op.c.1365-1398

JACOPO da Empoli
see Chimenti

JACOPO da Faenza
see Bertucci, Jacopo

JACOPO da Firenze
Italian, op.1410

JACOPO di Giovanni di
Francesco (Jacone)
Italian, -1553

JACOPO di Michele
see Gera

JACOPO da Milano
Italian, op.1511-1535

JACOPO or Giacomo di
Minto or Mino del
Pellicciaio
Italian, -a.1396

JACOPO di Nicola da
Recanati
Italian, 15th cent.

JACOPO da Norcia
(Jacopo Siciliano)
Italian, op.1524-m.1544

JACOPO di Paolo da
Bologna
Italian, op.1390-1426

JACOPO di Paolo di
Pomposa
Italian, 14th cent.

JACOPO da Riva
Italian, op.1372-m.a.1418

JACOPO da Roccantica
Italian, 15th cent.

JACOPO da San Polo
Italian, op.1451

JACOPO da San Severino
Italian, 15th cent.

JACOPO Siciliano
see Jacopo da Norcia

JACOPO Siciliano
see Duca, Giacomo del

JACOPO del Tedesco
see Jacopo di Sandro

JACOPO da Valenza
Italian, op.1485-1509

JACOPO Veneziano
Italian, op.1516

JACOPO da Verona
Italian, 1355-p.1442

JACOPONE da Faenza
see Bertucci, Jacopo

JACOPS, Joseph
Belgian, 1808-

JACOPUS de Turchlarius
Italian, 17th cent.

JACOTTET, Jean
Swiss, 1806-p.1843

JACOVACCI, Francesco
Italian, 1838-1908

JACQUAND, Mlle
French, op.1810-1818

JACQUAND, Claude or
Claudius
French, 1804-1878

JACQUARD, Antoine
French, op.1616-m.c.1640

JACQUART
French, 19th cent.

JACQUART or Jacquard,
Claude, II
French, 1686-1736

JACQUE, Charles Emile
French, 1813-1894

JACQUE, Louis
Canadian, 1919-

JACQUEMART de Hesdin
see Hesdin

JACQUEMART, Jules
Ferdinand
French, 1837-1880

JACQUEMART, Nélie, (née
André)
French, 1841-1912

JACQUEMIN
French, 17th cent.

JACQUEMIN, André
French, 1904

JACQUEMIN, Jeanne
French, 19th cent.

JACQUES, André
French, 1880-

JACQUES, Maurice
French, 1712-1784

JACQUES, Nicolas
French, 1780-1844

JACQUES, Norman
Christopher
British, 20th cent.

JACQUES, Pierre
(Jacques d'Angoulême)
French, 1516/20-1596

JACQUET, Achille
French, 1846-1908

JACQUET, Alain G.F.
French, 1939-

JACQUET, Clément
French, 1895-

JACQUET, Jean Gustave
French, 1846-1909

JACQUET, Mathieu
French, op.1590-m.a.1610

JACQUETTE, Yvonne
American, 1934-

JACQUIER, Elodie
see La Villette

JACQUIN, François
Xavier Joseph
Belgian, 1756-1826

JACQUIN, Nicolaus
Joseph von
Dutch, 1727-1817

JACQUIO, Ponsio
see Ponce

JACQUOTOT, Marie-
Victoire
French, 1778-1855

JADIN, Godefroy
(Louis Godefroy)
French, 1805-1882

JAECKEL, Karl Heinrich
(Jäckel Henry)
German, op.1853

JAECKEL, Willy
German, 1888-1944

JAEL, T.F. von
German(?), 19th cent(?)

JAENISCH, Hans
German, 1907-

JAFFAN, Ahmad
Syrian, 20th cent.

JAGEMANN, Caroline
see Heygendorf

JAGEMANN, Ferdinand
German, 1780-1820

JAEGER, Carl
German, 1833-1887

JÄGER, Bert
German, 1919-

JÄGER, Carl
German, 18th cent.

JÄGER, Franz, I
German, 1743-1809

JAGER, Friedrich
Wilhelm Johannes
German, 1833-1888

JÄGER, Gustav
German, 1808-1871

JAGER, Herbert de
Dutch, 1642-1705

JÄGER, Julius
German, -1887

JAGGER, Charles
British, c.1770-1827

JAGGER, David
British, -1958

JAGU, Francine Morin
French, 20th cent.

JAHN, Gustave
German, 1850-1904

JAHN, Quirin (John Quirin)
German, 1739-1802

JAHN-HEILEGENSTADT,
Albert
German, 1885-1961

JAHNS, Rudolf
German, 1896-

JAIME, Jean Francois
French, 1804-p.1831

JAKOB, Josef
South American,
20th cent.

JAKOB, Karl-Heinz
German, 1929-

JAKOULOV, Georges (Yuri
Bogdanovitch)
Russian, 1884-1928

JAKOVLEV, Alexander
Yevgenevitch
Russian, 1887-1938

JAKUPOW, W.
Polish, 20th cent.

JALABERT, Charles
François
French, 1819-1901

JALABERT, Jean
French, 1815-

JALABERT, Paulette
Eliane
French, 1904-

JALEA, Ton
Rumanian, 1887-

JALLAND, G.H.
British, 19th cent.

JALLIER de Savault,
Claude Jean Baptiste
French, 1738-1806

JALLIER,. Noel
French, op.1549

JAMAÇOIS, E.
French, 19th cent.

JAMAR, Armand Gustave
Gérard
Belgian, 1870-1946

JAME, Alphonse
French, op.1839-1880

JAMES, David
British, op.1881-1892

JAMES, Edith Augusta
British, 1857-1898

JAMES, Francis
British, op.1832-1845

JAMES, Francis Edward
British, 1849-1920

JAMES, George
British, op.1761-m.1795

JAMES, George
American, 20th cent.

JAMES, Gilbert
British, 19th cent.

JAMES, H.
British, op.c.1810

JAMES, Kim
British, 20th cent.

JAMES, Louis
Australian, 1920-

JAMES, Peter
British, op.1874

JAMES, R.
British, op.1841-1851

JAMES, Richard
British, 1937-

JAMES, Lord Walter
John (3rd Baron
Northbourne)
British, 1869-1933

JAMES, Will
American, 1882-

JAMES, William
British, op.1761-1771

JAMESON, Cecil
British, 20th cent.

JAMESON, Norma
British, 20th cent.

JAMESONE, George
British, 1587/8-1644

JAMIESON, Alexander
British, 1873-1939

JAMIESON, Elizabeth
British, 1924-

JAMIESON, F.E.
British, op.c.1920-1950

JAMIESON, Gil
Australian, 1938-

JAMIESON, Mitchell
American, 1915-
JAMIESON, Peter
British, 20th cent.
JAMIESON, Philip
American, 1925-
JAMIN, Diederik
Franciscus
Dutch, 1838-1865
JAMIN, Paul-Joseph
French, 1853-1903
JAMIS, Fayad
Spanish, 20th cent.
JAMNITZER, Christoph
German, 1563-1618
JAMNITZER, Wenzel, I
German, 1508-1585
JAMOIS, Edmund Victor
French, 1876-
JAN van Brügge or van
Broek
see Jorisz.
JAN van Brussel
(Jan de Bruxelles)
see Roome
JAN, Elvire
Bulgarian, 1904-
JAN JOEST von Calcar
or van Haarlem (Juan
de Holanda)
Netherlands,
op.1474-m.1519
JAN van Leyden
(possibly identified
with Johann van Leyden)
Dutch, op.1661-1683(?)
JANAIG
French, 17th cent.
JANCKE, August
(Martin Heinrich August)
German, 1810-1840
JANCO, M.
American, 20th cent.
JANCU, Marcel
Rumanian, 1895-
JANDA, Hermine von
German, 1854-1925
JANDI, David
Hungarian, 1893-1944
JANDL, Jännt or Jantl,
Anton
German, 1723-1805
JANECEK, Ota
Czech, 1919-
JANER
see Gener
JANET, Ange Louis
(Janet-Lange)
French, 1815-1872
JANIKOWSKI, Mieczyslaw
Tadeusz
Polish, 1912-1968
JANIN, Jean
French, 1899-
JANIN, Louise
(Jeanne Louise Sophie)
Swiss, 1781-1842
JANINET, Jean François
French, 1752-1814
JANJENKO or Ianenko,
Feodossij Iwanowitsch
Russian, 1762-1809
JANK, Angelo
German, 1868-1940
JANK, Christian
German, 1833-1888

JANKOWSKA, Bogena
Polish, 20th cent.
JANKOWSKY, F.W.
(or J.W.)
German, op.1825-1861
JANMOT, Anne Francois
Louis
French, 1814-1892
JANNECK, Franz Christoph
German, 1703-1761
JANNOT, Henri
French, 1909-
JANOS, Czencz
Czech, 1885-
JANOWSKI, Witold
Polish, 20th cent.
JANS, Edouard de
Belgian, 1855-1919
JANSCHA, Jantscha or
Janza (not Janschka),
Lorenz or Laurent
German, 1749-1812
JANSEM, Jean
Roumanian, 1920-
JANSEN, Heinrich
Danish, 1625-1667
JANSEN, Hendrik Willebrord
Dutch, 1855-1908
JANSEN, Johannes
Mauritz
Dutch, 1811-1857
JANSEN, Johan Wilhelm
Dutch(?), 18th cent.(?)
JANSEN, Joseph
German, 1829-1905
JANSEN, Lambertus
Mattheus
Dutch, 1891-1965
JANSEN, Louise,
(née Siebke)
German, 1835-1912
JANSEN, Wibrant
Flemish(?), op.1666
JANSEN, Willem
Dutch, 1892-
JANSEN, Willem George
Frederik
Dutch, 1871-1949
JANSON, Jakob
German, op.1806-1832
JANSON, Johannes
(sometimes also Jacobus)
Dutch, 1729-1784
JANSON, Johannes
Christiaan
Dutch, 1763-1823
JANSON, Pieter
Dutch, 1765-1851
JANSSEN or Jansen.
Gerhard
German, 1636-1725
JANSSEN, Gerhard
German, 1863-1931
JANSSEN, Horst
German, 20th cent.
JANSSEN, Peter Johann
Theodor
German, 1844-1908
JANSSEN, Victor Emil
German, 1807-1845
JANSSENS van Nuyssen,
Abraham, I
Flemish, c.1575-1632
JANSSENS, Anna Maria
Flemish, op.1645-1668

JANSSENS van Ceulen,
Cornelis
see Jonson
JANSSENS, Hendrik
Dutch, op.1673
JANSSENS, Hieronymus or
Jeroom (den Danser)
Flemish, 1624-1693
JANSSENS, Jan or
Joannes
Flemish, 1590-p.1646
JANSSENS, Johan
Belgian, 1809-
JANSSENS, Jozef Marie
Louis
Belgian, 1854-1930
JANSSENS Elinga, Pieter
Dutch, 1623-a.1683
JANSSENS, Victor Honoré
Flemish, 1658-1736
JANSSON, Eugène Frederik
Swedish, 1862-1915
JANSSON, F.
Scandinavian, c.1825
JANSSON, Karl Emanuel
Finnish, 1846-1874
JANSZ., Frans
Netherlands,
op.1523-m.a.1542
JANSZ., Govert
(Mijnheer)
Dutch, op.c.1655
JANVRY, H. de
French, op.1798-1800
JANZ, Philipp
German, 1813-1885
JAPHET or Jazet, Alexandre
Jean Louis
French, 1814-a.1864
JAPY, Louis Aimé
French, 1840-1916
JAQUEMIN or Jacquemin,
Francois
French, op.1787-1836
JAQUERIO, Giacomo, I
Italian, op.1404-m.1453
JAQUERIO, Matteo
Italian, op.1404-1453
JAQUES, Pierre
Swiss, 1913-
JAQUET
French, 20th cent.
JAQUOTOT, Marie Victoire
(Le Guay and Pinet)
French, 1772-1855
JARAY, Tess
British, 1937-
JARDEL, Bernard
French, 1932-
JARDIN
see Dujardin
JARDINES, José Maria
Spanish, 1862-
JAREMA, Maria
Polish, 1908-1958
JAREMITSCH, Stepan
Petrovitch
Russian, 19th cent.
JARKE, Hedwig
German, 1882-
JARMORINI, Giovanni
Giuseppe
Italian, 1732-1816
JARNEFELT or Jaernefelt,
Eero Nikolai
Danish, 1863-

JAROCKI, Wladyslaw
Polish, 1879-
JAROSCHENKO, Nikolai
Alexandrovich
Russian, 1846-1898
JARRATT, Mrs.
see Berners, Miss
JARRAUD, Léonard
Antoine
French, 1848-
JARRY, Nicolas
French, 1620-c.1674
JARVIS, Charles
see Jervas
JARVIS, Charles Wesley
American, 1812-1868
JARVIS, Donald
Canadian, 1923-
JARVIS, John Wesley
American, 1780-1840
JARVIS, Lewis
American, 1845-1900
JAS, Maria
Polish, 20th cent.
JASBERG, Unto
Finnish, 20th cent.
JASCHKE, Franz
German, 1775-1842
JASPERS, Caspers,
Gaspers or Jaspars,
Jan Baptist
Flemish, 1620(?)-1691
JASSAUD, Baron de
French, op.1834-1839
JASTRAU, Viggo
Danish, 1857-1946
JAULMES, Gustave
Louis
Swiss, 1873-
JAUMANN, Rudolf Alfred
German, 1859-
JAUNEZ, Lina
French, op.1833-1834
JAURAN
Canadian, 1926-
JAUREGUI, Xáuregui or
Jáurigui y Aguilar,
Juán de
Spanish, 1566/83-1641
JAVIER de Goribar,
Nicolas
Spanish, 17th cent.
JAWLENSKY, Alexei von
Russian, 1867-1941
JAWUREK, Karel
Czech, 1815-1909
JAY, Isabella Lee
British, op.1882-1896
JAY, W.
British, op.1809-1817
JAY, William Samuel
British, 1843-1933
JAZET, Alexandre Jean
Louis
see Japhet
JAZET, Jean Pierre Marie
French, 1788-1871
JAZET, Paul Léon
French, 1848-
JDANOFF, Andrei
Onnipovitch
Russian, op.1775-1811
JEAKES, Joseph
British, op.1796-1815
JEAN, Marcel
French, 1900-

JEAN de Boulogne
(Le Valentin)
see Bologna, Giovanni
da
JEAN de Bruxelles
see Roome
JEAN, Felix
Haitian, 1930-
JEAN, Georges
Haitian, 1945-
JEAN, J.D. de Saint
see Saint-Jean
JEAN, L.S.
French, 19th cent.
JEAN de Montlucon,
Molisson or Môlusson
French, op.c.1477-1492
JEAN, Philip
British, 1755-1802
JEAN de Luca (or Nucci
or Nuchii) of Siena
Italian, op.1347
JEAN d'Orléans
French, op.1361-1420
JEAN de Portugal
see Giovanni di
Consalvo
JEANES, Sigismond J.E.
French, op.1906-
JEANMAIRE, Edouard
Swiss, 1847-1916
JEANNERET, Gustave
Swiss, 1847-1927
JEANNERET, Charles
Edouard (Le
Corbusier
Swiss, 1888-1965
JEANNET, Jacques
French, 1931-
JEANNIN, Georges
French, 1841-1925
JEANNIOT, Georges
(Pierre Georges)
French, 1848-1934
JEANNIOT, Pierre
Alexandre
French, 1826-1892
JEAN-ROBERT, André
French, 1921-
JEANRON, Philippe
Auguste
French, 1809-1877
JEAURAT, Edmé
French, 1688-1738
JEAURAT, Etiénne
French, 1699-1789
JEAURAT, Nicolas Henry
(Jeaurat de Bertry or
Bertrix)
French, 1728-1796
JEAYES, Henry
British, op.1808
JEFFERSON, J.
British, 18th cent.
JEFFERSON, Joseph
American, 1829-1905
JEFFERSON, Thomas
American, 1743-1826
JEFFERYS, Charles W.
British, 1869-1951
JEFFERYS, James
British, 1751-1784
JEFFERYS, Marcel
Belgian, 1872-1924
JEFFERYS, William
British, op.1766-1775

JEFFRESON, J.W.
British, op.c.1850-1861
JEGERS, Julijs
American, 1910-
JEGGLI, Johann Heinrich
Swiss, op.1564
JEGHER or Jeghers,
Christoffel
Flemish, 1596-1652/3
JEGHERS or Jegher, Jan
Christoffel
Flemish, 1618-1666/7
JEGLI, Heggli, Jäckli,
Jeggli etc., Hans, II
Swiss, c.1580-1643
JEGOROFF, Iegoroff or
Jegorov, Alexej
Jegorowitsch
Russian, 1776-1851
JEGOROFF, Andrej,
Afanassjewitsch
Russian, 1878-1954
JEHAN de Paris
see Master of Moulins
JEHNER or Jenner,
Isaak
British, 1750-p.1806
JELFE, W.
British, 18th cent.
JELGERHUIS Rienksz.,
Johannes
Dutch, 1770-1836
JELGERHUIS, Rienk
Dutch, 1729-1806
JELGERSMA, Tako Hajo
Dutch, 1702-1795
JELINEK, Rudolph
German, 1880-
JELLICOE, John F.
British, op.1865-1880
JENDOGOUROFF
see Endogouroff
JENE, Edgar
German, 1904-
JENEWIEN or Jennewien,
Felix
Czech, 1857-1905
JENICHEN, Jenich
Jenisch or Jenitsch
(not Jenckel)
Balthasar
German, op.1563-m.a.1621
JENKIN, W.
British, 19th cent.
JENKINS, Edward
British, op.c.1826
JENKINS, G.H.
British, 19th cent.
JENKINS, J.
British, 1788-1832
JENKINS, Joseph John
British, 1811-1885
JENKINS, Mary
see Brewer
JENKINS, Nicholas
British, 20th cent.
JENKINS, Paul
American, 1923-
JENKINS, Thomas
British, c.1720-1798
JENKINS, Wilfred
British, 19th cent.
JENKINSON, J.
British, op.c.1780
JENNENS & Bettridge
Canadian, op.c.1850

JENNER, Isaak
see Jehner
JENNER, S.
British, op.c.1826
JENNER, Thomas
British, op.1631-1656
JENNER, W.
British, op.1855-1874
JENNINGS, E.Owen
British, 1899-
JENNINGS, Humphrey
British, 1907-1950
JENNINGS, J.J.
British, op.c.1845
JENNINGS or Jennys,
Richard
American, op.1777-1783
JENNINGS, Samuel
British, op.1789-1834
JENNINGS, W.G.
British, op.1797-1830
JENNINGS, W.R.
British, 19th cent.
JENNIS, Gurnell C.
British, op.c.1910-1936
JENNY, Arnold
British, 1831-1881
JENNYS, William (or J.
William)
American, op.c.1795-1797/8
JENSEN, Alfred
American, 1903-
JENSEN, Axel P.
Scandinavian, 20th cent.
JENSEN, Carl
Danish, 1851-1933
JENSEN, Christian
Albrecht
Danish, 1792-1870
JENSEN, Holger J.
Danish, 1900-1967
JENSEN, Jeppe Juel
Danish, 1930-
JENSEN, Johan Laurents
Danish, 1800-1856
JENSEN, Max
German, op.c.1885
JENSEN, Thomas Martin
American, 1831-1916
JENTZEN, Friedrich
German, 1815-1901
JENTZSCH, Johannes
Gabriel (Hans)
German, 1862-p.1903
JENTZSCH, Jentsch or
Jenzsch, Johann
Gottfried
German, 1759-1826
JENZSCH, Gustav
German, op.1804
JEQUIER, Jules
Swiss, 1834-1898
JERICHAU, Harald Adolf
Nikolas
Danish, 1851-1878
JERICHAU, Jens Adolph
Scandinavian, 1816-1883
JERICHAU-BAUMANN, Anna
Maria Elisabeth
Danish, 1819-1881
JERIGH, E.
see Jerrigh
JERMYN, Miss H.
British, op.1810
JERNBERG, August
Swedish, 1826-1896

JERNBERG, Olof August
Andreas
Swedish, 1855-
JERNDORFF, August
Andreas
Danish, 1846-1906
JEROAIACON, Germano
Greek, 16th cent.
JEROME, Ambrosini
French, op.1840-1871
JEROME, P.
American, op.c.1947
JERRIGH or Jerigh, E.
Flemish, op.1601
JERVAS, Gervais, Gervase
or Jarvis, Charles
British, c.1675-1739
JESCHIN, Jaroslav
Czech, 19th cent.
JESPERS, Floris
Belgian, 1889-1966
JESPERS, Oscar
Belgian, 1887-1970
JESSE, Henry
see Gissey
JESSEL, Jeremy
British, 1939-
JESSEL, Robert
British, 1899-
JESSEN, Karl Ludwig
Scandinavian, 1833-1917
JESSURUN de Mesquita,
Samuel
Dutch, 1868-1944
JESUS, Pablo de
Mexican, op.1796
JETTEL, Eugen
German, 1845-1901
JETTMAR, Rudolf
German, 1869-
JEUNE
see Lejeune
JEVOIS, Th.
see Bellevois, J.A.
JEWELL, D.B.
American, 19th cent.
JEWETT, William
American, 1795-1873
JEWITT, Thomas Orlando
Sheldon
British, 1799-1869
JIMENEZ, Juan
Spanish, op.1500
JIMENEZ, Luis
Spanish, 20th cent.
JIMENEZ, Miguel
see Ximenez
JIMENEZ y Aranda, José
Spanish, 1837-1903
JIMENEZ y Martin, Juan
Spanish, 1858-
JIMENEZ y Aranda, Luis
Spanish, 1845-
JIMENEZ, Prieto, Manuel
Spanish, 19th cent.
JIQUIDI, Aurel
Rumanian, 1896-
JIRANEK, Milos
Czech, 1874-1911
JO, Leo
French, 19th cent.
JOACHIMS, Joachim,
Joachimus, Joachmus or
Jochmuss, Jeronimus or
Hieronymus
Dutch, c.1619(?)-1660

JOANES, Vicente
 see Masip
JOANNES, Fra (Frater Johannes)
 Italian, 15th cent.
JOANNIS de lo Prete
 Italian, op.1642
JOANNON-NAVIER, Etiénne Albert Eugéne
 French, 1857-
JOANOWITCH, Joannovics or Joannovits, Paul or Pal
 Yugoslav, 1859-
JOBARD, Hippolyte Henri (Henri Job)
 French, 1857-1885
JOBBE-DUVAL, Félix Armand Marie
 French, 1821-1889
JOBIN, Bernhard
 German, op.1560-m.1597
JOBLING, J.
 British, 19th cent.
JOBLING, Louise
 British, 19th cent.
JOBLING, Robert
 British, 1841-1923
JOBSON, Frederick James
 British, 1812-1881
JOBST, Christoph
 German, 1557-1630
JOCELYN or Joscelyn, Nathaniel
 American, 1796-1881
JOCHEMS, Herbert
 Dutch, 1912-
JOCHMUSS, Jeronimus or Hieronymus
 see Joachims
JODE, Gerard de
 Dutch, 1509/17-1591
JODE, Hans de
 Dutch, op.1647-1662
JODE, Pieter, I de
 Flemish, 1570-1634
JODE, Pieter, II de
 Flemish, 1606-c.1674
JODELET, Emmanuel
 French, 1883-
JODL, Ferdinand
 German, 1805-1882
JODLOWSKI, Tadeusz
 Polish, 20th cent.
JOEL, Grace
 New Zealand, 1865-1924
JOEL, J.B.
 British, 19th cent.
JOENSEN-MIKINES, S.
 Scandinavian, 20th cent.
JOERDAENS, Hans
 see Jordaens
JOERDENS, Felix A.
 German, -1883
JOEST, Jan
 see Jan Joest
JOËTS, Jules Arthur
 French, 1884-
JOHAN Contrafeier (perhaps Johan Maler aus Flensburg, Johan dän Maler or Johan or Johan Jörgen)
 Norwegian, op.1640-1660
JOHANN, Jakob Greg
 German, 1813-1865

JOHANN von Aachen
 see Aachen
JOHAN van Antwerpen
 see Kniepper, Hans
JOHANN van Leyden
 see Jan van Leyden
JOHANNEAU, E.
 French, 18th cent.
JOHANNES, Frater
 see Joannes, Fra
JOHANNES, A.
 German, 15th cent.
JOHANNES, Godefridus
 Netherlands, op.1585
JOHANNES Hispanus
 Spanish, 15th cent.
JOHANNOT, Alfred (Charles Henri Alfred)
 German, 1800-1837
JOHANNOT, Tony
 German, 1803-1852
JOHANNSEN, Theodor
 German, 1868-
JOHANSEN, John Christen
 Danish, 1876-
JOHANSEN, Otto Emil
 Norwegian, 1886-1934
JOHANSEN, Viggo
 Danish, 1851-1935
JOHANSON, Boris Vladimirovich (Joganson)
 Russian, 1893-1973
JOHANSON, Patricia
 American, 1940-
JOHANSON-THOR, Emil Nils (Thor Emil Nils Johanson)
 Swedish, 1889-
JOHANSSON, Arvid Claes William
 Swedish, 1862-1923
JOHANSSON, Carl
 Scandinavian, 1863-1944
JOHANSSON, Eric
 German, 1913-
JOHANSSON, Johan
 Swedish, 1879-1951
JOHN, August (Augustin)
 German, 1602-p.1678
JOHN, Augustus Edwin
 British, 1879-1961
JOHN, Gwendolyn Mary
 British, 1876-1939
JOHN, Wilhelm (August Wilhelm)
 German, 1813-p.1837
JOHNS, Ambrose Bowden
 British, 1776/7-1858
JOHNS, H.
 Netherlands, op.1791-1816
JOHNS, J.
 British, op.c.1798
JOHNS, Jasper
 American, 1930-
JOHNSEN, Johan
 German, 1652-1708
JOHNSON, A.
 British, op.1848-1852
JOHNSON, Charles Edward
 British, 1832-1913
JOHNSON, Charles H.
 American, 19th cent.
JOHNSON, Cornelius
 see Jonson

JOHNSON, David
 American, 1827-1908
JOHNSON, Eastman
 American, 1824-1906
JOHNSON, Edward Killingworth
 British, 1825-1896
JOHNSON, Elaine
 British, 1945-
JOHNSON, Ernest Borough
 British, 1866-1949
JOHNSON, Frank Tenney
 American, 1874-1939
JOHNSON, Guy
 American, 1927-
JOHNSON, Harry John
 British, 1826-1884
JOHNSON, Henry
 British, op.1824-1847
JOHNSON, Herbert
 British, 1848-1906
JOHNSON, Isaac
 British, 1754-1835
JOHNSON, James
 British, 1803-1834
JOHNSON, John
 British, -c.1797
JOHNSON, Joshua
 American, 18th cent.
JOHNSON, Laura
 see Knight
JOHNSON, Laurence
 British, op.1603
JOHNSON, Lester
 American, 1919-
JOHNSON, Marshall
 American, 19th cent.
JOHNSON, Mary
 British, op.1814-1829
JOHNSON, Michael
 Australian, 1938-
JOHNSON, Nevill
 British, 20th cent.
JOHNSON, Ray
 American, 1927-
JOHNSON, Robert
 British, 1770-1796
JOHNSON, S.Y.
 British, 19th cent.
JOHNSON, Thomas
 British, op.1651-1685
JOHNSON, Thomas
 British, 1709-1767
JOHNSON, W.G.
 British, 19th cent.
JOHNSON, William
 British, 18th cent.
JOHNSON, William H.
 American, 1901-1970
JOHNSTON, Alexander
 British, 1815-1891
JOHNSTON, David Claypoole
 American, 1797-1865
JOHNSTON, Franz H.
 Canadian, 1888-
JOHNSTON, Henrietta
 American, op.1703-m.1728/9
JOHNSTON, John
 American, 1752-1812
JOHNSTON, John Humphreys
 American, 1857-
JOHNSTON, Joshua
 American, op.1796-1824
JOHNSTON, William
 American, 1732-1772

JOHNSTON, Ynez
 American, 20th cent.
JOHNSTONE, Dorothy
 British, 20th cent.
JOHNSTONE, Henry J.
 British, 1835-1907
JOHNSTONE, John
 British, 20th cent.
JOHNSTONE, Thomas
 American, 1708-1767
JOHNSTONE, William Borthwick
 British, 1804-1868
JOHNSTONE, William
 British, 1897-
JOINET, M.
 French, op.1804-1807
JOINVILLE, Antoine-Victor
 French, 1801-1849
JOINVILLE, Francois Ferdinand Phillippe Louis Marie d'Orléans, Prince de
 French, 1818-1900
JOLI, Gioli, Jolli or Yoli, Antonio
 Italian, c.1700-1777
JOLIN, Einar
 Swedish, 1890-
JOLIVARD, André
 French School, 1787-1851
JOLIVET, Henri
 French, op.1814-m.c.1825
JOLIVET, L.
 French, 18th cent.
JOLLAIN, Francois
 French, c.1641-1704
JOLLAIN, Gérard, I
 French, -1683
JOLLAIN or Joullain, Nicolas René
 French, 1732-1804
JOLLAIN, or Joullain, Pierre
 French, 1720-p.1762
JOLLI, Antonio
 see Joli
JOLLIVET, Louis
 see Jolivet
JOLLIVET, Pierre Jules
 French, 1794-1871
JOLLY, Henri Jean Baptiste
 Belgian, 1812-1853
JOLY, Alexis Victor
 French, 1798-1874
JOLY, André
 French, 1706-p.1781
JOLY, Viktorine (de Cadet)
 French, op.1800-1830
JOLYET, Philippe
 French, 1832-1908
JOMBERT, Pierre Charles
 French, c.1748/9-p.1777
JONAS, Henri
 French, 1878-1944
JONAS, Joseph
 Czech, op.1840-1850
JONAS, Karl R.
 German, 1822-1888
JONAS, Lucien Hector
 French, 1880-1947

JONCIERES, Léonce
J.V. de
French, 1871-
JONCKHEER, Jonc-heer or
Joncheer, Jacob de
Dutch, op.1668-1684
JONES, Adrian
British, 1845-1938
JONES, Alexander
Montgomery
British, op.c.1820
JONES, Alfred
British, 1819-1900
JONES, Allen
British, 1937-
JONES, Barbara
British, 20th cent.
JONES, Bayard
American, 20th cent.
JONES, Bolton (Hugh
Bolton)
American, 1848-
JONES, Charles
British, 1836-1892
JONES, C.M.
British, 1836-
JONES, Charlotte
British, op.1801-m.1847
JONES, David Michael
British, 1895-1974
JONES, E.H.
British, op.c.1887-1891
JONES, E.M.
British, op.1810
JONES, Emma
see Soyer
JONES, E.T.
British, 19th cent.
JONES, Francis C.
American, 1857-1932
JONES, Frederick
British, op.1867-1885
JONES, Fred Cecil
British, 1891-1956
JONES, Frederick G.
American, 20th cent.
JONES, Garth
British, 20th cent.
JONES, George
British, 1786-1869
JONES, G.R.
British, 19th cent.
JONES, G. Smetham
British, op.c.1890
JONES, Sir Horace
British, 1819-1887
JONES, H.J.
British, 19th cent.
JONES, H.F.
British, 19th cent.
JONES, Hugo
British, op.1848
JONES, Inigo
British, 1573-1652
JONES, James
British, op.1720
JONES, J. Hammond
British, op.1822-1833
JONES, Joe
British, 1909-
JONES, John
British, c.1745-1797
JONES, John Paul
American, 1924-
JONES, M.
British, op.1782
JONES, H. Mansell
British, 19th cent.

JONES, Maud Raphael
British, op.c.1889-1900
JONES, Owen
British, 1809-1874
JONES, Palmer
British, 20th cent.
JONES, Patrick
British, 1948-
JONES, Paul
British, 1860-
JONES, Prescott
American, 1904-
JONES, Purcell
British, op.1917
JONES, R.
British, op.c.1845
JONES, Raphael
British, 19th cent.
JONES, Reginald
British, 1857-1904
JONES, Richard
British, 1767-1840
JONES, Robert Edmond
American, 1887-1954
JONES, Samuel John
Egbert
British, op.1820-1845
JONES, T.W.
British, op.1832-1871
JONES, Thomas
British, 1730/43-1803
JONES, Thomas
British, op.1836-1848
JONES, Sir Thomas
Alfred
British, 1823-1893
JONES, Trevor
British, 20th cent.
JONES, V.M.
British, 19th cent.
JONES, W.
British, c.1798-1860
JONES, W.F.
British, op.1853
JONES, William
British, op.1632
JONES, William
British, op.1726-m.1747
JONES, William
British, op.1764-1775
JONES, William
British, op.1777
JONES, William
British, op.1779-1780
JONES, William
British, op.1832-1836
JONES, William E.
British, op.1849-1871
JONEY, E.
French, 19th cent.
JONG, Dirk de
Dutch, op.1779-1785
JONG, Frans de
Dutch, op.c.1666-m.1705
JONG, Gerrit Pietersz. de
Dutch, op.1630-m.1642
JONG, Pieter de
Josselin de
see Josselin de Jong
JONGE, Jacob de
Netherlands,
17th cent.
JONGE, R.H. de
Netherlands, 18th cent.
JONGERS, Alphonse
American, 1872-
JONGH, Claude de
Dutch, op.1626-m.1663

JONGH, Joannes de
Dutch, op.1684
JONGH, Ludolph or
Leuven de
Dutch, 1616-1679
JONGH, Martinus
Johannes (Tinus) de
Dutch, 1885-1942
JONGH, Oene Romkes
de
Dutch, 1812-1896
JONGHE, Gustave Léonard
de
Belgian, 1829-1893
JONGHE, Jan Baptiste de
Belgian, 1785-1844
JONGKIND, Johan
Barthold
Dutch, 1819-1891
JONI, Federico
Italian, 1866-
JONKER, Cornelis de
Dutch, 1761-1830
JONNIAUX, Alfred
Belgian, 1882-
JONSON, Johnson, Jansen
or Janssens van Ceulen,
(Köln) Cornelis, I
British, 1593-1661/2
JONSON or Janssens
van Ceulen (Köln),
Cornelis, II
British, p.1622-p.1698
JONSSON, Agneta
Scandinavian, 20th cent.
JONSSON, Asgrimur
Icelandic, 1876-p.1920
JONXIS, Pieter
Hendrik
Dutch, c.1757-1843
JONXIS, Pieter Hendrik
Lodewijk
Dutch, 1815-1852
JOORS, Eugène
Belgian, 1850-1910
JOOS van Cleve or Cleef
see Cleve
JOOS de Paepe
see Pape, Josse
JOOS van Wassenhove
see Justus of Ghent
JOOSTEN, Dirk Jan Hendrik
Dutch, 1818-1882
JOOSTENS, Antoon or
Antoine L.
Belgian, 1820-1886
JOPLING, Joseph
Middleton
British, 1831-1884
JOPLING, Louise, née
Goode (Mrs. Frank
Romer)
British, 1843-1933
JORAND, Jean Baptiste
Joseph
French, 1788-1850
JORDAENS, A.
Netherlands, op.1714
JORDAENS or Joerdaens,
Hans, I
Flemish, op.1572-m.1630
JORDAENS, Hans, III
Flemish, op.1619-m.1643
JORDAENS, Hans, IV
(Polepel or
Brypotlepel)
Dutch, 1616-1680
JORDAENS, Jacob, I
Flemish, 1593-1678

JORDAENS, L.
Netherlands, op.c.1660
JORDAENS, Simon, I
Dutch, c.1590-c.1640
JORDAN, Carl
German, 1826-1907
JORDAN, Carl
German, 1863-
JORDAN, Esteban
Spanish, c.1543-1600
JORDAN, L.
Spanish, 18th cent.
JORDAN, O.
see Monogrammist O.R.J.
JORDAN, Rudolf
German, 1810-1887
JORDAN, Samuel
American, op.1831
JORDE, Lars
Norwegian, 1865-
JORDENS, Antoni
Dutch, 1664-1715
JOREL, Colin
French, op.1855
JORG, Charles
Swiss, 1933-
JÖRGEN, Johan
see Johan
JØRGENSEN, Johan
Danish, op.1640
JØRGENSEN, Sven
Norwegian, 1861-
JORGENSON, N.
American, op.1894
JÖRGER, Johann Septimius
Graf von
German, 1594-1662
JORIS, Pio
Italian, 1843-1921
JORISZ, Jan or David
(Jan van Brügge or
Jan van Broek)
Netherlands, 1501-1556
JORN, Asger
Scandinavian, 1914-
JORON, Maurice
French, 1883-
JÖRRES, Carl
German, 1870-1947
JOSCELYN, Nathaniel
see Jocelyn
JOSEFA de Obidos
see Ayala
JOSEPH, George Francis
British, 1764-1846
JOSEPH, Jasmin
Haitian, 1923-
JOSEPH, Peter
British, 1929-
JOSEPH, Richard
American, 20th cent.
JOSEPHSON, Ernst
Swedish, 1851-1906
JOSEPIN
see Cesari, Giuseppe
JOSI, Charles
British, op.1827-1851
JOSSE, C.
German, 19th cent.
JOSSELIN de Jong,
Pieter de
Dutch, 1861-1906
JOSSOT, Henri-Gustave
French, 1866-
JOST, Joseph
German, 1875-
JOUANIN, Auguste Adrien
French, 1806-1887

JOUANON, Mlle.
French, op.1777
JOUAS, Charles
French, 20th cent.
JOUBERT, Léon
French, op.1883
JOUBIN, Georges
French, 20th cent.
JOUDERVILLE, Isaac de
Dutch, c.1613-c.1645/8
JOUETT, Matthew Harris
American, 1788-1827
JOUFFROY, Pierre
French, op.1743-1769
JOUKOVSKY, Stanislav
Joulianovitch
Russian, 1873-
JOULLAIN, François
French, 1697-1778
JOULLAIN, Nicolas René
see Jollain
JOULLAIN, Pierre
see Jollain
JOURAVLEFF or
Jouravlioff, Firs
Sergeievitch
Russian, 1836-1901
JOURDAIN, Desiré
Prosper
French, op.1787
JOURDAIN, Francis
French, 1876-1958
JOURDAIN, Henri
French, 1864-1931
JOURDAIN, Roger Joseph
French, 1845-1918
JOURDAN, Adolphe
French, 1825-1889
JOURDAN, Louis
French, 1872-
JOURDAN, Theodore
French, 1833-p.1905
JOURD'HEUIL, Jourdeville
or Jourdheull
French, 1759-1781
JOURNEY, John Gabriel
British, op.1749-1752
JOURNIAC
French, 20th cent.
JOUSSE, Mathurin
French, 1607-a.1692
JOUSSELIN, François
French, 20th cent.
JOUVE, Paul P.
French, 1880-
JOUVENET, François
French, 1664-1749
JOUVENET Le Grand,
Jean, III (Jean
Baptiste)
French, 1644-1717
JOUVENET, Noël, III
French, op.1685-m.1698
JOVANIC, Raja (Pavle)
Bulgarian, 1859-1957
JOVENEAU, Jean
French, 1888-
JOWETT, Mrs.
see Russell, Ann
JOWETT, Percy Hague
British, 1882-1955
JOY, George William
British, 1844-1925
JOY, Gordon
British, 1948-
JOY, John Cantiloe
British, 1806-1866

JOY, Thomas Musgrove
British, 1812-1866
JOY, William
British, 1803-1867
JOYANT, Jules
French, 1803-1854
JOYARD, Henriette
see Pesne
JOYEUX, Pierre Samuel
Louis
Swiss, 1749-1818
JOZELLI
Italian, op.1791
JOZSA, Karoly
Hungarian, 1872-
JUAN de Burgos
Spanish, op.c.1450
JUAN de Carrión
Spanish, 15th cent.(?)
JUAN de España
see Johannes
Hispanus
JUAN Flamenco
Spanish, op.1496-1499
JUAN de Flandes
Spanish,
op.c.1496-m.a.1519
JUAN II de Flandes
Spanish, 16th cent.
JUAN Hispalense or
Hispalensis
Spanish, op.c.1420
JUAN de Holanda
see Jan Joest von
Calcar
JUAN de Joanes or
Juanes
see Masip, Vicente
Juan, I
JUAN de Levi
Spanish, op.1392-1407
JUAN de la Miseria
see Narducci
JUAN de Pereda
Spanish, op.c.1525
JUAN del Pont
see Pons
JUAN de Sevilla y
Romero, or de Romero
y Escalante
Spanish, 1643-1695
JUAN de Tarragona
Spanish, op.1359-1410
JUAN de Toledo
(El Capitan)
Spanish, 1611-1665
JUAN de Valdes, Nica
see Valdes-Leal
JUAN de Zamora
Spanish, op.1531-1578
JUANES, Juan de
see Masip, Vicente
Juan, I
JUAREZ, Guadalupe
Spanish, 19th cent.
JUAREZ or Xuarez, José
Spanish, op.1642-1698
JUAREZ or Xuarez, Juan
Rodriguez
Spanish, 1676-1728
JUAREZ, Luis
Spanish, op.1610-1630
JUAREZ, Nicolas Rodriguez
Mexican, 1667-1734
JUARRA, Filippo
see Juvara
JUDD, Don
American, 1928-

JUDD, John
British, op.1774-1793
JUDKIN, Rev. Thomas
James
British, 1788-1871
JUDLIN, Alexis
German, op.1791-1793
JUECHSER, Hans
German, 20th cent.
JUEL, Cristence
Swedish, 17th cent(?)
JUEL, Jens
Danish, 1745-1802
JUERGENS, Alfred
American, 1866-
JUETTNER, Franz Albert
German, 19th cent.
JUFFRE or Jufre, Antonio
see Giuffre
JÜGEL, Friedrich
(Johann Friedrich)
German, op.1787-m.1833
JUGELET, Jean Marie
Auguste
French, 1805-1875
JUGOSLAV SCHOOL,
Anonymous Painters
of the
JUILLERAT, J.V.C.
Swiss, op.1797
JUILLERAT, Jacques Henri
Swiss, 1777-1860
JUKES, Francis
British, 1747-1812
JUKES, J.
British, op.1791-1802
JULES, Mervin
American, 1912-
JULES de Saux, Sophie
(née Bouteillier)
see Browne, Henrietta
JULIA, Ascencio
('El Pescadoret')
Spanish, a.1771-1816
JULIEN, Anthelme Joseph
Claude Julien
French, 1840-1867
JULIEN de Parme, Jean
Antoine
French, 1736-1799
JULIEN, Pierre
French, op.1731-1804
JULIEN, Rémy Eugéne
(Emile Julien)
French, 1797-1868
JULIEN or Jullien, Simon
French, 1735-1800
JULIO, Romano
see Aquiles
JULLIAN, Phillippe
French, 19th cent.
JULLIARD or Juliard,
Jacques Nicolas
French, 1715/19-1790
JULLIEN, Simon
see Julien
JULLIOTT, Mme. Made
French, 1887-1948
JUNCKER, Hermann
German, 18th cent.
JUNCKER von Prag,
Johann
German, op.1400
JUNCKER, Justus
German, 1703-1767
JUNCKER von Prag,
Wenzel
German, op.1400
JUNDT, Gustave Adolphe
French, 1830-1884

JUNE, John
British, op.1740-1770
JUNEAU, Denis
Canadian, 1925-
JUNEK, Lorris or Leo
Yugoslavian, 1899-
JUNG, Friedrich August
see Junge
JUNG, Jakob (Johann
Jakob)
German, 1819-1844
JUNG, Theodore
French, 1803-1865
JUNGBLUT, Johann
German, 1860-1912
JUNGE or Jung,
Friedrich August
German, 1781-1841
JÜNGER, Johann Christoph
German, op.1767
JUNGHANNS, Julius Paul
German, 1876-
JUNGHEIM, Carl
German, 1830-1886
JUNGMANN, Maarten Johannes
Balthasar
Dutch, 1877-1964
JUNGMANN, Nico
Dutch, 1872-
JUNGNICKEL, Ludwig
Heinrich
German, 1881-
JUNGSTEDT, Axel Adolf
Harald
Swedish, 1859-
JUNGSTEDT, Kurt
Swedish, 1894-
JUNGWIRTH, Joseph
German, 1869-1950
JUNIOR, L.
see Lemire, Antoine
JUNIPER, Robert
Australian, 1929-
JUNIUS, Isaak
Dutch, op.1640-1657
JUNIVAL, J.
American, 20th cent.
JUNKERS, Adja
American, op.1960
JUNOR, D.
British, op.1808
JUNYER, Joan
Spanish, 20th cent.
JUON, Andreas
Swiss, 1895-
JUON, Konstantin
Fjodorovitch
Russian, 1875-1958
JURA, Thomasz
Polish, 20th cent.
JURADO, Carlos
Mexican, 1926-
JÜRGENSEN, Fritz
(Georg Urban Frederik)
Danish, 1818-1863
JURRES, Johannes
Hendricus
Dutch, 1875-1946
JURY, Wilhelm
(Johann Friedrich
Wilhelm)
German, 1763-1829
JUSSUPOFF, Aleksander
Polish, 19th cent.
JUSTE
see Egmont
JUSTE, Juste de
(Giusto Betti)
French, op.c.1537-m.c.1559

JUSTINAT, Justina or
Justinar, Augustin
Oudert
French, -1743
JUSTUS de Alemannia
or Allamagna
German, op.1451
JUSTUS van Egmont
see Egmont
JUSTUS of Ghent (Joos
van Wassenhove or
Giusto da Guanto)
Netherlands,
op.c.1460-1480
JUSTUS of Padua
see Menabuoi, Giusto
di Giovanni de'
JUTSUM, Henry
British, 1816-1869
JUTTNER, Bruno
German, 1880-
JUTZ, Carl
German, 1838-1916
JUUEL, Andreas
Danish, 1817-1868
JUVARA, Aloisio
(Tommaso Aloisio)
Italian, 1809-1875
JUVARA, Ivara, Juarra
or Juvarra, Filippo
Italian, 1674/6-1736
JUVEE, J.B.
French, 19th cent(?)
JUVENEL or Juvenell,
Nicolas, I
Netherlands,
op.1550-m.1597
JUVENEL or Juvenell,
Paul, I
German, 1579-1643

K

K...., Charlotte de
French, op.1794
KAAZ or Katz, Carl
Ludwig
German, 1773-1810
KABEL or Cabel, Adrian
or Ary van der, or
Adrian Vandercable,
Vandrecable etc.
Dutch, 1630/1-1705
KABEL or Cabel, Engel,
Ange or Angelo van der
Dutch, op.1665-1695
KABELL, Ludvig Christian
Brinck Seidelin
Danish, 1853-1902
KACERE, John
American, 20th cent.
KACHADOORIAN, Zubel
American, 1924/6-
KACHEL, Ludwig
German, 1830-1858
KACZ, Endre Komaromi
Hungarian, 1880-
KACZHEIMER, Wolfgang
see Katzheimer
KADAR, Bela
Hungarian, 1877-1955
KADAR, Livia
Hungarian, 1894-
KADLIK or Thadlik,
Franz
Czech, 1786-1840
KADORIZI, Catoriza or
Kadoriza, Wolfgang Joseph
German, op.1697-1730

KADOUNIS
Greek, 17th cent.
KAEMMERER, Frederik
Hendrik
Dutch, 1839-1902
KAEMMERER, Johan Hendrik
Dutch, 1894- .
KAEMPFFER, Eduard
German, 1859-
KAESERMANN, Kaisermann
or Keiserman, François
Swiss, 1765-1833
KAEX, L. de
Dutch(?), op.1651
KAGER, Johann Mathias
German, 1575-1634
KAHL, Karl N.
German, 1873-
KAHLER, Eugen von
Czech, 1882-1911
KAHLO, Frida (de Rivera)
Mexican, 1910-
KAIL, Bernhard
see Keil
KAINER, Ludwig
German, 1885-
KAISER, Eduard
German, 1820-1895
KAISER, Friedrich
German, 1815-1890
KAISER, Hans
German, 1914-
KAISER, Ludwig
Friedrich
German, 1779-1819
KAISER, Richard
German, 1868-1941
KAISER-HERBST, Carl
German, 1858-
KAISERMANN, Franz
Swiss, 1765-1833
KAJA, Zbigniew
Polish, 20th cent.
KAJÁRI, Gyula
Hungarian, 20th cent.
KALCKREUTH, Leopold
Carl Walther Graf
von
German, 1855-1928
KALCKREUTH, Stanislaus
(Eduard Stanislaus)
Graf von
German, 1820-1894
KALDENBACH, Jan Antonie
Dutch, 1760-1818
KALDENBACH or Caldenbach,
Martin (Hesse or Hess)
(Master of the Frankfurt
Altar)
German, p.1470-1518
KALDING, Hans
German, 1514-
KALF, Willem
Dutch, 1619-1693
KALICHEW, G.L.
Russian, op.1799
KALKHOF, Peter
British, 1933-
KALLENBERG, Anders
Hansson
Swedish, 1834-1902
KALLENBERG, Jakob
Swiss, op.1535-1565
KALLMEYER, Hans Julius
Bernhard
German, 1882-
KALLMORGEN, Friedrich
German, 1856-1924

KALLOS, Paul
Hungarian, 1928-
KALLSTENIUS, Gottfried
Samuel Nikolaus
Swedish, 1861-1943
KALMAKOFF, Nicola
Russian, op.1927
KALNYNSH or Kalnins,
Edvards F.
Russian, 1904-
KALRAET
see Calraet
KALTENMOSER, Karl
German, 1853-1923
KALTENMOSER, Kaspar
German, 1806-1867
KALTENMOSER, Max
German, 1842-1887
KALTENOFER, Kalthoff
or Koltenoffen, Peter
German, op.1457-m.c.1490
KALTER, Joseph
see Kaltner
KALTHOFF, Peter
see Kaltenofer
KALTNER or Kalter,
Joseph
German, c.1758-p.1824
KALVACH, Rudolf
German, 1883-
KALVODA, Alois
Czech, 1875-1934
KAMENEV, Lev Lvovich
Russian, 1833-1886
KAMENOW, Saszo
Bulgarian, 20th cent.
KAMIHIRA, Ben
French, 20th cent.
KAMINSKI, Aleksander
Polish, 1823-1886
KAMKE, Georges
French, 1889-
KAMKE, Ivar
Scandinavian, 1882-1936
KAMM
German, 18th cent.
KAMOCKI, Stanislas
Polish, 1875-1944
KAMPEN, Jacob van
see Campen
KAMPER, Godaert
Dutch, c.1613/14-1679
KAMPF, Arthur
German, 1864-1950
KAMPF, Eugen
German, 1861-1902
KAMPF, Max
Swiss, 1912-
KAMROWSKI, Gerome
American, 1914-
KAMSETZER, Jan Baptist
German, 1753-1795
KANDEL, Kandell,
Kandler or Kannel,
David
German, c.1527-a.1596
KANDINSKY, Wassily
Wassiljewitsch
Russian, 1866-1944
KANDLER, David
see Kandel
KANDLER, Wilhelm
German, 1816-1896
KANE, John
American, 1860-1934
KANE, Paul
Canadian, 1810-1871

KANELBA, Rajmund
Polish, 1897-
KANNEL, David
see Kandel
KANNEMANS, Christiaan
Cornelis
Dutch, 1812-1884
KANOLDT, Alexander
German, 1881-1839
KANOLDT, Edmund
Friedrich
German, 1845-1904
KANOVITZ, Howard
American, 1929-
KANTARDZIEWA, Weni
Bulgarian, 20th cent.
KANTOR, Morris
American, 1896-
KANTOR, Tadeusz
Polish, 1915-
KANZ, Carl Christian
German, 1758-p.1818(?)
KAPELL, P.
German, 19th cent.
KAPELLER
French, op.1771
KAPELLER, J. von
German, op.1896
KAPELLER, Kappeller
or Kappler the Younger,
Joseph Anton
German, 1761-1806
KAPLAN, Anatoli
Russian, 1902-
KAPLINSKI, Léon
Polish, 1826-1873
KAPP, Edmond Xavier
British, 1890-
KAPPERS, Gerhard Martin
see Coppers
KAPPES, Alfred
American, 1850-1894
KAPPIS, Albert
German, 1836-1914
KARAKASZEW, Wilen
Russian, 20th cent.
KARALIS, Giovanni
Jacopo
see Caraglio
KARAVAK, Louis
see Caravaque
KARAZIN, Nicholas
Nicholaivich
Russian, 1842-1908
KARBOWSKY, Adrien
French, 1855-p.1945
KARCHER, Amalie
German, c.1860-
KARDAMITIS, J.
Greek, 1921-
KARDORFF, Konrad von
German, 1877-1945
KARELL, Johann or
Jan
see Careel
KARFIOL, Bernard
American, 1886-1952
KARGER, Carl
German, 1848-1913
KARI, Kaarina
Finland, 20th cent.
KARLOVSKY, Bertelan
(Bartolomaeus)
Hungarian, 1858-1938
KARLOWSKA, Stanislava
de
British, 1880-1952

KARLSTEEN, Arvid
Swedish, 1647-1718
KARMANN, Jacob
German(?), op.1824
KARNEC, J.E.
German, 19th cent.
KARNEJEFF, E.
Russian, 18th cent.
KARNER, C.
German, 18th cent.
KAROLIS, Adolfo de
Italian, 1874-1928
KARP, Leon
American, 1903-1951
KARPATHY, Jenö
Hungarian, 1871-
KARPELES, George
see Kars
KARPINSKI, Alfons
Polish, 1875-
KARPOFF, Giovanni
Russian, 19th cent.
KARS or Karpeles,
George
Czech, 1882-1945
KARSCH, Gerhard
Joseph
German, op.1700-1719
KARSH, Yousuf
American, 1908-
KARSEN, Johann Eduard
(Eduard)
Dutch, 1860-1941
KARSEN or Karssen,
Kasparus
Dutch, 1810-1896
KARSSEBOOM, Friedrich
see Kerseboom
KARSTEN, Elisabet
Charlotta (Kaschanoff)
Swedish, 1789-p.1833
KARSTEN, Ludvig
Norwegian, 1876-1926
KASCHANOFF, Elisabet
Charlotta
see Karsten
KASDAN, Paul
British, 20th cent.
KÄSEWEISS, Michael
German, op.1659-1671
KASPARIDES, Eduard
German, 1858-1926
KASSAK, Lajos
Hungarian, 1887-1967
KASSATKIN, Nikolaj
Alexejewitsch
Russian, 1859-1930
KASTEMAA, Heikki
Finnish, 20th cent.
KASTEN, J.E.
German, 18th cent.
KASTEN, Karl
New Zealand, 1916-
KASTENHETZ
German, 18th cent.
KASTNER, Johann
Evangelist
German, 1776-1827
KASTOR, R.
British, 19th cent.
KASYN, John
Canadian, 20th cent.
KATE, Herman Frederik
Carel ten
Dutch, 1822-1891

KATE, Johan Mari Henri
(Mari) ten
Dutch, 1831-1910
KATE, Johannes Marinus
(Jan) ten
Dutch, 1859-1896
KATSCHALOFF, Grigorij
Russian, 1711-p.1761
KATTLE
Swiss, 18th cent.
KATZ, Alex
American, 1927-
KATZ, Carl Ludwig
see Kaaz
KATZENBERGER,
Balthasar
see Kazenberger
KATZENHEIMER, Wolfgang
see Katzheimer
KATZENRAFAEL
see Mind
KATZENSTEIN, Irving
American, 1902-1973
KATZER, Anton
German, 1863-1940
KATZHEIMER, Kaczheimer
or Katzenheimer,
Wolfgang (Possibly
Master of the Hersbruck
High Altar)
German, op.1478-1508
KAUB-CASALONGA, Alice
German, 1875-
KAUDERBACH, Sigismund
Heinrich
German, op.1665-1700
KAUDETZKY, B.
German, 19th cent.
KAUFFER, Edward McKnight
American, 1891-1954
KAUFFMAN, Arthur
German, 1888-
KAUFFMAN, Johann Michael
see Kaufmann
KAUFFMANN or Kauffman,
Angelica (Maria Anna
Angelica Catherina)
British, 1741-1807
KAUFFMANN, Hermann, I
German, 1808-1889
KAUFFMANN, Hermann, II
German, 1873-
KAUFFMANN, Hugo Wilhelm
German, 1844-1915
KAUFFMANN, Joseph
Johann
Swiss, 1707-1782
KAUFMAN, Craig
American, 20th cent.
KAUFMAN, Donald
American, 1935-
KAUFMAN, W.
British, 19th cent.
KAUFMANN, Adolf
German, 1848/58-1916
KAUFMANN, Isiidor
Hungarian, 1853-1921
KAUFMANN or Kauffmann,
Johann Michael
German, 1713(?)-p.1786
KAUFMANN, Karl
German, 1843-
KAUFMANN, Theodor
German, 1814-p.1887
KAULBACH, Friedrich
German, 1822-1903

KAULBACH, Friedrich
August von
German, 1850-1920
KAULBACH, Hermann
German, 1846-1909
KAULBACH, Wilhelm
(Bernhard Wilhelm
Eliodorus) von
German, 1805-1874
KAULITZ, Christian
Ludwig
German, -1744
KAUNINCK, Kerstiaen de
see Coninck
KAUPERZ, Johann Veit
German, 1741-1816
KAUS, Max
German, 1891-
KAUSINS, Vytautas
Russian, 20th cent.
KAUTZ, Amélie de
see Lacépède
KAUTZKY, Johann
Czech, 1827-1896
KAUW, Albrecht, I
Swiss, 1621-1681
KAVAN, Vladislav
Russian, 20th cent.
KAVANAGH, Joseph Malachy
British, 1856-1918
KAVEL, Martin
French, 19th cent.
KAVLI, Arne Texnes
Norwegian, 1878-
KAWARA, On
Oriental, 20th cent.
KAWASHIMA, Takeshi
American, 1930-
KAY
see also Key
KAY, Archibald
British, 1860-1935
KAY, Bernard
British, 1927-
KAY, James
British, 1858-1942
KAY, John
British, op.1609
KAY, John
British, 1742-1826
KAY, N.A.
British, 18th cent.
KAY, William
British, op.1795
KAYNOT, Hans or Jan
see Keynooghe
KAYSER, Paul
German, 1869-
KAZENBERGER or Katzenberger,
Balthasar
German, op.1602-1613
KEABLE or Keeble,
William
British, op.1753-1754
KEARNEY, William Henry
British, 1800-1858
KEARNS, James
American, 1924-
KEARNY, Francis
American, 1785-1837
KEARSE, Mary
see Lawrence
KEARSLEY, Harriet
British, op.1824-m.1881
KEATE, George
British, 1729-1797

KEATING, George
British, 1762-1842
KEATS, Don Juan Llanos y
British, 19th cent.
KEATS, John
British, 1795-1821
KEDZIERSKI, Apolonusz
Polish, 1851/61-1939
KEEBLE, William
see Keable
KEEFE, John
see O'Keefe
KEELER, Charlotte
American, 19th cent.
KEELHOFF, Frans
Belgian, 1820-1891/3
KEELING, E.J.
British, op.1856
KEELING, Michael
British, 1750-1820
KEELING, William Knight
British, 1807-1886
KEEN, Oskar M.
Swedish, 1867-1947
KEENAN, John
British, op.1790-1819
KEENE, Charles Samuel
British, 1823-1891
KEENE, Thomas
British, 20th cent.
KEERINCKX, Alexander
see Keirincx
KEIGERLIN, Alois
German, op.1830
KEIL, Kail, Kailo,
Keilhau, Keillh
Keyl or Keylhau,
Bernhard (Eberhard?)
(Monsù Bernardo)
Danish, 1624-1687
KEIRINCX, Carings,
Cierinx, Keerinckx,
Keyrincx, Kierings
etc., Alexander
(also identified with
Jacob or Johann Carings
or Cierings)
Flemish, 1600-c.1652
KEISAR, Willem de
see Keyser
KEISER, Carl
Swiss(?), op.1762-1769
KEISERMAN, Francois
see Kaesermann
KEITH, William
American, 1839-1911
KELDERMAN, Jan
Dutch, 1741-1820
KELDRER, Jörg
see Kölderer
KELLEN, David, II
van der
Dutch, 1804-1879
KELLENBACH, Carel
Frederick
Dutch, 1897-
KELLER, Albert von
Swiss, 1844-1920
KELLER, Arthur
Ignatius
American, 1866-
KELLER, Balthasar
German, 1638-1702
KELLER, Charles
British, 20th cent.

KELLER, Friedrich
von
German, 1840-1914
KELLER, Gottfried
Swiss, 1819-1890
KELLER, Heinrich
Swiss, 1778-1862
KELLER, Henry George
American, 1869-1949
KELLER, Johann
Heinrich, I
Swiss, 1692-1765
KELLER, Joseph
German, 1740-1823
KELLER, Pierre
Swiss, 20th cent.
KELLER, Reinhardt
Swiss, 1759-1802
KELLERDALLER, Daniel
see Kellerthaler
KELLERHOVEN, Moritz
German, 1758-1830
KELLER-REUTLINGEN,
Paul Wilhelm
German, 1854-1920
KELLERS, Michael
American, 20th cent.
KELLERTHALER or
Kellerdaller, Daniel
German, op.1598-1665(?)
KELLERTHALER, Johann, I
German, 1530-p.1589
KELLERTHALER, Joannes
or Hans, II
German, c.1560-1637
KELLNER, Hermann, II
German, 1849-1926
KELLOGG, Miner Kilbourne
American, 1814-1889
KELLRER, Jörg
see Kölderer
KELLY, Ellsworth
American, 1923-
KELLY, Felix Runcie
British, 1917-
KELLY, Francis Robert
British, 1927-
KELLY, Sir Gerald
Festus
British, 1879-1972
KELLY, Nicholas
British, op.1810-1831
KELLY, Richard Barrett
Talbot
British, 1896-1971
KELLY, Robert George
Talbot
British, 1861-1934
KELMAN
American, 20th cent.
KELPE, Paul
American, 1902-
KELS, Franz
German, 1828-1893
KELTENHOFER or
Keltenofer, Christoph
German, op.1480-1524
KELTERBORN, Ludwig
Adam
German, 1811-1878
KELTRIDGE, William
British, op.1684
KEMAN, Georges
Antoine
French, 1765-1830
KEMENDY, Eugen (Jeno)
Hungarian, 1860-1925

KEMENY, Gyorgy
Hungary, 20th cent.
KEMENY, Zoltan
Hungarian, 1907-
KEMLY, Franz Peter
Joseph
see Kymli
KEMM, Robert
British, op.1874-1885
KEMMELMEYER, Frederick
American, op.1788-1803
KEMMER, Johann
German, c.1495-p.1554
KEMP, John
British, op.1868-1876
KEMP or Camp,
Nicolaes (Claes) de
Dutch, c.1574-1646
KEMP, Oliver
American, 1887-1934
KEMP, Roger
Australian, 1908-
KEMPE, Roland
Scandinavian, 1907-
KEMPENER, Johann de
German, 17th cent.
KEMPENER, Peter de
(Pedro Campaña,
Petrus Campania or
Campaniensis or
Peter Canpener)
Netherlands, 1503-1580
KEMPER, Henry W.
American, op.1859
KEMPFER, Manfred
German, 20th cent.
KEMPF-HARTENKAMPF,
Gottlieb Theodor von
German, 1871-
KEMPLAY, Charles H.
British, op.1872-1884
KEMP-WELCH, Lucy
Elizabeth
British, 1869-1958
KENCKEL, Kaspar
Swedish, 1650-1724
KENDALL, Edward
Nicholas
British, 18th cent.
KENDALL, William Sergeant
American, 1869-1938
KENDRICK, Emma Eleanora
British, 1788-1871
KENNEDY, Cecil
British, 1905-
KENNEDY, Cedric J.
British, 1898-
KENNEDY, Charles Napier
British, 1852-1898
KENNEDY, D.J.
American, op.1841-1872
KENNEDY, Edward Sherrard
British, op.1863-1890
KENNEDY, John
British, 19th cent.
KENNEDY, Reinier
Willem
Dutch, 1881-1960
KENNEDY, Richard
British, op.c.1846
KENNEDY, Richard
British, 20th cent.
KENNEDY, Thomas
American, 19th cent.
KENNEDY, William
British, 1859-1918

KENNEDY, William Denholm
British, 1813-1865
KENNELY
British(?), op.c.1800
KENNING, J.B.
British, 19th cent.
KENNINGTON, Eric Henri
British, 1888-1960
KENNINGTON, Thomas
Benjamin
British, 1856-1916
KENNION, Edward
British, 1743/4-1809
KENNY, Nicholas
British, c.1807-p.1856
KENNYMAN
British, 17th cent.
KENOY, Frans or
François
see Duquesnoy
KENSETT, John Frederick
American, 1818-1872
KENT, E.
British, 17th cent.
KENT, John
British, op.1770-1773
KENT, Rockwell
American, 1882-
KENT, Sarah
British, 1941-
KENT, William
British, 1684-1748
KEPES, Gyorgy
American, 1906-
KEPETS, Hugh
American, 1946-
KEPFER, Maximilien
Pierre
French, 1798-
KEPPELMANN, H.W.
American, 19th cent.
KERANVAL, L.
British, 19th cent.
KERCKHOVE, Ernest van den
Belgian, 1840-1879
KERCKHOVE, F. van den
Dutch(?), 17th cent.
KERCKHOVE or Kerchove,
Joseph van den
Flemish, 1667-1724
KERDEORET, Gustav de
French, 19th cent.
KERKEN, A. van den
Dutch, op.1647
KERKHOFF, Daniël Johannes
Torman
Dutch, 1766-1821
KERKOVIUS, Ida
German, 1879-1970
KERMADEC, Eugène Nestor
de (Le)
French, 1899-
KERMARREC
French, 20th cent.
KERN or Körne, Anton
(Franz Anton)
German, 1710-1747
KERN, Hermann
Hungarian, 1839-1912
KERN, Johann Adam
German, 1750-1800
KERN, Matthäus
German, 1801-1852
KERNAN, J.
British, 18th cent.
KERNSTOK, Karoly
Hungarian, 1873-1940

KERPENTER or Kerpentier,
P.
Flemish(?), op.c.1650
KERR, Charles Henry
Malcolm
British, 1858-1907
KERR, Henry W.
British, 19th cent.
KERRICH, Thomas
British, 1748-1828
KERR-LAWSON, James
British, 1865-1939
KERSEBOOM, Casauban,
Causabon or Kersseboom,
Friedrich (A.R. de
Charos)
German, 1632-1690
KERSEBOOM, J. (Johann?)
German, op.1680-m.1708
KERSHAW, Dan
American, op.1846
KERSSEMAKERS, Antonius
Cornelis Augustinus
(Anton)
Dutch, 1846-1924
KERSTEN, Wilhelm
German, op.1830-1842
KERSTING, Georg Friedrich
German, 1785-1847
KERSTING, Hermann Karl
German, 1825-1850
KERTBENY, Imre
see Benkert
KERVER, Jacob or Jacques
(Monogrammist 1K)
French, op.1535-m.1583
KESSANLIS, Nikos
Greek, 1930-
KESSEL, Ferdinand van
Flemish, 1648-p.1696
KESSEL, Hieronymus van
Flemish, 1578-p.1636
KESSEL, Jan, I van
Flemish, 1626-1679
KESSEL, Jan, II van
Flemish, 1654-1708
KESSEL, Jan Thomas van
Flemish, 1677-1741(?)
KESSEL, Johan or Jan
Thomasz. van
Dutch, 1641-1680
KESSEL, Theodor van
Dutch, c.1620-p.1660
KESSEL, W. van
Netherlands, op.1721
KESSELL, Mary
British, 20th cent.
KESSELSTADT, Franz
Ludwig, Count von
German, 1753-1841
KESSLER, C.A.
German, op.1814
KESSLER, Christian
Friedrich
German, 1799-1854
KESSLER or Kesseler,
Franz
German, c.1580-p.1650
KESSLER, Stephan, I
German, 1622-1700
KESSLER, Joseph
German, 1826-1887
KESTELMAN, Morris
British, 20th cent.
KESTER, de
British(?), 18th cent.

KESTING, Edmund
German, 1892-
KESTNER, August
German, 1777-1853
KESTOFF
Swiss, 20th cent.
KET, Dirk Hendrik
(Dick)
Dutch, 1902-1940
KETEL, Cornelis
Dutch, 1548-1616
KETT, Willem
Dutch, op.c.1756-1795
KETTEMANN, Erwin
German, 1897-
KETTERLIN, Andreas
Swiss, op.1732-m.1762
KETTLE, Sir Rupert A.
British, 1817-1894
KETTLE, Tilly
British, 1735-1786
KEUN, Hendrik
Dutch, 1738-1787
KEUNINCK or Keuning,
Kerstiaen de
see Coninck
KEUNINCXLOO, Pieter van
see Coninxloo
KEVER, Jacob Simon
Hendrik
Dutch, 1854-1922
KEWELL
British, op.1780
KEY or Kay, Adriaen
Thomasz.
Netherlands,
c.1544-p.1589
KEY, John Ross
American, 1832-1920
KEY, Julian
Belgian, 20th cent.
KEY or Kay, Willem
Netherlands,
c.1515/20-1568
KEYERT, Ruik or Rienk
Dutch, op.1728-1766
KEYHER or Keyhn
German, 18th cent.
KEYL, Bernhard
see Keil
KEYL, Friedrich Wilhelm
German, 1823-1871
KEYLHAU, Bernhard
see Keil
KEYMER, Matthew H.
British, op.1781-1800
KEYNOOGHE or Kaynot,
Hans or Jan
Netherlands, 1520(?)-
KEYRINCX, Alexander
see Keirincx
KEYSE, Thomas
British, 1722-1800
KEYSER, Elisabeth
(Hilda Elisabeth)
Swedish, 1851-1898
KEYSER, Emil
Swiss, 1846-1923
KEYSER, Hendrik de
Dutch, 1565-1621
KEYSER, J.
Netherlands, 17th cent(?)
KEYSER, Nicasius or
Nicaise de
Belgian, 1813-1887
KEYSER, Simon de
Dutch, 17th cent.
KEYSER or Keyzer,
Thomas Hendricksz. de
Dutch, 1596/7-1667

KEYSER or Keisar,
Willem de
Flemish, c.1647-1692
KEYT, George
British, 1901-
KEZDI-KOVACS, Elemér
Hungarian, 1898-
KHANNA, Krishen
American, 20th cent.
KHARLAMOFF
Russian, 18th cent.
KHATZIKIS, Manuel
Lascaris
Greek, 16th cent.(?)
KHAYATT, D.
British, 20th cent.
KHMELKO, Mikhail
Russian, 20th cent.
KHMELUK, Vassyl
Russian, 1903-
KHNOPFF, Fernand
Belgian, 1858-1921
KHRUMPPER, Hans
see Krumpper
KHRUZKY, I.
Russian, op.1837
KHUEN, Leonhard
see Kuen
KICK, Cornelis
Dutch, 1635-1681
KICK, G.
Dutch, 17th cent.
KICK, Simon (also,
erroneously, Jan)
Willemsz.
Dutch, 1603-1652
KICKERT, Conrad
see Kikkert
KIDD, John Bartholomew
British, op.1807-1858
KIDD, William
British, c.1790-1863
KIDMAN, Hilda Elisabeth
British, 1891-
KIDNER, Michael
British, 20th cent.
KIECKENBURGH, Dirck van
see Kyckenburgh
KIEFT, Pieter
Dutch, op.1674-1683
KIELLAND, Kitty
(Christine) Lange
Norwegian, 1843-1914
KIEN, J.V.
Dutch(?), 18th cent.
KIENBUSCH, William
American, 1914-
KIENHOLZ, Ed
American, 20th cent.
KIENINGER, Vincenz
Georg
see Kininger
KIERBERGER
German, op.1513
KIERINGS, Alexander
see Keirincx
KIERMAIER, Franz
see Kirchmaier
KIERS, Petrus
Dutch, 1807-1875
KIERSCHOU, Frederik C.
German, 19th cent.
KIERS-HAANEN, Elisabeth
Alida, (née Haanen)
see Haanen
KIESEL, Conrad
German, 1846-1921
KIESEL, Johanna Christina
see Küsel

KIESEL, Mathäus
see Küsel
KIESER, Eberhard
German, op.1609-1623
KIESSLING, Paul (Johann
Paul Adolf)
German, 1836-1919
KIETZ, Ernst
(Julius Ernst Benedikt)
German, 1815-1892
KIFF, Ken
British, 1935-
KIFFER, Charles
French, 1902-
KIHLE, Harald
Norwegian, 20th cent.
KIHN, Wilfred Langdon
American, 1898-1957
KIJNO, Ladislas
Polish, 20th cent.
KIKI, John
British, 1943-
KIKKERT, Adriaan (Ad)
Dutch, 1914-
KIKKERT, Conrad (Conrad
Kikkert tot den Egmond)
Dutch, 1882-
KIKOINE, Michel
French, 1892-
KILBURN, Lawrence
British, op.1754-m.c.1775
KILBURN, William
British, 1745-1818
KILBURNE, George Goodwin
British, 1839-1924
KILBY, T.
British, 19th cent.
KILIAN the Younger,
Bartholomäus
German, 1630-1696
KILIAN, Christoph
Gustav
German, 1724-p.1776
KILIAN, Georg
German, 1683-1745
KILIAN, Lukas
German, 1579-1637
KILIAN, Philip
German, 1628-1693
KILIAN, Thomas
German, 17th cent.(?)
KILIAN, Wolfgang
German, 1581-1662
KILLIGREW, Killegrew
or Killigren, Anne
British, c.1660-1685/6
KILLINGBECK, Benjamin
British, op.1769-1789
KILPACK, S.L.
British(?), 19th cent.
KIMBALL, Alonzo Myron
American, 1874-1923
KIMBALL, Katharine
American, 20th cent.
KIMBERLY, James H.
American, op.1841-1843
KIMLI or Kimly, Franz
Peter Joseph
see Kymli
KIMMEL, Cornelis
Dutch, 1804-1877
KIMPE, Reimond
Belgian, 1885-
KIMPFEL, Johann
Christoph
German, 1750-1805
KIMURA, Kosuke
Oriental, 20th cent.
KINCH, H.
British, op.1811-1824

KINBORG, John
Scandinavian,
1861-1907
KINDER, Revd. John
New Zealand, 1819-1903
KINDEREN, Antonius
Johannes der
see Derkinderen
KINDLER, Albert
German, 1833-1876
KINDT, David
German, 1580-1652
KING, Agnes Gardner
British, 19th cent.
KING, Billy
American, 20th cent.
KING, Cecil
British, 1881-1942
KING, Charles B.
American, 1785/6-1862
KING, Edward R.
British, 19th cent.
KING, Elizabeth Thomson
British, 1848-1914
KING, Emma, (née
Brownlow)
see Brownlow
KING, Frederic Leonard
American, 1879-
KING, Gunning
British, 1859-1940
KING, Haynes
British, 1831-1904
KING, Jessie Marion
British, 1875-1949
KING, John
British, 1788-1847
KING, John Crookshanks
American, 1806-1882
KING, Captain John
Duncan
British, 1789-1863
KING, John William
American, op.1855-1864
KING, Margaret
British, op.1779-1787
KING, Paul
American, 1867-1947
KING, Phillip
American, 20th cent.
KING Salter
see Salter
KING, Samuel
American, 1749-1819
KING, Thomas
British, -c.1769
KING, Thomas
British, op.1826-1846
KING, W.B.
American, 19th/20th cent.
KING, W.H.
British, op.1808-1836
KING, Yeend (Henry
John Yeend)
British, 1855-1924
KINGERLEE, John
American, 20th cent.
KINGMAN, Dong
American, 1911-
KINGSBURY, Henry
British, op.1775-1798
KINGSLEY, Elbridge
American, 1841-1915
KINIGSTEIN, Jonah
American, 1923-
KININGER, Kieninger or
Kinninger, Vincenz
Georg
German, 1767-1851

KINLEY, Peter
British, 1926-
KINNAIRD, F.G.
British, op.1864-1881
KINNAIRD, Henry John
British, op.1880-1908
KINNINGER, Vincent Georg
see Kininger
KINSETT, John
see Kensett
KINSOEN or Kinson,
François Josèphe
Belgian, 1771-1839
KINSTLER, Everett
Raymond
American, 19th cent.
KINZEL, Josef
German, 1852-1925
KIÖLER, Per
see Köhler
KIÖLSTRÖM, Isak
Scandinavian, op.1778-1792
KIÖRBÖE, Carl Frederik
Swedish, 1799-1876
KIP, Johannes
Dutch, 1652/3-1722
KIP, Willem or
William
Dutch, op.c.1598-1635
KIPPNICK, Heinz
German, 20th cent.
KIPRENSKIJ or Schwalbe,
Orest Adamowitsch
Russian, 1773-1836
KIPSHAVEN, Isaack van
Dutch, 1635/6(?)-p.1670
KIRBERG, Otto Karl
German, 1850-1926
KIRBERGER, Nikolaus
German, op.1519-1521
KIRBY, John Joshua
British, 1716-1774
KIRBY, John Kynnersley
British, op.1914-1939
KIRCHBACH, Franck
German, 1859-
KIRCHBERGER, Hermann
German, 1905-
KIRCHEBNER, Josef
German, 1756-1814
KIRCHEBNER, Peter Paul
German, op.1827-m.1842
KIRCHHOFFER, Henry
British, c.1781-1860
KIRCHMAIER or Kiermaier,
Franz
German, op.1560-m.1589
KIRCHMAIER or Kirchmair,
Sebastian
German, op.1590-1610
KIRCHNER, Albert Emil
German, 1813-1885
KIRCHNER, Ernst ·Ludwig
German, 1880-1938
KIRCHNER, Johann Jakob
German, 1796-1837
KIRCHNER, Matthias
German, 1735-1805
KIRCHNER, Otto
German, 1887-
KIRIAKI, Sapho
Greek, 20th cent.
KIRIN, Vladimir
Russian, 1894-
KIRK, Alexander H.
British, 19th cent.

KIRK, Eve
British, 1900-1969
KIRK, James
British, op.1847-1854
KIRK, Thomas
British, 1765(?)-m.1797
KIRKALL, Elisha
(not Edward)
British, c.1682-1742
KIRKBY, Thomas
British, op.1796-1847
KIRKLEY, Caroline
British, op.1796-1797
KIRKLEY, Miss S.
British, op.1793-1797
KIRKPATRICK, J.
British, 19th cent.
KIRKUP, Seymour Stokes
British, 1788-1880
KIRMER, Michel or
Michael
German, op.1552-1570
KIRNARSKY
Russian, 19th cent.
KIRNER, Johann Baptist
German, 1806-1866
KIRNER, Lukas
German, 1794-1851
KIROV, Dimitar
Bulgarian, 20th cent.
KIRSCH
British, op.1843
KIRSCH, Emanuel
German, 18th cent.
KIRSCHENBAUM, Jules
American, 1930-
KIRSCHMANN, J.
German, 18th cent.
KIRSTA, Georg
Russian, 20th cent.
KIRZINGER
see Kürzinger
KISIELEV, Alexandr
Alexeevich
Russian, 1855-
KISLING, Franz Joseph
German, op.1754-1770
KISLING, Moïse
French, 1891-1953
KISS, J.G.
Hungarian(?), op.c.1640
KISSELJOFF, Alexander
Alexejevitch
Russian, 1838-1911
KISTE, Adolf
German, 1812-1846
KITAJ, R.B.
American, 1933-
KITCHELL, H.M.
American, 19th cent.
KITCHIN, Thomas
British, op.c.1750
KITCHINGMAN or
Kitchinman, John
British, op.1740-1781
KITE, Joseph Milner
British, 1862-1946
KITSIMAGI
Oriental, op.1969
KITSON, Robert Hawthorn
British, 19th cent.
KITTELL, Nicholas
Biddle
American, 1822-1894
KITTELSEN, Theodor
Norwegian, 1857-1914

KITTENSTEYN, Cornelis
van
Dutch, c.1600-p.1638
KITTNER, Patrizius
German, 1809-1900
KIVCHENKO, Alexei
Danilovitch
Russian, 1851-1895
KIYOOKA, Roy Kenzie
Canadian, 1926-
KJERNER, Esther
Swedish, 1873-1952
KJERULF, Hjalmar
Norwegian(?), 19th cent.
KJOLSTRÖM, Isak
Swedish, 1769-p.1799
KLANZINGET
German(?), 18th cent.
KLAPECK, Conrad
see Klapheck
KLAPHAUER, Johann Georg
German, op.1634-1663
KLAPHECK, Konrad
German, 1935-
KLAS, Aleksander
Yugoslavian, 20th cent.
KLASEN, Peter
American, 20th cent.
KLASS, Friedrich Christian
German, 1752-1827
KLATT, Hans
German, 1876-
KLAUBER, Kluber or
Gluber, Hans Hug
Swiss, 1535/6-1578
KLAUBER, Ignaz Sebastian
German, 1753-1817
KLAUBER, Johann Baptist
German, 1712-p.1787
KLAUBER, Joseph Sebastian
German, c.1700-1768
KLAUSER, Jacob
see Clauser
KLAVEN, Marvin
American, 1931-
KLECZYNSKI, Bohdan
Polish, 1851-1916
KLEE, G.R.T.
Swiss, 20th cent.
KLEE, Paul
Swiss, 1879-1940
KLEEHAAS, Theodor
German, 1854-
KLEFMAN, Johann Jacob
German, 1739-1790
KLEEMANN, Nikolaus
Moritz
German, op.1726-m.1756
KLEEMAN, Ron
American, 1937-
KLEEN, Thyra af
Swedish, 1874-
KLEENEKNECHT, Cleeneknecht
or Cleyneknecht, Barent
Cornelisz.
Dutch, c.1608/10-1674
KLEIN, Bernat
Yugoslavian, 1922-
KLEIN, Bernhard
German, 1888-1967
KLEIN, Carl August von
German, 1794-1870
KLEIN, Caspar
German, 18th cent
KLEIN, Cesar Carl Robert
Andreas
German, 1876-1954

KLEIN, Daniel, II
German, op.1745-1747
KLEIN, Franz
see Cleyn
KLEIN, Johann Adam
German, 1792-1875
KLEIN, Johann L.
German, 19th cent.
KLEIN, Oscar
Czech, 20th cent.
KLEIN, Philipp
German, 1871-1907
KLEIN, Yves
French, 1928-
KLEIN-CHEVALIER,
Friedrich
German, 1862-
KLEIN-HALL
German, op.1846
KLEINE, Franz
see Cleyn
KLEINEH, Oscar Conrad
Finnish, 1846-1919
KLEINENBROICH, Wilhelm
German, 1814-1895
KLEINER, Salomon
German, 1700/3-1761
KLEINERT, Markus
Friedrich
German, 1694-1742
KLEINMICHEL, Julius
(Ferdinand Julius
Theodor)
German, 1846-1892
KLEINSCHMIDT, J.
German, 1859-1905
KLEINSCHMIDT, J.
German, 19th cent.
KLEINSCHMIDT, Paul
German, 1883-1949
KLEINT, Boris Herbert
German, 1903-
KLEIST, Heinrich von
German, op.c.1805
KLEIST, Louis de
French, 19th cent.
KLEMENS, Jozef
Bozetech
Czech, 1817-1883
KLENCK, Paul
Swiss, 1844-
KLENGEL or Klingel,
Johann Christian
German, 1751-1824
KLENZE, Leo von
German, 1784-1864
KLEPPER, Max Francis
German, 1861-1907
KLERCK, Hendrick de
see Clerck
KLERK, Willem de
Dutch, 1800-1876
KLEUDGEN, Fritz
German, 1846-
KLEVER, Julius Sergius
(Julij Juljewitsch) von
Russian, 1850-1924
KLEY, Heinrich
German, 1863-1945
KLEIJN, Johan Pieter
Vaupel
Dutch, 1813-1870
KLEIJN, Laurens Lodewijk
Dutch, 1826-1909
KLEIJN, Lodewijk Johannes
Dutch, 1817-1897
KLEYN, Pieter Rudolph
Dutch, 1785-1816

KLIEBER, Edouard
German, 1803-1879

KLIEBER, Josef
German, 1773-1850

KLIEMANN, Carl Heinz
German, 1924-

KLIMES, Thomas
German, op.1780-1788

KLIMKOVIC, Ignác
Hungarian, 1800-

KLIMOWSKI, Andrezj
Polish, 20th cent.

KLIMSCH, Eugen
German, 1839-1896

KLIMT, Ernst
German, 1864-1892

KLIMT, Gustav
German, 1862-1918

KLINCK, Germanns
German, op.1609

KLINCKENBERG, Eugene
Dutch, 1858-

KLINCKOWSTRÖM, Axel
Leonhard
American, 1775-1837

KLINCKOWSTRÖM, Harald
Scandinavian, 1897-

KLINE, Franz
American, 1910-1962

KLINGEL, J.C.
German, 19th cent.

KLINGER, Max
German, 1857-1920

KLINGHOFFER, Clara
German, 1900-

KLINGER, Albert
German, 1869-1912

KLINGSOR, Tristan
(Léon Leclère)
French, 1874-1966

KLINGSTAINER, Paul
German, op.1452-1461

KLINGSTEDT or
Klingstet, Carl Gustav
Swedish, 1657-1734

KLINKENBERG, Johannes
Christiaan Karel
Dutch, 1852-1924

KLINKOWSTRÖM, Friedrich
August von
German, 1778-1835

KLITSCH, Peter
Austrian, 1934-

KLIUN, Ivan
Russian, 20th cent.

KLOCKER, Anna Maria
(Ehrenstrahl)
Swedish, 1666-1729

KLÖCKER or Klöker,
David (Ehrenstrahl)
German, 1629-1698

KLODT v. Jürgensburg,
Michael (I)
Konstantinowitsch
Russian, 1832-1902

KLOEBER, August (Carl
Friedrich) von
German, 1793-1864

KLOMBECK, Johann
Bernard
Dutch, 1815-1893

KLOMP or Clomp,
Albert Jansz.
Dutch, c.1618-1688(?)

KLOOSTERMAN, Johann
Baptist
see Closterman

KLOPPER, Jan
Scandinavian,
op.1702-m.1734

KLOSE, Franz
Ludwig
see Close

KLOSE, Wilhelm
German, 1830-1914

KLOSOWSKI, Alfred
German, 20th cent.

KLOSS, Friedrich
German, op.1783-c.1790

KLOSS, Friedrich
Theodore
German, 1802-1876

KLOSS, Hans
German, 20th cent.

KLOSSOWSKI, Erich
German, 1875-1949

KLOTZ, Bernard
Dutch, op.1672

KLOTZ, Caspar Gerhard
German, 1774-1847

KLOTZ, Lenz
Swiss, 1925-

KLOTZ, Matthias
German, 1748-1821

KLOTZ, Simon Petrus
German, 1776-1824

KLOTZ, Clots or Clotz,
Valentin
Dutch, op.1669-1697

KLUBER, Hans Hug
see Klauber

KLUSKA, Stanislaw
Polish, 20th cent.

KLUTH, Ewald
German, -1923

KLUYVER, Pieter
Lodewijk Francisco
Dutch, 1816-1900

KLYBERG, Carl
Scandinavian, 1878-1952

KMETTY, János
Hungarian, 1889-

KMIT, Michael
Australian, 1910-

KNAB, Ferdinand
German, 1834-1902

KNABE, Hanns
German, op.1481

KNACKFUSS, Hermann
Joseph Wilhelm
German, 1848-1915

KNAP, G.
German, op.1770

KNAPP, Charles W.
American, 1823-1900

KNAPP, Johann
German, 1778-1833

KNAPP, Joseph
German, -1867

KNAPP, O.
German, 19th cent.

KNAPP, Stefan
British, 1921-

KNAPPE or Knapp,
Carl Friedrich
Ivanovitch
Russian, 1745-1808

KNAPTON, Charles
British, 1700-1760

KNAPTON, George
British, 1698-1778

KNARREN, Petrus
Renier Hubertus
Belgian, 1826-1869

KNATHS, Karl
American, 1891-

KNAUS, Ludwig
German, 1829-1910

KNEALE, Bryan
British, 1930-

KNEBEL, Franz
Swiss, 1809-1877

KNEEN, William
British, 1862-1921

KNELL, William
Adolphus
British, op.1825-m.1875

KNELL, William
Calcott
British, op.1848-1865

KNELLER or Kniller, Sir
Gottfried or
Godfrey
British, 1646-1723

KNELLER, Zacharias
see Kniller

KNIBBERGEN, Catherina
van (Catherina de
Hen or de Witte)
Dutch, op.1634-1672

KNIBBERGEN or Knipbergen,
François van
Dutch, 1597(?)-p.1665

KNIEP, Christoph
Heinrich
German, 1755-1825

KNIEPER or Knipper,
Hans (Johan von
Antwerpen or Hans
Maler)
Netherlands,
op.1577-m.1587

KNIGHT, A. Roland
British, 19th cent.

KNIGHT, Charles
British, 1743-c.1826

KNIGHT, Charles
British, 1901-

KNIGHT, Charles Parsons
British, 1829-1897

KNIGHT, Harold
British, 1874-1961

KNIGHT, John Baverstock
British, 1785-1859

KNIGHT, John Prescott
British, 1803-1881

KNIGHT, John William
Buxton
British, 1843-1908

KNIGHT, Joseph
British, 1837-1909

KNIGHT, Dame Laura,
(née Johnson)
British, 1877-1970

KNIGHT, Louis Aston
American, 1873-1948

KNIGHT, Loxton
British, 1905-

KNIGHT, Mary Ann
British, 1776-1851

KNIGHT, Ridgway
(Daniel Ridgway)
American, 1839-1924

KNIGHT, W.G.
British, 19th cent.

KNIGHT, William
British, op.1807-1845

KNIGHT, William
Henry
British, 1823-1863

KNIGHTS, Winifred
see Monington

KNILLE, Otto
German, 1832-1898

KNILLER, Godfrey
see Kneller

KNILLER or Kneller,
Johann Zacharias
German, 1644-1702

KNILLER, Kneller or
Knöller, Zacharias
German, 1611-1675

KNIP, Antoinette
Pauline Jacqueline,
(née Rifer de
Courcelles)
French, 1781-1851

KNIP, Hendrik Johannes
Dutch, 1819-

KNIP, Henriëtte
see Ronner

KNIP, Henriëtte
Gertruide
Dutch, 1783-1842

KNIP, Josephus
Augustus
Dutch, 1777-1847

KNIP, Matthijs Dirk
Dutch, 1785-1845

KNIP, Nicolaas
Frederik, I
Dutch, 1742-c.1809

KNIP, Willem Alexander
Dutch, 1883-1967

KNIPBERGEN, François
van
see Knibbergen

KNIPE, Eliza
British, op.1784-1787

KNIPPER, Hans
see Knieper

KNIPPER, Johann Adam
German, op.1780-1818

KNIPPER, Nicolaus
see Knüpfer

KNIRSCH, Otto
American, op.c.1860

KNISPEL, Ulrich
German, 1911-

KNOBELSDORFF, Georg
Wenceslaus von
German, 1699-1753

KNOFLER, Heinrich H.
German, 1824-1886

KNOLLER, Martin
German, 1725-1804

KNÖLLER, Zacharias
see Kniller

KNOOP, August
German, op.1856-1900

KNOOP, Johannes
Hend(e)rik
Dutch, 1769-1833

KNÖPFLE, Olga
(Olga van Iterson)
Dutch, 1879-1961

KNOPP, Imre
Hungarian, 1867-

KNORR, Georg David
Salomon
German, 1844-1916

KNORR, Hugo
German, 1834-1904

KNORRE, Julius
German, 1807-1884

KNOTT, Taverner
British, op.1858

KNOWLES, Adrian
British, 20th cent.

KNOWLES, Davidson
British, op.1879-1896

KNOWLES, George
Sheridan
British, 1863-1931

KNOWLES, Justin
British, 20th cent.
KNOX, G.J.
British, op.1839-1863
KNOX, Jack
British, 20th cent.
KNOX, John
British, 1778-1845
KNOX, Richard
American, 20th cent.
KNÜPFER, Beneš or
Benesch
Czech, 1848-1910
KNÜPFER, Knipper,
Knufer or Knupfer,
Nicolaus
Dutch, c.1603-1655
KNYFF, Alfred de
Belgian, 1819-1885
KNIJFF, Jacob
Dutch, 1639-1681
KNIJFF, Leendert or
Leonard
Dutch, 1650-1721
KNIJFF or Knijf,
Wouter
Dutch, c.1607-p.1693
KOBELL, Ferdinand
German, 1740-1799
KOBELL, Franz Innocenz
Josef
German, 1749-1822
KOBELL, Georg
German, 1807-1894
KOBELL, Hendrik
Dutch, 1751-1779
KOBELL, Jan, I
Dutch, 1756/7-1833
KOBELL, Jan, II
(Baptist)
Dutch, 1778-1814
KOBELL, Jan, III
Dutch, 1800-1838
KOBELL, Wilhelm Alexander
Wolfgang von
German, 1766-1855
KOBER, Cober, Koeber
or Koebner, Martin
German, op.1580-m.a.1609
KOBERWEIN, Georg
German, 1820-1876
KOBITZ, F.G.
German, 18th cent.
KOBKE, Christen
Schellerup
Danish, 1810-1848
KOBLER, Fritz
German, op.1516
KOBLIHA, Frantisek
Czech, 1877-1962
KOBOLD, Werner
(Johann Werner)
German, c.1740-1803
KOBZDEJ, Aleksander
Polish, 1920-
KOCH, Carl
German, 1827-1905
KOCH, Elisa
French, 19th cent.
KOCH, Franz Anton
German, 19th cent.
KOCH, Georg (Carl
Georg)
German, 1857-
KOCH, Georg Anton
German, 1685-1757

KOCH, Hans Halvorson
Norwegian, op.1752-1796
KOCH, Hermann
German, 1856-
KOCH, John
American, 1909-
KOCH, Joseph Anton
German, 1768-1839
KOCH, Louis
Swiss, op.1799-1802
KOCH, Ludwig
Swiss, 1577-
KOCH, Ludwig
German, 1866-1934
KOCH, Martin
South African, 19th cent.
KOCH, Matthias
German, op.1802-1804
KOCH, N.
German(?), op.1749
KOCH, Pyke
Dutch, 1901-
KOCHANOWSKI, Roman
Polish, 1856/7-1945
KOCHARSKY, Alexander
see Kucharski
KOCH-GOTHA, Fritz
German, 1877-1956
KOCK
see also Cock
KOCK van Aelst
see Coecke van Aelst
KOCK, Theodor
Friedrich
German, 1875-
KÖCKERT, Julius
German, 1827-1918
KŒ, Laurence E.
Leonard
British, op.1885-m.1913
KOEBERGER, Wenzel or
Wenceslaus
see Coebergher
KOEBNER or Koeber,
Martin
see Kober
KOECK, Michele
(Keck)
German, 1760-1825
KOECKE van Aelst
see Coecke van Aelst
KOEDIJCK, Isaac
Dutch, c.1616/18-c.1668
KOEHLER, George Frederic
British, op.1780-m.1800
KOEHLER, Henry
American, 1927-
KOEHLER, Mela
German, 19th cent.
KOEHLER, Robert
German, 1850-1917
KOEKKOEK, Barend Cornelis
Dutch, 1803-1862
KOEKKOEK, Gerardus Johannes
(Gerard)
Dutch, 1871-1956
KOEKKOEK, H.B.
Dutch, op.1874
KOEKKOEK, Hendrik Pieter
Dutch, 1843-
KOEKKOEK, Hermanus, I
Dutch, 1815-1882
KOEKKOEK, Hermanus, II
(Jan van Couver)
Dutch, 1836-1909
KOEKKOEK, Hermanus Willem
Dutch, 1867-1929

KOEKKOEK, Johannes
Hermanus
Dutch, 1778-1851
KOEKKOEK, Joannes Hermanus
Barend
Dutch, 1840-1912
KOEKKOEK, Marinus
Adrianus, I
Dutch, 1807-1870
KOEKKOEK, Willem
Dutch, 1839-1895
KOELMAN, Johan Daniel
Dutch, 1831-1857
KOENE or Koenen,
Isaac
Dutch, c.1637/40-1713
KOENIG, Fritz
German, 1924-
KOEPPEL, Reinhold
German, 1887-1951
KOERBECKE, Johann
German, op.1457-1471
KOERLE, Pancraz
German, 1823-1875
KOERNER, Ernest Carl
Eugen
German, 1846-1927
KOERNER, William Henry
Dethlef
American, 20th cent.
KOERTEN, Johanna
Dutch, 1650-1715
KOESLIG, Franciscus
Netherlands, op.1696
KOESTER, Alexander
German, 1864-1932
KOESTER, Christian
German, 1784-1851
KOETS, Andries
Dutch, 1621/2-p.1661
KOETS or Coets, Roelof, I
(Roelof Claessen)
Dutch, c.1592/3-1655
KOETS, Roelof, II
Dutch, a.1650-1725
KOETSCHET, Achille
Swiss, 1862-1895
KOETSIER, Johannes (Hans)
Dutch, 1930-
KOFFERMANS or Koffermaker,
Marcellus or Marcellis
see Coffermans
KOFTLIN, A.
German, 19th cent.
KOGAN, Moissej
Russian, 1879-1930
KOGLSPERGER, Adolf
German, 1891-
KOHAN, Gyorgy
Hungarian, 1910-
KOHARSKY, T.
Russian, 19th cent.
KOHL, Ludwig
German, 1746-1821
KOHL, Pierre Ernest
French, 1897-
KÜHLER, Albert
German, -1849
KÜHLER, Christian
German, 1809-1861
KÜHLER or Kiöler, Per
Swedish, 1784-1810
KOHLHOF
German, 20th cent.
KOK, Lucas Cornelisz.
de
see Cornelisz.
KOKARSKI, Alexander
see Kucharski

KOKAS, Ignác
Hungarian, 1926-
KOKEN, Edmund
German, 1814-1872
KOKORIN
Russian, 20th cent.
KOKOSCHKA, Bohuslav
German, 1893-
KOKOSCHKA, Oskar
German, 1886-
KOKULAR, Alexandre
Polish, 1793-1846
KOKURIN, V.G.
Russian, 20th cent.
KOLÁŘ, Jiří
Czech, 20th cent.
KOLB, Gideon
British, 1911-
KOLB, Peter
German, 1675-1726
KOLBE, Carl Wilhelm, I
German, 1757-1835
KOLBE, Carl Wilhelm, II
German, 1781-1853
KOLBE, Georg
German, 1877-1947
KOLBE, Heinrich Christoph
German, 1771-1836
KOLBE, J.P.
German, op.c.1776
KÖLDERER, Keldrer,
Kellrer, Koldrar,
Kollrer etc. Jörg
German, op.1497-m.1540
KOLESNIKOFF, Sergei M.
Russian, 1889-
KOLIG, Anton
German, 1886-1950
KOLITZ, Louis
German, 1845-1914
KOLLANEK or Kollanetz,
Josef K.
German, op.c.1760-1775
KOLLE, Claus Anton
Danish, 1827-1872
KOLLE, Helmut
(Helmut von Hugel)
German, 1899-1931
KOLLER, Broucia
German, 1867-
KOLLER, Gustav
German, 1870-
KOLLER, J.A.
Swiss, 19th cent.
KOLLER, Johann Jacob
Swedish, 1746-1805/6
KOLLER, Johann Rudolf
Swiss, 1828-1905
KOLLER, Wilhelm
(Guillaume)
German, 1829-1884
KOLLMANN or Kolman,
Hans Friedrich
Swiss, op.1592-m.c.1615
KÖLLNER, Augustus
German, 1813-1900
KOLLONITSCH or
Kolonitsch, Christian
(not Carl)
German, 1730-1802
KOLLRER, Jörg
see Kölderer
KOLLWITZ, Käthe, (née
Schmidt)
German, 1867-1945
KOIMA, Imre
Hungarian, 20th cent.

KOIMAN, Colman or
Koloman
German, 1471-1532
KOLOMANUS, Pater
see Fellner, Coloman
KOLOS-VARY, Sigismond
Hungarian, 1899-
KOLOZSVÁR, Thomas de
(Coloswar)
Hungarian, op.1427
KOLOZSVARY, Lajos
Hungarian, 1871-
KOLTENOFFEN, Peter
see Kaltenofer
KOMAROMI-KACZ, Endre
Hungarian, 1880
KOMJATI, Gyula
Wanyerka
Hungarian, 1894-
KOMLOSY or Komlossy,
Ede (Eduard)
Hungarian, 1862-
KOMPE, Jan ten
see Compe
KONASHCHEVITCH, Vladimir
Mikhailovitch
Russian, 1888-1963
KONCHALOVSKY, P.P.
Russian, 20th cent.
KONDOR, Béla
Hungarian, 1931-
KONDOR, Gyorgy
Hungarian, 1921-1945
KONDOR, Lajos
Hungarian, 1926-
KONEBERG, Johann
Michael
German, op.1765-1787
KONECNY, Joseph
Czech, 1907-
KONEK, Ida
Hungarian, 1856-p.1890
KÖNEKAMP, Frederick
German, 1897-
KONER, Max
German, 1854-1900
KONFAR, Gyula
Hungarian, 20th cent.
KONICZ, Tadeusz
see Kuntz, Thaddäus
KÖNIG or Konig
see also Koninck
KÖNIG, Anton Friedrich,I
German, 1722-1787
KÖNIG, Franz Xaver
German, c.1711-1782
KÖNIG, Gustav Ferdinand
Leopold
German, 1808-1869
KÖNIG, Hugo
German, 1856-1899
KÖNIG, Johann or Hans
(not Jakob)
German, c.1586-1632/5
KÖNIG, Leo Freiherr
von
German, 1871-1944
KÖNIG, Michael
German, op.1606
KÖNIG, Niklaus
(Franz Niklaus)
Swiss, 1765-1832
KÖNIG, Rudolph
(Georg Rudolph)
Swiss, 1790-1815
KONIGSWIESER, Heinrich
German, op.1552-m.1583

KONINCK
see also Coninck
KONINCK or Coning,
Andries de
Dutch, op.c.1620
KONINCK, Coning,
Conningh or Koning,
Jacob, I
Dutch, c.1610/15-p.1690
KONINCK, Coninck,
Coning, Coningh,
König, Konig etc.,
Jacob, II
Dutch, c.1648-1724
KONINCK, Coninckx or
Koning, Philips
Aertsz. (de)
Dutch, 1619-1688
KONINCK, Salomon
Dutch, 1609-1656
KONING, Cornelis
Dutch, op.1608(?)-m.1671(?)
KONING, Elisabeth Johanna
(Elisabeth Johanna Stapert)
Dutch, 1816-1887
KONINGH, Arie Ketting de
Dutch, 1815-1867
KONINGH, Leendert de
Dutch, 1777-1849
KONINGSLOO, Gillis van
see Coninxloo
KONINK or Coning,
Daniel de
Dutch, 1668-p.1720
KONISHI, Keisuke
Japanese, 20th cent.
KONRAD
see also Conrad
KONRAD von Friesach
German, op.1458
KONRAD von Straubing
German, op.c.1380
KONTCHALVOSKI, Piotr
Petrowitsch
Russian, 1876-
KONTOGLOU, F.
Greek, 20th cent.
KONUPEK, Jan
Czech, 1883-1950
KONIJNENBURG, Willem
Adriaan van
Dutch, 1868-1943
KOOGE, Abraham de
see Cooge
KOOGH, Adrianus van der
Dutch, 1796-1831
KOOI, Willem Bartel
van den
Dutch, 1768-1836
KOOL, Sipke (Cornelis)
Dutch, 1836-1902
KOOL or Koolen,
Jacobus
Dutch, -1666/7
KOOL, Cool, Coolen
or Koolen, Willem
Gillisz.
Dutch, 1608/9-1666
KOONING, Elaine de
American, 1920-
KOONING, Willem de
American, 1904-
KOOPMAN, Augustus
American, 1869-1914
KOPAC, Slavko
Yugoslavian, 20th cent.

KOPALLIK, Franz
German, 1860-
KOPF, Maxim
German, 1892-
KOPMAN, Benjamin D.
American, 1887-
KOPPAY, Joszi Arpád,
Baron von Drétoma
Hungarian, 1859-
KOPPEL, Heinz
British, 1919-
KOPS, Jacobus
see Goedschalksz
KORAB, Karl
German, 1937-
KORAKIANTES, Iphigenia
Evangelinos
Greek, 20th cent.
KORB, A.A.
German, op.c.1780
KORBMANN, C.
German, 19th cent.
KORENJ, Wassily
Russian, op.1696
KORGA, Györga
Hungarian, 1935-
KORIN, Pavel
Dmitrievitch
Russian, 1892-
KORN, Johan Filip
Swedish, 1728-1796
KORNACHER
German, 19th cent.
KORNBECK, Peter
(Johann Peter)
Danish, 1837-1894
KÖRNE, Anton
see Kern
KORNECK, Friedrich
Rudolf Albert
German, 1813-1905
KÖRNER, Anna Maria
Jacobine ('Minna')
German, 1762-1843
KÖRNER, Emma Sophie
German, 1788-1815
KÖRNER, Ernst
German, 1846-1927
KORNFELD, Herbert
American, 20th cent.
KORNHÄUSEL, Josef
German, 1782(?)-1860
KOROBOV, V.M.
Russian, 20th cent.
KOROCHANSKY, Michel
French, 20th cent.
KOROMPAY, Giovanni
Italian, 1904-
KOROVINE, Alexei
Konstantinovitch
Russian, 1897-1950
KOROWIN, Konstantin
Alexejewitsch
Russian, 1861-1939
KORSOUKHINE, Alexis
Russian, 1835-1894
KORUMPANY, Frantisek
Vavrinec
Russian, 19th cent.
KORWAN, Franz
German, 1865-
KOSAREK, Adolf
Czech, 1830-1859
KOSCIUSZKO, Tadeusz
Polish, 1746-1817
KOSEL, Hermann
German, 1896-

KOSINSKI, Jozef
Polish, 1753-1821
KOSKULL, Anders Gustaf
Scandinavian, 1831-1904
KOSLINSKY, Vladimir
Russian, 1891-1967
KOSLOWSKIJ, Michail
Iwanowitsch
Russian, 1753-1802
KOSNICK-KLOSS, Hannah
(Jeanne)
German, 1892-
KOSSAK, Jerzy
Polish, 1890-1963
KOSSAK, Juliusz
Fortunat
Polish, 1824-1899
KOSSAK, Wojciech
(Adalbert), Ritter von
French, 1857-1942
KOSSOFF, Leon
British, 1926-
KOSSOWSKA, Felicja
Polish, 18th cent.
KOST
American, op.c.1860
KOST, Frederick W.
American, 1865-1923
KOSTER, Antonie Lodewijk
(Anton)
Dutch, 1859-1937
KOSTER, Carl Georg
German, 1812-1893
KÖSTER, Christian
Philipp
German, 1784-1851
KOSTER, Everhardus
Dutch, 1817-1892
KÖSTER, Karl
German, 1842-1904
KOSTER or Coster,
Simon de
Dutch, 1767-1831
KOSTKA, Robert
American, 20th cent.
KOSTRZEWSKI, Franciszek
Polish, 1826-1911
KOSUTH, Joseph
Hungarian, 1945-
KOTASZ, Károly (Karl)
Hungarian, 1872-1941
KOTCHAR, Ervand
Russian, 1899-
KOTHGASSER, Kothgassner
or Kottgassner, Anton
German, 1769-1851
KOTOW, Piotr Ivanovitsh
Russian, 1889-1953
KOTSCH, Theodor
German, 1818-1884
KOTSCHENREITER, Hugo
German, 1854-1908
KOTSIS, Alexandre
Polish, 1836-1877
KOTTGASSNER, Anton
see Kothgasser
KOUARSKI, Alexander
see Kucharski
KOUDELKA, Pauline
Freiin von
German, 1806-1840
KOUDRIACHOV, Ivan
Russian, 1896-
KOUNAVINE, A.
Russian, 18th cent.
KOUNELAKIS
Greek, op.1864

KOUNIET, Michiel
see Congnet
KOUSTODIEFF, Boris M.
Russian, 1878-1927
KOUWENHORN, Pieter
see Couwenhorn
KOVACIC, Josip
Yugoslav, 1946-
KOVACS, Mihaly
Hungarian, 1818-1892
KOVACS, Vilmas
Hungarian, 20th cent.
KOVALEVSKY, Pavel
Osipovitch
Russian, 1843-1903
KOVAR, Stanislav
Czech, 20th cent.
KOWALKE, Ron
American, 1936-
KOWALSKI, Ivan
Ivanovitch
Russian, 20th cent.
KOWALSKI-WIERUSZ or
Wierusz-Kowalski,
Alfred von
Polish, 1849-1915
KOWALSKY, Anton
Hermann
German, 1813-
KOWARSKI, Felicjam
Szczesny
Polish, 1890-1948
KOWNER, Josef
Russian, 1895-
KOYANAGUI, Sei
Japanese, 1896-
KOZAKIEWICZ, Anton
Polish, 1841-
KOZLOWSKIJ, Michail
Iwanowitsch
see Koslowskij
KOZNIEWSKA, Anna
Polish, 20th cent.
KRACKER, Johann Lucas
Czech, 1717-1779
KRAECK or Carrach, Jan
or Giovanni, Carracha,
Carracka or Carragua,
(Isidoro Carracca)
Netherlands,
op.1568-m.1607
KRAEMER, Nathalie
French, 1891-1943
KRAEMER, Nicolaus
see Kremer
KRAEMER, Peter, I
German, 1823-1907
KRAEMER, Peter, II
German, 1857-
KRAEMER, Peter, III
German, 1896-
KRAER, Johann Georg
German, -c.1772
KRAFFT, Barbara (Maria
Barbara), (née
Steiner)
German, 1764-1825
KRAFFT, Carl
American, 1884-
KRAFFT, David von
German, 1655-1724
KRAFFT, Jan Lauwryn
Flemish, 1694-p.1765
KRAFFT, Johann
August
German, 1798-1829

KRAFFT, Josef
German, 1787-1828
KRAFFT, Per, I
Swedish, 1724-1793
KRAFFT, Per, II
Swedish, 1777-1863
KRAFFT, Peter (Johann
Peter)
German, 1780-1856
KRAFFT, Wilhelm
(Johann Wilhelm)
German, op.c.1828-1850/60
KRAFFT, Wilhelmina
(Maria Wilhelmina)
Swedish, 1778-1828
KRAHE, Peter Joseph
German, 1758-1840
KRAHE, Wilhelm Lambert
German, 1712-1790
KRAJEWSKA, Helena
Polish, 1910-
KRAJEWSKI, Andrzej
Polish, 20th cent.
KRAJEWSKI, Juliusz
Polish, 1905-
KRALINGE, Jan
German(?), 17th cent.
KRAMER or Krammor,
Gabriel
Swiss, op.1598-m.c.1611
KRAMER, Jacob
British, 20th cent.
KRÄMER, Johann Viktor
German, 1861-1949
KRAMER, Ludwig von
German, 1840-1908
KRÄMER, Nikolaus
German, 1521-1553
KRAMMOR, Gabriel
see Kramer
KRAMPE, Fritz
German, 1913-1966
KRAMSKOJ, Iwan
Nikolajewitsch
Russian, 1837-1887
KRAMSKY, S.
Russian, 1837-1887
KRANS, Olof
American, 1838-1916
KRANTZ, Amelie
German, op.1820
KRANZ, M.
American, op.1839
KRANZINGER, Joseph
German, c.1740-p.1772
KRASNER, Lee (Lee
Pollock)
American, 1909-
KRATKE, Charles Louis
French, 1848-1921
KRATOCHWIL, Marian
Polish, 20th cent.
KRATSCHKOWSKIJ, Iossif
(Josef, Jewstafjewitsch)
Russian, 1854-1914
KRATZENSTEIN-STUB,
Christian Gottlieb
Danish, 1783-1816
KRATZER, Carl Edler
von
German, 1827-1903
KRATZER, Nicolaus
German, 16th cent.
KRAUL, Karl Franz
German, 1754-1796
KRAUS, Anton
German, 1838-1872

KRAUS, Krause or
Krauss, Franz Anton
German, 1705-1752
KRAUS, Friedrich
German, 1826-1894
KRAUS, Krause or
Krauss, Georg Melchior
German, 1737-1806
KRAUS, Gustav Wilhelm
German, 1804-1852
KRAUS, Johann Ulrich
German, 1655-1719
KRAUS, Wenzel
German, 1791-1849
KRAUSE, Franz Emil
German, 1836-1900
KRAUSE, Hans
German, 1864-
KRAUSE, Wilhelm August
Leopold Christian
German, 1803-1864
KRAUSE, William
German, 1875-1925
KRAUSKOPF, Bruno
German, 1892-
KRAUSZ, Simon Andreas
Dutch, 1760-1825
KRAUSZ, Tiberiu
Rumanian, 1919-
KRAUSZ, Wilhelm Victor
German, 1878-
KRAY, Wilhelm
German, 1828-89
KRAYN, Hugo
German, 1885-1919
KRBEC, Rosemonde
Swiss, 20th cent.
KREFFT, Gerard
Australian, 19th cent.
KREGAR, Stane
Yugoslav, 1905-
KREGTEN, Johannes
Aurelius Richard Fedor
(Fedor) van
Dutch, 1871-1937
KREICZINGER, Josef
see Kreutzinger
KREIDOLF, Ernst Konrad
Theophil
Swiss, 1863-1956
KREIENBÜHL, Jürg
Swiss, 1932-
KREILIG von
German, 20th cent.
KREIMER
German, 20th cent.
KREIS, Wilhelm Heinrich
German, 1873-1955
KREITTER
see Greuter
KREIZINGER, Josef
see Kreutzinger
KREJCI, Jan
Czech, 1942-
KRELING, August von
German, 1819-1876
KRELING, Wilhelm
German, 1855-
KRELL, Krehl or Krel,
Hans
German, op.1522-m.c.1586
KREMEGNE, Pinchus
French, 1890-
KREMER or Kraemer,
Nicolaus
German, op.1521-m.1553
KREMER, Petrus
Belgian, 1801-1888

KREMLICKA, Rudolf
Czech, 1886-1932
KREMSER-SCHMIDT
see Schmidt, Martin
Johann
KRENDOWSKIJ, Jewgraf
Fjodorowitsch
Russian, 1810-
KRENN, Edmund
German, 1845/6-1902
KRENN, Hans
German, 1932-
KRESTIN, Lazar
German, 1868-
KRETHLOW or Kretlow,
Johann Ferdinand
German, 1767-1842
KRETSCHMAR, Carl
(Johann Carl Heinrich)
German, 1769-1847
KRETSCHMER, Albert
German, 1825-1891
KRETZSCHMAR, Bernhard
German, 1889-
KRETZSCHMER, Hermann
(Johann Hermann)
German, 1811-1890
KRETZCHMER, Robert
German, 1818-1872
KREUGER, Nils Edvard
Swedish, 1858-1930
KREUL, Carl (Johann
Friedrich Carl)
German, 1804-1867
KREUL, Johann Lorenz
German, 1765-1840
KREUTER
see Greuter
KREUTZBERGER or
Creutzberger, Paul
German, -c.1660
KREUTZINGER, Kreuzinger,
Kreizinger, Kreiczinger,
Josef
German, 1751/7-1829
KREUTZBERG, Peter
(Pit)
Russian, 19th cent.
KREUZFELDER, Johann
German, 1577-1636
KREYDER, Alexis
(Joseph Alexis)
German, 1839-1912
KREYSSIG, Hugo
German, 1873-p.1909
KRICHELDORF, Carl
German, 1863-
KRICHELDORF, Hermann
Gottlieb.
German, 1867-1949
KRIEG, Krig, Kriegck,
Krick, Kriag or
Krieger(?), Hans
(Joannes)
German, c.1590-1643/7
KRIEGEL, Willy
German, 1901-
KRIEGHOFF, Cornelius
Canadian, 1812-1872
KRIEHUBER, Joseph
German, 1800-1876
KRIMMEL, Johann Ludwig
(John Lewis)
German, 1787-1821
KRIMOV, Nicolas P.
Russian, 1884-

KRISAN
German, 19th cent.
KRISTENSEN, Johan von
Scandinavian, 20th cent.
KRIVOUTZ, Vladimir
Russian, 1901-
KRIWET, Ferdinand
German, 20th cent.
KROCK or Krogh,
Hendrik
German, 1671-1738
KRODEL, Crodel or
Krötel, Martin
German, op.1539-1547
KRODEL, Crodel or
Krötel, Matthias, I
German, op.1550-m.1605
KRODEL, Crodel or
Krötel, Matthias, II
German, op.1593-m.1618
KRODEL, Crodel or
Krötel, Wolfgang
German, a.1500-p.1561
KROES, Lenaert
see Master of the
Prodigal Son
KROESH, Jan van
Dutch, 17th cent.
KROGH, Hendrik
see Krock
KROHG, Christian
Norwegian, 1852-1925
KROHG, Oda, (née
Lasson)
Norwegian, 1860-1935
KROHG, Per Lasson
Norwegian, 1889-
KROHL, Heinz
German, 20th cent.
KROL, Abraham
French, 1919-
KROL, Stan
British, 1910-
KROLL, Leon
American, 1884-
KROMBACH, Max
(Peter Paul)
German, 1867-
KRONBERG, Julius
Swedish, 1850-1921
KRONBERG, Louis
American, 1872-
KRONBERGER, Carl
German, 1841-1921
KRÖNER, Christian
(Johann Christian)
German, 1838-1911
KRONOVER, Irene
British, 20th cent.
KRONSTRAND, Bror.
Scandinavian, 1875-1950
KROOS
see Croos
KROPF, J.A.
Swiss, op.1777
KRÖTEL, Matthias
see Krodel
KRØYER, Peter Severin
Danish, 1851-1909
KROUTHEN, Johan
Frederik
Swedish, 1858-1932
KROYMANN, Carl
Friedrich
German, 1781-1848
KRSIC, Bogdan
Yugoslavian, 20th cent.

KRUG, Edouard
French, 1829-1901
KRUG, Ludwig
German, c.1488/90-1532
KRÜGER, Andreas
Ludwig
German, 1742-1805
KRÜGER, Anton
(Ferdinand Anton)
German, 1795-1857
KRÜGER, Franz
(Pferde-Krüger)
German, 1797-1857
KRÜGER, Hermann
German, 1834-1908
KRÜGER, Johann August
German, op.1787-1830
KRÜGER, Johann Gottlob
German, op.1758
KRÜGER, Johann Heinrich
Carl
German, 1812-1880
KRÜGER, Werner
German, 1917-
KRUIFF, J. de
German(?), 17th cent.(?)
KRUMHOLZ, Ferdinand
German, 1810-1878
KRUMM, Martin
Swiss, 1540-1577/8
KRUMPPER, Khrumpper,
Krumper or Krumpter,
Hans (Hans von
Weilheim)
German, c.1570-1634
KRUSE, Christian
Scandinavian,
1876-1953
KRUSEMAN, Cornelis
Dutch, 1797-1857
KRUSEMAN, Frederik
Marinus
Dutch, 1816-1882
KRUSEMAN van Elten,
Hendrik Dirk
Dutch, 1829-1904
KRUSEMAN, Jan Adam
Janszoon
Dutch, 1804-1862
KRUSEMAN, Jan Theodor
Dutch, 1835-1895
KRUSHENICK, Nicolas
American, 1929-
KRUSZEWSKI, Jozef
Polish, 1856-1900
KRUYDER, Herman Justus
Dutch, 1881-1935
KRUYDER, Johanna Laura
(Jo), (née Bouman)
Dutch, 1886-
KRUIJFF, Cornelis de
Dutch, 1771-1854
KRUYS, Cornelis
see Cruys
KRYLOV, Porfiry
see Kukryniksky
KRZYZANOWSKI, Conrad
Polish, 1872-1922
KSELL, Georg
see Gsell
KUBANYI, Lajos
Hungarian, 1855-1912
KUBICEK, Jan
Czech, 20th cent.
KUBIN, Alfred
German, 1877-

KUBINZKY, Karl
Czech, 1837-1889
KUBISTA, Bohumil
Czech, 1884-1918
KÜBLER, Ludwig
German, op.c.1850-1868
KÜBLER, Werli, II
German, 1582-1621
KÜBLER, Werner (Werli), I
Swiss, 1555-1586
KUBOVSKY, Peter
German, 1930-
KUBRICK, Christiane
French, 20th cent.
KUCHARSKI, Couasky,
Kocharsky, Kokarski,
Kouarski etc.,
Alexander
Polish, 1741-1819
KÜCHEL, Michael
(Johann Jakob Michael)
German, 1703-1769
KÜCHENMEISTER, Rainer
German, 20th cent.
KÜCHLER, Albert
Scandinavian, 1803-1886
KUDRIASCHOW, Ivan
see Koudriachov
KUDRIN, Victor
Petrovich
Russian, 20th cent.
KUEHL, Gotthardt
German, 1850-1915
KUEHN, Frances
Tannebaum
American, 20th cent.
KUEN, Françoise
French, 20th cent.
KUEN, Franz Martin
German, 1719-1771
KUHN, Friedrich
Swiss, 20th cent.
KÜHN, Justus Englehardt
American, op.1708-m.1717
KUEN, Khuen, Kuhen,
Kuhn etc., Leonhard
(J. Leonhard)
German, 1765-p.1797
KUENINCXLOO, Pieter van
see Coninxloo
KUEPER, Abraham
see Cuyper
KÜGELGEN, Carl
(Ferdinand Carl) von
German, 1772-1832
KÜGELGEN, Gerhard
(Franz Gerhard) von
German, 1772-1820
KÜGELGEN, Wilhelm von
Russian, 1802-1867
KUGLER, Franz
German, 1808-1858
KUGLER, Luise
German, 1811-1884
KÜHLEN, Franz
German, op.1821-1854
KUHN, Max
German, 1838-1888
KUHN, Walt
American, 1877-1949
KUHNEL, Christian
Friedrich
German, op.1719-1792
KÜHNERT
German, 19th cent.

KUHNERT, Wilhelm
(Friedrich Wilhelm
Carl)
German, 1865-1926
KUHRT, Rolf
German, 20th cent.
KUHSTOSS, Paul
Belgian, 1870-1898
KUIL, Gysbert or
Gysbrecht van der
see Kuyl
KUINDJI, Arkhip
Ivanovitch.
Russian, 1842-1910
KUIPEL(?), J.E.P.
Dutch, op.1694
KUIPERS or Cuypers, C.
Dutch, op.1756-1784
KUIPERS, Dirk
see Kuypers
KUJAWSKI, Jerzy
Polish, 1921/2
KUKLA, Reinhold
German, op.c.1920
KUKRYNIKSY (Three
artists- P.N. Krylov,
M.V. Kupriyanov and
N.A. Sokolov.)
Russian, 20th cent.
KULBIN, Nicolai
Russian, 19th cent.
KULHANEK, Oldrich
Czech, 1940-
KULINYI, Istvan
Hungarian, 20th cent.
KULISIEWICZ, Tadeusz
Polish, 1899-
KULL, Hans Rudolf
Swiss, 1802-1824
KÜLL, Johann Baptist
German, 18th cent.(?)
KULLE, Axel Henrik
Swedish, 1846-1908
KULLE, Nils Jakob
Swedish, 1838-1898
KULLING, Ruedi
Swiss, 20th cent.
KULMBACH, Hans Suess
von
German, c.1480-1522
KULMER, Ferdinand
Yugoslav, 1925-
KUMLIEN, Akke
Swedish, 1884-
KUMLIEN, Hjalmar
Swedish, 1837-1897
KUMMER, Robert
(Carl Robert)
German, 1810-1889
KUMMERT, Otto
German, 20th cent.
KUNG, Edgar
Swiss, 20th cent.
KUNIYOSHI, Yasuo
American, 1889/94-1953
KUNKLER, Jean Jules
Adrien
Swiss, 1829-1866
KUNKLER, Johann Heinrich
German, 1756-1836
KUNST
see also Cornelisz.
KUNST, Nicolas
Netherlands, op.1543
KUNTZ, Carl
German, 1770-1830

KUNTZ, Rudolf
German, 1797-1848
KUNTZ, Kuntze, Cunz,
Gunz or Konicz,
Thaddäus or Tadeusz
German, 1731-1793
KUNZ, Adam (Ludwig
Adam)
German, 1857-1929
KUNZE, Alfred
German, 1866-1943
KUPELWIESER, Leopold
German, 1796-1862
KUPER
German, 20th cent.
KUPEZKY, Kopetzki,
Kupecky, Kupeczky
etc. the Elder,
Johann
Hungarian, 1667-1740
KUPFER, Johann Michael
German, 1859-1917
KUPKA, Frantz
Czech, 1871-1957
KUPPER, Christiaan
Emil Maria
see Doesburg, Theo van
KÜPPERS, Leo
German, 1884-
KUPRIYANOV, Mikhail
Vasilyevich
see Kukryniksy
KURELEK, William
Canadian, 20th cent.
KURETANOFF, J.
German, op.c.1850
KURIA, Francesco
see Curia
KURONEN, Pekka
Finnish, 20th cent.
KURT, Klay
American, 1944-
KURTE
see Cordua
KURTH, C.P.
German, 19th cent.
KURTYCZ, Jan Marek
Polish, 20th cent.
KURZ, Alois
German, op.c.1825
KURZBAUER, Eduard
German, 1840-1879
KÜRZINGER or Kirzinger,
Franz
German, 1730-p.1795
KÜRZINGER or Kirzinger,
Marianna
German, 1770-1809
KURZWEIL, Max
German, 1867-1916
KÜSEL, Ernst
Swedish, 1873-1942
KÜSEL, Küsell, Küssell,
Kiesel or Küslin,
Johanna Christina
(Christiana)
German, 1665-
KÜSEL, Küsell, Küssell
or Kiesel, Mätthäus
German, 1629-1681
KÜSLIN, Johanna
Christina
see Küsel
KUSNEZOFF, Pawel
Warfolomejewitsch
Russian, 1878-
KUSPEZIAN, Aram
Avakimovich
Russian, c.1928-

KÜSS, Ferdinand
German, 1800-1886
KUSSAEUS, Cornelis
see Kussens
KÜSSELL
see Küsel
KUSSENS, Cusseus or
Kussaeus (also, erroneously,
Kuffaeus, Kuffens or
Kuffeus), Cornelis Ysbrantsz.
Netherlands,
op.1597-m.1618
KUSTER, Conrad
Swiss, c.1730-c.1802
KUSTER, Johann Kaspar
Swiss, 1747-1818
KUSTODJEFF, Boris
Michajlowitsch
Russian, 1878-1927
KUSZTOS, Endre
Hungarian, 1925-
KUTTER, Joseph
Dutch, 1894-1941
KUVENET, J.
Dutch(?), 18th cent.
KUWASSEG, Charles
Euphrasie
French, 1833-1904
KUWASSEG, Josef
German, 1799-1859
KUWASSEG, Karl Josef
German, 1802-1877
KUYCK, Frans Pieter
Lodewijk van
Belgian, 1852-1915
KUYCK, Jean Louis
(Louis)
Belgian, 1821-1871
KUYK
see Cuyck
KUYL or Kuil, Gysbert
or Gysbrecht van der
Dutch, op.1631-m.1673
KUYPER, Abraham
see Cuyper
KUYPER, Diderick Herman
see Cuypers
KUYPER, Jacques
Dutch, 1761-1808
KUYPER, P. de
Dutch, 19th cent.
KUYPERS or Kuipers,
Dirk
Dutch, 1733-1796
KUYPERS, Jan
Dutch, 1819-1892
KUIJTEN, Henricus
Johannes (Harrie)
Dutch, 1883-1952
KUYTENBROUWER, Martinus
Antonius, II
Dutch, 1821-1897
KVAPIL, Charles
Belgian, 1884-1957
KWELL, A.W.
British, 19th cent.
KWIATKOVSKI, Jean
Polish, 20th cent.
KWIATOWSKI, Teofil
(Anton Teofil)
Polish, 1809-1891
KYCKENBURGH,
Kieckenburgh or
Kyckenburch, Dirck
Nicolaesz. van
Dutch, 1630-a.1663
KYD
see Clarke, Joseph
Clayton

KYDPORT or
Rydport, A.
British, op.1796(?)
KYHN, Vilhelm
(Peter Vilhelm Carl)
Danish, 1819-1903
KYLBERG, Carl
Swedish, 1878-1952
KYLBERG, Lars Wilhelm
Swedish, 1798-1865
KYLE, Joseph
American, 1815-1863
KYME, F.
German, 18th cent.
KYMER, M.H. of
Yarmouth
British, op.1781-1810
KYMLI, Kimli, Kimly
or Kymly, (Kymle,
Kemly or Himly), Franz
Peter Joseph
German,
1748(?)-c.1813(?)
KYRMU, Isaj
Russian, 20th cent.
KYTE, Francis
(Milvius)
British, op.c.1710-1745

L

LAAFF, Leendert de
see Laeff
LAAN, Adolf (also,
erroneously, Adriaan)
van der
Dutch, op.1717-1740
LAAN, Dirk Jan
van der
see Laen
LAANEN, Jasper van der
see Lanen
LAAR, Jan Hendrik
van de
Dutch, 1807-1874
LAAR, Pieter van
see Laer
LABARCHEDE, Dalila
(De Labarché)
French, op.1811-1826
LABAT, Fernand
French, 1889-
LABATIE, Pierre
French, -1777/9
LABBÉ, Emile-Charles
French, op.1836-1885
LABENWOLF, Georg
German, op.1559-m.1585
LABILLE-GUIARD,
Adelaide
see Guiard
LABIN, Cheorghe
Rumanian, 1907-
LA BIOCHAYE, Colin
de
French, 18th cent.
LABISSE, Félix
French, 1905-
LABLACHE, Elizabeth
British, 20th cent.
LABORDE, Comte
Alexandre de
French, op.1809
LABORDE, Charles
French, 1886-1941
LABORNE, Edmé-Emile
French, 1837-1883

LABOUCHERE, Pierre
Antoine
French, 1807-1873
LABOULAYE, Paul de
French, op.1882-1889
LABOUREUR, Jean
Emile
French, 1877-1943
LABRA, José Maria de
Spanish, 1925-
LABRADOR, Juan
Spanish, -c.1600
LABRO-FONT
French, op.c.1929-1932
LABROUCHE, Pierre
French, op.1905-1921
LABROUE, Alphonse de
French, 1792-1863
LABROUE (Barb de la
Broue, la Broue de
St. Avrit), Louise
Péron
French, op.1794-1825
LABROUSSE, Jeanne A.
French, 19th cent.
LABROUSSE, L.F.
French, 18th cent.
LABROUSTE, Henri
(Pierre François Henri)
French, 1801-1875
LABRUZZI, Carlo
Italian, 1748-1818
LABRUZZI, Pietro
Italian, 1739-1805
LABUS, Gerard
Polish, 20th cent.
LABY, Auguste François
French, 1784-1860
LACASSE, Joseph
Belgian, 1894-
LA CAVE, Peter
see Cave
LACCETTI, Valerico
Italian, 1836-1909
LACEPEDE, Amélie de,
(née Kautz)
French, 1796-1860
LACEY, W.S.
British, op.1827-1838
LACH, Andreas
German, 1817-1882
LACH, Fritz
German, 1868-1933
LACHAISE, Gaston
French, 1886-1935
LA CHAPPELLE, Georges
de
French, op.1638-1648
LACHENWITZ, F.Sigmund
German, 1820-1868
LACHIEZE, R.
French, 20th cent.
LACHMAN, Harry B.
American, 1886-
LACHNIT, Wilhelm
German, 1899-
LACHOWICZ, Andrzej
Ignacy
Polish, 20th cent.
LACHTROPIUS, Iacterius
or Lactorius, Nicolaes
Dutch, op.1656-1700
LACKOWIC, Ivan
Yugoslav, 1932-
LACLAU, Armand
French, 1892-
LACLOTTE, Hyacinthe
American, op.c.1815

LACOMA, Francisco José
 Pablo
 Spanish, 1784-1849
LACOMBE
 French, op.1787
LACOMBE, Georges
 French, 1868-1916
LACOMBE, Laura
 French,
 op.1862-1924/5
LACOMBLEZ, Jacques
 Belgian, 20th cent.
LACON, J.
 British, c.1757
LACOSTE, Charles
 French, 1870-
LACOSTE, Pierre
 Eugène
 French, 1818-1908
LACOSTE RIGAIL, Jean-
 Jacques
 French, 1782-1853
LACOUR, Delacour, de
 Lacour or de Lacourt,
 Antoine
 French, 1748-1837
LACOUR, Court, Delacour,
 de Lacour or Lacourt,
 Pierre, I.
 French, 1745-1814
LACRENON, Joseph
 Ferdinand
 French, 1794-1874
LACRETELLE, Jean
 Edouard
 French, 1817-1900
LACROIX, Anton
 French, 1843/5-1896
LACROIX, Charles F.
 (Francois?) de
 (Lacroix de Marseille,
 Delacroix or Della
 Croce)
 French, op.1754-m.1782
LACROIX, G. F. de
 French, -1764
LACROIX, Jean
 Swiss(?), op.1780
LACROIX, Paul
 French, 17th cent.
LA CROIX, Paul
 American, op.1858-1863
LA CROIX, Paul
 Canadian, 1929-
LA CROIX, Pieter
 Frederik de
 Dutch, 1709-1782
LACROIX, Richard
 Canadian, 1939-
LACTERIUS or Lactorius,
 Nicolaes
 see Lachtropius
LACY, Charles John de
 British, op.c.1885-1918
LADBROKE, Frederick
 British, op.1860-1864
LADBROOKE, Henry
 British, 1800-1869
LADBROOKE, John Burney
 British, 1803-1879
LADBROOKE, Robert
 British, 1770-1842
LADELL, Edward
 British, op.1856-1886
LA DELL, Edwin
 British, 1914-1970

LADELL, Ellen
 British, op.c.1886-1898
LANDENSPEIDER, Johann
 German, 1512-p.1561
LADERMAN, Gabriel
 American, 1929-
LADEUIL
 French, 19th cent.
LADISLAUS de Miskolch
 or Miskolc
 Hungarian, op.1394
L'ADMIRAL, Jan
 Dutch, 1699-1773
LADSTATTER, H.
 German, 19th cent.
LADUREAU, Pierre
 French, 1882-
LADURNER, Adolf
 French, c.1798-1856
LAECK, Artus van
 Flemish, op.1586-m.1616
LAECK, Reynier van der
 Dutch, op.1637-m.a.1659
LAEDERICH, Madame
 French, op.1815
LAEFF or Laaff, Leendert
 de
 Dutch, op.c.1660
LAELY, Christian Anton
 Swiss, 1913-
LAEMEN
 see Lamen
LAEMLEIN, Alexander
 French, 1813-1871
LAEN or Laan, Dirk
 Jan van der
 Dutch, 1759-1829
LAENEN, Christoph
 van der
 see Lamen
LAENEN, Gérard
 Belgian, 20th cent.
LAER, Alexander
 Theobald van
 American, 1857-1920
LAER, Jan van
 Dutch, 18th cent.
LAER or Laar, Pieter
 Jacobsz. van or de
 (Bamboccio or Bamboots)
 Dutch, 1592/5-1642
LAERMANS, Eugène Jules
 Joseph
 Belgian, 1864-1940
LAES, Lucas van der
 Dutch, op.1666
LAETHEM, Jacques van
 see Lathem
LAEVERENZ, Gustav
 German, 1851-1906
LAEZ, Jean van
 Flemish, 18th cent.
LAFABRIQUE, Nicolas
 Flemish, 1649-1733
LAFAGE, Raymond
 (not Nicolas R.)
 French, 1656-1690
LAFAIT, Prosper
 see Lafaye
LA FARGE, John
 American, 1835-1910
LA FARGUE, Jacob
 Elias
 Dutch, 1738-p.1771
LA FARGUE, Karel
 Dutch, 1738-1793

LA FARGUE, Maria
 Margaretha
 Dutch, 1743-1813
LA FARGUE, Paulus
 Constantijn
 Dutch, 1729-1782
LAFAYE, Lafait or
 Lafay, Prosper
 French, 1806-1883
LAFFON, Carmen
 Spanish, 1934-
LAFITE, Carl
 German, 1830-1900
LAFITTE, Alphonse
 French, 1863-
LAFITTE, Antonia
 French, op.1816
LAFITTE, Louis
 French, 1770-1828
LAFITTE, N.
 French, 19th cent.
LAFON, Emil Jacques
 French, 1817-1886
LAFON, François
 French, op.1875
LAFON, Henri
 French, op.1849-1859
LAFON, Marie Méloé
 (Marsand)
 French, op.1835-1857
LAFOND, Alexandre
 (François Henri
 Alexandre)
 French, 1815-c.1901
LAFOND, Charles Nicolas
 Raphaël
 French, 1774-1835
LAFOND, Daniel
 (Simon Daniel)
 Swiss, 1763-1831
LAFOND de Fenion,
 Aurore Etienette
 French, op.1812-1824
LAFONTAINE, Fontaine
 or Fountain, Georg
 Wilhelm
 German, 1680-1745
LAFONTAINE, Pierre
 Joseph
 Belgian, 1758-1835
LAFOSSE, Charles de
 French, 1636-1716
LA FOSSE, Coessin de
 Charles-Alexandre
 French, 1829-c.1910
LA FOSSE, Jean-Baptiste-
 Adolphe
 French, c.1810-1879
LAFOSSE, Jean Baptiste de
 French, 1721-1775
LAFOSSE, Jean Charles de
 French, 1734-1789
LAFRENSEN or Lawerantz,
 Niclas, I
 Swedish, 1698-1756
LAFRENSEN, Lawerentz,
 Lawreince, Lavreince
 or Lavrince, Niclas, II
 Swedish, 1737-1807
LAFRERI, Lafréry or
 Lanfrerius, Antonio
 Italian, 1512-1577
LAFUGIE
 American, 20th cent.
LAGAIA, Giovanni
 Antonio de
 Swiss, op.1519

LA GANDARA, Antonio
 see Gandara
LAGAR, Celso
 Spanish, 1891-
LAGARDE, Pierre
 French, 1853-1910
LAGERBERG, Don
 American, 20th cent.
LAGERHOLM, Wilhelmina
 Swedish, 1826-1917
LAGIER, Eugène
 French, 1817-1892
LAGIRAUDIERE
 French, 20th cent.
LAGNEAU or Lanneau,
 Nicolas(?)
 French, op.c.1590-1610
LAGNIET, Jacques
 French, 1620-1672
LAGOOR, Johann or
 Jan de
 Dutch, op.1645-1659
LA GOURDAINE, Jean
 Pierre Norblin de
 see Norblin de la
 Gourdaine
LAGOUZ or Lagous
 Family
 .French, 16th/17th cent.
LAGRANGE, André
 French, 1889-
LA GRANGE, F.C. de
 French, op.c.1670
LAGRENEE, Francois
 (Anthelme François)
 French, 1774-1832
LAGRENEE, Jean Jacques,
 II
 French, 1739-1821
LAGRENEE, Louis Jean
 François, I
 French, 1725-1805
LAGRU, Dominique
 French, 1873-
LAGUERNELA, Mariane
 Barbasan
 Spanish, 1864-1924
LAGUERRE, John
 British, 1688-1748
LAGUERRE, Louis
 French, 1663-1721
LAGUILLERMIE, Frédéric
 French, 1841-1934
LAGUT, Irène
 French, 1893-
LAGUY, Joseph
 French, 1738-1798
LAGYE, Victor
 Belgian, 1829-1896
LAHALLE, Charles
 Dominique Oscar
 French, 1832-1909
LAHARRAGUE, Teodore
 Spanish, 20th cent.
LAHAYE, Alexis-Marie
 French, 1850-1914
LA HAYE, Cristoffe
 French, op.1591-1622
LA HAYE, Jean de
 French, 1641-p.1688
LA HAYE, M. de
 French, 20th cent.
LA HAYE, Raymond de
 Belgian, 1882-1914
LA HAYE, Reinier de
 Dutch, c.1640-p.1695

LAHDE, Gerhard
Ludwig
German, 1765-1833
LA HIRE, Jean Nicolas
French, 1685-1727
LA HIRE or La Hyre,
Laurent de
French, 1606-1656
LA HIRE or La Hyre,
Louis de
French, 1629-1653
LAHNER, Emil
French, 1893-
LA HOULIERE, R. de
French, op.1789-1791
LA HOUVE, P. de
French, 16th cent.
LAHUERTA, Genaro
Spanish, 20th cent.
LAIB, Laibl or Leib,
Konrad
German, op.1448-1457
LAIDLAY, William James
British, 1846-1912
L'AIGLE, Comte de
French, 19th cent.
LAILLARD, Jeanne
French, 20th cent.
LAINE, Laîné or L'Aîné,
Francois or Francis
French, 1721-1810
LAINE, Tomson
British, 20th cent.
LAING, Frank
British, 1862-
LAING, Gerald
American, 20th cent.
LAING, Mrs J.G.
British, 19th cent.
LAING, James G.
British, 1852-1915
LAIR or Layr, Franz
Xaver
German, 1812-1875
LAIR, Jean Louis César
French, 1781-1828
LAIRD, Alicia H.
British, op.1881-1897
LAIRESSE, Gerard (de)
Flemish, 1641-1711
LAIRESSE, Jan de
Flemish, 1674-
LAISSEMENT, Henri Adolphe
French, c.1854-1921
LAIZICK
German, 18th cent.
LAJOCONO, Francesco
Italian, 19th cent.
LAJOUE, Jacques, II de
French, 1687-1761
LAKEMAN, Nathaniel
American, 1756-p.1830
LAKNER, László
Hungarian, 1936-
LALAING, Comte Jacques
de
Belgian, 1858-1917
LALAISSE, Hippolyte
(François Hippolyte)
French, 1812-1884
LALANNE, Maxime François
Antoine
French, 1827-1886
LALAU, Maurice Georges
Elie
French, 1881-
LALAUZE, Alphonse
French, 1872-

LALEMENT or Laleman,
Philippe
see Lallemand
LA LEZARDIERE, Aymar de
French, 1927-
LALIBERTE, Norman
American, 1925-
LA LIVE de Jully,
Ange Laurent de
French, 1725-1779
L'ALLEMAND, Conrad
German, 1809-1880
LALLEMAND, Lalleman or
Lallman, Georges
French, op.1598-m.c.1640
LALLEMAND, Henri
Belgian, op.c.1842
L'ALLEMAND, Jean
Baptiste
French, 1716-1803
LALLEMAND, Lalement or
Laleman, Philippe
French, 1636-1716
L'ALLEMAND, Siegmund
German, 1840-1910
LALLIE, Mademoiselle
French, 18th cent.
LALLIE, Jacques
Etienne
French, op.1774-1779
LALNY
German, 19th cent.
LALONDE, de
see Regnault-Delalande
LALONDE, Richard de
French, op.1788-1796
LA LONGE, Robert or
Uberto
see Longe
LALOUE, Galien Eugène
French, 1854-
LALOUE, Zarra and Charles
French, op.c.1840
LALOY, Emilie
French, 19th cent.
LAM, Jennett
American, 20th cent.
LAM, Wilfredo
Cuban, 1902-
LAMA, Giovanni Battista
Italian, c.1660-p.1740
LAMA, Giovanni Bernardo
Italian, 1508-1579
LAMA, Giulia
(Lisalba)
Italian, 18th cent.
LA MARE-RICHART, Florent
de
French, c.1630-1718
LAMARRA, Francesco
Italian, 18th cent.
LAMARTINE, Madame de
French, 19th cent.
LAMB, Adrian
American, 1901-
LAMB, Charles Vincent
British, 1893-1965
LAMB, Helen Adelaide
British, op.1913-1939
LAMB, Henry
British, op.1826-1861
LAMB, Henry
British, 1885-1960
LAMB, Lynton Harold
British, 1907-1977
LAMB, Thomas B.
British, 19th cent.

LAMBDIN, George
Cochran
American, 1830-1896
LAMBDIN, James Reid
American, 1807-1889
LAMBELET, H.
French, 18th cent.
LAMBERG, A.J.
Dutch, op.1702
LAMBERT
French, op.1740
LAMBERT van Amsterdam
see Sustris
LAMBERT, Camille
Nicolas
Belgian, 1876-
LAMBERT, E.F.
British, op.1790-1846
LAMBERT, George
British, 1710-1765
LAMBERT, George
Washington
British, 1873-1930
LAMBERT, Isobel
(Isobel Rawsthorne)
British, 1912-
LAMBERT, James, I
British, 1725-1788
LAMBERT, James, II
British, 1742-1799
LAMBERT, Jean Baptist
Ponce
French, op.1795-1812
LAMBERT, John, II
British, op.1696-m.1701
LAMBERT, Louis Eugène
(Eugène)
French, 1825-1900
LAMBERT, Martin
French, 1630-1699
LAMBERT, Maurice Walter
Edmond de
French, 1873-
LAMBERT, Walter H.
British, 1870/1-1950
LAMBERTI, Bonaventura
Italian, 1651/2-1721
LAMBERTI, Ludovico
Italian, op.1686
LAMBERTI, Simone
Italian, 15th cent.
LAMBERTINI
see Matteo da Bologna
and Michele di Matteo
da Bologna
LAMBERTC d'Amsterdam
see Sustris
LAMBERT-NAUDIN, H.
French, 20th cent.
LAMBERTON, Joseph Louis
French, op.1899-1914
LAMBERTS, Gerrit
Dutch, 1776-1850
LAMBERTUS de Amsterdam
see Sustris
LAMBINET, Emile Charles
French, 1815-1877
LAMBOURNE, Nigel
British, 1919-
LAMBRANZI, Giovanni Battista
Italian, op.c.1700-1716
LAMBRECHTS, Arent
Swedish, op.1585-1611
LAMBRECHTS, C.
Dutch, op.1668
LAMBRECHTS, Emile
Belgian, 20th cent.
LAMBRECHTS, Jan Baptist
Flemish, 1680-p.1731

LAMBRICHS, Edmond
Alphonse Charles
Belgian, 1830-1887
LAMBRON des Piltiéres,
Albert Anatole Martin
Ernest
French, 1836-
LIM CHONG SCHOOL
Chinese, 19th cent.
LAME, Biagio dalle
(Pipini, Pupini or
Puppini)
Italian, op.1511-1575
LAMEN, Laemen or Laenen,
Christoph Jacobsz. van der
Flemish, c.1606(?)-1652(?)
LAMEN or Laemen, Hubert
van der
Netherlands, 17th cent.
LAMERSSYN, de
Flemish, 17th cent.
LAMEYER y Berenguer,
Francisco
Spanish, 1825-1877
LAMEYER, Lavialle de
French, 19th cent.
LAMI, Eugène Louis
French, 1800-1890
LAMME, Arie
Dutch, 1748-1801
LAMME, Ary Johannes
Dutch, 1812-1900
LAMMERS, W.
German, 19th cent.
LA MONACA, Ricardo
Italian, 19th cent.
LAMOND, William B.
British, 20th cent.
LAMONT or La Monte,
Elish
British, c.1800-1870
LAMONT, John Charles
British, 1894-
LAMONT, Thomas Reynolds
British, 1826-1898
LAMORINIERE, Jean Pierre
Francois (François)
Belgian, 1828-1911
LAMOTHE, Louis
French, 1822-1869
LAMOTTE, Bernard
French, 1903-
LAMOUR, Jean (Jean
Baptiste)
French, 1698-1771
LAMPE, Jean-Baptiste
Belgian, op.c.1830
LAMPI, Franz Xaver
German, 1782-1852
LAMPI or Lamp, Johann
Baptist Edler von
German, 1751-1830
LAMPI, Johann Baptist
Edler von
German, 1775-1837
LAMSVELT or Lamsveld,
Joannes
Dutch, 1664/5-p.1725
LAMSWEERDE, Steven van
Dutch, op.1644-m.1686
LAMUNIERE, Gaspard
Swiss, 1810-1865
LAMY
French, 19th cent.
LAMY, Charles
French, 1689-1743
LAMY, Louis Augustin
French, 1747-1831

LAMY, Pierre Désiré
Eugène Franc
French, 1855-1919
LANA, Jaime
Spanish, op.1490-m.c.1515
LANA, Lodovico
Italian, 1597-1646
LANCASTER, Mark
British, 20th cent.
LANCASTER, Osbert
British, 1908-
LANCASTER, Percy
British, 1878-1950
LANCASTER, Richard
Hume
British, 1773-1853
LANCE, George
British, 1802-1864
LANCE, J.
British, 18th cent.
LANCEDELLI, Josef
see Lanzedelly
LANCELEY, Colin
British, 1938-
LANCELEY, Iain
British, 1938
LANCELOT, Monique
French, 20th cent.
LANCENI, Lanzani or
Lanzeni, Giovanni
Battista
Italian, c.1660-1737
LANCERAY, Evgeny
Evgenyevich
Russian, 1875-1946
LANCEROTTO, Egisto
Italian, 1848-1916
LANCHARES, Antonio de
Spanish, c.1586-1658
LANCHENICK, J.C.
British, 19th cent.
LANCIANO
see Polidoro da
Lanciano
LANCILAO or Lanzilago,
Nicolò (?)
Italian, op.1472-1508
LANCKOW, L.
German, 19th cent.
LANÇON, Auguste André
French, 1836-1887
LANCOSURE, L.D.
French, 19th cent.
LANCRENON, Joseph
Ferdinand
French, 1794-1874
LANCRET, Nicolas
French, 1690-1745
LANDAETA, Antonio
José
Venezuelan, 1748-1799
LANDAU, Dorothea
Natalie Sophia
(Dorothea Da Fano)
British, -1941
LANDAU, Zygmunt
(Sigismond)
Polish, 19th/20th cent.
LANDAUER, Berthold
(Master Berthold)
German, c.1365/70-1430/2
LANDE or Landen, Willem
van
Dutch, c.1610-p.1650
LANDELLE, Charles
(Zacharie Charles)
French, 1821-1908

LANDELLE, Georges H.
French, c.1860-1898
LANDENBERGER, Christian
Adam
German, 1862-1927
LANDER, Edgar Longley
British, 1883-
LANDER, John Saint-
Helier
British, 1869-1944
LANDERER, Ferdinand
German, 1730/46-1795
LANDERER, Georg
German, 17th cent.
LANDERSET, Joseph de
Swiss, 1753-1824
LANDESIO, Eugenio
Italian, op.c.1830-1840
LANDI, Edoardo
Italian, 1937-
LANDI, Gaspare
Italian, 1756-1830
LANDI, Gennaro
Italian, 17th cent.
LANDI, Ricardo Verdugo
Italian, 19th cent.
LANDINI
see Giovanni del
Biondo
LANDINI
see Jacopo dal
Casentino
LANDINI, Andrea
Italian, 1847-
LANDINI, Giuseppe
Italian, 1939-
LANDINI, Taddeo
Italian, c.1550-1596
LANDOLT, Salomon
Swiss, 1741-1818
LANDON, Charles Paul
French, 1760-1826
LANDON, John
British, op.1795-1827
LANDRIANI, Paolo
Cammillo (Duchino)
Italian, c.1560-c.1618
LANDRY, Louis
French, op.1791-1798
LANDRY, Pierre
French, 1630-1701
LANDSBERG
German, 18th cent.
LANDSEER, Charles
British, 1799-1879
LANDSEER, Sir Edwin
Henry
British, 1802-1873
LANDSEER, George
British, c.1834-1878
LANDSEER, Thomas
British, 1795-1880
LANDSLEY, Patrick
Canadian, 20th cent.
LANDULFO or Landolfo,
Pompeo
Italian, op.1588-1609
LANDUYT, Octave
Belgian, 1922-
LANE, Christopher
American, 1937-
LANE, F.
British, 19th cent.
LANE, Fitz Hugh
American, 1804-1865
LANE, Jane
British, 20th cent.

LANE, John Bryant
British, 1788-1868
LANE, Richard James
British, 1800-1872
LANE, Samuel
British, 1780-1859
LANE, Theodore
British, 1800-1828
LANE, William
British, 1746-1819
LANEN or Laanen, Jasper
van der
Flemish, op.1624
LANEUVILLE, Jean-Louis
French, 1748-1826
LANFANT or Lenfant,
François Louis
French, 1814-1892
LANFRANC, J.
French, 18th cent.
LANFRANCHI, Alessandro
Italian, 1662-1730
LANFRANCO, Giovanni
Italian, 1582-1647
LANFRANCO, Noemie
Italian, 20th cent.
LANFREDINI, Alessandro
Italian, 1826-1900
LANFRERIUS, Antonio
see Lafreri
LANG, Albert
German, 1847-1933
LANG, Andreas
German, 19th cent.
LANG, Daniel
Swiss, 1543-p.1606
LANG, Daniel
American, 1935-
LANG, Ernst Friedrich
Carl
German, op.1788
LANG, G.
Swiss, 19th cent.
LANG, George Jakob
German, 1655-1740
LANG, Hans Caspar, I
Swiss, 1571-1645
LANG, Heinrich
German, 1838-1891
LANG, Heinrich
see also Mang
LANG, Hieronymus or
Jeronymus
(Monogrammist J.L.G.)
Swiss, c.1520-1582
LANG, Karl
(Friedrich Karl)
German, 1766-1822
LANG, Louis
American, 1814-1893
LANG, Moritz or
Mauritius
German, op.1649-1665
LANGASKENS, Maurice
Belgian, 1884-
LANGDAIE, Marmaduke
British, 1840-1905
LANGDALE, Stella
British, -1905
LANGE, Antoni
German, 1779-1844
LANGE, Bernard
French, 1754-1839
LANGE, F.J. de
Dutch, 17th/18th cent.
LANGE, Franc
see Ange

LANGE, Johann
German, op.1558-1571
LANGE, Johann
German, 1823-1908
LANGE, Johann Gustav
German, 1811-1887
LANGE, Joseph
German, 1751-1831
LANGE, Julius
German, 1817-1878
LANGE, Larry
American, 20th cent.
LANGE, Ludwig
German, 1808-1868
LANGE, Søren Laessøe
Danish, 1760-1826
LANGE, Willi Otto
Max
German, 1876-
LANGELE, Maerten or
Martinus
see Lengele
LANGENDIJK, Dirk
Dutch, 1748-1805
LANGENDIJK, Jan
Anthonie
Dutch, 1780-1818
LANGENHÖFFEL, Johann
Joseph
German, 1750-1805/7
LANGENMANTEL, Ludwig von
German, 1854-1922
LANGER, Emil R. Julius
German, 1834-
LANGER, Johann Peter
von (Peter)
German, 1756-1824
LANGER, Robert
(Joseph Robert) von
German, 1783-1846
LANGERFELD or Langevelt,
Rutger von or van
Dutch, 1635-1695
LANGERINCK, Prosper
Henricus
see Lankrink
LANGEROCK, Henri
Belgian, 1830-1915
LANGETTI or Langhetti,
Giovanni Battista
Italian, 1625-1676
LANGEVELT, Rutger von
or van
see Langerfeld
LANGHAM, John
British, 19th cent.
LANGHAMMER, Arthur
German, 1854-1901
LANGHANS, Carl Gotthard
German, 1732-1808
LANGHE, J. de
Dutch, op.1671-1693
LANG-HEILBRONN, Richard
German, 1861-
LANGHEIM, Friedrich
Wilhelm
German, c.1804-p.1828
LANGKO, Dietrich
German, 1819-1896
LANGLACE, Jean Baptiste
Gabriel
French, 1786-1864
LANG-LARIS, Hermine
German, 1842-1913
LANGLEY, C.D.
British, op.1840

LANGLEY, Robert
British, op.1841
LANGLEY, Walter
British, 1852-1922
LANGLEY, William
British, 19th cent.
LANGLOIS, Charles
(Jean Charles)
French, 1789-1870
LANGLOIS, Eustache
Hyacinthe
French, 1777-1837
LANGLOIS, François
(F.L.D. Ciartres or
Chartres)
French, 1589-1647
LANGLOIS, Jean
French, 1649-c.1712
LANGLOIS, Jerôme
Martin
French, 1779-1838
LANGLOIS, Mark W.
British, 19th cent.
LANGLOIS, Nicholas
French, c.1695-
LANGLOIS, Pierre
Gabriel
French, 1754-c.1810
LANGLOIS, W.
French, 19th cent.
LANGMAIR, Anton
(Johann?)
German, op.1659
LANGNER, Wiktor
Zbigniew
Polish, 20th cent.
LANGNOUWER, Joachim
Dutch, op.1640-m.1653
LANGORI, R.
Italian, op.1801
LANGSCHMIDT, W.H.F.L.
South African, 19th cent.
LANGSTAFFE, J.
British, 19th cent.
LANGTON, Bennett
British, 1737-1801
LANGTON, E.
British, op.1751
LANGTON, George
British, 18th cent.
LANGUSTIE, de
French(?), op.1798
LANIER, Laniere or
Lannier, Nicholas
British, 1588-1665
LANINO, Bernardino
Italian, 1510/15-1581/3
LANINO, Girolamo
Italian, 1555-p.1589
LANKEN, Wilhelm
German, 1890-
LANKRINK, Langerinck,
Lankrinck, Lengerinckx
etc., Prosper Henricus
Flemish, 1628-1692
LANNEAU, Nicolas
see Lagneau
LANOS, Francois
French, 20th cent.
LANOS, Henri
French, 19th cent.
LANOUE, Félix Hippolyte
French, 1812-1872
LANOUX, B.
French, 19th cent.
LANQUETIN, Gilbert
(Paul Francois Berthoud)
French, 1870-

LANSCROON, Jean-
Baptiste van den
see Lantscroon
LANSDOWNE
British, op.1855
LANSDOWNE, Fenwick
Canadian(?), 1938-
LANSIAUX, A.
French, 20th cent.
LANSINCK, J.W.
Dutch, 17th cent.
LANSKOY, André
French, 1902-
LANSYER, Emmanuel
(Maurice Emmanuel)
French, 1835-1893
LANT, Thomas
British, 1556(?)-1600
LANTARAT, Simon
Mathurin (Lantara)
French, 1729-1778
LANTE, Giuseppe
Italian, 1726-
LANTE, Louis Marie
French, 1789-p.1825
LANTSCROON or Lanscroon,
Jean-Baptiste van den
Flemish, 1653-1737
LANYON, Ellen
American, 1926-
LANYON, George Peter
British, 1918-1964
LANZ, W.
German, 19th cent.
LANZA, Giovanni
Italian, 1827-
LANZANI, Andrea
Italian, c.1650-1712
LANZANI, Giovanni
Battista
see Lanceni
LANZANO da San Colombano,
Bernardino
Italian, op.1490-1526
LANZANO, Cesare
Italian, 17th cent.
LANZEDELLY, Lancedelli,
Lanzadelli or
Lanzedelli the Elder,
Josef
Italian, 1774-1832
LANZENI, Giovanni
Battista
see Lanceni
LANZIANI or Ianzani
see Polidoro da
Lanciano
LANZILAGO, Nicolò
see Iancilao
LAP, J.H.
Dutch, 19th cent.
LAP, Jan
see Lapp
LAPARA, or Laparra,
William
French, 1873-1920
LA PATELLIERE, Amédée
French, 1890-1932
LA PEGNA, La Pegnia or
La Peigne, Hyacinth de
Flemish, 1706-1772
LAPI, Emilio
Italian, c.1815-c.1890
LAPI, Nicolò
Italian, 1661-1732
LAPICCOLA, La Piccola
or Lapicola, Niccolò
Italian, c.1730-1790

LAPICQUE, Charles
French, 1898-
LA PIERRE, Tom
Canadian, 20th cent.
LAPINE, André
French, 1866-1952
LAPIS, Gaetano
Italian, 1706-1758
LAPIS, Hieronymus,
Girolamo or
Jeronimo
Italian, op.1758-1788
LAPITO, Auguste (Louis
Auguste)
French, 1803-1874
LAPLAU
French, 1938-
LAPO da Firenze
Italian, op.c.1260-1280
LAPORTE, G.
French, 20th cent.
LAPORTE, Henry
(George Henry)
British, 1799-1873
LAPORTE, John
British, 1761-1839
LA PORTE, Roland
French, 1725-1793
LAPOSTOLET, Charles
French, 1824-1890
LAPOUJADE, Robert
French, 1921-
LAPP or Lap, Jan
Willemsz.
Dutch, op.1625-1636
LAPPARENT, Paul de
French, 1869-
LAPPOLI, Giovanni
Antonio
Italian, 1492-1552
LAPRADE, Pierre
French, 1875-1932
LA QUEWELLERIE,
Guillaume de
Dutch, op.1611-1635
LAQUY, Willem Joseph
German, 1738-1798
LARA, E.
Spanish, 19th cent.
LARA, George
British, 19th cent.
LARCHER, Dorothy
British, 20th cent.
L'ARCHEVEQUE, Pierre
Hubert
French, 1721-1778
LARD, François Maurice
French, 1864-1908
LARDELLI, Fernando
Swiss, 1911-
LARDY, François
Guillaume
Swiss, 1749-1812
LARGILLIERE, Amédée
French, 18th cent.
LARGILLIERE or
Largillierre, Nicolas
de
French, 1656-1746
LARIEU, Pierre
see Larrieu
LARIONOFF, Michail
Fjodorowitsch
Russian, 1881-
LA RIVE or Larive,
Godefroy, Pierre
Louis de
Swiss, 1753-1817

LARIVIERE, Charles
Philippe Auguste
de
French, 1798-1876
LARIVIERE, Eugène
(Louis Eugène)
French, 1801-1823
LARKIN, William
British, op.1608-1619
LARMESSIN or L'Armessin,
Nicolas, II
French, op.1654-m.1694
LARMESSIN, Nicolas, IV
French, 1684-1755
LAROCHE, Amand or
Armand
French, 1826-1903
LAROCHE, Jacques
Haitian, 1936-
LAROCK, Evert or Evrard
Belgian, 1865-1901
LA ROCQUE, Barthelemy de
German, 1720-p.1760
LAROON, Marcellus, I
British, 1653-1702
LAROON, Marcellus
(not Jan), II
British, 1679-1774
LA ROSE or La Roze,
Jean Baptiste, I
de
French, 1612(?)-1687
LA ROUX, Renée
South African, 20th cent.
LARRIEU or Larieu,
Pierre
French, op.1762-1772
LARROQUE, Angel
Spanish, 20th cent.
LARRUE, Guillaume
French, 1851-p.1905
LARSEN, Adolf Alfred
Danish, 1856-1942
LARSEN, Emanuel
(Carl Frederik Emanuel)
Danish, 1823-1859
LARSEN, Johannes
Danish, 1867-1961
LARSEN, Karl Christian
Scandinavian, 1853-1910
LARSEN, Knud Erik
Danish, 1865-1922
LARSEN, Oskar
German, 1882-
LARSEN-STEVNS, Niels
Danish, 1864-1941
LARSON, Harold
Magnus
American, 20th cent.
LARSON, Markus
see Larsson
LARSSON, Carl Olof
Swedish, 1853-1919
LARSSON or Larson,
Markus (Simeon
Markus)
Swedish, 1825-1864
LA RUE, Fortune de
French, 1794-p.1827
LARUE, Leon, I (André
Leon) (Mansion)
French, 1785-p.1834
LARUE, Louis Félix de, II
French, 1731-1765
LARUE, Philibert
Benoît de, II
French, c.1725-1780

LA RUELLE, Claude de
French, op.c.1608
LARWIN, Hans
German, 1873-1938
LASALLE, Louis
French, 19th cent.
LASANSKY, Mauricio
Argentine, 1914-
LASCAUX, Elie
French, 1888-1968
LASCH, Carl Johann
German, 1822-1888
LASCHI, Michele da
Fiesole
Italian, op.1684
LA SERNA, Ismael
Gonzales de
Spanish, 1897-1968
LASINIO, Carlo
Italian, 1759-1838
LASINSKY, Adolf
(Johann Adolf)
German, 1808-1871
LASKA, G.
Czech, 19th cent.
LASKE, Oskar
German, 1874-1951
LASKER-SCHULER, Else
German, 1876-
LASNE, Asinio, Asinius,
Asinus or Asne,
Michel
French, a.1590-1667
LASNICKA, W.
Polish, 19th cent.
LASO, Francisco
Peruvian, 1823-1869
LASSALLE, Camille
French, 19th cent.
LASSALLE, Emile C.
French, 1813-1871
LASSALLE-BORDES, Gustave
French, 1814-p.1868
LASSAVE
French, op.1768-1790
LASSENCE, Paul de
Belgian, 1886-
LASSIER
French, op.1860
LASSON, Oda
see Krohg
LASSUS, Alexandre
Victoire de
French, 1781-p.1830
LASSUS, Jean Baptiste
Antoine
French, 1807-1857
LASTEYRIE du Saillant,
Charles Philibert,
Comte de
French, 1759-1849
LASTMAN, Nicolaes
(Claes) Pietersz.
(Nicolas Petri)
Dutch, c.1586-1625
LASTMAN, Pieter Pietersz.
Dutch, 1583-1633
LASTRA, Claudio
Italian, 19th cent.
LASTRICATI, Zanobi
Italian, 1508-1590
LASZCZUK, Timofiej
Russian, 20th cent.
LASZLO von Lombos,
Fülöp Elek or Philipp
Alexius
Hungarian, 1869-1937

LATAPIE, Louis Robert
Arthur
French, 1891-
LATASTER, Gerard (Ger)
Dutch, 1920-
LATE ITALIAN SCHOOL,
Anonymous Painters
of the
LATENAY, Gaston de
French, -1859
LATER, Jacobus de
Dutch, op.1696-1705
LATHAM, James
British, 1696-1747
LATHAM, John
British, 1921-
LA THANGUE, Henry
Herbert
British, 1859-1929
LATHBURY, Mrs.
British, 18th cent.
LATHEM or Laethem,
Jacques van
Netherlands,
op.1493-1522
LATHROP, Francis
British, 1849-1909
LATHROP, William
Langson
American, 1859-1938
LATILLA, Eugenio H.
Italian, c.1800-p.1859
LATINVILLE, François
Adrien Grasognon,
Grasoignon or
Grassoignon de
French, op.1741-m.1774
LATOIX, Gaspard
American, 19th cent.
LATOMBE, A. de
Dutch, 17th cent.
LATOMBE, Nicolaes de
Dutch, 1616-1676
LA TOUCHE, Gaston de
French, 1854-1913
LATOUCHE or La Touche,
Jacques Ignace
French, 1694-1781
LATOUCHE, Louis
French, 1829-1884
LATOUR, Alexandre de
Belgian, 1780-1858
LATOUR, Alfred
French, 1888-
LATOUR, Antoine Le
Blond de
see Le Blond
LA TOUR, Georges du
Mesnil or Dumesnil
French, c.1600-1652
LATOUR, Jan or Jean
Flemish, 1719-1782
LATOUR, Joseph
French, 1784-1865
LATOUR or La Tour,
Maurice Quentin de
French, 1704-1788
LA TRAVERSE, Charles
François Pierre de
French, 1726-c.1780
LATROBE or La Trobe,
Benjamin Henry
British, 1764-1820
LATTANZIO
see Pagani
LATTANZIO di Niccolò
di Liberatore da
Foligno
Italian, op.1491-1526

LATTANZIO da Rimini
Italian, op.1492-1500
LATTEUX, Eugène
French, 1805-1850
LATY, Michael
American, 1826-1848
LAUB, Antoni
Polish, 1788-1842
LAUB, Tobias
German, 1685-1761
LAUBADERE, Louis-Paul de
French, op.1895/6
LAUBIES, René
French, 1922-
LAUBSER, Maggi
South African, 1886-
LAUCH, Johann
Friedrich
German, op.c.1720-1760
LAUCHERT, Richard L.
German, 1823-1869
LAUDER, Charles James
British, -1920
LAUDER, James Eckford
British, 1811-1869
LAUDER, Robert Scott
British, 1803-1869
LAUDER, Sir Thomas D.
British, 1784-1848
LAUDY, Jean
Belgian, 1877-
LAUER, Josef
German, 1818-1881
LAUER, Nikolaus
German, op.1794-1802
LAUERS, Pieter van der
Netherlands, op.1704
LAUFBERGER, Ferdinand
German, 1829-1881
LAUGE, Achille
French, 1861-1944
LAUGEE, Désiré François
French, 1823-1896
LAUGEE, Georges
French, 1853-
LAUGHTON, Bruce
British, 20th cent.
LAUGIER, Auguste
French, 1816-p.1880
LAULE, Johann Baptist
German, 1817-1895
LAUMOSNIER
French, op.c.1690-1725
LAUNOIS, Jean
French, 1898-
LAUPHEIMER, Anton
German, 1848-1927
LAUQUIN, J.J.
French, 1932-
LAURA, Piermatteo
see Piermatteo da
Amelia
LAURAITH, M.
British(?), op.1725
LAURANA or Dellaurana,
Lucianus (Laurana
Martini or da Urbino)
Italian, 1420/5(?)-1479
LAURATI
see Lorenzetti
LAURE, Jules (Jean-
Francois-Hyacinthe-
Jules)
French, 1806-1861
LAURE, Marie
French, 20th cent.
LAUREN, A.
British(?), op.1711

LAURENCE or Lawrence,
Samuel
British, 1812-1884
LAURENCE or Lawrence,
Samuel
British, 1812-1884
LAURENCE, Sydney M.
American, 1856-
LAURENCIN, Marie
French, 1885-1956
LAURENS, Henri
French, 1885-1954
LAURENS, Jean Joseph
Bonaventure
French, 1801-1890
LAURENS, Jean Paul
French, 1838-1921
LAURENS, Jean Pierre
French, 1875-1932
LAURENS, Jules Joseph
Augustin
French, 1825-1901
LAURENS, M.
British, op.1774
LAURENS, Nicolas
Auguste
French, 1829-1908
LAURENS, Paul Albert
French, 1870-1934
LAURENSON, Edward Louis
British, 1868-
LAURENT, Ernest Joseph
French, 1859-1929
LAURENT, Félix
French, 1821-1905
LAURENT, Henri Adolphe
Louis
French, op.1866-1885
LAURENT the Elder, Jean
Antoine
French, 1763-1832
LAURENT, Pierre François
French, 1739-1809
LAURENT-DESROUSSEAUX,
Henri-Alphonse-Louis
French, 1862-1906
LAURENT-GSELL, Lucien
French, op.c.1887
LAURENTI, Cesare
Italian, 1854-1936
LAURENTI or Laurentini,
Giovanni (Arrigoni)
Italian, 1550-1633
LAURENTINO d'Andrea
see Lorentino
LAURENTY
Dutch, 19th cent.
LAURENTZ, Johann
Daniel
German, 1729-1810
LAURER, Laur or Lurer,
Jörg Thomen
Swiss, op.1576-1585
LAURET, François
French, 1820-1868
LAURETI or Lauretti,
Tommaso (Siciliano)
Italian, c.1530-1602
LAURI, Balthasar
see Lauwers
LAURI, Filippo
Italian, 1623-1694
LAURI, Francesco
Italian, 1612-p.1636
LAURI, Pietro
(Laurier, or Monsù
Piero di Guido)
French, op.1643-m.1696
LAURIE, E.L.
British, 19th cent.

LAURIE, Lawrey,
Iawrie or Lowery,
Robert
British, 1755-1836
LAURIN, Heinrich
Friedrich
German, 1756-c.1830
LAURO, Balthasar
see Lauwers
LAURO or Iauri,
Giacomo
Italian, op.1590-m.1605
LAURO Padovano
Italian, op.c.1471-1508
LAUSAN
French, 18th cent.
LAUSEN, Jens
German, 1937-
LAUTENSACK, Adolf
German, 1561-p.1595
LAUTENSACK, Hans Sebald
German, 1524-1561/6
LAUTENSACK, Paul
German, 1478-1558
LAUTERBACH, Bruno
German, 20th cent.
LAUTERBOURG, Philipp
Jakob
see Loutherbourg
LAUTERBURG, Martin
Swiss, 1891-1960
LAUTERBURG, Rudolf
Swiss, 20th cent.
LAUTERER, Johann Franz
Nepomuk Adam
German, 1700-1733
LAUTERS, Paulus
Belgian, 1806-1875
LAUTH, Frédéric
Charles
French, 1865-1922
LAUVERGNE, Barthélemy
French, 1805-1871
LAUVRAY, Abel
French, 1870-1950
LAUWERS, Lauri or
Lauro, Balthasar
Flemish, 1578-1645
LAUWERS, Coenrads
Flemish, c.1632-c.1685
LAUWERS, Jacobus
Johannes
Flemish, 1753-1800
LAUWES, Matteo
see Loves
LAVAL, Charles
French, 1862-1894
LAVAL, Fernand
French, 20th cent.
LAVALLEE, Etienne de
('Lavallée Poussin' or
Stephen Poussin)
French, c.1733-1793
LAVALLEY, Alexander
Claude Louis
French, 1862-1927
LAVATER, Diethelm
Swiss, 1780-1827
LAVATER, Johann Caspar
Swiss, 1741-1801
LAVAU, Jacobus
French, 1728-p.1781
LAVAUDAN, Alphonse
French, 1796-1857
LAVECQ, Jacobus
see Levecq

LAVERGNE, Claudius
French, 1814-1887
LAVERI, F.
Italian, 17th cent.
LAVEROCK, Florence H.
British, op.c.1902-1915
LAVERY, Sir John
British, 1856-1941
LAVIEILLE, Eugène
Antoine Samuel
French, 1820-1889
LAVILLE, Eugène
French, 1814-1869
LAVILLE, Henri
French, 1916-
LAVILLE-LEROUX, Marie
Guilhelmine
see Benoist
LA VILLEON, Emmanuel
Victor Auguste Marie
de
French, 1858-1944
LA VILLETTE, Elodie,
(née Jacquier)
French, 1843-p.1914
LAVOINE, Robert
French, 1916-
LAVOL, Marie Joséphine
Angelique
see Mongez
LAVON, Simon
French, 19th cent.
LAVOS, Joseph
German, 1807-1848
LAVREINCE
see Lafrensen, Nicolas
LAVRUT, Louise
French, 1874-
LAW, David
British, 1831-1901
LAW, Robert
British, 1934-
LAWERENTZ, Niclas
see Lafrensen
LAWLESS, Matthew James
British, 1837-1864
LAWMAN, Jasper Holman
American, 1825-1906
LAWRANSON, Laurenson
or Lawrenson, Thomas
British, op.1733-1786
LAWRANSON or Lawrenson,
William
British, op.1760-1780
LAWREINCE, Niclas
see Lafrensen
LAWRENCE, Alfred Kingsley
British, 1893-
LAWRENCE, Charles B.
American, -1828
LAWRENCE, David Herbert
British, 1885-1930
LAWRENCE, George
British, c.1758-1802
LAWRENCE, Jacob
American, 1917-
LAWRENCE, Mary, (née
Kearse)
British, op.1794-1830
LAWRENCE, S.
British, 19th cent.
LAWRENCE, Sir Thomas
British, 1769-1830
LAWRENCE, W. Hurd
British, 19th cent.
LAWRENSON, William
see Lawranson

LAWREY or Lawrie,
Robert
see Laurie
LAWSON, Cecil C.P.
British, op.1907-1914
LAWSON, Cecil Gordon
British, 1851-1882
LAWSON, Ernst
American, 1873-1939
LAWSON, Francis Wilfred
British, op.1867-1894
LAWSON, Frederick
British, 1888-
LAWSON, James Kerr
see Kerr-Lawson
LAWSON, John
British, 1868-1909
LAWSON, Robert
American, 1892-
LAWTON, Sir James
British, 19th cent.
LAY, Oliver Ingraham
American, 1845-1890
LAYNAUD, François Louis
French, 1804-p.1844
LAYNG, Mabel
British, op.c.1916-1928
LAYRAUD, Fortuné Joseph
Séraphin
French, 1834-1912
LAZARUS
Polish, op.1510
LAZARUS, Jacob H.
American, 1822-1891
LAZERGES, Jean Baptiste
Paul
French, 1845-1902
LAZERGES, Jean Raymond
Hippolyte
French, 1817-1887
LAZZARA, Gaetano
Italian, op.c.1703
LAZZARI, Giovanni
Antonio
Italian, 1639-1713
LAZZARI, Gregorio
Italian, 17th cent.
LAZZARI, Sebastiano
Italian, -c.1770
LAZZARINI, Antonio
Italian, 1672-1732
LAZZARINI or Lazarini,
Gregorio
Italian, 1655-1730
LEA, Anna
see Merritt
LEACH, Bernard Howell
British, 1887-
LEADBITTER, Margaret
Fletcher
British, op.c.1908-1940
LEADER, Benjamin
Eastlake
British, -1916
LEADER, Benjamin Williams
British, 1831-1923
LEADER, L.S.
British, 19th cent.
LEAHY, Edward Daniel
British, 1797-1875
LEAK, W.
British, op.1838
LEAKE, Eugene
American, 20th cent.
LEAKE, Stafford
British, 1881-

LEAKEY, James
British, 1775-1865
LEAL, Juan de Valdés
see Valdés
LEANDER
see Reder
LEANDRE, Charles
Lucien
French, 1862-1930
LEANDRO
see Reder
LEAR, Charles H.
British, op.1842-1863
LEAR, Edward
British, 1812-1888
LEAVER, B.W.
British, 19th cent.
LEAVERS, Lucy Ann
British, 19th cent.
LEAVITT, E.C.
American, op.1881
LEBARBIER, Elise
see Bruyere
LEBARBIER II, Jean
Jacques François
French, 1738-1826
LEBARBIER I, Louis
French, op.1770-1783
LEBAS, Jacques Philippe
French, 1707-1783
LEBAS, Jean-Baptiste
French, 1729-p.1795
LEBASQUE, Henri
French, 1865-1937
LEBDUSKA, Lawrence
South American, 1894-
LE BEAU, Alcide-
Marie
French, 20th cent.
LEBEAU, Pierre Adrien
French, 1748-p.1804
LEBEDEV, Vladimir
Russian, 1891-1967
LEBEDJEFF, Michail
Iwanowitsch
Russian, 1811-1837
LEBEL, Antoine
French, 1705-1793
LEBEL, Charles Jacques
French, op.1801-1827
LEBEL, Edmond
French, 1834-1908
LE BEL, J.B.
French, 18th cent.
LE BEL, Jean Etienne
French, op.1767-1774
LEBELLE, J. François
French, op.1809
LEBENSTEIN, Jan
Polish, 1930-
LE BERGER, Robert
French, 20th cent.
LEBERT, Henri
German, 1794-1862
LE BIHAN, D.
British(?), 19th cent.
LEBLANC, Alexandre
French, 1793-1866
LE BLANC, Horace
see Blanc
LEBLANC, Théodore
French, 1800-1837
LEBLANC, Walter
Belgian, 1932-
LE BLANT, Julien
French, 1851-

LE BLON, Jacob
Cristof
German, 1667-1741
LE BLON, Michel
German, 1587-1656
LE BLOND, Antoine
(Le Blond de Latour)
French, 1630-1706
LE BLOND, Jean
French, c.1635-1709
LEBORNE, Joseph Louis
French, 1796-1865
LEBOUCHER, Achille
Jean Baptiste
French, 1793-
LEBOUCQ, Jacques
French, -1573
LEBOURG, Albert Marie
French, 1849-1928
LEBOURG, Charles
Auguste
French, 1829-1906
LE BOUTEUX, Joseph
Barthélemy
French, c.1744-p.1771
LE BOUTEUX, Michel
French, op.c.1720-1755
LE BOUTEUX, Pierre
French, 1683-1750
LEBRE, André
French, 1629-1700
LEBRECHT, Georg
German, 1875-
LEBRET, Frans
Dutch, 1820-1909
LE BRETON, Constant
French, 1895-
LEBRETON or Le Breton,
Louis
French, op.1841-m.1866
LE BRETON, N.
British(?), 19th cent.
LE BROCQUY, Louis M.
British, 1916-
LE BRUN, Madame
French, 18th cent.
LE BRUN or Lebrun,
Charles
French, 1619-1690
LEBRUN, Elizabeth
Louise Vigée
see Vigée-Lebrun
LEBRUN, Jean Baptiste
Pierre
French, 1748-1813
LEBRUN, L.
French, 18th cent.
LEBRUN, Louis
French, 1844-1900
LEBRUN, Rico
American, 1900-
LEBSCHEE, Carl August
German, 1800-1877
LECAMUS, Louis Firmin
French, 1762-1808
LECAPELAIN, John
British, c.1814-1848
LECARPENTIER, Charles
Louis Francois
French, 1744-1822
LECARPENTIER or Carpentier,
Paul Claude Michel
French, 1787-1877
LECCA, Constantin
Rumanian, 1810-1887
LECERF, Louis Alexis
French, 1787-p.1844

LECHAT, Albert Eugene
French, 1863-1918
LECHAY, James
American, 20th cent.
LECHENDER, Charles
Louis
Swiss, 1751-1815
LE CHEVRIER, P.
French, op.1913
LECHNER, Gyula
Hungarian, 1841-1914
LECHNER, R.
German, op.c.1885
LECHTER, Melchior
German, 1865-1936
LECK, Bart Antony
van der
Dutch, 1876-1958
LECLEAR, Thomas
American, 1818-1882
LECLERC, David
Swiss, 1679-1738
LECLERC, Desirée
French, 19th cent.
LE CLERC, Jacques
Sébastien
French, c.1734-1785
LECLERC or Le Clerc,
Jakob (not Johann)
Friedrich
British(?), 1717-p.1768
LECLERC, Jean
(not Giovanni di Chere
or di Cheve)
French, 1587/8-1633
LE CLERC, Jean
French, op.c.1596-1625
LE CLERC, Louis Auguste
French, 1688/9-1771
LE CLERC, Philippe
German, 1755-1826
LE CLERC, Pierre Thomas
French, c.1740-p.1796
LECLERC, Sébastien, I
French, 1637-1714
LECLERC, Sébastien, II
French, 1676-1763
LECLERCQ, C.
Flemish(?), 18th cent.
LECOCQ, Ch.
French, 20th cent.
LECOEUR, Jean-Baptiste
French, 1795-1838
LE CŒUR, Louis
French, op.c.1780-1800
LECOINTE, Auguste
French, op.1757-1758
LE COMPTE, Marguerite
French, c.1719-p.1786
LECOMTE, Alexina
see Cherpin
LECOMTE, Ephrem
see Conte, Meiffren
LECOMTE, Etienne
Cherubim
French, 1766-p.1806
LECOMTE, Gerard
French, 20th cent.
LECOMTE, Hippolyte
French, 1781-1857
LECOMTE du Nouy, Jean
Jules Antoine
French, 1842-1923
LECOMTE, Paul
French, 1842-1920
LECOMTE, Victor
French, op.1877-m.1920

LECOMTE-VERNET, Emile
Charles Hippolyte
French, 1821-1900
LECONTE, Ephrem
see Conte, Meiffren
LE CONTE or Lecomte,
Sauveur
French, c.1659-1694
LECOQ de Boisbaudran
Horace
French, 1802-1897
LECOQUE, Alois
French, 20th cent.(?)
LE COULTRE, H.
French, 20th cent.
LECOULTRE, Jean
Swiss, 1930-
LECOW, Anton
Polish(?), 19th cent.
LE CROSIO
Italian, op.c.1879
LECURIEUX, Jacques
Joseph
French, 1801-p.1870
LEDELI, Joseph
Czech, 1820-
LEDERER
British(?), 19th cent.
LEDERER, Karl
Czech, -1853
LEDESMA, Blas de
Spanish, 16th cent.
LEDOULX, Pierre
François
Flemish, 1730-1807
LEDOUX, Auguste Louis
Charles
French, 1816-1869
LEDOUX, Charles Alexandre
Picard
French, 20th cent.
LEDOUX, Jeanne
Philiberte
French, 1767-1840
LE DOUX, Jean Picart
see Picart, Le Doux
LE DOUX, Lambert
see Suavius
LEDRU or Le Dru,
Hilaire
French, 1769-1840
LEDUC, Charles
French, 1831-p.1866
LEDUC, Fernand
Canadian, 1916-
LEDUC, Ozias
Canadian, 1864-1955
LEDUC, Paul
Belgian, 1876-
LE DUCQ, Johan
Dutch,
1629/30/36-1676/7
LEE, Anthony
British, 1735-1767
LEE, Arthur
British, 19th cent.
LEE, Doris
American, 1905-
LEE, Frederick Richard
British, 1798-1879
LEE, George
British, op.1921
LEE, John
British, 19th cent.
LEE, Sir John
Theophilus
British, op.1807-1827
LEE, Joseph
British, 1780-1859

LEE, R.D.
British, 1923-
LEE, Rosie
British, 1935-
LEE, Sydney
British, 1866-1949
LEE, Terry
British, 20th cent.
LEE, William
British, 1809-1865
LEECH, George William
British, 1894-1966
LEECH, John
British, 1817-1864
LEEKE, Ferdinand
German, 1859-
LEEMANN, Robert
Swiss, 1852-p.1882
LEEMANS, Anthony
Dutch, 1631-a.1674
LEEMANS, Egidius
Franciscus
Belgian, 1839-1883
LEEMANS, Johannes
Dutch, c.1633-a.1689
LEEMANS, K.
Dutch, 17th cent.
LEEMING, T.
British, op.1811-1822
LEEMPOELS, Joseph (Jef)
Belgian, 1867-1935
LEEMPUT, Lemmput,
Lemput or Vallemput,
Remi or Remee van
Flemish, 1607-1675
LEEMPUTTEN, Cornelis van
Belgian, 1841-1902
LEEMPUTTEN, Frans van
Belgian, 1850-1914
LEEN, Wilhelmus
(Willem) van
Dutch, 1753-1825
LEE-NOVA, Gary
Canadian, 1943-
LEERMANS or Lermans,
Pieter
Dutch, 1640/55-1706
LEE-ROBBINS, Lucy
American, 1865-
LEES, Charles
British, 1800-1880
LEES, Derwent
British, 1885-1931
LEES, Mrs. Frederic
British, 19th cent.
LEEST, Antonij van
Netherlands,
c.1545-c.1592
LEETE, Alfred
British, 1882-1933
LEEUW, Alexis de
Belgian(?), op.1864
LEEUW, Bert de
Belgian, 1926-
LEEUW, Govert or
Gabriel van der
(Gabriel de Lyon,
de Leone or de
Lione)
Dutch, 1645-1688
LEEUW, P. de
Dutch, 17th cent.
LEEUW, Pieter van der
Dutch, 1647-1679
LEEUW, Thomas de
see Leu
LEEUW, Willem van der
Flemish, 1603-c.1665(?)

LEEUWEN, Gerrit Johan
van
Dutch, 1756/8-1825
LEEUWEN, J. van
Dutch, op.1816-1830
LE FAIVRE, Jean-
Baptiste-Louis
see Faivre
French, 1766-1798
LE FAUCONNIER, Henri
Victor Gabriel
French, 1881-1946
LE FEBURE, Francois
French, op.c.1635
LEFEBURE, Valentin
see Lefebvre
LEFEBURE, Valère
French, op.c.1880
LE FEBVRE
French, op.1751-1779
LEFEBVRE, Charles
Victor Eugène
French, 1805-1882
LEFEBVRE or Lefebure,
Claude
French, 1632-1675
LEFEBVRE, J.
French, op.1690-1724
LEFEBVRE, Jules Joseph
French, 1836-1912
LEFEBVRE, Paul-Abel
French, 1859-
LEFEBVRE or Lefebure,
Valentin
Flemish,
c.1642-c.1680/2
LEFEBVRE, Victor
French, 1912-
LEFEUBURE, Carl
German, 1805-1885
LEFEVRE, A.
French, op.1753(?)-1792
LEFEVRE, Adolphe René
French, 1834-1868
LEFEVRE, Charles
French, op.1831-1875
LEFEVRE, François
French, c.1747-1817
LEFEVRE, Lucien
French, op.1872/3
LEFEVRE or Fevre,
Robert
French, 1755-1830
LEFEVRE de Venise,
Rolland
French, c.1608-1677
LEFLER, Franz
German, 1831-1898
LEFLER, Heinrich
German, 1863-1919
LEFORT
French, 18th cent.
LEFORT, Henri Emile
French, 1852-
LEFORT, Jean Louis
French, 1875-p.1924
LEFRANC, Jules
French, 1887-
LEFUEL, Hector Martin
French, 1810-1880
LEGA, Achille
Italian, 1899-1934
LEGA, Silvestro
Italian, 1826-1895
LEGAL, Charles Désiré
French, 1794-p.1839

LEGARE or L'Egaré,
Gilles
French, c.1610-p.1692
LEGARE, J.
Canadian, 1795-1855
LEGAT, Francis
British, 1755-1809
LEGAT, Léon
French, 1829-
LE GAY (P. Le Gay?)
French, op.1778-1804
LEGEAY, Jean-Laurent
French, op.1732-m.p.1786
LEGENDRE, Eugène Charles
Belgian, 1827-1900
LEGENDRE, Léonce
Belgian, 1831-1893
LEGENDRE, Louis
(Pierre Louis)
French, c.1723-1780
LEGENISEL, Eugène
(Louis François Eugène)
French, op.1819-m.1855
LEGENVRE
French, op.1817-1824
LEGER, Fernand
French, 1881-1955
LEGG, Owen
British, 20th cent.
LEGGAT, Alexander
British, op.1864
LEGGET, Rowley
British, 19th cent.
LEGI, Giacomo
Flemish, -c.1640/5
LEGILLON or Le Gillon,
Jean Francois
Flemish, 1739-1797
LEGNANI, Ernesta
see Bisi
LEGNANI, Giuseppe
Italian, 19th cent.
LEGNANI, Stefano Maria
(Legnanino)
Italian, 1660-1715
LEGOTE, Pablo
Spanish, c.1590-1670/2
LEGOUAZ, Yves Marie
French, 1742-1816
LE GOUT-GERARD, Fernand
Marie Eugène
French, 1856-1924
LEGOUX, L.R.
French, op.1785
LEGRAND or Grand,
André
French, 1759-
LEGRAND, Athalante
French, op.1822-1837
LEGRAND, Augustin or
Auguste Claude Simon
French, 1765-p.1815
LEGRAND, François de
Sertival
French, op.1658-c.1670
LE GRAND, Henry
American, op.1861
LEGRAND or Grand, Jenny
French, op.1801-1831
LEGRAND, Louis
French, 1863-p.1911
LEGRAND, Pierre Nicolas
(Legrand de Sérant
or Scot)
Swiss, 1758-1829

LE GRAND JOHNSTON,
Reuben
American, 1850-
LEGRIP, Frédéric
French, 1817-1871
LEGRIX, D.
French, 20th cent.
LEGROS, Alphonse
French, 1837-1911
LEGROS or Le Gros,
Jacques Marie
French, 1777-1825
LEGROS or Le Gros,
Jean
French, 1671-1745
LEGROS or Le Gros,
Sauveur (Jean Suaveur)
French, 1754-1834
LEGROS or Le Gros,
Pierre
French, 1666-1719
LE GUAY, Charles
Etienne or Etienne
Charles
French, 1762-1846
LE GUAY, Marie Victoire
see Jaquotot
LEGUEULT, Raymond
Jean
French, 1898-
LE HAY, Elisabeth
Sophie
see Cheron
LEHERB, Helmut
German, 1933-
LEHEUTRE, Gustave
French, 1861-1932
LEHMAN
American, op.c.1871
LEHMANN, Carl Peter
Danish, 1794-1876
LEHMANN, Edvard (Otto
Ludwig Edvard)
Danish, 1815-1892
LEHMANN, Gunther
German, 1920-
LEHMANN, Heinrich or
Henri (Karl Ernst
Rudolf Heinrich Salem)
French, 1814-1882
LEHMANN, Kurt
German, 1905-
LEHMANN, Leo
German, 1782-1859
LEHMANN, Paul
Swiss, 1924-
LEHMANN, Rudolf (Wilhelm
August Rudolf)
British, 1819-1905
LEHMANN, Wilhelm Ludwig
Swiss, 1861-1932
LEHMBRUCK, Wilhelm
German, 1881-1919
LEHMDEN, Anton
German, 1929-
LEHNEN, Jakob
German, 1803-1847
LEHOUX, Pierre Adrien
Pascal
French, 1844-1896
LEIB, Konrad
see Laib
LEIBL, Wilhelm Maria
Hubertus
German, 1844-1900
LEICESTER, Earl of
see Coke, Thomas William

LEICHER, Félix Ivo
German, 1727-p.1811
LEICKERT, Charles Henri
Joseph
Belgian, 1816-1907
LEIDL, Anton
German, 1900-
LEIGH, Clara Maria
see Pope
LEIGH, Conrad Heighton
British, 1883-
LEIGH, Fred
British, 19th cent.
LEIGH, T.
British, op.1634-1643
LEIGH, William Robinson
American, 1866-1955
LEIGHTON, Lady
British, 19th cent.
LEIGHTON, Alfred Crocker
British, 1901-
LEIGHTON, Charles Blair
British, 1823-1855
LEIGHTON, Edward Blair
British, 1853-1922
LEIGHTON, Frederick,
Lord
British, 1830-1896
LEIGHTON, Scott
American, -1898
LEIMBERGER, Leinberger,
Lemberg or Limburg,
Christian
German, 1706-1770
LEIN, N.J. or C. de
see Delin
LEINBERGER, Christian
see Leimberger
LEINBERGER, Hans
German, op.1516-1530
LEINECKER, Franz
German, 1825-1917
LEINWEBER, Heinrich
German, 1836-1908
LEISCHING
German, 18th cent.
LEISMANN, Johann Anton
see Eismann
LEISSLER, Friedrich
German, 1862-1926
LEISTIKOW, Walter
German, 1865-1908
LEISTNER, Albrecht
German, 1887-
LEITCH, Richard
Principal
British, op.1844-1865
LEITCH, Thomas
American, op.1771
LEITCH, William
Leighton
British, 1804-1883
LEITENSTORFFER,
Leitersdorffer,
Leutersdorffer,
Leydensdorf etc.,
Franz Anton von
German, 1721-1795
LEITGEB, Franz
German, 19th cent.
LEITKRATH, Joseph
German, 1736-1811
LEITNER, A. van
Dutch(?), 20th cent.
LEJEUNE, Eugène Joseph
French, 1818-1897

LEJEUNE, Henry
British, 1820-1904
LEJEUNE, Louis François
French, 1775-1848
LEJEUNE, Nicolas
French, c.1750-p.1804
LEJEUNE, Philippe
French, op.1957
LEKENE, Terese
Russian, 20th cent.
LE KEUX, John
British, 1783-1846
LELEN or lesen(?),
P. de (Possibly
identified with Paulus
Lesire)
Dutch, op.c.1650
LELEU, L.D.
French, 19th cent.
LE LEUP, Thomas
see Leu
LELEUX, Adolphe-Pierre
French, 1812-1891
LELEUX, Armand Hubert
Simon
French, 1818-1885
LELIE, Adriaan de
Dutch, 1755-1820
LELIENBERGH,
Lelienberch etc.,
Cornelis
Dutch, op.1646-1676
LELIO da Novellara
see Orsi
LELLEKIEN, C.
German, 17th cent.
LELLI or Lellio,
Giovanni Antonio
Italian, a.1580-1640
LELLO da Velletri
Italian, 15th cent.
LELLY, Lillei or Lilly,
Edmund
British, op.1703-m.1716
LELOIR, Auguste (Jean-
Baptiste Auguste)
French, 1809-1892
LELOIR, Louis
(Alexandre Louis)
French, 1843-1884
LELOIR, Maurice
French, 1853-1940
LELONG, P.
French, op.1795
LELONG, René
French, op.1890-1900
LE LORRAIN, Charles
see Mellin
LE LORRAIN, Louis
Joseph
French, 1715-1759
LE LORRAIN, Robert
French, 1666-1743
LELU, Pierre
French, 1741-1810
LELY, Lilley, Lilly,
Lylly, Lelio etc.,
Sir Peter van der Faes
British, 1618-1680
LE MAINS, Gaston
French, op.1879-1904
LEMAIRE, Charles
American, 19th cent.
LEMAIRE, François
French, 1620-1688

LEMAIRE, Jean (Le
gros Lemaire)
French, 1597-1659
LEMAIRE, Madeleine
Jeanne, (née. Colle)
French, 1845-1928
LEMAIRE, Pierre
(Le Petit Lemaire or
Lemaire-Poussin)
French, c.1612-1688
LE MAISTRE, Alexis
French, op.1873
LEMAITRE
French, 17th cent.(?)
LEMAITRE
French, 20th cent.
LEMAITRE, Maurice
French, 20th cent.
LEMAN, Jacques Edmond
French, 1829-1889
LEMAN, R.
British, 1799-1863
LE MANNIER or Lemaynier,
Eloi
French, op.1540-1579
LE MANNIER or Lemaynier,
Germain Musnier (?)
French, op.1548-1559
LE MARCIS, Comte Eugene
Ernest Edmond
French, 1829-1926
LEMARE, Pierre
French, 1904-
LEMASLE, Louis Nicolas
French, 1788-1870
LEMASSON, Paul
French, 20th cent.
LE MASURIER or Le
Mazurier, S.
Flemish, 1710-
LEMATTE, Fernand Jacques
François
French, 1850-p.1921
LE MAY, Olivier
French, 1734-1797
LEMBERG, Christian
see Leinberger
LEMBERGER, Georg
German, c.1495-c.1540
LEMBERSKI, Aleksander
Russian, 20th cent.
LEMENS, Balthasar van
Flemish, 1637-1704
LEMERCIER, Charles
Nicholas
French, 1797-1859
LEMERCIER, Eugène
Emmanuel
French, 1886-1915
LEMERCIER or Le Mercier,
Jacques
French, 1585-1654
LE MERLE, J.S.
French, op.1899
LE MESURIER, William
Abraham
British, op.1804-1820
LEMETTAY, Lemetay or
Le Mettay, Pierre
Joseph or Pierre Charles
French, 1728-1759
LEMIEUX, Irénée
French, 20th cent.
LEMIEUX, Jean Paul
Canadian, 1904-

LEMIRE, Antoine
French, 1773-p.1814
LEMIRE, Charles, I
(Sauvage)
French, 1741-1827
LE MIRE, Nicolas
French, 18th cent.
LEMIRE, Sophie, (née
Brinisholtz)
French, 1785-p.1819
LEMKE, Lembke or
Lemcke, Johann Philip
(Hans)
German, 1631-1711
LEMMEN, Georges
Belgian, 1865-1916
LEMMENS, Theophile
Victor Emile
French, 1821-1867
LEMMONIER, Madeleine
French, 20th cent.
LEMMPUT, Remi or
Remee van
see Leemput
LE MOAL, Jean
French, 1909-
LEMOCH, Karl
Vikentievitch
Russian, 1841-1910
LE MOINE, Elisabeth,
(née Bouchet)
French, op.1787
LEMOINE or Lemoyne,
Francois
French, 1688-1737
LEMOINE, Jacques Antoine
Marie
French, 1751-1824
LEMOINE, Lionel
Canadian, op.1931
LEMOINE, Marie Victoire
French, 1754-1820
LEMOINE or Le Moyne,
René-Jean
French, op.1759-m.1791
LEMON, Arthur
British, 1850-1912
LEMONNIER, Gabriel
(Anicet Charles Gabriel)
French, 1743-1824
LEMORDANT, Jean-Julien
French, 1882-
LEMORT, Jean Baptiste
French, op.1787-1789
LEMOS, Fernando
Brazilian, 20th cent.
LEMOTTES, J.F.B.
French(?), 17th cent.
LE MOYNE de Morogues,
Jacques
French, op.1564-m.1588
LEMOYNE, Jean Baptiste
French, 1704-1778
LEMOYNE, Jean Louis
French, 1665-1755
LEMPEREUR, Jean-Baptiste
Denis
French, c.1740
LEMPICKA, Tamara de
Polish, 1898-
LEMPUT, Remi or Remee
van
see Leemput
LEMUD, Aimé de (François
Joseph Aimé George)
French, 1816-1887

LEMUD, Ferdinand de
French, op.c.1852
LENAIN or Le Nain the
Elder, Antoine
French, c.1588-1648
LENAIN or Le Nain,
Louis
French, c.1593-1648
LENAIN or Le Nain,
Mathieu, II
French, 1607-1677
LENARDI or Leonardi,
Giovanni Battista
Italian, 1656-1704
LENARDIX, Pietro Paolo
Italian, -1691
LENBACH, Franz Seraph
von
German, 1836-1904
LENCI, Marino
Italian, 1874-1939
LENCKER, Christoph
German, op.1575-1613
LENDECKE, Otto
German, 1886-1918
LENDENSTREICH or
lendestreich, Valentin
German, op.1485-m.1506
LENDINARA
see Canozzi
LENDORFF, Hans
Swiss, 1863-
LENEPVEU, Eugène
(Jules Eugène)
French, 1819-1898
LENEPVEU, V.
French, 19th cent.
LENEY, William
Satchwell
British, 1769-1831
LENFANT, François Louis
see Lanfant
LENFANT, Jean
French, 1615-1674
LENFANT de Metz
see Lanfant, François
Louis
LENFANT, Pierre
French, 1704-1787
LENFERMA
French, 20th cent.
LENFESTEY, Giffard
Hocart
British, 1872-1943
LENGELE, Langele or
Lenglee, Maerten or
Martinus
Dutch, op.1648-m.1668
LENGERINCKX, Prosper
Henricus
see Lankrink
LENGO, John
American, 20th cent.
LENGO y Martinez,
Horacio
Spanish, -1890
LENGYEL-RHEINFUSS or
Lengyel-Reinfuss, Ede
Hungarian, 1873-
LENICA, Jan
Polish, 1928-
LENK, Franz
German, 1898-
LENNEP, Elias van
Dutch, op.1665-m.1694

LENOI, A.
Dutch(?), 18th cent.
LENOIR, Albert-
Alexandre
French, 1801-1891
LENOIR, B.F.
French, op.1806
LENOIR, Charles Amable
French, 1861-p.1903
LENOIR, Marcel
see Marcel-Lenoir
LENOIR, Paul-Marie
French, 1881-
LENOIR, Simon Bernard
French, 1729-1791
LENORMAND, Albert
French, 1915-
LENRI, S.J.
British, op.1720
LENS
British, op.1650
LENS, Andrew Benjamin,
IV
British, 1713-p.1779
LENS, Andries Cornelis
Belgian, 1739-1822
LENS, Bernard, II
British, 1659-1725
LENS, Bernard, III
British, 1682-1740
LENS, Cornelis
Flemish, op.1738-1766
LENS, Johannes
Jacobus
Flemish, 1746-1814
LENS, Peter Paul
British, op.1729-1750
LENTHAL, H.
British, 19th cent.
LENTULOV, Aristarkh
Russian, 1882-1943
LENTZ, Stanislas
Polish, 1863-1920
LENY, Fanny
British, 19th cent.
LENZ, F.W.
German, op.1787
LENZ or Lentz, Johann
Jakob Anton von
German, 1701-1764
LENZ, Maximilian
German, 1860-1948
LENZ, Philipp (Johann
Philipp Wilhelm)
German, 1788-1856
LEO, Paul
French, 20th cent.
LEOCADIO, Pablo de San
see San Leocadio
LEON, Charles Hermann
see Hermann-Leon
LEON y Escosura,
Ignacio de
Spanish, 1834-1901
LEON, J.
British, 20th cent.
LEON, Maurits
Dutch, 1838-1865
LEONARD or Leonart,
Johann Friedrich
Flemish, 1633-1680
LEONARD, John Henry
British, 1834-1904
LEONARD, Laurent
French, 1709-1788

LEONARD, Michael
British, 20th cent.
LEONARDELLI, Fra
Giovanni di Buccio
Italian, op.1357-1370
LEONARDI, Leoncillo
Italian, 1915-1968
LEONARDIS, Jacopo
Italian, 1723-p.1782
LEONARDO de Chavier,
José or Jusepe
Spanish, c.1605-1656
LEONARDO da Pavia
Italian, op.1466
LEONARDO da Pistoia
see Grazia & Malatesta
LEONARDO da Roma
Italian, 15th cent.
LEONARDO da Sarzano
Italian, 16th cent.
LEONARDO or Nardo da
Teramo
Italian, op.1376-1435
LEONARDO da Vinci
Italian, 1452-1519
LEONARDONI, Francesco
Italian, 1654-1711
LEONART, Johann
Friedrich
see Leonard
LEONBRUNO, Leombruno
or De Leombeni,
Lorenzo
Italian, 1489-1537(?)
LEON-DAX
French, 19th cent.
LEONE or Lione, Andrea di
Italian, 1610-1685
LEONE, Gabriel de
see Leeuw
LEONELLI da Crevalcore,
Antonio
Italian, op.1480-m.a.1525
LEONELLI, Dante
American, 1932-
LEONETTI
Italian, 19th cent.
LEONHARDI, Eduard
(Emil August Eduard)
German, 1826-1905
LEONHARDT of Brixen
German, op.c.1462
LEONI, Carlo
Italian, 1925-
LEONI, Giuseppe de
Italian, 17th cent.
LEONI or Lioni, Leone
(Leone Aretino)
Italian, 1509-1590
LEONI or Lione, Ludovico
(Il Padovanino)
Italian, 1542-1612
LEONI, Michele or
Miguel Angel
Spanish, op.1582-1610
LEONI de'Marsari,
Ottavio Mario
Italian, c.1578-1630
LEONID, (Leonid
Berman)
American, 1896-
LEONORI, Pietro
see Lianori
LEONORI, R.G.L.
American(?), op.1847-1848

LEONTUS, Adam
Haitian, 20th cent.
LEOPOLSKI, Wilhelm
Polish, 1830-1892
LEOPRECHTING, Marquard
Freiherr von
German, 1839-1897
LE PAGER, J.D.
French, op.1718
LEPAGNEZ, François
French, 1828-1870
LE PAON, Lepaon, Paon
or du Paon, Jean-
Baptiste (not Charles,
Francois or Louis)
French, 1736/8-1785
LEPAPE, George
French, 19th cent.
LE PARC, Julio
South Central American,
20th cent.
LEPAULLIE, Lépaule or
Lépaulie, Guillaume
(François Gabriel
Guillaume)
French, 1804-1886
LEPAUTRE, Le Paultre
or La Pauetre, Antoine
French, 1621-1691
LEPAUTRE, Jacques
French, op.1670-m.1684
LEPAUTRE, Le Paultre or
Le Pautre, Jean
French, 1618-1682
LEPAUTRE, Pierre
French, 1660-1744
LEPEINTRE or Le Peintre,
Charles
French, 1735-1803(?)
LEPELAER, Arent
Dutch, op.c.1673-1714
LEPELTIER, Léon
French, 1877-
LEPELTIER, Robert
French, 1913-
LEPENDRY
French, op.1831-1836
LEPERE, Auguste
(Louis Auguste)
French, 1849-1918
LE PESCHIER, N.
see Peschier, N.L.
LE PETIT
French, op.1803
LE PETIT, Alfred
French, 1841-1909
LE PETIT, Alfred Marie
French, 1876-1954
LE PETIT or Le Petyt,
Bernardus or Barend
Dutch, op.1652-1669
LEPIC, Ludovic Napoléon
French, 1839-1889
LEPICIE, Nicolas
Bernard
French, 1735-1784
LEPIE, Ferdinand
(or Lepge)
Czech, 1824-1883
LEPILIEUR
French, 18th cent.
LE PILLEUR, Jérémie
French, op.1624-1638
LEPINE
French, op.1768-c.1781

LEPINE, Stanislas Victor
Edouard
French, 1835-1892
LE PIPER, Francis
British, 1640-1698
LE PLAT, France
French, 1895-1953
LE PLAT, Le Pla or
Leplae, Gilles or Egidius
Flemish, c.1656-1724
L'EPLATTENIER, Charles
Swiss, 1874-1946
LEPOITTEVIN, Lepoitevin,
Le Poittevin or
Poidevin, Eugène
Modeste Edmond
French, 1806-1870
LE POITTEVIN, Louis
French, 1847-1909
LEPORT, Thomas M.
British, op.1819
LEPRE
French, op.1752
LEPRIEUR or Le Prieur,
Adrien
French, op.1715-1725
LEPRIN, Marcel François
French, 1891-
LEPRINCE, Xavier
(Auguste Xavier)
French, 1799-1826
LE PRINCE, Charles
Edouard, Baron de
Crespy
French, 1784-p.1850
LE PRINCE or Leprince,
Jean Baptiste
French, 1734-1781
LEPRINCE, Juliette,
Baronne de Crespy
French, 19th cent.
LEPRINCE, Léopold
(Robert Léopold)
French, 1800-1847
LEPSIUS, Reinhold
German, 1857-1922
LEPSIUS, Sabine
German, 1864-1942
LE QUESNE, Fernand
French, 1856-p.1900
LEQUEUTRE, Hippolyte
(Joseph Hippolyte)
French, 1793-1877
LEQUEUX, Paul Eugène
French, 1806-1873
LERAMBERT, Henri
French, op.1568-m.1609
LERAY, Prudent Louis
French, 1820-1879
LERCH, Johann Martin
German, op.1659-1684
LERCHE, Vincent
Stoltenberg
Norwegian, 1837-1892
LERGAARD, Nielsen
Christian
Danish, 1893-
LERICHE
(François Sebastien)
French, op.1780
LE RICHE, Pierre
French, c.1760-1811
LERINE
French, 18th cent.
LERIUS, Joseph Henri
François van
Belgian, 1823-1876

IERMA y Villegas, Francisco José de
Venezuelan, 1719-1753

LERMANS, Pieter
see Leermans

L'ERMITE, Daniel
see Eremita

LERMOND, C.C.E.
American, 19th cent.

LEROLLE, Henry
French, 1848-1929

LE ROUGE, Jean Nicolas
French, c.1776

LEROUILLE, Maurice Ernest
French, 19th cent.

LEROUX or Le Roux the Elder, Charles (Maria Guillaume Charles)
French, 1841-1895

LEROUX or Le Roux, Eugène
French, 1807-1863

LE ROUX, Fr.
French, op.1727-1766

LEROUX, Georges Paul
French, 1877-1957

LEROUX or Le Roux, Hector (Louis Hector)
French, 1829-1900

LEROUX, Jean Marie
French, 1788-1870

LEROUX, Jules Marie Auguste
French, 1871-

LEROUX-REVAULT, Laura
French, -p.1930

LE ROUX SMITH LE ROUX
South African, 20th cent.

LEROY
French, op.1717

LEROY, Eliza
see Desrivières

LEROY de Liancourt, François
French, c.1741/2-1835

LEROY, Guillaume (Guillaume le Flamand)
Netherlands, op.1493-m.c.1525/8

LE ROY, Jean
see Boissiere

LE ROY, Joseph Francois
French, 1768-1829

LE ROY, Jules
French, 1833-1865

LEROY, Paul-Alexandre-Alfred
French, 1860-p.1908

LEROY, Pierre Jean-Baptiste
Belgian, 1784-1862

LEROY, Sébastien (Denis Sébastien)
French, op.1798-m.1832

LE ROY, Terry
French, 1584-85

LEROY-SAINT-AUBERT, Charles
French, 1856-p.1907

IERPA, Nes
Scandinavian, 20th cent.

LERSEY or Lersy, Roger
French, 1920-

IESAC, Petrus
German(?), op.1746

LESAGE, Pierre Alexis
French, 1872-

LESBROUSSART, E.
French, 19th cent.

LESCOT, Antoine Cécile Hortense
see Haudebourt-Lescot

LESECQ, Henri
French, 1818-p.1880

LESELLIER, Edmond
French, 1885-1920

LESEN (?), P. de
see Lelen

LE SIDANER, Henri Eugène
French, 1862-1939

LESIEUR, Pierre
French, c.1920

LESIRE or Lezier, Paulus
Dutch, 1611-p.1656

LESLIE, Alfred
American, 1927-

IESLIE, Cecil
British, 1900-

LESLIE, Charles
British, op.1835-1863

LESLIE, G.F.
British, op.1899

LESLIE, George Dunlop
British, 1835-1921

LESLIE, Robert (Charles Robert)
British, 1794-1859

LESLIE, William
British, -1812

LESMA, Antonio
Italian, op.1690-1706

IESNE, Camille
French, 19th cent.

LESOURD-BEAUREGARD, Ange Louis Guillaume
French, 1800-1873

LESPILLIEZ, Carl Albert von
German, 1723-1796

IESPINASSE, Louis Nicolas de (Le Chevalier de Lespinasse)
French, 1734-1808

IESPINAY
French, op.1802

IESPINERIE, de
French, 17th cent.

LESREL, Adolphe Alexandre
French, 1839-p.1865

IESSELINE
French, op.1757

LESSER, Aleksander
Polish, 1814-1884

LESSEUR, Leseur or Lesserowicz, Wincentry de
Polish, 1745-1813

IESSI, Giovanni
Italian, 1852-1922

LESSI, Tito
Italian, 1858-1917

LESSIEUX, Ernest Louis
French, 1848-1925

LESSIEUX, Louis Ernest
French, 1874-1925

LESSING, Carl Friedrich
German, 1808-1880

LESSING, Konrad Ludwig
German, 1852-1916

LESSOE, Thorald
Danish, 1816-1878

LESSORE, Emile Aubert
French, 1805-1876

LESSORE, John
British, 20th cent.

LESSORE, Jules
French, 1849-1892

IESSORE, Thérèse (Thérèse Sickert)
British, 1884-1945

L'ESTAIN, Jacques de
see L'Estin

IESTER, Adrienne
British, 20th cent.

L'ESTIN, L'Estain, Létin or Lettin, Jacques de
French, 1597-1661

LE STRANGE, Henry L.S.
British, 1815-1862

LE SUEUR, Blaise Nicolas
French, 1716-1783

LESUEUR, Charles Alexandre
French, 1778-1846

LESUEUR or Le Sueur, Eustache
French, 1617-1655

LESUEUR, J.B.
French, op.1775-1778

LE SUEUR, Louis
French, 1746-1803

LE SUEUR, Nicolas
French, 1691-1764

LESUEUR, Pierre Etienne
French, op.1780-m.1786

LESUR, Victor Henri
French, op.1887-1927

LESVIGNES, Amelie
French, 19th cent.

LE TELLIER
French, 18th cent.

LE TELLIER, Jean Baptist Joseph
French, op.1759-1812

LETELLIER, Louis Alphonse
French, 1780-1830

LE TELLIER, Pierre
French, 1614-1676

LETENDRE, Rita
Canadian, 1929-

LETESSIER, Joseph
French, 1867-1949

LETH, Harald
Danish, 1899-

LETH, Hendrik de
Dutch, op.c.1700-1759

LETHABY, William Richard
British, 1857-1931

LETHBRIDGE, Walter Stephens
British, 1771-1831

IETHIERE, Le Thierre or Letiers, Guillaume (Guillon)
French, 1760-1832

LETIN, Jacques de
see L'Estin

LETO, Antonio
Italian, 1844-1913

LE TOURNIER, J.M.
French, 20th cent.

LETRONNE, Louis René
French, 1790-1842

LETTENBÜHLER or Lettenbichler, Matthias
German, op.1642-1667

LETTERINI or Litterini, Bartolommeo
Italian, 1669-1745

LETTIN, Jacques de
see L'Estin

LETTNER, Robert
American, 20th cent.

LEU, August Wilhelm
German, 1819-1897

LEU, Leuw or Löw the Elder, Hans (Master with the Violet)
Swiss, c.1460-c.1507

LEU the Younger, Hans
Swiss, c.1490-1531

LEU, Oscar
German, 1864-1942

LEU, Deleu or Leeuw, Thomas de or Thomas Le Leup
Flemish(?), op.1576-1614

LEUBACH, Franz Seraph von
German, 1836-1904

LEUCZEBELLBURGER
see Lutzelburger

LEUFERT, Gerd
Venezuelan, 1914-

LEUNENSCHLOSS, Anton Clemens
see Lünenschloss

LEUPENIUS or Leupe, Johannes
Dutch, 1647/8-1693

LEUPIN, Herbert
Swiss, 1916-

LEUPOLD, Isaak
Swiss, 1704-1759

LEUPOLD, Jean Jacques
Swiss, 1730-1795

LEUPPI, Leo
Swiss, 1893-

LEURS, J.K.
German, 19th cent.

LEURS, Johannes Karel
Dutch, 1865-1938

LEUSDEN, William Van
Dutch, 1886-

LEUSSE, Simone de
French, 20th cent.

LEUSSINCK, J.
Dutch, op.1676

LEUTERSDORFFER, Franz
Anton von
see Leitenstorffer
LEUTZE, Emanuel Gottlieb
German, 1816-1868
LEUUS, Jesus
Mexican, 20th cent.
LEUVEN, F. van
Flemish(?), 18th cent.
LEUX, Frans
see Luyckx
LEVA, Girolamo
Italian, op.1663
LEVACHEZ, Charles
François Gabriel, I
French, op.1760-1820
LEVACK, J.
British(?), op.1851
LEVAILLANT, François
French, op.1781-1785
LEVASSEUR, Eugène
French, 1822-p.1866
LE VEAU, Jean
Jacques
French, 1729-1786
LEVECQ, Lavecq, Leveck
or L'Evesque, Jacobus
Dutch, 1634-1675
LEVEDAG, Fritz
German, 1899-1951
LEVEE, John
American, 1924-
LEVEILLE, André
French, 1880-
LEVEILLE, J.Augustin
French, op.1785
LEVENS, H.
French, 19th cent.
L'EVEQUE or Levesque,
Henri
Swiss, 1769-1832
LEVEQUE, Yves
French, 20th cent.
LEVER, Hayley
American, 1876-1958
LEVERETT, David
British, 1938-
LEVERING, Albert
American, 20th cent.
L'EVESQUE, Jacobus
see Levecq
LEVETUS, Celia A.
British, op.c.1895
LEVI, Carlo
Italian, 1902-
LEVI, Juán de
see Juán de Levi
LEVI, Julian Edwin
American, 1900-
LEVI, Luigi
(Liegi, Ulva or Ulvi)
Italian, 1860-1939
LEVIER, Adolfo
Italian, 1873-1953
LEVIER, Charles
French, 1920-
LEVIEUX (Le Vieux),
Renaud
French, c.1620-1690
LEVIEV, Joan
Bulgarian, 20th cent.
LE VILLAIN, Ernest
French, 1834-1916
LEVILLY, J.P.
French, op.c.1792
LEVILLY, Philéad
Salvator
French, 1803-

LEVIN, Phoebus
British, 1836-1908
LEVINE, David
American, 1927-
LEVINE, Jack
American, 1915-
LEVINE, Marilyn
American, 1935-
LEVIS, Maurice
French, 1860-
LEVITAN, Isaac Ilyitch
Russian, 1860-1900
LEVOLI, Niccola
Agostiniano
Italian, op.1770
LEVORATI, Ernesto
Italian, op.1880
LE VRAC, Robert
see Tournieres
LEVREL, René
French, 20th cent.
LEVY, Alexander O.
American, 1881-1947
LEVY, Alphonse-
Jacques
French, 1843-1918
LEVY, Emile
French, 1826-1890
LEVY, Henri Léopold
French, 1840-1904
LEVY, Henri Michel
French, op.1868-1886
LEVY, Lawrence
American, 20th cent.
LEVY, Mervyn
British, 1915-
LEVY, Robert
French, 19th cent.
LEVY, Rudolf
German, 1875-1943
LEVY, Simon
see Simon-Levy
LEVY-DHURMER, Lucien
French, 1865-1953
LEWANDOWSKI, Andrzej
Polish, 20th cent.
LEWELLEN, Donald
American, 1936-
LEWEND, J.B.
British, 19th cent.
LEWERS, Margo
Australian, 1908-
LEWIN, C.L.
American, op.1850
LEWIN, Frederick
George
British, -1933
LEWIN, John William
Australian, 1770-1819
LEWIN, Stephen
British, op.c.1890-1908
LEWIN, William
British, op.1764-c.1795
LEWIS, A.
British, -1807
LEWIS, Ada I.
British, 20th cent.
LEWIS, Alfred Neville
British, 1895-1972
LEWIS, Charles
British, 1753-1795
LEWIS, Charles James
British, 1830/6-1892
LEWIS, E. Goddwyn
British, 19th cent.
LEWIS, Edmund Darch
American, 1835-1910
LEWIS, Edward Morland
British, 1903-1943

LEWIS, F.C.
British, op.1916
LEWIS, Frederick
Christian, I
British, 1779-1856
LEWIS, George
American, op.1841-1860
LEWIS, George Robert
British, 1782-1871
LEWIS, Henry
British, c.1819-1904
LEWIS, J.
British, 19th cent.
LEWIS, James
British, 1782-1858
LEWIS, James Otto
American, 1799-1858
LEWIS, John
British, op.1744-1757
LEWIS, John
British, op.1762-1776
LEWIS, John Frederick
British, 1805-1876
LEWIS, John Hardwicke
British, 1840-1927
LEWIS, Judith
British, op.1775/6
LEWIS, Kit
British, 20th cent.
LEWIS, Lennard
British, 1826-1903
LEWIS, Neville
South African, 1895-
LEWIS, Peter
British, 1939-
LEWIS, Samuel
British, op.1774-1791
LEWIS, William
British, op.1804-1838
LEWIS, Wyndham
British, 1884-1957
LEWITT, Sol
American, 1943-
LEWIZKIJ, Dimitrij
Grigorjewitsch
Russian, 1735/7-1822
LEWY, Kurt
German, 1898-1963
LEY, Pablo
Spanish, 20th cent.
LE YAOUANC, Alain
French, 20th cent.
LEYBOLD, Friedrich
(Eduard Friedrich)
German, 1798-p.1847
LEYBOLD or Leibold,
Johann Friedrich
German, 1755-1838
LEYDE, Otto Theodor
German, 1835-1897
LEYDENSDORF, Franz
Anton von
see Leitenstorffer
LEYEN, Jacques François
de
see Lyen
LEYENDECKER, Joseph
Christian
American, 1874-1951
LEYGEBE, Paul Carl
German, 1664-p.1730
LEYGUE, Eugène
French, 1813-1877
LEYLAND, Joseph Bentley
British, 1811-1851
LEYMAN
British, 18th cent.
LEYMARIE, Hippolyte
French, 1809-1844

LEYNIERS, Daniel, I
Flemish, 1618-1688
LEYPOLD, Karl Julius
von
German, 1806-1874
LEYS, Baron Jan August
Hendrik
Belgian, 1815-1869
LEYSON, Ellen Anne
British, op.1837
LEYSSENS or Lyssens,
Jacob
Flemish, op.1674/5-1698/9
LEYSTER, Judith
(Judith Molenaer)
Dutch, c.1600/10-1660
LEYTENS, Gysbrecht
see Lytens
LEZAY-MARNESIA, de
Nettancourt, Marie
Claudine, Marquise de
French, -1793
LEZCANO, Carlos
Spanish, 1860-
LEZIER, Paulus
see Lesire
LHARDY y Garrigues
Agustin
Spanish, 1848-1918
LHERMITTE, Léon
Augustin
French, 1844-1925
LHOMME, Jacques
French, 1600-p.1650
L'HOPITAL, René le
Brun, Comte de
French, 1877-
L'HOSPITAL, J.F. de
French, op.1763-1779
LHOTE, André
French, 1885-1962
LHUILLIER, Charles
French, 1824-1898
LHUILLIER, Susanne
see Perregaux
LIAGNO or Liano, Teodoro
Filippo di
see Angeli
LIANO, Felipe de
(El pequeño Titiano)
Spanish, 1556/66-1625
LIANO, Liani or Llanos,
Francesco
Italian, op.1765-1777
LIANORI or Leonori,
Pietro (Giovanni)
(not Pietro Giovanni
dalle Tovaglie)
Italian, op.1446-1460
LIARDO, Filippo
Italian, 1840-1917
LIATSKY, Elim Elmovich
Russian, 1929-
LIBALT, Gottfried
German, op.c.1649-1666
LIBERALE da Verona or
di Jacopo dalla Biave
Italian, c.1445-1526/9
LIBERATORE
see Niccolò da Foligno
LIBERI, Marco
Italian, 1640-p.1725
LIBERI, Pietro
Italian, 1614-1687
LIBERMAN, Alexander
American, 1912-
LIBERT, Georg Emil
Danish, 1820-1908

LIBERTI, Francesco
Italian, op.c.1630
LIBERTI, Juan Carlos
South American,
20th cent.
LIBOUR, Esprit Aimé
French, 1784-p.1845
LIBRI, Francesco, I
dai
Italian, 1452-1502/14
LIBRI
see Girolamo dai
LICATA, Riccardo
Italian, 1929-
LICHERIE or Lichery
de Beuron, Louis
French, 1629-1687
LICHTENBERG, Mechteld
van
see Boecop
LICHTENFELS, Eduard
Peithner von
German, 1833-1913
LICHTENHELD, Wilhelm
German, 1817-1891
LICHTENSTEIN, Roy
American, 1923-
LICINI, Osvaldo
Italian, 1894-1958
LICINIO da Pordenone,
Bernardino
Italian, c.1489-a.1565
LICINIO da Pordenone
II, Giovanni Antonio
(Il Sacchiense)
Italian, 1515-1576
LICINIO da Pordenone,
Giulio
Italian, 1527-p.1593
LIDDERDALE, Charles
Sillen
British, 1831-1895
LIE, Jonas
Norwegian, 1880-1940
LIE, O. Robert
American, 20th cent.
LIEB, Michael
see Munkacsy
LIEBACH, Lucas
German, 1684-1728
LIEBENWEIN, Maximilian
German, 1869-1926
LIEBER, Carl
German, 1791-1861
LIEBER, Max
German, 1851-1918
LIEBERG, Max
German, 1856-1912
LIEBERMANN, Ernst
German, 1869-
LIEBERMANN, Max
German, 1847-1935
LIEBMANN, Gebhardt
American, 1928-
LIEBMANN, Pinehas
(Pinchus ?)
German, 1777-1832
LIECHMANN(?), George
German, 19th cent.
LIEDER, Friedrich, II
German, 1807-1884
LIEDER, Friedrich
Johann Gottlieb
(Franz)
German, 1780-1859
LIEDTS or Liets, Abraham
Dutch, op.1653-1659

LIEFERINXE, Josse
(Master of St.
Sebastian)
French,
op.1490-m.c.1508
LIEFRINCK, Christiaen
Dutch, op.1643
LIEFRINCK, Cornelis
Johannesz.
Dutch, c.1581-p.1640
LIEFRINCK, Hans or
Jan, I
Netherlands,
1518(?)-1573
LIEGE
see France de Liège
LIEGEOIS, Simon Michel
French, 1687-1775
LIEGI, Ulva or Ulvi
see Levi, Luigi
LIEGOIS, Paul
French, 17th cent.
LIEMAKER, Nicolas de
(Roose)
Flemish, 1600/1-1646
LIENARD, Jean Baptiste
French, 1782-1857
LIENARD, Sophie
French, 19th cent.
LIENDER, Jacobus van
Dutch, 1696-1759
LIENDER, Paul or Paulus
van
Dutch, 1731-1797
LIENDER, Pieter van
Dutch, 1727-1779
LIENZ, Egger
German, 1868-
LIENZ, M.
German, 19th cent.
LIEPMANN, Jacob
German, 1803-1865
LIER, Abraham van
Flemish, op.1603-1618
LIER, Adolf Heinrich
German, 1826-1882
LIERE, Josse van
Netherlands,
op.1546-m.1583
LIEREMANS
Dutch, 17th cent.
LIES, Jozef Hendrik
Hubert
Belgian, 1821-1865
LIESEGANG, Helmuth
German, 1858-1945
LIESTE, Cornelis
Dutch, 1817-1861
LIETO, Alexandre
French, 19th cent.
LIETS, Abraham
see Liedts
LIEUR, Jacques le
French, 15th cent.
LIEVENSZ. or Livens,
Jan
Dutch, 1607-1674
LIEVENSZ. or Livens,
Jan Andrea
Dutch, 1644-1680
LIEVIN, Jacques
French, c.1850-
LIEVRE, Edouard
French, 1829-1886
LIEZEN-MAYER, Alexander
von Sandor
Hungarian, 1839-1898

LIFFERIN, Josse
see Lieferinxe,
Master of St.
Sebastian
LIFRINS, Josse
see Lieferinxe,
Master of St. Sebastian
LIFSHITZ, Uri
Israeli, 20th cent.
LIGABUE, Antonio
Italian, 1899-1965
LIGARE, David
American, 20th cent.
LIGARI or Ligario,
Angelo
Italian, op.1827-1849
LIGARI, Cesare
Italian, 1716-
LIGARI or Ligario,
Pietro (Giovanni
Pietro)
Italian, 1686-1752
LIGETI, Antal or Anton
Hungarian, 1823-1890
LIGHT, Colonel William
British, 1786-1839
LIGHTBODY, James
British, op.c.1700
LIGHTFOOT, Maxwell
Gordon
British, 1886-1911
LIGNIS, Pietro de
(Pietro Dubois or
van den Houte)
Flemish, op.1599-m.1627
LIGNON, Etienne Frédéric
French, 1779-1833
LIGNON, Raoul
French, 20th cent.
LIGORIO, Pirro
Italian, c.1500-1583
LIGOZZI, Giacomo
Italian, c.1547-1626
LIGOZZI, Paolo
Italian, op.1572-1615
LIGOZKIJ, Iwan
Russian, op.1753-1769
LIHL, Heinrich
German, 1690-1756
LILENFIELD, H.
British, 19th cent.
LILIENBERGH, Cornelis
see Lelienbergh
LILIO, Andrea
(Andrea d'Ancona nella
Marca)
Italian, 1555-1610
LILJEFORS, Bruno Andreas
Swedish, 1860-
LILLIE, Peter Andersen
Norwegian, 1671-1711
LILLIESTROM, Per
Scandinavian, 1932-
LILLONI, Umberto
Italian, 1898-
LILLY or Lillie, Edmond
see Lelly
LIMBORCH, Hendrik van
Dutch, 1681-1759
LIMBORCH or Limburg,
Michiel or Machiel D.
van
Dutch, op.1647-1675
LIMBOS, Karsten van
(Christian Valimboy,
Valumbes or Valumbras)
Netherlands, op.1537-1542

LIMBURG, Limbourc or
Limbourg, Armand
(Hermanus) de
French, -a.1439
LIMBURG, Christian
see Leinberger,
Christian
LIMBURG, Limbourc or
Limbourg, Jean or
Jeannequin de
French, -a.1439
LIMBURG, Michiel or
Machiel D. van
see Limborch
LIMBURG, Limbourc or
Limbourg, Paul or Pol
de (Master of the Très
Belles or Très Riches
Heures of the Duc de Berry)
French, op.1416
LIMMER, Emil
German, 1854-1931
LIMNELL, Emanuel (P.E.)
Swedish, 1764-1861
LIMOSIN, Léonard, I
French, c.1505-1575/7
LIMHOUSE, Roger Marcel
French, 1894-
LIMPERT, Heinrich
(Johann Heinrich)
German, 1858-p.1888
LIN, Herman (also,
erroneously, Jan
De Stille or van Stilheid)
Dutch, op.1659-1675
LIN, Richard (Show Yu)
British, 1933-
LINARD, Jacques (?)
French, c.1600-1645
LINATI
Italian, 19th cent.
LINCK, Jean Antoine
Swiss, 1766-1843
LINCK, Jean Philippe,
II
Swiss, 1770-1812
LINCK, Lorentz or
Laurent
see Link
LINCOLN, Anna Maria,
Countess of
British, 1760-1834
LINDAU, Dietrich
Wilhelm
German, 1799-1862
LINDAUER, Gottfried
Bohemian, 1839-1926
LINDE, Jan van der
Dutch, 1864-1945
LINDEGREN, Amalia
Swedish, 1814-1891
LINDELL, Lage
Swedish, 1920-
LINDEMANN-FROMMEL,
Karl
German, 1819-1891
LINDEMANN-FROMMEL,
Manfred
German, 1852-p.1929
LINDENSCHMIT or
Lindenschmitt,
Wilhelm, I
German, 1806-1848
LINDENSCHMIT, Wilhelm,
II von
German, 1829-1895

LINDER, Linderer or
Lindner, Franz
German, 1736-1802
LINDER, Lambert
German, 1841-1889
LINDER, Philippe-
Jacques
French, op.1857
LINDERUM, Richard
German, 1851-p.1881
LINDGAARD, Jacob
Pedersön
Norwegian, 1719-1789
LINDH, Johan Erik
Swedish, 1793-1865
LINDHOLM, Bernt Adolf
Finnish, 1841-1914
LINDHOLM, Lorenz August
Swedish, 1819-1854
LINDIN, Carl Olof
Eric
American, 1869-1942
LINDLAR, Johann Wilhelm
German, 1816-1896
LINDMAN, Axel
(Knut Axel)
Swedish, 1848-1930
LINDNER, Christian
August
German, 1728-1806
LINDNER, Ernest
Canadian, 1897-
LINDNER, Franz
see Linder
LINDNER, Moffat Peter
British, 1854-1949
LINDNER, Richard
American, 1901-
LINDNEUX, Robert
Ottokar
American, 20th cent.
LINDO, F.
British, op.1755-1761
LINDSA(?), Pieter
see Linse
LINDSAY, Sir Coutts
British, 1824-1913
LINDSAY, Sir Ernest
Daryl
British, 1889-
LINDSAY, Graham
British, 19th cent.
LINDSAY, J.
British, op.c.1845
LINDSAY, Sir Lionel A.
British, 1874-
LINDSAY, Marion Margaret
Violet
British, 1856-1937
LINDSAY, Norman
Australian, 1879-1969
LINDSAY, Robert
British, -1726
LINDSAY, Thomas
British, c.1793-1861
LINDSAY, Violet
see Rutland, Violet,
Duchess of
LINDSE(?), Pieter
see Linse
LINDSEY, S.Arthur
British, op.1920-1950
LINDSTRÖM, Arvid Maurits
Swedsih, 1849-p.1889
LINDSTRÖM, Bengt
Scandinavian, 1925
LINDSTRÖM, Fritz (August
Frederik)
Swedish, 1874-

LINDSTRÖM, Karl Johan
Swedish, 1801-p.1846
LINDSTRÖM, Rikard
Swedish, 1882-1943
LINDTMAYER or Lindmeyer
II, Daniel
Swiss, 1552-c.1606
LINDTMAYER I, Felix
Swiss, op.1524-m.c.1543
LINEN, George
American, 1802-1888
LINES, F.J.B.
British, op.1828/9
LINES, Henry Harris
British, 1800-1889
LINES, Samuel
British, 1778-1863
LINES, Samuel Restell
or Rostill
British, 1804-1833
LINES, Vincent Henry
British, 1909-1968
LINFORD, Alan Carr
British, 1926-
LINFORD, Charles
American, 1846-1897
LINGCKH, Lorentz or
Laurent
see Link
LINGELBACH, Johannes
Dutch, 1622-1674
LINGEMAN, Lambertus
Dutch, 1829-1894
LINGENFELDER, Eugen
German, 1862-p.1909
LINGER, Ottfried
German, op.1839-1848
LINGG or Lingk,
Lorentz or Laurent
see Link
LINGNER, Max
German, 1888-
LINGOE, C.
Netherlands, op.1588
LINK, Linck, Lingckh,
Lingg, Lingk or
lingckh, Lorentz or
Laurent
German, 1582-
LINKE, Paul Rudolf
German, 1844-1917
LINNELL, James Thomas
British, 1826-1905
LINNELL, John
British, -1796
LINNELL, John
British, 1792-1882
LINNELL, William
British, 1826-p.1891
LINNERHIELM, Jonas Carl
Swedish, 1758-1829
LINNIG, Egidius
Belgian, 1821-1860
LINNIG, Willem, I
Belgian, 1819-1885
LINNIG, Willem, II
Belgian, 1842-1890
LINNQVIST, Hilding
Swedish, 1891-
LINS, Adolf
German, 1856-1927
LINSCHOTEN or
Linschooten, Adriaen
Cornelisz. van
Dutch, c.1590-1677
LINSCHOTEN, Jan
Huygen van
Netherlands, 1563-1611

LINSDELL, Leonard
British, 19th cent.
LINSE,(?)Lindsa or
(?)Lindse, Pieter
Dutch, -1666
LINSEN, Jan
(Hermafrodito)
Dutch, 1602/3-1635
LINSON, Corwin Knapp
American, 1864-
LINSTOW, Hans Ditlev
Frants
Danish, 1787-1851
LINT, Hendrik Frans
van (Studio)
Flemish, 1684-1763
LINT, Louis van
Belgian, 1909-
LINT, Peter van
Flemish, 1609-1690
LINTELOO, Jan van
Dutch, op.1619
LINTHORST, Jacobus
Dutch, 1745-1815
LINTON, Henry Duff
British, 1815-1899
LINTON, Sir James
Dromgole
British, 1840-1916
LINTON, William
British, 1791-1876
LINTON, William James
British, 1812-1898
LINTOTT, Edward
Barnard
British, 1875-
LINTOTT, Henry C.
British, 1877-1965
LINWOOD, Mary
British, 1755-1845
LINZEN, Heinrich
German, 1886-1942
LION, Alexandre Louis
Belgian, 1823-1852
LION, Flora
British, 1878-p.1919
LION or Lyon, Pierre
Joseph
Flemish, 1729-1809
LIONARDO da Murano
see Corona
LIONE, Andrea di
see Leone
LIONE, Gabriel de
see Leeuw
LIONELLI
Italian, 17th cent.
LIONNET, Félix
French, 1832-1896
LIOT, Paul Louis
Frédéric
French, 1855-1902
LIOTARD, Jean Etienne
Swiss, 1702-1789
LIOTARD, Jean Michel
Swiss, 1702-1796
LIOUX de Savignac,
Edmé Charles de
French, op.1766
LIPCHITZ or Lipschitz,
Jakoff (Jacques)
French, 1891-
LIPHART, Ernst
Friedrich von
Russian, 1847-1934
LIPINSKI, Eryk
Polish, 1908-

LIPINSKI, Hipolit
Polish, 1846-1884
LIPINSKY, Sigmund
German, 1873-1940
LIPOUILLE
French, op.1838
LIPP, von
German, 18th cent.
LIPPARINI or Liparini,
Leopold
Italian, 1800-1850
LIPPARINI, Lodovico
Italian, 1800-1856
LIPPI, Filippino
Italian, c.1457-1504
LIPPI, Fra Filippo
Italian, c.1406-1469
LIPPI, Lorenzo
Italian, 1606-1665
LIPPINCOTT, William
Henry
American, 1849-1920
LIPPO di Benivieni
Italian, op.1296-1353
LIPPO di Dalmasio
(Maso da Bologna)
Italian, 1352-p.1410
LIPPO Fiorentino
Italian, c.1354-c.1410
LIPPOLD or Lippoldt,
Franz
German, 1688-1768
LIPPS, Richard
German, 1857-1926
LIPS, Johann Heinrich
Swiss, 1758-1817
LIPSCOMBE, Guy
British, op.c.1908-1937
LIPSKY, Pat
American, 20th cent.
LIPTON, Seymour Arthur
American, 1903-
LIQUIER, Gabriel
(Trick)
French, 1843-1887
LIRA, Pedro
Chilean, op.1872-1901
LISAERT, Pieter
Netherlands,
16th/17th cent.
LISCHKA, Johann Christoph
see Liska
LISIEWSKA or Liszewska,
Anna Dorothea von
(Therbusch)
German, 1721-1782
LISIEWSKA or Liszewska,
Anna Rosina von
(Matthieu and de Gasc)
German, 1716-1783
LISIEWSKI, Liszewski or
Liszewsky, Christian
Friedrich Reinhold
German, 1725-1794
LISIEWSKI, Liszewski
or Liszewsky, George
or Jerzy
Polish, 1674-1750
LISITSKY, L,M.
Russian, 20th cent.
LISKA, Emanuel Kresenc
Czech, 1852-1903
LISKA or Liachka,
Johann Cristoph
Ritter von
Rottenwa-d
German, c.1640-1712

LISLE, Fortunée de
French, op.1832
LISMER, Arthur
Canadian, 1885-
LISS, Lis, Lys or von
Lys, Johann or Jan
(Pan)
German, c.1590-1629
LISSANDRINO, Il
see Magnasco,
Alessandro
LISSE, Dirck van der
Dutch, op.1639-m.1669
LISSIM, Simon
Russian, 1900-
LISSITSKY, Eliezer (El)
Russian, 1890-
LIST, Georg Nikolaus
German, op.1653-1672
LIST, Wilhelm
German, 1864-1918
LISTER, Ed
American, 20th cent.
LISTER, Harriet
see Green, Harriet
LISTER, Raymond George
British, 1919-
LISTER-LISTER, William
Australian, 1859-1943
LISTNAU, Emanuel
German, c.1740-
LISZEWSKI
see Lisiewski
LITHUANIAN SCHOOL,
Anonymous Painters
of the
LITOVTCHENKO, Alexander
Russian, 1835-1890
LITTEN, Sidney
Mackenzie
British, 1887-1934
LITTERINI
see Letterini
LITTI
Italian, 17th cent.
LITTLE, Alice
British, 19th cent.
LITTLE, Anna M.
American, op.1878
LITTLE, George Léon
British, 1862-1941
LITTLE, Philip
American, 1857-1942
LITTLE, Robert
British, c.1855-1944
LITTLEFORD
British, op.1762-1763
LITTLEJOHNS, John
British, 1874-p.1918
LITTRET de Montigny,
Claude Antoine
French, c.1735-1775
LITVINOVSKY, Pinchas
Russian, 1894-
LIUZZI, Giacomo
Italian, 1785-1867
LIVEMONT, Privat
Belgian, 1861-
LIVENS
see also Lievens
LIVENS, Horace Mann
British, 1862-p.1890
LIVERANI, Antonio
Italian, 1795-1878
LIVERANI, Romolo
Italian, 1809-1872

LIVERATI, Carlo
Ernesto
German, 1805-1844
LIVERSEEGE, Henry
British, 1803-1832
LIVERTON, Thomas
Alfred
British, 1907-1973
LIVESAY, Richard
British, op.1776-m.c.1823
LIVESAY, Rose M.
British, op.c.1897
LIVINGSTON, H.
American, op.1791
LIVIO da Forli
see Agresti
LIVIO, Gianmaria di
Coldrerio
Italian, c.1693-1766
LIVIZZANI, Girolamo
de'
see Carpi
LIX, Frédéric Théodore
French, 1830-1897
LIZARA, Francesco
see Lizona
LIZARS, William Home
British, 1788-1859
LIZONA or Lizara,
Francesco
Spanish(?), op.1683
LJUBA
French, 20th cent.
LJUNGGREN, Carl Johan
Swedish, 1790-1852
LLANO or Llanos y Valdé,
Sebastián de
Spanish, op.1637-m.c.1668
LLANOS, Ferrando or
Fernando (Ferrando
Spagnuolo or Hernando ?)
see also under Yanez
Spanish, op.1504-1530
LLANOS, Francesco
see Liano
LLANOS, Suarez
Spanish, 19th cent.
LLASERA y Diaz, José
Spanish, 1882-
LLEWELLYN, S.
British, 19th cent.
LLEWELLYN, Sir William
Samuel Henry
British, c.1860-1941
LLIMONA y Bruguera
Juan (Joan)
Spanish, 1860-1926
LLONYE, Antonio de
see Llouye
LLORENTE, Bernardo
German de
see German y Llorente
LLOUYE or Llonye,
Antonio de
Spanish, op.1462
LLOYD, Edward
British, op.1866
LLOYD, Ernest H.D.
British, op.c.1895-1909
LLOYD, James
British, 1905-1974
LLOYD, Llewelyn
Italian, 1879-1949
LLOYD, Margaret
British, 19th cent.
LLOYD, Mary
see Moser

LLOYD, Norman
Australian, 1895-
LLOYD, Reginald J.
British, 20th cent.
LLOYD, T. Ivester
British, 19th cent.
LLOYD, Thomas James
British, 1849-1910
LLOYD, W. Stuart
British, op.c.1875-1929
LLUCH
see Borrassa, Lucas
LLUCH, Vicente
Spanish, 1771-1812
LLUYS de Valls, Juan
Spanish, 15th cent.
LOARTE, Alexandro de
Spanish, op.1622-1626
L'OBERLAND, Laitière de
French, op.c.1845
LOBLEY, John Hodgson
British, 1878-p.1915
LOBO, Balthazar
Spanish, 1911-
LOBO, Filipe
Portuguese, 17th cent.
LOBOS, Pedro
Chilian, 20th cent.
LOBRE, Maurice
French, 1862-1951
LOBRICHON, Timoléon
French, 1831-1914
LOBRY, W.
Dutch, 1774-
LOCARNO, Giovanni
Italian, 18th cent.
LOCATELLI or Lucatelli,
Andrea
Italian, 1695-1741
LOCATELLI, Giovan
Francesco
Italian, op.1840-1861
LOCATELLI, Lucatelli
or Lucattelli, Pietro
Italian, c.1634-1710
LOCATELLI or Lucatelli,
Rizzardo
Italian, 16th cent.
LOCH, J.
British, 18th cent.
LOCHEM, Michel van
see Lochom
LOCHER, Gottfried
German, 1730-1795
LOCHER, M.
Swiss, op.1784
LOCHHEAD, Kenneth
Canadian, 1926-
LOCHNER, Michel
German, 1897-
LOCHNER, Stefan
German, op.1442-m.1451
LOCHOFF, Nicholas
Russian, 19th cent.
LOCHOM, Lochem or
Lochon, Michel van
Flemish, 1601-1647
LOCHON, René
French, 1636-1675
LOCK, Anton
German, 1893-
LOCK, Beatrice (Fripp)
British, 19th cent.
LOCK, Frederick
British, op.1843-1846
LOCK, Mathias
British, op.1740-1769

LOCKE or Lock,
William, I
British, 1732-1810
LOCKE, William, II
British, 1767-1847
LOCKER, Edward Hawke
British, 1777-1849
LOCKER, John
British, op.c.1800
LOCKEY, Nicolas
British, op.1620
LOCKEY, Rowland
British, op.1590-1610
LOCKHART, William
Ewart
British, 1846-1900
LOCKMAN, DeWitt M.
American, 1870-p.1933
LOCKWOOD, Sir Francis
(Frank)
British, 1846-1897
LOCKWOOD, John
British, 19th cent.
LOCKWOOD, Wilton
American, 1862-1914
LOCKYER, Captain
British, 18th cent.
LOCSEI, Miklos
(Nicolas)
Hungarian, op.1484
LODDER, W.P.J.
British, op.1783-1804
LODER, James
British, 1784-1860
LODER, Matthäus
German, 1781-1828
LODER, R.
British, op.1780
LODGE, George Edward
British, op.1881-1891
LODGE, John
British, op.1782-m.1796
LODGE, William
British, 1649-1689
LODI, Carlo
Italian, 1701-1765
LODI, Ermenegildo
Italian, op.c.1600
LODI, G.
Italian, 19th cent.
LODI, Gilardo da
Italian, 18th cent.
LODI, Giovanni
Agostino da
see Boccaccino, Pseudo
LODI, Mario
Italian, 17th cent.
LODOVICO da Parma
Italian, 16th cent.
LOEB, Louis
American, 1866-1909
LOEBER, Louise Marie
(Lou)
Dutch, 1894-
LOEDING, Lotding,
Luidingh, Luydingh
etc., Harmen
Dutch, c.1637-p.1673
LOEF or Loeff, Jacob
Gerritz.
Dutch, c.1607-p.1648
LOEFF, Hillebrand
Dirk
Dutch, 1774-1845
LOEILLOT-HARTWIG, Karl
Henri Charles
German, 1798-p.1841

LOENEN, Johann
Cornelisz. van
Dutch, op.1620-1643

LOENINGA, Allaert van
Dutch, op.1635-m.c.1649/50

LOESCHENKOHL, Johann
Hieronymus
German, op.1779-m.1807

LOESEN, Rudolph
see Rudolph of
Antwerp

LOEW, Conrad Curt
German, 1914-

LOEW, Michael
American, 1907-

LOEWE, Margarete
(Bethe)
German, 1859-p.1896

LOEWENSBERG, Verena
(Vreni)
Swiss, 1912-

LOEWENSTERN, Christian
Ludwig von
German, 1701-1754

LÖFFLER, Berthold
German, 1874-1960

LÖFFLER, Ludwig
German, 1819-1876

LÖFFLER-RADYMNO, Léopold,
Edler von
Polish, 1827-1898

LÖFFTZ, Ludwig von
German, 1845-1910

LOFT, P.
American, op.c.1865

LOFVERS, Hendrik
Dutch, 1739-1805

LOGAN, A.
American, op.1874

LOGAN, George
British, 20th cent.

LOGAN, J.
British, op.1837

LOGAN, Robert Fulton
American, 1889-

LOGEAIS, Ellen
French, 20th cent.

LOGELAIN, Henri
French, 20th cent.

LOGGAN
British, op.1748

LOGGAN, David
British, 1633/5-1692

LOGSDAIL, William
British, 1859-p.1892

LOGUE, John James
American, c.1810-p.1864

LOH, F.
German, 18th cent.

LÖHR, Emil Ludwig
German, 1809-1876

LÖHRER, Johann Gottlieb
Swiss, 1791-1840

LOHRMANN or Lormann,
Friedrich Anton
German, c.1735-p.1776

LOHSE, Richard Paul
Swiss, 1902-

LOIR, Alexis, III
French, 1712-1785

LOIR, Luigi (Aloys
François Joseph)
French, 1845-1916

LOIR, Marianne
French, op.1737-1769

LOIR or Loyr, Nicolas
Pierre
French, 1624-1679

LOIRE, Léon Henri
Antoine
French, 1821-1898

LOIS or Loys, Jacob
Dutch, op.1643-m.1676

LOISEAU, Gustave
French, 1865-1935

LOISEL, Frédéric
French, 20th cent.

LOJACONO, Francesco
Italian, 1841-1915

LOKHORST, Dirk van
Dutch, 1818-1893

LOKHORST, Dirk Peter
van
Dutch, 1848-

LOLA, Francesco
Italian, op.1393-1419

L'OLMO, Bartolomeo
Italian, 1506-p.1578

LOMAS, J.A. Mease
British, op.c.1912-1919

LOMAS, J.L.
British, 19th cent.

LOMAX, Conrad Hope
British, 1885-

LOMAX, E.
British, 19th cent.

LOMAX, John Arthur
British, 1857-1923

LOMAZZO, Giovanni Paolo
Italian, 1538-1600

LOMBARD, Jean
French, 1895-

LOMBARD, Lambert
Netherlands, 1506-1566

LOMBARD or Lombart,
Pierre
French(?), c.1613-1682

LOMBARD SCHOOL AND MILAN,
Anonymous Painters
of the

LOMBARDELLI, Giovanni
Battista (della Marca
or Montano)
Italian, op.1566-m.1592

LOMBARDI, Giovanni
Domenico (Omino)
Italian, 1682-1752

LOMBARDO or Lombardi,
Pietro
Italian, c.1435-1515

LOMBELLINO, Sofonisba
see Anguisciola

LOMET, Antoine François
French, 1759-p.1807

LOMI, Aurelio
Italian, 1556-1622

LOMI, Orazio
see Gentileschi

LOMMELIN, Adriaen
Flemish, op.1654-1677

LOMMEN, Wilhelm van
German, 1839-1895

LOMONT, Eugène
French, 1864-

LÖNBERG, Lorens or
Lars
Swedish(?),
op.1771-m.1811

LONCKE, Jacob
Lambrechtsz.
Dutch, c.1580-p.1646

LONDERSEEL, Joannes or
Jan van
Flemish, c.1510-1624/5

LONDERVAN, Ja.
see Sondervan

LONDONIO, Francesco
Italian, 1723-1783

LONEN, Theodor or
Dirk van
see Loonen

LONG, Amelia (Lady
Farnborough), (née
Hume)
British, 1762-1837

LONG, Edwin
British, 1829-1891

LONG, John Kenneth
British, 1924-

LONG, John St. John
British, 1798-1834

LONG, Richard
British, 20th cent.

LONG, Sydney
Australian, 1871-1955

LONGACRE, James Barton
American, 1794-1869

LONGANESI, Leo
Italian, 1905-1957

LONGASTRE, L. de
British, op.1790-1798

LONGBOTHAM, Charles
Norman
British, 1917-

LONGCHAMP, Charles
Swiss, 1841-1898

LONGCHAMPS, Catherine
Julie, (née Guy)
Swiss, 1806-1879

LONGCROFT, Thomas
British, op.c.1786-m.1811

LONGDEN, Alfred
British, 1875-1954

LONGDEN, F.J.
British, 1840-

LONGE, Longi or Longo,
Robert or Uberto de,
or Robert La Longe
(il Fiammingo)
Flemish, c.1645-1709

LONGFELLOW, Ernest
Wadsworth
American, 1845-1921

LONGHI, Alessandro
(Falca)
Italian, 1733-1813

LONGHI, Antonio
see Antonio
Veneziano

LONGHI, Barbara
Italian, 1552-c.1638

LONGHI or Lunghi,
Francesco
Italian, 1544-c.1620

LONGHI, Giuseppe
Italian, 1766-1831

LONGHI, Jacobini
see Longo

LONGHI or Lunghi, Luca
Italian, 1507-1580

LONGHI, Pietro (Falca)
Italian, 1702-1785

LONGI, Robert or
Uberto de
see Longe

LONGJUMEAU, Gaillard de
French, 17th cent.

LONGLEY, Stanislaus
Soutten
British, 1894-1966

LONGO or Longhi,
Jacobini
Italian, op.1517-m.c.1542

LONGO, Robert or
Uberto de
see Longe

LONGPERIER, Henri
Adrien Prevost de
French, op.1816

LONGSTAFF, Sir John
Australian, 1862-1941

LONGUEIL, Joseph de
French, 1730-1792

LONGUELUNE, Zacharias
French, 1669-1748

LONGUET, Alexandre Marie
French, op.1831-m.1850/1

LONGUET, Michel
French, 20th cent.

LONGUEVILLE, Charles
French, 1829-p.1865

LONHY, Antoni de
Spanish, op.1459/60

LONING
British, 18th cent.

LONNE, Raphael
French, 20th cent.

LONS, Dirk Everson
Dutch, 1599/1600-p.1631

LONSDALE, James
British, 1777-1839

LONSDALE-HANDS, Richard
British, 20th cent.

LONSING, François
Joseph
Flemish, 1739-1799

LOO, Amédée (Charles
Amédée Philippe) van
(Vanloo or Vanlo)
French, 1719-1795

LOO, Carle (Charles
André) van (Vanloo or
Vanlo)
French, 1705-1765

LOO, César (Jules
César Denis) van
(Vanloo or Vanlo)
French, 1743-1821

LOO, Jakob or Jacques
Dutch, c.1614-1670

LOO, Jean Baptiste van
(Vanloo or Vanlo)
French, 1684-1745

LOO, Louis Michel van
(Vanloo or Vanlo)
French, 1707-1771

LOO or Loon, Pieter
van
Dutch, 1731-1784

LOOFF or Loof, Johannes
Dutch, op.1627-m.1651

LOON, F.W. van
Netherlands, 17th cent.

LOON, Pieter van
Dutch, 1801-1873

LOON, Theodor van
Flemish, c.1580/5-1667(?)

LOONEN or Lonen, Theodor
or Dirk van
Dutch, c.1620-p.1701

LOOPEY, Henry
British, 19th cent.

LOOS, Cornelius
Swedish, 1686-1738

LOOS, Friedrich
German, 1797-1890

LOOS, Henry
Belgian(?), op.1880

LOOSCHEN, Hermann, I
German, 1807-1873

LOOTEN, Jan
Dutch, c.1618-c.1681
LOOYMANS, Romain
Belgian, 1864-1914
LOPES, Cristobal or
Cristovao Lopez
Portuguese, 1516-1594
LOPES, Gil T.
Portuguese, 1936-
LOPES or Lopez,
Gregorio
Portuguese,
op.1514-m.1550
LOPES, Hilario T.
Portuguese, 1932-
LOPES, Sousa
Portuguese, 20th cent.
LOPEZ
see also Lopes
LOPEZ, Andres
Spanish, op.1505-1511
LOPEZ y Piquer, Bernardo
Spanish, 1800-1874
LOPEZ, Diego
Spanish, op.1427-1430
LOPEZ, Diego
Spanish, op.1686
LOPEZ y Martinez,
Enrique
Spanish, 1853-1875
LOPEZ, Francesco
Italian, op.1748
LOPEZ, Francisco
Spanish, op.1480-1505
LOPEZ, Gasparo
Italian, op.1730-m.c.1732
LOPEZ, Juan Pedro
Venezuelan, 1724-1768
LOPEZ y Portana, Vicente
Spanish, 1772-1850
LOPEZ-CARO, Francisco
Spanish, 1598-1661
LOPEZ-ENGUIDANOS, Tomás
Spanish, 1773-1814
LOPEZ-GARCIA, Antonio
Spanish, 1936-
LOPEZ-POLANCO, Andrés
Spanish, op.1612-1618
LOPICINO, Giovanni
Battista
see Lupicini
LOPPE, Gabriel
French, 1825-1913
LOPRIN, Marcel
French, 20th cent.
LORAINE, Nevison Arthur
British, op.c.1889-1908
LORAN, Erle
American, 1905-
LORANT, V.H.
French, op.1912
LORCA, Federico Garcia
Spanish, 1898-1936
LORCH, Lorichs or
Lorick, Melchoir
Danish, 1527-1594
LORCHER, Alfred
German, 1875-
LORCK, Carl Julius
Scandinavian, 1829-1882
LORD, Joseph
British, 17th cent.
LORDON, Jean Abel
French, 1801-p.1830
LORDON, Pierre Jérome
French, 1780-1838

LORENTINO or
Laurentino d'Andrea
(not d'Angelo)
Italian, c.1430-1506
LORENTZ, Alcide Joseph
French, op.1858
LORENTZ, Friedrich
Gottlieb
German, 1722-1790
LORENTZEN, Christian
August
Swedish, 1749-1828
LORENZETTI or Laurati,
Ambrogio
Italian, op.1332-m.1348(?)
LORENZETTI or Laurati,
Pietro
Italian, op.1306-m.1348(?)
LORENZETTI, Ugolino
(Master of Ovile
Madonna)
Italian, 14th cent.
LORENZETTI, Unknown
follower of the
(possibly Francesco
Traini)
Italian, 14th cent.
LORENZI, Francesco
Italian, 1723-1787
LORENZI, Stoldo or
Astoldo, di Gino
Italian, 1534-1583
LORENZINI, Giovanni
Italian, 1665-1740
LORENZINO da Bologna
see Sabatini
LORENZO d'Alessandro
da Severino II
(Lorenzo di M. Alessandro)
(Salimbeni)
Italian,
c.1440/50-1503(?)
LORENZO, Antonio
Spanish, 1922-
LORENZO de Avila
Spanish, op.1521
LORENZO di Credi
(Lorenzo d'Andrea
d'Oderigo)
Italian, 1459(?)-1537
LORENZO, Delleani
Italian, 1840-1908
LORENZO Monaco
(Piero di Giovanni)
(Lorenzo degli Angeli?)
Italian, c.1370/1-1425
LORENZO di Niccolò
see Gerini
LORENZO da Pavia
see Fasolo
LORENZO da Prato
see Piero di Lorenzo
di Pratese di Bartolo
Zuccheri
LORENZO di Salimbene
da San Severino I
see Salimbeni
LORENZO da San Severino I
see Salimbeni, Lorenzo
LORENZO Torresani
da Verona
Italian, 15th cent.
LORENZO Veneziano
Italian, op.1356-1379
LORENZO (di Jacopo di
Pietro Paolo) da Viterbo
Italian, 1437(?)-p.1476

LORENZO or Llorenc
de Zaragoza
Spanish, c.1340-p.1402
LORGE, Jacques de
French, op.c.1772
LORGNA, A.
French, 19th cent.
LORICHON
French, op.1812
LORICHS, Lorch or
Lorich, Melchior
see Lorch
LORIMER, John Henry
British, 1857-1936
LORIMIER, Etiénne
Chevalier de
French, 1759-1813
LORIMIER, Henriette
French, a.1800-1854
LORING, John
American, 1939-
LORIOL, Albert
Francisque Michel
French, 1882-
LORIS, Pio
Italian, 1843-1921
LORJOU, Bernard
French, 1908-
LORMANN, Friedrich
Anton
see Lohrmann
LORME, Anthonie de
see Delorme
LORME-RONCERAY, Marguerite
Louise Amélie
French, 1730-
LORMSTEIN, Louis de
French, op.1820
LORN, Jacob
American, op.1819
LORRAIN, Le
see Claude
LORRAIN, Louis Joseph
see Le Lorrain
LORRAIN, Nicolas
François de Bar
French, op.1627
LORRAINE, Jean Baptiste
de
French, 1737-p.1774
LORSAY, Louis Alexandre
Eustache (Lampsonius)
French, 1822-
LORTEL, Leberecht
French, 1826-1901
L'ORTOLANO
see Ortolano
LORY or Lori the Elder,
Gabriel Ludwig
(Lory Père)
Swiss, 1763-1840
LORY the Younger,
Mathias Gabriel
(Lory fils)
Swiss, 1784-1846
LOS, Waldemar
(Wlodzimierz)
Polish, 1849-1888
LOSADA, José Maria
Rodriguez de
Spanish, op.1849-1867
LOSCHI, Bernardino
Italian, c.1460-1540
LOSCHI, Jacopo d'Ilario
(Jacobi Luschis de
Parma)
Italian, c.1425-1504/5

LOSE, Friedrich
German, op.1816
LÖSER, Franz
Ferdinand
German, 1790-1851
LOSSENKO, Anton
Pawlowitsch
Russian, 1737-1773
LOSSOW, Karl
German, 1835-1861
LOTDING, Harmen
see Loeding
LOTH or Lotto, Johann
Carl (Carlo Lotti,
Carlotto)
German, 1632-1698
LOTH, Johann Ulrich
German, c.1600-1662
LOTH, Onofrio
Italian, c.1650-1717
LOTIRON, Robert
French, 1886-
LOTS, C.E.
Dutch, 18th cent.
LOTTI, Carlo
see Loth, Johann
Carl
LOTTI, Dilvo
Italian, 1914-
LOTTI da Siena,
Giovanni
Italian, 1435-1495
LOTTINI, G.
Italian, 19th cent.
LOTTINI, Lionetto
(Fra Giovanni Angelo)
Italian, 1549-1629
LOTTNER, Emmanuel
German, op.1852
LOTTO, Lorenzo
Italian, c.1480-1556
LOTZ, Karl or Károly
Hungarian, 1833-1904
LOTZE, Moritz Eduard
German, 1809-1890
LOUBCHANSKY, Marcelle
French, 1917-
LOUBON, Charles Joseph
Emile (Emile)
French, 1809-1863
LOUDAN, W.Mouat
British, 1868-1925
LOUDEN, Emily Eastman
American, op.c.1821
LOUDON, Jane, (née
Webb)
British, 1807-1858
LOUDON, Terence
British, 20th cent.
LOUIS XIII
French, 1610-1643
LOUIS van Brussel
see Loys van Brussel
LOUIS, Denyse
French, -1915
LOUIS, Morris
American, 1912-1962
LOUIS, Seraphine
see Seraphine de
Senlis
LOUIS, Victor (Louis
Nicolas)
French, 1731-1800
LOUISA, Domenico
see Lovisa

LOUISE Elisabeth of
France
see Bourbon
LOUISE, Princess,
Duchess of Argyll
British, 1848-1939
LOUISE, Princess
Hollandine
Dutch, 1622-1709
LOUND, Thomas
British, 1802-1861
LOUP, Eugène
French, op.1893
LOURDREY
French, 19th cent.
L'OURS, Constantin
French, 18th cent.
LOUSTAUNAU, Auguste
(Louis Auguste
Georges)
French, 1846-1898
LOUTHERBOURG,
LAUTERBOURG or
Lutherbourg II, Philippe
Jacques de
British, 1740-1812
LOUTREUIL, Maurice E.
French, 1885-1925
LOUTSCHINSKI, Eugène
Russian, 20th cent.
LOUTZ, A. or J.A.
see Lutz
LOUTZ, J.J.
Swiss, 18th cent.
LOUVET, Camille
French, 1847-
LOUVET, Denise
French, 20th cent.
LOUVION, Jean Baptiste
Marie
French, 1740-1804
LOUYOT, H.
French, 19th cent.
LOUYS or Louis, Pierre
Swiss, 1870-1925
LÖVE, Anders (Grunderen)
Norwegian, 1763-1848
LOVE, Horace Beevor
British, 1800-1838
LOVELACE, Francis
British, 17th cent.
LOVER, Samuel
British, 1797-1868
LOVES or Lauwes, Matteo
or Matthew
British, op.c.1615-1633
LOVETT, William
American, 1773-1801
LOVINFOSSE, Pierre
Michel de (Noblet)
Flemish, 1745-1821
LOVISA or Louisa,
Domenico
Italian, op.1720
LOVRENCIC, Ivan
Jugoslavian, 20th cent.
LOW, Sir David
British, 1891-1963
LÖW, Franz Thomas
'Aquin
Swiss, op.1785
LÖW, Hans
see Leu
LOW, Mary
(MacMonnies), (Née
Fairchild)
American, 1866-

LÖW, Rudolf
Swiss, 1878-
LOW, William Hicok
American, 1853-1932
LOWCOCK, Charles
Frederick
British, op.1878-1917
LOWDER, Dwayne
American, 20th cent.
LOWE, Mauritius
British, 1746-1793
LOWE, Peter
British, 1938-
LOWE, Will S.
American, 19th cent.
LÖWEGREN, Joh. Fr.
Swedish, op.1808-1816/17
LOWELL, Orson
American, 20th cent.
LÖWENSPRUNG, Paul
Swiss, op.1480-m.1499
LÖWENTHAL, Emil
Polish, 1835-1896
LOWERY, Robert
see Laurie
LOWINSKY, Thomas Esmond
British, 1892-1947
LÖWITH, Wilhelm
German, 1861-
LOWNDES, Alan
British, 1921-
LOWRY, Laurence Stephen
British, 1887-1976
LOWRY, Matilda
see Heming
LOWRY, Strickland
British, 1737-c.1785
LOWTHER, Julia
British, op.1820
LOWTHER, P.
British, op.1814
LOYBOS, Jan Sebastiaen
Flemish,
op.1653-m.a.1703
LOYD, Mrs. L.
British, op.1849
LOYE, Charles-Aug.
see Montbard
LOYR, Nicolas
see Loir
LOYS or Louis van
Brussel
Netherlands, 16th cent.
LOYS, Etienne
French, 1724-1788
LOYS, Jacob
see Lois
LOZANO, Francisco
Spanish, 1912-
LOZANO, Manuel
Rodríguez
Mexican, 1896-
LOZIK, T.
French, 20th cent.
LUARD, John Dalbaic
British, 1830-1860
LUARD, Lowes Dalbiac
British, 1872-1944
LUBARDA
Yugoslav, 20th cent.
LUBAROW, Renée
French, 1923-
LUBEN, Adolf
Russian, 1837-1905
LUBIENIECKI or
Lubienietzky, Christoffel
or Krzyztof
Polish, 1660/1-1724

LUBIENIECKI or
Lubienierzky, Theodor
or Bogdan
Polish, 1653-p.1729
LUBIN, Jules Désiré
French, 1854-
LUBITCH, Ossip
French, 20th cent.
LUBNIEWICZ, Albin
Polish, 1910-
LUC, Frère
see François, Claude
LUCA di Palestro
Italian, 13th cent.
LUCA di Paolo da
Matelica
Italian, op.1474
LUCA da Perugia
Italian, op.1417
LUCA da Pollutri
Italian, op.1190
LUCA da Reggio
see Ferrari
LUCA, di Tomè or
Tommè
Italian, 1330(?)-1389
LUCAE, Lucas
see Luce
LUCANO da Imola
see Sagio
LUCANTONIO degli Uberti
Italian, op.c.1495-1520
LUCAS, Albert Durer
British, 1828-1919
LUCAS, Auger
French, 1685-1765
LUCAS, August (George
Friedrich August)
German, 1803-1863
LUCAS, Caroline Byng
British, 20th cent.
LUCAS, Charles
British, 19th cent.
LUCAS, David
British, 1802-1881
LUCAS, Edward George
Handel
British, 1861-1936
LUCAS y Padilla, Eugenio
Spanish, 1824-1870
LUCAS, Francois
French, 1736-1813
LUCAS, Henry Frederick
Lucas
British, -1943
LUCAS, Hippolyte Felix
Marie
French, 1854-1925
LUCAS, J. Carrell
British, 19th cent.
LUCAS, James
British, 19th cent.
LUCAS, Jean Paul
French, -1808
LUCAS, John
British, 1807-1874
LUCAS, John Seymour
British, 1849-1923
LUCAS, John Templeton
British, 1836-1880
LUCAS Hugensz. van
Leyden
Netherlands, 1494-1533
LUCAS, Louis Desiré
French, 1869-
LUCAS, Marie Seymour
British, p.1877-1921

LUCAS, Samuel
British, 1805-1870
LUCAS, William
British, 1840-1895
LUCASSEN, Reinier
Dutch, 1939-
LUCATELLI
see Locatelli
LUCCHESE, Il
see Ricchi, Pietro
LUCCHESI
see Franchi, Antonio
LUCCHESI, Edmondo
Italian, op.1915
LUCCHESINO, Il
see Testa, Pietro
LUCCHI, Francesco
Italian, 1585-1632
LUCE, Lucae or Lusse,
Lucas
Dutch, c.1575-1661
LUCE, Maximilien
French, 1858-
LUCEBERT (Lubertus
Jacobus Swaanswijk)
Dutch, 1924-
LUCENA, Tomas Munoz
see Munoz y Lucena
LUCENTI, Girolamo
Spanish, op.1607-1624
LUCHESE, Bartolomeo
Italian, op.1696-1701
LUCHETTO
see Cambiaso
LUCHIAN, Stefan
Rumanian, 1868-1916
LUCIANI, Antonio
Italian, -c.1700
LUCIANI, Ascanio
Italian, op.1665-m.1706
LUCIANI, Sebastiano
see Sebastiano del
Piombo
LUCIANO da Velletri
Italian, op.1435-1444
LUCIDEL
see Neufchatel, Nicolas
LUCINI, Antonio
Italian, op.1702-1733
LUCIUS I Jacob
Roumanian, c.1530-1597
LUCKNER, Heinrich Graf
von
German, 1891-
LUCKS, Christiaan or
Carstiaen
see Luyckx
LUCKX, Frans Joseph
Belgian, 1802-1849
LUCRATELLE, E.
British, 19th cent.
LUCUS, J.H.
British, 19th cent.
LUCY, Adrian
British, op.1842-m.1875
LUCY, Charles
British, 1814-1873
LUCZUN, Robert
American, 1939-
LUCZYNSKA-SZYMANOWSKA,
Irena
Polish, 1890-
LUDBROKE, R.
British, 18th cent
LÜDDEN, Johann Paul
German, op.1728-m.1739

LUDEMANS, C.J.
Dutch, op.1808
LUDER, Roswitha
German, 20th cent.
LUDERITZ, Gustav
(Karl Friedrich)
German, 1803-1884
LÜDERS, David
German, c.1710-1759
LUDICK, Lodewijk van
Dutch, 1629-a.1697
LÜDICKE, Alfred Veit
German, 1867-
LUDLOW, Gabriel
Augustus
American, 1800-1838
LUDLOW, Henry Stephen
(Hal)
British, 1861-
LUDOVICE or Ludovici,
Joao Pedro Frederico
German, 1672/5-1752
LUDOVICI, Albert
British, 1820-1894
LUDOVICI, Paul
British, 19th cent.
LUDOVICO di Angelo
see Mattioli
LUDOVICO degli Arrighi
Vicentino, Raimondo
Italian, a.1520-p.1549
LUDOVICO da San
Severino
see Urbani, Ludovico
LUDWIG, Carl Julius
Emil
German, 1839-1901
LUDWIG, Heinrich
German, 1829-1897
LUDY, Friedrich August
German, 1823-
LUEDERITZ, Gustav
(Carl Friedrich
Gustav)
German, 1803-1884
LUEDERS, James
American, 1927-
LUEG, Konrad
German, 20th cent.
LUEGER, Michael
German, 1804-1883
LUFS, J.
American, op.1812
LUGARDON, Albert
Swiss, 1827-1909
LUGINBÜHL, Bernhard
Swiss, 1929-
LUGO, Emil
German, 1840-1902
LUHN or Luhne,
Joachim
German, c.1640-1717
LUIDINGH, Harmen
see Loeding
LUIGI, A. de
Italian, 19th cent.
LUIGI, Ludovico de
Italian, 20th cent.
LUIGI, Nono
see Nono, Luigi
LUIGI Siciliano
see Rodriguez, L.
LUIGINI, Ferdinand
Italian, 1870-
LUIJ
see Luzio
LUINI, Aurelio
Italian, 1530-1593

LUINI, Bernardino
Italian, 1480/5-1532
LUINI, Giulio Cesare
Italian, c.1520-p.1542
LUINI, Tommaso
(Caravaggino)
Italian, c.1600-c.1635
LUIZOT
French, 18th cent.
LUKA, Madeleine
French, 1900-
LUKE, George
American, op.1905
LUKER, William
British, op.1852-1889
LUKOV, Yoram
Israeli, 20th cent.
LUKS, George Benjamin
American, 1867-1933
LULLIN, Adolphe
Swiss, 1780-1806
LULVES, Jean
German, 1833-1889
LUMI, A.
Italian, 16th cent.
LUMINAIS, Evariste
Vital
French, 1822-1896
LUMLEY, George
British, 1708-1768
LUMLEY, Savile
British, 20th cent.
LUMLEY, William
British, op.1751(?)
LUMSDEN, Ernest S.
British, 1883-
LUNA
Italian, 19th cent.
LUNA, Charles de
French, op.1833-1866
LUNA y Novicio, Juan
Spanish, 1857-1900
LUNAUD, Nicolas
French, 1743-
LUND, Bernt
Norwegian, 1812-1885
LUND, C.
Danish, 18th cent.
LUND, Frederik
Christian
Danish, 1826-1901
LUNDI, Henrik Louis
Norwegian, 1879-1935
LUND, Jens Petersen
Danish, 1725/30-1798
LUND, Johan Ludwig Gebhard
Danish, 1777-1867
LUND, Niels Möller
Swedish, 1863-1916
LUNDBERG, Caroline
Swedish, 19th cent.
LUNDBERG, Gustaf
Swedish, 1695-1786
LUNDBERG, Robert
Scandinavian, 1861-1903
LUNDBYE, Johhan Thomas
Danish, 1818-1848
LUNDE, Anders Christian
Danish, 1809-1886
LUNDEGÅRD, Justus Evald
Scandinavian, 1860-1924
LUNDENS, Gerrit
Dutch, 1622-p.1683
LUNDGREN, Egron Sellif
Swedish, 1815-1875
LUNDH, Theodor Henrik
Swedish, 1812-1896
LUNDIN, Norman
American, 20th cent.

LUNDQUIST, Birget
Swedish, 1910-1952
LUNDQUIST, Evert
Swedish, 1904-
LUNDSTROM, Vilhelm
Danish, 1893-1950
LUNEL, Ferdinand
French, 1857-
LÜNENSCHLOSS or Leunenschloss,
Anton Clemens
German, c.1680/90-1762/3
LUNGHI, Francesco *see* Longhi
LUNGREN, Fernand Harvey
American, 1859-1932
LUNGREW, Fernand H.
British, 19th cent.
LUNOIS, Alexandre
French, 1863-1916
LUNTESCHÜTZ, Jules or
Isaak
French, 1822-1893
LUNTLEY, James
British, op.1581-1864
LUNY, Thomas
British, 1759-1837
LUPI, Miguel Angelo
Portuguese, 1826-1883
LUPI, Raffaello
see Montelupo
LUPIANEZ y Carrasco,
Jose
Spanish, op.c.1884
LUPICINI or Lopicino,
Giovanni Battista
Italian, op.c.1625
LUPO, Alessandro
Italian, 1876-
LUPPEN, Gerard Joseph
Adrian (Joseph) van
Belgian, 1834-1891
LUPTON, Nevil Oliver
British, 1828-
LUQUETO
see Cambiaso
LURCAT, Jean
French, 1892-1966
LURCZYNSKI, Mieczyslaw
Polish, 20th cent.
LURIGNY, Madame
French, 18th cent.
LÜSCHER, Johann Jakob
Swiss, 1884-
LUSCHIS da Parma
see Loschi
LUSCOMBE, Henry A.
British, 1820-1865
LUSIERE, Giovanni
Battista
Italian, op.1781-1821
LUSIERI, Titta
(Don Titto)
Italian, op.1785
LUSK, Doris
New Zealander, 1916-
LUSSE, Jean Jacques
Theresa
French, 1757-1833
LUSSE, Lucas
see Luce
LUSSENBERG, Johannes
(Jos)
Dutch, 1889-
LUSSIGNY, L.
French, 18th cent.
LUSSO, G.
Italian, 20th cent.
LUSSON, Louis-
Adrien
French, 1790-1864

LUST, A. de
Dutch, 17th cent.
LUSURIER, Catherine
French, c.1753-1781
LÜTGENDORFF-LEINBURG,
Ferdinand Carl
Theodor Christoph
Peter Freiherr
von
German, 1785-1858
LUTGERS, Petrus Joseph
Dutch, 1808-1874
LUTHER, Adolf
German, 1912-
LUTHERBOURG, Philipp
Jakob
see Loutherbourg
LÜTHI or Lüthy,
Johannes
Swiss, 1803-1873
LÜTHY, Oskar
Wilhelm
Swiss, 1882-1945
LUTI, Benedetto
Italian, 1666-1724
LUTI or Luthi,
Bernardino
Italian, 17th cent.
LUTIGHUIJS
see Luttichuijs
LUTIIS da Todi
see Luzio
LÜTKE, Peter Ludwig
German, 1759-1831
LUTMA, Janus, Jan,
Joannes or Johannes, I
Dutch, 1584(?)-1669
LUTMA, Janus or
Joannes, II
Dutch, 1624-1685
LUTTERELL or Luttrel,
Edward (not Henry)
British, c.1650-p.1723
LUTTEROTH, Ascan
German, 1842-1923
LUTTICHUIJS or
Lutighuijs (also,
erroneously,
Lustichuijs), Isaack
Dutch, 1616-1673
LUTTICHUIJS or
Lutighuijs, Simon
Dutch, 1610-1661
LUTTRELL, Hon. James
British, 18th cent.
LUTTRINGSHAUSEN, Johann
Heinrich
Swiss, 1783-1857
LUTYENS, Charles
Augustus Henry
British, op.1860-1893
LUTYENS, Robert
British, 20th cent.
LUTZ, Loutz or Lütz,
A. or J.A.
Dutch, op.1809-1822
LUTZ, Dan
American, 20th cent.
LÜTZELBURGER or
Leuczellburger, Hans
Swiss, -1526(?)
LÜTZENKIRCHEN, Peter
Joseph
German, 1775-1820
LÜTZOW, Gotthard
(Friedrich Christian
Gotthard Heinrich) von
German, 1777-1817

LUX, Ignatius
Dutch, 1649/50-p.1694
LUYCKS, Lucks or Lux,
Christiaan or
Carstiaen
Flemish, 1623-p.1653
LUYCKX, Leux, Lux
or Luycx, Frans
Flemish, 1604-1668
LUYDINGH, Harmen
see Loeding
LUYKEN or Luiken,
Caspar
Dutch, 1672-1708
LUYKEN or Luiken,
Jan
Dutch, 1649-1712
LUYTEN, Jean Henri
(Henry)
Belgian, 1859-
LUZIO Romano
(Luzzi or Luij or
Lutiis da Todi)
Italian, op.1540
LUZZI, Cleto
Italian, 19th cent.
LUZZO, Lorenzo
see Morto da Feltre
LWOW, Princess
see Parlaghy-Brachfeld
LYALL, Laura,
(née Muntz)
Canadian, 1860-1930
LYBAERT, Théophile
Marie Francois
Belgian, 1848-1927
LYBECK, Bertil
Swedish, 1887-1945
LYCETT, J.
British, op.1820-1824
LYDIS, Mariette
French, 1894-
LYDON, A.F.
British, 1836-1917
LYEN or Leyen, Jacques
François de, or
Jacques François de
Lien, Delyen, de
Lyn, Deslyens etc.
Flemish, 1684-1761
LYLE, Fannie
American, op.1848
LYMAN, John Goodwin
Canadian, 1886-
LYMINGE, Robert
British, 17th cent.(?)
LYNCH, Albert
British, 1851-
LYNCH, James Henry
British, op.c.1815-m.1868
LYNE, Charles Edward
Michael
British, 1912-
LYNE, Richard
British, op.c.1570-1575
LYNHOVEN, Nicolaes van
Dutch, op.1669-m.a.1702
LYNN, Frank W.
Canadian, op.1875-1901
LYNN, John
British, op.1826-1838
LYNN, William
American, op.1815
LYON, Gabriel de
see Leeuw
LYON, J.Howard
British, 20th cent.

LYS, Johann
see Liss
LYSER, Johann Peter
(Ludwig Peter August
Burmeister)
German, 1803-1870
LYSKER
British, 18th cent.
LYSSENS, Jacob
see Leyssens
LYSTAD, Elsa
Norwegian, 1899-
LYTENS or Leytens,
Gysbrecht (Possibly
identified with
Master of the Winter
Landscapes)
Flemish, 1586-a.1656

M

M...., Edgar
Italian, op.1886
MAAR, Dora
French, 20th cent.
MAAR, Johann
German, 1815-p.1870
MAAREL, Marinus van
der
Dutch, 1857-1921
MAAS
see also Maes
MAAS, Paul
Belgian, 1890-1962
MAASKAMP, Evert
Dutch, 1769-1834
MAASS, Johann Gottfried
German, op.1824-1848
MAATEN, Jacob Jan
van der
Dutch, 1820-1879
MAATSCH, Thilo
German, 1900-
MABE, Manabu
Brazilian, 1910-
MABER, Jan de
Dutch, op.1692(?)-m.1702
MABUSE or Mauberge,
Jennyn or Jan Gossaert
or Gossart van
(Joannes Malbodius)
Netherlands,
op.1503-m.1532
MABUSE or Mauberge,
Nicasius Gossaert
or Gossart van
Netherlands, op.1529
MACADRE, Jacques
French, op.1595-1620
MACAGNINI, Angelo di
Pietro di Angelo
(Angelo da Siena,
Angelo Parrasio)
Italian, op.1439-m.1456
MACALLUM, Hamilton
British, 1841-1896
McALPINE, W.
British, 19th cent.
McARDELL, James
British, 1728/9(?)-1765
MACARI or Maccari,
Emanuele
Italian, op.1519-m.1550
MACARRON, Ricardo
Spanish, 1926-
McARTHUR, John
British, op.1780-m.1840

MACARTHUR, Lindsay G.
British, op.1890-1930
MACARTNEY, Carlile Henry
Hayes
British, c.1842-1924
MACAULAY, James W.
British, 18th cent.
McAULIFFE, James J.
American, 1848-1921
MACAVOY, Edouard
Georges
French, 1905-
MACAW, H.S.
British, 19th cent.
MACBETH, Norman
British, 1821-1888
MACBETH, Robert Walker
British, 1848-1910
MACBETH-RAEBURN, Henry
British, 1860-1947
McBEY, James
British, 1883-1959
MacBRIDE, William
British, 1856-1913
McBRYDE, James
British, 20th cent.
MacBRYDE, Robert
British, 1913-1966
McCAHON, Colin
New Zealand, 1919-
McCALL, Charles James
British, 1907-
McCall, William
British, op.1818-1837
MacCALLUM, Andrew
British, 1821-1902
McCANNELL, W. Otway
British, 1883-1969
MACCARI, Cesare
Italian, 1840-1919
MACCARI, Enrico
Italian, 19th cent.
MACCARI, Mino
Italian, 1898-
McCARTHY, Eoin
British, 20th cent.
McCARTY, R.H.
American, 19th cent.
MACCHI, G.
Italian, 18th cent.
MACCHI, Lorenzo
Italian, 1804-
MACCHIATI, Serafino
Italian, -1916
MACCHIETTI, Girolamo
(del Crocefissaio)
Italian, 1535-1592
MACCIO, Romulo
South American, 20th cent.
McCLINTOCK, Herbert
Australian, 1906-
McCLOY, Samuel
British, 1831-1904
McCLURE, David
British, 1926-
MacCLURE, Victor
British, 20th cent.
MACCO, Alexander
German, 1767-1849
MacCOLL, Dugald
Sutherland
British, 1859-1948
McCOLLUM, Allan
American, 20th cent.
MACOMBER, Mary Lizzie
American, 1861-1916
M'CONNELL, W.
British, -1867

McCORD, George Herbert
American, 1848-1909
McCORMICK, Arthur David
British, 1860-1943
McCRACKEN, Francis
New Zealand,
1879-1959
McCRACKEN, John
American, 20th cent.
McCROSSAN, Mary
British, -1934
McCUBBIN, Frederick
Australian, 1855-1917
McCULLOCH, George
British, op.1859-1901
McCULLOCH, Horatio
British, 1805-1867
McCULLOCH, Ian
British, 20th cent.
McCULLOCH, Joseph Ridley
Radcliffe
British, 1893-1961
McDONALD
British, 19th cent.
McDONALD, Alexander
British, c.1839-1921
MACDONALD, Biddy
British, op.c.1895-1938
MACDONALD, Daniel
British, 1821-1853
MACDONALD, Frances
British, 1874-1921
MACDONALD, Grant
Kenneth
Canadian, 1909-
MACDONALD, James Edward
Hervey
Canadian, 1873-1932
MACDONALD, James
Williamson Galloway
Canadian, 1897-1961
MACDONALD, Margaret
(Margaret Mackintosh)
British, 1865-1933
MACDONALD, Richard
British, 1919-
MACDONALD, Thomas
Canadian, op.1837
MACDONALD, Tom
British, 1914-
MACDONALD, William A.
British, op.1884-1893
MACDONALD-WRIGHT,
Stanton
American, 1890-
McDONNELL, Hector
British, 1947-
McDOUGAL, John Alexander
American, 1810/11(?)-1894
MACDOUGALL, Allan
British, op.c.1880-1889
MACDUFF, William
British, 19th cent.
MACE, John Edmund
British, 1889-
MACEDO, Urbano de
Brazilian, 1912-
MACEDONE, Filippo
Italian, op.1700
MACEDONSKY, M.A.
Russian, 20th cent.
McEUNE, Robert Ernest
British, 1876-1952
MACENTYRE, Eduardo
South American, 20th cent.
McEVOY, Ambrose
Arthur
British, 1878-1927

McEVOY, Mary, (née
 Edwards)
 British, 1870-1941
McEWAN, Tom
 British, 1846-1914
McEWEN, Jean
 Canadian, 1923-
MacEWEN, Walter
 American, 1860-1943
McFARLANE, D.
 British, op.c.1848-1863
McFEE, Henry Lee
 American, 1886-1953
McGARRELL, James
 American, 20th cent.
McGEORGE, Andrew
 British, 19th cent.
MacGEORGE, William
 Stuart
 British, 1861-1931
McGHIE, John
 British, 1867-
McGILL, Donald Fraser
 Gould
 British, 1875-1962
McGILLIVRAY, George
 British, op.1847
MACGILLIVRAY, James
 Pittendrigh
 British, 1856-1938
McGLASHAN, Archibald
 A.
 British, 1888-
McGLYNN, Terry
 British, 1903-
MACGREGOR, Jessie
 British, op.1872-m.1919
MACGREGOR, John
 Canadian, 1944-
McGREGOR, Robert
 British, 1848-1922
McGREGOR, William
 York
 British, 1855-1923
MACHARD, Jules Louis
 French, 1839-1900
MACHEK, Anton
 Czech, 1775-1844
MACHELL, Reginald
 British, op.c.1881-1900
MACHEREN, Philip van
 Dutch, op.1654-1672
MACHIAVELLI or
 Macchiavello, Zanobi
 di Jacopo
 Italian, 1418-1479
MACHILOS or Machilon
 da Spoleto
 Italian, op.1230-1257
MÄCHSELKIRCHER, Gabriel
 see Malesskircher
MACHUCA, Pedro
 Spanish, op.1516-m.1550
MACHY, Pierre Antoine de,
 or Pierre Antoine
 Demachy
 French, 1723-1807
McIAN, Fanny
 British, op.c.1835-1857
McIAN, Robert Ronald
 British, 1803-1856
McILWORTH, Thomas
 American, op.1757-m.1769/70
McINNES, William
 Beckwith
 British, 1889-1939

McINTYRE, Joseph
 Wrightson
 British, op.c.1880-1894
McINTYRE, Raymond
 New Zealand,
 1879-1933
MACIP, Vicente Joanes,
 Juan or Juanes
 see Masip
MACIVER, Loren
 American, 1909-
McIVOR, John
 American, 1931-
MACK
 German(?), 19th cent.
MACK, Otto Heinz
 German, 1931-
McKAY or MacKay,
 American, op.c.1788-1791
MacKAY, John
 British, op.1881
MACKAY, Lucinda
 British, 20th cent.
MACKAY, T.W.
 British, op.c.1826-1853
McKAY, William Darling
 British, 1844-1923
MACKE, August
 German, 1887-1914
MACKELDEY, Carl
 (Carl Bernard)
 German, op.1866-1879
MACKENDRICK, Lilian
 American, 1906-
McKENNA, Stephen
 British, 20th cent.
MACKENSEN, Fritz
 German, 1866-1953
MACKENZIE, Alexander
 British, 1923-
MACKENZIE, David
 Maitland
 British, op.1820-1855
MACKENZIE, Frederick
 British, 1788(?)-1854
MACKENZIE, Hugh
 Canadian, 20th cent.
MACKENZIE, Kenneth
 British, op.c.1884-1899
MACKENZIE, Samuel
 British, 1785-1847
MACKENZIE, Thomas
 British, 1891-1944
McKENZIE-SMITH, Ian
 British, 1935-
MACKEPRANG, Adolf
 Henrik
 Danish, 1833-1911
MACKETANZ, Ferdinand
 German, 1902-
McKEWAN, David Hall
 British, 1816/17(?)-1875
McKEWAN, J.D.
 British, 19th cent.
MACKIE, Charles H.
 British, 1862-1920
McKIE, Helen
 Madeleine
 British, -1957
MACKIE, Peter Robert
 Macleod
 British, 20th cent.
MACKINNON, A.
 British, 1850-1935
MACKINNON, Esther
 Blaikie
 British, op.c.1913-1930

MACKINNON, Sine
 British, 1901-
MACKINNON, Stewart
 British, 20th cent.
MACKINNON, W.
 British, op.1798
MACKINTOSH, Charles
 Rennie
 British, 1868-1928
MACKLEY, George
 British, 1900-
MACKMURDO, Arthur
 Heygate
 British, 1851-1942
MACKNIGHT, Dodge
 American, 1860-1950
McKUBBIN, Florence
 American, c.1855-
McLACHLAN, Thomas
 Hope
 British, 1845-1897
MACLAREN, Donald
 Graeme
 British, 1886-1917
MACLAREN, Walter
 British, op.c.1881-1909
McLAUCHLAN, Archibald
 British, op.c.1768
MACLAUGHLIN, Gerald
 American, 20th cent.
McLAUGHLIN, John
 American, 1898-
McLAURAITH, M'Loraith
 or Macilwraith, Andrew
 British, 18th cent.
McLEA, D.F.
 British, op.1859
MACLEAN, Alexander
 British, 1840-1877
McLEAN, John
 British, 1939-
McLEAN, Richard
 American, 1934-
MACLEAY, G.R.
 British, op.1839
MACLEAY, Kenneth
 British, 1802-1878
MACLEAY, MacNeil
 British, op.1843-1871
MACLEOD, Jessie
 British, op.1845-1875
MACLEOD, John
 British, -1872
MACLEOD, Pegi Nicol
 Canadian, 1904-1949
MACLET, Elisée
 French, 1881-1937
MACLISE, Daniel
 British, 1806-1870
MACLURE, Andrew
 British, op.1857-1881
MacMASTER, James
 British, -1913
McMILLAN, William
 British, 1887-
McMINN, W.
 British, 19th cent.
MACMONNIES, Mary
 see Low
MACNAB, Peter
 British, -1900
MACNAMARA, Gordon
 British, 20th cent.
MACNAMARA, Nicolette
 British, 20th cent.
MACNEE, Sir Daniel
 British, 1806-1882

MACNEE, Robert
 Russell
 British, op.c.1884-m.1952
McNEID, George Joseph
 American, 1909-
MACNICOL, Bessie
 (Bessie Frew)
 British, 1869-1904
McNICOLL, Helen
 Galloway
 Canadian, 1879-1915
MAÇON, M.
 Dutch(?), op.1761
MACOVEI, Ligia
 Rumanian, 1916-
MACPHERSON, Alexander
 British, op.1925-m.1970
MACPHERSON, John
 British, op.1865-1884
MACPHERSON, Joseph
 British, 1726-c.1778
MACPHERSON, R.T.
 British, op.1835
McQUEEN, Mike
 British, 20th cent.
MACQUIN, Ange Denis
 British, 1756-1823
MACQUOID, Percy T.
 British, 1852-1925
MACQUOID, Thomas Robert
 British, 1820-1912
MACRINO d'Alba
 (Gian Giacomo de
 Alladio or Fava)
 Italian, c.1465/70-a.1528
MÁCSAI, István
 Hungarian, 1922-
MacTAGGART, J.
 British, 19th cent.
McTAGGART, William
 British, 1835-1910
MacTAGGART, Sir William
 British, 1903-
MACWHIRTER, John
 British, 1839-1911
MacWHISTER, J.
 British, 19th cent.
MADARASZ, Viktor von
 Hungarian, 1830-1917
MADDEN, Ann
 British, 1932-
MADDEN, Wyndham
 British, op.c.1775
MADDERSTEEG or
 Maddersteph, Michiel
 Dutch, 1659-1709
MADDOCKS, W.
 British, 19th cent.(?)
MADDOX, Conroy
 British, 1912-
MADDOX, Willes
 British, 1813-1853
MADELAIN, Gustave
 French, 1867-1944
MADELINE, Paul
 French, 1863-1920
MADELLA, Gianni
 Italian, 20th cent.
MADER, Louis
 American, op.1895
MADIOL, Adrien Jean
 Dutch, c.1845-c.1892
MADLENER, Antonius
 Josephus
 Dutch, 1827-1890
MADOU, Jean-Baptiste
 Belgian, 1796-1877

MADRASSI, Ludovic
Lucien
French, c.1869-1914
MADRAZO y Kuntz,
Federico de
Spanish, 1815-1894
MADRAZO y Agudo, José
Spanish, 1781-1859
MADRAZO y Garreta,
Raimundo de
Spanish, 1841-1920
MADRAZO y Garreta,
Ricardo de
Spanish, 1852-1917
MADRAZO, T-L.
South American, 20th cent.
MADSEN, Juel Christian
Danish, 1890-1923
MAEA, José
Spanish, op.1790-1826
MAEGLIN, Rudolph
Swiss, 1892-
MAELER or Maler, Ernst
Netherlands,
op.1537-1558
MAELLA, Mariano
Salvador de
Spanish, 1739-1819
MAELWAEL, Jean
see Malouel
MAERE, J.B. de
Flemish, 18th cent.
MAES or Maas, Aert(?)
van
Dutch, c.1620-p.1656
MAES or Maas, Dirk or
Théodore
Dutch, 1659-1717
MAES, E.R.
Belgian, 19th cent.
MAES, Everard
Quirijnsz., Crynsz. or
Krynsz. van der
Dutch, 1577-1656
MAES, Gerrit
Dutch, op.c.1669(?)
MAES, Godfried or
Godefroy
Flemish, 1649-1700
MAES, Jan Baptiste
Lodewijk (Maes-
Canini)
Belgian, 1794-1856
MAES, Johannes or Jan
Dutch, 1655-1690
MAES, Nicolaes
Dutch, 1632-1693
MAES, Pieter van
Dutch, 17th cent.
MAESTRI, Michelangelo
Italian, -c.1812
MAETERLINCK, Louis
Belgian, 1846-1926
MAEZTU, Gustavo de
Spanish, 1887-
MAFAI, Mario
Italian, 1902-1965
MAFFEI, Francesco
Italian, c.1620(?)-1660
MAFFEI, Giacomo (?)
Italian, 17th cent.(?)
MAFFEI, Guido
German, 1838-
MAFFEO da Verona
Italian, 1576-1618

MAFTEI, Gh.
Rumanian, 20th cent.
MAGAGNI, Girolamo di
Francesco (Giomo del
Sodoma)
Italian, 1507-1562
MAGANZA, Alessandro
Italian,
1556-p.1630
MAGANZA, Giovanni
Battista, I
(Magagno)
Italian, c.1513-1586
MAGATTI, Pietro Antonio
Italian, 1687-1768
MAGAUD, Dominique
(Antoine Jean Baptiste
Dominique)
French, 1817-1899
MAGEE, John L.
American, op.1844-1867
MAGENS, Johann Boye
Danish, 1748-1814
MAGERSTADT, Magerstedt
or Magerstetten,
Andreas
Danish, op.1639(?)-1651
MAGES or Magges, Josef
German, 1728-1769
MAGGERI, Cesare
see Maggieri
MAGGES, Josef
see Mages
MAGGI, Cesare
Italian, 1881-
MAGGI, Maggius or
Maius, Giovanni
Italian, 1566-1618
MAGGIERI or Maggeri,
Cesare
Italian, -1629
MAGGIOTTO, Francesco
Italian, 18th cent.
MAGGS, J.C.
British, op.1893
MAGINI, Carlo
Italian, 1720-1806
MAGINN, William
British, 1793-1842
MAGIOLLI, Giovanni
Andrea
see Maglioli
MAGIOTTO or Majotto,
Domenico
Italian, 1713-1794
MAGIOTTO or Majotto,
Francesco
Italian, 1750-1805
MAGISTRIS da Caldarola,
Simone de
Italian, 1540-1612
MAGLINGER, Caspar
see Meglinger
MAGLIOLI, Magiolli,
Majoli or Maliolus,
Giovanni Andrea
Italian, op.c.1580-1610
MAGLIONE, Milvia
Italian, 20th cent.
MAGLIUOLO or Magliolo,
Francesco
Italian, 17th cent.
MAGNANI, Cristoforo
Italian, c.1545-p.1580
MAGNANI di Fidenza,
Girolamo
Italian, 1815-1889

MAGNARD, Henri Charles
Alexandre
French, 1822-
MAGNASCO, Alessandro
(Il Lissandrino)
Italian, 1667-1749
MAGNASCO, Stefano
Italian, op.1655-m.1665
MAGNE, Désiré Alfred
French, 1855-
MAGNELLI, Alberto
Italian, 1888-1971
MAGNENAT, Paul
Swiss, 20th cent.
MAGNES, Isidore
British, op.1849-1852
MAGNI, Cesare
Italian, op.1530-1533
MAGNI, Giuseppe
Italian, op.1738-1743
MAGNI, Giuseppe
Italian, 1869-
MAGNIER, Philippe
French, 1647-1715
MAGNUS, Camille
French, 19th cent.
MAGNUS, Eduard
German, 1799-1872
MAGNUSSEN, Christian
Carl
Scandinavian, 1821-1896
MAGRITTE, René François
Ghislain
Belgian, 1898-1967
MAGUIRE, Thomas Herbert
British, 1821-1895
MAGYAR, Viktor
Yugoslav, 1934-
MAGYAR-MANNHEIMER,
Gusztáv
Hungarian, 1859-1937
MAHAFFEY, Noel
American, 20th cent.
MAHELOT, Laurent
French, 17th cent.
MÄHLER, Joseph
(Willibrord Joseph)
German, 1778-1860
MAHLER
see Pinhas, Salomon
MAHLKNECHT, Edmund
German, 1820-1903
MAHONEY, Cyril
British, 1903-1968
MAHONEY, James
British, 1810-1879
MAHRER, Helmuth
Swiss, 1934-
MAHRINGER, Anton
German, 1902-
MAHU, Cornelis
Flemish, 1613-1689
MAHU, Victor
Flemish, op.1689-m.1700
MAI, Tran
Vietnamese, 20th cent.
MAIDEN, J.
British, op.1813-1843
MAIDMENT, Henry
British, op.1889
MAIER, Zehat
German, 16th cent.
MAIER-AICHEN, Hansjerg
German, 20th cent.
MAIGNAN, Albert Pierre
René
French, 1845-1908

MAIGNEN de Sainte-
Marie, Désiré Adelaide
Charles
French, 1794-p.1834
MAIIS, Hieronimus
see Girolamo dei
Maggi
MAILAND, Gustave
(Nicolas Henri Gustave)
French, 1810-p.1859
MAILE, Georges
French, op.1824-1840
MAILLARD, Ludwig
German, op.1793-m.1806
MAILLART or Maillard,
Diogène Ulyssee
Napoléon
French, 1840-1926
MAILLART, Emile
French, op.c.1886-1893
MAILLART, Francois
French, op.1830
MAILLAUD, Fernand
French, 1863-1948
MAILLERI, Karel van
see Mallery
MAILLOL, Aristide
Joseph Bonaventure
French, 1861-1944
MAILLOT, J.H.
French, 19th cent.
MAILLOT, Nicolas
Sébastien
French, 1781-1856
MAILLOT, Théodore
Pierre Nicolas
French, 1826-1888
MAILLY or Malhy, Simon
de
(Simon de Châlons)
French,
op.1535-m.1561/2
MAINARDI, Andrea
(Chiaveghino)
Italian, op.1590-1620
MAINARDI, Sebastiano
di Bartolo
Italian, c.1450-1513
MAINCENT, Gustave
French, 1850-1887
MAINDS, Allan Douglass
British, 1881-1945
MAINELLA, Raffaele
Italian, 1858-
MAINERI, Antonio
Italian, op.1492-m.1514
MAINERI, Gian
Francesco de'
Italian, op.1491-1505
MAINERI, Jacopo and
Bartolomeo
Italian, op.1461-1462
MAINGAUD, Martin
Flemish(?), op.1692-1725
MAINO, Juan Bautista
see Mayno
MAINSSIEUX, Lucien
French, 1885-1958
MAIO, Paolo de
Italian, -1784
MAIONE, Robert
British, 19th cent.
MAIOTTI
Italian, 20th cent.
MAIR or Mayr, Alexander
(Monogrammist A.M.)
German, c.1559-p.1617

MAIR, Anton
 see Mayer
MAIR, Johann Ulrich
 see Mayr
MAIR von Landshut,
 Nicolaus Alexander
 German, op.1490-m.1520
MAIR, Ulrich
 German, op.1483
MAIRE, André
 French, 20th cent.
MAISEREULLES, Philippe
 de
 see Mazerolles
MAISEY, Thomas
 British, op.1818-m.1840
MAISON, Nicole de
 see Casa
MAISON, Pierre Eugène
 Jules
 French, 1814-1879
MAISSIAT, Joseph
 French, op.1835-1841
MAISTRE, Roy de
 Australian, 1894-1968
MAITLAND, Paul Fordyce
 British, 1869-1909
MAJER, Meier, Meyer
 or Meyers, Jeremias
 or Jeremiah
 German, 1735-1789
MAJERNIK, Cyprian
 Czech, 1909-
MAJEWSKI, Mieczyslaw
 Polish, 1915-
MAJO, W.M. de
 British, 20th cent.
MAJOLI, Clemente
 Italian, 1625-
MAJOLI, Giovanni Andrea
 see Maglioli
MAJOR or Mayor, Isaac
 German, c.1576-1630
MAJOR, Theodore
 British, 20th cent.
MAJOR, Thomas
 British, 1714-1799
MAJOTTO
 see Magiotto
MAKART, Hans
 German, 1840-1884
MAKART, Johann
 German, op.c.1850
MAKHAIEFF, Michail
 Ivanovitch
 Russian, c.1718-1770
MAKOWSKI, Konstantin
 Jegorowitsch
 Russian, 1839-1915
MAKOWSKI, Nicolai
 Yegorovich
 Russian, 1842-c.1886
MAKOWSKI, Tadé
 Polish, 1882-1932
MAKOWSKI, Wladimir
 Jegorowitsch
 Russian, 1846-1920
MAKOWSKI, Zbigniew
 Polish, 1930-
MAKS, Cornelis Johannes
 (Kees)
 Dutch, 1876-1967
MAKSIUTOV, Rashid
 Garifovich
 Russian, 20th cent.
MALABARBA
 see Cristoforo di
 Bindoccio

MALACH, Christoph
 German, 17th cent.
MALAGAVAZZO or
 Malaguazzo, Coriolano
 Italian, op.1570
MALAINE, Malin or
 Malines, Joseph
 Laurent
 French, 1745-1809
MALAN, Solomon
 Caesar
 British, 19th cent.
MALARDOT, Charles
 André
 French, 1817-1879
MALATESTA or
 Malatesti, Adeodato
 Italian, 1806-1891
MALATESTA, Leonardo di
 Francesco di Lazzaro
 (Leonardo da Pistoja)
 Italian, 1483-p.1518
MALATESTA, Narciso
 Italian, 1835-
MALATHIER, André
 French, op.1834-m.1852
MALATTO, Niccolò
 Italian, op.1727
MALAVAL
 French, 20th cent.
MALBERZ, Anton Franz
 see Maulbertsch
MALBON, William
 British, op.1850
MALBONE, Edward
 Greene
 American, 1777-1807
MALBRANCHE, Louis
 Claude
 French, 1790-1838
MALCHAIR or Melchair,
 John Baptist
 British, 1731-1812
MALCHIN
 French, 20th cent.
MALCHO or Malgo,
 Simon
 Danish, op.1763-1780
MALCHUS, Carl Freiherr
 von
 German, 1835-1889
MALCKE, Johann Christoph
 German, 1725-1777
MALCLES, Jean Denis
 French, 20th cent.
MALCOM or Malcolm,
 James Peller
 British, 1767-1815
MALCZEWSKI, Jacek or
 Hyacinth
 Polish, 1854-1929
MALDEN, Sarah, Countess
 of Essex, (née Bazett)
 British, c.1766-1838
MALDENARDO, P.
 Italian, op.1733
MALDEREN, Luc van
 Belgian, 20th cent.
MALDURA, Giovanni
 Italian, 1772-1849
MALECK, F. de
 German, op.1817
MALECKI, Stefan
 Polish, 20th cent.
MALEMPRE, Leo
 French, 1887-1901

MALENCHINI, Mathilde
 Italian, op.1844-1807
MALER, Alexander
 see Alexander
 Paduano
MALER, Ernst
 see Maeler
MALER zu Schwaz, Hans
 or Johan
 German, op.1510-1523
MALERY, Karel van
 see Mallery
MÄLESSKIRCHER,
 Mächselkircher,
 Maleskircher etc.,
 Gabriel
 German, op.1439(?)-m.1495
MALET, A.
 French, 19th cent.
MALEVICH, Kasimir
 Russian, 1878-1935
MALFAIT, Hubert
 Belgian, 1898-
MALFATTY, L.
 Italian, 19th cent.
MALFRAY, Charles
 French, 1887-1940
MALFROY, Charles
 French, 1862-1918
MALFROY, Henry
 French, 1895-
MALGO, Simon
 see Malcho
MALHERBE, W.
 French, 20th cent.
MALHOA, Jose
 Portuguese, 1855-1933
MALI, Christian
 Friedrich
 German, 1832-1906
MALI, Johann (Jan
 Cornelis)
 German, 1828-1865
MALIN or Malines,
 Joseph Laurent
 see Malaine
MALINCONICO, Nicola
 Italian, c.1654-1721
MALINSKY, Jaroslav
 Czech, 1897-
MALINUS, Hendricus
 see Broeck, Hendrick
 van den
MALIOLUS, Giovanni
 Andrea
 see Maglioli
MALJAWIN, Philip
 see Malyavin
MALJUTIN, Sergej
 Russian, 1859-1937
MALKIN, S.
 British, op.1821-1829
MALKINE, Georges
 French, 1901-
MALLERY, Mailleri or
 Malery, Karel van
 Flemish, 1571-p.1635
MALLET, Jean Baptiste
 French, 1759-1835
MALLEYN, Gerrit
 Dutch, 1753-1816
MALLITSCH, Ferdinand
 German, 1820-1900
MALLORY, Robert
 British, op.1670-1672
MALLY, Gustav
 Czech, 1879-1952

MALMSTRÖM, August
 (Johan August)
 Swedish, 1829-1901
MALO, Gertrude, (née
 van Veen,
 see Veen
MALO, Il
 see Monogrammist
 I.B.T.
MALO, Vincent, I
 (Vincenzo Armanno?)
 Flemish, op.1623/4-m.a.1656
MALOMBRA, Costantino
 Italian, 16th cent.
MALOMBRA, Pietro
 Italian, 1556-1618
MALOSSO, Il
 see Trotti, Giovanni
 Battista
MALOUEL, Maelwael,
 Manuel etc., Jean
 French, op.1396-m.1419
MALSKAT, Lothar
 German, 1913-
MALTESE, Fanny Jane,
 (née Fayrer)
 British, 1849-1926
MALTESE, Il
 see Fieravino, Francesco
MALTESTE, Louis
 French, 19th cent.
MALTHAIN or Malthan,
 Johan
 German(?), op.1595
MALTHOUSE, Eric
 British, 1914-
MALTON, James
 British, op.1785-m.1803
MALTON, Thomas, I
 British, 1726-1801
MALTON, Thomas, II
 British, 1748-1804
MALUBA
 South American, 20th cent.
MALVIEUX, Paul
 German, 1763-1791
MALYAVIN or Maljawin,
 Philip
 Russian, 1869-
MAMBOUR, Auguste
 Belgian, 1896-1968
MAMMEREN, Pieter van
 Russian(?), op.c.1630
MAMONTOV, Mikhail
 Anatolyevich
 Russian, 1865-1920
MAMPASO, Manuel
 Spanish, 1924-
MAN, Cornelis de
 Dutch, 1621-1706
MAN, Jan or Joan
 Adriansz., Arentsz.,
 Ariaensz. etc. de
 Dutch, op.1587-m.a.1641
MAN, L.D.
 British(?), 17th cent.(?)
MANAIGO or Maniago,
 Silvestro
 Italian, 1670-1734
MANARA, Orazio
 (Horace)
 Italian, 1804-p.1872
MANARESI, Paolo
 Italian, 1908-
MANASSERO, Felice
 Italian, op.1745-1747

MANAST, Pierre
French, 20th cent.
MANBY, Thomas
British, a.1672-1695
MANCADAN, Jacob
Sibrandi
Dutch, 1602-1680
MANCERT or Mancest
French, op.1783
MANCHELO, Antoine
Italian, op.1565
MANCINELLI, Giuseppe
Italian, 1813-1875
MANCINELLI, Gustavo
Italian, 1842-1906
MANCINI
Italian, c.1754-1794
MANCINI, Antonio
Italian, 1852-1930
MANCINI, Bartolomeo
Italian, op.1687
MANCINI, Carlo
Italian, 1829-1910
MANCINI, Domenico
Italian, op.1511
MANCINI, Francesco
Italian, c.1694-1758
MANCINI, Francesco
Giovanni
Italian, 1829-1905
MANDEKENS, Marten
Flemish, op.1630-m.1649/50
MANDELBERG, Johan
Edvard
Swedish(?), 1730-1786
MANDELGREN, Nils
Mansson
Swedish, 1813-1899
MANDELL, Dick
American, 20th cent.
MANDELLI, Pompilio
Italian, 1912-
MANDELSLOH, Ernst
August
German, 1886-1962
MANDER, Karel, I van
Netherlands, 1548-1606
MANDER, Karel, II van
Flemish, c.1579-1623
MANDER, Karel, III
van
Dutch, c.1610-1670
MANDER, William
British, op.1880-1922
MANDEVARE, Alphonse
N. Michel
French, op.1793-1848
MANDEVILLE, Anne
French, 20th cent.
MANDLICK, August
German, 1860-
MANDRE, Emile Albert
de
French, 1869-
MANDUIT, Louise
French, 19th cent.
MANDYN, Jan
Netherlands,
1500-c.1560
MANE-KATZ
French, 1894-1962
MANERT, T. Hooghen
Dutch, op.1651
MANES, Antonin
Czech, 1784-1843
MANES, Joseph
Czech, 1820-1871

MANES, Kuido or
Guido
Czech, 1828-1880
MANES, Václav or
Wenzel
Czech, 1793-1858
MANESSE, M.T.
(Thomas Manessier?)
Flemish(?), 17th/18th cent.
MANESSIER, Alfred
French, 1911-
MANET, Edouard
French, 1832-1883
MANETTI, Rutilio di
Lorenzo
Italian, 1571-1639
MANEVICH, Abraham
Russian, op.1922
MANFIELD, Conrad
British, 19th cent.
MANFIELD, Josef
British, op.1886
MANFREDI
Italian, 20th cent.
MANFREDI, Bartolomeo
Italian, 1580-c.1620
MANFREDINI, Giovanni
Italian, 1730-1790
MANFREDINO d'Alberto
or da Pistoia
Italian, op.1280-1293
MANG (not Lang),
Heinrich
see Master of the
House-Book
MANGANI, Marco
Italian, 17th cent.
MANGIA
French, 20th cent.
MANGIN, Edward
British, op.1812
MANGLARD, Adrien
French, 1695-1760
MANGOLD, Burkhard
Swiss, 1873-1950
MANGOLD, Josef
German, 1884-
MANGOLD, Robert
American, 20th cent.
MANGOLD, Sylvia
American, 1938-
MANGOLDT, H. von
German, 19th cent.
MANGUIN, Henri Charles
French, 1874-1943
MANIOGLU, Mesut
Turkish, 20th cent.
MANIU, Rodica (Mützner)
Rumanian, 1892-1958
MANKER, Jan
Swedish, 1941-
MANKES, Jan
Dutch, 1889-1920
MANKIN, Matti
Finnish, 20th cent.
MANLY, Eleanor E.
British, op.1892
MANLEY, George P.
British, op.1848-1859
MANN, Alexander
British, 1853-1908
MANN, Cathleen,
Marchioness of
Queensberry
British, 1896-1959
MANN, Cyril
British, 20th cent.

MANN, Harrington
British, 1864-1937
MANN, James
Scrimgeour
British, 1883-1946
MANN, Joshua Hargrave
Sams
British, op.1849-1884
MANNAGETTA, Matthäus
German, 1630-1680
MANNERS, William
British, op.1889-c.1910
MANNHEIMER, Gusztav
see Magyar-Mannheimer
MANNI, Giannicola di
Paolo
Italian, c.1460-1544
MANNING, H.D.
American, 19th cent.
MANNING, Westley
(William Westley)
British, 1868-1954
MANNINI, Giacomo Antonio
Italian, 1646-1732
MANNIX, Robert
British, op.c.1880-1898
MANNLICH, Johann
Christian (Christian)
von
German, 1741-1822
MANNLICH, Konrad
German, 1701-1758
MANNO, Antonio
Italian, 1752-1831
MANNOCCHI or Manocchi,
Giuseppe
Italian, op.1775-m.1782
MANNOURY, Armand Arsène
French, op.1888-1893
MANNOZZI, Manozzi or
Mannozi, Giovanni
(Giovanni da San
Giovanni)
Italian, 1592-1636
MANNOZZI or Manozzi,
Vincenzo
Italian, op.1650
MANNUCCI, Adriano
Italian, 20th cent.
MANNUCCI, C.
Italian, 19th cent.
MANOLO
see Hugué, Manuel
Martinez
MANOUVRIER
French, 20th cent.
MANRIQUE, César
Spanish, 1920-
MANS, Arnoud van
Flemish, op.c.1668
MANS, F.H.
see Heeremans, Thomas
MANSART or Mansard,
Jules Hardouin
French, 1646-1708
MANSBERGH, R. St.
George
British, op.1772-1778
MANSFELD or
Mannsfeld, Johann
Ernst
Czech, 1739-1796
MANSFELD, Johann
Georg
German, 1764-1817
MANSFELD, Josef
German, 1819-1894

MANSFIELD, August
(Heinrich August)
German, 1816-1901
MANSION
see Larue, Léon
MANSKIRCH or Manskirsch,
Bernard Gottfried
German, 1736-1817
MANSKIRCH, Franz
Joseph
German, 1768-1830
MANSON, George
British, 1850-1876
MANSON, James Bolivar
British, 1879-1945
MANSOUROV, Paul
Russian, 1896-
MANSUETI, Giovanni
di Niccolò
Italian, op.1485-1527
MANTA, Abel
Portuguese, 1888-
MANTEGAZZA, Giacomo
Italian, 1853-1920
MANTEGNA, Andrea
Italian, 1431-1506
MANTEGNA, Francesco
Italian, op.1494-m.1517(?)
MANTELET, Albert Goguet'
French, 1858-
MANTON, Grenville
British, 19th cent.
MANTOVANO
see also Ghisi,
Teodoro
MANTOVANO, Adamo
see Scultori
MANTOVANO, Rinaldo
Italian, op.c.1528
MANTUANO, Dionisio
Italian, 1624-1684
MANUEL, Hans Rudolph
see Deutsch
MANUEL, Jacques
French, 20th cent.
MANUEL, Niklaus I
see Deutsch
MANYOKI, Adam
Hungarian, 1673-1756
MANZANO y Mejorada,
Victor
Spanish, 1831-1865
MANZINI, Camille
French, op.1834-1841
MANZINI di Modena,
Ferdinando
Italian, 1817-1886
MANZONI, Michele
Italian, -1666
MANZONI, Piero
Italian, 1933-1963
MANZU, Giacomo
Italian, 1908-
MANZULIN da Ferrara
see Mazzolino
MANZUOLI, Tommaso
d'Antonio
see Maso da San Friano
MAO
French, 20th cent.
MAPLESTONE, Henry
British,
c.1819-1884
MARA, Pol
Belgian, 1920-
MARAIS-MILTON, R.
French, 19th cent.

MARAIS-MILTON,
Victor
French, 1872-
MARAK, Julius
Eduard
Czech, 1832-1899
MARASTONI, Giacomo
or Jakob
Italian, 1804-1860
MARATTI, Carlo
Italian, 1625-1713
MARAZ, Adriana
Yugoslav, 20th cent.
MARAZZONE
see Morazzone
MARBEAU, Philippe
French, 1807-1861
MARC, van
Netherlands,
op.1578-1608
MARC, Franz
German, 1880-1916
MARC, Wilhelm
German, 1839-1907
MARCA, Giovanni
Battista della
see Lombardelli
MARCAL de Sax or
Sas
see Marzal
MARCA-RELLI, Corrado
di
American, 1913-
MARCEL or Marcello,
Provenzale
see Provenzale
MARCEL-BERONNEAU, P.
French, 1869-p.1926
MARCEL-CLEMENT, Amédée
Julian
French, 1873-
MARCELLIS van Schrieck,
Otto
see Marseus van Schrieck
MARCENAY de Ghuy,
Antoine de
see Demarcenay
MARCETTE, Alexandre
Belgian, 1853-1929
MARCH, Esteban
Spanish, -1660
MARCH, Miguel
Spanish, c.1633-1670
MARCH, Peter
American, op.c.1840
MARCH, Vernon
British, 1891-1930
MARCH y Marco,
Vincente
Spanish, 1859-
MARCHAIS, Pierre Antoine
French, 1763-1859
MARCHAL, Charles
Francois
French, 1825-1877
MARCHAND, André
French, 1877-1951
MARCHAND, Charles
German, 1843-
MARCHAND, J.N.
American, 20th cent.
MARCHAND, Jean
French, 1883-1940
MARCHAND or
Marchant, Johann
Christian
German, 1680-1711

MARCHANT, Edward
Dalton
American, 1806-1887
MARCHANT, Jean
Belgian, 1808-1864
MARCHELLI, Rolando
Italian, 1664-1751
MARCHES, Anonymous
Painters of the
School of the
MARCHESANI, Josef
German, 1866-1942
MARCHESI da Cotignola,
Girolamo
Italian,
c.1471/5-c.1540/50
MARCHESI, Giuseppe
(Sansone)
Italian, 1699-1771
MARCHESI, Luigi
Italian, 1825-1862
MARCHESI, Salvatore
Italian, 1852-1926
MARCHESINI, Alessandro
Italian, 1664-1738
MARCHETTI
Italian, 18th cent.
MARCHETTI, Giuseppe
Italian, 18th cent.
MARCHETTI, Lodovico
Italian, 1853-1909
MARCHETTI, Marco
(Marco da Faenza)
Italian, op.1553-m.1588
MARCHI
Italian(?), 17th cent.
MARCHI, Giuseppe
Filippo Liberati
Italian, c.1735-1808
MARCHI, Vincenzo
Italian, 1818-1894
MARCHI, Virgilio
Italian, 1895-
MARCHINI, Giovanni
Francesco
Italian, op.1702-1736
MARCHIONI, Elisabetta
Italian, op.c.1700
MARCHIONNI, Marchioni
or Marchione, Carlo
Italian, 1702-1786
MARCHIS or Demarchis,
Alessio
Italian, c.1710-1725
MARCHIS, Domenico dei
(Tempestino)
(Domenico Tempesta or
Tempesti?)
Italian, 1652-1718/37
MARCIA, Giovanni
see Giovanni da
Oriolo
MARCILLAT or de
Marcillat, Guillaume
Pierre (Guglielmo di
Pietro de Marcillat)
French, op.c.1505-m.1529
MARCINOWSKA-BRYKNER,
Eugenia
Polish, 1892-
MARCIUS-SIMONS, Pinky
American, 1867-1909
MARCK, P. van der
Dutch(?), 17th cent.
MARCKE de Lummen,
Emile van
French, 1827-1890

MARCKELBACH, Alexandre
Pierre Jacques
see Markelbach
MARCKL, Louis
German, 1807-
MARCKS, Gerhard
German, 1889-
MARCLET-ROBERT, van
Belgian, 19th cent.
MARCO, Carl
see Markó
MARCO del Buono
Giamberti
Italian, 1402-1489
MARCO da Chioggia
Italian, 15th cent.
MARCO da Faenza
see Marchetti
MARCO di Monte-
Pulciano
Italian, op.1448
MARCO di Paolo
Italian, 14th cent.
MARCO da Ravenna
see Dente
MARCO da Siena
see Pino, Marco dal
MARCO di Tiziano
see Vecelli, Marco
MARCOLA, Giambattista
Italian, c.1711-1790
MARCOLA, Marco
Italian, c.1740-1793
MARCOLINI, Francesco
Italian, c.1500-p.1559
MARCONI, Rocco
Italian, op.1504-m.1529
MARCOS de Vilanova
Spanish, op.c.1388
MARCOTTE de Quivers,
Augustin
French, 1854-1907
MARCOTTE, Marie
Antoinette
Belgian, 1869-
MARCOU, François
French, 1595-c.1660
MARCOUSSIS, Louis
Casimir Ladislas
French, 1883-1941
MARCUS, Jacob Ernst
German, 1774-1826
MARCUS, Marcia
American, 20th cent.
MARE, André
French, 1885-1932
MARE, John
American, op.1761-1768
MAREC, Victor
French, 1862-1920
MARECHAL, Charles
Laurent (Maréchal de
Metz)
French, 1801-1887
MARECHAL, Claude
French, 20th cent.
MARECHAL, François
Belgian, 1861-
MARECHAL, Jean Baptiste
French, op.1779-1824
MARECHAL, Louis
French, -1803
MARACHET, Marachef,
Mareschet or Marichet,
Imbert or Humbert
French, op.1547-1581
MAREES, George de
see Desmarées

MAREES, Hans (Johann
Hans Reinhard) von
German, 1837-1887
MARELLUS, Jacob
see Marrel
MARENIA, S.
Italian(?), op.c.1759
MARENT, Franz
Swiss, 1895-1918
MARE-RICHART, Florent
de la
see La Mare-Richart
MARES, Pierre des
French, op.1517
MARESCALCO, Il
see Buonconsiglio,
Giovanni
MARESCALCO, Pietro
(Lo Spada)
Italian, 1503(?)-1584
MARESCOTTI, Bartolomeo
Italian, 1590(?)-1630
MARETT, C.
British, op.1773
MAREVNA, Marie Vorobieff
Russian, 20th cent.
MAREZ-DARLEY, Nelly
French, 20th cent.
MARFAING, André
French, 1925-
MARFITT-SMITH, C.
British, op.1934
MARFFY, Odon Edmund
Hungarian, 1878-1959
MARGARITONE di Magnano
da Arezzo
Italian, 1216-1293
MARGETSTON, William
Henry
British, 1861-1940
MARGHERI, Rodolfo
Italian, 1910-1967
MARGHINOTTI, Giovanni
Italian, op.1832-m.1865
MARGITAY, Tihamé von
Hungarian, 1859-1922
MARGITSON, Marie
British, op.1857
MARGOTTET, Hippolyte
Edouard
French, op.1869-1885
MARGOTTI, Anacleto
Italian, 1899-
MARI, Alessandro
Italian, 1650-1707
MARI, Enzo
Italian, 1932-
MARIA, de
Italian, 20th cent.
MARIA, Mario de
(Marius Pictor)
Italian, 1853-1924
MARIA-BERGLER, Ettore
de
Italian, 1851-
MARIAN, Maria
Netherlands, 17th cent.
MARIANI, Antonio
Italian, op.1742
MARIANI, Cesare
Italian, 1826-1901
MARIANI, Giuseppe
Italian, c.1650-1718
MARIANI, Pietro
Italian, 18th cent.
MARIANNE
see Marie Anna

MARIANO di Antonio
di Francesco Nutolo
Italian, op.1433-m.1468
MARIANO di Austerio
or Eusterio di
Bartolomeo di Mariano
da Monte Corneo
(Mariano da Perugia)
Italian, c.1470-1527/47
MARIANO da Pescia
(Graziadei)
Italian, -1620
MARIANO (Pelligrino
di Mariano Rossini)
see Rossini
MARIA THERESA, Empress
of Austria
German, 1717-1780
MARICOT, Jean Alexandre
French, 1789-p.1848
MARIE, Adrien Emmanuel
French, 1848-1891
MARIE Anna of Prussia,
Princess (Marianne)
German, op.1812
MARIEGE, Jean
French, 18th cent.
MARIE-LOUISE, Empress
of France
French, 1791-1847
MARIEN, Marcel
Belgian, 1920-
MARIENHOF, J.A.
Dutch, op.c.1640-1649
MARIES, Antonin
Czech, op.c.1830
MARIESCHI, Jacopo
Italian, 1711-1794
MARIESCHI, Michele
Italian, 1696-1743
MARIETTE, Jean
French, 1660-1742
MARIETTE, Pierre Jean
French, 1694-1774
MARIGLIANO, Merigliano,
Meriliano, Merliano
or Miriliano, Giovanni
(Giovanni da Nola)
Italian, c.1488-1558
MARIL, Herman
American, 1908-
MARILHAT, Prosper
Georges Antoine
Prosper (Prosper)
French, 1811-1847
MARILLIER, Clément
Pierre
French, 1740-1808
MARIN, John
American, 1870-1953
MARIN, Joseph Charles
French, 1759-1834
MARIN, Léonard
French, op.1779
MARIN, Louis
French, 19th cent.
MARIN, Louis
see Bonnet
MARINALI, Oragio
Italian, 1643-1720
MARINARI, Onorio
Italian, 1627-1715
MARINAS, Henrique de
las (Hendrik Cornelis
Vroom)
Spanish, 1560-1640
MARINELLI, Mario
Italian, 20th cent.

MARINELLI, Matteo
Italian, -1772
MARINELLI, Vincenzo
Italian, 1820-1892
MARINETTI, Antonio
(Il Chiozzoto)
Italian, c.1710-1796
MARINETTI, Emilio
Italian, op.1919
MARINI, Antonio
Italian, 1788-1861
MARINI, Leonardo
Italian, c.1730-p.1797
MARINI da Cattaro,
Lorenzo
Italian, op.1456-m.1478
MARINI, Marino
Italian, 1901-1966
MARINIS, Giovanni Angelo
de (Siciliano)
Italian, op.1550-1584
MARINKELLE or Marinkel,
Joseph
Dutch, 1732-1776(?)
MARINO, Cavaliere
Italian, 17th cent.
MARINO di Oderisio da
Perugia
Italian, op.1318
MARINONI, Antonio
Italian, 1796-1871
MARINOT, Maurice
French, 20th cent.
MARINUS Claesz. van
Reymerswaele or
Roymerswaele (Marino
de Seeu or de
Sirissea)
Netherlands,
op.1509(?)-1567(?)
MARINUS, Ferdinand
Joseph Bernard
Belgian, 1808-1890
MARIO de'Fiori
see Nuzzi, Mario
MARIO di Laureto
Italian, op.1503-1536
MARION, Antoine Fortuné
French, 1846-1900
MARION, Francois P.W.
French, op.1873
MARIOTTI, Carlo
Spiridione
Italian, 1726-1790
MARIOTTI, Giovanni
Battista
Italian, c.1685-1765
MARIOTTO da Volterra,
Andrea
Italian, op.1484
MARIOTTO, Bernardino di
see Bernardino di
Mariotto
MARIOTTO di Cristofano
Italian, 1393-1457
MARIOTTO di Nardo
Italian, op.1394-1424
MARIOTTO da Viterbo
Italian, op.1444
MARIS, Jacobus
Hendricus (Jacob)
Dutch, 1837-1899
MARIS, Matthijs
(Thijs)
Dutch, 1839-1917
MARIS, Willem
Dutch, 1844-1910

MARIS, Willem Matthijs
Dutch, 1872-1929
MARISOL (Marisol
Escobar)
American, 1930-
MARIV, J.
French, 19th cent.
MARK, George Washington
American, op.1817-m.1879
MARKE, Marie van
see Dieterli
MARKELBACH or Marckelbach,
Alexandre Pierre
Jacques
Belgian, 1824-1906
MARKES, Albert Ernest
British, 1865-1901
MARKHAM
British, 18th cent.
MARKINO, Yoshio
British, 1874-
MARKITANTE, Sam
Russian, op.1920
MARKLEW, H.
British, op.c.1826
MARKO, András or
Andreas
German, 1824-1895
MARKO (not Marco),
Karoly or Carl, I
Hungarian, 1791-1860
MARKO, Karoly or Carl, II
Hungarian, 1822-1891
MARKOWSKI, Eugeniusz
Polish, 1912-
MARKOWSKY, Wenzel
German, 1789-1846
MARKS, Barnett Samuel
British, 1827-1916
MARKS, Claude
British, 19th cent.
MARKS, Henry Stacy
British, 1829-1898
MARKS, J.
British, op.1787-1799
MARKS, Lewis
British, op.1814/15
MARLE, Félix del
French, 1889-1952
MARLEF, Mme. Lefebvre,
(née Andrea Josephine
Boyer)
French, 1864-
MARLET, Jean Henri
French, 1770-1847
MARLIER, Philippe de
Flemish, c.1610-1677
MARLOE, N.
British, 17th cent.
MARLOT, Albrecht
French(?), op.1665
MARLOW, A.
British, op.1882-1889
MARLOW, William
British, 1740-1813
MARME, Johann Christian
German, op.1741-1780
MARMI, Diacinto or
Giacinto
Italian, c.1600-
MARMION, Simon
French, op.1449-m.1489
MARMITTA, Francesco, Il
Italian, op.1496-m.1505
MARMITTA, Lodovico
Italian, 16th cent.
MARMOCCHINI CORTESI,
Giovanni
see Fratellini

MARNE, Demarne or
De Marne, Jean Louis
(Marnette)
Belgian, 1754-1829
MARNE, M. de
French(?), 19th cent.
MARNEFFE, Francois de
Belgian, 1793-1877
MARNIUS, G.A.
Dutch(?), 17th cent(?)
MARNY, Paul
French, 1829-1914
MAROLD, Ludek or
Ludwig
Czech, 1865-1898
MAROLI, Domenico
Italian, 1612-1676
MAROLLES, Antoine
Alexandre
French, op.1738-m.1751/2
MAROLLES, Philippe de
see Mazerolles
MARON, Anton von
German, 1733-1808
MARON, Ferdinand
Swiss, 19th cent.
MARON, Theresa Concordia
von
see Mengs
MARONE, Fra Benedetto
Italian, op.1560-1571
MARONE, Jacopo
Italian, op.c.1550
MARONE, Pietro
Italian, op.1544
MARONE, Pietro
Italian, 1548-1625
MARONIEZ, Georges
Philibert Ch.
French, 1865-
MAROSIN, Mircea
French, 20th cent.
MAROT, Daniel, I
French, c.1663-1752
MAROT, Daniel, II
British, 1695-1769
MAROT, Francois
French, 1666-1719
MARQUES, Bernardo
Portuguese, 1900-
MARQUES y Garcia,
José Maria
Spanish, 1862-
MARQUET, Albert
French, 1875-1947
MARQUEZ de Velasco,
Estéban
Spanish, op.c.1672-m.1720
MARR, A.
German, 19th cent.
MARR, Carl
American, 1858-1936
MARR, Heinrich
German, 1807-1871
MARR, Leslie
British, 20th cent.
MARRACCI, Giovanni
Italian, 1637-1704
MARRANI, A.
Italian, op.1905
MARRAST, Pierre
French, 1900-
MARRE, Hélène
French, 20th cent.
MARREE, G.
French, 19th cent.

MARREL, Marrell,
Marzell, Morrel or
Morsel, Jacob
Dutch, 1614-1681
MARRIOTT, Frederick
British, 1860-1941
MARRIS, Robert
British, 1750-1827
MARRYAT, Captain
Frederick
British, 1792-1848
MARSAL, Edouard Antoine
French, 1845-
MARSAL de Sax or
Sas, Andrés
see Marzal
MARSAUD, Marie
Méloé
see Lafon
MARSEUS van Schrieck,
Evert
Dutch, c.1614-p.1681
MARSEUS or Marcellis
van Schrieck, Otto
(Snuffelaer)
Dutch, c.1619-1678
MARSH, Miss
see Thynne, Lady
MARSH, Arthur H.
British, 1842-1909
MARSH, Charles
Australian, 1789-1882
MARSH, Reginald
American, 1898-1954
MARSH, William
American, 18th cent.
MARSHAL, Alexander
British, op.c.1660-1690
MARSHALL, Anthony
British, op.1812
MARSHALL, Benjamin
British, 1767-1835
MARSHALL, Charles
British, 1806-1890
MARSHALL, E.
British, 19th cent.
MARSHALL, George
British, -c.1732
MARSHALL, Herbert
Menzies
British, 1841-1913
MARSHALL, James
German, 1838-1902
MARSHALL, Lambert
British, 1810-1870
MARSHALL, Rita
British, 1946-
MARSHALL, Thomas Falcon
British, 1818-1878
MARSHALL, Thomas W.
American, 1850-1874
MARSHALL, William
British, op.1617-1649
MARSIGLI, Carlo
Italian, op.1773-1778
MARSIGLI, Filippo
Italian, 1790-1863
MARSIGLIA, Gerlando
Italian, 1792-1817
MARSTON, D.
British, op.1771
MARSTON, George
British, 20th cent.
MARSTRAND, Vilhelm
Nicolai
Danish, 1810-1873

MARSZALKIEWICZ, Stanislaw
Polish, 1789-1872
MARTEAU, Louis
French, c.1715-c.1805
MARTEL, Ange Etienne
see Martellange
MARTEL, Charles
French, 20th cent.
MARTEL, Eugène
French, 19th cent.
MARTELLANGE or
Martelange, Etienne
(Ange Etienne Martel)
French, 1564/9-1641
MARTELLI, Girolamo
Italian, op.1609-1646
MARTELLI, Giuseppe
Italian, 1792-1876
MARTELLIERE, Paul
French, 19th cent.
MARTELLINI, Gaspare
Italian, 1785-1857
MARTEN, John, I
British, op.1793-1802
MARTEN, John, II
British, op.1822-1834
MARTENS, Conrad
Australian, 1801-1878
MARTENS, Ernest Edmond
French, 1865-
MARTENS, Hans Ditlev
Christian
German, 1795-1864
MARTENS, Henry
British, op.1828-1854
MARTENS, Iris
British, 20th cent.
MARTENS, Johann Heinrich
German, 1815-1843
MARTENS, P.
Flemish, 18th cent.
MARTENS, Willem (Willy)
Dutch, 1856-1927
MARTENS, Willem Johann
Dutch, 1839-1895
MARTERSTEIG, Frederich
Wilhelm Heinrich
German, 1814-1899
MARTHAS, Takis
Greek, 1905-
MARTIG, Paul
Swiss, 1903-1962
MARTIN
French, op.1764
MARTIN (Martinus
'Opifex')
Hungarian, 15th cent.
MARTIN, Agnes
American(?), 20th cent.
MARTIN, Ambrose
British, op.1830-1844
MARTIN, André
French, 17th cent.
MARTIN, Andreas
Netherlands, op.1747
MARTIN, Anson
British, 19th cent.
MARTIN, C.J.
British(?), op.1854
MARTIN, Charles
British, 1820-1906
MARTIN, David
British, 1736/7-1798
MARTIN, Denise
French, 1905-
MARTIN, Elias
Swedish, 1739-1818

MARTIN, Etienne
French, 1858-1945
MARTIN, Eugène
Swiss, 1880-1954
MARTIN, Francis
Patrick
British, 1883-
MARTIN, G.
British, 19th cent.
MARTIN, Gabriel
French, op.1866-1870
MARTIN des Gobelins
see Martin, Pierre
Denis, II
MARTIN, Henri Jean
Guillaume
French, 1860-1943
MARTIN, Homer
Dodge
American, 1836-1897
MARTIN, James Edward
American, op.1941
MARTIN, Jean Baptiste,
I (Martin des
Batailles)
French, 1659-1735
MARTIN, Johann Fredrik
Swedish, 1755-1816
MARTIN, John
British, 1789-1854
MARTIN, John
Blennerhassett
American, 1797-1857
MARTIN, Jonathan
British, op.1830
MARTIN, Kenneth
British, 1905-
MARTIN, Maria
American, 1796-1863
MARTIN, Martin
German, 1792-1865
MARTIN, Mary Adela
British, 1907-
MARTIN, Paul
German, 1821-1901
MARTIN, Paul
American, 20th cent.
MARTIN, Philip
British, 20th cent.
MARTIN, Pierre
Denis, II
French, c.1663-1742
MARTIN, Pierre Edmond
French, 1783-
MARTIN, René
Swiss, 1891-
MARTIN, Thomas Mower
Canadian(?), op.1881
MARTIN y Robollo,
Tomás
Spanish, 1858-1919
MARTIN, William
British, op.1775-1816
MARTIN, William A.K.
American, 1817-1867
MARTIN, William Alison
British, 19th cent.
MARTINAZZI
see Spada, Simone
MARTINDALE, G.
British, 19th cent.
MARTINEAU, Edith
British, 1842-1909
MARTINEAU, Clara
British, op.1873-1890
MARTINEAU, Gertrude
British, op.c.1880-1911

MARTINEAU, Robert
Braithwaite
British, 1826-1869
MARTINELLI, Giovanni
Italian, c.1610-1659
MARTINELLI, Giulio
Italian, -1631
MARTINELLI, Luca
Italian, -1629
MARTINELLI, Onofrio
Italian, 1900-
MARTINELLI, Vincenzo
Italian, 1737-1807
MARTINET, Achille-
Louis
French, 1806-1877
MARTINET, Alphonse
French, 1821-1861
MARTINET, François
Nicolas
French, 1739-p.1796
MARTINET, Pierre
French, 1781-p.1812
MARTINETTI, Angelo
Italian, 19th cent.
MARTINETTI, Giacomo
Italian, 1842-1910
MARTINEZ de Bustos,
Ambrosio
Spanish, 1614-1672
MARTINEZ, Andrea
Italian(?), 18th cent.
MARTINEZ, Antonio
Spanish, op.1799-1802
MARTINEZ, Crisostomo
Spanish, 1628-1694
MARTINEZ, Domingo
Spanish, -1750
MARTINEZ, G.
Spanish, 19th cent.
MARTINEZ de Gradilla,
Juan
Spanish, op.1660-1682
MARTINEZ de Mendaro,
Juan
Spanish, 15th cent.
MARTINEZ, Jusepe (not
José)
Spanish, c.1600-1682
MARTINEZ, Ramos
S.American, 20th cent.
MARTINEZ, Raymond
British, 1937-
MARTINEZ de Hoyos,
Ricardo
American, 1918-
MARTIN-FERRIERES, Jac
French, 1893-
MARTINI, Alberto
Italian, 1876-1954
MARTINI, Biagio
Italian, 1761-1840
MARTINI, Donato
Italian, 14th cent.
MARTINI, G. de
Italian, 20th cent.
MARTINI, Giovanni
(Giovanni da Udine)
Italian, op.1497-m.1535
MARTINI, Innocenzo
Italian, 1551-1623
MARTINI, Johanes
German, 1866-
MARTINI, Joseph de
American, 1896-
MARTINI, Laurana
see Laurana, Lucianus

MARTINI, Martin
 Swiss, 1566/7(?)-1610
MARTINI, Pietro Antonio
 Italian, 1738-1797
MARTINI, Simone
 see Simone de Martino
MARTINI, Tommaso
 Italian, 1689-1747
MARTINIE, Berthe
 French, 20th cent.
MARTINIS, F.L.
 Spanish(?), 18th cent.
MARTINO di Bartolommeo
 di Biagio
 Italian,
 op.1389-m.1434/5
MARTINO del Don
 Italian, op.1896
MARTINO, Eduardo de
 Italian, 1838-1912
MARTINO da Udine
 see Pellegrino da
 San Daniele
MARTINS, Jacob
 see Mertens
MARTINS, Nabur
 (Nabucadonozor)
 Netherlands,
 op.1435-m.1454
MARTIN, Theophilus
 see Polak
MARTINZ, Fritz
 German, 1925-
MARTIS, Ottaviano de
 see Nelli
MARTIUS, C.Fr. Ph. de
 German, op.1832-1850
MARTONEZ, Florence
 Haitan, 1942-
MARTORANA, Carlo
 Italian, 1826-1849
MARTORANA, Giovacchino
 Italian, 1724-1782
MARTORANA, Pietro
 Italian, 18th cent.
MARTORELL, Bernardo
 (not Benito)
 Spanish, op.1427-m.1452/4
MARTORELLI, Giovanni
 Italian, 1390-1447
MARTORIELLO or
 Martorello, Gaetano
 Italian, c.1670-c.1720
MARTOSS, Iwan
 Petrowitsch
 Russian, 1754-1835
MARTSEN, Jacob
 Flemish, 1580-p.1630
MARTSZEN, Marssen,
 Martsen or Martss,
 Jan (or Jacob?), II
 Dutch, 1609(?)-p.1647
MARTY, André Edouard
 French, 1882-
MARTYN
 British, op.1728
MARTYN, Ferenc
 Hungarian, 1889-
MARUCELLI or
 Maruscelli, Giovanni
 Stefano
 Italian, 1586-1646
MARUCELLI, Valerio
 Italian, op.c.1589-1620
MARUSSIG or Marussik,
 Anton
 German, 1868-1925

MARUSSIG, Guido
 Italian, 1885-1938(?)
MARUSSIG, Pietro or
 Piero
 Italian, 1879-1937
MARVAL, Jacqueline
 French, 1866-1932
MARVIE or Marvye,
 Martin
 French, 1713-1813
MARWICKE, Eric
 British, 1946-
MARX, Gustav
 German, 1855-1928
MARX, Johann
 German, 1866-
MARX, Michelle
 Argentinian, 20th cent.
MARY, André
 French, 20th cent.
MARYAN
 French, 1927-
MARZAL, Marcal or
 Marsal de Sax or
 Sas, Andrés
 Spanish(?), op.1393-1410
MARZELL, Jacob
 see Marrel
MARZELLE, Jean
 French, 20th cent.
MARZI, Ventura
 see Mazzi
MARZIALE, Marco
 Italian, op.1492-1507
MARZIANO
 see also Morsiani
MARZIANO da Tortona
 Italian, 15th cent.
MARZIERI
 Italian, 18th cent.
MARZILLI, Franco
 Italian, 20th cent.
MARZO, Andrés
 Spanish, op.1653-1670
MARZOCCHI de Bellucci,
 Tito
 Italian, 1800-1871
MAS y Fondevila,
 Arcadio
 Spanish, 1850-
MASAAKI
 Japanese, 1938-
MASACCIO, Tommaso di
 Giovanni di Simone
 Guidi
 Italian, 1401-1428(?)
MASACODO
 see Garelli, Tommaso
 d'Alberto
MASCACOTTA
 see Greco, Gennaro
MASCAGNI, Donato
 (Fra Arsenio)
 Italian, 1579-1636
MASCAGNI, Leonardo
 Italian, op.1589-1618
MASCALL, Edward
 British, 17th cent.
MASCART, Gustave
 French, 19th cent.
MASCHERINO or Mascarino,
 Ottaviano
 Italian, 1524-1606
MASCHETTO
 Italian, 17th cent.

MASCLETI, Simon
 French, op.1478-1481
MASELLI, Titina
 Italian, op.1965
MASEREEL, Frans
 Belgian, 1889-1972
MASEROLLES, Philippe de
 see Mazerolles
MASERY, Gaspard
 French, op.1545-1565
MASHKOV, Ilya
 Ivanovich
 Russian, 1881-1944
MASILLO
 see Realfonso
MASINI, Cesare
 Italian, 1819-1888
MASIP or Macip,
 Vicente, I
 Spanish,
 c.1475-1545/50
MASIP, Vicente Juan, I
 (Juan de Juanes)
 Spanish, 1523(?)-1579
MASIP or Macip,
 Vicente Joanes or
 Juanes, II
 Spanish, c.1555-p.1621
MASLOWSKI, S.
 Polish, 20th cent.
MASO di Banco
 see Giottino
MASO da Bologna
 see Lippo di
 Dalmasio
MASO da San Friano
 (Tommaso d'Antonio
 Manzuoli)
 Italian, 1536-1571
MASOERO, Jeanne
 British, 1937-
MASOLINO di Cristoforo
 da Panicale, Tommaso
 Fini
 Italian, 1383-1447(?)
MASON, A.M.M.
 British, op.1901
MASON, Arnold
 British, 1885-1963
MASON, Bateson
 British, 1910-
MASON, Finch
 British, 1850-1915
MASON, Frank H.
 British, 1876-1965
MASON, George Heming
 British, 1818-1872
MASON, Gibbs
 American, 20th cent.
MASON, Miles
 British, 20th cent.
MASON, Raymond
 American, 20th cent.
MASON, W.H.
 British, op.1865
MASON, Rev. William
 British, 1724-1797
MASON, William
 Sanford
 American, 1824-1864
MASQUELIER, Claude
 Louis, II
 French, 1781-1852
MASQUELIER, Louis
 Joseph, I
 French, 1741-1811

MASQUERIER, John James
 British, 1778-1855
MASRELIEZ, Jean Baptiste
 Edouard
 Swedish, 1753-1801
MASRELIEZ, Louis
 Adrien
 French, 1748-1810
MASRIERA y Manovens,
 Francisco
 Spanish, 1842-1902
MASSA, Giuseppe
 Italian, -1738
MASSA, Lionello
 Fioravanti
 Italian, 1914-
MASSANET, L.
 French, 19th cent.
MASSANI, Pompeo
 Italian, 1850-1920
MASSARD, Andries
 French, op.1765
MASSARD, Felix (Jean
 Baptiste Felix)
 French, 1773-
MASSARD, Léopold
 French, 1812-1889
MASSARD, Louise
 French, op.1777-1808
MASSARI, Antonio
 see Antonio da
 Viterbo
MASSARI, Lucio
 Italian, 1569-1633
MASSAROTTI or
 Masserotti, Angelo
 Italian, c.1645-1732
MASSE, Emmanuel Auguste
 French, 1818-1881
MASSE, Jean Baptiste
 French, 1687-1767
MASSE, Jean Eugène
 Julien
 French, 1856-
MASSE, Jules
 French, 1825-1899
MASSIEU, Lola
 Spanish, 1921-
MASSINI
 Italian(?), 17th cent.
MASSOLINI, Giovanni
 Bernardo
 see Azzolini
MASSON, Alphonse Charles
 French, 1814-1897
MASSON, André
 French, 1896-
MASSON, Antoine
 French, 1636-1700
MASSON, Benedict
 French, 1819-1893
MASSON or Le Masson,
 Francois
 French, 1745-1807
MASSON, Henri
 Canadian, 1907-
MASSON, Henri Gustave
 French, 1869-
MASSON, Hippolyte
 French, op.1831-m.1878
MASSON, Richard
 (Sieur de La Richardière)
 French, op.1612-1630
MASSON, Roberto
 French, 20th cent.

MASSONE, Giovanni
see Mazone
MASSOT, Firmin
Swiss, 1766-1849
MASSUCCI, Agostino
see Masucci
MASSYS, Matsys, Messys
or Metsys, Cornelis
Netherlands,
op.1522-1560
MASSYS, Matsys, Messys
or Metsys, Jan
Netherlands, 1509-1575
MASSYS, Matsys, Messys
or Metsys, Quinten, I
Netherlands,
1465/6-1530
MASSYS, Matsys, Messys
or Metsys, Quinten, II
Netherlands,
1543(?)-1589
MAST, Herman van der
Netherlands, c.1550-1610
MASTELLETTA, Il
see Donducci, Giovanni
Andrea
MASTENBROEK, Johann
Hendrik
Dutch, 1875-1945
MASTER OF THE AACHEN
ALTARPIECE
German, op.c.1480-1520
MASTER OF THE AACHEN
DOORS
see Master of the
Aachener Schranktüren
MASTER OF THE AACHEN
MADONNA
German, op.c.1460-1470
MASTER OF THE AACHENER
SCHRANKTÜREN
German, 15th/16th cent.
MASTER OF AARSCHOT
Netherlands, 16th cent.
MASTER OF S. ABONDIO
Italian, 13th cent.
MASTER OF ABRANTES
Portuguese, 16th cent.
MASTER OF ABSALOM
Netherlands, 15th cent.
MASTER OF THE ACCADEMIA
ANNUNCIATION
Italian, 14th cent.
MASTER OF THE PORTRAIT
OF ADIE LAMBERTSZ.
Dutch, op.1592
MASTER OF THE ADIMARI
CASSONE
Italian, 15th cent.
MASTER OF THE ADORATION
Norwegian, 13th cent.
MASTER OF S. AEGIDIUS
see Master of St.Giles
MASTER OF THE ABBEY OF
AFFLIGHEM (Master of the
Joseph Sequence)
Netherlands, op.c.1500
MASTER OF ST. AGILOLFLUS
German, 16th cent.
MASTER OF AGNANI III
Italian, op.c.1300
MASTER OF AGRAM
German, 14th cent.
MASTER OF THE AIX
ANNUNCIATION
French, 15th cent.

MASTER OF THE AIX
PANELS
French, 14th cent.
MASTER OF ALACUAS
Spanish, op.c.1450-1470
MASTER OF ALBATARRECH
(formerly Master of the
Solsona Last Supper,
now identified with
Jaime Ferrer, I)
Spanish, 15th cent.
MASTER OF THE ALBRECHT
ALTAR
German, op.1430-1450
MASTER OF THE ALDOBRANDINI
TRIPTYCH
Italian, 14th cent.
MASTER OF ALFAJARIN
Spanish, 15th cent.
MASTER ALFONSO
see Alfonso de Cordoba,
Jaime
MASTER OF ALKMAAR
(Master of the Seven
Works of Mercy)
Netherlands, op.1504
MASTER OF ALL
Spanish, 15th cent.
MASTER OF THE ALLENDALE
ADORATION
see Giorgione
MASTER OF ALMUDEVAR
see Abadia, Juan de la
MASTER OF S. ALO
Italian, 14th cent.
MASTER OF THE ALTARPIECES
OF SAINTS
Netherlands, op.c.1500
MASTER OF ALTURA
Spanish, 15th cent.
MASTER OF AMBIERLE
Netherlands, op.1466
MASTER OF AMIENS
(The Amiens Mannerist)
Netherlands, op.1518-1520
MASTER OF AMPURIAS
Spanish, 15th cent.
MASTER OF THE AMSTERDAM
CABINET
see Master of the House-
Book
MASTER OF THE AMSTERDAM
DEATH OF THE VIRGIN
(Master of the Lantern
or Master of the Monastery
of the Seven Electors)
Netherlands, op.c.1500
MASTER OF THE ANAEMIC
FIGURES
Spanish, 15th cent.
MASTER OF THE ANDRE
MADONNA
Netherlands, 15th cent.
MASTER OF THE ST. ANDREW
ALTAR
German, op.c.1450
MASTER OF ANGHIARI
Italian, 15th cent.
MASTER OF THE ANGRER
PORTRAITS
German, op.1519
see also Apt the
Younger, Ulrich
MASTER OF ST. ANNE
Netherlands, 16th cent.
MASTER OF THE HOLY FAMILY
WITH ST. ANNE
Netherlands, op.c.1490

MASTER OF THE ANNUNCIATION
Norwegian, c.1275
MASTER OF THE ANNUNCIATION
TO THE SHEPHERDS
Italian, 17th cent.
MASTER OF THE ANSBACH
KELTERBILD
German, op.1510-1515
MASTER OF ANTON REHM
German, op.1522
MASTER OF THE ANTWERP
ADORATION
Netherlands, op.c.1520
MASTER OF THE ANTWERP
CRUCIFIXION
Netherlands, op.c.1520
MASTER OF THE ANTWERP
TRIPTYCH OF THE VIRGIN
Netherlands, 15th cent.
MASTER OF THE APOLLO
AND DAPHNE LEGEND
Italian, op.c.1480-1510
MASTER OF THE APOSTLE
MIRACLES
Netherlands,
op.c.1520-1530
MASTER OF THE ARCHINTO
PORTRAIT
Italian, op.1494
MASTER OF AREVALO
Spanish, 16th cent.
MASTER OF ARGANO
Spanish, 16th cent.
MASTER OF THE ARGONAUTS
Italian, op.c.1480
MASTER OF ARGUIS
Spanish, 15th cent.
MASTER OF ARMISEN
Spanish, 15th cent.
MASTER OF ARNOULT
Spanish, 15th cent.
MASTER OF ARTE DELLA
LANA CORONATION
Italian, 15th cent.
MASTER OF THE ARTES
FAMILY
Spanish, op.1512
MASTER OF THE ASHMOLEAN
PREDELLA
Italian, 14th cent.
MASTER OF THE VELE
D'ASSISI
Italian, 14th cent.
MASTER OF THE ASSUMPTION
OF THE VIRGIN
see Bouts, Aelbrecht
MASTER OF ASTORGA
Spanish, 16th cent.
MASTER OF THE AUGSBERG
VISITATION
German, op.1492
MASTER OF ST. AUGUSTINE
see Master of Neustift
MASTER OF ST. AUGUSTINE
Netherlands,
op.c.1480-1490
MASTER OF THE AUGUSTINE
ALTARPIECE
(not of the Peringsdörfer
Altarpiece)
German, op.1487
MASTER OF THE AUGUSTINE
CRUCIFIXION
German, op.c.1400
MASTER OF ST. AUTA
Portuguese, op.1512-1529

MASTER OF AVILA
Spanish, op.1470-1475
MASTER OF THE BADIA A
ISOLA MAESTÀ
Italian, 13th cent.
MASTER OF BAGNANO
Italian, op.1280-1285
MASTER OF THE BALDAQUIN
ALTAR
German, op.c.1480-1495
MASTER OF BALE OF 1445
Swiss, op.c.1440-1450
MASTER OF THE BAMBERG
ALTAR
German, op.c.1434-1437
MASTER OF THE BAMBINO
VISPO
Italian, 15th cent.
MASTER OF THE BANDEROLES
(Master of 1464)
German, op.1461-p.1467
MASTER OF THE BAPTISM
Italian, 14th cent.
MASTER OF THE BAPTIST'S
DOSSAL
Italian, op.1325-1350
MASTER OF ST. BARBARA
(BRESLAU)
German, op.1447-c.1470
MASTER OF ST. BARBARA
(RHENISH)
see Master of the
Darmstadt Passion
MASTER OF THE LEGEND OF
ST. BARBARA
Netherlands, op.c.1470-1500
MASTER OF THE BARBERINI
PANELS
Italian, 15th cent.
MASTER OF S. FRANCESCO
BARDI
Italian, 13th cent.
MASTER OF THE BÄRENPUTTO
Swiss, op.1542-1550
MASTER OF THE BARGELLO
TONDO
Italian, 15th cent.
MASTER OF THE BARONCELLI
PORTRAITS
Netherlands, op.c.1480-1490
MASTER OF THE ALTAR OF
ST. BARTHOLOMEW
(Master of the Altar of
St. Thomas)
German, op.c.1470-1510
MASTER OF BATI
Hungarian, 14th cent.
MASTER OF THE BATTUTI
NERI
Italian, 15th cent.
MASTER OF BECERRIL
Spanish, 16th cent.
MASTER OF THE BECK
COLLECTION
Spanish, 15th cent.
MASTER OF THE DUKE OF
BEDFORD
French, 15th cent.
MASTER OF BELLAERT
Netherlands,
op.c.1483-1486
MASTER OF THE BELORADO
PANELS
Spanish, 16th cent.
MASTER OF BENABBIO
Italian, 15th cent.

MASTER OF ST. BENEDICT
Italian, op.1417
MASTER OF THE LEGEND
OF ST. BENEDICT
German, 16th cent.
MASTER OF THE
BENEDIKTBEUREN CRUCIFIXION
German, op.c.1455
MASTER OF THE MELK ST.
BENEDICT LEGEND
German, 15th cent.
MASTER OF THE BENSON
PORTRAIT
French, 16th cent.
MASTER OF ST. BENTO
Portuguese, 16th cent.
MASTER OF THE PORTRAIT
OF THE BERGAMO PAGE
Italian, 15th cent.
MASTER OF THE BERGMAN
OFFICE
see Master of the
Terence Illustrations
THE MASTER OF BERLIN OF
1562
German, op.1562
MASTER OF THE BERLIN
BETROTHAL
Italian, op.c.1470
MASTER OF THE BERLIN
FAMILY PORTRAIT
see Pietersz., Pieter
MASTER OF THE BERLIN
PASSION
German, op.1482
MASTER OF THE BERLIN
SKETCH-BOOK
German, op.1523-1530
MASTER OF THE LEGEND
OF S. BERNARDINO
(Master of 1473)
Italian, op.1473
MASTER 'BERNARDO RAVENNATE'
Italian, 14th cent.
MASTER OF THE TRES RICHES
OR TRES BELLES HEURES
OF THE DUC DE BERRY
see under Limburg,
Paul de
MASTER OF THE BERSWORDT
ALTAR
see Master of the
Bielefeld Altar
MASTER OF THE BETTONA
ASSUMPTION
Italian, 14th cent.
MASTER OF THE BEYGHEM
ALTARPIECE
Netherlands, 16th cent.
MASTER OF THE BIADAIOLO
ILLUMINATIONS
Italian, 14th cent.
MASTER OF THE BIELEFELD
ALTAR.
(or of the Berswordt
Altar or of the Dortmund
Altar).
German, op.a.1431
MASTER OF THE BIGALLO
CRUCIFIX
Italian, op.c.1250
MASTER OF THE BLAUBEUREN
ALTAR
German, 16th cent.
MASTER OF THE BLONDE
MADONNAS
Italian, op.c.1475

MASTER OF THE BLUE
CRUCIFIXES
Italian, op.1265-1275
MASTER OF BOCCACCIO
German, 15th cent.
MASTER OF THE BOCCACCIO
ILLUSTRATIONS
Netherlands, op.c.1470
MASTER OF THE BOEHLER
TRIPTYCH
Italian, 14th cent.
MASTER OF BONNAT
Spanish, 15th cent.
MASTER OF BORBOTO
Spanish, 16th cent.
MASTER OF THE BORGHESE
NATIVITY
Italian, 15th cent.
MASTER OF THE BORGHESE
TONDO
Italian, 15th/16th cent.
MASTER OF BORGO ALLA
COLLINA
Italian, op.c.1400
MASTER OF ST. BOTOLPHE
Norwegian, 13th cent.
MASTER OF THE MARSHALL
OF BOUCICAUT
French, op.c.1414
MASTER OF BOVINO
Italian, 17th cent.
MASTER OF THE BRACCIOLINI
CHAPEL
Italian, op.c.1390-1410
MASTER OF THE BRANDON
PORTRAITS
Netherlands,
op.c.1510-1540
MASTER OF THE BREMGARTEN
ALTAR
Swiss, op.c.1500-1530
MASTER OF THE BRERA PREDELLA
Italian, 15th cent.
MASTER OF BRIXEN WITH
THE SCORPION
German, 15th cent.
MASTER OF THE BROCADE
BACKGROUND
Netherlands(?), 15th cent.
MASTER OF THE BRUGES
PASSION SCENES
(Master of Bruges of
1500)
Netherlands, 16th cent.
MASTER OF BRUGES OF 1473
Netherlands, op.1473
MASTER OF BRUGES OF
1500
see Master of the Bruges
Passion Scenes
MASTER OF THE BRUNSWICK
DIPTYCH
Netherlands, 15th cent.
MASTER OF THE BRUNSWICK
MONOGRAM (Also identified
with Jan van Amstel or
Jan Sanders van
Hemessen)
Netherlands, 16th cent.
MASTER OF THE BRUTUS
FRESCOES
Italian, 15th cent.
MASTER OF THE BUCKINGHAM
PALACE MADONNA
Italian, 15th cent.
MASTER OF BUDAPEST
Spanish, 15th cent.

MASTER OF THE BUDÑANY
ALTARPIECE
Czech, op.c.1490-1500(?)
MASTER OF MILDRED COKE,
LADY BURGHLEY
British, op.1565
MASTER OF BURGOS
see Alonso de Sedano
MASTER OF THE BURNHAM
COLLECTION
Spanish, op.c.1425
MASTER OF THE BYZANTINE
MADONNA
German, op.c.1510-20
MASTER OF CABANYES
(Antonio Cabanyes or
Cavanyes ?)
Spanish, op.1507
MASTER OF THE CADOLZBURG
ALTAR
German, op.1417-1430
MASTER OF THE CADUCEUS
see Barbari, Jacopo
de'
MASTER OF CALVIA
Spanish, 16th cent.
MASTER OF THE CALZADA
RETABLE
Spanish, 15th cent.
MASTER OF CAMPODONICO
Italian, 14th cent.
MASTER OF THE CAMUZIO
CHAPEL
Italian, op.c.1520
MASTER OF CANAPOST
Spanish, 15th cent.
MASTER OF THE CANDLELIGHT
(Bigot, Théophile)
French, c.1600-p.1650
MASTER OF S. JOHN
CAPESTRANO
Italian, 15th cent.
MASTER OF CAPPENBERG
German, 16th cent.
MASTER OF THE CARDONA
PENTECOST
Spanish, 14th cent.
MASTER OF THE CARMINE
MADONNA
Italian, 13th cent.
MASTER OF THE CARNATION
(Berner Nelkenmeister)
(Master of the Berne
St. John Altar)
Swiss, op.1466-1499
MASTER OF THE SAGRA OF
CARPI
Italian, op.c.1437
MASTER OF THE CARRAND
TONDO
see Master of the Bargello
Tondo
MASTER OF THE CARRAND
TRIPTYCH
see Giovanni di Francesco
del Cervelliera
MASTER OF THE ČÁSLAV
PANEL
Czech, op.c.1530
MASTER OF THE CASSONI
Italian, 15th cent.
MASTER OF THE CASTELLARE
CRUCIFIX
Italian, 13th cent.
MASTER OF THE CASTELLI-
MIGNANELLI MADONNA
Italian, 15th cent.
MASTER OF THE CASTELLO
NATIVITY
Italian, 15th cent.

MASTER OF CASTELSARDO
Italian, 16th cent.
MASTER OF CASTELVETRANO
Italian, op.c.1448
MASTER OF THE ST.
CATHERINE CHAPEL
Italian, 14th/15th cent.
MASTER OF THE LEGEND
OF ST. CATHERINE
Netherlands, 15th cent.
MASTER OF THE CATHERINE
WHEEL (Monogrammist ie)
German, 15th cent.
MASTER OF THE RETABLE
OF THE CATHOLIC KINGS
Spanish, 15th cent.
MASTER OF S. CECILIA
Italian, 14th cent.
see also Buffalmacco
MASTER OF CELL 2
see Fra Angelico
MASTER OF CELL 36
see Fra Angelico
MASTER OF CENEDA
Italian, 15th cent.
MASTER OF THE CESPO DI
GAROFANO
Italian, 15th cent.
MASTER OF CHANTILLY
Italian, 14th cent.
MASTER OF CHARLES CIII
French, op.c.1495-1499
MASTER OF THE TRIUMPH
OF CHASTITY
see also Gherardo del Fora
Italian, 15th cent.
MASTER OF CHATSWORTH
Italian, 16th cent.
MASTER OF CHIANCIANO
Italian, 14th cent.
MASTER OF THE CHIOSTRO
DEGLI ARANCI
Italian, 15th cent.
MASTER OF THE BEAU
CHRIST
Norwegian, 13th cent.
MASTER OF THE CHRISTCHURCH
CORONATION
Italian, op.c.1350
MASTER OF CHUDĚNICE
ALTARPIECE
Czech, op.c.1510
MASTER OF THE CHUR HIGH
ALTAR
Swiss, op.c.1492
MASTER OF CIERVOLES
Spanish, op.c.1500
MASTER OF CITTÀ DI
CASTELLO
Italian, op.c.1315/20
MASTER OF THE ST. CLARA
ALTARPIECE
German, 14th cent.
MASTER OF ST. CLARE
Italian, op.c.1280
MASTER OF THE BLESSED
CLARE
Italian, op.c.1340-1345
MASTER OF ST. CLARE
OF MONTEFALCO, I
Italian, op.1333
MASTER OF ST. CLARE OF
MONTEFALCO, II
Italian, 14th cent.
MASTER OF THE CLUMSY
CHILDREN
see Poussin, Nicolas

MASTER OF CLUSONE
Italian, 16th cent.
MASTER OF THE COBURG
ROUNDELS
German, op.c.1485
MASTER OF THE CODEX
HUYGENS (Possibly
identified with
Aurelio Luini)
Italian, 16th cent.
MASTER OF COËTIVY
(Possibly identified
with Henri de Vulcop)
French, 15th cent.
MASTER OF COLOGNE
German, 15th cent.
MASTER OF THE COMMENTARIES
ON THE GALLIC WARS
French, 16th cent.
MASTER OF THE CONVENTO
DEL T.
see Niccolò di Tommaso
MASTER OF THE ST.
CORBINIAN ALTAR
German, 15th cent.
MASTER OF THE CORONATION
OF THE VIRGIN
Italian, op.1420
MASTER OF THE CORSI
CRUCIFIX
Italian, 14th cent.
MASTER OF THE CORSINI
ADULTERESS
see Tintoretto, J.
MASTER OF COTETA
(Master of Loteta)
Spanish, 15th cent.
MASTER OF THE CRAB
see Crabbe van
Espleghem, Frans
MASTER OF THE CRADLE
Italian, 15th cent.
MASTER OF THE
CRAILSHEIM ALTAR
German, op.c.1490-1500
MASTER OF THE
CRATEROGRAPHY
see Master of 1551
MASTER OF THE CRAWFORD
THEBAID
Italian, op.c.1450
MASTER OF THE LEGEND
OF S. CRISPIN
German, op.1510-1525
MASTER OF THE
CRIVELLESQUE POLYPTYCHS
Italian, op.c.1490
MASTER OF THE S. CROCE
TOURNAMENT
Italian, op.c.1439
MASTER OF THE CRUCIFIXION
Norwegian, 13th cent.
MASTER OF THE CRUCIFIXION
Triptych
German, 15th cent.
MASTER OF SANTA CRUZ
see Santa Cruz
MASTER OF CUENCA
Spanish, 16th cent.
MASTER OF THE CUEZA
PANELS (Master of
Cueza)
Spanish, 16th cent.
MASTER OF CURIEL
Spanish, 15th cent.
MASTER OF THE CURTAIN
(identified with
Larkin, William)
British, op.c.1610-1615

MASTER OF THE
CYPRESSES
Spanish, op.1434
MASTER OF THE DARMSTADT
CRUCIFIXION
(Master of the Middle
Rhine St. Barbara)
German, op.c.1430
MASTER OF THE DARMSTADT
PASSION
German, op.c.1430-1450
MASTER OF THE DEATH
OF THE VIRGIN
see Cleve, Joos van
MASTER OF THE DEIPARA
VIRGO OF ANTWERP
(Master of Segovia)
see Benson, Ambrosius
MASTER OF DELFT
Netherlands, op.c.1510
MASTER OF THE DEOKARUS
ALTAR
German, op.1437
MASTER WITH THE DICE
Italian, op.c.1532
MASTER OF DIDO
Italian, op.1445
MASTER OF THE DIE
(wrongly called
Beatricius)
German, op.1532
MASTER OF DIEGO
(Diego Master)
Spanish, op.1504
MASTER OF THE DIJON
TRIPTYCH
Italian, op.1280
MASTER OF THE ABBEY OF
DILIGHEM
see Master of 1518
MASTER OF THE DIOTALLEVI
MADONNA
Italian, op.c.1498
MASTER OF THE DOM ALTAR
German, 15th cent.
MASTER OF THE DOMINICAN
EFFIGIES
Italian, 14th cent.
MASTER OF THE DOMINICAN
LEGEND
German, op.c.1500
MASTER OF DORDRECHT
Dutch, 17th cent.
MASTER OF THE DORMAGEN
TRIPTYCH (Master of
the Holy Night in the
Dormagen Collection)
see Beer, Jan de
MASTER OF THE DORMITION
OF THE VIRGIN
Italian, 14th cent.
MASTER OF THE DORTMUND
ALTAR
see Master of the
Bielefeld Altar
MASTER OF THE
DRACKENSTEIN ALTAR
German, 15th cent.
MASTER OF THE DRAPERY
STUDIES
German, 15th cent.
MASTER OF THE DRESDEN
ADAM AND EVE
Netherlands, 15th cent.
MASTER OF THE DRESDEN
HOHENZOLLERN PORTRAITS
German, op.1578

MASTER OF THE DRESDEN
MADONNA
Netherlands, op.c.1500
MASTER OF THE DRESDEN
PRAYER BOOK
German, op.c.1470-1500
MASTER OF DUDERSTADT
see Master of Göttingen
MASTER OF THE 1520 COPIES
AFTER DÜRER
German, op.1520-1526
MASTER OF THE COPIES
OF DÜRER'S VIENNA
SKETCHBOOK
German, op.1503-1515
MASTER OF THE DURHAM
RETABLE
(Durham Master)
Spanish, 16th cent.
MASTER OF THE DUTNISCH
MOUNT OF OLIVES
Hungarian(?) 15th cent.
MASTER OF THE DUTUIT
PASSION
German, 15th cent.
MASTER OF THE DYING
CATO
see Stomer, Matthias
MASTER OF THE EAR IN THE
PARTED HAIR
see Master of Perea
MASTER OF THE EBOLI
CORONATION
Italian, 15th cent.
MASTER OF THE ECCE HOMO
Portuguese, 16th cent.(?)
MASTER OF THE ECIJA
RETABLE
(Master of Ecija)
Spanish, 16th cent.
MASTER OF EGEA
Spanish, 15th cent.
MASTER OF EGGENBURG
German, 15th cent.
MASTER OF THE EGMONT
ALBUMS
Netherlands, 16th cent.
MASTER OF THE ST.
ELISABETH PANELS
(Master of Rhenen)
Netherlands, op.c.1500
MASTER OF ELNE
see Gassies, Arnaldo
MASTER OF S. ELSINO
Italian, 14th cent.
MASTER OF THE
EMBROIDERED FOLIAGE
Netherlands, op.c.1500
MASTER OF THE
EMMINDINGEN ALTAR
German, op.c.1473
MASTER OF THE ENCARNACION
(Possibly identified
with Louis Alimbrot)
Netherlands(?), 15th cent.
MASTER OF THE ENFANTS
DE FRANCE
French, 16th cent.
MASTER OF THE ENGELBERG
ALTAR OF OUR LADY
Swiss, op.c.1475-1500
MASTER OF ENTRAGUES
French, 16th cent.
MASTER OF THE MARTYRDOM
OF ST. ERASMUS
(Heinrich Satrapitanus(?))
German, op.1516

MASTER OF THE ERFURT
REGLER ALTARPIECE
German, op.c.1440-1450
MASTER OF THE VOTIVE
PICTURE OF ERNEST THE
IRON
German, op.c.1420
(Possibly identified
with Hans von Judenborg,
also with Master of the
S. Lambert Altar, q.v.
also with Master of the
Linz Crucifixion, q.v.)
MASTER OF ESANATOGLIA
Italian, 14th cent.
MASTER OF THE
ESCURIALENSIS CODEX
Italian, op.1489-1493
MASTER 'ESIGUO'
(Alunno di Benozzo
or Amadeo da Pistoia)
Italian, op.c.1470-1490
MASTER OF ST. EUFEMIA
Italian, 15th cent.
MASTER OF THE PATIO DE .
LOS EVANGELISTAS AT
SANTIPONCE
Spanish, 15th cent.
MASTER OF THE EVORA
ALTARPIECE
Netherlands, 15th cent.
MASTER OF THE FABRIANO
ALTARPIECE
Italian, 14th cent.
MASTER OF FABRICZY
Netherlands, 16th cent.
MASTER OF THE FARM
LANDSCAPES
Flemish, op.1606-1610
MASTER OF THE FEISTEN
HANDRÜCKEN
German, 15th cent.
MASTER OF THE FEMALE
HALF-LENGTHS
Netherlands, 16th cent.
MASTER OF THE FERRARESE
ENTOMBMENT
Italian, 15th cent.
MASTER OF FERREIRIM
Portuguese, 15th cent.
MASTER OF THE ALTAR-
PIECE OF FRAY
BONIFACIO FERRER
Spanish, 14th cent.
MASTER OF THE FIESOLI
EPIPHANY
Italian, 15th cent.
MASTER OF THE FIESOLE
NATIVITY
Italian, op.c.1480-1491
MASTER OF THE FIGDOR
DEPOSITION (Master of
the Martyrdom of St.
Lucy or Master of the Page
beneath the Cross or
Pseudo-Geertgen)
Netherlands, 15th cent.
MASTER OF FIGLINE
see Master of the Fogg
Pietá
MASTER OF THE FITZWILLIAM
(Fitzwilliam Master)
British, op.c.1540-1545
MASTER OF FLEMALLE
(Master of Mérode; also
identified with Robert
Campin)
Netherlands,
1378/9(?)-1444(?)

MASTER CALLED, THE
FLEMISH EMIGRE
Netherlands, op.1592-1607
MASTER OF FLORA
French School,
op.1540-1556
MASTER OF THE ST.
FLORIAN CRUCIFIXION
TRIPTYCH
German, 15th cent.
MASTER OF FLORIDA
Spanish, 15th cent.
MASTER OF THE FOGG
MADONNA
Italian, 15th cent.
MASTER OF THE FOGG
PIETA (Master of
Figline)
Italian, 14th cent.
MASTER OF FORLÌ
Italian, op.c.1300
MASTER OF FOSSA
Italian, 14th cent.
MASTER OF FRACANZANI
Italian, op.1428-1450(?)
MASTER FRANCESCO
Italian, 14th cent.
MASTER OF ST. FRANCIS
Venezuelan, 18th cent.
MASTER OF THE CRUCIFIXES
OF ST. FRANCIS
Italian, 13th cent.
MASTER OF THE FRANCISCAN
HIGH ALTAR
see Master with the
Pink
MASTER OF SAN FRANCISCO
Spanish, 16th cent.
MASTER OF SAN FRANCISCO
OF EVORA
Portuguese, 15th cent.
MASTER OF FRANKFURT
Netherlands,
op.c.1490-1515
MASTER OF THE FRANKFURT
ALTAR
see Kaldenbach, Martin
MASTER OF THE FRANKFURT
SALOME
German, 18th cent.
MASTER OF THE HISTORY
OF FREDERICK AND
MAXIMILIAN
(Master of Pulkau)
German, op.1506-1525
MASTER OF THE FRIEDBERG
ALTAR
German, 14th cent.
MASTER OF THE FRIEDRICH
ALTAR OF 1447
German, op.c.1420-1450
MASTER OF FROMISTA
Spanish, 16th cent.
MASTER OF THE FRÖNDENBERG
ALTAR
German, 15th cent.
MASTER OF FUCECCHIO
Italian, 15th cent.
MASTER OF FUENTEOVEJUNA
Spanish, 15th cent.
MASTER OF GABARDA
Spanish, op.1527
MASTER OF S. GAGGIO
Italian, op.c.1300
MASTER OF GAMONAL
Spanish, op.c.1500

MASTER OF THE GANDRIA
ALTAR
Italian, op.c.1500
MASTER OF THE GARDENS
OF LOVE
German, op.c.1440-1450
MASTER OF THE GARDNER
ANNUNCIATION
Italian, op.c.1480
MASTER OF THE GAROFANI
see Master with the Pink
MASTER OF THE GATHERING
OF THE MANNA
Netherlands, 15th cent.
MASTER OF THE ST. GEORGE
ALTARPIECE
Czech, op.c.1470-1480
MASTER OF THE ST. GEORGE
CODEX
Italian, op.c.1330-1350
LOMBARD MASTER OF ST.
GEORGE
Italian, 15th cent.
MASTER OF THE GUILD OF
ST. GEORGE AT MALINES
Netherlands,
op.c.1490-1500
MASTER OF THE LEGEND OF
ST. GEORGE
German, op.1450-1465
MASTER OF THE MARTYRDOM
OF ST. GEORGE
German, 14th cent.
MASTER OF ST. GEORGE
(Spanish)
see Martorell, B.
MASTER OF GERIA
(Master of the Carnations)
Spanish, op.c.1450-1490
MASTER OF GERLAMOOS
German, op.1450-1495
MASTER OF GERONA
Spanish, 15th cent.
MASTER OF THE GIANTS
(possibly identified
with Jefferys, James)
British, op.1779
MASTER OF THE
GIESSMANNSDORF ALTAR
German, op.c.1500-1520
MASTER OF GIJSBRECHT
VAN BREDERODE (Master
Zeno and Master
Zenobius)
Netherlands,
op.c.1450-1470
MASTER OF THE GIL PICTURE
(sometimes identified
with the Master of
the Bambino Vispo)
Spanish, 15th cent.
MASTER OF ST. GILLES
French, op.c.1500
MASTER OF GIRARD
Spanish, 15th/16th cent.
MASTER OF THE GLASGOW
ADORATION
Spanish, op.1505-1520
MASTER OF THE
GLAUBENSARTIKEL
German, op.1485-1501
MASTER OF THE GLORIFICATION
OF THE VIRGIN (Master
of Lüttich)
German, op.1460-1490

MASTER OF THE ST.
GOARER ALTAR
German, 1480-1510
MASTER OF THE GOLDEN
GATE
Italian, 14th cent.
MASTER OF THE GOLDENEN
TAFEL
German, 15th cent.
MASTER OF GOODHART
(Goodhart Master)
Italian, op.c.1300
MASTER OF THE GOTHIC
BUILDINGS
Italian, 15th cent.
MASTER OF GÖTTINGEN
German, 15th cent.
MASTER OF THE GÖTTINGEN
CRUCIFIXION
see Giovanni Jacopo
da Castrocaro
MASTER OF THE GRAPE
see Weiner, Hans
MASTER OF THE GRAZ
DOMBILD
German, 15th cent.
MASTER OF THE CHAPEL
OF ST. GREGORY
Italian, op.1228
MASTER OF THE MASS OF
ST. GREGORY
(Hans Abel)
German, op.c.1523-1543
MASTER OF THE LÜBECK
MASS OF ST. GREGORY
see Johan van Collen
MASTER OF THE GRIGGS
CRUCIFIXION
see Toscani, Giovanni
MASTER OF THE GRIGGS
TONDO
Italian, 15th cent.
MASTER OF GRISELDA
Italian, 15th cent.
MASTER OF THE VON
GROOTE ADORATION
Netherlands, op.c.1510
MASTER OF GROSSGMAIN
German, op.1499
MASTER OF THE GUALDO
TADINO CRUCIFIX
Italian, op.c.1275
MASTER OF THE GUBBIO
CRUCIFIX
Italian, 14th cent.
MASTER OF THE VIEW OF
ST. GUDULE
Netherlands, 15th cent.
MASTER OF THE GUHRAU
PASSION
German, 16th cent.
MASTER GUIDO
French, 16th cent.
MASTER OF THE GUIMERA
(AND CERVERA)
(identified with Ramón
de Mur)
Spanish, op.c.1412-1419
MASTER OF GÜSTROW
Netherlands, op.c.1520
MASTER OF HACKAS
Norwegian, 13th cent.
MASTER OF THE HALEPAGEN
ALTAR
German, op.c.1490-1510
MASTER OF THE HALLEIN
ALTAR
German, op.1440

MASTER OF THE HALLER
ALTAR
German, op.c.1440
MASTER OF THE HANOVER
MARKTKIRCHEN ALTAR
German, 15th cent.
MASTER OF THE HAPSBURGS
German, op.c.1490-1520
MASTER OF THE HASENBURG
MISSAL
Czech, 15th cent.
MASTER OF THE HAUSER
EPITAPHS
German, op.1480
MASTER OF HEILIGENKREUZ
German, op.c.1395-1420
MASTER OF HEILIGENTAL
(Conrad von Vechta)
German, op.c.1450
MASTER OF THE HEILSBRONN
HIGH ALTAR
German, 15th/16th cent.
MASTER OF THE HEILSBRONN
PASSION ALTAR
German, op.c.1350
MASTER OF THE HEILSZYKLUS
German, 15th cent.
MASTER OF THE HEISTERBACH
ALTAR
German, op.c.1430
MASTER OF THE HELENTREUTER
ALTAR
German, op.1496
MASTER OF THE HELSINUS
LEGEND
Italian, op.c.1375
MASTER OF HERACLITUS
Norwegian, 13th cent.
MASTER OF THE HERMITAGE
SKETCHBOOK
Flemish, op.c.1600
MASTER OF THE
HERPINHANDSCHRIFT
German, op.c. 1480-1490
MASTER OF THE HERSBRUCK
HIGH ALTAR
(Perhaps identified
with Wolfgang Katzheimer)
German, 15th/16th cent.
MASTER OF HERZOGENBURG
German, op.1491-1495
MASTER OF THE HIGH ALTAR
(SALZBURG)
German, op.1515
MASTER OF THE HILDESHEIM
JOHANNES ALTAR
see Master of the
Aachener Schranktüren
MASTER OF THE HILDESHEIM
LEGEND OF THE MAGDALEN
German, 15th cent.
MASTER OF THE HILTPOLTSTEIN
ALTAR
German, op.c.1420
MASTER OF THE HOHENFURTH
PASSION-CYCLE
see Master of Visebrod
MASTER OF THE
HOHENLANDENBERG ALTAR
German, op.1524
MASTER OF THE
HOHENZOLLERN-SIGMARINGEN
MADONNA
Netherlands, 15th cent.
MASTER OF THE HOLY BLOOD
(Master of the Precious
Blood or Master of St.
Sang)
Netherlands, op.c.1520

MASTER OF THE HOLY
KINDRED
German, c.1450-c.1515
MASTER OF THE HOLY
MARTYRS
German, op.1495
MASTER OF THE HOLY
NIGHT IN THE DORMAGEN
COLLECTION
see under Master
of the Dormagen
Triptych
MASTER OF THE HOLZHAUSEN
FAMILY
see Faber, Conrad
MASTER OF HOOGSTRAETEN
Netherlands, op.c.1500
MASTER OF THE HORNE
TRIPTYCH
Italian, 14th cent.
MASTER OF THE HOUSE-
BOOK or Master of the
Amsterdam Cabinet
German, 1430/5-op.1480
MASTER OF HOVINGHAM
see Poussin, Nicholas
MASTER OF THE HRADEC
KRÁLOVÉ ALTARPIECE
Czech, op.c.1494
MASTER OF THE EXHUMATION
OF ST. HUBERT
Netherlands, 15th cent.
MASTER OF THE IDYLLS
Italian, 16th cent.
MASTER OF SAN ILDEFONSO
Spanish, op.c.1480
MASTER OF THE ILSUNG
MADONNA
German, op.c.1475-1500
MASTER OF THE IMHOFF
ALTAR
German, op.c.1418-1421
MASTER OF INCA
Spanish, 14th cent.
MASTER OF THE INNOCENTI
CORONATION
see Master of the Bargello
Tondo
MASTER OF THE INTERNATIONAL
GOTHIC
see British School
15th cent. and the
Master of Peñafiel
MASTER OF THE ISAAC
FRESCOES
Italian, 13th cent.
MASTER OF THE ISERLOHN
ALTAR
German, op.c.1450-1460
MASTER OF ST. JACOB
German, 16th cent.
MASTER OF ST. JACOB
IN BRNO
Czech, op.1420
MASTER OF THE HIGH ALTAR
OF ST. JACOB'S IN
NUREMBERG
German, op.1370-1380
MASTER OF S. JACOPO A
MUCIANO
Italian, op.c.1400
MASTER OF ST. JACQUES
Portuguese, 16th cent.
MASTER OF JANOSRETI
Hungarian, op.1465
MASTER OF THE JARVES
CASSONI
Italian, 15th cent.

MASTER OF JATIVA
Spanish, 15th cent.
MASTER OF ST. JEAN DE
LUZ
French, 15th cent.
MASTER OF JESUS IN
BETHANY (Master D.A.
with the Anchor)
Netherlands,
op.c.1465-1485
MASTER JOHN
British, 16th cent.
MASTER OF THE ST. JOHN
ALTARPIECE
(Possibly identified
with Hugo Jacobsz.)
Netherlands,
op.c.1480-1490
MASTER OF ST. JOHN THE
BAPTIST
German, op.1467
MASTER OF THE BEHEADING
OF ST. JOHN THE BAPTIST
Italian, op.1510-1520
MASTER OF THE BERNE
ST. JOHN ALTAR
see Master of the Carnation
MASTER OF THE FRANKFURT
ST. JOHN ALTARPIECE
Netherlands, 15th cent.
MASTER OF THE LIFE OF
ST. JOHN
Italian, 14th cent.
MASTER OF THE ROTTERDAM
ST. JOHN ON PATMOS
(Also identified
with Dieric Bouts, I,
possibly identified
with Master of the Legend
of St. Lucy)
Netherlands,
op.c.1450-1480
MASTER OF THE MARTYRDOM
OF THE TWO ST. JOHNS
Netherlands, op.c.1520
MASTER OF THE JOHNSON
NATIVITY
Italian, op.c.1450
MASTER OF THE JOHNSON
POLPTYCH
Italian, op.1345
MASTER OF THE JOSEPH
SEQUENCE
see Master of the Abbey
of Afflighem
MASTER OF JOYEUSE
French, 16th cent.
MASTER OF THE JUDGEMENT
OF SOLOMON
French, 17th cent.
MASTER OF THE KAHLENBERG
LEGEND
German, 15th cent.
MASTER OF THE KALVARIEN-
BERG
German, 15th cent.
MASTER OF THE KARLSRUHE
ADORATION
Italian, 15th cent.
MASTER OF THE KARLSRUHE
PASSION
German, 15th cent.
MASTER OF THE MADONNA
OF KARTHAUSEN
German, op.1500-1505
MASTER OF THE KEMPTEN
CRUCIFIXION
German, op.1460-1470

MASTER OF THE KHANENKO
ADORATION
Netherlands, 15th cent.
MASTER OF THE LEGEND
OF ST. KILIAN
German, op.1480-1490
MASTER OF KIRCHHEIM
German, op.c.1500
MASTER OF THE KLOSTERNEUBURG
ST. STEPHEN ALTAR
German, op.c.1450
MASTER OF THE KRAINBURG
ALTAR
German, op.c.1490-1520
MASTER OF THE
KRATEROGRAPHIE
see Master of 1551
MASTER OF THE KRESS
LANDSCAPES
Italian, 16th cent.
MASTER OF THE LAMBACH
PORTRAITS
German, 15th cent.
MASTER OF THE ST.
LAMBERT VOTIVE
ALTARPIECE
German, op.c.1420
(Possibly identified
with Master of the
Votive Picture of Ernest
the Iron, also with Master
of the Linz Crucifixion,
also with Hans von
Tübingen)
MASTER OF LANAJA
Spanish, 15th cent.
MASTER OF THE
LANCKORONSKI ANNUNCIATION
Italian, op.c.1445
MASTER OF THE LANDAUER
ALTAR
German, op.1475
MASTER OF THE LANDSBERG
NATIVITY
German, 15th cent.
MASTER OF THE SMALL
LANDSCAPES
Netherlands, 16th cent.
MASTER OF LANGA
Spanish, 15th cent.
MASTER OF THE LANTERN
see Master of the
Amsterdam Death of
the Virgin
MASTER OF THE LARGE
FIGURES
Spanish, 15th cent.
MASTER OF LA SISLA
Spanish, 16th cent.
MASTER OF THE LAST
JUDGMENT
Italian, op.c.1307-1310
MASTER OF THE LAST
SUPPERS
(Maître des Saintes
Cènes)
see Coecke van Aelst,
Pieter, I
MASTER OF LASTRA A
SIGNA
Italian, 13th cent.
MASTER OF THE LATHROP
TONDO
Italian, 15th/16th cent.
MASTER OF LAUFEN
German, 15th cent.
MASTER OF ST. LAWRENCE
German, op.c.1415-1430

MASTER OF ST. LAZARUS
Spanish, 16th cent.
MASTER OF THE LECURIEUX
COLLECTION
French, 16th cent.
MASTER OF THE LORD
LEE POLYPTYCH
see Master of the
Dominican Effigies
MASTER OF THE LEGEND
SCENES (VIENNESE)
German, 16th cent.
MASTER OF THE LEIPZIG
CABINET
see Ort, Aert van
MASTER OF ST. LEONARD
German, op.1460
MASTER OF THE SCHLOSS
LICHTENSTEIN
German, op.c.1450
MASTER OF THE
LIECHTENSTEIN ADORATION
see Goes, Hugo van der
MASTER OF THE LIECHTENSTEIN
ADORATION DRAWINGS
(The Anonymous
Liechtenstein Master)
Netherlands, op.c.1550
MASTER LIENHARD
German, op.c.1450
MASTER OF LIESBORN
German, op.1465
MASTER OF SAINT-
LIEVEN
Netherlands, 15th cent.
MASTER OF THE LIFE OF
THE VIRGIN
Norwegian, 13th cent.
MASTER OF THE LIFE OF
THE VIRGIN (Master
of Wilten, Johann van
Duyren)
German, op.c.1463-1480
MASTER OF THE LINDAU
LAMENTATION
German, 15th cent.
MASTER OF LINNICH
German, 16th cent.
MASTER OF THE LINZ
CRUCIFIXION
German, 15th cent.
(Possibly identified
with Master of the St.
Lambert Votive Altarpiece,
also with Hans von
Tübingen)
MASTER OF THE LIPPBORGER
PASSION
German, op.c.1470-1480
MASTER OF THE LITOMĚŘICE
ALTARPIECE
Czech, op.c.1500-1520(?)
MASTER OF THE LITTLE
PASSION
German, 15th cent.
MASTER OF THE LIVES
OF THE EMPERORS
Italian, 14th cent.
MASTER OF LLANES
Spanish, op.c.1538
MASTER OF THE LLUSANES
Spanish, 13th cent.
MASTER OF THE LORDS
OF LOBKOWITZ
German, 16th cent.
MASTER OF THE LÖFFELHOLZ
ALTAR
German, op.a.1453

MASTER OF THE LONDON
MADONNA
Italian, op.c.1320-1325
MASTER OF THE LONDONER
GNADENSTUHL
see Master of the St.
Lambert Votive Altar-
piece
MASTER OF THE S. LORENZO
MADONNA
Italian, 14th cent.
MASTER OF THE S. LORENZO
RETABLE
Italian, 15th cent.
MASTER OF THE ST. LOUIS
MADONNA
Italian, op.c.1480-1490
MASTER OF LOURINHA
Portuguese, 16th cent.
MASTER OF LOUVRE
see Braccesco, Carl
MASTER OF THE LOUVRE
ANNUNCIATION
Italian, 15th cent.
MASTER OF THE LOUVRE
LIFE OF THE VIRGIN
Italian, op.c.1450
MASTER OF THE LOUVRE
NATIVITY
Italian, 15th cent.
MASTER OF LÜBECK
(Lübecker Hauptmeister)
German, op.1435
MASTER OF S. LUCCHESE
Italian, 14th/15th cent.
LUCCHESE MASTER OF THE
IMMACULATE CONCEPTION
Italian, 15th cent.
MASTER OF THE LUCERNE
PIETÀ
Swiss, op.1511
MASTER OF LUCON
French, 15th cent.
MASTER OF THE LEGEND
OF ST. LUCY
Italian, 15th cent.
MASTER OF THE LEGEND
OF ST. LUCY
(Possibly identified
with Master of the
Rotterdam St. John on
Patmos)
Netherlands, op.1480
MASTER OF THE MARTYRDOM
OF ST. LUCY
see Master of the
Figdor Deposition
MASTER OF THE LUDLOW
ANNUNCIATION
Italian, 15th cent.
MASTER OF THE LUNA
ALTARPIECE (Master
of Luna)
Spanish, op.1488 or 1498
MASTER OF LUNEBOURG
German, op.c.1405
MASTER OF THE LUNETTE
OF 1349
Italian, op.1349
MASTER OF LÜTTICH
see Master of the
Glorification of the
Virgin
MASTER OF LUXEMBOURG-
MARTIGUES
French, 16th cent.

MASTER OF THE
LYVERSBERG PASSION
German, op.1463-1480
MASTER OF THE MADONNA
OF THE ABBOT VALENTIN
PIRER
German, 16th cent.
MASTER OF THE MADONNA
IN THE LEDERER
COLLECTION
Italian, 14th cent.
MASTER OF THE MADONNA
DELLA MISERICORDIA
Italian, 14th cent.
MASTER OF THE MADONNA
DEL POPOLO
Italian, 14th cent.
MASTER OF THE MADONNA
WITH THE SCALES
Italian, 15th cent.
MASTER OF THE MADONNA
IN THE STRAUS COLLECTION
see Master of the
Straus Madonna
MASTER OF THE MADONNAS
see Starnina
MASTER OF THE MADRE
DE DEUS RETABLE
Portuguese, 16th cent.
MASTER OF THE MAESTÀ
DELLA VOLTE
Italian, 14th cent.
MASTER OF THE MAGDALEN
Italian, 13th cent.
MASTER OF THE EGYPTIAN
MAGDALEN
see Master of the
Assumption of Mary
Magdalen
MASTER OF THE MAGDALEN
LEGEND
Netherlands, op.c.1500
MASTER OF THE MANSI
MAGDALEN
Netherlands,
op.c.1510-1525
MASTER OF THE ASSUMPTION
OF MARY MAGDALEN
Italian, 15th/16th cent.
MASTER OF ST. MAGDALENA
German, op.1456
MASTER OF THE MAIHINGEN
CRUCIFIXION
German, op.c.1466-c.1474
MASTER OF MAIL
German (?) 15th cent(?)
MASTER OF THE MAJESTY
Norwegian, 12th cent.
MASTER WITH THE MALTESE
CROSS
see Master W.S. with
the Maltese Cross
MASTER OF MAMBRILLAS
Spanish, 16th cent.
MASTER OF THE MANCHESTER
MADONNA
Italian, op.c.1500
MASTER OF THE MANTEGNA
PLAYING CARDS
Italian, c.1465
MASTER OF THE MANZANILLO
ENTOMBMENT
(Manzanillo Master)
Spanish, 15th cent.
MASTER OF THE DAN MARCIAL
ALTAR (Master of San
Marcial)
Spanish, 16th cent.(?)

MASTER OF S. MARIA
IN BORGO
Italian, op.c.1290
MASTER OF MARIA AM
GESTADE
German, op.c.1460
MASTER OF THE S. MARIA
NOVELLA CRUCIFIX
Italian, 14th cent.
MASTER OF S. MARIA
DELLA PETRELLA
Italian, 15th cent.
MASTER OF S. MARIA
IN PORTO FUORI
Italian, 14th cent.
MASTER (FROM MUNICH)
OF THE MARIENTAFELN
German, op.1450-1455
MASTER OF ST. MARK
(Ferrer, Bassa)
Spanish, 14th cent.
MASTER OF THE RETABLE
OF SS. MARK AND
CATHERINE
see A. Contreras
MASTER OF MARRADI
Italian, op.c.1480-1500
MASTER OF ST. MARTIN
WITH THE PALM
Italian, 14th cent.
MASTER OF THE MARTIN DE
TORRES FAMILY
(possibly identified
with Perez, Gonzalo)
Spanish, 15th cent.
MASTER OF MARTINEZ
(possibly identified
with Nicolás Falcó
the Elder)
Spanish, 16th cent.
MASTER OF THE S. MARTINO
MADONNA
Italian, op.c.1280
MASTER OF S. MARTINO A
MENSOLA
Italian, 14th cent.
MASTER OF THE MARTYRDOM
OF THE APOSTLES
German, op.c.1500.
MASTER OF THE MARTYRDOM
OF THE TEN THOUSAND
German, 15th cent.
MASTER OF THE MARTYROLOGY
German, op.c.1402-1419
MASTER OF THE MARY ALTAR
see Master of the Nuremberg
Altar
MASTER OF MARY OF
BURGUNDY (also
identified with Alexander
Bening)
Netherlands, op.c.1480
MASTER OF THE CORONATION
OF MARY OF LANDERON
Swiss, op.c.1490
MASTER OF THE LIFE OF
MARY
Italian, op.1409-1411
MASTER OF QUEEN MARY
TUDOR
French, 16th cent.
MASTER OF MASQUEFA
Spanish, 15th cent.
MASTER OF THE CAPPELLA
MEDICI POLYPTYCH
Italian, 14th cent.
MASTER OF THE MELZI
MADONNA
see Master of S.Torpé

MASTER OF THE MENDICIDAD
Spanish, 16th cent.
MASTER OF MERODE
see Master of Flémalle
MASTER OF MESSKIRCH
(Jerg Ziegler ? Marx
Weiss I ?)
German, 1500-1543(?)
MASTER MICHAEL
Czech, op.c.1502-1522
MASTER OF S. MICHELE
Italian, 13th cent.
MASTER OF MILA
Spanish, 16th cent.
MASTER OF THE MILAN
ADORATION
see Beer, Jan de
MASTER OF THE S.MINIATO
ALTARPIECE
Italian, op.c.1480
MASTER OF THE PORTRAITS
OF THE MINNEMA FAMILY
Netherlands, op.1532-1537
MASTER OF THE MIRACLES
Norwegian, 13th cent.
MASTER OF THE MIRACLES
OF THE APOSTLES
see Master of the
Apostle Miracles
MASTER OF THE MIRACLES
OF MARIAZELL
German, 16th cent.
MASTER OF THE MISERICORDIA
Italian, 14th cent.
MASTER OF MOGUER
Spanish, 16th cent.
MASTER OF THE MONASTERY
OF THE SEVEN ELECTORS
see Master of the
Amsterdam Death of the
Virgin
MASTER OF MONDSEE
German, 15th cent.
MASTER OF MONTAIONE
Italian, op.c.1275-1285
MASTER OF MONTALCINO
Italian, 14th cent.
MASTER OF MONTEFALCO
Italian, op.c.1400
MASTER OF THE MONTEFAL-
CO CRUCIFIX
Italian, 14th cent.
MASTER OF MONTEMARTELLO
Italian, 14th cent.
MASTER OF MONTE-
OLIVETO
Italian, 14th cent.
MASTER OF MONTEPIANO
Italian, 13th cent.
MASTER OF THE CABALLERO
DE MONTESA
Spanish, 15th cent.
MASTER OF MONTE SIEPI
Italian, 14th cent.
MASTER OF MONTESION
Spanish, op.c.1406
MASTER OF THE MORATA
RETABLE
(Morata Master)
Spanish, 15th cent.
MASTER OF THE MORITZKAPELLE
German, c.1400
MASTER OF THE MORNAUER
PORTRAIT
German, op.c.1480-1490
MASTER OF THE MORRISON
TRIPTYCH
Netherlands, op.c.1500

MASTER OF MOULINS
(Jean Hey ?)
French, op.c.1483-m.1529(?)
MASTER WITH THE MOUSE
TRAP (Also called
Master with the Rat
Trap)
Italian, 16th cent.
MASTER OF MÜHLDORF
German, op.1508
MASTER OF THE MUNICH
ADORATION
see Blesius, Pseudo
MASTER OF THE MUNICH
BETRAYAL (Master of
the Munich Taking of
Christ; also identified
with Dieric Bouts, I)
Netherlands,
op.c.1450-1480
MASTER OF THE MUNICH
CATHEDRAL CRUCIFIXION
German, op.c.1450-1455
MASTER OF THE MUNICH
ST. JOHN ON PATMOS
German, 15th cent.
MASTER OF THE MUNTADAS
COLLECTION
(Muntadas Master)
(Possibly identical
with Pedro Girard
op.1479-1490)
Spanish, 15th cent.
MASTER OF THE MUSCLES
Italian, 17th cent.
MASTER OF ST. NARCISSUS
Spanish, 15th cent.
MASTER OF THE NAUMBURG
MADONNA
Italian, 15th cent.
MASTER OF THE NEUSITZER
ALTAR
German, op.1515
MASTER OF NEUSTIFT
(Master of St. Augustine)
German, op.c.1460-1480
MASTER OF THE S. NICCOLÒ
ALTARPIECE
Italian, 14th cent.
MASTER OF ST. NICHOLAS
Spanish, 15th cent.
MASTER OF THE ENTHRONEMENT
OF ST. NICHOLAS
Netherlands, 16th cent.
MASTER OF THE ST.
NICHOLAS FRESCOES
see Stefano Fiorentino
MASTER OF S. NICOLA
Italian, 14th cent.
MASTER OF THE NOAH
PICTURES
Italian, 16th cent.
MASTER OF NÖRDLINGEN
German, op.1520
MASTER OF THE NOTHELFER
ALTAR
German, op.c.1429-1445
MASTER OF THE NUREMBERG
ALTAR
(Master of the Mary
Altar)
German, op.c.1440
MASTER OF THE NUREMBERG
PASSION
German, op.c.1450

MASTER OF THE OBERALTAICH
MAN OF SORROWS
German, op.c.1510-1520
MASTER OF THE OBERSTENFELD
ALTAR
German, op.1512
MASTER OF THE OBLATE
CRUCIFIX
Italian, op.1255-1260
MASTER OF THE OCCHI
AMMICCANTI
Italian, op.c.1450
MASTER OF THE OLD
TESTAMENT SERIES
German, 16th cent.
MASTER OF OLLERIA
Spanish, 15th cent.
MASTER OF OLMOS ALBOS
Spanish, 16th cent.
MASTER OF ST. OLOF
Norwegian, 13th cent.
MASTER OF OLOT
Spanish, op.c.1500
MASTER OF THE ORCAGNESQUE
MISERICORDIA
Italian, 14th cent.
MASTER OF THE ORIENTAL
SASH
Italian, 15th cent.
MASTER OF THE ORSOY
ALTARPIECE
Netherlands, op.c.1500
MASTER OF THE ORTENBERG
ALTAR
German, 15th cent.
MASTER OF OSLO
Spanish, op.c.1500
MASTER OF OSMA
Spanish, op.c.1500
MASTER OF THE OSSERVANZA
ALTAR
Italian, op.1436-1444
MASTER OF THE OTTAUER
ALTAR
German, c.1430
MASTER OF OULTREMONT
see Mostaert, Jan
MASTER OF THE OVILE
MADONNA
see Lorenzetti, Ugolino
MASTER OF THE OWL ON
THE STAFF
German, 16th cent.
MASTER PACULLY
Spanish, 15th cent.
MASTER OF THE PAGE
BENEATH THE CROSS
see Master of the
Figdor Deposition
MASTER OF THE PAHERIA
ALTARPIECE
(identified with
Ferrer, Jaime, II)
Spanish, 15th cent.
MASTER OF PALANQUINOS
Spanish, op.c.1500
MASTER OF LE PALAZZE
Italian, op.c.1300
MASTER OF THE TRIUMPH
OF DEATH AT PALERMO
Italian, 15th cent.
MASTER OF THE PALLANT
ALTAR
German, op.1429
MASTER OF PANZANO
Italian, 14th cent.

MASTER OF PARADISE
Portuguese, op.c.1525
MASTER OF THE PARADISE
GARDEN
German, op.c.1410
MASTER OF PAREDES
Spanish, 16th cent.
MASTER OF THE PAREMENT
DE NARBONNE
French, 14th cent.
MASTER OF PARIS or
Paris Master
Italian, op.1470
MASTER OF EL PARRAL
Spanish, 15th cent.
MASTER WITH THE PARROT
Netherlands, 16th cent.
MASTER OF THE PARRY
NATIVITY
Italian, 14th cent.
MASTER OF THE PASSION
OF THE CHURCH OF THE
AUGUSTINS
Polish, c.1470
MASTER OF THE SMALL
PASSION PANELS
German, 14th/15th cent.
MASTER OF THE PASSION
PANELS (TROPPAU)
German, 15th cent.
MASTER OF PATULLO
Italian, 15th cent.
MASTER OF ST. PAUL
Italian, 14th cent.
MASTER OF THE PEARL
OF BRABANT
(Also identified with
Dieric Bouts, I and
Dieric Bouts, II)
Netherlands,
op.c.1450-1480
MASTER OF PEDRALBES
Spanish, op.c.1460
MASTER OF PEDRET
Spanish, op.c. 1130
MASTER OF THE PEN
DRAWINGS
Swiss, op.1457-1483
MASTER OF PEÑAFIEL
Spanish, 15th cent.
MASTER OF THE PALAZZO
PENDAGLIA
Italian, 15th cent.
MASTER OF PERALTA
Spanish, 15th cent.
MASTER OF PEREA
(Master of the Ear in
the Parted Hair)
Spanish, 15th cent.
MASTER OF THE PERINGS-
DÖRFER ALTARPIECE
see Master of the
Augustine Altatpiece
MASTER OF ST. PETER
Norwegian, 13th cent.
MASTER OF ST. PETER
MARTYR
Italian, 15th cent.
MASTER OF ST. PETER
OF TAROUCA
Spanish, 16th cent.
MASTER OF PETRARCH
see Weiditz
MASTER OF THE PFLOCK
ALTAR
German, op.c.1520

MASTER OF THE
PFULLENDORFER ALTAR
German, op.1490-1500
MASTER OF THE CROSS
OF THE PIAZZA ARMERINA
Italian, op.1460-1480
MASTER OF THE PIETÀ
Italian, op.c.1350
MASTER OF THE
PIEDIGROTTO PIETÀ
Italian, 15th cent.
MASTER WITH THE PINK
Swiss, c.1480-c.1510
MASTER OF THE PINK AND
LAVENDER
see Master with the
Pink
MASTER OF THE PIRANO
ALTARPIECE
Italian, op.1349-1372
MASTER OF THE PITTI
'THREE AGES'
Italian, op.c.1510
MASTER OF THE PLAYING
CARDS
Swiss, 15th cent.
MASTER OF THE POLLINGER
TAFELN
see Angler, Gabriel
MASTER OF S. POLO IN
ROSSO
Italian, 14th cent.
MASTER OF THE POLYPTYCH
OF THE VIRGIN
Spanish, 15th cent.
MASTER OF PORTILLO
Spanish, 16th cent.
MASTER OF PORTIUNCULA
Spanish, 15th cent.
MASTER OF THE PORTRAITS
OF THE EXILES
German, op.1570-1577
MASTER OF THE PORTRAITS
OF PRINCES (Master
of the Royal Portraits)
Netherlands, op.c.1490
MASTER OF THE POTTENDORF
PANEL
German, 15th cent.
MASTER OF THE POZUELO
RETABLE
(Master of Pozuelo)
Spanish, 16th cent.
MASTER OF THE PRADO
REDEMPTION
see Stock, Vrancke
van der
MASTER OF THE PRAGUE
FOUNTAIN OF LIFE
Netherlands, 16th cent.
MASTER OF PRATO
Italian, 15th cent.
MASTER OF PRATOVECCHIO
Italian, 15th cent.
MASTER OF THE PRECIOUS
BLOOD
see Master of the Holy
Blood
MASTER OF THE PREDELLAS
Spanish, 15th cent.
MASTER OF THE PRELATE
MUR (possibly
identified with Giner,
Tomas)
Spanish, 15th cent.

MASTER OF THE
PRESENTATION (VIENNA)
German, op.c.1420-1430
MASTER OF S. PRIMERANA
Italian, op.c.1255-1265
MASTER OF THE PRIVILEGIOS
Spanish, op.1334
MASTER OF THE PRODIGAL
SON
(Possibly identified
with Lenaert Kroes as
the Monogrammist L.K.)
Netherlands, 16th cent.
MASTER OF THE PROVIDENCE
CRUCIFIXION
Netherlands,
op.c.1450-1460
MASTER OF THE PUIXMARIN
Spanish, 15th cent.
MASTER OF THE PULGAR
RETABLE
(Master of Pulgar)
Spanish, 16th cent.
MASTER OF PULKAU
see Master of the
History of Frederick
and Maximilian
MASTER OF THE QUARATA
PREDELLA
Italian, 15th cent.
MASTER OF THE S. QUIRICO
CRUCIFIX
Italian, 14th cent.
MASTER OF S. QUIRICUS
AND S. JULITTA
Italian, 15th cent.
MASTER OF ST. QUIRSE
(includes Master of
Riglos and Garcia de
Benabarre, Pedro)
Spanish, op.c.1450
MASTER OF ST. QUITERIA
Spanish, 15th cent.
MASTER OF RAIGERN
German, 15th cent.
MASTER WITH THE RAT
TRAP
see Master with the
Mouse Trap
MASTER OF THE RAUDNITZ
ALTARPIECE
German, 14th cent.
MASTER OF THE REBEL
ANGELS
Italian, 14th cent.
MASTER OF THE
REFLECTIONS
Italian, 18th cent.
MASTER OF THE REGEL
EPITAPH
German, op.1515
MASTER OF THE REGENS-
BURGER DOMHERRNSPORTRAT
see under Apt the
Younger
MASTER OF THE REGENT
MARIA
see Master of the
Statthalterin Maria
MASTER OF THE REHLINGEN
ALTARPIECE
see Apt the Younger,
Ulrich
MASTER OF THE
REICHENHALLER ALTAR
German, op.1521

MASTER OF S. REMIGIO
Italian, op.c.1360
MASTER OF KING RENE
French, op.1442-1457
MASTER OF THE
REPUDIATION OF HAGAR
Netherlands, 16th cent.
MASTER OF RETASCON
Spanish, 15th cent.
MASTER OF RHENEN
see Master of the St.
Elizabeth Panels
MASTER OF THE RHINE
(WINKLER)
German, c.1500
MASTER OF RIBEAUCOURT
Flemish, 17th cent.
MASTER OF THE RIDOTTO
Italian, 18th cent.
MASTER OF RIEUX-
CHATEAUNEUF
French, 16th cent.
MASTER OF RIGLOS
Spanish, op.1435-1460
MASTER OF THE RINUCCINI
ALTAR
see Giovanni del Biondo
MASTER OF THE RINUCCINI
CHAPEL
see also Giovanni da
Milano
Italian, 14th cent.
MASTER OF RIOFRIO
Spanish, 16th cent.
MASTER OF ROBREDO
Spanish, 15th cent.
MASTER OF ST. ROCH
Spanish, 16th cent(?)
MASTER OF THE ST. ROCH
ALTAR
German, op.c.1484
MASTER OF THE GRANDES
HEURES DE ROHAN
French, op.c.1420-1430
MASTER OF THE ROHRDORFER
ALTAR
German, op.1480-1485
MASTER OF THE LORDS OF
ROSENBERG
German, op.1589
MASTER OF THE ROSTOCK
ALTAR OF THE THREE KINGS
German, op.c.1440-1460
MASTER OF THE ROTTAL
MADONNA
German, op.1505-1515
MASTER OF THE ROTTERDAM
PORTRAITS
Dutch, 17th cent.
MASTER OF ROTTWEIL
German, op.c.1440
MASTER OF ROUSSILLON
(Master of the Rusinol
Collection)
Spanish, 15th cent.
MASTER OF THE ROYAL
PORTRAITS
see Master of the
Portraits of Princes
MASTER OF RUBIELOS
Spanish, op.c.1410
MASTER OF RUBIO
Spanish, 14th cent.
MASTER OF THE RUCELLAI
MADONNA
Italian, 13th cent.

MASTER OF THE RUCELLAI
POLYPTYCH
Italian, 15th cent.
MASTER OF THE RUSIÑOL
COLLECTION
see Master of Roussillon
MASTER OF THE SACHS
FRAGMENTS
Italian, 15th cent.
MASTER OF SAINTES
CENES
see Master of the
Last Suppers
MASTER OF THE SALEM
ALTARPIECE
German, 15th cent.
MASTER OF ST. SANG
see Master of the Holy
Blood
MASTER OF SANNAZZARO
Italian, 15th cent.
MASTER OF THE LIFE OF
SANTIAGO
Portuguese, 15th cent.
MASTER OF THE SANTOCANALE
BAPTISM
Italian, 15th cent.
MASTER OF SANTOS-O-NOVO
Portuguese, 16th cent.
MASTER OF SARDOAL
Portuguese, 16th cent.
MASTER OF THE SASSENBERG
ALTAR
German, op.1517
MASTER OF ST. SAUVEUR
Netherlands, 16th cent.
MASTER OF THE SCHERMBECKER
ALTAR
German, 16th cent.
MASTER OF THE SCHLÄGLER
PASSION
German, op.c.1435
MASTER OF THE SCHLICHTLING
BOTTICELLI
Italian, 15th cent.
MASTER OF SCHÖPPINGEN
German, op.c.1450-1475
MASTER OF THE SCHOTTEN
ALTAR I
German, 15th cent.
MASTER OF THE SCHOTTEN
ALTAR II
German, 15th cent.
MASTER SCHRECKENBERGER
German, 15th cent.
MASTER OF THE SCHRETLEN
PANELS
(Schretlen Master)
Spanish, 15th cent.
MASTER OF THE SCHWABACH
ALTAR
German, 16th cent.
MASTER OF THE SCORCHED
SKETCHBOOK
German, 15th cent.
MASTER OF THE SEBALD
EPITAPH
German, op.c.1438
MASTER OF ST. SEBASTIAN
Italian, 15th cent
MASTER OF ST. SEBASTIAN
(Josse Lieferinxe)
French, op.1493-1508
MASTER OF THE MAINE
LEGEND OF ST. SEBASTIAN
German, 15th cent.

MASTER OF SE DE VISEU
Portuguese, 16th cent.
MASTER OF SEGOVIA
see Master of the
Deipara Virgo of
Antwerp
MASTER OF THE SEITENSTETTEN
ST. STEPHEN
German, 15th cent.
MASTER OF THE SEITTENSTETTEN
VIRGIN
German, op.1518
MASTER OF THE SELF-
PORTRAITS
(Domenico da Venezia)
Italian, 16th cent.
MASTER OF THE SELIGENSTADT
ALTAR
German, 16th cent.
MASTER OF THE VON SEPP
SAINTS
German, 15th cent.
MASTER OF THE SERNAGIOTTO
CENACOLO
Italian, 16th cent.
MASTER OF SERUMIDO
Italian, 16th cent.
MASTER OF THE SETMANI
SACRA CONVERSAZIONE
Italian, op.c.1500
MASTER OF THE SEVEN
WORKS OF MERCY
see Master of Alkmaar
MASTER OF ST. SEVERIN
German, op.1485-1515
MASTER OF S. SEVERINO
Italian, 15th cent.
MASTER OF THE
SEYFRIEDSBERGER ALTAR
German, op.c.1520-22
MASTER OF THE SFORZA
BOOK OF HOURS
Italian, 15th cent.
MASTER OF THE PALA
SFORZESCA
Italian, op.c.1480-1520
MASTER OF THE SHERMAN
PREDELLA
Italian, op.c.1325-1350
MASTER OF THE SHUTTLE
see Zwott
MASTER OF THE SIEFERSHEIM
ALTAR
German, 15th cent.
MASTER OF THE SIERENZ
ALTAR
Swiss, op.c.1450
MASTER OF SIGENA
Spanish, 16th cent.
MASTER OF SIGMARINGEN
German, 16th cent.
MASTER OF ST.SIGMUND
German, 15th cent.
MASTER OF SIGÜENZA
Spanish, 15th cent
MASTER OF SIJENA
see Master of Sigena
MASTER OF THE SILVER
BIRCH
see Poussin, Gaspar
MASTER OF THE SILVER
CRUCIFIX
Italian, 14th cent.
MASTER OF THE APOSTLE
SIMON
German, 1515-1525
MASTER OF SINOBAS
Spanish, op.1503

MASTER OF THE SIRGA
RETABLE
(Sirga Master)
Spanish, 15th cent.
MASTER OF THE KING
SOLOMON TRIPTYCH
Netherlands, op.c.1525
MASTER OF THE SOLSONA
LAST SUPPER
see Master of Albatarrech
MASTER OF SORIGUEROLA
Spanish, 13th cent.
'MASTER OF THE SPANISH
PANELS'
Spanish, 19th cent.
MASTER OF SPES NOSTRA
Netherlands, op.c.1500
MASTER OF S. SPIRITO
Italian, 15th cent.
MASTER OF SQUAD A
Netherlands, op.1531
MASTER OF STAFFOLO
Italian, 15th cent.
MASTER OF THE STALBURG
PORTRAIT
German, op.1504
MASTER OF THE STAR
see Vellert, Dirk
MASTER OF THE
STATTHALTERIN MARIA
(Master of the Regent
Maria, or formerly,
Master of the Tired
Eyes; possibly
identified with William
Scrots)
Netherlands,
op.c.1530-1540
MASTER OF THE STAUFEN
ALTAR
see Master of the
Tennenbach Altar
MASTER OF THE STEFANESCHI
ALTAR
see Giotto
MASTER OF THE STEIR
CRUCIFIXION
German, 15th cent.
MASTER OF THE STERBINI
DIPTYCH
Italian, 14th cent.
MASTER OF THE STERZINGER
ALTARPIECE
German, op.c.1458
MASTER OF THE STOCKHOLM
MUSICIANS
Dutch, 17th cent.
MASTER OF THE STOCKHOLM
PIETA
Italian, 15th cent.
MASTER OF THE STOCKHOLM
WOLF HUBER COPIES
German, 17th cent.
MASTER OF THE STRACHE
ALTAR
German, 15th cent.
MASTER OF THE STRASSBURG
ADORATION
Italian, 15th cent.
MASTER OF STRATONICE
Italian, op.c.1475-1490
MASTER OF THE STRAUS
MADONNA (Offner)
Italian, 14th cent.
MASTER OF THE STRAUS
MADONNA (Weigelt)
Italian, 14th cent.

MASTER OF THE STUTTGART
SKETCH BOOK OF 1483
German, op.1483
MASTER OF THE SZEPESHELYER
ALTAR
Hungarian, 15th cent.
MASTER OF THE SZMRECSANY
ALTAR
Hungarian, op.1480
MASTER OF THE TARASCON
PIETÀ
French, 15th cent.
MASTER OF THE TEN
COMMANDMENTS
German(?), 14th cent(?)
MASTER OF THE TENNENBACH
ALTAR
(Master of the Staufen
Altar)
German, 15th cent.
MASTER OF TEPL
German, op.c.1440
MASTER OF THE TERENCE
ILLUSTRATIONS or
BERGMAN OFFICE
Swiss, op.1490-1494
MASTER OF TERENZANO
Italian, 13th cent.
MASTER OF ST. TERESA
DE JESUS
Venezuelan, 18th cent.
MASTER OF THE TERNI
DORMITION
Italian, op.c.1350
MASTER OF THE ARCHDUCHESS
OF TESCHEN
German, 16th cent.
MASTER OF THE THENN
PORTRAITS
German, op.1516
MASTER OF THE INCREDULITY
OF ST. Thomas
Italian, 16th cent.
MASTER OF THE LEGEND OF
ST. THOMAS
Italian, 15th cent.
MASTER OF THE TRIUMPH OF
ST. THOMAS
Italian, 14th cent.
MASTER OF THE THRONES
Italian, 14th cent.
MASTER OF THE TIBURTINE
SIBYL
Netherlands,
op.c.1480-1495
MASTER OF THE TIRED
EYES
see Master of the
Statthalterin Maria
MASTER OF TOBED
see Serra, Pedro
MASTER OF THE STORY OF
TOBIT
Netherlands,
op.c.1480-1490
MASTER OF EL TOCUYO
Venezuelan, op.c.1702
MASTER OF TORPE
Norwegian, op.c.1275
MASTER OF S. TORPE
Italian, 14th cent.
MASTER OF TORRALBA
Spanish, 15th cent.
MASTER OF EL TRANSITO
Spanish, 15th cent.
MASTER OF THE TRANSLATION
Italian, op.1225

MASTER OF THE TRAPANI
POLYPTYCH
Italian, 14th cent.
MASTER OF TREBON
see Master of Wittingau
MASTER OF THE LONDON
TRINITY
see Master of the St.
Lambert Votive Altarpiece
MASTER OF THE TROPPAU
PASSION PANELS
see Master of the Passion
Panels
MASTER OF THE TUCHER
ALTARPIECE
German, 15th cent.
MASTER OF THE TURIN
ADORATION
Netherlands, op.c.1490-1510
MASTER OF THE LEGEND OF
ST. ULRICH
German, op.1453-1455
MASTER OF THE UNIVERSITAS
AURIFICUM
Italian, 14th cent.
MASTER OF THE UNIVERSITY
ALTARPIECE
(Monogrammist L.S.)
German, op.1512-1540
MASTER OF THE URBINO
CORONATION
Italian, 14th cent.
MASTER OF URGEL
Spanish, 15th cent.
MASTER OF THE LEGEND OF
ST. URSULA
Netherlands,
op.c.1470-1500
MASTER OF THE LEGEND OF
ST. URSULA
German, op.c.1499-1501
MASTER OF THE UTRECHT
ADORATION
Netherlands,
op.c.1520-1530
MASTER OF UTRECHT
CATHEDRAL
Netherlands, 15th cent.
MASTER OF THE UTTENHEIMER
TAFEL
German, op.1460-1480
MASTER OF THE VALENCIA
ALTARPIECE
Spanish, op.c.1400
MASTER OF VALLADOLID
Spanish, op.1496-1497
MASTER OF VALLTARGA
Spanish, 13th cent.
MASTER OF THE VALOIS
REVELS
French (?) 16th cent.
MASTER OF THE BISHOP OF
VANNES
French, 16th cent.
MASTER OF VARLUNGO
Italian, op.c.1285-1310
MASTER OF THE VATICAN
FLAGELLATION
Italian, 15th cent.
MASTER OF THE VELBURG
HIGH ALTAR
German, 16th cent.
MASTER OF THE VENETIAN
SEMINARY PICTURE
Italian, 15th cent.

MASTER OF THE PALAZZO
VENEZIA MADONNA
Italian, c.1340-c.1370
MASTER OF S. VERDIANA
Italian, c.1380-c.1410
MASTER OF VERDU
(identified with Ferrer,
Jaime, II)
Spanish, 15th cent.
MASTER OF ST. VERONICA
(Master of the Munich
St. Veronica)
German, op.c.1410-1420
MASTER OF VERUCCHIO
Italian, 14th cent.
MASTER OF VESCOVADO
Italian, 15th cent.
MASTER OF VESCOVO
GERARDO BIANCHI
Italian, 14th cent.
MASTER OF VICCHIO DI
RIMAGGIO
Italian, op.c.1390
MASTER OF THE VICTORIA
AND ALBERT MUSEUM
DIABLERIE
Italian, 16th cent.
MASTER OF VIDRE
Spanish, 15th cent.
MASTER OF VIENNA
see Master of the
Presentation
MASTER OF THE VIENNA
ADORATION
German, op.c.1415-1430
MASTER OF THE VIENNA
MODEL BOOK
German, op.p.1400
MASTER OF VIENNA OF
1469
German, op.1469
MASTER OF THE VIENNESE
CRUCIFIXION
German, op.c.1440
MASTER OF VIGNOLA
Italian, 14th cent.
MASTER OF VILLALOBOS
Spanish, 15th cent.
MASTER OF VILLAMEDIANA
Spanish, 15th cent.
MASTER OF VILLARROYA
Spanish, 15th cent.
MASTER WITH THE VIOLET
see Leu the Elder,
Hans
MASTER OF THE VIRGIL
CODEX
Italian, 15th cent.
MASTER OF THE VIRGO
INTER VIRGINES
Netherlands,
op.c.1480-1495
MASTER OF VISEBROD
Czech, 14th cent.
MASTER OF THE VISITATION
Spanish, 15th cent.
MASTER OF THE VITA
FRIDERICI
see Master of the History
of Frederick and
Maximilian
MASTER OF THE ST. VITUS
LEGEND
Netherlands, 15th cent.
MASTER OF VYSSI' BROD
see Master of Visebrod

MASTER OF WALDERSBACH
IN AISACE
German, 15th cent.
MASTER OF THE WALLENSTADT
ALTAR
Swiss, op.c.1460
MASTER OF THE WALTERS
PANELS
Italian, op.c.1450
MASTER OF WARTBERG
German, 15th cent.
MASTER OF THE COUNTESS
OF WARWICK
British, op.1567-1569
MASTER OF THE WASHINGTON
CORONATION OF THE VIRGIN
Italian, 14th cent.
MASTER OF WASSERBURG
German, 15th cent.
MASTER OF THE WASSERVASS
CRUCIFIXION
German, 15th cent.
MASTER OF THE WELL OF LIFE
Czech, 16th cent.
MASTER OF THE WELTZER
PORTRAITS
see Maler, Hans
MASTER OF THE
WENZELSCHEIBE
German, op.c.1410
MASTER OF WERDEN
see Master of the Life
of the Virgin
MASTER OF THE WESTMINSTER
ALTARPIECE
French, op.c.1260
MASTER OF THE WIENER
NEUSTADT ALTAR
see Master of the
Friedrich Altar of 1447
MASTER OF THE WIESBADEN
VISITATION
Italian, 16th cent.
MASTER OF WILTEN
see Master of the Life
of the Virgin
MASTER OF THE WILTEN
APOSTLES ALTAR
German, op.1495(?)
MASTER OF THE WINDSOR
CALVARY
German, op.1533
MASTER OF THE WINKLER
EPITAPH
German, op.1477
MASTER OF THE WINTER
LANDSCAPES
see Lytens, Gysbrecht
MASTER OF WITTINGAU
Czech, 14th cent.
MASTER OF THE WOLFEGG
HOUSE-BOOK
see Master of the
House-Book
MASTER OF THE WOLFGANG
ALTARPIECE
German, 15th cent.
MASTER OF THE WOLFSKEHL
ALTAR
German, op.c.1494
MASTER OF THE WORCESTER
CARRYING OF THE CROSS
German, op.c.1425
MASTER OF THE WÖRLITZ
PORTRAIT CABINET
German, c.1590
MASTER OF THE WÜRZBURG
BATTLE
German, op.1514

MASTER OF THE S. ZAN
DEGOLA
Italian, 14th cent.
MASTER OF ZARA
Italian, 14th cent.
MASTER ZENO
see Master of Gijsbrecht
van Brederode
MASTER OF S. ZENO, I
Italian, op.c.1325-1350
MASTER OF S. ZENO, II
Italian, op.1354
MASTER ZENOBIUS
see Master of Gijsbrecht
van Brederode
MASTER OF THE ZNAIMER
ALTAR
German, 15th cent.
MASTER OF ZÜRICH
see Master of 1532
MASTER OF THE ZÜRICH
ADORATION
Swiss, op.c.1475-1500
MASTER OF THE ZWÖLFBOTEN
ALTAR
German, 15th cent.
MASTER 185
Italian, 15th cent.
MASTER OF 1310
Italian, op.1310
MASTER OF 1342
Spanish, op.1342
MASTER OF 1417
Italian, op.1417
MASTER OF 1419
Italian, op.1419
MASTER OF 1445
German, op.1445
MASTER OF 1451
French, op.1451
MASTER OF 1456
French, op.1456
MASTER OF 1462
German, op.1462
MASTER OF 1464
see Master of the
Banderoles
MASTER OF 1467
German, op.1467
MASTER OF 1473
German, op.1473
MASTER OF 1473
Italian
see Master of the Legend
of S. Bernardino
MASTER OF 1477
German, op.1470-1490
MASTER OF 1488
German, op.1488
MASTER OF 1489
German, op.1489
MASTER OF 1498
German, op.1498
MASTER OF 1499
Netherlands, op.1499
MASTER OF 1505
German, op.1505
MASTER OF 1515
Italian, op.1515-1520
MASTER OF 1515
Portuguese, op.1515
MASTER OF 1518
(Master of the Abbey
of Dilighem)
Netherlands, op.1518
MASTER OF 1527
Netherlands, op.1527

MASTER OF 1532
Swiss, op.1532
MASTER OF THE 1540's
Netherlands,
op.c.1540-1550
MASTER OF 1550
French, op.1550
MASTER OF 1551
(Master of the
Craterography)(possibly
identified with
Mathias Zündt)
German, op.1551
MASTER OF 1573
German (?) op.1573
MASTER OF 1581
German, op.1581
MASTERS, Elisabeth
Booth
American, op.c.1820-1830
MASTERS, T.
British, 19th cent.
MASUCCI or Massucci,
Agostino
Italian, c.1691-1758
MASUCCI, Lorenzo
Italian, op.1759-m.1785
MASURE, Jules
French, 1819-1910
MASUROVSKY, Gregory
American, 20th cent.
MATALONI, G. Mario
Italian, 19th cent.
MATANIA, Edoardo
Italian, 1847-1929
MATANIA, Fortunino
Italian, 1881-
MATARE, Ewald
German, 1887-
MATAS
Spanish, 16th cent.(?)
MATCHAM, Julia
British, 1933-
MATE, Andras
Hungarian, 20th cent.
MATEJKA, Peter
Czech, 1913-
MATEJKO, Jan or Johann
Polish, 1838-1893
MATEO
Hungarian, c.1450
MATEOS, Francisco
Spanish, 1896-
MATES, Juan
Spanish, op.1392-m.1431
MATET, Charles Paulin
Francois
French, 1791-1870
MATHAM, Adriaen
Dutch, c.1599-1660
MATHAM, Jacob
Dutch, 1571-1631
MATHAM, Theodor or
Dirck
Dutch, 1605/6-1676
MATHEI, Mathieu or
Mattei, Gabriel
German, op.1727-1739
MATHELIN
French, 20th cent.
MATHER, T.
French, op.1671
MATHES or Matthes,
Christian Gottfried
German, 1738-c.1805
MATHES, Matthes or
Matthias, Diedrich
Jacob Christian
German, 1780-1833

MATHES or Matthis,
Paul
German, op.c.1787
MATHEU, Matteus,
Matthus or Mattue,
Cornelis
Dutch, op.1637-1656
MATHEUS, Jan
see Matthysz.
MATHEUS, Jean
French, op.c.1619-1620
MATHEWS, Alfred Edward
American, 1831-1874
MATHEWS, Arthur Frank
American, 1860-1945
MATHEWS, Denis
British, 20th cent.
MATHEWS, John Chester
British, 19th cent.
MATHEWS, Niki
(de Saint-Phall)
French, 20th cent.
MATHEWS, W.
British, 19th cent.
MATHEWS, William
American, 1821-1905
MATHEY, Jacques
French, 1883-
MATHEY, Paul
French, 1844-
MATHIAS, Gabriel
British, op.1740(?)-m.1804
MATHIEU, Anna Rosina
see Lisziewska
MATHIEU, Antoine
French, c.1631-1673
MATHIEU, Auguste
French, 1810-1864
MATHIEU, Gabriel
see Mathei
MATHIEU, Georges
French, 1921-
MATHIEU, Jean-Adam
French, 1698-1753
MATHIEU, Lambert
Joseph
Belgian, 1804-1861
MATHIEU, Paul
Belgian, 1872-1932
MATHILDE, Karoline von
Bayern or Hesse
German, 1813-1863
MATHILDE, Princess
see Bonaparte
MATHISSEN, D.
Dutch, 19th cent.
MATHON, Emile-Louis
French, op.1868-1887
MATHYS, Jan
see Matthysz.
MATI, Francesco
Italian, op.1583-1588
MATIAS de Valencia,
Fray
see Chafrion, Lorenzo
MATIC, Dusan
Yugoslavian, 1898-
MATIGNON, Albert
French, 1869-
MATILLA, Segundo
Spanish, 1924-
MATISSE, Auguste Philippe
French, 1866-1931
MATISSE, Camille
French, 20th cent.
MATISSE, Henri
French, 1869-1954

MATJUSCHIN, Michail
Wasilewitsch
Russian, 1861-1934
MATON or Matton,
Bartholomäus
Dutch, c.1643/6-p.1682
MATOUT, Louis Nicolas
French, 1811-1888
MATSCH, Franz von
German, 1861-1942
MATSON, Henry E.
American, 1887-
MATSYS
see Massys
MATTE, Denys
Canadian, 1930-
MATTEI, Gabriel
see Mathei
MATTEI, Michele
Italian, 15th cent.
MATTEI, Pasquale
Italian, 1813-1879
MATTEINI, Teodoro
Italian, 1754-1831
MATTEIS, Paolo de'
Italian, 1662-1728
MATTENHEIMER, Andreas
Theodor (Theodor)
German, 1787-1856
MATTENHEIMER, V.
German(?), 19th cent.
MATTEO da Bologna
(Lambertini)
Italian, op.1400
MATTEO da Campli
Italian, 15th cent.
MATTEO di Giovanetto,
Gianetti or Giovanetti
da Viterbo
Italian, op.1343-1366
MATTEO di Giovanni di
Bartolo (Matteo da
Siena)
Italian, c.1430(?)-1495
MATTEO da Gualdo
(Matteo di Pietro di
Giovanni di ser
Bernardo)
Italian, c.1430/5-p.1503
MATTEO da Lecce
see Perez de Alesio
MATTEO di Pacino
Italian, op.1360-1374
MATTEO di Perruchio
Italian, op.1417-1422
MATTEO da Siena
Italian, 1533-1588
MATTEO de la Tarsia
Italian, op.1497
MATTEO da Terranuova
Italian, op.1507-1529
MATTER, G.
American, 19th cent.
MATTESON, Tompkins
Harrison
American, 1813-1884
MATTEUCCI, V.
Italian(?), 18th cent.
MATTEUS, Cornelis
see Matheu
MATTHAEY, Heinrich
see Matthäi
MATTHÄI, Johann
Friedrich (Friedrich)
German, 1777-1845

MATTHÄI or Matthaey,
Heinrich
German, 1808-1880
MATTHES, Christian
Gottfried
see Mathes
MATTHES, Ernst
German, 1878-1918
MATHEWS, Philip
British, 20th cent.
MATHEWS, William
British, 20th cent.
MATTHIES, Holgar
German, 20th cent.
MATTHIESEN, Oscar
Adam Otto
German, 1861-
MATTHIEU, Georg David
German, 1737-1778
MATTHIEU, Rosina
Christiana Ludovica
German, 1748-1795
MATTHIEU-PIERRE, G.
French, 20th cent.
MATTHISEN, Broder
(not Mathäus)
German, op.1637-m.1666
MATTHISON, William
British, op.1885-1924
MATTHU, Cornelis
see Matheu
MATTHYS, Matthysens or
Mattys, Abraham
Flemish, 1581-1649
MATTHYSZ., Matheus,
Mathys or Matthyssen,
Jan
Dutch, op.c.1657-1685
MATTIA, Alessandro
(Alessandro da
Farnese)
Italian, 1631-p.1679
MATTIOLI, Carlo
Italian, 1911-
MATTIOLI, Girolamo
Italian, -1602
MATTIOLI, Lodovico
Italian, 1662-1747
MATTIOLI, Ludovico di
Angelo
Italian, op.1481-1522
MATTIONI, Eszter
Hungarian, 1902-
MATTMÜLLER, Hansjörg
Swiss, 1923-
MATTON, Bartholomäus
see Maton
MATTONCINI
see Giovanni Jacopo
da Castrocaro
MATTSSON, Erkki
Finnish, 20th cent.
MATTUE, Cornelis
see Matheu
MATTYS, Abraham
see Matthys
MATURINO, B.C.
Italian, 1490-1528
MATUSCYNSKI
French, op.1890
MATVEEFF, Andrej
Merkuljewitsch
Russian, 1701-1739
MATVEEFF or Matwejeff,
Feodor Michailovitch
German, 1758-1826

MAUBERGE, Gossaert
or Gossart van
see Mabuse
MAUBERT, James
British, -1746
MAUCERT, A.
French, op.1784
MAUCH, Mauchius or
Moch, Daniel
German, 16th cent.
MAUCOURT, Charles
French, 1718-1768
MAUD, W.T.
British, 1865-1903
MAUFRA, Maxime Camille
Louis
French, 1861-1918
MAUGENDRE, François
Adolphe (Adolphe)
French, 1809-1895
MAUKE, Rudolf
German, 1924-
MAUKNER, Georg
German, 1812-1881
MAULBERTSCH, Malberz,
Maulbersch, Maulpertsch
etc., Anton Franz
German, 1724-1796
MAUND, Miss S.
British, 18th cent.(?)
MAUNDRELL, Charles
Gilder
British, 1860-c.1924
MAUNY, Jacques
French, 1893-
MAUPERCHE, Maupercher
or Montpercher, Henri
French, 1602-1686
MAUPERIN
French, 18th cent.
MAURA y Montaner or
Muntaner, Bartholome
Spanish, 1844-1926
MAURA y Montaner or
Muntaner, Francisco
Spanish, 1857-
MAURER
see also Murer
MAURER, Alfred Henry
American, 1868-1932
MAURER or Murer, Hans
Jacob (Jacob)
Swiss, 1737-1780
MAURER or Mauerer,
Hubert
German, 1738-1818
MAURER, Jakob
German, 1826-1887
MAURER, John
British(?), op.1713-1761
MAURER, Louis
American, 1832-1932
MAURIER, George Louis
Palmella Busson du
British, 1834-1896
MAURIN, Charles
French, 1854-1914
MAURIN, Nicolas
Eustache
French, 1799-1850
MAURIN, Pierre
French, -1816
MAURINO, Il
see Tesi, Mauro
Antonio

MAURITIO, Carlo
Italian, op.1793
MAURO, Alessandro
Italian, op.1711-1748
MAURO, Domenico
Italian, op.1685-1693
MAURO, Girolamo
Italian, op.1692-1719
MAURON
British, 18th cent.
MAUROY, F.
French, 16th cent.
MAURY, Francois
French, 1861-1933
MAURY, Georges
French, 1872-
MAUSONIO, Giovanni
Paolo
Italian, op.1599-1616
MAUSSON, Théodore Henri
French, 1850-
MAUSZ, Manfred
German, 20th cent.
MAUVE, Antonij (Anton)
Dutch, 1838-1888
MAUZAISSE, Jean Baptiste
French, 1784-1844
MAVERICK, Peter
American, 1780-1831
MAVERICK, Samuel
American, 1789-1845
MAVIGNIER, Almir da
Silva
Brazilian, 1925-
MAVLET, Victor
French, 1819-1886
MAVOR, O.H.
British, op.1914-1942
MAVROIDIS, Georges
Greek, 1913-
MAWIG
French, 19th cent.
MAWRODIEW, Zdrawko
Bulgarian, 20th cent.
MAX, Agostini
Italian, 20th cent.
MAX, Gabriel Cornelius
Ritter von
Czech, 1840-1915
MAX, Jacob
French, 20th cent.
MAX, Peter
British, 20th cent.
MAXEE, P.(?) van
Dutch, 17th cent.
MAX-EHRLER, Louise
German, 1850-
MAXENCE, Edgard
French, 1871-
MAXENCE, Jean
French, 1901-
MAXIMOFF, Wassilij
Maximowitsch
Russian, 1844-1911
MAXTED, M.
British(?), op.1752
MAXWELL, Charles
British, 20th cent.
MAXWELL, Donald
British, 1877-1936
MAXWELL, John
British, 1905-1962
MAXY, M.H.
Rumanian, 1895-
MAY, Edward Harrison
American, 1824-1887
MAY, Fred
British, 20th cent.

MAY, Georg Oswald
German, 1738-1816
MAY, Mabel Henrietta
Canadian, 1884-
MAY, James
British, op.1874
MAY, Philipp William
(Phil)
British, 1864-1903
MAY, Walter William
British, 1831-1896
MAYALL, J.
British, 19th cent.
MAYBANK, Thomas
British, 20th cent.
MAYBURGER, Josef
German, 1813-1908
MAYBURY
British, 18th cent.
MAYDELL, Ernst
Freiherr von
German, 1888-1961
MAYDELL, Friedrich
Ludwig von
German, 1795-1846
MAYE, H.
British, op.1848
MAYER
see also Meyer
MAYER or Mair, Anton
German, 1777-1852
MAYER, Arminius
British, c.1798-1847
MAYER, August Georg
German, 1834-1889
MAYER, Auguste Etienne
Francois
French, 1805-1890
MAYER, Carl
German, 1798-1868
MAYER, Constance
Marie Francoise
French, c.1775-1821
MAYER, Erich
South African, 1876-1960
MAYER, Harmen de
Dutch, 1624/5-p.1701
MAYER, Henri
French, 1844-1899
MAYER, Johann Nepomuk
German, 1805-1866
MAYER, Joseph
German, op.1834
MAYER, L.
French, 18th cent.
MAYER, Louis (Luigi)
German, 1791-1843
MAYER or Meyer,
Mathias Johannes
German, op.1723-m.1737
MAYER, Michael
British, 1932-
MAYER, O. van
German, op.1825
MAYER, Thaddäus Fr.
Czech, 1814-1856
MAYER-LAMARTINIERE,
Constance
see Mayer, Constance
MAYOR-MARTON, George
Hungarian, 1897-1960
MAYERSON, Anna
German, 20th cent.
MAYET
French, 19th cent.

MAYET, Dominique
French, 20th cent.
MAYHEW, George
British, 20th cent.
MAYHEW, Nathaniel
American, op.1823
MAYKING, P.W.
British, 19th cent.
MAYNARD, Alister
British, 1903-
MAYNARD, Thomas
British, op.1777-1812
MAYNER, Alejandro
Spanish, op.1527
MAYNO or Maino, Juan
Bautista
Spanish, 1578-1649
MAYOL, Martin,
II
Spanish, op.c.1346-1374
MAYOR
see also Major
MAYOR, P.
British, 20th cent.
MAYOR, William Frederick
British, 1866-1916
MAYORGA or Mayorca,
Cristobal de
Spanish, op.c.1511-m.1533
MAYR, Alexander
see Mair
MAYR, Heinrich von
German, 1806-1871
MAYR or Mair, Johann
Ulrich
German, c.1630-1704
MAYR, Peter
German, 1758-1836
MAYR, Susanna
German, c.1600-1674
MAYRAND, Pierre
French, 17th cent.
MAYR-CASTELLBELL,
Joseph
German, 1821-1893
MAYR-GRAETZ, Carl
German, 1850-1929
MAYRHOFER, Johann
Nepomuk
German, 1764-1832
MAYS, Paul
American, 1888-
MAZE, Paul
French, 1887-
MAZELL, Peter
British, op.1761-1797
MAZELLA, J.
French, 19th cent.
MAZER, Carl Peter
Swedish, 1807-1884
MAZEROLLE, Alexis
Joseph
French, 1826-1889
MAZEROLLES, Maisereulles,
Maserolles or Marolles,
Philippe de
French, op.1454-1479
MAZIERE, Simon
French, c.1649-1720
MAZO, Juan Bautista
Martinez del
Spanish, c.1612-1667
MAZONE, Massone or
Mazzone, Giovanni
Italian, c.1433-a.1512
MAZUR, Edward
Russian, 20th cent.

MAZURIER
see Le Masurier
MAZZA, Damiano
Italian, op.1573
MAZZA, Giuseppe
Italian, 1653-1741
MAZZA, Tommaso del
(or di Marco)
Italian, op.1375-1391
MAZZA, Ventura
see Mazzi
MAZZANTI or Mazzante,
Lodovico
Italian, 1679-1775
MAZZAROPPI, Marco
Italian, 1550-1620
MAZZI, Marzi or Mazza,
Ventura
Italian, c.1560-c.1621
MAZZI or Mazza, Vincenzo
Italian, op.1748-1790
MAZZOLA, Alessandro
Italian, 1547-1612
MAZZOLA or Mazolla,
Filippo
Italian, c.1460-1505
MAZZOLA, Francesco
see Parmigianino
MAZZOLA, Giuseppe
Italian, 1748-1838
MAZZOLA, Michele
Italian, c.1469-p.1529
MAZZOLA, Pier Ilario
Italian, c.1476-c.1545
MAZZOLA-BEDOLI,
Girolamo
Italian, c.1500-1569
MAZZOLI, Maurizio
Italian, 1938-
MAZZOLINI, Giovanni
Bernardo
see Azzolini
MAZZOLINI, S.
Italian, 19th cent.
MAZZOLINO, Mazzuoli
or Manzulin, Lodovico
Mazzuoli da Ferrara
Italian, c.1480-p.1530
MAZZONI, Cesare Giuseppe
Italian, 1678-1763
MAZZONI, Giulio
Italian, 1525(?)-1618(?)
MAZZONI, Sebastiano
Italian, -1683/5(?)
MAZZUCHELLI
see Morazzone, Pietro
Francesco, Il
MAZZUOLI da Ferrara
see Mazzolino
MAZZUOLI, Annibale
Italian, -1743
MAZZUOLI, Francesco
see Parmigianino
MAZZUOLI, Giuseppe
(Il Bastarolo)
Italian, c.1536-1589
MAZZUOLI, Tommaso d'
Antonio
see Maso da San Friano
MEACCI, Ricciardo
Italian, 1856-
MEAD, Dorothy
British, 20th cent.
MEADE, Arthur
British, 1863-p.1948
MEADOWS, Arthur Joseph
British, 1843-1907

MEADOWS, Edwin L.
British, op.1854-1872
MEADOWS, James Edwin
British, 1828-1888
MEADOWS, Joseph Kenny
British, 1790-1874
MEADOWS, W.
British, 20th cent.
MEADOWS, W.G.
British, op.1874
MEARNS, Lois M.
British, op.c.1864-1885
MEARS, George
British, op.1875
MEASE, J.
British, op.1790-1798
MEASHAM, Henry
British, 1844-1922
MEAULLE, Fortune Louis
French, 1844-
MEAUX, Le Gay de
French, op.1779
MEBEECQ or Mebeecq
Cruywagen, Cornelis
Dutch, 1661/2-1690
MECARINO or Mecuccio
see Beccafumi,
Domenico
MECHAU, Jakob Wilhelm
German, 1745-1808
MECHEL, Christian or
Chrétien von
Swiss, 1737-1817
MECHEL, Johann Jakob
von
Swiss, 1764-1816
MECHELAERE, Léon
Belgian, 1880-
MECHELN, Henricus van
see Broeck, Hendrick
van den
MECHLINGER, Caspar
see Meglinger
MECKENEM, Israhel van
German, op.1450-m.1503
MECKLENBURG, Ludwig
German, 1820-1882
MECKSEPER, Frederick
German, 20th cent.
MECZKVEW, Anton
Bulgarian, 20th cent.
MEDA, Giuseppe
Italian, op.1570-m.1599
MEDALLA, David
British, 20th cent.
MEDARD, Eugène
French, 1847-1887
MEDARD or Medar, J.J.
French, op.1769-1772
MEDEARIS, Roger
American, 20th cent.
MEDEK, Nikulas
Czech, 1926-
MEDICI, Leopoldo de'
Italian, 1617-1675
MEDINA, John
British, 1721-1796
MEDINA, Sir John
Baptist de
British, 1655/60-1710
MEDLAND, Lilian
British, 20th cent.
MEDLAND, Thomas
British, op.1808-1822
MEDLEY, Robert
British, 1905-
MEDLEY, Samuel
British, 1769-1857

MEDNIKOFF, Reuben
British, 1906-
MEDNYANSZKY, Baron
László (Ladislaus)
Hungarian, 1852-1919
MEDVECZKY, Jeno
Hungarian, 1902-
MEDVEY, August von
German, 1814-1870
MEE, Anne, (née
Foldsone)
British, 1760/75-1851
MEECLE, Hennequin de
see Broeck, Hendrick
van den
MEEGAN, W.
British, 19th cent.
MEEGEREN, Henricus
Antonius (Hans) van
Dutch, 1889-1947
MEEKER, Joseph Rusling
American, 1827-1889
MEEKS, Eugene
American, 1843-
MEELE, Mathäus de
see Mele
MEEN, Margaret
British, op.1775-1810
MEER
see also Vermeer
MEER, Barend van der
or Barend Vermeer
Dutch, 1659-c.1690/1702
MEER, Ch. van
Belgian, 19th cent.
MEER van Utrecht,
Johann or Jan van der
or Johann Vermeer
Dutch,
c.1640(?)-p.1691
MEER (van Haarlem),
Jan, II van der, or
Jan Vermeer
Dutch, 1628-1691
MEER (van Haarlem),
Jan, III van der, or
Jan Vermeer
Dutch, 1656-1705
MEERE or Meeren,
Gerard van der
see Meire
MEERHOUD or Meerhout,
Johan or Jan
Dutch, -1677
MEERMAN, Hendrik
Dutch, op.1633-1650
MEERMANN, Arnold
German, 1829-1908
MEERT, Meerte or
Merten, Peeter
Flemish, c.1620-1669
MEERTENS, Meerté or
Meerten, Abraham
Dutch, 1757-1823
MEES, Guy
Belgian, 1935-
MEESON, Dora
British, -1956
MEFFERDT, Pieter
Dutch, 17th cent.(?)
MEFFETTONE, S.
Italian, 20th cent.
MEGAN, Meganck or
Meganet, Renier
Flemish, 1637-1690
MEGARA, Meki
Moroccan, 1932-

MEGARD, Joseph
Swiss, 1850-
MEGE du Malmont, René
French, 1859-1911
MEGEN, Pieter Willem
Dutch, 1750-1785
MEGERT, Christian
Swiss, 1936-
MEGID, Abdel Mohamed
el Hanafy
North African
(Egyptian) 1919-
MEGLINGER, Maglinger
or Mechlinger,
Johann Caspar
(Caspar)
Swiss, 1595-c.1670
MEGLIO, Giacomo del
see Coppi
MEHES, Laszlo
Hungarian, 1944-
MEHEUX, John
British, 18th cent.
MEHKEK, Martin
Yugoslavian, 1936-
MEHOFFER, Joseph
Polish, 1869-1946
MEHRING, Howard
American, 20th cent.
MEHUS, Mehuys or Meus,
Lieven, Livio or Livius
Flemish, 1630-1691
MEI, Bernardino
Italian, c.1615-1676
MEICHSNER, Johann
Nepomuk Michael von
German, 1737-1814
MEID, Hans
German, 1883-1957
MEIDNER, Ludwig
German, 1884-1966
MEIER, Friedrich
German, -1814
MEIER, Jeremias
see Majer
MEIER, Melchior
Swiss, op.1582
MEIFREN y Roig,
Elíseo
Spanish, 1859-
MEIGHAN, Robert
British, op.1628
MEIGS, Walter
American, 1918
MEIL, Johann Heinrich, I
German, 1730-1820
MEIL, Johann Wilhelm, II
German, 1733-1805
MEILHON, François
French, op.1819
MEILIN, Monique
Belgian, 20th cent.
MEINEL, Edith
British, 20th cent.
MEINELT, Carl
German, op.c.1852-1886
MEINER
German(?), 18th cent.(?)
MEINZ II
German, 17th cent.
MEIRE, Meere or Meeren,
Gerard van der
Netherlands, op.1452-m.1512
MEIREN, Jan Baptist
van der
Flemish, 1664-c.1708
MEISEL, Ernst
German, 1838-1895

MEISNER, Jan
Czech, 20th cent.
MEISSER, Leonhard
Swiss, 1902-
MEISSL, August
German, 1867-
MEISSNER, Ernst
German, 1837-1902
MEISSNER, Gustav
German, 1830-
MEISSONIER, Jean
Charles (Charles)
French, 1848?/52-1917
MEISSONIER, Jean Louis
Ernest (Ernest)
French, 1815-1891
MEISSONIER, Juste
Aurèle
French, 1693/5-1750
MEISTER, Simon
German, 1796-1844
MEISTERMANN, Georg
German, 1911-
MEISTNER, G.
British(?), op.1862
MEIXNER, Franz Xaver
von
German, op.1809-1825
MEIXNER, Ludwig
German, 1828-1885
MELANI, Francesco
Italian, 1675-1742
MELANI, Giuseppe
Italian, 1673-1747
MELANZIO, Francesco
Italian, op.1487-m.a.1525
MELBY, W.
Danish, op.1874
MELBYE, Daniel Herman
Anton (Anton)
Danish, 1818-1875
MELBYE, Fritz Sigrid
Georg
Scandinavian, 1826-1896
MELBYE, Knud Frederik
Vilhelm Hannibal
(Vilhelm)
Danish, 1824-1882
MELCHAIR, John Baptist
see Malchair
MELCHERS, Julius Gari
(Gari)
American, 1860-1932
MELCHIOR, Johann Peter
German, 1742-1825
MELCHIOR, Johann
Wilhelm (Wilhelm)
German, 1817-1860
MELCHIORI or Melchiorri,
Giovanni Paolo
Italian, 1664-1745
MELCHIORRE d'Enrico
Italian, op.1596-1619
MELDER, Gerard
Dutch, 1693-1754
MELDOLLA, Andrea
see Schiavone
MELDRUM, Duncan Max
Australian, 1875-1955
MELE or Meele, Mathäs de
or du, or Mathäus Demele
or Dimele
Dutch, 1664-1714/24
MELEKHOV, Grigory
Russian, 20th cent.
MELENDEZ, Francisco
Antonio
Spanish, 1682-a.1752

MELENDEZ, Luis
Spanish, 1716-1780
MELENDEZ, Miguel Jacinto
Spanish, 1679-p.1731
MELGAR, Luis de
Spanish, 17th cent.
MELGAREJO, Juan Ruiz
Spanish, 1705-1723
MELHUISH, George
British, 1916-
MELIDA y Alinari,
Enrique
Spanish, 1834-1892
MELIN, John
Swedish, 20th cent.
MELIN, Joseph Urbain
French, 1814-1886
MELINGUE, Etienne
Lucien (Lucien)
French, 1841-1889
MELINGUE, Georges
Gaston Théodore
French, 1840-1914
MELIORE di Jacopo
Toscano di Greco
Italian, op.1239-m.c.1284
MELIORI
see Migliori
MELIS, Henricus
Joannes
Dutch, 1845-1923
MELISSI or Melisi,
Agostino
Italian, op.1631-1675
MELLA, Toni J.
French, 20th cent.
MELLAN, Claude
French, 1598-1688
MELLE
see Oldeboerrigter,
Melle Johannes
MELLER, Samuel
British, op.1702
MELLERY, Xavier
Belgian, 1845-1921
MELLI, Roberto
Italian, 1885-
MELIN, Mellini, Meslin,
Messin or Milin,
Charles (Charles de
Lorrain, Carlo di
Lorena or Carlo
Lorenese)
French, 1597-1649
MELLING, Anton Ignaz
German, 1763-1831
MELLING, Henry
British, 1829-1853
MELLING, Josef
German, 1724-1796
MELLIS, Margaret Nairne
British, op.c.1934-1938
MELLISH, Thomas
British, op.1761-1766
MELLON, Campbell A.
British, 1876-1955
MELLOR, Sir John
British, 19th cent.
MELLOR, William
British, 1851-1931
MELIJNER
see Müllener
MELONI or Melone,
Altobello
Italian, op.1497-1517
MELONI, Gino
Italian, 1905-

MELONI, Marco
Italian, op.1504-1537
MELOZZO da Forli
(not Marco)
Italian, 1438-1494
MELROSE, Andrew
American, 1826-1901
MELTAND
French, op.1540
MELTZER, C.
German, 19th cent.
MELVILLE, Arthur
British, 1855/8-1904
MELVILLE, Harden S.
British, op.1837-1879
MELVILLE, Henry
British, op.1826-1841
MELVILLE, John
British, 1902-
MELVILLE, William
British, 19th cent.
MELZEDE
French, 17th cent.
MELZI, Francesco
Italian, 1493-c.1570
MEMBERGER, Hans
Kaspar, I
Swiss, -1618
MEMBERGER, Philip, I
Swiss, -1573
MEMLINC or Memling,
Hans
Netherlands,
op.1465-m.1494
MEMMI da Siena, Lippo
(Filippo di Memmo)
Italian, op.1317-1347
MEMMO di Filipuccio
Italian, op.1294-1326
MENABUOI, Giusto di
Giovanni de'
(Giusto Fiorentino
or Padovano or Justus
of Padua)
Italian, op.1363-m.1393
MENAGEOT, Auguste
French, op.1744-1755
MENAGEOT, François-
Guillaume
French, 1744-1816
MENAGEOT, Robert
French, 1748-
MENARD, Marie Auguste
Emile René (René)
French, 1862-1930
MENASSIER
French, op.1596
MENCIA, A.G.
Italian(?), 19th cent.(?)
MENDELLI, A.
British, op.c.1841
MENDELSON, Marc
Belgian, 1915-
MENDELSSOHN-BARTHOLDY,
Felix
German, 1809-1847
MENDENHALL, Jack
American, 1937-
MENDENHALL, J.Z.
American, op.1850
MENDEZ, Leopoldo
Mexican, 1902-
MENDLICK, Oscar
Hungarian, 1871-
MENDOLA, Sharon
American, 1949-
MENDOZE
French, 18th cent.

MENDS, G.P.
American, 19th cent.
MENE I
French, 19th cent.
MENEELEY, Ed
British(?), 20th cent.
MENESCARDI or
Miniscardi, Giustino
Italian, op.1751-1765
MENESES, The Viscount
Portuguese, 19th cent.
MENESES OSORIO, Francisco
Spanish, op.1666-1680
MENG, Gustav von
Polish, 1865-1957
MENGARI, Carlo
Italian, op.1495-m.1530
MENGAUD, Lucien
French, 19th cent.
MENGAZZINO
see Santi, Domenico
MENGELBERG, Egidius
German, 1770-1849
MENGIN, Auguste Charles
French, 1853-1933
MENGOLD, Esther
Swiss, 1877-1954
MENGOZZI, Girolamo
see Mingozzi
MENGS, Anton Raphael
German, 1728-1779
MENGS, Ismael Israel
Danish, 1688-1764
MENGS, Theresa Concordia
(Maron)
German, 1725-1808
MENGUCCI, Giovanni
Francesco
Italian, op.c.1639
MENIA, Raffaele
see Minia
MENICHINO del Brizio
see Ambrogi, Domenico
MENINSKY, Bernard
British, 1891-1950
MENJAUD, Alexandre
French, 1773-1832
MENKEN, Johann
Heinrich
German, 1766-1839
MENKES, Zygmunt
Polish, 1896-
MENN, Barthélémy
Swiss, 1815-1893
MENNES, J.
American, op.1860
MENNET, Denise
Swiss, 20th cent.
MENNI, Paolo
Italian, 15th cent.
MENNITI, Mario
see Minniti
MENNIXHOVE, Jan
Baptiste
see Meunincxhove
MENORVAL, Eugène
French, 19th cent.
MENOZZI, G.
Italian, 18th cent.
MENPES, Mortimer
L.
British, 1860-1938
MENSAQUE, A.
Spanish, 19th cent.
MENSE, Carlo
German, 1886-1965
MENSES, Jan
Canadian, 20th cent.

MENSION, Cornelis
Jan
Dutch, 1882-1950
MENTEL, Mendel or
Mentdel, Johann
Czech, 17th cent.
MENTELER, Franz
Joseph
Swiss, 1777-1833
MENTESSI, Giuseppe
Italian, 1857-1931
MENTON, Frans
Dutch, c.1550-1615
MENTOR
French, 20th cent.
MENTZ, Albrecht
German, op.1479
MENUISIER, Jean-
Pierre
French, 1783-
MENZEL, Adolf Friedrich
Erdmann
German, 1815-1905
MENZIO, Francesco
Italian, 1899-
MENZLER, Wilhelm
German, 1846-
MENZOCCHI, Manzocchi
or Minzocchi,
Francesco
Italian, c.1502-1584
MEO da Siena
Italian, op.1319-1333
MEQUIGNON, Peter
British, 1768-1826
MERA, Pietro
(Il Fiammingo)
Flemish, op.c.1570-1611
MERANO, Francesco
(Il Paggio)
Italian, 1619-1657
MERANO, Giovanni
Battista
Italian, 1632-1698
MERCADE y Fábregas,
Benito
Spanish, 1831-1897
MERCADIER, Le Jeune
French, 18th cent.
MERCANTI
see Spolverini, Ilario
MERCAR, Antonio
Spanish, c.1788
MERCATI, Giovanni
Battista
Italian, 1600-p.1637
MERCER, Stanley
British, 20th cent.
MERCER, William
American, op.1773-1850
MERCEY, Frédéric
Bourgeois de
French, 1803-1860
MERCIE, Marius Jean
Antonin (Antonin)
French, 1845-1916
MERCIER, Charles
British, 1834-
MERCIER, Charles Jean
French, -1909
MERCIER, Charlotte
French, 1757-m.1762
MERCIER, Elise
(Elise Clippele)
Belgian, op.1834-1836
MERCIER, Jacques Le
see Lemercier

MERCIER, John
Colclough
British, op.1826-1849
MERCIER, Louise
French, 19th/20th cent.
MERCIER, Philippe
French, 1689-1760
MERCK, Jacob Fransz.
van der
Dutch, c.1610-1664
MERCK, Johannes
see Merken
MERCKELBACH or
Merkelbach, Pieter
Dutch, c.1633-1673
MER-DORP, F.W.
Dutch, op.1640
MEREDITH, John
Canadian, 1933-
MEREDITH, Louisa,
(née Twamley)
British, op.c.1833
MERELLE, Pierre, II
French, 1713-1782
MERELLE, Pierre
Paul, I
French, op.1751-1764
MERGOLO, Francesco
Saverio
Italian, 1746-1786
MERIAN, A.
Swiss, op.1828
MERIAN, Johann
Matthäus von
German, 1659-1716
MERIAN, Maria Sibylla
(Graff)
German, 1647-1717
MERIAN, Matthäus, I
Swiss, 1593-1650
MERIAN, Matthäus, II
Swiss, 1621-1687
MERICA, Petrus a, or
Petrus Mericinus
see Heyden, Pieter
van der
MERIDA, Carlos
Mexican, 1893-
MERIGLIANO, Giovanni
see Marigliano
MERIGOT, J.
French, op.1772-1791
MERILIANO, Giovanni
see Marigliano
MERIMEE, Anna M.
(née Moreau)
French, -1852
MERIMEE, Jean François
Léonor
French, 1757-1836
MERIMEE, Prosper
French, 1803-1870
MERIVELL
British, 16th cent.
MERKE, H.
Swiss, op.c.1800-1820
MERKEL, E.
German, 19th cent.
MERKEL, Georg
German, 1881-
MERKELBACH, Pieter
see Merckelbach
MERKEN, Merck or
Merkeln (?), Johannes
Dutch,
1725(?)-p.1785(?)

MERKER, Max
German, 1861-1928
MERLE, Hugués
French, 1823-1881
MERLEN, Abraham van
Flemish, 1579-1660
MERLEN, Jacques van
French, 18th cent.
MERLETTE, Charles
French, 1861-1899
MERLI, Alessandro
Italian, op.1590-1608
MERLI or Merlo,
Giovanni Antonio
Italian, op.1474-1488
MERLIANO, Giovanni
see Marigliano
MERLIN, Victor Louis
French, op.1859-m.1892
MERLINI, Orlando de'
Italian, op.1501-m.1510
MERLOT
French, op.1788-1793
MERLOT, Emile Justin
French, 1839-1900
MERMET, Peter
Swiss, op.1609
MERODAK-JEANNEAU,
Alexis
French, 1873-1919
MERODE, Carl von
German, 1853-1909
MEROLA, Mario Virgilio
Canadian, 1931-
MERRELL
British, 18th cent.
MERRETT, Susan
American, op.c.1845
MERRICK, Emily M.
British, 1842-
MERRILD, Knud
Danish, 1894-1954
MERRITT, Anna Massey
Lea
British, 1844-1930
MERRITT, Thomas Light
British, op.1847-m.1870
MERRY, Godfrey
British, op.c.1883-1915
MERSE, Paul Szinyei
see Szinyei
MERSON, Luc Olivier
French, 1846-1920
MERSSEMAN, Auguste
Joseph Marie de
Belgian, 1808-1880
MERTEN, Peeter
see Meert
MERTENS, Charles
Belgian, 1865-1919
MERTENS, Hans
German, 1906-1944
MERTENS, Jan
Netherlands,
op.1473-m.c.1509
MERTENS, Martins,
Mertensij or Mertois,
Jacob
Netherlands,
op.1577-m.1609
MERTENS, Stella
Belgian, 20th cent.
MERTENS, W.
Dutch, 17th cent.
MERTON, John Ralph
British, 1913-
MERTON, Owen
Australian, 1887-1930

MERTZ, Johannes Cornelius
Dutch, 1819-1891
MERVELDT, J.
German, 19th cent.
MERWART, Paul
Polish, 1855-1902
MERWE, Eben van der
South African, 20th cent.
MERY, Alfred Emile
French, 1824-1896
MERY, Charles Léon
French, 19th cent.
MERY, Paul Auguste
Léon
French, op.1878
MERYMAN, Richard
Summer
American, 1882-
MERYON, Charles
French, 1821-1868
MERZ, Jacob
Swiss, 1783-1807
MES, François-
Constant
French, -1905
MES, Isack de
Dutch, op.1637-1640
MESA, Alonso de
Spanish, 1628-1668
MESA, Juan de
Spanish, op.1596-1614
MESCHEDE, Christine
German, 20th cent.
MESDACH or Mesdag,
Salomon
Dutch, op.1617-1628
MESDAG, Hendrik Willem
Dutch, 1831-1915
MESDAG, Taco
Dutch, 1829-1902
MESENS, E.L.T.
Belgian, 1903-1971
MESEROLE, H.
French, 20th cent.
MESGRIGNY, Claude
Francois Auguste,
Marquise de
French, 1836-1884
MESKENAS, Vladas
Australian, 1916-
MESKER, Johannes
Jacobus (Jan)
Dutch, 1843-1890
MESKER, Theodorus
Ludovicus (Theo)
Dutch, 1853-1894
MESLE, Joseph Paul
French, 1855-1929
MESNIL, Louis Michel
see Dumesnil
MESPLES, Paul Eugène
French, 1849-
MESQUIDA, Guillermo
Spanish, 1675-1747
MESQUITA, Samuel
Jessurun de
see Jessurun de
Mesquita
MESSAGER, Jean
French, op.1615-m.1649
MESSAGIER, Jean
French, 1920
MESSASTRIS, Pier
Antonio
see Mezzastris
MESSELL, Oliver
British, 1905-

MESSER, David
German, 20th cent.
MESSERSCHMITT, Kus
Ferdinand
German, 1858-1915
MESSIN, Charles
see Melin
MESSINA
Italian, op.1953
MESSMAN, Carl Ludwig
Ferdinand
Danish, 1826-
MESSMER, Franz
German, 1728-1773
MESSYS
see Massys
MESTCHERIN, N.
Russian, 19th cent.
MESTRALLET, André
Louis
French, 1874-
MESTRE, Xavier de
French, 19th cent.
MESTROVIC, Ivan
Russian, 1883-
MESZAROS, Lajos
Hungarian, 1925-
MESZOLY, Géza
Hungarian, 1844-1887
METCALF, Eliab
American, 1785-1834
METCALF, Willard
Leroy
American, 1858-1925
METCALFE, R.
British, 19th cent.
METELLI
see also Mitelli
METELLI, Orneore
Italian, 1872-1938
METEYARD, Sidney
Harold
British, 1868-1947
METEYARD, Thomas
Buford
American, 1865-
METEZEAU, Marie
French, op.1636
METHFESSEL, Adolf
Swiss, 1836-1909
METHUEN, Paul Ayshford,
Lord
British, 1886-1974
METIVET, Lucien Marie
Francois
French, 1863-1930
METIVIER, Jean-Baptiste
French, 1781-1853
METLICOVICH, Leopoldo
Czech, 1868-1944
METSU, Metsue, Metzu
or Metzue, Gabriel
Dutch, 1629-1667
METSYS
see Massys
METTAY, Pierre Joseph
le
see Lemettay
METTENLEITER, Johan
Jakob
German, 1750-1825
METTIER, Hanspeter
Swiss, 1927-
METTLING, Louis
French, 1847-1904
METZ, Caroline
German, op.1775-1794

METZ, Conrad Martin
German, 1749-1827
METZ, Franz Hieronimus
Friedrich (Friedrich)
German, 1820-1901
METZ, Hans von
see Hans von Metz
METZ, Jeanne Françoise
de, (née Ridderbosch)
see Ridderbosch
METZ, Johann Martin
German, 1717-c.1790(?)
METZGER, Christoph
German, op.1653-1664
METZGER, Evelyn
American, 20th cent.
METZGER, L.
German, op.1801
METZINGER, Jean
French, 1883-1956
METZLER, Johann Jacob
German, 1804-1839
METZMACHER, Emile
Pierre
French, 19th cent.
METZU or Metzue,
Gabriel
see Metsu
MEUCCI, M.
Italian, op.1877
MEUCCI, Vincenzo
Italian, 1699-1766
MEULEMANS, Adriaan
Dutch, 1763-1835
MEULEN
see also Vermeulen
MEULEN, Adam Frans
van der
Flemish, 1632-1690
MEULEN, Edmond van der
Belgian, 1841-1905
MEULEN, Francois
Pieter ter
Dutch, 1843-1927
MEULEN, Pieter van der
Flemish, 1638-p.1670
MEULEN, Sieuwert van der
Dutch, op.1698-m.1730
MEULEN or Muelen,
Steven van der
Netherlands,
op.1543-1568
MEULENER, Meulenaer
or Molenaer, Pieter
Flemish, 1602-1654
MEUNIER, Madame
French, 19th cent.
MEUNIER, Constantin
Emile
Belgian, 1831-1905
MEUNIER, Georges
French, 1869-
MEUNIER, Georgette
Belgian, 1859-
MEUNIER, Henri Georges
Jean Isidore (Marc
Henry)
Belgian, 1873-1922
MEUNIER, Philippe
see Meusnier
MEUNIER, Pierre
see Monier
MEUNIER, Pierre Louis
French, op.1783-1810
MEUNIER, Suzanne
French, 20th cent.

MEUNINCXHOVE or
 Mennixhove, Jan
 Baptiste van
 Flemish, op.1638-m.1704
MEURANT, Emmanuel
 see Murant
MEURER, C.A.
 American, 19th cent.
MEURET, Francois
 French, 1800-1887
MEURON, Albert de
 Swiss, 1823-1897
MEURON, Emanuel
 see Murant
MEURON, Maximilien de
 Swiss, 1785-1868
MEURS, Jacob van
 Dutch, 1619/20-a.1680
MEUS, D.
 French(?), 18th cent.(?)
MEUS, Lieven
 see Mehus
MEUSNIER or Meunier,
 Philippe, I
 French, 1656-1734
MEUTELER, Kaspar
 Anton
 German(?), 1783-1837
MEUTTMAN, W.
 American, 20th cent.
MEUWLY, Raymond
 Swiss, 1920-
MEVIUS, Hermann
 German, 1820-1864
MEXICAN SCHOOL,
 Anonymous Painters
 of the (Artists born
 before 1789 are included
 in SPANISH SCHOOL)
MEXICO, Icaza
 Mexican, 20th cent.
MEY, Hieronymus de
 see My
MEYANDI, Giovanni
 Sebastiano
 Italian, op.1762-1794
MEYBODEN, Hans
 German, 1901-1965
MEYBURGH, Bartholomeus
 Dutch, c.1625/8-1708/9
MEYER
 French, 19th cent.
MEYER
 French, op.1903
MEYER von Meilen
 Swiss, 19th cent.
MEYER of Tubingen
 German, 18th cent.
MEIJER, Antonij
 Andreas de
 Dutch, 1806-
MEYER, August Eduard
 Nicolaus (Claus)
 German, 1856-1919
MEYER, Beatrice
 British, op.c.1880-1899
MEYER, Carl Theodor
 (Meyer-Basel)
 Swiss, 1860-1932
MEYER, Carl Vilhelm
 Danish, 1870-
MEIJER, Christiaen
 Dutch, op.c.1803-1808
MEYER, Christian or
 Christopher H.
 German, -1836
MEIJER, Christoffel
 Dutch, 1776-1813

MEYER, Conrad
 Swiss, 1618-1689
MEIJER, Cornelis
 Dutch, op.1683-1708
MEYER or Mayer, Daniel,
 II (Monogrammist D.M.)
 German, 1576-1630
MEYER, Dietrich or
 Theodor, I
 Swiss, 1572-1658
MEYER, Edgar
 German, 1853-1925
MEYER, Eduard Claus
 German, 1856-1919
MEYER, Elias
 Danish, 1763-1809
MEYER, Emile
 German, 1872-
MEYER, Ernst Ahron
 Danish, 1797-1861
MEYER, F.W.
 British, op.1869-1922
MEYER, Felix
 Swiss, 1653-1713
MEYER, Frederick
 John
 British, op.1826-1844
MEYER, G.
 French, 20th cent.
MEYER or Mayer, Georg
 Friedrich
 German, 1735-1779
MEYER, Hans
 German, 1846-1919
MEIJER or Meyer,
 Hendrik de
 Dutch, op.1637-1683
MEIJER, Hendrik
 Dutch, 1737-1793
MEYER, Henry Hoppner
 British, c.1783-1847
MEYER, Hermann
 Swiss, 1878-
MEIJER, J.J.
 Dutch(?), 18th cent.
MEYER or Meijer, Jan,
 II de
 Dutch, op.1717-1740
MEIJER, Jan
 Dutch, 1927-
MEYER, Jeremias
 see Majer
MEYER, Jobst
 German, 1940-
MEIJER, Johan Hendrik
 Louis (Louis)
 Dutch, 1809-1866
MEYER, Johann Crescenz
 German, 1735-1824
MEYER, Johann Friedrich
 German, 1728-c.1789
MEYER von Bremen,
 Johann Georg
 German, 1813-1886
MEYER, Johann Heinrich
 Swiss, 1760-1832
MEYER, Johann Jacob
 Swiss, 1574-1629
MEYER, Johann (Hans)
 Jakob
 Swiss, 1749-1829
MEYER, Johannes, I
 Swiss, 1614-1666
MEYER, Johannes, II
 Swiss, 1655-1712
MEYER, Julius
 German, 1833-
MEYER, Mathias Johannes
 see Mayer

MEYER, Otto
 German, 1839-
MEYER, Rudolph, I
 Swiss, 1605-1638
MEIJER, Salomon (Sal)
 Dutch, 1877-1965
MEYER, Thaddaus
 see Mayer
MEIJER, Thomas Johannes
 Cornelis Marinus Carel
 (Ton)
 Dutch, 1892-
MEYER-AMDEN, Otto
 Swiss, 1885-1933
MEYERHEIM, Eduard
 Franz (Franz)
 German, 1838-1880
MEYERHEIM, Friedrich
 Eduard
 German, 1808-1879
MEYERHEIM, Hermann
 German, 19th cent.
MEYERHEIM, Paul Friedrich
 German, 1842-1915
MEYERHEIM, Robert
 Gustav
 German, c.1847-1920
MEYERHEIM, Wilhelm
 Alexander
 German, 1815-1882
MEYERING or Meyeringh,
 Albert
 Dutch, 1645-1714
MEYER-LAN
 French, 20th cent.
MEYER-MAINZ, Paul
 German, 1864-1909
MEYERN
 British(?), op.1649
MEYEROWITZ, William
 Russian, 1887-
MEYER-RHODIUS, Wilhelm
 Emile
 German, 1815-1897
MEYERS, Isidore
 Belgian, 1836-1917
MEYERS, William H.
 American, op.1847/8
MEYERSON, Vera
 French, 20th cent.
MEYER-WALDECK, Kunz
 German, 1859-p.1894
MEYER-WISMAR, Ferdinand
 German, 1833-1917
MEYHOFER, Elisabeth
 German, 1875-
MEYLAN, Paul J.
 American, 20th cent.
MEYLAN, Paul Jules
 Swiss, 1882-
MEYNER, J.F.
 German, op.c.1780
MEYNIER, Charles
 French, 1768-1832
MEYNIER, Jules Joseph
 French, 1826-p.1903
MEYNIER-SAINT-FAL,
 Louis Auguste
 Belgian, 1782-p.1840
MEYRICH, Sir S. Rush
 British, 19th cent.
MEYRSON, Anna
 German, 20th cent.
MEYS, Ferdinand de
 French, op.1790-1805
MEIJS or Meys, L.J.W.
 Dutch, 18th/19th cent.

MEYS, Marcel
 French, op.1880-1901
MEYSL, J.
 German, op.1767-1788
MEYSSENS, Joannes
 Flemish, 1612-1670
MEYTENS, Martin
 see Mytens
MEZA, Guillermo
 Mexican, 1917-
MEZASTRIS, Bernardino
 see Mezzastris
MEZEY, Jozef
 Hungarian, 1823-1882
MEZQUITA, Lopez Maria
 José
 Spanish, 1883-
MEZZASTRIS or Mezastris,
 Bernardino
 Italian, op.1507-1533
MEZZASTRIS, Mesastris,
 Mezastris or Mezzastri,
 Pierantonio (Pierantonio
 da Foligno)
 Italian, c.1430-1506
MICHAEL, A.C.
 British, op.1905-1909
MICHAEL, Johann Jonas
 German, op.1736-m.1791
MICHAEL, Max
 (Mayer Isaac)
 German, 1823-1891
MICHAEL, Moritz
 German, 1790-1849
MICHAELEDES, Michael
 British, 1925-
MICHAELIS, Gerrit Jan
 Dutch, 1775-1857
MICHAELIS, Paul
 German, 1914-
MICHAELSEN, Johan Carl
 Christian
 Norwegian, op.1770-1805
MICHAILOFF, Pavel
 Nikolejewitsch
 Russian, 1786-1840
MICHAILOW, Nikola
 Bulgarian, 1876-
MICHALAK, Antoni
 Polish, 1902-
MICHALITSCHKE, Emma
 German, 1864-1925
MICHALLON, Achille
 Etna
 French, 1796-1822
MICHALOFF, Léon
 French, 18th cent.
MICHALOWSKI, Piotr
 Polish, 1801-1855
MICHAU, Theobald
 Flemish, 1676-1765
MICHAUD, Hippolyte
 French, 1813-1886
MICHAULT, Germain
 (Ant. Victor)
 French, c.1752-1810
MICHAUX, Henri
 French, 1899-
MICHEL de Toulon
 French, op.1777
MICHEL, Andrée
 French, op.1966-1970
MICHEL, Charles
 Belgian, 1874-
MICHEL, Charles Henri
 Hilaire
 French, 1817-1905
MICHEL, Emile François
 French, 1828-1909

MICHEL, Ernest
Barthélemy
French, 1833-1902
MICHEL, G.
French, op.1712
MICHEL, Georges
French, 1763-1843
MICHEL, Jean
French, 1659-1709
MICHEL, Jean Baptiste
French, 1748-1804
MICHEL, Louis
see Michielsen
MICHEL, René
Swiss, 20th cent.
MICHEL, Robert
German, 1897-
MICHELA
Italian, op.1740
MICHELACCI, Luigi
Italian, 1879-
MICHELANGELO delle
Battaglie or delle
Bambocciati
see Cerquozzi
MICHELANGELO Buonarroti
(Michelagniolo di
Lodovico de Lionardo
di Buonarroto Simoni)
Italian, 1475-1564
MICHELANGELO da Siena
or da Lucca
see Anselmi
MICHELANGIOLO da Todi
see Ricciolini,
Michelangiolo
MICHELE
Italian, 18th cent.
MICHELE
see Mihai
MICHELE di Angelo da
Perugia
Italian, 15th cent.
MICHELE di Giovanni
da Fiesole
Italian, 15th cent.(?)
MICHELE di Matteo da
Bologna (Lambertini)
Italian, op.1416-1448
MICHELE di Matteo da
Modena or da Panzano
Italian, op.1440-1469
MICHELE di Ridolfo
see Tosini
MICHELE da Verona
Italian, c.1470-1536/44
MICHELE Ongaro
(Pannonio)
Hungarian, op.1415-m.a.1464
MICHELENA, Arturo
Venezuelan, 1868-1898
MICHELETTI, Marie
Italian, 20th cent.
MICHEL-HENRY
French, 20th cent.
MICHELI, M.
Italian, 19th cent.
MICHELI or Michieli,
Parrasio
Italian, a.1516-1578
MICHELIN, Jean
French, c.1623-1696
MICHELINI
Italian, op.c.1717
MICHELINO, Domenico di
see Domenico

MICHELL, M.
British, 18th cent.
MICHELLE
French, 18th cent.
MICHELSON, Leo
American, 1887-
MICHETTI, Francesco
Paolo
Italian, 1851-1929
MICHETTI, Niccolò
Italian, op.1718-m.1759
MICHEUX, Michel
Nicolas
French, 1688-1733
MICHIE, David Alan
Redpath
British, 1928-
MICHIE, James Coutts
British, 1861-1919
MICHIEL, Master
see Sittow
MICHIELI, Andrea
(Vicentino)
Italian, 1539(?)-1614
MICHIELI, Parrasio
see Micheli
MICHIELSEN or Michel,
Louis
Dutch, op.1672-1675
MICHON, Antoine
French, op.1771-m.1827
MICHONZE, Gregoire
(Michonznik)
Russian, 1902-
MICHOTTE, Jo
American, 19th cent.
MICKER, Jan
Christiaensz.
Dutch, c.1598-1664
MICONE, Niccolò
(Il Zoppo)
Italian, 1650-1730
MIDDIMAN, Samuel
British, c.1750-1831
MIDDLEDITCH, Edward C.
British, 1923-
MIDDLETON, Charles
British, op.1779-m.c.1818
MIDDLETON, Colin
British, 1910-
MIDDLETON, Horace
British, 20th cent.
MIDDLETON, James
Godsell
British, op.1827-1872
MIDDLETON, James
Raeburn
British, 1855-
MIDDLETON, John
British, 1826-1856
MIDDLETON, Stanley
American, 1852-1942
MIDDLETON, Thomas
American, 1797-1863
MIDLANE, Brian
British, 1917-
MIDWOOD, J.
British, op.1860-1880
MIDWOOD, Malcolm
British, 1887-1954
MIDWOOD, W.H.
British, op.1871
MIDY, Emmanuel Adolphe
(Adolphe), I
French, 1797-1874

MIDY, Théophile
Adolphe
French, 1821-
MIEG, Jean
German, 1791-1862
MIEL, Jan (Jan Bicke
or Bike, or
Cavaliere Giovanni
Miele, Milo or della
Vita)
Flemish, 1599-1663
MIELICH, Alfons
Leopold
German, 1863-1929
MIELICH, Hans
see Muelich
MIEREVELD, Miereveldt
or Mierevelt, Michiel
Jansz. van
Dutch, 1567-1641
MIEREVELD or Mierevelt,
Peter van
Dutch, 1596-1623
MIERHOP, Frans van
Cuyck de
see Cuyck
MIERIS, Frans, I Jansz.
van
Dutch, 1635-1681
MIERIS, Frans, II van
Dutch, 1689-1763
MIERIS, Jan van
Dutch, 1660-1690
MIERIS, Willem van
Dutch, 1662-1747
MIEROP, Frans van
Cuyck de
see Cuyck
MIETSCH, Christian
Gottlieb
German, 1742-1799
MIFELEW, Chananel
(Chan Canasta)
American, 20th cent.
MIGER, Simon Charles
French, 1736-1820
MIGLIARA, Giovanni
Italian, 1785-1837
MIGLIARO, Vincenzo
Italian, 1858-
MIGLIORI or Meliori,
Francesco
Italian, 1684-1734
MIGLO SCANIA or Scania
Miglio, G.
Italian, 16th cent.
MIGNARD d'Avignon,
Nicolas
French, 1606-1668
MIGNARD, Paul
French, 1639-1691
MIGNARD le Romain,
Pierre, I
French, 1612-1695
MIGNARD, Pierre, II
French, 1640-1725
MIGNECO, Giuseppe
Italian, 1908-
MIGNON, Abraham
German, 1640-1679
MIGNON, Jean
French, op.1537-1540
MIGNON, Lucien
French, 1865-1944
MIGNOT, Daniel
French, op.1593/6-1616

MIGNOT, Louis Henry
(Remy)
American, 1831-1870
MIGONNEY, Jules
French, 1876-1929
MIGUEL del Prado
Spanish, op.c.1519
MIHAI or Michele
Rumanian, 17th cent.(?)
MIHAILOVITCH, Milorad
Batta
Yugoslavian, 1923-
MIHALIK, Dániel
Hungarian, 1869-1910
MIHELIC, France
Yugoslav, 1907-
MIHO, Tomoko
American, 20th cent.
MIKL, Josef
Austrian, 1929-
MIKLOS, Gustave
Hungarian, 1888-
MIKLOSSY, Gavril
Roumanian, 1912-
MIKULA, Kurt
German, 1928-
MILAN, Pierre
French, c.1500-1557
MILANESE, Il
see Cittadini,
Pier Francesco
MILANESE SCHOOL,
Anonymous Painters
of the
see also Lombard
School
MILANI, Aureliano
Italian, 1675-1749
MILANI, Giuseppe
Italian, 1716-1798
MILANI, Umberto
Italian, 1912-
MILATZ, Franciscus
Andreas
Dutch, 1764-1808
MILBANKE, Mark Richard
British, 1875-1927
MILBERT, Jacques
Gérard
French, 1766-1840
MILBOURNE, C.
British, op.1790-1840
MILBOURNE, Henry
British, op.1797-1848
MILCENDEAU, Charles
Edmond Théodore
French, 1872-1919
MILDE, Karl Julius
German, 1803-1875
MILDER, R.
British, 19th cent.
MILDNER, Johann Joseph
German, op.1787-m.1808
MILDORFER or Müldorfer,
Joseph Ignaz
German, 1719-p.1756(?)
MILDORFER or Müldorfer,
Maria Elisabeth
German, 1713-1792
MILES, Arthur
British, op.1851-1872
MILES, Edward
British, 1753/5-1828
MILES, Thomas Rose
British, op.c.1869-1906
MILES, W.
British, 20th cent.

MILESI, Alessandro
Italian, 1856-1945
MILESI, Bianca
Italian, op.1821
MILESI, Giuseppe
(Beppe)
Italian, 1915-
MILET, J.
French, 18th cent.
MILET-MUREAU,
Iphigénie
see Decaux
MILIANI, Giac
Italian, 19th cent.(?)
MILICH, Adolph
Polish, 1886-1964
MILITZ, Joh. Michael
see Millitz
MILIUS, Carl Heinrich
see Mylius
MILIUTI, Nikolai
Russian, op.1905
MILIUTI, Vassily
Russian, op.1905
MILKA, Franz
German, 18th cent.
MILLAIS, Sir John
Everett
British, 1829-1896
MILLAIS, John Guille
British, 1865-1931
MILLAIS, Raoul
British, 19th cent.
MILLAIS, William
Henry
British, 1828-1899
MILLAN, Francisco
Spanish, 1778-p.1837
MILLAR, H.R.
British, 20th cent.
MILLAR, James
British, op.1771-1790
MILLAR, William
British, op.1751-1775
MILLARD, Charles S.
British, op.1866-1889
MILLARD, Patrick
Ferguson
British, 1902-
MILLARES, Manolo
Spanish, 1926-
MILLE, Jean-Baptiste
Flemish, op.1729-1766
MILLER, Alan
British, 1942-
MILLER, Mrs. Alexis
see Cameron, Mary
MILLER, Alfred
British, 20th cent.
MILLER, Alfred Jacob
American, 1810-1874
MILLER, Charles Henry
American, 1842-1922
MILLER, Felix Martin
British, op.1842-1880
MILLER, Fred
British, op.1886-1897
MILLER, Godfrey
Australian, 1893-1964
MILLER, J.
British, op.1830
MILLER, J.H.
British, op.1803-1829
MILLER, James
British, op.1773-1791
MILLER, Johann Peter
see Molitor

MILLER, John
British, op.1780
MILLER, Jno.
British, op.1761-1785
MILLER, Josef Adam
see Müller, Johann
Adam
MILLER, Kenneth Hayes
American, 1876-1952
MILLER, Laurence
British, 20th cent.
MILLER or Müller,
Michael
German, op.1607
MILLER, N.M.
American, 20th cent.
MILLER, Philip
British, op.1755
MILLER, Ralph Willet
British, 1762-1799
MILLER, Richard Emile
American, 1875-
MILLER, T.
British, op.c.1725
MILLER, Werner
Swiss, 1892-
MILLER, William
British, c.1740-c.1810
MILLER, William
British, 1796-1882
MILLER, William E.
British, op.1873-1903
MILLER, William G.
British, 19th cent.
MILLER, William
Ongley
British, 1883-
MILLER, William
Rickaby
American, 1818-1893
MILLER, Wirth
British, 20th cent.
MILLEREAU, Philippe
French,
op.c.1570-m.1610
MILLET, Francis Davis
American, 1846-1912
MILLET, Frédéric
French, 1786-1859
MILLET, Jean-Baptiste
French, 1831-1906
MILLET, Milet, Miley
or Millé, Jean
François, I (Francisque)
French, 1642-1679
MILLET, Jean François,
II (Francisque)
French, 1666-1723
MILLET, Jean François
French, 1814-1875
MILLET, Joseph François
French, 1697-1777
MILLET, Mich.
French, op.1748
MILLETT, H.
British, op.1809-1817
MILLIAN, Thaddäus
Polish, 1794-1875
MILLICHAP, Thomas
British, op.1813-1821
MILLIEZ
French, op.1755
MILLIN-DUPERREUX,
Alexandre Louis
Robert
French, 1764-1843

MILLINGTON, James
Heath
British, 1799-1872
MILLITZ or Milits,
Joh. Michael
German, 1725-1779
MILLMAN, Edward
American, 1907-
MILLNER, Karl
German, 1825-1895
MILLNER, William E.
British, op.c.1845-1896
MILLO-RADD
American, 20th cent.
MILLOT, G.
French, op.1599
MILLS, A. Wallis
British, 1878-
MILLS, Alfred
British, 1776-1833
MILLS, J.Dewer
British, 20th cent.
MILLS, S.F.
British, op.1858-1880
MILLY, Dezider
Czech, 1906-
MILNE, David Bruce
Canadian, 1882-1953
MILNE, John Maclauchlan
British, 1885-1957
MILNE, Joseph
British, c.1861/2-1911
MILNE, Malcolm
British, 1887-1954
MILNER, Frederick
British, -1939
MILNER, T. Stuart
British, 1909-
MILNET, Bernhardinus
German, op.c.1480
MILO, Domenico Andrea
de
Italian, 17th cent.
MILO, Cavaliere
Giovanni
see Miel, Jan
MILON, Alexis Pierre
French, 1784-p.1852
MILORADOVIC, Bole
Yugoslav, 20th cent.
MILOSAVLJEVIC
see Pedja
MILOW, Keith
British, 1945-
MILTENBERG, J.Jacob
British, op.1784-1790
MILTON, Viscountess
British, 19th cent.
MILTON, John
British, op.1767-1774
MILTON, Thomas
British, 1743-1827
MIMAULT, Bernardin
French, op.c.1650-1664
MIMAULT, François
French, 1580-1652
MINARDI, Tommaso
Italian, 1787-1871
MINARESI, Flavio
Italian, 16th cent.(?)
MINARTZ, Tony
French, 1873-
MINASSIAN, Leone
Italian, 1905-
MINAUX, André
French, 1923-

MIND, Gottfried
(Katzen-Raffael)
Swiss, 1768-1814
MINDERHOUT, Hendrik van
Dutch, 1632-1696
MINDERMAN, Willem
Dutch, 1910-
MINEI, Filippo
Italian, op.c.1750
MINELLA, Pietro di
Tommaso del
Italian, 1391-1458
MINET, Emile-Louis
French, -1920
MINGA, Andrea di
Mariotto del
Italian, op.1564-m.1596
MINGASSON de
Martinazeau, S.
French, op.1840
MINGAZZINO
see Santi, Domenico
MINGHETTI, Prospero
Italian, 1786-1853
MINGOT, Teodosio
Spanish, 1551-1590
MINGOZZI or Mengozzi,
Girolamo (Colonna)
Italian, c.1688-c.1776
MINGUZZI, Giovanni
Francesco
see Mengucci
MINGUZZI, Luciano
Italian, 1911-
MINI, Antonio
Italian, op.1523-m.1533
MINIA, Menia or Menia-
Rinaldi, Raffaele
Italian, op.1615
MINICH, H.
French, 19th cent.
MINIER, Suzanne
French, 1884-
MINIO, Tiziano
Italian, 1517-1552
MINIOKI, Adam
see Manyoki
MINKOWSKI, Maurycy
Polish, 1881-1930
MINNE, George
Belgian, 1866-1941
MINNIGERODE, Ludwig
German, 1847-
MINNIGH, Joost Leonard
Dutch, 1942-
MINNITI or Menniti,
Mario
Italian, 1557-1640
MINO da Fiesole, Mino
di Giovanni, Mino
da Poppio or Mino
da Florentia
Italian,
1430/1-1484
MINO di Graziano
(Mino da Siena)
Italian,
op.1289-1321
MINO da Poppio
see Mino da Fiesole
MINOR, Ferdinand
German, 1814-1883
MINOR, Robert
Crannell
American, 1840-1904

MINORELLO, Francesco
 Italian, 1624-1657
MINOZZI, Bernardino
 Italian, 1699-1769
MINOZZI, Flaminio
 Innocenzo
 Italian, 1735-1817
MINSHULL, Captain
 British, op.1772-1773
MINTCHINE, Abraham
 Russian, 1898-1931
MINTON, H.A.
 British, op.c.1891-1920
MINTON, John Francis
 British, 1917-1957
MINTORN, J.
 British, op.1820
MINTROP, Theodor
 German, 1814-1870
MINZOCCHI, Francesco
 see Menzocchi
MIO, Giovanni de'
 see Fratino
MIODONCHESKI, Faustin de
 French, 19th cent.
MIR y Trinxet,
 Joaquin
 Spanish, 1873-1937
MIRABELLO da Salincorno
 see Cavalori
MIRADORI or Miradoro,
 Luigi (Il Genovese
 or il Genovesino)
 Italian, op.1639-1651
MIRAILLET, Jean
 see Miralheti
MIRALDA
 French, 20th cent.
MIRALHETI or Miraillet,
 Jean
 French, -a.1457
MIRALLES, Enrique
 Spanish, 20th cent.
MIRALLES, Francisco
 Spanish, c.1850-
MIRALLES-DARMANIN, José
 Spanish, 1851-
MIRANDA y Rendon,
 Manuel
 Spanish, op.1833-1864
MIRANDA, Miguel de
 Spanish, 17th cent.
MIRANDOLESE, Il
 see Paltronieri
MIRANDOLESE, Il
 see Perraccini, Giuseppe
MIRANI, E.P.
 Italian, 1810-1881
MIRBEL, Lizinska Aimée
 Zoë de (née Rue)
 French, 1796-1849
MIREA, George
 Demetrescu
 Rumanian, 1852-1934
MIRETO, Miretti or
 Moreto, Niccolò
 Italian, 1375-p.1450
MIRICENYS, Miricinus
 or Miriginus, Petrus
 see Heyden, Pieter
 van der
MIRILIANO, Giovanni
 see Marigliano
MIRIS, J. van
 Flemish, 17th cent.

MIRKO (Basaldella)
 Italian, 1910-
MIRO, Joan
 Spanish, 1893-
MIROLI, Girolamo
 see Miruoli
MIROP, Frans van
 Cuyck de
 see Cuyck
MIROU, Anton
 German, a.1586-p.1661(?)
MIRUOLI or Miroli,
 Girolamo
 Italian, op.c.1570
MIRVAULT, Césarine
 Henriette Flore
 see Davin
MIRYS or Miris, Baron
 Silvestre de
 French, 1700-1788/93
MIRYS, Méris, Myris
 or Myrs, Silvestre
 David
 French, 1742/1750(?)-1810
MISCHKINE, Olga
 Polish, 20th cent.
MISERIA, Juan de la
 (Juan Narduck,
 Giovanni Narducci?)
 Spanish, a.1526-1616
MISSAGLIA (Negroni)
 Italian, 15th cent.
MISTI-MIFLIEZ,
 Ferdinand
 French, 19th cent.
MITA, Georges
 Léopold
 French, 19th cent.
MITARAKIS, Jean
 Greek, 20th cent.
MITCHELL, Arnold
 British, 20th cent.
MITCHELL, Colin G.
 British, op.1894-1936
MITCHELL, Hutton
 British, 20th cent.
MITCHELL, J.A.
 British, 19th cent.
MITCHELL, J. Edgar
 British, -1922
MITCHELL, Joan
 American, 1926-
MITCHELL, John
 British, 20th cent.
MITCHELL, John Campbell
 British, 1865-1922
MITCHELL, John T.
 British, op.1798-1830
MITCHELL, Joseph
 British, 19th cent.
MITCHELL, Peter Todd
 British, 20th cent.
MITCHELL, Philip
 British, 1814-1896
MITCHELL, Siporin
 American(?), 20th cent.
MITCHELL, Sir T.
 British, op.1838
MITCHELL, Thomas
 British, op.1763-1789
MITCHELL, W.F.
 British, 19th cent.
MITELLI, Metelli or
 Mittelli, Agostino
 Spanzani
 Italian, 1609-1660

MITELLI, Agostino, II
 Italian, 1671-1696
MITELLI, G.
 Italian, op.1739
MITELLI, Metelli or
 Mittelli, Giuseppe
 (Gioseffo) Maria
 Spanzani
 Italian, 1634-1718
MITFORD, Bertram
 Osbaldeston
 British, 1777-1842
MITOFF, Anton
 Bulgarian, 1862-1930
MITOIRE
 French, op.1813
MITRECEY, Maurice
 French, 1869-1894
MITTELSDORF, Jacob
 German, 1856-
MITTENDORFF
 Swiss, 18th cent.
MITTERFELLNER, Andreas
 German, 1912-1972
MITTERHOFER, Leopold
 German, 18th cent.
MITTERTTREINER, Johannes
 Jacobus
 Dutch, 1851-1890
MITURICH, Piotr
 Russian, 1887-
MIVILLE, Jakob Christoph
 Swiss, 1786-1836
MIXELLE, Jean Marie
 French, 18th cent.
MJASSOJEDOW, Grigori
 Grigorjevich
 Russian, 1835-1911
MLECZKO, Piotr
 Polish, 1919-
MLODOZENIEC, Jan
 Polish, 20th cent.
MOCETTO, Mocetto,
 Mozeto or Mozzetto,
 Girolamo
 Italian, c.1458-c.1531
MOCH, Daniel
 see Mauch
MOCHEZ, H.
 French, 19th cent.
MOCHI, Giovanni
 Italian, 1829-
MOCHKOF
 Russian, 18th cent.
MOCK, Johann Christian
 German, op.1732-1734
MOCK, Johann Samuel
 German, 1687-1737
MODELL, Elizabeth
 German, 1820-1865
MODERSOHN, Otto
 German, 1865-1943
MODERSOHN-BECKER, Paula
 German, 1876-1907
MODIGLIANI, Amedeo
 Italian, 1884-1920
MOE, Niels
 Danish, 1792-1854
MOELLER, Louis Charles
 American, 1855-1930
MOELLER or Moller,
 Otto Friedrich
 Theodor
 Russian, 1812-1874
MOELLON, Isaac
 see Moillon

MOELON, Nicolas
 see Moillon
MOENS, Jacques
 Flemish, op.1663
MOER, Jean-Baptiste
 van
 Belgian, 1819-1884
MOERENHOUT, Josephus
 Jodocus
 Belgian, 1801-1874
MOERKERKEN, Hans van
 Dutch, 19th cent.
MOESCHLIN, Walter
 Swiss, 1902-1961
MOESMAN, J.H.
 German, 20th cent.
MOESTED, Peder
 German, 1812-1881
MOEYAERT or Moyaert,
 Jan Cornelisz.
 Dutch, 1603-p.1635
MOEYAERT, Mooyaert
 or Moyaert, Nicolaes
 (Claes) Cornelisz.
 Dutch, 1592/3-1655
MOFFAT, Alexander
 British, 20th cent.
MOGALLI, Cosimo
 Italian, op.c.1720
MOGER, Rafael
 Spanish, op.c.1458-1483
MOGFORD, Henry
 British, op.1837-1846
MOGFORD, John
 British, 1821-1885
MOGFORD, Thomas
 British, 1800-1868
MOGGIOLI, Umberto
 Italian, 1886-1919
MOGILEVSKY, Y.B.
 Russian, 19th cent.
MOGIS, A.
 French, 19th cent.
MOHEDANO, Antonio
 Spanish, c.1560-1625
MOHN, Viktor Paul
 (Paul)
 German, 1842-1911
MOHOLY-NAGY, Laszlo
 Hungarian, 1895-1946
MOHR, Arno
 German, 1910-
MOHR, Hugo Lous
 Norwegian, 1889-
MOHR, Johann Georg
 Paul
 German, 1808-1843
MOHRBUTTER, Alfred
 German, 1867-1916
MOILLIET, Louis
 Swiss, 1880-
MOILLON, Isaac
 French, 1614-1673
MOILLON, Louise
 French, 1609/10-1696
MOILLON or Moelon,
 Nicolas
 French, op.1608-m.1627
MOINE
 see Lemoine
MOINOT, Marie Eugénie
 see Coulin-Moinot
MOIR, John
 British, 1776-1857
MOIRA (Lobo de Moura)
 Eduardo de
 British, 1817-1887

MOIRA (Lobo de Moura),
Giraldo Eduardo
(Gerald Edward)
British, 1867-1959
MOIS, Roland de
Spanish, op.1589-m.c.1590
MOISE, Theodore
Sydney
American, 1806-1883
MOISELET, Gabriel
French, 1885-
MOITTE, Alexandre
French, 1750-1828
MOITTE, Elizabeth
Mélanie
French, 18th cent.
MOITTE, Francois
Auguste
French, 1748-c.1790
MOITTE, Jean-Baptiste
Philibert
French, 1754-1808
MOITTE, Jean Guillaume
French, 1746-1810
MOITTE, Pierre Etienne
French, 1722-1780
MOJA, Frederico
Italian, 1802-1885
MOL, Philippe de
see Philippe, Master
MOL, Pieter van
Flemish, 1599-1650
MOL, Woutherus
Dutch, 1785-1857
MOLA, Giovanni
Battista
Italian, 1588-1665
MOLA, Jean Baptiste
see Mole
MOLA, Pier Francesco
Italian, 1612-1666
MOLANUS, Mattheus
Flemish, op.1613-m.1645
MÖLCH or Mölckh,
Josef Adam
see Mölk
MOLDINI, S.
Italian, 19th cent.
MOLDOVAN, Sacha
French, 20th cent.
MOLE, Mola, Molla di
Francia, Mollo or
Molly, Jean Baptiste
French, 1616-1661
MOLE, John Henry
British, 1814-1886
MOLENAER, Bartholomeus
Dutch, op.1640-m.1650
MOLENAER, Cornelis
(de Schele Neel)
Flemish, c.1540-1589(?)
MOLENAER, Johannes or
Jan Miensz.
Dutch, 1609/10(?)-1668
MOLENAER, Judith,
(née Leyster)
see Leyster
MOLENAER, Nicolas
(Klaes)
Dutch, op.1651-m.1676
MOLENAER, Pieter
see Meulener
MOLES
Spanish, op.1897
MOLES, Pascual Pedro
Spanish, 1741-1797
MOLET, A.
Netherlands, 16th cent.

MOLIER, Pieter
see Mulier
MOLIN, Anna
British, 20th cent.
MOLIN, Benoît Hermogaste
French, 1810-1894
MOLIN, Hjalmar J.
Swedish, 1868-
MOLINA y Mendoza,
Jacinto de
Spanish, c.1601-
MOLINA, Manuel de
Spanish, 17th cent.
MOLINA, Valentino
American, 1880-
MOLINARETTO
see Piane, Giovanni
Maria delle
MOLINARI
Italian(?), 19th cent.
MOLINARI or Molinary,
Alexander
German, 1772-1831
MOLINARI or Mulinari,
Giovanni Battista
Italian, 1636-p.1682
MOLINARI, Giovanni
Domenico
Italian, 1721-1793
MOLINARI, Guido
Canadian, 1933-
MOLINE, A. de
French, op.1873
MOLINERI, Mollineri
or Mulinari (called
Carraccino), Giovanni
Antonio
Italian, 1577-1645
MOLINIER, Pierre
French, 20th cent.
MOLINO, Jacopo
Italian, op.1540-1549(?)
MOLISSON, Jean de
see Jean de Montluçon
MOLITOR, Franz
German, 1857-1929
MOLITOR, Miller or
Müller, Johann
Peter
German, 1702-1756
MOLITOR, Martin von
German, 1759-1812
MÖLK, Mölch or Mölckh,
Josef Adam Ritter von
German, c.1714-1794
MOLL, Carl
German, 1861-1945
MOLL, Evert
Dutch, 1878-1955
MOLL, Oskar
German, 1875-1947
MOLLA di Francis
see Mole
MÖLIENDORF, W. von
German, op.1826
MÖLLER or Moeller,
Andreas
Danish, 1684-1762(?)
MÖLLER, Miller or
Moller, Anton, I
German, c.1563-1611
MOLLER, Hans
American, 1905-
MÖLLER, Johan Frederik
Danish, 1797-1871
MÖLIER, Johan Peter
Christoffer
Danish, 1829-

MØLLER, Jørgen Henrik
Danish, 1822-1884
MØLLER, Lars
Danish, 1842-1926
MØLLER, Nils Björnsen
Swedish, 1827-1887
MÖLLER, Otto
German, 1883-1964
MOLLER, Theodor de
Russian, 1812-1875
MOLLICA, Achille
Italian, op.1870-1883
MOLLINEUX
British, op.1729
MOLLINGER, Gerrit
Alexander Godart
Philip (Alexander)
Dutch, 1836-1867
MOLLO or Molly, Jean
Baptiste
see Mole
MOLMENTI, Pompeo
(Prospero)
Italian, 1819-1894
MOLNAR, Gabor
Hungarian, 20th cent.
MOLNAR, Iosif
Rumanian, 1907-
MOLNAR, Istvan
Hungarian, 1933-
MOLNAR, Janos
see Pentelei-Molnar
MOLNAR, József (Josef)
Hungarian, 1821-1899
MOLNAR, Paul
Hungarian, 1894-
MOLS, Robert Charles
Gustave Laurent
Belgian, 1848-1903
MOLSTED, Christian
Ferdinand Andreas
Danish, 1862-
MOLTENI, Giuseppe
Italian, 1800-1867
MOLTINO, F.
Italian, op.c.1850
MOLUSSON, Jean de
see Jean de Montluçon
MOLVIG, Jon
Australian, 1923-1970
MOLIJN, Anthony
Dutch, op.1654-m.a.1703
MOLIJN or Molyns, Hans
or Jean
Netherlands,
op.1532-1558
MOLIJN, Petrus Marius
Dutch, 1819-1849
MOLIJN, Pieter de
Dutch, 1595-1661
MOLZAHN, Johannes
German, 1892-1965
MOMAL, Jacques François
French, 1754-1832
MOMBELLO, Luca
Italian, 1520-p.1553
MOMELLINI, Plinio
Italian, 19th cent.
MOMMERS, Hendrik
Dutch, c.1623-1693
MOMMORENCY, B.
see Monmorency
MOMPER, Bartholomäus,
I de
Netherlands, 1535-p.1589
MOMPER, Frans de
Flemish, 1603-1660

MOMPER, Jan de
Flemish, op.1661-1665
MOMPER, Joos, Jodocus,
Joes, Joeys, Joost or
Josse, II de
Flemish, 1564-1634/5
MOMPO, Hernandez
Spanish, 1927-
MOMPOU, José
Spanish, 1888-
MONA, Domenico
Italian, c.1550-1602
MONACO, Lorenzo
(Piero di Giovanni)
see Lorenzo
MONACO or Monego,
Pietro
Italian, 1707/10-p.1775
MONALDI, Bernardino
Italian, op.1588-1614
MONALDI, Paolo
Italian, op.c.1760
MONALDO Trofi, Il
Truffetta or Monaldo
Corso
Italian, op.1507-1519
MONAMY, Peter
British, 1670/89-1749
MONANTEUIL, Jean Jacques
François
French, 1785-1860
MONARI, Cristoforo
Italian, op.1700-m.1720
MONASCIO
Italian, 17th cent.(?)
MONBEYNE, H.B.
Dutch, 18th cent.
MONCADA, Sonfonisba di
see Anguisciola
MONCALVO, Guglielmo
Caccia, Il
see Caccia
MONCAYOX, E.
South American, 20th cent.
MONCE
see Delamonce
MONCHABLON, Edouard or
André J. Edouard
French, 1879-1914
MONCHABLON, Ferdinand
Jean (Jan-Monchablon)
French, 1855-1904
MONCHABLON, Xavier
Alphonse or Alphonse
French, 1835-1907
MONCHET
French, 18th cent.
MONCKTON, the Hon. Frances
Jane
British, 18th cent.
MONCORNET or Montcornet,
Balthazar
French, c.1600-1668
MONCRIEFF
British, op.1790
MONCRIEFF, Robert Scott
British, op.1816-1820
MOND, Frank Vincent du
American, 1865-
MOND, Frederick Melville
du
American, 1867-1927
MONDA-MISZTRIK
Russian, 20th cent.
MONDELLA or Mondelli,
Galeazzo
(Il Rosso da San Zeno)
Italian, op.c.1500

MONDI, T.
Italian, 18th cent.
MONDIEU or Mondineu,
Jean Gaspard Etienne
French, 1872-
MONDINI, Fulgenzio
Italian, c.1625-1664
MONDO, Domenico del
Italian, 1717(?)-1806
MONDO, F. del
Italian, op.1700-1750
MONDON, Jean
(Mondon le fils)
French, op.1736-1745
MONDRAN, Mlle. de
French, op.1768
MONDRIAAN, Frédéric
Hendrik (Frits)
Dutch, 1853-1932
MONDRIAAN or Mondrian,
Pieter Cornelis
(Piet)
Dutch, 1872-1944
MONDZAIN, Simon
Polish, 1890-
MONEDERO
Spanish, 20th cent.
MONEGO, Pietro
see Monaco
MONET, Blanche Hoschedé
French, 20th cent.
MONET, Claude Oscar
French, 1840-1926
MONFALLET, Adolphe
François
French, 1816-1900
MONFRIED, Georges Daniel
French, 1856-1929
MONGARDINI, Pietro
see Venale
MONGE, Jules
French, 19th cent.
MONGENOR
French, 18th cent.
MONGEZ, Marie Joséphine
Angelique, (née
Lavol)
French, 1775-1855
MONGHINI, Antonio
Italian, 18th cent.
MONGIN, Pierre Antoine
French, 1761/2-1827
MONGINOT, Charles
French, 1825-1900
MONGRELL y Torrent,
José
Spanish, 1870-
MONI, Louis de
Dutch, 1698-1771
MONI, Monnj, Mony or
Monij, G. Paul
German, 1617-1700
MONIEN, Julien
German, 1842-1897
MONIER, Madeleine
French, 20th cent.
MONIER or Monnier de
la Sizeranne, Max
French, op.1857-m.1907
MONIER, Meunier,
Monnier, Monsnier or
Mosnier, Pierre
French, 1641-1703
MONIES, David
Danish, 1812-1894

MONINCKX, Monincks
or Monnieckx, Cornelis
Dutch, c.1623-1666
MONINCKX, Jan
Dutch, op.c.1672/3
MONINCKX, Monincks,
Monniex or Monnix,
Pieter
Dutch, 1606(?)-1686(?)
MONINGTON, Winifred,
(née Knights)
British, 20th cent.
MONK, William
British, 1863-1937
MONKHOUSE, Victoria
British, 20th cent.
MONMORENCY, Mommorency
or Montmorancy, B.
French, op.1742
MONNA, Joseph
Italian, 17th cent.
MONNET or Monet,
Charles
French, 1732-p.1808
MONNICKENDAM, Martin
(Martijn)
Dutch, 1874-1943
MONNICKX or Monnicx
see Moninckx
MONNIER
see also Monier
MONNIER, Henri
Bonaventure
French, 1799-1877
MONNIER, Pierre
see Monier
MONNINGTON, Sir Walter
Thomas
British, 1902-1976
MONNIX, Pieter
see Moninckx
MONNOT or Monot,
Pierre Etienne
French, 1657-1753
MONNOYER
British, 18th cent.
MONNOYER, Antoine
(Baptiste M. le jeune)
French, 1670-1747
MONNOYER or Monoyer,
Jean Baptiste
(Baptiste)
French, 1636-1669
MONOCOLO, Il
see Asaro, Pietro
MONOD, Lucien Hector
French, 20th cent.
MONOGRAMMISTS
A.
see Aartman, A.
A.A.
German, op.1519
A.A.P., A.P. or A.V.P.
Dutch, 17th cent.
A.B.
American, op.c.1840
A.B.
British(?), op.1520
A.B.
German, 16th cent.
A.B.
German, 16th cent.
A.B.
German, 17th cent.
A.B.
Russian(?), op.1838

(MONOGRAMMISTS: cont.)
A.Bo.
Dutch, 17th cent.
A.B.D.
Netherlands, 16th cent.
A.B.W.
Dutch, op.1664
A.C.
German, op.c.1562
A.C.
Dutch, 17th cent.
A.C.
French, op.1577
A.C.V.E.
Dutch, op.1619
A.D.
Dutch, op.c.1650
A.D.
German, op.1521
A.D.
Netherlands, 16th cent.
A.D.G. (or C.)
Dutch, op.1671
A.F.
Dutch, 17th cent.
A.F.
German, 17th cent.
A.F.
Italian, 15th cent.
A.F.R.
German, op.1524
A.G.
German, op.1540
A.H.
German, 16th cent.
A.H.
see Heusler, Antonius
A.H.M.
French(?), op.1607
A.H. v D.
German, 16th cent.
A.I.
German, 16th cent.
A.I.
Netherlands, 16th cent.
A.K.
Dutch(?), 17th cent.(?)
A...L...
British, op.1872
A.L.
German, 16th cent.
A.L.
German, 18th cent.
A.M.
Danish(?), 16th cent.(?)
A.M.(?)
French(?), 17th cent.
A.M.
German, op.1561-1562
A.M.
German, op.c.1840
A.M.
(possibly Aguirre,
Manuel)
Spanish, 19th cent.
A.M.
see Mair, Alexander
A.N.
German, 15th cent.
A.O.
see A.D.
German, 16th cent.
A.P.
British, 16th cent.
A.Q.F.
see Quesnel, Augustin, I
A.R.
Dutch, op.1640

(MONOGRAMMISTS: cont.)
A.S.
German, c.1530
A.S.
Netherlands, 18th cent.
A.S.L.
German, 18th cent.
A.S.V.
Dutch, 17th cent.
A.S.V.
Swiss(?), 16th cent.
A.T.
German, 16th cent.
A.V.D.
Dutch, 17th cent.
AVE (RH) or VEA (HR)
German, op.c.1520
A.v.L.
Netherlands, op.c.1520
A.V.S.G.
German, op.1568
A.V.Z.
Dutch, 18th cent.(?)
A.W.
Dutch, 17th cent.
A.W.
German, 16th cent.
B.
British, 18th cent.
B.
Dutch, 17th cent.
B.
German, op.1579
B.
German(?), 16th cent.
B.
see Beer, Joos de
B.A.
Flemish(?), 18th cent.(?)
B.
Italian, 17th cent.
B.A.D.
German, op.c.1530
B.B.
British, op.1797
B.B.
German, op.1502-1515
B.D.
Czech, op.c.1513
B.D.
Dutch, 17th cent.
B.D.
German, 16th cent.
B.E.
Dutch, 17th cent.
B.F.
Italian, 16th cent.
B.G.
German, 15th cent.
B.H.
Dutch, op.1650
B.H.
Flemish, op.1718
B.H.
German, op.1586
B.L.
Dutch, 17th cent.
B.M.
German, op.c.1480
B.S.
German, op.1540
B.V.M.
Dutch, op.1613
B.V.
Flemish, 17th cent.
B.W.
Dutch, 18th cent.
B.X.G.
German(?), 15th cent.(?)

(MONOGRAMMISTS: cont.)
6 in B.
 German, 16th cent.
C.
 Dutch, 17th cent.
C.A.
 German, op.1519
C.A.
 Swiss, op.c.1519
C.A.R.
 Flemish(?), op.1600
C.B.
 British, op.1814
C.B.
 Dutch, op.1626-1627
C.B.
 French(?), 17th cent.
C.B.
 German, op.1515
C.B.
 German, op.1531
C.B.
 German, op.1605
C.B.
 German(?), 18th cent.(?)
C.B.
 Netherlands, op.1556
C.B.
 see Conrad Bauer
C.B.P. or C.B.
 Dutch, op.1642
C.D.
 German, op.1552
C. D'E
 French, 18th cent.
C.E.
 Dutch, op.1663
C.G.
 Dutch, op.1627
C.G.
 Italian(?), op.1620
C.G.I.
 French, 17th cent.
C.H.
 British, 18th cent.
C.H.
 Flemish, 17th cent.
C.H.
 Swiss, op.1529-1543
C.I.
 German, op.1569
C.L.
 British, 19th cent.
C.L.
 Dutch, op.c.1650
C.L.
 French(?) 18th cent.
C.L. (not L.C.)
 German, 16th cent.
C.L.
 Italian, 19th cent.
C.M.
 Dutch, 17th cent.
C.M.H.V.
 Dutch, op.1652
C.N.
 Dutch(?), 18th cent.
C.P.
 Netherlands, op.1596
C.R.
 Dutch, 17th cent.
C.S.
 Netherlands, op.1533
C.S.
 German, op.1553
C.S.F.
 German, op.1607
C.T.
 Dutch(?), 18th cent.

(MONOGRAMMISTS: cont.)
C.T.B.
 German, op.c.1660
C.V.B.
 Flemish, 17th cent.
C.V.M.
 British, op.1791
C.V.N.
 see Noorde, Cornelis
 van
C.V.R.
 Dutch, 17th cent.
C.W.
 German, op.1518
C.W.
 Italian, op.1881
C.X.S.
 Netherlands, op.1526-1533
D.
 French, op.c.1811
D.A. with the Anchor
 see Master of Jesus
 in Bethany
D.B.
 German, 18th cent.(?)
D.C.
 Dutch, op.1622
D.C.
 Dutch, op.1682
D.C.
 Spanish, 17th cent.
D.D.V.
 Flemish, op.1622
D.E.
 Dutch, 17th cent.
D.E.
 Dutch, op.1862
D.F.
 British, 17th cent.
D.H.
 Flemish, 17th cent.
D. Hei
 German, 18th cent.(?)
D.J.
 Dutch(?) op.1641
D.K.
 Dutch(?) 18th cent.(?)
D.K.V.H.
 Swiss, 16th cent.
D.M.
 see Daniel Meyer
D.N.
 Dutch(?), 17th cent.(?)
D.R.
 German, op.c.1522
D.S.
 Swiss, op.1503-1515
D.V.B.
 Dutch, op.1624
D.V.D.
 Dutch, 17th cent.
D.V.G.
 Dutch, 17th cent.
D.V.H.
 Flemish, 17th cent.
D.V.P.
 Flemish, 17th cent.
D.W.
 German, op.1582
D.W.F.J.
 Italian, op.1623
D.W.L.
 German(?), op.1581
D.Z.
 German, c.1500
E.
 German, op.1522
E.B.
 Netherlands, op.1557

(MONOGRAMMISTS: cont.)
E.D.I.
 Dutch, 17th cent.
E.E.
 German, op.1626
E.I.
 German, 16th cent.
E.I.
 Netherlands, 16th cent.
E.K.
 Dutch, 17th cent.
E.L.
 German, 17th cent.
E.L.
 Netherlands(?), 16th cent.(?)
E.M.
 British(?), op.1606
E.M.
 Dutch, 17th cent.
E.R.
 British, 19th cent.
E.R.
 German, op.1516
E.S.
 German, op.c.1440-1468
E.S.
 German, op.1564
E.S.
 Flemish(?), 17th cent.
E.S.B.
 Dutch, op.1672
E.V.D.
 Dutch, 1508-1575
E.W.
 British, op.1750
E.W.
 German, op.c.1746
F.
 Dutch, 17th cent.
F.A.B.K.
 Dutch, 17th cent.
F.B.
 British, 19th cent.
F.B.
 Dutch, op.1724
F.B.
 German, op.1561
F.B.(?)
 German, 18th cent.
F.C.
 Flemish, op.1629
F.D.
 (Franc D.)
 Flemish, 17th cent.
F.D.
 German, op.1836
F.D.C.
 British(?), op.1668
F.E.
 Flemish, 17th cent.
F.E.
 Netherlands, 15th cent.
F.F.
 Italian, op.1563
F.H.
 Dutch, 17th cent.
F.H.
 Netherlands, op.1512
F.I.P.D.F.
 Italian, op.1537
F.M.
 Dutch, op.1646
F.M.
 Dutch, 17th cent.
F.M F.
 Italian, 16th cent.
F.M.v.S.
 Dutch, op.1720
F.M.W. or I.T.F.
 Flemish, op.1621

(MONOGRAMMISTS: cont)
F.R.
 Dutch, 17th cent.
F.S.C.N.S.
 Spanish(?), op.1640
F.V.
 Italian, op.1532
F.V.B.
 (Frans von Brugge?
 Formerly identified with
 Frans von Bocholt)
 Netherlands, op.1480-1500
F.V.C.
 Dutch, 17th cent.
F. von F.
 Netherlands, 16th cent.
F.V.H.
 Flemish, op.1647
F.v.K.
 Dutch, 17th cent.
F.v.S.
 see Schooten, Floris
 Gerritsz. van
F.W.
 British(?), 19th cent.
F.W.S.
 British(?), 19th cent.
G.
 Dutch(?), 17th cent.
G.B.
 German, op.1605
G.B.W.
 British, 19th cent.
G.C.
 French, op.1847
G.C.
 Italian, 17th cent.
G.D.S.
 German, op.1629
G.D.V.
 Italian(?), 18th cent.
G.E.C.
 French, 16th cent.
G.E.S.
 Swedish, op.1699
GESVGR
 Swiss(?), 16th cent.(?)
G.F.
 British, op.1614
G.H.
 Flemish(?) op.1626
G.H.
 German, op.1643
G.H.S.
 German, op.1633
G.J.T.
 see I.T.
G.K.
 British, op.1832
G.K.F.A.
 Flemish, 17th cent.
G.L.
 Swiss, op.1847
G.M.
 German, 18th cent.
G.N.
 Swiss, op.1588
G.P.
 French, op.c.1650
G.P.S.
 Netherlands, 16th cent.
G.R.
 British, op.1820
G.S.
 Italian, 15th cent.(?)
G.S.
 Swiss(?), op.1547
G.S.
 Swiss(?), 18th cent.
G.V.B.
 Dutch, op.c.1650

(MONOGRAMMISTS: cont.)

G.V.S.
 Dutch, op.1605
G.v.V.
 Dutch, 17th cent.
G.W.
 British, op.1837
Gw. Gr.
 German, op.1625
G.Z.
 German, op.1516-1521
G.Z.
 Italian, 15th cent.
H.
 French(?), 15th cent.(?)
H.A.
 Flemish, 17th cent.
H.A.
 German, op.c.1520
H.A.L. or H.A.V.
 German, 15th cent.
H.A.S.
 German, op.c.1540
H.B.
 French, op.1552
H.B.
 German, op.1518
H.B.
 German, op.1522
H.B.
 German, op.1528-1556
H.B.
 German(?), op.1529
H.B.
 German(?), op.1530
H.B.
 German, op.1546
H.B.
 German, 16th cent.
H.B.
 Netherlands, op.1510
H.B.
 Netherlands, op.c.1560
H.B.
 Swiss, op.1607
H.B.
 see Bogaert, Hendrick
 Hendricksz.
'H.B.'
 see Doyle, John
H.B.L.
 American, op.1861
H.B. WITH THE PLANE
 German, op.c.1520
H.C.
 Flemish, 17th cent.
H.Cr.S.
 German, 16th cent.
H.C.Z.A.
 German, 15th cent.
H.D.
 Dutch, 17th cent.
H.D.
 see Döring, Hans
H.E.
 German, op.1588
H.E.
 British(?) 16th cent.
H.E. or H.F.E.
 Italian, 16th cent.
HEW.
 see Weyer, Hermann
H.F.
 Swiss, op.1517
H.F.
 Swiss, op.1523-1524
H.F.G.
 Dutch(?), 17th cent.

(MONOGRAMMISTS: cont.)

HF or IF
 Italian, op.1519
H.G.
 Dutch, 17th cent.
H.G.
 Dutch, 17th cent.
H.G.
 Dutch, 17th cent.(?)
H.G.
 German, op.1497
H.G.
 German, op.1514
H.G.
 Hungarian(?), 16th cent.(?)
H.H.
 German, op.1509
H.H.
 German, op.1515
H.H.
 German, op.1530
H.h.
 German, 16th cent.
H.H.
 Swiss, op.1544
h.h.
 see Huber, Hans
H.H.B.
 German, op.1515
H.H.F.
 German, op.c.1510
H.H.S.
 German, op.1491-1519
HIH
 Netherlands, 17th cent.
H.J.H.
 British, 19th cent.
H.J.P.
 Dutch, 17th cent.
H.K.
 German, 15th cent.(?)
HK
 German, op.1531
H.K.
 German, op.1567
H.K.
 Italian, op.c.1450
H.K.P.
 German, 16th cent.
H.L.
 German, op.1510-1533
H.M.
 Flemish, 15th cent.
H.M.H.
 German(?), 16th cent.
H.N.
 German, op.c.1520
H.N.
 German(?), 18th cent.(?)
H.P.
 German, op.c.1530
H.P.
 German, op.1580
HP.
 German, 16th cent.
HR.
 German, op.1530
H.R.
 German, op.1531
H.R.
 German, op.c.1540
H.R.
 German, op.1568
H.R.
 German, op.1608
H.S.
 Dutch, 17th cent.
H.S.
 German, op.c.1520

(MONOGRAMMISTS: cont.)

H.S.
 German, op.c.1604
H.S.
 Swiss, op.1557
H.S.B.
 German, op.1530
H.T.
 British, op.1683
H.T.
 Netherlands(?),
 op.c.1560
H.V.
 Dutch, 17th cent.
H.V.B.
 Dutch, op.1570
H.V.B.
 German, op.1630
H.V.B.
 see Burgh, Hendrick
 van der
H. v D.
 Flemish, c.1700
H.V.E.
 see Vogtherr the Elder,
 Heinrich
H.V.F.
 see Franck, Hans Ulrich
H.V.L.
 Flemish(?) 17th cent.
H.V.S.
 Dutch, 17th cent.
H.v.W.
 German, op.1896
H.W.
 German, op.1548
H.W.
 see Wertinger, Hans
H.W.G.
 German, 16th cent.
I.
 German, 15th cent.
I.A.
 Italian, 17th cent.
I.A.M. of Zwolle
 (Possibly identified
 with Jan van den
 Mijnhesten)
 Netherlands, op.c.1475
I.B.
 British, op.1821
I.B.
 Dutch, 17th cent.
I.B.T. (Il Malo)
 Italian, op.1510
I.B. WITH THE BIRD
 Italian, 16th cent.
I.C.
 German, 15th cent.
I.D.C.
 French, 16th cent.
I.D.R.
 see Rousseau, Jacques, de
I.D.V.
 Dutch, 17th cent.
I.E.
 Dutch, op.1617
ie
 see Master of the
 Catherine Wheel
I.F.
 Netherlands, c.1500
IF
 see HF
I.G.
 Netherlands, 16th cent.
I.H.
 German, 16th cent.

(MONOGRAMMISTS: cont.)

I.H.
 British(?), op.1777
I.K.
 (Possibly identified
 with Hanns Knabe)
 German, op.1516
I.K.
 German, op.1537
I.K.
 see Kerver, Jacob
I.L.
 Swedish, op.1627
I.M.
 German, op.1620
I.M.
 Netherlands, 15th cent.
I.M.
 see Mores, Jacob
I.M.P.
 Dutch, op.1800
I.P.
 Dutch, 17th cent.
I. or J.P.M.
 see Moreelse, Johan
I.S.
 Dutch, 17th cent.
I.S.
 German, op.c.1528
I.S. (S.I.)
 German, op.c.1530-1560
I.S.
 Polish, op.1558
I.T.
 German, 16th cent.
I.T. (G.J.T., T.I.)
 Netherlands or German,
 op.c.1510-c.1530
I.T.F.
 see F.M.W.
I.V.
 French, op.1543
IVDS
 Netherlands, op.c.1580
I.V.M.
 see Vermeulen, J.
I.V.P.
 German, 18th cent.
I.V.R.
 Dutch, 17th cent.
I.W.
 Czech, op.c.1520-1555
I.W.
 German, op.1515
I.Z.
 German, op.c.1515
J.
 German, op.1725
J.A.
 French, op.1822
J.A.
 German, 16th cent.
JA
 Netherlands, op.c.1600
J.A.H.
 British, 18th cent.
J.B.
 Dutch, 17th cent.
J.B.
 Dutch, op.c.1700
J.B.
 German, 15th cent.(?)
J.B. WITH THE BIRD
 see I.B. with the Bird
J.B.G.
 French, 18th cent.
J.B.M.
 French, 18th cent.

(MONOGRAMMISTS: cont.)

J.C.
British, 17th cent.

J.C.
British, 19th cent.

J.C.
Dutch(?), op.1619

J.C.B.
Dutch, 17th cent.

J.C.H.
Dutch, op.1742

J.D.
British, op.1827

J.D.
British, 19th cent.

J.D.
German, 19th cent.

J.D.R.
see Rousseau, Jacques de

J.F.
Italian, 18th cent.

J.H.
British, op.1650

J.H.
Dutch(?), 17th cent.

J.H.Cs.
Dutch, op.1664

J.H.O.P.
British, op.1887

J.H.P.
see H.J.P.

J.H.S.
Dutch, 17th cent.

J.J.CA.
Italian, 16th cent.

J.L.
Dutch, op.1660

J.L.
Dutch, op.1674

J.L.
Dutch(?), 18th cent.

J.L.
Swiss, op.c.1538

J.L.G.
see Lang, Hieronymus

J.M.
British, op.1785

J.M.
British, 18th cent.

J.M.
British, 19th cent.

J.M.M.
Flemish, op.1638

J.P.
French, 19th cent.

J. or I.P.M.
see Moreelse, Johan

J.P.V.N.L.
Dutch, op.1635

J.R.
British, 19th cent.

J.R.
Dutch, op.c.1635

J.R.
Dutch, 17th cent.

J.R.P.
Dutch, 17th cent.

J.S.
Dutch, op.1652

J.S.
German, op.1511

J.S.
German, 16th cent.

J.S.
Netherlands, 16th cent.

J.V.H.
Dutch, op.c.1700

(MONOGRAMMISTS: cont.)

J.V.J.
Dutch, op.1682

J.v.L.
Dutch, 17th cent.

J.V.M.
Dutch, op.1654

J.V.M.
see Merck, Jacob van der

J.VR.
Dutch, op.1652

J.V.R.
Dutch, 17th cent.

J.V.R.
German, op.1590

J.W.
German, op.1525-1538

J.W.
German, op.c.1600

J.W.K.
Dutch, 17th cent.

J.Z.
see IZ

K
Dutch, 17th cent.

K.R.
Netherlands, 16th cent.

L.
German, op.1748

L.A.M.
French, op.1568-1574

L.B.
Dutch, 17th cent.

L.B.
German(?), op.1761

L.B.D.
Dutch, 17th cent.

L.C.
French(?), op.1541

L.C. or L.G.
German, op.1532

L.C.
see C.L.

L.C.R.
Dutch(?) 18th cent.(?)

L.c.z.
German, 15th cent.

L.D.
Dutch, 17th cent.

L.D.
French, op.1540-1556

L.F.
German, 15th cent.

L.F.
see Frölich, Lucas

L.H.
Flemish, 17th cent.

L.I.
British, op.1810

L.K.
German, op.1545

L.K.
(Possibly identified with Lenaert Kroes)
see Master of the Prodigal Son

L.M.W.
Flemish, op.c.1600

L.N.
Dutch, op.1660

L.N.
German, 15th cent.

L.P.
Dutch, 17th cent.

L.S.
British, 16th cent.

L.S.
Dutch, 17th cent.

(MONOGRAMMISTS: cont.)

L.S.
French, op.c.1775

L.S.
see Master of the University Altarpiece

LVDK
Flemish(?), 17th cent.(?)

M.
German, op.1539

M.B.
German, op.1573

M.C.A. or M.G.A.
Italian, op.1605

M.D.
British, 19th cent.

M.D.
Dutch, op.1641

M.E.
British, op.1825

M.F.
German, op.1498

M.F.
German, op.1561

M.F.P.
German, op.1495

M.F. van L.
Dutch, op.1824

M.G.N.
see Grünewald, Matthias

M.H.
German, 15th cent.

M.I.
Italian, op.c.1500

M.M.
Swiss(?), op.1608

M.N.
French, 17th cent.

M.N.
see Grünewald, Mathias

M.P.
Dutch, 17th cent.

M.R.
Italian(?), op.1685

M.S.
German(Alsatian?) op.c.1515

M.S.
German, op.c.1530-1550

M.S.
German, op.1557

M.S.
Hungarian, op.1506

M.T. (possibly Martin Treu)
German, 16th cent.

M.W.
British, 19th cent.

M.Z.
German, op.1500-1505

M.Z.
German, op.1593

N.A.
German, op.1531

N.D.
Netherlands, op.1572

N.D.
British, 17th cent.

N.F.
Italian, 18th cent.

NGB
Dutch, 18th cent.

N.H.
Netherlands, 16th cent.

N.J.
Dutch, op.1652

N.K.
Dutch, 18th cent.

(MONOGRAMMISTS: cont.)

N.K.
German, op.1519

N.K.
German, op.1529

N.M.
French(?), 19th cent.(?)

N.V.L.
Dutch, 17th cent.

N.W.
see Wirt, Niklaus

O.B.
German(?), op.c.1560

O.R.J. (ordan?)
(O. Jordan?)
German, op.1850

O.S.
German, op.1607

P.A.
Dutch, 17th cent.

P.A.B.
Flemish(?), op.1615

P.A.G.
Dutch, 17th cent.

P.A.H.B.
Dutch, op.1622

P.A.V.H.
Dutch, op.1646

P.B.
British, op.1886

P.B.
Dutch, op.1649

P.C.
Dutch, 17th cent.

P.C.
German, op.1566

P.C.
French, op.1672

P.C.
German, 18th cent.

P.C.H.
Dutch, 17th cent.

P.D.
Dutch(?), op.1778

P.D.H.
Dutch, op.c.1650

P.D.P. (?)
Dutch, op.1612 (1642?)

PF.K.
Dutch, 17th cent.

P.G.
see Gertner, Peter

P.G.C.
French, 18th cent.

P.H.
Dutch, op.1652

Ø H.
German, op.1581

P.H.K.
Dutch, 17th cent.

P.K.
Dutch, op.1670

P.K.
Dutch, op.1674

P.L.(?)
Dutch, 17th cent.

P.L.
Dutch, 18th cent.

P.L.S.
Flemish, op.1672

P.M.
German, 16th cent.

P.M.
Netherlands, 15th cent.

P.N.
Dutch, 17th cent.

P.N.
Hungarian, 15th cent.

(MONOGRAMMISTS: cont.)
P.N.
 Italian, 17th cent.
P.R.K.
 Dutch, op.1609-1617
P.P.
 Dutch, 17th cent.
P.P.
 Netherlands, 16th cent.
P.P.
 Flemish, 17th cent.
P.P. WITH THE LOOP
 Italian, 15th cent.
P.P.
 Italian, 16th cent
P.S.
 Dutch, 17th cent.
P.V.
 Flemish, 17th cent.
P.v.A.
 see Coecke van Aelst,
 Pieter, II
P.v.B.
 Dutch, op.1618
P.V.B.
 Dutch(?), 17th cent.
P.V.B.
 Flemish, op.c.1600
P.V.C.
 Flemish, op.1610
P.V.H.
 Dutch, op.1650
P.v.H.
 Dutch, 17th cent.
P.V.L.
 Netherlands, op.c.1520
P.W.
 German, op.c.1500
R.
 Dutch, op.c.1635
...R.
 Dutch, 17th cent.
R.A.
 German, op.1521
R.C.
 Swedish(?), op.1744
R.C.
 see Suycker, Reyer
 Claesz.
R.H.
 British, 19th cent.
R.K.
 Swiss, op.1785
R.O.S.
 Dutch(?), op.1611
R.V.
 Dutch, 17th cent.
R.V.A.
 see Auden-Aerd, Robert
 van
R. v. B.
 Dutch, op.1643
R.V.Fr.
 Dutch, 17th cent.
S.
 (possibly identified
 with Sanders Alexander
 van Brugsal)
 Netherlands,
 op.1505-1520
S.
 Dutch(?), 17th cent.(?)
S.
 see W.C.B.
S.A.
 German, op.1686
S.C.
 German, 18th cent.(?)

(MONOGRAMMISTS: cont.)
S.C.
 see Schmitt, Conrad
S.E.
 German, 16th cent.
S.F.
 German, op.1557
S.H.
 German, op.c.1540
S.H.
 Dutch, 17th cent.
S.I.
 Flemish(?), 18th cent.(?)
S.I.
 see I.S.
S.K.
 German, c.1520
S.K.
 Swiss, op.1550
S.L.
 Dutch, 18th cent.
S.M.
 British, op.1773
S.M.E.
 German, 16th cent.
S.N.
 Danish, op.1744
S.N.
 French(?), op.c.1830
S.N.
 German, 16th cent.
S.P.R.
 Netherlands, 16th cent.
S.T.
 Polish, 19th cent.
S.T.
 Swiss, op.1518
S.V.K.
 German, op.1537
S.W. (?)
 French, 18th cent.
S.Z.
 German, 16th cent.
T.B.
 Dutch, 17th cent.
T.F.
 German, op.1569
T.I.
 see I.T.
T.L.
 French, op.1828
T.R.
 British, 17th cent.
T.V.
 Dutch, op.1738
T.v.A.
 Dutch, op.c.1620
T.V.B.
 Dutch, 17th cent.
T.W.B.
 see Walther or
 Walthard, Thüring
V.
 Dutch, 17th cent.
V.B.
 Dutch, op.1660
V.E.
 French, op.1640
VEA (HR)
 see AVE (RH)
V.H.
 Dutch, 17th cent.
V.L.
 Dutch, 17th cent.
V.M.
 British, op.1637
V.M.H.
 Dutch, 17th cent.

(MONOGRAMMISTS: cont.)
V.P.
 German, op.1526
V.S.(?) or V.Z.(?)
 German, op.1530
V.S.Z.
 Dutch, op.1600
W. WITH THE SIGN ♀
 Netherlands, op.1465/85
W.
 German, 16th cent.
W.
 Spanish, op.1661
W.A.
 Netherlands, op.1460-1480
W.A.T.
 British, op.c.1780-1800
W.B.
 German, op.c.1480
W.C.B., née S.
 Dutch(?), 18th cent.(?)
W.C.H.
 Netherlands, op.1575
W.G.
 Flemish, 17th cent.
W.G.
 Flemish, op.1702
W.H.
 British, op.1787
W.H.
 British, 19th cent.
W.H.
 Flemish, 17th cent.
W.H.
 German, 15th cent.
W.K.
 German, op.1509
W.L.
 French, 18th cent.
W.R.
 Dutch, 17th cent.
W.R.
 German, c.1810
W.S.
 Dutch, 17th cent.
W.S.
 Dutch, 17th cent.
W.S. or V.V.S.
 Dutch, op.1653
W.S.
 German, op.1533-1548
W.I.B.
 German, 15th cent.
W.S. WITH THE MALTESE
 CROSS
 German, op.1515-1536
W.v.H.
 Dutch, 17th cent.
W.v.V.
 Dutch, op.1701
W.W.
 British, 19th cent.
W.W.M.
 German, 17th cent.
X.L.
 Italian, op.1491-1509
Y.C.L.
 Dutch, op.1623
Y.H.S.
 Italian, 16th cent.
Z.K.
 German, op.1531(?)-1541(?)
Z.T.
 Italian, 1500-1539
MONORY, Jacques
 French, 20th cent.
MONREALESE
 see Novelli, Pietro

MONRO, Alexander
 British, 18th cent.
MONRO, Henry
 British, 1791-1814
MONRO, John
 British, 1801-1880
MONRO, Nick
 British, 20th cent.
MONRO, Thomas
 British, 1759-1833
MONROY, Guillermo
 Mexican, 1924-
MONSALDY or Monsaldi,
 Antoine Maxime
 French, 1768-1816
MONSALVE
 Swiss, 20th cent.
MONSIAU, Nicolas
 André
 French, 1754-1837
MONSNIER, Pierre
 see Monier
MONSOCR
 see Callot, J.
MONSTED, Peder Mørk
 Danish, 1859-1941
MONSÙ, Bernardo
 see Keil
MONSÙ, Desiderio
 see Desiderio
MONT, A. Neven du
 French, 20th cent.
MONT, Deodat or
 Dieudonné van der
 see Delmont
MONT or Monte, Johannes,
 Jan or Hans
 Netherlands, op.1571-1581
MONTADER, Pierre Marie
 Alfred
 French, op.1881-1925
MONTAG, Carl
 Swiss, 1880-1956
MONTAGNA
 Italian(?), 19th cent.
MONTAGNA, Bartolomeo
 Italian, c.1450-1523
MONTAGNA, Benedetto
 Italian, c.1481-a.1558
MONTAGNA, Marco Tullio
 Italian, op.1618-1640
MONTAGNA, Monsù
 Italian, 17th cent.
MONTAGNA, Rinaldo della
 see Montagne
MONTAGNANA, Jacopo di
 Paride Parisati da
 Italian, c.1440/3-p.1499
MONTAGNE, Louis
 French, 1879-1926
MONTAGNE or Montaigne,
 Nicolas de
 see Plattenberg
MONTAGNE, Renaud de la
 (Rinaldo della Montagna)
 Dutch, -1644
MONTAGNY, Elie-Honore
 French, op.1819-m.1864
MONTAGUE, Alfred
 British, op.1832-1883
MONTAGUE, C.
 British, 19th cent.
MONTALANT, H. de
 French, 19th cent.
MONTALBA, Clara
 British, 1842-1929
MONTALBA, Ellen
 British, op.1868-1902

MONTALBA, Hilda
British, op.1876-1902
MONTALD, Constant
Belgian, 1862-
MONTALLIER, Pierre
French, 1643-1697
MONTALTO
see Danedi
MONTAN, Anders
Swedish, 1845-1917
MONTANARI, Dante
Italian, 1896-
MONTANARI, Giuseppe
Italian, 1889-
MONTANE, Roger
French, 1916-
MONTANINI, Pietro
(Pietruccio)
Italian, 1626-1689
MONTANO, Giovanni
Battista
Italian, 1534-1621
MONTANO, Giovanni
Battista (Il Montana)
see Lombardelli
MONTASSIER, Henri
French, 1880-
MONTAUD
French, 20th cent.
MONTBARD, George
(Charles Auguste
Loye)
French, 1841-1905
MONTCHINE, Abraham
Belgian(?), 20th cent.
MONTCORNET, Balthazar
see Moncornet
MONTE, Deodati del
see Delmont
MONTE del Fora or di
Giovanni
Italian, 1448-1529
MONTE, Johannes, Jan
or Hans
see Mont
MONTEBELLO
see Agostino da
Montebello
MONTEFUSCO, Vicenzo
Italian, 1926-
MONTEGUT, Maurice
French, 19th cent.
MONTEL, Alfred Lop
French, 20th cent.
MONTELATICI, Francesco
(Il Cecco Bravo)
Italian, op.1636-m.1661
MONTELUPO, Raffaele da
(Sinibaldi)
Italian, 1505(?)-1566
MONTEMEZZANO, Francesco
Italian, c.1540-p.1602
MONTEMEZZO, Antonio
Italian, 1841-1898
MONTEN, Dietrich
(Heinrich Maria)
German, 1799-1843
MONTENARD, Frédéric
French, 1849-1926
MONTENEGRO, Roberto
Mexican, 1885-
MONTEREGALI
see Enrico da Monreale
MONTERO de Rojas or
Roxas, Juan
Spanish, c.1613-1683
MONTERO, Ricardo
Spanish, 20th cent.

MONTES, José Cecilio
Spanish, 1833-1872
MONTESQUIOU-FEZENSAC,
Robert, Comte de
French, 1855-1921
MONTESSUY, Jean François
French, 1804-1876
MONTEZIN, Pierre
French, 1874-1946
MONTFIQUET
see Dupont, Louis
François Richard
MONTFOORT, Anthonie
(van) Blocklandt van
see Blocklandt
MONTFOORT, Hendrick
Assuerusz. van
see Assuerusz.
MONTFORT, Antoine Alphonse
French, 1802-1884
MONTFORT, Octavianus
French, 17th cent.
MONTHOLON, François
Richard de
French, 1856-
MONTI, A.
Hatian, 19th cent.
MONTI, Cesare
Italian, 1891-
MONTI, Francesco
(Il Brescianino delle
Battaglie)
Italian, 1646-1712
MONTI, Francesco
Italian, 1685-1768
MONTI, Gaetano Matteo
Italian, 1776-1847
MONTI, Giovanni
Battista
Italian, -1657
MONTI, Giovanni Giacomo
Italian, 1620-1692
MONTI, Niccolò
Italian, 1780-1864
MONTI, Virginio
Italian, op.1895
MONTICELLI, Adolphe
Joseph Thomas
French, 1824-1886
MONTIGNY, de
French, op.1772-m.a.1771
MONTIGNY, Jules Léon
Belgian, 1847-1899
MONTINI, Umberto
Italian, 1897-
MONTMARENCY, B.
see Monmorency
MONTOLIOT
Dutch(?), op.1665
MONTOLIU, Mateo
Spanish, c.1447-a.1504
MONTOLIU, Valentin
Spanish, op.1433-1469
MONTORFANO, Giovanni
Donato da
see Donato
MONTORSOLI or Montorsi,
Giovanni Angelo
(Angelo di Michele d'
Angelo da Poggibonsi)
Italian, 1507(?)-1563
MONTPENSIER, Duc de
French, op.1806
MONTPERCHER, Henri
see Mauperche
MONTPETIT, Armand
Vincent de
French, 1713-1800

MONTPEZAT, Henri Auguste
d'Ainecy, Comte de
French, 1817-1859
MONTRESOR, Beni
Italian, 19th cent.
MONTZAIGLE, Edgard de
French, op.1900
MONVERDE or Monteverde,
Luca
Italian, c.1500-1525/6
MONVOISIN, Domenica
(née Festa)
French, op.1831-m.1881
MONVOISIN, Raymond
Auguste Qimsac
(Pierre Raymond Jacques)
French, 1794-1870
MONZINI, Gennaro
Italian, 18th cent.
MOODIE, Donald
British, 1892-1963
MOODY, Fannie
British, 1861-
MOODY, Francis Wollaston
British, 1824-1886
MOODY, G.
British, 19th cent.
MOODY, W.R.
British, 20th cent.
MOON, Courtenay
American, 20th cent.
MOON, Henry George
British, 1857-1905
MOON, Jeremy
British, 20th cent.
MOON, Jim
American, 20th cent.
MOON, Michael
British, 20th cent.
MOONEY, Edward L.
American, 1813-1887
MOOR, A. de
Dutch(?), op.c.1600-1679
MOOR, Carel de
Dutch, 1656-1738
MOOR, J. de
Dutch, op.1659
MOORE, Abel Buel
American, 1806-1879
MOORE, Albert Joseph
British, 1841-1893
MOORE, Alexander Poole
British, op.1793-m.1806
MOORE, Barlow
British, op.1863-1890
MOORE, Charles H.
American, 1840-
MOORE, Claude T.
Stanfield
British, 1853-1901
MOORE, E.
British, 19th cent.
MOORE, Edward
British, op.1887
MOORE, Edwin
British, 1813-1893
MOORE, Ernest
British, 1865-
MOORE, G.
British, op.1797-1840
MOORE, George Belton
British, 1805-1875
MOORE, H.
British, 18th cent.
MOORE, Harriet
British, op.1852

MOORE, Harry Humphrey
American, 1844-1926
MOORE, Henry
British, 1831-1895
MOORE, Henry
British, 1898-
MOORE, J.
British, op.c.1825
MOORE, Jacob
see More
MOORE, James
British, 1762-1799
MOORE, John
British, op.1831-1837
MOORE, John Collingham
British, 1829-1880
MOORE, Ken
British, 1923-
MOORE, Michael Shannon
American, 1942-
MOORE, Pandora
British, 20th cent.
MOORE, R.H.
British, op.1878-1888
MOORE, Samuel
British, op.1680-1720
MOORE, Thomas Cooper
British, 1827-1901
MOORE, Thomas Sturge
British, 1870-1940
MOORE, William, I
British, 1790-1851
MOORE, William, II
British, 1817-1909
MOORE-PARK, Carlton
British, 1877-1956
MOORMANS, Franciscus
Leonardus Johannes
(Frans)
Dutch, 1832-p.1884
MOOS, Max von
Swiss, 1903-
MOOSBRUGGER or Mosbrugger,
Friedrich
German, 1804-1830
MOOSBRUGGER, Josef
German, 1810-1869
MOOSBRUGGER, Wendelin
German, 1760-1849
MOOY, Cornelis Pietersz.
de
Dutch, -1693
MOOY, Jaap
Scandinavian, 1915-
MOOY, Jan
Dutch, 1776-1847
MOPP
see Oppenheimer, Max
MOR van Dashorst,
Anthonis (Antonio
Moro)
Netherlands,
c.1517/21-1576/7
MORA, Francis Luis
American, 1874-1940
MORA, Francisco
Mexican, 1922-
MORA, Juan Gomez de
see Gomez de Mora
MORACH, Otto
Swiss, 1887-
MORADELL, Arcadi
Spanish, 20th cent.
MORADO, José
Chávez
Mexican, 1909-

MORAES or Morais,
 Cristóvão de
 Portuguese, op.1551-1571
MORAGAS y Torras,
 Tomas
 Spanish, 1837-1906
MORALES, Cristóbal de
 Spanish, op.1509-1542
MORALES, Divino
 Spanish, 16th cent.
MORALES, Juan Bautista
 Spanish, op.1600-1615
MORALES, (J)uanfranco
 Spanish, 17th cent.
MORALES, Luis de
 Spanish, c.1509(?)-1586(?)
MORALIS, Ioannis
 Greek, 1916-
MORALT, Paul
 German, 19th cent.
MORALT, Willy
 German, 1884-
MORAN(?), Auguste(?)
 French(?), op.1829
MORAN, Edward
 American, 1829-1901
MORAN, Edward Percy
 American, 1862-
MORAN, Santiago
 Spanish, op.1597-m.a.1629
MORAN, Thomas
 American, 1837-1926
MORAND, Eugène
 Edouard
 French, 1855-
MORAND, Guillemette
 French, 1913-
MORANDI, Francesco
 (Terribilia)
 Italian, op.1568-m.1603/4
MORANDI, Gino
 Italian, 1915-
MORANDI, Giorgio
 Italian, 1890-1964
MORANDI or Morando,
 Giovanni Maria
 Italian, 1622-1717
MORANDINI, Francesco
 (Il Poppi)
 Italian, 1544-1597
MORANDO, Paolo
 see Cavazzola
MORANI
 Italian, 18th cent.
MORANI, Vicenzo
 Italian, 1809-1870
MORANT, A.W.
 British, op.c.1855
MORANZONE, Jacopo
 Italian, op.c.1430-1467
MORARU, Theodor
 Rumanian, 20th cent.
MORAS, Walter
 German, op.1876-1910
MORASCH, Christian
 Gottfried
 German, 1749-1815
MORAT, Jean
 Swiss, 1869-1939
MORAZZONE, Marazzone,
 Moranzone or
 Pier Francesco
 Mazzuchelli, II
 Italian,
 1571/3-1626

MORBELLI, Angelo
 Italian, 1853-1919
MORCHAIN, Paul
 French, 1876-
MÖRCK, Jacob
 Swedish, 1748-1787
MORDANT, Daniel Charles
 Marie
 French, 1853-1914
MORDAUNT, Lady Mary
 Ann Holbech
 British, c.1778-1842
MORDEN, Robert
 British, op.1682
MORDT, Gustav Adolph
 Norwegian, 1826-c.1856
MORE or Moore, Jacob
 (James)
 British, 1740(?)-1793
MORE, Mary
 British, op.1574
MOREAU, Adrien
 French, 1843-1906
MOREAU, Anna
 see Merimee
MOREAU, Charles
 French, 1830-p.1881
MOREAU de Tours,
 Georges
 French, 1848-1901
MOREAU, Gustave
 French, 1826-1898
MOREAU, Jean Michel II
 French, 1741-1814
MOREAU, Louis
 French, 1883-
MOREAU, Louis Gabriel, I
 French, 1740-1806
MOREAU, Luc Albert
 French, 1882-1948
MOREAU, Pierre
 French, -1762
MOREAU, Pierre Louis
 French, 20th cent.
MOREAU-NELATON, Adolphe
 Etienne Auguste
 (Etienne)
 French, 1859-1927
MOREELS, Magd.
 Belgian, 20th cent.
MOREELSE, Benjamin
 Dutch, op.1648-m.1651
MOREELSE, Johan
 (Monogrammist J. or
 I. P.M.)
 Dutch, -1634(?)
MOREELSE, Paulus
 Dutch, 1571-1638
MOREELSE, Willem
 Dutch, op.1647-m.1666
MOREL, Arthur Pierre
 French, op.c.1880-1890
MOREL, Francois or
 Francesco Morelli
 Italian, c.1768-p.1830
MOREL, Jacob
 German, 1614-1681
MOREL, Jan Evert, I
 Dutch, 1777-1808
MOREL, Jan Evert, II
 Dutch, 1835-1905
MOREL, Jean-Baptiste
 (also, erroneously,
 Nicolas)
 Flemish, 1662-1732

MOREL d'Arleux,
 Louis Marie Joseph
 French, 1755-1827
MORELAND, H.
 British, 18th cent.
MOREI-PATIO, Antoine
 Léon
 French, 1810-1871
MORELL, H.
 Dutch(?), 18th cent.(?)
MORELL, Pit
 German, 20th cent.
MORELIET, F.
 French, 20th cent.
MORELLI, Bartolomeo
 (Il Pianoro)
 Italian, op.c.1674-m.1703
MORELLI, Carlo
 Italian, 16th cent.
MORELLI, Domenico
 Italian, 1826-1901
MORELLI, Francesco
 Italian, op.1581-1584
MORELLI, Francesco
 see Morel, Francois
MORENA
 Italian, 20th cent.
MORENI, Mattia
 Italian, 1920-
MORENO, José
 Spanish, c.1642-1674
MORENO, Maria
 Spanish, 1933-
MORERA y Galicia,
 Jaime
 Spanish, 1854-1927
MORERE, René
 French, 1907-1942
MORES or Mörs, Jacob
 (Monogrammist I.M.)
 German, c.1540-a.1612
MORET, Henri
 French, 1856-1913
MORETH (Morette)
 French, op.1796-1817
MORETI, Joseph
 Pasqualini
 see Moretti
MORETO
 see Mireto
MORETO, Jacinto
 Spanish, 1701-1759
MORETTE
 see Moreth
MORETTE, Jean Baptiste
 see Morret
MORETTI, Alberto
 Italian, 1922-
MORETTI, C.
 Italian, 19th cent.
MORETTI, Moreto or
 Moretto, Cristoforo
 de' (Rivelli)
 Italian, op.1452-1485
MORETTI, D.
 Italian, op.1823
MORETTI, Eugenio
 Italian, 1822-1874
MORETTI, Giovanni
 Battista
 Italian, op.1748
MORETTI, Giuseppe
 Italian, op.1776-1782
MORETTI or Moreti, Joseph
 Pasqualini (Pasquale,
 Pascalin) or Joseph Pascalin
 German, 1700-1758

MORETTI, Raymond
 Italian, 20th cent.
MORETTO, Alessandro
 Bonvicino
 Italian, c.1498-1554
MORETTO, Faustino
 Italian, -1668
MORGAN
 British, op.1814
MORGAN, Alfred
 British, op.1862-1904
MORGAN, Edward
 American, 19th cent.
MORGAN, Evelyn de,
 (née Pickering)
 British, 1850-1919
MORGAN, Fanny
 see Nonnen
MORGAN, Frederick
 British, c.1856-1927
MORGAN, Mrs. Frederick
 see Havers, Alice
MORGAN, Glyn
 British, 1926-
MORGAN, Jane
 American, 1832-1899
MORGAN, John
 British, 1823-1886
MORGAN, Louis
 American, 1814-1852
MORGAN, Matthew
 British, 1839-1890
MORGAN, R.
 British, 19th cent.
MORGAN, Randall
 American, 1920-
MORGAN-SNELL
 British, op.1964
MORGANTI, Bartolomeo
 (Bartolomeo di Matteo
 Marescalchi or
 Bartolomeo da Fano)
 Italian, op.1510-1536
MORGANTI, Pompeo
 (not Presciutto)
 Italian, op.1532-m.1569

MORGENS, de
 German(?), 18th cent.
MORGENSTERN, Carl
 German, 1811-1893
MORGENSTERN, Carl Ernst
 German, 1847-1928
MORGENSTERN, Christian
 Ernst Bernhard
 German, 1805-1867
MORGENSTERN, Friedrich
 Ernst
 German, 1853-1919
MORGENSTERN, Friedrich
 Wilhelm Christoph
 German, 1736-1798
MORGENSTERN, Johann
 Christoph
 German, 1697-1767
MORGENSTERN, Johann
 Friedrich
 German, 1777-1844
MORGENSTERN, Johann
 Ludwig Ernst
 German, 1738-1819
MORGENTHALER, Charles
 Swiss, op.1847
MORGENTHALER, Ernst
 Swiss, 1887-
MORGHEN, Antonio
 (Il Tenente)
 Italian, 1788-1853

MORGHEN, Raffaelle
Italian, 1758-1833
MORGNER, Wilhelm
German, 1891-1917
MORGUNOW, Alexej
Ale Keewitsch
Russian, 1884-1935
MORI, Ferdinando
Italian, 1775-
MORI, J.
French, 19th cent.
MORI, Neno
Italian, 1889-
MORIANI, Giuseppe
Italian, op.1729
MORIATE, N.
Italian(?), 17th cent.
MORIC, Sandor
Hungarian, 1885-1924
MORICCI, Giuseppe
Italian, 1806-1879/83
MORICONI, Angelo
Italian, 1932-
MORIER, David
Swiss, c.1705-1770
MORIES or Moriez
French, c.1760-c.1812
MORILLO, José
Spanish, 1854-1920
MORILLOT, Octave
French, 1878-
MORIN, Edmond
French, 1824-1882
MORIN, Eugénie
French, 1800-1875
MORIN, Eulalie,
(née Cornillaud)
French, op.1798-1800
MORIN, Jean
French, a.1600-c.1650
MORIN, Louis
French, 1855-
MORINA, Giulio
Italian, 16th cent.
MORINI, Giovanni
Italian, op.1611
MORINO, Edmund Pick
German, 1877-1958
MORISE, Max
French, 20th cent.
MORISOT, Berthe Marie
Pauline (Berthe Manet)
French, 1841-1895
MORISSET, François
Henri (Henri)
French, 1870-
MORISSON or Morison,
Friedrich Jakob
German, op.1693-1697
MORITZ, Carl
German, 1863-
MORITZ, Friedrich
Wilhelm (Wilhelm)
Swiss, 1783-1855
MORITZ, Louis
Dutch, 1773-1850
MORLAITER, Michelangelo
Italian, 1729-1806
MORLAND, George Charles
British, 1763-1804
MORLAND, George Henry
British, -1789
MORLAND, Henry
British, op.1675
MORLAND, Henry Robert
British, c.1730-1797

MORLAND, James Smith
British, 1846-1921
MORLEY, Countess
see Parker, Francess
MORLEY, George
British, op.1832-1863
MORLEY, Harry
British, 1881-1943
MORLEY, John
British, 20th cent.
MORLEY, Malcolm
British, 1931-
MORLON, Antony Paul
Emile
French, op.1868-1905
MORLOT, Alphonse
Alexis
French, 1838-1918
MORLOTTI, Ennio
Italian, 1910-
MÖRNER or Morner, Carl
Gustaf Hjalmar
Swedish, 1794-1837
MÖRNER, Stellan
Swedish, 1896-
MORNEWICK I and II,
Charles Augustus
British, op.1826-1874
MORNEWICK, Henry Claude
British, op.1827-1846
MORO, Antonio
see Mor
MORO, Battista Angolo
del
see Angolo
MORO, Ferrucio
Spanish, 1859-
MORO, Franz
German, op.1900-1940
MORO, Giacomo Antonio
Italian, 1519-1575
MORO, Il
see Torbido, Francesco
MORO, Lorenzo del
Italian, 1677-1735
MORO, Marco Angelo or
Angeli del
see Angolo del Moro
MORONE, Domenico
Italian, 1442-p.1517
MORONE, Francesco
Italian, 1471-1529
MORONI
Italian, 19th cent.
MORONI, Federico
Italian, 20th cent.
MORONI or Morone,
Giambattista
Italian, c.1525-1578
MOROSINI, Francesco
(Montepulciano)
Italian, op.c.1640
MOROSOW, Alexander
Ivanovich
Russian, 1835-1904
MOROT, Aimé Nicolas
French, 1850-1913
MOROT, Ernest Victor
Paul
French, op.1880-1920
MORPHEY, Garret
British, -1715/16
MORREALESE
see Novelli, Pietro
MORREL, Jacob
see Marrel

MORREN, George
French, 1868-
MORRET, Morette or
Morrette, Jean
Baptiste
French, op.1790-1820
MORRICE, James Wilson
Canadian, 1865-1924
MORRILL, D.
American, op.1860
MORRIS, A.
British, op.1788-1794
MORRIS, Alfred
British, op.1853-1873
MORRIS, Carl A.
American, 1911-
MORRIS, Cedric
British, 1889-
MORRIS, Charles Greville
British, 1861-1922
MORRIS, Desmond
British, 20th cent.
MORRIS, Ebenezer Butler
British, op.c.1833-1863
MORRIS, George Lovett
Kingsland
American, 1905-
MORRIS, J.C.
British, op.1851-1862
MORRIS, J.R.
British, op.1806
MORRIS, J.W.
British, 19th cent.
MORRIS, James Archibald
British, 1857-1942
MORRIS, Kathleen Moir
Canadian, 1893-
MORRIS, Kyle
American, 1917-
MORRIS, May
British, -1938
MORRIS, Michael
Canadian, 20th cent.
MORRIS, Oliver
British, 19th cent.
MORRIS, Miss Phil
British, 19th cent.
MORRIS, Philip Richard
British, 1836-1902
MORRIS, Richard
British, op.1830
MORRIS, Robert
American, 20th cent.
MORRIS, Robert
Mackenzie
British, 1899-
MORRIS, Thomas
British, op.1790
MORRIS, W.W.
British, op.c.1852
MORRIS, William
British, 1834-1896
MORRIS, William Bright
British, 1844-p.1912
MORRISON
British, op.1760
MORRISON, Alexander
British, 19th cent.
MORRISON, E.R.
British, 20th cent.
MORRISON, John
British, 1904-
MORRISSET, André
French, 1876-
MORRO, Francesco
Italian, 1759-1845

MORROCCO, Alberto
British, 1917-
MORROW, Albert
British, 1863-1927
MORROW, Edwin A.
British, 20th cent.
MORROW, George
British, 1870-1955
MORROW, Norman
British, 20th cent.
MÖRS, Jacob
see Mores
MORSE, Samuel Finley
Breeze
American, 1791-1872
MORSEL, Jacob
see Marrel
MORSIANI or Marziano
Italian, 16th cent.
MORSILO
Italian, 16th cent.(?)
MORSTADT, Anna
German, 1874-
MORSTADT, Vinzenz
German, 1802-1875
MORTAN, Thomas Corsan
British, 1869-
MORTEL, Johannes or Jan
Dutch, c.1650-1719
MORTELMANS, Frans
German, 1865-1936
MORTEN, Thomas
British, 1836-1866
MORTENSEN, Richard
Danish, 1910-
MORTIER, Antoine
Belgian, 1908-
MORTIMER, Alexander
British, 19th cent.
MORTIMER, John Hamilton
British, 1740-1779
MORTIMER, John Henry
British, 18th cent.
MORTO da Feltre
(Lorenzo Luzzo)
Italian, c.1467-1512
MORTON, Alastair
British, 1910-
MORTON, Andrew
British, 1802-1845
MORTON, Cavendish
British, 1911-
MORTON, Douglas G.
Canadian, 20th cent.
MORTON, Edward
British, 19th cent.
MORTON, G.
British, 18th cent.
MORTON, George
British, op.1879-1904
MORTON, Henry
British, op.1807-1825
MORTON, Thomas Corsan
British, 1859-1928
MORTREUIL
French, 18th cent.
MORVAN, Hervé
French, 20th cent
MOS, Lisbeth
German, 1902-
MOSBRUGGER
see Moosbrugger
MOSCA
Italian, 20th cent.
MOSCA, Francesco
Italian, op.1670

MOSCA, Simone
(Moschini)
Italian, 1492-1553
MOSCH, C.F.
German, op.1820-1830
MOSCHELES, Felix
Stone
British, 1833-1917
MOSCHER or Mosker,
I. van
Dutch, op.1635-1655
MOSCHOS, Elias
Greek, op.1645
MOSCHOS, Joannes
Greek, 17th cent.
MOSELEY, Henry
British, op.1842-1866
MOSELY, J.
British, op.1817
MOSENGEL, Adolf
German, 1837-1885
MOSER, George Michael
British, 1706-1783
MOSER, James Henry
Canadian, 1854-1913
MOSER, Josef
German, 1783-
MOSER, Julius
German, c.1808
MOSER, Koloman (Kolo)
German, 1868-1918
MOSER, Lukas
German, op.1431
MOSER, Mary (Lloyd)
British, 1744-1819
MOSER, Oswald
British, 1874-
MOSER, Richard
German, 1874-
MOSER, Wilfried
Swiss, 1914
MOSERN, Ernst
Christian
German, 1815-1867
MOSES, Anna Mary
Robertson (Grandma
Moses)
American, 1860-1961
MOSES, Edward Branco
American, 1926-
MOSES, Henry
British, c.1782-1870
MOSINSKI, Marek
Polish, 20th cent.
MOSKER, I. van
see Moscher
MOSLER, Henry
American, 1841-1920
MOSLEY, Charles
British, c.1720-c.1770
MOSLEY, Charles
British, 20th cent.
MOSMAN, Gulliver
British, op.1741-1747
MOSMANN, Nikolaus
German, 1727-1787
MOSNIER, Jean Laurent
French, 1743/4-1808
MOSNIER, Pierre
see Monier
MOSS, Marlow
British, 1890-1958
MOSS, William
British, op.1775-1782
MOSSA, Gustave Adolphe
French, 19th cent.
MOSSES, Alexander
British, 1793-1837

MOSSIS, Vincenzo
Valerio
Italian, op.1551
MOSSMAN, David
British, 1825-1901
MOSSMER, Joseph
German, 1780-1845
MOSSO, Francesco
Italian, 1849-1877
MOSSON, George
German, 1851-1933
MOST, Ludwig August
German, 1807-1883
MOSTAERT, Frans
Netherlands,
op.1554-m.1560
MOSTAERT, Gillis
Netherlands,
op.1554-m.1598
MOSTAERT, Jan
(Joannes Sinapius)
Netherlands,
c.1472/3-1555/6
MOSTYN, Thomas Edwin
(Tom)
British, 1864-1930
MOTE, George William
British, 1832-1909
MOTE, W.H.
British, op.c.1850
MOTELET
French, op.1795
MOTESICZKY, Marie
Louise
German, 1906-
MOTHE, Louis la
see Lamothe
MOTHERWELL, Robert
Burns
American, 1915-
MOTTA
see Raffaelino da
Reggio
MOTTE, Henri Paul
French, 1846-1922
MOTTET, Johann Daniel
Swiss, 1754-1822
MOTTET, Yvonne
French, 20th cent.
MOTTEZ, Mme.
French, 19th cent.
MOTTEZ, Victor Louis
French, 1809-1897
MOTTI or Mottis,
Agostino
Italian, c.1450/3-p.1483
MOTTI or Mottis,
Jacopo de'
Italian, op.1481-m.1505
MOUALLA, Fikret
French, 20th cent.
MOUCHERON, Frederik de
Dutch, 1633-1686
MOUCHERON, Isaac de
(Ordonanntie)
Dutch, 1667-1744
MOUCHET, François
Nicolas
French, 1749-1814
MOUCHOT, Louis Claude
French, 1830-1891
MOUCLIER, Marc
French, 1865-
MOULIGNON, Leopold
French, 1821-1897
MOULINET, Antoine
Edouard Joseph (Edouard)
French, 1833-1891

MOULINNEUF, Gabriel
French, 1749-1817
MOULLIN, Louis
French, 19th cent.
MOULLION or Mouillon,
Alfred
French, 1832-1886
MOULTHROP, Reuben
American, 1763-1814
MOULIJN, Simon
Dutch, 1866-1948
MOUNCEY, William
British, 1852-1901
MOUNT, Henry Smith
American, 1802-1841
MOUNT, Shepard Alonzo
American, 1804-1868
MOUNT, William Sidney
American, 1807-1868
MOUNTAIN, Mountin or
Muntinck, Gerard,
George or Gerrit
British, 17th cent.
MOUR, Jean Baptiste
van
French, 1671-1737
MOURA
see Moira
MOURAUD, Tania
French, 20th cent.
MOURIN, Charles
French, 19th cent.
MOUSSEAU, Jean-Paul
Canadian, 1927-
MOUSTAKI, Georges
Greek, 20th cent.
MOUTARD-MARTIN
French, 20th cent.
MOUTTE, Jean Joseph
Marie Alphonse
French, 1840-1913
MOUVEAU, Lefèvre
French, 20th cent.
MOWBRAY, Henry Siddons
American, 1858-
MOY, Joseph
German(?), 18th cent.
MOYA, Pedro de
Spanish, 1610-1674
MOYAERT
see Moeyaert
MOYER, Roy
American, 1921-
MOYES, Jim
British, 1937-
MOYNAN, Richard Thomas
British, 1856-1906
MOYNIER, Auguste
Louis Denis
French, -1891
MOYNIHAN, Rodrigo
British, 1910-
MOYURE, de
Dutch(?), op.1627
MOZART, Anton
German, 1573-1625
MOZATTO, Carlo
Italian, 17th cent.
MOZIN, Charles Louis
French, 1806-1862
MRKUSICH, Milan
New Zealand, 1925-
MRKVICZKA, Ivan Vazlav
Bulgarian, 1856-1938
MROCZKOWSKI, Alexandre
Polish, 1850-

MROZ, Daniel
Polish, 1917-
MUBLER
British, 19th cent.
MUCCHI, Gabriele
Italian, 1899-
MUCCINI, Marcello
Italian, 1926-
MUCH or Mugh, Enoch
Dutch, op.c.1650
MUCHA, Alfons Marie
Czech, 1860-1939
MUCHA, P.
German, op.c.1900
MUCHE, Georg
German, 1895-
MUCIANO, Jeronimo
Spanish, 15th cent.(?)
MÜCKE, Heinrich Carl
Anton
German, 1806-1891
MÜCKE, Karl Emil
German, 1847-1923
MUCKLEY, Louis Fairfax
British, op.1889-1914
MUCKLEY, William Jabez
British, 1837-1905
MUDO, El
see Fernández de
Navarrete, Juan
MUDO, Pedro el
(not Pelmado)
Spanish, op.1634-m.1648
MUDROCH, Jan
Czech, 1909-
MUELEN, Steven van der
see Meulen
MUELENBERG, M.
Dutch, 17th cent.
MÜELICH, Mielich or
Mülich, Hans
German, 1516-1573
MÜELICH, Mielich or
Muelich, Wolfgang
German, op.1509
MUELLER, George Ludwig
American, 1929-
MUELLER, Otto
German, 1874-1930
MUELLER, Stephen
American, 20th cent.
MUENIER, Jules Alexis
French, 1863-
MUENTER, Gabriele
see Münter
MUGH, Enoch
see Much
MUGUR, Costica
Romanian, 1895-
MUHL, Roger
French, 20th cent.
MÜHLDÖRFER, Josef
German, 1800-1863
MÜHLENEN, Max von
Swiss, 1903-
MÜHLIG, Albert
German, 1862-1909
MÜHLIG, Bernhard
German, 1829-1910
MÜHLIG, Meno
German, 1823-1873
MÜHLIG, Theodor Hugo
(Hugo)
German, 1854-1929
MUHLSTOCK, Louis
Canadian, 1904-
MUHRMANN, Henry
American, 1854-1916

221

MUILTGUER, Adrian
Danish, op.c.1637-1641
MUIRHEAD, David
British, 1867-1930
MUIRHEAD, John
British, 1863-1927
MUJE, H.D.
American, op.c.1770
MULARD, Francois Henri
French, 1769-1850
MULHOLLAND, S.A.
British, 19th cent.
MÜLICH
see Muelich
MULIER or Molier,
Pieter, I
Dutch, c.1615-1670
MULIER, Pieter, II
(Tempesta or Teempeest)
Dutch, c.1637-1701
MULINARETTO, Giovanni
Maria delle Piane
Italian, 1660-1745
MULINARI, Giovanni Battista
see Molinari
MULINARI, Stefano
Italian, c.1741-c.1790
MÜLLDORFER
see Mildorfer
MULLEN, A.
German, 19th cent.
MÜLLENER, Melluner or
Müller, Johann Carl
Swiss, 1768-1832
MÜLLER, Adam August
Danish, 1811-1844
MÜLLER, Albert
Swiss, 1897-1926
MÜLLER, Andreas Johann
Jakob Heinrich
German, 1811-1890
MÜLLER, Anton
German, op.c.1592
MÜLLER, Anton
German, 1853-1897
MÜLLER, August
German, 1836-1885
MÜLLER, Bertha
German, 1848-1925
MULLER, Bonaventura
German, 16th cent.
MULLER, Camille
Victor Louis
French, 1861-1880
MÜLLER, Carl Friedrich
Johann von
German, 1813-1881
MÜLLER, Carl Friedrich
Moritz
German, 1807-1865
MÜLLER, Carl Wilhelm
German, 1839-1904
MULLER, Charles François
French, 1789-1855
MÜLLER, Charles Louis
Lucien
French, 1815-1892
MÜLLER, Christian
David
German, 1718-c.1797
MÜLLER, Cornelius L.
German, op.c.1900
MULLER, Daniel
British, 19th cent.
MULLER, Edmund Gustavus
British, 1816-1888

MÜLLER, Eduard
French, 1823-1876
MÜLLER, Eduard Josef
German, 1851-
MULLER, Edward
American, 19th cent.
MÜLLER, Emil
German, 1863-
MÜLLER, Emma von
see German, 1859-
MÜLLER, Ernst Immanuel
German, 1844-
MÜLLER, F.
German, op.1847
MÜLLER, François Aloys
Swiss, 1774-p.1811
MÜLLER, Franz Hubert
German, 1784-1835
MÜLLER, Friedrich
(Maler Müller)
German, 1749-1825
MÜLLER, Frits
Dutch, 20th cent.
MÜLLER, G.
German, op.1617
MÜLLER, Gottlieb
(Gottfried) Friedrich
Ehrenreich
German, 1777-1858
MÜLLER, H.
German, 19th cent.
MÜLLER, Hans Peter
German, op.c.1600
MULLER, Harmen Jansz.
Dutch, c.1540-1617
MÜLLER, Heinrich
Swiss, 1885-1960
MULLER, Hendrik
Dutch, 1803-1889
MULLER, Jacques or
Jacob
Dutch, op.1645-m.1673
MULLER, Jan or Joannes
Dutch, 1571-1628
MÜLLER, Jan
American, 1922-1958
MÜLLER or Miller,
Johann (not Joseph)
Adam
German, op.1718-m.1738
MÜLLER, Johann Carl
see Müllener
MÜLLER, Johann Christian
Ernst (Christian)
German, 1766-1824
MÜLLER, Johann Christoph
German, op.1730-1750
MÜLLER, Johann Georg
Swiss, 1822-1849
MÜLLER, Johann Gotthard
von
German, 1747-1830
MÜLLER, Johann Jakob
Swiss, op.1649-1653
MÜLLER, Johann Jakob
German, 1765-1832
MÜLLER, Johann Peter
see Molitor
MÜLLER, Karl
German, op.1906
MÜLLER, Karl Erich
German, 1917-
MÜLLER, Leopold Carl
German, 1834-1892
MÜLLER, Mathis
Swiss, op.1502

MÜLLER, Max
German, 1871-
MÜLLER, Michael
German, op.1536-1574
MÜLLER, Michael, II
Swiss, op.1612
MÜLLER, Michael Kinig
German, op.1606
MÜLLER, Moritz
see Steinla
MÜLLER, Moritz, II
German, 1841-1899
MÜLLER, Morten
Norwegian, 1828-1911
MÜLLER, Peter Paul
Swiss, op.1623-m.1642
MÜLLER, Peter Paul
German, 1853-
MÜLLER, Richard
German, 1874-1930
MULLER, Robert
British, op.1789-1800
MÜLLER, Robert
(Warthmüller)
German, 1859-1895
MÜLLER, Robert
Swiss, 1920-
MÜLLER, Rolf
German, 1903-1956
MÜLLER, Rudolph
Swiss, 1802-1885
MÜLLER, T. (?)
German(?), op.1671
MÜLLER, Victor
German, 1829-1871
MULIER or Müller,
William James (John)
British, 1812-1845
MULLER-BAUMGARTEN, Carl
German, 1879-
MÜLLER-CORNELIUS, L.
German, op.c.1900
MÜLLER-HUFSCHMID, Willi
German, 1890-
MÜLLER-HUFSCHMIDT, E.
German, 20th cent.
MÜLLER-KRAUS, Erich
German, 1911-
MÜLLER-LANDECK, Fritz
German, 1865-1942
MÜLLER-LINGKE, Albert
German, 1844-
MÜLLER-URY, Adolf
Felix
American, 1862-1947
MULLEY, Oskar
German, 1891-1949
MULLICAN, Lee
American, 1919-
MULLIGAN, A.
British, op.1895
MULLINS, George
British, op.1756-1775
MULLOCK, J.
British, op.1854
MULNIER, T.B.
French, op.1755-1780
MULREADY, Augustus E.
British, op.1863-m.1886
MULREADY, Elisabeth
see Varley
MULREADY, P.A.
British, op.1827-1855
MULREADY, William
British, 1786-1863

MULRENIN, Bernard
British, 1803-1868
MULTSCHER, Hans
German, c.1400-1467
MULTZ, Andreas Paul
German, op.1680
MULVANY, George
Francis
British, 1809-1869
MULVANY, John George
British, 1766-1838
MULVANY, Thomas James
British, op.1809-1846
MULVIHILL, Terence
British, 1943-
MUNARI degli Aretusi,
Cesare
see Aretusi
MUNARI, Cristoforo
Italian, 17th cent.
MUNARI or Aretusi,
Pellegrino
see Aretusi
MUNCASTER, Claude
Grahaeme
British, 1903-
MUNCH, Anna Elisabeth
Danish, 1876-
MUNCH, Edvard
Norwegian, 1863-1944
MUNCH, Eggert
Norwegian, c.1685-1764
MUNCH, Jacob Edward
Norwegian, 1776-1839
MUNCK, C.H. de
German, 17th cent.
MUNCK or Munch, Justus
(J. Nic. Mönch ?)
German, op.1659-1677
MUNDELL, J.
British, 19th cent.
MUNDY, Henry
British, 1919-
MUNDY, Rosemary
American, 20th cent.
MUNDY, W.
British, op.1814
MUNERET, G.
French, op.1804-1814
MUNFORD, Robert
British, 20th cent.
MUNGER, George
American, 1783-1824
MUNGER, Gilbert
British, 1837-1903
MUNICKHUYSEN, Johannes
see Munnickhuysen
MUNIER, Amélie, (née
Romilly)
French, 1788-1875
MUNIER, Emile
French, 1810-p.1895
MUNKACSY, Mihaly or
Michael von (Leo Lieb)
Hungarian, 1844-1909
MUNN, George F.
American, 1852-1907
MUNN, James
British, op.1764-1774
MUNN, Paul Sandby
British, 1773-1845
MUNNEKUS, Hendrik
see Munniks
MUNNICH, Heinz
German, 1921-

MÜNNICHHOVEN or
Münnichhofen, Hendrik
Dutch, op.1648-m.1664
MUNNICKHUYSEN or
Munickhuysen, Johannes
Willemsz.
Dutch, 1654/5-p.1701
MUNNIKS or Munnekus,
Hendrik
Dutch, op.1627-1646
MUNNINGHOFF, Xeno
Augustus Franciscus
Ludovicus
Dutch, 1873-1944
MUNNINGS, Sir Alfred
James
British, 1878-1959
MUÑOZ, Blas
Spanish, 1620-p.1696
MUÑOZ y Cuesta,
Domingo
Spanish, 1850-1912
MUÑOZ, Evaristo
Spanish, 1684-c.1737
MUÑOZ, Lucio
Spanish, 1929-
MUÑOZ, M.
Spanish, 19th cent.
MUÑOZ, Pedro
Spanish, op.c.1640-1650
MUÑOZ, Sebastian
Spanish, 1654-1690
MUÑOZ y Lucena,
Tomas
Spanish, 1860-
MUÑOZ-DEGRAIN, Antonio
Spanish, 1843-1924
MUNSCH, Josef
German, 1832-1896
MUNSCH, Leopold
German, 1826-1888
MUNSON, William Giles
American, 1801-1878
MUNSTERHJELM, Hjalmar
(Magnus Hjalmar)
Finnish, 1840-1905
MUNSTERHJELM, Johan
Hjalmar
Finnish, 1879-1925
MÜNTER, Gabriele
German, 1877-1962
MUNTHE, Alf
Swedish, 1892-
MUNTHE, Gerhard Peter
Frantz Vilhelm
Norwegian, 1849-1929
MUNTHE, Ludwig
Norwegian, 1841-1896
MUNTHE-NORSTEDT, Anna
Swedish, 1854-1936
MUNTINCK or Munting,
Adriaen
Dutch, op.1597-1617
MUNTINCK, Gerard
see Mountain, Gerard
MÜNTZ or Muntz,
Johann Heinrich
French, 1727-1798
MÜNZER, Adolph
German, 1870-1952
MUR, Ramón de
(Identified with the
Master of Guimera)
Spanish, op.c.1420-1435
MURA, Charlotte
British, op.c.1894-1905

MURA or Muro
(not Lamura or della
Mura), Francesco de
Italian, 1696-1782
MURA, Frank
American, -1861
MURANO, Antonio da
see Vivarini,
Antonio
MURANO, Giovanni da
see Giovanni de
Alamagna
MURANT or Meuron,
Emanuel
Dutch, 1622-c.1700
MURARI, Giovanni
Italian, 1669-
MURATON, Alphonse
(Frédéric Alphonse)
French, 1824-1911
MURATON, Euphémie,
(née Duhanot)
French, 1840-
MURATORI, Domenico
Maria
Italian, c.1661-1744
MURATORI, Teresa
Italian, 1662-1708
MURAY, Robert
Hungarian, 20th cent.
MURCH, Walter Tandy
American, 1907-
MURE, Miss -
British, 19th cent.
MUREL, Jacob
see Marrel
MURER or Maurer,
Christoph
Swiss, 1558-1614
MURER, Eugène
French, 1845-1906
MURER, Hans, I
German, -1486/7
MURER, Hans, II
German, 15th cent.
MURER, Hans Jacob
see Maurer
MURER, Jacob
German, op.c.1525
MURER or Maurer, Jos
or Jodokus, I
Swiss, 1530-1580
MURER or Maurer, Josias,
II
Swiss, 1564-1630
MURET, Albert
Swiss, 1874-
MURGALIE, Murgalet or
Murgaley, Pierre
French, op.1610-m.1665
MURILLO, Bartolomé
Esteban
Spanish, 1617-1682
MURPHY
British, op.1854
MURPHY, Denis
Brownell
British, op.1763-m.1842
MURPHY, Gerald
American, 20th cent.
MURPHY, Hermann Dudley
American, 1867-1945
MURPHY, John Francis
American, 1853-1921
MURPHY, Myles
British, 1927-

MURPHY, William D.
American, 1834-1932
MURRAY, Albert K.
American, 1906-
MURRAY, Alexander
Hunter
Canadian, 19th cent.
MURRAY, Anne
British, op.1816
MURRAY, Charles
British, 1894-
MURRAY, Charles Fairfax
British, 1849-1919
MURRAY, Sir David
British, 1849-1933
MURRAY, Elizabeth,
(née Heaphy)
British, 1815-1882
MURRAY, Frank
British, op.1876-1899
MURRAY, J.
South African, op.1813
MURRAY, James
British, 1831-1863
MURRAY, John
British, -1735
MURRAY, John Reid
British, 1861-1906
MURRAY or Murrey,
Thomas
British, 1663-1734
MURRAY, W.
British, op.1797
MURRAY, William Grant
British, 1877-1950
MURTIC, Edo
Yugoslav, 1921-
MURU, Giovanni
Italian, op.1515
MUSARD, Daniel
Swiss, op.1739
MUSCHAMP, F. Sydney
British, op.1884-1903
MUSENIUS
see Muus
MUSGRAVE, Mrs
see Heaphy, M.A.
MUSGRAVE, George
British, op.1837
MUSGRAVE, Harry
British, op.1884-1903
MUSI, Agostino dei
see Agostino
Veneziano
MUSIALOWICZ, Henryk
Polish, 1914-
MUSIC, Zoran (Antonio)
Yugoslav, 1909-
MUSIN, Auguste
Henri
Belgian, 1852-
MUSIN, Francois Etienne
Belgian, 1820-1888
MUSS or Musso, Charles
British, 1779-1824
MUSSARD, Jean
Swiss, 1681-1754
MUSSARD, Robert
Swiss, 1713-1777
MUSS-ARNOLT, G.
American, 20th cent.
MUSSATOFF or Borissoff-
Mussatoff, Victor
Russian, 1870-1905
MUSSCHER, Michiel van
Dutch, 1645-1705

MUSSET, Alfred de
French, 1810-1857
MUSSILLA, W.
German, 19th cent.
MUSSINI, Cesare
German, 1804-1870
MUSSINI, Luigi
Italian, 1813-1888
MUSSO, Niccolò
Italian, -c.1618/20
MUTER, Mela
Polish, 1876-
MUTHSPIEL, Agnes
German, 1914-
MUTIN, Jean Baptiste
French, 1789-1855
MUTIS, Feliciano
see Feliciano da
Foligno
MUTOLO, Il
see Sabbatini, Gaetano
MUTRIE, Annie Feray
British, 1826-1893
MUTSCHELE, Moutchelle
or Muschelle, Martin
(Franz Martin)
German, 1733-1804
MUTTENTHALER, Anton
German, 1820-1870
MUTTONI, Pietro
(della Vecchia)
Italian, 1605-1678
MÜTZEL
German, op.1825-1828
MUTZENBECHER, Werner von
German, 1937-
MUUS or Musenius,
Didrik Nielssøn
Norwegian, 1633-1706
MUXART, Jaime
Spanish, 20th cent.
MUYCKENS, Jan Barentsz.
Dutch, op.1637-1648
MUYDEN, Evert van
Swiss, 1853-1922
MUYDEN, Henri van
Swiss, 1860-
MUYDEN, Jacques Alfred
(Alfred) van
Swiss, 1818-1898
MUYS, Nicolaas
Dutch, 1740-1808
MUYSER, Arnout de
Netherlands, 17th cent.(?)
MUZIANO, Girolamo
(Il Giovane dei paesi)
Italian, 1528-1592
MUZIKA, Frantisek
Czech, 1900-
MUZZI, Domenico
Italian, 1742-1812
MY, Mey or Mij,
Hieronymus van der
Dutch, 1687-1761
MYE, A.
Dutch(?), 18th cent.(?)
MYE, J. van
Dutch, op.c.1645
MYERHOP, Frans van
Cuyck de
see Cuyck
MYERS, B.
British, 18th cent.
MYERS, Bernard
British, 20th cent.

MYERS, C.H.
German(?), 19th cent.
MYERS, Jerome
American, 1867-1940
MYIER, G.
Netherlands, op.1624
MYIN or Myn, Hendrik
Aarnout
Flemish, 1760-1826
MYIN, Maria Jacoba,
(née Ommeganck)
see Ommeganck
MYLE, Simon
French, op.c.1535
MYLIUS or Milius,
Carl Heinrich
Swiss, 1734-1758
MYLNIKOW, Andrej
Russian, 20th cent.
MYN, Agatha van der
Dutch, op.1777
MYN, Cornelia van der
British, 1710-p.1737
MIJN, Frans van der
Dutch, 1719-1783
MIJN, George van der
Dutch, 1723/7-1763
MYN or Mijn, Gerard
van der
Dutch, 1706-p.1761
MYN, Hendrik Aarnout
see Myin
MYN, Herman or
Heeroman van der
Dutch, 1684-1741
MYN, P. de
Dutch, 17th cent.(?)
MIJN, Robert van der
Dutch, 1724-p.1764
MIJNHEER
see Jansz., Govert
MIJNNESTEN, Jan
van den
see Monogrammist
I.A.M. of Zwolle
MYNOTT, Derek
British, 20th cent.
MYRBACH-RHEINFELD,
Felician von
German, 1853-
MYRICENIS, Petrus
see Heyden, Pieter
van der
MYTENS, A.
Dutch, op.1656
MYTENS, Aert or
Arnold (Rinaldo
Fiammingo)
Netherlands,
c.1541(?)-1602
MYTENS or Mijtens,
Daniel, I. Martensz.
Dutch, c.1590-a.1648
MYTENS or Mijtens,
Daniel, II
Dutch, 1644-1688
MYTENS, Isaac
Dutch, 1602-1666
MYTENS or Mijtens,
Johannes or Jan
Dutch, c.1614-1670
MYTENS, Martin, I
Dutch, 1648-1736
MYTENS or Meytens,
Martin, II van
Swedish, 1695-1770

MYTS, J.
Dutch, op.1645/9

N

NABERT, Wilhelm
Julius August
German, 1830-1904
NACHTRIEB, Michael
Strieby
American, 1835-1916
NADAILLAC, Comtesse de
French, 19th cent.
NADAL, Miguel
Spanish, op.1453
NADALES or Nadal,
Andres
Spanish, op.1500-1512
NADALINO da Murano
see Natalino
NADAR
see Tournachon, Félix
NADELMAN, Elie
American, 1882-1946
NADLER, Hans
German, 1879-1958
NADLER, Robert
Hungarian, 1858-
NADORP, Franz Joseph
Heinrich
German, 1794-1876
NAEKE or Naecke,
Gustav Heinrich
German, 1786-1835
NAFTEL, Paul Jacob
British, 1817-1891
NAGEL, Hanna
German, 1907-
NAGEL or Naghel, Jan
Dutch, op.1592-m.1616
NAGEL, Johann Friedrich
German, 1765-1825
NAGEL, Peter
German, 20th cent.
NAGEL, Valentin
German, 20th cent.
NAGEL, Wilhelm (Bill)
German, 1888-
NAGEORIES, Jean de
see Vinne, Jan van der
NAGHEL, Jan
see Nagel
NAGLER, Edith Kroger
van
American, 1895-
NAGLI, Francesco
(Gianfrancesco)
(Il Centino)
Italian, -p.1654
NAGORINI
see Nogarini
NAGY, Endre
Hungarian, 1886-
NAGY, István
Hungarian, 1873-1937
NAGY von Fancsal, Janós
Hungarian, 1883-1908
NAGY, Sigismond de
Hungarian, 1872-1932
NAHL, Carl Christian
American, 1818/19-1878
NAHL, Johann August, II
German, 1752-1825
NAHL, Samuel
German, 1748-1813
NAIGEON, Jean Claude
French, 1753-1832

NAIRN, James
McLachlan
New Zealand,
1859-1904
NAIRNE, J.T.
British, 18th cent.
NAISH, John George
British, 1824-1905
NAISH, William
British, op.1786-m.1800
NAIVEU or Neveu,
Matthijs
Dutch, 1647-1721
NAIWINX, Nauwincx
or Nouwynx, Herman
Flemish, c.1624-p.1654
NAKAMURA, Kazuo
Canadian, 1926-
NAKKEN, Willem Karel
Dutch, 1835-1926
NAL
French, 20th cent.
NALBANDYAN, Dmitry
Arkadyevich
Russian, 1906-
NALDINI, Giovanni
Battista (Battista)
Italian, 1537-1591
NALECZ, Halima
British, 20th cent.
NALLENS, Josef Frans
Dutch, 17th cent.(?)
NAM, Jacques
French, 1881-
NAMUR, Jean de
see Saive, Jan
Baptist
NAMUR, Louis de
French, 1627-1693
NANCE, R. Morton
British, op.c.1895-1909
NANES, Norman
British, 20th cent.
NANI, Giacomo
Italian, 1701-1770
NANI, Mariano
Italian, op.1759-m.1804
NANI, Napoleone
Italian, 1841-1899
NANIN, Pietro
Italian, 1808-1889
NANNETTI, Nicolò
Italian, 1675-1749
NANNI di Jacopo
Italian, 14th cent.
NANNI, Mario
Italian, 1922-
NANNINGA, Jacob (Jap)
Dutch, 1904-1962
NANNO da San
Gimignano
Italian, 15th cent.
NANTEUIL, Charles
Gaugiran
French, 1811-p.1880
NANTEUIL, Robert
French, 1623-1678
NANTEUIL-LEBOEUF,
Celestin François
French, 1813-1873
NAPIER, George
American, 19th cent.
NAPIERACZ, Jerzy
Polish, 20th cent.
NAPOLEON I1
see Bonaparte

NAPOLETANO, Francesco
see Francesco
Napoletano
NAPOLETANO, I1
see Angeli, Filippo
de Liano d'
NAPPER, John
British, 1916-
NARBETH, William Arthur
British, 1893-
NARBONA, José Pla
Spanish, 20th cent.
NARDI, Angelo
Italian, 1584-1663/5
NARDINI, Dionisio
Italian, op.1491-1520
NARDINI, Gerolamo
Italian, op.1497-1516
NARDINI, Giacomo
Italian, op.1497-1544
NARDINO, Bernardino
da Gubbio
Italian, op.1511
NARDO, Mariotto di
see Mariotto
NARDUCCI or Narduck,
Juan or Giovanni
see Miseria
NARDUCCI, Pietro
Italian, op.1809-1841
NARICI, Francesco
Italian, 1719-1785
NARJOT, Ernesto Etienne
de Francheville
American, 1827-1898
NARNIUS, G.A.
Dutch(?), 17th cent.(?)
NAROTZKY
American, 20th cent.
NARUSE
French, 19th cent.
NASH, Edward
British, 1778-1821
NASH, Frederick
British, 1782-1856
NASH, John
British, 1752-1835
NASH, John Northcote
British, 1893-1977
NASH, Joseph
British, 1808-1878
NASH, Joseph
British, op.1872-m.1922
NASH, Paul
British, 1889-1946
NASH, Thomas
British, 1891-p.1938
NASH, Walter Hilton
British, 1850-1927
NASINI, Apollonio
Italian, 1692-1786
NASINI, Giuseppe Nicola
Italian, 1657-1736
NASMYTH, Alexander
British, 1758-1840
NASMYTH, Anne Gibson
(Bennett)
British, 1798-p.1838
NASMYTH, Barbara
British, 1790-p.1866
NASMYTH, Charlotte
British, op.1837-1862
NASMYTH, Elizabeth
Wemyss (Terry)
British, 1793-p.1860
NASMYTH, James
British, 1808-1890

NASMYTH, Jane
British, 1788-c.1866
NASMYTH, Margaret
British, 1791-p.1865
NASMYTH, Patrick or
Peter
British, 1787-1831
NASOCCHI, Bartolomeo
Italian, op.1508-1541
NASOCCHI, Francesco
Italian, c.1478-c.1550
NASON, Pieter
Dutch, c.1612-1688/90
NASONE, Cavaliere
Giuseppe
Italian, 17th cent.
NASSAU-HADAMAR,
Ernestine, Princess
von
see Ernestine
NAST, Thomas
American, 1840-1902
NASTASIO
Italian, 20th cent.
NASTIE, A.S.
South African, op.1901
NAT, Willem Hendrik
van der
Dutch, 1864-1929
NATALE, Gaugun Gauguin
Italian, 19th cent.
NATALI, Giovanni Battista,
I
Italian, op.1657-m.1696
NATALI, Renato
Italian, 1883-
NATALINO or Nadalino
da Murano
Italian, op.1554-m.c.1560
NATHAN, E.
British, 20th cent.
NATHE, Christoph
German, 1753-1806
NATHIEZ, D.
French, op.1812
NATIVI, Gualtiero
Italian, 1921-
NATKIN, Robert
American, 20th cent.
NATOIRE, Charles Joseph
French, 1700-1777
NATOIRE, Louis
French, 18th cent.
NATTALI, Margaret
British(?), 19th cent.
NATTES, John Claude
British, op.1781-m.1822
NATTIER, Charles Emile
French, 19th cent.
NATTIER, Jean Baptiste
(Nattier l'aîné)
French, 1678-1726
NATTIER, Jean Marc
(Nattier le jeune)
French, 1685-1766
NATUS, Antony
Dutch, c.1636-1660
NATUS, Johannes
Dutch, op.1658-1662
NAUDE, Henri
French, 19th cent.
NAUDET, Thomas Charles
French, 1773-1810
NAUDIN, Bernard
French, 1876-1946
NAUEN, Heinrich
German, 1880-1941

NAUER, Adolf
Dutch(?), 19th cent.
NAUMANN, Carl
German, 1813-1859
NAUMANN, Friedrich
Gotthard
German, 1750-1821
NAUNDORFER, Hans
German, op.c.1490
NAUWINX, Herman
see Naiwinx
NAVARRE, Geneviève
French, op.1762-1776
NAVARRETE, Juan
Fernández de
NAVARRO, José
Spanish, 1867-1923
NAVARRO, Juan Jose
Marques de la
Victoria
Spanish, 1687-1772
NAVARRO, Luis Antonio
Spanish, op.1660-1673
NAVELET, J.(?)
French, op.1793
NAVEZ, François
Joseph
Belgian, 1787-1869
NAVIASKY, Philip
British, 1894-
NAVLET, Joseph
French, 1821-1889
NAVLET, Victor
French, 1819-1886
NAVONE, Edoardo
Italian, op.c.1873-1887
NAVRATIL, Josef
Czech, 1798-1865
NAWIASKY, Mechthild
British, op.1939
NAY, Ernst Wilhelm
German, 1902-
NAYLOR, Thomas
British, op.1778-1800
NAZARI or Nazzari,
Bartolommeo
Italian, 1699-1758
NAZARI, Nazario
Italian, 1724-p.1793
NAZON, François Henri
French, 1821-1902
NAZZARI, Bartolommeo
see Nazari
NEAGLE, John
American, 1799-1865
NEAL, David
American, 1837-1915
NEAL, James H.P.
British, 1918-
NEALE, George Hall
British, 1863-1940
NEALE, Guy
British, 20th cent.
NEALE, John Preston
British, 1779-1847
NEALE, Maud Hall,
(née Rutherford)
British, op.c.1889-1940
NEALE, Samuel
British, 19th cent.
NEATBY, Edward Mossforth
British, 1888-1949
NEAVE, Sir Richard
Digby
British, 1793-1868

NEBBIA or Nebula,
Cesare
Italian, c.1536-c.1614
NEBEL, A.
French, op.1772-1793
NEBEL, Gustave
French, 20th cent.
NEBEL, Kay Heinrich
German, 1888-1953
NEBEL, Otto Wilhelm
Ernst
German, 1892-
NEBOT or Nebott,
Balthasar
British, op.1730-1762
NECHITAILO, Xenia
Vasilievna
Russian, 1942-
NECK, Jan van
Dutch, 1635-1714
NEDEK, Pieter Pieterz.
Dutch, c.1616-c.1686
NEDER, Johann Michael
German, 1807-1882
NEDHAM, T.W.
see Needham
NEDHAM, W.
British, 19th cent.
NEE, François Denis
French, 1739-1817
NEEDHAM, J.
British, 19th cent.
NEEDHAM or Nedham, T.W.
British, op.1826-1837
NEEF, Philip de
Dutch, 17th cent.
NEEFE, Hermann Joseph
German, 1790-1854
NEEFF
Russian, op.1844
NEEFFS, F.L.
Flemish, op.1645
NEEFFS or Neefs,
Jacobus or Jacques
Dutch, 1610-p.1660
NEEFFS, Lodewyck
Flemish, c.1617-p.1648
NEEFFS, Neefs or Nefs,
Peeter, I
Flemish, c.1578-c.1656/61
NEEFFS, Neefs or Nefs,
Peeter, II
Flemish, 1620-p.1675
NEELES, C.
British, op.1811
NEER, Adriana van der,
(née Spilberg)
see Spilberg
NEER, Aert, Aart or
Aernout van der
Dutch, 1603/4-1677
NEER, Eglon Hendrik
van der
Dutch, 1634(?)-1703
NEER, Johannes van der
Dutch, op.1638-1665
NEFEDOV, Ivan
Nikandrovich
Russian, 1887-
NEFF, Timoleon Carl
Andrejewitsch von
Russian, 1805-1876
NEFS
see Neeffs
NEGELEN, Joseph Mathias
Swiss, 1792-1870
NEGKER, Jost de
German, c.1485-1544

NEGRE, Charles
French, 1820-1881
NEGRETTI or Negreti
see Palma
NEGRI, Giovanni
Francesco
Italian, 1593-1659
NEGRI, Pietro
Italian, op.1673-1679
NEGRI, Pietro Martire
see Neri
NEGRO (de Nigris),
Gaspare
Italian, op.1503-m.1538
NEGROLI (Negroni)
see Missaglia
NEGROPONTE, Antonio da
see Antonio da
Negroponte
NEHAR, Caspar
German, 20th cent.
NEHER, Bernhard, II
(Carl Joseph Bernhard)
German, 1806-1886
NEHER, Michael
German, 1798-1876
NEHRLICH, Friedrich
see Nerly
NEHRLICH, Gustav, II
German, 1807-1840
NEIDHARDT, Paul G.
German, 1873-1951
NEIDLINGER, Michael
German, 1624-1700
NEIL, H.
British, op.1800-1804
NEILAND, Brendan
British, 20th cent.
NEILLOT, Louis
French, 1898-
NEILSON, Raymond Perry
Rogers
American, 1881-1964
NEIMAN, Leroy
American, 1921-
NEIMKE, Charles
French, op.1839-1850
NEITHARDT, Nithardt
or Gothardt, Matthias
see Grünewald, Matthias
NEIZVESTNY, Ernst
Russian, 20th cent.
NEJAD, Mehmed D.
French, 1923-
NEL, Peter
British, 1935-
NELE, E.R.
German, 1932-
NELEDVA, G.A.
Russian, 20th cent.
NELIMARKKA, Eero
Aleksanteri
Finnish, 1891-
NELLI, Mariano di
Montino
Italian, 1445-
NELLI, Niccolò
Italian, c.1530-
NELLI or di Nello,
Ottaviano di Martino
Italian, op.1370/5-1440
NELLI, Pietro
Italian, op.1375
NELLI, Pietro
Italian, 1672-1740
NELLI, Pulisena (Suor
Plautilla)
Italian, 1523-1588

NELLIUS, Abraham
Dutch, op.1693
NELLIUS, Martinus
Dutch, op.1674-1706
NELLO da Gubbio
Italian, 14th cent.(?)
NELLO, Bernardo
see Bernardo
NELSON, A.
British, op.1766-1790
NELSON, George
Laurence
British, 1887-
NELSON, Harold Edward
Hughes
British, 1871-p.1928
NEMCIK, Julius
Czech, 1909-
NEMES, Endre
Hungarian, 1909-
NEMETH, Bela
Hungarian, op.c.1880
NEMETH, György
Hungarian, op.c.1900
NEMETH, Lajos
Hungarian, 1861-
NEMOURS, Aurélie
French, 1910-
NEMOZ, Jean-Baptiste
Augustin
French, 19th cent.
NENCI, Francesco
Italian, 1781-1850
NENTZ, Burkhard
German, op.1451-1475
NEOGRADY, Antal
Hungarian, 1861-1942
NEOGRADY, Laszlo
Hungarian, op.c.1900
NEPO, Ernst
Czech, 1895-
NEPOTE, Alexander
American, 1913-
NERANUS, A.
Dutch, op.1639-1642
NEREE tot Babberich,
Christophe Karel
Henri de (Karel de
Nerée)
Dutch, 1880-1909
NERENZ, Wilhelm
German, 1804-1871
NERI di Bicci
Italian, 1419-1491(?)
NERI da Rimini
Italian, op.1300-1314
NERI da Volterra,
Francesco
see Francesco
NERI or Negri, Pietro
Martire
Italian, c.1601-1661
NERLI, Girolamo Pieri
Italian, 1863-1926
NERLY or Nehrlich,
Christian Friedrich,
Fritz or Federico
(Friedrich)
German, 1807-1878
NERLY, Friedrich, II
Italian, 1824-1919
NERMAN, Einar
Swedish, 1888-
NERO, Del
see Alberti, Durante

NERONI, Bartolommeo
(Il Riccio)
Italian, 1500(?)-1571/3
NERRINGER, Thomas
German, 17th cent.
NERROCCIO di Bartolommeo
di Benedetto de'
Landi
Italian, 1447-1500
NES, Johan or Jan
Dircksz. van
Dutch, op.1617-m.1650
NESBIT or Nesbitt,
Charlton
British, 1775-1838
NESBIT, Robert
British, op.1763-1768
NESBIT, W.
British, 19th cent.
NESBITT, Lowell
American, 1933-
NESBITT, Sidney
British, 19th cent.
NESCH, Rolf
German, 1893-
NESFIELD, William
Andrews
British, 1793-1881
NESFIELD, William Eden
British, 1835-1888
NESS, John Alexander
British, -1931
NESSENTHALER, Mathias
German, c.1698-c.1733
NESSI
French, 20th cent.
NESSI, Antonio
Italian, op.1739-1773
NESSI, M.-L.
Italian, 20th cent.
NESSLER, Walter H.
British, 1912-
NESTEROFF, Michail
Wassiljewitsch
Russian, 1862-1942
NESTIER
French, op.1784
NETER, Neeter or
Netter, Laurentius de,
or Laurentius Deneter
German, c.1600-p.1649
NETSCHER, Caspar or
Gaspar
Dutch, 1635/6/9-1684
NETSCHER, Constantijn
Dutch, 1668-1723
NETSCHER, Theodorus
(de Fransche Netscher)
Dutch, 1661-1732
NETTEMA, D.
Dutch, op.1697
NETTLESHIP, John
Trivett
British, 1841-1902
NEU, Theodor
German, 1810-
NEUBACHER, Karl
German, 20th cent.
NEUBAUER, Anton
German, 17th cent.
NEUBERGER, Daniel, I
German, c.1600-1660(?)
NEUBERT, Louis
German, 1846-1892
NEUE, Franciscus or
Frans de
see Neve

NEUERMER, P.
Dutch(?), op.1681
NEUFCHATEL, Nicolas
de (Lucidel; also
identified with Colyn
van Nieucasteel)
Netherlands,
op.1539(?)-1567
NEUFVILLE, Louise
Charlotte de, (née
Ritter)
Dutch, 1779-1859
NEUGEBAUER, Jarek
Polish, 20th cent.
NEUGEBAUER, Josef
German, 1810-1895
NEUHAUS, Alexander
Swiss, op.1771
NEUHAUSER, Franz, I
German, op.1781-p.1807
NEUHUYS, Johannes
Albert (Albert)
Dutch, 1844-1914
NEUHUYS, Joseph
Hendrikus (Jozef)
Dutch, 1841-1889
NEUKOM, C.
German, op.1820-1848
NEUMANN, Fritz
German, 1881-
NEUMANN, H.
German, 19th cent.
NEUMANN, Hans
German, 1888-
NEUMANN, Johann
Balthasar (Balthasar)
German, 1687-1753
NEUMANN, Johan Carl
(Carl)
Danish, 1833-1891
NEUMANN, Max
German, 1885-
NEUMANN, Otto
German, 1895-
NEUMANS, Alphonse
French, 19th cent.
NEUMONT, Maurice Louis
Henri
French, 1868-1930
NEUNHERTZ, Georg Wilhelm
German, 1689-c.1750
NEUQUELMAN
French, 20th cent.
NEUREUTHER, Eugen
Napoleon
German, 1806-1882
NEUSCHUL, Ernst
French, 1895-
NEUSTÜCK, Johann Jakob
Swiss, 1800-1867
NEUSTÜCK, Neustock
or Neustuck, Maximilian
German, 1756-1834
NEUVUILLE, Alphonse
Marie Adolphe de
French, 1835-1885
NEVAY or Nevey, James
or Giacomo
British, op.1764-1791
NEVE, Cornelis de
Flemish, op.c.1612-m.1678
NEVE or Neue, Franciscus
or Frans de, or
Franciscus Deneve
Flemish, 1606-p.1688
NEVE, Hieronymus de
Flemish, op.1641

NEVE, Peter de
British, 17th cent.
NEVELSON, Louise
American, 1900-
NEVEN du Mont, A.
German, 1868-1909
NEVEU, Mathijs
see Naiveu
NEVEY, James or
Giacomo
see Nevay
NEVIN, J.M.
British, 19th cent.
NEVINSON, Christopher
Richard Wynne
British, 1889-1946
NEVREV, Nicolai
Vasilevich
Russian, 1830-1904
NEW, Edmund Hort
British, 1871-1931
NEWBERY, Francis H.
British, 1885-1946
NEWBERY, William
British, 1787-1838
NEWBOTT, John
British, 1805-1867
NEWCOMB, Mary
British, 20th cent.
NEWCOMBE, A.E.
British, op.c.1908
NEWDEGATE, C.V.
British, 19th cent.
NEWDIGATE, Sir Roger
British, op.1774
NEWELL, Hugh
American, 1830-1915
NEWELL, J.P.
American, op.1858-1866
NEWENHAM, Frederick
British, -1859
NEWENHAM, Robert
O'Callaghan
British, 1770-1849
NEWHOUSE, C.B.
British, op.c.1820-1836
NEWMAN, Barnett
American, 1905-
NEWMAN, H.
American, 20th cent.
NEWMAN, Henry R.
American, c.1833-1918
NEWMAN, Mark
British, 20th cent.
NEWMAN, Robert Loftin
American, 1827-1912
NEWMAN, W.
British, op.1848
NEWSOME, Victor
British, 1935-
NEWTON, Alfred Pizzey
or Pizzi
British, 1830-1883
NEWTON, Algernon
British, 1880-1968
NEWTON, Ann Mary
(Charles), (née Severn)
British, 1832-1866
NEWTON, Francis Milner
British, 1720-1794
NEWTON, Gilbert Stuart
British, 1795-1835
NEWTON, Herbert H.
British, 1881-
NEWTON, I
British, op.1822
NEWTON, J.K.
British, 18th cent.

NEWTON, John Edward
British, op.1858-1884
NEWTON, Kenneth
British, 1933-
NEWTON, Lilias
Torrance
Canadian, 1896-
NEWTON, Richard
British, 1777-1798
NEWTON, William John
British, 1785-1869
NEY, Lancelot
French, 1900-
NEYN, Pieter de
Dutch, 1597-1639
NEYTS or Nyts,
Aegidius or Gillis
Flemish, 1623(?)-1687(?)
NEYTS, J.F.
Netherlands, 18th cent.
NEYTS, Leonardus
Netherlands, op.1525
NI, Victor Trofimovich
Russian, 1934-
NIB, Johannes
Dutch(?), op.1747
NIBBRIG, Ferdinand Hart
Dutch, 1866-1915
NIBES, Richard Henry
British, op.1841-1889
NICCOLINI, Antonio
Italian, 1772-1850
NICCOLINO
see Abbate, Niccolò
dell'
NICCOLÒ
see Nicolò
NICCOLÒ d'Antonio
Italian, op.1472
NICCOLÒ da Bologna
see Nicolò di Giacomo
NICCOLÒ da Cremona
Italian, op.c.1518-1520
NICCOLÒ da Filotesio
see Amatrice, Cola
dall'
NICCOLÒ da Foligno
see Niccolò di
Liberatore
NICCOLÒ da Guardiagre le
(Niccolò d'Andrea di
Pasquale Gallucci)
Italian, 1395(?)-1462(?)
NICCOLÒ di Liberatore
di Giacomo di Mariano
(Niccolò da Foligno,
not Niccolò Alunno)
Italian, c.1425/30-1502
NICCOLÒ di Magio
Italian, op.1399-1430
NICCOLÒ da Modena
see Belin, Nicolas
NICCOLÒ di Maestro Neri
Italian, 14th cent.
NICCOLÒ di Pietro
(Nicolaus Paradixi
de Veneciis or
Veneziano)
Italian, op.1394-1430
NICCOLÒ di Pietro
Gerini
see Gerini
NICCOLÒ di Pietro,
Paolo
Italian, 13th cent.
NICCOLÒ del Priore
see Priore

NICCOLÒ da Ragusa
(Nicolaus Ragusinus,
Nikola Dubrovcanin
or Bozidarević)
Italian, c.1460-1517
NICCOLÒ di Segna
Italian, op.1331-1345
NICCOLÒ da Siena
Italian, op.1461-1463
NICCOLÒ di Simone
Italian, op.c.1650
NICCOLÒ di Ser Sozzo
Tegliacci
Italian, op.1353-m.1363
NICCOLÒ di Stefano
Italian, op.c.1530
NICCOLÒ di Tommaso
Italian, op.c.1343-1376
NICCOLÒ da Varallo
Italian, 1420-1489
NICCOLÒ da Verona
(Solimani)
Italian, op.1461-1493
NICCOLÒ da Voltri
Italian, op.1385-1417
NICE, Anonymous Painters
of the School of
NICHKL or Nickl,
Philipp Jakob
German, op.1743-1746
NICHOL, Alan
British, 20th cent.
NICHOLAS, Hilda Rix
British, 20th cent.
NICHOLL, Andrew
British, 1804-1886
NICHOLL, William
British, 1794-1840
NICHOLLS, Bertram
British, 1883-
NICHOLLS, Charles
Wynne
British, 1831-1903
NICHOLLS, R.
British, 18th cent.
NICHOLLS, Sutton
British, op.1710-1725
NICHOLLS, W.
British, op.1810-1814
NICHOLS, Abel
American, 1815-1860
NICHOLS, Alfred
British, op.1866-1878
NICHOLS, Dale
American, 1904-
NICHOLS, Hobart (Henry)
American, 1869-
NICHOLS, Jack
Canadian, 1921-
NICHOLS, James
American, 1928-
NICHOLS (not Nicolas),
Joseph
British, op.1738
NICHOLSON, Alfred
British, 1788-1833
NICHOLSON, Ben
British, 1894-
NICHOLSON, E.
British, 19th cent.
NICHOLSON, Francis
British, 18th cent.
NICHOLSON, Francis
British, 1753-1844
NICHOLSON, J.
British, 20th cent.

NICHOLSON, Thomas
Henry
British, -1870
NICHOLSON, William
British, 1781-1844
NICHOLSON, Sir William
Newzam Prior
British, 1872-1949
NICHOLSON, Winifred
British, 1893-
NICHON, P.
French, 17th cent.
NICKELE
Dutch(?), op.1741
NICKELEN, Nickele or
Nikkelen, Isaak
Dutch, op.1660-m.1703
NICKELEN, Nickele or
Nikkelen, Jacoba
Maria (Jacoba Maria
Troost)
Dutch, c.1690
NICKELEN, Nickele or
Nikkelen, Jan
Dutch, 1656-1721
NICKLE, Robert
American, 1919-
NICKOL, Carl Friedrich
Adolf
German, 1824-1905
NICKOLLS, J.
British, op.1720-1748
NICODEMO, Augusto
Italian, op.1792-1797
NICOL, Erskine
British, 1825-1904
NICOL, John Watson
British, op.1876-1924
NICOLA di Maestro
Antonio
see Andrea da Ancona
NICOLA di Filotesio
see Amatrice
NICOLA da Guardiagrele
(Nicola d'Andrea di
Pasquale Gallucci)
see Niccolò da Guardiagrele
NICOLAC da Seregno or
Da Lugano
Italian, op.1463-1500
NICOLAI, Sytse Roelofs
Dutch, op.1762-m.1779
NICOLAO Fiorentino
see Dello di Niccolò
Delli
NICOLAS (Colin) d'Ypres
French, op.1504-1519
NICOLAS, Francés
French, c.1400-1468
NICOLAS, Joseph
see Nichols
NICOLAU, Pedro
Spanish, op.c.1390-1425
NICOLAUS and Johannes
Italian, 13th cent.
NICOLAUS Paradixi de
Veneciis
see Niccolò di Pietro
NICOLET, Nicollet,
Nikolet etc. Benedict
Alphonsius
(Bernhard Anton)
Swiss, 1743-1806
NICOLET, Gabriel Emile
Edouard
French, 1856-1921
NICOLET, P.
French, op.1764-1774

NICOLETTO da Modena
(Nicoleto Rosex,
Rosa or Rossi)
Italian, op.a.1500-1512
NICOLIE, Joseph Christiaan
Belgian, 1791-1854
NICOLL, Gordon
British, 1888-1959
NICOLLE, E.F.
French, 1830-1894
NICOLLE, Victor Jean
French, 1754-1826
NICOLÒ da Bologna
see Nicolò di Giacomo
di Nascimbene
NICOLÒ di Giacomo di
Nascimbene (Nicolò
da Bologna)
Italian,
op.1348-m.a.1402
NICZKY, Eduard
German, 1850-1919
NIEDEREE, Johann Martin
(Martin)
German, 1830-1853
NIEDERHÄUSERN, Sophie von
Swiss, 1856-
NIEDERHOFER, Josef
Czech, 20th cent.
NIEDERMANN, Johann
German, 1759-1833
NIEDLICH, Johann
Gottfried
German, 1766-1837
NIEDMANN, August
Heinrich
German, 1826-1910
NIEDORP or Nievdorp,
Thys Wiertsz.
Dutch, op.1640-1646
NIEGELSSOHN, Carl
Friedrich
German, 18th cent.
NIEGELSSON, August
German, op.1777-1807
NIEHAUS, Kasper
Dutch, 1889-
NIEL, Gabrielle-Marie
French, c.1840
NIEIS, J.
Dutch(?), 17th cent.(?)
NIELSEN, Amaldus Clarin
Norwegian, 1838-1932
NIELSEN, Ejnar August
Danish, 1872-
NIELSEN, Henry
Danish, 1907-1937
NIELSEN, Jais
Danish, 1885-
NIELSEN, Kay
Danish, 1886-1957
NIELSEN, Palle
Danish, 1920-
NIELSEN, Soren Hjorth
Danish, 1901-
NIEMANN, Edmund John
British, 1813-1876
NIEMANN, Edward H.
British, 19th cent.
NIEMANN, F.A.
British, 19th cent.
NIEMANN, Johann
German, op.1834-1874
NIEMEYER-HOLSTEIN, Otto
German, 1896-
NIESE, Isaac de
see Denies

NIETHAMMER, Eduard
Swiss, 1884-

NIETO, Anselmo Miguel
Spanish, 20th cent.

NIETSCHKE, W.F.
German, 18th cent.(?)

NIEULANDT, Nieulant
or Nieuwelandt, Adriaen,
I van
Flemish, 1587-1658

NIEULANDT, Nieulant
or Nieuwelandt,
Jacob van
Dutch, 1592/3-1634

NIEULANDT, Johann van
Dutch, 1569-1628

NIEULANDT, Nieulant
or Nieuwelandt, Willem,
I van (Guglielmo
Terranova)
Flemish, op.1604-m.1626

NIEULANDT, Nieulant
or Nieuwelandt, Willem,
II van (Guglielmo
Terranova)
Flemish, 1584-1635/6

NIEUWAL, Niewael or
Niwael, Jan Rutgers
Dutch, op.1620-1661

NIEUWELANDT
see Nieulandt

NIEUWENHUIS, Bob (Bonies)
Dutch, 1937-

NIEUWENHUIS, Theodorus
Wilhelmus (Theo)
Dutch, 1866-1951

NIEUWENKAMP, Wijnand
Otto Jan
Dutch, 1874-1950

NIEUWLAND, L.F. van
Dutch, op.1761-1767

NIEVDORP, Thys
see Niedorp

NIEWAEL, Jan Rutgers
see Nieuwal

NIEWEG, Jacob (Jaap)
Dutch, 1877-1955

NIGG, Joseph
German, 1782-1863

NIGHTINGALE, Frederick
C.
British, 19th cent.

NIGHTINGALE, Robert
British, 1815-1895

NIGRIS, de
see Negro, Gaspare

NIGUEVERT, Alphonse
Alexandre
French, 1776-1860

NIJINSKA, Bronislava
Russian, op.1924

NIJINSKY, Vaslav
Russian, 19th cent.

NIKITCH, Anatoli
Yurevich
Russian, 1918-

NIKITIN, Ivvan
Maximowitsch
Russian, 1690-1741

NIKITIN, Roman
Maximowitsch
Russian, 1689-1753/4

NIKKELEN
see Nickelen

NIKODEM, Artur
German, 1870-1940

NIKOLAUS GERHAERT von
Leyden
German, op.c.1462-1473

NIKONOV, P.V.
Russian, 1930-

NIKOS, Kessanlis
Greek, 1930-

NIKUTOWSKI, Erich
German, 1872-1921

NILSON, Johann Esaias
German, 1721-1788

NILSON, Johan Severin
Scandinavian, 1846-1918

NILSON, Rosina
Catharina
German, 1755-1785

NILSON, Wilhelm Joh.
Esaias
German, 1788-

NILSSON, Axel
Swedish, 1889-

NILSSON, Vera
Swedish, 1888-

NILUS, Peter
Alexandrovich
Russian, 1869-1943

NIMANI, Sucri
Yugoslav, 20th cent.

NINHAM, Henry
British, 1793-1874

NINHAM, John
British, op.1770-1820

NIOLLON, B.
French, 1849-1927

NIRO, Robert de
American, 1922-

NISA, Leal
see Valdes-Leal

NISART or Nisard,
Pedro
Spanish, op.1468-1470

NISBET, Noël Laura
(Bush)
British, 1887-1956

NISBET, Robert Buchan
British, 1857-1942

NISBET, S.
British, 20th cent.

NISBETT, John
British, op.1871

NISS, Thorvald Simeon
Danish, 1842-1905

NISSIM, Mario
French, 20th cent.

NISSINEN, Pekka
Finnish, 20th cent.

NISSKI, Georgi
Grigorevich
Russian, 1903-

NISSL, Rudolf
German, 1870-1955

NITHARDT, M.
see Grünewald, Matthias

NITSCH, Richard
German, 1866-

NITTIS, Giuseppe de
French, 1846-1884

NIVELON, Anne Baptiste
French, op.1750-1764

NIVIERO
Italian, 17th cent.

NIVOLLINO, Antonio
Italian, 18th cent.(?)

NIWAEL, Jan Rutgers
see Nieuwal

NIXON, Francis
Russell
Australian, op.1840-1850

NIXON, James
British, c.1741(?)-1812

NIXON, James Henry
British, c.1808-p.1847

NIXON, John
British, 1706-p.1760

NIXON, John
British, c.1760-1818

NIXON, Robert
British, 1759-1837

NIXON, W.
British, op.1796

NOACK, Christian Karl
August (August)
German, 1822-1905

NOAKES, Michael
British, 1933-

NOBEL, Jakob Hendrickz.
Netherlands, 1497-1573

NOBELE, Henry de
Belgian, c.1820-c.1870

NOBILE di Francesco
da Lucca
Italian, op.1490

NOBILLET, Auguste-
Michel
French, 19th cent.

NOBLE, James Campbell
British, 1846-1913

NOBLE, John
American, 1874-1935

NOBLE, John Sargeant
British, 1848-1896

NOBLE, R.P.
British, op.1836-1860

NOBLE, Robert
British, 1857-1917

NOBLE, Thomas Satter
American, 1835-1907

NOBLE, W.R.
British, op.c.1843

NOBLE, William Bonneau
British, 1780-1831

NOBLET
see Lovinfosse, Pierre
Michel de

NOBLET, A.
Netherlands, 17th cent.

NOBLET, Martini
French(?), 17th cent.(?)

NOCCHI, Bernardino
Italian, 1741-1812

NOCE, G, della
Italian, 19th cent.

NOCI, Arturo
Italian, 1874-

NOCKEN, Wilhelm Theodor
German, 1830-1905

NOCKOLDS, Roy Anthony
British, op.c.1930

NOCRET, Nancret or
Naquerez, Jean I
French, 1615-1672

NOCRET, Jean Charles II
French, 1648-1691

NODDER, R.P.
British, op.1793-1820

NODE, Joseph Charles
(Charles)
French, 1811-1886

NODET
French, op.1799(?)

NOE, Count Amédée
Charles Henry de
(Cham)
French, 1819-1879

NOEL, Alexandre Jean
French, 1752-1834

NOEL, Alexis Nicolas
French, 1792-1871

NOEL, Alphonse
Léon
French, 1807-1884

NOEL, Mrs. Amelia
British, op.1795-1804

NOEL, C.
French, op.1775

NOEL, F.
French, 19th cent.

NOEL, Jules Achille
French, 1815-1881

NOEL, Matthias Joseph
de
German, 1782-1849

NOEL, Peter Paul
Joseph
French, 1789-1822

NOELLE, William
American, 19th cent.

NOERR, Julius
German, 1827-1897

NOETHER, Ernst
Benedikt
German, 1864-

NOGALES SEVILLA, José
Spanish, c.1860-

NOGARI, Giuseppe
Italian, 1699-1763

NOGARI, Paris (Paris
Romano)
Italian, c.1536-1601

NOGARINI, Nagorini
or Nugerini, Dionisius
Yugoslav, 1702-1756

NOIRDEMANGE
French, 18th cent.

NOIRETERRE, Noireserre
or Noiresterres, Marie
Thérèse
French, op.1785-1787

NOLAN, Sidney Robert
Australian, 1917-

NOLAND, Kenneth
American, 1924-

NOLCINI, B.
Italian, 19th cent.

NOLD, Andrea
Swiss, 1920-

NOLDE or Hansen, Emile
German, 1867-1956

NOLLEKENS or Nolkens,
Josef Frans
Flemish, 1702-1748

NOLLEKENS, Joseph
British, 1737-1823

NOLLET, Dominicus
Flemish, 1640-1736

NOLLI, Carlo
Italian, op.1752-1770

NOLPE, Pieter
Dutch, 1613/14-1652/3

NOLTEE, Bernardus
Cornelis (Cor)
Dutch, 1903-1967

NOME, Francois de
see Desiderio, Monsù

NOMELLINI, Plinio
Italian, 1866-1943

NOMPARD
French, 19th cent.

NONELL y Monturiol,
Isidro
Spanish, 1873-1911

NONNEN, Fanny (Morgan)
Swedish, 19th cent.

NONNET, C.J.
French, op.1789

NONO, Luigi
Italian, 1850-1918

NONOTTE, Nonnotte,
Nonote or Nounotte,
Donatien (Donat)
French, 1708-1785
NOOMS, Reinier, Regnier,
Remigius or Remy
see Zeeman
NOORDE, Cornelis van
(Monogrammist C.V.N.)
Dutch, 1731-1795
NOORDERWIEL, Hendrick
Dutch, op.1644-1661
NOORT, Adam van
Flemish, 1562-1641
NOORT or Noordt, Joan
or Jan van
Dutch, op.c.1644-1676
NOORT or Oort, Lambert
van
Netherlands, c.1520-1571
NOORT or Noordt, Pieter
van
Dutch, op.1626-1648
NOORTWYCK, Franz
Joseph
German, 1767-1788
NOOS, Lambert
Belgian, op.1825
NOOTEBOOM, Jacobus
Hendricus Johannes
Dutch, 1811-1878
NOOIJEN, Lodewijk
Johannes
Dutch, 1827-1901
NORBERT, Pater
see Baumgartner, Johann
NORBLIN de la
Gourdaine, Jean Pierre
French, 1745-1830
NORBURY, Richard
British, 1815-1886
NORDBERG, Olle
Swedish, 1905-
NORDEN, John
British, c.1546-c.1626
NORDENBERG, Bengt
Swedish, 1822-1902
NORDGREN, Anna
Swedish, 1847-1916
NORDGREN, Axel Wilhelm
Swedish, 1828-1888
NORDLING, Adolf Fredrik
Swedish, 1840-1888
NORDMAND, Peder
see Andersen
NORDONS, John H.
Dunham
British, op.1881
NORDQVIST, Per
Swedish, 1770-1805
NORDSTRÖM, Carl
Fredrik
Swedish, 1855-1923
NORGATE, Edward
British, 1581-1650
NORICE
British, 19th cent.
NORIE, James, I
British, 1684-1757
NORIE, Robert
British, 18th cent.
NORLIND, Ernst
Norwegian, 1877-
NORMAN, Keith
British, 1935

NORMAN, Philip
British, c.1843-1931
NORMAND, Charles Pierre
Joseph
French, 1765-1840
NORMAND or Normann,
Eilert Adelsteen
(Adelsteen)
Norwegian, 1848-1918
NORMAND, Ernest
British, 1857-1923
NORMAND, Henrietta
see Rae
NÖRREGAARD, Asta
Norwegian, 1853-
NORRIS, Reginald
British, 20th cent.
NORRMAN, Herman
Swedish, 1864-1906
NORRY, Charles
French, 1756-1832
NORSTEDT, Johann
Reinhold (Reinhold)
Swedish, 1843-1911
NORSWORTHY, W.
British, op.1839
NORTH, Lady Georgina
British, 1798-1835
NORTH, John William
British, 1842-1924
NORTHAMPTON, Countess
of
British, 18th cent.
NORTHBOURNE, Lord
(Hon. Walter John
James)
British, 1869-1933
NORTHCOTE, James
British, 1746-1831
NORTHEN, Adolf
German, 1828-1876
NORTH ITALIAN SCHOOL,
Anonymous Painters
of the
NORTON, William Edward
American, 1843-1916
NORWAY, Carlo
British, 1886-
NORWEGIAN SCHOOL,
Anonymous Painters
of the
NORWIC or Northwic,
Georg Cord Jürgen
German, 1718-p.1794
NORWICH, Browning
British, 19th cent.
NOSADELLA
see Bezzi, Giovanni
Francesco
NOTARI, Romano
Italian, 1933-
NOTER, Annette de
Belgian, 1803-
NOTER, David Emil
Joseph de
Belgian, 1825-
NOTER, Pieter Frans,
II de
Belgian, 1779-1843
NOTERMAN, Emanuel
German, 1808-1863
NOTERMAN, Zacharias
German, 19th cent.
NOTHNAGEL, August
Friedrich Wilhelm
German, 1822-1899

NOTHNAGEL, Johann
Andreas Benjamin
German, 1729-1804
NOTKE, Bernt
German, 1440-1509
NOTTE, Claude Jacques
French, op.1771-1795
NOTZ, Johannes
Swiss, 1802-1862
NOTZLI, J.C.
Swiss, 18th cent.
NOUFFLARD, Berthe
French, 1886-
NOUNOTTE, Donatien
see Nonotte
NOURISSON, René
French, op.1644-1650
NOURRY, Jacques
see Noury
NOURSE, Elizabeth
American, 1859-1938
NOURY, Gaston
French, 1866-
NOURY or Nourry,
Jacques
French, 1747-1832
NOUTS, Michiel
Dutch, op.1656
NOUVEAU, Henri
French, 1901-1959
NOUVIAIRE, Francois
French, 1805-1837
NOUWYNX, Herman
see Naiwinx
NOUY, Lecomte du
French, 19th cent.
NOVAK, Ernst
see Nowak
NOVATI, Marco
Italian, 1895-
NOVELLI, Antonio
Italian, 1600-1662
NOVELLI, Francesco
Italian, 1764-1836
NOVELLI, Gastone
Italian, 1925-1968
NOVELLI or Novello,
Paolo
Italian, op.1670
NOVELLI, Pietro
(Monrealese or
Morealese)
Italian, 1603-1647
NOVELLI, Pietro
Antonio, III
Italian, 1729-1804
NOVELLI, Sebastiano
Italian, 16th cent.
NOVELLI, T. or I.
Italian, 20th cent.
NOVELLO, Emma A.
British, op.c.1830-1850
NOVELLO, Giuseppe
Italian, 19th cent.
NOVICE, William
British, op.1809-1833
NOVILLO, Cirillo
Martinez
Spanish, 1921-
NOVIS, Aegidius
Netherlands(?),
16th cent.
NOVOPACKY, Jan
German, 1821-1908
NOVROS, David
American, 20th cent.
NOWACK, Hans
German, 1866-1918

NOWAK, Anton
German, 1865-
NOWAK or Novak, Ernst
German, 1851-1919
NOWAKOWSKI, Czeslaw
Polish, 1912-
NOWELL, Arthur
Trevethin
British, 1861-1940
NOWLAN, Frank
British, 1835-1919
NOWOSIELSKI, Jerzy
Polish, 1923-
NOXIE, W.
British, 18th cent.
NOYER, Philippe
French, 1917-
NOYERS, Giorgio
Italian, 16th cent.
NOYES, Barbara
American, 20th cent.
NOYES, Dora
British, op.1919-1936
NOYES, Robert
British, 1780(?)-1843
NOZAL, Alexandre
French, 1852-1929
NUBALE, Francesco
Italian, op.c.1765/6
NUCCI
see Jean de Luca
of Siena
NUCCI, Avanzino
Italian, 1551-1629
NUCHII
see Jean de Luca of
Siena
NUGENT, Thomas
British, op.1791-1829
NUGERINI, Dionisius
see Nogarini
NUIELLE, Bernard
German, 1822-1898
NULCK, L.
Netherlands, op.1681
NÜLL, Edouard van
der
German, 1812-1868
NUMA, Pierre
French, op.1848
NUMAN, Hermanus
Dutch, 1744-1820
NUMERS, Fredrik Adolf
von
Swedish, 1745-1792
NUNE, De
British(?), op.1749
NUNES-VAIS, Italo
Italian, 1860-
NUNEZ, Juan
Spanish, op.1480-1525
NUNEZ, Pedro
Spanish, op.1613-m.1654
NUNEZ de Villavicencio,
Pedro
Spanish, 1644-1700
NURSEY, Claude Lorraine
British, 1820-1873
NURSEY, P.
British, op.1799-1801
NURSEY, Rev. Perry
British, op.1815-1839
NÜSCHELER, Christoph
Swiss, 1589-1661
NÜSCHELER, Hans Jakob,
I
Swiss, 1583-1654

NÜSCHELER, Hans
Jakob, II
Swiss, 1614-1658
NÜSCHELER, Heinrich
Swiss, 1550-1611
NUTGES, J.
Dutch, 18th cent.(?)
NUTT, James
American, 20th cent.
NUTTER, Matthew Ellis
British, 19th cent.
NUTTGENS, Heinrich
German, 1886-
NUTTING, Benjamin F.
American, 1801/13-1887
NUTTING, Joseph
British, c.1660-1722
NÜTZEL, Hieronymus
German, op.1584-1597
NUVOLONE, Carlo
Francesco (Il Panfilo)
Italian, 1608-1661/5
NUVOLONE or Nuvoloni,
Giuseppe (Panfilo)
Italian, 1619-1703
NUIJEN or Nuyen, Wijnandus
Johannes Josephus
Dutch, 1813-1839
NUYS or Nuijs, Arien
Jansz. van
Dutch, 17th/18th cent.
NUZI, Allegretto
Italian, c.1346-1385
NUZZI, Mario (Mario
de' Fiori)
Italian, c.1603-1673
NYBORG, Peter
Scandinavian, 20th cent.
NIJLAND, Dirk Hidde
Dutch, 1881-1955
NYLANDER, Oskar
Swedish, 1827-1849
NYMAN, Hilding Elof
Norwegian, 1870-
NIJMEGEN, Dionys van
Dutch, 1705-1798
NIJMEGEN, Elias van
Dutch, 1667-1755
NIJMEGEN, Gerard van
Dutch, 1735-1808
NIJMEGEN, Tobias van
Dutch, c.1670-
NYPOORT, Justus van den
Dutch, c.1625-p.1692
NYS, Pieter (de)
Dutch, 1624-1681
NYSTROM, Jenny
Swedish, 1857-
NYTS, Aegidius or
Gillis
see Neyts

O

OAKES, John Wright
British, 1820-1887
OAKLEY, Octavius
British, 1800-1867
OAKLEY, Philip
British, op.c.1780
OAKLEY, Thornton
American, 1881-1953
OAKLEY, Violet
American, 20th cent.
OATES, Captain Mark
British, op.1789-1811
OBACH, Caspar
Swiss, 1807-1868

OBERLÄNDER, Adam
Adolf
German, 1845-1923
OBERLE, Jean
French, 1876-1944
OBERMANN, Anthony
Dutch, 1781-1845
OBERMÜLLNER, Adolf
German, 1833-1898
OBERSTEINER, Ludwig
German, 1857-
OBERTEUFFER, Henriette
Amiard
French, 1878-
OBERTO, Francesco di
see Francesco d'
Oberto
OBIDOS, Josefa de
(Ayala)
Portuguese, c.1630-1684
OBIN, Antoine
Haitian, 1929-
OBIN, Philomé
Haitian, 1891-
OBIN, Seneque
Haitian, 1893-
OBLE, L.
French, 19th cent.
OBRAZOPISOW, Mikolaj
Russian, 1827-1911
OBREGON, Alejandro
Spanish, 1920-
OBREK, Simon de
see Wobreck
O'BRIEN, Franz
German, op.1846-1860
O'BRIEN, George
New Zealand, 1821-1888
O'BRIEN, J.J.
American, 19th cent.
O'BRIEN, Justin
Australian, 1917-
O'BRIEN, Lucius R.
Canadian, 1832-1899
O'BRIEN, Paddy Gunn
Canadian, 20th cent.
OBRIST, Hermann
Swiss, 1863-1927
OBROVSKY, Jakub
Czech, 1882-1949
OCA BIANCA, Angelo
dall'
Italian, 1858-1942
OCAMPO, Isadoro
Mexican, 1910-
OCCHIALI, Gasparo
dagli
see Wittel
OCEPEK, Louis
American, 20th cent.
OCHOA de Meruelo y
Antolinez
see Antolinez y Sarabia
OCHOA y Madrazo,
Raphael de
Spanish, 1858-
OCHS, Kathinka
German, 1863-
OCHS, W. v.
German, op.c.1800
OCHTERVELT, Jacob
Lucasz.
Dutch, 1634-1682
OCHTMAN, Leonard
American, 1854-
OCIEPKA, Teofil
Polish, 1892-

OCKEL, Eduard
German, 1834-1910
O'CONNOR, John
British, 1830-1889
O'CONNOR, John
British, 1913-
O'CONNOR, Kathleen
British, 20th cent.
O'CONOR, James Arthur
British, 1791-1841
O'CONOR, Roderick
British, 1860-1940
OCTAVIEN, Francois
French, 1682-1740
ODAZZI, Odasi or
Odazi, Antonio
Italian, c.1662-1707
ODAZZI, Odasi or
Odazi, Giovanni
Italian, 1663-1731
ODDI, Mauro
Italian, 1639-1702
ODDIE, Walter M.
American, c.1808-1865
ØDEGAARD, Hans
Norwegian, 1876-
ODEKERKEN or Odekercke,
Willem van
Dutch, op.c.1631-m.1677
O'DELL, M.
American, 19th cent.
ODELMARK, Frans Vilhelm
Scandinavian, 1849-1937
ODERISIO, Robertus di
Italian, 14th cent
ODERMATT, Siegfried
Swiss, 1926-
ODESCALCHI, Victor
Fürst
German, 1833-1880
ODEVAERE, Joseph
Dionysius
Flemish, 1778-1830
ODIER, Edouard Alexandre
French, 1800-1887
ODOM, S.
British, 20th cent.
ODONE, Pascale
Italian, 16th cent.
OECHS, Anton
German, op.c.1787-1790
OECHS, Joseph Dominicus
German, 1775-1836
OEDER
Danish, op.1761-1764
OEDER, Georg
German, 1846-1931
OEDING, Philipp Wilhelm
German, 1697-1781
OEFELE or Offele,
Franz Ignaz (Bavarese,
Hewelski or Piekarski)
German, 1721-1797
OEGG, Johann Georg
German, 1703-1780
OEHM, Herbert
German, 1935-
OEHME, Ernst Erwin
(Erwin)
German, 1831-1907
OEHME, Ernst Ferdinand
German, 1797-1855
OEHME, Karl
Friedrich
German, 1751-1801
OEHMICHEN, Hugo
German, 1843-p.1869

OEHRING, Hedwig
German, 1855-
OEITS, Pieter
Dutch, 1720-1790
OELENHAINZ, August
Friedrich (Friedrich)
German, 1745-1804
OELINGER, N.
German, op.1781
OELTJEN, Jan
German, 1880-1968
OELZE, Richard
German, 1900-
OELZENIDES, T.
Dutch, op.1618
OENSLAGER, Donald M.
American, 20th cent.
OEPTS, Willem Anthonie
(Wim)
Dutch, 1904-
OER, Theobald Reinhold
Freiherr von
German, 1807-1885
OERDER, Frans David
Dutch, 1867-1944
OERI, Hans Jakob
Swiss, 1782-1868
OERI, Ulrich
Swiss, 1567-1631
OERTEL, Johannes Adam
Simon
American, 1823-1909
OESCH, I.I.
Swiss, op.c.1826
OESER, Adam Friedrich
German, 1717-1799
OESER, Johann Friedrich
Ludwig (Friedrich
Ludwig)
German, 1751-1792
OESTERLEY, Carl August
Heinrich Ferdinand
German, 1839-1930
OESTERLEY, Carl Wilhelm
Friedrich
German, 1805-1891
OETINGER
German, 18th cent.
OEVER, Hendrick ten
Dutch, 1639-1716
OF, George F.
American, 1876-1954
OFFELE
see Oefele
OGBORNE, David
British, op.1740-m.1768
OGBORNE, John I
British, 1755-1795
OGDEN, Geoff
British, 1929-
OGGIONO, Oggionno,
Oglono, Uggione,
Ugginni, Uggiono or
Uglon, Marco d'
Italian, c.1475-1530
OGILBY, John
British, op.1651
OGILVIE, Will
Canadian, 1903-
OGLIO, Egidio dall'
Italian, 18th cent.
OGRUMOFF
Russian, 19th cent.
OGUISS, Takanari
Japanese, 1901-
O'HIGGINS, Pablo
Esteban
Mexican, 1904-

ÖHLERS, Johann Chr.
German, op.1718
OHLAMÜLLER, Joseph
Daniel
German, 1791-1839
OHLSON, Doug
American, 1936-
OHNEFALSCH-RICHTER, M.
German, op.1878
OINONEN, Mikko Oskar
Finnish, 1883-1956
OKADA, Kenzo
American, 1905-
OKAMATO, Taro
Japanese, 1911-
OKAMURA, Arthur
American, 1932-
O'KEEFFE, Georgia
American, 1887-
O'KEEFFE or Keefe,
John, I
British, 1747-1833
O'KELLY, Aloysius C.
British, 1853-
OKEY, Samuel
British, op.1765-1780
OKUN, Edouard
Polish, 1872-1945
OLAC, Vasile
Rumania, 20th cent.
OLAGNON, Pierre Victor
French, 1786-1845
OLBRICH, Josef Maria
German, 1867-1908
OLBRICH, V.
German, 19th cent.
OLDACH, Julius
German, 1804-1830
OLDEBOERRIGTER, Melle
Johannes (Melle)
Dutch, 1908-
OLDEROCK, Max
German, 1895-
OLDEWELT, Ferdinand
Gustaaf Willem
Dutch, 1857-1935
OLDFIELD, J. Edwin
British, op.1825-1854
OLDONI, Eusebio
Italian, op.1544-p.1562
OLEFFE, August
Belgian, 1867-1931
OLDE, Johannes Wilhelm
(Hans)
German, 1855-1917
OLDELAND or Oldellandt,
Hendrik E.
Dutch, op.1636-1643
OLDENBURG, Claes
American, 1929-
OLDHAM, T.H.
British, op.1820
OLDONI, Boniforte II
Italian, op.1548-p.1579
OLEARIUS, Adam
German, 1603-1671
OLEN, Adriaen van
see Oolen
OLGIATI or Olgiato,
Girolamo
Italian, op.1567-1575
OLIO, Egidio dall'
see Oglio
OLIS, Jan
Dutch, c.1610(?)-1676

OLITSKI, Jules
American, 1922-
OLIVA y Rodrigo,
Eugenio
Spanish, 1854-1925
OLIVA, Francesco
Italian, op.1794
OLIVE, Jean Baptiste
Joseph
French, 1848-1936
OLIVEIRA, Joao Marques
da Silva
Portuguese, 1853-1927
OLIVEIRA, Nathan
American, 1928-
OLIVER, Archer James
British, c.1774-1842
OLIVER, Charles W.
British, 19th cent.
OLIVER, Emma Sophia
(née Eburne)
British, 1819-1885
OLIVER, Olivier or
Ollivier, Isaac
British, 1556(?)-1617
OLIVER, Peter II
British, c.1594-1647
OLIVER, William
British, 1804-1853
OLIVER, William
British, op.1867-1897
OLIVERIO, Alessandro
Italian, op.1532-1544
OLIVES, Francisco ces
see Solibes
OLIVET, Hilaire d'
French, op.c.1700
OLIVE-TAMARI, (Henri)
French, 1898-
OLIVIE, D.
French, op.1780
OLIVIER, Ferdinand von
German, 1785-1841
OLIVIER, Ferdinand
French, 1873-
OLIVIER, Heinrich
German, 1783-1848
OLIVIER, Herbert
Arnould
British, 1861-
OLIVIER, J.B.
French(?) 18th cent.
OLIVIER, Jean
French, 19th cent.
OLIVIER, Woldemar
Friedrich (Friedrich)
German, 1791-1859
OLIVIERI, Claudio
Italian, 20th cent.
OLIVIERI, Leonardo
Antonio
Italian, 1690-92-p.1745
OLIVIERI, Pietro Paolo
Italian, 1551-1599
OLIVIERI, Salvatore
(Il Salvatoriello)
Italian, 1696(?)-1718(?)
OLIVIERO, Pietro
Domenico I
Italian, c.1672-1754
OLIVUCCIO di Ciccarello
da Camerino
Italian, c.1365-1439
OLLER y Cestero, Francisco
French, 1833-1917
OLLEROS y Quintana, Bias
Italian, c.1851-1919

OLLILA, Yrjö Aleksander
Finnish, 1887-1932
OLLIVARY, Annette
French, 1926-
OLLIVIER or Olivier,
Michel Barthélemy
French, 1712-1784
OLMENDORFFER
see Ostendorfer
OLMO, L'Olmo (Lolmo)
or Ulmus, Giovanni
Paolo
Italian, 1550(?)-1593
OLMO, Marco
Italian, 1683-1753
OLMÜTZ or Olomuntzer,
Hans (von)
Czech, op.1473-1518
OLMÜTZ, Wenzel von
see Wenzel
OLOMUNTZER, Hans von
see Olmütz
OLCNDE, Joel
French, 20th cent.
OLPEIUS or Olpenus
see Holbein, Hans II
OLRIK, Henrik
(Ole Henrik Benedikt)
Danish, 1830-1890
OLSEN, John
Australian, 1928-
OLSON, Erik
Swedish, 1901-
OLSSON, Albert Julius
(Julius)
British, 1864-1942
OLSSON, Sigvard
Swedish, 1936-
OLSSON-HAGALUND, Olle
Swedish, 1904-
OLST, Al. van
Dutch, 18th cent.
ÖLSZNER, Jakob
see Elsner
OLVER, Kate Elizabeth
British, 20th cent.
OMENAMAKI, Osmo
Finnish, 20th cent.
OMICCIOLI, Giovanni
Italian, 1901-
OMINO
see Lombardi, Giovanni
Domenico
OMMEGANCK, Balthasar
Paul
Flemish, 1755-1826
OMMEGANCK, Maria
Jacoba (Maria Jacoba
Myin)
Belgian, 1760-1849
ONDAATJE, Kim
Canadian, 20th cent.
O'NEAL, Jeffrey Hamet
British, op.c.1763-1772
O'NEIL, Henry Nelson
British, 1817-1880
O'NEILL, George Bernard
British, 1828-1917
O'NEILL or O'Niell,
Hugh
British, 1784-1824
ONESTI, Niccola
Italian, op.1784
ONGANIA, Umberto
Italian, 19th cent.
ONGARO, Michele
see Michele Ongaro

ONGHENA, Karel or Charles
Belgian, 1806-1886
ONGHERS, Oswald
German, 1628-1706
ONKEN, Carl Eduard
German, 1846-1934
ONLEY, Toni
Canadian, 1928-
ONNES, Harm Henrick Kamerlingh
Dutch, 1893-
ONOFRIJ, di Onofrio or
de Honufriis, Crescenzio
Italian, 1632-1698
ONOFRIO da Fabriano
Italian, op.1463
ONSLOW-FORD, Gordon
Max
British, 1912-
OOMS, Karel
Belgian, 1845-1900
OORDT, W. van
Dutch, 17th cent.
OORLOFT, Joseph Philippe
Belgian, 1793-1861
OORMEANU, Dorin
Dumitriu
Rumanian, 20th cent.
OORT, Hendrik van
Dutch, 1775-1847
OORT, Lambert van
see Noort
OOST, Jacob or Jacques,
I van
Dutch, 1601-1671
OOST, Jacob or Jacques,
II van
Dutch, 1637-1713
OOSTEN, or Osten,
Frans van
Flemish, -1679/80
OOSTEN, Izaak van
Flemish, 1613-1661
OOSTEN, Jan van
Flemish, -1634
OOSTERHOUDT or Osterhoudt,
Daniel van
German, 1786-1850
OOSTERHUIS, Haatje Peters
Dutch, 1784-1854
OOSTERWYCK, Maria van
Dutch, 1630-1693
OOSTSANEN, Jakob
Cornelisz. van
see Cornelisz.
OOSTSANEN or Oostzanen,
Reyer Cornelisz. van
Dutch, op.1656
OPAZO, Rodolfo
Chilean, 20th cent.
OPDENHOFF, George Willem
Dutch, 1807-1873
OPERA, Giovanni dell'
see Bandini, Giovanni
di Benedetto
OPHEY, Walter
German, 1882-1930
OPIE, Edward
British, 1810-1894
OPIE, John
British, 1761-1807
OPISSO SALA, Ricardo
Spanish, 1880-
OPITZ, P.
German, 18th cent.

OPIZ (not Opitz),
Georg Emanuel
German, 1775-1841
OPPEN, G.M.
Norwegian, op.1778
OPPENHEIM, Dennis
American, 20th cent.
OPPENHEIM, Meret
American, 1913-
OPPENHEIM, Moritz
Daniel
German, 1800-1882
OPPENHEIMER, Charles
British, 1875-1961
OPPENHEIMER, Joseph
German, 1876-
OPPENHEIMER, Max
(Mopp)
German, 1885-1954
OPPENORT, Gilles Marie
French, 1672-1742
OPPERMANN, Wilhelm
Ulrich
Swiss, 1786-1852
OPPI, Ubaldo
Italian, 1889-
OPPLER, Ernst
German, 1867-1929
OPSOMER, Isidore
Belgian, 1878-
OPSTAL, Anton van
Flemish, op.c.1621-1624
OPSTAL, Kaspar or
Jasper Jacob, II van
Flemish, 1654-1717
ORAA, Rolando de
Cuban, 20th cent.
ORACOLO delle Battaglie
see Falcone, Aniello
ORAM, Edward
British, op.1766-1799
ORAM, William
('Old Oram')
British, op.c.1730-m.1777
ORANGE, Maurice Henri
French, 1868-1916
ORAZI or Orazii, Andrea
Antonio
Italian, 1670-p.1749
ORAZI, Manuel
Italian, 19th cent.
ORAZIO di Jacopo
Italian, op.1432-1449
D'ORBAY, (?)
French, 18th cent.
ORBETTO
see Turchi, Alessandro
D'ORBIGNY, Alcide
French, op.1826-1833
ORCAGNA, Orgagna or
Arcagnuolo, Andrea
di Cione
Italian, 1308(?)-1368
ORCAGNA, Jacopo di
Cione (Robiccia)
Italian, op.1365-1398
ORCAGNA, Nardo di
Cione
Italian,
op.c.1343-1365/6
ORCHARDSON, Charles
M.Q.
British, 1873-1917
ORCHARDSON, Sir William
Quiller
British, 1832-1910
ORD, Joseph Biays
American, 1805-1865

ORDE, Thomas
British, 1746-1807
OREAR, Lucinda
Redmon
American, 20th cent.
O'REILLY, Joseph
British, op.1884-m.1893
O'REILLY, Admiral
Montague Frederic
British, 1822-1888
ORELLANA, Gaston
Chilean, 1933-
ORELLI, Giuseppe Antonio
Felice (not Giovanni)
Swiss, 1700-1770
ORESHNIKOV, Victor
Mikailovich
Russian, 1904-
ORFANOS, Lambros
Greek, 20th cent.
ORFEI, Orfeo
Italian, op.1862-1889
ORGAN, Bryan
British, 20th cent.
ORGANI, Guglielmo
degli
see Guglielmo da
Forlì
ORGEIX, Christian d'
French, 1927-
ORIANI, Pippo
Italian, 20th cent.
ORIENT (Urindt) Josef
German, 1677-1747
ORIHUELA, Luis
Spanish, 20th cent.
ORIOLI, Pietro di
Francesco degli
Italian, 1458-1496
ORIOLO
see Giovanni da
Oriolo
ORIZONTE
see Bloemen, Jan
Frans van
ORLAI-PETRICS, Soma
Hungarian, 1822-1880
ORLANDI
Italian, 17th cent.
ORLANDI, Deodatus
see Deodatus
ORLANDI, Giovanni
Italian, op.c.1590-1640
ORLANDI, Stefano
Italian, 1681-1760
ORLEANS, Eugène
A. L. d'
French, op.1820
ORLEANS, Princesse
Marguerite d'
French, 19th cent.
ORLEANS, Philippe d'
French, 1674-1723
ORLEY, Bernaert van
Netherlands,
op.1515-m.1541
ORLEY, Hieronymus van
Flemish, op.1612-1661
ORLEY, Jan van
Flemish, 1665-1735
ORLEY, Peter van
Flemish, 1638-p.1708
ORLEY, Philipp van
see Philippe, Master
ORLEY, Richard van
Flemish, 1663-1732

ORLEY, Valentin van
Netherlands, op.1512-1532
ORLIK, Emil
German, 1870-1932
ORLIK, Henry
German, 1947-
ORLOFF, J.
Russian, 19th cent.
ORLOFF, Pimen
Nikititsch
Russian, 1812-1863
ORLOWA, Chana
Russian, 1888-
ORLOWSKI, Alexander
Ossipowitch (Alexander)
Polish, 1777-1832
ORME, Daniel
British, c.1766-1802
ORME, Edward
British, op.1807
ORME, Ernest
British, op.1801-1803
ORME, William
British, op.1797-1819
ORMEA, Willem
Dutch, op.1638-m.1673
ORMEROD, George
British, 18th cent.
ORNBECK, Leonhard
Swedish, 1736-1789
OROZCO, José Clemente
Mexican, 1883-1949
ORPEN, Sir William
British, 1878-1931
ORR, Christopher John
British, 20th cent.
ORRENTE, Pedro
Spanish, 1588-1645
ORROCK, James
British, 1829-1913
ORSAY, Gédéon Gaspard
Alfred (Alfred)
Comte d'
French, 1801-1852
ORSCHIEDT, J.
German, 19th cent.
ORSEL, André Jacques
Victor (Victor)
French, 1795-1850
ORSELLI, A.
Italian, 19th cent.
ORSI, Bernardino
Italian, p.1450-p.1532
ORSI, Carlo
Italian, 19th cent.
ORSI da Novellara,
Lelio
Italian, 1511-1587
ORSI, Pasquale
Italian, 1817-1894
ORSOLINI, Carlo
Italian, c.1710-c.1780
ORSON, J.
British, op.1757-1777
ORT or Hort, Aert van,
or Aert Ortkens (Master
of the Leipzig Cabinet)
Netherlands, op.1513-1538
ORTA, Benedetto
Italian, 18th cent.
ORTEGA, José
Spanish, 20th cent.
ORTELIUS, Oertel or
Ortels, Abraham
German, 1527-1598
ORTELMANS, Damiaen, I
see Wortelmans

ORTET, Bernard
French, 18th cent.
ORTH, Benjamin Heinrich
German, 1803-1875
ORTH, Jakob
German, 1780-1861
ORTHNER, Martin
German, op.1785
ORTIZ, Emilio
Mexico, 1936-
ORTIZ de Zarate, Manuel
Chilean, 1886-
ORTIZ, Sebastian
Spanish, 19th cent.
ORTIZ-ECHAGÜE, Antonio
Spanish, 1883-
ORTKENS, Aert
see Ort
ORTLIEB, Friedrich
German, 1839-1909
ORTMAN, George
American, 1926-
ORTMANS, François
Auguste
French, 1827-1884
ORTOLANI DAMON, Giovanni
Battista
Italian, c.1750-1789
ORTOLANO, Giovanni
Battista Benvenuti L'
(Johannes Hispanus?)
Italian, c.1488-1525(?)
ORTONEDA, Mateo
Spanish, op.1403-1443
ORTONEDA, Pascual
Spanish, op.1437-1443
ORTOWJKI, Alexander
Polish(?) 18th cent.
ORVIETANO
see Ugòlino di Prete
Ilario
ORZINGER
German, op.1789
OS, George Jacobus
Johannes van
Dutch, 1805-1841
OS, Jacobus Petrus
Cornelis van
Dutch, 1869-1944
OS, Jan van
Dutch, 1744-1808
OS, Maria Margaretha
van
Dutch, 1780-1862
OS, Pieter Frederik
van
Dutch, 1808-1892
OS, Pieter Gerardus
van
Dutch, 1776-1839
OSBERT, Alphonse
French, 1857-1939
OSBORN, Dorothy
British, 20th cent.
OSBORN, Emily Mary
British, 1834-p.1913
OSBORN, Robert Chesley
American, 1904-
OSBORNE, Elizabeth
American, 20th cent.
OSBORNE, John
British, op.1641
OSBORNE, Malcolm
British, 1880-1963
OSBORNE, Tim
British, 1909-
OSBORNE, Walter Frederick
British, 1859-1903

OSBORNE, William
British, 1823-1901
OSCROFT, Samuel William
British, 1834-1924
OSEN, Erwin Dominik
German, 20th cent.
OSGOOD, Charles
American, 1809-p.1842
OSGOOD, S.S.
American, 1808-1885
O'SICKEY, Joseph
American, 20th cent.
OSIR, Paulo Rossi
Brazilian, 20th cent.
OSIS, Sens
Russian, 1925-
OSMAN, Austin
British, op.1888-1907
OSMERKIN, Alexander
Alexandrovich
Russian, 1890-
OSMOND, J.D.
British, op.1797
OSNAGO, Domenico
Italian, 18th cent.
OSONA
see Rodrigo
OSORIO, Francisco
see Meneses
OSPOVAT, Henry
British, 1877-1909
OSSENBEECK, Jan van
Dutch, c.1624-1674
OSSLUND, Jonas Helmer
(Helmer)
Swedish, 1866-1938
OSSOLA, Giancarlo
Italian, 1935-
OSSORIO, Alfonso
American, 1916-
OSSWALD, Eugen
German, 1879-1960
OSSWALD, Fritz
Swiss, 1878-
OSTADE, Adriaen Jansz.
van
Dutch, 1610-1685
OSTADE, Isaac Jansz. van
Dutch, 1621-1649
OSTEN, Frans van
see Oosten
OSTENDORFER, Osdentorffer,
Ostendorffer or
Ostndorffer (not
Olmdorf or Olmendorffer)
Hans I
German, op.1460-m.1524
OSTENDORFER, Osstendorfer,
Osthdorrffer,
Ostendorffer or
Ostndarffer, Michael
or Michel
German, c.1490-1559
OSTERHOUDT, Daniel van
see Oosterhoudt
OSTERLIND, Allan
Swedish, 1855-1938
OSTERLIND, Anders
French, 1887-
OSTERMAN, Carl Emil
(Emil)
Swedish, 1870-
ÖSTERMAN, Gustav
Bernhard (Bernhard)
Swedish, 1870-1938
OSTERROHT, Gustav
German, 1836-1875

OSTERSETZER, C.
German, 19th cent.
OSTERTAG, Heinrich
Jonas
German, op.1711-1725
OSTERWALD, Georg
German, 1803-1884
OSTHAUS, Edmund Henry
American, 1858-1928
OSTOIA-KOTKOWSKI,
Stanislaw
Polish, 1922-
OSTROSHENKO, S.B.
Russian, 20th cent.
OSTROUCHOW, Ilja
Semjonowitsch
Russian, 1858-1929
OSVER, Arthur
American, 1912-
OSWALD, C.W.
British, op.1892
OTERO, Rodriguez
Alejandro
Venezuela, 1921-
OTHON, Narcisse
French, op.1839-1847
OTIS, Bass
American, 1784-1861
OTREBA, Ryszard
Polish, 20th cent.
OTT, Fridolin
Swiss, 1775-1849
OTT, Johann Neoimuk
German, 1804-1870
OTT, Susette
see Hirzel
OTTANI, Gaetano
Italian, c.1790
OTTAVIANO da Faenza
Italian, 14th cent.
OTTAVIANO di Martino
di Nello
Italian, op.1400-1444
OTTENFELD, Rudolf Otto
Ritter von
Italian, 1856-1913
OTTEREN, Hubert van
Flemish, op.1671-1713
OTTERSON, Heinz
German, 20th cent.
OTTESEN, Otto Didrik
Danish, 1816-1892
OTTEVAERE, August
Ferdinand
French, 1810-1856
OTTH, Adolf Carl
Swiss, 1803-1839
OTTINI, Felice
(Felicetto di Brandi)
Italian, -1695
OTTINO or Ottini,
Pasquale (Pasqualotto)
Italian, 1580-1630
OTTLEY, William Young
British, 1771-1836
OTTMANN, Henri
French, 1877-1927
OTTO, Johannes Samuel
German, 1798-1878
OUASSE
see Houasse
OUBORG, Pieter (Piet)
Dutch, 1893-1956
OUBOTEN, H.
Dutch, op.1796
OUCHAKOV, Simon
Russian, 1626-1686

OUDEN-ALLEN, Folpert
van
Dutch, 1635-1715
OUDENDYCK, Adrian
Dutch, 1648-p.1700
OUDENDYCK, Evert
Dutch, op.1646
OUDENHOVEN, H. van
Netherlands, op.1726
OUDENROGGE, Johannes
Dircksz. van
Dutch, 1622-1653
OUDERAA, Pierre Jean or
Pieter (Piet) Jan
van der
Belgian, 1841-1915
OUDINOT, Achille
François
French, 1820-1891
OUDOT, Roland
French, 1897-
OUDRY, Jacques Charles
French, 1720-1778
OUDRY, Jean Baptiste
French, 1686-1755
OUDRY, P.
French, op.1578
OUFFET, Gérard d'
see Douffet
OUGRUMOW
see Ugrjumoff
OULESS, Catherine
British, 1879-p.1937
OULESS, P.J.
British, 19th cent.
OULESS, Walter William
British, 1848-1933
OULTREMONT, P, d'
French, 17th cent(?)
OURY, Léon Louis
French, 1846-
OUTCAULT, Richard Felton
American, 1863-
OUTIN, Pierre
French, 1840-1899
OUVILLE, Claude Charles
Antoine Berny d'
French, op.1810-1842
OUVRIE, Pierre Justin
French, 1806-1879
OUWATER, Albert van
Netherlands,
op.c.1430-1460
OUWATER, Isaak
Dutch, 1750-1793
OUWATER, J.H. van
Dutch, op.1628
OUWATER, Jacob
Dutch, op.1750-1784
OUWERKERK, Jan van
Dutch, 1774-p. 1836
OVENDEN
British, op.1780
OVENDEN, F.W.
British, op.1834-1843
OVENDEN, Graham
British, 1943-
OVENS, Friedrich Adolf
German, op.1681-m.1699
OVENS, Jürgen
German, 1623-1678
OVER, Charles
British, op.1758
OVERBECK, August
Friedrich (Fritz)
German, 1869-1909
OVERBECK, Bonaventura van
see Overbeek

OVERBECK, Friedrich
German, 1789-1869
OVERBECK-SCHENK,
Gerta
German, 1898-
OVERBEEK, Overbeck or
Overbeke, Bonaventura
van (Romulus)
Dutch, c.1660-1705
OVERBEEK, Michel van
Dutch, op.c.1650-1680
OVERBEKE, Bonaventura
van
see Overbeek
OVEREND, William Heysham
British, 1851-1898
OVERLAET, Antoon
Flemish, 1720-1774
OVERSCHEE, Overschie
or Overzee, Pieter
van
Dutch, op.1661
OVERSTRAETEN, Wav
Edouard van
Belgian, 1892-
OVERSTREET, Joe
American, 20th cent.
OVERZEE, Pieter van
see Overschee
OVIEDO y Valdes
Spanish, op.1535
OW, Meinrad von
see Aw
OWEN, Rev. Edward
Pryce
British, 1788-1863
OWEN, H.Smythe
British, 19th cent.
OWEN, Samuel
British, 1768-1857
OWEN, Will
British, 1869-1957
OWEN, William
British, 1769-1825
OXFORD, Ignazio Enrico
see Hugford
OXTOBY, David
British, 1938-
OYENS, David
Dutch, 1842-1902
OYENS, Pieter
Dutch, 1842-1894
OZANNE, Nicolas Marie
French, 1728-1811
OZANNE, Pierre
French, 1737-1813
OZENFANT, Amédée
French, 1886-1966

P

PAAL, Ladislaus
(Laszló)
Hungarian, 1846-1879
PAALEN, Wolfgang
German, 1905-
PABLO, Pedro
Spanish, op.1563-1566
PABST, Hermann
German, 19th cent.
PACCHIA, Girolamo del
Italian, 1477-p.1533
PACCHIA, Pseudo
Italian, 16th cent.
PACCHIAROTTO, Bartolommeo
Italian, op.1535
PACCHIAROTTO, Giacomo
Italian, 1474-1540(?)
PACE or Pase, Pace
Italian, op.1594-1616

PACE da Faenza
Italian, op.1374
PACE, Gian Paolo
Italian, op.1528-1560
PACE, Giovanni
Battista
Italian, op.c.1650
PACE, Ranieri del
Italian, op.1704-1719
PACECCO or Pacicco
see Rosa, Francesco
di
PACELLI, Matteo
Italian, -c.1732
PACETTI, Vincenzo
Italian, c.1746-1820
PACH, Walter
American, 1883-
PACHECO, Fernando
Castro
Mexican, 1918-
PACHECO, Francisco
Spanish, 1564-1654
PACHER, Ferdinand
German, 1852-1911
PACHER, Friedrich
German, c.1435/40-p.1508
PACHER, Michael
German, c.1435-1498
PACHMANN, Georg
see Bachmann
PACIARZ, Jacques
Polish, 1921-
PACIFIC, Gertrude
American, 20th cent.
PACIFICUS, Horatius
Italian, op.c.1625
PACINI, Sante
Italian, op.1762-1790
PACINO di Bonaguida
Italian, op.1303-1320/39
PACK, Ann Mary
British, 20th cent.
PACK, Faithful
Christopher
British, 1759-1840
PACKX, Pacx, Paix or
Pax, Hendrick
Ambrosius
Dutch, c.1602/3-p.1658
PADAREWSKI, Franciszek
Polish, c.1759-1819
PADDAY, Charles
British, op.1889-1906
PADER, Hilaire
French, 1607-1677
PADERNA, Paolo Antonio
Italian, 1649-1708
PADERNI, Camillo
Italian, op.c.1738-1769
PADINA-MOSER, Alexandru
Rumanian, 1904-
PADOVANINO, Il
see Leoni, Ludovico
PADOVANINO, Il
(Alessandro Varotari)
Italian, 1590-1650
PADOVANO, Benedetto
see Bordone
PADOVANO, Lauro
see Lauro
PADOVINI, Alexander
see Paduano
PADUAN SCHOOL,
Anonymous Painters
of the
PADUANO or Padovini,
Alexander or Alexo
(Alessandro Scalzi)
Italian, op.1570-m.1596

PADWICK, Philip Hugh
British, 1876-1958
PAE, W.
British, 20th cent.
PAELINCK, Joseph
Flemish, 1781-1839
PAEMEL, Frederick van
Dutch, op.1792
PAEP, Pape or Papen,
Thomas de
Flemish, op.1648-m.1670
PAEPE, Joos, Josse or
Jodocus de
see Pape
PAERELS, Willem Adriaan
Dutch, 1878-1962
PAERT, Henry
see Peart
PAESCHKE, Paul
German, 1875-1920
PAETS, Willem
Dutch, 1636/8-1715
PAETZ, Eric
German, 20th cent.
PAEUW, Charles de
German, 20th cent.
PAEZ, Jose de
Mexican, 18th cent.
PAGAN, Mattia
Italian, op.1543-1555
PAGANELLI, Nicolò
Italian, 1538-1620
PAGANELLO da Siena
Italian, 13th cent.
PAGANI, Francesco
Italian, op.1644
PAGANI, Francesco
Figini di Antonio
(Francesco da Milano)
Italian, op.1502-1542
PAGANI, Gaspare
Italian, 1518-p.1543
PAGANI, Gregorio or
Goro
Italian, 1558-1605
PAGANI, Lattanzio
(Lattanzio della Marca,
Lattanzio di Monte
Rubbiano)
Italian, op.1535-1582
PAGANI, M.
Italian, op.1893
PAGANI, Paolo
Italian, 1661-1716
PAGANI, Vincenzo
Italian, c.1490-1568
PAGANINI, Antonio
see Peganini
PAGANO, Michele
Italian, c.1697-1732
PAGE, Géo
Belgian, 20th cent.
PAGE, R.
British, 18th cent.
PAGE, Walter
American, 1862-1934
PAGE, William
American, 1811-1885
PAGE-ROBERTS, James
British, 20th cent.
PAGES, Aimée
see Brune
PAGES, Irène
French, 20th cent.
PAGET, Henry Marriott
British, 1856-1936
PAGET, Sidney
British, 1861-1908

PAGET, Walter
British, op.1884-1886
PAGGI or Page, Giovanni
Battista
Italian, 1554-1627
PAGGIO, Il
see Merano, Francesco
PAGLIA, Antonio
Italian, 1680-1747
PAGLIA, Francesco
Italian, 1636-1713
PAGLIANO, Eleuterio
Italian, 1826-1903
PAGLIARINI, Giovanni
Italian, 1808-1873
PAGLIEI, Gioacchino
Italian, 1852-1896
PAGNEST, Amable Louis
Claude
French, 1790-1819
PAGNI, Benedetto
Italian, op.1525
PAGNI, Raffaello
Italian, op.1588-1597
PAGNIERRE, Mme. V.
see Drölling, Louise
Adéone
PAHL
see Pohl
PAICE, Christopher
British, 20th cent.
PAIL, Edouard
French, 1851-
PAILES, Isaac
French, 1895-
PAILLET, Antoine
French, 1626-1701
PAILLETTE, Mme.
French, op.1776
PAILLOU, Peter. I
British, c.1720-1785/90
PAILLOU, Peter
British, op.1759-1805
PAILTHORPE, Grace
British, 1883-
PAIN, Robert Tucker
British, op.1863-1877
PAINE or Payne, James II
British, op.1761-m.c.1829
PAINE, Jean
see Pesne
PAIRMAN, J.
British, op.1833
PAIX, Hendrick Ambrosius
see Packx
PAJETTA, Pietro
Italian, 1845-1911
PAJOU, Augustin
French, 1730-1809
PAJOU, Augustin Désiré
French, 1800-1878
PAJOU, Jacques Augustin
Catherine
French, 1766-1828
PAJVANCIC, Aleksander
Alex
Yugoslav, 20th cent.
PAK, Engel
Hungarian, 20th cent.
PAKENHAM, Catherine
British, 20th cent.
PAL
French, 19th cent.
PAL, Böhm
German, 19th cent.
PALACIOS, Francisco
Spanish, c.1640-1676
PALADINI, Arcangela
Italian, 1599-1622

PALADINI or Palladini,
Filippo di Lorenzo
Italian, op.1572-m.1608
PALADINI, G.
Italian, 15th cent.
PALADINI or Palladino,
Giuseppe
Italian, 1721-1794
PALADINI or Paladino,
Litterio
Italian, 1691-1743
PALADINO
see Zabarelli
PALAGI, Pelagio
Italian, 1775-1860
PALAMEDESZ or Palamedes,
Anthonie (Stevers)
Dutch, 1601-1673
PALAMEDESZ, Palamedes, I
(Stevaerts, Stevens
or Stevers)
Dutch, 1607-1638
PALAVICINI, Giacomo
see Pallavicini
PALAZZI, Bernardino
Italian, 1907-
PALAZZI, Riva
Italian, op.c.1750
PALBITZKI, Mathias
Swedish, 17th cent.
PALCHINSKI, Sylvia
Canadian, 20th cent.
PALCKO, Franz Anton
German, -1824
PALENCIA, Benjamin
Spanish, 1901-
PALESSA, Waclaw
Polish, 1902-
PALETHORPE, Mary Cox
British, op.c.1887-1916
PALEY, W.
British, op.1789
PALFREY, Penry Powell
British, 1830-1902
PALGRAVE, Lady
British, 19th cent.
PALIARD
French, op.1789
PALICZ, Jozsef
Hungarian, 1931-
PALING, Isaack
Dutch, op.1664-1719
PALING, Johannes
Jacobus
Dutch, 1844-1892
PALIZZI, Filippo
Italian, 1818-1899
PALIZZI, Francesco
Paolo
Italian, -1871
PALIZZI, Giuseppe
Italian, 1812/13-1888
PALIZZI, Nicola
Italian, 1820-1870
PALKO, Palcko, Palco,
Balco, Balko etc. or
Polke, Franz Xavier
Carl (Franz Carl)
German, 1724-1767
PALLADINI, Filippo di
Lorenzo
see Paladini
PALLADINO
see Zabarelli
PALLADINO, Giuseppe
see Paladini
PALLADY, Theodor
Rumanian, 1871-1956

PALLARES y Allustante,
Joaquin
Spanish, op.1890-1910
PALLARGUES, Pedro
see Despallargues
PALLAVICINI, Palavicini
or Parravicino, Giacomo
(Il Giannolo or
Gannuolo)
Italian, c.1660-1729
PALLAVICINI, Giuseppe
Italian, 1736-1812
PALLAVICINI, Leone
Italian, op.c.1590-1616
PALLIERE, Armand Julien
French, 1784-1862
PALLIERE or Paillière,
Jean Léon
French, 1823-
PALLIERE, Louis Vincent
Léon
French, 1787-1820
PALLIK, Béla
Hungarian, 1845-1908
PALLMANN, Götz
German, 1908-1966
PALLYA, C. Arulus
Hungarian, 1875-1930
PALLYA, Celesztin
Hungarian, 1864-1948
PALM, Anna Sofia
(de Rosa)
Swedish, 1859-1924
PALM, Gustaf Wilhelm
Swedish, 1810-1890
PALM, Torsten
Swedish, 1885-1934
PALMA, Antonio Negreti,
Nigreti or Nigretti
Italian, c.1510/15-p.1575
PALMA il Vecchio,
Jacopo d'Antonio
Negreti, Nigreti or
Nigretti
Italian, 1480(?)-1528
PALMA il Giovane,
Jacopo Negreti,
Nigreti or Nigretti
Italian, 1544-1628
PALMA, Luiz
Portuguese, op.1622
PALMAROLI y Gonzalez,
Vicente
Spanish, 1834-1896
PALME, Augustin
German, 1808-1897
PALME, Francois
French, op.1656-1686
PALMEIRO, José
Spanish, 20th cent.
PALMER, Alfred
British, 1877-1951
PALMER, Amanda
American, 20th cent.
PALMER, C.
American, op.c.1870
PALMER, Edith
British, 1770-1834
PALMER, F.E.
American, 19th cent.
PALMER, Frances Flora
(Fanny), (née Bond)
American, c.1812-1876
PALMER, Garrick
British, 20th cent.
PALMER, H.R.
British, op.c.1800

PALMER, Hannah Emma
(née Linnell)
British, 1881-
PALMER, Harry Sutton
(Sutton)
British, 1854-1933
PALMER, Herbert Sidney
Canadian, 1881-
PALMER, J.
Dutch, 17th cent(?)
PALMER, Sir James
British, 1584-1657
PALMER, James Lynwood
British, 1865-1941
PALMER, John
American, 20th cent.
PALMER, Lilli
British, 20th cent.
PALMER, Mary
see Thomond
PALMER, Samuel
British, 1805-1881
PALMER, William
British, 1763-1790
PALMER, William Charles
American, 1906-
PALMERINI, Pier
Antonio (Girolamo
Crocchia or Il
Crocicchia)
Italian, -1538
PALMERIO
see Palmieri
PALMERUCCI
see Guido di Palmerucci
PALMETTO
Italian, op.1423
PALMEZZANO, Marco
Italian, 1458/63-1539
PALMIE, Charles J.
(Joh. Ad. Robert Ch.)
German, 1863-1911
PALMIERI, Giuseppe
(Gioseffo ?)
Italian, 1674-1740
PALMIERI or Palmeri,
Pietro I (Pietro
Giacomo) (Petrus
Jacobus Palmerius)
Italian, 1737-1804
PALMIERI, Pietro II
(Palmerio)
Italian, -p.1819
PALMORE, Tom
American, 20th cent.
PALMSTEDT, Erik
Swedish, 1741-1803
PALO
French, 20th cent.
PALOMINO de Castro y
Velasco, Antonio
Acisclo
Spanish, 1655-1726
PALTHE, Antony
Dutch, 1726-1772
PALTHE, Gerard Jan
Dutch, 1681-p.1750
PALTHE, Jan
Dutch, 1719-1769
PALTRONIERI, Antonio
Italian, 1654-1717
PALTRONIERI, Pietro
(Il Mirandolese dalle
Prospettive)
Italian, 1673-1741
PALUDANUS
see also Broeck

PALUDANUS, Francois
Dutch, c.1631-p.1664
PALUDANUS van
Gröningen, Gerard
see Groenning
PALUGYAY, Zolo
Czech, 1898-1935
PALUMBO, Jaques
French, 20th cent.
PALVISINO da Putignano,
Francesco
Italian, op.1528
PAMFIL, Rodicastanca
Italian, 20th cent.
PAMFILIO da Spoleto
Italian, op.1482
PAN
see Liss, Jan
PAN, Barthélemy du
see Dupan
PANADERO, El
see Rodriguez, Juan
PANAGGI, Capo
Italian, 19th cent.
PANCALDI, Leone
Italian, 1917-
PANCETTI, José
Brazilian, 1900-
PANCIATICO di Antonello
da Calvi
Italian, op.1477
PANDOLFI, Giovanni
Giacomo
Italian, op.1608-p.1630
PANETTI, Domenico
Italian, c.1460-a.1513
PANFI, Romolo
Italian, 1632-1690
PANFILI, Pio
Italian, 1723-1812
PANFILO, Il
see Nuvolone, Carlo
Francesco
PANFILO
see Nuvolone, Giuseppe
PANICCIATI, Panniciati
or Panizzatti, Jacopo
Italian, -1540
PANIGAROLA, Domenico
Italian, 14th cent.
PANILLI
French, 18th cent.
PANIS, Jules Ernest
French, 1827-1895
PANKIEWICZ, József
Polish, 1866-1940
PANKOK, Bernhard
German, 1872-1943
PANKOK, Otto
German, 1893-
PANN, Abel (Pfefferman)
Russian, 1883-
PANNEELS, Willem or
Guillaume
Flemish, c.1600-p.1632
PANNICCIATI, Jacopo
see Panicciati
PANNINI, Francesco
Italian, op.1790
PANNINI, Giovanni
Paolo
Italian, 1691/2-1765
PANNONIO, Michele
see Michele Ongaro
PANORMITA, Antonello
see Antonello da
Palermo

PANSING, Fred
American, 19th cent.
PANSJA, Joannes Baptiste
des
see Espinosa
PANTAZIS, Pericles
Greek, 1849-1884
PANTOJA de la Cruz,
Juan
Spanish, 1551-1608
PANTON, Alexander
British, op.1861-1888
PANTON, Joseph
Australian, 1853-1913
PANTON, Lawrence Arthur
Colley
Canadian, 1894-1954
PANTORBA, Bernardino
de
Spanish, 19th cent.
PANZA, Federico
Italian, c.1633/43-1703
PAOLA
Italian, 20th cent.
PAOLETTI, Antonio Ermolao
Italian, 1834-1912
PAOLETTI, Paolo
Italian, -1735
PAOLETTI, Pietro
Italian, 1801-1847
PAOLETTI, Sylvius D.
Italian, 1864-1921
PAOLINI, Pietro
Italian, 1603-1681
PAOLINO or Paolo da
Pistoja, Fra (Signoraccio)
Italian, 1490(?)-1547
PAOLO de Angelis, Abbate
Italian, op.1621-1646
PAOLO da Brescia
Italian, op.1458
PAOLO di Dono
see Uccello
PAOLO di Giovanni Fei
see Fei
PAOLO di Giovanni da
Visso
Italian, op.1451-1483
PAOLO di Martino
Italian, op.1376-1426
PAOLO da Modena
Italian, op.1370
PAOLO di Maestro Neri
Italian, op.1343-1382
PAOLO da San Leocadio
(Paolo de Regio or
Pablo de Aregio)
Spanish, op.1472-1520
PAOLO di Stefano
see Schiavo, Paolo
PAOLO da Venezia
(Maestro Paolo)
Italian, op.1333-m.1362(?)
PAOLOTTO, Fra
see Ghislandi
PAOLOZZI, Edouardo
British, 1924-
PAON, Jean Baptiste le
see Lepaon
PAP, Emil
Hungarian, 1884-
PAPA, Simone I
Italian, 1430-1488
PAPACELLO or Paperello,
Bernabei Tomaso
Italian, c.1500-1559

PAPALOUKOS, S.
Greek, 20th cent.
PAPALUCA, L.
Italian, 19th cent.
PAPART, Max
French(?) 20th cent.
PAPAZOFF, Georges
Bulgarian, 1894-
PAPE, Abraham or
Abram Isaacksz. de
Dutch, a.1621(?)-1666
PAPE, Eduard
German, 1817-1905
PAPE, Frederick L.M.
British, 19th cent.
PAPE or Paepe, Joos,
Josse or Jodocus de
Flemish, op.1629-m.1646
PAPE or Papen, Thomas
de
see Paep
PAPELEU, Victor Eugène
de
French, 1810-1881
PAPETY, Dominique
Louis Ferréol
French, 1815-1849
PAPIKIAN, Albert S.
Russian, 1926-
PAPIN, Heinrich
German, 1786-1839
PAPPERITZ, Friedrich
George (Georg)
German, 1846-1918
PAPPERITZ, Gustav
Friedrich
German, 1813-1861
PAPPRILL, Henry
American, op.1846-1848
PAPS, (Waldemar Rusche)
German, 1882-1965
PAPWORTH, John
Buonarotti
British, 1775-1847
PAQUET-STEINHAUSEN,
Marie Henriette
German, 1887-
PARADISE, John
American, 1783-1833
PARADISE, John Wesley
American, 1809-1862
PARADYEN or Parisien
Dutch(?), op.1748-1757
PARAGANO, E.
Italian, 19th cent.(?)
PARAMONOV, Vasily
Federovich
Russian, 20th cent.
PARANT or Parent,
Louis Bertin
French, 1768-1851
PARCELLIS, Jan
see Porcellis
PARDO, Isaac Diaz
Mexican, 20th cent.
PARDON, James
British, op.1811-1848
PAREDES, Vicenta de
Spanish, 19th cent.
PAREJA, Diego de
Spanish, 15th cent.
PAREJA, Juan de
Spanish, c.1610-1670
PARELLE, M.A.
French, op.1774
PARENT, Henri Joseph
Aubert (Aubert)
French, 1753-1835

PARENT, J.
French, op.1822-1833
PARENT, Louis Bertin
see Parant
PARENT, Omer
Canadian, 1907-
PARENTINO or Parenzano,
Bernardo
Italian, c.1437-1531
PARESCE, René Herbert
French, 1886-
PARET y Alcázar, Luis
Spanish, 1747-1799
PARGOY, A.
German(?) op.c.1800
PARIGI, Alfonso II
Italian, 1590-1656
PARIGI, Giulio
Italian, op.1568-m.1635
PARIS, Camille Adrien
French, 1834-1901
PARIS, G.
French, op.1773
PARIS, Pierre Adrien
French, 1745-1819
PARIS Romano
see Nogari
PARIS, Walter
British, 1842-1906
PARISANI, Napoleone
Italian, 1854-p.1884
PARISE or Paresi,
Francesco (Il
Cabresello or Calabrese)
Italian, op.1713-m.1743
PARISH, Tom
American, 1933-
PARISIEN
see Paradyen
PARIZEAU, Philippe
Louis
French, 1740-1801
PARIZOT, Claude
French, 18th cent.
PARK, David
American, 1911-1960
PARK, Gerald
British, 1937-
PARK, Henry
British, 1816-1871
PARK, J.R.S.
British, 19th cent.
PARK, J. Stuart
British, 1862-1933
PARK, Linton
American, 1826-p.1880
PARKE, Henry
British, c.1792-1835
PARKER, Bill
American, 20th cent.
PARKER, Brynhild
British, 20th cent.
PARKER, Edgar
British, 1840-
PARKER, F.
British, 18th cent.
PARKER, Francess,
Countess Morley
(née Talbot)
British, -1857
PARKER, George
British, op.1688
PARKER, Henry H.
British, 1858-1930
PARKER, Henry Perlee
(Smuggler Parker)
British, 1795-1873

PARKER, John (?)
British, op.1627-1635
PARKER, John
British, op.1739(?)-m.1765(?)
PARKER, John
British, op.1762-1785
PARKER, John
British, 1798-1860
PARKER, Lawton S.
American, 1868-
PARKER, Raymond
American, 1922-
PARKER, Sam
American, 20th cent.
PARKER, W.
British, 19th cent.
PARKES, David
British, 1763-1833
PARKIN, F.
British, 19th cent.
PARKINSON, John
British, op.1640
PARKINSON, Sydney
British, c.1745-1771
PARKINSON, Thomas
British, op.1763-1789
PARKYNS, George Isham
British, 1749/50-p.1820
PARLAGHY-BRACHFELD,
Vilma von (Princess
Lwow)
Hungarian, 1863-1924
PARLBY, James
British, 19th cent.
PARMA, Anonymous
Painters of the
School of
PARMENTIER, Jacques
or James
French, 1658-1730
PARMESAN SCHOOL
see Parma
PARMIGIANINO, Il
see Scaglia, Girolamo
PARMIGIANINO or
Parmigiano, Il
(Girolamo Francesco
Maria Mazzola or
Mazzuoli)
Italian, 1503-1540
PARMIGIANO or
Parmagianino, Il
see Rocca, Michele
PARODI, Domenico
Italian, 1668-1740
PARODI, Giacomo Filippo
(Filippo)
Italian, 1630-1702
PARODI, Giovanni
Battista
Italian, 1674-1730
PARODI, Giuseppe
Italian, 18th cent.
PAROLINI, Giacomo
Italian, 1663-1733
PAROUTKA, Franz
German, 1808-p.1857
PARPETTE, Louison
French, op.1771-1800
PARR, Remi or Remigius
British, 1723-p.1750
PARRA, Gines
Spanish, 1899-1960
PARRA, José Felipe
Spanish, op.1832-1858
PARRA, Miguel
Spanish, 1784-1846

PARRISIO, Angelo
see Macagnini, Angelo
di Pietro di Angelo
PARRASIO, Micheli
see Micheli
PARRAVICINO, Giacomo
see Pallavicini
PARRIS, Edmund Thomas
British, 1793-1873
PARRISH, F.Maxfield
American, 1870-
PARRISH, Stephen
American, 1846-
PARROCEL, Charles
French, 1688-1752
PARROCEL, Etienne I
(Le Romain)
French, 1696-1776(1773?)
PARROCEL, Joseph
(Parrocel des Batailles,
Parrocel père)
French, 1646-1704
PARROCEL, Joseph Ignace
François (Joseph
François)
French, 1704-1781
PARROCEL, Pierre
French, 1670-1739
PARROCEL, Pierre Ignace
French, 1702-c.1775
PARROT, Amandine
French, 19th cent.
PARROT, Philippe
French, 1831-1894
PARROTT, Samuel
British, 1797-1876
PARROTT, William
British, 1813-p.1875
PARROTT, William Samuel
American, 1844-1915
PARRY, David Henry I
British, 1793-1826
PARRY, F.S.
British, op.1806
PARRY, John
British, 1812-1865
PARRY, Joseph
British, 1744-1826
PARRY, Thomas Gambier
British, 1816-1888
PARRY, William
British, 1742-1791
PARS, William
British, 1742-1782
PARSELLES, Jan
see Porcellis
PARSEY, A.
British, op.1823-1843
PARSHALL, Douglas
American, 1899-
PARSONS, Alfred William
British, 1847-1920
PARSONS, Arthur Wilde
British, op.1888-1920
PARSONS, Beatrice
British, 19th cent.
PARSONS, Betty
American, 1900-
PARSONS, Charles
British, 1821-1910
PARSONS, D.
British, 20th cent.
PARSONS, Francis
British, op.1763-m.1804
PARSONS, James
British, op.1746

PARSONS, Steven
British, 20th cent.
PARTE, Antonio della
see Particino
PARTICINO or della
Parte, Antonio
Italian, op.1567-m.1588
PARTIKEL, Alfred
German, 1888-1946
PARTINGTON, John H.E.
British, 1843-1899
PARTIOT, Bernard
French, 20th cent.
PARTON, Arthur
American, 1842-1914
PARTON, Ernest
American, 1845-1933
PARTOS, Paul
Australian, 1943-
PARTRIDGE, Bernard
British, 1861-1945
PARTRIDGE, E.
British, 19th cent.
PARTRIDGE, John
British, 1790-1872
PARVEZ, Ahmed
British, 1926-
PASANEN, Osmo
Finnish, 20th cent.
PASCAL, Antoine
French, 1803-1859
PASCAL, Léopold
French, 1900-1962
PASCAL, Michel François
French, 1810-1882
PASCAL, Paul
French, 1832-1903
PASCALETTI, Giuseppe
Italian, op.1738
PASCALI, Pino
Italian, 1935-
PASCALIN, Joseph
see Moretti
PASCAU, J.P.P.
Eugène
French, 1875-
PASCH, Johan I
Swedish, 1706-1769
PASCH, Lorenz I
Swedish, 1702-1766
PASCH, Lorenz or Lorens
II
Swedish, 1733-1805
PASCH, Ulrika Fredrika
Swedish, 1735-1796
PASCHE, John
British, 20th cent.
PASCHKE, Ed
American, 20th cent.
PASCIN, Jules
(Julius Pincas)
French, 1885-1930
PASCUCCI, Paride
Italian, 1867-
PASCUTTI, J.
German, op.c.1820
PASE, Pace
see Pace
PASE, Gian Paolo
see Pace
PASINELLI, Lorenzo
Italian, 1629-1700
PASINI, Alberto
Italian, 1826-1899
PASINI, Giuseppe
Italian, op.1562-m.1590/5

PASINI, Lazzaro
Italian, 1861-
PASMORE, Daniel
British, op.1829-1865
PASMORE, Edwin John
Victor
British, 1908-
PASMORE, John II
British, op.1830-1845
PASMORE, John Frederick
British, 1820-1881
PASMORE, Wendy
British, 1915-
PASOTTI, Bernardo
Italian, 1910-
PASQUALINI, Felice
Italian, op.1570-1589
PASQUALINI, Pascalini
or Pasqualino, Giovanni
Battista
Italian, op.c.1619-1634
PASQUALINI, Jules
Italian, 1820-1886
PASQUALINO
see Rossi, Pasquale
de'
PASQUALINO da Venezia
Italian, op.1496-m.a.1505
PASQUALOTTO
see Ottini, Pasquale
PASQUETTI, Fortunato
Italian, c.1700-1773(?)
PASQUIER, Pierre
French, c.1731-1806
PASS, J.
British(?) op.1800
PASS, William
German, 1598(?)-1637
PASSAEUS
see Passe
PASSANTE or Bassante,
Bartolommeo
Italian, 1614-1656
PASSARINI, Filippo
Italian, c.1638-1698
PASSAROTTI, Passarotto,
Passaroto or
Passerotti, Bartolommeo
Italian, 1529-1592
PASSAROTTI, Passarotto
Passaroto or
Passerotti, Passarotto
Italian, c.1560-p.1606
PASSAROTTI, Passarotto,
Passaroto or
Passerotti, Tiburzio
Italian, c.1555-1612
PASSAROTTI, Passarotto,
Passaroto or
Passerotti, Ventura
Italian, c.1560-p.1577
PASSAVANT, Johann David
German, 1787-1861
PASSAVANT, Lucile
French, 19th cent.
PASSE, Crispijn, I (van)
de (Crispianus Passaeus)
Dutch, 1564-1637
PASSE, Crispijn, II
(van) de (Crispianus
Passaeus)
Dutch, c.1597-c.1670
PASSE, Magdalena (van)
de (Magdalena van
Bevervoordt)
Dutch, 1600-a.1640

PASSE, Simon de
(Simon Passaeus)
Dutch, 1595-1647
PASSE, Willem de
(Wilhelmus Passaeus)
Dutch, 1598-a.1638
PASSERI, Andrea de'
Italian, op.1487-1511
PASSERI, Passari or
Passaro, Bernardino
Italian, c.1540-c.1590
PASSERI, Giovanni
Battista
Italian, c.1610-1679
PASSERI, Giuseppe
Italian, 1654-1714
PASSERINI, Domenico
Italian, 1723-1788
PASSEROTTI or Passerotto
see Passarotti
PASSI, Marco
Italian, 19th cent.
PASSIGNANO or Passignani,
Domenico (Domenico
Cresti)
Italian, c.1560-1636
PASSINI, Johann Nepomuk
German, 1798-1874
PASSINI, Ludwig Johann
German, 1832-1903
PASSMORE, John
Australian, 1904-
PASSMORE, John Richard
British, 19th cent.
PASSOT, Gabriele
Aristide
French, 1797-1875
PASTEGA, Luigi
German, 1858-1927
PASTELOT, Jean Amable
Amédée (Amédée)
French, 1820-1870
PASTERNAK, Leonid
Ossipowitsch
Russian, 1862-1945
PASTEUR, Louis
French, 1822-1895
PASTOR
French, 19th cent.
PASTORINI, Pastorino
di Giovan Michele de'
Italian, c.1508-1592
PASTORIS, Federico
Italian, 1837-1884
PASTOUR, Louis
French, 1876-
PASTURA
see Antonio da Viterbo
PASTURE, André
French, 20th cent.
PATA, Cherubino
Swiss, op.1868-1884
PATANAZZI, Alfonso
Italian, op.1580-1616
PATAS, Charles Emmanuel
(not Jean Baptiste)
French, 1744-1802
PATCH, Thomas
British, c.1720-1782
PATEL, Benoît Nicolas
(not Bernard)
French, c.1701-
PATEL, Jacques
(Patel le Tué)
French,
1630/35-1662

PATEL, Pierre I
(Le bon Patel)
French, c.1605-1676
PATEL, Pierre Antoine
(Pierre) II
French, 1648-1707
PATELLI, Paolo
Italian, 20th cent.
PATELLIERE, Amédée de la
French, 20th cent.
PATENIER, Patinier or
Patinir, Joachim
Netherlands,
op.1515-m.a.1525
PATER, Jean Baptiste
Francois
French, 1695-1736
PATERSON, Emily Murray
British, 1855-1934
PATERSON, G.W. Lennox
British, 1915-
PATERSON, Helen
see Allingham
PATERSON, James
British, 1854-1932
PATERSON, John Ford
British, 19th cent.
PATERSON, R.
British, 19th cent.
PATERSSON, Paterson
or Pattersen, Benjamin
Swedish, c.1747-p.1815
PATIN, Jacques
French, op.1564-m.a.1604
PATIN, Louis Joseph
Alphonse
French, 19th cent.
PATINI, Teofilo
Italian, 1842-1906
PATINIR or Patinier,
Joachim
see Patenier
PATISSOU, Jacques
French, 1880-1925
PATKO, Karoly
Hungarian, 1895-1941
PATON, Amelia Robertson
see Hill
PATON or Patton, David
British, op.1668-1693
PATON, Frank
British, 1856-1909
PATON, J.
British, op.1829
PATON, Joseph Neil
British, 1797-1874
PATON, Sir Joseph Noel
(Noel)
British, 1821-1901
PATON, P.
British, op.1780
PATON, Richard
British, 1717-1791
PATON, Waller Hugh
British, 1828-1895
PATOUN, John
British, op.1746
PATRICE
French, 20th cent.
PATRICK, James McIntosh
British, 1907-
PATRICK, John
Rutherford
British, op.c.1891-1898
PATRICOT, Jean
French, 1865-1928

PATRIX, Michel
French, 1917-
PATRIZI
Italian, 17th cent.
PATROIS, Isidore
French, 1815-1884
PATRU, Louis
Swiss, 1871-1905
PATRY, Edward
British, 1856-1940
PATTANTYUS, Miklos
Hungarian, 20th cent.
PATTEN, George
British, 1801-1865
PATTEN, Thomas
British, 18th cent.
PATTEN, William Vandyke
British, op.1844-1871
PATTERN, W.
British, op.1800
PATTERSON, Ambrose
British, 1877-
PATTERSON, Charles
Robert
British, 1878-
PATTERSON, H.
British, op.1840-1851
PATTERSON, James
British, 1854-
PATTERSON, Malcolm
British, 19th cent.
PATTISON, Edgar L.
British, 1872-
PATTISON, Thomas
William
British, 1894-
PAU de Saint-Martin,
Pierre Alexander
French, op.1784-1834
PAUDISS, Pauditz or
Bauditz, Christoph
or Christoffer
German, c.1618-1666/7
PAUELSEN, Paulsen,
Pavelsen or Poulsen,
Erik
Danish, 1749-1790
PAUER, Gyula
Hungarian, 20th cent.
PAUL, Bruno
German, 1874-
PAUL, Ernst Wilhelm
German, 1856-
PAUL, Eugène (Gen)
see Gen-Paul
PAUL, J.
British, 1804-1887
PAUL, Jeremiah
American, op.c.1791-1820
PAUL, Sir John Dean
British, 1775-1852
PAUL, Louis
French, 19th cent.
PAUL, R. I
British, op.1805-1815
PAUL, Georges Hermann
René (Hermann)
French, 1864-
PAUL, Robert Boyd II
British, op.1858-1863
PAULI, Fritz
Swiss, 1891-
PAULI, Georg Vilhelm
Swedish, 1855-1935
PAULI or Hirsch-Pauli,
Hanna (née. Hirsch)
Swedish, 1864-1940

PAULIN, H.
French, 19th cent.
PAULIN, Horatius
see Paulyn
PAULO, Joao
Portuguese, 1929-
PAULSEN, Anton
German, op.1718-1748
PAULSEN, Erik
see Pauelsen
PAULSEN, Fritz
German, 1838-1898
PAULSEN, Oscar Julius
Danish, 1860-1932
PAULSON, R.E.
British, 19th cent.
PAULTRE, le
see Lepautre
PAULUCCI, Enrico
Italian, 1901-
PAULUS
see San Leocadio
PAULUS, Pierre
Belgian, 1881-1959
PAULUS, S.
German, 19th cent.
PAULUSZ. or Paulwelsz.,
Zacharias (Zacharias
van Alkmaar)
Dutch,
c.1580 (1600?)-1648
PAULYN or Paulin,
Horatius
Dutch, c.1644/5-p.1682
PAUPION, Eduard
French, 1854-1912
PAUQUET, Jean Louis
Charles (Louis)
French, 1759-c.1824
PAUSER, Sergius
German, 1896-
PAUSINGER, Clemens von
German, 1855-1936
PAUSINGER, Franz Xaver
von
German, 1839-1915
PAUW, René de
Belgian, 1887-1946
PAUWELS, Ferdinand
Wilhelm
Belgian, 1830-1904
PAUWELS, Maximilien
Flemish, op.1643-1661
PAUZET
French, 18th cent.
PAVANINO da Palermo
Italian, 15th cent.
PAVELSEN, Erik
see Pauelsen
PAVESE, Donato de' Bardi
see Donato
PAVIA, Lorenzo
Italian, 1741(?)-1764
PAVIA, Michele da
see Besozzo
PAVIA, Philip
American, 20th cent.
PAVIL, Elie Anatol
French, 1873-1948
PAVILLON, Isidore
Péan de
French, op.1833-m.1856
PAVLOS
French, 20th cent.
PAVLOVETS, Nikita
Ivaniv
Russian, -1677

PAVLOWSKY, Jacqueline
Russian, 20th cent.
PAVONA, Francesco
Italian, 1695-1777
PAVY, Eugène
French, 19th cent.
PAVY, Philippe
French, op.1878-1887
PAWSON, T.
British, op.1812-1817
PAX, Hendrick Ambrosius
see Packx
PAXSON, Edgar Samuel
American, 1852-
PAXTON, Sir Joseph
British, 1801-1865
PAXTON, William
McGregor
American, 1869-1941
PAY, Engelhard de
see Pee
PAY, Depay, Depey or
Pey, Johann de
German, 1609-1660
PAYE, Richard Morton
British, op.1773-m.1821
PAYEN, Auguste Antoine
Joseph
Belgian, 1792-1853
PAYEN, Ennemond
French, -1896
PAYER, Ernst
German, 1863-
PAYER, Julius Ritter
von
German, 1842-1915
PAYNE, Albert Henry
British, 1812-1902
PAYNE, D.
British, op.1757
PAYNE, David
British, op.1877
PAYNE, Harry
British, op.1910
PAYNE, Henry A.
British, 1868-1940
PAYNE, James
see Paine
PAYNE, John
British, c.1608-a.1648
PAYNE, William
British, 1755/60-p.1830
PAYOT, Marc
Belgian, 20th cent.
PAYSON, J.
British, 19th cent.
PAZE, Gian Paolo
see Pace
PAZZI, Pier Antonio
(Antonio)
Italian, 1706-p.1766
PAZZINI, Norberto
Italian, 1856-1936
PEACHAM, Henry
British, c.1576-1643(?)
PEACHEY, James
British, op.1780-1787
PEACKE, Edward
British, op.c.1640
PEACOCK, Brian
British, 20th cent.
PEACOCK, Joseph
British, c.1783-1837
PEACOCK, Ralph
British, 1868-1946
PEAKE, Mervyn
British, 1911-1968

PEAKE or Peak,
Robert I
British, op.1598-m.1626(?)
PEALE, Anna Claypole
American, 1791-1878
PEALE, Charles Willson
American, 1741-1827
PEALE, James I
American, 1749-1831
PEALE, James
American, 1789-1876
PEALE, James Godman
American, 1823-1891
PEALE, Margaretta
Angelica
American, 1795-1882
PEALE, Mary Jane
(or Jean)
American, 1827-1902
PEALE, Raphael
(Raphaelle)
American, 1774-1825
PEALE, Rembrandt
American, 1778-1860
PEALE, Rubens
American, 1784-1865
PEALE, Sarah Miriam
American, 1800-1885
PEALE, Titian Ramsay
American, 1799-1885
PEAN, René
French, 20th cent.
PEARCE, Bryan
British, 1930-
PEARCE, Charles Maresco
British, 1874-1964
PEARCE, Charles Sprague
American, 1851-1914
PEARCE, E.M.
British, op.1810
PEARCE, Stephen
British, 1819-1904
PEARCE, William
British, op.1798-1799
PEARLSTEIN, Philip
American, 20th cent.
PEARS, A.
South African, op.1850
PEARSALL, Phyllis
British, 20th cent.
PEARSE, B.S.
British, 19th cent.
PEARSON, Cornelius (?)
British, 1807-1891
PEARSON, David
British, 1937-
PEARSON, George
British, 19th cent.
PEARSON, J.
British, op.c.1860
PEARSON, John
British, 1777-1813(?)
PEARSON, John
American, 20th cent.
PEARSON, Mary Martha
(née Dutton)
British, 1799-1871
PEARSON, William
British, op.1798-1813
PEART or Paert
(not Paest), Henry
British, -c.1697
PEART, William
British, op.1815
PEASE, D.
American, 20th cent.
PEAT, Thomas
British, op.1791-1805

PECCHIO, Domenico
Italian, 1712/15-1759
PECHAM or Peham, Georg
German, op.1593-m.1604
PECHANEK, Miroslav
Czech, 20th cent.
PECHER, Jules Romain
French, 1830-1899
PECHEUX, Benoît
French, 1779-p.1831
PECHEUX, Laurent
French, c.1729-1821
PECHSTEIN, Hermann Max
(Max)
German, 1881-1955
PECHT, August Friedrich
(Friedrich)
Swiss, 1814-1903
PECK, Nathaniel
American, op.1827-1830
PECK, Orrin or Orvin
American, 1860-1921
PECKITT, William
British, 1731-1795
PECOEN, Jean
French, 20th cent.
PECORI, Domenico
Italian, c.1480-1527
PECQUEREAU, Alphonse-
Ernest
French, 1831-
PECRUS, Charles
François
French, 1826-p.1905
PECZARSKI, Feliks
Polish,
1805 (1804?)-1862
PEDERSEN, Carl Henning
Danish, 1913-
PEDERSEN, Viggo
Christian Frederik
Vilhelm
Danish, 1854-1926
PEDERSEN, Vilhelm
Danish, 1820-1859
PEDJA, Milosavljevic
Predrag
Yugoslav, 1908-
PEDONE, Bartolomeo
(Pedon)
Italian, 1665-1732
PEDRAZZI, Luigi
Italian, op.1827-m.1841/3
PEDRETTI, Gian
Swiss, 1926-
PEDRETTI, Giuliano
Swiss, 20th cent.
PEDRETTI, Giuseppe
Carlo
Italian, 1694-c.1778
PEDRETTI, Turo
Swiss, 1896-1964
PEDRINI, Domenico
Italian, 1728-1800
PEDRINI, Filippo
Italian, 18th cent.
PEDRINI, Giovanni
Pietro Rizzo
see Gianpietrino
PEDRO, Antonio
Portuguese, 1909-
PEDRO de Cordoba
see Cordoba
PEDRO, Maestre (Pedro
de la Vega?)
Spanish, op.1480-1521

PEDRO de la Vega
see Pedro, Maestre
PEE or Pay, Engelhard
de (also, erroneously,
Engelhard de Peer)
Netherlands, op.1570-1605
PEE, Henriette van
see Wolters
PEE, Peene, Peenen,
Penen or Penne, Jan van
Flemish, op.1656-m.1710
PEE, Pene cr Peenen,
Theodor van
Dutch, 1668/9-1746
PEEL, E.
British, 19th cent.
PEEL, James
British, 1811-1906
PEEL, Michael
British, 20th cent.
PEEL, Paul
Canadian, 1860-1892
PEELE, James
Australian, 1846-
PEELE, John Thomas
British, 1822-1897
PEENE or Peenen
see Pee
PEER, Pauwels van de
Flemish, op.1658-1659
PEERDT, Ernst Carl
Friedrich te
German, 1852-1932
PEETERS, Bonaventura, I
Flemish, 1614-1652
PEETERS, Bonaventura, II
Flemish, 1648-1702
PEETERS or Pieters,
Clara
Flemish, c.1589-p.1657
PEETERS, Gillis, I
Flemish, 1612-1653
PEETERS, Jacob
Flemish, op.1675-1721
PEETERS, Jan, I
Flemish, 1624-c.1677/80
PEETERS, Jozef
Belgian, 1895-1960
PEETERS, P.
Flemish(?), op.1612
PEETERS, P.D.
Dutch(?), 17th cent.
PEGANINI, Paganini
or Paganino, Antonio
or Gianantonio di
Giammaria de'
Italian, op.1574-1587
PEGG, William
British, 18th cent.
PEGLER, Charles William
British, op.1823-1832
PEGNA or Pegnia,
Hyacinth de la
see La Pegna
PEGRAM, Frederick
British, 1870-1937
PEGURIER, Auguste
French, 1856-1936
PEHAM
see Beham and Pecham
PEHM, Wazlaw
see Wenzel von
Riffiano
PEIFFER, Johann Joachim I
see Pfeiffer

PEIFFER-WATENPHUL,
Max
German, 1896-
PEIGNE, Hyacinth de la
see La Pegna
PEINE, Piena or Pegne,
Antonio de la
Italian, op.1675
PEINER, Werner
German, 1897-
PEINTRE, Charles le
see Lepeintre
PEIRCE, Waldo
American, 1884-
PEIRE, Luc
Belgian, 1916-
PEIROTTE, A.
see Peyrotte
PEIRSON, J.
British, op.c.1798
PEITHNER, Eduard
see Lichtenfels
PEITRET, Jacques
see Peytret
PELACANE
see Morone, Domenico
PELAYO, Orlando
Spanish, 1920-
PELEGNY, Arsène
French, op.c.1858
PELEYSIER, Ary
see Pleysier
PELEZ, Fernand
Emmanuel
French, 1843-1913
PELGROM, Jacobus
Dutch, 1811-1861
PELHAM, Henry
American, 1749-1806
PELHAM, J.
British, 19th cent.
PELHAM, Peter
British, c.1684-1751
PELHAM, Thomas Kent
British, op.1860-1891
PELISSIER or Pellissier,
Jean Joseph
French, 19th cent.
PELISSIER, Johann Anton
Theodor (Theodor)
German, 1794-1863
PELLAN, Alfred
Canadian, 1906-
PELLAR, Hans
German, 1886-
PELLEGRIN, Honoré
French, 19th cent.
PELLEGRINI, Alfred
Heinrich
Swiss, 1881-1958
PELLEGRINI, Carlo
Italian, 1605-1649
PELLEGRINI, Carlo
(Ape)
Italian, 1839-1889
PELLEGRINI, Carlos
Enrique
Italian, 1800-1875
PELLEGRINI or Pelegrini,
Domenico
Italian, 1759-1840
PELLEGRINI, Felice
Italian, 1579-1630
PELLEGRINI, Giovanni
Antonio
Italian, 1675-1741

PELLEGRINI, Itala
Italian, 1865-
PELLEGRINI, Riccardo
Italian, 1863-1934
PELLEGRINI, Vincenzo
Italian, 1575-1612
PELLEGRINO da Bologna
see Tibaldi
PELLEGRINO, Domenico
see Tibaldi de'
Pellegrini
PELLEGRINO di Mariani
(Rossini)
Italian, op.1449-m.1492
PELLEGRINO di Mariano,
Pseudo
Italian, 15th cent.
PELLEGRINO da Modena,
Aretusi
see Aretusi
PELLEGRINO da San
Daniele (Martino da
Udine)
Italian, c.1467-1547
PELLERIN, Baptiste
French, op.1563-m.a.1595
PELLICCIAIO, Giacomo di
Mino del
Italian, op.1342-m.a.1396
PELLIER, Pierre Edmé-
Louis
French, op.1800-1827
PELLING, John
British, 20th cent.
PELLINO di Vannuccio
Italian, op.1377
PELLIZZA or Pelizza,
Giuseppe
Italian, 1868-1907
PELMADO
see Mudo, Pedro el
PELOSIO, Francesco
Italian, op.1476
PELOUSE, Léon Germain
French, 1838-1891
PELS, Albert
American, 1910-
PELTRO, John
British, 1760-1808
PELUSO, Francesco
Italian, 1836-
PEMBERY, R.
British, 19th cent.
PEMBROKE, Thomas
British, 1662(?)-1690(?)
PEMELL, J.
British, op.1838-1851
PEN, Jacob
see Penn
PENA y Munoz, Maximino
Spanish, 1863-
PENA, Narcisse Virgile
Diaz de la
see Diaz
PENALOSA, José Antonio
Venezuelan, 1782-1803
PENALOSA y Sandoval,
Juan de
Spanish, 1581-1636(?)
PENATER, Benedikt
German, 1793-1840
PENCK, A.R.
German, 1939-
PENCZ, Benntz, Benz, Pens,
Pentz, Penz or Prenntz,
Jörg or Jorg
German, c.1500-1550

PENDL, Erwin
 German, 1875-
PENE, Jean
 see Pesne
PENE, Theodor van
 see Pee
PENEN, Jan van
 see Pee
PENET, L.
 French, 19th cent.
PENFIELD, Edward
 American, 1866-1925
PENGER
 German, 19th cent.
PENGUILLY-L'HARIDON
 Octave
 French, 1811-1870
PENICAUD, Penicau,
 Penicault or Peniquad,
 Jean, I
 French, op.1510-1540
PENICAUD, Pierre
 French, -p.1590
PENIQUAUD
 see Penicaud
PENIZ, Josef
 (Giuseppe)
 Italian, 16th cent.
PENLEY, Aaron Edwin
 British, 1807-1870
PENN or Pen, Jacob
 Dutch, -1680
PENN, Stephen
 British, op.1732
PENN, William Charles
 British, 1877-1968
PENNA, Arnau de la
 Spanish, op.c.1375
PENNA or Pene, Jean
 see Pesne
PENNACCHI (?), Gerolamo
 di Pier Maria (?)
 (Gerolamo da Treviso II)
 Italian, 1497(?)-1544
PENNACCHI, Pier Maria
 Italian, 1464-1514/15
PENNACCHINI, Domenico
 Italian, 1860-
PENNANT, Thomas
 British, op.1773
PENNASILICO, Giuseppe
 Italian, 1861-1940
PENNE, Charles Olivier
 de (Olivier)
 French, 1831-1897
PENNE, Jan van
 see Pee
PENNELL, Harry
 British, op.1899-1900
PENNELL, Joseph
 American, 1860-1926
PENNETHORNE, James
 British, 1801-1871
PENNEY, James
 American, 1910-
PENNI, Giovanni
 Francesco (Il Fattore)
 Italian, 1488(?)-c.1528
PENNI, Luca (Romanus)
 Italian, c.1500-1556
PENNIER
 French, 17th cent.
PENNIMAN, John Ritto
 American, 1783-
PENNING, Nicolaas Lodewic
 Dutch, 1764-1818

PENNINGTON, John
 British, op.1811-1840
PENNINKS, Johann (?), P.
 Dutch, 1627-p.1682
PENNISS, F.
 British(?), op.1696
PENNK, J.
 Dutch(?), op.1694
PENNY, C.
 British, op.1814-1825
PENNY, Edward
 British, 1714-1791
PENNY, William D.
 British, 1834-1924
PENOT, Albert Joseph
 French, op.1896
PENOT, Jean Falgores
 Vallette
 French, 1710-p.1777
PENROSE, James Doyle
 British, 1864-1932
PENROSE, Roland Algernon
 British, 1900-
PENSABEN, Fra Marco
 (Fra Marco Veneto)
 Italian, 1486-1531
PENSABENE, Marchese
 Giuseppe
 Italian, 19th cent.
PENSEE, Charles Francois
 Joseph
 French, 1799-1871
PENSON, Frederick T.
 British, 19th cent.
PENSTONE, C.
 British, 19th cent.
PENSTONE, Edward
 British, op.1890
PENSTONE, John Jewell
 British, op.1835-1895
PENTELEI-MOLNAR, Janos
 (Johann)
 Hungarian, 1878-1924
PENTINI, Domenico
 Italian, 17th cent.
PEOLI, Juan Jorge
 Spanish, op.1847
PEOLOSI, Francesco
 Italian, op.1476
PEPLOE, Denis Frederic
 Neal
 British, 1914-
PEPLOE, Samuel John
 British, 1871-1935
PEPPER, George Douglas
 Canadian, 1903-
PEPPERCORN, Arthur
 Douglas
 British, 1847-1926
PEPYN, Marten
 Flemish, 1575-1643
PEQUEGNOT, Auguste
 French, 1819-1878
PEQUIGNOT, Jean Pierre
 (Pierre)
 French, 1765-1807
PEQUIN, Charles Etienne
 French, 1879-
PERABO, Giovanni
 Italian, op.1768
PERAC, Etienne du
 French, c.1525-1604
PERAHIM, Jules
 Rumanian, 1914-
PERAIRE, Achille
 French, 19th cent.

PERAIRE, Paul
 Emmanuel
 French, 1829-1893
PERALTA DEL CAMPO,
 Francisco
 Spanish, -1897
PERALTIS, Jean
 French(?) 14th cent(?)
PERANDA, Santo
 Italian, 1566-1638
PERAUX, Lionel
 French, 1871-
PERBOYRE, Paul Emile
 Léon
 French, 19th cent.
PERCELLES, Jan
 see Porcellis
PERCEVAL, John
 Australian, 1923-
PERCIER, Charles
 French, 1764-1838
PERCIN
 French, 18th cent.
PERCIVAL, Hon. Charles
 British, op.1770
PERCIVAL, H.
 British, 19th cent.
PERCY, Arthur Carlsson
 Swedish, 1886-
PERCY or Williams,
 Sidney Rich
 British, 1821-1886
PERCY, William
 British, 1820-1893
PERDRIAT, Hélène
 (Hellesen)
 French, 1894-
PERDRIX, Jean Francois
 French, op.1764-m.1809
PERE, Anton or Antonio
 van (de)
 Flemish, op.1659-1673
PEREA y Rojas, Alfredo
 Spanish, 1839-1895
PEREA or Pereira,
 Braz
 Portuguese, op.1520-1555
PEREDA, Antonio
 Spanish, 1608/11-1678
PEREDA, Franz
 Spanish, 17th cent.
PEREGO, Giovanni
 Italian, 1776-1817
PEREGRINO
 Italian, op.1428
PEREGRINO da Cesena
 Italian, 16th cent.
PEREHUDOFF, William
 Canadian, 1919-
PEREIRA, Braz
 see Perea
PEREIRA, Irene Rice
 American, 1905-
PEREIRA, Perea or
 Pereyra, Vasco
 Portuguese, c.1535-1609
PERELLE, Adam
 French, 1640-1695
PERELLE or Perrelle,
 Gabriel
 French, c.1603-1677
PERELLE or Perrelle,
 Nicolas
 French, 1631-1695
PERESINOTTI or Pariginotti,
 Antonio
 Italian, 1708-1778

PERETZ, David
 French, 1906-
PEREYNS, Simon
 Netherlands, op.1566-1568
PEREZ, Alonso
 Spanish, op.1893-1914
PEREZ, Andrés
 Spanish, 1660-1727
PEREZ, Bartolomé
 Spanish, 1634-1693
PEREZ de Pineda,
 Francisco I
 Spanish, op.1664-1673
PEREZ or Sarriá,
 Gonzalo (possibly
 identified with the
 Master of the Martin de
 Torres Family)
 Spanish, op.1432-1440
PEREZ, Joseph Berres
 Edler von
 German, 1821-
PEREZ de Alesio, Mateo
 (Matteo da Lecce or
 Leccio)
 Spanish, c.1547-c.1600
PEREZ de Albar, Miguel
 Spanish, -1697
PERGENTILE, Niccolò (?),
 di
 Italian, op.1518-1529
PERGER, Sigmund
 Ferdinand von
 German, 1778-1841
PERGOLESI, Michelangelo
 Italian, op.1777-1801
PERI, Peter
 British, 20th cent.
PERICCIOLI or Pericciuoli,
 Giuliano
 Italian, op.1634-m.c.1646
PERICLE, Luigi
 (Giovanetti)
 Italian, 20th cent.
PERICO, Alessandro
 Italian, 20th cent.
PERICOLI, Il
 see Tribolo, Niccolò
PERIES, Ivan
 British, 20th cent.
PERIGAL, Arthur II
 British, 1816-1884
PERIGNON, Alexis
 Joseph
 French, 1806-1882
PERIGNON, Alexis
 Nicolas I
 French, 1785-1864
PERIGNON, Nicolas
 French, 1725-1782
PERILLI, Achille
 Italian, 1927-
PERIN, Alphonse Henri
 French, 1798-1874
PERIN, Lié Louis
 (P. Salbreux)
 French, 1753-1817
PERINECTUS
 see Perrinetto
PERINO da Perugia
 see Cesarei, Pietro
PERINO del Vaga
 (Pietro Buonaccorsi)
 Italian, 1501-1547
PERINO da Vinci
 see Pierino

240

PERIS, R.
 Spanish, op.1869
PERIZI, Nino
 Italian, 1917-
PERKINS, A.E.
 British, 19th cent.
PERKINS, Granville
 American, 1830-1895
PERKOIS, Jacobus
 Dutch, 1756-1804
PERKS, Paul
 German, 1879-
PERLAU, Joseph
 Belgian, 1809-
PERLBERG, Friedrich
 ('Fredy')
 German, 1848-1921
PERLBERG, Georg
 German, 1807-1884
PERLET, Jean Marc
 Swiss, 1759-c.1820
PERLIN, Bernard
 American, 1918-
PERLIN, Firmin (?)
 French, op.1768-m.1783
PERLMUTTER, Zoltan
 American, 20th cent.
PERLSEE, Ignaz
 German, 19th cent.
PERMEKE, Constant
 Belgian, 1886-1952
PERMENIATES, Joannes
 Greek, 16th cent.
PERMOSER, Balthazar
 German, 1651-1732
PERNA, C.E.
 French(?) 19th cent.
PERNAT, Franz Sales
 German, 1853-1911
PERNATH, Johann Peter
 German, 20th cent.
PERNET, Jean Henry
 Alexandre
 French, c.1763-p.1789
PERNET, Pierre Denis
 French, 18th cent.
PERNHART, Marcus
 German, 1824-1871
PERNICHARO, Pablo
 Spanish, op.1736-m.1760
PERNOT, François
 Alexandre
 French, 1793-1865
PEROFF, Wassilij
 Grigorjewitsch
 Russian, 1833-1882
PEROLI or Perola,
 Juan Bautista
 Spanish, op.1569-1596
PERON, Louis Alexandre
 (Alexandre)
 French, 1776-1856
PERONI, Giuseppe
 Italian, 1710-1776
PERONNE, Louis
 French, 1892-
PEROSINO, Giovanni
 Italian, op.1517-1523
PEROTTI, Pietro
 Antonio
 Italian, 1712-1793
PEROUX, Joseph Nicolaus
 German, 1771-1849
PEROVANI, José
 American, op.1796-m.1838
PERPIGNANI, Cav. Galgano
 Italian, 1694(1696?)-1771

PERRACCINI or Perracini,
 Giuseppe (Il
 Mirandolese)
 Italian, 1672-1754
PERRACHON, André
 French, 1827-1909
PERRAULT, Claude
 French, 1613-1688
PERRAULT, Henri Paul
 French, 1867-1932
PERRAULT, Léon Bazile
 French, 1832-1908
PERRAULT, Louis
 French, 19th cent.
PERRAULT or Perault,
 Martin
 French, c.1650-1700
PERREAL, Jean (Jean
 de Paris)
 French, c.1455-1530
PERREGAUX, Charles
 Swiss, 1788-1842
PERREGAUX, Susanne
 (née Lhuillier)
 French, op.c.1820
PERRELET, Paul
 Swiss, 1872-
PERRENCT
 French, op.1810
PERRET, Aimé
 French, 1847-1927
PERRET, Félix
 French, op.1865-1869
PERRET, Henri François
 French, op.1847-1870
PERRET, Jean Baptiste
 French, op.1848-1877
PERRET, Marius
 French, 1853-1900
PERRET, Pieter
 Flemish, 1555-c.1625
PERRIER, E.S.
 Spanish, op.1887
PERRIER, François
 (Bourguignon)
 French, 1590-1650
PERRIER of Strassburg
 French, op.c.1740-1780
PERRIN, Feyen
 see Feyen-Perrin
PERRIN, J.B.
 French(?), op.1740
PERRIN, Jean Charles
 Nicoise
 French, 1754-1831
PERRIN, L.L.
 see Perin
PERRIN, Olivier
 Stanislas
 French, 1761-1832
PERRINE, van Dearing
 American, 1869-
PERRINETTO di Maffeo
 (Perinectus)
 Italian, op.c.1450-1457
PERRING, William
 British, op.1845
PERRISSIN or Perrisim,
 Jean
 French, c.1536/38-a.1611
PERRONEAU, Jean
 Baptiste
 French, 1715-1783
PERROT, Ferdinand
 Victor
 French, 1808-1841

PERROT, Peyrot or
 Peyrotte, Pierre
 Joss, Josse or Joseph
 French, op.1724-1735
PERRY, Alfred
 British, op.1847-1881
PERRY, Enoch Wood
 American, 1831-1915
PERRY, Henry
 British, op.1810-1848
PERRY, Lilla Cabot
 American, 1848-1933
PERRYMAN, Margot
 British, 1938-
PERSELLES, Jan
 see Porcellis
PERSOGLI, M.
 Italian, 19th cent.
PERSOGLIA, Franz von
 German, 1852-
PERSON, Henri
 French, 1876-1926
PERSON, Nikolaus
 German, op.1668-m.1710
PERSON, Ragnar
 Swedish, 1905-
PERSOY, Pieter
 Dutch, 1668-p.1694
PERSSON, Peter Adolf
 Swedish, 1862-1914
PERUGINI, Charles
 Edward (Carlo)
 British, 1839-1918
PERUGINI, Kate
 British, 1839-1929
PERUGINO, Cavaliere
 see Cerrini, Giovanni
 Domenico
PERUGINO, Eusebio
 see Eusebio da San
 Giorgio
PERUGINO, Petruccio
 see Montanini, Pietro
PERUGINO, Pietro di
 Cristoforo Vanucci
 Italian, c.1450-1523
PERUSINI, R.
 Italian, 20th cent.
PERUZZI, Perucci,
 Perucio, Perugo,
 Perutio or Petrucci,
 Baldassare Tommaso
 Italian, 1481-1536
PERUZZINI, Domenico
 Italian, op.1633-1665
PERUZZINI, Giovanni
 (Giambattista)
 Italian, c.1629-1694
PERVUCHIN, Konstantin
 Russian, 1863-1915
PERY, D.J.
 Flemish(?), op.1783
PESARESE, Il
 see Cantarini, Simone
PESARO, Giovanni
 Antonio
 see Giovanni
PESCATORI, Francesco
 Italian, 1816-1849
PESCHEL, Carl Gottlieb
 German, 1798-1879
PESCHIER, N.L., or
 N. Le Peschier
 Dutch, op.1659-1661
PESCHKA, Anton
 German, 1885-1940

PESCI, Gasparo
 Prospero
 Italian, -1784
PESCI, Girolamo
 Italian, 1684-1759
PESELLINO, Compagno di
 see Piero di Lorenzo
 di Pratese di Bartolo
 Zuccheri
PESELLINO, Francesco
 di Stefano
 Italian, c.1422-1457
PESELLO, Giuliano
 (Giuliano d'Arrighi,
 Il Pesello)
 Italian, 1367-1446
PESENTI, Francesco I
 see Pisenti
PESKE, Jean Misceslas
 French, 1880-1949
PESNE, Antoine
 German, 1683-1757
PESNE, Henriette
 (Mme J.-B. Joyard)
 German, c.1720-c.1790
PESNE, Paine or Pêne,
 Jean
 French, 1623-1700
PESSARELLI, Germano
 Italian, 1928-
PESSINA, Giovanni
 Italian, 1856-
PESSINA, Pietro Paolo
 Italian, op.1775-1777
PESZKA, Josef
 Polish, 1767-1831
PETARLINI, Domenico
 Italian, 1822-1897
PETEL, Petle, Petele,
 Betle or Pöttle, Georg,
 Jörg or Jerg
 German, 1590/3-1633/4
PETER
 Swedish, op.1450-1460
PETER, Alfred
 Swiss, 1877-
PETER, Emmanuel Thomas
 German, 1799-1873
PETER, Johann Wenzel
 (Wenzel)
 German, 1745-1829
PETER von Mainz
 German, op.1520
PETERDI, Gabor
 American, 1915-
PETERELLE, Adolphe
 French, 1874-1947
PETERNELJ, Konrad
 Yugoslav, 1936-
PETERS, Anton de
 see Peters, Johann
 Anton de
PETERS, C.L.
 German, 19th cent.
PETERS, Christian
 German, 1808-1830
PETERS, Johann Anton de
 German, 1725-1795
PETERS, Rev. Matthew
 William
 British, 1742-1814
PETERS, Pieter Franciscus, II
 Dutch, 1818-1903
PETERS, Remmert
 see Petersen
PETERSEN, Carl Olof
 Swedish, 1880-1939

PETERSEN, Christian
Kongstad
Danish, 1862-1940
PETERSEN, Fredrik
Norwegian, 1759-1825
PETERSEN, Hans Ritter von
German, 1850-1914
PETERSEN, Johan or
John, Erik Christian
Danish, 1839-1874
PETERSEN or Peters,
Remmert
Danish, op.1601-m.1649
PETERSEN, Robert Storm
Swedish, 1882-1949
PETERSEN, Walter
German, 1862-1950
PETERSEN-ANGELN,
Heinrich
German, 1850-1906
PETERSEN-FLENSBURG,
Heinrich
German, 1861-1908
PETERSON, Jane
American, 1876-1965
PETERSON, Otto Fredrik
Swedish, 1672-1729
PETERSON, Roland
American, 20th cent.
PETERSSEN, Hjalmer
Eilif Emanuel
(Eilif)
Norwegian, 1852-1928
PETERZANO, Petarzano,
Petrazzano or
Pretezzano, Simone
(Simone Veneziano)
Italian, op.1573-1592
PETHER, Abraham
British, 1756-1812
PETHER, Henry
British, op.1828-1862
PETHER, Sebastian
British, c.1790-1844
PETHER, William
British, 1731-c.1795
PETHERBRIDGE, Deanna
British, 20th cent.
PETICOLAS, Philip A.
Italian, 1760-1843
PETILLION, Jules
French, 1845-1899
PETION
French, op.1803-1828(?)
PETIT, Bernardus or
Barend le
see Le Petit
PETIT, Constant
French, op.1860
PETIT, Eugène
French, 1839-1886
PETIT, H.
French, 19th cent.
PETIT or Parvi, Jean
or Johannes
French, op.c.1470-1517
PETIT, Jean Louis
French, 1795-1876
PETIT, Rev. John
Louis
British, 1801-1868
PETIT, Louis
French, op.1771-1800
PETIT, Louis
French, 1864-
PETIT, Pierre Joseph
French, op.1785-1819

PETIT, Simon
French, op.1781-1797
PETITI, Filiberto
Italian, 1845-1924
PETITJEAN, C.
German, op.1826-1836
PETITJEAN, Edmond
Marie
French, 1844-1925
PETITJEAN, Hippolyte
French, 1854-1929
PETITOT, Ennemond or
Edmond Alexandre
French, 1727-1801
PETITOT, Jean I
Swiss, 1607-1691
PETITOT, Jean Louis
French, 1653-p.1699
PETITOT, Joseph
French, 1771-p.1800
PETLEVSKI, Ordan
Yugoslav, 1930-
PETLEY-JONES,
Llewellyn
British, 20th cent.
PETLIN, Irving
American, 1934-
PETO, John Frederick
American, 1854-1907
PETORUTTI, Emilio
Italian, 1892-1971
PETRASCU, Gheorghe
Rumanian, 1872-1949
PETRASCU, Mariana
Rumanian, 1915-
PETRASCU, Milita
Rumanian, 1892-
PETRAZZI, Astolfo
Italian, 1579-1665
PETRI, Dirk
see Pietersz.
PETRI, Jakob
German, op.c.1715
PETRI, P.
see Calzetta, Pietro di
PETRIDES, Konrad
German, -1943
PETRIE, George
British, 1790-1866
PETRIE, Graham
British, 1859-1940
PETRIE, James
British, op.1780-m.1819
PETRIE, S.
British, 19th cent.
PETRINI, Antonio
German, 1624-1701
PETRINI or Pietrini,
Giuseppe Antonio
Italian, 1677-1757/8
PETRINI, Marco
Swiss, op.1769-1774/76
PETROFF, Nikolai Filippowitsch
Russian, 1872-
PETRONI da Spoleto,
Ginevra
Italian, op.1564
PETRONI, Maria
Italian, 20th cent.
PETROV, Mitko
American, 20th cent.
PETROV, Vassili
Petrovich
Russian, c.1770-1811
PETROVIC, Rastko
Yugoslavian,
1898-1949

PETROVIC, Zoran
Yugoslav, 1921-
PETROVICHEV, Peter
Ivanovich
Russian, 1874-1947
PETROVITS, Ladislaus
Eugen
German, 1839-1907
PETROV-VODKIN, Kuzma
Sergeyevich
Russian, 1878-1939
PETRUCCI, Astolfo
Italian, op.c.1600
PETRUCCIOLI
see Cola
PETRUOLO, Salvatore
Italian, 1857-
PETRUS
see Pietro
PETRUS Pictor
Italian, 13th cent.
PETT, John
British, op.1782
PETTENKOFEN, August
Xaver Carl von
German, 1822-1889
PETTER, Anton
German, 1781-1858
PETTER, Franz
Maximilian
German, op.1819
PETTER, Franz Xaver
German, 1791-1866
PETTER, P.
Dutch, op.1654
PETTER, Theodor
German, 1822-1872
PETTET, William
American, 20th cent.
PETTICOLAS, Edward F.
American, op.1805-1834
PETTIE, John
British, 1839-1893
PETTIER, Colette
French, 1907-
PETTINICCHI, A.
Italian, 20th cent.
PETTIT or Pettitt,
Joseph Paul
British, 1812-1882
PETTITT, Charles
British, op.1855-1889
PETTITT, Edwin Alfred
British, c.1840-1912
PETTITT, George
British, op.1858-1862
PETTORUTI, Emilio
Argentinian, 1895-
PETZELDT, Hans
German, op.1590-1597
PETZHOLDT,.Ernst
Christian Frederik
(Frederick)
Danish, 1805-1838
PETZL, Joseph
German, 1803-1871
PEUCKER or Peuckert,
Leopold
German, op.1790-1793
PEUGNIEZ, Pauline
French, 1890-
PEURER, Wolfgang
German, 15th cent.
PEURL or Beurl,
Hans
German, op.1518-1527

PEUTEMAN, Pieter
(also, erroneously,
Nicolas Peuteman or
Penteman)
Dutch, op.1674-m.1692
PEVERELLI, Cesare
Italian, 1922-
PEVSNER, Antoine
French, 1886-
PEY, Johann de
see Pay
PEYRAC
see Pérac
PEYRE, Antoine François
(Peyre le jeune)
French, 1739-1823
PEYRISSAC, Jean
French, 1895-
PEYROLERI, Pietro
Italian, op.c.1760
PEYRON, Jean François
Pierre
French, 1744-1814
PEYRONNET, Dominique
Paul
French, 1872-1943
PEYROT or Peyrotte,
Pierre Josse
see Perrot
PEYROT, Simone
French, 20th cent.
PEYROTTE, Peirotte or
Peyrot, Alexis
French, 1699-1769
PEYROU, Christian
French, 1926-
PEYTRET or Peitret,
Jacques
French, op.1673-1675
PEZ, Aimé
Belgian, 1808-1849
PEZANT, Aymar
Franch, 1846-
PEZEY or Pezey, Antoine
French, op.1695-1710
PEZTEL, A.
German, 20th cent.
PEZZO, Lucio del
Italian, 1933-
PFAFFENHOFFEN, B.
German, 18th cent.
PFANDL, Ludwig
German, 16th cent(?)
PFANDZELT, Lucas
Conrad
German, 1716-1786
PFANHAUSER, Pfanhauzer
or Fanhauzer, Franciszek
Polish, c.1797-c.1865
PFANHAUZER, Franciszek
see Pfanhauser
PFANNSCHMIDT, Ernst
Christian
German, 1868-1949
PFEFFEL, Joannes
Andreas
German, 1674-1748
PFEIFER, Bodo
Canadian, 20th cent.
PFEIFER, Hermann
Swiss, 1864-
PFEIFFER, François
Joseph
German, 1778-1835
PFEIFFER, H.B.
German, 20th cent.

PFEIFFER, Henri
French, 1907-
PFEIFFER or Peiffer,
Johann Joachim I
German, 1662-1701
PFEIFFER, Richard
German, 1878-
PFEIFFER, Wilhelm
German, 1822-1891
PFEIFFER-KOHRT,
Gertrud
German, 1875-
PFEILER or Pfeiller,
Maximilian
German, op.1683
PFENNING, D.
German, op.1449
PFENNINGER, Alfred
German, 19th cent.
PFENNINGER, Elisabeth
Swiss, 1772-1837
PFENNINGER, Heinrich
Swiss, 1749-1815
PFENNINGER, Matthias
Swiss, 1739-1813
PFLAUM, Harry
German, 20th cent.
PFLEGER, Ludwig
German, op.1720-1747
PFLUG, Johann-Baptist
(Pflug von Biberach)
German, 1785-1866
PFORR, Franz
German, 1788-1812
PFORR, Johann Georg
German, 1745-1798
PFOSI, Peter
Swiss, 1913-
PFRIEM, Bernard
American, 1914-
PFUNDER, Jacobus de
see Poindre
PFUNNER, Johann
German, c.1716-1788
PHELIPEAUX, Louis
Michel
French, op.1802
PHELIPPES-BEAULIEUX,
Emmanuel
French, 1829-1874
PHELPS, Elizabeth
Henriette
British, op.1778-1780
PHELPS, Richard
British, op.1736-m.1785
PHENIK, G.
British, 17th cent.
PHILIPAULT
see Phlipaut
PHILIPON, Charles
French, 1806-1862
PHILIPP, Michael
German, op.1652-1662
PHILIPP, Robert
American, 1895-
PHILIPPE, Master
(identified with
Philippe de Mol,
Philipp van Orley and
Philip Truffin)
Netherlands, op.1513
PHILIPPEAU or Phlippeau,
Karel Frans
Dutch, 1825-1897
PHILIPPI, Peter
German, 1866-1958(?)

PHILIPPI, Robert
German, 1877-1959
PHILIPPOT, Carl Ludwig
French, 1801-1859
PHILIPPOTEAUX, Félix
Henri Emmanuel
French, 1815-1884
PHILIPPOTEAUX, Paul
Dominique
French, op.c.1850-1876
PHILIPS, Caspar
Jacobsz.
Dutch, 1732-1789
PHILIPS, Hermann August
German, 1844-1927
PHILIPS, Jan Caspar
Dutch, c.1700-c.1773
PHILIPS, Nathaniel
George
British, 1795-1831
PHILIPSEN, Theodor
Esbern
Danish, 1840-1920
PHILIPSEN or Flipsen,
Victor Philippe
French, 1841-1907
PHILIPSON, Robin
British, 1916-
PHILLEO, E.A.
American, op.1888
PHILLIP, J.P.
British, 19th cent.
PHILLIP, John
British, 1817-1867
PHILLIPA, K.A.
German, 19th cent.
PHILLIPS, Ammi
American, 1787/88-1865
PHILLIPS, Arthur
Lawrence Barnett
(Lawrence)
British, 1842-1922
PHILLIPS, Bert Greer
American, 20th cent.
PHILLIPS, C. Coles
American, 20th cent.
PHILLIPS, Charles
British, 1708-1747
PHILLIPS, Ellen A.
American, 19th cent.
PHILLIPS, F.A.
British, c.1849-1913
PHILLIPS, Giles Firman
British, 1780-1867
PHILLIPS, Henry Wyndham
British, 1820-1868
PHILLIPS, J.
British, op.1784-1799
PHILLIPS, J. Campbell
American, 1873-
PHILLIPS, James
American, 20th cent.
PHILLIPS, John
British, op.1840-1852
PHILLIPS, Patrick
British, 20th cent.
PHILLIPS, Peter
British, 20th cent.
PHILLIPS, Philip
British, 1826-1864
PHILLIPS, R.
British, 18th cent.
PHILLIPS or Philips,
Richard
British, 1681-1741
PHILLIPS, T.
Canadian, 20th cent.

PHILLIPS, T.W.
British, op.1821-1826
PHILLIPS, Thomas
British, 1770-1845
PHILLIPS, Tom
British, 1937-
PHILLIPS, Watts
British, 1825-1874
PHILLOTT, Constance
British, op.1864-1893
PHILPOT, Ernest
British, 20th cent.
PHILPOT, Glyn Warren
British, 1884-1937
PHILPOT, Leonard
Daniel
British, 1877-
PHIPPS, Paul
British, 20th cent.
PHIPPS, R.
British, op.1844
PHIPSON, Evacustes A.
British, 19th cent.
PHIZ
see Browne, Hablot
Knight
PHLIPAUT (Philipault)
Julie
French, 1780-1834
PHLIPPEAU, Karel Frans
see Philippeau
PHOENIX, George
British, 1863-1935
PIAGGIO, Teramo
Italian, 1480/90-a.1572
PIAN, Antonio de
Italian, 1784-1851
PIANCA, Giuseppe
Antonio
Italian, op.c.1720-1745
PIANE, Giovanni Maria
dalle (Molinaretto or
Mulinaretto)
Italian, 1660-1745
PIANI, Pietro
Italian, 1770-1841
PIANORO, Il
see Morelli, Bartolomeo
PIASTRINI, Giovanni
Domenico
Italian, 1678-1740
PIATTI, Antonio
Italian, 1875-
PIATTI, Santo
Italian, c.1687-1747(?)
PIATTOLI, Gaetano
Italian, 1703-1774
PIATTOLI, Giuseppe
Italian, op.1785-1807
PIAUBERT, Jean
French, 1900-
PIAZZA, Albertino or
Alberto della (de'
Toccagni)
Italian, c.1475(?)-a.1529
PIAZZA, Alessandro
Italian, op.1702
PIAZZA, Callisto
(Callisto da Lodi)
Italian, a.1500-1561
PIAZZA, Martino
Italian, op.1513-m.1527
PIAZZA, Nicolò
Italian, op.1676
PIAZZA, Paolo
Italian, c.1557(?)-1621

PIAZZA da Lodi,
Scipione
Italian, op.1530-1532
PIAZZETTA or Piazetta,
Giambattista (Giovanni
Battista Valentino)
Italian, 1682-1754
PIAZZOLI
Italian, 17th cent.(?)
PIC, Charles S. Higgins
British, 1893-
PICABIA, Francis
French, 1878-1953
PICARD, Edmond
French, 1861-1899
PICARD, Georges-Picard
(Georges)
French, 1857-
PICARD, Hugues
French, 1841-1900
PICARD, Jean Michel
see Picart
PICARD, Louis
(Louis-Picard)
French, 1861-
PICARDO, Leon
Spanish, op.1520-1527
PICART or Picard,
Bernard
French, 1673-1733
PICART, Charles
British, c.1780-c.1837
PICART, Etienne or
Stephanus (Le Romain)
French, 1632-1721
PICART, Heinrich
Christian
see Pickhardt
PICART, Jean
French, op.1620-1670
PICART or Picard, Jean
Michel
Flemish, c.1600-1682
PICART Le Doux, Charles
Alexandre
French, 1881-1959
PICART Le Doux, Jean
French, 1902-
PICASSO or Picassi,
Matteo
Italian, c.1800-p.1866
PICASSO or Ruiz y
Picasso, Pablo
Spanish, 1881-1973
PICCART, Heinrich
Christian
see Pickhardt
PICCHI, Giorgio
Italian, c.1550-c.1599
PICCINELLI, Andrea
see Bresciaino
PICCINI, Antonio
Italian, 1846-1920
PICCINI, Gaetano
Italian, op.1724-1744
PICCINI or Picina,
Isabella
Italian, op.c.1665-1692
PICCIO, Il
see Carnovali, Giovanni
PICCIONE, Matteo
Italian, op.c.1615-1617
PICCIONI, Felice
Italian, op.1830-1842
PICCOLI, Augusto
Italian, 1927-

PICCOLPASSO, Piccolpassi
or Picolpasso, Cipriano
Italian, 1524-1579
PICCONE, Angelo
Italian, op.1346
PICELJ, Ivan
Yugoslav, 1924-
PICELLER or Pitscheller,
Bernhard
German, 1775-1853
PICENNI
Italian, 1929-
PICHAT, Olivier
French, -1912
PICHETTE, James
French, 1920-
PICHIO (Picq), Ernest
Louis
French, 1840-1893
PICHLER, Giovanni
(Johann Anton II)
Italian, 1734-1791
PICHLER, Johann Peter
German, 1765-1807
PICHLER, Josef von
German, 1730-1808
PICHLER, Walter
German, 20th cent.
PICHON, Pierre-Auguste
French, 1805-1900
PICIARI, J.
Italian, 17th cent.
PICINA, Isabella
see Piccini
PICINARDI, Donato
Italian, op.1606
PICKAERT, Jeronimus
Dutch, c.1628-p.1674
PICKARD, A.
British, op.1647
PICKARD, Louise
British, 1865-1928
PICKEN, Andrew
British, 1815-1845
PICKENOY
see Eliasz., Nicolaes
PICKER, Heinrich
Christian
see Pickhardt
PICKERING, Evelyn
see Morgan
PICKERING, F.
British, op.1755
PICKERING, George
British, c.1794-1857
PICKERING, Henry
British, op.1752-1790
PICKERING, J.L.
British, 1845-1912
PICKERNELL, Francis
British, op.1866
PICKERSGILL, Francis
British, 1820-1900
PICKERSGILL, Frederick
Richard
British, 1820-1900
PICKERSGILL, Henry Hall
British, 1812-1861
PICKERSGILL, Henry William
British, 1782-1875
PICKERSGILL, Mrs.
Rose M.
British, op.c.1889-1892
PICKETT, Joseph
American, op.1776
PICKETT, Joseph
American, 1848-1918

PICKETT, W.
British, op.1792-1820
PICKHARDT, Picart,
Piccart or Picker,
Heinrich Christoph
German, 1699-1767
PICKMAN, Clarke Gayton
American, 1791-1860
PICK-MORINO, Edmund
German, 1877-1958
PICKNELL, William
Lamb (Lucien)
American, 1854-1897
PICOLET, Cornelis
Dutch, 1626-1673
PICOLO y Lopez, Manuel
Spanish, c.1850-p.1892
PICOLPASSO
see Piccolpasso
PICOT, Francois Edouard
French, 1786-1868
PICOT de Limoelan de
Cloriviere, Joseph
Pierre
French, 1768-1826
PICOT de Limoelan,
Victor
French, 1814-1872
PICOU, Henri Pierre
French, 1824-1895
PICQ, Ernest Louis
see Pichio
PICQUE, Charles
Belgian, 1799-1869
PICQUET
French, 16th cent.
PICQUOT, Thomas
French, op.c.1636
PICTOR, Marius
see Maria, Mario de
PIDDING, Henry James
British, 1797-1864
PIDGEON, Henry Clark
British, 1807-1880
PIDOLL zu Quintenbach,
Carl Michael Valentin,
Freiherr von
German, 1847-1901
PIECHOWSKI, Wojciech
(Adalbert)
Polish, 1849-1911
PIEKARSKI
see Oefele
PIELER, Franz Xaver
German, 1879-1952
PIELMANN, Edmund Georg
German, 1923-
PIEMANS, Hinderk
see Pyman
PIEMONT or Pimont,
Nicolaes (Opgang)
Dutch, 1644-1709
PIEMONTE, Cesare di
see Cesare
PIENE, Otto
German, 1928-
PIENEMAN, Jan Willem
Dutch, 1779-1853
PIENEMAN, Nicolaas
Dutch, 1809-1860
PIEPENHAGEN, August
Czech, 1791-1868
PIEPER, Josef
German, 1907-
PIER or Pietro,
Antonio da Foligno
see Mezzastris

PIER Antonio di
Niccolò (or Giacomo?)
da Pozzuolo or di
Pociolo
Italian, op.c.1450-m.1478
PIER Francesco
Fiorentino
Italian, op.c.1470-1500
PIER Francesco
Fiorentino, Pseudo
Italian, 15th cent.
PIER Francesco di Jacopo
di Domenico (not di
Sandro)
see Toschi
PIER Francesco da Pavia
or Pavese
see Sacchi
PIERA, P.
Dutch, -1784
PIERCE, Edward
British, -1658
PIERCE, Mrs. W.
see Beaumont, Anne
PIERGENTILE da Camerino
(Pietro Gentile)
Italian, op.1537-1538
PIERI (Pieri Rossi),
Stefano
Italian, 1542-1629
PIERIE, Captain William
British, op.1775
PIERINGER
German, op.1840
PIERINI, Andrea
Italian, 1798-1858
PIERINO da Vinci
Italian, 16th cent.
PIERMATTEO da Amelia
(Pier Matteo Lauro de'
Manfredi)
Italian, c.1450-1503/8
PIERNEEF, J.H.
South African, 20th cent.
PIERO d'Antonio Dei
see Bartolommeo della
Gatta
PIERO di Cosimo or di
Lorenzo
Italian, 1462-1521(?)
PIERO della Francesca
or dei Franceschi
Italian, p.1416-1492
PIERO di Guido, Monsù
see Lauri Pietro
PIERO di Lorenzo di
Pratese di Bartolo
Zuccheri (Compagno di
Pesellino) (Lorenzo
da Prato)
Italian, 1413-1487
PIERO di Nello
see Nelli
PIERO Paolo da Fermo
Italian, 15th cent.
PIERO da Vinci
see Pierino
PIERRE, André
Haitian, 20th cent.
PIERRE, Claude
see Spierre
PIERRE, Fernand
Haitian, 1922-
PIERRE, François
see Spierre
PIERRE, Gustave René
French, 1875-

PIERRE, Jean Baptiste
Marie
French, 1713-1789
PIERRE, Nicolas Benjamin
de la
see Delapierre
PIERREY, Louis Maurice
French, c.1854-1912
PIERSON, A.
French, 20th cent.
PIERSON, Blanche
Adeline
French, 19th cent.
PIERSON, Christoffel
Dutch, 1631-1714
PIERSON, John
British, 18th cent.
PIERSON, Sarah
American, op.1821
PIESOWOCKI, Leon
Polish, 20th cent.
PIEST, Andries van
Netherlands(?), 18th cent(?)
PIET, Fernand
French, 1869-1942
PIETER van Harlingen
see Feddes
PIETERS, Clara
see Peeters
PIETERS, Evert
Dutch, 1856-1932
PIETERSEN, Gerrit
see Pietersz.
PIETERSZ., Aert
Netherlands, c.1550-1612
PIETERSZ. or Petri,
Dirk
Dutch, op.1608-1621
PIETERSZ. or Pietersen,
Gerrit (Gerrit
Pietersz. Sweelink)
Dutch, 1566-p.1612
PIETERSZ., Gertrude or
Geertje
Dutch, op.1718
PIETERSZ., Pieter, I
(Jonge Lange Pier;
identified with Master
of the Berlin Family
Portrait)
Netherlands, c.1543-1603
PIETERSZ., Pieter, II
Flemish, c.1578-1631
PIETERSZEN, Abraham
van der Wayen
Dutch, 1817-1880
PIETKIN
French, 18th cent.
PIETRE, Mme.
see Vallain
PIETRE or Petri, Pietro
Antonio de
Italian, 1663-1716
PIETRO or Petrus
Italian, op.1241
PIETRO d'Ancona
Italian, 15th cent.
PIETRO d'Andrea da
Volterra
Italian, op.c.1503-1529
PIETRO de Belizio
Italian, 12th cent.
PIETRO da Bologna
Italian, 14th cent.
PIETRO da Cortona
(Pietro Berrettini)
Italian, 1596-1669
PIETRO di Domenico
Italian, 1457-1506(?)

PIETRO di Domenico
da Montepulciano
(not Pietro da
Recanati)
Italian, op.1418-1422
PIETRO Gentile da
Camerino
see Piergentile
PIETRO di Giovanni
(Pietro di Giovanni
delle Tovaglie)
Italian, op.1410-1420
PIETRO di Giovanni di
Ambrogio (Pietro di
Giovanni Pucci ?)
Italian, op.1428-1447
PIETRO da Messina
see Pietro de Saliba
PIETRO di Miniato
Italian, 1366-c.1450
PIETRO da Novara
Italian, op.1370
PIETRO Paolo da Imola
Italian, 15th cent.
PIETRO de' Pietri
Italian, 17th cent.
PIETRO di Puccio
Italian, op.1364-1394
PIETRO da Recanati
see Pietro di Domenico
da Montepulciano
PIETRO da Rimini
Italian, op.1309-1333
PIETRO de Saliba
(Risaliba) or da
Messina
Italian, op.1497-1530
PIETRO da San Vito
see Giovanni Pietro
PIETRO da Spoleto
Italian, op.1242
PIETRO del Trombetto
Italian, 16th cent.
PIETRO della Vecchia
see Muttoni
PIETRO da Vicenza
(Vicentino)
Italian, 1467-1527
PIETSCH, Ludwig
German, 1824-1911
PIETSCHMANN, Michael
German, op.1668
PIETTE, Ludovic
French, 1826-1877
PIETZSCH, Richard
German, 1872-1960
PIGAGE, Nicolas de
French, 1723-1796
PIGAL, Edmé Jean
French, 1798-1872
PIGALLE
French, c.1887-1890
PIGHIUS, Stephan
Vinand
German, 16th cent.
PIGLHEIN, Elimar
Ulrich Bruno
German, 1848-1894
PIGNATELLY y Moncayo,
Vicente
Spanish, op.1767-m.1770
PIGNE, Nicolas
French, 1700-
PIGNEROLLE, Charles
Marcel de
French, c.1815-1893

PIGNOLAT, Pierre
Swiss, 1838-1913
PIGNON, Edouard
French, 1905-
PIGNONI, Simone
Italian, 1614-1698
PIGOT, R. St. Leger
British, op.1869
PIGOT, T.
British, op.c.1800
PIGRATELLI
Italian (?) 19th cent.
PIGUENIT, William
Charles
Australian, 1836-1915
PIGUET, Rodolphe
Swiss, 1840-1915
PIJUAN, Hernandez
Spanish, 1931-
PILICHOWSKI, Leopold
Russian, 1869-1933
PILKINGTON, R.W.
British, op.1808-1827
PILLAUT, M.
French, 18th cent.
PILLE, Charles Henri
French, 1844-1897
PILLEAU, Henry
British, 1815-1899
PILLEMENT, Jean Baptiste
(Jean)
French, 1727-1808
PILLEMENT, Paul
French, op.1727
PILLET, Edgard
French, 1912-
PILLORI, Antonio Nicola
Italian, 1687-1763
PILO, Carl Gustaf
Swedish, 1712/13-1792
PILO, Jöns
Swedish, 1707-p.1750
PILOT, Robert W.
Canadian, 1898-1968
PILOTTI, Girolamo
Italian, op.1597-m.1649
PILOTY, Carl Theodor
von
German, 1826-1886
PILOTY, Ferdinand I
German, 1786-1844
PILOTY, Ferdinand II
German, 1828-1895
PILS, Isidore Alexandre
Augustin
French, 1813/15-1875
PILSBURY, Wilmot
British, 1840-1908
PILTZ, Otto
German, 1864-1910
PIMENOV, Yuri
Ivanovich
Russian, 1903-
PIMLOTT, John
British, 1905-
PIMONENKO, Nikolai
Korniliewitsch
Russian, 1862-1912
PIMONT, Nicolaes
see Piemont
PINA, Agapito Rincon
Mexican, 1897-
PINARD, René
French, 19th cent.
PINAS
see Pynas

PINAZO-CAMARLENCH,
Ignacio
Spanish, 1849-1916
PINAZO-MARTINEZ,
José
Spanish, 1879-
PINCAS, Julius
see Pascin, Jules
PINCHART, Emile Auguste
French, 1842-
PINCHON, Jean Antoine
French, 1772-1850
PINCHON, Robert A.
French, 20th cent.
PINDAR, Peter
see Wolcott, John
PINE, John
British, 1690-1756
PINE, Robert Edge
British, 1742-1788
PINEAU, Nicolas
French, 1684-1754
PINELLI, Achille
Italian, 1809-1841
PINELLI, Bartolomeo
Italian, 1781-1835
PINET, Marie Victoire
see Jaquotot
PINGE, Alexander
British, op.1760
PINGRET, Edouard Henri
Théophile
French, 1788-1875
PINGUENTE, Giovanni
Orifici da
Italian, 14th cent(?)
PINHAS, Salomon or
Leo (Mahler)
German, 1759-1837
PINHEIRO
see Bordallo-Pinheiro
PINI, Eugenio
Italian, 1600-p.1653
PINI or Pino, Paolo
Italian, op.1534-1565
PINILLA, Juan de
Spanish, op.1500
PINION, R.
French, op.c.1786
PINKAS, Hippolyt Sobeslav
(Sobeslav)
Czech, 1827-1901
PINNA, Diego (Franciscus
Pinna Sardus?)
Italian, op.1615
PINNERMANN
British, op.1815
PINO, Giambattista di
Italian, op.1624-1647
PINO, Marco dal
(Marco da Siena)
Italian, c.1525-c.1587/8
PINO da Messina
Italian, 15th cent.
PINO, Paolo
see Pini
PIÑOLE, Nicanor
Spanish, 1877-
PINOWAR, Joseph
Polish, 1904-
PINSON, Isabelle
French, op.1796-1812
PINSON or Pinzon, Nicolas
Nicolas
French, 1640-p.1672

PINTORICCHIO or
Pinturicchio, Bernardino
di Betto-Benedetto di
Biagio
Italian, c.1454-1513
PINWELL, George John
British, 1842-1875
PIOLA, Domenico I
Italian, 1627-1703
PIOLA, Paolo Gerolamo
Italian, 1666-1724
PIOLA, Pellegro
Italian, 1617-1640
PIOMBO, Fra Sebastiano
del (Sebastiano
Luciani)
see Sebastiano
PIOT, Etienne Adolphe
French, 1850-1910
PIOT, F.E.
French, 19th cent.
PIOT, Jacques Samuel
Louis
French, 1743-1812
PIOT, René
French, 1869-1934
PIOTROWSKI, Maksymiljan
Antoni
Polish, 1813-1875
PIPAL, Viktor
German, 1887-1971
PIPER, Frederik
Magnus
Swedish, 1746-1824
PIPER, J.D.
British, 19th cent.
PIPER, John
American, 18th cent.
PIPER, John
British, 1903-
PIPINI, Biagio dalle
see Lame
PIPPAL, Hans Robert
German, 1915-
PIPPEL, Otto
German, 1878-
PIPPI, Giulio
see Giulio Romano
PIPPICH, Carl
German, 1862-1932
PIPPIN, Horace
American, 1888-1946
PIQUER, Bernardo
see Lopez
PIRACCINI, Osvaldo
Italian, 1931-
PIRAMO, Reginaldo
Italian, op.c.1500-1524
PIRANDELLO, Fausto
Italian, 1899-
PIRANESI, Francesco
Italian, c.1758/9-1810
PIRANESI, Giovanni
Battista
Italian, 1720-1778
PIRES
see Alvaro
PIRIE, Sir George
British, 1867-1944
PIRINGER, Benedikt
German, 1780-1826
PIRKHERT, Alfred von
German, 1887-
PIRONKOV, Enco
Bulgarian, 20th cent.

PIROSMANISHVILI, Niko
Russian, 1863-1918
PIROVANI, Giuseppe
(Il Bresciano)
Italian, c.1759-1787(?)
PIRRI, Antonio di
Manfredo da Bologna
Italian, op.1509-1511
PISAN SCHOOL
Anonymous Painters
of the
PISANELLI, Spisanelli
or Spisano, Vincenzo
Italian, 1595-1662
PISANELLO, Antonio
(not Vittore) di
Puccio Pisano (Il
Pisanello)
Italian, a.1395-1455
PISANI, Giovanni Paolo
Italian, 1574-1637
PISANO, Jacopo or
Giacomo del
Italian, 15th cent.
PISANO, Nicola
Italian, op.1464-1538
PISANO, Sebastiano
Italian, 16th cent.
PISAREV, Alexsei
Ivanovich
Russian, 1909-
PISCATOR, Nicolas
Joannis
see Visscher
PISCHINGER, Carl
German, 1823-1886
PISENTI or Pesenti,
Francesco I
(Sabbioneta)
Italian, op.1557
PISIS, Filippo de
Italian, 1896-1956
PISKORSKI, Tadeusz
Polish, 20th cent.
PISSARRO, Camille
Jacob
French, 1831-1903
PISSARRO, Felix
French, 1874-1906
PISSARRO, Georges
(Manzana)
French, 1871-
PISSARRO, Lucien
British, 1863-1944
PISSARRO, Ludovico
Rodolphe (Ludovic-Rodo)
French, 1878-1952
PISSARRO, Oravida
Camille
French, 1893-
PISSARRO, Paul Emile
French, 1884-
PISTOLETTO, Michelangelo
Italian, 1933-
PISTOR, W.
German, 19th cent.
PISTORIUS, Eduard
German, 1796-1862
PISTORIUS, Max
German, 1894-
PISTRUCCI, Filippo
Italian, 19th cent.
PITATI, Bonifazio di
see Bonifazio
Veronese

PITAU, Pitault or
Pittauw, Nicolas
French, 1632-1671
PITCHER, William J.C.
(C. Wilhelm)
British, c.1858-1925
PITCHFORTH, Roland
Vivian
British, 1895-
PITLOO, Antonie Sminck
Dutch, 1790-1837
PITLOO, Claudio
Italian, op.1820
PITMAN, Charles
British, op.1828
PITMAN, John
British, op.1820-1832
PITNER, Franz
German, 1826-1892
PITOCCHI, Matteo de'
Italian, op.c.1650-1700
PITSCHMANN, Joseph
Franz Johann (Carl?)
German, 1758-1834
PITT, William
British, 19th cent.
PITTAR, J.F. Barry
British, -1947
PITTARA, Carlo
Italian, 1836-1890
PITTATORE, Michel
Angelo
Italian, op.1869
PITTERI, Marco Alvise
(Giovanni Marco)
Italian, 1702-1786
PITTERIO, Jacobo
Italian, 15th cent.
PITTMAN, Hobson
American, 1899-
PITTONI, Francesco
Italian, op.1687-1718
PITTONI, Giovanni
Battista I
(Battista Vicentino)
Italian, 1520-1583
PITTONI, Giovanni
Battista II
Italian, 1687-1767
PITTORINO, Padre
see Bisi, Fra
Bonaventura
PITTS, William
British, 1790-1840
PITZ, Carl Caspar
(Caspar)
German, 1756-1795
PITZA, Johannes
German, 18th cent.
PITZLER or Pizzler,
Christoph
German, op.1685-m.c.1710
PIUGIGANO, A.
Italian, 19th cent.
PIVA
see Biva
PIVIDOR, Giovanni
Italian, -1872
PIXELL, Maria
British, op.1793-m.1811
PIZZINATO, Armando
Italian, 1910-
PIZZIRANI, Guglielmo
Italian, 1886-
PIZZLER, Christoph
see Pitzler

PIZZOCARO, Antonio
Italian, op.1675
PIZZOLI, Gioacchino
Italian, 1651-1731
PIZZOLO, Niccolò
Italian, 1421-1453
PJUSS, Kojt
Russian, 20th cent.
PLA, Cecilio
Spanish, 1860-
PLAAS or Plaats
see Plas
PLACE, Francis
British, 1647-1728
PLACE, George
British, op.1775-m.1809
PLAES, David van der
see Plas
PLAETSEN, Joannes
Egidius (Jan Gillis)
van der
Belgian, 1808-1857
PLAGEMANN, Carl Gustaf
Swedish, 1805-1868
PLAKHOFF, L.
Russian, 19th cent.
PLAMONDON, Antoine
Canadian, 1804-1895
PLANELLS, Ricardo
Italian, 19th cent.
PLANES, Luis Antonio
Spanish, 1742-1821
PLANET, Marie François
Xavier Louis de
(Louis)
French, 1814-1875
PLANK
German, op.1469
PLANQUETTE, Felix
French, 1873-
PLANTOU, Julia
American, 1778-1853
PLARENCIO
Spanish, 19th cent.
PLAS, Plaas, Plaats
or Plaes, David
van der
Dutch, 1647-1704
PLAS, G.
Dutch, op.c.1653
PLAS, Laurens van de
(Lorenz von der
Platz)
Dutch, op.1606(?)-1622
PLAS, Plaas or Plassche,
Pieter van der
Flemish, c.1595-c.1650/(1661?)
PLAS, Pieter
Dutch, 1810-1853
PLASENCIA y Maestro,
Casto
Spanish, 1846-1890
PLASKETT, Joseph
Canadian, 1918-
PLASS, Ernst L.
German, 1855-1917
PLASSAN, Antoine Emile
(Emile)
French, 1817-1903
PLASSARD, Vincent
French, op.1642-1650
PLASSCHAERT, Jacobus
Flemish, op.1739-m.1765
PLASSCHE, Pieter van der
see Plas
PLASSE, Georges
French, 1878-

PLASTOV, Arkady
Aleksandrovich
Russian, 1893-
PLATANIA, Giacinto
Italian, 1647-1720
PLATE, Carl
Australian, 1909-
PLATEL, J.B.
French, op.1785
PLATHNER, H.A.
German, 1831-1902
PLATINA, Giovanni
Maria
Italian, c.1450-1500
PLATONOV, Anatolij
Ivanovich
Russian, 1930-
PLATSCHEK, Hans
German, 1923-
PLATT, Charles Adams
American, 1861-1933
PLATT, Deborah
British, 1951-
PLATT, H.
British, op.1827
PLATT, John
British, 18th cent.
PLATT, Russell
British, 20th cent.
PLATTEEL, Jean P.
Belgian, op.1839-1867
PLATTENBERG, Platte-
Montague or Platten,
Matthieu van
Flemish, c.1608-1660
PLATTENBERG, Montagne
or Platte-Montagne,
Nicolas
French, 1631-1706
PLATTNER, Karl
German, 1919-
PLATZ, Ernst Heinrich
German, 1867-p.1895
PLATZ, Lorenz von der
see Plas
PLATZER, Ignaz Franz
Czech, 1717-1787
PLATZER, Johann Christoph
(Christoph)
German, op.c.1720
PLATZER, Johann Georg
German, 1704-1761
PLATZER or Plazer,
Johann Victor
German, 1665-1708
PLATZER, Joseph
Czech, 1751-1806
PLAUTILLA, Suor
see Nelli, Pulisena
PLAZZOTTA, Enzo
Italian, op.1948
PLEGINCK, Martin
German, 16th cent.
PLEHN, Rose
German, 1865-
PLEIDENWURFF
see Pleydenwurff
PLEISSNER, Ogden
Minton
American, 1905-
PLEPP, Blepp or Pläpp,
Hans Jakob
Swiss, op.1576-1595
PLEPP, Joseph
Swiss, 1595-1642

PLETSCH, Oskar
German, 1830-1888
PLEUER, Hermann
German, 1863-1911
PLEYDENWURFF or
Pleidenwurff, Hans
German, op.1451-m.1472
PLEYDENWURFF or
Pleidenwurff, Wilhelm
German, op.1482-m.1494
PLEIJSIER, Ary
Dutch, 1819-1879
PLIMER, Andrew
British, 1763-1837
PLIMER, Nathaniel
British, 1757-1822
PLIMMER, John
British(?), op.1760
PLIMSOLL, Fanny Grace
British, op.c.1907-1914
PLINKE, Carl
German, 1867-
PLITT, Hermann
German, 1821-1900
PLOCKHORST, Berhard
German, 1825-1907
PLOETZ, Hans Henrik
(Henrik)
German, 1748-1830
PLONSKI, Michal
Polish, 1778-1812
PLONTKE, Paul
German, 1884-
PLOOS van Amstel,
Cornelis Jacobsz.(?)
Dutch, 1726-1798
PLOOS van Amstel,
Sara, (née Troost
see Troost
PLOSZCZYNSKI, N.
Polish, op.1847-50
PLOTT, John
British, 1732-1803
PLOUZEAU-GALLICE
French, 19th cent.
PLOWDEN, Trevor J.
Chichele
British, 1783-
PLOWMAN, W.
British, 20th cent.
PLUCHART, Jewgenij
(Eugène)
Alexandrowitsch
Russian, c.1809-p.1880
PLUMB, Harriot Kirby
American, 19th cent.
PLUMB, John
British, 1927-
PLUMIER, Pierre Denis
Flemish, 1688-1721
PLUMIER, Théodore
Aimond (Edmond)
Flemish, 1694-1733
PLUMMER, Brian
British, 20th cent.
PLUMOT, André
Belgian, 1829-1906
PLURIO, Sebastiano da
Italian, 16th cent.
PLUYETTE, Auguste Victor
French, 1820-1871
PLUYM, Karel van der
Dutch, 1625-1672
PO, Giacomo del
Italian, 1652-1726
PO, Pietro del
Italian, 1610-1692

PO. Teresa del
Italian, op.1678-1716
POATE, R.
British, op.1845-1869
POCCETTI, Bernardino
(Barbatelli, Bernardino
delle Facciati, delle
Muse and delle
Grottesche)
Italian, 1548-1612
POCCI, Graf Franz von
German, 1807-1876
POCHITONOV, Ivan
Pavlovitch
Russian, 1850-1923
POCHMANN, Traugott
Leberecht
German, 1762-1830
POCHNA, Mike
French, 20th cent.
POCHWALSKI, Kazimierz
Polish, 1855-1940
POCK, Alexander
German, 1871-1950
POCK, Antonio
French(?) 19th cent.
POCK or Bock, Tobias
German, op.c.1640-p.1681
POCKER(?)
Dutch(?), 18th cent.(?)
POCOCK, D.W.
British, 18th cent.
POCOCK, Isaac
British, 1782-1835
POCOCK, Lexden Lewis
British, 1850-1919
POCOCK, Nicholas
British, 1740-1821
POCOCK, William Innes
British, 1783-1836
PODESTÀ, Giovanni
Andrea (Andrea)
Italian, op.1650-m.a.1674
PODESTI, Francesco
Italian, 1800-1895
PODKOWINSKI, Wladyslaw
Polish, 1866-1895
PODLASHUC, Alexander
South African, 20th cent.
POECKH, Theodor
German, 1839-1921
POEDAIEFF, Georges de
see Pogedaieff, Georges de
POEL, Adriaen Lievensz.
van der
Dutch, 1626-1685/6
POEL, Egbert Lievensz.
van der
Dutch, 1621-1664
POELENBURGH, Poelenborch
or Poelenburg, Cornelis
van (Satyr)
Dutch, 1586(?)-1667
POELMAN, Pieter Frans
Belgian, 1801-1826
POERSON, Charles
French, 1609-1667
POERSON, Charles
François
French, 1653-1725
POETTING, Adrienne de
German, 1856-
POETZ, Johann Diederich
German, op.1736
POETZELBERGER
Robert
German, 1856-1930

POGANY, Vilmos
(Willy)
Hungarian, 1882-1956
POGEDAIEFF, Georges de
Russian, 1897-
POGGENBEEK, George Jan
Hendrik (Geo)
Dutch, 1853-1903
POGGESCHI, Giovanni
Italian, 1905-
POGGI, Antonio
Italian, op.1776-1781
POGGI, Raphael
French, op.1863-1879
POGLIAGHI, Lodovico
Italian, 1857-
POGONKIN, Vladimir
Ivanovitch
Russian, 1793-p.1847
POHACKER, Leopold or
Joseph
German, 1782-1844
POHL, Hinrich Jacob
Danish, op.1729-1747
POHL, Wenzel (W.Pahl?)
German, op.1765-1771
POHLE, Friedrich Léon
(Léon)
German, 1841-1908
POIDEVIN, Eugène Modeste
Edmond
see Lepoittevin
POILLY, François de I
French, 1622-1693
POILLY, François II de
French, 1671-1723
POILLY, Nicolas Jean-
Baptiste de
French, 1712-p.1758
POILPOT, Théophile II
French, 1848-1915
POINDRE, Pfunder or
Punder, Jacques or
Jacobus de
Netherlands,
c.1527-p.1572
POINGDESTRE, Charles H.
British, op.1849-m.1905
POINT, Armand
French, 1861-1932
POINTELIN, Auguste
Emmanuel
French, 1839-1933
POIRE, Emmanuel
see Caran d'Ache
POIRIER, Claude
French, 1653-1729
POIROT, Pierre Achille
French, 1797-p.1852
POISSON
see Pompadour
POITREAU, Etienne
French, 1713-1767
POITTEVIN, E.M.E. Le
see Le Poittevin
POITTEVIN, Louis Le
see Le Poittevin
POIX, Hugh de
British, op.c.1908-1955
POL, Christiaan van
Dutch, 1752-1813
POLACK, Polägk, Poleck,
Polegkh, Pollack, Pollak,
Pollek or Polonus, Jan,
Hanns, Johannes, Johan
or Jon
German, op.1479-m.1519

POLAK or Pollak,
Martin Theophile
Polish, 1570-1639
POLANCO, Francisco
and Miguel
Spanish,
op.1646-m.1651(Francisco)
POLANZANI, Francesco
(Felice)
Italian, 1700-p.1783
POLAZZO, Francesco
Italian, 1683-1753
POLEDNE, F.
German, 19th cent.
POLENOV, Vassily
Dmitrievich
Russian, 1844-1927
POLEO, Hector
Venezuelan, 1918-
POLETTI
Italian, 16th cent.(?)
POLI, Bartolomeo
German, op.1725-1738
POLI, Gherardo
Italian, c.1679-p.1739
POLI, Jacques
French, 20th cent.
POLIAKOFF, Serge
Russian, 1906-
POLIDORINO, Il
see Ruviale, Francesco
POLIDORO di Bartolomeo
da Foligno
Italian, op.1457-m.1483(?)
POLIDORO Caldara da
Caravaggio
Italian, 1490/1500-1543
POLIDORO da Lanciano
(Polidoro Veneziano)
Italian, c.1515-1565
POLIDORO da Messina
Italian, 16th cent.
POLIDORO di Stefano
see Ciburri
POLINO, C.
Italian, 16th cent(?)
POLISCH, Charles
French, op.1845
POLISH SCHOOL
Anonymous Painters
of the
POLITI, Michele
Italian, op.1845
POLITI, Odorico
Italian, 1785-1846
POLJENOWA or Polenoff,
Jelena (Hélène)
Russian, 1850-1898
POLK, Charles Peale
American, 1767-1822
POLKE, Sigmar
German, 20th cent.
POLL, Daniël Herbert
(Herbert) van der
Dutch, 1877-1963
POLLACK, Eduard
German, op.1825-1864
POLLACK, Jan
see Polack
POLLAIUOLO or Pollagiolo,
Antonio di Jacopo
d'Antonio Benci del
Italian, 1433-1498
POLLAIUOLO, Piero di
Jacopo d'Antonio
Benci del
Italian, 1443-1496

POLLAIUOLO, Salvestro
di Jacopo
Italian, 1438-p.1483
POLLAIUOLO, Simone del
(Cronaca)
Italian, 1457-1508
POLLAK, August
German, 1838-
POLLAK, Jan
see Polack
POLLAK, Julius
German, 1845-p.1881
POLLAK or Pollack,
Leopold
German, 1806-1880
POLLAK, Martin
Theophilus
see Polak
POLLAK, Wilhelm
German, 1802-1860
POLLARD, James
British, 1797-p.1859
POLLARD, Robert I
British, 1755-1838
POLLARD, Samuel
British, 20th cent.
POLLASTRINA, Gaetano
Palazzi
Italian, 19th cent.
POLLASTRINI, Enrico
Italian, 1817-1876
POLLEN, John Hungerford
British, 1820-1902
POLLENTINE, Alfred
British, op.1861-1889
POLLET, A.N.
British, op.1783-1785
POLLET, Victor Florence
French, 1809/11-1882
POLLINGER, Felix
German, 1817-1877
POLLINI or Pollino,
Cesare (dal Francia)
Italian, c.1560-c.1630
POLLITE, Albert
British, 20th cent.
POLLITZER, Sigmund
British, 1913-
POLLOCK, Mrs. Jackson
see Krasner, Lee
POLLOCK, Jackson
American, 1912-1956
POLO, Diego
Spanish, c.1560-1600
POLONCEAU, Blanche
French, 1846-1914
POLS, D.
Dutch, 19th cent.
POLSTERER or Polster,
Hans
see Bolsterer
POLUNIN, Elizabeth V.
née Hart
British, 1887-
POLUNIN, Vladimir
Russian, 1880-
POMARANCIO, Antonio
(Circignani)
Italian,
c.1570(?)-c.1630(?)
POMARANCIO, Il
(Cris. Roncalli)
Italian, 1552-1626
POMARANCIO, Niccolò
(Circignani)
Italian, 1517-p.1596
POMARDI, Simone
Italian, 1760-1830

POMAREDE, Silvester
or Silvio
Italian, op.1736-1768
POMEDELLI, Pomadello
Pomedello, Giovanni
Maria
Italian, 1478/9-1537
POMI, Alessandro
Italian, 1890-
POMIAN, Pascal
French, 1775-1817
POMIS, Pietro
(Giovanni Pietro
Telesphoro de)
Italian, 1569-1633
POMMERENCKE, Heinrich
German, 1821-1873
POMMIER, Alfred
French, 1802-1840
POMODORO, Arnaldo
Italian, 1926-
POMODORO, Gio
Italian, 1930-
POMPA, Gaetano
Italian, 1933-
POMPADOUR, Jeanne
Antoinette d'Etioles,
Marquise de, née
Poisson
French, 1721-1764
POMPE, Gerrit
Dutch, 1655-1705
POMPEO dell' Aquila
see Cesura
POMPEYO (il Violinista)
Italian, op.1730-1753
PONC, Joan
Spanish, 20th cent.
PONC, Juan
see Pons
PONCE, Antonio
Spanish, 17th cent.
PONCE, Jacquio, Jacquiau,
Jacquieu or Jacquin
(Maître Ponce or
Maestro Ponsio, not
Paulo Ponzio Trebatti)
Italian, op.1527-1570
PONCE-CAMUS, Marie
Nicolas
French, 1778-1839
PONCELET, Maurice
Georges
French, 1897-
PONCET-DELPECHE, Eugène
French, op.1839
PONCHINO, Giovanni
Battista (Bozzato,
Bazzacco or Brazano)
Italian, c.1500-1570
POND, Arthur
British, c.1705-1758
POND, Clayton
American, 1941-
PONGA, G.
Italian, 19th cent.
PONHEIMER, Kilian I
German, 1757-1828
PONS, Fortuné
French, op.1861-1869
PONS or Ponc, Juan
(Juan del Pont ?)
Spanish, op.1474-1492/8
PONS, Louis
French, 20th cent.
PONSE, Joris
Dutch, 1723-1783

PONSFORD, John
British, c.1790-1870
PONSI, Girolamo di
Domenico de'
(di monna Nera)
Italian, op.1498-1507
PONSIO, Maestro
see Ponce
PONSON, Raphaël Luc
French, 1835-1904
PONSONELLI, Giacomo
Antonio
Italian, 1654-1735
PONT, J.
British, op.1811
PONT, Juan del
see Pons
PONTE, Antonio da
see Scaiaro
PONTE, Francesco
Italian, c.1725-
PONTE, Giovanni dal
see Giovanni
PONTE, Jacopo da
see Bassano
PONTEVIO, Silvio
Italian, op.c.1532
PONTHUS-CINIER
see Cinier
PONTI, Giovanni (Gio)
Italian, 1897-
PONTI, Pino
Italian, 1905-
PONTISFORD of Plymouth
British, op.1826
PONTIUS, Paulus
Flemish, 1603-1658
PONTONS, Pablo
Spanish, -1691
PONTORMO, Jacopo
(Carucci or Carrucci)
Italian, 1494-1557
PONTORNINI
Italian, op.1785
PONZONE, Carlo
Francesco
Italian, op.1741
PONZONE, Matteo
Italian, c.1580/90-1664
PONZONI, Leonardo
Italian, op.1472-1477
POOL, John van der
American, 1765-1799
POOL, Juriaen, II
Dutch, 1665/(?)6-1745
POOL, Matthys
Dutch, 1670-c.1732
POOL, Rachel, (née
Ruysch)
see Ruysch
POOLE, Paul Falconer
British, 1807-1879
POONS, Larry
American, 1937-
POOR, Henry Varnum
American, 1888-
POORE, Henry Rankin
American, 1859-1940
POORT, Aldert Jacob
van der
Dutch, 1771-1807
POORTEN, Hendrik
Jozef Franciscus
van der
Belgian, 1789-1874
POORTEN, Jacobus
Johannes van
Dutch, 1841-1914

POORTER, Willem de
Dutch, 1608-p.1648
POOSCH, Max von
German, 1872-1968
POOTUYH, J.
Dutch, 17th cent.
POPA, Eugen
Rumanian, 1919-
POPE, Alexander
British, 1688-1744
POPE, Alexander
British, 1763-1835
POPE, Alexander
American, 1849-1924
POPE, Clara Maria
(née Leigh)
British, 1750(?)-1838
POPE, Gustav
British, op.1852-1895
POPE, Henry Martin
British, 1843-1908
POPE, John
American, 1821-1881
POPE, Kerig
American, 20th cent.
POPELIN, Gustave Léon
Antoine Marie
French, 1859-
POPELS, Johannes or
Jan
Flemish, op.1633-1664
POPESCU, Justina
Rumanian, 1917-
POPESCU, Stefan
Rumanian, 1872-1948
POPIEL, Tadeusz
Polish, 1863-1913
POPOFF, Ben
Russian, 19th cent.
POPOV, Lukian
Vasilievich
Russian, 1873-1914
POPOWA, Ljubow Sergeewna
Russian, 1889-1924
POPOVIC, Misa
Yugoslav, 1925-
POPOVICI, Gheorghe
Rumanian, 1859-1933
POPP, Heinrich
German, 1637-1682
POPP, J.G.
German, op.1752
POPP, Sabin
Rumanian, 1896-1928
PÖPPEL, Heinrich
Rudolph Albert
(Rudolph)
German, 1823-1889
PÖPPELMANN, Johann
David
German, 1731-1813
PÖPPELMANN, Matthäus
Daniel
German, 1662-1736
POPPI, Il
see Morandini, Francesco
POPPIG, Eduard
Friedrich
German, 1798-1868
POPPLE, H.
American, op.1733
POR, Bartholomäus
(Bertalan)
Hungarian, 1880-1964
PORBUS, Frans
see Pourbus

PORCELLIS, Parcellis,
Parselles, Percelles,
Perselles etc., Jan I
Flemish, c.1584-1632
PORCELLIS, Julius
Dutch, c.1609-1645
PORCHER, Albert
French, 1834-1895
PORCK or Pork, Pieter
de
Dutch, op.1650
PORDENONE
see Licinio
PORDENONE, Giovanni
Antonio de Lodesanis
or de Sachis
Italian, c.1484-1539
PÖRGE, Gergely (Gregor)
Hungarian, 1858-1930
PORK, Pieter de
see Porck
PORPORA, Paolo
Italian, 1617-1673
PORRETTI da Arpino,
Eugenio
Italian, op.1766
PORRO, Girolamo
Italian, op.1574-c.1604
PORTA, Andrea
Italian, 1656-1723
PORTA, Ferdinando
Italian, 1689-c.1767
PORTA of Gerona
(? Felipe II op.1589
or Juan Miguel op.1568)
Spanish, 16th cent.
PORTA, Giuseppe
see Salviati
PORTA, Guglielmo della
Italian, op.1537-m.1577
PORTA, Pablo
Spanish, 16th cent.
PORTA, Teodoro della
(Cavaliere)
Italian, 1567-1638
PORTA, Tomaso
Italian, 1689-1768
PORTAELS, Jan Frans
Belgian, 1818-1895
PORTAIL, Portal or
Du Portail, Jacques
André (André)
French, 1695-1759
PORTALUPI, Mario
Italian, 20th cent.
PORTCH, Julian
British, -1855
PORTE, Henri Horace
Roland de la
see Roland
PORTELLI, Carlo
Italian, op.1545-m.1574
PORTENGEN, Lumen van
Dutch, op.1638-m.1649
PORTENGEN, Pieter van
Dutch, op.1624-m.1643
PORTENGEN, Roetert van
Dutch, 17th cent.
PORTER, Benjamin
Curtis
American, 1845-1908
PORTER, David
American, 1912-
PORTER, Fairfield
American, 1907-
PORTER, Frederick James
British, 1883-1944

PORTER, Louis
British, 20th cent.
PORTER, Sir Robert
Ker
British, 1777-1842
PORTH, Hans Heinrich
German, 1796-1882
PORTIELJE, Edward
Antoon
Belgian, 1861-
PORTIELJE, Gerard
Jozef
Belgian, 1856-1929
PORTIELJE, Jan or
Jon Frederik Pieter
Belgian, 1829-1895
PORTINARI, Candido
Brazilian, 1903-1962
PORTIO, Aniello
Italian, 18th cent.
PORTTMANN, Wilhelm
German, 1819-1893
PORTUGALOYS or
Portugalois, Eduwart
Netherlands,
op.1504-1508
PORTUGUESE SCHOOL,
Anonymous Painters
of the
PORTWAY, Douglas
British, 1922-
PORZANO, Giacomo
Italian, 1925-
POSADA, José Guadalupe
Mexican, 1852-1913
POSCH, Alois
German, 1776-1807
POSCHINGER, Richard von
German, 1839-1915
POSCUIO, Gaspare
Italian, 17th cent.
POSCUIO, Teodoro
Italian, 17th cent.
POSE, Eduard Wilhelm
German, 1812-1878
POSEN, Stephen
American, 20th cent.
POSEY, Ernest
American, 1937-
POSI, Paolo
Italian, 1708-1776
POSINGER, N.
German, 18th cent.
POSNER, Johann Jacob
German, 17th cent.
POSSART, Felix
German, 1837-1928
POSSENTI, Benedetto
Italian, 17th cent.
POSSENTI, Bernardino
Italian, 17th cent.
POST, Frans Jansz.
Dutch, c.1612-1680
POST, Johan
Dutch, 1639-c.1685/93
POST, Peter Martinus
Dutch, 1819-1860
POST, Pieter Jansz.
Dutch, 1608-1669
POSTELLE, Germain
French, op.1826-1847
POSTHUMUS, Herman
(Master Herman)
German, op.c.1540-1542
POSTIGLIONE, Luca
Italian, 1876-1936

POSTIGLIONE, Salvatore
Italian, 1861-1906
POSTL, Karel
Czech, 1769-1818
POT, Hendrick Gerritsz.
Dutch, c.1585(?)-1657
POTEMONT, Adolphe
Théodore Jules Martial
French, 1828-1883
POTERLET, Hippolyte
see Poterlet, Pierre
Saint-Ange
POTERLET, Marie Victor
French, 1811-1889
POTERLET, Pierre
Saint-Ange (called
Hippolyte)
French, 1804-1835
POTHAST, Bernard Jean
Corneille
Dutch, 1882-1966
POTHEUCK, Jan
Dutch, 1626-1669
POTHOVEN, Hendrik
Dutch, 1726-1807
POTIER, Michel
French, 20th cent.
POTRE, Antoine le
see Lepautre
POTROW
Russian(?) 18th cent.(?)
POTSCH, Ruprecht
German, 1480-1530
POTT, Charles L.
British, op.1888-1890
POTT, Laslett John
British, 1837-1898
POTTEKENS-VERHAGEN,
Jean Joseph
see Verhagen
POTTER, Beatrix
British, 1866-1943
POTTER, Charles
British, 1878-
POTTER, Frank
Huddlestone
British, 1845-1887
POTTER, Jérôme de
Flemish, op.c.1658
POTTER, John Briggs
American, 1864-1949
POTTER, Mary
British, 1900-
POTTER, Paulus Pietersz.
Dutch, 1625-1654
POTTER, Pieter Symonsz.
Dutch, c.1597/1600-1652
POTTGIESSER, Dietrich
German, 1621-p.1645
POTTGIESSER, Johann
Wilhelm
German, 1626-1676/90
POTTHAST, Edward Henry
American, 1857-1927
POTTIER, H.
French, 19th cent.
POTTNER, Emil
German, 1872-
POTUYL, H.
Dutch, op.c.1630-1660
POTWOROWSKI, Tadeusz.
Piotr
Polish, 1898-1962
POUCHON, Charles
French, 19th cent.
POUDREAU, Josephus
French, 17th cent.

POUGET, Jean Henri
Prosper (Pouget
fils)
French, -1769
POUGIN, A.L.
French, op.1754
POUGIN de Saint-
Aubin, Claude
French, op.1750-m.1783
POUGNY, Jean
see Puni, Iwan
POUJET, André
French, 1919-
POULAKIS, Theodoros
see Pulakis
POULBOT, Francisque
French, 1879-1946
POULBOT, Jean
French, 20th cent.
POULSEN, Erik
see Pauelsen
POULTON, James
British, op.1844-1859
POUNCY, Benjamin
Thomas
British, op.1772-m.1799
POUPELET, Jane
French, 1878-1932
POURBUS, Frans, I
Netherlands, 1545-1581
POURBUS, Purbis or
Porbus, Frans, II
Flemish, 1569-1622
POURBUS, Pieter Jansz.
Netherlands, c.1510-1584
POURCELLY, Jean Baptiste
French, op.1791-1802
POURTAU, Léon
French, 19th cent.
POUSAO, Henriques Cesar
de Araujo
Portuguese, 1859-1884
POUSETTE-DART, Richard
American, 1916-
POUSSIN, Charles
see Poussin, Pierre
Charles
POUSSIN, Gaspard
(Dughet or Le Guaspre)
French, 1615-1675
POUSSIN, Nicolas
French, 1594-1665
POUSSIN, Pierre Charles
French, 1819-1904
POUSSIN, Stephen
see Lavallée, Etienne
de
POUWELSEN, Martinus
Dutch, 1806-1891
POUWELSEN, Willem
Dutch, 1801-1873
POUZAYGUES, Lucien
Paul
French, 19th cent.
POWELL, Alfred H.
British, op.1890-c.1922
POWELL, C.M.
British, op.1783-m.1824
POWELL, Cordall
British, op.1768-1788
POWELL, E.
British, 17th cent.
POWELL, Sir
Francis
British, 1833-1914

POWELL, George William
Henry
American, 1824-1879
POWELL, H.M.T.
American, op.1849-1858
POWELL, John
British, op.1770-1785
POWELL, Joseph
British, op.1796-1833
POWELL, Martin
British, op.1687-m.1711
POWELL, S.
British, op.1799
POWELL, W.E.
British, 19th cent.
POWER, A.
British, op.1789-1800
POWERS, Marion
American, 20th cent.
POWLE, George
British, op.1764-1770
POWLES, Lewis Charles
British, 1860-1942
POYET, E.
British, 19th cent.
POYET, Léonard
French, 1798-1873
POYNTER, Ambrose
British, 1796-1886
POYNTER, Sir Edward
John
British, 1836-1919
POYNTZ, T.
British, op.1816
POZAR
French, 20th cent.
POZIER, Jácinthe
French, 1844-1915
POZZA, Neri
Italian, 1912-
POZZATI, Concetto
Italian, 1935-
POZZATTI, Rudy O.
American, 1925-
POZZETTI di Reggio
Emilia, Lodovico
Italian, 1782-1854
POZZI, Andrea
Italian, 1778-p.1831
POZZI, Carlo
Italian, 1618-1668
POZZI, Carlo Ignazio
Italian, 1766-1842
POZZI, Giacomo or
Jiacobo
German, 1814-1897
POZZI, Giovanni Battista
Italian, 1561-1589
POZZI, Joseph Anton
(Giuseppe)
Italian, 1732-1811
POZZI, Stefano
Italian, c.1707-1768
POZZO or Puteus,
Andrea
Italian, 1642-1709
POZZO, Giuseppe da
Italian, op.1880-1889
POZZO, Isabella
Maria del
Italian, op.1674-m.1700
POZZOBONELLI, Giuliano
Italian, op.1612-1627
POZZOSERRATO or Pozzo
da Treviso, Lodovico
see Toeput

POZZUOLANI, Il
see Diana, Giacinto
PRAAG, Alexander
Solomon van
Dutch, 1812-1865
PRAAG, Arnold van
British, 1926-
PRACHENSKY, Markus
German, 1932-
PRACK, Fredy
Swiss, 20th cent.
PRADALIE
French, 20th cent.
PRADAY, Hélène
French, 20th cent.
PRADES, A.F. de
French, op.1862-1879
PRADIER, Jean Jacques
(James)
Swiss, 1790-1852
PRADIER, R.
French, 1929-
PRADILLA y Ortiz,
Francisco
Spanish, 1848-1921
PRADILLA, I.
Spanish, 19th cent.
PRADO, Blas del
Spanish, c.1545-p.1592
PRADO, Carlos
Brazilian, 20th cent.
PRAETERE, Edmond
Joseph de
see Pratere
PRAGER
German, 20th cent.
PRAMPOLINI, Alessandro
Italian, 1823-1865
PRAMPOLINI, Enrico
Italian, 1894-1956
PRANISHNIKOFF, Ivan
Russian, 19th cent.
PRANKER, Robert
British, op.1761
PRANSKY, Stanley
American, 20th cent.
PRANZINI, Lorenzo
Italian, 19th cent.
PRAQUIN, Pierre
French, 20th cent.
PRASCH or Brasch,
Wenzel Ignaz
Czech, op.1731-m.1761
PRASSINOS, Mario
Greek, 1916-
PRAT, Loys Joseph
French, op.1906
PRATA, Francesco
Italian, op.1662-1664
PRATELLA, Attilo
Italian, 1856-1943
PRATELLI, Esodo
Italian, 1892-
PRATERE or Praetere,
Edmond Joseph de
Belgian, 1826-1888
PRATESE, Piero di Lorenzo
see Piero
PRATI, Eugenio
Italian, 1842-1907
PRATO da Caravaggio,
Francesco
Italian, 16th cent.
PRATO, Francesco
Ortensi di Girolamo dal
Italian, 1512-1562

PRATS y Velasco,
Francisco
Spanish, op.1842-1866
PRATT, Christopher
Canadian, 1935-
PRATT, Claude
British, 19th cent.
PRATT, E.
British, op.1810
PRATT, Henry Cheeves
American, 1803-1880
PRATT, Henry Lark I
British, 1805-1873
PRATT, Hilton L. II
British, op.1867-1873
PRATT, J.
American, 18th cent.
PRATT, Jonathan
British, 1835-1911
PRATT, Matthew
American, 1734-1805
PRATT, W.
British, op.1726
PRATT, William
British, 1855-
PRATTENT, T.
British, 18th cent.
PRAX, Valentine
Henriette
French, 1899-
PRAZERES, Heitor dos
Brazilian, 1898-
PREAULX, Michel
Francois
French, 1796-1827
PREAUX, Raymond
French, 1916-
PREBOSTE, Francisco
Spanish, op.1554(?)-1607
PRECHTEL, Bartholomaeus
see Brechtel
PRECHTL, Michael
Mathias
German, 1926-
PRECIADO de la Vega,
Francisco
Spanish, a.1733-1789
PREDIS or Preda, Ambrogio
(Giovanni Ambrogio) de
Italian, c.1455-p.1522(?)

PREDIS, Cristoforo de
Italian, op.1472-m.1486
PREETORIUS, Emil
German, 1883-
PREGELJ, Marijan
Yugoslav, 1913-
PREGLIASCO, Giacomo
Italian, 1759-
PREGNO, Enzo
Italian, 20th cent.
PREINDLSBERGER, Marianne
see Stokes
PREISLER
see Preissler
PREISLER, Jan
Czech, 1872-1918
PREISSIG, Vojtech
Czech, 1873-1944
PREISSLER, Anna Felicitas
see Zwinger
PREISSLER, Daniel
Czech, 1627-1665
PREISSLER or Preisler,
Georg Martin
German, 1700-1754

PREISSLER, Johann
Daniel
German, 1666-1737
PREISSLER, Johann
Justin
German, 1698-1771
PREISWERK, Theophil
Swiss, 1846-1919
PRELL, Hermann
German, 1854-1922
PRELL, Walter
German, 1857-
PRELLER, Alexis
British, 20th cent.
PRELLER, Ernst Christian
Johann Friedrich
(Friedrich)
German, 1804-1878
PREM, Heimrad
German, 1934-
PRENDERGAST, Charles
American, 1868-1948
PRENDERGAST, J.
British, op.1843
PRENDERGAST, Maurice
Brazil
American, 1859-1924
PRENNER or Brenner,
Anton Joseph von
German, 1683-1761
PRENNER, Georg Kaspar
German, c.1720-1766
PRENNER, Johann
Joseph von
German, 18th cent.
PRENTICE, David
British, 1936-
PRENTICE, John R.
British, 19th cent.
PRENTICE, Kate
British, 1845-1911
PRENTICE, L.W.
American, 19th cent.
PRENTIS, Edward
British, 1797-1854
PREPIANI, Girolamo
Italian, op.1805
PRES, Daniel du
see Dupré
PRESCIUTTI, Persiutti,
Persutti or Presuzio,
Giuliano
Italian, op.1499-1554
PRESCIUTTO, Pompeo
see Morganti
PRESCOTT, C. Trevor
British, op.1893
PRESER, C.
German, 19th cent.
PRESS, Otto
German, op.1866-1888
PRESSAC, Marcel
French, 20th cent.
PRESSMANE, Joseph
Polish, 1904-
PRESTEL, Johann Adam
German, 1775-1818
PRESTEL, Johann Erdmann
Gottlieb
German, 1804-1885
PRESTEL, Johann Gottlieb
(Theophilus or Amadeus)
German, 1739-1808
PRESTEL, Ursula
Magdalena (Reinheimer)
German, 1777-1845

PRESTON, Margaret
 Australian, 1883-1963
PRESTON, Thomas
 (Captian Preston)
 British, -1759/85(?)
PRESTOPINO, Gregorio
 American, 1907-
PRETE Savonese, Il
 see Guidobono,
 Bartolommeo
PRETERZONO, Simone
 see Peterzano
PRETI or del Preta,
 Gregorio
 Italian, op.1634-m.1672
PRETI, Mattia (Il
 Cavalier Calabrese)
 Italian, 1613-1699
PRÊTRE, Jean Gabriel
 French, op.1800-1840
PREU or Prew, Jörg
 see Breu
PREUDHOMME or Prud'homme
 German, 1686-1726
PREUDHOMME, Jean
 Swiss, 1732-1795
PREUDHOMME, Jérôme
 French, op.1767-1789
PREUSCHEN, Hermione von
 German, 1854-1918
PREVIATI, Gaetano
 Italian, 1852-1920
PREVITALI, Andrea
 (Cordeliaghi or
 Cordella)
 Italian, c.1470-1528
PREVOST, Alexandre
 Céleste Gabriel
 French, 19th cent.
PREVOST, Benoît Louis
 French, c.1735-1804(1809?)
PREVOST, Charles Eugène
 French, 1855-
PREVOST, Constantin Jean
 Marie
 French, 1796-1865
PREVOST, Jan
 see Provoost
PREVOST, Jean Louis
 French, c.1760-p.1810
PREVOT, Gomier Marie
 French, 19th cent.
PREVOT-VALERI, Auguste
 French, -1930
PREWET, William
 see Prewitt
PREWITT, Prewit or
 Prewet, William
 British, op.1733-1735
PREY, J.J.
 Czech, 1813-1865
PREY, J.Z.
 Czech, 1744-1823
PREYDAUR, Gamba de
 French, 19th cent.
PREYER, Emilie
 German, 1849-1930
PREYER, Ernest Julius
 British, 1842-1917
PREYER, Gustav
 German, 1801-1839
PREYER, Johann
 Wilhelm
 German, 1803-1889
PREYER, Paul
 German, 1847-1931

PREZIOSI, Amadeo
 Italian, -1882
PRIAMO di Pietro
 (Priamo della Quercia)
 Italian, op.1438-1467
PRIANICHNIKOFF, Illarion
 Russian, 1849-1894
PRICA, Zlatko
 Yugoslav, 1916-
PRICE, James
 British, op.1842-1876
PRICE, Julius Mendes
 British, -1924
PRICE, Kenneth
 American, 20th cent.
PRICE, Robert
 British, op.1739
PRICE, William Lake
 (Lake)
 British, 1810-p.1891
PRIECHENFRIED, A.
 Polish, 1867-
PRIENZ
 Scandinavian(?), op.1670
PRIEST, Alfred
 British, 1810-1850
PRIEST, Thomas
 British, op.1738-1750
PRIESTMAN, Arnold
 British, 1854-1925
PRIESTMAN, Bertram
 British, 1868-1951
PRIETO, Fermin
 Gonzalez
 Cuban, 20th cent.
PRIETO MUNOZ, Gregorio
 Spanish, 1900-
PRIEUR, Barthélemy
 French, c.1540-1611
PRIEUR, François Louis
 French, op.c.1780-1800
PRIEUR, Jean Louis, II
 French, 1759-1795
PRIEUR or Le Prieur,
 Paul
 Swiss, c.1620-p.1683
PRIEUR, Romain Etienne
 Gabriel
 French, 1806-1879
PRIKING, H.
 French, 20th cent.
PRIMATICCIO or Primadizzi,
 Francesco (Bologna)
 Italian, 1504-1570
PRIMAVESI, Johann Georg
 (Georg)
 German, 1774-1855
PRIMO, Louis
 see Gentile, Luigi
PRIMOLI, Juan Bautista
 Spanish, op.c.1735
PRINCE, le
 see Leprince
PRINCETEAU, René
 Pierre Charles
 French, 1844(?)-1914
PRINET, René Xavier
 French, 1861-1946
PRINGLE, Alexander
 British, op.1761
PRINGLE, J.
 British, op.1770
PRINGLE, W.I.
 British, 19th cent.
PRINS, Balthasar
 Dutch, op.1631

PRINS, Ernest Pierre
 (Pierre)
 French, 1848-1913
PRINS, Johannes Huibert
 Dutch, 1757-1806
PRINS, Raphaël Mozes
 (Ralph)
 Dutch, 1926-
PRINSEP, Anthony
 British, 1908-
PRINSEP, James
 British, 1799-1840
PRINSEP, Valentine
 Cameron
 British, 1836-1904
PRINTZ, Christian
 August
 Norwegian, 1819-1867
PRINZ, Karl Ludwig
 German, 1875-1944
PRINZHOFER, August
 German, 1817-1885
PRIOR, Thomas Abiel
 British, 1809-1886
PRIOR, William Henry
 British, 1812-1882
PRIOR, William Matthew
 American, 1806-1873
PRIORE, Nicolò del
 Italian, op.c.1470-m.1501
PRIOU, Louis
 French, 1845-
PRITCHARD, Edward F.D.
 British, 1809-1905
PRITCHARD, George
 British, 19th cent.
PRITCHETT, Edward
 British, op.1828-1864
PRITCHETT, Robert
 Taylor
 British, 1828-1907
PRIWITZER, Privisier
 or Priwitzerus, Johannes
 Hungarian, op.1627-1647
PROBERT, Sidney
 American, 1865-1919
PROBST, Carl
 German, 1854-1924
PROBST, Georg Balthasar
 German, 18th cent.
PROCACCINI, Andrea
 Italian, 1671-1734
PROCACCINI, Camillo
 Italian, 1551(?)-1629
PROCACCINI, Carl
 Antonio
 Italian, c.1555-1605(?)
PROCACCINI, Ercole, I
 Italian, 1515-p.1595
PROCACCINI, Ercole, II
 Italian, 1596-1676
PROCACCINI, Giulio
 Cesare
 Italian, c.1570-1625
PROCHAZKA, Antonin
 Czech, 1882-1945
PROCKTOR, Patrick
 British, 20th cent.
PROCRIUS, Andrew
 British, 17th cent.
PROCTER, Mrs. Dod
 British, -891-1972
PROCTER, Ernest
 British, 1886-1935
PROCTOR, John
 British, 19th cent.
PROCTOR, Thea
 Australian, 1879-1966

PROCTOR, Thomas
 British, 1753-1794
PRODA, Carlo
 Italian, 18th cent.
PROGER, Gilich Kilian
 German, op.1531-1540
PROKOFJIEFF, Iwan
 Prokofjewitsch
 Russian, 1758-1828
PRÖLSS, Friedrich
 Anton Otto
 German, 1855-
PRON, Louis-Hector
 French, 1817-1902
PRONASZKO, Zbigniew
 or Zygmunt
 Polish, 1885-1958
PRONK or Pronck,
 Cornelis
 Dutch, 1691-1759
PRONTI, Domenico
 Italian, op.1790-1815(?)
PROSDOCIMI, Alberto
 Italian, 1852-
PROSPERO Bresciano
 see Bresciano
PROTAIS, Paul Alexandre
 (Alexandre)
 French, 1826-1890
PROTIC, Miodrag B.
 Yugoslav, 1922-
PROTO, Serge
 French, 1930-
PROTTI, Alfredo
 Italian, 1882-1949
PROU, Jacques
 French, 1655-1706
PROUDFOOT, James
 British, 1908-
PROUST, André
 French, 19th cent.
PROUT, John Skinner
 British, 1806-1876
PROUT, Margaret Fisher
 British, 1881-
PROUT, Samuel
 British, 1783-1852
PROUT, Samuel Gillespie
 British, 1822-1911
PROUTY, L.A.
 American, op.1870
PROUVE, Emile Victor
 (Victor)
 French, 1858-
PROUX, Patrice
 French, 20th cent.
PROVAGLI or Provaglia,
 Alessandro
 Italian, op.1626-m.1636
PROVENZALE or Provenzali,
 Marcello
 Italian, 1577-1639
PROVENZANI, Domenico
 Italian, -1794
PROVEREL(?)
 Dutch(?), 17th cent.(?)
PROVIS, Alfred
 British, op.1843-86
PROVOOST, Prévost or
 Provost, Jan
 Netherlands,
 op.1491-m.1529
PROVOST, Jean Louis
 French, 1781-1850
PROWETT, James C.
 British, op.c.1890-1925

PROWETT, W.
British, op.c.1785

PROWSE, Ruth
South African, 1883-1967

PRUCHA, Gustav
German, 1875-

PRUCKENDORFER, Hans
German, op.c.1510-m.1518

PRUCKER, Brucker,
Bruckher or Prugger,
Nikolaus
German, c.1620-1694

PRUDENT, Ferdinand
French, op.1776

PRUDENTI, Bernardino
Italian, op.1631-1694

PRUDHOMME, Antonie
Daniël
Dutch, c.1745-1826

PRUDHOMME, Jean
see Preudhomme

PRUDHON, Pierre Paul
French, 1758-1823

PRUGGER, Nikolaus
see Prucker

PRÜLL
see Bril

PRUNA, Pedro
Spanish, 1904-

PRUNATI, Santo
Italian, 1652-1728

PRUNIER, Gaston
French, 1863-1927

PRUSZKOWSKI, Witold
Polish, 1846-1896

PRYDE, James
(Brothers Beggarstaff)
British, 1869-1941

PRYNNE, Edward A.
Fellowes
British, 1854-1921

PRZEPIORSKI, K. Lucien
French, 1830-1898

PSENNER, Anton
German, 1791/3-1866

PUCCI, Pietro di
Giovanni
see Pietro di Giovanni
di Ambrogio

PUCCINELLI, Angelo di
Puccinello
Italian, op.1350-1399

PUCCINELLI, Antonio
Italian, 1822-1897

PUCCINI, Biagio
Italian, 1675-1721

PUCCINI, Mario
Italian, 1869-1920

PUCCIO, Pietro di
see Pietro

PUCCIO di Simone
Italian, 14th cent.

PUCELLE, Jehan
French, op.1319-1343

PUCHE,
Spanish, op.1716

PUCHERNA, Antonin
German, 1776-1852

PUCHINGER, Erwin
German, 1876-1944

PÜCHLER, Johann Michael
German, op.1680-1702

PUDLICH, Robert
German, 1905-

PUEYRREDON, Prilidiano
Mexican, 19th cent.

PUGA, Antonio
Spanish, 17th cent.

PUGET, Francois
French, 1651-1707

PUGET, Pierre
French, 1620-1694

PUGH, C.
British, op.1759

PUGH, Charles J.
British, op.1797-m.1805

PUGH, Clifton
Australian, 20th cent.

PUGH, Edward
British, op.1805-1813

PUGH, Herbert
British, op.1758-m.p.1788

PUGIN, Augustus
Charles
British, 1762-1832

PUGIN, Augustus Welby
Northmore
British, 1812-1852

PUGLIANI, Domenico
Italian, -1658

PUGLIESCHI, Antonio
Italian, 1660-1732

PUHLMANN, Johann
Gottlieb
German, 1751-1826

PUHSWALD
German, op.1850

PUIG, Jean Vila
Spanish, 19th cent.

PUIGAUDEAU, Fernand
Loyen de
French, 1866-1930

PUILLARD, le Père
Jacques Gabriel
French, 1751-1823

PUJOL, Alexandre Denis
Abel de (Abel de Pujol)
French, 1785-1861

PUJOL de Guastavino,
Clément
French, 19th cent.

PUJOS, André
French, 1738-1788

PULAKIS or Poulakis,
Theodoros
Greek, op.1650

PULEGIO, Antonio
Italian, c.1600-c.1689

PULGA, Bruno
Italian, 1922-

PULHAM, Peter Rose
British, 1910-1956

PULIGO, Domenico
Italian, 1492-1527

PULINCKX, Louis
Belgian, 1843-

PULLER, John Anthony
British, 19th cent.

PULLEY, J.
British, 19th cent.

PULZONE, Polzone or
Pulzoni, Scipione
(Il Gaetano)
Italian, 1550-1598

PUNDER, Jacobus de
see Poindre

PUNI, Iwan Albertowitsch
(Jean Pougny)
Russian, 1892-1956

PUNT, Jan
Dutch, 1711-1779

PUPINI, Biagio dalle
see Lame

PURBIS, Frans
see Pourbus

PURCELL, Edward
British, op.1812-1815

PURCELL, Richard
('C. or Chas. Corbutt')
British, op.c.1755-m.c.1766

PURGAU or Burgau, Franz
Michael Siegmund von, I
German, 1677/78-p.1751

PURICELLI, Giuseppe
Italian, 1832-1894

PURIFICATO, Domenico
Italian, 1915-

PURKYNE, Karel
Czech, 1834-1868

PURRMANN, Hans
German, 1880-

PURSER, Sarah
British, 1848-1943

PURSER, William
British, op.1805-1839

PUSHKAREV, Prokofy
Yegorovich
Russian, op.1845-1848

PUSHMAN, Hovsep T.
American, 1877-

PUTEANI, Friedrich von
Czech, 1849-1917

PUTEUS
see Pozzo

PUTHMANN, J.L.
German, op.c.1752

PUTTE, Jean Van de
Belgian, 1828-1872

PUTTEN
Dutch, 17th cent.

PUTTER, C de
Dutch, 18th cent.

PUTTER, Pieter de
Dutch, op.1626-m.1659

PUTTNER, Josef Karl
Berthold
Czech, 1821-1881

PUTTNER, Walther
German, 1872-

PUTZ, Leo
German, 1869-

PUVIS de Chavannes,
Pierre
French, 1824-1898

PUXBAUMB, Hans
see Buchsbaum

PUY, Jean
French, 1876-

PUYL, Louis Francois
Gerard (Gerard) van der
Dutch, 1750-1824

PUYTLINCK, Christoffel
(Trechter)
Dutch, 1640-p.1671

PUZYREV, Vasily
Vasilievich
Russian, 20th cent.

PY, Achille
French, 1823-

PYALL, H.
British, op.1831-1833

PYBOURNE, Thomas
British, 18th cent.

PYBUS, W.
British, 19th cent.

PYE, John I
British, 1745-p.1773

PYE, William
British, op.1881-1890

PYKE, Anthony
British, 20th cent.

PYLE, Howard
American, 1853-1911

PYLE, Robert
British, op.1761-1766

PYM, Roland
British, 20th cent.

PYMAN or Piemans,
Hinderk
German, c.1580-1647

PYNACKER, Adam
Dutch, 1622-1673

PYNAS or Pinas, Jacob
Symonsz.
Dutch, c.1585-p.1650

PYNAS or Pinas, Jan
Symonsz.
Dutch, 1583/4-1631

PYNE, Charles Claude
British, 1802-1878

PYNE, George
British, 1800-1884

PYNE, James Baker
British, 1800-1870

PYNE, William Henry
British, 1769-1843

PYNEMAN, J.W.
Dutch(?), op.1815

PIJNENBURG, Reinier
Marinus
Dutch, 1884-1968

Q

QUA, Lam
British, 18th cent.

QUACK or Quacq, Jacob
Dutch, -1668

QUAD, Mathias
(von Kinkelbach)
German, 1557-p.1609

QUADAL or Chwátal,
Martin Ferdinand
German, 1736-1808

QUADRONE, Giovanni
Battista
Italian, 1844-1898

QUADT or Quaet, Jan
Dutch, op.1673-m.1696

QUAGLIA, Ferdinand
(Paul Ferdinand
Louis)
Italian, 1780-1853

QUAGLIATA, Andrea
(Giovanni Andrea)
Italian, c.1600-1660

QUAGLIATA, Giovanni
Battista
Italian, 1603-1673

QUAGLIO, Angelo, I
(Michel Angelo)
German, 1778-1815

QUAGLIO, Angelo, II
German, 1829-1890

QUAGLIO, Domenico, II
German, 1786/7-1837

QUAGLIO, Franz
German, 1844-1920

QUAGLIO, Giovanni Maria
Italian, 1700-1765

QUAGLIO, Giulio or
Julius, II
Italian, 1668-1751

QUAGLIO, Joseph
German, 1747-1828

QUAGLIO, Julius, III
German, 1764-1801

QUAGLIO, Lorenzo, I
von
Italian, 1730-1804
QUAGLIO, Lorenzo, II
German, 1793-1869
QUAGLIO, Simon
German, 1795-1878
QUAINI, Luigi, II
Italian, 1643-1717
QUAISSER, Josef
German, 1777-1845
QUANDT, Silvia
German, 1939-
QUANT, Andreas
Danish, op.1678-1692
QUANTIN
see Quentin
QUARENGHI, Giacomo
Italian, 1744-1817
QUARTARARO, Riccardo
Italian, op.1485-1501
QUARTENMONT, Bernardus
de Andreas
see Quertenmont
QUARTON, Enguerrand
see Charonton
QUAST, Anna
Dutch, op.1640
QUAST, Pieter Jansz.
Dutch, 1605/6-1647
QUAY TWINS, The
American, 20th cent.
QUEBOORN, Queborne
or Queckborne, Crispyn
van den
Dutch, 1604-1652
QUEBORN, Queeborne or
Queeckborne, Daniel
Flemish, op.1577-m.a.1619
QUEENSBERRY,
Marchioness of
see Mann, Cathleen
QUEESCHE, Petrus
Dutch(?), op.1672
QUELLINUS, Quellien or
Quellyn, Artus or
Arnoldus, I
Flemish, 1609-1668
QUELLINUS, Erasmus, II
Flemish, 1607-1678
QUELLINUS, Hubertus
(Saracin)
Flemish, 1619(?)-1687
QUELLINUS, Jan Erasmus
(Seederboom)
Flemish, 1634-1715
QUELVEE, François
Albert
French, 1884-
QUENEDEY, Edmé
French, 1756-1830
QUENTIN or Quantin,
Philippe (not Nicolas)
French, c.1600-1636
QUERCETUS, Franciscus
see Duquesnoy, Frans
QUERCI, Dario
Italian, 1831-p.1877
QUERCIA, Jacopo della
(Jacopo di Pietro
d'Angelo)
Italian, 1367-1438
QUERCIA, Priamo della
see Priamo di Pietro
QUERENA, Lattanzio
Italian, 1768-1853

QUERENA, Luigi
Italian, op.1880
QUERFURT or Querfurth,
August
German, 1696-1761
QUERFURT or Quefurt,
Tobias, I
German, op.1689-1730
QUERNER, Kurt
German, 1904-
QUERTENMONT, Quartenmont
or Quertemont, Andreas
Bernardus de
Flemish, 1750-1835
QUESNE, Fernand le
see Le Quesne
QUESNEL, Augustin, I
French, 1595-1661
QUESNEL, Augustin, II
French, 1630-1697
QUESNEL, Francois
French, 1543-1619
QUESNEL, Nicolas
French, op.1574-m.1632
QUESNEL, Pierre
French, op.1545-m.p.1574
QUESNOI or Quesnoy, Frans
or François du, de or di
see Duquesnoy
QUEST, Charles F.
American, 1904-
QUESTA, Francesco de la
see Cuosta
QUESTA, G.M.
Spanish, c.1658
QUEVERDO, François Maria
Isidore
French, 1748-1797
QUICK, Richard
British, 19th cent.
QUIDOR, John
American, 1800-1881
QUIGLEY, D.
British, op.1773
QUIGNON, Fernand Just
French, 1854-
QUILLARD or Quilliard,
Antoine (Pierre
Antoine)
French, 1701-1733
QUILLER, Magnus de
German, 18th cent.
QUILLINAN, Dorothy,
(née Wordsworth)
British, 1804-1847
QUINART or Quinaurt,
Charles Louis
Francois
French, 1788-1848/51
QUINAUX, Joseph
Belgian, 1822-1895
QUINETUS, Aegidius
see Congnet
QUINKHARD, Jan Maurits
Dutch, 1688-1772
QUINTANILLA, Luis
Spanish, 1895-
QUINTERO, Daniel
Spanish, 1949-
QUINTON, Alfred Robert
British, op.1879-1902
QUINTON, Clement
French, 1851-
QUINTON, George
British, 1779-

QUIRICO, Giovanni
Quirico di Giovanni
or Giovanni da Tortona
Italian, op.1467-1503
QUIRIZIO di Giovanni
da Murano
Italian, op.1461-1478
QUIRT, Walter Wellington
American, 1902-
QUITER or Quitter,
Herman Hendrik, I de
Dutch, 1628-1708
QUITTON, Edouard
Belgian, 1842-
QUIZET, Alphonse
French, 1885-1955
QUOST, Ernest
French, 1844-1931
QUOSTA, Francesco
Italian, op.1672-m.1723
QUOYZEVEAU, Antoine
see Coysevox

R

RAAB, Ferdinand
German, 19th cent.
RAAB, Ignaz Josef
Russian, 1715-1787
RAABE, Josef (Carl
Josef)
German, 1780-1846
RAALTE, Marinus Julius
van
Dutch, 1872-1944
RAAPHORST, Cornelis
Dutch, 1875-1954
RABASCALL
French, 20th cent.
RABASSE, Jean
French, op.1650
RABBONI, Marco
Italian, 17th cent.
RABEL or Ravel, Æ. van
Dutch, op.1653
RABEL, Daniel
French, c.1578-1637
RABEL, Jean
French, c.1545-1603
RABELAIS, François
French, 1495-1553
RABES, Max Friedrich
Ferdinand
German, 1868-1944
RABIN
French, 20th cent.
RABIN, Oskar
Russian, 20th cent.
RABIN, Sam
British, 1908-
RABISINO
see Tommaso da Modena
RABL, Veit
German, op.c.1654-c.1692
RABON, Nicolas
French, 1644-1686
RABON, Pierre
French, 1619-1684
RABUZIN, Ivan
Russian, 20th cent.
RACCAGNI, Andrea
Italian, 1921-
RACH, Johannes
Danish,
1721(?)-p.1761

RACHETTE, Dominique
(Antoine Jacques
Dominique)
Russian, 1744-1809
RACITI, Mario
Italian, 20th cent.
RACKHAM, Arthur
British, 1867-1939
RACKHAM, Edyth,
(née Starkie)
British, 1867-
RACOFF, Ratislaw
Polish, 20th cent.
RACOVIER(?), J.(?)
Flemish, 16th/17th cent.
RADCLYFFE, Charles Walter
British, 1817-1903
RÄDECKER, Johannes
Anton (Johan)
see Raedecker
RADEJ, J.
Yugoslav, 20th cent.
RADEL
French(?), op.1751-1767
RADEMAKER, Abraham
Dutch, 1675-1735
RADEMAKER, Gerrit
Dutch, c.1672-1711
RÄDERSCHEIDT, Anton
German, 1892-1970
RADFORD, Edward
British, 1831-1920
RADGEB, Jerg
Polish, 16th cent.
RADICE, Mario
Italian, 1900-
RADICE, Renzo
Bongiovanni
Italian, op.1899
RADIGUET, Maurice
French, op.1923
RADIMSKY, Wenzel
(Vaclav)
German, 1867-1946
RADL, Anton
German, 1774-1852
RADL, Julius
German, 1878-1902
RADOUX, Leopold
German, op.1754-1781
RADT, G. van
Dutch, op.1676
RADTKE, Eduard Leopold
German, 1825-
RADZIWILL, Prince Anton
Heinrich
Polish, 1775-1833
RADZIWILL, Franz
German, 1895-
RADZIWILL, Princess
Marie Eleanore, (née
Princess of Anhalt-
Dessau)
German, 1671-1756
RAE, Henrietta
(Mrs. Ernest Normand)
British, 1859-1928
RAE, Isŏ
British, 20th cent.
RAEBURN, Sir Henry
British, 1756-1823
RAEBURN, Henry Macbeth
see Macbeth-Raeburn
RAEDECKER, Johannes Anton
(John)
Dutch, 1885-1956
RAEHN, E.A.
German(?), op.1804

RAEMAEKER, Henri
François
see Ramah
RAEMAEKERS, Louis
Belgian, 1869-1956
RAESON, A.
Dutch(?), 18th cent.
RAETH or Raet, Ignace
Flemish, c.1626-1666
RAETZ, Markus
Swiss, 20th cent.
RAF, Jan
see Corvus, Johannes
RAFAEL, Joaquim
see Raphael
RAFF, Franz Ludwig
see Raufft
RAFFAEL, Joseph
American, 1935-
RAFFAELLINO dal Colle,
Raffaello di Borgo
San Sepolchro,
Raffaellino di
Michelangelo dal Colle
Italian, c.1490-1566
RAFFAELLINO da Reggio
(Motta)
Italian, c.1550-1578
RAFFAELLI, Jean
François
French, 1850-1924
RAFFAELLINO del Garbo
(Raffaellino di
Bartolommeo del Garbo,
Raphael Bartolomei,
Nicolai Capponi or
Capponibus pictor nel
Garbo or Raffaello di
Bartolommeo di Giovanni
di Carlo)
Italian, 1466-1524
RAFFAELLO da Messina, Il
see Alibrando, Girolamo
RAFFAELLO da Montelupo
see Montelupo
RAFFALT, Ignaz
German, 1800-1857
RAFFALT, Johann
Gualbert
German, 1836-1865
RAFFET, Denis Auguste
Marie
French, 1804-1860
RAFFORT, Etienne
French, 1802-1895
RAFFY-LE-PERSAN, Jean
French, 1920-
RAGAZZINI, Giovanni
Battista
Italian, c.1520-1547
RAGGI, Giovanni
Italian, 1712-1792/4
RAGNONI, Sister
Barbera
Italian, op.c.1500
RAGOT, Francois
French, 1638-1670
RAGUENEAU or Raguineau,
Abraham
French, 1623-p.1681
RAGUENET, François
French, op.1751-1777
RAGUENET, Nicolas and
Jean Baptiste
French, op.1750-1775

RAGUINEAU
see Ragueneau
RAHL, Carl
German, 1812-1865
RÄHMEL, Achatius
Gottlieb
German, 1732-1811
RAHN, C.
see Rohn
RAHN, Otto
German, op.1848
RAIBOLINI
see Francia
RAICEVITZ, Federigo
de
German(?), op.1813
RAIGERSFIELD, Captain
(Baron) J. de
British, op.1798-1811
RAILTON, F.J.
British, op.1847-1866
RAILTON, Herbert
British, 1857-1910
RAIMBACH, David Wilkie
British, 1820-1895
RAIMÓNDI, Carlo
Italian, 1809-1883
RAIMONDI, Marcantonio
Italian, c.1480-1527/34
RAIMONDI, Pietro
Italian, 17th cent.
RAINALDO di Ranuccio
da Spoleto (not
Benaidictus)
Italian, op.1265
RAINBEAUX, F.
Flemish(?), 18th cent.(?)
RAINE or Rame, E.
French, 18th cent.
RAINE, Thomas Surtees
British, 19th cent.
RAINER, Arnulf
German, 1929-
RAINER
see Reiner
RAINERI, Francesco (Il
Schivenoglia)
Italian, 1703-1785
RAINEY, William
British, 1852-1936
RAINOLD, C.E.
German, op.1823
RAINUCCI, Benedetto
see Rainaldo di
Ranuccio da Spoleto
RAITH
see Reith
RAITTILA, Tapani
Finnish, 1921-
RAJECKA, Anna (?)
(Madame Gault de
Saint-Germain)
Polish, 1760-1832
RAJLICH, Jan
Czech, 20th cent.
RAJLICH, Tomas
Czech, 1940-
RAJON, Paul Adolphe
French, 1842/3-1888
RAJOTTE, Yves
Canadian, 1932-
RAKOW, Leonid
Russian, 20th cent.
RALEIGH, Charles S.
American, 1831-1925
RALLI, Theodore Jacques
French, 1852-1909

RALPH, George Keith
British, op.1778-1811
RALPH, Lester
American, 1876-1927
RALSTON, John
British, 1789-1833
RALSTON, William
British, 1848-1911
RALZE, Raymond
German, 19th cent.
RAMADIER, F.A.
German, a.1800-c.1833
RAMAGE, John
British, op.1777-m.1802
RAMAH, Henri François
(Henri François
Raemaeker)
Belgian, 1887-1946
RAMAZZANI, Ercole
Italian, c.1530-1598
RAMBERG, Arthur George
Freiherr von
German, 1819-1875
RAMBERG, Johann Heinrich
German, 1763-1840
RAMBERVILLERS, Alphonse
de
French, 1553-1633
RAMBOSSON, Mme. Yvanhoé
see Gonyn de Lirieux
RAMBOUX, Johann Anton
German, 1790-1866
RAMBOW, Gunther
German, 20th cent.
RAMBUSCH, Agnes
see Slott-Möller
RAMDOHR, Friedrich
Wilhelm Basilius von
German, 1752-1822
RAME, E.
see Raine
RAMEAU, Louis Jean
Jacques du
French, 1733-1796
RAMEL, Pierre
French, 20th cent.
RAMELET, Charles
French, 1805-1851
RAMELLI, Antonio Cassi
Italian, 1902-
RAMELLI, Felice
Italian, 1666-1741
RAMENGHI
see Bagnacavallo
RAMERU, Samuel de
French, op.1649-m.a.1681
RAMIREZ, Everardo
Mexican, 1906-
RAMIREZ, Felipe
Spanish, 17th cent.
RAMIREZ, Juan
Spanish, op.1515-1554
RAMIS, Julio
Spanish, -1909
RAMLO, Lorenz
Flemish, op.1767-1770
RAMM, August Leopold
German, op.c.1800
RAMMELAER
see Coninck, David de
RAMON, Navarro
Spanish, 1903-
RAMON, S.
Spanish, 19th cent.
RAMONDOT,
French, 20th cent.

RAMOS, Marin
Spanish, op.c.1900-1910
RAMOS, Mel
American, 20th cent.
RAMPLING, Madeleine
British, 1941-
RAMSAY, Allan
British, 1713-1784
RAMSAY, Dennis
British, 20th cent.
RAMSAY, Hugh
Australian, 1877-1906
RAMSAY, James
British, 1786-1854
RAMSEY, Milne
American, 1847-1915
RAMSAY, Lady Patricia
British, 1886-
RAMSAY, W.
British, 19th cent.
RAMSAY-LAMONT, L.
British, 19th cent.
RAMSDELL, Frederick
Winthrop
American, 1865-1915
RANC, Jean
French, 1674-1735
RANCILLAC
French, 20th cent.
RAND, Ellen G. Emmet
American, 1876-1941
RAND, John Goffe
American, 1801-1873
RANDAL, Frank
British, 19th cent.
RANDALL, James
British, op.1798-1814
RANDANINI, Carlo
Italian, op.1881-m.1884
RANDE, Abraham van de
Dutch, c.1603-p.1673
RANDON, Gilbert
French, 1814-1884
RANDT
German, 18th cent.(?)
RANFT, Richard
Swiss, 1862-1931
RANFTL, Johann Mathias
(Mathias)
German, 1805-1854
RANG-BABUT, Louise,
(née Vaucorbeil)
French, 1806-1884
RANGE, Andreas
German, 1762-p.1828
RANGER, Henry Ward
American, 1858-1916
RANIERI del Pace
Italian, 17th cent.
RANIERI d'Ugolino
Italian, 13th cent.
RANKEN, William Bruce
Ellis
British, 1881-1941
RANKIN, Andrew Scott
British, 1868-
RANKIN, George
British, 19th cent.
RANKIN, John
British, 19th/20th cent.
RANKINE, V.V.
American, 20th cent.
RANKLEY, Alfred
British, 1819-1872
RANNEY, William
American, 1813-1857

RANSOM, Alexander
American, op.c.1840-1865
RANSON, Paul Elie
French, 1862-1909
RANSON, Pierre
French, 1736-1786
RANTVIC, Bernardo
(Bernardo Fiammingo)
Netherlands,
op.1573-m.1596
RANUCCI, Giuseppe
Italian, op.1736
RANUCCI, Rinaldo
Italian, 13th cent.
RANVIER, Joseph Victor
French, 1832-1896
RANVIER-CHARTIER,
Lucie
French, 1867-1932
RANWELL, W.
British, op.1830-1843
RANZONI, Daniele
Italian, 1843-1889
RANZONI, Gustav
German, 1826-1900
RANZONI, Hans, I
German, 1868-1956
RAO, Rama
American, 20th cent.
RAOUX, Jean
French, 1677-1734
RAPHAEL or Raffaello
Santi or Sanzio da
Urbino
Italian, 1483-1520
RAPHAEL, Joaquim
Portuguese, 1783-1864
RAPHAEL, Joseph
American, 1872-1950
RAPHAEL, Mary F.
British, op.1889-1915
RAPHAEL, Shirley
Canadian, 20th cent.
RAPHAEL, William
Canadian, 1833-1914
RAPHON or Rebhuhn,
Hans
German, op.1499-m.1512
RAPIN, Alexandre
French, 1839-1889
RAPOTEC, Stanislav
Australian, 1911-
RAPOUS, Rapos, Raposo,
Rapozzo or Rapus,
Michele Antonio
Italian, 1733-p.1819
RAPOUS, Rapos, Raposo,
Rapozzo or Rapus,
Vittorio Amedeo
Italian, 1728(?)-a.1800
RAPP, Ginette
French, 1928-
RAPPARD, Anton Gerhard
Alexander van
Dutch, 1858-1892
RAPPINI
Italian, 19th cent.
RASCH, Heinrich
German, 1840-1913
RASCHEN, Henry
American, 1856-1937
RASCHKA, Robert
Rumanian, 1847
RASMUSSEN, Carl
Danish, 1841-1893

RASMUSSEN, Georg
Anton
Swedish, 1842-1914
RASMUSSEN, Poul Lauritz
Danish, 1897-
RASNESI, Giuseppe
Italian, op.1841
RASPAL, Antoine
French, 1738-1811
RASSE, C. de
French, 17th cent.(?)
RASSENFOSSE, Armand
Belgian, 1862-1934
RASSET, Jean
see Valentin de
Boullogne
RASTRELLI, Bartolomeo
Carlo
Italian, c.1675-1744
RASTRUM, Margareta
German, 1611-1678
RATCLIFFE, William
British, 1870-1955
RATGEB, Jerg
(Schürzjürgen)
German, a.1480-1526
RATH, Henriette
Swiss, 1773-1856
RATHBONE, John
British, c.1750-1807
RATHBONE, Mary
British, op.1795-1802
RATTE
French, 18th cent.
RATTI, Carlo Giuseppe
Italian, 1737-1795
RATTI, Eduard
German, 1816-p.1856
RATTI, Giovanni
Agostino
Italian, 1699-1775
RATTNER, Abraham
American, 1893-
RATTNHAMER
see Rottenhammer
RATTRAY, A. Wellwood
British, 1849-1902
RATZEL, Gene
American, 20th cent.
RÄTZER, Hellmuth
German, 1838-1909
RAU, Emil
German, 1858-1897
RÄUBER, Wilhelm Carl
German, 1849-1926
RAUCH, Charles
French, 1791-1857
RAUCH, Christian Daniel
German, 1777-1857
RAUCH, Ferdinand
German, 1813-1852
RAUCH, Johann Nepomuk
German, 1804-1847
RAUCHINGER, Heinrich
German, 1858-
RAUCHMILLER or
Rauchmüller, Matthias
German, c.1645-1686
RAUFFT, Raff, Rauft
or Rouw, Franz Ludwig
Swiss, 1660-1719/28
RAUFT, Franz Ludwig
see Raufft
RAULIN, André
French, 19th cent.
RAULINO, Johann (Tobias?)
German, op.1820-1831

RAUMANN
French, 19th cent.
RAUPP, Karl
German, 1837-1918
RAUSCH, J.
German, op.1840
RAUSCH, Leonard
German, 1813-1895
RAUSCH, Peter Bernhard
von
German, 1793-1865
RAUSCHENBERG, Robert
American, 1925-
RAUSCHER, Johann August
Albrecht ? Friedrich
(Friedrich)
German, 1754-1808
RAUSCHER or Rausscher,
Johannes (Jan)
see Ruijscher
RAVAISSON, F.
French, 1811-1884
RAVE, Jan de
see Corvus, Johannes
RAVEEL, Roger
Belgian, 1921-
RAVEL, Æ. van
see Rabel
RAVEL, Daniel
French, 1915-
RAVEL, Edouard
Swiss, 1847-1920
RAVELAER, A.
Dutch(?), 18th cent.(?)
RAVEN, Ernst von
German, 1816-1890
RAVEN, John Samuel
British, 1829-1877
RAVEN, Samuel
British, c.1775-1847
RAVEN, Rev. Thomas
British, 1795-1868
RAVENET, I, Simon
Francois
French, 1706/(?)1721-
RAVEN-HILL, Leonard
British, 1867-1942
RAVENNATE, Il
see Ingoli
RAVENSTEIN, Paul von
German, 1854-1938
RAVENZWAAY or
Ravenswaay, Adriana
van
Dutch, 1816-1872
RAVENZWAAY or
Ravenswaay, Jan van
Dutch, 1789-1869
RAVERAT, Gwendolen,
(née Darwin)
British, 1885-1957
RAVESCHOT, Jan Gillis
Ferdinand van
Flemish, 17th cent.(?)
RAVESTEYN, Anthony van
Dutch, c.1580-1669
RAVESTEYN, Arnoldus or
Arent van
Dutch, c.1615-1690
RAVESTEYN, Caspar van
see Monogrammist CR
RAVESTEYN, Dirk de
Quade van
Dutch, op.1589-1619
RAVESTEYN, Hendrik van
Dutch, op.1659-m.1670(?)

RAVESTEYN, Hubert van
Dutch, 1638-a.1691
RAVESTEYN, Jan Antonisz.
van
Dutch, c.1570-1657
RAVESTEYN, Nicolaes,
II van
Dutch, 1661-1750
RAVET, Victor
Belgian, 1840-
RAVIER, Auguste
(Francois-Auguste)
French, 1814-1895
RAVILIOUS, Eric
British, 1903-1942
RAWLE, Samuel
British, 1771-1860
RAWLINS, Thomas
British, op.1641
RAWLINS, T.J.
British, op.1837-1840
RAWLINSON, James
British, c.1769-1848
RAWLISON
British, op.c.1630
RAWSTHORNE, Isobel,
(née Lambert)
see Lambert
RAY, Don
American, 19th cent.
RAY, Jean
British, 20th cent.
RAY, Man
American, 1890-
RAYMO, Anne
American, 1939-
RAYMOND, Casimir
French, 1870-
RAYMOND or Reymond,
Julius Poisson
French, c.1678-1779
RAYMOND, Marie
French, 20th cent.
RAYMOND, Mary
British, 20th cent.
RAYMOND, Vincent
French, -1557
RAYNAUD, Fortuné
French, op.1892
RAYNAUD, J.P.
French, 20th cent.
RAYNER, Louise
British, op.1852-1886
RAYNER, Samuel A.
British, op.1821-m.1874(?)
RAYNES, Sidney
American, 1907-
RAYNOLT, Antoine Marie
French, 1874-
RAYNOUARD, J.
French, 1880-
RAYO, Omar
South American, 20th cent.
RAYSKI, Louis Ferdinand
von (Ferdinand)
German, 1806-1890
RAYSSE, Martial
French, 1936-
RAZZALI or Razali,
Sebastiano
Italian, op.c.1571-1602
RE, Antonio de lu
see Giuffre
RE, Vincenzo dal
Italian, op.1737-m.1762

READ, Catherine
British, 1723-1778
READ, David Charles
British, 1790-1851
READ, Captain Edward
Henry Handley
see Handley-Read
READ, F.W.
American, 20th cent.
READ, Samuel
British, c.1816-1883
READ, Thomas Buchanan
American, 1822-1872
READ, William
British, 1607-1679
READ, William
British, op.1778-1808
READE, John R.
British, op.1773-1798
READER, William
British, op.1672-1680
READER, William
see Leader
READING, Burnet
British, op.1776-1822
READMAN, D.
British, op.1815
READY, William James
Durant
British, 1823-1873
REAL, Joël
Spanish, 20th cent.
REAL DEL SARTE, Marie
Magdeleine
French, -1928
REALFONSO, Tommaso
(Masillo)
Italian, 18th cent.
REALIER-DUMAS, Maurice
French, 1860-1928
REAM, Carducius
Plantagenet
American, 1837-1917
REAM, Morston C.
American, 19th cent.
REASON, Cyril
British, 1931-
REATINO
see Gherardi, Antonio
REATTU, Jacques
French, 1760-1833
REAU,
French, 20th cent.
REBECCA, Biagio
Italian, c.1735-1808
REBEL, Eléonore
Sophie
French, 1790-
REBELL, Joseph
German, 1787-1828
REBEYROLLE, Paul
French, 1926-
REBHUHN
see Raphon
REBOIRO, Antonio
Fernandez
Cuban, 20th cent.
REBON, Pierre
see Rabon
REBOUL, Marie Thérèse
see Vien
REBOUR, Francisque
French, 19th cent.
REBOUSSIN, Roger
French, 1881-
RECALCATI, Antonio
Italian, 1938-

RECANATI, Giacomo da
Italian, op.1446
RECCHI, Giovanni
Paolo
Italian, c.1600-1683(?)
RECCO, Giacomo
Italian, 1603-a.1653
RECCO, Giovan Battista
Italian, c.1630-1675
RECCO, Giuseppe
Italian, 1634-1695
RECCO, Nicolà
Italian, 18th cent.
RECCO, Pierre
Dutch, 1765/6-1820
RECHBERG, Arnold
Friedrich Wilhelm
German, 1879-
RECHLIN, Carl
German, c.1804-1882
RECHT, N.
German, op.1824
RECK, Hermine von
German, 1833-1906
RECKELBUS, Lodewijk
(Louis)
Belgian, 1864-1958
RECKNAGEL, Otto
German, 1845-1926
RECLAM, Frédéric or
Friedrich (Jean
Frédéric)
German, 1734-1774
RECLEVA, Mario
Yugoslav, 1930-
REDDOCK, A. of Falkirk
British, -1842
REDER, Reuder, Reuter
or Röder, Christian
(Leandro)
German, 1656-1729
REDER, Cyriakus
see Röder
REDER, Giovanni
German, 1693-p.1760
REDFIELD, Edward Willis
American, 1869-
REDGATE, Arthur W.
British, op.1886-1901
REDGRAVE, Sir Richard
British, 1804-1888
REDI, Tommaso
Italian, 1665-1726
REDIG, Laurent Herman
Belgian, 1822-1861
REDITA, Aniello
Italian, 17th cent.
REDMORE, E.K.
British, 19th cent.
REDMORE, H.
British(?), op.1857
REDON, Georges
French, 1869-1943
REDON, Odilon (Bertrand)
French, 1840-1916
REDONDELA, Agustin
Spanish, 1922-
REDOUTE, Antoine
Ferdinand
Flemish, 1756-1809
REDOUTE, Pierre Joseph
French, 1759-1840
REDPATH, Anne
British, 1895-1965
REDTENBACHER, Rudolf
Swiss, 1840-1885

REDWOOD, Allen C.
American, 19th cent.
REED, Miss
British, 18th cent.
REED, Edward Tennyson
British, 1860-
REED, Joe
British, 20th cent.
REEKERS, Hendrik
Dutch, 1815-1854
REEKERS, Johannes
Dutch, 1790-1858
REENE, Charles
British, 19th cent.
REES, Graham L.
British, 1952-
REES, Lloyd
Australian, 1895-
REES, Ronnie
British, 1945-
REESBROECK or
Rysbroeck, Jacob van
Flemish, 1620-1704
REEUWICH, Reeuwyk,
Reuwich or Rewich,
Erhard
Netherlands,
op.c.1483-1486
REEVE, F.
British, 18th cent.
REEVE, Russel Sidney
British, 1895-
REEVES, Thomas
British, op.c.1820
REEVES, Walter
British, 19th cent.
REFINGER or Reffinger,
Ludwig
German, c.1510/15-1548/9
REGAGNON, Albert
French, 20th cent.
REGAMEY, Frédéric
French, 1849-1925
REGAMEY, Felix Elie
French, 1844-1907
REGAMEY, Guillaume
Urbain
French, 1837-1875
REGEL, Johann Christoph
German, 1713-1770
REGEMORTER, Ignatius
Josephus van
Belgian, 1785-1873
REGEMORTER, Petrus
Johann van
Flemish, 1755-1830
REGENFUS(S), Franz
Michael
German, c.1712-1780
REGGIANINI, Vittorio
Italian, 1858-
REGGIONI, Mauro
Italian, 1897-
REGIO, Paolo de
see Paolo da San
Leocadio
REGIS, Augustin
French, 1813-1880
REGIS, Alexandre
Georges Henri (Henri)
French, 1843-1871
REGNAULT or Renault,
Etienne
French, 1646-1720
REGNAULT, Baron Jean
Baptiste
French, 1754-1829
REGNAULT, Nicolas François
French, 1746-c.1810

REGNAULT, Pieter Willem
Dutch(?), op.1754
REGNAULT-DELALANDE,
François Léandre
French, 1762-1824
REGNESSON, Nicolas
French, 1620-1670
REGNIER, Antony
French, 1835-1909
REGNIER, Auguste
(Jacques Augustin)
French, 1787-1860
REGNIER, Claude
French, op.1840-1866
REGNIER, Jean Marie
French, 1796-1865
REGNIER or Renieri,
Nicolas (Niccolò
Renieri)
French, c.1590-1667
REGO MONTEIRO, Vicente
de
Brazilian, 1899-1970
REGOYOS, Dario de
Spanish, 1857-1913
REGSCHEK, Kurt
Rumanian, 20th cent.
REGTERS, Tibout
Dutch, 1710-1768
REHBENITZ, Theodor
(Markus Theodor)
German, 1791-1861
REHBERG, Caroline
German, 18th cent.
REHBERG, Friedrich
German, 1758-1835
REHM, Fritz
German, 1871-
REHN, Frank Knox
Morton
American, 1848-1914
REHN, Jean (Johan)
Eric
Swedish, 1717-1793
REICH, Adolf
German, 1887-1963
REICH, David
German, 1715-1771
REICH, Karoly
Hungarian, 1922-
REICH, Lucian
German, 1817-1900
REICHARDT, Ferdinand
Danish, 1819-1895
REICHEK, Jesse
American, 1916-
REICHEL, August
Friedrich
German, 1784-1840
REICHEL, Franz de
Paula von
German, -1804
REICHEL, Hans
German, 1892-1958
REICHENBACH, Ludowike
see Simanowitz
REICHENBACH, Woldemar
Graf von
German, 1846-1914
REICHENCKER, Ulrich
German, op.1410
REICHER, F.C.
German, op.1701
REICHERT, Carl
German, 1836-1918
REICHLICH, Marx
German, op.1494-1508

REICHMANN, Franz
German, 1868-
REICHMANN, Georg
Friedrich
German, 1798-1853
REICH-MUNSTERBERG,
Eugen
German, 1866-
REICHSTADT, duc de
see Bonaparte
REICREM
see Mercier, Philippe
le
REID, Alexander
British, 1747-1823
REID, Alexander
British, 1893-
REID, Flora M.
British, op.1879-1903
REID, Sir George
British, 1841-1913
REID, George Agnew
Canadian, 1860-1947
REID, George Ogilvy
British, 1851-1928
REID, James
British, op.1859
REID, John Robertson
British, 1851-1926
REID, Robert
American, 1862-1929
REID, Samuel
British, 1854-1919
REID, Stephen
British, 1873-1948
REIFFENSTEIN, Reifenstein
or Reiffstein, Johann
Friedrich
German, 1719-1793
REIFFENSTUEL,
Reifenstuhl, Reyffenstol
or die Stol in Ripa,
Gregor I
German, op.1587
REIGMORLER
Dutch, 18th cent.
REILLY, Michael Leeds-
Paine
British, 1898-
REIMER, Georg
German, 1828-1866
REIMERS, Peter
Norwegian, op.1590-1628
REINA or Reyna,
Francisco de
Spanish, op.1645-m.1659
REINAGLE, George Philip
British, c.1802-1835
REINAGLE, Hugh
American, 1790-1834
REINAGLE, Philip
British, 1749-1833
REINAGLE, Ramsay Richard
British, 1775-1862
REINER or Rainer,
Vaclav Vavrinec, or
Wenzel Lorenz
German, 1689-1743
REINERMANN, Friedrich
Christian
German, 1764-1835
REINERS, Jacob
German, 1828-1907
REINGANUM, Victor
British, 1907-
REINHARD, Andreas, II
Danish, 1715-1752

REINHARDT, A.
German, 19th cent.
REINHARDT, Adolph
Frederick
American, 1913-
REINHARDT, Carl August
German, 1818-1877
REINHARDT, Johann
Jakob
German, 1835-
REINHARDT, Louis
German, -1870
REINHARDT, Sebastian
Carl Christian
(Carl)
German, 1733-1827
REINHARDT, Siegfried
American, 1925-
REINHARDT, Wilhelm
German, 1815-1881
REINHART, Benjamin
Franklin
American, 1829-1885
REINHART, Heinrich
German, 1790-1840
REINHART, Johann
Christian
German, 1761-1847
REINHART or Reinhardt,
Joseph
Swiss, 1749-1829
REINHARDT, Louis
German, 1790-1858
REINHART, Paulus
German, op.1573
REINHEIMER, Johann
Georg
German, 1777-1820
REINHEIMER, Ursula
Magdalena
see Prestel
REINHOLD, Bernhard
German, 1824-1892
REINHOLD, Franz
German, 1816-1893
REINHOLD, Friedrich
German, 1814-1881
REINHOLD, Friedrich
Philipp
German, 1779-1840
REINHOLD, Gustav
German, 1798-1849
REINHOLD, Heinrich
German, 1788-1825
REINHOLD, Johann
Friedrich Laberecht
German, 1744-1807
REINICKE, Pancratius
German(?), op.1608
REINICKE, René
German, 1860-1926
REINIGER, Ernst Otto
German, 1841-1873
REINWALD, Christophine,
(née Schiller)
German, 1757-1847
REISCHAT, van
Dutch(?), op.1742
REISER, Carl
German, 1877-1950
REISER, Leopold
German, 19th cent.
REISER, R.
Dutch(?), op.1735
REISERER, Lal
German, 20th cent.

REISSMANN, Karoly
Miksa
Hungarian, 1856-1917
REISTHALL
German, 18th cent.(?)
REISZ, Hermann
Hungarian, op.1890
REITER, Bartholomäus
German, op.1583-1622
REITER, Joachim
see Reuter
REITER, Johann Baptist
German, 1813-1890
REITH, Raith or Reidt,
Ambrosius
German, op.1726-1729
REIXARCH, Reixat,
Reixats or Reixet,
Juan
see Rexach
REJCHAN, Stanislaw
Polish, 1858-1919
REKTORZIK, Franz
Xaver
Czech, 1793-1851
RELOGIO, Francisco
Portuguese, 1926-
REM or Rems, Caspar
Flemish, c.1542-c.1615/17
REMB, Franz Carl
see Remp
REMBOWSKI, Jan
Polish, 1879-1923
REMBRANDT Harmensz.
van Rijn or Rhijn
Dutch, 1606-1669
REMDE, Friedrich
German, 1801-1878
REMEEUS, David
Flemish, 1559-1626
REMEEUS, Gillis
Flemish, op.1644-1674(?)
REMENICK, Seymour
American, 1923-
REMFRY, David
British, 1942-
REMICK, Christian
American, 1726-p.1769
REMINGTON, II
British, 19th cent.
REMINGTON, Deborah
American, 20th cent.
REMINGTON, Frederic
American, 1861-1909
REMISOFF, Nicolay
Russian, 20th cent.
REMMERS or Remme,
Abraham
Dutch, op.1655
REDMOND, Charles (Jean
Charles Joseph)
French, 1795-1875
REMP, Remb or Rempp,
Franz Carl
German, c.1675-1718
REMY, Alexandre
French, op.1808-1812
REMY, Carl Heinrich
Friedrich Emil August
(August)
German, 1800-1872
RENALDI, Francesco
Italian, op.1777-1798
RENALDICTUS de Spoleto
see Rainaldo di Ranuccio

RENAN, Ary Cornélis
French, 1858-1900
RENARD, Emile
French, 1850-1930
RENARD, Fredericus
Theodorus
Dutch, 1778-
RENARD, or Reynard,
Nicolas
French, 1654-c.1720
RENARD de Saint-André,
Simon
French, c.1613-1677
RENAUD, Paul Louis
French, 19th cent.
RENAUDIN, Alfred
French, 1866-p.1908
RENAUDOT, Paul
French, 1871-1920
RENDON, Manuel
Ecuador, 1894-
RENDU, Etienne
French, op.1647-1670
RENE or Renatus I,
Duke of Anjou and
Provence, King of
Naples (Le Bon)
French, 1409-1480
RENEAULME, Paul
French, 1560-1624
RENEFER, Jean Constant
Raymond (Raymond)
French, 1879-1957
RENEMAN, I.
Dutch(?), op.1772
RENESSE, Constantijn
Daniel à or. van
Dutch, 1626-1680
RENI, Guido (Il Guido
or Le Guide)
Italian, 1575-1642
RENIER, Nicolas
see Regnier
RENI-MEL, Léon
French, 1893-
RENIS, Joseph
Belgian, 20th cent.
RENKEWITZ, Theodor
Swiss, 1833-1913
RENNELL, Mary
British, 20th cent.
RENNELL, Thomas
see Reynell
RENNER, Narziss
German, c.1502-p.1535
RENNIE, John
British, 1761-1821
RENOIR, Pierre Auguste
French, 1841-1919
RENORCARD, P.
French, op.1877
RENOU, Antoine
French, 1731-1806
RENOUARD, Baron
French, 1918-
RENOUARD, Charles Paul
(Paul)
French, 1845-1924
RENOUF, Emile
French, 1845-1894
RENOUX, Charles Caius
French, 1795-1846
RENOUX, Ernest
French, 1863-1932
RENQUIST, Torsten
Scandinavian, 20th cent.

RENSHAW, A.
British, 19th cent.
RENTINCK, Johannes
Dutch, c.1798-1846
RENTON, John
British, op.1799-1841
RENTY, Yann de
French, 20th cent.
RENTZ or Renz,
Michael Heinrich
German, 1701-1758
RENTZELL, August von
German, 1810-1891
RENWICK, James
American, 1818-1895
REPIN, Ilja
Jefimowitsch
see Rjepin
REPPEN, Jack
Canadian, 20th cent.
REPTON, George Stanley
British, -1858
REPTON, Humphrey
British, 1752-1818
REPTON, John Adey
British, 1775-1860
REQUENA, Gaspar
Spanish, op.1540-1583
REQUICHOT, Bernard
French, 1928-1961
RESANI, Arcangelo
Italian, 1670-1740
RESCH, Ernst
German, 1807-1864
RESCHI or Resch,
Pandolfo
German, 1643-1699
RESIKA, Paul
American, 20th cent.
RESLFELD, Reselfeld,
Resfeld or Rösslfeltd,
Johann Carl von
German, 1658-1735
RESNICK, Milton
American, 1917-
RESSANO
French(?), op.1811
RESSLER, Michael
see Röszler
RESSU, Camil
Rumanian, 1880
RESTALLINO, Carlo
Italian, 1776-1864
RESTOUT, Eustache
French, 1655-1743
RESTOUT, Jean, II
French, 1692-1768
RESTOUT, Jean Bernard
French, 1732-1797
RESTOUT, Marc Antoine
French, 1616-1684
RETH, Alfred
French, 1886-1966
RETHEL, Alfred
German, 1816-1859
RETHEL, Otto
German, 1822-1892
RETI, Istvan
Hungarian, 1872-1945
RETZSCH, Moritz
(Friedrich August
Moritz)
German, 1779-1857
REULING, Johann Nepomuk
German, op.1742-1759
REUMONTE, Anton
Dutch, c.1741-p.1778

REUS, Johann Georg
German, 1730-c.1810
REUSCH, Erich
German, 1925-
REUSS, Albert
German, 1926-
REUTER, Friedrich
Wilhelm (Wilhelm)
German, 1768-1834
REUTER, Georg
German, 19th cent.
REUTER, Reiter, Reitter
or Reutter, Joachim
German, op.1610-1630
REUTERN, Gerhard Wilhelm
von
Russian, 1794-1865
REUTERSWALD, Carl
Fredrik
Swedish, 20th cent.
REUVEN, Pieter van
see Ruijven
REUWICH, Erhard
see Reeuwich
REVEL, Gabriel
French, 1642-1712
REVELEY, William
(Willey)
British, op.1781-m.1799
REVELLY, Honoré
French, op.1748-1777
REVERDIN, François
Gédéon
Swiss, 1772-1828
REVERDY, Georges
French, op.1531-1564/70
REVERE, Paul
American, 1735-1818
REVETT, J.
British, 19th cent.
REVOIL, Pierre Henri
French, 1776-1842
REVOLD, Axel
Norwegian, 1887-
REVOLG
French, 20th cent.
REWICH, Erhard
see Reeuwich
REX, Oskar
German, 1857-
REXACH, Rexarch, Reixach,
Reixarch, Reixet, Reixat
or Reixats, Juan, II
Spanish, op.1437/9-1484
REXACH, Reixach or Rexat,
Pedro
Spanish, op.1471
REY, Adolphe Augustin
(Augustin)
French, 1864-
REY, Miguel del
Spanish, 14th cent.
REY, Philippe
French, op.1785
REYGER, Jacob de
Dutch, -a.1646
REYMERSWAELE, Marinus
Claesz. van
see Marinus
REYMOND, Carlos
French, 1884-
REYMOND, Julius Poisson
see Raymond
REYN, Jan van
(de)
see Rijn

REYNA, Antonio
Spanish, 19th cent.
REYNEK, Bohuslav
French, 1892-
REYNELL or Rennell,
Thomas
British, 1718-1788
REYNENBURG, Nicolaas
see Rijnenburg
REYNERS, T.
British(?), op.1759
REYNOLDS, Alan
British, 1926-
REYNOLDS, Frances
British, 1729-1807
REYNOLDS, Frank
British, 1876-1953
REYNOLDS, Frederick
George
British, c.1828-1921
REYNOLDS, Sir Joshua
British, 1723-1792
REYNOLDS, Samuel William,
I
British, 1773-1835
REYNOLDS, Samuel William,
II
British, 1794-1872
REYNOLDS, Wade
American, 20th cent.
REYNOLDS, Walter
British, op.1859-1885
REYNOLDS, Warwick
British, 1880-1926
REYNOLDS-STEPHENS, Sir
William
British, 1862-1943
REIJNTJENS or Reyntjens,
Henricus Engelbertus
Dutch, 1817-1900
REYSET, W.
German, 17th cent.
REYSSCHOOT, Petrus
Johannes van (de
Engelschman)
Flemish, 1702-1772
REYSSCHOOT, Petrus
Norbertus van
Flemish, 1738-1795
RHEAD, George
Woolliscroft
British, 1855-1920
RHEAD, Louis John
British, 1857-
RHEAM, Henry Meynell
British, 1859-1920
RHEIN, Friedrich
(Fritz)
German, 1873-1948
RHEINER, Louis
Swiss, 1868-1924
RHEINFELDER (Rheinfelder-
Anspach), Friedrich G.
German, 1838-1903
RHO, Manlio
Italian, 1901-1957
RHODEN
see Rohden
RHODES, John N.
British, 1809-1842
RHODES, Joseph
British, 1782-1854
RHOMBERG, Hanno
German, 1820-1869
RHOMBERG, Joseph
Anton
German, 1786-1855

RHIJN, Rembrandt
Harmensz. van
see Rembrandt
RHIJN, Titus Rembrandtsz.
van
see Rijn
RHYS, Oliver
British, op.1876-1893
RIALI, Giambattista
see Riari
RIARI, Riario or Riali,
Giambattista
Italian, 1605-1671
RIBALTA, Enrique
Spanish, 16th cent.
RIBALTA, Francisco
Spanish, 1565-1628
RIBALTA, Juan de
Spanish, 1596-1628
RIBARZ, Rudolf
German, 1848-1904
RIBAULT, Julie
French, op.1810-1826
RIBBING, Sofia Amalia
Swedish, 1835-1894
RIBBLESDALE, Thomas
Lord
British, 1752-1826
RIBEIRO, João, Baptista
Portuguese, 1790-1868
RIBEIRO, Norberto José
Portuguese, c.1774-1844
RIBELLES or Rivells y
Helip, José
Spanish, 1778-1835
RIBERA y Fernandez,
Juan Antonio
Spanish, 1779-1860
RIBERA y Fieve,
Carlos Luis
Spanish, 1815-1891
RIBERA, Juan Vicente
de
Spanish, op.1703-1725
RIBERA, Jusepe, Giuseppe
or José (Lo
Spagnoletto)
Spanish, c.1590-1652
RIBERA, Pedro
Spanish, 1867-1932(?)
RIBOT, Augustin Théodule
French, 1823-1891
RIBOT, Germain Théodore
French, -1893
RIBOU
French, op.1775-1776
RICARD, Louis Gustave
(Gustave)
French, 1823-1873
RICARD, René
French, 1889-
RICARDI, Ernesto
Italian, 19th cent.
RICCA, Bernardino
(Ricco)
Italian, c.1450-p.1521
RICCARDI, Luigi
Italian, 1808-1877
RICCHI or Righi, Pietro
(Il Lucchese)
Italian, 1605-1675
RICCHINO or Richino,
Francesco
Italian, c.1518-p.1570

RICCI or Rizi, Antonio
(da Viti)
Italian, op.1585-m.1631
RICCI, Archita
Italian, op.1599-1622
RICCI, Arturo
Italian, 1854-
RICCI, Carlo
Italian, op.c.1700
RICCI, Rici or Rizi,
Francisco
Spanish, 1608-1685
RICCI, Rici or Rizi,
Fray Juan Andrés
Spanish, 1600-1681
RICCI, Giovanni Battista
Italian, 1537-1627
RICCI, Luigi
Italian, 1823-1896
RICCI, Rizzi or Rizi,
Marco or Marchetto
Italian, 1676-1729
RICCI, Paolo
Italian, 1908-
RICCI, Pio
Italian, -m.1919
RICCI or Rizzi,
Sebastiano
Italian, 1659-1734
RICCI, Ubaldo
Italian, op.c.1650
RICCIARDELLI, Gabriele
Italian, op.1741-1777
RICCIARDI, Oscar
Italian, 1864-
RICCIARELLI, Daniele
see Daniele da
Volterra
RICCIO, Antonello
Italian, 16th cent.
RICCIO or Rizzio,
David
Italian, 1533(?)-1566
RICCIO da Siena
see Neroni, Bartolommeo
RICCIOLINI, Michelangelo
(Michelangelo da Todi)
Italian, 1654-1715
RICCO, Bernardino
see Ricca
RICE, Anne Estelle
American, 1879-1959
RICE, Dan
American, 1926-
RICE, Henry
British, 1788-p.1833
RICE of Hartford,
William
American, op.1844
RICE, William S.
American, 1873-
RICH, Alfred William
British, 1856-1921
RICH, F.A.
British, 20th cent.
RICH, Garry
American, 1943-
RICH, William George
British, op.c.1876-1897
RICHARD
French, 18th cent.
RICHARD, Alexandre Louis
Marie Théodore
(Théodore)
French, 1782-1859

RICHARD, Fleury-
Francois
French, 1777-1852
RICHARD, Victor Lucien
French, 1848-
RICHARD-CAVARO, Charles
Adolphe
French, 1819-p.1880
RICHARDS, Albert
British, 1919-1945
RICHARDS, B.(?)
British, op.c.1766
RICHARDS, Ceri
British, 1903-1971
RICHARDS, Edward
British, 18th cent.
RICHARDS, Emma
Gaggiotti
see Gaggiotti-Richards
RICHARDS, Frances
British, 1903-
RICHARDS, G.
British, op.1769
RICHARDS, John
American, 1831-1889
RICHARDS, John Inigo
British, op.1753-m.1810
RICHARDS, L.
British, 19th cent.
RICHARDS, Lee Greene
American, 1878-
RICHARDS, Richard Peter
British, 1840-1877
RICHARDS, Thomas Addison
American, 1820-1900
RICHARDS, William
American, 18th cent.
RICHARDS, William Trost
American, 1833-1905
RICHARDSON, Arthur
British, 1865-1928
RICHARDSON, Charles
British, op.1855-1901
RICHARDSON, Charles James
British, 1806-1871
RICHARDSON, Constance
Coleman
American, 1905-
RICHARDSON, Daniel
British, op.1783-1830
RICHARDSON, Edward
British, op.1856-m.1874/75
RICHARDSON, F.Stuart
British, op.1894
RICHARDSON, George
British, 1736(?)-1817
RICHARDSON, George
British, 1808-1840
RICHARDSON, Henry Burdon
British, op.1828-1872
RICHARDSON, J.M.Jnr.
British, 19th cent.
RICHARDSON, Jonathan
British, 1665-1745
RICHARDSON, Jonathan, II
British, 1694-1771
RICHARDSON, R.J.
British, 20th cent.
RICHARDSON, Thomas
Miles, I
British, 1784-1848
RICHARDSON, Thomas
Miles, II
British, 1813-1890
RICHARDSON, William
British, op.1842-1877

RICHARDSON-JONES,
Keith
British, 1925-
RICHARDT, Ferdinand
Danish, 1819-1895
RICHART, E.
German, op.1719
RICHART, F. de la Mare
see La Mare-Richart
RICHE, Adèle
French, 1791-1878
RICHEMONT, Alfred
Paul Marie, Vicomte
de
French, 1857-1911
RICHENBURG, Robert
American, 1917-
RICHER, N.
French, 17th cent.
RICHET, Léon
French, 1847-1907
RICHIER, Germaine
French, 1904-1959
RICHIR, Herman Jean
Joseph
Belgian, 1866-
RICHMOND, George
British, 1809-1896
RICHMOND, James Crowe
New Zealand, 1822-1898
RICHMOND, Leonard
British, op.c.1912-40
RICHMOND, Thomas, I
British, 1771-1837
RICHMOND, Thomas, II
British, 1802-1874
RICHMOND, W.
British, 1815-1878
RICHMOND, Sir William
Blake
British, 1842-1921
RICHOMME, Jules
French, 1818-1902
RICHTER, Adolf
German, 1812-1852
RICHTER, Adrian Ludwig
(Ludwig)
German, 1803-1884
RICHTER, Albert
German, 1845-1898
RICHTER, Alice
Martinez
French, 20th cent.
RICHTER, Anton
German, 1781-1850
RICHTER, August
German, 1801-1873
RICHTER, Carl August
German, 1770-1848
RICHTER, Christian, I
German, op.1612-m.1667
RICHTER, Christian
Swedish, 1678-1732
RICHTER, David, I
Swedish, 1662-1735
RICHTER, Donner von
German, 19th cent.
RICHTER, Edouard
Frédéric Wilhelm
French, 1844-1913
RICHTER, Franz
German, 1774-1863
RICHTER, Franz Ferdinand
(Ferdinand)
German, 1693-

RICHTER, Gerd
German, 1903-
RICHTER, Gerhard
German, 1932-
RICHTER, Gottfried
German, 1904-
RICHTER, Gustav Carl
Ludwig
German, 1823-1884
RICHTER, Hans
German, op.1597
RICHTER, Hans
German, 1888-
RICHTER, Hans Theo
German, 1902-1969
RICHTER, Heinrich
German, 1920-
RICHTER, Henry James
British, 1772-1857
RICHTER, Herbert Davis
British, 1874-1955
RICHTER, Jean Louis
Swiss, 1766-1841
RICHTER, Johan, Giovanni
or Jean
Swedish, 1665-1745
RICHTER, Johann Carl
August
German, 1785-1853
RICHTER, Johann
Heinrich
German, 1803-1845
RICHTER, Johann Salomo
German, 1761-1798/1802
RICHTER, Joseph
German, 1780-1837
RICHTER, Klaus
German, 1887-1948
RICHTER, L.
Swiss, 19th cent.
RICHTER, Roman
German, op.c.1630
RICHTER, Wilhelm
German, 1824-1892
RICHTER, Willibald
German, op.1824-m.1880
RICHTERICH, Marco
Swiss, 1929-
RICHTERS, Marius
Johannes
Dutch, 1878-1955
RICHTIE, Ross
New Zealander, 1941-
RICI
see Ricci
RICKARDS, T.
British, 18th cent.
RICKELLS, C.R.
British, op.1876
RICKERE, B.
Spanish, 18th cent.
RICKETTS, Charles
British, 1866-1931
RICKETTS, Charles R.
British, 19th cent.
RICKLUND, Folke
Swedish, 1900-
RICKMAN, Philip
British, op.c.1936
RICO de Candia
see Andreas Rico
RICO Ortega, Martin
Spanish, 1833-1908
RICOIS, Francois Edmé
French, 1795-1881

RICQUIER, Lodewijk
or Louis
see Riquier
RIDAURA, Augustin
Spanish, op.1619-1634
RIDDELL, R.A.
British, 19th cent.
RIDDER, Abraham de
Dutch, op.c.1690
RIDDERBOSCH, Bernard
Auguste
Flemish, 18th cent.
RIDDERBOSCH, Jeanne
Françoise (Jeanne
Françoise De Metz)
Flemish, 1754-1837
RIDEOUT, Philip H.
British, op.c.1880-1900
RIDER, T.
Australian, op.c.1850
RIDER, William
British, op.1824-1842
RIDGEWELL, John
British, 1937-
RIDINGER, Johann Elias
German, 1698-1767
RIDINGER, Martin Elias
German, c.1730-1780
RIDLEY, Matthew White
British, 1837-1888
RIDLEY, William
British, 1764-1838
RIDOLFI, Carlo
Italian, 1594-1658
RIDOLFI, Claudio
Italian, c.1570-1644
RIECK, E.
German, op.c.1832-1858
RIEDEL, H.
German, 19th cent.
RIEDEL, Heinrich
Carl, II
German, 1756-p.1820
RIEDEL, Johann
Friedrich Ludwig
Heinrich August (August)
German, 1799-1883
RIEDER, Georg, I
German, op.1550-m.1564
RIEDER, Georg, II
German, op.1564-m.1575
RIEDER, Wilhelm August
German, 1796-1880
RIEDER, William
see Reader
RIEDLER, L.
German, 19th cent.
RIEDT, Niklaus von
German, op.1585-1616
RIEFFENSTUHL, Anton
German, 19th cent.
RIEFSTAHL, Wilhelm
Ludwig Friedrich
German, 1827-1888
RIEG, Baron de
French(?), op.c.1790
RIEG, M.
see Rigg, Mary Ann
RIEGEN, Nicolass
Dutch, 1827-1889
RIEGER, Albert
German, 1834-1905
RIEHL, Ruhl or Rul,
Andreas, I
German, op.1542-m.1567

RIEHL, Riel, Rihel,
Rihl, Rühl, Ruhl or
Ryll, Andreas, II
German, c.1551-1613
RIEMENSCHNEIDER, Tilman
German, c.1460-1531
RIENKSZ, Johannes
Jelgerhuis
see Jelgerhuis
RIEP, Balthasar
see Riepp
RIEPENHAUSEN, Ernst
Ludwig
German, 1765-1840
RIEPENHAUSEN, Franz
(Friedrich)
German, 1786-1831
RIEPENHAUSEN, Johann
(Christian)
German, 1788/9-1860
RIEPER, August
German, 1865-
RIEPP, Johann Balthasar
(Balthasar)
German, 1703-1764
RIERA, Amelia
Spanish, 1934-
RIES or Riese, Johann
Helfrich
German, 1656-p.1711
RIES or Riess, Paul
German, 1857-1933
RIESE, Johann Helfrich
see Ries
RIESENBERGER, Johann
Moritz
German, 1673/7-1740
RIESENER, Henri Francois
French, 1767-1828
RIESENER, Louis Antoine
Léon (Léon)
French, 1808-1878
RIET, Will. van
Belgian, 20th cent.
RIETER, Heinrich
Swiss, 1751-1818
RIETH, Paul
German, 1871-1925
RIETSCHOOF, Hendrik
Dutch, 1687-1746
RIETSCHOOF, Jan Claesz
Dutch, 1652-1719
RIETTI, Arturo
Italian, 1863-1942
RIETWIJK, Cornelis Dame
see Dame
RIGAL, J.
German, 19th cent.
RIGAUD, Denise
French, 19th cent.
RIGAUD, Rigault or
Rigau y Ros, Hyacinthe
François Honoré Mathias
Pierre André Jean
French, 1659-1743
RIGAUD, Jacques (not
Jean or Jean-Baptiste)
French, c.1681-p.1753
RIGAUD, John Francis
French, 1742-1810
RIGAUD, Pierre Gaston
French, 1874-
RIGAUD, Stephen Francis
Dutilh
British, 1777-1861

RIGBY, Cuthbert
British, 1850-1935
RIGEAUD, Pauline
French(?), 18th cent.
RIGER, W.
German, op.1668
RIGG, Ernest Higgs
British, op.c.1910-1930
RIGG, Mary Ann
(Mrs. Edmund Scott)
British, op.1777-1785
RIGHETTI or Rigetti,
Mario
Italian, op.c.1618
RIGHI, Pietro
see Ricchi
RIGHINI, Pietro
Italian, 1683-1742
RIGHINI, Sigismund
German, 1870-1937
RIGHTMYER, Levi
American, 19th cent.
RIGO, Jules Alfred
Vincent
French, 1810-1892
RIGOLOT, Albert
Gabriel
French, 1862-1932
RIKET, Léon
Belgian, 1876-1938
RIKKERS, Willem
Dutch, 1812-1873
RILETTE
British, 20th cent.
RILEY, Bernard
American, 20th cent.
RILEY, Bridget
British, 1931-
RILEY, Charles Reuben
see Ryley
RILEY or Ryley, John
British, 1646-1691
RILEY, Thomas
British, op.1880-92
RILKE, Reiner
German, 20th cent.
RILLAER or Rillaert,
Jan, I van
Netherlands,
op.1518-m.1568
RILLAER or Rillaert,
Jan, II van
Netherlands, c.1547-1592
RIMBERT, René
French, 1896-
RIMER, William
British, op.1845-1888
RIMINALDI, Orazio
Italian, 1586-1630/1
RIMINESE SCHOOL,
Anonymous Painters
of the
RIMINGTON, Alexander
Wallace
British, 1854-1918
RIMMER, William
American, 1816-1879
RIMPACTA
see Antonio da Bologna
RINALDI, M.
Italian, 20th cent.
RINALDI, Pellegrino
Danti de'
see Danti, Egnazio
RINALDI, Rinaldo
Italian, 1793-1873

RINALDO, Mantovano
Italian, op.1528-p.1564
RINCKLAKE, Johann
Christoph
German, 1764-1813
RINCON, Abundio
Mexican, op.1853
RINCON del Figueroa,
Fernando del (not
Antonio del Rincón)
Spanish, op.1491-1518
RINCON, S.M. del
Spanish, op.c.1877
RINDISBACHER, Peter
American, 1806-1834
RINEHART, Captain Levi
American, op.c.1862
RING or Rink, Hermann
tom
German, 1521-1596
RING, Laurits Andersen
(Lars)
Danish, 1854-1933
RING, Ludger, I tom
German, 1496-1547
RING, Ludger, II tom
German, 1522-1584
RING, Nikolaus tom
German, 1564-1622
RING, Ringh or Ryng,
Pieter de
Dutch, 1615-1660
RING, Thomas
German, 1892-
RINGEISEN, J.
German, 19th cent.
RINGEL, d'Illzach
Jean Desire
French, 1847-1916
RINGELHAN, Antoin
French, op.1786
RINGELING, Hendrik
Dutch, 1812-1874
RINGELNATZ, Joachim
(Hans Bötticher)
German, 1883-1934
RINGGLI, Ringli or
Ringly, Gotthard
Swiss, 1575-1635
RINGH, Pieter de
see Ring
RINGLER, Ludwig
Swiss, c.1535-1605
RINK, J.J.
Netherlands, op.1793
RINK, Paulus Philippus
(Paul)
Dutch, 1861-1903
RINKE, Claus
German, 20th cent.
RINSEMA, Thijs
Dutch, 1877-1947
RINTOUL, William
British, op.1791
RIOPELLE, Jean-Paul
Canadian, 1923-
RIOS y Losada, Don
José Maria Rodriguez
de
Spanish, 1826-1896
RIOS, Luigi da
Italian, 1844-1892
RIOS, Ricardo de los
Spanish, 1846-1929
RIOU, Edouard
French, 1833-1900

RIOULT, Louis Edouard
French, 1790-1855
RIP
French(?), 20th cent.
RIP, Willem Cornelis
Dutch, 1856-1922
RIPANDA or Ripranda,
Jacopo (Jacopo da
Bologna)
Italian, op.c.1490-1530
RIPLEY, Aiden
Lassell
American, 1896-
RIPOSO, Il
see Ficherelli,
Felice
RIPPINGILLE, Edward
Villiers
British, 1798-1859
RIPPL-RONAI, Jozsef
Hungarian, 1861-1927
RIQUARD
French, op.c.1721-1739
RIQUER é Inglada,
Alejandro
Spanish, 1856-1920
RIQUET, Gustave D.
French, 19th cent.
RIQUIER or Ricquier,
Lodewijk or Louis
Belgian, 1792-1884
RISBECK, Philip E.
American, 20th cent.
RISCHANEK, Werner
German, 1943-
RISCHER, Johann Jacob
German, 1662-1755
RISING, John
British, op.1756-1815
RISLER, Auguste Charles
French, 1819-1899
RISS, Thomas
German, 1871-1959
RISSANEN, Juho Vilho
Finnish, 1873-1950
RIST, Alix
French, 20th cent.
RISTIC, Marko
Yugoslav, 1902-
RISUENO, José
Spanish, 1667-1721
RISUTI, Filippo
see Rusuti
RITCHIE, John
British, op.1858-1875
RITMAN, Louis
American, 1889-1963
RITOIRE, E.
French, op.c.1880
RITSCHEL, Wilhelm
(William)
American, 1864-1949
RITSCHL, Eduard
Czech, 1822-1906
RITSCHL, Otto
German, 1885-
RITT, Augustin
Russian, 1765-1799
RITTER, Caspar
German, 1861-1923
RITTER, Christoph, III
German, 1610-1676
RITTER, Edouard
German, 1808-1853
RITTER, Georg
German, 17th cent.

RITTER, George
Nikolaus
German, 1748-1809
RITTER, Johann Baptist
German, 20th cent.
RITTER, Louise
Charlotte
see Neufville
RITTER, Paul, I
German, 1829-1907
RITTER, Wilhelm Georg
German, 1850-1926
RITTIG, Peter
German, 1789-1840
RITTS, Valentine
see Ritz
RITZ, Thomas
German(?), 18th cent.
RITZ or Ritts,
Valentine
British, c.1695-1745
RITZART, Johann Anton
German, op.1723
RITZBERGER, Albert
German, 1853-1915
RIUS, Juan
Spanish, 15th cent.
RIUZUTI, Filippo
see Rusuti
RIVA, Gabriel
Italian, op.1945
RIVA, Nicolas Louis
Albert della
see Delerive
RIVAL, André
Swiss, 1802-1825
RIVALZ, Rivals or
Rivaltz, Antoine
French, 1667-1735
RIVALZ, Rivals or
Rivaltz, Jean Pierre, I
French, 1625-1706
RIVE, Pierre Louis
de la
see La Rive
RIVELLI, Cristoforo
see Moretti
RIVELLO, Giuseppe
Italian, op.1544
RIVERA, Diego
Mexican, 1886-1957
RIVERA, Manuel
Spanish, 1927-
RIVERO, José
Spanish, op.1805-1815
RIVERS, C.
British, op.1799-1804
RIVERS, Larry
American, 1923-
RIVERS, Leopold
British, 1852-1905
RIVIER, Louis
Swiss, 1885-
RIVIERE
French, op.c.1782-1799
RIVIERE, Mlle.
French, 19th cent.
RIVIERE, Briton
British, 1840-1920
RIVIERE, Charles
French, 1848-1920
RIVIERE, Charles Dagnac
French, 1864-1945
RIVIERE, F.
French(?), 18th cent.
RIVIERE, Henri
French, 1864-1951

RIVIERE, Henry Parsons
British, 1811-1888
RIVIERE, Hugh Goldwin
British, 1869-1956
RIVIERE, R.P.
French, op.1896
RIVIERE, William
British, 1806-1876
RIVOLA, Giuseppe
Italian, op.1736-m.1740
RIX, Julian Walbridge
American, 1851-1903
RIXENS, Jean André
French, 1846-1924
RIZI
see Ricci
RIZO, Francesco
see Santa Croce
RIZUTI, Filippo
see Rusuti
RIZZI
Italian(?), op.1860
RIZZI, Antonio
Italian, 1869-1941
RIZZINI, Alexandre
Italian, 19th cent.(?)
RIZZIO, David
see Riccio
RIZZO, Andrea
see Andreas
RIZZONI, Alexander
Antonovich
Russian, 1836-1902
RJEPIN or Repine,
Ilja Jefimowitsch
Russian, 1844-1930
ROATA, T.
Roumanian, 20th cent.
ROBART, R.G.
British, op.1757-1767
ROBAUDI, Alcide
Théophile
French, op.1874-1884
ROBAUT, Alfred Ernest
French, 1830-1909
ROBB, Brian
British, 1913-
ROBB, William George
British, 1872-1940
ROBBE, Henri
Belgian, 1807-1899
ROBBE, Louis Marie
Dominique Romain
Belgian, 1806-1887
ROBBE, Manuel
French, 1872-
ROBBEL, Kurt
German, 1909-
ROBBESANT
see Ryckz, Lambert
ROBBIA, Andrea della
Italian, 1435-1525
ROBBIA, Luca di Simone
di Marco della
Italian, 1400-1482
ROBBIA, Mattia della
Italian, op.1522-1524
ROBBINS, Raisa
American, 20th cent.
ROBELLAZ, Emile
Swiss, 1844-1882
ROBERT, Alexandre
Nestor Nicolas
Belgian, 1817-1890
ROBERT, Aurèle
Swiss, 1805-1871
ROBERT, Fanny
French, 1795-1872

ROBERT, Hubert
French, 1733-1808
ROBERT, Jean
French, op.1746-1782
ROBERT, Leo Paul
Samuel (Paul)
Swiss, 1851-1923
ROBERT, Louis Léopold
(Léopold)
Swiss, 1794-1835
ROBERT, Nicolas
French, 1614-1685
ROBERT, Paul Ponce
Antoine (Robert de
Séri)
French, 1686-1733
ROBERT, Paul Théophile
(Théophile)
Swiss, 1879-1953
ROBERT
see Ruprecht
ROBERT-FLEURY, Joseph
Nicolas
French, 1797-1890
ROBERT-FLEURY, Tony
French, 1837-1911
ROBERTI, Pierre
Albert (Albert)
Belgian, 1811-1864
ROBERTI or Ruberti,
Domenico
Italian, c.1642-1707
ROBERTI, Ercole de'
Italian, a.1456(?)-1496
ROBERTI, M.
Italian, 19th cent.
ROBERTI, Roberto
Italian, 1786-1837
ROBERTI, Roberto
Italian, 1942-
ROBERTS, Arthur Henry
British, 1819-1900
ROBERTS, Bishop
American, op.1735-m.1739
ROBERTS, David
British, 1796-1864
ROBERTS, Captain David
British, 18th cent.
ROBERTS, Donald
British, 1923-
ROBERTS, Doreen
British, 20th cent.
ROBERTS, Edward John
British, 1793-1865
ROBERTS, Edwin
British, op.1862-1886
ROBERTS, Ellis William
British, 1860-1930
ROBERTS, G.R.
British, op.1843-1853
ROBERTS, Goodridge
Canadian, 1904-
ROBERTS, Henry
British, c.1710-a.1790
ROBERTS, Henry Benjamin
British, 1831-1915
ROBERTS, James, I
British, 1725-1799
ROBERTS, James, II
British, op.1766-1809
ROBERTS, James
British, op.1824-1846
ROBERTS, Priscilla
American, 1916-
ROBERTS, Thomas
British, c.1749-1778
ROBERTS, Thomas Edward
British, 1820-1901

ROBERTS, Thomas
Sautelle
British, c.1760-1826
ROBERTS, Tom
Australian, 1856-1931
ROBERTS, William
British, 1788-1867
ROBERTS, William
Patrick
British, 1895-
ROBERTSON, Alexander
British, 1768-1841
ROBERTSON, Alexander
Duff
British, 1807-1886
ROBERTSON, Andrew
British, 1777-1845
ROBERTSON, Archibald
British, 1765-1835
ROBERTSON, Arthur
British, 1850-p.1905
ROBERTSON, Charles
British, 1759-1821
ROBERTSON, Charles
British, 1844-1891
ROBERTSON, Christina,
(née Saunders)
British, op.1823-1844
ROBERTSON, D.
British, 19th cent.
ROBERTSON, Edward
British, 1809-p.1837
ROBERTSON, Eric Forbes
British, 1887-
ROBERTSON, George
British, c.1748-1788
ROBERTSON, George Edward
British, 1864-p.1926
ROBERTSON, John Ewart
British, 1820-1879
ROBERTSON, Percy
British, 1869-1934
ROBERTSON, Sarah
Margaret
Canadian, 1891-1948
ROBERTSON, Susanne
(Suze) (Susanne
Bisschop)
Dutch, 1856-1922
ROBERTSON, Tom
British, 1850-1947
ROBERTSON, Victor John
British, op.c.1892-1909
ROBERTSON, W.
British, op.1750
ROBERTSON, Walford
Graham
British, 1867-1948
ROBERTSON, Walter
(Irish Robertson)
British, op.1769-m.1802
ROBERTSON, William
British, 19th cent.
ROBERTSON-AIKMAN,
George
British, op.1803
ROBERTSON-SWANN, R.
British, 20th cent.
ROBETTA, Cristoforo
di Michele
Italian, 1462-p.1522
ROBIDA, Albert
French, 1848-1926
ROBIE, Jean-Baptiste
Belgian, 1821-1910
ROBIN
French, 20th cent.

ROBIN, Louis
French, 1845-
ROBIN, Pierre M.
French, 19th cent.
ROBINEAU, Charles
Jean
French, op.1780-m.1787(?)
ROBINS, Brian
British, 20th cent.
ROBINS, Mrs. Mabel
Louisa
British, 19th cent.
ROBINS, Thomas, I
of Bath
British, 1716-1770
ROBINS, Thomas, II
British, 1743-1806
ROBINS, Thomas Sewell
British, op.1839-m.1880
ROBINS, Thomas
Valentine
British, op.1859
ROBINS, William Palmer
British, 1882-1959
ROBINSON, Albert Henry
Canadian, 1881-1956
ROBINSON, Barbara
British, 1928-
ROBINSON, Boardman
Canadian, 1876-1952
ROBINSON, Charles of
Dublin
British, op.1790
ROBINSON, Charles
British, 1870-1937
ROBINSON, Charles F.
British, op.1874-1915
ROBINSON, Douglas F.
British, 1864-c.1929
ROBINSON, E. Fothergill
British, 19th cent.
ROBINSON, Edward
British, 1824-1883
ROBINSON, Edward W.
British, op.1859-1876
ROBINSON, Frederick
Cayley
British, 1862-1927
ROBINSON, Henry Harewood
British, op.1884-1896
ROBINSON, Hugh
British, c.1755-1790
ROBINSON, J.C.
American, op.1848
ROBINSON, John
British, 1715-1745
ROBINSON, Mathias
British, op.1856-1884
ROBINSON, Mrs. M.D.
Webb
British, op.1893/4
ROBINSON, Peter
Frederick
British, 1776-1858
ROBINSON, R.
British, op.1688-1696
ROBINSON, Sheila
British, 20th cent.
ROBINSON, Theodore
American, 1852-1896
ROBINSON, Thomas
British, a.1770-1810
ROBINSON, W.R.
British, 19th cent.
ROBINSON, William
British, 1799-1839
ROBINSON, William Heath
British, 1872-1944

ROBIQUET, Lucas or
Lucien
French, 20th cent.
ROBOZ, Zsuzsi
Hungarian, 20th cent.
ROBSON, George Fennel
British, 1788-1833
ROBSON, J.
British, op.1839
ROBSON, R.
British, 19th cent.
ROBSON, W.
British, 18th cent.
ROBUSTI, Marietta
see Tintoretta, La
ROCCA, Giacomo
Italian, op.1592-1605
ROCCA or Rocco, Michele
(Il Parmigianino or
Parmeggiano)
Italian, c.1670/5-p.1751
ROCCHI, Giuseppe
Italian, op.1883
ROCH
French(?), op.c.1750
ROCH or Roche, Sampson
Towgood
British, 1759-1847
ROCHA, Antonio
Spanish, 17th cent.
ROCHA, Joaquim Manoel
da
Portuguese, 1727-1786
ROCHARD, François
Theodore
French, 1798-1858
ROCHARD, Simon Jacques
(Acajou Rochard)
French, 1788-1872
ROCHAT, Louise
see Viollier
ROCHAUX, Jacques de
(Monogrammist J.D.R.)
see Rousseau
ROCHE, Alexander
British, 1863-1921
ROCHE, Gustave Marcel
French, 1890-1959
ROCHE, Odilon
French, 20th cent.
ROCHE, Pierre
(Fernand Massignon)
French, 1855-1922
ROCHE, Sampson Towgood
see Roch
ROCHEBRUNE, Octave
Guillaume, Comte de
French, 1824-1900
ROCHEFORT, Pierre or
Pedro de
French, c.1673-1728
ROCHEFOUCAULD, Antoine
de la
French, 1862-1960(?)
ROCHEGROSSE, Charles
French, 20th cent.
ROCHEGROSSE, Georges
(Antoine Georges
Marie)
French, 1859-1938
ROCHER
French, 18th cent.
RÖCHLING, Carl
German, 1855-1920
ROCHUSSEN, Charles
Dutch, 1814-1894
ROCKLINE, Vera
(Schlezinger)
French, -1934

ROCKMORE, N.
American, 20th cent.
ROCKSTUHL, Alois
Gustav
Russian, 1798-1877
ROCKWELL, Norman
American, 1894-
ROCOPLAN, Camille
Joseph Etienne
see Roqueplan
ROCQUETTE, Johan de la
Dutch, op.1658-1694
RODA, Vincenzo
Italian, 1923-1961
RODAKOWSKI, Henryk
Hipolit
Polish, 1823-1894
RODARI, Tomaso
Italian, op.1487-1526
RODTSCHENKO or
Rodschenko, Alexander
Michajlowitsch
Russian, 1891-1956
RODDE, Michel
French, 1913-
RODE, Bernhard
(Christian Bernhard)
German, 1725-1797
RODE, Hermen
German, op.1468-1504
RODE or Roode, Niels
Danish, 1743-1794
RODECK, Carl
German, 1841-1909
RODEN, William Thomas
British, 1817-1892
RÖDER or Reder,
Cyriakus
German, c.1560-1598
RODERIGO, Bernardino
see Rodriguez
RODERMONT, Peeter
see Rottermond
RODES y Aries, Vicente
Spanish, 1791-1858
RODIAN(?)
British(?), op.1774
RODIANI, Onorata
Italian, op.c.1422-m.1452
RODIN, Auguste
(François A. René)
French, 1840-1917
RODINGH, Pieter
Dutch, op.1676-1685
RODINS, C.
American, 19th cent.
RODIUS, Charles
Australian, 1802-1860
RODRIGO de Osona, I
Spanish, op.1476-1484
RODRIGO de Osona, II
(Le Fil de Mestre
Rodrigo)
Spanish, op.1502-1513
RODRIGUE, George
American, 20th cent.
RODRIGUE, Ventura
Spanish, op.1738-c.1770
RODRIGUES, Augusto
Brazilian, 20th cent.
RODRIGUEZ, Adriano
(Adriaen Dierickx)
Flemish, op.1629-m.1669
RODRIGUEZ or Rodriquez,
Alonso or Alfonso
Italian, 1578-1648

RODRIGUEZ or Roderigo,
Bernardino (Giovanni
van Bernardino)
Italian, -1667
RODRIGUEZ y Jiménez,
Juan (El Panadero)
Spanish, 1765-1830
RODRIGUEZ de Toledo,
Juan
Spanish, op.1395-c.1400
RODRIGUEZ or Roderigo,
Luigi (Il Siciliano)
Italian, op.1594-1606
RODRIGUEZ, Manuel
Mariano
Spanish, op.1829-1834
RODRIGUEZ Barcaza,
Ramón
Spanish, c.1820-
RODRIGUEZ, Severo
Argentinian, 1864-
RODRIGUEZ, Vicente
Venezuelan, 17th cent.
RODRIGUEZ TIZON,
Ventura
Spanish, 1717-1785
RODRIQUES, Bernardo
Spanish, 17th cent.
RODTSCHEFF, Wassilij
Palladiewitsch
Russian, 1768-1803
RODWELL, T.
British, 18th cent.
ROE, Clarence
British, -1909
ROE, Fred
British, 1864-1947
ROE, J.
British, op.1771-1811
ROE, R.
British, op.1879
ROE, Robert
British, 1793-1880
ROE, Robert Henry
British, 1790-1884
ROEBER, Ernst
German, 1849-1905
ROEBEYS
Dutch, 17th cent.
ROECK, Pierre Paul
Maria de
Belgian, 1923-
ROED, Jorgen Pedersen
Danish, 1808-1888
ROEDEL
French, 18th cent.
ROEDEL
French, 1859-1900
ROEDER, Julius
Sigismund
German, 1824-1860
ROEDERSTEIN, Ottilie
Wilhelmine
German, 1859-1938
ROEDIG, Johannes
Christiaan
Dutch, 1750-1802
ROEGGE, Wilhelm (Ernst
Friedrich W.)
German, 1829-1908
ROEHL or Röhl, Maria
Christina
Swedish, 1801-1875
ROEHN, Adolphe Eugène
Gabriel
French, 1780-1867

ROEHN, Jean Alphonse
French, 1799-1864
ROEHRICH, Karl Hermann
German, 1928-
ROELAS, Ruela or
Ruelas, Juan de
Spanish, 1558/60-1625
ROELOFS, Otto Willem
Albertus (Albert)
Dutch, 1877-1920
ROELOFS, Willem
Dutch, 1822-1897
ROEPEL, Coenraet
Dutch, 1678-1748
ROER, Jacob (Jacob
van de Roer of
Dordrecht?)
Netherlands,
op.1694-1707
ROERE, Jacobus Ignatius
de
see Roore
ROERBYE or Rorbye,
Martinus Christian
Wesseltoft or
Wedseltoft
Norwegian, 1803-1848
ROERICH, Nicolai
Konstantinowitsch
Russian, 1874-1947
ROERMEESTER, Gerardus
Johannes
Dutch, 1844-1936
ROESCH, Carl
Swiss, 1884-
ROESCH, Kurt
American, 1905-
ROESEL von Rosenhof,
August Johann
German, 1705-1759
ROESEL, Franz
see Rösel
ROESELER, August
German, 1866-1934
ROESEN, Severin
American, op.1848-m.1871
ROESLER-FRANZ, Ettore
Italian, 1845-1907
ROESSINGH, Henry de
Buys
Dutch, 1889-
ROESSLER, Georg
German, 1861-1925
ROESSLER or Rösler,
Johann Carl
German, 1775-1845
ROESTRAETEN, Pieter
Gerritsz. van
Dutch, c.1630-1700
ROETING, Julius Amatus
German, 1821/2-1896
ROETTIERS, Roettier,
Rottiers etc., Francois
British, 1685-1742
ROETTIERS, Roettier,
Rottier or Rottiers,
Francois
French, 1702-1770
ROETTIERS, Jacques
Nicolas
French, 1736-
ROETTIERS, Joseph
Charles
French, 1692-1779
ROFFIAEN, Jean François
Xavier (François)
Belgian, 1820-1898

ROFFLER, Thomas
Swiss, 1897-1930
ROGANEAU, François
Maurice
French, 1883-
ROGER, Deodat
German, 1726-1821
ROGER, Eugène
French, 1807-1840
ROGER, Francoise
French, 20th cent.
ROGER, Georges
Guillaume
French, 1867-1943
ROGER, Léon
French, 19th cent.
ROGER, Suzanne
French, 1899-
ROGERS, B.
British, 19th cent.
ROGERS, Claude Maurice
British, 1907-
ROGERS, George
British, op.1761-1793
ROGERS, Gertrude
American, 1896-
ROGERS, H.
British, op.1835-1837
ROGERS, J.
British, 19th cent.
ROGERS the Elder, J.
British, op.c.1828
ROGERS, Nathaniel
American, 1788-1844
ROGERS, Otto D.
Canadian, 20th cent.
ROGERS, Peter
British, 20th cent.
ROGERS, Philip Hutchins
British, 1794-1853
ROGERS, W.
British, 20th cent.
ROGERS, William
British, op.c.1589-1604
ROGERSON, P.
British, 18th cent.
ROGET, John Lewis
British, 1828-1908
ROGHMAN or Roghmans,
Geertruydt
Dutch, op.c.1647
ROGHMAN, Roelant
Dutch, op.1646-m.c.1686
ROGNES
French, 19th cent.
ROGOWSKA, Bozena
Polish, 20th cent.
ROHBOCK, Ludwig
German, 19th cent.
ROHDE, Carl
German, 1840-1891
ROHDE, Johan Gudmann
Danish, 1856-1935
ROHDE, Frederik (Niels
F. Martin)
Danish, 1816-1886
ROHDE, Niels
see Rode
ROHDEN, Franz
(Francesco, Checco) von
(de)
Italian, 1817-1903
ROHDEN, Rhoden or Roden,
Johann Martin von
German, 1778-1868
RÖHL, Karl Peter
German, 1890-

ROHLFS, Christian
German, 1849-1938
ROHN or Rahn, C.
German, op.1854
ROHNER, Georges
French, 1913-
ROHRBACH, Paul
German, 1817-p.1862
ROHRICH or Rorich,
Franz Wolfgang
German, 1787-1834
RÖHRICHT. Wolf
German, 1886-1953
ROHRIG, F.
German, 18th cent.
ROIG, Salvador
Spanish, 15th cent.
ROJDESTVIENSKY, Vladimir
Russian, 19th cent.
ROJKA, Fritz
German, 1878-1939
ROKES
see Sorgh, Hendrik
Martensz.
ROKOTOFF, Fjodor
Stepanowitsch
Russian, c.1735-1808
ROLAND, Jacques François
Joseph
French, 1757/8-1804
ROLAND de Mois
see Mois
ROLAND de la Porte,
Henri Horace
French, c.1724-1793
ROLAND-MANUEL, Suzanne
French, 20th cent.
ROLANDO, Charles
Australian, op.1880-1890
ROLDAN, Enrique
Spanish, 19th cent.
ROLDAN y Martinez,
José
Spanish, 1808-1871
ROLFE, Alexander F.
British, op.1839-1873
ROLFE, Frederick
William(Baron Corvo)
British, 1860-1913
ROLFE, H.
British, op.1828
ROLFE, Henry Leonidas
British, op.1847-1881
ROLFFSEN, Franz
Nikolaus
German, c.1719-1802
ROLFSEN, Alf
Norwegian, 1895-
ROLI (Rolli), Giuseppe
(Gioseffo) Maria
Italian, 1645-1727
ROLL, Alfred Philippe
French, 1846-1919
ROLL, Marcel Philippe
French, 1881-
ROLLA, Léon
French, 19th cent.
ROLLAND, Benjamin de
French, 1777-1855
ROLLAND, Henri Horace
see Roland
ROLLE, Miss
British, 18th cent.
ROLLE, Carl Gottlieb
German, 1814-1862
ROLLER, Alfred
German, 1864-1935

RÖLLER, Gottfried-
Gunther
German, 1785-1869
ROLLER, Jean
French, 1798-1866
ROLLIER, Charles
Swiss, 1912-
ROLLIER, Jean
French, op.1532
ROLLIN, J.
German(?), op.c.1890
ROLLINSON, William
British, 1762-1842
ROLLMANN, Julius
German, 1827-1865
ROLLO, Joseph
American, 1907-
ROLLOS, Peter, I
German, op.1619-1639
ROLO, S.P.E.
German(?), op.1770
ROLSHOVEN, Julius C.
American, 1858-1930
ROM, Per
Norwegian, 1903-
ROMA, Spiridone
Italian, op.1774-m.1787
ROMADIN, Michail
Nicolaievich
Russian, 1940-
ROMAGNA, Anonymous
Painters of the
ROMAGNESI, Michel
Italian, op.1766
ROMAGNOLI, E.
Italian, 18th cent.
ROMAGNOLI, Giovanni
Italian, 1893-
ROMAGNOLI, Guidone
Italian, 1912-
ROMAGNONI, Giuseppe
Italian, 1930-
ROMAKO, Anton
German, 1832-1889
ROMAN SCHOOL
Anonymous Painters
of the
ROMAN, Bartolomé
Spanish, 1596-1659
ROMAN, Max Wilhelm
German, 1849-1910
ROMANA, Pedro
Spanish, 1488-1536
ROMANCE, Adèle de
see Romany
ROMANELLI, Giovanni
Francesco (Il
Viterbese, Raffaello
or Il Raffaelino)
Italian, 1610(?)-1662
ROMANET, Antoine Louis
French, 1742/3-p.1810
ROMANI, Juana
Italian, 1869-1924
ROMANI, Romolo
Italian, 1884-1916
ROMANIDES, Kastas
Greek, 18th cent.
ROMANINI, B.
French(?), op.1830
ROMANINO, Alessandro
(Alessandro Bresciano)
Italian, c.1490-p.1534
ROMANINO, Girolamo
(Romani of Il Romanino)
Italian, 1484/7-p.1562(?)

ROMANO, Giulio
see Giulio
ROMANO, Il
see Catalano, Antonio
ROMANO, Luzio
see Luzio
ROMANS, Bernard
Dutch, c.1720-1784
ROMANUS, Frater
Italian, op.1237-1250
ROMANY, Adèle (Marie
Jeanne) (née de Romance)
French, 1769-1846
ROMBACH, Th.
Dutch, 17th cent.(?)
ROMBAUER, Jànos (Johann)
Hungarian, 1782-1849
ROMBAUTS, Jan, I
(Scaeldeken)
Netherlands,
op.1485-m.1534
ROMBOUTS, Adriaen
Flemish, op.1653-1667
ROMBOUTS, Rombout,
Rom Bout or Rontbout,
Gillis, Gilles, Jellys
or Jillis
Dutch, 1630-c.1678
ROMBOUTS, Johannes or
Jan
Dutch, 17th cent.
ROMBOUTS, Salomon
Dutch, p.1650-a.1702
ROMBOUTS, Theodor
Flemish, 1597-1637
ROMEGAS, Jean Baptiste
French, 1800-1867
ROMEK, Arpad
Hungarian, 1883-
ROMERO, Carlos Orozco
Mexican, 1898-
ROMERO y Lopez, José
Maria
Spanish, op.1840-1883
ROMERO, Juan Battista
Spanish, op.1765-1790
ROMERO, Simon
Spanish, op.1647-1664
ROMERO y Escalante
see Juan de Sevilla
ROMEU, Juan
Spanish, 20th cent.
ROMEYN, Willem
Dutch, c.1624-c.1694
ROMILLY, Amélie
see Munier
ROMIREZ, Gustavo
Francisco
Mexican, 20th cent.
ROMITI, Gino
Italian, 1881-1967
ROMITI, Sergio
Italian, 1928-
ROMMELAERE, Emile
Belgian, 1873-
ROMNEY, George
British, 1734-1802
ROMNEY, Peter
British, 1743-1777
ROMYN, Conrad
British, 1915-
RONALD, William
Canadian, 1926-
RONCALLI, Cristoforo
see Pomarancio

RONCHELLI, G.B.
Italian, 1716-1788
RONCELLI
see Ronzelli
RONDANI, Francesco
Maria
Italian, 1490-p.1548
RONDELLI, Francesco
Antonio
Italian, 1759-1848
RONDENAY, Marcelle
Andrée
French, 1880-
RONDINELLO or Rondanello,
Nicolò
Italian, op.1495-1502
RONDINOSI, Zaccaria
Italian, op.1643-1670
RONET, B.
French(?), op.1718
RONGIER, Jeanne
French, op.c.1869
RONIG, Ludwig Ernst
German, 1885-1960
RONMY, Guillaume
Frédéric
French, 1786-1854
RONNER, Henriette,
(née Knip)
Dutch, 1821-1909
RONOT, Charles
French, 1820-1895
RONSIN, Jean
French, 1905-
RONTBOUT, Gillis
see Rombouts
RONTINI, Alessandro
Italian, 1854-
RONZELLI or Roncelli,
Fabio
Italian, op.1628-1630
RONZELLI or Roncelli,
Don Giuseppe
Italian, c.1663-1729
RONZELLI or Roncelli,
Pietro
Italian, c.1560-p.1621
RONZEN, Antonio
Netherlands(?),
op.1512-1520
RONZONI, Pietro
Italian, 1780-1862
ROOD, Jan
Dutch, c.1710-p.1770
ROODE, Niels
see Rode
RÖÖK, Lars Jacob von
Swedish, 1778-1867
ROOK, S.
British, op.1794
ROOKE, Thomas Matthews
British, 1842-1942
ROOKER, Michael
(Michael Angelo)
British, 1743-1801
ROOM, Henry
British, 1802-1850
ROOME, Jan van (Jan
van Brussel, or Jan
de Bruxelles)
Netherlands,
op.1498-1521
ROORE or Roere, Jacobus
Ignatius de
Flemish, 1686-1747
ROOS, Antonius
French(?), 16th cent.(?)

ROOS, Cajetan
(Gaetano de Rosa)
German, 1690-1770
ROOS, Franz
German, 1672-
ROOS, Jacob (Joseph
Nikolaus Jacob
Hyacinth Johann)
(Rosa da Napoli)
Italian, 1682-p.1707
ROOS or Roosen, Jan
(Giovanni Rosa)
Flemish, 1591-1638
ROOS, Roose or Rose,
Johann Heinrich
German, 1631-1685
ROOS or Rose, Johann
Melchior
German, 1659-1731
ROOS or Rosa, Joseph, I
German, 1726-1805
ROOS, K.
Netherlands, 17th cent.(?)
ROOS af Hjelmsäter,
Leonard Henrik
Swedish, 1787-1827
ROOS, Philipp Peter
(Rosa da Tivoli)
(Mercurius)
German, 1655/7-1706
ROOS, Sjörd Hendrik de
Dutch, 1877-1962
ROOS or Rosa, Theodor
or Dietrich
German, 1638-1698(?)
ROOSE, Nicolas
see Liemaker
ROOSEN, Jan
see Roos
ROOSENBOOM, Albert
Belgian, op.c.1865-1875
ROOSENBOOM, Margaretha
Cornelia Johanna
Wilhelmina Henriëtta
(Margaretha Vogel)
Dutch, 1843-1896
ROOSENBOOM, Nicolaas
Johannes
Dutch, 1805-1880
ROOSENDAEL, Nicolaes
see Rosendael
ROOSING, Pieter
Dutch, 1794-1839
ROOSKENS, Joseph Anton
(Anton)
Dutch, 1906-
ROOSSENDAEL, Nicolaes
see Rosendael
ROOSTERMAN, Ed.
Dutch, 20th cent.
ROOSWYCK, Engel Jansz.
Dutch, 1584-c.1651
ROOSZMAEL, Dominicus
Ambrosius
see Rosemale
ROOTIUS, Rootsius or
Rotius, Jacob
Dutch, 1644-c.1681/2
ROOTIUS or Rotius,
Jan Albertsz.
Dutch, c.1615-1674
ROOY, Johannes Baptist
van
Belgian, 1808-
ROPER, E.
Canadian, 20th cent.
ROPER, J.
Australian, 19th cent.

ROPER, Richard or T.
British, op.1749-1765
ROPES, George
American, 1788-1819
ROPPOLI, Giambattista
see Ruoppoli
ROPS, Félicien
Belgian, 1833-1898
ROQUEPLAN or Rocoplan,
Camille Joseph
Etienne
French, 1800-1855
ROQUES, Anne Charlotte
French, op.1790
ROQUES, Joseph
Guillaume
French, 1754-1847
RORBYE, Martinus
Christian Wessektoft
see Roerbye
RORKE, Basil
British, 20th cent.
RORSNIGER, M.J.
British(?), 19th cent.
ROS, Baroness de
see Boyle, Charlotte
ROSA
see Nicoletto da
Modena
ROSA
Italian, 19th cent.
ROSA da Napoli
see Roos, Jacob
ROSA da Tivoli
see Roos, Philipp
Peter
ROSA, Annella de
see Rosa, Diana
ROSA, Cajetano or
Gaetano
see Roos
ROSA, Carlo
Italian, -1678
ROSA, Constantino
Italian, 1803-1878
ROSA, Diana (Annella
de Rosa)
Italian School.
1602-1649(?)
ROSA, Francesco
Italian, -1687
ROSA, Francesco de
(Pacecco or Pacecco
de Rosa)
Italian, c.1600-1654
ROSA, Giovanni
see Roos, Jan
ROSA, Joseph
see Roos
ROSA, M.
British(?), 17th cent.
ROSA, Pietro
Italian, c.1540-1577
ROSA, Salvator
Italian, 1615-1673
ROSA, Saverio dalla
Italian, 1745-1821
ROSADO del Vale, Julio
Puerto Rican, 1922-
ROSAI, Ottone
Italian, 1895-1957
ROSALBA
Italian, 20th cent.
ROSALBA
see Carriera
ROSALBIN de Buncey,
Marie Abrahams
French, 19th cent.

ROSALES Martinez,
Eduardo
Spanish, 1836-1873
ROSANOWA, Olga
Wladimirowna
Russian, 1886-1918
ROSATI, Giulio
Italian, 1858-1917
ROSASPINA, Francesco
Italian, 1762-1841
ROSASPINA, Giuseppe
Italian, 1765-1832
RÖSCH, Ludwig
German, 1865-1936
ROSCHLAU, Michael
German, 20th cent.
ROSE
British, op.1677
ROSE(?)
German, 19th cent.
ROSE, Daniel
British, op.1602-m.1639/40
ROSE, Sir Francis
British, 1909-
ROSE, Gerard de
British, 20th cent.
ROSE, Guy
American, 1867-1925(?)
ROSE, Herman
American, 1909-
ROSE, Joseph
British, 1745-1799
ROSE, Julius
German, 1828-1911
ROSE, Martin
British, 20th cent.
ROSE, Peggy
British, 20th cent.
ROSE, William
Australian, 1930-
ROSE
see also La Rose
RÖSEL von Rosenhof,
Franz
German, 1626-1700
RÖSEL, Johann Gottlob
Samuel
German, 1768-1843
ROSELAND, Harry
American, 1868-1950
RÖSELFELDT, Johann
Carl von
see Reslfeld
ROSELL, A.
British, 19th cent.
ROSELLI or Rosselli,
Niccolò
Italian, op.1550-m.1580
ROSEMALE, Rooszmael
or Rosmale, Dominicus
Ambrosius
Dutch, c.1620-1699
ROSEN, Ernest T.
American, 1877-1926
ROSEN, Georg (Johan
Georg Otto)Graf von
French, 1843-1923
ROSEN, Jan
Polish, 1854-1936
ROSEN, Reinhold von
Swedish, 1894-1961
ROSEN, Robert van
American, 19th cent.
ROSENBERG, C.
British, 19th cent.
ROSENBERG, Edward
(Axel Edward John)
Swedish, 1858-1934

ROSENBERG, Frances
Elizabeth Louise
see Harris
ROSENBERG, Friedrich
German, 1758-1833
ROSENBERG, George
Frederick
British, 1825-1870
ROSENBERG, Isaac
British, 1890-1918
ROSENBERG, Johann Carl
Wilhelm
German, 1737-1809
ROSENBERG, Johann (Jean)
Georg
German, 1739-1808
ROSENBERG, Mary Elizabeth
see Duffield
ROSENDAEL, Roosendael,
Roossendael or
Rozendaal, Nicolaes
Dutch, 1636-1686
ROSENHAUER, Theodor
German, 1901-
ROSENHEIM, Johan von
(Rozelius)
Swedish, 1725-1803
ROSENKRANZ, Heinrich
(Johan Heinrich Jacob
Christian)
German, 1801-1851
ROSENMAYER, Franz
Hungarian, 1864-1912
ROSENQUIST, James
American, 1933-
ROSENROD or Rosenrodh,
Johannes
Swedish, op.1437
ROSENSTAND, Vilhelm
Jakob
Danish, 1838-1915
ROSENTHAL, Albert
American, 1863-1939
ROSENTHAL, David
(Constantin)
Hungarian, 1820-1851
ROSENTHAL, Doris
(Charash)
American, 20th cent.
ROSENTHAL, Toby Edward
American, 1848/9-1917
ROSENZWEIG-WINDISCH,
Nanette
German, op.c.1820
ROSER, J. Henry
British(?), 19th cent.
RÖSER, Werner
German, 15th cent.
ROSETTE,
see Städel, Anna
Rosina Magdalena
ROSETTI or Rositi,
Giovanni Battista
Italian, op.1495-1545
ROSEX
see Nicoletto da
Modena
ROSHARDT, Walter
Swiss, 20th cent.
ROSI, Alessandro
Italian, c.1627-c.1707
ROSI, Andres
Spanish, 1771-p.1829
ROSI or Rossi, Zanobi
or Zanobio
Italian, op.1626
ROSIER, Amédeé
Swiss, 1831-

ROSIERSE, Johannes
Dutch, 1818-1901
ROSIERSZ, Peter
Flemish(?), 18th cent.(?)
ROSITI
see Rosetti
RÖSLER, Johann Carl
see Roessler
ROSLER, Michael
see Röszler
RÖSLER, Waldemar
German, 1882-1916
ROSLIN, Alexander
Swedish, 1718-1793
ROSLIN, Suzanne (Maria
Suzanne) (née Giroust)
French, 1734-1772
ROSS, J.
British, op.1729-1731
ROSSI, Barbara
American, 20th cent.
ROSSI
see also Rosi
ROSMALE, Dominicus
Ambrosius
see Rosemale
ROSMÄSSLER, Johann
August
see Rossmässler
ROSOMAN, Leonard
British, 1913-
ROSPIGLIANI
see Vicentino, Giuseppe
Niccolò
ROSS, Alvin
American, 19th cent.
ROSS, Charles
American, 1937-
ROSS, Frederick Joseph
Canadian, 1927-
ROSS, Hugh
British, op.1815-1845
ROSS, Captain J.
British, op.1829
ROSS, J.
British, 18th cent.
ROSS, James
British, 1745-1821
ROSS, Janet (Mrs.
Barrow)
British, op.1817-1830
ROSS, Sir John
British, 1777-1856
ROSS, Karl (Charles)
German, 1816-1858
ROSS, Robert Thorburn
British, 1816-1876
ROSS, T.
British, op.1741
ROSS, Thomas
British, 18th cent.
ROSS, William
British, op.1753
ROSS, Sir William
Charles
British, 1794-1860
ROSSANO, Federico
Italian, 1835-1912
ROSSE, Susan Penelope,
(née Gibson)
British, 1652-1700
ROSSEELS, Jacob
Belgian, 1828-1912
ROSSEAU, Percival Leonard
American, 1869-
ROSSEL DE CERCY, Auguste
Louis, Marquise de
French, op.1779-1824

ROSSELLI, Bernardo di
Girolamo di Clemente
(del Buda)
Italian, op.1532-1569
ROSSELLI, Cosimo
Italian, 1439-1507
ROSSELLI, Francesco
Italian, 16th cent.
ROSSELLI, Francesco
di Lorenzo
Italian, 1445-a.1513
ROSSELLI, Matteo
Italian, 1578-1650
ROSSELLI, Pietro di
Giacomo
Italian, 1474(?)-p.1531
ROSSELLINO, Antonio
Italian, 1427-1479
ROSSELLO di Jacopo
Franchi
see Franchi, Rosello
di Jacopo
ROSSEM
see Rossum
ROSSERT, Paul
French, op.18-0-1910
ROSSET, François Marie
French, 1752-1824
ROSSET-GRANGER, Paul
Edouard
French, 1853-
ROSSETTI, Cesare
Italian, 17th cent.
ROSSETTI, Elizabeth
Eleanor (Lizzie)
see Siddall
ROSSETTI, Gabriel
Charles (Dante
Gabriel)
British, 1828-1882
ROSSETTI, Gian Mauro
see Rovere
ROSSETTI, Giovanni
Paolo
Italian, op.1551-1600
ROSSETTI, Lucy Madox
see Brown, Lucy Madox
ROSSETTI, Pietro
Antonio
Italian, op.1707
ROSSI, Alexander M.
British, op.1870-1903
ROSSI, André
Spanish, op.1651
ROSSI, Rosis or Rossis,
Angelo
Italian, 1670-1742
ROSSI or Rosso, Antonio
Italian, op.1472-m.1525
ROSSI, Antonio
Italian, 1700-1753
ROSSI, Bernardino de'
Italian, a.1475-c.1515
ROSSI, Charles
British, 1762-1839
ROSSI, Davide
Italian, 1744-p.1720
ROSSI, Domenico de
Italian, op.1627-1640
ROSSI, Emilio
Italian, 19th cent.
ROSSI, Erminio
Italian, 20th cent.
ROSSI, Francesco de'
see Salviati

ROSSI, Gino
Italian, 1884-1947
ROSSI or de Rubeis,
Giovanni Jacopo
Italian, op.1649-1680
ROSSI, Girolamo
Italian, 1547-p.1588
ROSSI, Ilario
Italian, 1911-
ROSSI, Joseph
Italian, 1892-1930
ROSSI, Lucius
French, 1846-1913
ROSSI, Luigi
Swiss, 1853-1923
ROSSI, Mariano
Italian, 1731-1807
ROSSI, Mattia de'
Italian, 1637-1695
ROSSI, Nicoleto
see Nicoletto da
Modena
ROSSI, Pasquale de'
(Pasqualino)
Italian, 1641-1725
ROSSI, Pieri
see Pieri, Stefano
ROSSI, Pietro de'
Italian, 1761-1831
ROSSI, Vincenzo di
Raffaello de'
Italian, 1525-1587
ROSSI, Zaccaria
Italian, 18th cent.
ROSSI, Zanobi
see Rosi
ROSSI-GAZZOLI, Henri
de
Italian, 19th cent.
ROSSINE, Vladimer
Baranoff
Russian, 1888-1942
ROSSINI
Italian, 18th cent.
ROSSINI, Luigi
Italian, 1790-1857
ROSSINI, Pellegrino di
Mariano
see Pelligrino
ROSSINI, Romano
Italian, 1890-
ROSSI-SCOTTI, Lemmo
Italian, 1848-1926
ROSSITER, Charles
British, 1827-p.1890
ROSSITER, Thomas
Pritchard
American, 1818-1871
RÖSSLER, Adalbert von
German, 1853-1922
RÖSSLER, Paul (Otto
Paul)
German, 1873-1957
ROSSMÄSSLER or
Rosmässler, Johann
August
German, 1752-1783
ROSSMÄSSLER or
Rosmässler, Johann
Christian Andreas
German, 1769-1821
ROSSO Fiorentino
see Rosso, Giovanni
Battista
ROSSO, Giovanni Battista
di Jacopo di Guasparre
(Il Rosso Fiorentino)
Italian, 1494-1540

ROSSO, Medardo
Italian, 1858-1928
ROSSO da S. Zeno, Il
see Mondella, Galeazzo
ROSSUM or Rossem, Gerard
van
Dutch, c.1699/1700-1772
ROSSUM or Rossem,
Jan van
Dutch, op.1654-1673
ROSSUM, Jan Cornelis van
Dutch, 1820-1905
ROSSUM du Chattel,
Fredericus Jacobus van
see Chattel
ROSSUTI, Filippo
see Rusuti
ROST, Johann Gottlieb
German, op.1807-p.1860
ROSTGAARD, Alfredo G.J.
Cuban, 20th cent.
ROSYK, Roman
Polish, 20th cent.
ROSZAK, Theodore J.
American, 1907-
RÖSZLER or Ressler,
Michael
German, 1705-1777
ROT, Dieter
German, 1930-
ROT, Hans
German, 1513-
ROTA, Giuseppe
Italian, 1777-1821(?)
ROTA, Martino
Italian, c.1520-1583
ROTARI, Pietro Antonio
Conte
Italian, 1707-1762
ROTELLA, Domenico
(Mimmo)
Italian, 1918-
ROTH, Clemence
French, op.c.1880
ROTH, Frank
American, 1936-
ROTH, George
British, op.1771-1781
ROTH, George Andries
Dutch, 1809-1887
RÖTH, Philipp
German, 1841-1921
ROTH, Toni
German, 19th cent.
ROTH, William
British, op.1768-1777
ROTHAUG, Alexander
German, 1870-
ROTHAUG, Leopold
German, 1868-1959
ROTHBART, Ferdinand
German, 1823-1899
ROTHE, Hans
German, 1929-
ROTHENSTEIN, Michael
British, 1908-
ROTHENSTEIN, Sir William
British, 1872-1945
ROTHENSTEIN
see Rutherston
ROTHERMEL, Peter
Frederick
American, 1817-1895
ROTHKO, Mark
American, 1903-1970
ROTHMAIR
see Rottmayr

ROTHSCHILD, Charlotte
Baronne Nathaniel de
French, op.c.1864
ROTHSTEN, Carl Abraham
Swedish(?), 1826-1877
ROTHWELL, Richard
British, 1800-1868
RÖTING or Rotingus,
Lazarus
German, 1549-1614
ROTIUS
see Rootius
ROTNHAMER
see Rottenhammer
ROTTA, Antonio
Italian, 1828-1903
ROTTE, Carl (Martin
Heinrich Carl)
German, 1862-1910
ROTTENHAMMER, Rättnhamer,
Rotnhamer, Tottenhamer,
Rothamer or Rätchamer,
Hans, I
German, 1564-1625
ROTTENWALD, Ritter von
see Liska, Johann
Christoph
RÖTTER, Paul
German, op.1834-1845
ROTTERMOND, Rodermont,
Rottermondt or
Rottermont, Peeter
(also, erroneously,
Aegidius Paul)
Dutch, op.1639-1645
ROTTGER, Dieter
German, 1930-
ROTTIER or Rottiers,
Francois
see Roettiers
ROTTMANN, Carl
German, 1797-1850
ROTTMANN, Leopold
German, 1812-1881
ROTTMAYR, Rothmair or
Rothmayer, Johann
Franz Michael (Rottmayr
von Rosenbrunn)
German, 1654-1730
ROUARD, Georges Jean
Baptiste
French, 19th cent.
ROUARGUE, Adolphe
French, 1810-p.1870
ROUART, Ernest
French, 1874-1942
ROUAULT, Georges
French, 1871-1958
ROUBAUD, Franz
Russian, 1856-1928
ROUBAUD
see Benjamin
ROUBILIAC, Louis
Francois
French, 1702-1762
ROUBILLE, Auguste Jean
Baptiste
French, 1872-
ROUBLEV, Andrej
see Rubljoff
ROUBY, J.J.
British, op.1792
ROUE
French, 19th cent.
ROUFFET, Jules
French, 1862-1931
ROUFFIO, Albert Alexander
Paul (Paul)
French, 1855-1911

ROUGEOT, Charles
Antoine
French, 1740-1797
ROUGERON, Jules James
French, 1841-1880
ROUGET, Georges
French, 1784-1869
ROUILLARD, Françoise
Julie Aldovrandine
French, 1796-1833
ROUILLARD, Jean
Sebastien
French, 1789-1852
ROULLET, Marie Anatole
Gaston (Gaston)
French, 1847-1925
ROUMANIAN SCHOOL,
Anonymous Painters
of the
ROUMEGOUS, Auguste
François
French, op.1875
ROUMIER or Romié,
Pierre
French, -1725
ROUND, S.H.
British, 1879-
ROUPERT, Louis
French, 17th cent.
ROUQUET, Jean-André
(André)
Swiss, 1701-1758
ROUS or Ross, John
British, 1411-1491
ROUSE, Robert William
Arthur
British, op.1882-1893
ROUSIN
French, 18th cent.(?)
ROUSSCHER, Johannes or
Jan
see Ruijscher
ROUSSEAU, Adrien
French, 20th cent.
ROUSSEAU, Charles
Belgian, 1862-1916
ROUSSEAU, Henri (le
Douanier)
French, 1844-1910
ROUSSEAU, Henri Emilien
French, 1875-1933
ROUSSEAU, Jacques de,
or Jacques des
Rousseaux (Monogrammist
J.D.R.)
Dutch, c.1600(?)-c.1638
ROUSSEAU, Jacques
French, 1630-1693
ROUSSEAU, Jean Jacques
French, 1861-
ROUSSEAU de la Rottière,
Jean Simeon
French, 1747-p.1781
ROUSSEAU, Maurice
French, 19th cent.
ROUSSEAU, Philippe
French, 1816-1887
ROUSSEAU, Pierre Etienne
Théodore (Théodore)
French, 1812-1867
ROUSSEAUX, Alfred Emile
French, 1831-1874
ROUSSEAUX, Jacques des
see Rousseau
ROUSSEEL or Roussel,
Theodore
see Russel

ROUSSEL, K. Xavier
French, 1867-1944
ROUSSEL, Pierre
British, 1927-
ROUSSEL, Théodore
French, 1847-1926
ROUSSELET, Gilles
French, c.1610-1686
ROUSSELIERE
French, 20th cent.
ROUSSELOT, L.
French, 19th cent.
ROUSSIN, Georges
French, 1854-
ROUSSIN, J.F.
French, 17th cent.
ROUSSOFF, Alexandre
Nicolaievich (or
Volkoff-Muromzoff)
Russian, 1844-1928
ROUSSY, Toussaint
French, 1847-
ROUVEYRE, André
French, 1879-
ROUVIER or Rouvière,
Pierre
French, c.1742-p.1782
ROUVIERE, M.
French(?), op.1785-1789
ROUW, Franz Ludwig
see Raufft
ROUX, Antoine (Joseph
Ange Antoine)
French, 1765-1835
ROUX, Charles le
see Leroux
ROUX, Francois Geoffroy
French, 1811-1882
ROUX, Frédéric
French, 1805-1874
ROUX, Jakob Wilhelm
Christian
German, 1775-1831
ROUX, Johann Friedrich
Wilhelm Theodor
German, 1806-1880
ROUX, Joseph Ange
Antoine
see Roux, Antoine
ROUX, Karl
German, 1826-1894
ROUX, Louis François
Prosper
French, 1817-1903
ROUX, Paul Louis
Joseph
French, -1918
ROUX-CHAMPION, Victor
Joseph
French, 1871-
ROVEDATA, Giovanni
Battista
Italian, op.1601-m.1620
ROVERE, Giovanni Battista
(della) (Il Fiammenghino)
Italian, c.1561-p.1627
ROVERE, Giovanni Mauro
della (Il Fiammenghino
or Gian Mauro Rossetti)
Italian, c.1575-1640
ROVERIO, Bartolomeo
(Il Genovesino)
Italian, c.1577-p.1626
ROVEZZANO, Giovanni
see Giovanni di Francesco
del Cervelliera
ROVIALE, Francesco
see Ruviales

ROVIGO da Urbino
see Xanto-Avelli,
Francesco
ROVIRA, Carme
Spanish, 20th cent.
ROVIRA y Brocandel,
Hipólito
Spanish, 1693-1765
ROVIRA, José
Spanish, 16th cent.
ROWARTH, Edward
British, 20th cent.
ROWBOTHAM, Charles
British, op.c.1881-1913
ROWBOTHAM, Thomas Charles
Leeson
British, 1823-1875
ROWBOTHAM, Thomas Leeson
British, 1783-1853
ROWDE, Teddy
Norwegian, 20th cent.
ROWE, E.Arthur
British, -1922
ROWE, Mrs. Frank
see Jopling, Louise
ROWE, H.
British, op.1799
ROWE, J.
British, op.1812
ROWELL, Keith
Australian, 20th cent.
ROWLAND, F.W.
British, op.1860
ROWLANDSON, Thomas
British, 1756/7-1827
ROWLSTONE, F.
British, op.1824-1841
ROWNTREE, Kenneth
British, 1915-
ROWSE, Samuel Worcester
American, 1822-1901
ROY, Donatien
French, 1854-1930
ROY, Jamini
Hindustani, 20th cent.
ROY, Jean-Baptiste de
Flemish, 1759-1839
ROY, Le
see Le Roy
ROY, Louis
French, 19th cent.
ROY, Marius
French, 1833-
ROY, Peter van
Flemish, op.1683-c.1740
ROY, Pierre
French, 1880-1950
ROY-AUDY, Jean-Baptiste
Canadian, c.1785-1848
ROYBET, Ferdinand
Victor Léon
French, 1840-1920
ROYEN or Roye, Wilhelm
Frederik van
Dutch, c.1645/(?)54-1723(?)
ROYER, Henri Paul
French, 1869-
ROYER, Lionel-Noel
French, 1852-1926
ROYER, Pierre Alexandre
French, op.1769-1796
ROYLE
British, 17th cent.(?)
ROYLE, Herbert F.
British, op.1893-1909
ROYLE, Stanley
British, 1888-1961

ROYMERSWAELE, Marinus
Claesz. van
see Marinus
ROZAIRE, Arthur-
Dominique
Canadian, 1879-1922
ROZELIUS
see Rosenheim, Johan
von
ROZEN, Felix
French, 20th cent.
ROZENDAAL, Nicolaes
see Rosendael
ROZGONYI, László
Hungarian, 1894-1948
ROZIER, Jules Charles
French, 1821-1882
ROZOY
French, 20th cent.
ROZZOLONE, Ruzolone,
Ruzulone, Ruzzolone
or Ruzzulone, Pietro
Italian, op.1484-1522
RUBBENS, Arnold Frans
see Rubens
RUBBO, A. Dattilo
Australian, 1870-1955
RUBE, Auguste Alfred
French, 1815-1899
RUBEN, Christoph
Christian(Christian)
German, 1805-1875
RUBEN, Franz Leo
German, 1842-1920
RUBEN, Harry
American, 20th cent.
RUBEN, Richards
American, 1924-
RUBENS or Rubbens,
Arnold Frans
Flemish, 1687-1719
RUBENS, Joannes Baptist
Flemish, op.1776-m.c.1824
RUBENS, L.
Flemish, 17th cent.(?)
RUBENS, Sir Peter
Paul
Flemish, 1577-1640
RUBEUS
see Bermejo, Bartolomé
RUBIALES, Pedro de
Spanish, 1511-1582
(*see also* Francesco
Ruviales with whom this
artist used to be
confused)
RUBICK, F.
Dutch(?), 17th cent.(?)
RUBIDGE, Joseph William
British, 1802-1827
RUBIN, Reuven
Israeli, 1893-
RUBINI, Pietro
Italian, c.1700-p.1765
RUBINO, Il
Italian, op.1700-1740
RUBIO, Antonio Pérez
Spanish, 1822-p.1887
RUBIO, Luigi or Louis
Italian, 1797/1808-1882
RUBLAGH, Rublach or
Rüblagh, Peder
Danish, op.1682-1692
RUBLJOFF, Rublev, Riublev
or Rubliow, Andrej
Russian, 1360/70-1427/30
RUBOVICS, Márk
Hungarian, 1867-1947

RUCKI, Lambert
South American, 20th cent.
RUDA, Edwin
American, 1922-
RUDAUX, Edmond Adolphe
French, 1840-
RUDDIGKEIT, Frank
German, 20th cent.
RUDE, Olaf
Danish, 1886-
RUDE, Sophie (née Fremiet)
French, 1797-1867
RÜDISÜHLI, Hermann (Traugott Hermann)
Swiss, 1864-1945
RÜDISÜHLI, Jacob Lorenz
Swiss, 1835-1918
RUDNAY, Gyula
Hungarian, 1878-1957
RUDOLPH of Antwerp (identified with Rudolph Loesen)
Netherlands, op.1553-1595
RUDOLPH, Arthur
German, 1885-
RUDOLPH, Wilhelm
German, 1889-
RUDOLPHI, Johann Georg
German, -1693
RUDZKA-CYBISOWA, Hanna
Polish, 1897-
RUE, Hendrik de la
see Straaten
RUE, Lambert de la
see Straaten
RUE, Lizinska Aimée Zoë
see Mirbel
RUE, Louis Félix de la
see Larue
RUE, Philibert Benoît de la
see Larue
RUEDA, Gerardo
Spanish, 1926-
RUEDA, Jeronimo de
Spanish, 1671-
RUEDA, Manuel de
Spanish, 17th cent.
RUEGG, Ernst Georg
Swiss, 1883-1948
RUEGG, Ruedi
Swiss, 20th cent.
RUEL, Rul, Rüll etc., Johann Baptist de
Flemish, c.1634-1685
RUELAS, Juan de
see Roelas
RUELLE, Claude de la
French, op.1608
RUELLE, Jean (La Ferté)
French, op.1670
RUELLES, Pieter des
Dutch, 1630-1658
RUES, Bernaert van
see Rycke
RUETER, Wilhelm Christian Georg (Georg)
Dutch, 1875-1966
RUGA, Pietro
Italian, op.1812-1838
RUGENDAS, Georg Philipp, I
German, 1666-1742

RUGENDAS, Georg Philipp, II
German, 1701-1774
RUGENDAS, Johann Lorenz, II
German, 1775-1826
RUGENDAS, Johann Moritz (Moritz)
German, 1802-1858
RUGERO,
Italian, 15th cent.
RUGGENBERG or Ruggenbergh
Netherlands, op.1704-1707
RUGGERI, Ferdinando
Italian, 1831-
RUGGERI, Piero
Italian, 1930-
RUGGI di Bologna, Lorenzo
Italian, 1802-1877
RUGGIERI or Ruggeri, Ferdinando
Italian, c.1691-1741
RUGGIERI, Giovanni Battista (Battistino del Gessi)
Italian, 1606-1640
RUHL, Andreas
see Riehl
RUHL, Julius Eugen
German, 1796-1871
RUHL, Ludwig Sigmind
German, 1794-1887
RUHL, W.
German, 19th cent.
RUHLMANN, Ludwig
French, 19th cent.
RUHMAN, Walter
German, 1899-
RUINART de Brinant, Jules
German, 1836-1898
RUIPEREZ, Luis
Spanish, 1832-1867
RUISCHER, Johannes or Jan
see Ruijscher
RUISDAEL or Ruysdael, Isaack Jacobsz. van (Isaack Jacobsz. de Goyer or Gooyer)
Dutch, 1599-1677
RUISDAEL, Ruijsdael or Ruysdael, Jacob Isaacksz. van
Dutch, 1628/9(?)-1682
RUISDAEL or Ruysdael, Jacob Salomonsz. van
Dutch, 1629/30(?)-1681
RUISDAEL, Ruyesdael, Ruijsdael or Ruysdael, Salomon Jacobsz. van (Salomon Jacobsz. de Goyer or Gooyer)
Dutch, c.1600/1603(?)-1670
RUITH, Horace van
Italian, op.1874-1919
RUIZ, Antonio Gonzalez
see Gonzalez, Ruiz
RUIZ, Bartolomé
Spanish, op.c.1500
RUIZ de la Iglesia, Francisco Ignacio
Spanish, 1648(?)-1704

RUIZ, Jose Antonio Rey
Spanish, 1695-1767
RUIZ, Melgarejo, Juan
Spanish, op.1705-1727
RUIZ, Pablo
see Picasso
RUIZ Gonzalez, Pedro
Spanish, 1640-1706
RUIZ, Tommaso
Spanish(?), op.1740
RUL, Andreas
see Riehl
RULAND, Johannes
German, 1744-1830
RULL or Rul, Johann Baptist de
see Ruel
RULLMANN, Ludwig
German, 1765-1822
RUMINSKI, Tomasz
Polish, 20th cent.
RUMMELHOFF, John
American, 1942-
RUMMELSPACHER, Josef
German, 1852-1921
RUMNEY, Ralph
British, 1934-
RUMOHR, Carl Friedrich Ludwig Felix, Freiherr von
German, 1785-1843
RUMOHR, Knut
Norwegian, 1916-
RUMP, Christian Gotfred (Gotfred)
Danish, 1816-1880
RUMP, Emil
German, 19th cent.
RUMPF, Georg Graf von
German, 18th cent.
RUMPF, M.
German, 19th cent.
RUMPF, Peter Philipp (Philipp)
German, 1821-1896
RUMPLER, Franz
German, 1848-1922
RUNCIMAN, Alexander
British, 1736-1785
RUNCIMAN, John
British, 1744-1768
RUNDLE, Captain
British, 1815-1880
RUNDT, Carl Ludwig
German, 1802-1868
RUNDT, Hans Hinrich
German, c.1660-c.1750
RUNGALDIER, Ignaz
German, 1799-1876
RUNGE, Otto Sigismund
German, 1806-1839
RUNGE, Philipp Otto
German, 1777-1810
RUNGIUS, Carl
American, 1869-
RUNK, Ferdinand
German, 1764-1834
RUOPPOLI, Ruopolo, Ruoppolo, Roppoli or Ruppoli, Giovanni Battista
Italian, 1620-1685

RUOPPOLI, Ruopolo or Ruoppolo, Giuseppe
Italian, 1631(?)-c.1710
RUOTSINALO, Alex Rauno
Finnish, 20th cent.
RUOTTE, Louis Charles
French, 1754-c.1806
RUPALLEY, Joachim
French, c.1713-1780
RUPELLE, Henrica
French, 20th cent.
RUPENHAUSEN
German, 19th cent.
RUPERT, Ruprecht, Prince of Bavaria, Prince Palatine of the Rhine
British, 1619-1682
RUPERT
see also Ruprecht
RUPPE, Christina, (née Chalon)
see Chalon
RUPPRECHT, Johann
see Ruprecht
RUPRECHT or Rupert, Johann Christian (Christian)
German, c.1600-1654
RUPRECHT or Rupprecht, Johann
German, op.1800-1831
RUSCA or Ruschi, Cavaliere Carlo Francesco
Italian, 1696-1769
RUSCA, Jacopo
Italian, op.1770
RUSCELLI, Girolamo
Italian, 1538-1604
RUSCHA, Edward
American, 20th cent.
RUSCHEWEYH, Ferdinand
German, 1785-1846
RUSCHI, Cavaliere Carlo Francesco
see Rusca
RUSCHI or Rusca, Francesco
Italian, op.1643-1656
RUSCHI, Pietro
Italian, 16th cent.
RUSCONI, Camillo
Italian, 1658-1728
RUSCONI, Giuseppe
Italian, 1687-1758
RUSCONI
see Diana, Benedetto
RUSERUTI, Filippo
see Rusuti
RUSH, Mrs. Honour
British, op.c.1810
RUSHBURY, Sir Henry
British, 1889-1968
RUSHOUT, The Hon. Anne
British, op.1809
RUSHTON, George Robert
British, op.c.1894-1940
RUSHTON, Josiah
British, op.1875-1881
RUSINOL y Prats, Santiago
Spanish, 1861-1931
RUSKIN, John
British, 1819-1900
RUSKOWSKY
Russian, 20th cent.

RUSS, Clementine
German, c.1810-1850
RUSS, Franz
German, 1844-1906
RUSS, Karl
German, 1779-1843
RUSS, Leander
German, 1809-1864
RUSS, Robert
German, 1847-1922
RUSSEL, James John
British, -1827
RUSSEL, Rousseel or
Roussel, Theodore
British, 1614-1689
RUSSELL, Ann (Mrs.
Jowett)
British, 1781-1851
RUSSELL, Lady Arthur
British, -1910
RUSSELL, Benjamin
American, 1804-1885
RUSSELL, Charles Marion
American, 1865-1926
RUSSELL, Fanny
British, op.1744
RUSSELL, George Horne
Canadian, 1861-1933
RUSSELL, Gyrth
Canadian, 1892-
RUSSELL, Henrietta
British, 1775-1849
RUSSELL, Janet Catherine
British, op.c.1884-1894
RUSSELL, Joan
British, 20th cent.
RUSSELL, John
British, 1745-1806
RUSSELL, John Peter
Australian, 1858-1931
RUSSELL, John Wentworth
Canadian, 1879-1959
RUSSELL, Maria
British, 1783-1881
RUSSELL, Moses B.
American, c.1810-1884
RUSSELL, Morgan
American, 1886-1953
RUSSELL, Robert
British, 20th cent.
RUSSELL, S.
British, op.1849
RUSSELL, T.
British, op.1813
RUSSELL, Walter Westley
British, 1867-1949
RUSSELL, William
British, 1780-1870
RUSSELL-EARLE, J.C.
British, op.1866
RUSSELL SMITH, W.T.
American, 1812-1896
RÜSSI, Silvester
Swiss, 16th cent.
RUSSIAN SCHOOL,
Anonymous Painters
of the
RUSSO, Mario
Italian, 1925-
RUSSO, Michele
American, 20th cent.
RUSSO, Nicolò Maria
Italian, 1647-1702
RUSSOLO, Luigi
Italian, 1885-1947
RUSSUTI, Filippo
see Rusuti
RUST, Graham
British, 19th cent.

RUST, Johan Adolph
Dutch, 1828-1915
RUSTEM, Jan
Polish, 1762-1835
RUSTI or Rusten, Olav
Norwegian, 1850-1920
RUSTICI, Cristoforo
(Cristofano) (Il
Rusticone)
Italian, 1560-1640
RUSTICI, Francesco
(Il Rustichino)
Italian, op.1591-m.1626
RUSTICI, Gianfrancesco
Italian, 1474-1554
RUSTICI, Lorenzo
(Lorenzo di Cristoforo
Brazzi) (Il Rustico)
Italian, 1521-1572
RUSTIGE, Heinrich Franz
Gaudenz von
German, 1810-1900
RUSUTI, Risuti, Rizuti,
Rossuti, Russuti,
Riuzuti or Ruseruti,
Filippo (possibly
identical with Filippo
Bizuti)
Italian, op.c.1300
RUSZCZYC, Ferdynand
Polish, 1870-1936
RUSZKOWSKI, Zdzislaw
Polish, 1907-
RUT, J. van der
Dutch, 18th cent.
RUTA or Rutta, Clemente
Italian, 1685-1767
RUTAULT, Claude
French, 20th cent.
RUTGERS, Abraham
Dutch, op.c.1660-1690
RUTHART, Carl Borromäus
Andreas
German, 1630(?)-p.1703
RUTHERFORD, A.
British, op.1775
RUTHERFORD, Alexander
American, 1826-1851
RUTHERFORD, Eric
British, 20th cent.
RUTHERFORD, Maud Hall
see Neale
RUTHERSTON or Rothenstein,
Albert Daniel
British, 1881-1953
RUTHS, Johann Georg
Valentin (Valentin)
German, 1825-1905
RUTLAND, Violet, Duchess
of (Marchioness of Granby),
(née. Lindsay)
British, 19th cent.
RUTLINGER, Johannes
British, op.c.1588-m.1609
RUTTA, Clemente
see Ruta
RUTTE, Antonius
German, op.1799
RUTTEN, Johannes
Dutch, 1809-1884
RUTTKAY, George
Hungarian, 1898-
RUUHINEN, Erkki
Finnish, 20th cent.
RUVIALLES, Roviale,
Ruvialles or Rubiales,
Francesco (Il Polidorino)
(not Rubiales, Pedro de)
Spanish, op.1527-1555

RUYSCH, Anna Elisabeth
(Anna Elisabeth
Hellenbroek)
Dutch, op.1685-1741
RUYSCH, Rachel (Rachel
Pool)
Dutch, 1664-1750
RUIJSCHER, Ruischer,
Ruycher, Ruysscher,
Rauscher, Rausscher,
Rousscher, etc.,
Johannes or Jan (Jonge
Hercules)
Dutch, c.1625-p.1675
RUYSDAEL or Ruijsdael
see Ruisdael
RUYTEN, Jan Michiel
Belgian, 1813-1881
RUYTENBACH, E.
Dutch, op.1683-1686
RUYTENSCHILDT, Abraham
Johannes
Dutch, 1778-1841
RUYTER, I. de
Dutch, 17th cent.
RUIJVEN, Reuven or
Ruyven, Pieter Jansz. van
Dutch, 1651-1716
RUZOLONE, Pietro
see Rozzolone
RUZZOLONE, Pietro
see Rozzolone
RYAN, Adrian
British, 1920-
RYAN, Anne
American, 20th cent.
RYAN, Charles J.
British, op.1885-1892
RYBACK, Issachar
Russian, 1897-
RYBKOWSKI, Tadeusz
Polish, 1848-1926
RIJCK, Cornelia de
(Cornelia van Goor
and Cornelia
Schijnvoet)
Dutch, 1656-p.1694
RYCK, J. van
Dutch, 17th cent.
RYCK, John de
Dutch, 17th cent.(?)
RIJCK or Ryck, Pieter
Cornelisz. van
Dutch, 1568-1628
RIJCK, Roelof van
Dutch, op.c.1650-1670
RYCK, Willem or
Guilliam de
Flemish, 1635-p.1713(?)
RYCKAERT or Rijckaert,
David, I
Netherlands, 1560-c.1607
RYCKAERT or Rijckaert,
David, II
Flemish, 1586-1642
RYCKAERT or Rijckaert,
David, III
Flemish, 1612-1661
RYCKAERT or Rijckaert,
Marten
Flemish, 1587-1631
RYCKE or Ryckere,
Abraham de
Netherlands, 1566-c.1599
RYCKE or Ryckere,
Bernaert de (Bernaert
van Rues)
Netherlands, c.1535-1590
RYCKEBUSCH or Ryckebus
French, op.1850-1872

RIJCKHALS or Ryckhals,
Frans
Dutch, op.1628-m.1647
RYCKX or Rycx, Lambert
or Lambert Ryck Aertsz.
(Robbesant)
Netherlands, op.1543-1572
RYD, Carl Magnus
Swedish, 1883-1958
RYDBERG, Gustaf
Fredrik
Swedish, 1835-1933
RIJDER, van
Netherlands, op.1682
RYDER, Albert Pinkham
American, 1847-1917
RYDER, Chauncey
Foster
American, 1868-1949
RYDER, Henry Orne
American, 19th cent.
RYDER, Platt Powell
American, 1821-1896
RYDER, R.
British, 19th cent.
RYDER, Thomas
British, 1746-1810
RIJK, James de
Dutch, 1806-1882
RYLAND, Miss
British, op.1841
RYLAND, Henry
British, 1856-1924
RYLAND, William
Wynne
British, 1732-1783
RYLANDER, Carl Isak
Swedish, 1779-1810
RYLEY or Riley,
Charles Reuben
British, c.1752-1798
RYLOFF, Arkadij
Alexandrowitsch
Russian, 1870-1939
RYMAN, Robert
American, 20th cent.
RIJMSDYCK, Andreas van
Dutch, op.1767-m.1786
RIJMSDYCK, Jan van
Dutch, op.c.1767-1778
RIJN, Reyn or Ryn,
Jan van (de)
Flemish, 1610-1678
RIJN or Rhijn,
Rembrandt Harmensz.
van
see Rembrandt
RIJN or Rhijn, Titus
Rembrandtsz. van
Dutch, 1641-1668
RYNE, Jan or Johannes
van
Dutch, c.1712-c.1760
RIJNENBURG, Reynenburg,
or Rynenburg, Nicolaas
Dutch, 1716-p.1784
RYNG, Pieter de
see Ring
RIJNVISCH or Rynvisch,
Evert
Dutch, 1590-1661
RYOTT, J.R.
British, op.1849
RYP, Abraham de
Dutch, c.1644-p.1705
RYSBRAECK, Geerard
Flemish, 1696-1773
RYSBRACK, John
Michael
Flemish, 1693-1770

RYSBRAECK, Ludovicus
Flemish, op.1716
RYSBRAECK, Pieter
Flemish, 1655-1729
RYSBRAECK, Pieter
Andreas
Flemish, 1690-1748
RYSBROECK, Jacob van
see Reesbroeck
RYSEN, Jan van
Dutch, 17th cent.
RYSEN, Ryssen or
Ryzen, Warnard van
Dutch, c.1625-p.1665
RYSSEL, Paul Van
(Docteur Gachet)
French, 1828-1909
RYSSELBERGHE, Théodore
(Théo) van
Belgian, 1862-1926
RYTTER, P.H.
Swiss, op.1607
RYZEN, Warnard van
see Rysen
RYZIKH, V.I.
Russian, 20th cent.
RZEPINSKI, Czeslaw
Polish, 1905-
RZYSKI, Antoni
Polish, 20th cent.

S

SA, Simplicio
Rodrigues de
Portuguese, op.1820-m.1830
SAAGMOLEN, Saeghmeulen,
Zaagmolen or
Zaegmolen, Martinus
Dutch, c.1620-1669
SAAL, Georg Eduard
Otto
German, 1818-1870
SAALBORN, Loe
see Zaalborn
SAAR, Alois von
German, 1779-p.1838
SAAR, Karl von
German, 1797-1853
SAARBURCK, Bartholomäus
see Sarburgh
SABAT, Manuel
French, 19th cent.
SABATELLI, Francesco
Italian, 1803-1829
SABATELLI, Gaetano
Italian, op.1842-1893
SABATELLI, Giuseppe
Italian, 1813-1843
SABATELLI, Luigi, I
Italian, 1772-1850
SABATELLI, Luigi, II
Italian, 1818-1899
SABATIER, Léon Jean
Baptiste
French, op.1827-m.1887
SABATINI or Sabbatini,
Andrea (Andrea da
Salerno)
Italian, c.1484-1530
SABATINI, Sabadini,
Sabattini or
Sabbatini, Lorenzo
(Lorenzino da Bologna)
Italian, c.1530-1576

SABATINI, Raphael
American, 1898-
SABATTE, Fernand
French, 1874-1940
SABATTIER, L.
French, 20th cent.
SABBAGH, Georges-
Hanna
Egyptian, 1877-1951
SABBATINI, Andrea
see Sabatini
SABBATINI or Sabadini,
Gaetano Il Mutolo
Italian, 1703-1732
SABBATINI, Lorenzo
see Sabatini
SABBIONETA
see Pisenti
SABEL
German, 19th cent.
SABLET, François
(Jean François) (Le
Romain)
Swiss, 1745-1819
SABLET, Jacques
French, 1749-1803
SABLOUKOFF, J.
Russian, 1735-1777
SABOURAUD, Emile
French, 1900-
SABRAN, Comtesse de
French, op.1779
SABRAN-PONTEVES, Eléazar
Charles Antoine Duc de
French, 1840-1894
SACCAGGI, Cesare
Italian, 1868-1934
SACCHETTI, Antonio
Italian, 1790-1870
SACCHETTI, Enrico
Italian, 1877-
SACCHETTI, Giotto
Italian, 19th cent.
SACCHETTI, Lorenzo
Italian, 1759-p.1830
SACCHETTO, Attilio
German, 1876-
SACCHI, Andrea
Italian, 1599-1661
SACCHI, Bartolomeo
Italian, 1892-
SACCHI, Carlo
Italian, 1616/7-1707
SACCHI, Gaspare
(Gaspare da Imola)
Italian, op.1517-1527
SACCHI da Pavia or
Pavese, Pier
Francesco
Italian, 1485-1528
SACCHIENSE, Il
see Pordenone
SACCO, Luigi
Italian, 17th cent.
SACCONI, Giovanni
Italian, 1648-1732
SACCONI, Giuseppe
Italian, op.1785-1800
SACHERI, Giuseppe
Italian, 1863-1950
SACHINIS, Nicos
Greek, 20th cent.
SACHS, Lambert
American, op.1854-1857
SACHS, Michael
German, 1836-1893

SACHSEN-TESCHEN,
Erzherzogin Maria
Christine
German, 1742-1798
SACHTLEVEN
see Saftleven
SACQUESPEE, Adrien
French, 1629-p.1688
SACRE, Emile
Belgian, 1844-1882
SADEE, Philip Lodewijk
Jacob Frederik
Dutch, 1837-1904
SADELER, Aegidius
Egidius or Gillis, II
Flemish, 1570-1629
SADLER, Johann or Jan, I
Netherlands, 1550-1600
SADELER, Johann or Jan, II
Flemish, op.1611-m.1665
SADELER, Marcus
Christoph
German, 1614-p.1650
SADELER, Raphael, I
Flemish,
1560/(?)61-c.1628/32
SADELER, Raphael, II
Flemish, 1584-1632
SADEWASSER, Daniel
German, op.1671
SADKOWSKY, Alex
Swiss, 1934-
SADLER, E.
British, 18th cent.
SADLER, Robert
British, 1909-
SADLER, Thomas
British, 1647(?)-1685(?)
SADLER, Walter Dendy
British, 1854-1923
SADLER, William, II
British, c.1782-1839
SADOWNIKOFF
Russian, op.1841
SAEDELEER, Valerius de
Belgian, 1867-1941
SAEGHMEULEN, Martinus
see Saagmolen
SAEISS, Jakob or
Jacques Ferdinand
see Saeys
SAEN or Zaen, Egidius
or Gilles de or van
Netherlands, op.c.1600
SAENREDAM, Sanredam
or Zaenredam, Jan
Pietersz.
Netherlands, 1565-1607
SAENREDAM or Zaenredam,
Pieter Jansz.
Dutch, 1597-1665
SAETTI, Bruno
Italian, 1902-
SAEYS, Saeiss, Saës,
Saey, Saiss etc., Jakob
or Jacques Ferdinand
Flemish, 1658-1725(?)
SAFFARO, Lucio
Italian, 1929-
SAFTLEVEN, Sachtleven
or Zachtleven, Abraham
Dutch, 1612/13-p.1646
SAFTLEVEN, Sachtleven
or Zachtleven, Cornelis
Dutch, 1607-1681

SAFTLEVEN, Sachtleven,
Saftleben, Saft-Leven
or Zachtleven, Herman
Hermansz.
Dutch, 1609-1685
SAFTLEVEN, Sara
(Sara Broers)
Dutch, op.1671
SAFVENBOM, Johan
see Sevenbom
SAGAN, Francoise
French, 20th cent.
SAGE, Kay
American, 1898-
SAGER, Hans
Norwegian, op.1700-1710
SAGER-NELSON, Olof
(Johan Olof Gudmund)
Swedish, 1868-1896
SAGEWKA, Ernst
German, 1883-1959
SAGIO or Zagio,
Lucano (Lucano da
Imola)
Italian, op.1519-1568
SAGLIO, Edouard
French, 1867-
SAGRESTANI, Giovanni
Camillo
Italian, 1660-1731
SAHLER, Louis or
Lewis
see Sailliar
SAHUT, Marcel
French, 1905-
SAID, Anne
British, 1914-
SAILER, Johann Georg
see Seiller
SAILLIAR, Sahler or
Saillar, Louis or
Lewis
French, 1748-1795
SAILMAKER or Sailmacker,
Isaac
Dutch, c.1633-1721
SAIN, Edouard
Alexandre
French, 1830-1910
SAÏN, Paul
French, 1853-1908
SAINAVE, Philippe-
Auguste
American, 20th cent.
SAINIO, Pertti
Finnish, 20th cent.
SAINT, Daniel
French, 1778-1847
SAINT-ALBAN, Michel de
French, 19th cent.
SAINT-ANDRE, Berthome
French, 20th cent.
SAINT-AUBIN, Augustin
French, 1736-1807
SAINT-AUBIN, Aurelie
Legrand de
French, 18th cent.
SAINT-AUBIN, Charles
Germain
French, 1721-1786
SAINT-AUBIN, Claude
Pougin de
see Pougin

SAINT-AUBIN, Gabriel
Jacques
French, 1724-1780
SAINT-AUBIN, Louis
Michel
French, 1731-1779
SAINT-AUBIN, Marie
Francoise
French, op.1769
SAINT-AULAIRE, Félix
Achille Beaupoil
French, 1801-p.1838
SAINT-DELIS, René de
French, -1949
SAINT-EVRE, Gillot
French, 1791-1858
SAINT-FAR or Saint-Phar,
Eustache
French, 1746-1822
SAINT-GERMAIN, Madame
Gault de
see Rajecka
SAINT-GERMIER, Joseph
French, 1860-1925
SAINT-IGNY, Jean de
French, c.1600-1649
SAINT-ILAIRE
French, 18th cent.
SAINT-JEAN, J. Dieu de
French, op.1695
SAINT-JEAN, Paul
French, 1842-1875
SAINT-JEAN, Simon
French, 1808-1860
SAINT-JOIRE, Jehan de
French, 19th cent.
ST. JOHN, E.
British, 19th cent.
ST. JOHN, G.F.
British, op.1803
SAINT-LANNE, Georges
French, op.c.1878
SAINT-MAL, J.
French, op.1790
SAINT-MARCEL, Edmé
(E. Charles Cabin)
French, 1819-1890
SAINT-MARCEL, Emile
Norman (Normand)
French, 1840-
SAINT-MEMIN or Saint-
Mesmin, Charles
Balthazar Julien
Févret de
French, 1770-1852
SAINT-NON, Richard
Jean Baptiste Claud,
Abbé de
French, 1727-1791
SAINTON, Charles P.
British, 1861-1914
SAINT-OURS, Jean
Pierre Paul
Swiss, 1752-1809
SAINT-PAUL, Saint-Pol
or Simpol, Claude
French, c.1666-1716
SAINT-PHALL, Niki de
see Mathews
SAINT-PIERRE or
Saintpierre, Gaston
Casimir
French, 1833-1916
SAINT-POL, Claude
see Saint-Paul

SAINT-QUENTIN, Jacques
Philippe Joseph de
French, 1738-p.1780
SAINT-YVES, Pierre de
French, 1666-1716
SAINTHILL, Loudon
Australian, 1918-1969
SAINTIN, Henri
French, 1846-1899
SAINTIN, Jules Emile
French, 1829-1894
SAINZ y Sainz,
Casimiro
Spanish, 1853-1898
SAINZ, Gumersind
Spanish, 1904-1974
SAISS, Jakob or
Jacques Ferdinand
see Saeys
SAIVE, Sayve, De Saive,
Le Saive or Le Save,
Jan Baptist (Jean
de Namur)
Flemish, c.1540-1624
SAJDAK, Jerzy
Polish, 20th cent.
SAKATA, Kadzut
Japanese, 20th cent.
SAKHAROV, Alexandre
Russian, 20th cent.
SAKHAROV, Piotr
Sakharovitch
Russian, 1816-1852
SALA, Eliseo
Italian, 1813-1879
SALA y Frances,
Emilio
Spanish, 1850-1910
SALA, Giosuè
Italian, op.1799
SALA, Jean
French, 20th cent.
SALA, Juan
Spanish, 1895-
SALA, Paolo
Italian, 1859-1924
SALA, Vitale
Italian, 1803-1835
SALABOSS, Melchior
British(?), op.1588
SALAINO, Andrea
see Salaj
SALAJ (Gian Giacomo
de' Caprotti) (Andrea
Salaino or Andrea da
Salerno)
Italian, c.1480-a.1524
SALAMANCA, Antonio
Italian, c.1500-1562
SALANDRINO da Venzone,
Giulio
Italian, 15th cent.
SALANSON, Eugénie Maria
French, op.1864
SALATHE, Friedrich
Swiss, 1793-1858
SALBREUX, P.
see Perin, Lie Louis
SALCI, Gabriele
Italian, op.1713-1716
SALDANA, Il Pescador
Spanish, 19th cent.
SALDÖRFFER, Conrad
German, op.1562-1583

SALEN, Radeaa
(Sarief Bastaman)
British, 1814-1880
SALEMAN
British, 17th cent.
SALEMBIER, Henri
see Sallembier
SALEMME, Attilio
American, 1911-1955
SALENTIN, Hubert
German, 1822-1910
SALERNO di Coppo
Pistoia
see Coppo di Marcovaldo
SALERNO di Coppo di
Marcovaldo
see Coppo di Marcovaldo
SALES, Carl von
German, 1791-1870
SALES, Francisco
American, 20th cent.
SALESA, Buenaventura
Italian, 1756-1819
SALGADO, Demetrio
Portuguese, 20th cent.
SALGADO, José
see Velloso-Salgado
SALIETTI, Alberto
Italian, 1892-
SALIMBENE di Girolamo
da Pupiglio
Italian, op.1550
SALIMBENI, Arcangelo
di Leonardo
Italian, op.1567-1580/9
SALIMBENI or di
Salimbene, Lorenzo, I
(San Severino)
Italian, c.1374-a.1420
SALIMBENI, Lorenzo, II
see Lorenzo d'Alessandro
da Severino
SALIMBENI, Simondio
Italian, 1597-1643
SALIMBENI, Ventura di
Arcangelo (Bevilacqua)
Italian, 1567/8-1613
SALINAS y Teruel, Augustin
Spanish, 1862-
SALINAS, Juan Pablo
(Pablo)
Spanish, 1871-
SALINI, Salinas or
Solini, Cavaliere
Tommaso (Mao)
Italian, c.1575-c.1625
SALIS, Carl Albert von
German, 1886-1941
SALIS, Carlo
Italian, 1680-1763
SALISBURY, Frank O.
British, 1874-1962
SALISBURY, J.
British, op.1783-1784
SALISTEANU, Ion
Rumanian, 1929-
SALLAERT or Sallaerts,
Anthonis
Flemish, c.1590-c.1657/8
SALLAMBIER, Henri
see Sallembier
SALLEE, G. de la
see La Sallée
SALLEMBIER, Salembier
or Sallembier, Henri
French, c.1753-1820

SALLES, Francis
American, 1928-
SALLES, Jules
French, 1814-1898
SALLIETH, Mathias de
Czech, 1749-1791
SALLINEN, Tyko
Konstantin
Finnish, 1879-1955
SALM, Adriaan (van der)
Dutch, op.1708-m.1720
SALM, Reynier van
Dutch, 1688-1765
SALMEGGIA, Enea
(Il Talpino)
Italian, 1550(?)-1626
SALMELAINEN, Tapio
Finnish, 20th cent.
SALMERO, Juan Sanches
Spanish, 16th cent.(?)
SALMERON, Cristóbal
Garcia y
Spanish, c.1603-1660
SALMON
British, 19th cent.
SALMON, Balliol J.
British, 1868-1953
SALMON, Gabriel
French, op.1504-1542
SALMON, John Cuthbert
British, 1844-1917
SALMON, John Francis
British, 1808-1886
SALMON or Salomon,
Robert
British, c.1775-c.1842
SALMSON, Hugo Fredrik
Swedish, 1843-1894
SALNAVE, Philippe-
August
Haitian, 1908-
SALOMAN or Salomon,
Geskel
Swedish, 1821-1902
SALOME, Anthony de
British, op.1860
SALOME, Emile
French, 1833-1881
SALOMON von Danzig
German, op.1677-1691
SALOMON, Benett
(Benedict)
Russian, -1810
SALOMON, Bernard
(Le Petit Bernard
or Bernardus Gallus)
French, 1506/10-c.1561
SALOMON, Jacques
French, 20th cent.
SALOMON, Joseph
German, op.1822-1844
SALT, Henry
British, 1780-1827
SALT, John
British, 19th cent.
SALT, John
British, 1937-
SALTARELLO, Luca
Italian, 1610-1655(?)
SALTER, Elisabeth Ann
American, op.1810
SALTER, King
British, op.1882
SALTER, William
British, 1804-1875

SALTINI, Pietro
 Italian, 1839-1908
SALTONSTALL or
 Salstonstall, R.
 British, 18th cent.
SALTZMANN, Carl
 German, 1847-1923
SALUCCI or Saluzzi,
 Alessandro (Il
 Salviosse)
 Italian, op.1648
SALUCCI, Giovanni
 Italian, 1769-1845
SALUZZO, Cesare da
 see Cesare di
 Piemonte
SALVADOR, Ruiz, Juan
 Spanish, op.1671-1704
SALVADOR CARMONA, Luis
 Spanish, 1709-1767
SALVADOR CARMONA,
 Manuel
 Spanish, 1734-1820
SALVADOR GOMEZ,
 Vicente
 Spanish, 1645(?)-1698(?)
SALVADORI, Aldo
 Italian, 1905-
SALVADORI, Marcello
 Italian, 20th cent.
SALVAT, François
 Martin
 French, 1892-
SALVATORE, Anna
 Italian, 1917-
SALVATORELLO
 see Olivieri, Salvatore
SALVENDY, Frieda
 German, 1887-
SALVESTRINI, Bartolomeo
 Italian, -1630
SALVI, Giovanni
 Battista
 see Sassoferrato
SALVI, Nicola
 Italian, 1697-1751
SALVI, Tarquinio
 Italian, op.1593-1609
SALVIATI, Francesco
 (Cecchino)
 (Francesco de' Rossi)
 Italian, 1510-1563
SALVIATI, Giuseppe
 (Porta)
 Italian, c.1520-c.1575
SALVIOSSE, Il
 see Salucci,
 Alessandro
SALVINI, Salvino
 Italian, 1824-1899
SALVO di Antonio da
 Messina (Gian Salvo)
 Italian, op.c.1493-1525
SALY or Sailly, Jacques
 François Joseph
 French, 1717-1776
SALZEDO, Paul Elie
 French, -1910
SALZER, Friedrich
 German, 1827-1876
SALZMANN, Gottfried
 German, 1943-
SAM, Engel
 Dutch, 1699-1769

SAMACCHINI, Sammacchini,
 Somacchini or
 Sannacchini (not
 Fummaccini), Orazio
 Italian, 1532-1577
SAMARAS, Lucas
 Greek, 1936-
SAMBACH, Caspar Franz
 German, 1715-1795
SAMBACH, Johann
 Christian (Christian)
 German, 1761-1797
SAMBAT, Jean-Baptiste
 French, c.1760-1827
SAMBELL
 British, 19th cent.
SAMBERGER, Leo
 German, 1861-1949
SAMBIN, Hugues
 French, 1515/20-1601/2
SAMBOURNE, Linley
 British, 1845-1910
SAMFLETH, Anthonius
 Swedish, op.1576
SAMHAMMER or Samheimer,
 Johann Jakob
 German, 1728-1787
SAMHEIMER, Johann
 Jakob
 see Samhammer
SAMIMI, Reza
 Italian, 20th cent.
SAMIRAJLO, Viktor
 Dimitrievitch
 (or Zamirailo)
 Russian, 1868-
SAMMOCCHINI
 see Samacchini
SAMOKHVALOV, A.N.
 Russian, 20th cent.
SAMOKICH, Nicolai
 Semionovich
 Russian, 1860-
SAMOSTRZELNIK,
 Stanislas
 Polish, 16th cent.
SAMPENS, F. de
 Polish, 17th cent.
SAMPLE, Paul Starrett
 American, 1896-
SAMPSON
 British, op.1597
SAMPSON, Thomas
 British, op.1838-1853
SAMUEL, George
 British, op.1785-1823
SAMUEL, Richard
 British, op.1772-1785
SANCASCIANI
 see Gherardi, Filippo
SANCHEZ d'Avila,
 Andres
 Spanish, 1701-1762
SANCHEZ de Guadalupe,
 Anton (not Juan)
 Spanish, op.1487-m.1506
SANCHEZ, Diego
 Spanish, 15th cent.
SANCHEZ, Josefa
 Spanish, op.1639
SANCHEZ, Juan
 (possibly identified
 with Juan Sanchez
 Izquierdo)
 Spanish, 15th cent.

SANCHEZ de Castro,
 Juan
 Spanish, op.1454-1484
SANCHEZ de Guadalupe,
 Juan
 see Sanchez de
 Guadalupe, Anton
SANCHEZ de Guadalupe,
 Miguel
 Spanish, op.1505-1530
SANCHEZ, Pedro
 Spanish, op.1454-1480
SANCHEZ, Pedro
 Spanish, op.c.1500
SANCHEZ-COELLO, Alonso
 Spanish, 1531/2-1588
SANCHEZ-COELLO, Isabel
 (Madame de Herrera)
 Spanish, 1564-1612
SANCHEZ COTAN, Fray
 Juan
 Spanish, 1561(?)-1627
SANCHEZ-PERRIER, Emilio
 Spanish, 1855-1907
SAN CLEMENT, José
 Rodriguez
 Spanish, 20th cent.
SANCTIS, Guglielmo De
 Italian, 1829-1911
SANCTIS, Orazio de
 Italian, 16th cent.
SANCTUS di Venetiis,
 Fra
 Italian, 1571-1609
SAND, George, (née Dupin)
 (Aurore Amantine
 Lucile)
 French, 1804-1876
SAND, Jean François
 Maurice (Devant)
 French, 1823-1889
SANDARS or Sanders,
 George (not G.L.
 Saunders)
 British, 1774-1846
SANDBACK, Frederick
 Laue
 American, 20th cent.
SANDBERG, Einar
 Norwegian, 1876-
SANDBERG, Johann Gustaf
 Swedish, 1782-1854
SANDBERG, Ragnar
 Swedish, 1902-
SANDBY, Paul
 British, 1725-1809
SANDBY, Thomas
 British, 1721-1798
SANDBY, Thomas Paul
 British, op.1791-1811
SANDE, Sanden or Zande,
 Jan van de
 Dutch, 17th cent.
SANDELS, Gösta
 (Adrian Gösta Fabian)
 Swedish, 1887-1919
SANDER, Ludwig
 American, 20th cent.
SANDERS ALEXANDER van
 Brugsal
 see monogrammist S
SANDERS, F.
 British, op.1772
SANDERS, George
 see Sandars

SANDERS, Gerard
 Dutch, 1702-1767
SANDERS, Hercules
 Dutch, 1606-p.1673
SANDERS, Jan
 see Hemessen
SANDERS, John
 British, 1750-1825
SANDERS, Susan
 British, 20th cent.
SANDERS, T.
 British, op.1783
SANDERS or Sandars,
 Thomas
 British, op.1775-1781
SANDERSON, Douglas
 American, 20th cent.
SANDERSON, E.
 British, 19th cent.
SANDERSON, Robert
 British, 19th cent.
SANDERSON-WELLS, John
 British, 20th cent.
SANDFORD, W.
 American, 19th cent.
SANDHAAS or Sandhas,
 Karl
 German, 1801-1859
SANDHAM, J. Henry
 Canadian, 1842-1912
SANDLE, Michael
 British, 1936-
SANDOL, Ulysse
 see Sandoz
SANDOZ, Alfred
 Swiss, 1882-
SANDOZ or Sandol,
 Ulysse
 Swiss, c.1788-1815
SANDOZ-ROLLIN, David
 Alphonse, Baron de
 Swiss, 1740-1809
SANDRART, Jakob von
 German, 1630-1708
SANDRART, Joachim, I von
 German, 1606-1688
SANDRART, Johann or Jan
 van
 German, p.1610-p.1679
SANDRART, Johann Jakob
 von
 German, 1655-1698
SANDRART, Lorenz von
 German, c.1682-1753
SANDRART, Susanne
 Maria
 German, 1658-1716
SANDREUTER, Hans
 Swiss, 1850-1901
SANDRINO, Tommaso
 Italian, 1575-1630
SANDROCK, Leonhard
 German, 1867-1945
SANDS, Ethel
 British, 1873-1962
SANDS, Roberts
 British, 1792-1855
SANDYS, Anthony
 British, 1806-1883
SANDYS, Anthony
 Frederick Augustus
 (Frederick)
 British, 1829-1904
SANDYS, Emma
 British, 1834-1877

SANE, Jean Francois
French, c.1732-1779
SANEJOUAND, J.M.
French, 20th cent.
SANESE, Riccio
see Neroni
Bartolommeo
SANESI, Nicola
Italian, 1818-1889
SANFELICE, Ferdinando
Italian, 1675-1748
SANFORD, C.T.
American, op.1845
SAN FRIANO, Tommaso
da
see Maso
SANG, F.J.
French, 19th cent.
SANGALLO, Antonio da
Italian, 1455-1534
SANGALLO, Bastiano da
(Aristotile)
Italian, 1481-1551
SANGALLO, Battista da
(Il Gobbo) (Cordiani)
Italian, 1496-1552
SANGALLO, Francesco da
(Il Margotta)
Italian, 1494-1576
SANGALLO, Giuliano da
Italian, 1445-1516
SANGSUE
American, 20th cent.
SANGUINETTI, Giovanni
Italian, 1789-1867
SANI, Alessandro
Italian, 19/20th cent.(?)
SANI, Domenico Maria
Italian, 1690-1772
SAN LEOCADIO, Paolo da
see Paolo da San
Leocadio
SAN MIGUEL, Roger
Mexican, 20th cent.
SANNACCHINI, Orazio
see Samacchini
SANO, Dino di
Italian, 15th cent.
SANO di Pietro
(Ansano di Pietro di
Mencio)
Italian, 1406-1481
SANQUIRICO, Alessandro
Italian, 1777-1849
SANQUIRICO, Pio
Italian, 1847-1900
SANREDAM, Jan
see Saenredam
SANS, Domingo
Spanish, op.1476-1482
SAN SEVERINO
see Severino
SANSOM, Joseph
American, op.1811
SANSOM, L. Charles
British, op.1870-1871
SANSONE
see Argento, Giovanni
Antonio Dianti dall')
SANSONE
see Marchesi, Giuseppe
SANSOVINO, Andrea
(Andrea dal Monte San
Savino) (Contucci)
Italian, c.1460-1529
SANSOVINO, Jacopo Tatti
Italian, 1486-1570

SANSOVINO, Lorenzo da
Italian, 16th cent.
SANT, James
British, 1820-1916
SANT-ACKER, F.
Dutch, op.1668
SANTA CROCE, Francesco,
II, di Bernardo de,
Vecchi or de' Galizzi
(Francesco Rizzo da
Santa Croce)
Italian, a.1490-p.1548
SANTACROCE, Francesco I
di Simone de
Italian, 1440/5-1508
SANTACROCE, Francesco
III da
Italian, 1516-1584
SANTACROCE, Girolamo da
Italian, op.1503-m.1556
SANTACROCE, Pietro Paolo
da Rizzo
Italian, op.1584-m.a.1620
SANTA CRUZ
Spanish, -1508
SANTAFEDE, Fabrizio
Italian, op.1576-p.1628
SANTAGOSTINO, Agostino
Italian, op.1671-m.1706
SANTAGOSTINO, Giacinto
Italian, op.1624-1674
SANTARELLI, Gaetano
Italian, 18th cent.
SANTA ROSA, Tomás
Brazilian, 1909-1956
SANTBERGEN, Jerry
Canadian, 1942-
SANT'ELIA, Antonio
Italian, 1888-1916
SANTEN, Gerrit van
Dutch, op.1629-1650
SANTERRE, Jean-Baptiste
French, 1651-1717
SANTERRE, Jeson de
French, op.1740
SANTESE, Vincenzo or
Cinzio
Italian, op.1497-1501
SANTHEUVEL, H. van der
Dutch, op.1760
SANTI, Domenico
(Mengazzino or
Mingazzino)
Italian, 1621-1694
SANTI or Sanzio,
Giovanni
Italian, c.1435(?)-1494
SANTI, Giovanni Battista
(della Lavandara)
Italian, -1732
SANTI, Giovanni Giuseppe
Italian, 1644-1719
SANTI, Raffaello
see Raphael
SANTI di Tito
Italian, 1536-1603
SANTINI, Niccolò
Italian, op.1554-1570
SANTINO
see Cattaneo, Santo
SANTO, Santi or Sante,
Pietro
see Bartoli
SANTOMASO, Giuseppe
Italian, 1907-
SANTORI, Giacomo
(Siculo)
Italian, op.1524-1544

SANTORO, Francesco
Raffaello
Italian, 1844-.
SANTORO, Rubens
Italian, 1859-1942
SANTOS, Ambrosio de
los
Spanish, op.a.1736
SANTURINI, Francesco
Italian, 1627-1682
SANTVOORT, Abraham
Dircksz.
Dutch, op.1636-m.1669
SANTVOORT or Zantvoort,
Dirck Dircksz. (van)
(Bontepaert)
Dutch, 1610/11-1680
SANTVOORT, Philippus
van
Flemish, op.1711-1722
SANTVOORT or Zantvoort,
Pieter Dircksz. (van)
(Bontepaert)
Dutch, p.1603-1635
SANUTO, Giulio
Italian, op.1540-1580
SANZ, Bernhard Lucas
German, c.1650-p.1710
SANZ, Eduardo
Spanish, 1928-
SANZ Y Checa, Ulpiano
Spanish, 19th cent.
SAPUNOV, Nikolai
Russian, op.1910
SARABIA, José de
Spanish, 1608-1669
SARACENI, Carlo
(Carlo Veneziano)
Italian, 1585-1620
SARACENI, Pensionante
del
Italian, 17th cent.
SARACHI, Chatin
Spanish, 20th cent.
SARACIN
see Quellinus,
Hubertus
SARAGA-MAXY, Mimi
Rumanian, 1923-
SARANENA
see Zarinena
SARASIN
see Sarazin
SARAZIN, Sarasin or
Sarrazin, Jacques I
French, 1592-1660
SARAZIN or Sarrazin,
Jean Baptiste
French, op.1740-1793
SARAZIN, Jean Philippe
French, -c.1795
SARAZIN de Belmont,
Louise Joséphine
see Belmont
SARBURGH, Sarburg or
Saarburck, Bartholomäus
or Bartolomé
(Trevirensis)
German, c.1590-p.1637
SARDAGNA, Lodovico
Italian, op.1647-1660
SARDI or Sarri, Gaetano
Italian, 18th cent.
SARDINIAN SCHOOL,
Anonymous Painters
of the

SARGANT, Mary
see Florence
SARGENT, Frederick
British, op.1834-m.1899
SARGENT, G.F.
British, op.c.1842-1851
SARGENT, Henry
American, 1770-1845
SARGENT, John Singer
American, 1856-1925
SARIAN, Martiros
Russian, 1880-
SARINENA
see Zarinena
SARJANKO, Sergei
Konstantinovitch
see Zarianko
SARJENT, Charles
British, 19th cent.
SARJENT, F.J.
British, op.c.1790-1803
SARJENT or Serjent,
G.R.
British, op.1811-1849
SARLUIS, Leonard
French, 1874-1949
SARMENTO, Visconte
Georgio de Moraes
Italian, 1866-1922
SARNELLI, Antonio
Italian, op.1742-1793
SARNELLI, Giovanni
Italian, op.1742-1793
SARNYENA
see Zarinena
SAROFINI da Perosia,
Baldo de
Italian, 15th cent.
SARP, Gerda Ploug
(née Sorensen)
Danish, 1881-
SARRABAT, Isaac
French, 1667-
SARRABAT, M.F.
French, op.1738(1758?)
SARRAGON, Joannes
Dutch, op.1621-1644
SARRAZIN
see Sarazin
SARRI, Gaetano
see Sardi
SARRIA, Gonzalo
see Perez
SART, Cornelis du
see Dusart
SARTAIN, William
American, 1843-1924
SARTHOU, Maurice E.
French, 1911-
SARTO, Andrea del
see Andrea
SARTORELLI, Francesco
Italian, 1856-
SARTORI, Felicita
see Hoffmann
SARTORIO, Giulio
Aristide (Aristide)
Italian, 1860-1932
SARTORIUS, C.J.
British, op.1810-1821
SARTORIUS, Francis, I
British, 1734-1804
SARTORIUS, Francis, II
British, c.1777-p.1808
SARTORIUS, J.F.
British, c.1775-c.1830

SARTORIUS, Johann
Christof
German, op.1680-1739
SARTORIUS, John I
British, 1700(?)-c.1780
SARTORIUS, John Nost
British, 1759-1828
SARU, Gheorghe
Rumanian, 1920-
SARULLO, P.
Italian, 18th cent.
SARVIDONIA
Italian, op.1781
SARZANA, Il
see Fiasella, Domenico
SASSE or Sass,
Richard
British, 1774-1849
SASSENBROUCK, Achille
van
Belgian, 1886-
SASSETTA, Stefano di
Giovanni
Italian, 1392-1450
SASSI, Giovanni Battista
Italian, op.1713-1747
SASSOFERRATO, Giovanni
Battista Salvi
Italian, 1605-1685
SASSU, Aligi
Italian, 1912-
SATA or Baera, Nils H.
Norwegian, op.1827
SATLER
see Sattler
SATLER, Johann Michael
see Sattler
SATO, Kei
Oriental, 1906-
SATORSKY, Cyril
British, 20th cent.
SATRAPITANUS, Heinrich
see Master of the
Martyrdom of St. Erasmus
SATTLER, Caroline
see Tridon
SATTLER, Hubert
German, 1817-1904
SATTLER, J.
German, 20th cent.
SATTLER or Satler,
Johann Michael
German, 1786-1847
SATTLER or Sadler,
Josef Ignaz
German, 1725-1767
SATURNO, Camille
French, 16th cent.
SAUAGE, Reginald
British, 19th cent.
SAUBER, Robert
British, 1868-1936
SAUBES, Léon Daniel
French, 1855-1922
SAUCKEN, Ernst von
German, 1856-
SAUERLAND, Philipp
German, 1677-1762
SAUERWEID, Alexander
Iwanowitsch
Russian, 1783-1844
SAUFFEN, van der
Dutch(?), 18th cent.

SAUL, Paul
American, 1934-
SAULEY of Farnham, G.
British, op.1806
SAUNDERS, Christina
see Robertson,
Christina
SAUNDERS, David
British, 1936-
SAUNDERS, George
Lethbridge
(not G. Sandars)
British, 1807-1863
SAUNDERS, Helen
British, 1885-1963
SAUNDERS, John
see Sanders
SAUNDERS, Joseph I
British, op.1772-1808
SAUNDERS, Matthew
British, op.1730-1765
SAUNDERS, Raymond
American, 20th cent.
SAUNIER, M.
French, op.c.1910
SAUNIER, Noel
French, 1847-1890
SAUNIER, Octave Alfred
French, op.1865-1889
SAUR, Corbinian
German, op.c.1590-m.1635
SAUR, Hans Rudolph
Swiss, 16th cent.
SAURA, Antonio
Spanish, 1930-
SAURINES, Félix
French, op.c.1800
SAURL, H.
Dutch(?), 17th cent.
SAURLAY, Jerome
see Sourley
SAUSSURE, Eric de
French, 20th cent.
SAUTAI, Paul Emile
French, 1842-1901
SAUTER, Georg
German, 1866-1935
SAUTEREAU, Jean
French, 17th cent(?)
SAUTOY, Jacques Léon du
see Dusautoy
SAUTS, D. or T.
see Smits, Casparus
SAUTTER, Jo. (Johann?)
Swiss, op.1745
SAUVAGE, Jean Pierre
Armand (Pierre)
French, 1821-1883
SAUVAGE, Piat Joseph
Flemish, 1744-1818
SAUVAIGE, Louis Paul
French, 1827-1885
SAUVAN, M.
French, op.1821
SAUVAN, Philippe
French, 1695/8-1789
SAUVE, Jean
French, op.c.1660-1691
SAUX, Mme. Jules de
see Browne, Henrietta
SAUZAY, Adrien Jacques
French, 1841-1928
SAUZEAU, Hubert
French, 20th cent.
SAVAGE, A.J.
American, op.1845

SAVAGE, A. Raffaello
Italian, 18th cent.
SAVAGE, Edward
American, 1761-1817
SAVAGE, Eugene Francis
American, 1883-
SAVAGE, John
British, op.1680-1700
SAVARDO, Dino
Italian, 20th cent.
SAVARY, Robert
French, 1920-
SAVAZZINI, Antonio
Italian, 1766-1822
SAVELBERGEN, C.H.
Dutch, op.c.1620
SAVELLI, Angelo
Italian, 1911-
SAVERY, Jacob or
Jacques Jacobsz., I
Flemish, op.1591-m.1602
SAVERY, Jacob or
Jacques Jacobsz., II
Flemish, c.1593-c.1627
SAVERY, Jan or Hans
Flemish, 1597-1654
SAVERY or Saveri, Jan
Baptist
see Xavery
SAVERY, Pieter
Dutch, op.1593-1637
SAVERY or Saverij,
Roelandt Jacobsz.
Flemish, 1576(?)-1639
SAVERY or Savry,
Salomon Jacobsz.
Dutch, 1594-p.1665
SAVERYS, Albert
Belgian, 1886-1964
SAVIGNAC, Lioux de
see Lioux
SAVIGNAC, Louis de
French, 1734-p.1759
SAVILL
British, op.1661-1662
SAVILLE, William
American, op.1801
SAVIN, Maurice
French, 1894-
SAVINE, Léopold Pierre
Antoine
French, 1861-
SAVINE, Nazaire
see Sawin, Nikifor
SAVINI, Alfonso
Italian, 19th cent.
SAVINIO, Alberto
Italian, 1891-1952
SAVITSKY, Konstantin
Apollonovitch
Russian, 1845-1905
SAVOLDO, Giovanni
Girolamo
Italian, a.1480(?)-p.1548
SAVOLINI, Cristoforo
Italian, op.1650-1680
SAVONANZI, Emilio
Italian, 1580-1660
SAVORETTI, Giovanni di
Giuliano
*see*Giovanni da Oriolo
SAVORY, Thomas C.
American, op.1837-1852
SAVOURNIN
French, op.1767-1778

SAVOY, Savoye or
Savoyen, Carel van
Flemish, c.1621-1665
SAVOY, Savoye or
Savoyen, Philip or
Filips van
Flemish, c.1630-1664
SAVOYE, Daniel de
French, 1654-1716
SAVREUX, Maurice
French, 1884-
SAVRIJ, Hendrik
Dutch, 1823-1907
SAWICHI, Adolf
German, 19th cent.
SAWIN or Savine,
Nikifor or Nazaire
Russian, op.c.1610-1620
SAWITZKY, K.
Russian, 19th cent.
SAWOSTIUK, Oleg
Russian, 20th cent.
SAWRASSOW, Alexei
Konratjevich
Russian, 1830-1897
SAWYER, Amy
British, 19th cent.
SAWYER, Frederick
British, op.1838-1841
SAWYER, R.
British, op.1820-1830
SAXE, Martial de
see Marzal
SAXON, James
British, op.1795-1828
SAXONE
Italian(?) op.1723
SAY, Frederick Richard
British, op.1827-1854
SAY, William
British, 1768-1834
SAYEN, H. Lyman
American, 1875-1918
SAYER or Sayers,
James
British, 1748-1823
SAYER, Robert
British, op.1750-1780
SAYERS, Reuben T.W.
British, 1815-1888
SAYVE, Jan Baptist
see Saive
SCABUO, Luca
see Scalvo
SCACCIATI, Andrea
Italian, 1642-1710
SCACCIERA, Scacceri,
Scaccierare or
Scazeri, Giovanni
Antonio (Il Frate)
Italian, op.1502-1524
SCACCO or Scaccho,
Cristoforo
Italian, op.1499
SCACKI, Francisco
American, op.1815
SCAFFAI, Luigi
Italian, 1837-
SCAGLIA, Girolamo
(Il Parmigianino)
Italian, op.1657-m.1686
SCAGLIA, Leonardo
Italian, op.1640-1650
SCAGNIA MIGLO, G.
Italian, 16th cent.

SCAIARO or Scajario,
Antonio (Bassano)
(da Ponte)
Italian, 1586-1630
SCAJARIO
see Scaiaro
SCALA, Vincenzo
Italian, 19th cent.
SCALABRINO, Lo
see also Anselmi,
Michelangelo
SCALABRINO or
Scalatrino, Lo
(Scalabrinus
Pistoriensis)
Italian, 16th cent.
SCALATRINO, Lo
see Scalabrino
SCALBERGE, Scall Berge
or Schallberge, Pierre
French, c.1592-1640
SCALBERT, Jules
French, 1851-p.1901
SCALETTI, Leonardo I
Italian, op.1457-1487
SCALETTI, Sebastiano
Italian, op.1503-1559
SCALF, Wilhelm
Dutch, op.1751
SCALL BERGE, Pierre
see Scalberge
SCALVO, Luca
Italian, op.1450-1500
SCALZA or Scalzi,
Lodovico
Italian, op.1548-1578
SCALZI, Alessandro
see Paduano
SCALZI, Lodovico
see Scalza
SCAMINOZZI, Raffaello
see Schiaminossi
SCANAVINO, Emilio
Italian, 1922-
SCANDRETT, Thomas
British, 1797-1870
SCANLAN, J.
British, op.1730
SCANLAN, Robert Richard
British, op.1826-p.1876
SCANNABECCHI
see Lippo di Dalmasio
SCANNELL, Edith
British, op.1870-1903
SCAPARRA, Pedro
Spanish, op.1446
SCARABELLI, Orazio
Italian, op.c.1589
SCARAMUCCIA, Giovanni
Antonio
Italian, 1580-1633
SCARAMUCCIA, Luigi
(Perugino)
Italian, 1616-1680
SCARAMUZZA, Francesco
Italian, 1803-1886
SCARBOROUGH, John
American, op.c.1830
SCARBOROUGH, William
Harrison
American, 1812-1871
SCARFE, Gerald
British, 1936-
SCARPAZA, Vittore
see Carpaccio

SCARSELLA, Ippolito
(Scarsellino or
Scarsellini)
Italian, 1551-1620
SCARSELLI, Alessandro
Italian, 1684-1773
SCATTAGLIA, Pietro
Italian, 18th cent.
SCATTOLA, Domenico
Italian, 1814-1873
SCATTOLA, Ferruccio
Italian, 1873-
SCAVEZZI
see Bresciano, Prospero
SCAZERI
see Scacciera
SCEDRIN, S.F.
see Schtschedrin
SCERNIER, Cornelis
van Coninxloo
see Coninxloo
SCHAAK, J.S.C.
British, op.1761-1769
SCHAAL, Louis Jacques
Nicolas
French, 1800-p.1859
SCHAAN, Paul
French, op.1892-1903
SCHAAP, Hendrik
Dutch, 1878-1955
SCHAASBERG, Simon
Dutch, op.1779-1794
SCHAB, P.
Dutch(?), 17th cent.
SCHACHINGER, Gabriel
German, 1850-1912
SCHACHNER, Therese
German, 1869-
SCHACK, Sophus Peter
Lassenius
Danish, 1811-1864
SCHAD, Christian
German, 1894-
SCHADE, Rudolf Christian
German, 1760-1811
SCHADE, Wilhelm
German, 1859-
SCHADOW, Johann Gottfried
(Gottfried)
German, 1764-1850
SCHADOW, Wilhelm Friedrich
(Wilhelm)
German, 1788-1862
SCHAD-ROSSA, Paul
German, 1862-1916
SCHAECK, Cornelis
Dutch, op.1657-1663
SCHAECKEN
Dutch, op.1614
SCHAEFELS, Hendrik
Frans or Henri François
Belgian, 1827-1904
SCHAEFELS, Lucas Victor
Belgian, 1824-1885
SCHAEFFER, Carl Fellman
Canadian, 1903-
SCHAEFFER, August
German, 1833-1916
SCHAEFFER, Carl
German, op.1812-1833
SCHAEFFER, Johann
Evangelist
see Scheffer
SCHAENBORGH, Pieter van
see Schaeyenborgh
SCHAEP, Hendrik Adolf
Dutch, 1826-1870

SCHAERAERD, J.E.
Netherlands, op.1665
SCHAETZELL, Johann Baptist
German, 1763-p.1800
SCHAEYENBORGH, Schaenborgh,
Schayenborgh,
Schaffenburg etc.,
Pieter van
Dutch, op.1635
SCHÄFER, Heinrich
German, c.1815
SCHÄFER, Henry Thomas
British, op.1873-1915
SCHÄFER, Hermann
German, 19th cent.
SCHAFFENBURG, Pieter van
see Schaeyenborgh
SCHÄFFER, Adalbert
(Bela)
German, 1815-1871
SCHAFFER, Gustav Adolph
German, 1881-1937
SCHAFFER, Hans Jacob
German, -1662
SCHAFFER, Joseph
German, op.1780-1810
SCHAFFER, Marcel
Swiss, 1931-
SCHAFFNER, Martin
German, 1478/9-1546/9
SCHAGEN, Eeuwout
Adriaensz. van
Dutch, op.1654-m.1663
SCHAGEN, Gillis
Dutch, 1616-1668
SCHAICK, Evrard van
Dutch, 17th cent.
SCHALCH, Johann Jakob
Swiss, 1723-1789
SCHALCK or Schalk,
Heinrich Franz
German, 1791-1832
SCHALCKE, Cornelis
Symonsz. van der
Dutch, 1611-1671
SCHALCKEN, Godfried
Dutch, 1643-1706
SCHALCKH, J.C.
German, op.1701
SCHALK
British, op.1747
SCHALL, Jean Frédéric
(Frédéric)
French, 1752-1825
SCHALL, Joseph Friedrich
August
German, 1785-1867
SCHALL, Karl
German, op.1828-1860
SCHALLBERGE, Pierre
see Scalberge
SCHALLER, Anton
German, 1773-1844
SCHALLHAS, Carl Philipp
German, 1767-1797
SCHALTENBRAND, Johann
Peter (Peter)
Swiss, op.1763-1764
SCHALTZ, Daniel
see Schultz
SCHAMBERG, Morton
American, 20th cent.
SCHAMPHELEER, Edmond de
Belgian, 1824-1899
SCHAMS, Franz
German, 1823-1883
SCHAPER, Hermann
German, 1853-1911

SCHAPER, Johann
German, 1621-1670
SCHAPIRO, Miriam
American, 1925-
SCHÄRER or Scherrer,
Johann (Hans) Jakob
Swiss, 1676-1746
SCHARF, George
British, 1788-1860
SCHARFF, Niels William
(William)
Danish, 1886-1959
SCHARL, Josef
German, 1896-1954
SCHARLACH, Edward
German, 1811-a.1891
SCHARNER, Michael
German, op.1666-1676
SCHARNHORST, H.
Swedish, op.1701-1702
SCHATZELL
German, op.c.1830
SCHATZLE, Julie
Swiss, 1903-
SCHAUBERGER, L.
German, 19th cent.
SCHAUBROECK, Pieter
see Schoubroeck
SCHÄUFELEIN, Schauffele,
Scheifelin, Scheufelein,
Scheuflein or
Scheyffelin, Hans
Leonhard
German, c.1480(?)-1538/40
SCHAUMANN, Ernst
German, 1890-
SCHAUSS, Ferdinand
German, 1832-1916
SCHAUTA, Friedrich
(Moos)
German, 1822-1895
SCHAVARY, Gustave
Dutch, 19th/20th cent.
SCHAVENIUS, Johan
Nicolai
Norwegian, op.1742-1744
SCHAYCK, Ernst or
Eerst, II van
Netherlands, op.1558-1569
SCHAYCK, Ernst or
Eerst, III van
Dutch, op.1567-1626
SCHAYENBORGH, Pieter
van
see Schaeyenborgh
SCHEDONI, Bartolomeo
see Schidone
SCHEEL, Schel or Schöll,
Sebastian
German, c.1479-1554
SCHEEMAECKERS or
Scheemakers, Peter, II
Flemish, 1691-1781
SCHEEMAECKERS or
Scheemakers, Thomas
British, 1740-1808
SCHEERBOOM, Andries
Dutch, 1832-
SCHEERRE, Herman
British, op.1407
SCHEFFEL, Johann Henrik
German, 1690-1781
SCHEFFEL, Joseph
Viktor von
German, 1826-1886

SCHEFFER, Ary
Dutch, 1795-1858
SCHEFFER, Ary Arnold
(Arnold)
French, 1839-1873
SCHEFFER, F.
British, op.c.1700-c.1710
SCHEFFER, Henry
Dutch, 1798-1862
SCHEFFER, Jean-Baptiste
(Johann Bernhard)
German, 1765-1809
SCHEFFER, Jean Gabriel
Swiss, 1797-1876
SCHEFFER or Schaeffer
von Leonhartshoff,
Johann Evangelist
German, 1795-1822
SCHEFFER, Ritter von
German, 18th cent.
SCHEFFER, Wilhelm
see Dilich
SCHEFFLER, Felix
Anton
German, 1701-1760
SCHEFFLER, Thomas
Christian
German, 1700-1756
SCHEGGIA, Giovanni di
Ser Giovanni (Guidi)
Italian, 1407-1480/90
SCHEGGINI, Giovanni di
Michele
see Graffione
SCHEIBER, Hugo
Hungarian, 1873-1950
SCHEIDEGGER, Johann
Swiss, 1777-1858
SCHEIDEL (Scheidl)
Franz Anton von
German, 1731-1801
SCHEIDER
German, 19th cent.
SCHEIDT, Werner von der
German, 1894-
SCHEIFELIN, Hans
Leonhard
see Schäufelein
SCHEINER, Jakob
German, 1821-1911
SCHEINS, Ludwig
(Carl L.)
German, 1808-1879
SCHEIRING, Leopold
German, 1884-1927
SCHEITS or Scheidts,
Andreas
German, c.1655-1735
SCHEITS, Scheitz or
Scheutz, Matthias
German, c.1625/30-1700
SCHEIVEN, Gürgan von
German, op.1546
SCHEIVEN, J. van
German, op.1546
SCHEL, Sebastian
see Scheel
SCHELFHOUT, Andreas
(Andries)
Dutch, 1787-1870
SCHELFHOUT, Lodewijk
Dutch, 1881-1943
SCHELK, Maurice
Belgian, 1906-
SCHELLEIN, Karl
German, 1820-1888
SCHELLEMANN, Carlo
German, 1924-

SCHELLEMANS, Franz
see Schillemans
SCHELLENBERG or
Scholtemberge, Johann
Rudolf
Swiss, 1740-1806
SCHELLENBERG, Johann
Ulrich
Swiss, 1709-1795
SCHELLER, H.J.
German(?) op.1587-1594
SCHELLINKS, Daniel
Dutch, 1627-1701
SCHELLINKS, Schellincks
or Schellings, Willem
Dutch, 1627(?)-1678
SCHELTEMA, Jan Hendrik
Dutch, 1861-
SCHELTEMA, Taco, I
Dutch, 1760-1837
SCHELVER, August Franz
German, 1805-1844
SCHEMBERA, Josef
see Sembera
SCHENAU, Johann Eleazar
(Zeissig)
German, 1737-1806
SCHENCK, August Friedrich
Albrecht
Danish, 1828-1901
SCHENCK, Pieter
see Schenk
SCHENCKER or Schenker,
Nicolas
French, c.1760-1848
SCHENDEL
see also Schyndel
SCHENDEL, Aegidius or
Gillis van
see Scheyndel
SCHENDEL or Schijndel,
Bernardus van
Dutch, 1649-1709
SCHENDEL, Petrus van
Belgian, 1806-1870
SCHENER, Mihaly
Hungarian, 20th cent.
SCHENK
see also Tilemann,
Simon Peter
SCHENK, Jan
Dutch, op.c.1731-1746
SCHENK, Leonardus
Dutch, 1696-1767
SCHENK or Schenck, Pieter,
I
Dutch, 1660-1718/19
SCHENK, William
American, 1947-
SCHENKEL, Jan Jacob
Dutch, 1829-1900
SCHENKER, Nicolas
see Schencker
SCHENNIS, Hans Friedrich
Emanuel (Friedrich)
German, 1852-1918
SCHEPENS, Johannes
Dutch, op.1736-1776
SCHEPPELIN, (Scheppem)
Jakob Andreas
Swiss, op.1736-1763
SCHERER, Giorgio
Italian, 1831-1896
SCHERER, Herman
German, 1893-1927
SCHERER, Mark
American, 20th cent.
SCHERM, Lorenz
Dutch, op.1690-1707

SCHERNIER
see Coninxloo,
Cornelis van
SCHERRER, Johann
Jakob
see Schärer
SCHERREWITZ, Johan
Frederik Cornelis
Dutch, 1868-1951
SCHERWASCHIDZE, A.
Russian, 20th cent.
SCHERWIN, John Keyse
see Sherwin
SCHETKY, John Christian
British, 1778-1874
SCHETTINI, Ulrico
Italian, 1932-
SCHEUBEL, Johann Joseph
II
German, 1686-1769
SCHEUBEL, Johann Joseph
III
German, 1733-1801
SCHEUCHZER, Wilhelm
Rudolf
Swiss, 1803-1866
SCHEUERER, Julius
German, 1859-1913
SCHEUERER, Otto
German, 1862-1934
SCHEUFELEIN, Hans
Leonhard
see Schäufelein
SCHEUREN, Caspar Johann
Nepomuk
German, 1810-1887
SCHEURENBERG, Josef
German, 1846-1914
SCHEURICH, Paul
American, 1883-
SCHEUTZ, Matthias
see Scheits
SCHEY, J.B.
see Beschey, Balthasar
SCHEY, Philip
Flemish(?), op.1626
SCHEYERER, Scheurer,
Scheurer or Scheyrer,
Franz
German, 1770-1839
SCHEYNDEL or Schendel,
Aegidius or Gillis van
Dutch, op.1622-1654
SCHEYNDEL; Gillis van
Dutch, 1635-1678
SCHIAMINOSSI, Scaminossi,
Scaminozzi or
Sciaminossi, Raffaele
Italian, c.1529-1622(?)
SCHIAVO, Else
Swiss, 20th cent.
SCHIAVO, Paolo (Paolo
di Stefano Badaloni)
Italian, 1397-1478
SCHIAVONE (Andrea
Meldolla)
Italian, op.1527/30-1563
SCHIAVONE, Giorgio di
Tomaso (Giorgio
Chiulinovic, erroneously
called Gregorio)
Italian, 1436/7-1504
SCHIAVONE, Gregorio
see Schiavone, Giorgio
SCHIAVONE, Michele
(Michelangelo)
Dalmatian, op.1766

SCHIAVONETTI, Luigi
or Lewis
Italian, 1765-1810
SCHIAVONI, Felice
Italian, 1803-1881
SCHIAVONI, Giovanni
Italian, 1804-1848
SCHIAVONI, Natale
Italian, 1777-1858
SCHIBANOFF, Michail
Russian, op.1770-1787
SCHIBIG, Philippe
Swiss, 1940-
SCHIBNEV, D.
Polish, op.1912
SCHICK, Christian
Gottlieb(Gottlieb)
German, 1776-1812
SCHICK, Jakob
German, op.1497-1529/30
SCHICK, Rudolf
German, 1840-1887
SCHICK, Thomas
German, op.c.1460-1544
SCHIDER, Fritz
German, 1846-1907
SCHIDONE or Schedoni,
Bartolomeo
Italian, c.1570-1615
SCHIEDGES, Petrus Paulus
Dutch, 1813-1876
SCHIEFER, Johannes
American, 20th cent.
SCHIEL, Johann Niklaus
Swiss, 1751-1803
SCHIELE, Egon
German, 1890-1919
SCHIELIN, Hans
see Schüchlin
SCHIEPATI or Schieppati,
Antonio
Italian, op.1804
SCHIERTZ, Franz
Wilhelm
German, 1813-1887
SCHIESS, Ernst
Swiss, 1872-1919
SCHIESS, Hans Rudolf
Swiss, 1904-
SCHIESS or Scheuss,
Johannes
Swiss, 1799-1844
SCHIESTL, Karl
German, 1899-1966
SCHIESTL, Matthäus
German, 1869-1939
SCHIFANO, Mario
Italian, 1934-
SCHIFFER, Anton
German, 1811-1876
SCHIFFER, Matthias
German, 1744-1827
SCHIFONI, Idda Botti
Italian, 1812-1844
SCHILBACH, Johann
Christian
German, op.1887
SCHILBACH, Johann
Heinrich
German, 1798-1851
SCHILCHER, Friedrich
German, 1811-1881
SCHILDERS, Jan A.M.
Dutch, 20th cent.
SCHILGEN, Philipp
Anton
German, 1792-1857

SCHILL, Emil
Swiss, 1870-1958
SCHILL, Jeremias
Adriaan Adolf
Swiss, 1849-1902
SCHILLEMANS or
Schellemans, Frans
Dutch, 1575-p.1620
SCHILLER, Christophine
see Reinwald
SCHILLING, Hans
German, op.1459-1469
SCHILLY, L.L.
French, op.1770-1793
SCHIMMELPENNINCK, Gerrit
Dutch, 1759-1818
SCHIMON, Ferdinand
Hungarian, 1797-1852
SCHINDLER, Albert or
Albrecht
German, 1805-1861
SCHINDLER, Carl
German, 1821-1842
SCHINDLER, Emil Jacob
German, 1842-1892
SCHINDLER, Johann
Josef
German, 1777-1836
SCHINKEL, Karl Friedrich
German, 1781-1841
SCHINNAGL, Maximilian
Joseph
German, 1697-1762
SCHINNAGL, Tobias
German, op.1653-m.1702
SCHINTZ
German, 20th cent.
SCHINZ, Johann Kaspar
Swiss, 1797-1832
SCHIÖLER, Inge
Swedish, 1908-1971
SCHIOTT, Heinrich
August Georg
(August)
Danish, 1823-1895
SCHIPPER, Gerrit
American, 1775-c.1830
SCHIPPER, H.
Dutch, 18th cent.
SCHIPPERS, Jos.
Belgian, 19th/20th cent.
SCHIPPERUS, Pieter
Adrianus (Piet)
Dutch, 1840-1929
SCHIRMER, August Wilhelm
Ferdinand (Wilhelm)
German, 1802-1866
SCHIRMER, Johann Wilhelm
German, 1807-1863
SCHIRREN, Ferdinand
Belgian, 1872-1944
SCHISCHKIN, Iwan
Iwanowitsch
Russian, 1831-1898
SCHITZ, Jules Nicolas
French, 1817-1871
SCHIVERT, Victor
Rumanian, 1863-
SCHJERFBECK, Helena
Sofia
Finnish, 1862-1946
SCHLABITZ, Adolf
German, 1854-1953
SCHLECHTERTORS, E. van
Dutch, op.1670
SCHLEER, Sem
see Schloer

SCHLEGEL, Friedrich
August
German, 1828-
SCHLEIBNER, Kaspar
German, 1863-1931
SCHLEICH, Anton
German, 1809-1851
SCHLEICH, August
German, 1814-1865
SCHLEICH, Carl Johannes
(Hans)
German, 1834-1912
SCHLEICH, Eduard I
German, 1812-1874
SCHLEICH, Eduard II
German, 1853-1893
SCHLEICH, Johann Carl
German, 1759-1842
SCHLEICH, Robert
German, 1845-1934
SCHLEINGER, F.
German, 19th cent.
SCHLEMMER, Oskar
German, 1888-1943
SCHLENK, Georg
German, op.1524-m.1557
SCHLESINGER, Felix
German, 1833-1910
SCHLESINGER, Johann
German, 1768-1840
SCHLESINGER, Karl
Swiss, 1825-1893
SCHLESINGER, Wilhelm
Heinrich (Heinrich)
German, 1814-1893
SCHLEUEN, Johann David
German, op.1740-1774
SCHLEUSING, Thomas
German, 20th cent.
SCHLEY, Jacobus van der
Dutch, 1715-1779
SCHLEY, Philippus van der
Dutch, 1724-1817
SCHLEYER, Sem
see Schloer
SCHLIGHT, Abel
German, 1754-1826
SCHLICHTEN, Johann
Philipp von der, or
Jan Philips van der
Dutch, 1681-1745
SCHLICHTEN, Th. von
German, 18th cent.
SCHLICHTER, Rudolf
German, 1890-1955
SCHLICHTING, Hinrich
German, op.1725
SCHLICHTING, Max
German, 1866-1937
SCHLIECKER, August
Eduard
German, 1833-1911
SCHLIESSMANN, Hans
German, 1852-1920
SCHLIMARSKI, Hans Heinrich
German, 1859-
SCHLITTGEN, Hermann
German, 1859-1930
SCHLITZOR, Schlitooc
or Schlitzoc, Erhard
German, op.1515-1519
SCHLOER, Schleer or
Schleyer, Sem (Simon)
German, c.1530-1597/98
SCHLÖGL, Josef van
German, 1851-

SCHLÖSSER or
Schloesser, Carl
Bernhard
German, 1832-p.1914
SCHLOTTER, Eberhard
German, 1921-
SCHLOTTERBECK, Christian
Jakob
German, 1757-1811/2
SCHLOTTERBECK, Wilhelm
Friedrich
Swiss, 1777-1819
SCHLOTTHAUER, Joseph
German, 1789-1869
SCHLOTTI, Emmanuel
Swiss. 1925-
SCHLÜTER, Andreas
German, c.1660-1714
SCHMAEDEL, Max von
German, 1856-p.1885
SCHMALEN, I.C.H. von
German, op.c.1778
SCHMALZ, Herbert
Gustave
British, 1856-
SCHMALZIGAUG, Ferdinand
German, 1847-1902
SCHMAROFF, Pavel
Dmitrievitch
Russian, 1874-
SCHMEIDLER, Carl
Gottlob
German, 1772-1838
SCHMELKOW, Pjotr
Michailovich
Russian, 1819-1890
SCHMETZ, Johann Jakob
see Schmitz
SCHMID, C.
British, op.1868
SCHMID, David Alois
Swiss, 1791-1861
SCHMID, Julius
German, 1854-1935
SCHMID, Matthias
German, 1835-1923
SCHMID, Walter
Swiss, 20th cent.
SCHMID, Wilhelm
Swiss, 1892-
SCHMID, Willi
German, 1890-
SCHMIDHAMMER, Arpad
German, 1854-1921
SCHMIDT,
British, 1745-1806
SCHMIDT, Adolf
German, 1827-1880
SCHMIDT, Alfred
Michael Roedstad
Danish, 1858-
SCHMIDT, Allan
Danish, 1923-
SCHMIDT, Bernhard
German, 1820-1870
SCHMIDT, C.C. Alexander
Danish, 1842-1903
SCHMIDT, Carl
see Schmidt-Rottluff
SCHMIDT, Eduard
German, 1806-1862
SCHMIDT, Franz Xaver
German, -1917
SCHMIDT, Friedrich
Albert
German, 1846-1916
SCHMIDT, Georg Christoph
German, 1740-1811

SCHMIDT, Georg Friedrich
German, 1712-1775
SCHMIDT, George Adam
Dutch, 1791-1844
SCHMIDT, Hans W.
German, 1859-1950
SCHMIDT, Heinrich
German, c.1740-1821
SCHMIDT, Hermann
German, 1819-1903
SCHMIDT, Izaäk
Dutch, 1740-1818
SCHMIDT, J.C.
German, op.1768
SCHMIDT, Johann Heinrich
(Henry)
German, 1749-1829
SCHMIDT, Karel Albert
Dutch, 1880-1920
SCHMIDT, Käthe
see Kollwitz
SCHMIDT, L.
German, 18th cent(?)
SCHMIDT, Martin
Johann (Kremser-Schmidt)
German, 1718-1801
SCHMIDT, Matthias
German, 1749-1823
SCHMIDT, Robert
German, 1863-
SCHMIDT, Rudolf
German, 1873-
SCHMIDT, Thomas
Swiss, 1490-1550/60
SCHMIDT, Willem
Hendrik
Dutch, 1809-1849
SCHMIDT-NIECHCIOL,
Arnold
German, 1893-1960
SCHMIDT-ROTTLUFF, Karl
German, 1884-
SCHMIECHEN, Hermann
German, 1855-
SCHMIEGELOW, Pedro
German, 1863-
SCHMISCHEK or Schmisek,
Johann
see Smisek
SCHMISSEN, Dominicus
van der
see Smissen
SCHMITHALS, Hans
German, 19th cent.

SCHMITSON, Teutwart
German, 1830-1863
SCHMITT or Schnitt
von Konstanz, Conrad
(Monogrammist S.C.)
Swiss, op.1519-m.1541
SCHMITT, David
German, 18th cent.
SCHMITT, Franz
German, 1816-1891
SCHMITT, Georg Philipp
German, 1808-1873
SCHMITT, Guido Philipp
German, 1834-1922
SCHMITT, Nathaniel
German, 1847-1918
SCHMITT, Oskar
German, 19th cent.
SCHMITTNER, Johann
Georg Melchior
German, 1625-1705
SCHMITZ, C.L.
German, 19th cent.

SCHMITZ, Ernest
German, 1859-1917
SCHMITZ, Heinrich
Gustav Adolf,(Adolf)
(Schmitz-Crolenburg)
German, 1825-1894
SCHMITZ or Schmetz,
Johann Jakob
German, 1724-1810
SCHMITZBERGER, Josef
German, 1851-
SCHMITZER, Matthias
German, 18th cent.
SCHMITZ-GILLES, Walter
German, 1893-
SCHMOLL von Eisenwerth,
Carl
German, 1879-1947
SCHMOLL or Schmohl,
Georg Friedrich
German, op.c.1774-m.1785
SCHMUHR, Conrad
Norwegian, op.c.1911
SCHMUTZ, Johann Rudolf
(Rudolf)
Swiss, 1670-1715
SCHMUTZER, Andreas
German, 1700-1740
SCHMUTZER or Schmuzer,
Jakob Mathias
German, 1733-1811
SCHMUTZER, Joseph
German, 1683-1740
SCHMUTZLER, Leopold
German, 1864-1941
SCHMUZER, Jakob Mathias
see Schmutzer
SCHNAIDER, Amable
see Schneider
SCHNAKENBERG, Henry
Ernest
American, 1892-
SCHNAPHAN, Abraham (de)
see Snaphaen
SCHNARRENBERGER, Wilhelm
German, 1892-1966
SCHNARS-ALQUIST, Hugo
German, 1855-
SCHNATTERPECK, Hans
German, op.1478-1540
SCHNÄTZLER, Ulrich
see Schnetzler
SCHNEBBELIE, Robert
Blemmell (not Blemme,
Bremme or Bremmel)
British, op.1803-m.1849(?)
SCHNEELI, Gustav R.
Swiss, 1872-
SCHNEGG, Gaston
French, 19th cent.
SCHNEID, Otto
Canadian, 1900-
SCHNEIDER, Emile Philippe
Auguste
French, 1873-1947
SCHNEIDER, Félicie,
née Fournier
French, 1831-1888
SCHNEIDER, G.
German, op.1883
SCHNEIDER, Georg
German, 1759-1843
SCHNEIDER, Gerard
Ernest
Swiss, 1896-
SCHNEIDER, Heinrich
Justus
German, 1811-1884

SCHNEIDER, Herbert
German, 20th cent.
SCHNEIDER, Hermann
German, 1847-1918
SCHNEIDER, Jo Anne
American, op.1974
SCHNEIDER, Johann
Caspar (Caspar)
German, 1753-1839
SCHNEIDER, Johann Jacob
Swiss, 1822-1889
SCHNEIDER or Schnaider,
Louis Amable (Amable)
French, 1824-1884
SCHNEIDER, N.(?) N.(?)
Flemish, op.1753
SCHNEIDER, Otto Ludwig
German, 1858-
SCHNEIDER, Robert
German, 1809-1885
SCHNEIDER, Sascha
(Alexander)
Russian, 1870-1927
SCHNEIDER, Walter
Swiss, 1903-1968
SCHNEIDT, Max
German, 1858-
SCHNELL, Johannes
Swiss, 1672-1714
SCHNETZ, Jean Victor
(Victor)
French, 1787-1870
SCHNETZLER or Schnätzler,
Johann Ulrich (Ulrich)
Swiss, 1704-1763
SCHNITT, Conrad
see Schmitt
SCHNITZER or Schnizer,
Josef Joachim von
German, 1792-1870
SCHNITZLER, Johann
Michael (Michael)
German, 1785-1861
SCHNITZLER, R.
American, op.1884
SCHNORR von Carolsfeld,
Johann (Hans), Veit
Friedrich
German, 1764-1841
SCHNORR von Carolsfeld,
Julius
German, 1794-1872
SCHNORR von Carolsfeld,
Ludwig II
German, 1824-1905
SCHNORR von Carolsfeld,
Ludwig Ferdinand
German, 1788-1853
SCHNYDER, Albert
Swiss, 1898-
SCHOBER, Franz von
German, 1796-1882
SCHOBER, Hans Wilhelm
German, op.1675-1680
SCHÖDL, Max
German, 1834-1921
SCHÖDLBERGER or
Schödelberger, Johann
Nepomuk
German, 1779-1853
SCHOEFF, Schooff or
Schuyff, Johannes
Dutch, 1608-p.1666
SCHOEFFT, August
(Agoston) Theodor
Hungarian, 1809-1888
SCHOEFFT, J.K.
Hungarian, 19th cent.

SCHOEL or Schol,
Hendrik van
Flemish(?), -1622
SCHOELL, Johann
Abraham
German, 1733-1791
SCHOELLER, Johann
Christian
German, 1782-1851
SCHOENBERG, Arnold
German, 1874-1951
SCHOENBRUN, Dorothy
American, 20th cent.
SCHOENER, Jason
American, 1919-
SCHOENER, Johannes
German, 1477-1547
SCHOENFELD, Friedrich
Swiss(?) 1807-1853
SCHOENFELD, Johann
Heinrich (Heinrich)
German, 1609-1682/3
SCHOENROCK, Julius
German, 1835-
SCHOEVAERDTS, Mathys
Flemish, op.1682-1694
SCHÖFFER
American, 20th cent.
SCHOFIELD, Walter Elmer
(Elmer)
American, 1867-
SCHOL, Hendrik van
see Schoel
SCHOLANDER, Fredrik
Vilhelm
Swedish, 1816-1881
SCHOLDERER, Otto
German, 1834-1902
SCHÖLL, Sebastian
see Scheel
SCHÖLLHORN, Hans Carl
Swiss, 1892-
SCHOLTEMBERGE, Johann
Rudolph
see Schellenberg
SCHOLTEN, Hendrik
Jacobus
Dutch, 1824-1907
SCHOLTZ or Schultz,
Georg II
German, 1622-1677
SCHOLTZ, Robert Friedrich
Karl
German, 1877-
SCHOLZ, Daniel
German, op.c.1600
SCHOLZ, Georg
German, 1890-1945
SCHOLZ, Max
German, 1855-
SCHOLZ, Werner
German, 1898-
SCHOMMER, François
French, 1850-1936
SCHOMPERS, J.F.
British, op.1810
SCHÖN (Schongauer)
Barthel
German, op.1427-1440
SCHÖN, Erhard (Pseudo-
Beham)
German, p.1491-1542
SCHÖN, Friedrich Wilhelm
German, 1810-1868
SCHÖN, Johann Gottlieb
(not Gottlob)
German, c.1720-p.1746
SCHÖN, Martin
see Schongauer

SCHÖN, Otto
German, 1893-
SCHONBERG, Torsten
Johan
Swedish, 1882-
SCHÖNBERG, (Schönberg-
Rothschönberg) Xaver
Maria Cäsar von
French, 1768-1853
SCHÖNBERGER, Alfred Karl
Julius Otto von
German, 1845-
SCHONBERGER, Armand
Hungarian, 20th cent.
SCHÖNBERGER, Lorenz
Adolf
German, 1768-1847
SCHÖNCHEN, Leopold
German, 1855-1935
SCHÖNER, Daniel
German, op.1654
SCHÖNER, Georg
Friedrich Adolph
German, 1774-1841
SCHÖNFELD, Heinrich
German, 1809-1845
SCHÖNFELD, Johann
Heinrich (Heinrich)
German, 1609-1682/3
SCHÖNFELDT, G.
German, 20th cent.
SCHONGAUER, Ludwig
German, a.1440-1494
SCHONGAUER, Martin
German, c.1430-1491
SCHÖNHEIT, Johann Carl
Simon (Carl Simon)
German, 1764-1798
SCHÖNHERR, Josef (not
Johann)
German, 1809-1833
SCHÖNHERR, Karl Gottlob
German, 1824-1906
SCHÖNLEBER, Gustav
German, 1851-1917
SCHÖNLEBER, Hans Otto
German, 1889-1930
SCHÖNMANN, Joseph
German, 1799-1879
SCHÖNN, Friedrich Alois
(Alois)
German, 1826-1897
SCHÖNPFLUG, Fritz
German, 1873-1951
SCHONREITHER, Georg
German, op.1861-1881
SCHÖNSTEDT, F.
German, 19th cent.
SCHÖNWALD, Rudolf
German, 1928-
SCHONZEIT, Ben
American, 1942-
SCHOOCK or Schook,
Hendrik
Dutch, op.1669-1696
SCHOOF, Guiliam
Flemish, op.1614-1636
SCHOOFF, Johannes
see Schoeff
SCHOOK, Hendrick
see Schoock
SCHOONE, Adrianus Gerardus
van
Dutch, 1785-1843
SCHOONEBEECK or Schoonebeek,
Adriaan
Dutch, 1657/8-p.1714
SCHOONJANS, Anthoni
(Parrhasius)
Flemish, c.1655-1726

SCHOONOVER, F.E.
 American, 20th cent.
SCHOOR, Abraham van der
 Dutch, op.1643-1650
SCHOOR or Schore,
 Guilliam van
 Flemish, op.1653-1676
SCHOOR, Ludwig van
 Flemish, op.c.1700
SCHOOR, Nicholas van
 Flemish, op.c.1690
SCHOOREL or Schoorl,
 Jan van
 see Scorel
SCHOORMAN
 (Possibly identified
 with Jacob Schorman)
 Dutch, op.1649
SCHOOTEN or Schoten,
 Floris Gerritsz. van,
 or Floris Verschoten
 (Monogrammist F.v.S.)
 Dutch, op.1612-1655
SCHOOTEN or Schoten,
 Franciscus van
 Dutch, c.1581-1646
SCHOOTEN, Joris van
 Dutch, 1587-1651
SCHOOTEN or Schoten,
 Pauwels
 Dutch, 17th cent.
SCHOPF, Johann Adam
 German, 1702-1772
SCHÖPF (von Schöpf)
 Johann Nepomuk
 Czech, c.1735-p.1785
SCHÖPF, Josef
 German, 1745-1822
SCHÖPFER, Abraham
 German, op.1533
SCHÖPFER, Franziska
 German, 1763-1836
SCHÖPFER, Hans I
 German, op.1520-p.1567
SCHÖPFER, Hans II
 German, op.1558-m.1610
SCHÖPFLIN, August
 Friedrich
 German, 1771-p.1806
SCHOPIN, Henri Frédéric
 (Frédéric)
 French, 1804-1880
SCHOPPE, Julius I
 German, 1795-1868
SCHOPPEN, J.
 British(?) op.1751
SCHOR, Egid
 German, 1627-1701
SCHOR, Johann Paul
 (Giovanni Paolo
 Tedesco)
 Italian, 1615-1674
SCHORE, Guilliam van
 see Schoor
SCHOREL, Jan van
 see Scorel
SCHORER, Hans
 Friedrich I
 see Schrorer
SCHORER, Leonhard
 German, 1715-1777
SCHORMAN, Jacob
 see Schoorman
SCHORN, Karl
 German, 1803-1850
SCHORNER, A.
 German(?), op.1705

SCHOTANUS, Petrus
 Dutch, 1601-a.1675
SCHOTEL, Andreas
 Dutch, 1896-
SCHOTEL, Johannes
 Christiaan
 Dutch, 1787-1838
SCHOTEL, Petrus Johannes
 Dutch, 1808-1865
SCHOTEN
 see Schooten
SCHOTT, Erhard
 German, 1810-
SCHOU, Ludvig Abelin
 Danish, 1838-1867
SCHOUBROECK,
 Schaubroeck or Schubruck,
 Pieter
 Netherlands, c.1570-1607
SCHOUKHAIEFF, Basile
 (Vassili)
 Russian, 1877-
SCHOUMAN, Aart
 Dutch, 1710-1792
SCHOUMAN, I.
 Dutch, 17th cent.(?)
SCHOUMAN, Martinus
 Dutch, 1770-1848
SCHOUTE, Hermanus Pieter
 see Schouten
SCHOUTE, Jan
 Dutch, 18th cent.
SCHOUTEN, Henry
 Belgian(?), 19th cent.(?)
SCHOUTEN or Schoute,
 Hermanus Pieter
 Dutch, 1747-1822
SCHOUTEN, W.
 Dutch(?), op.1776
SCHOVELIN, Axel Thorsen
 Danish, 1827-1893
SCHOYERER, Josef
 German, 1844-1923
SCHRADER, C.F.
 Danish, op.1770
SCHRADER, Julius
 Friedrich Anton
 German, 1815-1900
SCHRAM, Alois Hans
 German, 1864-1919
SCHRAMM, Alexander
 German, op.1834-p.1853
SCHRAMM, Johann Heinrich
 German, 1810-1865
SCHRAMM, Peter
 Dutch, op.1662
SCHRAMM, Viktor
 Rumanian, 1865-1929
SCHRAMM-ZITTAU, Max
 Rudolf (Rudolf)
 German, 1874-1929
SCHRANI, J.
 British, 19th cent.
SCHRANK, Franz von
 Paula
 German, 1747-1835
SCHRANTZ, A.
 German, 19th cent.
SCHRANTZ, John
 American, 19th cent.
SCHRANZ, G.
 German, 19th cent.
SCHRANZ, Josef
 German, op.1761-1797
SCHRAUDOLPH, Johann van
 German, 1808-1879
SCHREIBER, Charles
 French, -1903

SCHREIBER, E.
 German, 19th cent.
SCHREIBER, Georges
 American, op.1906-
SCHRIEBER, Gustav
 Adolf
 German, 1889-1958
SCHREIER, Ulrich
 German, c.1430-c.1490
SCHREINER, Friedrich
 Wilhelm
 German, 1836-
SCHREITTER, von
 Schwarzenfeld, Adolf
 German, 1854-1913
SCHREUER, Wilhelm
 German, 1866-1933
SCHREYER, Christian
 Adolf (Adolf)
 German, 1828-1899
SCHREYER, Franz
 German, 1858-
SCHREYER, Johann Friedrich
 Moritz
 German, 1768-1795
SCHREYER, Lothar
 German, 1886-1966
SCHREYVOGEL, Charles
 American, 1861-1912
SCHRIECK, H. van
 Dutch, 17th cent.
SCHRIECK, Otto Marseus
 or Marcellis van
 see Marseus
SCHRIMPF, Georg
 German, 1889-1938
SCHRÖDER, Albert
 Friedrich
 German, 1854-
SCHRÖDER, Georg
 Engelhardt
 Swedish, 1684-1750
SCHRÖDER, Johann
 Heinrich
 German, 1757-1812
SCHRÖDER, Julius Carl
 Hermann (Karl)
 German, 1802-1867
SCHRÖDER, P.
 Czech, 17th cent.
SCHRODER, R.
 British(?) op.1695
SCHRÖDL, Anton
 German, 1823-1906
SCHRÖDTER, Adolph
 German, 1805-1875
SCHROEDER-SONNENSTEIN,
 Friedrich
 German, 1892-
SCHROETER, Johann
 Friedrich Carl
 Constantin (Constantin)
 German, 1795-1835
SCHRORER or Schrorrer,
 Hans Friedrich
 German, op.1609-1649
SCHRÖTER, Johann
 German, op.1637-1665
SCHROTT, Maximilian
 German, 1783-1822
SCHROTTER, Alfred von
 German, 1856-
SCHROTTER, Bernhard
 Edler von
 German, 1772-1842
SCHROTZBERG, Franz
 German, 1811-1889

SCHRYVER, Louis de
 French, 1863-1942
SCHTSCHEDRIN, Silvester
 Fedorovitch
 Russian, 1791-1830
SCHTSCHEDRIN, Simon
 Russian, op.1770
SCHU, Daniel
 German, op.1599
SCHUBACK, Gottlieb
 Emil (Emil)
 German, 1820-1902
SCHUBAUER, Friedrich
 Leopold
 German, 1795-1852
SCHUBERT, Franz August
 German, 1806-1893
SCHUBERT, Heinrich
 Carl
 German, 1827-1897
SCHUBERT, Johann David
 German, 1761-1822
SCHUBERT van Ehrenberg,
 Wilhelm van
 see Ehrenberg
SCHÜBLER, Johann Jacob
 German, 1689-1741
SCHUBRUCK, Pieter
 see Schoubroeck
SCHUCH, Schuchel,
 Schuech or Schuoch,
 Andreas
 German, op.1645-1680
SCHUCH, Carl
 German, 1846-1903
SCHUCH, Werner Wilhelm
 Gustav
 Swiss, 1843-1918
SCHUCHAJEFF, Wassilij
 Iwanowitch
 see Shuhaev
SCHUCHEL, Andreas
 see Schuch
SCHÜCHLIN, Schuchlin,
 Schyechlin, Schuelin
 or Schielin, Hans
 German, op.1462-m.1505
SCHUCHMANN, J.E.
 German, op.1755
SCHUECH, Andreas
 see Schuch
SCHUELER, Jon
 American, 1916-
SCHUELIN, Hans
 see Schüchlin
SCHUER or Schuur,
 Theodor Cornelisz.
 van der (Vriendschap)
 Dutch, 1628-1707
SCHUERMANS, Jan
 Dutch, op.1710
SCHUFFENECKER, Claude
 Emile (Emile)
 French, 1851-1934
SCHUFFENECKER, Jacques
 French, 1941-
SCHUFRIED, Dominik
 German, 1810-p.1871
SCHÜHLY, Hans
 German, 1850-1884
SCHUKIN, S.
 see Stchoukine
SCHULBROECK, E.
 Belgian, 19/20th cent.
SCHÜLDT, Fritiof
 Johannes
 Swedish, 1891-

SCHULEIN, Julius
Wolfgang
German, 1881-
SCHULER, Jules
Théophile (Théophile)
French, 1821-1878
SCHULMAN, David
Dutch, 1881-1966
SCHULTE, Antoinette
American, 1897-
SCHULTEN, Arnold
German, 1809-1874
SCHULTHEISS, Karl
German, 1852-1944
SCHULTZ, Erdmann
German, c.1810-c.1841
SCHULTZ, Georg
see Scholtz
SCHULTZ, Schültz, Schults
or Schutz, George
Daniel (Daniel) II
German, c.1615-1683
SCHULTZ, Harry
German, 1874-
SCHULTZ, Johann Carl
German, 1801-1873
SCHULTZ, Martin
German, op.1602-m.a.1632
SCHULTZE, Bernhard
German, 1915-
SCHULTZE, Jean
German, 19th cent.
SCHULTZE, Karl
German, 1856-
SCHULTZ-WETTEL, Fernand
French, 1872-
SCHULZ, Joachim
Christian
German, 1721-1786/7
SCHULZ, Karl Friedrich
(Jagdschulz)
German, 1796-1866
SCHULZ, Wilhelm
German, 1865-
SCHULZBERG, Anshelm
Leonard
Swedish, 1862-1945
SCHULZ-BRIESEN, Eduard
German, 1831-1891
SCHULZE, Franziska
German, 1805-1864
SCHULZENHEIM, Ida von
Swedish, 1859-
SCHULZE-ROSE, Wilhelm
German, 1872-1950
SCHUMACHER, Bernard
German, 1872-
SCHUMACHER, Carl Georg
Christian
German, 1797-1869
SCHUMACHER, Emil
German, 1912-
SCHUMACHER, Ernst
German, 1905-
SCHUMACHER, Fritz
German, 1869-1947
SCHUMACHER, Willem
(Wim)
Dutch, 1894-
SCHUMANN, Wilhelm
German, op.1830-1844
SCHUNEMAN, L.
German(?), op.1666
SCHUNTH(?)
German(?), op.1838
SCHUOCH, Andreas
see Schuch

SCHUPPEN, Jacob or
Jacques van
French, 1670-1751
SCHUPPEN, Pieter
Ludwig or Pierre Louis
van
Flemish, 1627-1702
SCHÜRCH, Robert (Johann
Robert)
Swiss, 1895-1941
SCHURMAN, Anna Maria
van
Dutch, 1607-1678
SCHURR, Claude
French, 1921-
SCHURTZ, Cornelius
Nicolaus
German, 17th cent.
SCHÜRZJÜRGEN
see Ratgeb
SCHUSSELE, Christian
American, c.1824-1879
SCHÜSSLER, Alfred von
German, 1820-1849
SCHUSTER, Adele
German, op.1865
SCHUSTER, Heinrich
Rudolf (Rudolf)
German, 1848-1902
SCHUSTER, Joseph
German, 1812-1890
SCHUSTER, Karl Maria
German, 1871-1953
SCHUSTER-WOLDAN,
Raffael
German, 1870-1951
SCHUT, C.W.
Dutch, 17th cent.
SCHUT, Cornelis, I
Flemish, 1597-1655
SCHUT, Escut or Scut,
Cornelis, III
Flemish, c.1629-1685
SCHUT, Pieter
Hendricksz.
Dutch, 1618/19-p.1660
SCHUTT, Gustav
German, 1890-
SCHÜTTER
German, 18th cent.
SCHUTTER, Theodorus
Cornelis
Dutch, op.c.1760
SCHÜTZ
see Schultz
SCHÜTZ or Schytz,
Carl
German, 1745-1800
SCHÜTZ, Carl
German, 1808-
SCHÜTZ, Christoph
German, op.1683
SCHÜTZ, H.
German, 19th cent.
SCHÜTZ, Johann
Friedrich
German, op.c.1790
SCHÜTZ, Johann Georg
see Schüz
SCHÜTZE, Johann
Christoph
German, op.1718-m.1765
SCHÜTZE, Ludwig
German, 1807-
SCHÜTZE, Wilhelm
German, 1840-1898

SCHÜTZENBERGER, Louis
Frédéric
French, 1825-1903
SCHÜTZERCRANTZ, Adolp
Ulric
Swedish, 1802-1854
SCHUUR, Theodor van der
see Schuer
SCHUYFF, Johannes
see Schoeff
SCHÜZ or Schültz,
Christian Georg I
German, 1718-1791
SCHÜZ or Schütz, Franz
German, 1751-1781
SCHÜZ or Schütz,
Heinrich Joseph
German, 1760-1822
SCHÜZ or Schütz,
Johann Georg
German, 1755-1813
SCHÜZ, Theodor Christoph
German, 1830-1900
SCHVALBE
see Kiprensky, Orest
Adamovitch
SCHWAB, Hans
see Wertinger, Hans
SCHWAB, Johann Caspar
(Jean Gaspard)
German, 1727-p.1810
SCHWAB, M.
German, 19th cent.
SCHWABE, Carlos
French, 1866-1926
SCHWABE, Randolph
British, 1885-1948
SCHWABEDA, Johann
Michael
German, 1734-1794
SCHWABENTALER, Thomas
see Schwanthaller
SCHWAGER, Richard
German, 1822-1880
SCHWAIGER, Hans
(Hanus)
Czech, 1854-1912
SCHWAHENTHALER, Thomas
see Schwanthaller
SCHWANDALLER, Thomas
see Schwanthaller
SCHWANENTHALLER, Thomas
see Schwanthaller
SCHWANFELDER, Charles
Henry
British, 1774-1837
SCHWANFELDER, W.
German, 19th cent.
SCHWANTHALER, Ludwig
German, 1802-1848
SCHWANTHALLER, Schwanenthaller,
Schwandaller,
Schwahenthaler or
Schwabentaler, Thomas
German, 1634-1707
SCHWARTZ, Andrew
Thomas
American, 1867-1942
SCHWARTZ or Swartz,
Johan David
Swedish, 1679-1740(?)
SCHWARTZ, Johan Georg
Frans or Frans
Danish, 1850-1917

SCHWARTZ, Johann
Christian August
German, 1756-1814
SCHWARTZ or Schwarze,
Johann Heinrich
(perhaps identical
with Schwartz Eques
and Johan Hinrich
Schwartze)
German, op.1705-1707
SCHWARTZE, Johann Georg
Dutch, 1814-1874
SCHWARTZE, Thérèse
(Thérèse van Duyl)
Dutch, 1851-1918
SCHWARTZENBACH, Jacob
see Schwarzenbach
SCHWARTZ EQUES
see Schwartz, Johann
Heinrich
SCHWARZ, Carl Benjamin
German, 1757-1813
SCHWARZ or Schwartz,
Christoph
German, c.1545-1592
(not 1597)
SCHWARZ, Else, (née
Berg)
see Berg
SCHWARZ, Hans
German, 1492-p.1532
SCHWARZ, Lukas (Lux)
Swiss, op.1498-m.a.1526
SCHWARZ von Rothenburg,
Martin
German, op.c.1480-1522
SCHWARZ, Paul Wolfgang
German, 1766-1815
SCHWARZ, Robert
German, 1899-
SCHWARZ, Wjatscheslaw
Grigorjevich
Russian, 1838-1863
SCHWARZE, Johan Hinrich
see Schwartz
SCHWARZENBACH or
Schwartzenbach, Jacob
Dutch, 1763-1805
SCHWATZ, Molusken
British, 20th cent.
SCHWEGLER, Jakob
Swiss, 1793-1866
SCHWEGMAN, Hendricus
see Sweegman
SCHWEICH, Karl
German, 1823-1898
SCHWEICKARDT or
Schweickhardt, Heinrich
Wilhelm
German, 1746-1797
SCHWEIGER, Georg
German, op.1507-m.1533/34
SCHWEIGER, Johan
Friedrich
German, op.1740-m.1788
SCHWEIKART, Karl Gottlieb
German, 1772-1855
SCHWEINFURTH, Georg
German, 19th cent.(?)
SCHWEITZER, Adolf
Gustav
German, 1847-1914
SCHWEITZER-CUMPANA,
Rudolf
Rumanian, 1886-
SCHWEIZER, Christoph
Swiss, op.1561-1567

SCHWEIZER, Hans
Swiss, 20th cent.
SCHWEMMINGER, Heinrich
German, 1803-1884
SCHWEMMINGER, Josef
German, 1804-1895
SCHWENDER, Franz
German, op.1662
SCHWENDER or Schwenter,
Johann Paul (Paul)
German, op.1619
SCHWENDY, Albert
German, 1820-1902
SCHWENINGER, Karl I
German, 1818-1887
SCHWENINGER, Karl II
German, 1854-1903
SCHWENINGER, Rosa
German, 1849-
SCHWENTERLEY, Christian
Heinrich (Heinrich)
German, 1749-1815
SCHWERDGEBURTH,
Charlotte Amalia
German, 1795-1831
SCHWESTERMULLER, David
German, 1596-1678
SCHWICHTENBERG, Martel
German, 1896-1945
SCHWIND, Moritz von
German, 1804-1871
SCHWINDT, Karl I
German, 1797-1867
SCHWINGEN, Peter
German, 1813-1863
SCHWITER, Louis Auguste
Baron de
French, 1805-1889
SCHWITTERS, Kurt
German, 1887-1954
SCHWOERER, Friedrich
(Fritz)
German, 1833-1891
SCHWOISER, Eduard
German, 1826-1902
SCHWOLL or Zwoll,
Joachim van
Netherlands,
op.1566-m.1586(?)
SCHYECHLIN, Hans
see Schüchlin
SCHIJNDEL, Bernardus
van
see Schendel
SCHYNDEL or Schendel,
C.L. van
Dutch, op.1650
SCHYNDEL or Schendel,
J. van
Dutch, 17th cent.
SCHIJNVOET, Cornelia,
(née Rijck)
see Rijck
SCHIJNVOET, Jacobus
Dutch, op.1704-1733
SCHIJNVOET, K.
Dutch, 17th cent.
SCHYZ, Carl
see Schütz
SCHYZ, Sebastien
German, 17th cent.
SCIALOJA, Toti
Italian, 1914-
SCIAMINOSSI, Raffaello
see Schiaminossi
SCIFONI, Antolio
Italian, 1841-1884

SCILLA, Agostino
Italian, 1629-1700
SCIORINA or Sciorini,
Lorenzo dello
(Vaiani)
Italian, 1540/50-1598
SCIPIONE, Gino Bonighi
Italian, 1904-1933
SCIPIONI, Jacopino
(Giacomo) degli
Italian, op.1507-m.1532/43
SCIUTI, Giuseppe
Italian, 1834-1911
SCKELL, Ludwig
German, 1833-1912
SCLAVA, Luca
see Scalva
SCLOPIS dal Borgo,
Ignazio
Italian, op.1786-m.1793
SCOENERE, Jan de
see Stoevere
SCOLARI, Giuseppe
Italian, op.c.1580
SCONCE, H.
British, 19th cent.
SCOPPA, Giuseppe
Italian, 19th cent.
SCOPPETTA, Pietro
Italian, 1863-1920
SCOREL, Schorel, Schoorel,
Schoorl, Scorelius or
Scorellius (also,
erroneously, Scoreel or
Schoreel), Jan van
Netherlands, 1495-1562
SCORER, R. Coulson
British, 19th cent.
SCORODOUMOFF, Gabriel
Russian, 1748-1792
SCORRANO, Luigi
Italian, 1849-1924
SCORTAT, Joseph
French, 19th cent.
SCORZA, Pietro Antonio
Italian, op.1680
SCORZA, Sinibaldo
Italian, 1589-1631
SCORZELLI, Eugenio
Italian, 20th cent.
SCORZONI, Alessandro
Italian, 1858-1933
SCOTIN, Gérard Jean
Baptiste
French, 1671-1716
SCOTIN, Gérard Jean
Baptiste (Gérard II)
French, 1698-p.1733
SCOTSON-CLARK
British, 19th cent.
SCOTT, Lady
British, 1784-1857
SCOTT, Bernard
British, 20th cent.
SCOTT, David
British, 1806-1849
SCOTT, Digby
British, op.1795-1802
SCOTT, Edward
British, 19th cent.
SCOTT, Edwin
American, 1863-1929
SCOTT, G. Forrester
British, 20th cent.
SCOTT, Georges Bertin
(Scott de Plagnolles)
French, 1873-

SCOTT, Hilda
British, 20th cent.
SCOTT, J. Beattie
British, 20th cent.
SCOTT, James Fraser
British, 1878-
SCOTT, John
British, op.1862-1904
SCOTT, John Henderson
British, 1829-1886
SCOTT, John William A.
American, 1815-1907
SCOTT, Julian
American, 1846-1901
SCOTT, L.
British, 19th cent.
SCOTT, M.
British, 18th cent.
SCOTT, M.H. Baillie
British, 20th cent.
SCOTT, Marian Dale
Canadian, 1906-
SCOTT, Mary Ann
see Rigg
SCOTT, Patrick
British, 1921-
SCOTT, Peter Markham
British, 1909-
SCOTT, Robert
British, 1771-1841
SCOTT, Samuel
British, 1710-1772
SCOTT, T.
British, 19th cent.
SCOTT, Thomas
British, 1854-1927
SCOTT, Will
British, 20th cent.
SCOTT, William
British, op.1852
SCOTT, William
British, 1848-1918
SCOTT, William Bell
British, 1811-1890
SCOTT, William George
British, 1913-
SCOTT, William Henry
Stothard
British, 1783-1850
SCOTT, William J.
American, op.1938
SCOTT-BROWN
British, 20th cent.
SCOTTI de Cassano,
Giosue (?)
Italian, 1729-1785
SCOTTI, (de Scotis,
Schotis or Scoto)
Gottardo
Italian, op.1452-m.1485
SCOTTI, Luigi
Italian, op.1799
SCOTT-MOORE, Elizabeth
British, 20th cent.
SCOTTO or Scotti,
Francesco Emanuele
Italian, 1756-1826
SCOTTO, Stefano
Italian, op.1508
SCOTTOWE, Charles
British, 19th cent.
SCOUFLAIRE, Fernand
Belgian, 1885-
SCOUGALL or Scougal,
David
British, op.1654

SCOUGALL, George
British, op.1715-1724
SCOUGALL or Scougal,
John
British, c.1645-c.1730
SCOULER or Scoular,
James
British, 1741-p.1787(?)
SCOVADAEL or Scovad
Flemish, op.c.1700
SCRIVEN, Edward
British, 1775-1841
SCROETES, William or
Guillarme
see Scrots
SCROPPO, Filippo
Italian, 1910-
SCROTES, William or
Guillarme
see Scrots
SCROTH, William or
Guillarme
see Scrots
SCROTS, William or
Guillarme
(Possibly identified
with Master of the
Statthalterin Maria)
British, op.1537-1554
SCUDDER, Mrs. A.M.
American, op.1845
SCULLY, Sean
British, 20th cent.
SCULPTOR
see Scultori
SCULTORI, Scultor,
Scultore or Sculptor,
Adamo (Mantovano)
Italian, c.1530-1585
SCULTORI, Scultor,
Scultore or Sculptor,
Diana (Mantovana)
Italian, c.1535-p.1587
SCULTORI, Scultor,
Scultore or Sculptor,
Giovanni Battista
(Mantovano)
Italian, 1503-1575
SCUT, Cornelis
see Schut
SEABROOKE, Elliot
British, 1886-1950
SEAFORTH, Charles
Henry
British, op.1825-1853
SEAGO, Edward Brian
British, 1910-1974
SEALY, Allen Culpeper
British, op.1873-1886
SEAMAN, Noah
British (?) op.1724-1728
SEARL, John
British, 15th cent.
SEARLE, Ronald
British, 1920-
SEARS, M.U.
British, c.1800-
SEATON or Seton, John
Thomas
British, op.1761-1806
SEBASTIANI, Lazzaro
di Jacopo
see Bastiani
SEBASTIANO di Cola del
Casentino
Italian, op.1480-m.1506
SEBASTIANO, Fra
Italian, 18th cent.

SEBASTIANO, del Piombo
(Fra Sebastiano
Luciani)
Italian, 1485-1547
SEBASTIANO da Plurio
Italian, op.1512-1517
SEBBERS, Julius Ludwig
German, 1804-p.1837
SEBEN, Henri van
Belgian, 1825-1913
SEBES, Pieter Willem
Dutch, 1827-1906
SEBILLEAU, Paul
French, c.1847-1907
SEBIRE, Gaston
French, 1920-
SEBOTH, Josef
German, 1814-1883
SEBRIGHT, George
British, op.c.1850
SEBRON, Hippolyte
Victor Valentin
French, 1801-1879
SECCANTE, Sebastiano I
Italian, op.1537-m.1581
SECCOMBE, Th.
British, 20th cent.
SECHAN, Polycarpe Charles
(Charles)
French, 1803-1874
SECKEL, Christian
German, 18th cent.
SECKEL, Joseph
Dutch, 1881-
SECQ, Henri le
see Lesecq
SECUNDA, Arthur
American, 1927-
SEDDON, Thomas
British, 1821-1856
SEDGLEY, Peter
British, 1930-
SEDLACEK, Vojtech
Czech, 1892-
SEEBACH, Adam
German, op.1629-1655
SEEDERBOOM
see Quellinus, Jan
Erasmus
SEEFISCH, Hermann Ludwig
German, 1816-1879
SEEGER, Carl Ludwig
German, 1808-1866
SEEGERS, Hercules or
Herkeles
see Seghers
SEEHAS, Christian
Ludwig
German, 1753-1802
SEEHAUS, Paul Adolf
German, 1891-1919
SEEKATZ, Johann Conrad
German, 1719-1768
SEEL, A.
German, 1923-
SEEL, Louis
German, 1881-1958
SEELE, Johann Baptist
German, 1774-1814
SEELLER
German, 19th cent.
SEELOS, Gottfried
Italian, 1829-1900
SEELOS, Ignaz
German, 1827-1902
SEEMAN, Reinier, Regnier,
Remigius or Remy
see Zeeman

SEEMANN, Seeman or
Zeeman, Enoch, II
British, 1694-1744
SEEMANN, Isaac
Polish, op.1739-m.1751
SEERY, John
American, 20th cent.
SEETISCH, H. Louis
German, op.1831
SEEVAGEN, Lucien
French, 1887-
SEEWALD, Richard
German, 1889-
SEFTON, Anne Harriet
see Fish
SEGAER, P.
Netherlands, 17th cent.
SEGAL, Arthur
Rumanian, 1875-
SEGAL, Dorothy
American, 20th cent.
SEGAL, George
American, 1924-
SEGAL, Simon
French, 1898-
SEGALA, Giovanni
Italian, 1663-1720
SEGALL, Lasar
Brazilian,
1889/91-1957
SEGALLA, Irene
Italian, 20th cent.
SEGANTI
Italian, 19th cent.(?)
SEGANTINI, Giovanni
Italian, 1858-1899
SEGAR, Sir William
British, op.1585-m.1633
SEGARELLI, V.
Italian, op.c.1830
SEGART, Pierre
French, 17th cent.
SEGE, Alexandre
French, 1818-1885
SEGELCKE, Severin
Norwegian, 1867-
SEGERON, A.
French, 20th cent.
SEGHERS, Segers,
Zegers or Zeghers,
Daniel
Flemish, 1590-1661
SEGHERS, Segers,
Zegers or Zeghers,
Gerard
Flemish, 1591-1651
SEGHERS, Seegers, Segers,
Zegers or Zeghers,
Hercules or Herkeles
Pietersz.
Dutch, 1589/90-p.1635
SEGHIZZI, Sighizzi or
Sigizzi, Andrea
Italian, op.1630-m.1684
SEGNA di Bonaventura
Italian, op.1298-m.a.1331
SEGNER, Klaus
German, 20th cent.
SEGOFFIN, Victor Joseph
French, 1867-1925
SEGONI, Alcide
Italian, 1847-1894
SEGONI, L.
Italian, 19th cent.
SEGONZAC, André
Dunoyer de
French, 1884-

SEGOVIA
Spanish, 20th cent.
SEGRE, Sergio
Italian, 1932-
SEGUELA, Harry
French, 20th cent.
SEGUI, Antonio
Argentinian, 1934-
SEGUIER, John
British, 1785-1856
SEGUIN, Armand
French, 1869-1903
SEGUIN, Gérard
French, 1805-1875
SEGUIN-BERTAULT,
Paul
French, 1869-
SEGUR, Louis Gustave
Adrien (Gustave)
French, 1820-1881
SEGUY, E.
French, 20th cent.
SEIBELS, Carl
German, 1844-1877
SEIBOLD, Christian
see Seybold
SEIDEL, August
German, 1820-1904
SEIDL, Alois
German, 1897-
SEIDL, Andreas
German, 1760-1834
SEIDLER, Louise Caroline
Sophie
German, 1786-1866
SEIFERT, Alfred
German, 1850-1901
SEIFERT, David
British, 1896-
SEIFERT, Max
German, 1914-
SEIFFERT, Johann
Gottlieb
see Seyfert
SEIGNAC, Guillaume
French, 19th cent.
SEIGNAC, Paul
French, 1826-1904
SEIGNEMARTIN, Jean
French, 1848-1875
SEILER, Carl Wilhelm
Anton
German, 1846-1921
SEILER, Johann Georg
see Seiller
SEILER, Josef Albert
German, op.1837-1848
SEILLER, Sailer, Seiler
or Seyler, Johann
Georg
Swiss, 1663-1740
SEIMERSHEM-DESGRANGE, Mme.
French, op.1908
SEIPTIUS, Seipsius or
Seiptius, Georg
Christian
Danish, 1744-1795
SEISENEGGER, Seisenecker,
Seysenegger or
Zeyssnecker, Jakob
German, 1505-1567
SEISTRZENCEWICZ, F.
Bohusz
Polish, 20th cent.
SEITER, Saiter, Seitter,
Seuter, Seyter or Soiter,
Joseph Daniel (Daniel)
(Il Cavaliere Daniele
or Der Abendstern or
Daniele Fiammingo)
German, 1647/9-1705

SEITTER, Daniel
see Seiter
SEITZ, Alexander
Maximilian
German, 1811-1888
SEITZ, Anton
German, 1829-1900
SEITZ, Georg
German, 1810-1870
SEITZ, Gustav
German, 1906-
SEITZ, Johann
German, -p.1809
SEITZ or Seiz,
Johannes
German, 1717-1779
SEIWERT, Franz Wilhelm
German, 1894-1933
SEIZ, Johannes
see Seitz
SEKOTO, Gerard
South African, 1913-
SELDRON, Elizabeth
French(?), 18th cent.
SELF, Colin
British, 20th cent.
SELFE, Madeline
British, 20th cent.
SELIGER, Max
German, 1865-1920
SELIGMAN, Georg Sofus
Danish, 1866-1924
SELIGMANN, Johann
Michael
German, 1720-1762
SELIGMANN, Kurt
Swiss, 1900-
SELIGMANN, M.
German, 1748-p.1786
SELIM, Honorine
French, op.1864-1870
SELL, Christian I
German, 1831-1883
SELLAER, Zeelare or
Zellaer, Vincent
Netherlands,
op.1538-1544
SELLAIO, Jacopo del
Italian, 1441/2-1493
SELLAR, E.
British, op.1782
SELLARI, Girolamo
see Girolamo
SELLENY, Joseph
German, 1824-1875
SELLER, John
American, op.c.1677
SELLES, Pierre Nicolas
French, 1751-1831
SELLETH, James
see Sillett
SELLIER, Charles
Francois
French, 1830-1882
SELLITTO, Carlo
Italian, -1614
SELLMAYR, Ludwig
German, 1834-1901
SELLON
British, op.1784
SELLS, Rev. Alfred
Australian, op.1880-1888
SELLSTEDT, Lars Gustav
American, 1819-1911
SELOUS, Dorothea
British, op.c.1920-1960
SELS, J.J.
Dutch(?), op.1647

SELTHENHAMMER, Paul
French, 20th cent.
SELTZER, Olaf C.
American, 19th cent.
SELVAGGI
Italian, 19th cent.
SELVATICO, Lino
Italian, 1872-1924
SELWAY, John
British, 1938-
SELWIN, J.T.
British, op.1826
SEM
see Goursat, Georges
SEMANT, Paul
French, 18th cent.
SEMBERA or Schembera,
Josef
German, 1794-1866
SEMEGHINI, Pio
Italian, 1878-
SEMENOWSKY, Eisman
French, 19th cent.
SEMENTI, Sementa or
Semenza, Giacomo
(Giovanni Giacomo)
Italian, 1580-1636
SEMERTZIDES, B.
Greek, 20th cent.
SEMIGINOWSKI or
Szymonowicz, Jersy
(Eleuter)
Polish, c.1660-m.1711
SEMINO or Semini,
Andrea
Italian, 1525(?)-1595(?)
SEMINO or Semini,
Antonio
Italian, 1485(?)-1554/55
SEMINO or Semini,
Ottavio
Italian, 1520(?)-1604
SEMITECOLO, Nicoletto
Italian, op.1353-1370
SEMOLEI, Il
see Franco, Giovanni
Battista
SEMPEL, J.
German(?) op.1868
SEMPER, Gottfried
German, 1803-1879
SEMPERE, Eusebio
Spanish, 1924-
SEMPLICE da Verona,
Fra (il Cappuccino)
Italian, op.1617-m.1654
SEMYRADSKI, Henri
Russian, 1843-1902
SEN, L.
French(?), 18th cent.
SENAPE, Antonio
Italian, op.1842
SENAVE, Jacques Albert
Flemish, 1758-1829
SENE, Henry
French, 20th cent.
SENE, Louis
Swiss, 1747-p.1804
SENET, Rafael
Spanish, 1856-
SENEZCOURT, Jules de
French, 1818-1866
SENFF, Carl Adolf
(Adolf)
German, 1785-1863
SENFF, Carl August
German, 1770-1838

SENIOR, Bryan
British, 1935-
SENKEISEN, Johann
Christian
German, op.1693-1729
SENN, Jakob
Swiss, 1790-1881
SENN, Johannes
Swiss, 1780-1861
SENN, Traugott
Swiss, 1877-
SENNO, Pietro
Italian, 1831-1904
SENSENEY, George
American, 1874-1943
SEON, Alexandre
French, 1855-1917
SEPESHY, Zoltan L.
Hungarian, 1898-
SEPHTON, George Harcourt
British, 19th cent.
SEPP, Jan Christiaen
Dutch, 1739-1811
SEQUEIRA, Domingos
Antonio de
Portuguese, 1768-1837
SEQUIN, Otto
Swiss, 1892-
SERAETS, Seraet or
Serati, Jan
Dutch, op.1644
SERAFIN, Pedro
(El Griego)
Spanish, op.1554-1578
SERAFINI, Paolo
Italian, 14th cent.
SERAFINI, Serafino
Italian, a.1324-p.1393
SERAFINI, Serafino di
Francesco
Italian, c.1533-1595/1605
SERAFINO, Giovanni
Italian, op.1781
SERANGELI, Gioacchino
Giuseppe
Italian, 1768-1852
SERAPHINE, Séraphine
(Louis)
French, 1864-1934
SERATI, Jan
see Seraets
SERBELLONI, Camillo
Italian, op.1595-1603
SERBIAN SCHOOL
Anonymous Painters
of the
SERDUKOFF, G.
Russian, 19th cent.
SEREGNO, Cristoforo da
see Cristoforo
SEREGNO, Nicolao da
see Nicolao
SEREVILLE, Philippe de
French, 1820-
SERGEEV, Ivan
Russian, 1760-op.1793
SERGEEV, Nikolai
Alexandrovich
Russian, 1855-1919
SERGEL, Johan Tobias
Swedish, 1740-1814
SERGENT, Lucien
French, 1849-1904
SERGERNT-MARCEAU or
Sergent, Antoine
François
French, 1751-1847

SERIN, Harmanus
Dutch, op.c.1720-1738
SERJENT, G.R.
see Sarjent
SERMONETA, Girolamo
see Sicciolante
SERMOVER, T.
Dutch(?), 18th cent.(?)
SERNA, Manuel
Spanish(?), 17th cent.
SERNESI, Raffaello
Italian, 1838-1866
SERODINE, Giovanni
Italian, c.1594-1631
SEROV, Valentin
Alexandrovitch
Russian, 1865-1911
SEROV, Vladimir
Russian, 20th cent.
SERPAN, Jaroslaw
Czech, 1922-
SERPOTTA, Giacomo
Italian, 1656-1732
SERR, Johann Jokob
(Jakob)
German, 1807-1880
SERRA, Bernardo (Bernat)
Spanish, op.c.1423-m.a.1456
SERRA y Auque, Enrique
Spanish, 1859-1918
SERRA, Jaime (Jacobo
or Jaume)
Spanish, op.1360-1375
SERRA y Porson, José
Spanish, 1824-1910
SERRA, Luigi
Italian, 1846-1888
SERRA, Pablo
Spanish, 1749-1796
SERRA, Paolo
Italian, 1946-
SERRA, Pedro (Pere)
(Master of Tobed)
Spanish, op.1363-1399
SERRANO, Manuel
Mexican, op.1865
SERRE or Serra, Michel
(Miguel Serra)
Spanish, 1658-1733
SERRES, Antony
French, 1828-1898
SERRES, Dominic I
British, 1722-1793
SERRES, Dominic M.
British, op.1778-1804
SERRES, John Thomas
British, 1759-1825
SERRES, O. de
British(?) 17th cent.
SERRES, Olivia Wilmot
British, 1772-1834
SERRES, S. F.
British, op.1797
SERRET, Charles Emmanuel
French, 1824-1900
SERRIER, Georges
French, 1852-1949
SERRUR, Henri Auguste
Calixte César
French, 1794-1865
SERRURE, Auguste
Belgian, 1825-1903
SERRURIER, L.P.
Dutch, op.c.1730
SERRURIER, Louis
German, op.1790-1800

SERT y Badia, José
Maria
Spanish, 1876-1945
SERTEW, Aleksander
Bulgarian, 20th cent.
SERUSIER, Paul
French, 1864-1927
SERVAES, Albert
Belgian, 1883-1966
SERVANDONI, Servando,
Servandon or Servandony,
Giovanni Niccolò
(Jean Nicolas)
French, 1695-1766
SERVANT, J.
British, op.1768
SERVIERES, Eugénie,
née Charen
French, 1786-p.1824
SERVIN, Amédée Élie
French, 1829-1884
SERVOLINI, Benedetto
Italian, 1805-1879
SERVRANCKX, Victor
Belgian, 1897-
SERWOUTERS, Pieter
Flemish, 1586-1657
SERYCH, Jaroslav
Russian, 20th cent.
SESTO, Cesare da
see Cesare
SESTRI, Antonio
Italian, 17th cent.
SETCH, Terry
British, 20th cent.
SETCHEL, Sarah
British, 1813/14-1894
SETON, Ernest Thompson
American, 1860-
SETON, F.
British, op.1776
SETON, John Thomas
see Seaton
SETTARI, W.
Italian, op.1868
SETTEGAST, Joseph
Anton
German, 1813-1890
SETTERINGTON, J.
British, 18th cent.
SETTI, Ercole
Italian, op.1568-1575
SETTLE, William
Frederick
British, 19th cent.
SEUPHOR, Michel
French, 1901-
SEURAT, Georges Pierre
French, 1859-1891
SEUTER, Daniel
see Seiter
SEVE, Gilbert de
French, c.1615-1698
SEVE, Jacques de
French, op.1742-1788
SEVE, Pierre
French, c.1623-1695
SEVENBOM or Säfvenboom,
Johan
Swedish, c.1721-1784
SEVENE, Marie
French, 18th cent.
SEVERAC, Gilbert
Alexandre de
French, 19th cent.
SEVERDONCK, Frans van
Belgian, 1809-1889

SEVEREN, Dan van
Belgian, 1927-
SEVERIN, C.
British, 19th cent.
SEVERIN, Mark
Belgian, 1906-
SEVERINI, Gino
Italian, 1883-1966
SEVERINO, Cristoforo
da San
see Cristoforo di
Giovanni
SEVERINO, Jacopo da San
see Jacopo
SEVERINO, Lorenzo, I, San
see Salimbeni
SEVERINO, Lorenzo, II,
San
see Salimbeni
SEVERINO da Cingoli,
Ulisse
Italian, 16th cent.
SEVERN, Ann Mary
see Newton
SEVERN, Arthur
British, 1842-1931
SEVERN, Joseph
British, 1793-1879
SEVERN, Walter
British, 1830-1904
SEVESI, Fabrizio
Italian, -1837
SEVILLA, Juan de
see Romero
SEVIN, Pierre Paul
French, 1650-1710
SEWELL, H.
American, op.1837
SEWELL, Robert
American, 1860-1924
SEWOHL, Waldemar
German, 1887-
SEXTIE, William
British, 19th cent.
SEYBOLD or Seibold,
Christian
German, 1697/1703-1768
SEYDEL, Gustav Eduard
(Eduard)
German, 1822-1881
SEYDELMANN, Crescentius
Josephus Johannes
(Jacob).
German, 1750-1829
SEYFARTH, Alfred
German, 1877-
SEYFERT,
French, op.1817-1822
SEYFERT, Seyffert or
Seiffert, Johann
Gottlieb or Gotthelf
German, 1761-1824
SEYFFARTH, Louisa
see Sharpe
SEYFFERT, Heinrich
Abel
German, 1768-1834
SEYFFERT, Johann
Gottlieb
see Seyfert
SEYFFERT, Leopold
Gould
American, 1888-1956
SEYLER, Johann Georg
see Seiller
SEYLER, Julius
German, 1873-1958

SEYMOUR, Colonel
British, op.1702-m.1739
SEYMOUR, Edward
British, -1757
SEYMOUR, George L.
British, op.c.1876
SEYMOUR, James
British, 1702-1752
SEYMOUR, Jane Fortescue
see Coleridge, Lady
SEYMOUR, Robert
British, 1798-1836
SEYMOUR, Samuel
British, op.1797-1823
SEYMOUR-HADEN, Sir
Francis
British, 1818-1910
SEYSENEGGER, Jakob
see Seisenegger
SEYSSAUD, René Auguste
French, 1867-1952
SEYTER, Daniel
see Seiter
SEZANNE, Augusto
Italian, 1856-1935
SFERINI, Carlo
Italian, 17th cent.
SFORZOLINI, Domenico
Italian, 1810-1860
SGUAZELLA or Chiazzella,
Andrea
Italian, op.1517-1557
SHACKLETON, John
British, op.1749-1767
SHACKLETON, William
British, 1872-1933
SHADBOLT, Jack Leonard
Canadian, 1909-
SHAFER, Robert
American, 20th cent.
SHAFFER, Brian
British, 1929-
SHAFTOE, W.
British, 18th cent.
SHAHN, Ben
American, 1898-
SHAKESPEARE, Percy
British, 1906-
SHALDERS, George
British, c.1826-1873
SHAMBERG, Morton
Livingston
American, 20th cent.
SHANKS, Alec
American, 20th cent.
SHANKS, William
Somerville
British, 1864-1951
SHANNON, Charles
Haslewood (Charles)
British, 1865-1937
SHANNON, E.J.
British, 19th cent.
SHANNON, Sir James
Jebusa
British, 1862-1923
SHANNON, Joseph
American, 1940-
SHANNON, Michael
British, 20th cent.
SHAPIRO, Shmuel
American, 1924-
SHAPLAND, John
British, -1927
SHARER, William E.
British, 20th cent.

SHARP, Dorothea
British, 1874-1955
SHARP, Edwin V.
American, op.1842-1854
SHARP, Joseph Henry
American, 1859-1953
SHARP, Michael William
British, op.1801-m.1840
SHARP, Paul S.
British, 20th cent.
SHARP, William
British, 1749-1824
SHARPE, Alfred
New Zealand, 19th cent.
SHARPE, Charles
Kirkpatrick
British, 1781-1851
SHARPE, Eliza
British, 1796-1874
SHARPE, J.F.
British, op.1826-1830
SHARPE, Louisa
(Seyffarth)
British, 1798-1843
SHARPE, Martin Ritchie
Australian, 1941-
SHARPE, Mary Anne
British, 1802-1867
SHARPLES or Sharpless,
Mrs. Ellen (née
Wallace)
British, 1769-1849
SHARPLES or Sharpless,
James I
British, c.1751/2-1811
SHARPLES or Sharpless,
James II
British, 1789-1839
SHARPLES, Maria
British, c.1753-1849
SHARPLES or Sharpless,
Rolinda
British, 1794-1838
SHATTUCK, Aaron Draper
American, 1832-1928
SHAW, A.
British, op.1826-1839
SHAW, Casto Fernandez
Spanish, op.1792
SHAW, Charles E.
British, op.1879-1892
SHAW, Charles Green
American, 1892-
SHAW, Charles S.
British, 19th cent.
SHAW, Henry
British, 1800-1873
SHAW, Horatio
American, op.1885-1890
SHAW, James
British, op.1776-1787
SHAW, John, II
British, 1803-1870
SHAW, John Byam Liston
(Byam)
British, 1872-1919
SHAW, Joshua (Shaw of
Bath)
British, 1776-1861
SHAW, Stephen William
British, 1817-1900
SHAW, Susan M.
American, op.1852
SHAW, William
British, op.1755-1772
SHAYER, Charles
British, op.1860

SHAYER, William, I
British, 1788-1879
SHAYER, William J.
British, 1811-p.1885
SHCHEDRIN, Seymon
Feodorovich
Russian, 1745-1804
SHCHERBOV, Pavel
Russian, 1866-1938
SHEARBON, Andrew
British, op.1868
SHEARD, Thomas Frederick
Mason
British, 1866-1921
SHEARER, Brodie
Canadian, 20th cent.
SHEE, Sir Martin
Archer
British, 1769-1850
SHEELER, Charles
American, 1883-1965
SHEEPING, J.
British, 20th cent.
SHEERWOOD, Rosina
Emmet
American, op.1892
SHEETS, Millard Owen
American, 1907-
SHEFFIELD, George
British, 1839-1892
SHEFFIELD, Isaac
American, 1798-1845
SHEGOGUE, James Henry
American, op.1835-m.1872
SHELDON-WILLIAMS,
Inglis
Canadian, 1870-1940
SHELLEY, John
British, 20th cent.
SHELLEY, Percy Bysshe
British, 1792-1822
SHELLEY, Lady Percy
Florence
British, 19th cent.
SHELLEY, Samuel
British, c.1750-1808
SHELTON, Philip E.
British, 20th cent.
SHEMAN, M.
French(?) op.1806
SHEPARD, Ernest Howard
British, 1879-
SHEPHARD, William
see Sheppard
SHEPHEARD or Shepherd,
George
British, 1770-1842
SHEPHERD, C.
British, 18th cent.
SHEPHERD, David
British, 20th cent.
SHEPHERD, E.
British, op.1808-1828
SHEPHERD, F.H.S.
British, 19th cent.
SHEPHERD, G.M.
British, op.c.1820
SHEPHERD, George
British, op.1800-1830
SHEPHERD, George Sidney
British, op.1831-m.1858(?)
SHEPHERD, James Affieck
British, 1867-
SHEPHERD, J.H.
British, op.c.1817
SHEPHERD, Juliana C.
British, op.1858-m.1898

SHEPHERD, Rupert
British, 1909-
SHEPHERD, Thomas Hosmer
British, op.1813-1851
SHEPHERD, William
see Sheppard
SHEPPARD, M.R.
British, op.1826
SHEPPARD, Philip
British, 1838-1895
SHEPPARD, W.
British, op.c.1801-1814
SHEPPARD, Warren W.
American, 1858-
SHEPPARD, Shephard or
Shepherd, William
British, op.c.1650-1660
SHEPPERSON, Claude Allin
British, 1867-1921
SHEPPERSON, Patricia
British, 20th cent.
SHERATON, Thomas
British, 1751-1806
SHERIDAN, Harry
British, op.1857
SHERRIFF, John
British, 1816-1844
SHERINGHAM, George
British, 1884-1937
SHERLOCK, Marjorie
British, 1897-1973
SHERLOCK, William P.
British, c.1780-c.1850
SHERMAN, Welby
British, op.1827
SHERRIFF, Charles
see Shirreff
SHERRIFF, James
British, op.c.1740
SHERRIN, Daniel
British, 19th cent.
SHERRIN, John
British, 1819-1896
SHERWIN, Charles
British, c.1764-1794
SHERWIN, John Keyse
British, c.1751(?)-1790
SHERWIN, William
British, c.1645-1711(?)
SHERWOOD, W.P.
British, op.c.1850-1870
SHIBRAIN, Ahmed
Mohammed
Sudanese, 20th cent.
SHIELDS, Alan
American, 20th cent.
SHIELDS, Frederic
James
British, 1833-1911
SHIELDS, Thomas W.
American, 1849-1920
SHIELLS, Sarah
British, op.1783-1787
SHIELS, William
British, 1785-1857
SHIERCLIFF, Edward
British, op.1765-1786
SHIKLER, Aaron
American, 1922-
SHINN, Everett
American, 1876-1953
SHIPHAM, Benjamin
British, 19th cent.
SHIPLEY, William
British, 1714-1803
SHIRLAW, Walter
British, 1838-1909

SHIRLEY, Henry
British, op.1844-1859
SHIRREFF, Sheriff or
Shireff, Charles
British, c.1750-p.1831
SHIRT, W.
British, op.c.1807
SHISKIN, Ivan
Ivanovitch
Russian, 1831-1898
SHKOLNIK, I.
Russian, 19th cent.
SHOEMAKER, Peter
American, 1920-
SHOOSMITH, F.V.
British, 19th cent.
SHOOSMITH, Thurston
Laidlaw
British, op.1899
SHOOTE, John
see Shute
SHORE, Arnold
Australian, 1897-1963
SHORE, F.
British, op.1870-1895
SHORE, Susan
American, 20th cent.
SHORT, Sir Frank
British, 1857-1945
SHORT, Obadiah
British, 1803-1886
SHORT, Richard
British, 18th cent.
SHORT, Robert
British, op.c.1748-1751
SHOTER, G.
Dutch(?), op.1770
SHOUBRIDGE, W.
British, op.1831-1853
SHRAGER, A.J.
British, 20th cent.
SHUCKARD, F.P.
British, op.1868-1888
SHUHAEV, Vasili
Ivanovich
Russian, 1887-
SHURAWLJOW, Firs
Sergejevich
Russian, 1836-1901
SHURY, J.
British, op.1812
SHUTE or Shoote,
John
British, op.1550-m.1563
SHUTE, R.W.
American, op.1834-1836
SHUTER, William
British, op.1771-1799
SHVESHNIKOV
Russian, 20th cent.
SIBERDT, Eugene
German, 1851-
SIBERECHT, Willem or
Guillaume van
Flemish, op.1666
SIBERECHTS, Jan
Flemish, 1627-c.1703
SIBERT, G.E.
French, 18th cent.
SIBILLA or Sybilla,
Gijsbert
Dutch, op.1635-1652
SIBLEY, Andrew
Australian, 1933-
SIBMACHER or Siebmacher
or Syber, Johann (Hans)
German, op.1596-m.1611

SIBSON, Thomas
British, 1817-1844
SICARD, Sicardi,
Siccardi or Sicardy,
Louis Marie
French, 1746-1825
SICARD, Nicolas
French, 1855-1920
SICARD, Pierre
French, 1900-
SICARDI, Louis Marie
see Sicard
SICCARD, August von
see Sicard
SICCIOLANTE or
Siciolante, Girolamo
(il Sermoneta)
Italian, 1521-c.1580
SICHEL, Ernest Leopold
British, 1862-1941
SICHEL, Nathaniel
German, 1843-1907
SICHEM, Christoffel, I
van
Dutch, c.1546-1624
SICHEM, Christoffel,
II van
Dutch, c.1581-1658
SICHEM, Karel van
Dutch, op.1604
SICHT, J.J.
German, op.1621
SICILIANO or Ciciliano,
Giacomo
see Duca, Giacomo del
SICILIANO, Il
see Rodriguez, Luigi
SICILIANO, Ricci
Italian, 17th cent.
SICILIANO, Tommaso
see Laureti
SICIOLANTE
see Sicciolante
SICKENDORF, G.
German, 19th cent.
SICKERT, Bernard
British, 1863-1932
SICKERT, Walter Richard
British, 1860-1942
SICKINGER, Gregorius
Swiss, 1558-1631
SICULO, Giacomo
see Santori
SIDANER, Henri Eugène
le
see Le Sidaner
SIDDALL, Elizabeth
Eleanor (Lizzie)
British, 1834-1862
SIDEBOTHAM, I.
British, op.1814
SIDLEY, Samuel
British, 1829-1896
SIDOROWICZ, Zygmunt
Polish, 1846-1881
SIEBELIST, Arthur
German, 1870-1945
SIEBER, A.P.
German, 19th cent.
SIEBERG, Peter
German, 18th cent.
SIEDOFF, Gregor
Russian, 1831-1886
SIEFERT
French, 20th cent.
SIEFERT, Arthur
German, 1858-

SIEGEL, Anton
see Siegl
SIEGEN, A. von
German, 19th cent.
SIEGEN or Segen,
Ludwig von
German, 1509-1680(?)
SIEGERT, August
Friedrich
German, 1820-1883
SIEGERT, Augustin
(August)
German, 1786-1869
SIEGFRIED, Heinrich
Swiss, 1814-1889
SIEGFRIED, Walter
Swiss, op.1968
SIEGL or Siegel,
Anton
German, 1763-1846
SIEGMUND, Sigismund or
Zygmunt, III
King of Poland
Swedish, 1566-1632
SIEMANOWSKI, Raymond
American, 1938-
SIEMERING, Fritz
German, op.1872-m.1883
SIEMIGINOWSKI, Jerzy
(Georges)
Polish, -1711
SIEMIRADZKI, Hendrik
Polish, 1843-1902
SIENESE SCHOOL,
Anonymous Painters
of the
SIEROCINSKI, Jacek
Polish, 20th cent.
SIESTRZENCEWICZ,
Stanislas Bohusz
Polish, 1869-1927
SIEURAC, Francois
Joseph Juste
French, 1781-1832
SIEWERT, A.W.
German, -1751
SIEYE, Emmanuel
French, op.1652-1697
SIGALON, Alexander
Francois Xavier
(Xavier)
French, 1787-1837
SIGHIZZI
see Seghizzi
SIGISMUND
see Siegmund
SIGIZZI
see Seghizzi
SIGNAC, Paul
French, 1863-1935
SIGNAC, Pierre
French, op.1646-m.1684
SIGNOL, Emile
French, 1804-1892
SIGNORACCIO
see Paolino da
Pistoja, Fra
SIGNORELLI, Francesco
Italian, op.1520-m.1599
SIGNORELLI, Luca
Italian, 1441(?)-1523
SIGNORINI, Gaetano
Italian, 1806-1879
SIGNORINI, Giovanni
Italian, 1808-p.1858
SIGNORINI, Giuseppe
Italian, 1857-1932

SIGNORINI, Telemaco
Italian, 1835-1901
SIGNOVERT, Jean
French, 1919-
SIGNY, Louis
French, op.1768-1782
SIGRIST, Franz I
German, 1727-1803
SIGVARD, Rune
Swedish, 1907-1943
SIKORSKI, Tadeusz
Polish, 1913-
SILBER, Jonas
(Monogrammist J.S.)
German, op.c.1572-1589
SILBERT, Marie José
Jean Raymond
French, 19th cent.
SILLBERG
German, op.1797
SILLEMANS, Experiens
Dutch, c.1611-1653
SILLEN, Herman Gustav
af.
Swedish, 1857-1908
SILLETT or Selleth,
James
British, 1764-1840
SILLS, Thomas Albert
American, 1914-
SILLUE, Francisco
South American,
20th cent.
SILO, Adam
Dutch, 1674-a.1757(?)
SILT, W.
German(?) op.1830
SILVA, Francis
Augustus
American, 1835-1886
SILVA, Henrique José
da
Portuguese, 1772-
SILVA, Quirino da
Brazilian, 1897-
SILVA, S. da
Portuguese(?), op.1752
SILVEN, Jacob (Johan
Jacob)
Swedish, 1851-1924
SILVERSTONE, Micky
American, 20th cent.
SILVESTRE or Sylvestre,
Charles François
French, 1667-1738
SILVESTRE, François
French, c.1620-
SILVESTRE or Sylvestre,
Israel
French, 1621-1691
SILVESTRE or Sylvestre,
Louis I
French, 1669-1740
SILVESTRE or Sylvestre,
Louis II
French, 1675-1760
SILVESTRE or Sylvestre,
Marie Maximilienne de
French, 1708-1797
SILVESTRE or Sylvestre,
Nicolas Charles de
French, 1699-1767
SILVESTRI, Guglielmo
Italian, 1763-
SILVESTRI, Martino
Italian, 17th cent.

SILVESTRO dei
Gherarducci
(Silvestro
Camaldolense)
Italian, -1399
SILVETTE, David
American, 20th cent.
SILVETTE, Ellis M.
American, 1876-
SILVIO, Giampietro di
Marco di Francesco
Italian, op.1532-m.c.1552
SIMA, Josef
Czech, 1891-
SIMANOWITZ, Kunigunde
Sophie Ludovika
(Ludovika)
née Reichenbach
German, 1761-1827
SIMASHKEVICH, L.V.
Russian, 20th cent.
SIMBARI, Nicola
Italian, 1927-
SIMBERG, Hugo Gerhard
Finnish, 1873-1917
SIMCOCK, Jack
British, 1929-
SIME, Sidney H.
British, 1867-
SIMEONE da Spoleto
Italian, op.1230-1257
SIMEROVA-Martincekova,
Ester
Czech, 1909-
SIMIAN, Jean
French, 20th cent.
SIMINETTI, F.
American, 18th cent,(?)
SIMITIERE or Simitier,
Pierre Eugène Du
Swiss, c.1736-1784
SIMKIN, R.
British, 19th cent.
SIMLER, Johann
see Simmler
SIMM, Franz Xaver
German, 1853-1918
SIMMLER, Friedrich Carl
Joseph
German, 1801-1872
SIMMLER or Simler,
Johann
Swiss, 1693-1748
SIMMLER, Jozef
Polish, 1823-1868
SIMMLER, Wilhelm Karl
Melchior
German, 1840-1914(?)
SIMM-MAYER, Marie
Swiss, 1851-1912
SIMMONDS, John
see Simmons
SIMMONDS, William
George
British, 1876-
SIMMONS, Edward Emerson
American, 1852-1931
SIMMONS or Simmonds,
John
British, c.1715-1780
SIMMS, G.
British, op.1877
SIMO, Ferenc (Franz)
Hungarian, 1801-1869
SIMO or Simoni, Juan
Bautista
Spanish, -1717

SIMOLONG, Michel
German, 20th cent.
SIMON, Symons or
Symonds, Abraham
British, 1617-1692
SIMON von
Aschaffenburg (Franck?)
(Pseudo-Grünewald)
German, op.1526-1549
SIMON de Châlons
see Mailly
SIMON, E.
British, op.1734
SIMON, François
French, 1818-1896
SIMON, Friedrich
Rudolf
Swiss, 1828-1862
SIMON, Jacques Roger
French, 1875-1945
SIMON, Jean Pierre
(Pierre)
British, a.1750-c.1810
SIMON, Jeanne, née
Dauchez
French, 19th cent.
SIMON, Lucien
French, 1861-1945
SIMON, Paul
French, 20th cent.
SIMON, Pierre
French, c.1640-p.1710
SIMON, Susana
German, 1913-
SIMON, T. Frantisek
Czech, 1877-1942
SIMON von Taisten,
Tästen or Tastenz
German, c.1460-c.1530
SIMONAU or Simoneau,
François
Belgian, 1783-1859
SIMONAU or Simoneau,
Gustave Adolph
Belgian, 1810-1870
SIMON-AUGUSTE
French, 20th cent.
SIMONE da Bologna
see Crocifissi
SIMONE da Corbetta
Italian, op.1382
SIMONE da Cusighe
Italian, op.1382-m.a.1416
SIMONE di Filippo di
Benvenuto
see Crocifissi
SIMONE, Giuseppe de
Italian, 1841-p.1892
SIMONE di Martino
(Simone Martini)
Italian, 1280/5(?)-1344
SIMONE del Tintore
Italian, 17th cent.
SIMONE, Tommaso de
Italian, op.1852-1857
SIMONEAU
see Simonneau or
Simonau
SIMONET, Jean Baptiste
Blaise
French, 1742-1813
SIMONET, John-Pierre
Swiss, 1860-1915
SIMONETTI, Alfonso
Italian, 1840-1892
SIMONETTI, Attilio
Italian, 1843-1925

SIMONETTI, Ettore
Italian, 19th cent.
SIMONETTI, Masi
Italian, 20th cent.
SIMONI, Gustavo
Italian, 1846-
SIMONI, Scipione
Italian, op.1898
SIMONI, Stefan
German, 1860-1950
SIMONIDY, Michel
Roumanian, 1870-1933
SIMONIN, Claude
French, c.1635-1721
SIMONIN, Henri Alexis
French, op.1867-1877
SIMONINI, (not Simoncini,
Simonetti or Simoni)
Francesco
Italian, 1686-1753
SIMONIS, Louis Eugène
(Eugène)
Belgian, 1810-1882
SIMON-LEVY
French, 1886-
SIMONNEAU or Simoneau,
Charles I
French, 1645-1728
SIMONNEAU or Simoneau,
Louis II
French, 1654-1727
SIMONNEAU or Simoneau,
Philippe
French, 1685-p.1753
SIMONNET, Lucien
French, 1849-1926
SIMONS, Mlle. J.
French, op.1786
SIMONS, Michiel
Dutch, op.1648-m.1673
SIMONS, P. Marcius
British, op.c.1890
SIMONS or Symons,
Peeter
Flemish, op.1629-1637
SIMONS, W.H.
British, op.1863
SIMONSEN, Niels
Danish, 1807-1885
SIMONT, J.
French, 20th cent.
SIMPOL, Claude
see Saint-Paul
SIMPSON, A. Brantingham
British, 19th cent.
SIMPSON, Charles Walter
British, 1885-
SIMPSON, David
American, 1928-
SIMPSON, George
British, op.1799-1806
SIMPSON, Henry
British, 1853-1921
SIMPSON, James
Alexander
American, 1805/13-1880
SIMPSON, John
British, 1782-1847
SIMPSON, William
British, 1823-1899
SIMS, Charles H.
British, 1873-1928
SIMS, F.J.
British, 19th cent.
SIMSON, William
British, 1800-1847

SIMULA, Johann
German, op.1720
SIMUNOVIC, Frane
Yugoslav, 1908-
SINAPIUS, Joannes
see Mostaert, Jan
SINCLAIR, Alexander
Garden
British, 1859-1930
SINCLAIR, M.
British, 19th cent.
SINDING, Otto Ludvig
Norwegian, 1842-1909
SING, Johann Kaspar
German, 1651-1729
SINGELAER, Melchior
see Cingelaer
SINGER, Gérard
French, 1929-
SINGER, William H.jr.
American, 1868-
SINGH, Truong
Vietnamese, 20th cent.
SINGIER, Gustave
French, 1909-
SINGLETON, Henry
British, 1766-1839
SINGLETON, John
British, op.1773-1788
SINGLETON, William
British, op.1770-m.1793
SINGRY, Jean Baptiste
French, 1782-1824
SINIBALDI
see Montelupo
SINIBALDI, Jean Paul
French, 1857-1909
SINICKI, Reni
French(?) 20th cent.
SINTES, Giovanni
Battista
Italian, c.1680-c.1760
SINTZENICH, Elisabeth
German, c.1778-p.1798
SINTZENICH, Gustavus
Ellinthorpe
British, op.1844-1866
SINTZENICH, Heinrich
German, 1752-1812
SIOERTSMA or Siourtsma,
Anthonie Heeres
Dutch, 1626/7-p.1664
SIOLI
Italian, 19th cent.
SION, Peeter
Flemish, op.1649/50-m.1695
SIOURTSMA, Anthonie
Heeres
see Sioertsma
SIPILA, Sulho
Finnish, 1895-1949
SIPORIN, Mitchell
American, 1910-
SIQUEIROS, David Alfaro
Mexican, 1898-
SIRANI, Elisabetta
Italian, 1638-1665
SIRANI, Giovanni
Andrea
Italian, 1610-1670
SIRATO, Francisc
Rumanian, 1877-1953
SIRIES, Violante
Beatrice (Cerroti)
Italian, 1709-1783
SIRONI, Mario
Italian, 1885-1961

SISLEY, Alfred
French, 1839-1899
SITTOW or Sithium,
Michiel, or Miguel
Zittoz (Master Michiel,
or Michiel Flamenco)
Netherlands, c.1469-1525
SIUDMAK, Wojciech
Polish, 1942-
SIVELL, Robert
British, 1888-1958
SIVIERO, Carlo
Italian, 1882-1954
SIVRI
see Ingres
SJAMAAR, Pieter
Gerardus
Dutch, 1819-1876
SJOBERG, Axel
Swedish, 1866-
SJÖSTRÖM, Vilho
(Frans Vilho)
Finnish, 1873-1944
SKAAR, Britta
Norwegian, 20th cent.
SKANBERG, Carl
Emmerik
Swedish, 1850-1883
SKANBERG, L.
Swedish, 19th cent.
SKARBINA, Franz
German, 1849-1910
SKEAPING, John
British, 1901-
SKEATS, Leonard Frank
British, 1874-1943
SKEIT, Ambrosius
German, op.c.1500
SKELL, Ludwig
German, 1842-1905
SKELLY, Col. R.
British, op.1792-1794
SKELTON, James or
John
British, op.1745-m.1758
SKELTON, Percival
British, 19th cent.
SKELTON, William
British, 1763-1848
SKENE, James, of Rubislaw
British, 1775-1864
SKERL, Friedrich
Wilhelm
German, 1752-1810
SKILBECK, Clement O.
British, op.1884-1892
SKILLET, S.D.
British, op.1840-1865
SKINNER, W.
British, op.1834
SKIOLD, Birgit
Scandinavian, 20th cent.
SKIPPE, John (J.B.)
British, 1742-1811
SKIPWORTH, Frank Markham
British, 1854-1929
SKIRVING, Archibald
British, 1749-1819
SKJELBORG, Axel
Danish, 1895-
SKODLERRAK, Horst
German, 1920-
SKOLD, Otte
Swedish, 1894-
SKOTNIKOFF, Jegor
Russian, 1782-1843

SKOU, Sigurd
Scandinavian, 19th cent.
SKOVGAARD, Joachim
Frederik
Danish, 1856-1933
SKOVGAARD, Niels
Kristian
Danish, 1858-1938
SKOVGAARD, Peter
Christian Thamsen
Danish, 1817-1875
SKRAMSTAD, Ludvig
Norwegian, 1855-1912
SKREDSVIG, Christian
Eriksen
Norwegian, 1854-1924
SKRETA or Secreta,
Karel Sotnovsky
Czech, 1610-1674
SKULME, D.O.
Russian, 20th cent.
SKUM, Nils Nilsson
Swedish, 1872-1951
SKURJENI, Matija
Yugoslav, 1888-
SKUTEZKY, Döme or
Dominik (David)
Czech, 1850-1921
SKYNNER, T.
American, op.c.1845
SLABBAERT, Karel
Dutch, c.1619-1654
SLABBINCK, Hendrik
(Rik)
Belgian, 1914-
SLABY, František
Czech, 1863-1919
SLADE, Conrad
French, 20th cent.
SLADE, Roy
American, 20th cent.
SLAGER, Iris
Dutch, 20th cent.
SLATER, F.
British, op.1815
SLATER, F.
American, op.1862
SLATER, John Francis
South African,
c.1817-1876
SLATER, Joseph (J.W.)
British, op.1803-m.1847
SLATTERY, John Joseph
British, op.1846-1858
SLAUGHTER, Stephen
British, op.1712-m.1765
SLAVICEK, Antonin I
Czech, 1870-1910
SLAVONA, Maria
German, 1865-1931
SLAWINSKI, Kazimierz
Polish, 20th cent.
SLEAP, Joseph Axe
British, 1808-1859
SLEIGH, Bernard
British, 1872-1954
SLETER, Francesco
Italian, 1685-1775
SLEVOGT, Max
German, 1868-1932
SLEWINSKI, Wlasislaw
Polish, 1854-1918
SLICHTEN, J.F. van den
Netherlands, 18th cent.
SLIGH, S.
British, 19th cent.

SLINGELAND,
Slingelandt,
Slingelant, Slingeland
or Slingherlandt, Pieter
Cornelisz. van
Dutch, 1640-1691
SLINGELANDT, H.
(or J.N.?) van
Netherlands, op.1548
SLINGENEYER, Ernest
Belgian, 1820-1894
SLIWKA, Karol
Polish, 20th cent.
SLOAN, John
American, 1871-1951
SLOANE, Eric
American, 20th cent.
SLOCOMBE, Charles
Philip
British, 1832-1895
SLOCOMBE, Frederick
Albert
British, 1847-1920
SLODTZ or Slods, Antoine
Sébastien
French, c.1694/5-1754
SLODTZ or Slods, René
Michel (Michel-Ange)
French, 1705-1764
SLOMCZYNSKI, Jan
Polish, 20th cent.
SLOOVERE, Georges de
Belgian, 1873-
SLOTT-MÖLLER, Agnes
née Rambusch
Danish, 1862-1937
SLOTT-MÖLLER, Georg
Harald (Harald)
Danish, 1864-1937
SLOUS or Selous, Henry
Courtney
British, 1811-1890
SLUIS or Sluys, Jacob
van der
Dutch, c.1660-1732
SLUITER, Jan Willem
(Willy)
Dutch, 1873-1949
SLUITER or Sluyter,
Pieter
Dutch, 1675-p.1713
SLUYS, Jacob van der
see Sluis
SLUYS, Théo van
Belgian, 19th cent.
SLUYTER, Pieter
see Sluiter
SLUIJTERS, Johannes
Carolus Bernardus (Jan)
Dutch, 1881-1957
SMAK-GREGOOR, Gillis
Dutch, 1770-1843
SMALE, B.H.
British, 20th cent.
SMALL, Florence Véric
Hardy
British, op.1881-1909
SMALL, Frank O.
American, 20th cent.
SMALL, William
British, 1843-
SMALLFIELD, Frederick
British, 1829-1915
SMALLWOOD, William
Frome
British, 1806-1834
SMARGIASSI, Gabriele
Italian, 1798-1882

SMARGIASSO
see Ciafferi, Pietro
SMART, Edgar Rowley
British, 1887-1934
SMART, Jeffrey
Australian, 1921-
SMART, John I
British, 1741-1811
SMART, John II
British, op.1775-m.1809
SMART, John
(of Ipswich)?
British, -1813
SMART, John
British, 1838-1899
SMARTLY
British, 19th cent.
SMEBERT, J. van
Flemish, 17th cent.
SMEDLEY, William
Thomas
American, 1858-1920
SMEDT, Th. de
Belgian, op.1845
SMEES, Jan
Dutch, op.1705-m.1728/9
SMELLIE, William
British, 1697-1763
SMET, Antoni de
Dutch, op.c.1665
SMET, Gustave de
Belgian, 1877-1943
SMET, Léon de
Belgian, 1881-1966
SMET, Wolfgang de
Flemish, op.1667
SMETH, Hendrick (Rik)
de
Belgian, 1865-
SMETHAM, James
British, 1821-1889
SMETHAM, W.
British, 20th cent.
SMETS, Louis
Dutch, 19th cent.
SMEYERS, Egide or Gillis
Flemish, 1634-1710
SMEYERS, Egide or Gilles
Joseph
Flemish, 1694-1771
SMEYERS, Jacques
Flemish, 1657-1732
SMIADECKI, Sniadecki
or Szniadecki,
Frantiszek
Polish, op.1596-1616
SMIBERT or Smybert,
John
American, 1688-1751
SMIBERT, Nathaniel
American, 1734-1756
SMICCA
see Manni
SMIDT, Abraham de
South African, op.1889
SMIDT, Aernout
see Smit
SMIDTH, Hans Ludvig
Danish, 1839-1917
SMIDTS, Johannes
see Smits
SMIES, Jacob
Dutch, 1764-1833
SMILLIE, George Henry
American, 1840-1921
SMIRKE, Mary
British, op.1809-1814

SMIRKE, Richard
British, 1778-1815
SMIRKE, Robert
British, 1752-1845
SMIRNOFF, Boris
French, 1895-
SMISEK (Schmischek,
Schmisek or Swischegg),
Johann (Hans)
German, a.1585-p.1650
SMISSEN, Dominicus
van der
German, 1704-1760
SMIT or Smidt, Aernout
Dutch, 1641/2-1710
SMIT, Andres
Flemish, op.1650
SMIT, G.
see Smith
SMIT, G.
Dutch, op.1636
SMIT, Jan
Dutch, op.1721-1768
SMIT, Pieter
Dutch, c.1663-p.1694
SMITH, A.T.
British, 20th cent.
SMITH, Albert Delmont
American, 1886-
SMITH, Alfred George
French, 1842-
SMITH, Alfred Newland
British, 1812-1876
SMITH, Allan
American, 1810-1890
SMITH, Anker
British, 1759-1819
SMITH, Arthur Reginald
British, 1872-1934
SMITH, Benjamin
British, -1833
SMITH, Benjamin F.
American, 1830-1927
SMITH, Mrs. C.
British, op.c.1800
SMITH, Carlton Alfred
British, op.1871-1916
SMITH, Charles
British, 1749-1824
SMITH, Charles Hamilton
British, 1776-1859
SMITH, Charles John
British, 1803-1838
SMITH of Enderby, Charles
Loraine
British, 1751-1835
SMITH, Cockburn
British, 19th cent.
SMITH, Colvin
British, 1795-1875
SMITH, D. Atherton
British, op.c.1910
SMITH, Dana
American, op.c.1860
SMITH, Daniel Newland
British, 1791-1839
SMITH, David
British, 1906-1965
SMITH, David
British, 1920-
SMITH, E.
British, op.1827-1875
SMITH, E.L.
British, 19th cent.
SMITH, Edward
British, op.1773
SMITH, Edwin Dalton
British, 1800-p.1866

SMITH, Elinor
Bellingham
British, op.1940
SMITH, Eric
Australian, 1919-
SMITH, F.M. Bell
Canadian, 1846-1923
SMITH, F.S.
British, 19th cent.
SMITH, Francis or
Francesco
British, op.1763-m.a.1780
SMITH, Francis
American, 20th cent.
SMITH, Francis
Hopkinson
American, 1838-1915
SMITH, Frank Vining
American, 19th cent.
SMITH, Frederick
British, 19th cent.
SMITH or Smit, G.
British, op.1653
SMITH, G. (Giacomo?)
British, 18th cent.
SMITH, G.
British, op.1789-1805
SMITH, Mrs. G.
British, 19th cent.
SMITH, G.M.
Australian, 20th cent.
SMITH, Gabriel
British, 1724-1783
SMITH, Gaspar
British, op.1662
SMITH, Gean
American, 1851-1928
SMITH, George
see Armfield
SMITH of Chichester,
George
British, 1714-1776
SMITH, George
British, 1829-1901
SMITH, George
British, 1870-1934
SMITH, Gordon Appelbe
Canadian, 1919-
SMITH, H.
British, 18th cent.
SMITH, H.C.
British, op.1820-1833
SMITH, Hassel Wendel
American, 1915-
SMITH, Hely Augustus
Morton
British, 1862-1941
SMITH, Henry
British, op.1852
SMITH, Henry Pember
American, 1854-1907
SMITH, Herbert Luther
British, 1811-1870
SMITH, Captain Hervey
or Harvey
British, op.1759-1791
SMITH, Hobbe
Dutch, 1862-1942
SMITH, Howard Everett
American, 1885-
SMITH, Hugh Bellingham
British, 1866-1922
SMITH, J.
British, 18th cent.
SMITH, J.A.
British, 20th cent.
SMITH, Jack
British, 1928-

SMITH, Jack Carington
Australian, 1908-
SMITH, James Burrell
British, op.1850-1881
SMITH, James H.
British, op.1783-1789
SMITH, Johan
Flemish, 17th cent.
SMITH, John
British, 1652(?)-1742
SMITH of Chichester,
John I
British, 1717-1764
SMITH, John (Warwick
Smith or Italian
Smith)
British, 1749-1831
SMITH, John Brandon
British, op.1859-1884
SMITH, John Moyr
British, 19th cent.
SMITH, John Raphael
British, 1752-1812
SMITH, John Rubens
British, 1775-1849
SMITH, John Thomas
British, 1766-1833
SMITH, Jones G.
British, 19th cent.
SMITH, Joseph B.
American, 1798-1876
SMITH, Joseph
Clarendon
British, 1778-1810
SMITH, Kimber
American, 1922-
SMITH, Leon Polk
American, 1906-
SMITH, Leslie
British, 20th cent.
SMITH, M.N.
British, 18th cent.
SMITH, Marchant
British, 20th cent.
SMITH, Mathilde A.
British, op.1804-1824
SMITH, Sir Matthew
British, 1879-1959
SMITH, Nathaniel
British, 1740/1-p.1787
SMITH, Patricia
Allman
British, 20th cent.
SMITH, Percy John
British, 1882-1948
SMITH, R.
British, op.1791
SMITH, Richard
American, 1929-
SMITH, Richard
British, 1931-
SMITH, Captain Robert
British, 1792-1882
SMITH, Robert E.
American, 20th cent.
SMITH, S.
British, op.1811-1828
SMITH, Mrs S.
American, op.1857
SMITH, Samuel Mountjoy
British, op.1830-1857
SMITH, Sidney
British, op.1842
SMITH, Sophia
British, op.1766
SMITH, Stephen
Catterson I
British, 1806-1872

SMITH, T.
British, op.c.1684-1690
SMITH, T.
British, op.1755
SMITH, Thomas
American, op.1680-1693
SMITH of Derby,
Thomas
British, op.1745-m.1767
SMITH, Thomas
British, op.c.1780-1822
SMITH, Thomas Henry
American, op.1854-1871
SMITH, Tony
American, 20th cent.
SMITH, V.
British, 18th cent.
SMITH, W.A.
British, op.1787-1793
SMITH, W.T.
British, 20th cent.
SMITH, Walter Granville
American, 1870-1938
SMITH, Wilhelm
Swedish, 1867-1947
SMITH, Willcox Jessie
American, -1935
SMITH of Chichester,
William
British, 1707-1764
SMITH, William
British, op.1813-1859
SMITH, William
Collingwood
British, 1815-1887
SMITH, Worthington
George
British, op.1862-1865
SMITH, Xanthus
American, 1838-1929
SMITHARD, G.S.
British, 20th cent.
SMITHER, Michael
New Zealand, 1939-
SMITH-HALD, Frithjof
Norwegian, 1846-1903
SMITS or Smitz, Casparus
(Theodorus Hartcamp)
(Possibly identified
with D. or T. Sauts)
Netherlands,
c.1635-1707(?)
SMITS, Eugène
Belgian, 1826-1912
SMITS, Jakob
Dutch, 1855-1928
SMITS, Jan Gerard
Dutch, 1823-1910
SMITS or Smidts,
Johannes
Dutch, op.1660
SMITZ, Casparus
see Smits
SMOUT, Lucas, II
Flemish, 1671-1713
SMUGLEWICZ or
Szmuglewicz,
Franciszek
Polish, 1745-1807
SMYBERT, John
see Smibert
SMYTH, David
American, 1943-
SMYTH, Eugene Leslie
American, 1857-1932
SMYTH, H.
British, op.1845

SMYTH, Margarita
British, 20th cent.
SMYTH, Montague
British, 1863-1965
SMYTH, T.
British, 19th cent.
SMYTH, William
British, 1813-1878
SMYTHE, Edward Robert
British, 1810-1899
SMYTHE, Emily R.
British, op.1850-1874
SMYTHE, J.
British, op.1854-1862
SMYTHE, Lionel Percy
British, 1839-1918
SMYTHE, Thomas
British, 1825-1907
SNABILIE or Snabilé,
Marie Geertruyd
(Maria Geertruyd
Barbiers)
Dutch, 1776-1838
SNACK, Johan
Swedish, op.1782-1783
SNAGG, Thomas
British, 1746-1812
SNAPHAEN, Schnaphan
or Snaphan, Abraham
(de)
Dutch, 1651-1691
SNARBRECK, S.D.
British, 19th cent.
SNAYERS, Peeter
Flemish, 1592-p.1666
SNELL, Olive
British, 20th cent.
SNELL, T:O.
British, op.1829
SNELLINCK, Andries
Flemish, 1587-1653
SNELLINCK, Cornelis
Dutch, -1669
SNELLINCK, Geeraert
Flemish, 1577-p.1609
SNELLINCK or Snellinx,
Jan, Hans or Joan, I
Flemish, c.1549-1638
SNELLINCK, Jan or Hans, II
Flemish, 1575(?)-
SNELLINCK, Jan, III
Dutch, 1640-a.1691
SNELLING, L.
British, 18th cent(?)
SNELLING, Matthew
British, op.1647-1652
SNELLINX
see Snellinck
SNICKARE, Lars
Swedish(?) 16th cent.(?)
SNOW, J.W.
British, op.c.1832
SNOW, John
Canadian, 1911-
SNOW, Michael
Canadian, 1929-
SNOWMAN, Isaac
British, 1874-
SNYDER, William
Henry
American, 1829-1910
SNYDERS or Snijders,
Frans
Flemish, 1579-1657
SNYERS or Snijers,
Peeter
Flemish, 1681-1752

SOBIESKI, Jean
Polish, 20th cent.
SOBLEO or Sobleau,
Michele de
see Desubleo
SOBRILE, Giuseppe
Italian, 20th cent.
SOBRINO
French(?), 20th cent.
SOCQUET, Jeanne
French, 20th cent.
SODERINI, Antonio
Italian, 17th cent.
SODERINI, Mauro
Italian, 1704-p.1739
SÖDERMARK, Johan Per
(Per)
Swedish, 1822-1889
SÖDERMARK, Olof Johan
Swedish, 1790-1848
SODOMA, Giovanni Antonio
Bazzi
Italian, 1477-1549
SÖDRING, Frederik
Hansen
Danish, 1809-1862
SOEBORG, Knud Christian
Norwegian, 1861-1906
SOENS, Jan
see Sons
SOEST, Conrad von
see Conrad
SOEST, Soeste, Zoust or
Zoest, Gerard
German, c.1600-1681
SOEST, Louis Willem
van
Dutch, 1867-1948
SOEST, Nikolaus von
German, op.c.1480
SOEST, Pieter
Cornelisz. van
Dutch, op.1642-1667
SOETE, Lambert
see Suavius
SOFFICI, Ardengo
Italian, 1879-
SOGGI, Niccolò
Italian, 1480(?)-a.1552
SOGLIANI, Giovannantonio
di Francesco
Italian, 1492-1544
SOGNI, Giuseppe
Italian, 1795-1874
SOHL, Will
German, 1906-
SOHLBERG, Harald Oscar
Norwegian, 1869-1935
SOHN, Carl Ferdinand
German, 1805-1867
SOHN, Carl Rudolph
German, 1845-1908
SOHN, Johann August
Wilhelm (Wilhelm)
German, 1830-1899
SOHN-RETHEL, Alfred
German, 1875-
SOHN-RETHEL, Carl
Ernst (Karli)
German, 1882-1966
SOINARD, François
Louis
French, op.1824-1837
SOIRON, François David
Swiss, 1764-
SOIRON, Jean Francois
Swiss, 1756-1813

SOITER, Daniel
see Seiter
SOJARO, Il
see Gatti, Bernardino
SOJARO, Il
see Gatti, Gervasio
SOKOLNICKI, Michal
Polish, 1760-1816
SOKOLOFF, Piotr
Ivanovitch
Russian, 1752-1791
SOKOLOFF, Piotr
Petrovitch
Russian, 1821-1899
SOKOLOV, Nilolai
Alexandrovich
see Kukryniksy
SOLANA, José Gutiérrez
Spanish, 1886-1945
SOLANO, Nicolas
Spanish, op.1402
SOLARI, Achille
Italian, 1835-
SOLARI or Solario,
Andrea (di Milano)
Italian, op.1495-1522
SOLARI or Solario,
Cristoforo (da)
(il Gobbo)
Italian, op.1489-m.1527
SOLARIO, Antonio
(di Giovanni di Pietro)
(Lo Zingaro)
Italian, op.1502-1514/18
SOLDANI or Soldani-
Benzi, Massimiliano
Italian, 1658-1740
SOLDATI, Atanasio
Italian, 1896-1953
SOLDAU, H.
German, op.1837
SOLDENHOFF, Alexander
Leo von
Swiss, 1882-1951
SOLI, Andrea or Andrew
Italian, c.1703-p.1771
SOLDI, Baldassare
Italian, op.1626
SOLDINI, Luigi Dominique
French, 1715-p.1775
SOLE, Giovanni Battista
del
Italian, op.1649-m.1719
SOLE, Giovanni Gioseffo
dal
Italian, 1654-1719
SOLERI or Solero,
Giorgio
Italian, op.1575-m.1587
SOIFAROLO, Il
see Tavella, Carlo
Antonio
SOLIBES or Solives,
Francisco
Spanish, op.1480
SOLIMANI
see Niccolò da Verona
SOLIMENA, Angelo
Italian, c.1630-c.1716
SOLIMENA, Francesco
(L'Abate Ciccio)
Italian, 1657-1747
SOLIMENA, Giulio
Italian, c.1667-1722
SOLINI, Cavaliere
Tommaso
see Salini

SOLIS, Francisco de
Spanish, 1629-1684
SOLIS, Juan Rodriguez
de
Spanish, 16th cent.
SOLIS, Nikolaus
German, c.1542-1584
SOLIS, Virgilius, I
German, 1514-1562
SOLIVES, Jaime
Spanish, 15th cent.
SOLLAZZINO, Giuliano
Italian, c.1470-1543
SOLLEWIJN, Hendrina Alida
Dutch, 1783-1863
SOLLIER, Henri
Alexandre
French, 1886-
SOLMAN, Joseph
American, 1909-
SOLMI, Valentino
Italian, 1810-1866
SOLOMATKIN, Leonid
Ivanovich
Russian, 1837-1883
SOLOMON, Abraham
British, 1824-1862
SOLOMON, Rebekka
British, op.1852-1869
SOLOMON, Simeon
British, 1840-1905
SOLOMON, Solomon
Joseph
British, 1860-1927
SOLOMONS, Estella
Frances (Starkey)
British, 1882-
SOLON, Leon Victor
American, 1872-
SOLOSMEO or Solismeo,
Antonio, da
Settignano
Italian, op.1525-1536
SOLSONA, Jaime Cerera
de
Spanish, 15th cent.
SOLTAU, Hermann Wilhelm
German, 1812-1861
SOLUTUS or Soluti(?)
Italian, op.1555
SOLVYNS, Frans
Balthazar (Balthazar)
Flemish, 1760-1824
SOLY or Solly, Arthur
British, op.1683
SOLYOM, Robert
American, 20th cent.
SOMACCHINI
see Samacchini
SOMER(?), G. van
Netherlands, op.1684(?)
SOMER or Someren,
Hendrick van
Dutch, 1615-1684/5
SOMER or Someren,
Jan van
Dutch, 1645-p.1699
SOMER, Someren or
Sommern, Mathias van
Dutch, op.1649-1672
SOMER or Someren,
Paul or Paulus, I van
Flemish, c.1576-1621
SOMER, Paul, II van
Dutch, c.1649-c.1694
SOMERS
British, op.1842

SOMERS, Louis Jean
Belgian, 1813-1880
SOMERSCALES, Thomas
British, 1842-1927
SOMERVILLE, Andrew
British, 1808-1834
SOMERVILLE, Howard
British, 1873-1952
SOMIS, Lorenzo
Italian, 1702-1775
SOMM, Henri
see Sommier, Francois
Clément
SOMME, Jacob Kielland
Norwegian, 1862-
SOMMER, H.S.
Swedish, op.1753
SOMMER, Otto
German, 19th cent.
SOMMER, William
American, 1867-1949
SOMMERN, Mathias van
see Somer
SOMMIER, Francois
Clément (Henri Somm)
French, 1844-1907
SOMOFF or Ssomoff,
Constantin
Andreievitch
Russian, 1869-
SOMOGYI, Daniel
Hungarian, 1837-1890
SOMOZA, Fernando
Spanish, 1927-
SOMPEL or Sompelen,
Pieter van
Flemish,
c1600(?)-p.1643
SOMPSOIS, De
French, op.1778
SOMVILLE, Roger
Belgian, 1923-
SON, Erik Wahlberg
Swedish, 19th cent(?)
SON, Jan Frans van
Flemish, 1658-c.1718
SON, Joris or Georg
van
Flemish, 1623-1667
SON or Deson, Nicolas
(Antoine)
French, op.c.1628
SONDERBORG (Kurt
Hoffmann)
Danish, 1923-
SONDEREGGER, Jacques
Ernst
Swiss, 1882-1956
SØNDERGAARD, Jens
Danish, 1895-1957
SONDERLAND, Fritz
German, 1836-1896
SONDERLAND, Johann
Baptist Wilhelm
Adolf
German, 1805-1878
SONDERMANN, Hermann
German, 1832-1901
SONDERVAN or
Londervan, Ja.
Dutch, op.1795
SONJE, Jan Gabrielsz.
Dutch, c.1625-1707
SONMANS or Sunman,
Wilhelm or William
Dutch, op.1691-m.1708

SONNABEND, Yolanda
British, 20th cent.
SONNE, Jörgen Valentin
Danish, 1801-1890
SONNENSTERN
American, 20th cent.
SONNERAT, P.
French, c.1745-1814
SONNIER, Keith
American, 20th cent.
SONNIUS or Zonius,
Hendrik(also, erroneously,
Frederick)
Dutch, op.1631-m.a.1663
SONNTAG, Josef
German, 1784-1834
SONNTAG, V.
German, 19th cent.
SONNTAG or Sontag,
William Louis
American, 1822-1900
SONREL or Sorrel,
Elisabeth
French, 1874-
SONS or Soens, Jan
Netherlands,
c.1547/8-1611/(?)14
SONTAG, William Louis
see Sonntag
SOOIMAKER, Jan Frans
Flemish, op.1654-1665
SOORD, Alford Usher
British, 1868-1915
SOOT, Eyolf
Norwegian, 1858-1928
SOPER, Thomas George
(or James)
British, op.1836-1890
SORBI, Giovanni
Italian, c.1695-
SORBI, Raffaelo
Italian, 1844-1931
SORCH, Hendrik
see Sorgh
SORDET, Eugéne
Swiss, 1836-1915
SORDILLO de Pereda,
El
see Arco, Alonso del
SORDO del Barezzo
see Baglione,
Giovanni
SORDO d'Urbino, Il
see Viviani, Antonio
Maria
SORE, Nicolas (or
Antoine)
see Son
SOREAU or Soriau,
Daniel
Flemish, op.1586-m.1619
SOREAU or Soriau,
Jan (?)
German, op.1620-1638
SOREAU or Soriau,
Peter
German, op.1637-m.a.1672
SØRENSEN, Carl Frederik
Danish, 1818-1879
SØRENSEN, Henrik Ingvar
Norwegian, 1882-
SØRENSEN, Jörgen
Norwegian, 1861-1894
SORENSEN, Kurt
Trampedach
Danish, 1943-

SØRENSEN, Poul
Danish, 1896-1959
SORET, Nicolas
Swiss, 1759-1830
SORG, Johann Jacob
French, 1743-1821
SORGH, Sorch, Sorg,
Zorg or Zorgh, Hendrik
Martensz. (Rokes)
Dutch, c.1611-1670
SORGMEISTER
German, op.1475-1493
SORI, Pietro
see Sorri
SORIA, Martin de
Spanish, op.1475
SORIA, Salvador
Spanish, 1915-
SORIANO, Juan
Mexican, 1920-
SORIAU
see Soreau
SORINE or Ssorin,
Savely Abramovitch
Russian, 1878-
SORLAIN, J.
French, 20th cent.
SORLAY, Jerome
see Sourley
SORLET, Jerome
see Sourley
SOROKA, Grigori V.
Russian, 1823-1864
SOROKIN, Ivan
Vasilievich
Russian, 20th cent.
SOROLLA y Bastido,
Joaquin
Spanish, 1863-1923
SOROTES, William or
Guillarme
see Scrots, William
SORRELL, Alan
British, 1904-
SORRELL, Elizabeth
British, 1916-
SORRELL, Richard
British, 1948-
SORRI or Sori, Pietro
Italian, c.1556-1621/22
SOS, Laszlo
Hungarian, 20th cent.
SOSPIZIO, Seve
Italian, 1908-
SOTIO, Alberto
Italian, op.1187
SOTNOVSKY, Karel
see Skreta
SOTO, Jesus Raphael
Venezuelan, 1923-
SOTOMAYOR, Alvarez de
Spanish, 20th cent.
SOUBEYRAN, Pierre
Swiss, 1709-1775
SOUCEK, Karel
Czech, 1915-
SOUCH, John
British, op.1635
SOUCHON, Francois
French, 1787-1857
SOUCY, Jean
Canadian, 1915-
SOUDEIKINE, Sergei
Russian, 1883-
SOUDRY, Antoine
French, op.1730

SOUILLET, Georges
Francois
French, 19th cent.
SOUKENS, Hendrik
Dutch, 1680-1711
SOULACROIX, Joseph
Frédéric Charles or
Ferderigo (Charles)
French, 1825-
SOULAGES, Pierre
French, 1919-
SOULAS, Louis Joseph
French, 1905-
SOULES, Mathieu Eugène
Edouard (Eugène)
French, 1811-1876
SOULET, Maurice
French, 20th cent.
SOULIE, Léon
French, 1807-1862
SOUMY, Joseph Paul
Marius
French, 1831-1863
SOUNES, William Henry
British, 1830-1873
SOUR or Souse, Lawrence
British, op.1650-1677
SOURIKOFF, Vassily
see Surikov
SOURLEY, Saurley, Sorley
or Sorlet, Jérôme
French, op.1660-1669
SOUSA, Rocha de
Portuguese, 20th cent.
SOUSA Pinto or Souza
Pinto, José Julio de
Portuguese, 1855-1939
SOUSE
see Sour
SOUTER, Camille
British, 1929-
SOUTER, J.B.
British, op.1920-1950
SOUTES
Finnish(?), op.1600
SOUTHALL, Derek
British, 1930-
SOUTHALL, Joseph
Edward
British, 1861-1944
SOUTH ITALIAN SCHOOL,
Anonymous Painters
of the
SOUTHWELL, Viscount
British, op.c.1866
SOUTINE, Chaim
French, 1894-1943
SOUTMAN, Pieter Claesz.
Dutch, op.1619-m.1657
SOUTTER, Louis
Swiss, 1871-1942
SOUTTER, T.
British, op.c.1794
SOUVERBIE, Jean
French, 1891-
SOUZA, Francis Newton
Indian, 1924-
SOUZA Pinto
see Sousa Pinto
SOVACE, Raffaello
Angiolo
Italian, 18th cent.
SOWERBY, James
British, 1756-1822
SOYA-JENSEN, Carl
Martin
Danish, 1860-1912

SOYER, Elizabeth
Emma (Emma), née
Jones
British, 1813-1842
SOYER, Moses
American, 1899-
SOYER, Paul Constant
French, 1823-1903
SOYER, Raphael
American, 1899-
SOZZI, Olivio
Italian, 1696-1765
SPAAN, Jan
Dutch, c.1742-1828
SPACKMAN, Isaac
British, -1771
SPADA, Leonello
Italian, 1576-1622
SPADA, Lo
see Marescalco, Pietro
SPADA, Michelangelo
Italian, op.c.1730
SPADA, Simone (dei
Martinazzi or de
Martinatiis dictus de
Spadis)
Italian, 1482-1546
SPADA, Valerio
Italian, 1613-1688
SPADARINO, Lo
see Gallo
SPADARO, Micco
see Gargiulo, Domenico
SPADINI, Armando
Italian, 1883-1925
SPADINO, Giovanni Paolo
Italian, op.1687
SPAENDONCK, Cornelis
van
Dutch, 1756-1840
SPAENDONCK, Gerardus
(Gerard) van
Dutch, 1746-1822
SPAEY, M. van
Dutch, 18th cent.
SPAGNA, Lo (Giovanni
di Pietro)
Italian, c.1450-1528
SPAGNOLETTO, Lo
see Ribera, Jusépe de
SPAGNUOLO, Lo
see Crespi, Giuseppe
Maria
SPALA, Václav
Czech, 1885-1946
SPAIDING, C.B.
British, 19th cent.
SPALTHOVEN or Spalthof,
Joannes Philippus
Flemish, op.1700-1724
SPANG, Michael Henry
Danish, op.1750-m.1766/67
SPANGENBERG, Gustav
Adolph
German, 1828-1891
SPANGENBERG, Louis
German, 1824-1893
SPANISH SCHOOL,
Anonymous Painters
of the
SPANYI, Béla (Adalbert)
Hungarian, 1852-1914
SPANYIK, Kornél
Hungarian, 1858-1943
SPANZOTTI, Giovanni
Martino
Italian, a.1456-1526/28

SPARAPANE, Agostino
Spanish, op.1497
SPARAPANE or Desparapane,
Antonio
Italian, op.1464-1487
SPARAPANE or Desparapane,
Giovanni
Italian, op.1464-1466
SPARAPANE, Pietro
Spanish, op.1497
SPARE, Austin Osman
British, 1888-1956
SPARKES, J.C.L.
British, 19th cent.
SPARMANN, Karl
Christian
German, 1805-1864
SPARRE, Axel Freiherr
Swedish, 1652-1728
SPARRE, Emma
Swedish, 1851-1913
SPARRE, Konrad Freiherr
Swedish, 1680-1744
SPARRE, Louis, Count
of Sofdebourg
Swedish, 1863
SPARRGREN, Lorens (Lars)
Svensson
Swedish, 1763-1828
SPARTALI, Marie S.
see Stillman
SPATZ, Willy
German, 1861-1931
SPAULDING, S.
American, 1922-
SPAZZAPAN, Luigi
Italian, 1890-
SPEAR, Ruskin
British, 1911-
SPEARS, Frank
British, 20th cent.
SPECCARD, Hans or Jan
see Speeckaert
SPECCHI, Alessandro
Italian, 1668-1729
SPECCHI, Michelangelo
Italian, c.1684-p.1750
SPECHT, August
German, 1849-
SPECKAERT, Hans or Jan
see Speeckaert
SPECKLIN, Speckel or
Speckle, Daniel
German, 1536-1589
SPECKTER, Erwin
German, 1806-1835
SPECKTER, Hans
German, 1848-1888
SPECKTER, Otto
German, 1807-1871
SPEDDING, James
British, 1808-1881
SPEECHLEY, Gilbert
British, 20th cent.
SPEECKAERT, Speccard
or Speckaert, Hans
or Jan
Netherlands,
op.1575-m.c.1577
SPEED, Harold
British, 1872-1957
SPEELBERG, Gabriel
see Spilberg
SPEER, Johann Martin
(Martin) (not Michael)
German, c.1702-1765

SPEICHER, Eugene Edward
American, 1883-
SPEISSEGGER or
Speisegger, Alexander
Swiss, 1750-1798
SPELT, Adriaen van der
Dutch, c.1630-1673
SPENCE, Charles James
British, 1848-1905
SPENCE, John
British, 1944-
SPENCE, Percy F.S.
Australian, 1868-1933
SPENCE, Samuel John
British, 1842-1879
SPENCE, Thomas Ralph
British, c.1855-p.1916
SPENCE, William
British, c.1783-1849
SPENCE, William Blundell
British, c.1815-1900
SPENCELAYH, Charles
British, 1865-1958
SPENCER, Arthur
British, 19th cent.
SPENCER, C.
British, op.1836
SPENCER, Frederick R.
American, 1806-1875
SPENCER, Gervase or
Jarvis
British, op.1753-m.1763
SPENCER, Gilbert
British, 1892-
SPENCER, J.
British, op.1812-1822
SPENCER, Lavinia,
Countess, née Bingham
British, 1762-1831
SPENCER, Lily Martin
American, 1822-1902
SPENCER, Niles
American, 1893-1952
SPENCER, R.B.
British, op.1805
SPENCER, R.R.
British, 19th cent.
SPENCER, Robert
American, 1879-1931
SPENCER, Sir Stanley
British, 1891-1959
SPENCER, T.
British, op.1753
SPENCER, William
British, 19th cent.
SPENCER PRYSE, Gerald
British, 1881-1956
SPENDER, Humphrey
British, 1910-
SPENGLER, Caspar
Swiss, 1553-1604
SPENGLER, Hieronymus
Swiss, 1589-1635
SPENGLER, Nikolaus
Michael
German, 1770-1776
SPENGLER, Wolfgang
Swiss, 1624-p.1684
SPENLOVE-SPENLOVE, Frank
British, 1864-1933
SPERANDIA di Jacobello, F.
Italian, 16th cent.
SPERANDIO Savelli
Italian, a.1431(?)-p.1504
SPERANZA, Francesco
Italian, 1902-
SPERANZA, Giovanni
Italian, c.1480-a.1532

SPERL, Johann
German, 1840-1914
SPERLI, Johann Jacob, I
Swiss, 1770-1841
SPERLING, Catherina,
née Heckel
German, 1699-1741
SPERLING, Hans
German, op.1594-1601
SPERLING, Hieronymus
German, 1695-1777
SPERLING, Johann
Christian
German, 1690/1-1746
SPERMON, Cornelius
(Kees)
Dutch, 1941-
SPESCHA, Matias
Swiss, 1925-
SPICCIOTTI, de Spiciotis
or Spiciotto, Giacomo
Antonio
Italian, 1520-1601
SPICER, Charles
British, op.c.1875-1890
SPICER, Henry
British, 1741-1804
SPICER, Peter
British, op.1890
SPICRE, Pierre
French, op.1470-m.1478
SPIEGEL, Hans
German, 1894-
SPIEGLER, Franz Joseph
Swiss, 1691-1757
SPIELMANN, Oskar
German, 1901-
SPIELTER, Carl Johann
German, 1851-1922
SPIER, François
see Spierre
SPIERINCKS, Spieringh
or Spirinck, Karel
Philips
Flemish, c.1609-1639
SPIERINCX, Spierinck
or Spiering, Aert or
Arnold
Dutch, c.1593-p.1626
SPIERINCX, Veit
Flemish(?), 17th cent.(?)
SPIERRE, Spire or
Pierre, Claude
French, 1642-1681
SPIERRE, Spier or
Pierre, François
French, 1639-1681
SPIERS, Benjamin Walter
British, op.1875-1893
SPIERS, Richard Phené
British, 1838-1916
SPIESS, Heinrich
German, 1832-1875
SPIESS, Johann Nepomuk
German, 1838-
SPIESS, Walter
Russian, 1896-1947
SPILBERG, Adriana
(Adriana Breekvelt or
van der Neer)
Dutch, c.1652-p.1697
SPILBERG or Spielberg,
Gabriel
German, op.c.1590-1620
SPILBERG, Spielberg,
Spielberger or Spilberger,
Johann, II
German, 1619-1690

SPILIMBERGO, Adriano
Italian, 1908-
SPILLAR, Karel
Czech, 1871-1939
SPILLENBERGER or
Spilenberger, Johann
von
Hungarian, c.1628-1679
SPILLER, Jürg
Swiss, 1913-
SPILLIAERT, Léon
Belgian, 1881-1946
SPILMAN, Hendricus
Dutch, 1721-1784
SPILMAN, S.
British, 18th cent.
SPILSBURY, Francis B.
British, op.1803
SPILSBURY, Mary
(Mrs. John Taylor)
British, 1777-1823(?)
SPIN, Jacob
Dutch, 1806-1875
SPINDLER, Mrs
British, 19th cent.
SPINDLER, Charles
German, 1865-1938
SPINDLER, Louis Pierre
British, 1800-1889
SPINELLI, Giovanni
Battista
Italian, -c.1647
SPINELLI, Parri
(Gasparri)
Italian, c.1387-1453
SPINELLO di Luca
Spinelli (Spinello
Aretino)
Italian, c.1346(?)-1410
SPINKS, Thomas
British, 19th cent.
SPINNY, Guillaume Jean
Joseph de
Flemish, 1721-1785
SPIR, Peter Drach
Swiss, 15th cent.
SPIRA, Mrs Robert
British, 20th cent.
SPIRE, Claude
see Spierre
SPIRIDON, Ignace
Italian, op.1889-1900
SPIRO, Eugene
German, 1874-
SPISANELLI, Vincenzo
see Pisanelli
SPISANO, Vincenzo
see Pisanelli
SPITTLE, William
M.
British, 1858-1917
SPITZEL or Spizel,
Gabriel
German, 1697-1760
SPITZER, Emmanuel
German, 1844-1919
SPITZER, Walter
French, 20th cent.
SPITZWEG, Carl
German, 1808-1885
SPIX, J.B. von
German, 19th cent.
SPIZZICO, Raffaele
Italian, 1912-
SPLITGERBER, Karl Martin
August (August)
German, 1844-1918

SPODE, S.
British, op.1810-1860
SPOEDE, Jean Jacques
Flemish, c.1680-1757
SPOERER or Sporer,
Eduard
German, 1841-1898
SPOERRI, Daniel
French, 20th cent.
SPOHLER or Spöhler,
Jan Jacob
Dutch, 1811-1866
SPOHLER or Spöhler,
Jacob Jan Coenraad
Dutch, 1837-1923
SPOHLER or Spöhler,
Johannes
Franciscus
Dutch, 1853-1894
SPOHN, Jurgen
German, 20th cent.
SPOHRER, Hans
see Sporer
SPOLVERINI, Ilario
(Mercanti)
Italian, 1657-1734
SPOONER, Charles
British, c.1720-1767
SPORCKMANS, Huibrecht
Flemish, 1619-1690
SPORER or Spohrer,
Hans or Johannes I
German, 1573-p.1600
SPORING, Herman Dietrich
Finnish, c.1730-1771
SPORL, Jobst
German, 1583-1665
SPORNBERG, Jacob
Scandinavian, 1768-1840
SPORRER, Philipp
German, 1829-1899
SPORRING, Ole
Danish, 1941-
SPOTTISWOOD, Elspeth
British, 20th cent.
SPRAGUE, Ken
British, 20th cent.
SPRANGER or Sprangers,
Bartholomaeus
Netherlands, 1546-1611
SPREAFICO, Eugenio
Italian, 1856-1919
SPREEUEWEN, Jacob van
Dutch, 1611-p.1658
SPRENGER, B.
German, 16th cent.
SPRINCK, Leon
German(?) op.1919
SPRING, Alfons
German, 1843-1908
SPRINGER
British, 19th cent.
SPRINGER, Cornelis
Dutch, 1817-1891
SPRINGINKLEE, Hans
German, c.1495-p.1523
SPRINGOLO, Nino
Italian, 1886-
SPROSSE, Carl
Ferdinand
German, 1819-1874
SPRÜNGLI or Sprünglin,
Niklaus
Swiss, 1725-1802
SPRUYT, Jacob
Philips
Flemish, op.1764-1772

SPRUYT, Johannes
Dutch, 1627/8-1671
SPRUYT, Philippe Lambert
Joseph
Flemish, 1727-1801
SPRY, William
British, op.1832-1847
SPURLING, Jack
British, 1871-1933
SPURRIER, Steven
British, 1878-1961
'SPY'
see Ward, Sir Leslie
SPYCHALSKI, Jan
Polish, 1893-1946
SPYCK, Hendrick van der
Dutch, op.1667-1716
SPYROPOULOS, Jannis
Greek, 1912-
SQUARCIONE, Francesco
Italian, 1397-1468
SQUAZELLA, Andrea
see Sguazella
SQUIRRELL, Leonard
Russell
British, 1893-
SRAMKIEWICZ, Kazimierz
Polish, 1914-
SRBINOVIC, Mladen
Yugoslav, 1925-
STAAF, Carl Theodor
Swedish, 1816-1880
STAAL, Pierre Gustave
Eugène (Gustave)
French, 1817-1882
STAAL, Pieter
see Stael
STAATEN, Louis van
Dutch, 19th/20th cent.
STABB, C.T.
British, 19th cent.
STABEN, Hendrik
Flemish, 1578-1658
STÄBER, Georg
German, op.1495-1500
STABLI, Johann Adolf
(Adolf)
Swiss, 1842-1901
STACEY, Gloria
British, 20th cent.
STACHEL, Rudolph
see Stahel
STACHOWICZ, Michal
Polish, 1768-1825
STACHURSKI, Marian
Polish, 20th cent.
STÄCK, Joseph Magnus
Swedish, 1812-1868
STACK, L.
German(?) op.1793
STACKELBERG, Sophie von,
née Zoege von
Manteuffel
German, 1775-1828
STACQUET, Henry
Belgian, 1838-1906
STADE, Paul
German, 19th cent.
STÄDEL, Anna Rosina
Magdalena (Rosette)
née von Willemer
German, 1782-1845
STADEMANN, Adolf
German, 1824-1895
STADLER, Albert
American, 1923-

STADLER, Hans Ludwig
Swiss, 1605-c.1660
STADLER, Joseph
Constantine
British, op.1780-1812
STADLER, Toni (Anton)
von
German, 1850-1917
STADLMAIER, Johann
Nepomuk Anton
German, op.1777
STAEGER, Ferdinand
German, 1880-
STAEL, Nicolas de
French, 1914-1955
STAEL or Staal,
Pieter Michielsz.
(den Hyger)
Dutch, c.1575-1622
STAETS, Hendrick
Dutch, op.c.1630-1660
STAFFE, Jan Jacobus
van der
Netherlands, 17th cent.
STAGNON, Antonio Maria
Italian, 1751-1805
STAGURA, Albert
German, 1866-1947
STAHEL or Stachel,
Rudolph
Swiss, op.1473-m.1527/8
STAHI, C.D.
Rumanian, 19th cent.
STAHL, Friedrich
German, 1863-
STAHL, Heinrich
German, 1880-
STAHL, P.
German, 19th cent.
STAHLBOM, J.
Swedish(?) 18th cent(?)
STAHLI, Johann
Swiss, 1778-1861
STAIGER, Otto
Swiss, 1894-1967
STAIGER, Paul
American, 20th cent.
STAIGG, Richard Morrell
British, 1817-1881
STAINER, Ferdinand
see Steiner
STAINHAUSER, Gandolph
Ernst (St. von
Treuberg)
German, 1766-1805
STAINTON, George
British, 19th cent.
STALARD
see Stella
STALBEMT, Adriaen van
Flemish, 1580-1662
STÅLBOM, Johan
Swedish, 1712-1777
STALLARD,
see Stella
STALPAERT or Stalpert,
Daniel
Dutch, 1615(?)-1676
STALPAERT, Pieter
Flemish, c.1572-a.1639
STAMBACCHI, Protasio
Girolamo
see Stambucchi
STAMBUCCHI or
Stambacchi, Protasio
Girolamo
Italian, 1759(?)-1833

STAMFORD, Everard
British, 18th cent.
STAMOS, Theodorus
American, 1922-
STAMP, Ernest
British, 1869-1942
STAMPART, Frans van
Flemish, 1675-1750
STAMPFLI or Staempfli,
Peter
American, 20th cent.
STAN, Done
Rumanian, 20th cent.
STANCARI, Antonio
Italian, 18th cent.
STANCHI, Giovanni
Italian, c.1645-
STANCIC, Miljenko
Yugoslav, 1926-
STANCZAK, Julian
American, 20th cent.
STANCZEL, Theophilus
Hungarian, c.1470-1531
STANCZEW, Christo
Polish, 1875-1950
STANDFAST, G.B.
see Standfust
STANDFUST or Standfast,
G.B.
British, op.1844
STANE, Kregar
Yugoslav, op.1960
STANETTI or Stanety,
Johann
German, 1663-1726
STANETY, Johann
see Stanetti
STANFIELD, Clarkson
(William)
British, 1793-1867
STANFIELD, George
Clarkson
British, 1828-1878
STANGE, Bernhard
German, 1807-1880
STANGERUS or Stanger,
Cornelis
Dutch, 1616-a.1668
STANGL, Heinz
German, 1942-
STANHOPE, John Roddam
Spencer
British, 1829-1908
STANIC, Vojislav
Yugoslav, 1924-
STANILAND, Charles
Joseph
British, 1838-p.1896
STANISLAS of Mogila
Polish, op.c.1530
STANISLAWSKI, Jan
Grzegorz
Polish, 1860-1907
STANKA, F.J.
German, op.c.1790
STANLAWS, Penryhn
(or Penrhyn Stanley
Adamson)
American, 1877-
STANLEY, A.R.
American, op.1840
STANLEY, Bob
American, 1932-
STANLEY, Caleb or
Colet, Robert
British, c.1795-1868

STANLEY, Charles
Frederik
British(?), 1740-1813
STANLEY, Lady Dorothy,
née Tennant
British, op.1886-m.1926
STANLEY, G.
British, op.1800-1817
STANLEY, James M.
American, 1814-1872
STANNARD, Alfred
British, 1806-1889
STANNARD, Alfred George
British, 1828-1885
STANNARD, Eloise
Harriet
British, op.1845-m.1914
STANNARD, Emily
British, 1875-1907
STANNARD, Henry
Sylvester
British, 1870-1951
STANNARD, Joseph
British, 1797-1830
STANNEY, John
British, c.1678-p.1750
STANNUS, Anthony Carey
British, op.1862-1903
STANOEWA, Ralica
Bulgarian, 20th cent.
STANTON, George Clark
(Clark)
British, 1832-1894
STANWOOD, Franklin
American, op.1881
STANZIONE or Stanzioni,
Massimo (Cavaliere
Massimo)
Italian, 1585-1656
STAP, Jan Woutersz.
see Woutersz.
STAPERT, Elizabeth
Johanna, (née Koning)
see Koning
STAPHORST, Abraham
Dutch, c.1638-1696
STAPLES, Sir Robert
Ponsonby
British, 1853-p.1897
STAPLETON, C.
British, op.1790-1796
STAPRANS, Raimonds
American, 20th cent.
STAR
see Stella
STARACE, Girolamo
Italian, op.1757
STARBUS, Johan or Jaen
Dutch, 1679-1724
STAREJSZINSKI, Asen
Bulgarian, 20th cent.
STAREN, Dirk van
see Vellert
STAREZEWSKI, Artur
Polish, 20th cent.
STARK, Arthur James
British, 1831-1902
STARK, C.
British, op.1810
STARK, James
British, 1794-1859
STARK, Karl
German, 1921-
STARKE, Samson
see Strong

STARKEY, Samson
see Strong
STARKIE, Edyth
see Rackham
STARNINA, Gherardo or
Gherardo di Jacopo
(lo Starnina) (Compagno
di Agnolo Gaddi)
Italian, op.1387-m.1409/13
STAROWIEYSKI, Franciszek
Polish, 20th cent.
STARR, Louisa, née
Canziani
British, 1845-1909
STARR, Sidney
British, 1857-1925
STASACK, Edward
American, 1929-
STASS, Peter
German, op.1534
STATTLER, Hubert
German, 1817-1904
STATTLER or Stattler-
Stanski, Wojciech
(Albert) Korneli
Polish, 1800-1875
STATZ, Vinzenz
German, 1819-1898
STAUDACHER, Hans
German, 1923-
STAUDER, Franz
German, c.1734-p.1759
STAUDER, Jacob Carl
(Karl), II
German, a.1700-1751
STAUFFER, Fred
Swiss, 1892-
STAUFFER, Viktor
German, 1852-1934
STAUFFER-BERN, Carl
Swiss, 1857-1891
STAVELEY or Stavely, W.
British, op.1785-1805
STAVERDEN, Jacob van
Dutch, op.c.1674
STAVEREN, Jan Adriaensz.
van
Dutch, c.1625-p.1668
STAVERENUS, Petrus
Dutch, op.1634-1654
STAYNEMER, Jan van
see Stinemolen
STAZEWSKI, Henryk
Polish, 20th cent.
STCHEDRIN, Simon
see Stschedrin
STCHOUKINE, S.S.
Russian, 1754-1828
STEARNS, Junius Brutus
American, 1810-1885
STECH, Stecher, Steg
or Stegh, Andreas
German, 1635-1697
STECH, Lucas van der
Flemish, 17th cent.
STECHER, Franz Anton
German, 1814-1853
STECK, Leo
Swiss, 1883-
STEEGMAN, John
British, 18th cent.
STEEL, George Hammond
British, 1900-
STEEL, Gourlay
British, 19th cent.
STEEL, James W.
American, 1799-1899

STEELE, Captain
American, op.1814
STEELE, Christopher
British, c.1730-p.1762
STEELE, Edwin
British, 19th cent.
STEELE, Jeffrey
British, 20th cent.
STEELE, Theodore
Clement
American, 1847-1926
STEELINK, Willem, II
Dutch, 1856-1928
STEEN, van der
Dutch, 20th cent.
STEEN, Cornelis
Dutch, 1655/6-1697
STEEN or Stein,
Franciscus van der
Flemish, c.1625-1672
STEEN, Jan Havicksz.
Dutch, 1625/6-1679
STEEN, Thadaeus (Tede)
Dutch, 1651-p.1684
STEENBERGEN, Albertus
Alides
Dutch, 1814-1900
STEENBOCK, M.
Netherlands, op.1713
STEENE, Augustus
van den
Belgian, 1803-1870
STEENS, N.D.
Dutch, op.1784
STEENWINKEL, Abraham
German(?) 17th cent.
STEENWINKEL or
Stenwinkel, Morten or
Martin
Danish, 1595-1646
STEENWYCK, Abraham
Dutch, c.1640-1698
STEENWYCK, Harmen or
Herman Evertsz. van
Dutch, 1612-p.1655
STEENWYCK, Hendrik,
I van
Flemish, c.1550-1603
STEENWYCK, Hendrik,
II van
Flemish, c.1580-a.1649
STEENWYCK, Pieter
Evertsz. van
Dutch, op.1632-1654
STEEPLE, John
British, op.1852-m.1887
STEER, Henry Reynolds
British, 1858-1928
STEER, Philip Wilson
British, 1860-1942
STEERBEEK, Francois
van
see Sterbeeck
STEEVENS
see Stevens
STEFANI
see also Stevens
STEFANI, Sigismondo
de'
Italian, op.1563-p.1574
STEFANINI, Vincenzo De
Italian, 1859-1937
STEFANINI, Giovanni
Grisostomo
Italian, 1714-p.1735
STEFANO da Ferrara
see Falzagalloni

STEFANO Fiorentino
or da Ponte Vecchio
Italian, 14th cent.
STEFANO di Giovanni
see Sassetta
STEFANO di Giovanni
da Verona (da Zevio)
Italian, c.1374/5-p.1438
STEFANO Piovano di
Sant' Agnese
see Stefano Veneziano
STEFANO Veneziano
or Stefano Piovano
di Sant'Agnese
Italian, op.1369-1385
STEFANONE
Italian, 14th cent.
STEFANONI, Steffanoni
or Stephanoni, Pietro
Italian, c.1589-p.1627
STEFANSSON, Jón
Scandinavian, 1881-
STEFFAN
see also Stevens
STEFFAN, Johann
Gottfried
Swiss, 1815-1905
STEFFANI, Luigi
Italian, 1827-1898
STEFFECK, Carl
Constantine Heinrich
German, 1818-1890
STEFFELAAR, Cornelis
Dutch, 1797-1861
STEFFENINI, Ottavio
Italian, 1889-
STEFFENS
see Stevens
STEFULA, Dorothea
German, 1914-
STEFULA, Gyorgy
German, 1913-
STEGEMANN, Heinrich
German, 1888-1945
STEGER or Stöger,
Johann
German, op.1663-1677
STEGERER, Casimir
Wilhelm
German, 1813-
STEGMANN, Franz
German, 1831-1892
STEIDEL
German, op.1760-1765
STEIDL, Melchior
Michael
German, a.1687-1727
STEIL, Henry
British, op.1836-1838
STEIN, August Ludwig
German, 1732-1814
STEIN, Charlotte von
German, 1742-1827
STEIN, Franciscus
van der
see Steen
STEIN, Georges
French, 1890-1910
STEIN, Peter
Swiss, 1922-
STEINACKER, Alfred
German, 1838-
STEINBERG, Saul
American, 1914-
STEINBÖCK, Carl
German, op.1793-1828
STEINBRÜCK, Eduard
German, 1802-1882

STEINGER, Agnes
Norwegian, op.c.1889
STEINER, Barbara
see Krafft
STEINER, Carl Friedrich
Christian
German, 1774-1840
STEINER, David Eduard
(Eduard)
Swiss, 1811-1860
STEINER, Emanuel
Swiss, 1778-1831
STEINER or Stainer,
Ferdinand
German, op.1688-m.1725
STEINER, Johann Nepomuk
German, 1725-1793
STEINER-PRAG, Hugo
German, 1880-1945
STEINFELD, Franz II
German, 1787-1868
STEINFELD, Wilhelm
German, 1816-1854
STEINFELS, Johann Jacob
see Stevens
STEINFORTH, Peter
German, 1923-
STEINFURTH, Hermann
German, 1823-1880
STEINHAMMER, Friedrich
Christoph
German, op.1608-1622
STEINHARDT, Jakob
German, 1887-
STEINHART, Anton
German, 1889-
STEINHAUSEN, Marie
Paquet
see Paquet-Steinhausen
STEINHAUSEN, William
August Theodor
German, 1846-1924
STEINHEIL, Adolphe
Charles Edouard
French, 1850-1908
STEINHEIL, Louis
Charles Auguste
German, 1814-1885
STEINHOUSE, Tobie
Canadian, 20th cent.
STEINKOPF, Gottlob
Friedrich
German, 1778-1860
STEINLA, Franz Anton
Erich Moritz (Müller)
German, 1791-1858
STEINLE, Edward Jakob
von
German, 1810-1886
STEINLE, G.
German, 19th cent.
STEINLE, Matthias
German, c.1644-1727
STEINLEITNER, Max
German, 1887-
STEINLEN, Christian
Gottlieb (Théophile)
German, 1779-1847
STEINLEN, Théophile
Alexandre
Swiss, 1859-1923
STEINMETZ, Fritz
German, 19th cent.
STEINMETZ, Ludwig
German, op.c.1755-1760
STEINMÜLLER, G.F.
German, 18th cent.
STEKELENBURG, Jan
Dutch, 1922-

STELLA
see Stern, Ignaz
STELLA
French, 18th cent.(?)
STELLA, Claudine
see Bouzonnet
STELLA, Fermo da
Caravaggio
Italian, op.1519-1562
STELLA, Stalard,
Stallard, Star or
Stellaert, Francois, I
Netherlands, 1563-1605
STELLA, Stalard,
Stallard, Star or
Stellaert, Francois, II
French, 1603(?)-1647
STELLA, Frank
American, 1936-
STELLA, Giacomo
Italian, op.1568
STELLA, Stalard,
Stallard, Star or
Stellaert, Jacques
French, 1596-1657
STELLA, Joseph
American, 1879-1946
STELLAERT
see Stella
STELLETSKY, Dmitri
Semionovitch
Russian, 1875-
STELLINGWERFF, Gerrit
Louwerensz. van
Dutch, op.1633-1657
STELLINGWERFF, Jacobus
Dutch, op.1682-m.a.1737
STELZNER, Anna Carolina
(Carolina)
German, 1808-1875
STELZNER, Carl
Ferdinand
German, c.1805-1894
STEN, John
Swedish, 1879-1922
STENBERG, Georgy
Russian, 1900-1933
STENBERG, Isak Johan
Emerik Gustaf (Emerik)
Swedish, 1873-1927
STENBERG, Vladimir
Russian, 1899-
STENE
German, op.1859
STENERSEN, Gudmund
Norwegian, 1863-1934
STENGELIN, Alphonse
French, 1852-
STENNER, Hermann
German, 1891-1914
STENNETT, Ralph
American, 19th cent.
STENQUIST, Nils G.
Scandinavian, 20th cent.
STENT, Peter
Dutch, op.c.1640-1667
STENWINKEL, Morten or
Martin
see Steenwinkel
STEPAN, Ivan
Czech, 20th cent.
STEPHAN or Stephani
see also Stevens
STEPHAN, Johann
German, 1795-1855
STEPHAN, Joseph
German,
c.1709-1786

STEPHAN, Leopold
 Czech, 1826-1890
STEPHAN, Meister
 see Lochner
STEPHANE, Micius
 Haitian, 1912-
STEPHANOFF, Francis
 Philip
 British, 1790(?)-1860
STEPHANOFF, James
 British, 1788(?)-1874
STEPHENS
 see also Stevens
STEPHENS, Alice
 Barber
 American, 1858-1932
STEPHENS, Frederick
 George
 British, 1828-1907
STEPHENS, Peter
 British, op.1760-1769
STEPHENS, Thomas E.
 American, 20th cent.
STEPHENSON, G. Torrance
 British, 20th cent.
STEPHENSON, Ian
 British, 1934-
STEPHENSON, John Cecil
 British, 1889-
STEPHENSON, T.
 British, op.c.1700
STEPHENSON, Thomas
 British, op.1798
STEPPE, Romain
 Belgian, 1859-
STEPPES, Edmund
 German, 1873-
STERBEECK or Steerbeek,
 François van
 Flemish, 1630-1693(?)
STERENBERG, David
 Petrowitsch
 Russian, 1881-
STERER, Richard
 German, 1874-1930
STERIADI, Ioan
 Alexander
 Rumanian, 1880-
STERIO, Károly (Karl)
 Hungarian, 1821-1862
STERITZ, Hans, I
 Swiss, 16th cent.
STERL, Robert
 German, 1867-1932
STERLING, Marc
 Russian, 1898-
STERN, Alan
 British, 20th cent.
STERN, Alois Anton
 (Anton)
 German, 1827-1924
STERN, Bernard
 French, 20th cent.
STERN, Ernst
 German, 1876-1954
STERN, Ignaz
 ('Stella')
 German, 1698-1746
STERN, Irma
 South African, 1894-1966
STERN, Jonasz
 Polish, 20th cent.
STERN, Joseph
 Czech, 1716-1775
STERN, Ludwig
 Italian, 1709-1777

STERN, Max
 German, 1872-
STERN, Veronica
 Italian, 1717-1801
STERNBERG, David
 American, 20th cent.
STERNE, Hedda
 American, 1916-
STERNE, Maurice
 American, 1877-1957
STERNER, Albert Edward
 American, 1863-1946
STERNHOVEN or Sternhoove,
 C.
 Dutch, c.1634-p.1664
STERUP-HANSEN, Dan
 Danish, 1918-
STERVARD, J.
 British, 18th cent.
STERZ, Andreas
 German, op.1633-1647
STETTHEIMER, Florine
 American, -1944
STETTINIUS, Samuel
 Enredy
 American, 1768-1815
STETTLER, Gustav
 Swiss, 1913-
STETTLER, Marthe
 Swiss, 1870-
STETTLER, Wilhelm
 Swiss, 1643-1708
STETTNER, Georg
 Friedrich
 German, -1639
STEUART, Ronald
 British, 20th cent.
STEUBEN, Alexander
 Joseph von
 French, 1814-1862
STEUBEN, Charles
 Guillaume Auguste
 Henry François Louis
 de
 German, 1788-1856
STEUERWALDT, Wilhelm
 German, 1815-1871
STEVAERTS or Stevens
 see also Palamadesz
STEVENS
 see also Palamadesz
STEVENS, Alfred
 Belgian, 1823-1906
STEVENS, Alfred George
 British, 1818-1875
STEVENS, D.
 British, op.1722
STEVENS, Edouard
 Joseph (Joseph)
 Belgian, 1819-1892
STEVENS, Francis
 British, 1781-1822/3
STEVENS, George
 British, op.1810-1865
STEVENS, Gustave Max
 Belgian, 1871-
STEVENS, I.
 British, op.c.1745
STEVENS, Jan or John
 Dutch, -1722
 Steffens, Stephan,
 Stephani, Stephens,
 Stivens or Steinfels,
 Johann Jacob
 German, 1651-1730

STEVENS, John
 British, 1793-1868
STEVENS, Joseph
 see Stevens, Edouard
 Joseph
STEVENS, Norman
 British, 20th cent.
STEVENS, Steevens,
 Stefani, Steffan,
 Steffens, Stephan,
 Stephani, Stephens
 or Stivens, Pieter, I
 Netherlands,
 c.1540-p.1566
STEVENS, Steevens,
 Stefani, Steffan,
 Steffens, Stephan,
 Stephani, Stephens
 or Stivens, Pieter, II
 Flemish, c.1567-p.1624
STEVENS, Richard
 British, 1547-1592
STEVENS, William Dodge
 American, 1870-1942
STEVENSON, G.S.
 British, op.1830
STEVENSON, Hugh
 British, 20th cent.
STEVENSON, J.H.
 British, op.c.1776-1833
STEVENSON, James
 British, op.1837-1841
STEVENSON, Robert Alan
 Mowbray
 British, 1847-1900
STEVENSON, Robert Louis
 British, 1850-1894
STEVENSON, Robert
 Macaulay
 British, 1860-1952
STEVER, Gustav Curt
 German, 1823-1877
STEVERS
 see Palamedesz
STEWARD, Joseph
 American, 1753-1822
STEWARDSON, Thomas
 British, 1781-1859
STEWART
 see also Stuart
STEWART
 British, 19th cent.
STEWART, Alexander
 British, 18th cent.
STEWART, Allan
 British, 1865-1951
STEWART, Anthony
 British, 1773-1846
STEWART, Arthur
 British, 1877-1941
STEWART, Charles
 British, op.1762-1790
STEWART, Charles
 Edward
 British, op.1890-c.1930
STEWART, Frank Algernon
 British, 1877-1945
STEWART, Hope James
 British, op.1834-1865
STEWART, James S.
 British, 1791-1863
STEWART, John
 British, 1800-
STEWART, Julius L.
 American, 1855-1919
STEWART, Robert Wright
 British, op.1905-1950

STEWART, Thomas
 British, op.1784-1801
STEWART, Wallace
 British, op.1889
STEWART, William
 British, 1886-
STEWART, Ann Linsdell
 British, 20th cent.
STEYAERT, Antoine
 Flemish, 1740-1781
STEYNEMOLEN, Jan van
 see Stinemolen
STICKGOLD, Stanislaus
 Russian, 1868-1933
STIEF, Sebastian
 German, 1811-1889
STIEFEL, Eduard
 Swiss, 1875-
STIEGLITZ, Henry
 German, 18th cent(?)
STIELER, Joseph Carl
 German, 1781-1858
STIEPEVICH, Eugene
 Russian, 19th cent.
STIFTER, Adalbert
 German, 1805-1868
STIFTER, Moritz
 German, 1857-1905
STIGLMAIER, Johann
 Baptist
 German, 1791-1844
STILL, Clyfford E.
 American, 1904-
STILLER, Vic
 French, 20th cent.
STILLMAN, George K.
 American, op.1840-1860
STILLMAN, Marie S.,
 née Spartali
 British, 1844-
STILWELL, Sarah S.
 American, 20th cent.
STIMMER, Abel
 Swiss, 1542-1606
STIMMER, Christopher, I
 Swiss, c.1490-1562
STIMMER, Hans Christoffel
 (Johan Christoph)
 Swiss, 1549-1578
STIMMER, Tobias
 Swiss, 1539-1584
STINEMOLEN, Staynemer
 or Steynemolen, Jan van
 Netherlands, 1518-p.1582
STIPNIEKS, Margarita
 British, 20th cent.
STIPPERGER, Lukas
 German, 1755-1806
STIRNBRAND, Franz
 Seraph
 German, c.1796-1882
STIVENS
 see Stevens
STOBART, John
 British, op.c.1852
STOBBAERTS, Jan
 Belgian, 1838-1914
STÖBER, Franz
 German, 1760-1834
STÖBER, Johann Jakob
 German, op.1763-1796
STÖBERL, Mathias
 German, op.1497-1515
STOBJEUBERG, C.
 German, 1784-1858

STOBWASSER, Johann
Heinrich
German, 1740-1829
STOCADE, Nicolaes de
Helt
see Helt
STOCH, Johann Martin
see Stock
STOCK or Stockius,
Andries Jacobsz.
Dutch, c.1580-1648(?)
STOCK, Ernest
American, 20th cent.
STOCK, H.
Dutch(?), op.c.1618
STOCK, Henry John
British, 1853-1931
STOCK, Ignatius van der
Flemish, op.1660-
STOCK, Jacobus van der
see Stok
STOCK, Johann
Friedrich
German, -1866
STOCK or Stoch, Johann
Martin
German, 1742-1800
STOCK, Johanna Dorothea
(Dorothea)
German, 1760-1832
STOCK or Stocke,
Johannes van der
Dutch, op.1656-1676
STOCK, Joseph Whiting
American, 1815-1855
STOCK, Vranke van der
see Stockt
STOCKDALE, Frederick
Wilton Litchfield
British, op.1803-1848
STOCKE, Johannes van der
see Stock
STOCKER
British(?), 18th cent.
STOCKER, Hans
Swiss, 1896-
STÖCKER, Jörg
German, op.1481-1525
STOCKIUS, Andries
Jacobsz.
see Stock
STOCKLER
German(?), 1676-1681
STOCKLIN, Christian
Swiss, 1741-1795
STOCKLIN, Friedrich
German, 1770-1828
STÖCKLIN, Peter
Swiss, op.1616-m.1652
STOCKMAN or Stockmans,
Jan Gerrits
Dutch, op.1636-m.1670
STOCKMANN, Johann Adam
German, op.1720-1783
STOCKS, Arthur
British, 1846-1889
STOCKS, Lumb
British, 1812-1892
STOCKS, Walter Fryer
British, op.1850-1865
STOCKT, Stock or
Stoct, Vranke van der
(Also identified with
Master of the Prado
Redemption)
Netherlands,
op.1444-m.1495

STODART, George
British, -1884
STODDARD, Alice Kent
American, 19th cent.
STODDART, J.
British, 20th cent.
STODHART, Simon
British, 19th cent.
STOECKLIN, J.
Swiss, 18th cent.
STOECKLIN, Niklaus
Swiss, 1896-
STOENESCU, Eustatin
Grigorie
Roumanian, 1889-1957
STOER, Storer or
Storr, Lorenz
German, p.1553-1589
STOESSEL, Henry
American, 20th cent.
STOEVERE, Stoovere,
Stovere or Stovre,
Jean, I de (Jean
d'Estouvre)
Netherlands, op.1416-1443
STOFFE, Jan Jacobsz.
van der
Dutch, c.1611-1682
STÖGER, Johann
see Steger
STOHL, Michael
German, 1813-1881
STOHOM, Matthias
see Stomer
STÖHR, Ernst
German, 1865-1917
STOIFI, Ermano
see Stroifi
STOILOFF, C.
Russian, 19th cent.
STOITZNER, Constantin
German, 1863-1934
STOJAN, Celic
Yugoslav, 1925-
STOJANOW, Pjotr
Bulgarian, op.1887-1894
STOK or Stock, Jacobus
van der
Dutch, 1795-1864
STOKBRES, L.
British, op.1788
STOKES, Adrian Durham
British, 1902-1972
STOKES, Adrian Scott
British, 1854-1935
STOKES, Constance
British, 20th cent.
STOKES, John
American, op.1873
STOKES, Marianne,
(née Preindlsberger)
German, 1855-1927
STOKLER, Emanuel
German, op.c.1819
STOKOE, Michael
British, 1933-
STOLBA, Leopold
German, 1863-1929
STOLKER, Jan
Dutch, 1724-1785
STOLL, Leopold
Dutch, op.c.1828-1869
STOLNIK, Slavko
Yugoslav, 1929-
STOLTENBERG, Mathias
Norwegian, 1799-1871

STOLZ, Lucien Alix
French, 19th cent.
STÖLZEL, Christian
Ernst
German, 1792-1837
STÖLZEL, Christian
Friedrich
German, 1751-1815
STOM, Antonio
Italian, 18th cent.
STOM, Augustinus
Dutch, op.1652-m.a.1682
STOM, Jan de
see Stomme
STOM, W.
Dutch, op.c.1650
STOMER, Stohom, Stom
or Stomma, Matthias, I
(Matteo Tomar)
Flemish, c.1600-p.1650
STOMME or Stom, Jan
Jansz. de
Dutch, op.1643-1657
STOMME, Maerten Boelema
de
see Boelema
STONE, Alice Balch
American, 1876-
STONE, Benjamin
Bellows Grant
American, 1829-1906
STONE, Frank
British, 1800-1859
STONE, Gilbert
British, 20th cent.
STONE, Henry
British, 1616-1653
STONE, John
British, 1942-
STONE, Marcus
British, 1840-1921
STONE, Paul
American, 20th cent.
STONE, R.
British, c.1640
STONE, R.
British, 19th cent.
STONE, Reynolds
British, 20th cent.
STONE, Sarah
British, 18th cent.
STONE, W.R.
British, 18th cent.
STONE, Walter King
American, 1875-
STONEHOUSE, C.
British, op.1833-1865
STONEY, Charles B.
British, 20th cent.
STOOF, Willem Benedictus
German, 1816-
STOOP, Dirck, Roderigo
or Theodorus (also
identified with Jan
Pieter Stoop)
Dutch, c.1610-1686
STOOP, Jan Pieter
see Stoop, Dirck
STOOP, Maerten
Dutch, c.1618-1647
STOOP, Maria van der
Dutch(?), 18th cent.(?)
STOOPENDAEL
see Stopendael
STOOPS, Herbert M.
American, 20th cent.
STOOTER, Cornelis Leonardsz.
Dutch, op.1623-m.1655

STOOVERE, Jean de
see Stoevere
STOPENDAEL, Daniel
Dutch, op.1695-m.a.1741
STOPENDAEL or
Stoopendael, Sebastiaen
(Bastiaen)
Dutch, 1636/7-a.1708
STOPFORD, Robert Lowe
British, 1813-1898
STOPPEL, G.
Dutch(?), 17th cent.(?)
STOPPELAER, Charles
British, op.1703-1745
STOPPELAER, Herbert
British, op.1730-1775
STOPPOLONI, Augusto
Italian, 1855-1910
STÖR, Hans Konrad
Swiss, op.1608-m.1630
STÖR, Störer or Störr,
Lorenz
German, op.c.1550-1570
STÖR, Niklas
German, op.1532-1563
STORCH, Frederik Ludvig
Danish, 1805-1883
STORCK, Sturck or
Sturckenburg, Abraham
Jansz.
Dutch, c.1635-c.1710(?)
STORCK, Adolf Eduard
German, 1854-
STORCK, Sturck or
Sturckenburg, Jacobus
Jansz.
Dutch, op.c.1660-1686
STORCK, Jörgen
Danish, 1880-1924
STORELLI, Felice Marie
Ferdinand
Italian, 1778-1854
STORER, James
British, c.1781-1852
STORER or Storrer,
Johann Cristoph
Swiss, 1611-1671
STORER, Johann Lukas
German, c.1645-1675
STOREY, George Adolphus
British, 1834-1919
STOREY, John
British, 1827-1877
STORIE, José
Belgian, 1899-1961
STORLATO, Giovanni
Italian, op.1407-1454
STORMIUS or Stormio,
Fernando or Hernando
see Sturm
STORMONT, Howard Gull
British, op.1884-1892
STORMONT, Mary
British, 20th cent.
STORREKE, Lerret
Scandinavian, 18th cent.
STORRER, Johann Christoph
see Storer
STORRS, John Bradley
American, 1885-1956
STORSTEIN, Aage
Norwegian, 1900-
STORY, George Henry
American, 1835-1922
STORY, J.
British, op.1789-1793

STORY, Julian Russel
American, 1850-1919
STORY, Thomas Waldo
(Waldo)
British, 1855-1915
STOSKOPF, Stosskopf or
Stoskopff, Sébastien
or Sébastian
French, 1597-1657
STOSS, Guy
German, 15th cent.
STOSS, Veit
German, c.1447-1533
STOTHARD, Charles
Alfred
British, 1786-1821
STOTHARD, Thomas
British, 1755-1834
STOTT, Edward
British, 1859-1918
STOTT, W.R.S.
English, op.1920
STOTT of Oldham,
William
British, 1857-1900
STOTZ, Otto
German, 1805-1873
STOUDER, Jean Rodolphe
Swiss, 1700-1769
STOUF, Jean-Baptiste
French, 1742-1826
STOUTER, D.G.
American, op.1840
STÖVER, A.
Dutch, op.1882-1886
STOVERE or Stovre,
Jean de
see Stoevere
STOW, James
British, c.1770-p.1820
STOWERS, Thomas
British, op.1778-1814
STOZINGER, Hans
German, op.1407
STRAATEN, Bruno, I van
Dutch, 1786-1870
STRAATEN, Bruno, II van
Dutch, 1812-1887
STRAATEN or Straeten,
Hendrik van der, or
Hendrik de la Rue
Dutch, c.1665-1722
STRAATEN, Johannes
Josephus Ignatius
van
Dutch, 1766-1808
STRAATEN, Lambert
van der, or Lambert
Verstraaten or
Verstraten (Lambert
de la Rue)
Dutch, 1631-1712
STRACHAN, David Edgar
Australian, 1919-1970
STRACHEY, Julia
Charlotte
see Chance
STRACK, Anton Wilhelm
(Wilhelm)
German, 1758-1829
STRACK, Heinrich
German, 18th cent.
STRACK, Ludwig Philipp
German, 1761-1836
STRADA, Scipione
Italian, op.1579-1601

STRADA, Vespasiano
Italian, 1582-1622
STRADANUS, Stradano or
della Strada, Johannes
or Giovanni
see Straet, Jan van der
STRADONE, Giovanni
Italian, 1911-
STRADONWORT
American(?), op.c.1812
STRAECHEN, Arnold van
Dutch(?), 18th cent.
STRAEHUBER, Alexander
German, 1814-1882
STRAELY, Eduard
see Ströhling
STRAET, Jan van der
(Johannes or Giovanni
Stradano, Stradanus or
della Strada)
Netherlands, 1523-1605
STRAETEN, Hendrik van der
see Straaten
STRAETEN, Jan van der
Flemish, op.1685-m.c.1729
STRAFELLA, Gianserio
(Giovanni Saverio)
Italian, op.c.1560-1577
STRAFFORD, George
British, op.1842-1860
STRAFFORD, H.
British, 19th cent.
STRAIDY
American, op.1845
STRALEN, Antoni van
see Verstralen
STRALENDORFF, Carl
Friedrich von
German, 1811-1859
STRANG, Ian
British, 1886-1952
STRANG, William
British, 1859-1921
STRANGE, Sir Robert
British, 1721-1792
STRANOVER, Tobias
German, 1684-p.1735
STRANSKY, Ferdinand
German, 1904-
STRAPP, M. George
British, op.1886
STRASCHIRIPKA, Johann
von
see Canon
STRASSBERGER, Ernest
Wilhelm
German, 1796-1866
STRASSER, Matthäus
German, op.1586-m.1659
STRASSGSCHWANDTNER,
Joseph Anton
German, 1826-1881
STRATER, Henry
American, 1896-
STRATFORD, John
British, op.1447-1463
STRATHMANN, Carl
German, 1866-1939
STRATTON, F.
British, 19th cent.
STRATTON, Helen
British, 20th cent.
STRAUS, Johann Baptist
German, 1704-1784
STRAUCH, Georg
German, 1613-1675

STRAUCH, Lorenz
German, 1554-1636
STRAUCH, Stephan
German, 1643-1677
STRAUCH, Wolfgang
German, op.1554-1572
STRAUSS, André
French, 1885-
STRAUSS, Carl
American, 1873-1957
STRAVINSKY, Theodore
Russian, 1907-
STRAVIUS, Hinrich
German, op.1630-1690
STRAYBL, F.
Czech, op.1870
STRAZEWSKI, Henryk
Polish, 20th cent.
STRAZZA, Guido
Italian, 20th cent.
STREATER, Robert
British, 1624-1680
STREATFEILD, Robert
British, 1786-1852
STREATFIELD, Rev.
Thomas
British, 1777-1848
STREBEJKO, Wieslow
Polish, 20th cent.
STRECKER, Emil
German, 1841-1925
STRECKER, Johann
Ludwig
German, 1721-1799
STRECKER, Wilhelm
German, 1795-1857
STREECK or Streek,
Hendrik van
Dutch, 1659-p.1719
STREECK or Streek,
Juriaen van
Dutch, 1632-1687
STREET, George Edmund
British, 1824-1881
STREET, Peter
American, 20th cent.
STREET, Robert
American, 1796-p.1840
STREETER, Robert
see Streater
STREETON, Sir Arthur
Australian, 1867-1943
STREETS, William or
Guillaume
see Scrots
STREICHER, Franz
Nikolaus
German, 1738-1811
STREIT, Karl
German, 1852-
STREIT, Robert
German, 1883-1957
STREITT, Francisek
Polish, 1839-1890
STRENG, Johan Joachim
Swedish, 1707-1763
STRETES, William or
Guillarme
see Scrots
STRETTON, Henry
British, 19th cent.
STRETTON, Philip
Eustace
British, op.1884-1915
STREVENS, John L.
British, 20th cent.

STRICKLAND, William
American, 1787-1854
STRIEDBECK, Jean
French, 18th cent.
STRIEP, Christian
Jansz.
Dutch, 1634-1673
STRIGEL, Bernhard
German, 1460/1-1528
STRIGEL de Memmingen,
Claus
German, op.c.1500
STRIGEL, Hans, I
German, op.1430-m.1462
STRIGEL, Hans, II
German, 1450-1488(?)
STRIGEL or Strigeler,
Yvo, Yfo, Eyff or Yff
German, 1430-1516
STRIIS or Strüs, C.
Dutch(?), op.c.1620
STRIK, Jacob van
Flemish(?), 17th cent.
STRIMPL, Ludwik
Czech, 1880-1937
STRINDBERG, August
Johan
Swedish, 1849-1912
STRINGA, Francesco
Italian, 1635-1709
STRINGER, Daniel
British(?), op.c.1770
STRINGER, E.
British, 18th cent.
STRINGER, F.
British, op.1770
STRINGER, Samuel
British, -1784
STRINGINI, Angelo
Italian, op.1772
STRIXNER, Johann Nepomuk
(Nepomuk)
German, 1782-1855
STROBEL, Bartholomäus, II
German, 1591-
STROBEL, Mathias or
Mathes
German, -1572
STROBEL, Tom
American, 1931-
STROEBEL, Johannes
Anthonie Balthasar
Dutch, 1821-1905
STRÖHLING, Straely or
Stroely, Peter Eduard
(Eduard)
German, 1768-p.1826
STROIFI or Stoifi,
Ermano
Italian, 1616-1693
STROM, Halfdan Frithjof
Norwegian, 1863-
STROMBOTNE, James
American, 1934-
STROMER, W.J. v.
Danish(?), op.1582
STROMEYER, Helen Marie
German, 1834-1924
STRONACH, Ancell
British, 1901-
STRONG, Joseph D.
American, 1852-1900
STRONG, Starkey or
Starke, Samson
British, c.1550-1611
STROTHER, David Hunter
American, 1816-1888

STROUD, Peter
British, 1921-
STROULY
German, op.c.1800
STROZZI, Bernardo
(Il Cappuccino or
Prete Genovese)
Italian, 1581-1641/4
STROZZI, Zanobi di
Benedetto
Italian, c.1412-1468
STRUBEN, Edith F.M.
British, op.c.1914-1933
STRUBIN, Robert
Swiss, 20th cent.
STRUCK, Hermann
German, 1876-1944
STRUCKER, Jacobus
Gerritsen
see Stricjker
STRUDEL von Strudelsdorf,
Baron Pieter
German, 1660-1714
STRÜDT or Strütt,
Johann Jakob
German, 1773-1807
STRUDWICK, John
Melhuish
British, 1849-1937
STRUETT, Johann Jakob
Swiss, 1773-1820
STRUIVING, Domenicus
Jansz.
Dutch, 1755-1817
STRÜS, C.
see Striis
STRUTT, Alfred W.
British, 1856-1924
STRUTT, Arthur John
British, 1819-1888
STRUTT, Jacob George
British, 1790-1864
STRUTT, William
British, 1825-1915
STRUTT, William Thomas
British, 1777-1850
STRUYCKEN, Peter
Dutch, 1939-
STRUYK, Hubert T.W.
Dutch, 1923-
STRUYS, Alexander
Théodore Honoré
Belgian, 1852-1941
STRUYS, Jan Jansz.
Dutch, 1630-1694(?)
STRUYS, Pierre
Dutch(?), 20th cent.
STRÜZEL, Otto
German, 1855-1930
STRIJ, Abraham, I van
Dutch, 1753-1826
STRIJ, Jacob van
Dutch, 1756-1815
STRIJCKER or Strucker,
Jacobus Gerritsen
Dutch, 1617-1687
STRIJCKER, Willem
(Willem Brassemary)
Dutch, 1606/7-c.1673/7
STRYDONCK, Guillaume
van
Belgian, 1861-1937
STRYJECKI, Maurycy
Polish, 20th cent.
STRYJENSKA, Zofia
Polish, 1894-
STRZALECKI, Wandalin
Polish, 19th cent.

STRZEMINSKI, Wladyslaw
Polish, 1893-1952
STRZODA, V.
Czech, 20th cent.
STUART, Charles
British, op.c.1880-1904
STUART, Gabriel
American, 18th cent.
STUART or Stewart,
Gilbert
American, 1755-1828
STUART, James
British, 1713-1788
STUART, Sir James,
5th Baronet of
Allanbank
British, 1779-1849
STUART, James Everett
American, 1852-
STUART, Jane
American, 1812-1888
STUART, T.
British, op.c.1789
STUART, William
British, op.1848-1867
STUART-HILL, A.
British, op.c.1918-1950
STUART-WORTLEY,
Archibald J.
British, op.1874-1893
STUART-WORTLEY, Lady
Caroline Elizabeth
Mary
British, 1778-1856
STUBBS, George
British, 1724-1806
STUBBS, George Townley
British, 1756-1815
STUBBS, Ralph
British, 19th cent.
STUBBS, William P.
American, op.1855
STUBENRAUCH, Philipp
von
German, 1784-1848
STUBER, Nikolaus
Gottfried
German, 1688-1749
STUBLEY, John
British, 20th cent.
STUBLEY, P.
British, 18th cent.
STÜBNER, Robert Emil
German, 1874-1931
STUCCHI
Italian, op.1790
STUCHLIK, Konstantin
Czech, 1877-
STUCK, Franz von
German, 1863-1928
STÜCKELBERG, Johann
Melchior Ernst
Swiss, 1831-1903
STUCKENBERG, Fritz
German, 1881-1944
STUDD, Arthur Haythorne
British, 1864-1919
STUDDY, G.E.
British, 20th cent.
STUDER, Johann Rudolf
Swiss, 1700-p.1769
STUDNICKI, Juliusz
Polish, 1906-
STUEMPFIG, Walter
American, 1914-
'STUFF'
see Wright, H.

STUHFF, Elsa
German, 20th cent.
STUHLMANN, Heinrich
German, 1803-1886
STUHLMULLER, Karl
German, 1858-
STUHR, Johann Georg
German, 1640-1721
STUKELEY, William
British, 1687-1765
STULL, Henry
American, 1851-1913
STUMME, Absolon
German, op.1486
STUMP, John Samuel
British, a.1790-1863·
STUNDER, Johann Jacob
Danish, 1759-1811
STUNTZ or Stunz,
Johann Baptist
Swiss, 1753-1836
STUPICA, Gabrijel
Yugoslav, 1913-
STURCK or Sturckenburg
see Storck
STURDEE, Percy
British, op.c.1885-1939
STURGESS, John
British, op.c.1874-1884
STURGESS-LIEF, C.
British, 20th cent.
STÜRLER, Franz Adolph
von
French, 1802-1881
STURM, Ferdinand
German, op.1555
STURM, Desturmes,
Estormes, Esturmes,
Stormio, Stormius or
Sturmio, Fernando
or Hernando
Netherlands,
op.1537-1557
STURM, Friedrich
German, 1822-1898
STURM, J.(?)
German, 20th cent.
STÜRMER, Johann
Heinrich
German, 1774/5-1855
STÜRMER, Karl
German, 1803-1881
STURMIO, Fernando or
Hernando
see Sturm
STURM-SKRLA, Eugen
German, 1894-1925
STURROCK, Alick
Riddell
Scottish, 1885-1953
STURT, John
British, 1658-1730
STURTEVANT, Helen
American, 1872-
STURZ, Stürz or Sturtz,
Helfrich Peter
German, 1736-1779
STURZENEGGER, Hans
Swiss, 1875-1943
STUVEN or Stuvens,
Ernst
German, 1657-1712
STUWMAN, W.
Dutch, op.1667
STYCHE, Frank
British, 20th cent.

STYKA, Adam
Polish, 1890-
STYKA, Jan
Polish, 1858-1925
STYLES, J.
British, 19th cent.
STYRSKY, Jindrich
Czech, 1899-1942
SUARDI, Bartolommeo
see Bramantino, Il
SUAREZ de Valasquez,
Aurora
Mexican, 20th cent.
SUAVIUS, Lambert, III
(Lambert Soete, Sutman,
Suttemine, Zoetman,
Zutman etc., or Lambert
Le Doux)
Netherlands, c.1510-1567
SUBLEYRAS, Maria Felicita,
(née Tibaldi)
Italian, 1707-1770
SUBLEYRAS, Pierre or
Hubert
French, 1699-1749
SUCCA, Antoine or
Anthonis de
Flemish, op.1598-m.1620
SUCH, W.T.
British, 19th cent.
SUCHET, Joseph Francois
French, 1824-1896
SUCHY, Adalbert
German, 1782-1849
SUCHY, Franz
German, 19th cent.(?)
SUCRE, José M. de
Spanish, 1886-
SUDDABY, Rowland
British, 1912-
SUDRE, Jean Pierre
(Pierre)
French, 1783-1866
SÜE, Louis
French, 1875-p.1950
SUERBANTS, J.
Dutch, 17th cent.
SUEUR, Le
see Le Sueur
SUGAI, Kumi
French, 1919-
SUGAR, Andor
Hungarian, 1903-1944
SUGHI, Alberto
Italian, 1928-
SUHR, Christoph
German, 1771-1842
SUHR, Cornelis
German, 1781-1857
SUHR, Peter
German, 1788-1857
SUHRLANDT, Carl
German, 1828-1919
SUHRLANDT, Rudolph
Friedrich Karl
German, 1781-1862
SUJA, Pietro
Italian, 19th cent.
SULLIVAN, Edmund Joseph
British, 1869-1933
SULLIVAN, James F.
British, op.1875-1877
SULLIVAN, Luke
British, 1705-1771
SULLIVAN, Patrick J.
American, 1894-

SULLIVAN, William Holmes
British, op.1870-m.1908
SULLY, Robert Matthew
American, 1803-1855
SULLY, Thomas
American, 1783-1872
SULLY, Thomas Wilcocks
American, 1811-1847
SULZBERGER, Konrad
Swiss, 1771-1822
SULZER, David
Swiss, 1784-1864
SULZER von Winterthur,
Jacob
Swiss, op.1746
SULZER, Johann
Swiss, 18th cent.
SUMMER, Andreas
German, op.c.1567-1580
SUMMERS, S.N.
British, op.1764-1806
SUMMERS, W.
British, op.1833
SUMNER, Maud
British, op.c.1930
SÜNDER, Balthasar
Swiss, 1418-m.1478/9
SUNDERLAND, Thomas
British, op.1798
SUNDT-HANSEN, Carl
Norwegian, 1841-1907
SUNDVALL, Carl
Fredrik
Swedish, 1754-1831
SUNEV
German, 19th cent.
SUNMAN, Wilhelm or
William
see Sonmans
SUNTACH, Giovanni
Italian, 1776-1842
SUNTER, Jacob
German, op.1470
SUNYER, Joaquin
Spanish, 1875-1957
SUPERVILLE, David
Pierre Giottino
Humbert de
see Humbert de
Superville
SUPPANTSCHITSCH, Max
German, 1865-1954(?)
SURA, Jaroslav
Czech, 20th cent.
SURAND, Gustave P.A.
French, 1860-
SURBECK, Victor
Swiss, 1885-
SURCHI, Giovanni
Francesco (Dielai)
Italian, op.1543-m.1590
SUREDA, André
French, 1872-1930
SURIE, Jacoba (Coba)
Dutch, 1879-1970
SURIKOV, Vasily
Russian, 1848-
SURINY, J. Doucet de
(née Glaesner)
French, op.1793-1806
SURMONT, V.W.
Netherlands, op.1785
SURREY, Philip Henry
Howard
Canadian, 1910-
SURTEES, John
British, 1817-

SURVAGE, Léopold
French, 1879-1968
SUS, Gustav Konrad
German, 1823-1881
SUSENIER, Abraham
Dutch, op.1640-1666
SUSIO, Ludovico
Flemish, op.1616-1620
SÜSS, Johann J.
German, 1857-
SUSTERMANS, Susterman,
Sutterman, Suttermans
etc., Justus
Flemish, 1597-1681
SUSTRIS, Suchtris,
Suster, Susterus,
Sustri, Sustrich;
Süstris or Zustris,
Friedrich (Federicho
di Lamberto Sustris;
Federigo di Lamberto
Fiammingo; Federigo
di Lamberto d'Amsterdam
Fiammingo; Federigo del
Padovano; Friedrich de
Lamberto)
Netherlands, c.1540-1599
SUSTRIS, Suster, Süster,
Susterus, Zustris or
Zustrus, Lambert or
Lamprecht (Lambert van
Amsterdam; Lambertus
de Amsterdam; Lamberto
d'Amsterdam; Lamberto
Fiammingo; Lamberto
tedesco; Lamberto
veneziano)
Netherlands,
c.1515/20-p.1568
SUTCLIFFE, Harriet F.A.
British, op.c.1881-c.1922
SUTCLIFFE, John
British, op.1853-1879
SUTCLIFFE, Lester
British, 1880-c.1930
SUTCLIFFE, S.
British, 20th cent.
SUTCLIFFE, Thomas
British, 1828-1871
SUTER, Jakob
Swiss, 1793-1874
SUTHERLAND, David
Macbeth, R.S.A.
British, 1883-
SUTHERLAND, Elizabeth
Duchess of
British, 1765-1839
SUTHERLAND, Graham
Vivian
British, 1903-
SUTHERLAND, Thomas
British, c.1785-
SUTMAN, Lambert, III
see Suavius
SUTRO, Esther (Stella)
née Isaacs
British, op.1909
SUTTEMINE, Lambert, III
see Suavius
SUTTER, Joseph
German, 1781-1866
SUTTER, Jules de
Belgian, 1895-
SUTTERMANS or Sutterman,
Justus
see Sustermans

SUTTON, Elizabeth
Evelyn
British, c.1767-p.1789
SUTTON, Joseph
British, op.1798-1824
SUTTON, Keith
British, 20th cent.
SUTTON, Philip
British, 1928-
SUTTON, Thomas
British, 19th cent.
SUVEE, Joseph Benoît
French, 1743-1807
SUWEYNS, Antoine
Flemish, 1720-1789
SUYCKER, Reyer Claesz.
(Monogrammist R.C.)
Dutch, c.1590-c.1653/5
SUYDAM, James
American, 1817-1865
SUYDERHOEF, Jonas
Dutch, c.1613-1686
SUYLEN, Hendrick van
see Zuylen
SUZOR-COTE, Marc-
Aurèle de Foy
Canadian, 1869-1937
SVABINSKY, Max
Czech, 1873-
SVANBERG, Max Walter
Swedish, 1912-
SVARSTAD, Anders
Castus
Norwegian, 1869-
SVEDOMSKY, Paul
Alexander
Russian, 1849-1904
SVENIN, Paul Petrovich
Russian, op.1811-1813
SVENSON, Gunnar
Swedish, 1892-
SVERTCHKOFF, Nicolas
Gregorovitch
Russian, 1817-1898
SVOBODA, Eduard
Czech, 20th cent.
SVOBODA, Josef
Czech, 1920-
SWAEN, J.R.
Netherlands, 16th cent.
SWAERDECROON, Bernardus
see Zwaerdecroon
SWAEY, Lucas van der
Dutch, op.1666
SWAGERS, Charles
French, 1792-p.1840
SWAGERS, Elisabeth,
(née Méri)
French, -1837
SWAGERS, François or
Frans
Dutch, 1756-1836
SWAIN, Robert
American, 1940-
SWAINE, Francis
British, op.1760-m.1782
SWAINE, John
British, 1775-1860
SWAINSON, William
British, 1789-1855
SWAISH, Frederick
George
British, 1907-m.1931
SWALUE, Albertus Otto
Dutch, 1683-c.1768(?)
SWAMMERDA, Johannes
Dutch, 1637-1685

SWAN, Alice Macallan
British, op.1882-1928
SWAN, Cuthbert
Edmund
British, 1870-1931
SWAN, John Macallan
British, 1847-1910
SWANE, Sigurd
Danish, 1879-
SWANENBURGH, Cornelis
van
Dutch, op.1655-m.1710
SWANENBURGH or
Swanenburch, Isaac
Nicolai or Isaac
Claesz.
Dutch, c.1538-1614
SWANENBURGH or
Swanenburch, Jakob
Isaacsz.
Dutch, c.1571-1638
SWANENBURGH or
Swanenburch, Willem
Isaacsz.
Dutch, 1581/2-1612
SWANEVELT, Herman van
(Herman d'Italie)
Dutch, c.1600-1655
SWANWICK, Betty
British, 1915-
SWANWICK, Joseph Harold
British, 1866-1929
SWARBRECK, Samuel
Dunkinfield
British, op.1852-63
SWART, Frans Jurjens
Dutch, 1752-1839
SWART van Groningen,
Jan
Netherlands,
c.1490/1500-p.1553(?)
SWARTS, D.
Dutch, op.1779
SWARTZ, Johann David
see Schwartz
SWEBACH, Bernard Edouard
(Edouard)
French, 1800-1870
SWEBACH, Jacques
Francois Joseph
(Fontaine or
Desfontaines)
French, 1769-1823
SWEDEN, King Gustav
Adolph of
Swedish, 18th cent.
SWEDLUND, Pelle
Swedish, 1865-
SWEELINK, Gerrit
Pietersz
see Pietersz
SWEERTS, Jeronimus
Dutch, 1603-1636
SWEERTS, Michiel or
Michael (Michele
Suars or Suarssi, or
Michiello Suerts)
Flemish, 1624-1664
SWEETING, Garrington
British, op.1845-1865
SWEIDEL, Gabriel
Gotthard
Finnish, 1744-1813
SWEJKART, Carl Gottlieb
see Schweikart
SWELINCK, Jan Gerrits
Dutch, c.1601-p.1645

SWENDALE, G.
British, op.1824-1833
SWETE, Rev. John
(Tripe)
British, c.1752-1821
SWETT, Moses
American, op.1828-1837
SWIDDE, Willem
Dutch, 1660/1-1697
SWIERZY, Waldemar
Polish, 1931-
SWIESZEWSKI, Alexander
Polish, 1839-1895
SWIETEN, Cornelis van
see Zwieten
SWIETEN, Jan van
Dutch, op.1653-m.1661
SWIEYKOWSKI, Alfred
French, 19th cent.
SWINBURNE, Edward
British, 1765-
SWINDEN, Glenn
American, 20th cent.
SWINDERWIJK or
Swinderswijk, Willem
Willemsz.
Dutch, c.1621-1664
SWINNERTON, James G.
American, 19th cent.
SWINSTEAD, George
Hillyard
British, 1860-1926
SWINTON, James Rannie
British, 1816-1888
SWISCHEGG, Johann
see Smisek
SWISS SCHOOL,
Anonymous Painters
of the
SWOBODA, Eduard
German, 1814-1902
SWOBODA, Gerhard
German, 1923-
SWOBODA, Rudolph, I
German, 1819-1859
SWYNNERTON, Annie
Louisa, (née Robinson)
British, 1844-1933
SYBER, Johann
see Sibmacher
SYBERG, Fritz
Danish, 1862-1939
SYBILLA, Gijsbert
see Sibilla
SYBOLD, Sybolt or
Syboltt, Samuel
Swiss, op.1568-m.1615
SYDER, Daniel
see Seiter
SYDNEY, Berenice
British, 1944-
SYER, James
British, op.1867-1878
SYER, John
British, 1815-1885
SYER, R.
British, 18th cent.
SYKE, V.
British(?), 18th cent.
SYKES, Godfrey
British, 1824-1866
SYKORA, Zdenek
Czech, 1920-
SYL, Roelof van
see Zijl
SYLEVELT, Anthony van
see Zylvelt

SYLVAIN
Haitian, 20th cent.
SYLVANUS, B.
see Brownover
SYLVELT, Anthony van
see Zylvelt
SYLVESTRE
see also Silvestre
SYLVESTRE, Joseph Noël
French, 1847-1926
SYLVIUS, Balthasar
see Bosch
SYLVIUS, Cornelis
see Bosch
SYLVIUS, Johan
Swedish, -1695
SYME, John S.
British, 1795-1861
SYMES, Ivor J.J.
British, 19th cent.
SYMONDS, Abraham
see Simon
SYMONDS, William Robert
British, 1851-1934
SYMONS, George Gardner
(Gardner)
American, 1863-1930
SYMONS, Mark Lancelot
British, 1887-
SYMONS, Patrick
British, 1925-
SYMONS, Peeter
see Simons
SYMONS, William
Christian
British, 1845-1911
SYNAVE, Tancrède
French, 1860-
SYPE, J.
Netherlands,
17th/18th cent.
SIJPKENS, Ferdinand
Hendrik
Dutch, 1813-1860
SYS, Maurice
Belgian, 1880-
SZABO BELA, Gy
Vladimir
Hungarian, 1905-
SZALAY, Lajos
Hungarian, 1909-
SZALMAS, Béla
Hungarian, 1908-1961
SZAMOSSY, Elek (Alexius)
Hungarian, 1826-1888
SZANKOWSKY, Boleslav
von
Polish, 1873-1953
SZANTHO, Maria
Hungarian, 1898-
SZANTO, Lajos (Ludwig)
Hungarian, 1889-
SZARVASY
Hungarian, 17th cent.
SZAYBO, Roslaw
Polish, 20th cent.
SZCHOKKE, Alexander
Swiss, 1894-
SZEKELY von Adamos,
Bertalan (Berthold)
Hungarian, 1835-1910
SZENES, Arpad
Hungarian, 1897-
SZENTJÓBY, Tamás
Hungarian, 20th cent.
SZERMETOWSKI, Józef
Polish, 1833-1876

SZERNER, Wladislaw
Polish, 1836-1915
SZILVASY, Nandor
Hungarian, 20th cent.
SZINYEI, Merse Paul
von
Hungarian, 1845-1920
SZIRMAI, Antal (Anton)
Hungarian, 1860-1927
SZMUGLEWICZ
see Smuglewicz
SZOBEL, Geza
Czech, 1905-
SZOBOTKA, Imre
Hungarian, 1890-1961
SZONTAGH, Tibor
Hungarian, 1873-1930
SZONYI, Istvan
Hungarian, 1894-
SZÖNYI, Stefan
Rumanian, 1913-
SZYBANOW, M.
Russian, op.1777
SZYK, Artur
American, 1894-1951
SZYKIER, Ksawery
Polish, 1860-1895
SZYMANOWSKI, Waclaw
Polish, 1859-1930
SZYMONOWICZ
see Semiginowsky
SZYSZKIN, I.I.
Russian, 20th cent.

T

TAANMAN, Jacob
Dutch, 1836-1923
TABAR, Francois
Germain Léopold
French, 1818-1869
TABIGOT
Swiss, 19th cent.
TABINSKI, Jan
Polish, 1836-1915
TABORDA, José da
Cunha
Portuguese, 1766-1834
TACCA, Ferdinando
Italian, 1619-1690
TACCA, Pietro
Italian, 1577-1640
TACCONI, Taconi or
Tachoni, Francesco di
Giacomo
Italian, op.1458-1500
TACCONI or Taccone,
Innocenzo
Italian, op.1604-1631
TACH, Etienne or
Stephan
Polish, 1893-1964
TACK, Augustus Vincent
American, 1870-1949
TACKLE, E.A.
British, 19th cent.
TADASKY, Kuwayama
American, 20th cent.
TADDEO di Bartolo
Italian, c.1363-1422
TADEUSZ, Norbert
German, 1940-
TAEUBER-ARP, Sophie
Henriette, (née
Taeuber)
Swiss, 1889-1943
TAFELMAIER, Walter
German, 1935-

TAFI or Tafo, Andrea
see Andreas
TAFURI, Raffaele
Italian, 1857-1929
TAGG, Robert
British, 20th cent.
TAGLIACCI, Niccolò
see Tegliacci
TAGLIAFICHI, Giovanni
Italian, op.1800
TAGLIANI, Luigi
(Ludovico)
Swiss, c.1800-
TAGLIASACCHI, Giovanni
Battista
Italian, 1697-1737
TÄGTSTRÖM, David
Swedish, 1894-
TAHI, Antal
Hungarian, 1855-1902
TAHVANAINEN, Reima
Finnish, 20th cent.
TAICEK, Martin
see Tejcek
TAIG, Sebastian
see Deig
TAILLASON, Jean Joseph
French, 1745-1809
TAILLEUX, Francis
French, 1913-
TAIT, Arthur
Fitzwilliam
British, 1819-1905
TAIT, F. (Louis?)
British, op.1903
TAIT, Robert S.
British, op.1845-1875
TAITE, Alice
see Fanner
TAJIRI, Shinkichi
American, 1923-
TAKANARI, Oguiss
French, 20th cent.
TALAGRAND, L.
French, op.1887
TALARI, Erkki (Forsström)
Finnish, 1907-
TALBOT, Francess
see Parker
TALBOT, Mary
British, 20th cent.
TALBOYS, Agnes
Augusta
British, op.1920
TAL-COAT, Pierre
Louis Corentin Jacob
French, 1905-
TALENO, L.
Italian, 19th cent.
TALENTI, Simone
Italian, 1340/5-p.1381
TALER, Ulrich
German, op.c.1513
TALFOURD, Field
British, 1815-1874
TALLONE, Cesare
Italian, 1853-1919
TALMAGE, Algernon
Mayow
British, 1871-1939
TALMAN, John
British, 1677-1726
TALPINO, Il
see Salmeggia, Enea
TAM, Reuben
American, 1916-
TAMAGNI da San
Gimignano, Vincenzo
Italian, 1492-c.1530

TAMAGNO
French, 19th cent.
TAMARA
Oriental, 20th cent.
TAMAROCCIO, Cesare
Italian, op.1506
TAMAYO, Rufino
Mexican, 1900-
TAMBRONI
Italian, 19th cent.
TAMBURI, Orfeo
Italian, 1910-
TAMBURINI
Italian, 18th cent.
TAMBURINI, Arnoldo
Italian, 1843-
TAMBURINI, Giovanni
Maria
Italian, op.1640-1660
TAMIETTI, Carlo
Italian, -1796
TAMIR, Moshe
Israeli, 1924-
TAMM, Franz Werner
von
German, 1658-1724
TANAKA, Yasushi
French, 1886-
TANCHE, Nicolas
French, c.1740-p.1770
TANCREDI
Italian, 1927-
TANCREDI, Filippo
Italian, 1655-1722
TANGERMANN, Christian
German, 1760-1830
TANGUY, Yves
French, 1900-1955
TANISCH, J.
see Daniche
TANJE, Pieter
Dutch, 1706-1761
TANK, Heinrich
Friedrich
German, 1808-1872
TANNAUER
French, 18th cent.
TANNAUER, Gottfried
see Danhauer
TANNENT
British, 19th cent.
TANNER, Benjamin
American, 1775-1848
TANNER, Henry Ossawa
American, 1859-1937
TANNER, J.(?)
British, op.1795
TANNER, J.G.
American, op.c.1891
TANNEUR, Philippe
French, 1795/6-1873
TANNING, Dorothea
(Dorothea Ernst)
American, c.1910/16-
TANNOCK, James
British, 1784-1863
TANOUX, Henri Adrien
French, 1865-1923
TANZI, Léon Louis
Antoine
French, 1846-1913
TANZIO da Varallo,
Antonio d'Enrico
(il Tanzio)
Italian, c.1575-1635

TAPARELLI d'Azeglio
Massimo
see Azeglio
TAPIES, Antonio (Antoni)
Spanish, 1923-
TAPIRO y Baro, José
Spanish, 1830-1913
TAPPERT, Georg
German, 1880-1957
TAPY, A.
American, op.1859
TARANCZEWSKI, Waclaw
Polish, 1903-
TARASCHI, Giovanni
Italian, op.1564
TARASCHI, Giulio
Italian, op.1564
TARAVAL, Guillaume
Thomas Raphael
French, 1701-1750
TARAVAL, Gustave or
Louis Gustave
French, 1738-1794
TARAVAL, Hugues or
Jean H.
French, 1729-1785
TARAVAL, Jean Gustave
French, 1765-1784
TARBELL, Edmund Charles
American, 1862-1938
TARCHIANI, Filippo
Italian, op.1619-1621
TARCHOV, Nikolai
Alexandrovitch
Russian, 1871-
TARDIEU, Ambroise
French, 1788-1841
TARDIEU, Jacques
Nicolas
French, 1716-1791
TARDIEU, Jean Charles
French, 1765-1830
TARENGHI, Enrico
Italian, 1848-
TARLETON, Lady
British, op.1820
TARLTON
British, 19th cent.
TARNÓCZY, Bertha von
German, 1846-1936
TARRA, Luigi
Italian, 1882-
TARRAGO, Leticia
South American,
20th cent.
TARRANT, Margaret
Winifred
British, 1888-
TARSIA or Tersia,
Bartolommeo
Italian, -1765
TARTAGLIA or Tartalja,
Marin
Yugoslav, 1904-
TARTARIUS, Cornelis
Cornelisz.
German, op.1657-1684
TARTE, Jean la
French, 17th cent.
TARUFFI, Emilio
Italian, 1633-1696
TARVISIO, Hieronymus
Italian, op.1470-1492
TASCA, Cristoforo
Italian, 1667-1737
TASCA, Lombardo Luigi
Italian, op.1813/14

TASELLI, Domenico
Italian, 17th cent.
TASKER, John
British, op.1782-1814
TASKER, William
British, 1808-1852
TASLITZKI, Boris
Russian, 1911-
TASSAERT, Henriette
Félicité
French, 1766-1818
TASSAERT, Nicolas
Francois Octave
(Octave)
French, 1800-1874
TASSAERT, Philippe
Joseph
Flemish, 1732-1803
TASSEL, Jean
French, 1608-1667
TASSEL, Richard
French, 1588-1666
TASSI, Agostino
Buonamici
Italian, c.1580-1644
TASSY, Joseph
French, op.1791
TATE, N.
American(?), 20th cent.
TATE, Thomas Moss
British, op.1784-m.1806
TATE, William
British, c.1750-1806
TATHAM, Frederick
British, 1805-1878
TATLIN, Vladimir
Yevgrafovitch
Russian, 1885-1956
TATTEGRAIN, Francois
French, 1852-1915
TATTERSALL, George
(Wildrake)
British, 1817-1852
TATTERSFIELD, Brian
British, 20th cent.
TATTI, Francesco dei
Italian, op.1512
TATTI, Jacopo
see Sansovino
TAUBERT, Bertoldo
French, 1915-
TAUBERT, Carl Gregor
German, 1778-1861
TAUBERT, Gustav
Friedrich Amalius
German, 1755-1839
TAUN
Dutch, op.1769
TAUNAY, Félix-Emile,
Baron
French, 1795-1881
TAUNAY, Nicolas Antoine
French, 1755-1830
TAUNTON, W.
British, op.1855-1875
TAURELLE
French, 20th cent.
TAUTE, Christian
German(?), 16th cent.(?)
TAUZIN, Louis
French, op.1867-1914
TAUZIN, Mario
French, c.1910
TAVARONE, Lazzaro
Italian, 1556-1641
TAVELLA, Carlo Antonio
(Il Solfarolo)
Italian, 1668-1738

TAVELLE, Robert
French, op.1820-1886
TAVENIER or Tavernier,
Hendrik
Dutch, 1734-1807
TAVENNIER, Jules
French, 19th cent.
TAVENRAAT, Johannes
Dutch, 1809-1881
TAVERAY, Chevalier
French, 18th cent.
TAVERNA, Gaudenz
Swiss, 1814-1878
TAVERNER, Jeremiah
British, 18th cent.
TAVERNER, William
British, 1703-1772
TAVERNIER de Junquières
French, 1742-
TAVERNIER, Andrea
Italian, 1858-1932
TAVERNIER, Francois
French, 1659-1725
TAVERNIER, Hendrik
see Tavenier
TAVERNIER, Jules
Canadian, 20th cent.
TAVERNIER, Melchior
Flemish, 1564(?)-1641
TAVERNIER, Paul
French, 1852-
TAWL, Max
American, 20th cent.
TAYG, Sebastian
see Deig
TAYLER, Albert
Chevallier
British, 1862-1925
TAYLER, John Frederick
(Frederick)
British, 1802-1899
TAYLER, Laurie
British, op.1926
TAYLOR, Alfred Henry
British, op.1832-m.1868
TAYLOR, Arthur H.
British, 20th cent.
TAYLOR, Charles
British, op.c.1880-1891
TAYLOR, Charles Foot
British, op.1820-1853
TAYLOR, Edward Richard
British, 1838-1911
TAYLOR, F.Walter
American, 1874-1921
TAYLOR, Frederick
Bourchier
Canadian, 1906-
TAYLOR, Horace
British, 1881-1934
TAYLOR, Isaac,I
British, 1730-1807
TAYLOR, Isaac, II
British, 1759-1829
TAYLOR, James
British, 1925-
TAYLOR, John, II
British, c.1630-1714
TAYLOR, John, III
British, c.1735-1806
TAYLOR, John (Old
Taylor)
British, 1739-1838
TAYLOR, John
British, 19th cent.
TAYLOR, Joseph
British, 1586(?)-1653(?)
TAYLOR, Joseph
British, op.1847-1867

TAYLOR, Joshua or
Josiah
British, op.1846-1877
TAYLOR, Leonard
Campbell
British, 1874-1969
TAYLOR, Lorna
British, 1941-
TAYLOR, Luke
British, 1876-1916
TAYLOR, Mary (née
Spilsbury)
see Spilsbury
TAYLOR, Peter
British, 1756-1788
TAYLOR, R.
British, op.1743
TAYLOR, Stephen
British, op.1817-1849
TAYLOR, Thomas
British, op.1843-1852
TAYLOR, W.
British, op.1748
TAYLOUR, G.
British, 20th cent.
TCHEBANOFF, Michail
see Schibanoff
TCHEKHONINE, Sergei
Russian, 1878-
TCHELITCHEW, Pavel
Russian, 1898-1957
TCHERNICHEFF, Alexei
Filipovitch
Russian, 1827-1863
TCHESSKY, C.
Russian, 18th cent.
TCHORZEWSKI, Jerzy
Polish, 1928-
TCHOUKIN, S.S.
Russian, 1754/8-1828
TEAGUE, C.P.T.
American, 19th cent.
TEBBY, Arthur Kemp
British, op.c.1883-1928
TEDESCHI, Giovanni
Battista
Italian, 17th cent.
TEDICE, Enrico di
Italian, op.1254
TEDICE, Maestro
Italian, 13th cent.
TEDICE, Ugolino di
Italian, 13th cent.
TEER, S.R.
French, 19th cent.
TEERLINK, Abraham
Dutch, 1776-1857
TEERLINK, Lievine,
(née Bening)
see Bening
TEGELBERG or Tegelberch,
Cornelis
Dutch, op.1642-1667
TEGELGAARD, Rasmus
Jacobsen
see Teilgaard
TEGLIACCI or Tagliacci,
Niccolò
(Niccolò di Ser Sozzo)
see Niccolò
TEGNER, Hans Christian
Harald
Danish, 1853-1932
TEICHEL, Albert
German, 1822-1873
TEICHLEIN, Anton
German, 1820-1879

TEICHMANN, Sabina
American, 1905-
TEICHS, Adolf
Friedrich
German, 1812-1860
TEICZEK, Martin
see Tejcek
TEIGE, Karel
German, 20th cent.
TEILGAARD or
Tegelgaard, Rasmus
Jacobsen
Norwegian, 1685-1754
TEILLET, Jean
French, 17th cent.
TESSIER, Teisier or
Tessier, Jean George
Dutch, 1749-1821
TEIXEIRA, A.
Portuguese, op.1777
TEIXEIRA de Mattos,
Joseph
Dutch, 1892-
TEIXEIRA de Mattos,
Joseph Henri (Henri)
Dutch, 1856-1908
TEJCEK, Taicek or
Teiczek, Martin
Czech, 1780-1847
TEJEO, Rafael
Spanish, 1798-1856
TELCHER, Joseph
German, 1802-1838
TELE
German, 18th cent.
TELEMAQUE, Herve
French, 20th cent.
TELIA, Garcia
Spanish, 20th cent.
TELMANS, S.
Dutch, op.1637
TELT, William
British, 17th cent.
TELTSCHER, Joseph
Eduard
German, 1801-1837
TEMMINCK, Henriëtta
Christina (Henriëtta
Christina Winkelaar-
Temminck)
Dutch, 1813-1886
TEMMINCK, Leonardus
Dutch, 1746-1813
TEMPEL, Abraham
Lambertsz. van den
Dutch, 1622/3-1672
TEMPERELLI
see Caselli, Cristoforo
TEMPEST, John
British(?), op.c.1680
TEMPESTA, Antonio
Italian, 1555-1630
TEMPESTA, Domenico
see Marchis
TEMPESTA
see also Mulier,
Pieter, II
TEMPESTI, Antonio
Italian, 1695-1784
TEMPESTI, Giovanni
Battista
Italian, 1729/32-1802/4
TEMPESTINO
see Marchis
TEMPLE, H.
British, op.c.1810
TEMPLE, Hans
German, 1857-1931

TEMPLETON, Elizabeth,
Viscountess
British, op.1769-m.1823
TENCALLA, Carpoforo
Italian, 1628-1685
TENCY, Jan-Baptiste
Flemish, op.1772-1793
TENENTE, Il
see Haffner, Enrico
TENGBERG, Violet
American(?), 20th cent.
TENGELER, Johan Wilhelm
Dutch, 1746(?)-p.1805
TENGNAGEL, Jan
Dutch, 1584/5-1635
TENIERS, Abraham
Flemish, 1629-1670
TENIERS, David, I
Flemish, 1582-1649
TENIERS, David, II
Flemish, 1610-1690
TENIERS, David, III
Flemish, 1638-1685
TENIERS, Juliaen, II
Flemish, 1616-1679
TENNANT, Dorothy
see Stanley
TENNANT, Gordon Coombe
British, op.1843
TENNANT, John F.
British, 1796-1872
TENNANT, N.
British, op.1849
TENNER, Eduard
German, 1830-1901
TENNIEL, Sir John
British, 1820-1914
TENRE, Charles Henry
French, 1884-1926
TENTHEM, William J.
British, op.1808
TENZEL, Michael
German, 18th cent.
TEOFILO
Italian, 20th cent.
TERALI, Alessandro
Italian, 18th cent.
TERASSON, H.
British, op.1713-1714
TERBORCH
see Borch
TERBRUGGHEN, Hendrick
Jansz.
see Brugghen
TERBUSCH
see Lisiewska
TEREBENEFF, Ivan
Ivanovitch
Russian, 1780-1815
TEREBENEFF, Michail
Ivanovitch
Russian, 1795-1866
TERECHKOVITCH,
Konstantin (Kostia)
Russian, 1902-
TERLES, Jean
French, 20th cent.
TERLIKOWSKI, Wlodzimierz
Polish, 1873-
TERLINCK, Lievine
British, op.c.1590
TERUNDEN, Félix
Belgian, 1836-1912
TERMANINI, Giuseppe
Italian, 1769-1850
TERNITE, Wilhelm
German, 1786-1871

TERNON, John
British, op.c.1834
TERRANOVA, Guglielmo
see Nieulandt, Willem
van
TERRASSE, Michel
French, 20th cent.
TERRENCHO, Pedro
Spanish, op.1488
TERRENI, Antonio
Italian, op.1785
TERRENI, Giuseppe
Maria
Italian, 1739-1811
TERRIBILIA
see Morandi
TERRINE
Italian, 20th cent.
TERRIS, John
British, 1865-1914
TERROUX, Elisabeth
Swiss, 1759-p.1795
TERRY, C.W.
British, op.c.1840
TERRY, Frederick C.
Australian, 1827-1869
TERRY, Garnet
British, op.1786-1796
TERRY, Henry John
British, 1818-1880
TERRY, John
British, 20th cent.
TERRY, Sara F.
American, op.c.1800-1820
TERSIA, Bartolommeo
see Tarsia
TERUZ, Orlando
Brazilian, 20th cent.
TERWESTEN, Augustin, I
Dutch, 1649-1711
TERWESTEN, Elias
(Den Brander)
Dutch, 1651-1724/9
TERWESTEN, Matthäus
(Aquila or Den Arent)
Dutch, 1670-1757
TERZAGO, P.M.
Italian, op.c.1666
TERZI, Aleardo
Italian, 1870-1943
TERZI, Cristoforo
Italian, 1692-1743
TERZI or Terzo,
Giovanni Francesco
Italian, 1523-1591
TESCHENDORFF, Emil
German, 1833-1894
TESCHNER, Richard
German, 1879-1948
TESHIGAHARA, Sofu
Oriental, 1900-
TESI, Mauro Antonio
(Il Maurino)
Italian, 1730-1766
TESSARI, Vittorio
Italian, 1860-
TESSIER, Jean George
see Teissier
TESSIER, Louis
French, c.1719-1781
TESSIN, Nicodemus, I
German, 1615-1681
TESSIN, Nicodemus, II
Swedish, 1654-1728
TESTA, Armando
Italian, 1917-

TESTA, Pietro
(Il Lucchesino)
Italian, 1611-1650
TESTANA, Giuseppe
Maria
Italian, 1648-1679
TESTARD, Jacques
Alphonse
French, 1810-
TESTAS, Willem de
Famars
Dutch, 1834-1896
TESTELIN or Tettelin,
Henri
French, 1616-1695
TESTELIN or Tettelin,
Louis
French, 1615-1655
TETAR van Elven, Jan
or Johannes Baptist
or Jean Baptiste
Dutch, 1805-1889
TETAR van Elven, Petrus
Henricus Theodorus
(Pierre)
Dutch, 1828-1908
TETMAYER, Wlodimierz
Polish, 1862-1923
TETRODE, Tetroede,
Tetterode etc.,
Willem Danielsz. van
(Guglielmo Fiammingo)
Netherlands,
op.c.1550-1575
TETSIS, Panaciotis
Greek, 20th cent.
TETSU (Tetsu)
French, 1913-
TETTELIN
see Testelin
TETTSCHER, Joseph
German, 1802-1838
TEUBING or Teubingen
see Hans von Tübingen
TEUBNER, Peter
American, 20th cent.
TEULON, Pierre
French, 20th cent.
TEUNISSEN, Teunisz.
or Theunissen,
Cornelis Anthonisz
see Anthonisz.
TEUPKEN, Dirk Antoon
see Töpke
TEXIDOR AMICH, F.
Spanish, 19th cent.
TEXTOR, Franz Josef
(Weber)
German, op.1727-m.1741
TEYLER, Johan
(Speculatie)
Dutch, 1648-p.1697
TEYLINGEN, Jan van
Dutch, op.1624-m.1654
TEIJSSEN, H.C.
Dutch, op.1798
TEYTON, Charles
French, 20th cent.
THAANNING, Christian
Norwegian, op.1760-1763
THACHE or Thach,
Nathaniel
British, 1617-p.1649
THACKERAY, William
Makepeace
British, 1811-1863
THADDEUS, Henry Jones
British, 1859-1929

THADLIK, Franz
see Kadlik
THAKE, Eric Anchor
British, 20th cent.
THALO, Alonso
Spanish, 16th cent.
THAN, Moritz (Mòr)
Hungarian, 1828-1899
THANE, John
British, 18th cent.
THANGUE, Henry Herbert
la
see La Thangue
THARRATS, Juan José
Spanish, 1918-
THATCHER, C.F.
British, op.1816-1846
THAULOW, Johan Fredrik
(Frits)
Norwegian, 1847-1906
THAYER, Abbott Henderson
American, 1849-1921
THAYER, Polly
American, 20th cent.
THEAKER, Harry George
British, 1873-1954
THEAULON or Theolon,
Etienne
French, 1739-1780
THEBAUT, J.P.
French, 1763-1824
THEDY, Max
German, 1858-1924
THEER, Adolf
German, 1811-1868
THEER, Albert
German, 1805-1902
THEER, Robert
German, 1808-1863
THEGERSTROM, Robert
Swedish, 1857-1919
THEIL, Gottfried
Johann Benedict
German, 1745-1797
THEIS, Heinz
German, 1894-
THELANDER, Pär Gunnar
Swedish, 1936-
THELOTT, Antoine
Charles
French, -1853
THELOTT or Thelot,
Johann Andreas
German, 1655-1734
THEMERSON, Franciszka
British, 1907-
THENOT, Jean Pierre
French, 1803-1857
THEODORESCU-SION, Ion
Rumanian, 1882-1939
THEODORIC of Prague,
Master
Czech, op.1348-1380
THEOLON, Etienne
see Théaulon
THEOPHANES of Crete
Greek, op.1527-1548
THEOPHILUS, Martin
see Polak
THEOTOCOPOLI, Domenico
see Greco, El
THEPOT, Roger-François
French, 1925-
THERBUSCH, Anna
Dorothea
see Lisiewska
THERKILDSEN or
Therkelsen, Hans Michael
Danish, 1850-1925

THEUNISSEN, Cornelis
Anthonisz.
see Teunissen
THEUS, Jeremiah
Swiss, 1719-1774
THEVART, Daniel
see Thievaert
THEVENET, Jacques
French, 1891-
THEVENET, Louis
Belgian, 1874-1930
THEVENETI, Lorenzo
see Thewenti
THEVENIN, Catherine
Caroline
see Cogniet
THEVENIN, Charles
French, 1764-1838
THEVET, André
French, 1504-1592
THEWENTI, Lorenzo
British, 1800-1878
THIAN
French, op.1791
THIBAULT, Aimée
French, 1780-1868
THIBAULT, Jean Thomas
French, 1757-1826
THIBAUT or Thybout,
Willem Willemsz.
Netherlands,
c.1524/6-1597/9
THIBOUST, Jean Pierre
French, 1763-c.1824
THICKNESSE, Ann
British, 19th cent.
THIEBAUD, Wayne
American, 1920-
THIECK
French(?), 19th cent.
THIEDEMANN, Thiedeman
or Tideman, Philipp
German, 1657-1705
THIELE, H.
German(?), 20th cent.
THIELE, Johann Alexander
German, 1685-1752
THIELE, Johann Friedrich
Alexander
German, 1747-1803
THIELEN or Thielen-
Rigouldts, Jan Philip van
Flemish, 1618-1667
THIELENS, Gaspar
Flemish, op.1676-m.1691
THIELENS, Johannes,
Jan or Hans
see Tilens
THIELER, Fred
German, 1916-
THIELO, Johann Gerhard
Wilhelm, II
German, 1735-1796
THIEM, Conrad
German, 1815-1898
THIEM, Paul
German, 1858-1922
THIENON, Anne Claude
French, 1772-1846
THIENON, Louis Désiré
French, 1812-p.1884
THIENPONDT, Carl
Friedrich
German, 1720/30-1796
THIER, Bernhard
Heinrich or Barend
Hendrik
Dutch, c.1740-1811

THIER, Hendrik de
see Dethier
THIERRIAT, Augustin
Alexandre
French, 1789-1870
THIERRY, Charles S.
French, 1755-1851
THIERRY, Hilaire
French, 19th cent.
THIERRY, Wilhelm Adam
German, 1761-1823
THIERY de Sainte-
Colombe, Luc Vincent
French, 1734-p.1811
THIEVAERT, Thevart,
Thivart or Tivaert,
Daniel Jansz.
Dutch, a.1613-a.1658
THIM, Cornelis
Dutch, 1754-1813
THIM, Reinhold
see Timm
THIOLLET, A.
French, 1824-1895
THIRIAT, Henri
French, 1866-1897
THIRIAT, Paul
French, 20th cent.
THIRIET, Henri
Belgian, 19th cent.
THIRION, André
French, 20th cent.
THIRION, Eugène Romain
French, 1839-1910
THIRTLE, John
British, 1777-1839
THIRY, Thiri or Tyri,
Leonard (Lionardo
Fiamingo)
Netherlands,
op.1536-m.c.1550
THIVART, Daniel
see Thievaert
THIVET, A.L.
French, op.c.1880
THIVET, Antoine
Auguste
French, 19th cent.
THOEFT
Swiss, 19th cent.
THOF, Cornelius van
Dutch, 17th cent.
THOLEN, Willem
Bastiaan
Dutch, 1860-1931
THOLENTINUS
see Francesco di
Tolentino
THOM, James Crawford
American, 1835-1898
THOMA, Hans
German, 1839-1924
THOMA, Josef
German, 1828-1899
THOMA-HÖFELE, Carl
Swiss, 1866-
THOMANN, Grosshens
Swiss, 1525-1567
THOMANN, Gustav Adolf
Swiss, 1874-
THOMANN, Henri
Swiss, 1760-1820
THOMAS, Captain
see Hastings
THOMAS von Klausenberg
Hungarian, op.c.1427
THOMAS, Albert Gordon
British, 1893-
THOMAS, Bert P.S.
British, 1883-1966

THOMAS, Claude
French(?), op.1724-1725

THOMAS, Edmund
British, 19th cent.

THOMAS, Francis Inigo
British, 19th cent.

THOMAS, George
Housman
British, 1824-1868

THOMAS, Gerard
Flemish, 1663-1720

THOMAS, Grosvenor
British, 1856-1925

THOMAS, H.
French, 19th cent.

THOMAS, Henri Joseph
Belgian, 1878-

THOMAS, J.
German(?), op.c.1840

THOMAS, J.L.
British, op.1855-1869

THOMAS, Jean-Baptiste
or Antoine-Jean-
Baptiste
French, 1791-1834

THOMAS of Ypres,
Johannes or Jan
Flemish, 1617-1678

THOMAS, John Havard
British, 1854-1921

THOMAS, Keith
British, 1946

THOMAS or Thomason,
Kristofer
Swedish, op.1694-m.1715

THOMAS, M.
British, op.1832-1843

THOMAS, Master
British, 14th cent.

THOMAS, Paul
French, 1859-

THOMAS, Pieter Hendrik
Dutch, 1814-1866

THOMAS, R.S.
British, op.1839-1842

THOMAS, Raffaele
Spanish, op.1455-1456

THOMAS, Reynolds
American, 20th cent.

THOMAS, Robert Kent
British, op.c.1843-1883

THOMAS, Sidney
British, 19th cent.

THOMAS, T.
British, 19th cent.

THOMAS, W.
British, op.1806-1838

THOMAS, William Cave
British, 1820-p.1884

THOMAS, William Luson
British, 1830-1900

THOMASON, Kristofer
see Thomas

THOMASSIN, Désiré
German, 1858-1933

THOMASSIN, Philippe
French, 1536-1606

THOMASSIN, Simon
French, 1655-1733

THOME, Verner
Finnish, 1878-

THOMING, Christian
Frederik Ferdinand
(Frederik)
German, 1802-1873

THOMISE, François
French, 18th cent.

THOMKINS, André
Swiss, 1930-

THOMLINSON
American, op.c.1775

THOMON, Thomas de
French, 1754-1813

THOMOND, Mary,
Marchioness of,
(née Palmer)
British, 1751-1821

THOMPSON
British, 18th cent.

THOMPSON, A. Wordsworth
American, 1840-1896

THOMPSON, Cephas G.
American, 1809-1888

THOMPSON, Charles H.
British, op.c.1894-1923

THOMPSON, E.W.
British, 1770-1847

THOMPSON, Elizabeth
Southerden
see Butler, Lady

THOMPSON, George
American, 1859-1935

THOMPSON, George
British, 19th cent.

THOMPSON, Harry
British, -1901

THOMPSON, Sir Henry
British, 1820-1904

THOMPSON, Henry Yates
British, 1838-

THOMPSON, Jacob
British, 1806-1897

THOMPSON, James Robert
British, op.1807-1843

THOMPSON, Jérome B.
American, 1814-1886

THOMPSON, Sir Matthew
William
British, 1872-

THOMPSON, Michel
French, 1921-

THOMPSON, Thomas
American, 1767(?)-1852

THOMPSON, Thomas
Clement
British, c.1780-1857

THOMPSON, W.
British, 19th cent.

THOMPSON, Wilfred
British, op.1891

THOMPSON, William
John
American, 1771-1845

THOMS, Ernst
German, 1896-

THOMSEN, August Carl
Vilhelm
Danish, 1813-1886

THOMSON, Adam Bruce
British, 1885-

THOMSON, Alfred
Reginald
British, 1895-

THOMSON, Clifton
British, 19th cent.

THOMSON, George
British, 19th cent.

THOMSON, Henry
British, 1773-1843

THOMSON, Hugh
British, 1860-1920

THOMSON, James
British, 1787-1850

THOMSON of Duddingston,
Rev. John
British, 1778-1840

THOMSON, John
British, op.1863-1872

THOMSON, John Murray
British, 1885-

THOMSON, Leslie
British, 1851-1929

THOMSON, Tom
Canadian, 1877-1917

THON, William
American, op.c.1949

THONAUER, Hans
see Donauer

THONY, Eduard
Swiss, 1866-1950

THONY, Gustav
German, 1888-1949

THONY, Wilhelm
Austrian, 1888-1947

THOPAS, Johan
Dutch, c.1630-c.1700

THOR, Emil Nils
Johanson
see Johanson-Thor

THORAIN, Charles
see Thorin

THORAUWER, Georg
German, op.1616

THORBURN, Archibald
British, 1860-1935

THORBURN, Robert
British, 1818-1885

THOREAU, Sophia
American, op.1839

THORELL, Hildegard
Katerina, (née
Bergendahl)
Swedish, 1850-1930

THOREN, Otto von
German, 1828-1889

THORIGNY, Félix
French, 1824-1870

THORIN, Thorain, Torin
or Torrin, Charles
French, c.1600-1635

THORMANN, Theodor von
German, 1840-1895

THORNBORG or Tornborg,
Andreas
Norwegian, 1730-1780

THORNBURY, W. Anslow
British, op.c.1883-1906

THORNE, J.
British, op.1838-1864

THORNE, S.E.
British, op.c.1845

THORNE, Sven Alfred
Swedish, 1850-1916

THORNELY, Charles
British, op.c.1858-1893

THORNE WAITE, Robert
British, 1842-1893

THORNHILL, Sir James
British, 1676-1734

THORNHILL, John
British, op.1730-1760

THORNLEY, William
British, 1857-

THORNTON, Alfred Henry
Robinson
British, 1863-1939

THORNTON, R.J.
British, op.1798

THORNTON, Thomas
British, op.1778-1785

THORNTON, Valerie
British, 20th cent.

THORNTON, William
American, 1759-1828

THORNYCROFT, Sir William Hamo
British, 1850-1925

THOROGOOD, Stanley
British, 1873-1953

THORP
British, 20th cent.

THORPE, Freeman
American, 1844-1922

THORPE, John
British, op.1834-1873

THORS, Joseph
British, op.1863-1884

THORVALDSEN, Alberto
or Bertel
Danish, 1770-1844

THOURON, Jacques
Swiss, 1749-1789

THRALE, Sophia
British, p.1763-

THRESHER, George
American, op.1806-1812

THRILLIER, G.
Swiss(?), op.1846

THROSBY, John
British, c.1740-1803

THRUMPTON, T.
British, op.1667

THUAR, Hans
German, 1887-1945

THUBRON, Harry
British, 1915-

THUILLIER, Pierre
French, 1799-1858

THULDEN or Tulden,
Theodor van
Flemish, 1606-1669

THULSTRUP, Thure or
Bror Thure
American, 1848-1930

THUM, Christian
Swedish, 1625-1696

THUMA, Karl Maria
German, 1870-1925

THUNAUER, Hans
see Donauer

THÜRMER, Joseph
German, 1789-1833

THURNER, Gabriel
French, 1840-1907

THURSTON, John
British, 1774-1822

THWENGER, Johann
see Twenger

THYBOUT, Willem
see Thibaut

THYGESEN, Rudolf
Norwegian, 1880-

THYNNE, Lady, (née
Marsh)
British, 18th/19th cent.

THYS, Tys, Tysen or
Tyssens, Pieter
Flemish, 1624-1677

THYS, Pieter Pauwel
Flemish, 1652-c.1679

THYSEBAERT, E.
Flemish, op.1826

TIAPUSHKIN, A.
Russian, 20th cent.

TIARINI, Alessandro
Italian, 1577-1668

TIARINI, Francesco
Italian, op.1654

TIBALDI de' Pellegrini,
Domenico Pellegrino
Italian, 1541-1583

TIBALDI di Bologna,
Gaetano
Italian, 1799-p.1857

TIBALDI, Maria
Felicita
see Subleyras
TIBALDI, Pellegrino
da Bologna
Italian, 1527-1596
TIBBITS, H.
Australian, op.c.1850
TIBBLE, Geoffrey
Arthur
British, 1909-1952
TIBERIO d'Assisi
(Diotallevi, Diatelivi
or Detalevo)
Italian, c.1470-1524
TIBERIO di Tito
Italian, 1573-1627
TICHY, Hans
German, 1861-1925
TICKELL, Mrs. H.
British, op.1842
TICKNOR, George
American, 1791-1871
TIDD, Julius
British, op.1773-1779
TIDEMAN, Philipp
see Thiedemann
TIDEMAND, Adolphe
Norwegian, 1814-1876
TIDEY, Alfred
British, 1808-1892
TIDEY, Henry
British, 1813-1872
TIECHE, Adolf
Swiss, 1877-
TIECK, Christian
Friedrich
German, 1776-1851
TIEDJEN, Willy
German, 1881-1950
TIEER, Hendrik de
see Dethier
TIELEMAN or Tielemann,
Melchior Gommar
Belgian, 1784-1864
TIELENS, Johannes,
Jan or Hans
see Tilens
TIELING, Lodewyk
Dutch, op.1696
TIELIUS, Jan
see Tilius
TIELKER, Friedrich
Carl
German, 1765-1845
TIELKER, Johann
Friedrich
German, 1763-1832
TIELT, Louis du
see Du Tielt
TIENEN, J. van
Dutch, op.1637
TIEPOLO, Giovanni
Battista
Italian, 1696-1770
TIEPOLO, Giovanni
Domenico
Italian, 1727-1804
TIEPOLO, Lorenzo
Baldissera
Italian, 1736-1776
TIER, H.
German, op.c.1678
TIERCE, Jean Baptiste
French, 1737-c.1790
TIFERNATE da Castello,
Francesco
Italian, op.1524

TIFFANY, Louis
Comfort
American, 1848-1933
TIKOS, Albert
Hungarian, 1815-1845
TILBORGH or Tilborch,
Gillis van
Flemish, c.1625-c.1678
TILE, Johann Andreas
German, op.c.1670-1680
TILEMANN or Tilman,
Simon Peter (Schenck)
Dutch, 1601-c.1668/70
TILENS, Thielens or
Tielens, Johannes,
Jan or Hans
Flemish, 1589-1630
TILIUS or Tielius, Jan
Dutch, op.1680-1694
TILL, Johann
German, 1827-1894
TILL, Leopold
German, 1830-1893
TILLACK, Johannes
Adolf
German, 1861-
TILLEMANS, Peter
Flemish, 1684-1734
TILLERAND or Tisserand(?)
French, op.1790
TILLIER, Paul Prosper
French, 1834-
TILLY, Vilhelm Eyvind
Scandinavian, 1860-1935
TILSON, Henry
British, 1659-1695
TILSON, Joseph (Joe)
British, 1928-
TILT, F.A.
British, op.1866-1868
TILYARD, Philip
American, 1787-1827
TIMBAL, Louis Charles
French, 1821-1880
TIMBRELL, James
Christopher
British, 1807-1850
TIMM or Thim, Reinhold
Danish, op.1615-m.1639
TIMMAS, Osvald
Canadian, 20th cent.
TIMMER, Cornelis (Kees)
Dutch, 1903-
TIMMERMANN, Franz
German, op.1538-1541
TIMMERMANS, Louis
French, 1846-1910
TINANT, Louis Félix
Edouard
French, op.1859
TINAYRE, Jean Paul
Louis (Louis)
French, 1861-
TINDLE, David
British, 1932-
TINELLI, Tiberio
Italian, 1586-1638
TING, Wallace
Oriental, 1929-
TINGUELY, Jean
Swiss, 1925-
TINKER, David
British, 20th cent.
TINTI, Giambattista
Italian, 1558-1604
TINTO, Gabriel
see Anthony, George
Wilfrid

TINTORE, Simone del
Italian, op.1630-1670
TINTORETTO, Domenico
Robusti
Italian, 1560-1635
TINTORETTO, Jacopo
Robusti, Il
Italian, 1518-1594
TINTORETTO, Marco
Italian, c.1560-1637
TINTORETTO, Marietta
(Robusti)
Italian, c.1560-c.1590
TIPPETT, W.V.
British, op.1866
TIRATELLI, Aurelio
Italian, 1842-1900
TIRATELLI, Cesare
Italian, 1864-
TIRCHBETT, C.
British, op.1830
TIRÉN, Johan
Swedish, 1853-1911
TIRONI, Francesco
Italian, -c.1800
TIRPENNE, Jean Louis
French, 1801-p.1878
TISCHBEIN, Anton
Wilhelm
German, 1734-1804
TISCHBEIN, August
Anton
German, 1805-p.1867
TISCHBEIN, Carl Ludwig
German, 1797-1855
TISCHBEIN, Carl Wilhelm
German, 1751-1824
TISCHBEIN, Jacob
German, 1760-1804
TISCHBEIN, Johann
Anton, I
German, 1720-1784
TISCHBEIN, Johann
Friedrich August
German, 1750-1812
TISCHBEIN, Johann
Heinrich, I
German, 1722-1789
TISCHBEIN, Johann
Heinrich, II
German, 1742-1808
TISCHBEIN, Johann
Heinrich Wilhelm
German, 1751-1829
TISCHBEIN, Johann
Jakob
German, 1725-1791
TISCHBEIN, Johann
Valentin
German, 1715-1768
TISCHBEIN, Wilhelm
Eduard
German, 1791-1819
TISCHBEIN, Wilhelmine
Caroline Amalie
see Appel
TISCHLER, Alexander
Russian, 1898-
TISCHLER, Victor
German, 1890-1951
TISDALE, Elkanah
American, c.1771-p.1834
TISDALL, Hans Aufseeser
(Hans)
British, 1910-
TISO, Oronzo
Italian, 1729-1800

TISOIO, Antonio da
Italian, op.1512
TISSAC, Comte de
French, op.1823
TISSERAND, Gerard
French, 20th cent.
TISSERAND
see also Tillerand
TISSIER, Jean Baptist
Ange
French, 1814-1876
TISSOT, James Joseph
Jacques
French, 1836-1902
TITANI
British(?), 19th cent.
TITCOMB, Jessie Ada
British, op.1892-1895
TITCOMB, William Holt
Yates
British, 1858-1930
TITEL, Wilhelm
German, 1784-1862
TITIAN or Tiziano
Vecelli
Italian, 1477/89-1575
TITO, Diego Quispe
South American, 17th cent.
TITO, Ettore
Italian, 1859-1941
TITO, Santi di
see Santi
TITO or Titi, Tiberio
or Valerio di
Italian, 1573-1627
TITTLE, Walter
British, 1883-
TITUS-CARMEL, Gerard
French, 1942-
TIVAERT, Daniel
see Thievaert
TIVOLI, Serafino de
Italian, 1826-1892
TIZIANELLO
see Vecellio, Tiziano
TOBAR or Tovar, Alonso
Miguel de
Spanish, 1678-1758
TOBEEN, Félix
French, 1880-1920
TOBEY, Mark
American, 1890-1976
TOBIASSE, Theo
French, 19th cent.
TOBIN, Captain George
American, op.1796
TOBIN, J.
British, op.1776
TOBLER, Al
Swiss(?), op.1818
TOBLER, Victor
Swiss, 1846-1915
TOCCAGNI
see Piazza, Albertini
TOCHE, Charles
French, 1851-1916
TOCQUE or Toucquet,
Louis
French, 1696-1772
TODD, Arthur Ralph
Middleton
British, 1891-1966
TODD, Charles Stewart
American, 1886-
TODD, George
British, 1847-1898
TODD, Henry George
British, 1847-1898
TODD, Justin
British, 20th cent.

TODD, R.C.
British, 18th cent.
TODESCHINI
see Cipper, Giacomo
Francesco
TODESCHINI, Giovanni
Battista
see Todeschis
TODESCHIS or Todeschini,
Giovanni Battista
Italian, op.1691-1718
TODT, Max
German, 1847-1890
TOECK, C.
German, 17th cent.
TOEPFFER, Adam
Wolfgang
see Töpffer
TOEPUT, Lodewyk
(Pozzoserrato;
Lodovico Pozzo da
Treviso; Ludovico
Fiammingo),
Netherlands,
c.1550-c.1603/5
TOFANELLI, Agostino
Italian, 1770-1834
TOFANELLI, Stefano
Italian, 1752-1812
TOFANO, Eduardo
Italian, 1838-1920
TOFFOLI
French(?), 20th cent.
TOFT, Peter Petersen
British, 1825-1901
TOGNI, Ponziano
Swiss, 1906-
TOGNONE
see Antonio Vicentino
TOGORES, José de
Spanish, 1893-
TOIDZE, Irakli
Moisejevitch
Russian, 1902-
TOIVANEN, Laurie
Finnish, 20th cent.
TOKUNAGA, N.
Oriental, 19th cent.
TOL, Dominicus van
Dutch, c.1635-1676
TOL, Nicolaes (Claes)
Jacobsz.
Dutch, op.1634-1652
TOLANS, Eugene de
French, 19th cent.
TOLEDO, Francisco
Mexico, 1940-
TOLEDO, Juan, II de
(El Capitan)
gee Juan
TOLGYESSY, Artur
Hungarian, 1853-1920
TOLLAST, Robert
British, op.1963
TOLLEMACHE, Duff
British, 1859-1936
TOLLIN, Ferdinand
Swedish, 1807-1860
TOLMEZZO, Giovanni
Francesco da
see Zotto
TOLSTOI, Fedor, Count
Russian, 1783-1873
TOM, Jan Bedijs
Dutch, 1813-1894
TOMA, Giovacchino
Italian, 1838-1891

TOMA, Matthias
Rudolf
German, 1792-1869
TOMAR, Matteo
see Stomer, Matthias
TOMASELLI di Bomporto,
Contardo
Italian, 1827-1877
TOMASEVIC, Aleksandar
Yugoslav, 1921-
TOMASZEWSKI, Henryk
Polish, 1914-
TOMBLESON, William
British, c.1795-
TOMEA, Federigo
Italian, 20th cent.
TOMEA, Fiorenzo
Italian, 1910-1960
TOMEC, Heinrich
German, 1863-
TOMINZ, Giuseppe
Italian, 1790-1866
TOMKINS, Charles
British, c.1750-c.1810
TOMKINS, Charles F.
British, 1798-1844
TOMKINS, Margaret
American, 20th cent.
TOMKINS, Peltro William
British, 1760-1840
TOMKINS, William
British, c.1730-1792
TOMLIN, Bradley
Walker
American, 1899-1953
TOMMASI, Angiolo
Italian, 1858-1923
TOMMASI, Ludovico
Italian, 1866-1941
TOMMASI, Publio de
Italian, 1849-
TOMMASINI, G.
Italian, op.1622
TOMMASO
Italian, 15th cent.
TOMMASO di Antonio
see Finiguerra, Maso
TOMMASO da Bologna
(Vincitore or
Vincidor)
Italian, op.1520-m.c.1536
TOMMASO da Cortona
Italian, 16th cent.
TOMMASO di Lorenzo di
Credi
see Tommaso di Stefano
TOMMASO di Marco
see Mazza
TOMMASO da Modena
(Barisino or Rabisino)
Italian, 1325-1376
TOMMASO da San Friano
see Maso
TOMMASO degli Stefani
Italian(?), 15th cent.
TOMMASO di Stefano
Lunetti or di Lorenzo
di Credi
Italian, c.1496-1564
TOMPKE, Johann Georg
German, op.c.1754
TOMS, Peter
British, -1776
TOMS, William Henry
British, c.1700-c.1750
TOMSON, Arthur
British, 1858-1905

TOMSON, Clifton
British, op.c.1830
TONAUER, Hans
see Donauer
TONCI, Salvatore
Italian, 1756-1844
TONDU, André
French, 1903-
TONDUCCI, Giulio
Italian, c.1531-1582/98
TONELLI, Anna
Italian, op.1794-1797
TONELLI, Giuseppe
Italian, 18th cent.
TONGE, Louis van der
Dutch, 1871-
TONGE, Robert
British, 1823-1856
TONGEREN, Jan van
Dutch, 1897-
TONGUE, Richard
British, op.c.1835
TONI, Matteo
Italian, op.1785
TONITZA, Nicolas
Rumanian, 1885-1940
TONKS, Henry
British, 1862-1937
TONKS, Myles Denison
Bosewell
British, 1890-
TONNANCOUR, Jacques de
Canadian, 1917-
TOOKER, George
American, 1920-
TOORENBURG, Toorenburgh
or Torenburg, Gerrit
Dutch, 1732-1785
TOORENVLIET, Toornvliet
or Torenvliet, Jacob
(Jason)
Dutch, c.1635/6-1719
TOORN, Jan Willem van
Dutch, 1932-
TOOROP, Annie Caroline
Pontifex (Charley)
Dutch, 1891-1955
TOOROP, Jean Theodoro
(Jan)
Dutch, 1858-1928
TOOTH
see Toth
TOOTHS, Anthony
British, 20th cent.
TOOVEY, Edwin
British, op.1865-1867
TÖPFFER or Toepffer,
Adam Wolfgang
Swiss, 1766-1847
TÖPFFER, Rodolphe
Swiss, 1799-1846
TOPHAM, Edward
British, 1751-1820
TOPHAM, Francis
William
British, 1808-1877
TOPHAM, Frank William
Warwick
British, 1838-1924
TÖPKE, Dirk Antoon
Josephus Franciscus
(Dirk Antoon Teupken)
Dutch, 1828-1859
TOPLIS, Charles
British, 1780-1851
TOPOLSKI, Feliks
Polish, 1907-
TOPOLSKI, Maciej
Polish, 1766-1812

TOPOR, Roland
French, 20th cent.
TOPP, Arnold
German, 1887-
TOPPELIUS, Waldemar
Russian, 1858-1936
TORBIDO, Francesco
(Il Moro)
Italian, c.1482/3-p.1562
TORDI, Sinibaldo
Italian, 1876-1955
TORDINI, U.
Italian, 19th cent.
TORELLI, Felice
Italian, 1670-1748
TORELLI, Cavaliere
Giacomo
Italian, 1608-1678
TORELLI, Lucia
see Casalini
TORELLI, Stefano
Italian, 1712-1784
TORELLINO
see Giorgi, Giovanni de'
TORENBURG, Gerrit
see Toorenburgh
TORENVLIET, Jacob (Jason)
see Toorenvliet
TORESANI, Andrea
Italian, op.1727-1760
TORF, Harry
American, 1950-
TORI, Giuseppe
Italian, op.1758-1789
TORIN, Charles
see Thorin
TORLAKSON, Jim
American, 20th cent.
TÖRMER, Benno
Friedrich
German, 1804-1859
TÖRNA, Oskar Emil
Swedish, 1842-1894
TORNABUONI, Lorenzo
Italian, 1934-
TORNAI, Gyula
Hungarian, 1861-1928
TORNAU, Carl Wilhelm
Gustav (Wilhelm)
German, 1820-1864
TORNBORG, Andreas
see Thornborg
TORNEMAN, Axel
Swedish, 19th cent.
TORNER, Gustavo
Spanish, 1925-
TORNER, Martin
Spanish, op.1480-1497
TORNI, Jacopo
(L'Indaco)
Italian, 1476-1526
TORNIOLI, Niccolò
Italian, op.1622-1640
TÖRNSTRÖM, Johan
Swedish, 1743-1828
TORO or Turreau, Jean
Bernard Honoré (Bernard)
French, 1672-1731
TORQUE, F.
Dutch(?), 17th cent.(?)
TORRADO or Alvarez
Torrado, Antonio
Spanish, 18th cent.
TORRE, Alessandro della
see Casolani
TORRE, Enrico della
Italian, 1931-
TORRE, Flaminio (degli
Ancinelli)
Italian, 1621-1661

TORRE, Giulio del
Italian, 1856-1932
TORRE, Teofilo
Polish, 17th cent.
TORREGIANI, Bartolommeo
Italian, 1590-p.1674
TORREGIANI, Vincenzio
Italian, op.1742-1770
TORRENTIUS, Johannes or
Jan Symoonisz.
(Johannes Symoonisz.
van der Beeck)
Dutch, 1589-1644
TORRENTS y de Amat,
Stanislas
French, 1839-1916
TORRES, Fra Antonio de
Mexican, op.1720
TORRES, Clemente de
Spanish, 1665-1730
TORRES, Julio Romero
de
Spanish, 1880-1930
TORRES, Matias de
Spanish, 1631-1711
TORRESANI, Bartolomeo
di Cristoforo
Italian, c.1500-c.1567
TORRESANI da Verona,
Lorenzo
Italian, 15th cent.
TORRES GARCIA, Joaquin
South American,
1875-1949
TORRETTI or Torri,
Giambattista
Italian, op.1640
TORRI, Bartolomeo
Italian, 16th cent.
TORRI, Pietro Antonio
Italian, op.1655
TORRIGIANO, Pietro
Italian, 1472-1528
TORRIGLIA, Giovanni
Battista
Italian, 1858-
TORRIN, Charles
see Thorin
TORRINI, E.
Italian, 19th cent.
TORRINI, Pietro
Italian, 1852-
TORRITI, Jacopo
see Turrita
TORSCH, J.
German(?), 18th cent.(?)
TORSTEINSON, Torstein
Norwegian, 1876-
TORSTRUP, C.
Norwegian(?), 19th cent.
TORTEBAT, Francois
French, 1616-1690
TORTEBAT, Jean
French, 1652-1718
TORTELLI, Giuseppe
Italian, 1662-
TORTOREL, Jacques
Netherlands,
op.1568-1592
TORY or Toury,
Geoffroy or Godefroy
French, 1485-1533/54
TOSCANI, Giovanni di
Francesco
Italian, c.1370-1430
TOSCHI, Paolo
Italian, 1788-1854

TOSCHI, Pier Francesco
di Jacopo di Domenico
(not di Sandro)
see Foschi, Pier Francesco
TOSELLI, Angelo
Italian, op.c.1800
TOSI, Arturo
Italian, 1871-1956
TOSINI, Michele
(Michele di Ridolfo
Ghirlandajo)
Italian, 1503-1577
TOSO, Girolamo del
Italian, op.1500-1538
TOTH or Tooth(?)
British, 18th cent.
TOTO del Nunziata,
Antonio
Italian, 1498-1556
TOTT, Sophie, Comtesse
de
French, op.1801
TOUCHAGUES, Louis
French, 1893-
TOUCHE, Gaston de la
see Latouche
TOUCQUET, Louis
see Tocqué
TOUDOUZE, Anais
French, 1822-1899
TOULMOUCHE, Auguste
French, 1829-1890
TOULONGNE, Alfred
Charles
British, op.c.1868
TOULOUSE, Edgar
French, 20th cent.
TOULOUSE-LAUTREC,
Henri de
French, 1864-1901
TOUPILEW
Russian, 1757-
TOUR, de la
see Latour
TOURNACHON, Félix
(Pseudo Nadar)
French, 1820-1910
TOURNAI, Julius
German, 1861-
TOURNAY, C.
French, 17th cent.
TOURNES, Etienne
French, 1857-1931
TOURNI
French(?), 18th cent.
TOURNIER, Jean Ulrich
French, -1865
TOURNIER, Nicolas
French, 1590-1660
TOURNIER, Robert
see Tournier, Nicolas
TOURNIERES, Robert
Le Vrac de
French, 1668-1752
TOUROUDE, Michel
British, op.1678
TOURRIER, Alfred
Holst
British, c.1836-1892
TOURRIER, G.L.
French, op.1870-1876
TOURS, Simon François or
Francoys de
French, 1606-1671
TOURTE, Suzanne
French, 1904-
TOURY, Geoffroy or Godefroy
see Tory

TOUSIGNANT, Claude
Canadian, 1932-
TOUSSAINT, Fernand
Belgian, 1873-
TOUSSAINT, Louis
German, 1826-
TOUSSYN, Toussin or
Tussin, Johann
German, op.c.1630-1660
TOUTIN, Henri
French, 1614-p.1683
TOUTIN, Jean
French, 1578-1644
TOUZE, Jacques Louis
Francois
French, 1747-1809
TOUZE, Jean
French, 1747-1809
TOVAGLIE
see Pietro di
Giovanni
TOVAR, Alonso
Miguel de
see Tobar
TOVAR, Ivan
Czech, 20th cent.
TOVEY, John
British, op.1843
TOWN, Harold
Canadian, 1924-
TOWNE or Town of
Liverpool, Charles
British, 1763-1840
TOWNE or Town of
London, Charles
English, 1781-1854
TOWNE, Francis
British, 1740-1816
TOWNLEY, Charles
British, 1746-c.1800
TOWNROE, Reuben
British, 1835-1911
TOWNSEND, Frederick H.
British, 1868-1920
TOWNSEND, Harry
Everett
American, 1879-
TOWNSEND, Henry James
British, 1810-1890
TOWNSEND, William
British, 1909-1973
TOWNSHEND, Rev. Chauncey
Hare
British, 1798-1868
TOWNSHEND, George,
Marquis of
British, 1724-1807
TOYEN, Marie Cernisova
French, 20th cent.
TOYNBEE, Lawrence
British, 1922-
TOYNTON, Norman
British, 1939-
TOZELLI, Francesco
Italian, op.c.1794-1822
TOZER, H. Spernon
British, op.1889
TOZZI, Mario
Italian, 1895-
TOZZI, Pietro Paolo
Italian, op.1596-1627
TRABALLESI, Bartolommeo
Italian, 16th cent.
TRABALLESI, Francesco
Italian, 1544-1588
TRABALLESI, Giuliano
(Il Giulianno)
Italian, 1727-1812

TRABINSKY, Max
Czech, 20th cent.
TRABUTE, William
British, op.1670
TRACHSEL, Albert
Swiss, 1863-1929
TRACY, John M.
American, 1844-1893
TRAFFELET, Fritz
Swiss, 1897-
TRAGARDH, Carl Ludwig
Swedish, 1861-1899
TRAIES, William
British, 1789-1872
TRAILL, T.
British, op.1620
TRAIN, Edward
British, op.1850
TRAINI, Francesco
(see also Lorenzetti,
unknown follower of
the)
Italian, op.1341
TRAJECTENSIS, Jacobus
see Jacob van Utrecht
TRAMASURE, P. de
Flemish, c.1790-
TRAMONTINI, Giorgio
Italian, 20th cent.
TRAMPON, P.
British, op.1708
TRANTPLY
British, op.1744
TRAPP, Hede Von
German, 1877-
TRAUT, Hans
German, op.1477-m.1516
TRAUT, Wolfgang
German, op.c.1510-m.1520
TRAUTHMAN, Valentin
Swedish(?), op.1626
TRAUTMANN, Johann
George
German, 1713-1769
TRAUTSCHOLD, Wilhelm
German, 1815-1877
TRAVERSART
French, 19th cent.
TRAVERSE, Charles de la
French, 18th cent.
TRAVERSI, Gaspare or
Giuseppe
Italian, c.1725-1769
TRAVERSIER, Jacques
French, 1875-1935
TRAVERT, Louis
French, 20th cent.
TRAVI, Antonio (Sordo
da Sestri)
Italian, 1608-1665
TRAVIES, Charles Joseph
French, 1804-1859
TRAVIES, Edouard
French, 1809-
TRAVIS, Stuart
American, 20th cent.
TRAYER, Jean Baptiste
Jules
French, 1824-1909
TREBATI, Paulo Ponsio
see Ponce
TRECCANI, Ernesto
Italian, 1920-
TRECK, Jan Jansz.
Dutch, c.1606-1652(?)
TRECOURT, Giacomo
Italian, 1812-1882

TREDINNICK, Francis
British, 1933-
TREE, Dolly
American, 20th cent.
TREFZGER, Paula
German, 20th cent.
TREGEAR, C.
British, op.c.1825-1840
TREIDLER, Adolph
German, 1846-1905
TREMBLAY, Gerard
Canadian, 1928-
TREMENHEERE, Captain
Henry Pendarves
British, -1841
TREML, Friedrich
German, 1816-1852
TREMOIS, Pierre-Yves
French, 1921-
TREMOLLIERE, Pierre
Charles
French, 1703-1739
TRENCHARD, James
American, op.1777-1790
TRENGRADE, M.
French, 19th cent.
TRENKWALD, Josef
Mathias von
German, 1824-1897
TRENTSENSKY, Josef
German, 1793-1839
TRESCA, Trescha or
Trisca, H. Salvatore
Italian, op.1740
TRESGUERRAS, Francisco
Eduardo
Spanish, 1759-1833
TRESHAM, Henry
British, 1757-1814
TRETCHIKOFF, Vladimir
Russian, 20th cent.
TREU or Trey,
Catherine
German, 1742-1811
TREU, Jacobus
German, op.1762
TREU or Trey, Johann
Nikolaus
German, 1734-1768
TREU or Trey, Joseph
Christoph
German, 1739-1798
TREU, Martin
German, op.1540-1543
TREUTLER, Jerzy
Polish, 20th cent.
TREVEDY, Yves
French, 1916-
TREVELYAN, Hilda
British, 20th cent.
TREVELYAN, Julian
Otto
British, 1910-
TREVES, André
French, 1904-
TREVES, Dario
French, 20th cent.
TREVETT, Robert
British, -1723
TREVIRENSIS
see Sarburgh,
Bartholomäus
TREVISANI, Angelo
Italian, 1669-p.1753
TREVISANI, Francesco
Italian, 1656-1746
TREVISE, Hippolyte de
French, 1868-

TREVOR, Helen Mabel
British, 1831-1900
TREVOUX, Joseph
French, 1831-1909
TREXEL, Pierre Felix
French, 1782-1855
TREY
see Treu
TRIAK, Roger
American, 20th cent.
TRIBOLO, Niccolò
(Il Pericoli)
Italian, 1500-1550
TRIBOULET, Louis
French, 19th cent.
TRIBOUT
French, 20th cent.
TRICCA, Fosco
Italian, 1856-1918
TRICHTL, Alexander
German, 1802-1884
TRICIUS, Jan
Polish, op.1657-m.1692
TRICK
see Liquier, Gabriel
TRIDON, Caroline,
(née Sattler)
German, 1799-1863
TRIEBEL, Carl
German, 1823-1885
TRIER, Hans
German, 1877-
TRIER, Henry A.
British, 19th cent.
TRIGA, Giacomo
Italian, 1746-
TRIGOSO, Falcão
Portuguese, 1878-1955
TRIGOULET, Eugène
French, 1867-1910
TRIGT, Hendrik Albert
van
Dutch, 1829-1899
TRILLHAASE, Adalbert
German, 1858-1936
TRIMMER, H. Syer
British, op.1839
TRIMOLET, Claude
Anthelme Honor
(Anthelme)
French, 1798-1866
TRINO, Francesco da
see Trevisani
TRINQUESSE, Joseph
French, 1749-
TRINQUESSE, Louis
Roland
French, c.1746-c.1800
TRIPPEL, Alexander
Swiss, 1744-1793
TRIPPENMEKER
see Aldegrever,
Heinrich
TRIQUET, Jules Octave
French, 1867-1914
TRISCA, H. Salvatore
see Tresca
TRISTAN de Escamilla,
Luis
Spanish, 1586(?)-1624
TRIVA, Antonio Domenico
Italian, 1626-1699
TRIVELLINI, Francesco
Italian, 1660-c.1733
TRIVICK, Henry Houghton
British, 20th cent.

TRIVIGNO, Pat
American, 1922-
TROBE, Benjamin
Henry La
see Latrobe
TROFI, Monaldo
see Monaldo
TROGER, Johann
Sebastian
German, -1792
TROGER, Paul
German, 1698-1762
TROILI, Gustav Uno
Swedish, 1815-1875
TROIVAUX, Jean-
Baptiste-Désiré
French, 1788-1860
TROJANOWSKI, Edward
Polish, 1873-1930
TROKES, Heinz
German, 20th cent.
TROLL, Johann Heinrich
Swiss, 1756-1824
TROMBADORI, Francesco
Italian, 1886-1961
TROMBETTI di Bologna,
Alfonso
Italian, 1840-1892
TROMETTA, Niccolò da
Pesaro
Italian, op.1565-1620
TROMP, Johannes (Jan)
Zoetelief
Dutch, 1872-1947
TROMPEI, Felice
Italian, op.1665
TROMPEO, Giovanni
Italian, op.1679
TRONCY, Emile
French, 1860-
TRONI, Giuseppe
Italian, op.c.1820
TROOD, William Henry
Hamilton
British, 1860-1899
TROOP, Miriam
American, 1917-
TROOST, Cornelis
Dutch, 1697-1750
TROOST, Jacoba Maria,
(née Nickelen)
see Nickelen
TROOST van Groenendoelen,
Jan Hendrik
Dutch, op.1754-1771
TROOST, Sara (Sara
Poos van Amstel)
Dutch, 1731-1803
TROOST, Willem
Dutch, 1684-1759
TROOSTWIJK, Wouter
Johannes van
Dutch, 1782-1810
TROPBRILLANT
French, op.1830
TROPER, Paul
German(?), 1698-1762
TROPININE, Vassily
Andrejevitch
Russian, 1776-1857
TROPPA, Girolamo
Italian, c.1636-p.1706
TROSCH, Johannes
Swiss, 1767-1824
TROSCHEL, Hans
German, 1585-1628
TROSO da Monza (Troso
di Giovanni Jacobi)
Italian, c.1450-p.1500

TROSSARELLI, Francesco
Italian, 1735-1808
TROST, Carl
German, 1811-1884
TROTIN, Hector
French, 1894-
TROTT, Benjamin
American, c.1770-p.1841
TROTTER, John
British, op.c.1756-m.1792
TROTTER, Newbold
Hough
American, 1827-1898
TROTTER, Thomas
British, c.1750-1803
TROTTI, Giovanni
Battista (Il Malosso)
Italian, 1555-1619
TROTTI, S.
Italian, 20th cent.
TROUBETZKOY, Igor
Russian, 20th cent.
TROUBETZKOY, Prince Paul
Russian, 1866-1938
TROUBETZKOY, Prince
Pierre
Russian, 1864-1936
TROUEIL, Petrus
British, op.1636
TROUILLE, Clovis
French, 20th cent.
TROUILLEBERT, Paul
Désiré
French, 1829-1900
TROUVAIN, Antoine
French, 1656-1708
TROUVE, Hélène
French, op.1835
TROUVE, Le
see E.A. Heuzé
TROVA, Ernest
American, 1927-
TROY, Antoine de
French, 1608-1684
TROY, François de
French, 1645-1730
TROY, Jean de
French, 1645-1691
TROY, Jean François
de
French, 1679-1752
TROY, Nicolas de
French, 17th cent.
TROYE, Edward
Swiss, 1808-1874
TROYEN, Rombout van
Dutch, c.1605-1650
TROYER, Prosper de
Belgian, 1880-1961
TROYON, Constant
French, 1810-1865
TRÜBNER, Heinrich Wilhelm
(Wilhelm)
German, 1851-1917
TRUCHET, Abel
French, 1857-1918
TRUCHOT, Henri Edouard
French, 1798-1822
TRUEMAN
British, 18th cent.
TRUFFAUT, Georges
French, 1857-1882
TRUFFETTA, Il
see Monaldo
TRUFFIN, Philippe
(also identified with
Master Philippe)
Netherlands, 1457-m.1506

TRULSON, Anders
 Swedish, 1874-1911
TRUMAN, Edward
 American, 18th cent.
TRUMBULL, John
 American, 1756-1843
TRUPHEME, Auguste
 Joseph
 French, 1836-1898
TRUPPE, Karl
 German, 1887-1959
TRUSTTUM, Philip
 New Zealand, 1940-
TRUSZ, Ivan
 Russian, 1869-c.1950
TRUTAT, Félix
 French, 1824-1848
TRYON, Dwight William
 American, 1849-1925
TRZEBIATOWSKI, Janusz
 Polish, 20th cent.
TRZEBINSKI, Marian
 Polish, 1871-
TSANKAROLOS, Stephanos
 Greek, 17th cent.(?)
TSAROUCHIS, Ioannis
 Greek, 1910-
TSCHACHTLAN, Bendicht
 Swiss, op.1470-m.1493
TSCHAGGENY, Charles
 Philogène
 Belgian, 1815-1894
TSCHAGGENY, Edmond
 Jean-Baptiste
 Belgian, 1818-1873
TSCHANN, Hans
 Swiss, op.c.1500
TSCHARNER, Johann
 Wilhelm von
 Polish, 1886-1946
TSCHELAN, Hans
 German, 1873-1964
TSCHERMEZOW, Ivan
 Russian, c.1730-
TSCHERNEZOFF, Nikanor
 Grigorjevich
 Russian, 1804-1879
TSCHERNIGOFF
 Russian, 19th cent.
TSCHOPP, Gerhard G.
 Swiss, 20th cent.
TSCHUDI, Lili
 Swiss, 1911-
TSCHUIKOFF
 see Chuikov
TSCHUMI, Otto
 Swiss, 1904-
TSINGOS, Thanos
 Greek, 1914-
TSIVINSKY
 Russian, 20th cent.
TSUJIMOTO, K.
 Oriental, 20th cent.
TUBBECKE, Paul
 Wilhelm
 German, 1848-1924
TÜBINGEN, Hans von
 see Hans
TUBY or Tubi, Jean
 Baptiste, I
 French, 1635-1700
TUCCARI, Giovanni
 Italian, 1667-1743
TUCCIO di Andrea
 Italian, op.1487
TUCCIO di Giofreda
 da Fonda
 Italian, op.1494

TUCKER, Albert
 Australian, 1914-
TUCKER, Allen
 American, 1866-1939
TUCKER, Arthur
 British, 1864-1929
TUCKER, Edward
 British, c.1846-1909
TUCKER, James Walker
 British, 1898-
TUCKER, Kidger
 South African, op.1879
TUCKER, L.
 British, op.1771
TUCKER, Nathaniel
 British, op.1740-1760
TUCKSON, Anthony
 Australian, 1921-
TUDGAY, I.
 British(?), op.1844
TUDOR, J.O.
 British, op.1809-1824
TUDOR, Joseph
 British, op.1739-m.1759
TUDOR-HART, Percyval
 Canadian, 1873-1954
TUER, Herbert
 British, op.c.1650-m.a.1680
TUERENHOUT, Jef van
 Belgian, 20th cent.
TUGMAN, J.
 British, op.1826
TUKE, Henry Scott
 British, 1858-1929
TULBING
 see Hans von Tübingen
TULDEN, Theodor van
 see Thulden
TULL, Nicholas
 British, -1762
TULLOCH, E.
 Australian, op.1850
TULPEN, van
 Dutch, op.c.1720
TUMA
 Austrian, 19th cent.
TUNCKERTON, Jones
 see Dunkarton
TUNER, Josef
 German, 1792-1877
TUNMARCK, E.G.
 Norwegian, op.1762-1787
TUNNARD, J.C.
 British, 20th cent.
TUNNARD, John
 British, 1900-
TUNNICLIFFE, Charles
 Frederick
 British, 1901-
TUOHY, Patrick Joseph
 British, 1894-1930
TURA, Cosimo (Cosmè
 da Ferrara)
 Italian, a.1430-1495
TURBEN
 French, op.1779
TURCATO, Giulio
 Italian, 1912-
TURCHI, Alessandro
 (Orbetto or Alessandro
 Veronese)
 Italian, 1578-1649
TURCHI, Gaetano
 Italian, 1817-1851
TURCHIARO, A.
 Italian, 20th cent.
TURCO, Cesare (Cesar
 de Langanazo de terra
 Hyschitelles)
 Italian, op.1549-1566

TURGAY, Betil
 Turkish, 20th cent.
TURIN, F.
 British, op.c.1750
TÜRING, Konrad, II
 Swiss, op.1497-m.1525/7
TURLETTI, Celestine
 Italian, 1845-1904
TURMEAU, John
 British, 1777-1846
TURNBULL, Alan
 British, 20th cent.
TURNBULL, Andrew
 Watson
 British, op.1911
TURNBULL, Anne Charlotte
 see Bartholomew
TURNBULL, W.
 British, 19th cent.
TURNBULL, William
 British, op.1795
TURNER, Rev.C.
 British, op.1799-1800
TURNER, Charles
 British, 1773-1857
TURNER, Charles F.
 American, 20th cent.
TURNER, Charles Yardley
 American, 1850-1919
TURNER, Daniel
 British, op.1782-1817
TURNER, David
 British, op.1782-1801
TURNER, E.J.
 British, -1907
TURNER, Elizabeth
 British, op.1819-1841
TURNER, F.
 British, op.1844
TURNER, F.C.
 British, op.1810-1846
TURNER, F.E.
 British, 19th cent.
TURNER, G.A.
 British, op.1845
TURNER, George, I
 British, op.1782-1820
TURNER, George, II
 British, op.1865-1905
TURNER, H.A.
 British, op.1851
TURNER, James
 American, op.1744-m.1759
TURNER, John Doman
 British, op.c.1873-1938
TURNER, Joseph Mallord
 William
 British, 1775-1851
TURNER, Raphael Angelo
 British, 1784-
TURNER, Rev. W.H.
 British, op.1840
TURNER, William
 ('de Lond')
 British, op.1767-1826
TURNER of Oxford,
 William
 British, 1789-1862
TURNER of Walthamstow,
 William
 British, op.1787-1792
TURONE
 Italian, op.1360
TURPIN de Crissé,
 Lancelot Théodore,
 Comte de
 French, 1782-1859
TURPIN, Pierre Jean
 François
 French, 1775-1840

TURREAU, Jean Bernard
 Honoré (Bernard)
 see Toro
TURRITA or Torriti,
 Jacopo
 Italian, op.1287-1292
TURRO, Girolamo
 Italian, 1689-p.1744
TURSHANSKI, Leonid
 Viktorovich
 Russian, 1875-1945
TUSCAN SCHOOL
 Anonymous Painters
 of the
TUSCHER, Discher,
 Tüscher or Tyscher,
 Carl Marcus
 German, 1705-1751
TUSSAUD, Francis
 French, 1800-1873
TUSSIN, Johann
 see Toussyn
TUTTINE, Johann Baptist
 German, 1838-1889
TUTTLE, Richard
 American, 20th cent.
TUTTNAUER, Phoebus
 Israeli, 20th cent.
TUTUNDJIAN, Leon
 French, 1905-1968
TUXEN, Laurits Regner
 Danish, 1853-1927
TUXHORN, Victor
 German, 1892-1964
TWACHTMAN, John Henry
 American, 1853-1902
TWAIN, Mark
 see Clemens, Samuel
 Langhorne
TWAMLEY, Louisa
 see Meredith
TWBING
 see Hans von Tübingen
TWENBERG, S. van
 Dutch(?), op.1663
TWENGER or Thwenger,
 Johann
 German, 1543-1603
TWENHUSEN, Helmich, II
 von
 Dutch, c.1590-p.1660
TWOMBLY, Cy
 American, 1929-
TWOPENY, William
 British, 1797-1873
TWORKOV, Jack
 American, 1900-
TYCK, Edward
 Belgian, 1847-1922
TYLER
 British, op.c.1835
TYLER, James Gale
 American, 1855-1931
TYLER, William R.
 American, 1825-1896
TYMEWELL, Joseph
 British, op.1737
TYNDALE, Walter Frederick
 Roofe
 British, c.1859-p.1925
TYRI, Leonard
 see Thiry
TYRWHITT, Ursula
 British, 20th cent.
TYS or Tysen, Pieter
 see Thys
TYSCHER, Carl Marcus
 see Tuscher
TYSHLER
 Russian, 20th cent.

TYSON, Ian
British, 20th cent.
TYSON, Michael
British, 1740-1780
TYSSENS, Jan Baptist
Flemish, op.1688-1691
TYSSENS, Pieter
see Thys
TYTGAT, Edgard
Belgian, 1879-1957
TYZACK, Michael
British, 1933-
TZANE, Emanuel
Greek, op.1640
TZANPHOURNARIS,
Emmanuel
Greek, 17th cent.

U

UBAC, Raoul
Belgian, 1910-
UBEDA, A.
South American, 20th cent.
UBEDA, Carlos Vazquez
Spanish, op.1913
UBELESKI, Alexandre
(Alexandre Alexandris)
Polish, 1649-1718
ÜBELIN, Lukas Friedrich
Swiss, op.1764-m.1806
UBERFELDT, Jan Braet
von
Dutch, 1807-1894
UBERTI or Uberto,
Pietro
Italian, 1671-p.1758
UBERTINI, Francesco
see Bacchiacca
UCANSU, Leyla
Turkish, 20th cent.
UCCELLO, Paqlo di
Dono
Italian, 1397-1475
UCHERMANN, Carl
Norwegian, 1855-
UDALTSOVA, Nadezhda
Russian, 20th cent.
UDEN, Lucas van
Flemish, 1595-1672
UDINE, Giovanni da
or Recamatori (Nanni)
see Giovanni
UDOROWIECKI, Pawel
Polish, 20th cent.
UECKER, Günther
German, 1930-
UEMATSU, Kuniomi
Japanese, 20th cent.
UFER, Johannes Paul
German, 1874-
UFER, Walter
American, 1876-1936
UFFENBACH, Philipp
German, 1566-1636
UGGERI, Angelo
Italian, 1754-1837
UGGIONE, Marco d'
see Oggione
UGGLAS, Therese
Swedish, op.1800
UGLOW, Euan
British, 1932-
UGOLINI, Agostino
Gaetano
Italian, 1755-1824

UGOLINO da Siena or
di Neri
Italian, -1339(?)
UGOLINO di Tedice
see Tedice
UGOLINO da Viterbo
Italian, 14th cent.
UGOLINO di Prete,
Ilario (Orvietano)
Italian, op.1364-1378
UGRJUMOFF or Ougrumow,
Grigori Ivanovitch
Russian, 1764-1823
UHDE, Anne
German, 19th cent.
UHDE, Fritz Carl
Hermann von
German, 1848-1911
UHDE, Konstantin
German, 1836-1905
UHDEN, Maria
German, 1892-1918
UHLE, Bernard
American, 1847-1930
UHLMAN, Fred
British, 1901-
UHLMANN, Hans
German, 1900-
UHRDIN, Sam
Swedish, 1886-
UITENBROECK, Moyses
van
see Uyttenbroeck
UITZ, Béla
Hungarian, 1887-
UJVARY, Ferenc
Hungarian, 1898-
ULBRICH, Hugo
German, 1867-
ULBRICHT, John
American, 20th cent.
ULBRICK, Simon de
see Wobreck
ULFELDT, Ebbe
Danish, 17th cent.
ULFT, Jacob van der
Dutch, 1627-1689
ULIANOFF, Nikolai
Pawlowitsch
Russian, 1816-1856
ULISMAYER, M.
British(?), op.1666
ULISSE da Sansovino
Italian, op.1600
ULIVELLI, Cosimo
Italian, 1625-1704
ULKE, Henry
American, 1821-1910
ULLMAN, Eugene Paul
(Paul)
American, 1877-1953
ULLMANN, Julius
German, 1861-1918
ULMANN, Benjamin
French, 1829-1884
ULMANN, Raoul André
French, 1867-
ULMO, Giovanni Paolo
see Olmo
ÜLNMEIGR, Nikolaus
German, op.c.1500
ULRICH, Charles
Frederick
American, 1858-1908
ULRICH, Johann Jakob
Swiss, 1798-1877
ULRIKE ELEONORA I,
Queen of Sweden
Swedish, 1656-1693

ULSEN, H. van
Dutch, op.1785-1786
ULST, Maerten van der
see Hulst
UMBACH, Jonas
German, c.1624-1693
UMBRIAN SCHOOL, Anonymous
Painters of the
UMBRICHT, Honoré Louis
French, 1860-
UMBRO-SIENESE SCHOOL,
Anonymous Painters of
the
UMLAUF, Johann
German, 1825-1916
UNCETA y Lopez,
Marcelino de
Spanish, 1836-1905
UNDERHILL, Anthony
Australian, 1923-
UNDERHILL, Frederick
Charles
British, op.1851-1875
UNDERWOOD, G.A.
British, op.1826
UNDERWOOD, Leon
British, 1890-
UNDERWOOD, Richard
Thomas
British, c.1765-1836
UNGER, Christian Wilhelm
Jacob
German, 1775-1855
UNGER, Hans
German, 1872-1936
UNGEWITTER, Hugo
German, 1869-
UNG NO LEE
Oriental, op.1970
UNKER LUTZOW, Carl
Henrik d'
Swedish, 1828-1866
UNOLD, Max
German, 1885-
UNSWORTH, Peter
British, 1937-
UNTERBERGER, Christoph
German, 1732-1798
UNTERBERGER, Franz
Richard
German, 1838-1902
UNTERBERGER, Franz
Sebald
Italian, 1706-1776
UNTERBERGER, Ignatz
German, 1742/8-1797
UNTERBERGER, Michel
Angelo
German, 1695-1758
UNTERHUBER, Karl Jacob
German, 1700-1752
UNWIN, F.Mabelie
American, 19th cent.
UNWIN, Francis Sydney
British, 1885-1925
UNZELMANN, Friedrich
Ludwig
German, 1797-1854
UPHAM, John William
British, 1772-1828
UPHAM, M.
British, op.1814
UPPINK, Harmanus
Dutch, c.1765-1791
UPPINK, Willem
Dutch, 1767-1849

UPRKA, Joža
Czech, 1861-1940
UPTON, Florence K.
American, -1922
UPTON, Michael
British, 20th cent.
URBACH, Elsa-Olivia
German, 1935-
URBAN, Hermann
American, 1866-
URBAN, John
British, 20th cent.
URBAN, Joseph
American, 1872-1933
URBANI, Ludovico
Italian, op.1466-1493
URBANIEC, Maciej
Polish, 20th cent.
URBANO da Cortona
Italian, c.1426-1504
URBANO, Pietro
Italian, 16th cent.
URBINI, Carlo
Italian, op.1565-1585
URBINO da Cremona,
Vittoriano
Italian, 17th cent.(?)
URECH, Rudolf
Swiss, 1888-
URENIUS, J.
Russian, op.1816
URGELL y Inglada,
Modesto
Spanish, 1839-1919
URGELL, Ricardo
Spanish, 1874-1924
URIBURU
French, 20th cent.
URINDT, Josef
see Orient
URLAUB, Georg Anton, I
German, op.1744-m.1759
URLAUB, Georg Karl
German, 1749-1811
URLAUB, Johann Andreas
German, 1735-1781
URMENETA, Ana Urrutia
de
Spanish, 1812-1850
URQUHART, Annie
British, 20th cent.
URQUHART, Murray
McNeel Caird
British, 1880-
URQUHART, Tony
Canadian, 1934-
URSELINCX, Johannes
Dutch, -1664
URSONI, Filippo
Italian, op.1554
URSULA
German, 20th cent.
URTEIL, Andreas
German, 1933-1963
URWICK, Walter
Chamberlain
British, 1864-1943
URY, Lesser
German, 1861-1931
USQUIN, Henri
French, op.1852
USSI, Stefano
Italian, 1822-1901
USTERI, Johann Martin
Swiss, 1763-1827
USTINOV, Alexander
Wassiljevich
Russian, c.1796-c.1868

USWALD, E.
German, op.1789
UTENS, Giusto
Italian, op.1599-m.a.1609
UTENWAEL, Joachim
see Uytewael
UTERMOHLEN, William
American, 1933-
UTHER, Johan Baptista
van
Swedish, op.1562-m.1597
'UTILI' da Faenza,
Giovanni Battista
see Biagio di Antonio
UTKIN, Petr
Russian, 1880-
UTRECHT, Adriaen van
Flemish, 1599-1652/3
UTRERA y Cadenas, José
Spanish, 1827-1848
UTRILLO, Maurice
French, 1883-1955
UTRILLO, Don Miguel
Spanish, 1862-1934
UTTER, André
French, 1886-1948
UTTERHEIM, Erik
Swedish, 1662-1717
UWINS, Thomas
British, 1782-1857
UYL or Vuyl, Johannes
or Jan Jansz. (van) den
Dutch, 1595/6-1639/40
UYLENBURGH, Hendrick
Dutch, c.1584/9-c.1660
UYTENBOGAART or
Uvtenbogaerd, Isaac
Dutch, 1767-1831
UYTEWAEL, Utenwael,
Wtenwael, Wtewael,
or Wttewael, Joachim
Antonisz.
Dutch, c.1566-1638
UYTEWAEL, Wtewael
or Wttewael, Peter
Dutch, 1596-1660
UYTTENBROECK,
Uitenbroeck, Uyt den
Broeck, Uytenbroeck,
Uyttenbrouck,
Wttenbrouck etc.,
Moyses van
Dutch,
c.1595/1600-1648

V

VAARBERG, Joannes
Christoffel
Dutch, 1825-1871
VAART, Jan van der
Dutch, 1647-1721
VACA, Karel
Czech, 20th cent.
VACCA, Giovanni
Italian, 1787-1839
VACCARO, Andrea
Italian, 1598(?)-1670
VACCARO, Domenico Antonio
Italian, c.1680-1750
VACCARO, Nicola
Italian, 1634(?)-1709(?)
VACCELLINI, Gaetano
see Vascellini
VACCHI, Sergio
Italian, 1925-

VACHAL, Josef
Czech, 1884-
VACHER, Charles
British, 1818-1883
VACHER de Tournemine
or de Touraine,
Charles Emile
French, 1814-1873
VACHER, Thomas
Brittain
British, 1805-1880
VACHOT, Lucile
see Foullon
VADARÁSZ, Viktor
Hungarian.
VADASZ, Endre
Hungarian, 1901-1941
VADASZ, Miklos
Hungarian, 1884-1927
VADDER, Lodewyk de
Flemish, 1605-1655
VADOVELLI or Vedovelli
Italian, 19th cent.
VAEN, J.R. v.
German, 16th cent.(?)
VAENIUS, Otto, Otho
or Octavius
see Veen
VAES, Walter
Belgian, 1882-
VAFFLARD, Pierre Antoine
Augustin
French, 1777-1840(?)
VAGA, Perino del
(Pietro Buonaccorsi)
see Perino
VAGAGGINI, Memo
Italian, 1892-
VAGH-WEINMANN, Elemer
German, 1906-
VAGH-WEINMANN, Maurice
German, 1899-
VAGNETTI, Gianni
Italian, 1898-1956
VAGNIARELLI, Lorenzo
Italian, 16th cent.(?)
VAGNIER, Louis
Flemish(?),
17th/18th cent.
VAGO, Valentino
Italian, 20th cent.
VAIL, Eugene Laurent
American, 1857-
VAIL, Laurence
American, 1891-
VAIL, Roger
British, 20th cent.
VAILLANT, Bernard
Dutch, 1632-1698
VAILLANT, Jacques or
Jacob (De Leeuwerik)
Dutch, c.1625-1691
VAILLANT, Pierre Henri
French, 1878-
VAILLANT or Vaillandt,
Wallerandt or
Wallerand
Dutch, 1623-1677
VAILLAS, D.B.
French, op.1677
VAJDA, Lajos
Hungarian,
1908-1941
VAKALO (Vakalopoulos),
Georges
Greek, 1904-

VAL, du
see Duval
VALADE, Jean
French, 1709-1787
VALADIE, J.B.
French, 20th cent.
VALADIER or Valladier,
Giuseppe
Italian, 1762-1839
VALADIER, Luigi
Italian, 1726-1785
VALADON, Jules
Emmanuel
French, 1826-1900
VALADON, Marie
Clementine, (Suzanne)
French, 1867-1938
VALCIN, Gerard
Haitian, 20th cent.
VALCKENBORCH,
Falckenburg or
Valckenborg, Frederik
or Friedrich van
Flemish, c.1570-1623
VALCKENBORCH,
Falckenburg, Valckenburg,
Valkenburg or Walckenburg,
Gillis or Aegidius, I
van
Flemish, c.1570-1622
VALCKENBORCH, Falckenburg,
Valckenburg, Valkenburg
or Walckenburg, Lucas
van
Netherlands,
a.1535-1597
VALCKENBORCH, Falckenburg,
Valckenburg, Valkenburg
or Walckenburg, Martin,
I van
Netherlands, 1535-1612
VALCKENBORCH or
Falckenburg, Nikolaus
Netherlands, op.1632
VALCKENBORCH, Falckenburg,
Valckenburg, Valkenburg
or Walckenburg, Quinten
Hendrik (Hendrik) van
Netherlands, op.1560-1585
VALCKENBURG, Dirk or
Theodor
see Valkenburg
VALCKERT or Valckaert,
Werner or Warner
Jacobsz. van den
Dutch,
c.1585-c.1627/8
VALDENUIT
French, op.1797
VALDES, Lucas de
Spanish, 1661-1724
VALDES-LEAL, Juan de
(Juan de Valdes Nica
or Nisa Leal)
Spanish, 1622-1690
VALDES NICA, Juan de
see Valdes-Leal
VALDORCIA, Benedetto
di Bindo da
see Benedetto di Bindo
Zoppo
VALDRE or Waldre, Vicenzo
Italian, 1742-1814
VALEGGIO, Valegio, Valesio
or Vallegio, Francesco
Italian, c.1560-p.1643

VALENCIENNES, Pierre
Henri de
(Devalenciennes)
French, 1750-1819
VALENS, Carel van
see Falens
VALENSI, Henri
French, 1883-
VALENTA, Ludwig
German, 1882-1943
VALENTI, Italo
Italian, 1912-
VALENTI, J.
Swiss, 20th cent.
VALENTIN, Francois
French, 1738-1805
VALENTIN, Gottfried
German, 1661-1711
VALENTIN de Boullogne,
Boullongne or
Boulogne, Moïse
French, 1594-1632
VALENTINE, Edward
Virginius
American, 1838-1930
VALENTINI
Italian, op.1600
VALENTINI, Alexandre
de
French, op.1827-1848
VALENTINI, Valentino
Italian, 1858-
VALERIANI, Domenico
Italian, op.1700-m.a.1771
VALERIANI, Giuseppe
Italian, 1542-1596
VALERIANI, Giuseppe
Italian, op.1742-m.1761
VALERIO, Théodore
French, 1819-1879
VALERIO Vicentino
see Belli
VALERNE or Valernes,
Evariste Bernardi de
French, 1816-
VALERY, Paul Ambroise
French, 1871-1945
VALESIO, Francesco
see Valeggio
VALESIO or Valesi,
Giovanni Luigi
Italian, c.1583-1650
VALET
French, 18th cent.
VALETTE, Adolf
French, 20th cent.
VALIANI, Giuseppe
Italian, 1731-1800
VALIMBOY, Christian
see Limbos, Karsten
van
VALISSET, Francois
French, op.1595-1643
VALK, H. de
Dutch, op.1693-1717
VALK, Maurits Willem
van der
Dutch, 1857-1935
VALKENBURG or Valckenburg,
Dirk or Theodor
Dutch, 1675-1721
VALKENBURG, Hendrik
Dutch, 1826-1896
VALL, Pere
see Master of the
Cardona Pentecost

VALL, Pere
Spanish, c.1400
VALLADIER, Giuseppe
see Valadier
VALLAIN, Nanine
(Nanine Piètre)
French, op.1788-1793
VALLARI or Valleri,
Nicolas
French, op.1646-1670
VALLAYER-COSTER,
Anne
French, 1744-1818
VALLAZZA, Markus
German, 1936-
VALLE, Pietro della
Italian, 19th cent.
VALLEE, Jean Francois
American, op.1795-1828
VALLEE, Louis
Dutch(?), op.1649-1652
VALLEE, Louis
French, op.c.1905-1910
VALLEE, Maxime E.
French, op.1873-1881
VALLEGIO, Francesco
see Valeggio
VALLEMPUT, Remi or
Remee van
see Leemput
VALLENTIN, François
see Valentin
VALLERI, Nicolas
see Vallari
VALLES, Lorenzo
Spanish, 1830-1910
VALLÈS, Román
Spanish, 1923-
VALLET, Edouard
Swiss, 1876-1929
VALLET, Jean Emile
French, -1899
VALLET, Jean Pierre
French, 1809-1886
VALLET, Louis
French, 1856-
VALLET, Pierre
French, 1575-p.1657
VALLET-BISSON,
Frederique
French, 1865-
VALLGREN, Otto Henrik
Swedish, 1795-1857
VALLIER, Lina
French, op.1836-1852
VALLIN, Jacques Antoine
French, 1760-p.1831
VALLMAN, Uno
Scandinavian, 20th cent.
VALLMITJANA, Abel
Spanish, 20th cent.
VALLOIS, Paul Félix
French, 19th cent.
VALLORSA or Valorosa,
Cipriano
Italian, op.1536-1597
VALLORZ, Paolo
Italian, 1931-
VALLOT, A.
French, 17th cent.
VALLOTTON, Félix
Swiss, 1865-1925
VALLOU de Villeneuve,
Julien
French, 1795-1866
VALLOUY, Paul
Swiss, 1832-1899

VALLS, Domingo
Spanish, op.1366-1400
VALMIER, Georges
French, 1885-1937
VALOIS, Jean Francois
Dutch, 1778-1853*
VALORI, Romano
Italian, 1886-1918
VALOROSA, Cipriano
see Vallorosa
VALORY or Valori,
Caroline de, (née d'Ette)
French, op.1813
VALSECCHI, Pietro
Bagatti
Italian, 1801/2-1864
VALTAT, Louis
French, 1869-1952
VALTER, H.
German, 19th cent.
VALTON, Edmond Eugène
French, 1836-1910
VALTON, Henri or Hughes
French, 1810-1878
VALUMBES or Valumbras,
Christian
see Limbos, Karsten van
VANACKER, J.
German(?), 19th cent.
VANACKER, Johannes
Baptista or Jean-Baptiste
see Acker
VANAISE, Gustave
Belgian, 1854-1902
VANDENBRANDEN, Guy
Belgian, 1926-
VANDENSTAMM, Lucas
Dutch(?), op.1635
VANDERBANCK, John
British, c.1694-1739
VANDERBANK, M.
Netherlands, op.1746
VANDERBIN(?)
Dutch(?), op.1632
VANDERBRACH
see Houbraken
VANDERBURCH, Jacques
André Edouard
French, 1756-1803
VANDERCABLE, Adrian
or Ary
see Kabel
VANDERCAM, Serge
Danish, 1924-
VANDERCHAMP, Jean
Joseph
French, 19th cent.
VANDERGUCHT, Benjamin
see Gucht
VANDERLICK, Armand
Belgian, 1897-
VANDERLYN, John
American, 1776-1852
VANDERLYN, Pieter
American, 1682-1778
VANDERMEER
see Vermeer
VANDERSTEEN, Germain
French, 1925-
VANDERTAELEN, J.
Dutch, op.1781
VANDESTEENE, A.
Dutch, 18th cent.
VANDINELO, Andrea
Spanish, 15th cent.
VANDRECABLE, Adrian
or Ary
see Kabel

VANDYCKE, Yvon
Belgian, 20th cent.
VANGELINI, Benigno
Italian, op.1634-1655
VANHOUBRACKEN
see Houbraken
VANIER, Bernard
Canadian, 1927-
VANLOO
see Loo
VANMOUR, Jean Baptiste
French, 1671-1737
VANNI, Andrea di
Italian, c.1332-p.1413
VANNI, Francesco, I
Italian, op.1373
VANNI, Francesco, II
Italian, 1563/5-1610
VANNI, Giovanni
Battista
Italian, 1599-1660
VANNI, Giuseppe
Italian, 16th cent.
VANNI, Lippo
Italian, op.1341-1375
VANNI, Pietro
Italian, 1845-1905
VANNI, Raffaello
Italian, 1587-1673
VANNI, Stefano d'Antonio di
Italian, 1409-1485(?)
VANNI, Turino
Italian, op.1390-1397
VANNINI, Ottavio
Italian, 1585-1643
VANNOCCI
see Biringucci, Oreste
VANNUTELLI, Scipione
Italian, 1834-1894
VANOT, Jean Pierre
French, 20th cent.
VANOTTI, Amalie
(Amalie Sejenck)
German, 1853-
VANSIER, Boris
Russian, 1928-
VANSO MERCANTI,
Giustiniano
Italian, 17th cent.(?)
VANTEUIL, Mademoiselle de
French, 17th cent.
VANTONGERLOO, Georges
Belgian, 1886-1965
VANVITELLI, Gasparo
see Wittel
VANVITELLI, Luigi
Italian, 1700-1773
VAPOUR, M.
Dutch(?), 18th cent.
VAPRIO, Agostino
Zenone da
Italian, op.1460-1501
VAQUER, Jacques
see Vauquer
VAQUERO Palacios,
Joaquin
Spanish, 1900-
VAQUET, Jean
French, op.1540-1550
VARCOLLIER, Atala,
(née Stamaty)
French, op.1827-1835
VARDENEGA, Gregorio
Italian, 1923-
VAREIA, Francisco
Spanish, op.1618-m.1656
VARELST
see Verelst

VARENNE, Charles Santoire
French, 1763-1834
VARGA, Mátyás
Hungarian, 1910-
VARGAS, Francisco de
Spanish, 17th cent.
VARGAS, Luis de
Spanish, 1502-1568
VARIAN, George Edmund
American, 1865-1923
VARIN, Quentin
French, c.1570-1634
VARIS, Kyosti
Finnish, 20th cent.
VARLAMOV, A.
Russian, 20th cent.
VARLET, Felicie
(Felicie Watteville)
French, op.1819-1822
VARLET, Louis-Jean
French, 20th cent.
VARLEY, Albert Fleetwood
British, 1804-1876
VARLEY, Cornelius
British, 1781-1873
VARLEY, Edgar John
British, op.1861-m.1888
VARLEY, Elisabeth
(Elisabeth Mulready)
British, op.1801-1819
VARLEY, Frederick Horsman
Canadian, 1881-
VARLEY, John
British, 1778-1842
VARLEY, John, II
British, op.1870-1895
VARLEY, William
Fleetwood
British, 1785-1856
VARLIN, Willy
Guggenheim
Swiss, 1900-
VARNELIS, Kazys
American, 20th cent.
VARNEY, Neville
South African, 20th cent.
VARNI, Santo
Italian, 1807-1885
VARNIER, Jules
French, op.1837-1850
VAROLI, Luigi
Italian, 1889-
VARONI or Varrone,
Giovanni or Johann
German, 1832-1910
VAROTARI, Alessandro
see Padovanino
VAROTARI, Chiara
Italian, 17th cent.
VAROTARI, Dario, I
Italian, 1539-1596
VAROTTI, Pier Paolo
Italian, 1686-1752
VARRALL, J.C.
British, op.1815-1827
VARRONE, Giovanni or
Johann
see Varoni
VASARELY, Jean-Pierre
see Yvaral
VASARELY, Victor de
Hungarian, 1908-
VASARI, Giorgio, II
Italian, 1511-1574
VASARI, Lazzaro (Taldi)
Italian, 1396-1468
VASARRI, Emilio
Italian, 19th/20th cent.

VASCELLINI or
Vaccellini, Gaetano
Italian, 1745-1805
VASCO, Giulio
Italian, op.1675
VASCONI, Filippo
Italian, c.1687-1730
VASE, Pierre
see Eskrich
VASELIN, Gaetano
Italian, op.1764
VASELLUS, Jacobus
Flemish, op.1742
VASI, Giuseppe
Italian, 1710-1782
VASILYEV
see Vassiliev
VASLET (of Bath),
Lewis
British, 1742-1808
VASNETSNOV, Apollinari
Mikhailovich
Russian, 1856-1933
VASNETSOV, Victor
Mikjailovitch
Russian, 1848-1919
VASQUEZ or Vazquez,
Alonso
Spanish, a.1600-a.1637
VASQUEZ, Antonio
Spanish, 1483(?)-p.1563
VASQUEZ, Carlos
Spanish, 19th cent.
VASQUEZ, Diego
Spanish, op.1634
VASQUEZ del Rio,
Salvador
Spanish, 19th cent.
VASSALLO, Antonio
Maria
Italian, op.1639-1648
VASSE, Francois
Antoine
French, 1681-1736
VASSE, Louis Claude
French, 1716-1772
VASSILACCHI, Antonio
see Aliense
VASSILIEV, Feodor
Alexandrovitch
Russian, 1850-1873
VASSILIEV, Marie
Russian, 1884-1957
VASSILIEVITCH, Yevgeny
(Eugene)
Russian, 20th cent.
VASSILKOVSKY, Sergei
Ivanovitch
Russian, 1854-
VASTAGH, Géza
German, 1866-1919
VASTAGH, György, I
Hungarian, 1834-1922
VASZARY, Johann
(János)
Hungarian, 1867-1939
VATELE, Henri
see Watele
VATIER de Nantes
French, 18th cent.
VAUCAMP, Edith
Belgian, 20th cent.
VAUCHELET, Théophile
Auguste
French, 1802-1873
VAUCORBEIL
see Rang-Babut

VAUDECHAMP, Jean Joseph
French, 1790-1866
VAUGHAN, E.
British, op.c.1772-1814
VAUGHAN, Keith
British, 1912-
VAUGHAN, Michael
British, 1938-
VAUGHAN, Robert
British, c.1600-m.1660/7
VAUGHAN, T.
British, op.1812-1821
VAUGHAN, William
British, 17th cent.
VAUGHN, Joseph
American, 20th cent.
VAUGON, C.
French, 18th cent.
VAUQUER, Vaquer or
Vauquier, Jacques
French, 1621-1686
VAUTHIER, Jules-Antoine
French, 1774-1832
VAUTHIER, Pierre Louis
Léger
French, 1845-1916
VAUTIER, Benjamin, II
Swiss, 1895-
VAUTIER, Benjamin
Louis Marc
Swiss, 1829-1898
VAUTIER, Otto
German, 1863-1919
VAUTIER, Otto, II
Swiss, 1893-1918
VAUX, Marc
British, 1932-
VAUZELLE, Jean Lubin
French, 1776-p.1837
VAWSER, Charlotte E.
(Charlotte Walkenden)
British, 1837-1875
VAWSER, G.R., I
British, 1794-1882
VAWSER, G.R., II
British, 1815-1893
VAXILLIER, Vaxcillières
or Vaxillières
French, op.1758-1793
VAYREDA, José
Spanish, 20th cent.
VAYSON, Paul
French, 1842-1911
VAZ, Antonio
Portuguese, 16th cent.
VAZ, Gaspar
Portuguese, 16th cent.
VAZQUEZ, Alonso
see Vasquez
VAZQUES de Arce y
Ceballos, Gregorio
Spanish, 1638-1711
VEAL, Hayward
Australian, 1913-
VERBER, Jean
French, 1864-1928
VECCHI, Giovanni dei
(dal Borgo)
Italian, 1536-1615
VECCHIA, Pietro
see Veglia
VECCHIA, Pietro della
see Muttoni
VECCHIATI, Pompeo
Italian, 1911-
VECCHIETTA, Lorenzo
di Pietro, Il
Italian, c.1412-1480

VECELLIO, Cesare
Italian, c.1521-1601
VECELLIO, Francesco
Italian, 1475-c.1560
VECELLIO, Marco (Marco
di Tiziano)
Italian, 1545-1611
VECELLIO, Orazio
Italian, a.1525-1576
VECELLIO, Titian or
Tiziano
see Titian
VECELLIO, Tiziano, II
(Il Tizianello)
Italian, c.1570-c.1650
VECELLIO, Tommaso
Italian, 1587-1629
VECHARIGI
French(?), op.1763
VECHTA, Conrad von
see Master of
Heiligental
VEDDER, Elihu
American, 1836-1923
VEDEL, Herman Albert
Gude
Danish, 1875-
VEDOVA, Emilio
Italian, 1919-
VEDOVELLI
see Vadovelli
VEELWAARD or Veelward,
Daniel, I
Dutch, 1766-1851
VEEN, Balthasar van
der
Dutch, 1596/7-p.1657
VEEN, Gerardus van
Dutch, op.1643-1670
VEEN, Gertrude or
Geertruyt van
(Gertrude Malo)
Flemish, 1602-1643
VEEN, Otto or Otho
van (Otto, Otho or
Octavius Vaenius or
Venius)
Dutch, 1558-1629
VEEN, P. van
Flemish, op.c.1700
VEEN, Rochus van
Dutch, op.1660-m.1709
VEEN, William van
Dutch, op.c.1800
VEENHUIZEN, Gerrit
Dutch, 20th cent.
VEENHUYSEN, Jan
Dutch, op.c.1656-1685
VEER, A.
Flemish(?), op.1635(?)
VEER, Johannes de
Dutch, c.1610-c.1662
VEERENDAEL, Nicolaes
van
see Verendael
VEGA, Antonio de
Spanish, op.1506-1511
VEGA, José Gutierrez
de la
see Gutierrez
VEGA y Munoz, P. de
Spanish, op.1886-1882
VEGETTI, Enrico
Italian, 1863-
VEGLIA, Pietro Paolo
Italian, op.1679
VEHM, Zacharias
see Wehme

VEIEL, Marx Theodosius
German, 1787-1856
VEILLON, Louis Auguste
(Auguste)
Swiss, 1834-1890
VEISTOLA, Jukka
Finnish, 20th cent.
VEIT, Johannes (Jonas)
German, 1790-1854
VEIT, Philip
German, 1793-1877
VEITH, Edouard
German, 1856-1925
VEITH, Johann Philipp
German, 1768-1837
VEKEN, Willem Philip
van der
Belgian, 1863-
VELA, Vicente
Spanish, 1931-
VELAERT, Dirk
see Vellert
VELASCO da Coimbra
Portuguese, op.1530-1540
VELASCO, Cristobal de
Spanish, 1578-1627
VELASCO, Giuseppe
Italian, 1750-1826
VELASCO, José Maria
Mexican, 1840-1912
VELASCO, Luis de
Spanish, op.1555-m.1606
VELAZQUEZ, Antonio
Gonzalez
see Gonzalez
VELAZQUEZ, Diego
Rodriguez de Silva y
Spanish, 1599-1660
VELASQUEZ, Zacarias
Fernandez
Spanish, 18th cent.
VELDE, Abraham Gerardus
(Bram) van
Dutch, 1895-
VELDE, Adriaen van de
Dutch, 1636-1672
VELDE, Anthony, II van de
Dutch, 1617-1672
VELDE, Cornelis van de
Dutch, op.1699-1729
VELDE, Esaias, I van de
Dutch, c.1590(?)-1630
VELDE, Gerardus (Geer) van
Dutch, 1898-
VELDE, Henry van de
Belgian, 1863-1957
VELDE, Jan or Hans,
I van de
Dutch, c.1568-1623
VELDE, Jan, II van de
Dutch, c.1593-1641
VELDE, Jan, III van de
Dutch, 1619/20-c.1663
VELDE, Jan or Johan, IV
van de
Dutch, op.1642-m.1686
VELDE, Peter van den
Flemish, 1634-p.1687
VELDE, Petrus van der
see Velden
VELDE, Willem, I van de
Dutch, c.1611-1693
VELDE, Willem Willemsz
(Willem, II) van de
Dutch, 1633-1707
VELDE, Willem, III van de
Dutch, 1667-p.1708

VELDEN, van der
Dutch, op.1723
VELDEN, Franz Xaver
German, op.1776
VELDEN, J. van
Dutch, 18th cent.(?)
VELDEN or Velde, Petrus
van der
Dutch, 1837-1915
VELI, Benedetto
Italian, 1564-1639
VELICKOVIC, Vladimir
Yugoslav, 1935-
VELLACOTT, Elizabeth
British, 20th cent.
VELLANI, Domenico
Maria
Italian, op.1740
VELLERT, Felaert or
Velaert, Dirk
Jacobsz. (Dirk van
Staren, or Master
of the Star)
Netherlands,
op.1511-1544
VELLINI, Giovanni
Italian, 16th cent.
VELLOSO-SALGADO, José
Portuguese, 19th cent.
VELLVE, Tomas
Spanish, 20th cent.
VELSEN, Jacob Jansz.
van
Dutch, op.1625-m.1656
VELTEN, Wilhelm
Russian, 1847-1929
VELTENS, J.
Dutch, 1790-1860
VELTENS, Johan Diderik
Cornelis
Dutch, 1814-1894
VELY, Anatole
French, 1838-1882
VELIJN, Philippus
Dutch, 1787-1836
VELZEN, Johannes
Petrus van
Dutch, 1816-1853
VENABLES
British, op.1848
VENALE, Pietro di
Giovenale Mongardini
Italian, op.1541-1583
VENANT, Francois
Dutch, 1591/2-1636
VENANZI, Giovanni
Battista
Italian, 1627-1705
VENANZIO da Camerino
Italian, op.1518-1529
VENARD, Claude
French, 1913-
VENCESLAO
see Wenzel von
Riffiano
VENDETTI, Antonio
Italian, 18th cent.
VENDRAMINI, Giovanni
Italian, 1769-1839
VENDRI, Antonio da
Italian, 1485-1545
VENEAUME, Gilleber
French, op.1702
VENET, Bernar
French, 1941-
VENETIAN SCHOOL,
Anonymous Painters
of the

VENETZIANOV, Alexei
Gavrilovitch
Russian, 1779-1847
VENEZIANO, Antonio
see Antonio
VENIER, Pietro
Italian, 1673-1737
VENITZER, Georg
see Fennitzer
VENIUS, Otto, Otho
or Octavius
see Veen
VENNA, Lucio
Italian, 1897-
VENNE, Adolf van der
German, 1828-1911
VENNE, Adriaen Pietersz.
van de
Dutch, 1589-1662
VENNE, Fritz van der
German, op.c.1900
VENNE, Jan van de
Dutch, op.1670
VENNE, Pieter van de
Dutch, op.1618-m.1657
VENNE, Pseudo van de
Dutch, 17th cent.
VENNEKOOL or Vennecool,
Jacob
Dutch, 1632(?)-1673
VENNEMAN, Karel or
Charles Ferdinand
Belgian, 1802/3-1875
VENTURA di Gualtieri
da Siena
Italian, op.1257-1273
VENTURA di Moro
Italian, op.1416-1456
VENTURA, Giorgio
Italian, 16th/17th cent.
VENTURINI, Angelo
Italian, op.1730
VENTURINI, Gaspare
Italian, 1570-1617
VENTURINI, Giovanni
Francesco
Italian, 1650-p.1710
VENUS, Franz Albert
(Albert)
German, 1842-1871
VENUSTI, Marcello
Italian, 1512/15-1579
VENUTI, Lodovico
Italian, op.1799-1810
VENY
French, 18th cent.
VERA, Alejo
Spanish, 1834-1923
VERAGUTH, Gérold
Swiss, 1914-
VERBEECK or Verbeecq,
Cornelis
Dutch, c.1590-c.1631/5
VERBEECK, Frans
Flemish, op.1521-m.1570
VERBEECK or Verbeek,
Frans Xaver Hendrik
Flemish, 1686-1755
VERBEECK, Henri Daniel
Belgian, 1817-1863
VERBEECK or Verbeke,
Jan or Hans
Flemish, op.1569-1619
VERBEECK, Jodocus Jost
German, c.1646-1700
VERBEECK, P.
Dutch, op.1634-1674

VERBEECK or Verbeecq,
Pieter Cornelisz
Dutch, c.1610/15-c.1652/4
VERBEECQ
see Verbeeck
VERBEEK, Frans Xaver
Hendrik
see Verbeeck
VERBEEK, Gustav
American, 1853-1932
VERBEEK, J.
Dutch, 18th cent.
VERBEET, Gijsberta
Dutch, 1838-1916
VERBEET, Willem
Dutch, 1801-1887
VERBEKE, Jan or Hans
see Verbeeck
VERBOECKHOVEN, Charles
Louis (Louis)
Belgian, 1802-1889
VERBOECKHOVEN, Eugène
Joseph
Belgian, 1799-1881
VERBOOM, Adriaen
Hendriksz.
Dutch, c.1628-c.1670
VERBRUGGE, Emile
Belgian, 1856-1936
VERBRUGGE, Gijsbert
Andriesz.
Dutch, 1633-1730
VERBRUGGE, Jean Charles
Flemish, 1756-1831
VERBRUGGEN or
Verbrugghen, Gaspar
Peeter, I
Flemish, 1635-1681
VERBRUGGEN or
Verbrugghen, Gaspar
Peeter or Pedro, II
Flemish, 1664-1730
VERBRUGGEN, Hendrik
Frans
Flemish, c.1655-1724
VERBRUGGEN, Verbrugghen
or van der Brugghen,
Pieter, I
Flemish, c.1609-1686
VERBRUGGEN, Verbrugghen
or van der Brugghen,
Pieter, II
Flemish, c.1640-1691
VERBURGH, Cornelis
Gerrit
Dutch, 1802-1879
VERBURGH, Verburch or
Verburg, Dionijs
Dutch, op.1677-m.1722
VERBURGH, Gerardus
Johannes
Dutch, 1775-1864
VERBURGH, Médard
Belgian, 1886-1957
VERBURGH or Verburg,
Rutger
Dutch, 1678-p.1710
VERBUYS or Verbuis,
(also, erroneously,
Verbius), Arnold
Dutch, op.1673-1717
VERCELLESI, Sebastiano
Italian, 1603-1657
VERCRUYS, Theodore
see Verkruys
VERDEJO, Y.
Spanish, 19th cent.
VERDERA, Nicolas
Spanish, op.1406

VERDI, Francesco
Ubertini dei
seeBacchiacca, Il
VERDIER or van Hamken,
François
French, 1651-1730
VERDIER, Jean
Swiss, 1901-
VERDIER, Jean Louis
Joseph
French, 1849-1895
VERDIGUIER, Jean Michel
(Michel)
French, 1706-1796
VERDILHAN, Mathieu
French, 1875-1928
VERDIZOTTI, Giovanni
Mario
Italian, c.1525-1600
VERDOEL or van Doel,
Adriaen
Dutch, c.1620-p.1692
VERDONCK, Cornelis
Dutch, op.1715
VERDOUN
Flemish, 17th cent.
VERDREN, Henri
Belgian, 1933-
VERDUN, Raymond J.
French, 19th cent.
VERDUSSEN, Jan Peeter
Flemish, c.1700-1763
VERDUSSEN, Peeter
Flemish, 1662-p.1710
VERDYEN, Eugène
Belgian, 1836-1903
VERE, H. du Chene de
French, op.c.1882
VEREISKY, Georgy
Semionovitch
Russian, 1886-
VERELLEN, Jan Joseph
Belgian, 1788-1856
VERELST, Bartholomeus
see Helst
VERELST, Cornelis
Dutch, c.1667-1728(?)/34
VERELST or Verhelst,
Egidius, II
German, 1733-1818
VERELST, Herman
Dutch, c.1641/2-c.1690
VERELST, Johannes
Dutch, op.1719
VERELST or Varelst,
Maria
British, 1680-1744
VERELST, van der Elst
or ver Elst, Pieter
Hermansz.
Dutch, c.1618-p.1671
VERELST, Varelst or
ver Elst, Simon
Pietersz.
Dutch, 1644-1710(?)/21
VERELST, William
British, -p.1756
VERENDAEL or
Veerendael, Nicolaes
van
Flemish, 1640-1691
VERENDAEL, Pieter
Flemish, 16th cent.
VERESMITH or Wehrschmidt,
Daniel Albert
American, 1861-1932
VERETSCHAGIN, Piotr
Petrovitch
Russian, 1836-1886

VERETSCHAGIN or
Vereschagin, Vasili
Vasilievitch
Russian, 1842-1904
VEREYCKE, Hans
see Master of the
Female Half-Lengths
VERGANI da Amandola,
Giulio
Italian, op.c.1511
VERGARA, José
Spanish, 1726-1799
VERGE-SARRAT, Henri
French, 1880-1966
VERGEZ, Eugène
French, op.c.1879
VERGNAUX, Nicolas
Joseph
French, op.1798-1818
VERGOS, Jaime, II
Spanish, op.1459-m.1503(?)
VERGOS, Pablo
Spanish, op.1493-m.1495
VERGOS, Rafael
Spanish, op.1492-1500
VERHAECHT, Verhaagt
or Verhaeght, Tobias
see Haecht
VERHAEREN, Alfred
Belgian, 1849-1924
VERHAERT or Verhart,
Dirck
Dutch, op.1631-1664
VERHAERT, Pieter (Piet)
Belgian, 1852-1908
VERHAGEN or Verhaege
see Hagen
VERHAGHEN, Jean Joseph
(Pottekens-Verhagen)
Flemish, 1726-1795
VERHAGHEN, Pierre
Joseph
Flemish, 1928-1811
VERHART, Dirck
see Verhaert
VERHAS, Frans
Belgian, 1827(?)-1897
VERHAS, Jan Frans or
Francois
Belgian, 1834-1896
VERHAS, Theodor
German, 1811-1872
VERHEGGEN, Hendrik
Frederik
Dutch, 1809-1883
VERHEIDEN or Verheyden,
Jost
Danish, op.1554
VERHELST, Bartholomeus
see Helst
VERHELST, Egidius
see Verelst
VERHEYDEN, Franck
Pietersz.
Dutch, c.1655-1711
VERHEYDEN, Francois
Belgian, 1806-1890(?)
VERHEYDEN, Isidore
Belgian, 1846-1905
VERHEYDEN, Jost
see Verheiden
VERHEYDEN, Mattheus
Dutch, 1700-p.1776
VERHEYDEN, Pieter
see Heyden
VERHEYEN or Verkeyen, A.
Dutch, 17th cent.
VERHEIJEN, Jan Hendrik
Dutch, 1778-1846

VERHEYEN, Jef
Belgian, 1932-
VERHOEK, Gysbert
Dutch, 1644-1690
VERHOESEN, Albertus
Dutch, 1806-1881
VERHOEVEN, Jan or Hans
Flemish, c.1600-p.1676
VERHOEVEN-BALL, Adrien
Joseph
Belgian, 1824-1882
VERHOUT or Voorhout,
Constantyn
Dutch, op.1663-1667
VERHUIK, Cornelis
see Verhuyck
VERHULST
see also Hulst
VERHULST, Charles Pierre
Flemish, 1774-1820
VERHULST, Rombout
Dutch, 1624-1698
VERHUYCK or Verhuik,
Cornelis
Dutch, 1648-p.1718
VERI da Milano, Filippo
de
Italian, op.1400
VERI da Milano,
Lanfranco
Italian, op.1400
VERKADE, Jan (Pater
Willibrord Verkade)
Dutch, 1868-1946
VERKERK, A.J.B.
Dutch, 18th cent.
VERKEYEN, A.
see Verheyen
VERKOLJE, Jan, I
Dutch, 1650-1693
VERKOLJE, Nicolaes
Dutch, 1673-1746
VERKRUYS or Vercruys,
Theodor (Theodor della
Croce)
Netherlands, op.c.1707-m.173⁹
VERLA, Alessandro
Italian, 16th cent.
VERLA, Francesco
Italian, op.1490-m.1520
VERLAT, Charles
Belgian, 1824-1890
VERLIN, Venceslao
Italian, op.1768-m.1780
VERLY, Francois
French, 1760-1822
VERMAY, Jean Baptiste
French, 1790-1833
VERMEER
see also Meer
VERMEER van Delft,
Johannes or Jan
Reyniersz.
Dutch, 1632-1675
VERMEERSCH, Ivo Ambros
Belgian, 1809/10-1852
VERMEHREN, Gustav
Danish, 1863-1931
VERMEHREN, Johan Fredrik
Nicolai
Danish, 1823-1910
VERMEIRSCH, S.
Dutch(?), 18th cent.
VERMEJO, Bartolomé
see Bermejo
VERMEULEN, Andreas
Franciscus
Belgian, 1821-1884

VERMEULEN, Andries
Dutch, 1763-1814
VERMEULEN or van der
Meulen, Cornelis
Dutch, 1642-1692
VERMEULEN, Cornelis
Flemish, c.1732-1813
VERMEULEN, Frederik
Netherlands, 16th cent.
VERMEULEN or van Meulen,
J. (Johannes or Jan(?);
also, erroneously, Isaak)
(Monogrammist I.V.M.)
Dutch, op.1638-1674(?)
VERMEYEN, Jan Cornelisz.
Netherlands, c.1500-1559
VERMIGLIO, Giuseppe
Italian, 1575/85-p.1635
VERMOELEN, Jacob Xaver
Flemish, c.1714-1784
VERMONT, Hyacinthe
Collin de
French, 1693-1761
VERMONT, Nicolae
Rumanian, 1886-1932
VERMOTE, Séraphin
François
Dutch, 1788-1837
VERNANSAL, Guy Louis de
French, 1648-1729
VERNAY, Francois Miel
French, 1821-1896
VERNER, Frederick
Arthur
Canadian, 1836-1928
VERNET, Antoine Charles
Horace (Carle)
French, 1758-1836
VERNET, Antoine François
French, 1730-1779
VERNET, Antoine Ignace
French, 1726-c.1775
VERNET, Claude Joseph
(Joseph)
French, 1714-1789
VERNET, Emile Jean
Horace (Horace)
French, 1789-1863
VERNET, Jules
French, c.1792-1843
VERNEUIL, Maurice
Pillard
French, 1869-
VERNIER, Charles
French, 1831-1887
VERNIER, Emile Louis
French, 1829-1887
VERNIER, Pierre Louis
French, op.1764-1768
VERNON, Arthur Longley
British, op.1871-c.1922
VERNON, Emile
British, op.c.1870-1904
VERNON, H.J.
British, op.c.1840-1860
VERNON, Paul
French, op.1874-1882
VERON, Alexandre René
French, 1826-1897
VERONA, Arthur
Gauguromin
Rumanian, 1868-1946
VERONA, Bartolomeo
Italian, -1813
VERONESE, Alessandro
see Turchi
VERONESE, Bastiano
see Bastiano

VERONESE, Francesco
see Montemezzano
VERONESE, Il
see Cignaroli, Martino
VERONESE, Paolo
Caliari
Italian, 1528-1588
VERONESE, Philippo
Italian, 16th cent.
VERONESE SCHOOL,
Anonymous Painters
of the
VERONESI, Luigi
Italian, 1908-
VERPILLEUX, Emile
Antoine
Belgian, 1888-1964
VERREYT, Jacob Johann
Belgian, 1807-1872
VERRIO, Antonio
Italian, c.1639-1707
VERROCCHIO, Andrea del
Italian, 1435-1488
VERROCHIUS, Augustinus
Italian, 17th cent.
VERRIJCK or Verrijk,
Theodor or Dirk
Dutch, c.1735-1786
VERSCHAEREN, Jan Antoon
Belgian, 1803-1863
VERSCHAFFELT, Maximilian
von
German, 1754-1818
VERSCHOOR, Willem
Dutch, op.1653-m.1678
VERSCHOOT, Bernard
Flemish, 1728-1783
VERSCHOTEN, Floris
see Schooten
VERSCHOYLE, C.
British, 19th cent.
VERSCHUIER, Verschuer,
Verschuir or Verschuur,
Lieve
Dutch, c.1630-1686
VERSCHUREN, Jan
Dutch, 17th cent.(?)
VERSCHURING, Verschuyring
etc., Hendrik
Dutch, 1627-1690
VERSCHURING, Willem
Dutch, 1657-1715
VERSCHUUR, Lieve
see Verschuier
VERSCHUUR, Wouterus, I
Dutch, 1812-1874
VERSCHUYRING, Hendrik
see Verschuring
VERSPRONCK, Cornelis
Engelsz.
see Engelsz.
VERSPRONCK, Johannes or
Jan Cornelisz.
Dutch, 1597-1662
VERSTAPPEN, Martin
Belgian, 1773-1853
VERSTEEG or Versteegh,
Machiel
Dutch, 1756-1843
VERSTEEGH, Jakob
Dutch, 1730-1816
VEERSTEEGH, Machiel or
Michiel
see Veersteeg
VERSTER van Wulverhorst,
Floris Hendrik (Floris
Verster)
Dutch, 1861-1927
VERSTILLE, William
American, c.1755-1803

VERSTRAATEN, Lambert
see Veersteeg
VERSTRAETE, Theodor
Belgian, 1850-1907
VERSTRAETEN, Edmond
Belgian, 1870-
VERSTRALEN, Antoni
or Antoni van Stralen
Dutch, c.1594-1641
VERSTRATEN, Lambert
see Straaten
VERTANGEN, Daniel
Dutch, c.1598-c.1681/4
VERTES, Marcel
Hungarian, 1895-1961
VERTIN, Petrus
Gerardus
Dutch, 1819-1893
VERTINGA, W.
Italian(?), op.1697
VERTOMMEN, Willem
Joseph
Belgian, 1815-
VERTUE, George
British, 1684-1756
VERTUNNI, Achille
Italian, 1826-1897
VERVEER, Adriaen or
Ary Huybertsz.
Dutch, op.1641-m.1680
VERVEER, Elchanon Leonardus
Dutch, 1826-1900
VERVEER, Salomon
Leonardus
Dutch, 1813-1876
VERVLOET, Franciscus
(Frans)
Belgian, 1795-1872
VERVOORN(?), G.
Dutch, op.1658
VERVOORT, M.
American, op.1819
VERVOORT, Michiel
see Voort
VERWEE, Alfred Jacques
Belgian, 1838-1895
VERWEE, Louis Pierre
Belgian, 1807-1877
VERWER or Verweer van
Burghstrate, Abraham
de
Dutch, op.1617-m.1650
VERWER, Johan
Dutch, op.1647-1659
VERWER, Justus de
Dutch, c.1626-a.1688
VERWEIJ, Kees
Dutch, 1900-
VERWILT, Domenicus
Netherlands,
op.1544-1566
VERWILT, François
Dutch, c.1615/20-1691
VERZYLL, Rinse
Dutch, 1690-p.1716
VESIN, Jaroslav Fr.
Julius
Bulgarian, 1859-1915
VESNIN, Aleksandr
Aleksandrovich
Russian, 1883-1959
VESPIGNANI, Renzo
Italian, 1924-
VESSA, Michael
American, 20th cent.

VESTER, Willem
Dutch, 1824-1895
VESTERBERG, Eduard
Danish, 1824-1865
VESTIER, Antoine
French, 1740-1824
VESTIER, Jean
French, -1810
VESTIER, Marie Nicole
see Dumont
VETERANO, Federico
Italian, op.1552
VETH, Jan Daemsz. or
Damesz. de
Dutch, c.1595-1625
VETH, Jan Pieter
Dutch, 1864-1925
VETRI, Paolo
Italian, 1855-1937
VETTER, Charles
German, 1858-
VETTER, Ewald
German, 1894-
VETTER, Jean Hégésippe
French, 1820-1900
VETTER, Johann
German, op.1602-m.1619
VETTEWINKEL, Hendrik
Dutch, 1809-1878
VEVERN, Alexandre
Swiss, 20th cent.
VEYRASSAT, Jules
Jacques
French, 1828-1893
VEZELAY, Paule
British, 1893-
VIALA, Eugène
French, 1859-1913
VIALE, Karl
German, op.1837-1862
VIALY or Viallis,
Louis René de
French, 1680-1770
VIANDE or Doviane,
Auguste
French, 1825-1887
VIANELLI, Vianelly or
Viennelly,
Achille
Italian, 1803-1894
VIANELLI, Pasquale
Italian, op.c.1820-1825
VIANEN, Adam van
Willemsz.
Dutch, c.1569-1627
VIANEN, Jan van
Dutch, c.1660-p.1726
VIANEN, Paulus Willemsz.
van
Dutch, c.1570-1613/(?)14
VIANI, Domenico Maria
Italian, 1668(?)-1711
VIANI, Giovanni Maria
Italian, 1636-1700
VIANI, Lorenzo
Italian, 1882-1936
VIARD, Georges
French, op.c.1831-1869
VIBERT, Jean Georges
French, 1840-1902
VIBERT, Pierre-Eugène
Swiss, 1875-1937
VIBOUD, Jean
French, op.1920
VICAJI, Dorothy E.
British, op.c.1915-1930

VICAR, Jean Baptiste
Joseph
see Wicar
VICARI, Andrew
British, 1933-
VICENTE, Eduardo
Italian, 20th cent.
VICENTE, Esteban
American, 1906-
VICENTE, Jeronimo
Spanish, 16th cent.(?)
VICENTINI, Antonio
see Visentino
VICENTINO, Andrea
see Michieli
VICENTINO, Battista
see Pittoni, Giovanni
Battista, I
VICENTINO, Giuseppe
Niccolò (Rossigliani)
Italian, c.1510-
VICENZINO, Giuseppe
Italian, 17th cent.
VICINO da Ferrara
Italian, 15th cent.
VICINO or Visino II, Il
Italian, op.1530
VICKERS, A.H.
British, op.1853-1868
VICKERS, Alfred
British, 1786-1868
VICKERS, Alfred Gomersal
British, 1810-1837
VICKERS, C.
British, 19th cent.
VICKREY, Robert
American, 1926-
VICO
Italian(?), 18th cent.(?)
VICO, Vicùs or Vighi,
Enea
Italian, 1523-1567
VICO, Francesco da
Italian, op.c.1471/2
VICTOIRE, E.
French, 18th cent.
VICTOR
Greek, op.c.1660
VICTORIA, Princess
(Empress Frederick
of Germany)
British, 1840-1901
VICTORIA, Queen
British, 1819-1901
VICTORIA, Salvador
Spanish, op.1960
VICTORS, Victoor,
Victoors or Victor,
Jacobus or Jacomo
Dutch, 1640-1705
VICTORS, Victoor,
Victoors or Victor,
Johannes or Jan
Dutch, 1619/20-c.1676
VICTORYNS, Anthonie
Flemish, op.1637-m.a.1656
VICUS, Enea
see Vico
VIDA, Gheza
Rumanian, 1913-
VIDAL, Emeric Essex
British, 1791-1861
VIDAL, Eugène Vincent
French, op.c.1873-1900
VIDAL, Hahn
French, 20th cent.
VIDAL, L.
French, c.1754

VIDAL, Pedro Antonio
Spanish, op.c.1617
VIDAL, Pierre
French, 1849-1929
VIDAL, Vincent
French, 1811-1887
VIDALES, Martin de
Spanish, 1930-
VIDOLENGHI, Leonardo
Italian, op.1453-1499
VIEGELMANN, John
German, op.1820
VIEILLARD, Roger
French, 1907-
VIEILLEVOYE,
Barthélemy
Belgian, 1798-1855
VIEIRA, Domingos
Portuguese, -a.1678
VIEIRA de Mattos, Francisco, I
(Lusitano)
Portuguese, 1699-1783
VIEIRA, Francisco, II
(Portuguese)
Portuguese, 1765-1806
VIEIRA da Silva,
Maria Helena
French, 1908-
VIELE-GRIFFIN, Francis
Swiss, 1864-1937
VIELFAURE, J.P.
French, 20th cent.
VIEN, Joseph Marie, I
French, 1716-1809
VIEN, Joseph Marie, II
French, 1762-1848
VIEN, Marie Thérèse,
(née Reboul)
French, 1738-1805
VIENNELLY, Achille
see Vianelli
VIENOT
French, 17th cent.
VIERECK, August
German, 1825-1865
VIERGE, Daniel Urrabieta
French, 1851-1904
VIERHEILIG, Sebastian
German, 1761-1805
VIERIN, Emmanuel
Belgian, 1869-1954
VIERO, Teodoro
Italian, 1740-1795
VIERPYL or Vierpeyl,
Jan Carel
Flemish, op.1697-1723
VIERTEL, Johann Carl
Frederik
Danish, 1772-1834
VIETH, Friedrich Ludwig
von
German, 1768-1848
VIGARANI, Carlo
Italian, op.1677
VIGEE, H.
French, 18th cent.(?)
VIGEE, Louis
French, 1720-1767
VEGEE-LEBRUN, Marie
Louise Elizabeth (Elizabeth)
French, 1755-1842
VEGEON, Bernard du
French, c.1683-1760
VIGER-DUVIGNEAU, Jean
Louis Hector
French, 1819-1879
VIGERS, A.F.
British, 19th cent.

VIGH, Bartolomaus
Hungarian, 1890-
VIGHI, Antonio
Italian, 1764-1844
VIGHI, Enea
see Vico
VIGHI, Giacomo
(L'Argenta)
Italian, c.1510-1573
VIGIER, Walter von
Swiss, 1851-1910
VIGILIA, Juan di
Italian, op.1460
VIGILIA, Tommaso di
Italian, op.c.1435-1495
VIGNAL, Pierre
French, 1855-1925
VIGNALI, Jacopo
Italian, 1592-1664
VIGNAUD, Jean
French, 1775-1826
VIGNE, Edouard de
Belgian, 1808-1866
VIGNE, Félix de
Belgian, 1806-1862
VIGNE, G.T.
French, 19th cent.
VIGNERON
Belgian, 20th cent.
VIGNERON, Pierre Roch
French, 1789-1872
VIGNOLA, Girolamo,
da Modena
Italian, -1544
VIGNOLES, André
French, 20th cent.
VIGNON, Claude, I
French, c.1590-1670
VIGNON, Claude François, II
French, 1634-1703
VIGNON, Philippe
French, 1638-1701
VIGNON, Victor
French, 1847-1909
VIGNY, Sylvain
French, 20th cent.
VIGOR, Charles
British, 19th cent.
VIGOROSO da Siena
Italian, 1269-1292
VIGRI, Caterina
Italian, 1414-1463
VIL, C. de
Dutch(?), 18th cent.
VILACASAS
Spanish, 1920-
VILADOMAT, Antonio
Spanish, 1678-1755
VILAIN, Eugène
French, 19th cent.
VILAIN, Philip
Dutch, op.1694-1717
VILANOVA, Juan B.
Spanish, 1923-
VILBAULT, Jacques
see Wilbault
VILIGIARDI, Arturo
Italian, 1869-
VILKOVIR
Russian, 20th cent.
VILLA, Aleardo
Italian, 1865-1906
VILLA, Emile
French, 1836-
VILLA, Hernando
American, 1881-1952

VILLA, Miguel
Spanish, 1905-
VILLACH, Friedrich
von
German, 15th cent.
VILLACIS, Nicholas de
Spanish, 1618-1694
VILLAFRANCA MALAGON,
Pedro de
Spanish, op.1632-m.c.1690
VILLAGAS, G.
Spanish, 19th cent.
VILLAIN, Francois
Alexandre
French, 1798-1884
VILLAIN, Henri
French, 1813-
VILLALPANDO, Cristobal
Mexican, 1649(?)-1714
VILLAMENA, Francesco
Italian, 1566-1624
VILLAMIL y Marraci,
Bernardo
Spanish, 19th cent.
VILLAMIL, Genaro Perez
de la
Spanish, 1807-1854
VILLAMIL, Lucas
Spanish, 19th cent.
VILLAMIL, P.
Spanish, 19th cent.
VILLANDRANDO, Rodrigo de
Spanish, -a.1628
VILLARD, Antoine
French, 1867-1934
VILLARS, F.
French, op.1780
VILLASENOR, Isabel
Mexican, 1910-1954
VILLATE, Pierre
French, -a.1505
VILLAVICENZIO
see Nuñez, Pedro
VILLE, Guilliam de
Dutch, 1614-1672
VILLEBOUEF, André
French, 1893-1956
VILLEBOIS, Paul
French, 1705-1765
VILLECOCQ, Henri de
see Vulcop
VILLEERS, Jacob de
Dutch, 1616-1667
VILLEGAS y Cordero, José
Spanish, 1848-1922
VILLEGAS, Juan de
Venezuelan, 17th cent.
VILLEGAS MARMELEJO,
Pedro, I
Spanish, 1520-1596
VILLEGLE
French, 20th cent.
VILLELIA, Moisés
Spanish, 1928-
VILLENEUVE, Arthur
Canadian, 1910-
VILLENEUVE, Cecille
French, op.c.1850
VILLENEUVE, Paul Glon
French, 1803-p.1841
VILLEQUIN, Etienne
French, 1619-1688
VILLERET, Francois
Etienne
French, 1800-1866

VILLERI, Jean
French, 1898-
VILLEROY, Maurice de
French, c.1844-1914
VILLERS, L.
French, op.1788-1804
VILLERS, Maximilien
French, op.1788-1804
VILLIERS-HUET, François
see Huet
VILLODAS, Ricardo de
Spanish, 1896-1904
VILLOLDO, Jean
Spanish, 16th cent.
VILLON, Jacques
(Gaston Duchamp)
French, 1875-1963
VILLORESI, Franco
Italian, 1920-
VILLOT, F.
German, 1739-1793
VILLOT, Frédéric
French, 1809-1875
VILMA, Doresic
Yugoslav, op.1935-1968
VILOTEAU
French, 20th cent.
VIMAR, A.
French, 1851-1916
VIMERCATI, Carlo
Donelli
Italian, 1660-1715
VIÑAS, Antonio de
las
see Wyngaerde, Antonius
van den
VINAY, Jean
French, 1907-
VINCA, Ferario
see Vincio
VINCELET, Victor
French, 1840-1871
VINCENT
French, 18th cent.
VINCENT, Adelaide
see Labille-Guiard
VINCENT, Antoine Paul
French, op.1800-1812
VINCENT, F.
French, op.1782
VINCENT, F.W.
French, 18th cent.(?)
VINCENT, Francois André
French, 1746-1816
VINCENT, Francois (Elie)
French, 1708-1790
VINCENT, George
British, 1796-1831
VINCENT, Henriette
Antoinette
French, 1786-1830
VINCENT, René
French, 1871-1936
VINCENT, Vincent
Swiss, 20th cent.
VINCENZO
Italian, 18th cent.
VINCENZO da Canal
Italian, 17th cent.
VINCENZO da Castua
Italian, op.1475
VINCENZO da Pavia
see Aniemolo
VINCENZO de Rogata
Italian, op.1498
VINCENZO di Stefano
Italian, op.1432-1463

VINCENZO da Treviso
see Destre
VINCHON, Auguste Jean-
Baptiste
French, 1789-1855
VINCI, Pierino da
see Pierino
VINCIATA
Italian, 20th cent.
VINCIDOR
see Tommaso da
Bologna
VINCIO or Vinca(?),Ferario
Italian, 19th cent.
VINCITORE, Tommaso
see Tommaso da Bologna
VINCK, J.
Dutch(?), op.1614
VINCKEBOONS, Vinckbooms
or Vinckboons, David
Flemish, 1576-1629/32(?)
VINCKEEBON, Johannes
German, 1617-
VINE, John
British, 1809(?)-1867
VINEA, Francesco
Italian, 1845-1902
VINER, Giuseppe
Italian, 1875-1925
VINI, Sebastiano dai
see Bastiano Veronese
VINIEGRA y Lasso,
Salvador
Spanish, 1862-1915
VINKELES, Hermanus
Dutch, 1745-p.1817
VINKELES, Johannes
Dutch, 1783-
VINKELES, Reinier
Dutch, 1741-1816
VINNE, F. van der
Dutch, op.1665
VINNE, Isaac Vincentsz.
van der
Dutch, 1665-1740
VINNE, J.P. van der
Dutch, 17th cent.
VINNE, Jan Vincentsz.
van der (Jan de Nageoires)
Dutch, 1663-1721
VINNE, Laurens Jacobsz.
van der
Dutch, 1712-1742
VINNE, Laurens Vincentsz.
van der
Dutch, 1658-1729
VINNE, Vincent Jansz. van der
Dutch, 1736-1811
VINNE or Winne, Vincent
Laurentsz., I van der
Dutch, 1629-1702
VINNE, Vincent Laurensz.,
II van der
Dutch, 1686-1742
VINNEN, Carl
German, 1863-1922
VINOGRADIV, Sergei A.
Russian, 1869-
VINSAC, Claude Dominique
French, 1749-1800
VINSON, Ludovicus
or Louis
see Finson
VINTER, John Alfred
British, c.1828-1905

VINTON, Frederick
Porter
American, 1846-1911
VIOLA, Giovanni
Battista
Italian, 1570-1662
VIOLA, Tommaso
Italian, c.1810-
VIOLAT, Eugène Joseph
French, -1901
VIOLET, Pierre
French, 1749-1819
VIOLINISTA, el
see Pompeyo
VIOLLET-LE-DUC, Adolphe
Etienne, II
French, 1817-1878
VIOLLET-LE-DUC, Eugène
Emmanuel
French, 1814-1879
VIOLLET-LE-DUC, Victor
French, 1848-1901
VIOLLIER, Henri François
Gabriel
Swiss, 1750-1829
VIOLLIER, Jean
Swiss, 20th cent.
VIOLLIER, Louise, (née
Rochat)
Swiss, 1819-1856
VIREBENT, Pascal
French, 1746-1831
VIRIEU, Sophie de
French, op.1816
VIRIOT, Pierre, II
see Woeiriot
VIRULY, Willem, V
Dutch, c.1636-1678
VIRY, Paul Alphonse
French, 19th cent.
VISACCIO, Il
see Cimatori, Antonio
VISCARDI, Giovanni
Antonio
Italian, 1826-1853
VISCH, Mathias de
Flemish, 1702-1765
VISCHER, Georg Mathias
Austrian, 1628-1696
VISCHER, Hans
German, c.1489-1550
VISCHER, Hermann, II
German, 1486-1517
VISCHER, Hieronymus
Swiss, op.1583-1610
VISCHER or Fischer,
Johann Georg
German, 1580-1643
VISCHER, Lucas
Swiss, 1780-1840
VISCHER, Peter, I
German, c.1459-1529
VISCHER, Peter, II
German, op.1527-m.1528
VISCHER, Peter
Swiss, 18th cent.
VISCONTI, Adolfo
Ferragiti
Italian, 20th cent.
VISCONTI, Angelo
Italian, 1829-1861
VISCONTI, Eliseu
Italian, 1867-1944
VISENTINI or Vicentino,
Antonio
Italian, 1688-1782

VISENTYN
see Fratino, Giovanni
VISEUX, Claude
French, 1927-
VISHNIAKOFF, J.J.
Russian, 1699-1761
VISO, Andrea
Italian,
1657(?)/8-1740/(?)42
VISO, Nicola
Italian, op.1730
VISONE, Giuseppe
Italian, c.1800-
VISPRE, Victor
French, op.1763-1778
VISSCHER, Claes Jansz.
see Visscher, Nicolas
VISSCHER, Cornelis de
Netherlands, c.1520-1586
VISSCHER, Cornelis
Dutch, c.1619(1629?)-1662
VISSCHER, Gardenier
Dutch, 18th cent. (?)
VISSCHER, Johannes or
Jan de
Dutch, c.1636-p.1692
VISSCHER, Lambert
Dutch, 1633(?)-p.1690
VISSCHER, Nicolas
Dutch, 1618-1709
VISSCHER, Nicolas (Claes)
Jansz., I (Nicolas
Joannis Piscator)
Netherlands, c.1550-c.1612
VISSCHER, Nicolas (Claes)
Jansz., II
Dutch, 1586-1652
VISSER, Adrianus de
Dutch, 1762-1837
VISSER, Jan Gerritsz.
Dutch, c.1755-1821
VISSER, Johannes Gesinus
see Gesinus, Bob
VISSER, Pier Johannes de
Dutch, 1764-1848
VITA, Vincenzo
Italian, -1782
VITAL, Edgar
Swiss, 1883-1970
VITAL, Pauleus
Haitian, 1918-
VITALE da Bologna or
delle Madonne (Cavalli)
Italian, 1289/1309-1359/69
VITALI, Alessandro
Italian, 1580-1630
VITALI, Candido
Italian, 1680-1753
VITALIANO di Tommaso
Italian, op.1770
VITE, Antonio
Italian, op.c.1378-m.1407
VITI, Tiberio
Italian, 16th cent.(?)
VITI or Vito da Urbino,
Timoteo
Italian, 1469-1523
VITO, Giovanni Pietro
da San
see Giovan. Pietro
VITO, Michele de
Italian, 19th cent.
VITORIA, Juan Vicente
Spanish, 1650-1712
VITORIO, Alessandro
see Vittoria

VITRINGA, Wigerus
Dutch, 1657-1721
VITTINI, Jules
Italian, 20th cent.
VITTORE GRECO
Greek, op.1522
VITTORE PRETE
(Daraki Klapatzaras
Vittore)
Greek, op.c.1670
VITTORI, H.
Italian, op.1858
VITTORIA or Vitorio,
Alessandro
Italian, 1525-1608
VITTORIANO da Cremona
Italian(?), 17th cent.(?)
VIVALDI, Giuseppe
Italian, op.1692
VIVANCOS
French, 20th cent.
VIVAR, Correa de
Spanish, 16th cent.
VIVARES, Francois
French, 1709-1780
VIVARES, Thomas
British, c.1735-p.1787
VIVARINI, Alvise or
Luigi
Italian, c.1445/6-1503/5
VIVARINI, Antonio
(Antonio da Murano)
Italian, c.1415-m.1476/84
VIVARINI, Bartolommeo
Italian, c.1432-c.1499
VIVIAN, A.J.
British, 19th cent.
VIVIAN, George
British, 1798-1873
VIVIAN, Timothy
British, 20th cent.
VIVIANI, A.
see Codazzi
VIVIANI, Antonio Maria
(Il Sordo d'Urbino)
Italian, 1560-1620
VIVIANI, Belardino
Italian, 17th cent.
VIVIANI, Giuseppe
Italian, 1898-
VIVIANI, Lodovico
Italian, -1649
VIVIANI, Ottavio
Italian, 1579-
VIVIEN, Joseph
French, 1657-1734
VIVIER, Ignace du
see Duvivier
VIVIN, Louis
French, 1861-1936
VIVO, Tommaso de
Italian, 1787/90-1884
VIZETELLY, Frank
British, 1830-1883
VLADIMIROFF, Ivan
Alexejevitch
Russian, 1869-
VLAMINCK, Maurice de
French, 1876-1958
VLAMYNCK, Pieter Jan
de
Belgian, 1795-1850
VLERICK, Pieter
Netherlands, 1539-1581
VLETTER, P. de
Dutch, 19th cent.

VLETTER, Samuel de
Dutch, 1816-1844
VLEUGHELS, Vleugels
or Wleughels, Nicolas
Flemish, 1668-1737
VLIEGER, Eltie or
Neeltje de
Dutch, op.1634-1651
VLIEGER, Simon
Jacobsz. de
Dutch, c.1600(?)-1653
VLIER
Dutch, op.1768
VLIET, Hendrik Cornelisz.
van (der)
Dutch, 1611/2-1675
VLIET, Jan Hendricksz.
Dutch, op.c.1650
VLIET, Johannes or Jan,
Georg or Joris van
Dutch, c.1610-p.1635
VLIET, Willem van der
Dutch, 1856-1924
VLIET, Willem Willemsz.
van (der)
Dutch, 1583/4(?)-1642
VLINDT, Paul
see Flindt
VLOORS, Emile
Belgian, 1871-
VOBERE, Simon de
see Wobreck
VOCASEK, Johann Anton
Czech, 1706-1757
VOCHT, Pieter de
see Hofstadt
VOCKHETZ, J.G.
German, 18th cent.
VOELKER, Robert
German, 1854-1924
VOERMAN, Jan, I
Dutch, 1857-1941
VOERST, Voorst or Vorst,
Robert van
Dutch, 1597-1635/6
VOESCHER, Leopold
Heinrich
German, 1830-1877
VOET, Alexander, I
Flemish, 1613-1689/90
VOET, (also, erroneously,
Vouet), Jakob Ferdinand
(Ferdinand)
Flemish, 1639-1700(?)
VOET, Karel Borchaert
Dutch, 1670-1743
VOGEL, Andreas
German, 1588-
VOGEL von Vogelstein,
Carl Christian
German, 1788-1868
VOGEL, Carl Friedrich
Otto (Otto)
German, 1816-1851
VOGEL, Christian Lebrecht
German, 1759-1816
VOGEL, Cornelis
Johannes de
Dutch, 1824-1879
VOGEL, G.F.
German, op.1790
VOGEL, Georg Ludwig
(Ludwig)
Swiss, 1788-1879
VOGEL, Hansjorg
Scandinavian, 20th cent.

VOGEL, Hermann
Wilhelm
German, 1856-1918
VOGEL, Hugo
German, 1855-1934
VOGEL, Johannes
Gijsbert
Dutch, 1828-1915
VOGEL, Margaretha,
(née Roosenboom)
see Roosenboom
VOGEL, Pierre Werner
Swiss, 20th cent.
VOGEL, Sigismund von
German, op.1636-1654
VOGEL, Zygmund von
Polish, 1764-1826
VOGELAARE, Livinus de
Flemish, op.1600
VOGELAER, Abraham
Dutch, 17th cent.
VOGELAER, Karel van
(Distelbloom; .Carlo
dei Fiori)
Dutch, 1653-1695
VOGELAER, Pieter
Dutch, 1641-c.1720
VOGELER, Heinrich
Johann
German, 1872-1942
VÖGELIN, Johann
Swiss, 1754-1784
VOGELS, Guillaume or
Willem
Belgian, 1836-1896
VOGELSANG or Vogelsanck,
Izaak
Dutch, 1688-1753
VOGLER, Paul
French, 1852-1904
VOGTZ, Armin
Swiss, 20th cent.
VOGTHERR, Heinrich, I
(Monogrammist H.V.E.)
German, 1490-1556
VOGTHERR, Heinrich, II
German, 1513-1568
VOIGT, Frans Wilhelm
German, 1867-
VOIGT, Gerhard
German, 1926-
VOIGT, Teresa, (née
Fioroni)
Italian, 1810(?)-
VOIGTS, Carl Daniel
Danish(?), 1747-1813
VOILLE, Voiles or
Voilles, Louis
French, 1744-c.1796
VOILLEMOT, Charles
French, 1822-1893
VOIRIN, Jules Antoine
French, 1833-1898
VOIRIOT, Guillaume
French, 1713-1799
VOIS or Voys, Ary or
Arie de
Dutch, c.1632-1680
VOISARD, J.
Dutch(?), 18th cent.(?)
VOISARD-MARGERIE,
Adrien Gabriel
French, 19th cent.
VOISON, J.
French, 18th cent.
VOLAIRE, Pierre Jacques
or Jacques Antoine
French, 1729-a.1802

VÖLCKER, Friedrich
Wilhelm
German, 1799-1870
VÖLCKER, Gottfried
Wilhelm
German, 1775-1849
VÖLCKER, Otto Hermann
Emil
German, 1810-1848
VOLCKHART, Nicholaes
Netherlands, op.1568
VOLDER, L.D.
Dutch, 17th cent.
VOLDERS, Jan
Flemish, op.c.1660-1670
VOLDERS, Lancelot (also,
erroneously, Louis)
Flemish, op.1657-1666
VOLFREDO, Pelizza da
Italian, 1868-1907
VOLK, Douglas
American, 1856-
VÖLKEL
German, 19th cent.
VÖLKER, Gottfried
Wilhelm
German(?), 1775-1849
VÖLKER, Johann Wilhelm
(Wilhelm)
German, 1812-1873
VOLKERS, Adrianus
Dutch, 1904-
VOLKERS, Emil
German, 1831-1905
VÖLKERS, Karl (Kurt)
German, 1868-1944
VOLKHART, Georg Wilhelm
German, 1815-1876
VOLKHART, Max
German, 1848-1924
VOLKMANN, Arthur Joseph
Wilhelm
German, 1851-1941
VOLKMANN, Hans Richard
von
German, 1860-1927
VOLKOV, Yefim
Yefimovich
Russian, 1843-1920
VOLLENHOVE, Bernart
Dutch, 1633-p.1691
VOLLENHOVEN, Herman
van
Dutch, op.1611-1627
VOLLENWEIDER, Johann
Gustav (Gustav)
Swiss, 1852-1919
VOLLERDT, Johann
Christian
German, 1708-1769
VOLLEVENS, Johannes or
Jan, I
Dutch, 1649-1728
VOLLEVENS, Johannes or
Jan, II
Dutch, 1685-1758
VÖLLINGER, Joseph
German, 1790-1846
VÖLLINGER, Leopold
German, 1818-1844
VOLLMAR, Ludwig
German, 1842-1884
VOLLMER, Adolph
Friedrich
German, 1806-1875

VOLLMER, Ruth
British, 20th cent.
VOLLON, Alexis
French, 1865-
VOLLON, Antoine
French, 1833-1900
VOLLWEIDER, Johann
Jacob
German, 1834-1891
VOLMAR, Johann Georg
German, 1770-1831
VOLMAR, Joseph Simon
Swiss, 1796-1865
VOLMARYN, Crijn
Hendricksz.
Dutch, c.1604-1645
VOLMARYN, Pieter
Crijnse
Dutch, c.1629-1679
VOLOVICK
French, 20th cent.
VOLPATO, Giovanni
Italian, 1733-1803
VOLPE, Fra Gabriele de
see Bulpe
VOLPE, Vincent
Italian, op.1514-1530
VOLPI, Alessandro
Italian, 20th cent.
VOLPINI, Renato
Italian, 1934-
VOLSCHENK, Jan Ernst
Abraham
Dutch(?), 20th cent.
VOLTERRA
see Capriani, Francesco
VOLTERRA, Daniele da
see Daniele
VOLTERRANO, Il
see Franceschini,
Baldassare
VOLTIGEM or Voltigeant,
Josse de
Flemish, op.1612-1617
VOLTOLINA, Laurentius
de
Italian, 14th cent.
VOLTZ, Friedrich Johann
German, 1817-1886
VOLTZ, Johann Michael
German, 1784-1858
VOLTZ, Ludwig Gustav
(Louis)
German, 1825-1911
VOLZ, Hermann
German, 1814-1894
VOLZ, Wilhelm
German, 1855-1901
VONCK, Cornelius
see Funck
VONCK, Elias
Dutch, 1605-1652
VONCK or Vonk, Jacobus
Dutch, op.1717-m.1773
VONCK, Jan
Dutch, c.1630-c.1662(?)
VONESCH, Anna Barbara
see Abesch
VONHOFF, Heinrich
see Funhof
VONK, G.
Dutch, 17th cent.
VONK, Jacobus
see Vonck
VONNOH, Robert William
American, 1858-1933
VONZUN, Anny
Swiss, 1910-

VOOGD or Voogt,
Hendrik
Dutch, 1768-1839
VOORDE, Cornelis van der
see Voort
VOORDECKER, Henri
Belgian, 1779-1861
VOORDEN, August Willem
van
Dutch, 1881-1921
VOORDT, F. van
Flemish, 17th/18th cent.
VOORDT, Jan van
Netherlands, op.1727-1745
VOORHOUT, Constantyn
see Verhout
VOORHOUT, Johannes, I
Dutch, 1647-1723
VOORST, Robert van
see Voerst
VOORT or Voorde,
Cornelis van der
Dutch, c.1576-1624
VOORT in de Betouw,
Herman Jacob van der
Dutch, 1847-1902
VOORT or Woort, Michiel
van der, or Michiel
Vervoort
Flemish, 1704-p.1777
VORBRUCK, Heinrich
German, op.1623-m.1632
VORDEMBERGE, Friedrich
German, 1897-
VORDEMBERGE-GILDEWART,
Friedrich
German, 1899-1962
VORGANG, Paul
German, 1860-1927
VOROBYEV, Maksim
Nikiforovitch
Russian, 1787-1855
VORONIKHIN, Andrey
Nikiforovitch
Russian, 1759-1814
VÖRÖS, Geza
Hungarian, 1897-
VORST, Robert van
see Voerst
VORSTERMAN, Vorstermans
or Vosterman, Johannes
Dutch, 1643(?)-1699(?)
VORSTERMAN, Lucas, II
Flemish, 1624-p.1652
VORSTERMAN, Lucas, I
Emil
Flemish, 1595-1675
VORSTERMAN, Ottho
Dutch, op.1632
VORTCAMP or Worscamp
German, op.1641
VOS, Cornelis de
Flemish, 1584(?)-1651
VOS, E. van
Flemish, 17th cent.
VOS, Henri Martin
French, 19th cent.
VOS, Hubert
American, 1855-1935
VOS, Jan
Dutch, op.1812
VOS, Johannes or Jan,
I de
Dutch, 1593-1649
VOS, Johannes or Jan,
II de
Dutch, 1615-p.1683

VOS, Johannes or Jan,
IV de
Dutch, op.1652-1663

VOS, Maria
Dutch, 1824-1906

VOS, Marten de
Netherlands, 1532-1603

VOS, Paul de
Netherlands, 16th cent.

VOS, Paul de
Flemish, c.1596-1678

VOS, Peter, I de
Netherlands, 1490-1567

VOS, Simon de
Flemish, 1603-1676

VOS, Vincent de
Belgian, 1829-1875

VOSBERG, Heinrich
German, 1833-1891

VOSKRESSENSKY
Russian, 20th cent.

VOSKUYL, Huygh Pietersz.
Dutch, c.1593-1665

VOSMAER or Vosmeer,
Daniel
Dutch, op.1650-1666

VOSMAER or Vosmeer,
Jacob
Dutch, 1584-1641

VOSPER, Sydney Curnow
British, 1866-1942

VOSS, F.B.
British, 20th cent.

VOSS, Karl
German, op.1854-1871

VOSS, Karl Leopold
German, 1856-1921

VOSSEN, Andrea Theodorus
(André) van de
Dutch, 1893-1963

VOSTELL, Wolf
German, 1932-

VOSTERMAN, Johannes
see Vorsterman

VOUET, Aubin
French, 1595-1641

VOUET, P.
French, op.c.1691

VOUET, Simon
French, 1590-1649

VOUILLEMONT, Sébastien
French, c.1610-p.1641

VOULLAIRE, Marc
Swiss, 1749-

VOULLEMIER, Anne
Nicole
French, 1796-1886

VOUW, Johannes de
Dutch, -a.1691(?)

VOUW, P. de
Netherlands, op.1701

VOYEZ, François
French, 1746-1805

VOYS, Ary or Arie de
see Vois

VOYSEY, Charles
Francis Annesley
British, 1857-1941

VRAELEN, W.
Netherlands, op.1666

VRALATI, Jacques
French, 20th cent.

VRANCX, Adriaen
Flemish, op.1582

VRANCX, Franck or
Franks, Sebastian
Flemish, 1573-1647

VRANKEN, Gabriel
see Francken

VREE, Nicolaes de
Dutch, 1645-1702

VREEDENBURGH, Cornelis
Dutch, 1880-1946

VREEM, Anthony
Dutch, 1660-1681

VREL, C.
Dutch, 17th cent.

VREL or Frel, Jacobus
Dutch, op.c.1654-1662

VRIE, Adriaan de
see Vrij

VRIELINCX, J.
Flemish, 17th cent.

VRIENDSCHAP
see Schuer

VRIENDT, Albrecht or
Albert Frans Lieven
de
Belgian, 1843-1900

VRIENDT, Juliaan de
Belgian, 1842-1935

VRIENNTT, Josephus
Flemish, 17th cent.

VRIES, Abraham de
Dutch, c.1590-c.1650/62

VRIES, Fries or Frys,
Adriaen de
Dutch, c.1560(?)-1626

VRIES, Dirck or
Theodorus de
(Theodorus Frisius)
Dutch, op.1590-1592

VRIES, Hans Vredeman de
Netherlands,
1527-c.1606

VRIES, Herman de
Dutch, 1931-

VRIES, Jacob Feyt or
Feyck de
Dutch, 17th cent.

VRIES, Michiel van
Dutch, op.1656-m.a.1702

VRIES, Paul Vredeman de
Dutch, 1567-p.1630(?)

VRIES, Roelof Jansz.
van or de (also,
erroneously, Jan Regnier
or Reynier de Vries)
Dutch, 1630/1-p.1681

VRIES, Simon Wynhoutsz.
or Weynouts de (Simon
Wynhoutsz. Vriesius)
see Frisius

VROILYNCK or Vroylynck,
Ghislain
Flemish, op.1613-m.1635

VROLIJK, Jacobus
Adrianus (Adrianus)
Dutch, 1834-1862

VROLIJK, Johannes (Jan)
Martinus
Dutch, 1845-1894

VROMANS or Vroomans,
Isaak
(Slangenschilder)
Dutch, c.1655-1719

VROMANS, Pieter, (III)
Pietersz.
Dutch, op.1635

VROOM, Cornelis
Hendriksz.
Dutch, c.1590/1-1661

VROOM, Frederik
Hendriksz.
Dutch, c.1600-1667

VROOM, Hendrik
Cornelisz.
Dutch, 1566-1640

VROOM, Matheus
Flemish, op.1620-1632

VROOMANS, Isaak
see Vromans

VROYLINCK, Ghislain
see Vroilynck

VRIJE or Vrie,
Adriaan Gerritsz. de
Dutch, op.1591-m.1643

VRIJMOET, Jacobus
Dutch, op.1777-1787

VUAGNAT, Francois
French, 1826-1910

VUCHT, Gerrit van
Dutch, op.1658-1697

VUCHT, Jan van (der)
Dutch, 1603-1637

VUCO, Aleksander
Yugoslavian, 20th cent.

VUERST, F.R. von
Dutch(?), op.1637

VUEZ, Arnold de
French, 1644-1720

VUIBERT, Vibert or
Wibert, Remy
French, c.1600-1651

VUILLARD, Jean Edouard
French, 1868-1940

VUILLEFROY, Félix
Dominique de
French, 1841-

VUILLERMET, Charles
Joseph
Swiss, 1846-1913

VUILLIER, Gaston Charles
French, 1847-1915

VUJAKLIJA, Lazar
Yugoslav, 1914-

VUKOVIC, Svetislav
Yugoslav, 20th cent.

VULCOP, Villecocq,
Wilcop or Wulcob,
Henri de
see Master of Coëtivy

VULLIAMY, Gerard
Swiss, 1909-

VULLIAMY, Lewis
British, 1791-1871

VULPE, Fra Gabriele de
see Bulpe

VUYL, Johannes or Jan
(van) den
see Uyl

VYGH, Ph.
Dutch, op.1697

VYGNE, Godfrey Thomas
British, op.c.1836

VIJLBRIEF, Ernst
Dutch, 1934-

VIJVER, Willem Simon
Petrus van der
Dutch, 1820-p.1853

W

WAAGEN, Adalbert
German, 1833-1898

WAALS, Gottfried
see Wals

WAARD or Waardt,
Antoni de
Dutch, 1689-1751

WAARDEN, J. van der
Dutch, 18th cent.

WAAS, Aert van
see Waes

WAATERLOO, Anthonie
see Waterloo

WAAY, Nicolaas van
der
Dutch, 1855-1936

WABBE or Waben, Jakob
Dutch, op.c.1602-1634

WABER, K.
German, 19th cent.

WACH, Karl Wilhelm
German, 1787-1845

WACHENS, P.
Dutch(?), 17th cent.

WACHSMANN, Anton
German, c.1765-c.1836

WACHSMUTH, Ferdinand
German, 1802-1869

WACHSMUTH or Waxmuth,
Jeremias
German, 1711-1771

WACHSMUTH, Maximilian
German, 1859-

WACHTER, Cornelia
German, 19th cent.

WÄCHTER, Georg Friedrich
Eberhard (Eberhard)
German, 1762-1852

WACKER, Rudolf
Austrian, 1893-1939

WACKLIN, Isak
Finnish, 1720-1758

WADDEKK, Malcolm
Canadian, 20th cent.

WADDINGTON, John Barton
British, op.1835-m.1857

WADE, Thomas
British, 1828-1891

WADSWORTH, Edward
British, 1889-1949

WAEL, Cornelis de
Flemish, 1592-1667

WAEL, Jan Baptist de
Flemish, 1632-p.1658

WAEL, Lucas de
Flemish, 1591-1661

WAELS, Gottfried
see Wals

WAERDIGH, Dominicus
Gottfried
German, 1700-1789

WAES or Waas, Aert van
Dutch, c.1620-p.1664

WAGEMAKER, Adriaan
Barend (Jaap)
Dutch, 1906-

WAGEMAN, Michael
Angelo(?), II
British, 19th cent.

WAGEMAN, Thomas Charles
British, c.1787-1863

WAGENAAR or Wagenaer, P.
Dutch, op.c.1788-1792

WAGENBAUER, Max Joseph
German, 1774-1829

WAGENFELDT, Otto
German, c.1610-1671

WAGENSCHÖN, Franz Xaver
German, 1726-1790

WAGGONER
British, 17th cent.(?)

WAGGUNO
American, op.1858

WAGMANN or Wegmann,
Hans Heinrich
Swiss, 1557-c.1628

WAGNER, Albert
German, 1816-1867
WAGNER, Alexander von
Hungarian, 1838-1919
WAGNER, C.A.
German, c.1720-p.1750
WAGNER, Carl
German, 1796-1867
WAGNER, Cornelius
German, 1870-1956
WAGNER, Ernst
German, 1877-1951
WAGNER, Ferdinand, II
German, 1819-1881
WAGNER, Friedrich
German, 1801-p.1840
WAGNER, Fritz
German, 1896-1939
WAGNER, H.
German, 19th cent.
WAGNER, Johann Daniel
Lebrecht Franz
(Franz)
German, 1810-p.1864
WAGNER, Johann Georg
German, 1744-1767
WAGNER, Johann Martin
(Martin)
German, 1777-1858
WAGNER, Johann Peter
Alexander
German, 1730-1809
WAGNER, Joseph
German, 1706-1780
WAGNER, Jozsef
Hungarian, 18th cent.
WAGNER, Klaus
German, 20th cent.
WAGNER, Konrad
German, op.1479-m.1496
WAGNER, Ludwig
Christian
German, 1799-1839
WAGNER, Maria Dorothea,
(née Dietrich)
German, 1719-1792
WAGNER, Otto
German, 1803-1861
WAGNER, Paul
German, 1852-
WAGNER, Pierre Frederic
French, 19th cent.
WAGNER, R.
German, 19th cent.
WAGNER, Sigismundus
Norwegian, op.1700-m.1738
WAGNER, Valentin
German, c.1610-1655
WAGNER, Wilhelm
German, 1887-
WAGNER, Zacharias, I
German, 1582-1658
WAGNER-HÖHENBERG,
Josef
German, 1870-
WAGONER, Maria
American, op.c.1830
WAGREZ, Jacques
Clément
French, 1846-1908
WAHL, Johann Salomon
German, 1689-1765
WAHL, Josef
see Wall
WAHL, R.
German, 19th cent.
WAHLBERG, Herman Alfred
Leonard
Swedish, 1834-1906

WAHLBOM, Johan Wilhelm
Carl
Swedish, 1810-1858
WAHLQUIST, Ehrnfried
Scandinavian, 1815-1895
WAHLSTEDT, Walter
German, 1898-
WAIKER, John
American, 20th cent.
WAILAND, Friedrich
German, 1821-1904
WAILLY, Charles de, or
Charles Dewailly
French, 1729-1798
WAIN, Louis William
British, 1860-1939
WAINEWRIGHT, John
British, op.1860-1869
WAINEWRIGHT, Thomas
Francis
British, op.1831-1883
WAINWRIGHT, Thomas
Griffiths
Australian, 1794-1847
WAINWRIGHT, William John
British, 1855-1931
WAITE, Henry Clarence
British, op.1860
WAITE, James Clarke
Australian, op.1855-1905
WAITE, Robert Thorne
see Thorne Waite
WAITT, Richard
British, -1732
WAKE, John Cheltenham
British, 19th cent.
WAKEFORD, Edward
British, 1914-1973
WAKELEY, Archibald
British, op.c.1901
WAKELIN, Roland
New Zealand, 1887-1971
WAKEMAN, Thomas
American, 1812-1878
WAL, Wale or Wall,
Johannes van der
Dutch, 1728-1788
WALBOURN, Ernest
British, op.1900
WALBURG, Rudolph von
Dutch, c.1632-
WALCH, Charles
French, 1896-1948
WALCH, Johann
German, 1757-1816
WALCH, Thomas
German, 1867-1943
WALCKENBURG
see Valckenborch
WALCOT, William
British, 1874-1943
WALCOTT, Harry Mills
American, 1870-1944
WALDE, Alfons
German, 1891-1958
WALDECK, Johann
Friedrich Maximilian
Graf von
German, 1766-1875
WALDEN, Lionel
American, 1861-1933
WALDMANN, Johann Joseph
German, 1676-1712
WALDMANN, Kaspar
German, 1657-1720
WALDMÜLLER, Ferdinand
Georg
German, 1793-1865

WALDMÜLLER, Heinrich
(Heinz)
German, 1887-1945
WALDO, Samuel Lovett
American, 1783-1861
WALDOR, Jean, II
French, 1616-1670
WALDORP, Antonie
Dutch, 1803-1866
WALDORP, Jan Gerard
Dutch, 1740-1808
WALDSTEIN, Marie Anna
Gräfin
German, 1763-1808
WALE, Johannes van der
see Wal
WALE, Samuel
British, op.1752-m.1786
WALES, James
British, c.1747-1795
WALHAIN, Charles Albert
French, 1877-1936
WALISZEWSKI, Zygmunt
Polish, 1897-1936
WALKE, Henry
American, 1808-1896
WALKER, Anthony
British, 1726-1765
WALKER, C.
British, op.1909
WALKER, Edmund
British, op.1836-m.1882
WALKER, Elizabeth,
(née Reynolds)
British, 1800-1876
WALKER, Dame Ethel
British, 1867-1951
WALKER, Francis S.
British, 1848-1916
WALKER, Frederick
British, 1840-1875
WALKER (of Liverpool),
Frederick
British, 1841-1874
WALKER, George
British, op.1792-m.1795
WALKER, Henry Oliver
American, 1843-1929
WALKER, Hirst
British, 1868-
WALKER, Horatio
Canadian, 1858-1938
WALKER, J.
British, op.1788
WALKER, J.
British, op.1843
WALKER, James
British, op.1744-1745
WALKER, James
American, 1819-1889
WALKER, James Alexander
British, op.1871-m.1898
WALKER, James William
British, 1831-1898
WALKER, Jessica
British, op.1905
WALKER, John
British, op.1792-1803
WALKER, John
British, 1939-
WALKER, John Hanson
British, op.1869-1902
WALKER, John Rawson
British, 1796-1873
WALKER, Robert
British, 1607-1658(?)
WALKER, Robert McAllister
British, 1875-

WALKER, Thomas Larkins
British, -1860
WALKER, William
British, 1780-1863
WALKER, William
British, 1791-1867
WALKER, William Aiken
American, c.1838-1921
WALKER, William Eyre
British, 1847-1930
WALKER, William Henry
American, 1871-1940
WALKHOFF, Johann
Wilhelm (Wilhelm)
German, 1789-1822
WALKIES, Eddie Wilfram
American, 20th cent.
WALKOWITZ, Abraham
American, 1880-
WALL, Alfred S.
American, 1809-1896
WALL, Johannes van der
see Wal
WALL, John
British, 1708-1776
WALL or Wahl, Josef
Polish, 1754-1798
WALL, William Allen
American, 1801-1885
WALL, William Coventry
American, 1810-1886
WALL, William Guy
American, 1792-p.1864
WALL, Willem Rutgaart
van der
Dutch, 1756-1813
WALLACE, Ellen
see Sharples
WALLACE, Harry
British, op.c.1881-1934
WALLACE, R.(?)
American, 20th cent.
WALLACE, Robin
British, 1897-
WALLACE, Hon. William
British, op.1791
WALLAERT, Pierre Joseph
French, 1753-1812
WALLANDER, Alf
Swedish, 1862-1914
WALLANDER, Gerda Charlotta
Swedish, 1860-1926
WALLANDER, Joseph
Wilhelm
Swedish, 1821-1888
WALLAYS, Edouard Auguste
Belgian, 1813-1891
WALLCUTT, William
American, op.1776
WALLEN, F.
British, 20th cent.
WALLEN, Gustave Theodor
Swedish, 1860-
WALLER, C.
British, op.c.1788
WALLER, G.R.D.
German, 18th cent.(?)
WALLER, J.
British, op.1665
WALLER, John Green
British, op.1835-1848
WALLER, Mary Lemon,
(née Fowler)
British, op.1877-1916
WALLER, Richard
British, 1650(?)-1715
WALLER, Samuel Edmund
British, 1850-1903
WALLER, W.
British, op.1831-1832

WALLESHAUSEN-CSELENY,
Sigismund Antoine de
German, 1888-
WALLET, Albert Charles
French, 1852-1918
WALLGREN, Otto Henrik
Swedish, 1795-1857
WALLIEU, F.
French, 19th cent.
WALLIN, David August
Swedish, 1876-
WALLIS, Alfred
British, 1855-1942
WALLIS, George
British, 1811-1891
WALLIS, George Augustus
(not John William)
British, 1770-1847
WALLIS, Henry
British, 1830-1916
WALLIS, Joshua
British, 1789-1862
WALLIS, Neville Arthur
Douglas
British, 1910-
WALLIS, T.S.
British, 19th cent.
WALLMAN, Uno
Swedish, 1913-
WALLS, Robert
British, 20th cent.
WALLS, William
British, 1860-1942
WALMISLEY, Frederick
British, 1815-1875
WALMSLEY, Thomas
British, 1763-1806
WALRAVEN, Isaak
Dutch, 1686-1765
WALRAVEN van Haften
or Haeften, Nicolas
see Haften
WALS, Waals or Waels,
Gottfried (Goffredo)
German, op.1615-1631
WALSCAPPELLE, Walscapel,
Walscapele or Walscappel,
Jacob van
Dutch, 1644-1727
WALSCHE, P.G. de
Belgian, op.c.1833-1843
WALSER, Karl
Swiss, 1877-1943
WALSH, E.
British, 19th cent.
WALSH, Sam
British, 20th cent.
WALTER, Eric
British, 20th cent.
WALTER, Franz
German, 1733-1804
WALTER, Henry
British, 1786/90-1849
WALTER, Johann Jakob
see Walther
WALTER, Joseph
British, 1783-1856
WALTER, Ottokar
German, 1853-1904
WALTER, W.
British, 18th cent.
WALTERS, F.
British, 19th cent.
WALTERS, George
Stanfield
British, 1838-1924
WALTERS, Gordon
New Zealand, 1919-

WALTERS, Miles
British, 1774-1849
WALTERS, Samuel
British, 1811-1882
WALTERS, Susane
American, op.1852
WALTHARD, Johann Jakob
Friedrich (Friedrich)
Swiss, 1818-1870
WALTHARD, Thuring
see Walther
WALTHER, Adolf Wilhelm
(Wilhelm)
German, 1826-1913
WALTHER, Christian
Gottlieb (not Johann
August)
German, c.1745-1778
WALTHER, Friedrich
German, a.1440-p.1494
WALTHER or Walter,
Johann Jakob
German, c.1600-p.1679
WALTHER, Karl
German, 1905-
WALTHER or Walthard,
Thuring
Swiss, 1546-1615
WALTMAN, Harry Franklin
American, 1871-1951
WALTMANN, Jacob
German, 1802-1871
WALTON, Cecile
British, 1891-1956
WALTON, Edward Arthur
British, 1860-1922
WALTON, Elijah
British, 1832-1880
WALTON, Frank
British, 1840-1928
WALTON, G.
British, 18th cent.
WALTON, Henry
British, 1746-1813
WALTON, John Whitehead
British, op.1831-1885
WALTON, Parry
British, -1699
WALTON, W.L.
British, op.1834-1855
WALTZ, Johann Jakob
('Hansi')
German, 1873-
WALVES, Johannes
Baptista (van)
Flemish, 1622-p.1692
WALVIS, S.
Netherlands(?), 18th cent.(?)
WANDBY, A.J.
British, op.1842-1848
WANDELAAR, Johannes,
Joannes or Jan
Dutch, 1690-1759
WANDEREISEN, Hans
German, op.1535-1548
WANE, Richard
British, 1852-1904
WANKOWICZ, Walenty
Polish, 1800-1842
WANNENWECZ or Wanenwetsch,
Hans
German, 1555-1621
WANSLEBEN, Arthur
German, 1861-1917
WANUM, Ary van
Dutch, 1733-1780
WAPPERS, Egide Charles
Gustave (Gustave)
Belgian, 1803-1874

WARD, Bernard E.
British, op.1894-1896
WARD, Charles
British, op.1826-1869
WARD, Charles Caleb
American, c.1831-1896
WARD, Charlotte Blakeney,
(née Blakeney)
British, op.c.1898-1939
WARD, Edward Matthew
British, 1816-1879
WARD, George Raphael
British, 1797-1879
WARD, Henrietta Mary
Ada
British, 1832-1924
WARD, James
British, 1769-1859
WARD, James
British, 1800-1884
WARD, John
British, 1798-1849
WARD, John Stanton
British, 1917-
WARD, Sir Leslie
('Spy')
British, 1851-1922
WARD, Martin Theodore
British, 1799-1874
WARD, T.
British, op.1819-1840
WARD, Thomas William
British, 1918-
WARD, Vernon
British, 1905-
WARD, William
British, 1766-1826
WARD (of Hull), William
British, op.c.1830-1870
WARD, William E.
American, 20th cent.
WARD, William H.
British, op.c.1876
WARDELL, J.
British, 18th cent.
WARDLE, Arthur
British, 1864-1949
WARDLEWORTH, J.L.
British, 19th cent.
WARDLOW, A.H.
British, 19th cent.
WARENBERGER, Simon
see Warnberger
WAREWRIGHT, L.
British, op.1852
WARHOL, Andy
American, 20th cent.
WARING, J.
British, 20th cent.
WARING, John Burley
British, 1823-1875
WARING, W.
British, op.1881
WARING, W.H.
British, op.1886-1918
WARMAN, W.
British, op.c.1810
WARNBERGER or Warenberger,
Simon
German, 1769-1847
WARNECK, Karl Eduard
German, 1803-1889
WARNER, C.I.
American, op.1837
WARNER, J.
British, 19th cent.
WARNER, Lee
British, 19th cent.

WARNERSEN, Warnergoen
or Warnerssen, Pieter
German, op.1540-1560
WAROQUIER, Henri de
French, 1881-
WAROQUIER, Louis de
French, op.1844-1848
WARRE, Sir Henry J.,
General
British, 1819-1898
WARRELL, James
American, c.1780-a.1854
WARREN, Alan
British, 20th cent.
WARREN, Andrew
British, 18th cent.
WARREN, Charles
British, op.1833-1835
WARREN, Charles Knighton
British, 19th cent.
WARREN, Charlotte
British, 18th cent.
WARREN, Edmund George
British, 1834-1909
WARREN, Guy
Australian, 1921-
WARREN, Henry
British, 1794-1879
WARREN, Sophy S.
British, op.1869-1878
WARREN, William White
British, 19th cent.
WARRENER, William Tom
British, 1861-1934
WARRINGTON, R.W.
British, op.c.1900
WARWICK, Anne, Countess
of
British, 19th cent.
WASER, Anna
Swiss, 1678-1714
WASER, Heinrich
Swiss, 1743-1801
WASHINGTON, Georges
French, 1827-1910
WASHINGTON, W.
British, 20th cent.
WASLEY, Frank
British, 1854-
WASMANN, Rudolf
Friedrich
German, 1805-1886
WASNER, Arthur
German, 1887-1938
WASOWICZ, Waclaw
Polish, 1891-1942
WASSENBERGH, Elisabet
Geertruda (Elisabet
Geertruda Fockens)
Dutch, 1726/9-1781
WASSENBERGH, Jan Abel
Dutch, 1689-1750
WASSENHOVE, Joos van
see Justus of Ghent
WASSERSCHOT, Heinrich
van
see Waterschoot
WASSHUBER, Josef
Ferdinand
German, 1698-1765
WASSILIEFF, Nicolai
Russian, 1901-
WASSILLI
Russian, 20th cent.
WASSNER, Valentin
German, 1808-1880
WASTRY, Carlo
Italian, 1865-

WATE, G.
British, op.1809

WATE, William
British, op.1815-1832

WATELE, Wattele, Vatele
or Vuatelet, Henri
French, 1640-1677

WATELET, Charles
Joseph
Belgian, 1867-

WATELET, Claude Henri
French, 1718-1786

WATELIN, Louis Victor
French, 1835-1907

WATENPHUL, Max Peiffer
Swiss, 1896-

WATERFIELD, Aubrey
British, 1874-1944

WATERFORD, Louisa,
Marchioness of
British, 1818-1891

WATERHOUSE, Alfred
British, 1830-1905

WATERHOUSE, John
William
British, 1849-1917

WATERLOO, Waaterloo
or Waterlo, Anthonie
Dutch, c.1610-1690

WATERLOW, Sir Ernest
Albert
British, 1850-1919

WATERMAN, Marcus
American, 1834-1914

WATERS, Thomas
British, 19th cent.

WATERS, W.R.
British, op.1838-1867

WATERSCHOOT, Wasserschot
Watterschoot etc.,
Heinrich van
Flemish, op.1720-m.1748

WATFORD, Kirby
British, 20th cent.

WATHEN, James
British, -1828

WATHERSTON, Marjorie
Violet
British, op.c.1920-m.c.1970

WATKINS, Bartholomew
Colles
British, 1833-1891

WATKINS, Franklin
Chenault
American, 1894-

WATKINS, John
British, 19th cent.

WATKINS, W.M.
Australian, op.1888

WATKINS, William Arthur
British, 1885-1965

WATLING, Thomas
Australian, 1762-

WATMOUGH, Amos
British, op.1877

WATROUS, Harry Willson
American, 1857-1940

WATSON, Caroline
British, 1760-1814

WATSON, Charles John
British, 1846-1927

WATSON, Edward Albert
Douglas
Australian, 1920-

WATSON, Edward Facon
British, op.1839-1870

WATSON, George
British, 1767-1837

WATSON, George Spencer
British, 1869-1934

WATSON, Harry
British, 1871-1936

WATSON, Homer Ransford
Canadian, 1855-1936

WATSON, J.
British, 19th cent.

WATSON, John
British, 1685-1768

WATSON, John
British, op.1819-1848

WATSON, John Dawson
British, 1832-1892

WATSON, R.
British, op.1914

WATSON, Raymond
British, 20th cent.

WATSON, Robert
British, op.1652

WATSON, Robert
British, op.1899-1920

WATSON, Robert
British, 20th cent.

WATSON, Stewart
British, op.1843-1847

WATSON, W.
British, op.c.1864

WATSON, Walter J.
British, 1879-

WATSON, William
British, -1765

WATSON, William
British, op.1866-m.1921

WATSON, William Peter
British, op.1883-m.1932

WATSON, William
Smellie
British, 1796-1874

WATT, George Fiddes
British, 1873-1960

WATTEAU, Francois Louis
Joseph (Watteau of
Lille, II)
French, 1758-1823

WATTEAU, Jean Antoine
French, 1684-1721

WATTEAU, Louis Joseph
(Watteau of Lille, I)
French, 1731-1798

WATTENTU, A.
Dutch, op.1670

WATTERSCHOOT, Heinrich van
see Waterschoot

WATTEVILLE, Madame
Felicie (née Varlet)
see Varlet

WATTIER, Edouard
French, 1793-1871

WATTIER, Emile
French, 1800-1862

WATTLES
American, op.c.1840

WATTS, Arthur George
British, 1883-1935

WATTS, Austin
British, op.1905

WATTS, Elisabeth B.
American, 1940-

WATTS, Frederick W.
British, 1800-1862

WATTS, George Frederick
British, 1817-1904

WATTS, John
British, op.1766-1786

WATTS, Walter Henry
British, 1776-1842

WATTS, William
British, 1752-1851

WAUD, Alfred R.
American, 1828-1891

WAUGH, Eric
British, 20th cent.

WAUGH, Frederick Judd
American, 1861-1940

WAUGH, Samuel Bell
American, 1814-1885

WAUTERS or Wouters,
Charles Augustin
Belgian, 1811-1869

WAUTERS or Wouters,
Constant
Belgian, 1826-1853

WAUTERS, Emile Charles
Belgian, 1846-1933

WAUTIER, Wautiers or
Woutiers, Charles
Flemish, op.1652-1685(?)

WAUTIER, Michaelina
see Woutiers

WAWRZKIEWICZ, Helen
British, 20th cent.

WAXMANN, Martinus
Hungarian, op.1630

WAXMANN, Michel
Belgian, 20th cent.

WAXMUTH, Jeremias
see Wachsmuth

WAXSCHLUNGER, Johann
Georg
German, op.1720-1725

WAY, Andrew J.H.
American, 1826-1888

WAY, Charles Jones
British, 1834-

WAY, Johann Vilhelm
Carl
Swedish, 1792-1873

WAY, Thomas Robert
British, c.1852-1913

WAY, William Cosens
British, 1832-1905

WAYMER, Enrico
Italian, 1665-1738

WDOWISZEWSKI, Czeslaw
Polish, 1901-

WEATHERHEAD, William
Harris
British, 1843-

WEATHERILL, George
British, op.1868-1873

WEATHERSON, Alexander
British, 1930-

WEAVER, John Pyefinch
British, 1814-

WEAVER, P.T.
American, op.c.1797

WEAVER, Thomas
British, 1775-1843

WEBB, Archibald
British, op.1825-1866

WEBB, Charles Meer
British, 1830-1895

WEBB, Clifford C.
British, 1895-1972

WEBB, Edward
British, c.1805-1854

WEBB, J.
British, op.1805-1816

WEBB, James
British, c.1825-1895

WEBB, Jane (née Loudon)
see Loudon

WEBB, Philip
British, 1831-1915

WEBB, William
British, 1790-1856

WEBB, William Edward
British, op.1881-m.1903

WEBB or Webbe, William J.
British, op.1853-1878

WEBBER, John
British, 1750-1793

WEBBER, Sacharias or
Zacharias
Dutch, c.1644/5-1696

WEBER
French, op.1794

WEBER
German, 19th cent.

WEBER, Alfred Charles
French, 1862-1922

WEBER, Andreas Paul
German, 1893-

WEBER, Anton
German, 1833-1909

WEBER, August
German, 1817-1873

WEBER, Ch.
German(?) op.1848

WEBER, Dominik
German, 1819-1887

WEBER, Evarist Adam
German, 1887-

WEBER, Friedrich
German, 1765-1811

WEBER, Henrik
Hungarian, 1818-1866

WEBER, Henry William
British, 1783-1818

WEBER, Hugo
Swiss, 1918-

WEBER, Idelle
American, 1932-

WEBER, Irene
American, 20th cent.

WEBER, J.
German, op.1826

WEBER, Mathias
Swiss, 1757-1794

WEBER, Max
German, 1847-

WEBER, Max
American, 1881-1961

WEBER, Otto
German, 1832-1888

WEBER, Paul (Gottlieb
Daniel Paul)
German, 1823-1916

WEBER, Philipp
German, 1849-

WEBER, Rudolf
German, 1872-

WEBER, Theodor
Alexander
German, 1838-1907

WEBLING, Ethel
British, op.1888

WEBSKY, Wolfgang von
German, 1895-

WEBSTER, Angela
Australian, 20th cent.

WEBSTER, E.Ambrose
American, 20th cent.

WEBSTER, George
British, op.1797-1832

WEBSTER, H. Bullock
Canadian, 20th cent.

WEBSTER, Joseph S.
British, -1792

WEBSTER, Moses
British, 1792-1870
WEBSTER, Norman
British, 20th cent.
WEBSTER, Thomas
British, 1800-1886
WEBSTER, Tom
British, 1890-
WEBSTER, Walter Ernest
British, 1878-
WECHELEN, Jan van
Netherlands, op.1557
WECHINGER, Hieronymus
German, op.1571-1594
WECHTER, Wächter, Georg, II
German, c.1560-a.1630
WECHTER, Hans, II
German, op.1615-1646
WECHTLIN, Wächtle, or
Wechtel, Hans, I
German, 1480/85-p.1526
WECK, Louis Joseph de
Swiss, 1794-1882
WECKBRODT, Ferdinand
German, 1838-1902
WECKESSER, August
Swiss, 1821-1899
WEDDERBURN, J.
see Blackburn, Mrs.
Hugh
WEDIKIND, Wedekindt
or Wendekin, Johann
Heinrich
Swedish, 1674-1736
WEDEKIND, L.
German, 19th cent.
WEDEL, Nils
Swedish, 1897-
WEDER, Wolff-U.
German, 20th cent.
WEDGE, John Helder
British, 1792-1872
WEDGWOOD, Geoffrey
Heath
British, 1900-
WEDIG or Wedige,
Gotthardt de
(Godert)
German, 1583-1641
WEDSTED
American(?) op.c.1813
WEEGE, William
American, 1935-
WEEKES, Frederick
British, 19th cent.
WEEKES, Henry
British, op.1851-1888
WEEKES, William
British, op.1856-1909
WEEKS, Edwin Lord
American, 1849-1903
WEEKS, G.
American(?) 1857-
WEEKS, John
New zealand, 20th cent.
WEELE, C.M.W.
Dutch, op.1632-1652
WEELE, Herman Johannes
van der
Dutch, 1852-1930
WEELING, Nicolaes
see Willing
WEENIX or Weeninx,
Jan
Dutch, 1642(?)-1719

WEENIX, Weenincks,
Weenincx or Weeninx,
Jan Baptist or Giovanni
Battista (Ratel)
Dutch, 1621-a.1664
WEERDEN, Jacques van
see Werden
WEERDT or Werdt,
Abraham van
German, op.c.1636-1680
WEERDT or Weert,
Adriaan de
Netherlands,
c.1510(?)-c.1590
WEERPAS, A.
German, c.1880-
WEERT, Henricus Jacobus
Johannes Franciscus
(Jan) van
Dutch, 1871-1955
WEERTS or Weert,
Henricus van
Dutch, op.1667
WEERTS, Jean Joseph
French, 1847-1927
WEESOP
Flemish, op.1641-1649
WEGENER, Gerda
Danish, 1889-
WEGENER, Johann Friedrich
Wilhelm
German, 1812-1879
WEGMAN, William
American, 20th cent.
WEGMANN, Bertha
Danish, 1847-1926
WEGMANN, Hans Heinrich
see Wägmann
WEGMAYR or Wegmayer,
Sebastian
German, 1776-1857
WEGUELIN, John Reinhard
British, 1849-1927
WEHLE, Heinrich Theodor
German, 1778-1805
WEHLY
French, 19th cent.
WEHME, Vehm, Wehem
or Wehm, Zacharias
German, c.1558-1606
WEHNERT, Edward Henry
British, 1813-1868
WEHRLI, Ernst
Swiss, 20th cent.
WEHRLIN
see Verlin
WEHRS, Johann Friedrich
Hermann
German, 1735-1797
WEHRSCHMIDT, Daniel A.
see Veresmith
WEIBEL, Samuel
Swiss, 1771-1846
WEICHBERGER, Eduard
German, 1843-1913
WEICHSELBAUM, Johann
see Weixlbaum
WEICHSELGARTER, J.
German, 19th cent.
WEID, von der
Swiss, op.1793
WEIDEMANN or Weydemann,
Carl Emil
German, 1684-1735

WEIDEMANN, Friedrich
Wilhelm
German, 1668-1750
WEIDEMANN, Jakob
Norwegian, 1923-
WEIDENAUER, J.H.
Norwegian, op.1776-1787
WEIDITZ, Christoph, II
German, a.1517-a.1572
WEIDITZ or Wydytz,
Hans, II (Master of
Petrarch)
German, a.1500-p.1536
WEIDMANN, F.
German, 18th cent.
WEIDNER, Johann
German, 1628-1706
WEIDNER, Josef
German, 1801-c.1870
WEIE, Edvard (Viggo
Thorvald Edvard)
Danish, 1879-1943
WEIER
see Weyer
WEIGALL, Arthur Howes
British, op.1856-1894
WEIGALL, Charles Harvey
British, op.1810-m.1877
WEIGALL, Emily
British, op.1853-1860
WEIGALL, Henry
British, 1829-1925
WEIGAND, Konrad
German, 1842-1897
WEIGEL, Christoph
German, 1654-1725
WEIGEL or Weygal,
Hans, I
German, 1549-a.1578
WEIGELSPERG, Fanny
German, 1814-1895
WEIGHT, Carel
British, 1908-
WEIGHT, J.H.
British, 19th cent.
WEIGL, Franz
German, 1810-
WEIGMANN, Marie
British, 19th cent.
WEIKERT, Johann
Georg
German, 1745-1799
WEILAND, Johannes
Dutch, 1856-1909
WEINBERG, Justus
Fredric
Swedish, 1770-1832
WEINBERGER, Anton
German, 1843-1912
WEINBRENNER, Friedrich
German, 1766-1826
WEINER, Georg
German, 17th cent.(?)
WEINER, Weinher,
Weinhor, Weiher or
Weicher, Hans (Johannes
Meyners) (Master of
the Grape)
German, c.1575-p.1619
WEINER, Isidor
American, 20th cent.
WEINER, J.
German, 19th cent.
WEINER, Lawrence
American, 20th cent.

WEINER-Král, Imro
Czech, 1901-
WEINGARTEN, Georg
German, op.1599-1632
WEINGÄRTNER, Peter (Pedro)
Brazilian, op.1886-1898
WEINHOLD, Johann Georg
German, 1813-1880
WEININGER
German(?), 18th cent.(?)
WEININGER, Andor
Hungarian, 1899-
WEINMANN, Johann
Polish, 1734-1788
WEINRICH von Wesel,
Herman
see Wynrich
WEINSCHROETER, Sebald
German, 1318/28-1363/70
WEINSTEIN, M.
Russian, 20th cent.
WEINZHEIMER, Friedrich
August
German, 1882-
WEIR, Harrison William
British, 1824-1906
WEIR, John Ferguson
American, 1841-1926
WEIR, Julian Alden
American, 1852-1919
WEIR, Robert Walter
American, 1803-1889
WEIR, William
British, op.1855-m.1865
WEIROTTER or Weyrotter,
Franz Edmund
German, 1730-1771
WEIS or Weiss, Johann
Martin
German, 1711-1751
WEISBERG, Vladimir
Grigorievich
Russian, 1924-
WEISBORT, George
German, 19th cent.
WEISBROD, Carl Wilhelm
German, 1743-1806
WEISBUCH, Claude
French, 1927-
WEISE, Friedrich
German, c.1775-p.1822
WEISE, Robert
German, 1870-1923
WEISER, Bernard Pieter
Belgian, 1822-
WEISER, Joseph Emanuel
German, 1847-1911
WEISGERBER, Albert
German, 1878-1915
WEISGERBER, Carl
German, 1891-1968
WEISHAUPL, Georg
German, 1789-1864
WEISHAUPT, Victor
German, 1848-1905
WEISHUN, Nicolas
German, 1607-1687
WEISMANN, Gabi
German, 20th cent.
WEISS, Adalbert
Polish, 1875-
WEISS, Anton
German, 1801-1851

WEISS, Bartholomeus
Ignaz
German, c.1740-1814
WEISS, Eleazer
see Albin
WEISS, Emil Rudolf
German, 1875-1942
WEISS, Emile Géorges
(Géo)
French, 1861-
WEISS, Gustav
Swiss, 1886-
WEISS, Ivor
British, 1919-
WEISS, Jacob
Dutch(?) 17th cent.
WEISS, Johann Baptist
German, 1812-1879
WEISS, José
French, 1859-1919
WEISS, Joseph Carl
German, 1701-
WEISS, Maria del
Rosario
Spanish, 1814-1845
WEISS, Marx I
see Master of
Messkirch
WEISS, W.
Dutch, op.1836-1838
WEISS, Wojciech
Stanislaw
Polish, 1875-1950
WEISSBROD, Johan Baptist
Gabriel Eduard
German, 1834-1912
WEISSENBRUCH, Hendrik
Johannes (Johannes
Hendrik)
Dutch, 1824-1903
WEISSENBRUCH, Johannes
(Jan)
Dutch, 1822-1880
WEISSENKIRCHNER or
Weisskircher, Johann
Adam (Hans)
German, 1646-1695
WEISSER, Ignaz
German, 1809-1880
WEISZ, Adolphe
French, 1838-p.1900
WEISZ, Josef
German, op.c.1520-p.1565
WEITNER, W.F. van
German, 19th cent.(?)
WEITROTTER, Franz
Edmund
German, 19th cent.
WEITSCH, Friedrich
Georg
German, 1758-1828
WEITSCH, Johann Friedrich
(Pasha)
German, 1723-1802
WEIXLBAUM, Weichselbaum
or Weixelbaum, Johan
(not Michael)
German, 1752-1840
WEIXLBAUM, Michael
German, c.1790-1824
WEIXLGÄRTNER, Eduard
Hungarian, 1816-1873
WEKLER, George
German, 19th cent.
WELBOURN, Ernest
British, op.1895
WELCH, Thomas B.
American, 1814-1874

WELCKER, J.D.
German, 17th cent.
WELCZ or Wels, Concz
German, op.1532-1551
WELIE, Johannes Antonius
(Antoon) van
Dutch, 1866-1956
WELKER, Ernst
German, 1788-1857
WELLE, David (van)
Dutch, 1772-1848
WELLENHEIM, Pauline von
German, op.1840
WELLER, Theodor
Leopold
German, 1802-1880
WELLES, E.F.
British, op.1826-1856
WELLINGS, William
British, op.1782-1793
WELLINGTON, Hubert
Lindsay
British, 1879-1967
WELLIVER, Neil
American, 20th cent.
WELLS, E.J.
British, op.1905
WELLS, George
British, 19th cent.
WELLS, Henry Tanworth
British, 1828-1903
WELLS, J. Sanderson
British, op.1892-1938
WELLS, Joanna Mary
née Boyce
British, 1831-1861
WELLS, John
British, op.c.1792-1809
WELLS, John
British, 1907-
WELLS, Joseph Collins
American, 1813-1860
WELLS, William
Frederick
British, 1762-1836
WELLS, William Page
Atkinson
British, 1871-1923
WELME, Zacharias
German, 16th cent.(?)
WELPER, Jean Daniel
French, c.1729-1789
WELSCH, Paul
French, 1889-1954
WELSEN, F.
German, 19th cent.
WELSING, G.
Dutch, 17th cent.
WELTE, Gottlieb
German, c.1745-c.1790
WELTER, Michael
German, 1808-1892
WELTI, Albert
Swiss, 1862-1912
WELY, Jacques
French, 1873-1910
WELZ, Jean Max
Friedrich
S.African, 1900-
WEMAERE, Pierre
French, 1913-
WENCKEBACH, Ludwig
Willem Reijmert
(Willem)
Dutch, 1860-1937
WENCKERS, Joseph
French, 1848-1919
WENCZLA
see Wenzel

WENDEL, Theodore M.
American, 1857-
WENDEROTH, Karl
German, op.1880
WENDLER, Friedrich
Moritz
German, 1814-1872
WENDT, Erwin
German, 1900-1951
WENETZIANOW, Alexei
Gawrilowitch
Russian, 1779-1847
WENGLEIN, Josef
German, 1845-1919
WENGLER, Helmut
German, 20th cent.
WENGLER, Johann
Baptist
German, 1816-1899
WENIG or Veningue,
Karl Gottlieb (Karl
Bogdanovich)
Russian, 1830-1908
WENING, Michael
German, 1645-1718
WENNING, Pieter
Dutch, 1873-1921
WENSLER
Danish(?), op.1807
WENTWORTH, Cecile,
Marquise de
American, op.1886-m.1933
WENTWORTH, Thomas
Hanford
American, 1781-1849
WENTZEL or Wenzel,
Johann Friedrich
German, 1670-1729
WENTZEL, Nils Gustav
Norwegian, 1859-1927
WENTZEL, Peter
German, op.1627
WENZEL, Coebergher
German, 19th cent.
WENZEL von Olmütz,
Ollmütz or Olomucz
German, op.1481-1500
WENZEL von Riffian
(Wenczlaus, Venceslao,
probably Wazlaw Pehm)
German, op.1415
WENZELL, Albert Beck
American, 1864-1917
WENZINGER, Christian
Swiss, 1710-1797
WERDEHAUSEN, Hans
German, 1910-
WERDEN or Weerden,
Jacques van
Flemish, op.c.1645-1666
WERDMÜLLER, Heinrich
Swiss, 1774-1832
WERDMÜLLER, Johann
Rudolf
Swiss, 1639-1668
WEREFKIN, Marianne
von
Russian, 1870-1938
WERENFELS, Rudolph
German, 1629-1673
WERENSKIOLD, Erik
Theodor
Norwegian, 1855-1938
WERESZCZYNSKA, Wanda
Polish, 1910-
WERFF, Adriaen van der
Dutch, 1659-1722

WERFF, Pieter van der
Dutch, 1665-1722
WERGANT or Bergant,
Fortunat
German, 1721-1769
WERGELAND, Oskar
Arnold
Norwegian, 1844-1910
WERKMAN, Hendrik
Nicolaas
Dutch, 1882-1945
WERL, Hans
German, op.1589-m.1608
WERL, Werle,Wehrl,
Wernl or Wörle, Johann
David
German, op.1605-m.1621/2
WERNARS, Gerhardus (Gerard)
Dutch, 1924-
WERNER, Alexander
Friedrich (Fritz)
German, 1825-1908
WERNER, Anna Maria,
(née Hayd or Haid)
German, 1688-1753
WERNER, Anton Alexander
von
German, 1843-1915
WERNER, Carl Friedrich
Heinrich
German, 1808-1894
WERNER, Frank Rolf
American, 20th cent.
WERNER, Friedrich
Bernhard
German, 1690-1778
WERNER, Gotthard
(Gudfast) Adolf
Swedish, 1837-1903
WERNER, Johan, I
Swedish, c.1600-1656
WERNER, Johan, II
Swedish, c.1630-1684
WERNER, Joseph, II
Swiss, 1637-1710
WERNER, Rinaldo (or
Reinhold)
Italian, 1842-1922
WERNER, Theodor
German, 1886-
WERRO, Roland
Swiss, 20th cent.
WERTERHOLM, Victor Axel
Finnish, 1860-1919
WERTHEIMER, Gustav
German, 1847-1902
WERTINGER, Hans
(Monogrammist H.W.?)
(Hans Schwab)
German, 1465/70-1533
WERTMÜLLER, Adolf Ulrich
Swedish, 1751-1811
WERY, Emile Auguste
French, 1868-1935
WESCHKE, Karl
British, 1925-
WESSEL, C.F.
German, 18th cent.
WESSEL, Isaac van
Dutch, op.1670-1736
WESSEL, Jakob
German, a.1710-1780
WESSEL, W. van
German, op.1677-1721
WESSEL, Wilhelm
German, 1904-

WESSELMAN, Tom
American, 20th cent.
see Westervelt
WESSELS, Glenn
American, 20th cent.
WESSELY, Anton
German, 1848-
WESSEL-ZUMLOH, Irmgart
German, 1907-
WESSON, Edward
British, 1910-
WEST, Alexander R.
British, 19th cent.
WEST, Benjamin
American, 1738-1820
WEST, Benjamin
Franklin
American, 1818-1854
WEST, Edgar E.
British, op.c.1881-1889
WEST, Enholme
British, 19th cent.
WEST, Francis
British, 1936-
WEST, Francis Robert
British, 1749(?)-1809
WEST, G.R.
British, op.1847
WEST, H.
British, 19th cent.
WEST, J.C.
British, 19th cent.(?)
WEST, James B. jnr.
British, op.1851-1856
WEST, Joan
British, 20th cent.
WEST, Joseph
British, 1797-p.1834
WEST, Joseph Walter
British, 1860-1933
WEST, Raphael Lamar
British, 1769-1850
WEST, Richard Whately
British, 1848-1905
WEST, Robert
British, op.1744-m.1770
WEST, Robert Lucius
British, c.1774-1850
WEST, Samuel
British, c.1810-p.1867
WEST, Colonel Temple
British, 1739-1783
WEST, William
British, 1801-1861
WEST, William Edward
American, 1788-1857
WESTALL, Richard
British, 1765-1836
WESTALL, William
British, 1781-1850
WESTCHILDHOF, C.
German, 19th cent.
WESTCOTT, Lilian
see Hale
WESTCOTT, Philip
British, 1815-1878
WESTENBERG, Pieter George
(Pieter George)
Dutch, 1791-1873
WESTENDORF, Fritz
German, 1867-1926
WESTERBAEN, Jacob
Dutch, op.1626-m.a.1661
WESTERBAEN, Jan Jansz. I
Dutch, c.1600-1686
WESTERBAEN, Jan Jansz., II
Dutch, c.1631-p.1669
WESTERBEEK, Cornelis, I
Dutch, 1844-1903

WESTERFELDT, Abraham van
see Westervelt
WESTERHOUT, Arnold
van
Flemish, 1651-1725
WESTERIK, Jacobus
(Co)
Dutch, 1924-
WESTERMAN, H.C.
American, 1922-
WESTERMAYR, Konrad
German, 1765-1834
WESTERN, Charles
British, op.1885-1893
WESTERVELT or Westerfeldt,
Abraham van
Dutch, op.1647-m.1692
WESTHOVE, C. van
Dutch, 17th cent.(?)
WESTIN, Fredrik
Swedish, 1782-1862
WESTLAKE, Alice
née Hare
British, c.1840-1923
WESTMACOTT, Sir Richard
British, 1775-1856
WESTOBY, E.
British, op.1806-1823
WESTON, G.F.
British, op.1840
WESTPFAHL, Conrad
German, 1891-
WESTPHAL, Fred
German, 20th cent.
WESTWATER, Robert H.
British, op.c.1925-1955
WET, Gerrit or
Gerardus de
Dutch, op.1640-m.1674
WET, Jacob Jacobsz. de
Dutch, 1640-1697
WET or Wett, Jacob
Willemsz. de
Dutch, op.1633-p.1674
WET or Wette, Johan
(Jan) de, or Johan
Düwett
Dutch, c.1617-
WETERING de Rooij,
Johannes Embrosius
van de
Dutch, 1877-1972
WETHERALL
British, 19th cent.
WETHERBEE, F.F.
American, 19th cent.
WETHERBEE, George
Faulkner
American, 1851-1920
WETJEN, O. von
German, 20th cent.
WETT or Wette
see Wet
WETTERLING, Alexander
Clemens
Swedish, 1796-1858
WETZEL, Ines
German, 1878-
WETZEL, Johann Jakob
Swiss, 1781-1834
WEUYSTER, J.
Dutch(?) op.1784
WEX, Willibald
German, 1831-1892
WEXELBERG, F.G.
Swiss, c.1745-p.1775

WEIJAND, Jacob Gerrit
(Jaap)
Dutch, 1886-1960
WEYDE, Julius
German, 1822-1860
WEYDEN, Goossden or
Goswyn van der
Netherlands, c.1465-c.1538
WEYDEN, Pieter or
Pieret van der
Netherlands,
c.1437-1514
WEYDEN, Rogier van der
(Rogier de la
Pasture)
Netherlands,
c.1399-1464
WEYDMANS, H.
Netherlands, 17th cent.
WEYER, Conradt
German, op.1619
WEYER, Weier or Wyer,
Gabriel
German, 1576-1632
WEYER, Hans, I
German, op.1595-m.1621
WEYER or Weyher,
Hermann (Monogrammist
HEW)
German, op.c.1600-1620
WEYER or Weier, Jacob
German, op.1648-m.1670
WEYER or Weier, Johann
Mathias
German, c.1620-c.1690
WEIJER, Johannes
Hermannus van de
Dutch, 1817-1889
WEYER, Pit
Netherlands, 20th cent.
WEYERMAN, Jacob Campo
Dutch, 1677-1747
WEYERMANN, Jacob
Christoph
Swiss, 1698-1757
WEYGEL, Hans, I
see Weigel
WEYLER, Weiler or
Weiller, Jean
Baptiste
French, 1747-1791
WEYLER, Louise
see Bourdon
WEYMAN, Leendert
Dutch, op.1774
WEYROTTER, Franz
Edmund
see Weirotter
WEYSS, B.
German, 18th cent.
WEYSSENHOFF, Henryk
Polish, 1859-1922
WHAITE, Henry Clarence
British, 1828-1912
WHAITE, James
British, op.1867-1896
WHARNCLIFFE, Lady
British, -1856
WHEATLEY, Edith Grace
British, 1888-1970
WHEATLEY, Francis
British, 1747-1801
WHEATLEY, John
British, 1892-1955
WHEELER, A.
British, op.1894-1896

WHEELER, Edward J.
British, op.1872
WHEELER of Bath,
James
British, 1820-1885
WHEELER, T.
British, op.1817-1845
WHEELWRIGHT, Roland
British, 1870-
WHEELWRIGHT, W.H.
British, 19th cent.
WHELDON, J.
British, 19th cent.
WHESSELL, John
British, c.1760-p.1797
WHETHAM
British, 19th cent.
WHICHELO, Wichelo or
Wichello, C. John M.
British, a.1800-1865
WHIDBORNE, Timothy
British, 20th cent.
WHISHAW, Anthony
British, 1930-
WHISTLER, James Abbott
McNeill
American, 1834-1903
WHISTLER, Rex John
British, 1905-1944
WHITAKER, David
British, 1938-
WHITAKER, George
British, 1834-1874
WHITBY, William
British, op.1772-1792
WHITCOMBE or Whitecomb,
Thomas
British, c.1760-p.1824
WHITE, C.
American, op.1848
WHITE, Charles
British, 1751-1785
WHITE, Clarence
British, 20th cent.
WHITE, Edwin
American, 1817-1877
WHITE, Ethelbert
British, 1891-1972
WHITE, Franklin
British, 20th cent.
WHITE, G.F.
British, op.1838
WHITE, George
British, c.1684-1732
WHITE, George Harlow
Canadian, op.1839-1883
WHITE, Gilbert
British, 1720-1793
WHITE, J.
American, op.1738
WHITE, John
British, op.1585-1593
WHITE, John
British, 1851-1933
WHITE, John Blake
American, 1782-1859
WHITE, Newton H.
American, 19th cent.
WHITE, Richard
British, 17th cent.
WHITE, Robert
British, 1645-1703
WHITE, Thomas
British, c.1730-c.1775
WHITE, Thomas Henry
British, op.1841-1862
WHITE, Vera M.
American, 1888-1966

WHITE, W.
British, op.1918
WHITEFIELD, Edwin
British, 1816-1892
WHITEHEAD, Frederick
William Newton
British, 1853-1938
WHITEHEAD, J.
British, 19th cent.
WHITEHEAD, J.P.
American, 19th cent.
WHITEHEAD, T.W.
British, op.1863
WHITELEY, Brett
Australian, 1939-
WHITESIDE, Frank Reed
American, 1866-1929
WHITESIDE, Forbes
American, 20th cent.
WHITEFIELD, Henry
British, op.c.1819
WHITFORD, R.
British, op.1871
WHITING, Frederick
British, 1874-1962
WHITLEY, Edward
Duncan
British, op.1841
WHITLEY, J.
American, 19th cent.
WHITMAN, Sarah de
St. Prix Wyman
American, 1842-1904
WHITMORE, S.
British, 20th cent.
WHITTAKER, James
William
British, 1828-1876
WHITTAKERS, John
British, op.c.1619
WHITTALL, John
British, 20th cent.
WHITTLE, Thomas
British, op.c.1854-1895
WHITTOCK, Nathaniel
British, op.1820-1844
WHITTREDGE, Worthington
American, 1820-1910
WHOOD or Wood, Isaac
British, 1688-1752
WHORF, John
American, 1903-
WHYMPER, Josiah
Wood
British, 1813-1903
WHYTE, William
Patrick
British, 19th cent.
WIBEKES, Bartholt
see Wiebke
WICAR or Vicar, Jean
Baptiste Joseph
French, 1762-1834
WICART, Nicolaas
Dutch, 1748-1815
WICHELO or Wichello,
C.John M.
see Whichelo
WICHMANN, Adolf
Friedrich Georg
German, 1820-1866
WICKENBERG, Alfred
German, 1885-
WICKENBERG, Peter
Gabriel
Swedish, 1812-1846

WICKERODE, Oscar
von Krackow von
German, 1826-1871
WICKEY, Henry Herman
American, 1892-
WICKSTEAD, Philip
British, op.1763-m.a.1790
WICKSTEED, C.F.
British, op.1790-m.1846
WIDDAS, R.D.
British, op.1847
WIDEMANN, Widmann or
Wiedemann, Elias
German, op.1634-1651
WIDFORSS, Gunnar
Mauritz
Swedish, 1879-1934
WIDGERY, Frederick
John
British, 1861-1942
WIDGERY, William
British, 1822-1893
WIDHOLM, Gunnar
Swedish, 1882-
WIDHOPFF, D.O.
French, 1867-1933
WIDIS, P.F.
German(?) op.1727
WIDMANN, Friedrich
August Vitalis
Swiss, 1869-1937
WIDT, Frederik de
see Wit
WIDULA
French, 19th cent.
WIEBERKOM, Richard
American, 20th cent.
WIEBKE or Wiebekes,
Bartholt
Dutch, op.1679-1682
WIECZOREK, Max
Polish, 1863-1955
WIEGAND, Charmion von
American, 1899-
WIEGAND, Martin
German, 1867-
WIEGELE, Franz
German, 1887-1944
WIEGERS, Jan
Dutch, 1893-1959
WIEGHORST, Olaf
American, 19th cent.
WIEGMAN, Matthes
Johannes Marie (Matthieu)
Dutch, 1886-
WIEKMYNS, D.
Netherlands, op.1643
WIELAND, Hans Beatus
Swiss, 1867-
WIELAND, Joyce
Canadian, 20th cent.
WIELAND, Karl
German, op.c.1840
WIELING or Wielings,
Nicolaes
see Willing
WIEMKEN, Walter Kurt
Swiss, 1907-1940
WIENWALD, August
Schaffer von
German, 1833-1916
WIERINGA, Franciscus
Gerardus (Gerardus)
Dutch, 1758-1817/19
WIERINGA, Nicolaas
Dutch, op.1644-1681
WIERINGEN, Cornelis
Claesz. van
Dutch, 1580(?)-1643

WIERIX, Wierx, Wiricx
or Wiericz, Antoine
Flemish, c.1552-1624(?)
WIERIX, Wierx, Wiricx
or Wiericz, Hieronymus
Flemish, 1553(?)-1619
WIERIX, Wierx, Wiricx
or Wiericz, Johan
Flemish, c.1549-p.1615
WIERTZ, Antoine Joseph
Belgian, 1806-1865
WIERUSZ-KOWALSKI,
Alfred von
see Kowalski-Wierusz
WIESCHERBRINK, Franz
German, 1818-1884
WIESSNER, Konrad
German, 1796-1865
WIEST
German, 18th cent.
WIEST, Johann Leonhard
see Wuest
WIETHASE, S.
American, 19th cent.
WIETHÜCHTER, Gustav
German, 1873-1946
WIFFEN, Alfred Kemp
British, 1896-
WIGAND, Balthasar
German, 1771-1846
WIGAND, Friedrich
German, c.1800-1853
WIGANS, Isaac
Flemish, 1615-1662/3
WIGGERS, Dirk (Derk)
Dutch, 1886-1933
WIGGINS, Carleton
American, 1848-1932
WIGGINS, Guy Carleton
American, 1883-
WIGGLI, Oscar
Swiss, 20th cent.
WIGHI
Russian, 18th cent.
WIGHT, Moses
American, 1827-1895
WIGLEY, James V.
Australian, 1918-
WIGLEY, Joseph
British, op.1811
WIGMANA, Gerard
Dutch, 1673-1741
WIGMORE, J.
British, op.1813
WIGNALL, Robert
British, 17th cent.
WIGSTEAD, Henry
British, op.1784-m.1793
WIKTOROWSKI, Janusz.
Polish, 20th cent.
WILATCH, Micha
French, 20th cent.
WILBAULT or Vilbault,
Jacques
French, 1729-1806
WILBURG, Christian
Johannes
German, 1839-1882
WILCK or Willck,
Johann Carl
German, 1772/4-1819
WILCKEN, G.
German(?) 18th cent.
WILCKENS, August
German, 1870-1939
WILCOP, Henri de
see Vulcop

WILCOX, John Angel
James
American, 1835-
WILCOX, Leslie Arthur
British, 1904-
WILD, Charles
British, 1781-1835
WILD, David
British, 20th cent.
WILD, Hans
German, op.1480
WILD, J.C.
American, op.1848
WILD, Johann Michael
German, 1715-1783
WILD, P. de
Netherlands(?) op.1797
WILD, William
British, op.1830
WILDA, Charles
German, 1854-1907
WILDE, August de
Belgian, 1819-1886
WILDE, Christoffel de
Dutch, 1784-1860
WILDE, Gerald William
Clifford
British, 1905-
WILDE, Jan Willemsz.
van der
Dutch, 1586-1636(?)
WILDE, John
American, 1919-
WILDE, Paul
Swiss, 1893-1936
WILDE, Percy
British, 19th cent.
WILDE, Samuel de
British, 1748-1832
WILDE, William
British, 1826-1901
WILDEMAN, C.J.I.
Dutch(?) 1774-1813
WILDENRADT, Johan Peter
Danish, 1861-1904
WILDENS, Jan
Flemish, 1584/6-1653
WILDER, André
French, 1871-1965
WILDHACK, Paula
German, 1872-
WILDHAGEN, Fritz
German, 1878-1956
WILDING
German, 20th cent.
WILDMAN, Edmund, II
British, op.1829-1847
WILDMAN, John R.
British, op.1823-1839
WILDMAN, William
Ainsworth
British, 1882-
WILDRAKE, George
see Tattersall
WILDSMITH, Brian
British, 20th cent.
WILDSTOSSER, Alfred
Polish, 1859-
WILDT, Adolfo
Italian, 1868-1931
WILEBOORTS, Thomas
American, 19th cent.
WILEMAN, J. Paula
Dutch(?), op.1659
WILES, Irving Ramsey
American, 1861-1948

WILES, Lemuel Maynard
American, 1826-1905
WILEY, William. T.
American, 1937-
WILGUS, John
American, op.1839
WILHELM, C.
see Pitcher, W.J.
WILHELM von Cöln,
(Wilhelm von Herle)
see Wynrich, Herman
WILHELM, Gaspar Heinrich
German, 18th cent.
WILHELM, Paul
German, 1886-
WILHELMSON, Carl
Wilhelm
Swedish, 1866-1928
WILHJELM, Johannes
Martin Fasting
Danish, 1868-1938
WILKANOWICZ, Wlodimierz
Polish, 1904-
WILKE, Rudolf
German, 1873-1908
WILKE, Ulfert
German, 1907-
WILKENS, Theodorus
(Goedewil)
Dutch, c.1690-c.1748
WILKIE, Sir David
British, 1785-1841
WILKIE, John
American, op.c.1840
WILKIN, Charles
British, 1750-1814
WILKIN, Frank W.
British, c.1800-1842
WILKINS, George
British, op.c.1880-1884
WILKINS, Robert or
John
British, c.1740-c.1790
WILKINS, William
British, 1778-1839
WILKINSON, Edward Clegg
British, op.1882-1904
WILKINSON, Henry
Australian, op.1855-1856
WILKINSON, J.
American, op.1773-1801
WILKINSON, J.B.
Canadian, op.1871
WILKINSON, Rev. Joseph
British, op.1810
WILKINSON, M.
Australian, 20th cent.
WILKINSON, Norman
British, 1878-1971
WILKINSON, Norman
British, 1882-1934
WILKINSON, R.E.
British, op.1874-1890
WILKINSON, W.S.
British, 19th cent.
WILKS, P.
American, 20th cent.
WILL, Frank
French, 1900-
WILL, Johann Martin
American, 1727-1806
WILLAERT, Ferdinand
Belgian, 1861-1938
WILLAERTS, Abraham
Dutch, c.1603-1669
WILLAERTS, Adam
Dutch, 1577-1664

WILLAERTS, Cornelis
Flemish, op.1622-m.1666
WILLAERTS, Isaac
Dutch, c.1620-1693
WILLARD, Archibald M.
American, 1836-1918
WILLARS or Willarst,
Otto de
Danish, c.1662-1722
WILLCOCK, George
Burrell
British, 1811-1852
WILLCOCKS, Jonathan
British, 20th cent.
WILLE, August von
German, 1829-1887
WILLE, Friedrich
(Fritz) von
German, 1860-1941
WILLE or Will, Johann
Georg
German, 1715-1808
WILLE, Pierre Alexandre
French, 1748-1821
WILLEBEECK, Petrus
Flemish, op.1632-1646
WILLEBOIRTS or Willeborts,
Thomas (Bosschaert)
Flemish, 1614-1654
WILLEMER, Anna Rosina
Magdalena von
see Städel
WILLEMIN, Nicolas
Xavier
French, 1763-1839
WILLEMS, Charles Henri
French, 19th cent.
WILLEMS, Florent
Belgian, 1823-1905
WILLEMS, L.
Belgian, 19th cent.
WILLEMS or Wyllems,
Winolt
Dutch, op.1604-1636
WILLEMSENS, Jean Blaise
French, op.c.1800
WILLENBECHER, John
American, 1936-
WILLENBERGER or
Willenberg, Johann
German, a.1571-1613
WILLERS, Ernst
German, 1803-1880
WILLETTE, Léon Adolphe
(Adolphe)
French, 1857-1926
WILLIAM of Bruges
Netherlands, 16th cent.
WILLIAM, Master
see Wynrich, Herman
WILLIAM of Westminster
British, c.1200-1280
WILLIAM-POWLETT,
Katherine
British, 20th cent.
WILLIAMS, Alexander
British, 1846-1930
WILLIAMS, Alfred Walter
British, 1823-1905
WILLIAMS, Arthur
(Gilbert)
British, 1819-1895
WILLIAMS, Aubrey
British, 20th cent.
WILLIAMS, Benjamin
British, 1868-1920

WILLIAMS, C.
British, 18th cent.
WILLIAMS, C.
British, op.1825-1826
WILLIAMS, Christopher
British, 1873-1934
WILLIAMS, Denis
British, 1924-
WILLIAMS, E.
British, 20th cent.
WILLIAMS, E.P.
American(?) 19th cent.
WILLIAMS, Edward
British, 1782-1855
WILLIAMS, Edward
Charles
British, op.1839-1875
WILLIAMS, Edward
Ellerker
British, 1793-1822
WILLIAMS, Edwin
British, op.1843-1875
WILLIAMS, F.
British, op.a.1829
WILLIAMS, Fred
Australian, 1927-
WILLIAMS, Frederick
Ballard
American, 1871-
WILLIAMS, G.
British, op.1801
WILLIAMS, George
Augustus
British, op.1841-1885
WILLIAMS, Gwillym
British, op.1725
WILLIAMS, Harry
British, op.1854-1877
WILLIAMS, Henry
American, 1787-1830
WILLIAMS, Henry
British, 1807-1886
WILLIAMS, Hiram
American, 1917-
WILLIAMS, Hugh William
('Grecian Williams')
British, 1773-1829
WILLIAMS, James Francis
British, c.1785-1846
WILLIAMS, John Alonzo
American, 1869-
WILLIAMS, John Edgar
British, op.1846-1883
WILLIAMS, John Michael
British, 1710-c.1780
WILLIAMS, Kyffin
British, 1918-
WILLIAMS, Lizzie
American, 19th cent.
WILLIAMS, Margaret
Lindsay
British, op.1907-m.1960
WILLIAMS, Marshall
American, 20th cent.
WILLIAMS, Micah
American, op.c.1790
WILLIAMS, Neil
American, 20th cent.
WILLIAMS, Penry
British, 1798-1885
WILLIAMS, Robert or
Roger
British, op.1680-1704
WILLIAMS, Samuel
British, 1788-1853
WILLIAMS, Sidney Rich
see Percy

WILLIAMS, Solomon
British, op.1771-m.1824
WILLIAMS, Susan
British, 20th cent.
WILLIAMS, T.H.
British, op.1801-1830
WILLIAMS, Terrick
British, 1860-1936
WILLIAMS, Thomas
British, op.1860
WILLIAMS, Virgil
American, 1830-1886
WILLIAMS, W.Frank
British, op.1851
WILLIAMS, Walter
British, op.1843-1884
WILLIAMS, William
British, 1727-1791
WILLIAMS, William
(of Norwich)
British, op.1758-1794
WILLIAMS, William (of
Plymouth)
British, 19th cent.
WILLIAMS, William
Joseph
American, 1759-1823
WILLIAMSON, Daniel
British, 1783-1843
WILLIAMSON, Daniel
Alexander
British, 1822-1903
WILLIAMSON, Frederick
British, op.1856-1900
WILLIAMSON, Harold
Sandys
British, 1892-
WILLIAMSON, J.B.
British, 19th cent.
WILLIAMSON, John
British, 1751-1818
WILLIAMSON, John
American, 1826-1885
WILLIAMSON, Samuel
British, 1792-1840
WILLIAMSON, Thomas
George
British, 1758/59-1817
WILLIAMSON, W.H.
British, op.1853-1875
WILLIAMSON, W.M.
British, op.1868-1873
WILLICH, Cäsar
German, 1825-1886
WILLIGEN, Claes Jansz.
van der
Dutch, c.1630-1676
WILLIGEN, Pieter
van der
Flemish, 1635-1694
WILLING, Weeling,
Wieling, Wielings,
Willingh or Willings,
Nicolaes
Dutch, c.1640-1678
WILLINGES, Johann
German, op.1590-m.1625
WILLINK, Albert
Carel (Carel)
Dutch, 1900-
WILLIOT, Louis Auguste
Adolphe
French, 1829-1865
WILLIS, Edmund Aylburton
British, 1808-1899
WILLIS, Henry Brittan
British, 1810-1884

WILLIS, M.
British, 18th cent.
WILLISON, George
British, 1741-1797
WILLMANN, Michael
Lucas Leopold
German, 1630-1706
WILLMS, J.A.
Dutch, op.1710
WILLOUGHBY, R.
British, 18th cent.
WILLROIDER, Josef
German, 1838-1915
WILLROIDER, Ludwig
German, 1845-1910
WILLS, James
British, op.1746-m.1777
WILLS, Jan
see Wils
WILLSON, Harry
British, op.1813-1852
WILLSON, Mary Ann
American, op.1810-1825
WILLUMS, Olaf
Abrahamsen
Norwegian, 1886-
WILLUMSEN, Jens
Ferdinand
Danish, 1863-1958
WILLYAMS, Cooper
British, 1762-1816
WILMER, John Riley
British, op.1926
WILS, Jan
Dutch, c.1600-1666
WILS or Wills, Jan
Dutch, op.1774
WILSON, Alexander
British, 1766-1813
WILSON, Andrew
British, 1780-1848
WILSON, Benjamin
British, 1721-1788
WILSON, Bryan
American, 1927-
WILSON, C.
British, op.1706
WILSON, Cecil
British, op.c.1900-1913
WILSON, Charles
Edward
British, op.c.1889-1929
WILSON, Daniel
British, 1816-1892
WILSON, David
British, 1872-1935
WILSON, E.
British, op.1800-1801
WILSON, Edgar
British, -1918
WILSON, Edward Adrian
British, -1912
WILSON, Eric
British, 1911-1946
WILSON, Frank Avray
British, 1914-
WILSON, George
British, 1848-1890
WILSON, George
British, 1882-
WILSON, Herbert
British, op.1858-1876
WILSON, Isabella
Maria
American, op.1826
WILSON, J.T.
British, op.1856-1882

WILSON, J. Walter
British, 19th cent.
WILSON, James
British, op.c.1856
WILSON, John (Jock)
British, 1774-1855
WILSON, John James, II
(Young Jock)
British, 1818-1875
WILSON, Joseph
British, op.1770-1800
WILSON, L.W.
New Zealand, 19th cent.
WILSON, Richard
British, 1714-1782
WILSON of Birmingham,
Richard
British, 1752-1807
WILSON, Robert
British, op.1778-1818
WILSON, Ronald York
Canadian, 1907-
WILSON, Scottie
British, 1889-
WILSON, T.
British, 18th cent.
WILSON, T.C.
British, 18th cent.
WILSON, Thomas
Harrington
British, op.1842-1886
WILSON, Thomas Walter
British, 1851-
WILSON, Tony
British, 1944-
WILSON, William
British, op.1798-1836
WILSON, William
British, 1905-
WILSON, William F.
Canadian, 20th cent.
WILT, Hans
German, 1867-1917
WILT, Thomas van der
Dutch, 1659-1733
WIMAR, Charles
Ferdinand
American, 1829-1863
WIMMER, Edward Joseph
German, 1882-
WIMMER, Konrad
German, 1844-1905
WIMPERIS, Edward
Morison
British, 1835-1900
WINCK, Johann Amandus
see Wink
WINCK, Winckh, Wink
or Winkh, Joseph
Gregor
German, 1710-1781
WINCKELMANN, J.J.
German, 19th cent.
WINCKER, A.
German, 1848-1919
WIND, Gerhard
German, 1928-
WINDER, Franz Joseph
see Winter
WINDHAGER, Franz
German, 1879-1959
WINDISCH-GRAETZ, Ernst
Verland, Prinz von
und zu
German, 1905-
WINDMAIER, Anton
German, 1840-1896

WINDRED, H.
British, 19th cent.
WINDSOR-FRY, H.
British, op.1884
WINDT, Christophe (Chris)
van der
Belgian, 1877-1952
WINDT, Philip Pieter
Dutch, 1847-1921
WINDUS, William
Lindsay
British, 1822-1907
WING, C.W.
British, op.1826
WINGATE, James Lawton
British, 1846-1924
WINGE, Marten Eskil
Swedish, 1825-1896
WINGE, Sigurd
Norwegian, 1909-
WINGFIELD, James Digman
British, 1800-1872
WINGHE, Wingen or
Winghen, Jeremias
van
Flemish, 1578-1645
WINGHE, Wingen or
Winghen, Jodocus,
Joos, Josse or
Jost
Netherlands, 1544-1603
WINGHEN, B. van
Dutch, op.1667
WINIARSKI, Franciszek
Bogdan
Polish, 20th cent.
WINK or Winck, Johann
Amandus
German, c.1748-1817
WINK or Winck, Johann
Christian Thomas
(Christian)
German, 1738-1797
WINK or Winck, Johann
Chrysostumus
(Chrysostumus)
German, 1725-1795
WINK or Winkh, Joseph
Gregor
see Winck
WINKELAAR-TEMMINCK,
Henriëtta Christina
(née Temminck)
see Temminck
WINKELMANN, Johann
Friedrich
German, 1767/72-1821
WINKFIELD, Frederick A.
British, op.1873-1909
WINKLER, Adam
German, op.1592
WINKLER, Elise
(Börner)
German, op.c.1800
WINKLER, Johann Michael
German, 1729-1796
WINNE, Liévin de
Belgian, 1821-1880
WINNER, Gerd
American, 20th cent.
WINNER, William E.
American, c.1815-1883
WINSLOW, Carl
Danish, 1796-1834
WINSTANLEY, Hamlet
British, 1698-1756

WINSTANLEY, Henry
British, 1644-1703
WINSTANLEY, William
British, op.1795
WINSTON, Charles
British, 1814-1864
WINT, Peter de
British, 1784-1849
WINTER or Winder,
Franz Joseph
German, c.1690-p.1756
WINTER, Fritz
German, 1905-
WINTER, Gillis or
Aegidius de
Dutch, c.1650-1720
WINTER, Heinrich
German, 1843-1911
WINTER, Hendrik de
Dutch, 1717-1790
WINTER or Wintter,
Johann Georg
German, 1707-1768/70
WINTER or Wintter,
Joseph Georg
German, 1751-1789
WINTER, Klaus
German, 1928-
WINTER, Michael
German, op.c.1518
WINTER, Pharaon de
French, 1849-1924
WINTER, Raphael
German, 1784-1852
WINTER, William
Arthur
Canadian, 1909-
WINTERBACH, Johann
Christian
German, op.1725-1729
WINTERGERST, Joseph
German, 1783-1867
WINTERHALDER, Josef, II
German, 1743-1807
WINTERHALTER, Franz
Xaver
German, 1805-1873
WINTERHALTER, Hermann
German, 1808-1891
WINTERLIN or Winterle,
Anton
Swiss, 1805-1894
WINTERNITZ, Richard
German, 1861-1929
WINTERS
American, 19th cent.
WINTERSBERGER, Lambert
Maria
German, 20th cent.
WINTHER, Poul
Danish, 1939-
WINTHUYSEN y Losada,
Francisco Javier
Spanish, 1874-
WINTOUR, John Crawford
British, 1825-1882
WINTZ, Raymond
French, 1884-1956
WINTZ, Wilhelm
(Guillaume)
French, 1823-1899
WINZER, Charles
Freegrove
British, 1886-
WIRGMAN, Charles
British, 1832-1891

WIRGMAN, Theodore
Blake
British, 1848-1925
WIRICX
see Wierix
WIRSCHING, Otto
German, 1889-1919
WIRSUM, Karl
American, 20th cent.
WIRT, Niklaus
Swiss, op.c.1565-m.1584
WIRTH, Anna Marie
Russian, 1846-p.1922
WIRTH, Philipp
German, 1808-1878
WIRTH-MILLER, Denis
British, 1915-
WIRZ, Conrad
Swiss, -p.1540
WIRZ or Wirtz, Johann
Swiss, 1640-1710
WISARD, Gottfried
Emanuel
see Wysard
WISCHACK, Weiszhock,
Wischeck, Wiszhock
or Wysschock,
Maximilian (Maximin)
Swiss, c.1500-a.1556
WISCHNIOWSKY, Josef
German, 1856-1926
WISE-CIOBOTARU,
Gillian
British, 20th cent.
WISHART, Michael
British, 1928-
WISHART, T.
British, 18th cent.
WISHAW, Anthony
British, 1930-
WISINGER-FLORIAN,
Olga
German, 1844-1926
WISNIESKI, Oskar
German, 1819-1891
WISSELINGH, Johannes
Pieter van
Dutch, 1812-1899
WISSING, Willem
Dutch, c.1656-1687
WIT, de
Dutch(?), 17th cent.(?)
WIT, de
Russian(?), 18th cent.
WIT, Emmanuel or
Manuel de
see Witte
WIT, Franciscus de
(Febus or Apol)
Flemish, op.1629
WIT, Widt or Witt,
Frederick de
Dutch, op.c.1650
WIT, Izaac Jansz. de
Dutch, 1744-1809
WIT, Jacob de
Dutch, 1695-1754
WIT, N. de
Dutch, op.1740
WIT, P.J. de
see Dewit
WIT, Peter de
see Witte
WITDOECK or Witdouc,
Jan or Hans
Flemish, c.1615(?)-p.1635

WITEMAN, Elias
see Widemann
WITH or Wit, Pieter
de
Dutch, op.c.1650-1660
WITHAM, J.
British, 19th cent.
WITHERINGTON, John
Augustus
British, 19th cent.
WITHERINGTON, William
Frederick
British, 1785-1865
WITHERS, Mrs.
British, 19th cent.
WITHERS, Alfred
British, 1856-1932
WITHERS, Walter
Australian, 1854-1914
WITHOOS, Alida
Dutch, c.1660-p.1715
WITHOOS, Maria
Dutch, 17th/18th cent.
WITHOOS, Matthias
(Calzetta Bianca)
Dutch, 1621/7-1703
WITHOOS, Pieter
Dutch, 1654-1693
WITJENS, Jan Willem
Hendrick (Willem)
Dutch, 1884-1962
WITKEWITZ, Sol
American, 20th cent.
WITKIEWICZ, Stanislaus
Polish, 1851-1915
WITKOWSKI, Karl
American, 1860-1910
WITKOWSKI, Romuald
Adam
Polish, 1876-
WITMONT, Heerman
Dutch, c.1605-p.1683
WITSEN, Nicolaes
Cornelisz.
Dutch, 1641-1717
WITSEN, Willem Arnold
Dutch, 1860-1923
WITSENBURGH, Dirck or
Theodorus, I
Dutch, op.1689-m.1700
WITT, Anthony de
Italian, 20th cent.
WITT, Christopher
Dutch, 1675-1765
WITT, Frederik de
see Wit
WITT, James de
Dutch, op.c.1675
WITTE, Catharina de
(née Knibbergen)
see Knibbergen
WITTE or Wit,
Emmanuel or Manuel de
Dutch, 1615/17-1691/2
WITTE, Gaspar or
Jasper de
Flemish, 1624-1681
WITTE, L. de
Flemish, op.1737
WITTE or Wit, Peter
(Peter Candid, or
Pietro Candido)
Flemish, c.1548-1628
WITTE, Pieter, II de
Flemish, 1617-1667
WITTE, W.
Swiss, 19th cent.

WITTEL, Gaspar
Adriaensz. van
(Gaspare Vanvitelli,
or Gasparo dagli
Occhiali)
Dutch, 1653-1736
WITTENBERG, Jan Hendrik
Willem
Dutch, 1886-1963
WITTHOFT, Wilhelm
German, 1816-1874
WITTIG or Wittich,
Bartholomaus
(Bartholóme)
German, c.1613-1684
WITTING, D.
Dutch, op.1630
WITTKAMP, Johann
Bernhard
Belgian, 1820-1885
WITTKUGEL, Klaus
German, 1910-
WITTMAN, Charles
French, 20th cent.
WITTMANN, J.L.
German, 19th cent.
WITTMANN, Michael
German, 1629-1706
WITTMAN, Wolffgang
Wilhelm von
German, op.1679-m.1727
WITTMER, Johann
Michael
German, 1802-1880
WITTOP, Freddy
American, 20th cent.
WITZ, Hans
German, 15th cent.
WITZ, Konrad
(Conradus Sapientis)
German, 1400/10-1444/46
WITZEL, Joseph Rudolf
German, 1867-
WITZLEBEN, Friedrich
Hartmann von
German, 1802-1873
WIVELL, Abraham
British, 1786-1849
WIVELL, W.
British, 19th cent.
WIZANI or Witzani,
Carl
German, 1767-1818
WIZANI or Witzani,
Johann Friedrich
(Friedrich)
German, 1770-1835
WLADARSKI, Marek
Czech, 20th cent.
WLADYSLAW, Anatol
Polish, 20th cent.
WLERICK, Robert
French, 1882-
WLEUGHELS, Nicolas
see Vleughels
WOBRECK, Obrek,
Ulbrick, Vobere,
Woberck or Wobrok,
Simon de
Netherlands,
op.1557-1585
WOCHER, Marquand
Fidel Dominikus
Swiss, 1760-1830
WOCHER, Tiberius
Dominikus (Theodor)
Swiss, 1728-1799
WODDERSPOON, J.
British, 19th cent.

WODICK, Edmund
German, 1813-1866
WODNANSKY, Wilhelm
German, 1876-1958
WODWALL, William
British, op.c.1583
WODZINOWSKY, Wincenty
Polish, 1864-1940
WODZINSKI, Josef
Polish, 1859-
WOEIRIOT, Wiriot,
Woeriot, Woiriot,
Woriot or Viriot, Pierre, II
French, 1532-p.1596
WOELFLE, Franz Xavier
German, 1887-
WOENSAM or Wonsam,
Anton von 'Worms'
German, a.1500-a.1541
WOENSEL, Petronella
van
Dutch, 1785-1839
WOERNDLE von Adelafried,
Edmund
German, 1827-1906
WOESTDRECHT, E.
Dutch, 18th cent.
WOESTYNE, Gustave van de
Belgian, 1881-1947
WOHLFAHRT, Bernard
Wilhelm
Swedish, 1812-1863
WOHLHAUPTER, Emanuel
Johann Karl
German, 1688-1756
WOHLHAUPTER, Franz
Johann
German, 1644-1706
WOHLMAN, E.
German, 18th cent.
WOIRIOT, Pierre, II
see Woeiriot
WOISERI, J. I.
Bouquet de
American, op.c.1803
WOJNIAKOWSKI, Kasimir
Polish, 1771/72-1812
WOJTKIEWICZ, Witold
Polish, 1879/80-1909/11
WOLCOTT, John
(Peter Pindar)
British, 1738-1819
WOLD-TORNE, Oluf
Norwegian, 1867-1919
WOLEDGE, Frederick
William
British, op.1840
WOLF, Carl Anton
German, 20th cent.
WOLF, Caspar
Swiss, 1735-1798
WOLF, Franz
German, 1795-1859
WOLF, Franz Xaver
German, 1896-
WOLF, Friedrich
German, 1833-1884
WOLF, Gerhard
German, 20th cent.
WOLF, Henry
American, 1852-1916
WOLF or Wolff, Jeremias
German, 1663/73-1724
WOLF, Johann
German, 1749-1831

WOLF, Joseph
British, 1820-1899
WOLF, Louise
German, 1798-1859
WOLF, Remo
Italian, 1912-
WOLF, Rudolf
German, 1877-
WOLFAERTS, Wolfaert,
Wolfart, Wolfert,
Wolffordt or
Wolfordt, Artus
Flemish, 1581-1641
WOLFAERTS, Wolfaert,
Wolfart, Wolfert,
Wolffordt or
Wolfordt, Jan
Baptist
Flemish, 1625-1687(?)
WOLFE, Edward L.G.
British, 1897-
WOLFE, George
British, 1834-1890
WOLFE, Jack
American, 1925-
WOLFENSBERGER, Johann
Jacob
Swiss, 1797-1850
WOLFERT
see Wolfaerts
WOLFF or Wolf von
Bamberg, Hans
German, op.1518-m.1542
WOLFF, Heinrich
German, 1875-1940
WOLFF or Wolf, Johann
Andreas (Andreas)
German, 1652-1716
WOLFF or Wolf, Jonas
German, op.1652-m.1680
WOLFF or Wulff,
Nicolaj
Danish, 1762-1813
WOLFF, Robert Jay
Americn, 1905-
WOLFFORDT or Wolfordt
see Wolfaerts
WOLFFSEN, Aleijda
see Wolfsen
WOLFF-ZAMZOW, Paul
German, 1872-
WOLFGANG, Georg
Andreas, II
German, 1703-1745
WÖLFL, Adelbert
German, 1827-1896
WÖLFLI, Adolf
Swiss, 1864-1930
WOLFRAET
see Wulfraet
WOLFSON or Wolffsen,
Aleijda
Dutch, 1648-p.1690
WOLFSFELD, Erich
German, 1884-1956
WOLFTHORN or Wolf-Thorn,
Julie
German, 1868-
WOLFVOET, Victor
Flemish, 1612-1652
WOLGEMUT, Michael
German, 1434-1519
WOLKONSKY, Maria,
Princess
Russian, 20th cent.
WOLLASTON or Woolaston,
John, I
British, c.1672-p.1741

WOLLASTON or Woolaston,
John, II
British, -c.1770
WOLLBERIN, Gerd
German, 20th cent.
WOLLEB, Johann Rudolf
Swiss, op.1769-m.1824
WOLLEN, William
Barnes
British, 1857-1936
WOLLES, Lucien
Belgian, 1862-
WOLLHEIM, Gert
German, 1894-
WOLLUST
see Eichler, Johann
Conrad
WOLMAR, Gustaf
Andersson
Danish, 1880-
WOLMARK, Alfred Aaron
British, 1877-1961
WOLPE, Ada
Swiss, 20th cent.
WOLS, Wolfgang
Schulze
German, 1913-1951
WOLSKI, Stanislaw
Pomian
Polish, 1859-1894
WOLSTENHOLME, Dean, I
British, 1757-1837
WOLSTENHOLME, Dean, II
British, 1798-1882
WOLTER, Hendrik Jan
Dutch, 1873-1952
WOLTERS, Henriette,
(née van Pee)
Dutch, 1692-1741
WOLTZE, Berthold
German, 1829-1896
WOLVENS, Henri Victor
Belgian, 1896-
WOMACKA, Walter
Czech, 1925-
WOMRATH, Andrew Kay
American, 1869-
WONDER, Pieter
Christoffel
Dutch, 1780-1852
WONNACOTT, John
British, 1940-
WONNER, Paul
American, 1920-
WONTNER, William
Clarke
British, op.1879-1912
WOOD, Alan
British(?) 20th cent.
WOOD, Catherine M.
British, op.1883-1892
WOOD, Charles C.
British, 1791-1856
WOOD, Charles Haigh
British, 1856-1927
WOOD, Christopher
British, 1901-1930
WOOD, Edwin
British, op.1865
WOOD, Francis Derwent
British, 1871-1926
WOOD, Grant
American, 1892-1942
WOOD, I.
British, 18th cent.
WOOD, J.C.
British, 20th cent.

WOOD, John
British, 1801-1870
WOOD, John George
British, op.1792-m.1838
WOOD, Joseph
American, 1778-c.1832
WOOD, Kenneth
British, 20th cent.
WOOD, Lawson
British, 1878-1957
WOOD, Leona
American, 20th cent.
WOOD, Lewis John
British, 1813-1901
WOOD, Matthew
British, c.1813-1855
WOOD, Robert
American, 20th cent.
WOOD, Samuel Peploe
British, -1872
WOOD, Starr
British, 1870-
WOOD, Thomas Peploe
British, 1817-1845
WOOD, Thomas Waterman
American, 1823-1903
WOOD, Thomas William
British, op.1855-1872
WOOD, William
British, op.1674
WOOD, William
British, c.1768-1809
WOOD, William Thomas
British, 1877-1958
WOODALL, William
British, op.1773-1787
WOODBURY, Charles
Herbert
American, 1864-1940
WOODCOCK, Percy
Franklin
Canadian, 1855-1936
WOODCOCK, Robert
British, c.1691-1728
WOODFORDE, Samuel
British, 1763-1817
WOODHOUSE, Basil
British, 20th cent.
WOODHOUSE, John Thomas
British, c.1780-1845
WOODHOUSE, William
British, 1857-1939
WOODIN, Samuel
British, op.1798-1843
WOODMAN, Charles
Henry
British, 1823-1888
WOODMAN, Richard
British, 1784-1859
WOODNER, Ian
American, 20th cent.
WOODROFFE, A.
British, op.c.1820
WOODROFFE, Paul
British, 20th cent.
WOODS, Henry
British, 1846-1921
WOODSIDE, John
Archibald
American, 1781-1852
WOODVILLE, Richard
Caton, I
American, 1825-1855
WOODVILLE, Richard
Caton, II
British, 1856-1926

WOODWARD, George
Moutard
British, c.1760-1809
WOODWARD, Mabel May
American, 1877-
WOODWARD, Thomas
British, 1801-1852
WOODWELL, Joseph R.
American, 1843-1911
WOODYEAR
British, op.1768
WOOLASTON
see Wollaston
WOOLF, Samuel Johnson
American, 1880-1948
WOLLARD, Dorothy E.G.
British, op.c.1910-1955
WOOLLASTON, Mountford
Tosswill
New Zealand, 1910-
WOLLETT, H.C.
British, 19th cent.
WOOLLETT, Henry A.
British, op.1857-1873
WOOLLETT, I.
American, op.c.1830
WOOLLETT, William
British, 1735-1785
WOOLLEY, Harry
British, 20th cent.
WOOLLEY, W.
British, op.1773-1791
WOOLMER, Alfred
Joseph
British, 1805-1892
WOOLNOTH, Thomas A.
British, 1785-p.1836
WOORT, Michiel van der
see Voort
WOOTTON, John
British, c.1686-1765
WOPFNER, Joseph
German, 1843-1927
WORDSWORTH, Dorothy
see Quillinan
WORES, Theodore
American, 1860-
WORIOT, Pierre, II
see Woeiriot
WORKMAN, Harold
British, 1897-
WORLIDGE, Thomas
British, 1700-1766
WORMS, Jules
French, 1832-1914
WORMS, Roger
French, 1907-
WOROBJEFF, Maxim
Nikiforowitsch
Russian, 1787-1855
WORONA, Aleksandr
Russian, 20th cent.
WORONICHIN, Andry
Nikiforowitsch
Russian, 1759-1814
WORRALL
British, op.1840
WORRALL, Mike
British, 1942-
WORRELL, Abraham
Bruinings or Bruiningh
van
Dutch, 1787-p.1823
WORSCAMP
see Vortcamp
WORSDALE, James
British, c.1692-1767

WORSEY, Thomas
British, 1829-1875
WORST, Jan
Dutch, op.c.1645-1655
WORTELMANS or
Ortelmans, Damiaen, I
Netherlands,
op.1545-1589
WORTH, Leslie Charles
British, 1923-
WORTH, Thomas
American, 1834-1917
WORTHINGTON, Robert
British, 1878-1945
WORTHINGTON, Thomas
Locke
British, 1826-1909
WORTHINGTON, William
Henry
British, c.1790-p.1839
WORTON, J.
British, 19th cent.
WOTKE, Manfred
German, 20th cent.
WOTRUBA, Fritz
German, 1907-
WOU, Claes Claesz.
Dutch, c.1592-1665
WOUDT or Wout, Jan
Cornelisz. van or
Jan Cornelisz.
Woudanus
Dutch, c.1570-1615
WOU-KI, Zao
French, 1920-
WOUTERMAERTENS,
Edouard
French, 1819-1897
WOUTERS, Augustinus
Jacobus Bernardus
Dutch, 1829-1904
WOUTERS, Charles
Augustin
see Wauters
WOUTERS, Constant
see Wauters
WOUTERS, Franchoys
or Frans
Flemish, 1612-1659/60
WOUTERS, Gomar
Flemish,
c.1649(1658?)-p.1696
WOUTERS, Jan
see Woutersz.
WOUTERS, Rik
Belgian, 1882-1916
WOUTERS, Wilhelmus
Hendrikus Marie (Wilm)
Dutch, 1887-1957
WOUTERSIN, L.F.
Dutch, op.1630
WOUTERSZ, Wouters or
Woutersen, Jan (Stap)
Dutch, 1599(?)-1663(?)
WOUTIERS, Charles
see Wautier
WOUTIERS or Wautier,
Michaelina
Flemish, op.1643-1652
WOUWERMAN or
Wouwermans, Jan
Pauwelsz
Dutch, 1629-1666
WOUWERMAN or Wouwermans,
Philips Pauwelsz.
Dutch, 1619-1668

WOUWERMAN or
Wouwermans, Pieter
Pauwelsz.
Dutch, 1623-1682
WRAGG, Gary
British, 1946-
WRANGEL, (Wrangel
von Brehmer) Hans
Jurgen (Jurgen)
Swedish, 1881-
WRANKMORE, C.
British, 19th cent.
WRAY, A.
British, 19th cent.
WRAY or Wrey, Sir
Bouchier
British, -1784
WRIGHT
British, op.1790
WRIGHT, Andrew
British, -1543
WRIGHT, Christopher
British, 1945-
WRIGHT, Ethel
British, op.1893-1898
WRIGHT, Ferdinand von
Swedish, 1822-1906
WRIGHT, George
British, 1860-1942
WRIGHT, George
American, op.1881-1885
WRIGHT, George Hand
American, 1872-1951
WRIGHT, Gilbert S.
British, op.1896
WRIGHT, H. ('Stuff')
British, 19th cent.
WRIGHT, H.C.S.
British, 19th cent.
WRIGHT, James Henry
American, 1813-1883
WRIGHT, John
British, c.1745-1820
WRIGHT, John Massey
British, 1777-1866
WRIGHT, John Michael
British, c.1623-1700
WRIGHT, John William
British, 1802-1848
WRIGHT, Joseph
(Wright of Derby)
British, 1734-1797
WRIGHT, Joseph
American, 1756-1793
WRIGHT, Magnus von
Scandinavian, 1805-1868
WRIGHT, Peter
British, 20th cent.
WRIGHT, Priscilla
British, 18th cent.
WRIGHT, R.
American, op.1801
WRIGHT, Richard
(Wright of Liverpool)
British, c.1730-c.1774
WRIGHT, Richard Henry
British, 1857-1930
WRIGHT, Robert W.
British, op.1871-1906
WRIGHT, Rufus
American, 1832-p.1875
WRIGHT, T.
British, op.1801-1842
WRIGHT, Thomas
British, op.1750-1790

WRIGHT, Thomas
British, op.1845
WRIGHTSON, J.
British, op.1854-m.1865
WRIOTHESELY, Sir
Thomas
British, -1534
WRITS, Willem
Dutch, 1734-1786
WRUBEL, Michael
Alexandrovitsch
Russian, 1856-1910
WTEWAEL, Wtenwael or
Wttewael
see Uytewael
WTTENBROUCK, Moyses
van
see Uyttenbroeck
WUCHTERS, Abraham
Dutch, c.1610-1682
WUEST or Wüst, Johann
Heinrich (Heinrich)
Swiss, 1741-1821
WUEST or Wiest,
Johann Leonhard
German, c.1665-1735
WUESTER, Adolf
German, 1888-
WUILLERET, Pierre
Swiss, c.1580-1643
WULCOB, Henri de
see Vulcop
WULFF, Nicolaj
see Wolff
WULFFAERT, Adrianus
Belgian, 1804-1873
WÜLFING, Sulamith
German, 1901-
WULFRAET or Wolfraet,
Margaretha
Dutch, 1678-p.1741
WULFRAET or Wolfraet,
Mathijs
Dutch, 1648-1727
WUNDERLICH, Carl
Gustav
German, 1809-1882
WUNDERLICH, Paul
German, 1927-
WUNDERLICH, Sonia
German, 20th cent.
WUNDERWALD, A.
German, 19th cent.
WUNDERWALD, Gustav
German, 1882-1945
WÜNNENBERG, Carl
German, 1850-1929
WÜRALT, Edward
Russian, 1898-
WÜRBEL, Franz Theodor
German, 1858-
WÜRBS, Carl
Polish, 1807-1876
WURM, Hans
German, op.1501-1520
WÜRSCH, Johan Melchior
Joseph
see Wyrsch
WÜRTENBERGER, Ernst
Swiss, 1868-1924
WURZELBAUER, Wurtzlbaur
or Wurtzbauer, Benedikt
German, 1548-1620

WURZER, Wutzer or
Wuzer, Johann
Matthias (Matthias)
German, op.1710
WÜSTEN, Johannes
German, 1896-1943
WUSTLICH, Otto
German, 1819-1886
WUTKY, Michael
German, 1739-1823
WUTTKE, Carl
German, 1849-1927
WUTZER, Matthias
see Wurzer
WYANT, Alexander H.
American, 1836-1892
WYATT, Benjamin Dean
British, 1775-1850
WYATT, Henry
British, 1794-1840
WYATT, Matthew Cotes
British, 1777-1862
WYATVILLE, Sir Jeffrey
British, 1766-1840
WYBURD, Francis John
British, 1826-
WYCK, A. van
Dutch, op.1712
WYCK, H.J. van der
German, op.1819-1827
WYCK, J.P. van
Dutch, op.1651
WYCK, Jan or John
Dutch, c.1640-1700
WIJCK, Thomas
Dutch, c.1616-1677
WYCKAERT, M
Belgian, 1923-
WYCKERSLOOT, Jan van
Dutch, op.1643-1683
WYCZOLKOWSKI, Leon
Polish, 1852-1936
WYDEVELD, Arnoud
American, op.1855-1862
WIJDOOGEN, N.M.
Dutch, op.c.1830-1850
WYDYTZ, Hans, II
see Weiditz
WIJEN, Jacques van der
see Wyhen
WYETH, Andrew Newell
American, 1917-
WYETH, James
American, 1947-
WYETH, Newell Convers
American, 1882-1945
WYETH, Paul James
Logan
British, 1920-
WYHEN or Wijen, Jacques
van der
Dutch, c.1588-p.1638
WYK, Henry van
Dutch, 1833-
WYL, Weyl, Wil
or Wyel
Swiss, 1586-1619/21
WYLD, William
British, 1806-1889
WYLDMAN, Thomas
British, op.1801
WYLIE, Robert
British, 1839-1877
WYLIE, Theophilus Adam
American, 1810-1895

WYLLEMS, Winolt
see Willems
WYLLIE, Charles
William
British, 1853-1923
WYLLIE, Harold
British, 1880-
WYLLIE, William Lionel
British, 1851-1931
WYMAN, Lance
American(?) 20th cent.
WYMER, R.
British, 19th cent.
WIJNANDS or Wijnantz,
Augustus
Dutch, 1795-c.1848
WIJNANTS or Wynants,
Jan
Dutch, op.1643-m.1684
WIJNANTZ, Augustus
see Wijnands
WYNDHAM, Richard
British, 1896-
WYNEN, Dominicus van
(Ascanius)
Dutch, 1661-p.1690
WYNFIELD, David
Wilkie
British, 1837-1887
WYNFYIS, E.
Netherlands, op.1625
WYNGAERDE, Antonius
van den (Antonio de
Bruxelas or Antonio
de las Viñas)
Netherlands, op.1510-1572
WYNGAERDE, Franz van
den
Flemish, 1614-1679
WIJNGAERDT, Anthonie
Jacobus van
Dutch, 1808-1887
WIJNGAERDT, Petrus
Theodorus
Dutch, 1816-1893
WYN-HAWKER, Gareth
British, 20th cent.
WYNN, John Arthur
British, 19th cent.
WYNNE, Mrs. H.
British, op.1797
WYNRICH, or Winrich
von Wesel, Herman
German, c.1378-c.1413
WYNTER, Bryan
British, 1915-
WYNTGIS, Eevert
Netherlands, op.c.1600
WIJNTRACK or Wijntrak,
Dirck
Dutch, a.1625-1678
WIJNVELD, Barend
Dutch, 1820-1902
WYRSCH or Würsch,
Johann Melchior
Joseph
Swiss, 1732-1798
WYSARD or Wisard,
Gottlieb Emanuel
Swiss, 1787-1837
WIJSBRACH, W.
Dutch(?) 17th cent.
WYSE, Henry Taylor
British, 1870-1951
WIJSMULLER, Jan
Hillebrand
Dutch, 1855-1925

WYSOCKI, Charles
American, 20th cent.
WYSPOANSKI, Stanislas
Polish, 1869-1907
WYSS, Caspar Leontius
Swiss, c.1762-1798
WYSSENBACH, Rudolf
Swiss, op.1545-1560
WYSSHAUPT, Wishaupt
or Wesshaupt, Hans
Jakob
Swiss, op.1612-1687
WIJTMANS, Mattheus
Dutch, c.1650(?)-c.1689
WYTSMAN, Rodolphe
Belgian, 1860-1927
WYWIORSKI, Michal
Polish, 1861-1926

X

XANTEN, Ludige von
German, op.1570
XANTO-AVELLI,
Francesco (Fra
Xanto, Rovigo da
Urbino)
Italian, op.1530-1542
XAVERIJ, Franciscus
Xaverius
Dutch, 1740-p.1770
XAVERY, Gerard Joseph
Flemish, op.1729-1741
XAVERIJ, Jacobus
Dutch, 1736-p.1769
XAVERY, Saveri or
Savery, Jan Baptist
Flemish, 1697-1742
XAVIER, Francisco
Portuguese, op.c.1775
XELL, Georg
see Gsell
XELLER, Johann
Christian (Christian)
German, 1784-1872
XENAKIS, Kosmas
Greek, 20th cent.
XHROUET, Matthieu
Flemish, op.1731
XIMENES, Coelestis
Auctor
German, op.1697-m.1704
XIMENEZ, Francisco
Spanish, op.1510-1511
XIMENEZ, Miguel
Spanish, op.1466-m.1505
XIMENO, Raphael y
Planes
Spanish, 1759-1802
XNEREB, A.
Italian, op.1768
XUAREZ, José
see Juarez
XUAREZ, Juan
Rodriguez
see Juarez

Y

YAKADUNA
Australian, op.1804
YAKOULOV, Georges
see Jakoulov

YAKOVLEV, Alexander
Yevgenevitch
see Jakovlev
YALE, Linus
American, 1821-1868
YAMPOLSKY, Mariana
Mexican, 1925-
YAÑEZ, Ferrando or
Hernando (Ferrando
de Almendina; Ferando
Spagnolo?)
Spanish, op.1504(?)-1526
YANKEL, Jacques
(Kikoine)
French, 1920-
YARNOLD, George B.
British, op.1876
YAROSHENKO, Nicolai
Alexandrovitch
see Jaroshenko
YARWOOD, Walter Hawley
Canadian, 1917-
YATE, George
British, op.c.1617-1622
YATES, Cullen
American, 1866-1945
YATES, G.
British, op.1825-1837
YATES, Thomas
British, op.1750-1796
YATES, William Henry
American, 1845-1934
YATON, W.
British, 19th cent.
YEAGER, Joseph
American, c.1792-1859
YEAMES, William
Frederick
British, 1835-1918
YEATS, Jack Butler
British, 1871-1957
YEATS, John Butler
British, 1839-1922
YEATS, William
Butler
British, 1865-1939
YEGOROV, Alexej
Jegorowitsch
see Jegoroff
YEKTAI, Manoucher
American, 1922-
YELLOWLEES, William
British, 1796-1856(?)
YEO, Richard
British, 1720-1779
YEOMANS, T.
British, op.1834-1851
YEPES, Tomas
Spanish, 1600-1674
YHAP, Laetitia
British, 20th cent.
YK, Abraham van der
see Eyk
YKENS, Eyckens or
Ijkens, Catharina
Flemish, 1659-p.1688
YKENS, Eyckens or
Ijkens, Frans
Flemish, 1601-c.1693
YKENS or Ijkens, Jan
Pieter
Flemish, 1673-p.1701
YKENS, Eyckens or
Ijkens
Flemish, 1682-p.1718
YKENS, Eyckens or
Ijkens, Pieter
Flemish, 1648-1695

YNSCH, Antonio
Gonzalez Ruiz
see Gonzalez Ruiz
YNZA, Joaquin X.
see Inza
YOHN, Frederick
Coffay
American, 1875-1933
YOLI, Antonio
see Joli
YON, Albert
French, 20th cent.
YON, Edmond Charles
French, 1836-1897
YORK, William Hoard
British, op.1858-1903
YORKE, Eliot
British, op.1830
YORKE, Admiral Sir
Joseph Sydney
British, op.1798
YORKE, William H.
American, op.1870-1884
YOSHIDA, Ray
American, 20th cent.
YOUNG, Alexander
British, op.1917
YOUNG, Blamire
Australian, 1862-1935
YOUNG, Brian
British, 1934-
YOUNG, Edward
British, 1823-1882
YOUNG, Eileen
British, 20th cent.
YOUNG, H.
British, op.1832
YOUNG, Harvey
American, 1840-1901
YOUNG, J. Crawford
Canadian, 19th cent.
YOUNG, J.T.
British, op.1811-1822
YOUNG, James
British, op.1755
YOUNG, John
British, 1755-1825
YOUNG, Mahonri
American, 1877-1957
YOUNG, Peter
American, 1940-
YOUNG, Robert
American, 1938-
YOUNG, Thomas
American, op.1817-1840
YOUNG of Southampton,
Tobias
British, -1824
YOUNG, Tobias
American, op.c.1824
YOUNG, Webb
American, 20th cent.
YOUNG, William Weston
British, op.1795-m.c.1838
YOUNGERMAN, Jack
American, 1926-
YOUNGMAN, John
Mallows
British, 1817-1899
YOUNGMAN, Nan
British, 1906-
YPERMAN, Louis Joseph
Belgian, 1856-
YPRES, John Richard
Lowndes French,
Viscount
British, 1881-

YRIARTE, Charles
French, 1832-1898
YSENBRANT or Ysenbaert,
Adriaen
see Isenbrant
YSENDYCK, Antoon van
Belgian, 1801-1875
YSSELSTEIN, Essesteyn
or Isselsteyn,
Adrianus (van)
Dutch, op.1653-m.1684
YSSELSTEIN or
Isselsteyn, G. van
Flemish, 17th cent.
YULE, William J.
British, 1869-1900
YUNKERS, Adja
American, 1900-
YUON, Konstantin
Fjodorovitch
see Juon
YVARAL, Jean-Pierre
Vasarely
French, 1934-
YVON, Adolphe
French, 1817-1893

Z

ZAAGMOLEN, Martinus
see Saagmolen
ZABALETA, Rafael
Spanish, 1907
ZABARELLI, Adriano,
(Il Paladino or
Palladino)
Italian, 1610-1680
ZABOLOTSKI, P.
Russian, 18th cent.
ZACCAGNA or
Zaccagnini, Turpino
Italian, -1542
ZACCHETTI, Bernardino
Italian, op.1510-1523
ZACCHIA di Antonio da
Vezzano
(Zacchia il Vecchio
or Paolo Zacchia)
Italian, op.1520-m.c.1561
ZACCHIA da Lucca,
Lorenzo (Zacchia il
Giovane)
Italian, 1524-p.1587
ZACHARIAS van Alkmaar
see Paulusz., Zacharias
ZÄCHENBERGER, Joseph
German, 1732-1802
ZACHO, Peter Morch
Christian (Christian)
Danish, 1843-1913
ZACHTLEVEN
see Saftleven
ZACK, Léon
French, 1892-
ZADKINE, Ossip
Russian, 1890-1967
ZADOK, Ribi
British(?) 18th cent.
ZADOVECHI, M.J.
Italian, op.1870
ZAEGMOLEN, Martinus
see Saagmolen
ZAEN, Egidius
(Gilles) de or van
see Saen

ZAENREDAM
see Saenredam
ZAFFONI
see Calderari,
Giovanni Maria
ZAGANELLI di Bosio,
Bernardino (Bernardino
da Cotignola)
Italian, c.1460/70-1510/12
ZAGANELLI di Bosio,
Francesco (Francesco
da Cotignola)
Italian, 1470/80-1531
ZAGIO, Lucano
see Sagio
ZAGO, Luigi
Italian, 1894-
ZAHN, Friedrich
German, 1828-
ZAHND, Johann
Swiss, 1854-1934
ZAHRA, Francisco
Italian, c.1680-c.1760
ZAHRADNICZEK, Joseph
German, 1813-1844
ZAHRTMANN, Peder Henrik
Kristian (Kristian)
Danish, 1843-1917
ZAIS, Giuseppe
Italian, 1709-1784
ZAISINGER, Matthaus
see Zasinger
ZAJICEK, Karl Josef
Richard
German, 1879-
ZAK, Eugène
Polish, 1884-1926
ZAK, Lev Vasilievich
Russian, 1892-
ZAKANYCH, Robert
American, 1935-
ZAKARIAN, Zacharie
Turkish, 19th cent.
ZAKHARCHUK, Alexei
Nicolaevich
Russian, 1929-
ZAKHAROV, Feodor
American, 20th cent.
ZAKHAROV, Piotr
Sakharovitch
see Sakharov
ZAKRZEWSKI, Wlodimierz
Polish, 1916-
ZALCE, Alfredo
Mexican, 1908-
ZALESAK, Frantisek
Czech, 20th cent.
ZALESKI, Marcin
Polish, 1796-1877
ZALONE, Benedetto
Italian, op.c.1650
ZAMACOIS y Zabala,
Eduardo
Spanish, 1842-1871
ZAMBECCARI, Francesco
Italian, op.1804
ZAMBELLETTI, Lodovico
Italian, 1881-
ZAMBONI
see Cremonini,
Giovanni Battista
ZAMBONI, Angelo
Italian, 1895-1939
ZAMBONO
see Bono, Michele
di Taddeo

ZAMBRANO, Juan Luis
Spanish, op.1590-m.1639
ZAMOLO, Francesco
Italian, 17th cent.
ZAMORA, José de
Spanish, 20th cent.
ZAMOS, E.
Spanish, op.c.1883
ZAMPA, Giacomo
Italian, 1731-1808
ZAMPA, Luigi
Italian, op.c.1810-1813
ZAMPIERI, Domenico
see Domenichino
ZAMPIGHI, Eugenio
Italian, 1859-
ZAMPIS, Anton
German, 1820-1883
ZAMPOLINI, Giacomo
Italian, op.1488
ZAN, Bernhard
German, op.c.1580
ZANARTU, Enrique
Chilean, 1921-
ZANCANARO, Tono
Italian, 1906-
ZANCARLI, Polifilo
see Giancarli
ZANCHI, Antonio
Italian, 1631-1722
ZANCHI, Giuseppe
Italian, -1750
ZANDE, Jan van de
see Sande
ZANDLEVEN, Jan Adam
Dutch, 1868-1923
ZANDOMENEGHI, Federico
Italian, 1841-1917
ZANDT, William Van
American, 19th cent.
ZANELLA, Zanelli or
Zanello, Francesco
Italian, op.1671-1717
ZANELLA, S.
Italian, 20th cent.
ZANELLO da Bologna,
Giovanni
Italian, op.1276
ZANNERIO, C.
Italian, 20th cent.
ZANETTI, Conte Antonio
Maria, I
Italian, 1680-1757
ZANETTI, Antonio
Maria, II (Zanetti Giovane)
Italian, 1706-1778
ZANETTI, Davide
see Zanotti
ZANETTI, Domenico
Italian, op.1694-1712
ZANETTI, Giuseppe
Italian, op.c.1750
ZANETTI-MITI, Giuseppe
Italian, 1860/3-
ZANETTI-ZILLA, Wettore
Italian, 1864-
ZANFURNARI, Emmanuel
see Tsanfurnari
ZANG, J.J.
American, op.1870
ZANGS, Herbert
German, 1924-
ZANGUIDI
see Bertoja, Jacopo
ZANIMBERTI or
Zaniberti, Filippo
Italian, 1585-1636

ZANIN or Zannin,
Francesco
Italian, 19th cent.
ZANINO di Pietro
Italian, 15th cent.
ZANNICHELLI, Prospero
Italian, 1698-1772
ZANNINO di Pietro
da Venezia
see Giovannino
ZANOLETTI, Carlo
Italian, 20th cent.
ZANOLI, Alessandro
Italian, 19th cent.
ZANONI, Andrea
Italian, 1669-p.1718
ZANOTTI di Ascoli
Piceno, Calisto
Cavazzoni
Italian, 1825-1857
ZANOTTI or Zanetti,
Davide
Italian, -1808
ZANOTTI, Giampietro
Cavazzoni
Italian, 1674-1765
ZANTWOORT
see Santvoort
ZANUSI or Zanussi,
Jakob or Jacopo
German(?) 1700-1755
ZAORTIGA, Bonanat
Spanish, op.1403-1440
ZAO WOU-KI
French, 1920-
ZAPPI, Lavinia
see Fontana
ZAPPONI, Giovanni
Domenico
Italian, op.1602-1617
ZARA, Petrus
Italian, 18th cent.
ZARAGA, Angel
South American, 1886-1946
ZARAGOZA, Lorenzo
Spanish, op.1366-1395
ZARATE, Ortiz
Spanish, 20th cent.
ZAREMBSKI, M
Polish, 19th cent.
ZARETSKY, Andrei
Andreievitch
Russian, 1864-
ZARIANKO, Sergei
Konstantinovitch
Russian, 1818-1870
ZARINENA, Saranena,
Saranyena, Sarinena or
Sarnyena, Cristobal
Spanish, -1622
ZARINENA, Francisco
Spanish, 1550-1624
ZARINENA, Juan
Spanish, op.1596-m.1634
ZARITSKY, Joseph
Israeli, 1891-
ZAROTTI, Giovan Pietro
Italian, op.c.1475-1502
ZARRAGA, Angel
Mexican, 1886-1946
ZASCHE, Franz
German, 19th cent.
ZASCHE, Theo
German, 1862-1922
ZASINGER, Zaisinger,
Zayssinger or Zeissinge,
Matthäus (Mathes)
German, c.1477-p.1555

ZATTA, Antonio
 Italian, 18th cent.
ZATZKA, Hans
 German, 1859-
ZAUFFALY or Zauphaly,
 John
 see Zoffany
ZAVATTARI or Zavatari,
 Cristoforo
 Italian, op.1404-1453
ZAVATTARI or Zavatari,
 Francesco
 Italian, op.1417-1453
ZAVERIO, Gaetano
 Italian, op.1796
ZAWISKI, Edouard
 French, 19th cent.
ZAYSSINGER, Matthäus
 see Zasinger
ZBINDEN, Ellis
 Swiss, 20th cent.
ZBINDEN, Emil
 Swiss, 1929-
ZDANEVICH, Kyril
 Russian, 19th cent.
ZEBO da Firenze
 Italian, 15th cent.
ZECCHIA, Vittorio
 Italian, 1878-1947
ZECHENDER, Carl
 see Zehender
ZECHETMAIR or
 Zechetmayer, Thomas
 German, op.c.1572-m.1613
ZECHOWSKI, Stefan
 Polish, 1912-
ZEEGELAER, Gerrit
 see Zegelaar
ZEELANDER, Pieter de
 (Kaper)
 Dutch, op.1647-1648
ZEELARE, Vincent
 see Sellaer
ZEEMAN, Abraham
 Dutch, c.1695/6-1754
ZEEMAN, Enoch
 see Seeman
ZEEMAN or Seeman,
 Reinier, Regnier
 Remigius or Remy
 (Reinier Nooms)
 Dutch, c.1623-1667
ZEEMANS, P.
 German, 17th cent.
ZEETMAYER, Johann
 see Zehetmayer
ZEEU or Zeeuw,
 Cornelis de
 Dutch, op.1558-1570
ZEFFIRELLI, Franco
 Italian, 20th cent.
ZEGELAAR or Zeegelaer,
 Gerrit
 Dutch, 1719-1794
ZEGGEN, Max Joseph
 German, op.1728
ZEGHERS or Zegers
 see Seghers
ZEHENDER or Zechender,
 Carl
 Swiss, 1751-1814
ZEHENDER or Zehnter,
 Johann Caspar
 German, 1742-1805
ZEHENDER, Matthäus
 German, 1641-1697(?)
ZEHETMAYER, Zeetmayer
 or Zettmayer, Johann
 German, 1638-1721

ZEHME, Werner
 German, 1859-
ZEILLER, Franz Anton
 German, 1716-1793
ZEILLER, Johann Jakob
 German, 1708-1783
ZEINER, Lukas (Lux)
 Swiss, c.1450-a.1519
ZEINER, Peter
 Swiss, 1464-1510
ZEISENIS, Georg
 German, 18th cent.
ZEISEG, Johann
 Eleazar
 see Schenau
ZEISSINGE, Matthäus
 see Zasinger
ZEITBLOM or Zeytblum,
 Bartholome
 German, 1455/60-1518/22
ZEITTER, John Christian
 British, op.1824-m.1862
ZEKVELD, Jacob
 Dutch, 1945-
ZELECHOWSKI, Kaspar
 Polish, 1863-
ZELEK, Bronislaw
 Polish, 20th cent.
ZELGER, Jakob Joseph
 (Joseph)
 Swiss, 1812-1885
ZELIFF, A.E.
 American, op.c.1850
ZELL, Johann Michael
 German, 1740-1815
ZELLAER, Vincent
 see Sellaer
ZELLENBERG, Franz
 Zeller von
 German, 1805-1876
ZELLER, Franz Anton
 (Anton)
 German, 1760-c.1837
ZELLER, Magnus
 German, 1888-
ZELLI, Costantino
 Italian, op.1501-1517
ZELOTTI, Giambattista
 (Battista Farinato,
 Battista de Verona)
 Italian, c.1526-1578
ZELVEN, van
 Netherlands, op.1605
ZEMITIS, Jan Karlovich
 Russian, 1940-
ZENALE, Bernardo
 (Bernardino)
 Italian, c.1436-1526
ZENDEL, Gabriel
 French, 1906-
ZENDER, Rudolf
 Swiss, 1901-
ZENISEK, Frantisck
 (Franz)
 Czech, 1849-1916
ZENKER, Josef
 German, 1832-1907
ZENON Veronese
 Italian, 1484-c.1550
ZEPP, Christian
 German, -1809
ZEPTER, Dagmar
 German, 20th cent.
ZERBE, Karl
 American, 1903-
ZERBE, Max
 German, 1903-

ZERLACHER, Ferdinand
 Matthias
 German, 1877-1923
ZERMATI, Jules
 French, 19th cent.
ZETSCHE, Eduard
 German, 1844-1927
ZETTMAYER, Johann
 see Zehetmayer
ZEUNER, Jonas
 Dutch, 1724-1814
ZEUS
 Italian, 18th cent.
ZEVIO, Stefano da
 see Stefano di
 Giovanni da Verona
ZEWY, Karl
 German, 1855-1929
ZEYL, Roelof van
 see Zijl
ZEYSSNECKER, Jakob
 see Seisenegger
ZEYTBLUM, Bartholome
 see Zeitblom
ZEZZOS, Alessandro
 Italian, 1848-1914
ZGLINICKI, Friedrich
 Pruss von
 German, 19th cent.
ZICHY, Mihaly
 (Michael von)
 Hungarian, 1827-1906
ZICK, Alexander
 German, 1845-1907
ZICK, Conrad
 German, 1773-1836
ZICK, Gustav
 German, 1809-1886
ZICK or Zickh, Johann
 German, 1702-1762
ZICK, Johann Rosso
 Januarius
 (Januarius)
 German, 1730-1797
ZIEBLAND, Hermann
 German, 1853-1896
ZIEGER von Laachen
 German, op.1763
ZIEGLER, Andreas
 German, 1815-1893
ZIEGLER, Archibald
 British, 1903-
ZIEGLER, Christian
 von
 Swiss, 18th cent.
ZIEGLER, Daniel
 Swiss, 1716-1806
ZIEGLER, Heinrich
 Jakob
 Swiss, 1888-
ZIEGLER, Henry Bryan
 British, 1798-1874
ZIEGLER, Jakob
 German, op.1559-1597
ZIEGLER, Jakob
 Swiss, 1823-1856
ZIEGLER, Jerg or
 Wilhelm
 see Master of
 Messkirch
ZIEGLER, Johann
 German, c.1750-c.1812
ZIEGLER, Josef
 German, 1785-1852
ZIEGLER, Jules Claude
 French, 1804-1856
ZIEGLER, Karl
 German, 1866-p.1935
ZIEGLER, L.
 Swiss, 18th cent.

ZIEGLER, Richard
 German, 1891-
ZIEGLER, Rodolphe
 German, op.1634-1682
ZIEGLER, Zdenek
 Czech, 20th cent.
ZIELER, Mogens
 Danish, 1905-
ZIEM, Félix François
 Georges Philibert
 French, 1821-1911
ZIER, Edouard
 French, 1856-1924
ZIESEL, Georg Frederik
 Flemish, 1756-1809
ZIENSENIS or Zisenis,
 Johann Georg
 Danish, 1716-1776
ZIETTER, F.C.
 British, 19th cent.
ZIFRONDI, Antonio
 see Cifrondi
ZIG
 French, 20th cent.
ZIGAINA, Giuseppe
 Italian, 1924-
ZILBERTO da Milano,
 Giovanni Antonio
 Italian, op.1445
ZILCKEN, Charles Louis
 Philippe (Philip)
 Dutch, 1857-1930
ZILLE, Heinrich
 German, 1858-1929
ZILOTTI, Don Bernardo
 Italian, c.1730-1780/95
ZIMENGOLI, Paolo
 Italian, op.1717-m.1720
ZIMMER, Frans Xaver
 German, 1821-1883
ZIMMER, Wilhelm Carl
 August
 German, 1853-1937
ZIMMERMAN, August Richard
 (Richard)
 German, 1820-1875
ZIMMERMAN, Jacques
 French, 20th cent.
ZIMMERMANN, Adolf
 Gottlob
 German, 1799-1859
ZIMMERMANN, August
 Albert
 German, 1808-1888
ZIMMERMANN, August
 Maximilian (Max)
 German, 1811-1878
ZIMMERMANN, Carl
 German, 1863-1930
ZIMMERMANN, Carl Friedrich
 German, 1796-1820
ZIMMERMANN, Catharina
 Swiss, 1756-1781
ZIMMERMANN, Christoph
 German, op.1590-m.1639
ZIMMERMANN, Dominikus
 German, 1685-1766
ZIMMERMANN, Ernst Carl
 Georg
 German, 1852-1901
ZIMMERMANN, Friedrich
 (Frédéric)
 Swiss, 1823-1884
ZIMMERMANN or
 Czymermann
 (Carpentarius), Hans
 Polish, op.1496-1532
ZIMMERMANN, Johann
 Baptist
 German, 1680-1758

ZIMMERMANN, Joseph
Anton
German, 1705-1797
ZIMMERMANN, Julius
German, 1824-1906
ZIMMERMANN, Mac
German, 1912-
ZIMMERMANN, Reinhard
Sebastian
German, 1815-1893
ZIMMERMANN, Rene
German, 20th cent.
ZINCK, Mathis
see Zundt
ZINCKE or Zink,
Christian Friedrich
German, 1685-1767
ZINCKE, Zinck or
Zink, Paul Christian
German, 1687-1770
ZINGARO, Lo
see Solario, Antonio
ZINGG or Zink, Adrian
Swiss, 1734-1816
ZINGG, Jules Emile
French, 1882-1942
ZINGONI, Aurelio
Italian, 1853-1922
ZINKE, Johann Wenzel
German, 1797-1858
ZINKEISEN, Anna
Katrina
British, 1901-
ZINKEISEN, Doris Clare
British, 20th cent.
ZINNÖGGER, Leopold
German, 1811-1872
ZINOVIEV
Russian, 20th cent.
ZINTT, Mathis
see Zundt
ZIPELIUS, Emile
German, 1840-1865
ZIPPA, Giacomo
Francesco
see Cipper
ZIRALDI, Guglielmo di
see Giraldi
ZISENSIS, Johann Georg
see Ziesenis
ZITMAN, Cornelis
Jacominus
Dutch, 1926-
ZITTOZ, Miguel
see Sittow
ZITZEWITZ, Augusta
von
German, 1880-1960
ZIVANOVIC, Radojica
Noe
Yugoslav, 1903-1944
ZIVERI, Alberto
Italian, 1908-
ZIX, Benjamin
German, 1772-1811
ZMURKO, Franciszek
Polish, 1859-1910
ZO, Henri
French, 1873-1933
ZOAN ANDREA
(Andrea di Mantova,
Guadagnino)
Italian, op.1475-1505
ZOBEL, Benjamin
German, 1762-1831
ZOBEL, Franz Xaver
Polish, op.1779-1780
ZOBEL, George J.
British, 1810-1881

ZOBOLE, Ernest
British, 20th cent.
ZOBOLI, Jacopo
Italian, 1681-1767
ZOCCHI, Giuseppe
Italian, 1711-1767
ZOCCHI, Guglielmo
Italian, 1874-
ZOCCOLO or Zoccoli,
Carlo
Italian, 1717-1771
ZOEST, Gerard
see Soest
ZOETMAN, Lambert, III
see Suavius
ZOFF, Alfred
German, 1852-1927
ZOFFANY, Zauffaly,
Zauphaly, Zoffani,
Johann (John) Joseph
British, 1733-1810
ZOGBAUM, Rufus
Fairchild
American, 1849-1925
ZOGOLOPOULOU, Hélène
Greek, 1909-
ZOGRAF, Zachari
Russian(?) 1810-1853
ZOIA, Krukowskaja
Russian, 1903-
ZOIR, Emil
Swedish, 1867-1936
ZOLA or Zolla,
Giuseppe
Italian, 1672-1743
ZOLL, Kilian Christoffer
Swedish, 1818-1860
ZOLLER, Anton
German, 1695-1768
ZOLLER, Franz Carl
German, 1747-1829
ZOLTOWSKI, Stanislaw
Polish, 1914-
ZOMPIN or Zompini,
Gaetano Gherardo
Italian, 1700-1778
ZON, Jacob Abraham
(Jacques)
Dutch, 1872-1932
ZONA, Antonio
Italian, 1813-1892
ZONCA, Giovanni
Antonio
Italian, 1652-1723
ZONIUS, Hendrik
see Sonnius
ZOPPI, Antonio
Italian, 1860-1926
ZOPPINO, Nicolò
Italian, 16th cent.(?)
ZOPPO, Marco
Italian, 1433-1478
ZOPPO, Paolo
Italian, op.1492-m.1530/38
ZORACH, Marguerite
American, 1888-1968
ZORACH, William
American, 1887-
ZORAN, Antonio
Spanish(?), 20th cent.
ZORG or Zorgh, Hendrik
Martensz.
see Sorgh
ZORN, Anders Leonard
Swedish, 1860-1920
ZORNLIN, Georgiana
Margaretta
British, 1800-1881

ZOTTO, Giovanni
Francesco dal
(da Tolmezzo)
Italian, c.1450-p.1510
ZOX, Larry
American(?) 20th cent.
ZRZAVY, Jan
Czech, 1890-
ZSCHOKKE, Alexander
Swiss, 1894-
ZSISSLY
see Albright
ZSOTER, Laszlo
Hungarian, 20th cent.
ZUAN Fiammengo
Netherlands
op.1516-1526
ZUANE da Murano
see Giovanni da
Alamagna
ZUBER, Jean Henri
French, 1844-1909
ZUBER, Julius
Polish, 1861-
ZUBER-BÜHLER, Fritz
German, 1822-1896
ZUBIAURRE, Ramon de
Spanish, 1882-
ZUBIAURRE, Valentin de
Spanish, 1879-
ZUBLER, Johann Albert
(Albert)
Swiss, 1880-1927
ZUBRICZKY, Lorand
Hungarian, 1869-
ZUCCA, Carlo Antonio
Italian, op.1697
ZUCCARELLI or
Zuccherelli, Francesco
Italian, 1702-1788
ZUCCARI or Zuccaro,
Federico
Italian, 1540-1609
ZUCCARI, Zuccaro or
Zuccheri, Ottaviano
Italian, op.1528-1555
ZUCCARI, Zuccaro or
Zuccheri, Taddeo
Italian, 1529-1566
ZUCCATO or Zuccati,
Sebastiano
Italian, a.1467-1527
ZUCCHERELLI, Francesco
see Zuccarelli
ZUCCHERI, L.
Italian, 20th cent.
ZUCCHI, Antonio
Italian, 1726-1795
ZUCCHI, Francesco
Italian, c.1562-1622
ZUCCHI, Francesco
Italian, 1692-1764
ZUCCHI, Giovanni
Francesco
Italian, op.1531-1547
ZUCCHI, Giuseppe
Italian, 1730-1790
ZUCCHI, Jacopo (del
Zucca)
Italian, c.1541-1589/90
ZUCCHI, Marie Anna
Angelika Katherine
see Kauffmann
ZUCCOLI, Luigi
Italian, 1815-1876
ZUCHO, Agostino
Italian, op.1654

ZUERA or Cuera, Pedro
Spanish, 15th cent.
ZÜGEL, Heinrich von
German, 1850-1941
ZUGEL, Karl
German, op.1863
ZUGN or Zugni,
Francesco
Italian, 1709-1787
ZUHR, Hugo
Swedish, 1895-
ZUKOWSKA, Danuta
Polish, 20th cent.
ZULAWSKI, Marek
Polish, 1908-
ZULIANI, Giuliano
Italian, c.1730-c.1814
ZULIANO, Adolfo
Italian, 16th cent.
ZULOAGA y Zabaleta,
Ignacio
Spanish, 1870-1945
ZÜLOW, Franz von
German, 1883-1963
ZUMBUSCH, Ludwig von
German, 1861-1927
ZÜND, Robert
Swiss, 1827-1909
ZÜNDT, Zinck, Zintt,
Zyndler, Zynndt or
Zynnth, Mathis
(possibly identified
with Master of 1551)
German, 1498(?)-1572
ZUNIGA, Francisco
South American, 20th cent.
ZUNON, Maria Rius
Spanish, 20th cent.
ZUPNICK, Irving
American, 1920-
ZUPPIO, G.
Italian, 18th cent.
ZURBARAN, Francisco de
Spanish, 1598-p.1664
ZURBARAN, Juan
Spanish, 17th cent.
ZÜRCHER, Frederik
Willem
Dutch, 1835-1894
ZURITA or Surita,
José Lorenzo
Venezuelan, 1727-1756
ZURKINDEN, Irene
Swiss, 1909-
ZURLAUBER, Beat Fidele
Swiss, 1720-1799
ZÜRN, Unica
German, -1971
ZURÜQUE(?)
German(?) 18th cent.
ZUSTRIS or Zustrus
see Sustris
ZUTMAN, Lambert, III
see Suavius
ZUYLEN or Suylen,
Hendrick van
Dutch, op.1613-1646
ZVORIKINE, Boris
Russian, 20th cent.
ZWAERDECROON or
Swaerdecroon,
Bernardus
Dutch, c.1617-1654
ZWART, Wilhelmus
Hendrikus Petrus
Johannes (Willem) de
Dutch, 1862-1931

ZWEDEN, Johan Hendrik
van
Dutch, 1896-
ZWEIGLE, Walter
German, 1859-1904
ZWENGAUER, Anton
German, 1810-1884
ZWENGAUER, Anton Georg
German, 1850-1928
ZWERVER, Jan
Dutch, 1907-
ZWIETEN or Swieten,
Cornelis van
Dutch, op.1648-1671

ZWILLER, Marie
Augustin (Auguste)
French, 1850-
ZWINGER, Anna
Felicitas, née
Preissler
German, 1740-1808
ZWINGER, Gustav
Philipp
German, 1779-1819
ZWINTSCHER, Oskar
German, 1870-1914
ZWIRN, Matthias
Swiss, op.1640-1678

ZWOBADA, Jacques
French, 1900-
ZWOLL, Joachim van
see Schwoll
ZWOTT, Zwoller or
Zwoll (Master of the
Shuttle)
German, 15th cent.
ZYGMUNT
see Siegmund
ZYL or Zyll, Gerard
Pietersz. van
Dutch, c.1607-1665

ZIJL, Syl or Zeyl,
Roelof van
Dutch, op.1608-1628
ZYLVELT, Sylevelt or
Sylvelt, Anthony
van
Dutch, c.1640-p.1695
ZYNNDT, Zyndler
or Zynnth,
Mathis
see Zundt
ZYW, Aleksander
Polish, 1905-

337